# The Permanence and Care
of Color Photographs:

## Traditional and Digital Color Prints,
## Color Negatives, Slides, and Motion Pictures

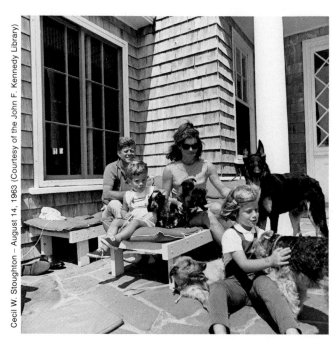

President John F. Kennedy and his family at their summer home on Squaw Island, near Hyannis Port, Massachusetts.

The John Fitzgerald Kennedy Library in Boston, Massachusetts. The Library is administered by the National Archives.

## About the Cover

The photograph of President John Fitzgerald Kennedy, his wife Jacqueline Bouvier Kennedy, and their children Caroline B. Kennedy and John F. Kennedy Jr., on the cover of this book was taken on August 14, 1963 at the Kennedys' summer home on Squaw Island, near Hyannis Port, Massachusetts. The photographer, Cecil W. Stoughton, was an officer in the U.S. Army Signal Corps and served as a White House photographer. The photograph was made with Ektacolor color negative film in a Hasselblad camera.

Allan B. Goodrich, audiovisual archivist at the John Fitzgerald Kennedy Library in Boston, related the following about the picture: "John Jr. was approaching 3 years of age in 1963; Caroline would turn 6 years old in November. The dogs all belonged to the Kennedy family — JFK always liked dogs. The pups were the offspring of Charlie (the dog with Caroline) and Pushinka, which was the dog that Chairman Nikita Khrushchev of the Soviet Union gave to President Kennedy in 1961. John Jr. has his arm draped around Shannon. The shepherd's name was Clipper; the Irish Wolfhound was called Wolf."

On November 22, 1963 — exactly 100 days after this picture was taken — President Kennedy was assassinated in Dallas, Texas while campaigning for re-election.

It was during the 1960's that the historic shift from black-and-white to color photography began in earnest. Kennedy, who was inaugurated in 1961, was the first president to be photographed primarily in color. The Kennedy Library preserves these color photographs in 0°F (–18°C) and 55°F (12.8°C) cold storage vaults that are maintained at 30% relative humidity. When the Kennedy Library opened in 1979, it was the first collecting institution in the world to provide such a facility (see Chapter 20).

The Kodak Ektacolor and Kodacolor-X color negative films in the White House collection at the Kennedy Library have very poor image stability. According to unpublished Kodak data, these films are expected to suffer a 10% loss of density of the least stable image dye in less than 6 years when stored at normal room temperature (see **Table 5.14** on page 204). After President Kennedy's death, the White House color negatives were stored for more than 15 years under non-refrigerated conditions until the Library building was completed in 1979 and the negatives were placed in cold storage.

The photograph on the cover was reproduced from a Kodak Dye Transfer print that was made in 1975 from the original color negative (using an Ektacolor Print Film interpositive). In the course of making the Dye Transfer print, adjustments were made to correct for curve imbalances and loss of contrast in the original negative.

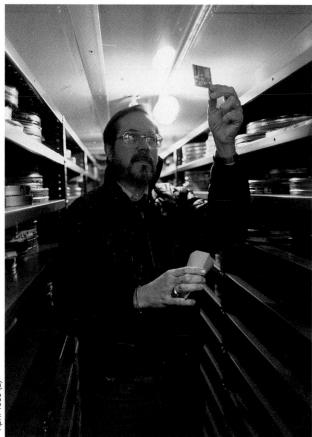

Allan B. Goodrich, audiovisual archivist at the Kennedy Library, in one of the Library's cold storage vaults examining the original color negative from the Kennedy family photograph. Since 1980, this negative and many of the other 18,000 color negatives in the collection have been stored at 55°F (12.8°C) and 30% RH. The Library plans to move the negatives to the 0°F (–18°C), 30% RH vault as soon as an improved image-reference system is implemented.

# The Permanence and Care of Color Photographs:
## Traditional and Digital Color Prints, Color Negatives, Slides, and Motion Pictures

by
## Henry Wilhelm
with contributing author
**Carol Brower**

PRESERVATION PUBLISHING COMPANY

GRINNELL, IOWA

U.S.A

*This book is dedicated to*
*Sarah, David, and Charles Wilhelm,*
*and all the children of the world,*
*past, present, and future . . .*

*Sarah*
*7½ years old*

*David*
*5 years old*

*Charles*
*9½ months old*

First Edition

Library of Congress Cataloging-in-Publication Data:

Wilhelm, Henry Gilmer, 1943–
    The permanence and care of color photographs:
    traditional and digital color prints, color negatives,
    slides, and motion pictures.

    Includes index.
    1. Photographs—Conservation.
2. Moving-picture film—Preservation and storage.
I. Brower, Carol, 1951–            .    II. Title.
TR465.W55    1993 770'.28'384-6921
ISBN 0-911515-00-3 (hardbound)
ISBN 0-911515-01-1 (paperback)

PRESERVATION PUBLISHING COMPANY
719 State Street
P.O. Box 567
Grinnell, Iowa  50112-0567
U.S.A.
Telephone: 515-236-5575
Fax: 515-236-7052

This book was manufactured with alkaline-buffered papers and binders board.

Printed in the United States of America

This book was written and designed with Aldus PageMaker software on Apple Macintosh computers.  Jim Powers, publications art director at Grinnell College, educated the authors about the nuances of PageMaker.  Imagesetter output was supplied by Waddell's Computer Graphic Center in Des Moines, Iowa.  Color separations, black-and-white duotones, printing, and binding were provided by Arcata Graphics Company in Kingsport, Tennessee. Black-and-white lab work was done by the authors, and by The Fine Print and North-Light custom labs in Minneapolis, Minnesota. The index was prepared by Rus Caughron for Carlisle Publishers Services in Dubuque, Iowa.

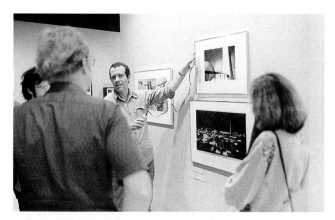 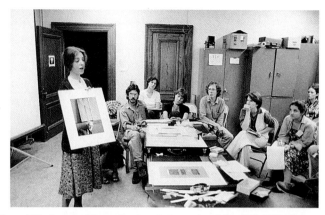

Henry Wilhelm and Carol Brower give presentations on the preservation of black-and-white and color photographs at the Visual Studies Workshop in Rochester, New York. The week-long workshop, which took place in August 1978, also featured as speakers Klaus B. Hendriks of the National Archives of Canada, Frank McLaughlin of Eastman Kodak, and Guenther Cartwright of the Rochester Institute of Technology.

## About the Authors

Henry Wilhelm is one of the founding members of the American National Standards Institute subcommittee established in 1978 to write the now-completed ANSI IT9.9-1990 Standard on test methods for measuring the stability of color photographs. For the past 6 years he has served as secretary of that group. Wilhelm is also a member of the ANSI subcommittees on test methods for evaluating the stability of black-and-white films and prints, and is a founding member of the Photographic Materials Group of the American Institute for Conservation.

In 1980, Wilhelm served as a volunteer technical advisor to film director Martin Scorsese and his staff (Scorsese is the director of *Taxi Driver* [1976], *Cape Fear* [1991], *The Age of Innocence* [1993], and other films) in their successful effort to persuade Eastman Kodak and Fuji Photo Film Co. Ltd. to increase the stability of their color motion picture films.

In 1981, Wilhelm received a one-year fellowship from the John Simon Guggenheim Memorial Foundation of New York City for a long-term study of color print fading and staining under low-level tungsten illumination that simulates museum display conditions. In 1982, Grinnell, Iowa businessman and entrepreneur Sharp Lannom IV and Wilhelm established Preservation Publishing Company, which published this book.

Wilhelm has been involved with photography since childhood. In 1961–62, while attending high school in Arlington, Virginia, he was a part-time photographer for the *Washington Daily News* and also had a summer job at Hunter Associates Laboratory, Inc. assembling electronic instruments for measuring color and whiteness. Wilhelm became interested in the preservation of photographs in 1963 while working in the hot and humid jungles of Bolivia as a member of the Peace Corps.

In the mid-1960's, as a student interested in fine art and documentary photography, he and several of his friends at Grinnell College spent much of their time photographing news events for the college newspaper and other publications. They traveled to Selma, Alabama; Chicago; Washington, D.C.; and other cities to photograph the civil rights struggle and the emerging protests against the Vietnam war.

Wilhelm and fellow student John Phillips photographed, designed, and wrote *Grinnell College – 1966*, which was seized and banned by the college after it had been delivered to the printer. Twenty years later, under a new president, the college finally published this controversial yearbook.

In 1966, Wilhelm served as an assistant to Ansel Adams during one of Adams's photography workshops in Yosemite

National Park in California. Discussions with Adams further increased Wilhelm's interest in the preservation of photographs. In 1967, Wilhelm established the East Street Gallery in Grinnell to exhibit the work of Midwestern fine art photographers.

In 1972, Wilhelm received the first of two U.S. patents for the design of archival print washers for black-and-white fiber-base prints; he produced the print washers for a number of years under the East Street Gallery name. In 1969, Wilhelm published a 26-page booklet entitled *Procedures for Processing and Storing Black and White Photographs for Maximum Possible Permanence*. Research which began with that publication led to the writing of this book.

Carol Brower, an artist, became actively interested in the subject of preservation as an undergraduate student in the School of Art and Design, Department of Fine Arts, at Pratt Institute in New York City (1969–1974). Her concerns regarding the longevity of drawing papers, pencils, inks, and paints used in her own work led to her working for galleries where a high priority was placed on conservation.

In 1972, Brower began to investigate and promote the proper handling and conservation matting of photographs; she is best known for her matting of photographic prints for many of the major museums and galleries in New York City, including Castelli Graphics, Laurence Miller Gallery, Life Picture Gallery, Light Gallery, Pace/MacGill Gallery, and others. During the past 20 years, Brower has worked with many photographers, curators, and private collectors, and has matted a wide variety of photographs made by a broad spectrum of photographers, ranging from the little-known to the historically prominent. She has been a member of the Photographic Materials Group of the American Institute for Conservation since 1982, and a member of the Professional Picture Framers Association since 1985.

As contributing author to this book, Brower wrote Chapter 12, which discusses the handling, presentation, and conservation matting of fine photographic prints. With Wilhelm, she co-authored Chapter 13 on the composition and stability of mount boards. Brower assists Wilhelm in various aspects of his research and writing, and she took many of the photographs in this book. In addition to her work at Preservation Publishing Company, Brower continues to do conservation matting for clients in New York City and elsewhere.

Brower and Wilhelm became acquainted in 1978 when Brower's concern about possible adverse effects of alkaline-buffered boards and papers on color photographs led her to contact Wilhelm. Brower moved to Grinnell from New York in 1990. Wilhelm and Brower were married in 1991.

# Introduction: Looking Toward the Future

Since the modern era of color photography began with the introduction of Kodachrome and Agfacolor transparency films in 1935–36, there has never been a more exciting time in the fields of still and motion picture photography. Or, taking into account the rapid emergence of "photo-realistic" digital imaging, recording, and high-resolution color printing technologies, it would be more appropriate to say that there has never been a more exciting time in the history of color *imaging!*

Many more ways are now available to make color still photographs and moving images than at any time in the past, and there are more ways to make color prints than ever before. Photographs can be originated on traditional color film and scanned to produce a digital image file for input to a personal computer or workstation running Adobe Photoshop or other image-processing software. The computer-corrected/enhanced/manipulated color image can be written back to color negative or transparency film with a high-resolution film recorder, creating what is called a "second-generation original," which in turn can be used to make prints in a darkroom with traditional color papers from Kodak, Fuji, Konica, Agfa, or Ilford.

Or the digital file can be output directly on plain paper with an Iris high-resolution ink jet printer; or to a Kodak XL 7700-series printer to produce an Ektatherm thermal dye-transfer (dye-sublimation) print; or to an imagesetter to generate separation negatives for making an UltraStable pigment color print; or to a Canon Color Laser Copier or other color copier with a digital signal interface to produce a low-cost, plain-paper print; or to a large-format Xerox Versatec liquid-toner electrostatic color printer; or to an imagesetter to make separation negatives for high-quality 4-color (or 7-color, or 10-color) printing by offset lithography or other process; or printed with . . . ?

Or the digital image file can be output with a Metrum Foto Printer to directly expose a Fujicolor, Ektacolor, Konica Color, or Agfacolor print; or output to an Ilford Digital Imager to create an Ilfochrome silver dye-bleach print; or output to a . . . ?

The digital image file may be stored on a magnetic hard disc, a rewritable magneto-optical disc, a writable CD (e.g., a Kodak Photo CD), magnetic tape; or stored on . . . ?

The digital image file may be transmitted to the other side of the world and be recorded and/or immediately output using any of the above color imaging systems. (Some daunting hardware and software problems must be solved, however, before it is certain that these digital image files will still be usable 15, or 25, or 100 years from now — and beyond.)

The merging of traditional photography with computer image processing, viewing, data recording, and image data-base technology; graphic arts electronic prepress systems; television (which will accelerate with the adoption of digital HDTV systems during the remainder of the decade); and telecommunications networks — including direct satellite broadcast and high-capacity wire and fiber-optic cable TV systems — has greatly expanded the options available in color imaging, storage, printing, and transmission. Indeed, among the most promising technologies for producing highly stable color prints at reasonable cost are the high-resolution liquid-toner electrophotographic systems (e.g., 3M Digital Matchprint) and ink-jet printing systems (e.g., Iris Graphics printers) that have been developed for the graphic arts proofing field.

The potentially extremely long-lasting UltraStable, EverColor, and Polaroid Permanent-Color pigment color prints, which are printed with separation negatives produced from digital files generated on high-resolution graphic arts scanners, are examples of the merging of old and new imaging technologies.

(At the time of this writing, Charles Berger, the inventor of the UltraStable process, was preparing UltraStable prints of photographer William Coupon's portraits of the six living United States presidents: Clinton, Bush, Reagan, Carter, Ford, and Nixon. Produced under contract for Time Inc. in New York City, a set of these six prints is to be given to the National Portrait Gallery in Washington, D.C. The UltraStable prints will last far longer than the very faded Kodak Ektacolor and Dye Transfer portraits of five presidents in the collection of the Lyndon Baines Johnson Library and Museum in Austin, Texas, which are reproduced on page 36.)

Multimedia systems, which in various ways combine still images, moving images, and sound, are finally bringing together the previously separate fields of still photography and motion picture and television moving-picture imaging.

More than 20 years ago, when this author began the image stability research reported in this book, there were fewer color films and papers to contend with. Electronic systems for still photography — which had achieved considerable sophistication in space exploration, military intelligence-gathering, and certain scientific fields — had not yet appeared in the general marketplace. In recent years, however, with increased international competition among the world's four principal manufacturers of color films and papers — Kodak, Fuji, Agfa, and Konica — the pace of new product introduction has accelerated greatly. Most color negative films are now on the market for only 2 or 3 years before they are replaced by new products. Improved color papers are being introduced almost as frequently. New "photo-realistic" digital color printing (color hardcopy) systems are announced almost monthly.

While it appears that traditional color films will continue to be the primary means of taking still photographs until well into the next century, alternative methods of making color prints will become increasingly important in many segments of the photography market.

When exposed to light during display, or when stored in the dark, some color materials last far longer than others. Evaluating the image stability characteristics of a color film or paper takes time. Once samples of a new product are obtained,

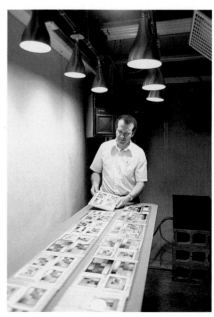

Henry Wilhelm examining color print samples in a low-level, 1.35 klux incandescent tungsten light fading test that had been in progress for more than 10 years at the time this book went to press in 1992. Similar 1.35 klux tests are conducted with fluorescent illumination. Data obtained from these long-term tests allow predictions to be made for permissible display periods for various types of color prints when displayed in museums and archives.

1983

up to a year or more is required to conduct meaningful tests. The recommendations for the longest-lasting color films and papers given in Chapter 1 on pages 3 to 6 were based on this author's tests together with the often incomplete but nonetheless very valuable accelerated dark fading data supplied by the manufacturers. Most of this information has not previously been available.

It was this author's goal that these recommendations be *current* at the time this book went to press at the end of 1992, and all of those involved with this book can take satisfaction in the fact that this goal was, for the most part, achieved.

In making a recommendation for a particular type of color film or paper — the longest-lasting color slide film, for example — it is of course necessary to test all the different products on the market. In recommending Fujichrome films as, overall, the longest-lasting transparency films available, this was done. At the Photokina trade show in Germany in September 1992, however, Kodak announced that new Ektachrome films would be introduced in 1993. Samples of these films — Ektachrome Lumiere professional films and Ektachrome Elite amateur films — were not available in time to include test data on these products in this book. Is the projector-fading and dark storage stability (including rates of yellowish stain formation) of these new films better than that of previous Ektachrome films? Are they more stable than the Fujichrome films listed in the recommendations on page 3? At the time this book went to press, Kodak had declined to disclose the results of its stability tests with these new films.

(In recent years, Kodak has been very reluctant to make stability data available; for example, Kodak has not released image stability data for *any* of its Process RA-4 Ektacolor papers, the first of which, Ektacolor 2001 paper, was introduced in 1986. Likewise, no stability data have been disclosed for Ektachrome Radiance paper for printing color transparencies, or for the Ektatherm electronic print paper used in Kodak's XL 7700-series digital thermal dye-transfer printers.)

As with other new products, tests with the new Ektachrome Lumiere and Elite films will be started by this author as soon as production samples of the films can be obtained in 1993. Meaningful stability data should become available in the months that follow. This research — which will incorporate new digital imaging materials as soon as they appear on the market — is an ongoing effort, and it is hoped that a way will be found to publish stability test results and product recommendations on a regular basis.

To assure continued independence in this research, it is this author's firm policy not to accept paid consulting work from any manufacturer of traditional photographic films and papers or from any manufacturer of electronic imaging systems. Although this author has frequently voiced his opinions about the merits — or lack thereof — of various products with their respective manufacturers, this has been done without financial compensation.

The coming years look highly promising for image preservation. Color materials are, overall, much more stable than they were at the beginning of the 1980's. The Fujicolor SFA3 color papers introduced in 1992, for example, last far longer when exposed to light on display, and when stored in the dark, than any previous color paper for printing color negatives. Increasing numbers of museums and motion picture studios are providing cold storage facilities to preserve their collections. Digital image data-base systems are providing greatly increased access to collections while avoiding handling and physical damage to irreplaceable photographic originals.

## Acknowledgments

Throughout the past 20 years during which this book was created, many individuals, collecting institutions, and companies in the United States, Japan, Germany, Switzerland, Canada, and other countries have contributed information, image-stability data, samples of color films, papers, electronically produced color prints, and other materials that were vital to the completion of this book and to the research upon which it is based. For all of these contributions, both large and small, I am extremely grateful.

This book would not exist were it not for the long-standing support and encouragement of Sharp Lannom IV, a Grinnell businessman and a friend. Endowed with a keen intellect, Sharp has wide-ranging interests and an acute appreciation of the importance of history. Many years of research were required to develop the accelerated light fading tests described in Chapter 2, and to establish their validity as meaningful image-life predictors for various types of color prints when they are displayed in homes, offices, museums, and archives. Sharp became involved in this work in 1981, and his patience and comprehension of the problems inherent in long-term image-stability testing will forever be appreciated. Without his firm but understanding guidance, the writing of this book would not have been completed. Sharp has made an immeasurable contribution to the preservation of the world's photographic and motion picture heritage.

I also express my appreciation to William, Thomas, and Charles Lannom for their contributions to this effort. In addition, I thank Mark Bjorndal, who has handled the business affairs of this project since it began.

No one is more familiar with my work than John Wolf, a science writer, editor, and long-time friend from Madison, Wisconsin. John read and edited the countless revisions of my manuscript during the past 15 years, and he deserves particular thanks for his dedication to this book. John is the most intelligent editor I have ever worked with.

June Clearman, a mathematician and computer programmer working at the Robert Noyce computer center at Grinnell College, volunteered countless hours over a period of more than 5 years to write the computer programs used to record, stain-correct, and analyze the well over one million individual densitometric readings generated during the course of the stability tests reported in this book. Without June's computer programs, the image-life predictions for displayed prints listed in Chapter 3 would not have been possible.

I also give special thanks to Klaus B. Hendriks, the director of conservation research at the National Archives of Canada, for his contributions and friendship over the years; to Bob Schwalberg, whose support and humor helped Carol Brower and me get through both happy and difficult times, and who will always be a trusted friend and colleague; to Jane Gilmer Wilhelm, my exceptional mother, who contributed to this book in many important ways; to Sarah Wilhelm, my 14-year old daughter, whose gentle skepticism ("I will believe it when I see it") encouraged me to work a little harder; to David Wilhelm, my 11-year old son, who has always somehow understood the difficulties of my tasks; to Carol Brower Wilhelm, my best friend and wife, whose strength, determination, and sensitivity brought this long project to completion; and to Charles Wilhelm, our infant son, who waited so patiently, day after day, night after night, throughout his first year of life, while his mother and father completed this book.

Henry Wilhelm

# Contents

# Contents

# 1. Traditional and Digital Color Prints, Color Negatives, and Color Slides: Which Products Last Longest?

**The Hidden Problem: Simply Looking at a Beautiful Color Photograph Provides Absolutely No Indication of How Long It Will Retain Its Original Brilliance — Whether Exposed to Light on Display or Stored in the Dark**

From its earliest period of conception in the 19th century, photography depended on two inextricably interwoven processes: making the image appear and keeping the image from disappearing, so the history of photography is strewn with the skeletons of inventors who did not take seriously, from the first concept, the ecology of permanence.[1]

Edwin H. Land (1909–1991)
Founder of the Polaroid Corporation

A Gregory Heisler photo of New York City Mayor Edward I. Koch may wind up as Koch's official portrait in City Hall. Unlike the Mayor's predecessors, whose portraits are both painted and formal, Koch is looking rather relaxed and candid in this color photo. The photo, taken for the June 11, 1989, *New York Times Sunday Magazine*, was Heisler's first assignment to shoot Koch. The Art Commission, which decides on all art works in city buildings, still must approve the photo. "I'm excited," says Heisler, who thinks the concern of the Art Commission is that of archival quality — whether a photograph will last as long as a painting.[2]

"PDNews" by Susan Roman
*Photo District News*
New York City – 1989

. . . part of the reason the Cabinet project was done with photographs instead of the traditional oil paintings was that Smith was able to convince White House officials that the photographic papers such as Kodak Ektacolor Professional Paper offer improved image stability. In addition, photography offers quick results at a fraction of the cost of oil painting. So a 30" x 40" photograph taken by Smith and printed on Kodak Ektacolor Professional Paper now hangs at the entry of every Cabinet member's office on Capitol Hill.[3]

From a 1986 interview with
photographer Merrett T. Smith
in *Kodak Studio Light* magazine

When I came into Fehrenbach Studios I was angry. My son's graduation portrait had faded so badly that I brought it in to see what they would do about it. The picture was only seven years old! They said it was printed on Kodak paper and they thought it would last but it didn't. They said it wasn't their fault that it faded and they could replace it for half price. I wasn't satisfied with that so I left and wrote to Kodak and told them that I thought Kodak should replace the print. Kodak said it wasn't their fault and it wasn't the studio's fault.

I had a picture that wasn't any good and I knew it wasn't *my* fault! We never had a problem before — we have all our own baby pictures and they lasted forever. If these were taken in black-and-white, would they have faded? All the ads I've seen in the newspapers say that photographs live forever . . . . It sort of takes you by surprise when you've never seen it happen before. It's such a gradual thing you don't notice it at first.[4]

Mrs. Lloyd Karstetter
Reedsburg, Wisconsin – 1980

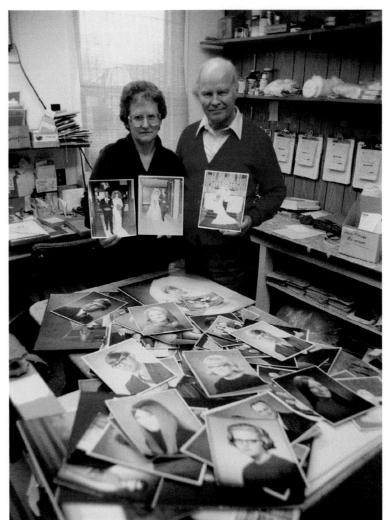

January 1981

The worldwide shift from black-and-white photography to color photography — which got under way rather slowly with the introductions of Kodachrome and Agfachrome transparency films in 1935 and 1936, Kodacolor color negative film in 1942, and Eastman Color motion picture films in 1950 — began to proceed in earnest in the 1960's and is now essentially complete in all but a few segments of the still photography and motion picture fields. Unfortunately, as gradually became apparent, the change to color resulted in the loss of the essentially permanent images provided by black-and-white photography that had long been taken for granted by photographers and the general public alike. Shown here in 1981 are Bernice and Robert Fehrenbach of Fehrenbach Studios in Reedsburg, Wisconsin with some of the faded and cracked Kodak Ektacolor prints made between 1969 and 1976 that were brought back to the studio by angry customers asking for replacements. The highly unstable Ektacolor RC paper of this period was one of the most memorable low points in the often-troubled history of permanence in the color photography field.

## The Organic Dye Images of Color Films and Prints versus the Metallic Silver Images of Black-and-White Photographs

Black-and-white photographs have images made of metallic silver — the images appear black because the filamentary structure of the tiny grains of silver absorb, rather than reflect, light. These silver images are unaffected by prolonged exposure to light and are also essentially permanent when stored in the dark (at least this is true with correctly processed fiber-base prints; as discussed in Chapter 17, black-and-white RC prints, with their sometimes self-destructing images, are another matter altogether). Many people have black-and-white photographs of their ancestors that have remained in good condition for 50 to 100 years — or even longer. Museum collections have significant numbers of black-and-white photographs from the late 1800's and early 1900's that are still in excellent condition.

Unlike the usually very long-lasting silver images of black-and-white photographs, most color photographs have images formed of cyan, magenta, and yellow organic dyes that fade when exposed to light on display. The brighter the light, the faster they fade. Kodak Ektacolor prints and most other types of color photographs also gradually fade

and form yellowish stain when stored in the dark; the slow but inexorable image deterioration begins the moment processing is completed. High temperatures and/or high humidity in storage accelerate the deterioration process.

## The Longest-Lasting Color Films and Color Print Materials

Recommendations for the most stable, longest-lasting color materials are given in the next four pages. These recommendations, which cover color materials that were available at the time this book went to press in late 1992, are based on extensive accelerated light fading tests and accelerated dark fading/staining tests — conducted by this author over a period of more than 15 years and reported in Chapters 2 through 6 — together with often incomplete but nonetheless vitally important accelerated dark fading data made available by Agfa, Fuji, Ilford, Kodak, Konica, and 3M (reported in Chapters 5 and 9).

As existing products are improved and new products are introduced — and as procedures for predicting color image fading and staining become more sophisticated — it is certain that the product recommendations given in this book will change. Further improvements in image stability

*(text continued on page 7 . . .)*

# Recommendations

## Longest-Lasting Color Transparency Films:

### Longest-Lasting Overall:

Fujichrome Professional Films

Fujichrome Velvia Professional Film (ISO 50)

Fujichrome "Amateur" Films

Fujichrome CDU Duplicating Films

### Longest-Lasting if Projection Can Be Avoided:

Kodachrome Professional Films

Kodachrome "Amateur" Films

For a photographer who prefers Process E-6 films, Fujichrome films are clearly the best choice. Fujichrome's resistance to fading during projection is the best of all slide films — for a given amount of fading, Fujichrome slides can be projected twice as long as Ektachrome slides. However, when yellowish stain that occurs over time in storage is considered, Fujichrome's stability in dark storage is roughly equal to that of Ektachrome films. Fujichrome Velvia Professional film, a very sharp, extremely fine-grain 50-speed film introduced by Fuji in 1990, is not quite as stable as the other Fujichrome films when projected, but Velvia nevertheless has better projector-fading stability than Ektachrome. Velvia lasts far longer under projection than Kodachrome film, Velvia's principal competitor.

Kodachrome has the best dark storage dye stability of any color film, and Kodachrome, as a result of its unique, external-coupler processing method, is the only color transparency film that remains completely free from yellowish stain formation during prolonged storage in the dark. Unfortunately, however, Kodachrome has the worst projector-fading stability of any color slide film on the market. Kodachrome film is a very good choice if projection can be avoided, but if originals sometimes must be projected, and time or money prevents routine duplication of originals, Fujichrome is the better choice. There are no stability differences between the "amateur" and "professional" transparency films of a given type (e.g., Fujichrome, Ektachrome, Kodachrome, and Agfachrome).

## Longest-Lasting Color Negative Films:

### Very Low Speed (ISO 25–50):

Kodak Ektar 25 Film

Kodak Ektar 25 Professional Film

Konica Color Impresa 50 Professional Film

### Low Speed (ISO 100):

Kodak Ektar 100 Film

3M ScotchColor 100 Film

Fujicolor Super G 100 Film

Fujicolor Reala Film (ISO 100)

## Medium Speed (ISO 160–200):

Kodak Vericolor III Professional Film Type S
(called Ektacolor Gold 160 Professional Film in Europe and Asia)

Fujicolor 160 Professional Film Type L

Fujicolor Super G 200 Film

Konica Color Super SR 200 Film

Konica Color Super SR 200 Professional Film

3M ScotchColor 200 Film

Polaroid OneFilm Color Print Film (ISO 200)
(made for Polaroid by the 3M Company in Italy)

## High Speed (ISO 400):

Kodak Vericolor 400 Professional Film
(called Ektacolor Gold 400 Professional Film in Europe and Asia)

Kodak Ektapress Gold 400 Film

Kodak Gold Plus 400 Film

Fujicolor HG 400 Professional Film

Fujicolor Super G 400 Film

3M ScotchColor 400 Film

## Very High Speed (ISO 1000–3200):

Kodak Ektar 1000 Film

Kodak Ektapress Gold 1600 Film

Kodak Gold 1600 Film

Fujicolor Super HG 1600 Film

Among the color negative films included in the five ISO speed-range groups are films intended for a variety of applications, and the films judged to be the most stable products of each type have been listed. While a photographer may, of course, decide to select a film with lower stability to gain some other advantage, it is best to stay away from the very worst products, such as Kodak Vericolor II Professional Film Type L and Agfacolor XRS 1000 Professional Film.

In the Medium Speed group (ISO 160–200), for example, Kodak Vericolor III Professional Film Type S is a daylight/electronic-flash film of moderate contrast and color saturation intended primarily for professional portrait and wedding photography. Fujicolor 160 Professional Film Type L is a tungsten-balanced color negative film generally used for product and commercial photography; this film is considerably more stable than Kodak's equivalent tungsten-balanced color-negative film, Vericolor II Professional Film Type L. Fujicolor Super G 200 Film, 3M ScotchColor 200 Film, Polaroid OneFilm (ISO 200), and the pleasingly lower-contrast Konica Super SR 200 Film are daylight color negative films intended for the general amateur market.

The 3M ScotchColor 200 and Polaroid OneFilm recommended here are the "improved stability" types introduced in late 1990 (Polaroid OneFilm is made in Italy by the 3M Company for Polaroid and is essentially identical to 3M ScotchColor 200 film). Pre-1990 versions of these 3M and Polaroid films had very poor dark fading stability.

The recommendations for color negative films given here are based on Arrhenius accelerated test data supplied by the various manufacturers and on single-temperature accelerated dark fading tests conducted by this author. These recommendations were based on the best information available at the time this book went to press in 1992. Because of differences in test conditions and methods of evaluation, however, the available data did not in every case permit a precise comparison of the stability of one film with another.

## Longest-Lasting Color Internegative Film:

### Fujicolor Internegative Film IT-N

Color internegative films are used by labs for making color internegatives from transparencies. Fujicolor Internegative Film IT-N has considerably better dark fading stability than Kodak Vericolor Internegative 6011 and 4114 films (stability data for Vericolor Commercial Internegative Film, to be introduced in 1993, were not available at the time this book went to press).

## Longest-Lasting Papers for Printing Color Negatives:

### *Longest-Lasting Overall (RA-4 Compatible Papers):*

**Fujicolor Paper Super FA Type 3**

**Fujicolor Supreme Paper SFA3**

**Fujicolor SFA3 Professional Portrait Paper**

**Fujicolor Professional Paper SFA3 Type C**

**Fujiflex SFA3 Super-Gloss Printing Material**

### *Second Longest-Lasting (RA-4 Compatible Papers):*

**Konica Color QA Paper Type A5**

**Konica Color QA Paper Type A3**

**Konica Color QA Paper Professional Type X2**

**Konica Color QA Super Glossy Print Material Type A3**

Introduced in 1992, Fujicolor SFA3 papers are **by far** the best of the fast-processing RA-4 compatible color negative papers. In fact, considering the Fujicolor papers' greatly superior light fading and dark fading stability, combined with their very low rate of yellowish stain formation in dark storage, these are without question the finest chromogenic color papers ever made. On display, the Fujicolor SFA3 papers will last **more than four times longer** than Ektacolor papers. The color, tone reproduction, and image sharpness of the Fujicolor papers are also outstanding. Fujicolor Professional Paper SFA3 Type C and its lower-contrast counterpart, Fujicolor SFA3 Professional Portrait Paper (tentative name), are particularly recommended for portrait, wedding, commercial display, and fine art photography — markets where long-lasting color prints are a must.

### *Longest-Lasting Process EP-2 Compatible Papers:*

**Konica Color Paper Type SR**

**Konica Color Paper Professional Type EX**

**Konica Color Paper Type SR (SG)**

By the beginning of 1990, Process RA-4 compatible papers had largely replaced the older EP-2 papers in minilabs, and by the end of 1991 RA-4 papers had become standard in most large photofinishing and commercial labs. Among the Process EP-2 compatible papers, Konica Color Paper Type SR and its lower-contrast counterpart, Konica Color Professional Paper Type EX, are recommended. These papers have better long-term light fading and dark fading stability than Kodak Ektacolor Plus or Ektacolor Professional papers.

In a given manufacturer's line of color papers, there are no significant stability differences between papers intended for professional markets and those sold to photofinishers catering to amateurs. For example, all current Kodak Ektacolor RA-4 papers have essentially the same image stability characteristics — there are no significant light fading stability differences between Ektacolor Portra II Paper, a "professional" paper used in the upscale portrait and wedding field where a single large print may sell for $1,000 or more, and Ektacolor Edge paper, an "amateur" paper used by minilabs and large-volume, low-cost photofinishers for their 35-cent prints.

## Longest-Lasting Papers for Printing Color Transparencies:

### *Longest-Lasting Overall:*

**Ilford Ilfochrome Classic print materials**

**Ilford Ilfochrome Rapid print materials**
(for best stability, high-gloss, polyester-base versions of Ilfochrome [formerly called Cibachrome] are recommended)

### *Longest-Lasting Process R-3 Compatible Papers:*

**Fujichrome Paper Type 35**

**Fujichrome Paper Type 35-H**

**Fujichrome Super-Gloss Printing Material**

Although subject to light fading, Ilford Ilfochrome prints can be considered absolutely permanent (with essentially zero stain levels) in normal, room-temperature dark storage; this property makes Ilfochrome unique among conventional, easy-to-process color print materials. When kept in the dark in normal storage conditions, Ilfochrome polyester-base prints should last much longer than most black-and-white photographs. Here we see the great advantage of the Ilfochrome preformed dye (silver dye-bleach) system compared with the less stable and generally yellowish-stain-prone chromogenic processes.

It would be a major advance for photography if Ilford would offer a negative-printing version of Ilfochrome (with improved light fading stability) for color negative users. Ilford has long had the technology to produce such a material — in 1963 a color negative version of Cibachrome (now called Ilfochrome) named Cibacolor was actually shown at the Photokina trade show in Germany, but, unfortunately, it was never marketed. Such a new "Ilfocolor" print material would be a fabulously successful product in the portrait, wedding, and fine art fields.

Among Process R-3 compatible print materials, Fujichrome Paper Type 35 is by far the best choice; Type 35 paper has much better light fading and dark storage stability (with much lower rates of yellowish stain formation) than Kodak Ektachrome Radiance Paper and polyester-base Ektachrome Radiance Select Paper. It should be noted, however, that when exposed to light on display, neither Fujichrome Type 35 nor Ilfochrome is as stable as Fujicolor SFA3 color negative paper.

(*Recommendations* continued on next page . . . )

# Recommendations *(continued from previous page)*

## Longest-Lasting Translucent and Transparent Color Display Materials:

### *Longest-Lasting Overall:*

**Ilford Ilfochrome Display Film** (translucent base)
**Ilford Ilfochrome Display Film** (transparent base)

### *Longest-Lasting RA-4 Compatible Materials:*

**Fujitrans SFA3 Display Material** (translucent base)
**Fujiclear SFA3 Display Material** (transparent base)

Although this author did not conduct comparative tests with display materials (they will be tested in the future), the fact that these products have the same dye sets as their corresponding reflection-print materials (e.g., Kodak Duratrans RA and Ektatrans RA display materials have the same dye set as Ektacolor Supra and other Ektacolor RA-4 papers) allows a meaningful comparison to be made. In tests, Ilford Ilfochrome materials had reduced rates of light fading under the moderately heated, low-humidity conditions associated with backlit displays, and this gives Ilfochrome an added advantage over chromogenic materials such as Duratrans RA.

Fujitrans and Fujiclear SFA3 Display materials, expected to be introduced in 1993, will employ the same emulsion technology used in Fujicolor SFA3 papers, and in demanding backlit display applications, Fujitrans and Fujiclear will probably last on the order of four times as long as Kodak Duratrans RA, Duraclear RA, and Ektatrans RA. Only long-term tests will show whether or not Fujitrans and Fujiclear SFA3 materials will outlast Ilfochrome display materials in backlit display applications.

## Longest-Lasting, Most Stable Color Photographs of Any Type:

**UltraStable Permanent Color Prints** (tentative)
**Polaroid Permanent-Color Prints** (tentative)
**EverColor Pigment Color Prints** (tentative)
**Fuji-Inax Photocera Ceramic Color Photographs**

On long-term display — perhaps going on even for centuries — UltraStable Permanent Color Prints (made with the improved-stability yellow pigment to be introduced in early 1993) and Polaroid Permanent-Color Prints are in a class by themselves. Accelerated test data from prototype materials indicate that in normal display situations the prints should last 500 years or more without significant fading or staining. The prints should last as long as (or quite possibly even longer than) the best "archivally" processed and toned fiber-base black-and-white prints. These are the Rolls Royce's of the color photography field — materials against which all others must be compared. Unlike conventional color prints in which the image is formed with organic dyes, the prints use color pigments that have truly extraordinary light fading stability.

EverColor Pigment Color Prints, to be introduced in early 1993 by the California-based EverColor Corporation, are produced with a high-stability version of the AgfaProof process. Samples were not available for testing at the time this book

went to press in 1992, but it is expected that EverColor prints will have very good light fading and dark storage stability.

The recommendations given here for UltraStable, Polaroid Permanent Color, and EverColor prints are listed as "tentative," pending the results of stability tests with production materials.

All three of these processes employ digitally produced separation negatives and may be used to make prints from color transparencies, color negatives, existing color prints, computer-generated images, Photo CD's, and other digital sources.

Fuji-Inax Photocera Ceramic color photographs, which are available only in Japan, use inorganic pigments to form images on ceramic plates which are fired at high temperatures. The resulting "photographic ceramic tiles" are claimed by Fuji to be unaffected by light, rain, seawater, and fire.

## Systems for Printing Digital Color Images from Computers, CD-ROM's, Photo CD's, Electronic Still Cameras, and Video Sources:

An ever-increasing number of methods are available for producing color prints ("hardcopy") from digital image sources. Included are "photorealistic" thermal dye transfer printers (also called dye-sublimation printers, the Kodak XL7700-series printers and the Tektronix Phaser IISD are examples); "photorealistic" ink jet printers (i.e., Iris Graphics ink jet color printers); and digital printers using traditional color photographic materials (e.g., Metrum FotoPrint Digital Printers, Agfa Digital Printing Systems, and Kodak LVT Digital Image Recorders, all of which can print high-quality digital images on standard process RA-4 compatible color negative papers). The 3M Color Laser Imager is a digital printer using a special EP-2 color paper made by 3M (stability data not available). Fuji (Fujix) Pictrography Digital Printers use a unique photographic-thermal-transfer process.

Producing lower-quality color images — which are nevertheless adequate for many business applications, proofs, and publication layouts — are digital electrophotographic color copier/printers (e.g., the Canon Color Laser Copier 500 and other color electrophotographic plain-paper copier/printers equipped with digital interfaces). Liquid-toner electrostatic color printers such as the Xerox/Versatec 8900-series digital plotter/printers (making prints up to 54 inches wide by 15 feet or more in length, the printers are used in the Cactus Digital Color Printing System) provide a method for making pleasing — if not quite "photorealistic" — color prints in large sizes and at low cost.

This author has not had an opportunity to test the image stability of all of the many digital color printing materials in the important and rapidly expanding "color hardcopy" and graphic arts proofing field; however, among those printing devices whose output was evaluated, the following deserve particular note:

**Metrum FotoPrint Digital Printers** (RA-4 color prints)
**Agfa Digital Printing Systems** (RA-4 color prints)
**Bremson Laser Color Recorders** (RA-4 color prints)
**Kodak LVT Digital Image Recorders** (RA-4 color prints)
**Ilford Digital Imagers** (Ilfochrome color prints)
**Kodak XL 7700-series Digital Printers** (Ektatherm prints)
**Fuji Pictrography Digital Printers** (Pictrography prints)
**Cactus Digital Color Printers** (electrostatic color "prints")
**Canon Color Laser copier/printers** (plain-paper "prints")
**Kodak ColorEdge copier/printers** (plain-paper "prints")

Of the available methods for making high-quality, "photo-realistic" color prints from digital sources, printers using RA-4 compatible Fujicolor SFA3 color papers or Ilfochrome materials produce the longest-lasting prints; color prints made with these devices are inexpensive and their overall image quality can be as good or better than prints exposed with an optical enlarger.

The overall image quality of Kodak Ektatherm prints and other types of thermal dye transfer color prints can approach that of prints made with conventional color negative papers. In the United States, Kodak Ektatherm prints were initially the only type of print available from Kodak Photo CD images when the Photo CD system was introduced in the summer of 1992.

The recommendations for Fuji Pictrography prints and Cactus digital prints are tentative, pending completion of stability tests.

Iris ink jet printers are capable of producing high-quality, large-format color images from digital sources. At the time this book went to press in 1992, the light fading stability of Iris prints was very poor. However, Iris Graphics, Inc. (a Scitex company), the maker of the printers, has said that inks of greatly increased stability would be introduced before the end of 1993.

## Longest-Lasting Polaroid "Instant" Color Prints:

### *Longest-Lasting Overall:*

**Polaroid Polacolor ER, 64T, 100, and Pro 100 Prints**

Polaroid "peel-apart" instant prints have inferior light fading stability compared with chromogenic color papers such as Fujicolor and Ektacolor; because Polacolor prints are unique images with no usable negatives from which additional prints can be made, the prints should be displayed with caution.

Because of excessive yellowish stain that occurs over time in normal, room-temperature dark storage, and because of poor light fading stability, Polaroid "Vision 95" prints, Spectra HD ("Image" in Europe), Polaroid 600 Plus, and Polaroid SX-70 prints available at the time this book went to press in 1992 were not recommended for other than short-term applications.

## Photo CD's, CD-ROM's, and Other Optical Disk and Magnetic-Media-Based Systems Are Not Recommended for the Long-Term Preservation of Photographically Originated Images:

The suitability of Kodak Photo CD's and other types of digital optical disk and magnetic systems for the long-term storage of photographically originated color images involves three distinct considerations. To use the Kodak Photo CD as an example of a laser-read optical disk image storage medium, the first consideration is the long-term stability (readability) of the Photo CD itself. The second consideration is what assurance there is that compatible hardware for reading Photo CD's will still be available in 25, 50, or 100 years (or more) from now. The third consideration is what assurance there is that software for decompressing and reading Photo CD images will be available for the vastly different computer and electronic imaging systems that will be in use in 25, 50 or 100 years (or more) from now. To rely on the Photo CD as a long-term image storage medium, all three of these considerations must be satisfied. At the time this book went to press in 1992, none of

them was. The continuing rapid technological change and the consequent obsolescence of hardware, software, and data storage media in the computer and video industries make it questionable that today's Photo CD's will be usable even 25 years from now (recall the Sony Betamax camcorders and VCR's of the 1980's?). Although Photo CD's and other CD-ROM's — and other optical disk and magnetic digital image storage systems — have tremendous utility for the rapid access and distribution of color images, color photographic originals must be carefully preserved for long-term image preservation.

## Longest-Lasting Color Microfilm and Microfiche Products:

### Ilford Ilfochrome Micrographic Films

Because they are essentially permanent in dark storage at normal room temperature, polyester-base Ilford Ilfochrome Micrographic films are the only color microfilm/microfiche materials suitable for long-term museum and archive applications. Kodachrome film and motion picture print films such as Eastman Color and Fujicolor do not even approach the outstanding dark storage stability of Ilfochrome Micrographic films. The image stability of Ilfochrome Micrographic films is so good, in fact, that this author believes that under normal storage conditions, these films likely will outlast conventionally processed silver-image black-and-white microfilms on polyester base.

## Longest-Lasting Motion Picture Color Negative and Color Print Films:

### *Longest-Lasting Color Negative Films:*

**Fujicolor Negative Film F-64, 8510 and 8610**

**Fujicolor Negative Film F-64D, 8520 and 8620**

**Fujicolor Negative Film F-125, 8530 and 8630**

**Fujicolor Negative Film F-250, 8550 and 8650**

**Fujicolor Negative Film F-250D, 8560 and 8660**

**Fujicolor Negative Film F-500, 8570 and 8670**

**Eastman Color Negative Film 7291**

**Eastman EXR 500T Color Negative Film 5296 and 7296**

### *Longest-Lasting Color Intermediate Film:*

**Fujicolor Intermediate Film, 8213 and 8223**

### *Longest-Lasting Color Print Films:*

**Fujicolor Positive Film LP, 8816 and 8826**

These recommendations for color motion picture negative and print films are based on Arrhenius accelerated dark fading data supplied by the manufacturers: Fuji Photo Film Co., Ltd., Eastman Kodak Company, and Agfa-Gevaert AG (refer to Chapter 9 for further information). Fuji's accelerated aging data indicate that the Fujicolor motion picture print films are not greatly affected by high humidities, and this can be particularly advantageous when films must be stored in less than ideal conditions. Agfa CP1 and CP2 color motion picture print films have poor image stability, and their use should be avoided.

will be made, and with Fuji, Kodak, Konica, and Agfa all trying hard to outdo each other, a color film or paper that was rated "longest-lasting" in its category at the time this book went to press will inevitably be eclipsed by an even better product in the future.

While the relative performance of films and papers processed, stored, and displayed in the wide variety of conditions that one might encounter in the real world may differ from that reported in this book, the image-life predictions and product recommendations presented here represent a concerted effort over a period of many years by this author to make sense out of a complex and constantly changing body of information. The assessments of the light fading stability of color print materials and the projector-caused fading of color slides deserve particular note, and the data presented in this book help fill major gaps in the information that has been published previously.

## The *Inherent* Dye Stability and Yellowish Staining Characteristics of a Color Material

The most important factors that will, ultimately, determine the useful life of a color film or color print are the *inherent* dye stability and resistance to yellowish stain formation that have been built into the product by its manufacturer. These are fundamental properties of each and every color film or color print material. The inherent light fading and dark storage stability properties differ greatly among current products — for any given storage or display situation, some materials will last far longer than others.

At present, when a photographer buys a roll of color film, no information is provided about how long the processed color images will last before noticeable changes take place. The photographer has no idea whether another film — made by the same or a different manufacturer — might last longer.

The sharpness, graininess, color, and tone-scale reproduction characteristics of a film can be examined immediately after processing, and if the photographer is not pleased with the results, he or she can try a different product. Indeed, Kodak, Fuji, and the other major manufacturers routinely publish image-quality data for their films, including RMS granularity values, resolving power values, modulation transfer functions (MTF), characteristic curves, spectral sensitivity curves, and spectral dye density curves. Missing, in most cases, has been even the most basic information about the image stability characteristics of the film. Looking at a processed color film or print will tell you nothing about how long it will last.

Since the introduction of Kodachrome in 1935 and Agfacolor-Neu transparency film in 1936 — the first modern color films — the major manufacturers have conducted extensive image stability tests with their color films and papers. In years past, however, the results of these tests were for the most part kept secret. For photographers and the general public alike, image stability has remained a hidden characteristic — one that manifests itself only years after a product is purchased. And by then, of course, it is too late.

Most manufacturers of color materials have long included a fading warranty disclaimer on every package of color film and paper to help protect themselves from upset customers once the inevitable has occurred and color prints and films have faded to the point that they are no longer acceptable.

The wording of Kodak's disclaimer is typical:

> Since color dyes may change over time, this product will not be replaced for, or otherwise warranted against, any change in color.

Similarly, Fuji states on its packages:

> Since color dyes may change in time, no warranty against or liability for any color change is expressed or implied.

Agfa includes the following on its color film boxes:

> As all color dyes may in time change, there is no warranty against, or any liability for, any change in color.

For the most part, the above disclaimers have been the only information supplied to the general public concerning the longevity of color films and color print materials they use. It is hoped, however, that in the future basic image stability information will be routinely included in the technical data sheets that Kodak, Fuji, and the other manufacturers publish for each of their color films and papers.

## Image Permanence Is an Important Consideration When Selecting a Color Film or Color Paper

Although a photographer must consider many factors when selecting a color film or print material for a particular purpose, it is only prudent to choose the most stable products available from those that otherwise meet the photographer's requirements (e.g., color negative or color transparency; high-speed film or slow-speed film with sharp, fine-grain images; color negative or color reversal paper; and so forth).

Other factors being equal — and if there is a choice — almost every photographer will choose a longer-lasting film or paper over a less stable one. The same is true of the general public. If a portrait studio offers a customer a print on a color paper that when displayed would last four times longer than a print made on the "leading brand" color paper — and both prints cost the same and were essentially identical in appearance — which print would the customer prefer?

## With the Photography Industry Undergoing a Fundamental Restructuring, Eastman Kodak is No Longer the Unchallenged Leader

Although the Eastman Kodak Company, with 1992 revenues in excess of $20 billion, is still the world's largest photographic manufacturer, the company no longer dominates the photographic industry as it once did. Competition among the world's seven principal manufacturers of color films and papers — Kodak, Fuji, Agfa, Konica, 3M, Ilford, and Polaroid — has greatly intensified since the mid-1980's.

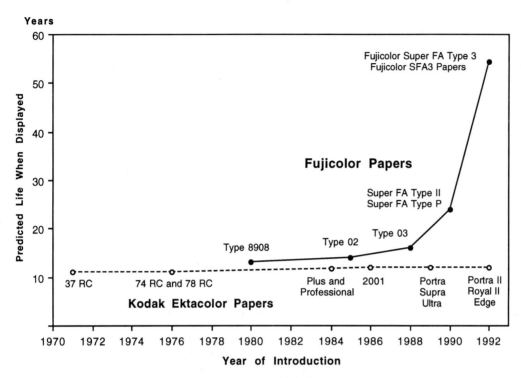

**Figure 1.1** Beginning in 1980, successive generations of Fujicolor EP-2 and RA-4 compatible papers have exhibited steadily increasing light fading stability, with current Fujicolor SFA3 papers having an estimated display life of more than 50 years according to this author's tests. Kodak's Ektacolor papers, on the other hand, have shown negligible improvements in light fading stability since the introduction of Ektacolor 37 RC Paper more than 20 years ago in 1971. When exposed to light on display, Fujicolor SFA3 papers last more than **four times longer** than current Ektacolor papers (e.g., Ektacolor Portra II Paper).

The increased worldwide competition, together with the threats to the traditional photography companies posed by the rapid advances in television, computer imaging systems, desktop publishing, electronic biomedical imaging, electronic document management systems, and other electronic imaging systems that increasingly are displacing silver-halide-based photography, have all contributed to confusion and uncertainty in the photography industry.

A prime example of the changes taking place in the photography industry is the complete destruction of the once huge television newsfilm and home movie markets in the span of only a few years by the introduction of portable ENG (electronic news gathering) video cameras and the now-ubiquitous amateur camcorder.

New technologies for making high-quality color prints from digital sources — including ink jet printing, dry- and liquid-toner electrophotographic printing, and thermal dye transfer printing — offer the hope that in the future highly stable color prints will become available at reasonable cost. In the entire history of photography, there have never been as many ways to make color prints as there are now. The color imaging field has finally opened up to competitors from outside the traditional photography industry.

These forces have put the entire photography industry into a state of unprecedented upheaval. Kodak, Fuji, and the other photographic manufacturers are now not only fighting each other for market share, but are also trying to respond to the often unclear needs of a rapidly changing marketplace. Because of these pressures, the manufacturers have sharply increased their research and development efforts, and the rate of new product introductions has accelerated dramatically during the past few years.

Image permanence — and the long-overdue recognition that it is a key aspect of overall product quality — has in the past decade been receiving increased attention by al-

most every manufacturer. With the Japanese manufacturers Fuji Photo Film Co., Ltd. and Konica Corporation making ever-improving image permanence a primary corporate objective, color stability has finally become a major competitive issue in the marketplace.

In recent years, Fuji has achieved substantial improvements in the stability of its color negative papers, and Fujicolor papers now have far better light fading and dark fading stability than Kodak's corresponding Ektacolor papers (see Chapter 3 and Chapter 5). In dark storage, the Fujicolor papers also have better dye stability and much lower rates of objectionable yellowish stain formation than the Kodak papers. The stability of color papers has been a weak area for Kodak, and at the time this book went to press in late 1992, Kodak's papers fell short in almost every respect when compared with the image stability of all of its competitors' papers.

On display, Fujicolor SFA3 papers for printing color negatives are more than *four times more stable* than Ektacolor Portra II Paper and the other Ektacolor papers that were available at the time this book went to press in late 1992.

In fact, as shown above in **Figure 1.1**, this author's tests have revealed that the light fading stability of Ektacolor papers has seen almost no improvement since Ektacolor 37 RC Paper was introduced in 1971 (see Chapter 3). In that period of more than 20 years, the only significant advance made by Kodak in the image stability of Ektacolor paper was the introduction of a more dark-stable cyan dye in August 1984.

(Konica had introduced an improved-stability cyan dye in its Konica Color Type SR color negative paper several months earlier in April 1984, and at the time this book went to press, Konica continued to maintain superiority over Kodak in the overall image stability of its Konica Color process RA-4 and EP-2 compatible papers.)

## Comparative Light Fading of Fujicolor SFA3 Papers and Kodak Ektacolor Papers

The dramatic improvements made in the light fading stability of Fujicolor SFA3 papers, introduced in 1992, are clearly evident in these illustrations.

The prints were subjected to accelerated fluorescent light fading tests conducted at 21.5 klux for accumulated light exposures equivalent to those which the prints would receive during the listed years of display (at 450 lux for 12 hours a day). The prints were covered with glass during the tests.

As reported in Chapter 3, this author's predicted display life for Fujicolor SFA3 prints is 54 years, based on this author's "home and commercial" display conditions. Current Ektacolor prints, on the other hand, have a predicted display life of only a little over 12 years.

Current Ektacolor, Fujicolor, Konica Color, and Agfacolor color negative and color reversal papers all incorporate UV absorbing emulsion overcoats, and in most indoor display situations it makes little difference in fading rates whether or not the illumination source contains UV-radiation. Most of the fading that occurs with these papers is caused by visible light — and *not* by UV radiation. Framing with Plexiglas UF-3 or other UV filters is of little if any benefit. Ilford Ilfochrome prints, Kodak Dye Transfer prints, and Kodak Ektatherm digital prints do not have UV-absorbing overcoats, however, and the stability of these prints can be greatly impaired when UV radiation from bare-bulb fluorescent lamps is present.

The Fujicolor test prints were made on Fujicolor SFA3 Professional Paper Type C, and the Ektacolor prints were made on Kodak Ektacolor Supra Paper. Supra paper, which is one of Kodak's Ektacolor "professional" papers, was chosen as the best contrast match for Fujicolor Type C paper.

All of the Ektacolor papers available at the time this book went to press in late 1992 had essentially identical light fading characteristics (these papers included Ektacolor Edge Paper, Ektacolor Royal II Paper, Ektacolor Supra Paper, Ektacolor Portra II Paper, Ektacolor Ultra Paper, and Duraflex RA Print Material). The light fading stability of Ektacolor 74 RC paper, in use from 1977 until 1986, is similar to that of current Ektacolor papers.

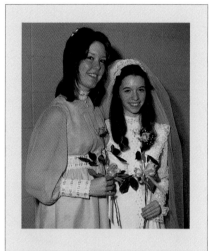

Unfaded print made with Fujicolor SFA3 paper available at end of 1992.

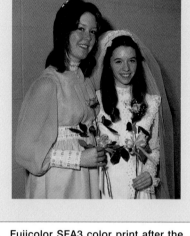

Fujicolor SFA3 color print after the equivalent of 10 years of display.

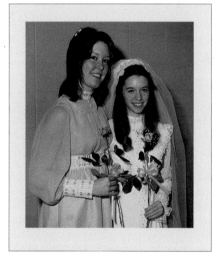

Unfaded print made with Kodak Ektacolor paper available at end of 1992.

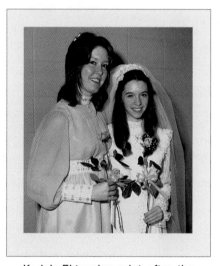

Kodak Ektacolor print after the equivalent of 10 years of display.

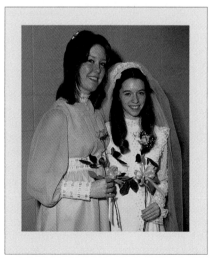

Unfaded print made with Kodak Ektacolor 74 RC paper (1977–1986).

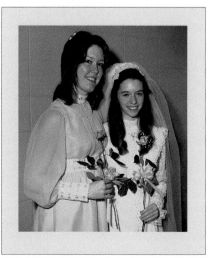

Kodak Ektacolor 74 RC print after the equivalent of 10 years of display.

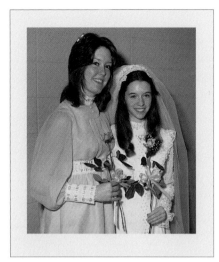

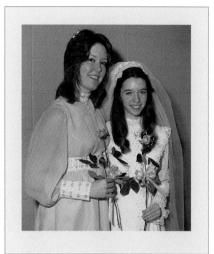

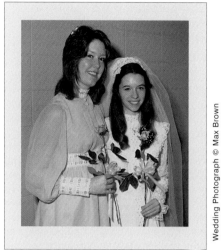

Wedding Photograph © Max Brown

Fujicolor SFA3 color print after the equivalent of 15 years of display.

Fujicolor SFA3 color print after the equivalent of 30 years of display.

Fujicolor SFA3 color print after the equivalent of 50 years of display.

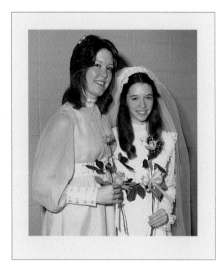

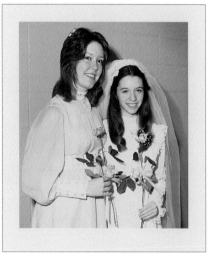

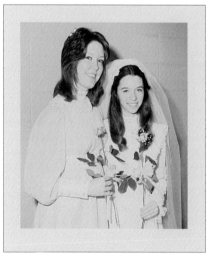

Kodak Ektacolor print after the equivalent of 15 years of display.

Kodak Ektacolor print after the equivalent of 30 years of display.

Kodak Ektacolor print after the equivalent of 50 years of display.

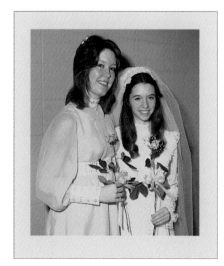

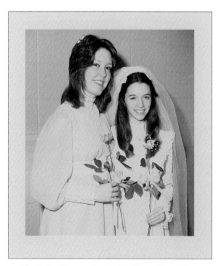

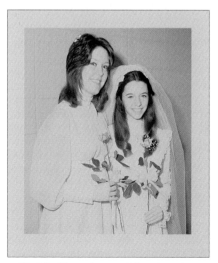

Kodak Ektacolor 74 RC print after the equivalent of 15 years of display.

Kodak Ektacolor 74 RC print after the equivalent of 30 years of display.

Kodak Ektacolor 74 RC print after the equivalent of 50 years of display.

## Comparative Dark Fading and Yellowish Staining Behavior of Fujicolor SFA3 Papers and Kodak Ektacolor Papers

The superior dark storage stability of Fujicolor SFA3 papers, introduced in 1992, is clearly evident in these illustrations. In addition to having better *dye stability* in dark storage, the Fujicolor papers also have far lower rates of *yellowish stain formation* than the Ektacolor papers that were available at the time this book went to press in late 1992. With Ektacolor and most other current chromogenic papers, brilliance-robbing yellowish stain that occurs over time in dark storage is a more serious problem than is dye fading itself.

The prints were subjected to an accelerated dark fading/staining test conducted at 144°F (62°C) and 45% RH for the number of days listed. Results from this author's single-temperature comparative dark storage tests for color papers — and 20% dye fading predictions based on multi-temperature Arrhenius tests conducted by the major manufacturers — are listed in Chapter 5.

The Fujicolor test prints were made with Fujicolor SFA3 Professional Paper Type C, and the Ektacolor prints were made with Kodak Ektacolor Supra Paper. Supra paper, which is one of Kodak's Ektacolor "professional" papers, was chosen as the best contrast match for the Fujicolor Type C paper.

With the exception of Ektacolor Portra II Paper, all of the Ektacolor papers available at the time this book went to press in 1992 had essentially identical dark fading/staining stability (these included Ektacolor Edge Paper, Ektacolor Royal II Paper, Ektacolor Supra Paper, Ektacolor Ultra Paper, and Duraflex RA Print Material). Ektacolor Portra II Paper, introduced in 1992, has somewhat better dye stability in dark storage, but the poor yellowish stain behavior of the paper remains the same as that of the previous Portra paper (1989–92) and other Ektacolor papers.

Ektacolor 74 RC paper, in use from 1977 until 1986, employed a cyan dye with very poor dark fading stability; in addition, over time the papers developed high levels of yellowish stain in dark storage. (Konica PC Color Paper Type SR, introduced in 1984, was the first chromogenic paper to use a high-stability cyan dye, and this greatly improved the paper's overall stability.)

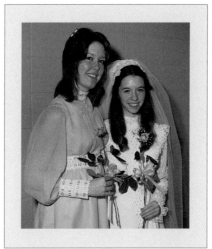

Unfaded print made with Fujicolor SFA3 paper available at end of 1992.

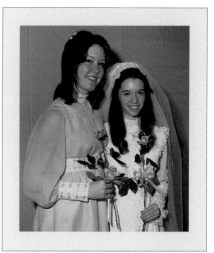

Fujicolor SFA3 print after 60 days in accelerated dark fading/staining test.

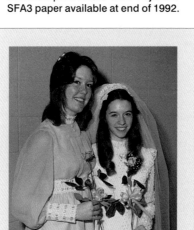

Unfaded print made with Kodak Ektacolor paper available at end of 1992.

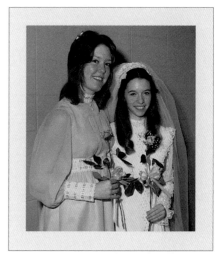

Kodak Ektacolor print after 60 days in accelerated dark fading/staining test.

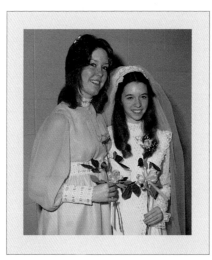

Unfaded print made with Kodak Ektacolor 74 RC paper (available from 1977 until 1986).

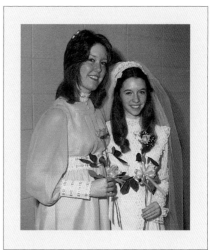

Kodak Ektacolor 74 RC print after 60 days in accelerated dark fading/ dark staining test.

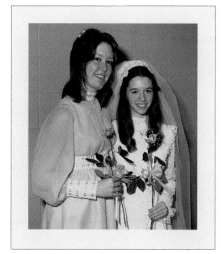

Fujicolor SFA3 print after 120 days in accelerated dark fading/staining test.

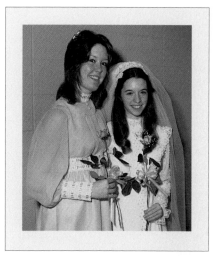

Fujicolor SFA3 print after 180 days in accelerated dark fading/staining test.

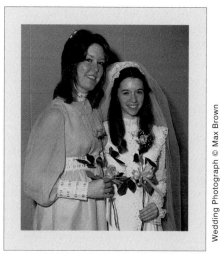

Fujicolor SFA3 print after 240 days in accelerated dark fading/staining test.

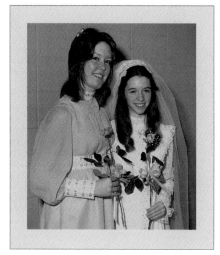

Kodak Ektacolor print after 120 days in accelerated dark fading/staining test.

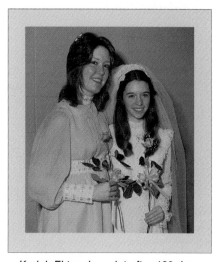

Kodak Ektacolor print after 180 days in accelerated dark fading/staining test.

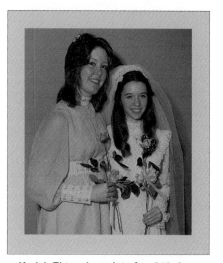

Kodak Ektacolor print after 240 days in accelerated dark fading/staining test.

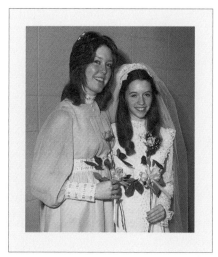

Kodak Ektacolor 74 RC print after 120 days in accelerated dark fading/ dark staining test.

Kodak Ektacolor 74 RC print after 180 days in accelerated test — sample print not available.

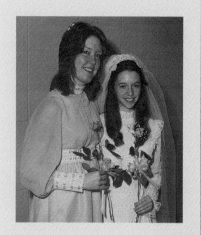

Kodak Ektacolor 74 RC print after 240 days in accelerated dark fading/ dark staining test.

Wedding Photograph © Max Brown

## Comparative Dark Fading and Yellowish Staining Behavior of Color Papers Used to Print Color Transparencies

Among "easily processed" color print materials, Ilford Ilfochrome silver dye-bleach prints are the only type of color prints that are essentially permanent in normal, room-temperature dark storage. Polyester-base Ilfochrome prints, which can be made only from color transparencies, are expected to last 500 years or more without noticeable fading or staining when kept in the dark; no other type of conventional color print can even approach this level of stability. Kodak Dye Transfer prints, which are far more expensive than Ilfochrome prints, also have excellent dark storage stability. (Both Ilfochrome and Dye Transfer prints are subject to light fading, however.)

Among process R-3 compatible reversal papers, Fujichrome Paper Type 35 is by far the most stable material, both in dark storage and when exposed to light on display.

© Robert Hodierne – Vietnam (Hill 881 North), May 1967

Unfaded Ilford Cibachrome II print (now called Ilfochrome Classic). Prints shown below made with other processes were similar in appearance prior to accelerated aging.

Kodak Dye Transfer fiber-base print after one year in the accelerated dark fading/staining test. The print showed almost no fading and suffered only slight staining. The one-year test period was twice as long as that used with the now-obsolete Ektachrome and Fujichrome papers below.

Ilford Cibachrome II (now called Ilfochrome Classic) print, made on a glossy polyester-base, after one year in the accelerated dark fading/staining test. The print showed no detectable fading or staining at the completion of the test (the prints are subject to light fading, however).

Kodak Ektachrome 22 RC print (initial type: 1984–90) after 6 months in the accelerated dark fading/staining test. Ektachrome Radiance paper (1991—) has greatly improved dye stability in dark storage, but over time the paper still develops high levels of yellowish stain.

Fujichrome Paper Type 34 RC print (1986–92) after 6 months in the accelerated dark fading/staining test. Fujichrome Paper Type 35 (1992—) has similar stability. Note the low yellowish stain level and the much better cyan dye stability compared with Ektachrome 22 paper.

## UltraStable and Other Pigment Color Prints May Have a Display Life of More Than 500 Years

The only way to make truly long-lasting color photographs that can safely be displayed for hundreds of years is to form the color images with high-stability color pigments instead of the far less light-stable organic dyes used with Fujicolor, Ektacolor, and most other color processes.

Currently available high-stability pigment color prints include UltraStable Permanent Color prints (see description on page 49) and prints made with Polaroid Permanent-Color materials, both invented by California photographer Charles Berger, and EverColor Pigment Color Prints made with a high-stability modification of the AgfaProof graphic arts proofing system and planned for introduction in 1993 by the EverColor Corporation (see description on page 122 and the suppliers list on page 293).

At the time this book went to press in late 1992, production samples of prints made with these three processes were not yet available, and it was not known which of the three produced the most stable prints — nor which was capable of the best color and tone reproduction. This author will start long-term stability tests with these processes as soon as verified production samples are obtained.

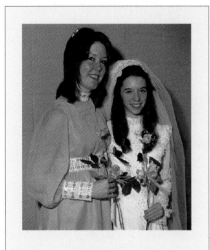

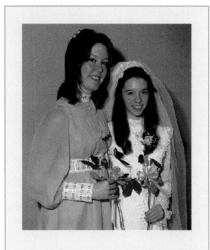

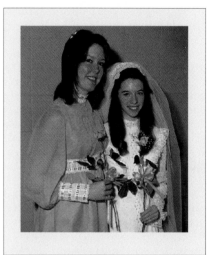

Wedding photograph © Max Brown

Unfaded pigment print made with Polaroid Permanent-Color materials. The color of the pink dress in this early prototype print is exaggerated because the digital laser scanner used to make the separations had not been properly adjusted for the process.

Polaroid Permanent-Color print after light exposure in an accelerated test equivalent to 575 years of display. Some magenta fading occurred, but the print remains in good condition. (The print was exposed to 21.5 klux fluorescent illumination for 6 years.)

Polaroid Permanent-Color print after 6 years in an accelerated dark fading/staining test. No fading or staining of the image or polyester base material could be observed. (The accelerated test was conducted at 144°F [62°C] and 45% RH.)

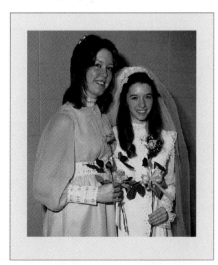

Unfaded print made on Kodak Ektacolor Plus Paper in 1985. Ektacolor Professional Paper and the Process RA-4 Ektacolor papers available at the time this book went press in 1992 have similar image stability.

Kodak Ektacolor Plus print after light exposure in an accelerated test equivalent to 250 years of display. (The print was exposed to 21.5 klux glass-filtered fluorescent illumination for 2.7 years [75°F and 60% RH].)

Kodak Ektacolor Plus print after one year in an accelerated dark fading/staining test. Note the severe, overall yellowish staining of the image. (The accelerated test was conducted at 144°F [62°C] and 45% RH.)

## Color Photographic Images Are Composed of Cyan, Magenta, Yellow, and Sometimes Black Layers

Most color films and prints have images composed of organic cyan, magenta, and yellow (the subtractive primary colors) dyes residing in very thin gelatin layers that are coated on transparent film base, polyethylene-coated RC paper base, or white polyester base. At any given point in an image, the color is determined by the relative concentration of the three dyes. No dye is present in white areas, and black areas have a maximum concentration of all three dyes. Some types of color prints, including the UltraStable Permanent Color print reproduced at the right, employ high-stability pigments instead of generally much less light-stable organic dyes to form the image.

UltraStable prints, EverColor pigment prints, Iris and Stork ink jet prints, some types of thermal dye transfer prints, and offset-printed color illustrations such as those in this book utilize a "black printer" in addition to cyan, magenta, and yellow image layers used with traditional color photographs in order to obtain the required densities in dark areas and to increase apparent sharpness. Color copier-printers such as the Canon Color Laser Copier, Xerox 5775 Digital Copier, and Kodak Color Edge Copier also employ a black image in addition to cyan, magenta, and yellow.

Unlike Ektacolor prints and most other current types of color photographs, the color image layers of UltraStable prints are prepared individually. Examples of these layers (and various combinations of layers) are reproduced below.

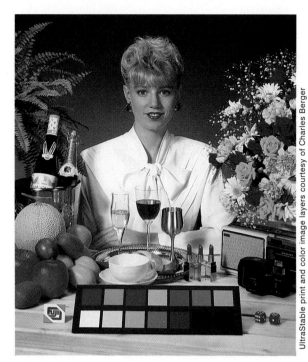

UltraStable print and color image layers courtesy of Charles Berger

UltraStable Permanent Color print with an image composed of cyan, magenta, yellow, and black pigment layers. The print was made from a 6x7-cm transparency supplied by Fuji as an aid for setting up graphic arts color scanners.

Cyan image.

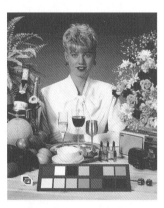

Magenta image.

Yellow image.

Black image.

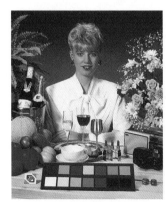

Cyan and magenta without yellow or black images.

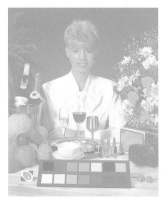

Cyan and yellow without magenta or black images.

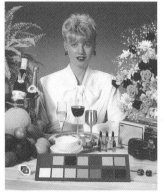

Magenta and yellow without cyan or black images.

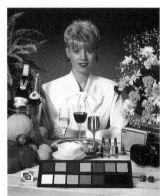

Cyan, magenta, and yellow without black image.

## How Color Photographs Can Look After They Fade and Stain in Normal Display and Dark Storage

When color prints and films fade, the three image dyes (and black image, if present) rarely fade at the same rate, and the result is a progressive shift in color balance. Light fading characteristically results in a partial or total loss of highlight and low-density detail as well as a color-balance change that is visually most apparent in low- and medium-density portions of an image. Fading that occurs in dark storage with Ektacolor and other chromogenic color prints is usually characterized by an overall change in color balance and ever more objectionable yellowish stain. Fujicolor SFA3 and Fujichrome Type 35 papers, introduced in 1992, have greatly reduced rates of yellowish stain formation.

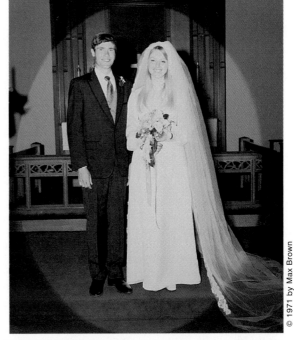

© 1971 by Max Brown

A magnified cross-section of an Ektacolor 74 RC print, with the cyan, magenta, and yellow dyes that were formed during processing. Beneath the print emulsion is a polyethylene plastic (RC) layer containing a white titanium dioxide pigment, followed by a core of fiber-base photographic paper. At the bottom is a layer of clear polyethylene.

Courtesy of Klaus B. Hendriks

This 1971 Kodak Ektacolor RC print was framed behind an oval mat. After 7 years of home display, the image suffered severe magenta dye fading and developed yellowish stain.

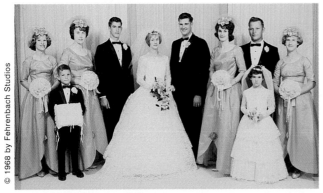

© 1968 by Fehrenbach Studios

Displayed 1968 Ektacolor print with severe magenta dye fading and loss of detail in skin tones and in the bride's dress while the groom's black tuxedo appears unaffected.

1950 Kodacolor print kept in the dark (note stain).

Courtesy of Sarah Wilhelm

1980 Agfacolor print kept in the dark (note cyan fade).

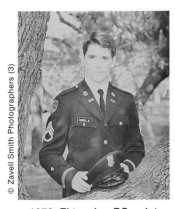

© Zavell Smith Photographers (3)

1970 Ektacolor RC print after 10 years of display.

1970 Ektacolor RC print after 10 years of display.

1973 Ektacolor RC print after 8 years of display.

© 1969 by Fehrenbach Studios

1969 Ektacolor RC print after 13 years of display.

## Color Photography Has Now Largely Replaced Black-and-White Photography

Long before Louis Daguerre publicly revealed his daguerreotype process in France in 1839, he and another Frenchman, Joseph Nicephore Niepce, had been experimenting with various materials which they hoped could be used to produce color images. In 1816, Niepce wrote to his brother Claude:

> The experiments I have thus far made lead me to believe that my process will succeed as far as the principal effect is concerned, but I must succeed in fixing the colors; this is what occupies me at the moment, and it is the most difficult.

While neither Daguerre nor Niepce succeeded in producing a workable color process, the desire to make photographs in color persisted, and it was not long before many photographers began to hand-color their daguerreotypes. Often the coloring consisted of nothing more than adding a little rosy color to the cheeks of people in the portraits; sometimes rather elaborate work was done in an attempt to simulate the full range of colors in the original scene.

It is interesting to speculate about what place black-and-white pictures would have had in the history of photography if practical color processes had been invented before black-and-white systems had become widespread. Assuming equal costs and ease of use of both black-and-white and color, it is not unlikely that black-and-white pho-

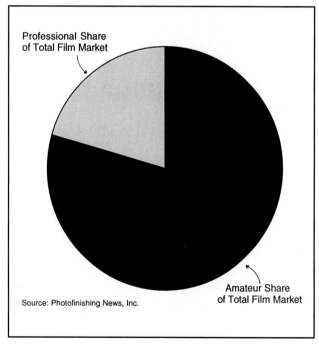

Source: Photofinishing News, Inc.

Professional Share of Total Film Market

Amateur Share of Total Film Market

**Figure 1.2**  Beginning in the mid-1960's, amateur photography in the United States embarked on a major shift toward color negative films and color prints — and away from the previously popular black-and-white films and color slide films. By 1990, approximately 90% of all amateur photographs were made with color negative films and printed on color negative papers.

tography would have been considered something of a curiosity, perhaps desirable only for certain scientific or artistic applications. The principal achievement of photography has always been to record events, people, and scenes; color is almost always an important part of this reality.

When portrait and wedding photographers made the virtually total shift from black-and-white to color photography during the 10 years from 1965 to 1975, there was very little realization on their part that in abandoning black-and-white photography, they were also giving up the long-term stability of the metallic silver images that they had come to take almost for granted.

The ability to make a portrait — to "Take A Moment Out Of Time . . . And Make It Last Forever," as a 1980 Kodak color portrait advertising slogan[5] put it — and know that the photograph could be displayed without worry for many generations to come was a very important part of the appeal of portrait photography ever since highly stable silver-gelatin materials (the ordinary black-and-white print) came into general use around 1900.

Despite their great stability advantages, black-and-white photographs are missing one crucial element, and that is color. We see in color; and the general public has shown an overwhelming preference for color images, whether they be color photographs, color television, color motion pictures, or color illustrations in newspapers, magazines, books, and advertisements. At their best, color photographs are stunningly beautiful in a way that is very different from the monochromatic images of carefully made black-and-white photographs. Color photographs offer a much more complete depiction of reality and provide much more visual information than do black-and-white photographs.

Joel Meyerowitz, a New York City fine art and commercial photographer who started his career in 1962 with black-and-white films and became an accomplished black-and-white printmaker, said this about color photography in an interview with Bruce K. MacDonald in *Cape Light,* his celebrated book of color photographs taken on Cape Cod which also served as the catalogue for a 1978 exhibition of the same name at the Museum of Fine Arts in Boston:

> . . . Color film appears to be responsive to the full spectrum of visible light while black and white reduces the spectrum to a very narrow wavelength. This stimulates in the user of each material a different set of responses.
>
> . . . Color is always a part of experience. Grass is green, not gray; flesh is color, not gray. Black and white is a very cultivated response.
>
> . . . [Color] makes everything more interesting. Color suggests more things to look at, new subjects for me. Color suggests that light itself is a subject. . . . Black and white taught me about a lot of interesting things: life in the streets, crazy behavior in America, shooting out of a car. Black and white shows how things look when they're stripped of their color. We've accepted that that's the way things are in a photograph for a long time because that's all we could get. That's changed now. We have color and it tells us more. There's more content! The form for the content is more complex, more interesting to work with.[6]

*profits are bigger
when the "something blue"
shows its*

COLOR

With one set of wedding candids to last a lifetime, a bride doesn't usually look for the economy assortment when she orders. One look at a set of *color* candids will usually sell her. ■ It makes excellent sales sense for you to offer color. Because (1) while your selling price is considerably higher than for a comparable black-and-white job, your fixed costs—rent, depreciation, etc.—don't rise at all; and (2) customers are beginning to expect color! ■ Figure it out for yourself. Shoot color roll film, and you can deliver a dozen "jumbo" color proofs at nominal cost—including film, processing, and proofing by a quality-minded color lab. ■ Now that new *ASA 80* KODAK EKTACOLOR Professional Film is available in sheet and now in 120 roll-film size, the job is easier than ever. Because EKTACOLOR Professional Film is balanced for daylight and electronic flash, you can go from indoors to out and never use a filter. ■ Next wedding, shoot color. Prospects for a top-profit color sale are the best ever. And what better way to break into color than with prospects like that? Check with your Kodak Technical Sales Representative for details.

**EASTMAN KODAK COMPANY,** Rochester 4, N. Y.

A 1963 Kodak ad that appeared on the back cover of the company's **Studio Light** magazine encouraged photographers to give up black-and-white photography and switch to color. The ad suggested that the Ektacolor prints of the time would "last a lifetime," which proved not to be true. When portrait and wedding photographers switched to color during the 1960's and early 1970's, most had no realization that in giving up black-and-white photography, they were also giving up a highly stable medium that could indeed last a lifetime. Properly processed black-and-white fiber-base prints can potentially be displayed for hundreds of years under normal conditions without significant change.

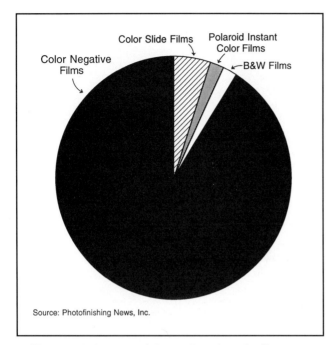

Source: Photofinishing News, Inc.

**Figure 1.3** In terms of the total number of still camera exposures made in the United States, amateur photographers have by far the largest share of the market. In 1990, professionals made only about 20% of the total exposures, while amateurs — mostly using color negative films — contributed about 80%. Color negative films and papers designed for the amateur market have become the core of the worldwide photographic industry.

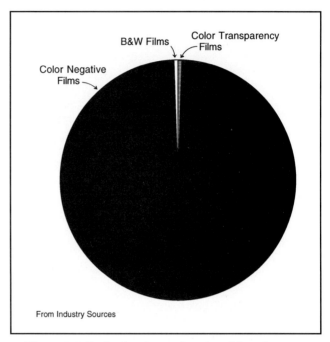

From Industry Sources

**Figure 1.4** Professional portrait and wedding photographers have converted almost entirely to color negative films and papers (the Ektacolor papers used by many professional labs have the same image stability as their amateur "35-cent drugstore print" Ektacolor counterparts). In 1992, it was estimated that portraits and wedding photographs made with color transparency films and B&W films amounted to less than one percent of the total.

## The Desire for Color Led to the Colorization of B&W Movies and Television Productions

The desire for color on the part of the general public is so strong that in the mid-1980's — over the heated objections of many movie directors and film curators — Turner Broadcasting System, through its Turner Entertainment Company subsidiary, and others began releasing "colorized" video versions of old black-and-white movies such as *It's a Wonderful Life* and *Yankee Doodle Dandy*. The colorized films are being broadcast over television and, in many cases, released on videocassette.

The colorization process is done with computers — with human operators making determinations about appropriate colors for each scene — and is output on videotape.[7] The movies themselves are not harmed and remain in their original black-and-white form. The computer-aided colorization of movies has become a flourishing industry, and many hundreds of films and early black-and-white television programs have been colorized for sale and rental in the global broadcast, cable, and videocassette markets.

Colorizing a film costs $2,500 to $3,000 a minute, with the costs for a feature-length film sometimes amounting to more than $350,000. Turner, which holds some 3,300 theatrical motion pictures in its library along with about 2,000 shorts and cartoons and more than 2,000 hours of television programs,[8] is by far the biggest customer of the colorizing business. At the time this book went to press in 1992, Turner had colorized several hundred films and had spent many millions of dollars on the effort.

Said Wilson Markle, president of Colorization Inc., a Toronto-based company that pioneered the colorization of black-and-white films: "People don't like black and white. They do like color, and when we color it, they buy it."[9]

According to Earl Glick, chairman of Hal Roach Studios, a Hollywood studio with many classic black-and-white movies in its archives:

> People who buy the movies for distribution and sale — television stations, networks, cable television and so on — always classify the black-and-white movie as a lesser picture, and therefore don't pay as much as they would pay for a color picture. Every time we went to sell something to them they'd say, "Well, this is only worth so much, because it's black and white." So we thought, well, if these pictures were in color, they'd command a much bigger price.[10]

An audience survey commissioned by the studio showed that "85 percent of people would watch something only if it were in color. In the age group under 20, nobody wants to watch anything in black and white." Glick went on to say: "We've sold more color cassettes of 'Way Out West' in six months than the black and white has sold in 10 years — and at a higher price."

Ironically, perhaps, at the present time the entertainment film industry is spending more money *adding* color to black-and-white films than it is spending to prevent color from fading away in existing color movies.

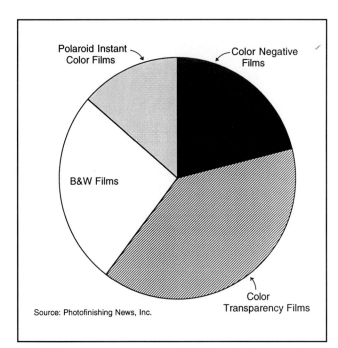

Source: Photofinishing News, Inc.

**Figure 1.5** It is among photographers working in photo-journalism, stock photography, fine art photography, and in commercial, industrial, educational, and scientific fields that color transparency films, black-and-white films, and Polaroid instant photographs are still widely used. But even these branches of photography are increasingly employing color negative films for their work.

### The Modern Era of Color Photography Began in 1935–36 with the Introduction of Kodachrome and Agfacolor Neu Color Transparency Films

Although a number of color processes were available in the early 1900's, such as the additive screen Autochrome plates introduced by the Lumiere brothers in France in 1907, and dye-transfer and tricolor carbro prints made from glass-plate separation negatives photographed sequentially through red, green, and blue filters — or in complex "one-shot" cameras that exposed all three separation negatives with a single exposure — all of these early color processes saw only limited use. They were either so cumbersome and time-consuming that only the most dedicated photographers would consider using them, or, in the case of Autochrome plates and the other additive screen processes of the time, they lacked the resolution necessary to produce satisfactory results in any but large-format cameras, and making good-quality prints from the additive screen images was difficult and time-consuming.

With the introduction of Kodak Kodachrome transparency film in 1935 and Agfa Agfacolor Neu transparency film in 1936, high-quality color photography suddenly became accessible to everyone. These films, which formed images by a process known as *chromogenic development*, were the first successful integral tripack color films.

Kodachrome film was first marketed in 1935 as a 16mm amateur movie film. Kodachrome for 35mm color slides was introduced in 1936; the film had an ASA speed of 10. Kodachrome sheet films in sizes up to 8x10 inches were supplied for the professional market from 1938 until 1951.

Beginning in 1941, Kodak supplied the amateur market with prints made with the Kodachrome process under the Minicolor name; the prints, which had rounded corners, were made with a white pigmented acetate base. From 1946 until 1955, the acetate-base prints were sold under the Kodachrome Print name. The Kodachrome Print name continued to be used for many years after 1955 to signify any print made from a Kodachrome or Ektachrome transparency by Kodak Processing Laboratories. Most of these prints were printed on Kodak fiber-base or RC-base color negative papers with an internegative made from the transparency. In later years, many "Kodachrome Prints" were made with Ektachrome RC reversal papers.

Kodachrome process acetate-base prints supplied to the professional market were called Kotavachrome Prints from 1941 until 1946; from 1946 until 1956, the prints were sold under the Kodachrome Professional Print name. All Kodachrome process prints have very good dark storage stability — their dark stability is much better, in fact, than that of any current Kodak color negative or reversal paper.

Kodachrome grew out of the research of Leopold D. Mannes and Leo Godowsky, Jr., who were professional musicians and avid amateur photographers. Interested in the work of the two inventors, Kodak coated a number of experimental plates for Mannes and Godowsky beginning about 1922, and in 1930 Mannes and Godowsky accepted an invitation to join the staff of the Kodak Research Laboratories and work with other Kodak personnel in perfecting their new process. From 1935 to 1938 Kodachrome was designed to be processed using what was known as the controlled-diffusion bleach method; this was a very complex 28-step, 3½-hour process requiring three separate processing machines. The dark-storage stability of this first version of Kodachrome was relatively poor, and most examples have by now suffered nearly total loss of yellow dye.

In 1938 the processing of Kodachrome — as well as some aspects of the film itself — was changed to the selective re-exposure method, and the use of controlled-diffusion bleach baths was abandoned.

February 1989

The Kodachrome processing machine at The Color Place in Dallas, Texas (the line was closed at the end of 1992). Kodachrome has suffered a considerable loss of market share in recent years in favor of the much easier to process E-6 Fujichrome and Ektachrome films. At the time this book went to press in 1992, only two independent professional labs in the U.S. still processed Kodachrome.

Russell Lee for the Farm Security Administration – 1939 (Courtesy of the Library of Congress)

Russell Lee – 1940 (Library of Congress)

In 1938 Kodachrome film was modified and the processing procedure changed to the selective re-exposure reversal method that is still in use today. The excellent dark fading stability and freedom from yellowish stain of the improved Kodachrome process are evident in this 1940 photograph of a depression-era New Mexico family eating dinner.

The initial "controlled-diffusion bleach" Kodachrome film and processing procedure was in use from 1935 until around 1940. As can be seen in this 35mm Kodachrome photograph taken in Oklahoma in 1939 by Russell Lee for the Farm Security Administration, the dark fading stability of Kodachrome film from this early period was poor.

Beginning with the improved film and processing procedure introduced in 1938, Kodachrome has had very good dark fading stability. Kodachrome film is still the only transparency film that remains totally free of yellowish stain formation during long-term storage.

Kodachrome processing continues to be a very complex procedure and can be done only with large, continuous processors. The three separate color developers and the two precisely controlled colored light re-exposure steps make it impractical for the user to process the film.

### Agfacolor Neu Transparency Film Was the First Incorporated-Coupler Color Film

Agfacolor Neu film, introduced by Agfa in Germany in 1936, one year after Kodachrome film became available, was probably more significant than Kodachrome in that the basic incorporated-coupler design of Agfacolor Neu is now used in all chromogenic materials except Kodachrome. Because the color couplers were incorporated into the emulsion layers during manufacture, only one color developer

was required and processing was greatly simplified compared with that required with Kodachrome film.

Although the technique Agfa devised to prevent color couplers in Agfacolor Neu film from migrating from one emulsion layer to another when the emulsion was wet and swollen during manufacturing and processing has been replaced by other methods (e.g., the "protected" or oil-encapsulated couplers invented by Kodak in the early 1940's and the latex "L-couplers" employed by Fuji in recent years), the incorporated-coupler concept pioneered by Agfa is now used with all color negative films, color negative papers, and with all Process E-6 compatible transparency films.

### Formation of Color Image Dyes in Film and Print Emulsion Layers with Chromogenic Development

Chromogenic development (coupling color development) was first disclosed by the German chemist Rudolf Fischer in patents, and in articles written with his co-worker, Hans Siegrist, that were published between 1912 and 1914. In simple terms, the process of chromogenic development can be described as follows:

When a silver halide emulsion is developed with certain types of developers, oxidation products that are produced in the course of development of the silver image can be used to react with, or couple with, special types of chemical compounds known as *color couplers* to form colored dye images.[11] Thus, during processing, the dyes are chemically synthesized in the thin emulsion layers where they remain in place after they are formed.

With the exceptions of the special color-correcting "masking" couplers used with modern color negative films, the couplers themselves are colorless; it is the chemical reaction between the couplers and the developer oxidation products that forms the colored dyes. It can be seen that where there has been no light exposure and no development takes place, developer oxidation products are not produced and even though color couplers are present, no dye will be formed. Thus, the density of the dye image corresponds to the density of the silver image — which in turn is deter-

As illustrated by this 1938 Agfacolor transparency, the dark storage stability of early Agfacolor films was poor. The photograph is of Klaus B. Hendriks, the director of the Conservation Research Division of the National Archives of Canada, at the age of 10 months in Germany.

Courtesy of Klaus B. Hendriks

mined by the amount of light exposure received by the emulsion at each point in the image. After chromogenic development is completed, both a silver image and a colored dye image are present at the same locations in the emulsion; the silver image is later removed by converting it back into a silver halide (chemical bleaching) and then removing the silver halide with a fixer.

The great virtue of the chromogenic process is that it permits the same extremely light-sensitive silver halides employed in black-and-white films to be used to form high-resolution color images. Modern color photography is often referred to as "silver-based photography" or "silver halide photography" even though — unlike black-and-white photography — there is no silver left in color films or prints at the completion of processing.

In 1913, the year after he first described color couplers and suitable developers for producing color images, Fischer obtained a patent for the design of an integral tripack color film containing incorporated couplers that would form yellow, magenta, and cyan dyes in the three emulsion layers. Fischer was unable to make a usable color material based on his ideas, however. His main difficulty was in finding a way to prevent the couplers from wandering from their assigned layer into another layer of the emulsion while it was wet during manufacture or processing. If, for example, a magenta coupler diffuses out of the green sensitive emulsion layer into the red sensitive layer, magenta dye will be formed where there should be only a cyan dye image — thus preventing proper color reproduction.

Application of the original Fischer process was finally achieved by Agfa in the Agfacolor Neu transparency film introduced in 1936. In early 1939, Agfa introduced the world's first incorporated-coupler motion picture color negative film and a companion color print film. These products were the forerunners of all current still camera and motion picture color negative films, as well as motion picture print films and papers for printing color negatives.

Many thousands of different couplers have been formulated to date; new couplers are constantly being produced in the course of research and development by the manufacturers of color materials. Of course, only a relatively

small number of couplers have actually been used in commercially available film and print materials. Among the properties of a coupler that determine its suitability for use in a particular emulsion layer are the following:

1. The color (and color purity) of the dye formed by the coupler. Couplers can be formulated to form dyes of almost any color, but in color photography, cyan, magenta, and yellow dyes are of primary interest. (A perfect magenta dye, for example, would absorb only green light and would be fully transparent to both red and blue light. In color photography, "perfect" dyes do not yet exist, and this degrades color reproduction.)

2. The color of the unreacted coupler. (Except with color negative films, couplers must be colorless.)

3. The coupler's reaction characteristics with the oxidation products that result from development of the particular silver halide used in an emulsion with the color developer at the time and temperature specified by the process (e.g., E-6, C-41, RA-4, R-3, and EP-2).

4. The light fading stability of the dye formed by the coupler. (Various chemical "stabilizers" may be incorporated in an emulsion during manufacture to reduce the harmful effects of light exposure. In addition, Ektacolor, Fujicolor, and all other *current* chromogenic print materials employ UV-absorbing emulsion overcoats that essentially eliminate UV radiation as a cause of fading in prints displayed under normal indoor conditions.)

5. The dark fading stability of the dye formed by the coupler. (Unreacted couplers that remain in the emulsion may have a significant deleterious effect on the dark fading stability of a dye.)

6. The tendency of unreacted couplers, which remain in the emulsion after processing, to produce stain over time. Such stain, which is almost always yellowish or brownish in color, is particularly noticeable in whites and other low-density areas of color prints. Yellowish stain can occur in dark storage, or it can be caused by exposure to light and ultraviolet radiation. With the Kodak Ektacolor papers available at the time this book went to press in 1992, yellowish stain formation in dark storage — caused primarily by the gradual discoloration of the initially colorless magenta couplers that remain in the print following processing — was a more serious problem than the dark fading of the image dyes themselves. Fujicolor SFA3 color negative paper and Fujichrome Type 35 reversal paper employ new types of "low-stain" magenta couplers that have greatly reduced rates of yellowish stain formation.

7. Whether or not the coupler is protected by a patent held by a competitor and, if it is, whether or not it can be licensed on acceptable terms.

Selection of a particular dye-forming coupler always involves a compromise of these and many other properties. Unless accelerated light fading and dark fading tests are performed, the stability characteristics of the dye formed by a particular coupler generally are not apparent until many months or years after processing.

From a manufacturer's point of view, the single most important characteristic of a color coupler is the color purity of the cyan, magenta, or yellow dye that it produces. The color purity of these dyes has a direct bearing on the color reproduction, color saturation, and other aspects of image quality that are apparent immediately after processing is completed. It is not surprising, then, that in the marketplace coupler characteristics relating to the visual quality of the dyes that make up the color image have *tended* to have priority over the long-term stability characteristics of a particular color dye.

## Among Available Dyes and Pigments, Chromogenic Dyes Are Virtually Unique in Terms of Their Instability in Dark Storage

Among the available color processes, chromogenic films and prints as a group have the distinct limitation of being relatively unstable in dark storage. While most classes of dyes are subject to light fading, chromogenic dyes are almost unique among commercially available dyes in that many of them also have poor stability when stored in the dark unless kept at refrigerated temperatures.

While many of the dyes and pigments intended for use with fabrics, printing, watercolors, and other purposes have less than adequate light fading stability, nearly all of these colorants have very good stability when kept in the dark. For example, although the 4-color process inks used in offset printing typically have poor light fading stability (the magenta and yellow inks are generally much less stable than the cyan and black inks when exposed to light), the dark storage stability of these inks appears generally to be excellent. When a book of color photographs is printed on good-quality, long-lasting paper and is protected from undue exposure to light, the printed reproductions will probably far outlast the original color prints.

## In the Years Following the Introduction of Kodachrome Film, There Have Been Tremendous Differences in the Permanence of the Many Types of Color Films and Prints That Have Been Marketed

While Kodachrome films and prints were successful products for Kodak, the company, which from its very beginnings has always been oriented toward the mass market, believed that the Kodachrome system had several serious shortcomings. First, in common with all color transparency films designed to be viewed by projection, Kodachrome films had a very narrow exposure latitude, which meant that the film was unusable in the simple, fixed-exposure box cameras of the day. This limitation alone effectively closed Kodak out of the bulk of the potentially huge market for amateur color snapshots. Kodak was well aware of the fact that although advanced amateur photographers were for the most part satisfied with putting on family slide shows to view their color photographs, most people preferred to have color prints which could be displayed, sent to friends and relatives, kept in wallets and purses, and arranged in carefully inscribed and dated albums.

With the Kodacolor process, introduced in 1942, Kodak believed that it had solved most of the marketing limitations of Kodachrome. Kodacolor was a wide-latitude chro-

Courtesy of Virginia Wolf

A 1944 Kodacolor print of John Wolf, the editor of this book, and his mother, Virginia Wolf. The severely stained print has been kept in an album and has not been displayed. All Kodacolor prints made from 1942 until 1953 now exhibit similar staining. Kodacolor prints from this period also have extremely poor light fading stability.

mogenic color negative film designed for use in fixed-exposure box cameras; both the film and prints were relatively simple to process. Kodacolor prints were made with a low-cost fiber-base paper support (it was many years later, in 1968, before a low-cost polyethylene resin-coated RC support was introduced as a substitute for the more expensive, non-absorbent acetate-base support of the type that was required with the Kodachrome print process).

## The Totally Lost Kodacolor Era of 1942–53

The fact that both Kodacolor films and prints were far less stable than Kodachrome films and prints — and of black-and-white films and prints — did not dissuade Kodak from marketing the products to an unsuspecting public. Consumers who made the unfortunate decision to use Kodacolor now have nothing left but unprintable negatives and faded, severely stained prints. In fact, this author does not know of a *single* Kodacolor print taken from 1942 until 1953 (the year that Kodak managed to significantly reduce the print staining problem) that survives today in reasonable condition; all have faded and developed an ugly, overall orange or yellow stain regardless of whether they

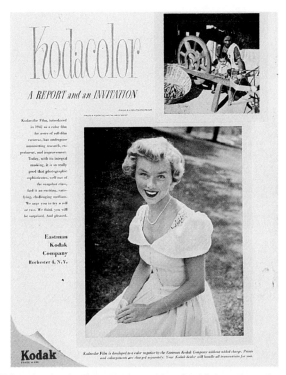

Printed reproductions such as this ad, which appeared on the back cover of the July 1950 issue of **Popular Photography** magazine, are the only record of what pre-1953 Kodacolor prints once looked like.

were exposed to light on display or kept in the dark in albums. The discoloration is caused by unstable magenta dye-forming color couplers that remain in the print after processing. These hundreds of millions — perhaps billions — of Kodacolor prints and negatives represent the first great era of color photography to be *totally* lost.

## For Years the Permanence of Color Films and Prints Has Been Shrouded in Secrecy

It was during the early days of color photography that Kodak adopted a policy of strict secrecy on matters of color stability; the company concluded that it would not be in its best interests to let the public become aware of the extreme stability advantages of Kodachrome over Kodacolor. (Looking back on the history of color photography, it is difficult to find another pair of products offered by a manufacturer at the same time that had such an extreme difference in image stability.)

Kodak apparently feared that if the general public knew just how poor the stability of Kodacolor prints was — even if the prints were kept in an album in the dark — the market for Kodacolor would be seriously restricted. Most amateur photographers would simply continue to use black-and-white films. Color photography was much more profitable to Kodak than was black-and-white photography.

The decision not to disclose color stability information to the public meant that there was little incentive to introduce more stable color print processes. With stability data kept secret, Kodak could not advertise improvements in image stability, and over the years this has effectively doomed

Kodak's interest in silver dye-bleach materials and other potentially long-lasting (and probably more expensive) color print processes for the general market.

As a result, during the early 1940's Kodak made a policy decision that was to have far-reaching consequences in terms of color permanence: the company decided that it should try to satisfy the requirements of nearly *every* branch of photography with one basic chromogenic color print material. This allowed considerable economies of production and a concentration of research and development activities. The design, processing speed, and cost requirements of this color print material were unfortunately dictated by its principal market: drugstore photofinishing. This is a hotly competitive market in which every fraction of a cent spent in producing a print is considered important.

Thus we have arrived at the present, with professional portrait and wedding photographers, fine art photographers, and photographers producing prints for historical documentation, all using a color print material whose every design aspect was dictated by the drugstore photofinishing and minilab business.

Very few people know that the most expensive color portrait or wedding photograph purchased from their local studio is printed on the *same type* of color paper that is used for the 35-cent prints they pick up at their local drugstore. In fact, as discussed in Chapter 8, because of the stability problems associated with the lacquering and retouching commonly done in the professional portrait field, there is a good possibility that the drugstore print, made on Ektacolor Edge Paper, is *more* stable than portrait and wedding photographs costing hundreds of dollars.

## Kodak Continues to Keep Stability Data for Its Ektacolor and Ektachrome Papers Secret

Although Fuji, Konica, and Agfa have been routinely releasing basic image stability data for their color papers in recent years, Kodak has not disclosed stability data for any of its Process RA-4 Ektacolor papers, which date back to the introduction of Ektacolor 2001 Paper in 1986. At the time this book went to press in 1992, these papers included Ektacolor Edge, Royal II, Portra II, Supra, Ultra, and Duraflex. Likewise, Kodak had not released any stability data for Ektachrome Radiance or Radiance Select papers for printing color transparencies. Kodak also had not released stability data for Ektatherm thermal dye transfer paper, which is used in the Kodak XL 7700-series digital printers for making prints from Kodak Photo CD's and other digital sources. The index print ("contact print") accompanying every Kodak Photo CD is an Ektatherm print.

For a few years, beginning in the early 1980's, Kodak did publish dark fading and light fading data for its Ektacolor and Ektachrome papers. At that time the company also published stability data for its color negative, color transparency, and color motion picture films. A summation of Kodak's dark fading predictions is included in Chapter 5; data for motion picture films are included in Chapter 9.

At the time this book went to press in 1992, the most recent image stability data published by Kodak for its color papers dated back to February 1985 and were for Ektacolor Plus Paper,[12] a Process EP-2 paper that was introduced in 1984 as a replacement for Ektacolor 78 Paper.

Albert Wittmer – Courtesy of the International Museum of Photography (Gift of Walter Clark)

This 1941 Kodak Azochrome silver dye-bleach print is in the collection of the International Museum of Photography at George Eastman House in Rochester, New York. The print is believed to have been made from a 4x5-inch or 8x10-inch Kodachrome transparency. After more than 50 years of storage in the dark, the extremely sharp color image remains in excellent condition, with no apparent fading or staining. In dark storage, Azochrome was probably the most stable color print material ever developed by Kodak. In abandoning the high-stability silver dye-bleach process, Kodak embarked on a policy of focusing its color photography efforts on the high-volume, low-cost amateur snapshot market. Beginning with the introduction of Kodak Color Print Material Type C in 1955 (renamed Ektacolor Paper in 1958), there has been no significant difference in stability between Kodak's amateur and professional color papers — a situation that continues to exist today.

### Kodak Almost Introduces Azochrome, a Highly Stable Silver Dye-Bleach Material, in 1941

In 1941, Eastman Kodak announced the Azochrome color print process, a high-stability silver dye-bleach direct positive process that Kodak had started work on in 1934.[13] (In the silver dye-bleach process — Ilfochrome is the only modern example — the image is made up of highly stable, fully formed dyes that are incorporated in the emulsion layers during manufacture. The dye layers are selectively bleached during processing to form the color image.)

The outbreak of World War II caused Kodak to postpone the marketing of Azochrome, and by the end of the war, Kodak had decided to abandon the Azochrome process and to concentrate its efforts on far less stable chromogenic materials such as Kodacolor for the general market and let the already existing Dye Transfer process satisfy the needs of the specialized, and small, advertising market.

A number of examples of early Azochrome prints examined by this author suggest that the process has excellent dark storage stability — certainly much better than any current Kodak chromogenic print material. If Kodak had actually gone ahead and introduced Azochrome in the early

1940's — and disclosed its superior stability characteristics — it is certain that the evolution of Kodak's color print materials would have proceeded much differently and that today the company would be producing far more stable color print materials for the professional market.

A high-stability, negative-printing version of Azochrome would have been extremely successful in the professional portrait and wedding market — and in the fine art field. Color microfilms and motion picture print films made with Azochrome technology would last *far longer* than Kodak's current chromogenic products for these applications.

### Early Ektachrome Films Were Far Less Stable Than the Kodachrome Films They Replaced

When Kodak replaced large-format Kodachrome sheet films with Ektachrome films at the beginning of the 1950's, no one outside of the company was aware that these new films faded in the dark at least 20 times faster than the discontinued Kodachrome films. The large differences in image stability between these films was a closely held secret within Kodak. The unfortunate results of this product downgrading can be seen in the now severely faded Ekta-

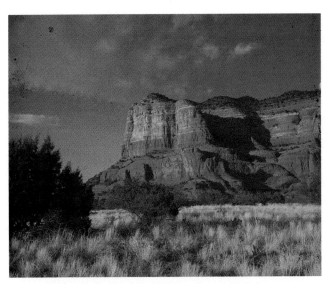

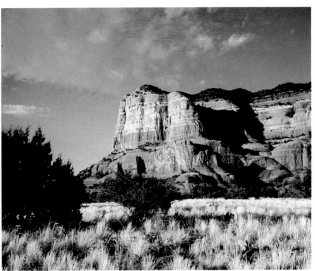

An Ektachrome 120 transparency shot in 1959 by Norman Rothschild and stored in the dark in New York City under normal room-temperature conditions since it was taken. The severe cyan and yellow dye loss is characteristic of the Kodak Process E-1, E-2, and E-3 Ektachrome films in use from 1946 until 1976.

Above is a Kodachrome duplicate made in 1961 of the original Ektachrome transparency on the left. During the more than 30 years that have passed since the Kodachrome was made, it is estimated to have faded less than 10%. It not only shows what the original Ektachrome looked like but also illustrates the dramatic difference between the dark-storage stability of the two films.

chromes from the period in the collections of *Life* magazine (at Time Warner Inc.), *Vogue* magazine, the National Geographic Society, the Library of Congress, the International Museum of Photography at George Eastman House, and other institutions all over the world.

For example, the original 8x10-inch Process E-1 Ektachromes of the famous Marilyn Monroe calendar photographs taken by Los Angeles photographer Tom Kelly in 1947 have suffered severe fading. The images survive only because Dye Transfer and tricolor carbro (pigment) prints were made from the Ektachromes and because many photomechanical reproductions have been published in the years since the photographs were made.

During the period from 1959 to 1976, most professional commercial, advertising, and fashion photographers in the United States used Kodak Process E-3 Ektachrome films in sheet-film and roll-film formats. These films, and the E-3 duplicating films, had very poor dark fading stability and were far inferior to the then-available "amateur" 35mm Process E-4 Ektachrome films (1966–1977). Kodak has never explained why — for a 10-year period — professional photographers using Ektachrome were supplied with a far less stable product than were amateurs, a fact that was kept secret from professionals and amateurs alike. It was not until 1977, when all Ektachrome films were replaced by improved E-6 Ektachrome films, that the stability of the professional films finally equalled that of the amateur films.

## The Eastman Color Motion Picture Process: A Major Problem for Film Studios and Archives

Color motion pictures, most of which are now made with a negative/positive color process that is in most respects similar to that used with still-camera color negatives and prints, have (with some exceptions) been significantly improved in terms of image stability since the mid-1980's.

However, even the improved products require humidity-controlled cold storage for long-term preservation. Most motion picture color negatives and prints made after the introduction of the Eastman Color process in 1950 until about 1985 have by now suffered significant fading.[14] Nearly all Eastman Color prints made between 1950 and around 1970 have now lost most of the cyan dye component of their images (and usually much of the yellow dye as well), and all that remains is a ghastly reddish-magenta reminder of what once were brilliant, full-color images.

When the Technicolor Corporation abandoned its dye-imbibition motion picture print process in the mid-1970's, few people in the Hollywood movie industry realized that

The July 9, 1980 edition of **Variety**, the entertainment industry publication, featured a front-page story on the color film fading crisis. The article described film director Martin Scorsese's efforts to focus attention on the very poor image stability of the motion picture color negative and print films supplied by Kodak, Fuji, and Agfa.

As is vividly shown in this frame from the 1961 film **West Side Story**, starring Natalie Wood, Eastman Color Print Film from the period had extremely poor dark fading stability (the 70mm film clip containing this image was 30 years old at the time this book went to press). All Eastman Color Print Films dating from the introduction of the process in 1950 until 1982 have similarly poor image stability. Fortunately, in the case of **West Side Story**, black-and-white separation negatives were made from the camera color negative, and a new intermediate negative and release prints can be made from these separations.

Reproduced above is an actual frame from the 1935 Technicolor film **Becky Sharp**, which starred Miriam Hopkins and Alan Mowbray. **Becky Sharp** was the first feature-length movie filmed with Technicolor 3-strip cameras. The Technicolor dye-imbibition printing process produced color images that are essentially permanent in dark storage. Except for surface scratches, the cellulose nitrate film base of this 57-year old film clip, which has been kept in normal room-temperature storage in Hollywood, also remains in very good condition. A modern adaptation of the Technicolor imbibition printing process is currrently in use in China, but in the United States and Europe, the Technicolor imbibition process was replaced by the far less stable Eastman Color print process in the mid-1970's (see Chapter 10).

they were giving up permanent color motion pictures. Current Eastman Color Print Film 5384 is far less stable than prints made by the Technicolor dye-imbibition process.

### The 3M Company Announces, and Then Withdraws, Its Pioneering Electrocolor Process for Making Highly Stable Electrophotographic Color Prints

The 3M Electrocolor process, which was introduced in 1965, produced color prints from both color negatives and color transparencies using a liquid-toner electrophotographic process developed by Vsevolod Tulagin and his co-workers at the 3M Company in St. Paul, Minnesota. In this author's accelerated aging tests, the prints appeared to be essentially permanent in the dark and had much better light fading stability than the Kodak Ektacolor paper and other chromogenic color negative papers available at the time.

Although 3M used organic dyes to form the images of Electrocolor prints, patents for the process state that pigments could also be employed.[15] With the proper selection of pigments, the process would have been capable of producing prints that were essentially permanent both when exposed to light on display and when kept in the dark.

Had the stability advantages of Electrocolor prints been properly promoted, the process would have been very successful in the upper tier of the portrait and wedding photography business. In a classic example of limited vision and missed opportunity, 3M failed to exploit the potential of the process and withdrew it from the market only 2 years after it was introduced. The basic technology employed in the Electrocolor process reappeared in 1990 in the 3M Digital Matchprint graphic arts direct-digital proofing system. As discussed later in this chapter, the Digital Matchprint system has the potential to produce inexpensive, highly stable color prints of excellent quality.

Courtesy of Donald R. Hotchkiss

The 3M Electrocolor liquid-toner electrophotographic process, introduced in 1965 and abandoned by 3M shortly thereafter, had the potential of producing color prints with outstanding image stability. This portrait is from a 2-inch-wide section of an 8x10-inch Electrocolor test print.

## In 1970 Agfa of Germany Introduces, but Soon Abandons, the World's Most Stable Conventionally Processed Color Print Material

One of the saddest legacies from the era of secrecy regarding color stability is that on a number of occasions, when a promising process was being actively researched, or, in a few cases, actually put on the market, the veil of secrecy prevented the manufacturer from exploiting the stability advantages of the process — resulting in the product's demise. For example, in 1970 Agfa started production of Agfachrome CU-410, a reversal silver dye-bleach material used for printing transparencies in Agfa's photofinishing plants. According to the noted German color photography historian Gert Koshofer, the silver dye-bleach process had been investigated by Agfa since 1927, with intensive work beginning in 1962 culminating with the introduction of Agfachrome CU-410.[16]  Samples of CU-410 tested by this author proved to be essentially permanent in dark storage and to have very good light fading stability; in fact, the prints have much better light fading stability than current Ilford Ilfochrome and Kodak Dye Transfer prints.

To this author's knowledge, Agfa never advertised the stability advantages of these prints. Because the material was somewhat more costly and also more difficult to manufacture and process than chromogenic reversal materials, Agfa stopped producing the material in 1976, just as quietly as it had begun 6 years earlier. Koshofer reports that few Agfa customers who received these prints even realized

An Agfachrome CU-410 silver dye-bleach print made in 1970. Essentially permanent in dark storage, the light fading stability of the prints is far better than in any other print material ever made by Agfa. In light fading tests conducted by this author, CU-410 lasted approximately **three times longer** than current Ilfochrome silver dye-bleach materials. Like Kodak, Agfa failed to recognize the importance of the silver dye-bleach system and abandoned the technology in favor of the far less stable chromogenic negative and reversal print systems.

*Courtesy of Gert Koshofer and Klaus B. Hendriks*

that they were made by the silver dye-bleach process or were otherwise different from other prints. The chromogenic Agfachrome reversal paper with which Agfa replaced the CU-410 process was vastly inferior in both light fading and dark-storage stability. If Agfachrome CU-410 were on the market today, it would in an overall sense be the world's most stable color print product (excluding the complex and considerably more expensive pigment color print processes). As it was well within Agfa's capability to perfect a negative-printing version of CU-410, the company could also have achieved tremendous sales in the professional portrait and wedding markets (which use color negative materials almost exclusively), and in the fine art field.

Agfachrome CU-410, and improved versions that would have followed if work on the process had continued, would have without a doubt been commercially successful if Agfa had had the wisdom to depart from its policy at the time of maintaining strict secrecy on matters concerning color stability. Image stability — the principal advantage of CU-410 over the company's chromogenic materials — was never promoted and the product was considered a failure. Agfa apparently was reluctant to publicize the excellent stability of Agfachrome CU-410 because this would inevitably have led to requests for information on Agfa's chromogenic Agfachrome and Agfacolor papers, which, by comparison, had very poor stability.

## The Worst Color Paper in Modern Times: Agfacolor Paper Type 4 (1974–1982)

In 1974, as a replacement for its then popular Agfacolor fiber-base paper, Agfa-Gevaert introduced Agfacolor PE Paper Type 4, the firm's first RC color paper. As the lowest-cost color paper available, Type 4 paper enjoyed wide use, especially in the mass portrait business, from the mid-1970's until the paper was discontinued in 1982. The paper was also used by a significant number of photofinishing labs in Europe and the U.S. The cyan dye in Agfacolor Type 4 paper had unbelievably poor dark fading stability, with the prints in most cases suffering from near-total cyan dye fading in less than 6 years. Untold millions of portraits

1987

A very faded 1977 childhood portrait of 13-month-old Donald Wilhelm IV and his 7-year-old sister Donna Jo that was made with Agfacolor Type 4 paper sits on the center of Donald's coffin. In 1987, at age 11, Donald died of cancer. The portrait was taken by a discount store photographer and the original negative no longer exists.

1991

Some color photographs last much longer than others. Like many people, Betty J. Gerber of Walnut Creek, California, shown here with her mostly very faded collection of family photographs, did not learn this fact until it was too late. In the 1970's and early 1980's, she had the misfortune of sending her color negative film to a photofinisher that used Agfacolor Type 4 paper. Whether kept in the dark or exposed to light on display, every single one of the countless millions of prints made with this paper worldwide has now faded to an ugly reddish ghost of the original color image.

of children, adults, and families made with Type 4 paper by PCA International, Inc. of Matthews, North Carolina and other mass-market portrait labs are now worthless. Business losses resulting from the exceedingly poor stability of the paper led to the filing of a nationwide class-action suit in 1985 against Agfa-Gevaert on behalf of labs and photographers across the United States who had used Type 4 paper; the case was settled out of court for an undisclosed sum in 1987. It is almost certain that, had the extremely poor stability of the paper been known, not a single lab would have used the product.

The fiasco did have one beneficial outcome, however — Agfa began to make a serious effort to improve the stability of its color papers, and the Agfacolor Type 8 and Type 9 papers that were available at the time this book went to press in 1992 represent a vast improvement over Agfa's ill-fated Type 4 paper.

## In 1963 Ciba-Geigy Announces the Cibacolor Silver Dye-Bleach Process for Printing Color Negatives — But Cibacolor Is Never Marketed

Cibachrome (renamed Ilfochrome in 1991) and other silver dye-bleach products are inherently direct positive materials and therefore have always been used for making prints from color transparencies. It is possible, however, to make silver dye-bleach prints from color negatives by means of a special reversal processing procedure, and Ciba-Geigy announced such a product under the Cibacolor name at the same time the firm introduced Cibachrome in 1963. For reasons that have never been understood by this author, Ciba-Geigy decided not to market Cibacolor.

Essentially permanent in dark storage, Cibacolor prints also had light fading stability that was *far* superior to that of Ektacolor and other chromogenic materials available at the time. This author believes that the demand for Cibacolor would have been far greater than the currently limited market for Ilfochrome materials and that Ciba-Geigy's failure to exploit the potential of Cibacolor was a major blunder. Cibacolor would have been extremely successful in the portrait and wedding fields, which, because they use color negative films almost exclusively, have never been able to benefit from the superior permanence of Cibachrome.

Courtesy of Armin Meyer

This Cibacolor print, made directly from a color negative, was one of the prints exhibited by the Swiss firm Ciba-Geigy at the Photokina trade show in Germany in 1963.

The upper print, made in 1971 with Ektacolor RC paper, faded much more than the lower print, made in 1968 with fiber-base Ektacolor Professional Paper, even though the fiber-base print had been displayed for 3 years longer than the RC print when this picture of the two choir photographs was taken in 1980. Both prints were framed under glass and had been on display next to each other in a church under similar lighting conditions.

Max Brown, an Iowa portrait and wedding photographer, is shown here in 1981 with a group of severely faded prints that were made from 1969 to 1974 with the then-new Ektacolor RC papers. The prints had been returned to Brown's studio by irate customers asking for free replacements (see Chapter 8 for an account of Brown's lawsuit against Kodak which was brought about by the very poor stability of the early Ektacolor RC papers).

## Displayed Ektacolor RC Prints Made in the Late 1960's and Early 1970's Have Suffered from Very Rapid Fading and Severe Color Shifts

Most Kodak Ektacolor RC prints made between 1968 and 1977 now exhibit severe image fading and shifts in color balance if they have been displayed; framing of these prints under glass — usually a recommended practice — appears to have actually *contributed* to their rapid deterioration. The prints were made with the first RC color papers marketed by Kodak, and this author believes that the RC base used with these products was itself a major factor in the rapid light fading that occurred (see discussion of RC base-associated fading and staining on page 72).

The rapid deterioration of these RC papers, which were introduced by Kodak during the period when many photography studios made the switch from black-and-white to color, caused considerable difficulties for professional portrait and wedding photographers after disgruntled customers returned faded prints to their studios (see Chapter 8).

Displayed under similar lighting conditions in a home, the Ektacolor RC print on the left faded much more than the fiber-base Ektacolor Professional print on the right, even though the RC print had been displayed for a shorter period when this photograph was taken in 1981.

This Polaroid SX-70 print, made in 1972 only a few months after the SX-70 system was introduced, has developed an overall yellowish stain which is plainly evident in the once-white background of this photograph. Cracks can be seen over the whole area of the image; the cracks are located in the image-receiving layer, beneath the transparent polyester print cover sheet. The print has been kept in the dark under normal storage conditions.

### Polaroid SX-70 Instant Color Prints Made In the 1970's Quickly Developed Objectionable Levels of Yellowish Stain — Many Prints from the Period Also Suffer from Internal Image-Layer Cracking

The Polaroid SX-70 camera and instant color prints were quite a sensation when they were introduced in 1972, but it soon became apparent that both the image stability and physical stability of the one-of-a-kind prints was very poor. Objectionable levels of yellowish stain were often reached after only a few months in dark storage (see page 174). In addition, with SX-70 prints from the 1970's, the image receiving layer, located beneath the transparent print cover sheet, is subject to catastrophic cracking (see page 125).

During the 1970's and 1980's, Polaroid ran many advertisements for the company's SX-70 and Polacolor peel-apart instant color films which claimed that the prints had outstanding stability. An ad entitled "This Polaroid SX-70 Photograph Is Part of the Collection of the Museum of Modern Art" appeared in *The New Yorker* and other magazines in 1977; it stated that SX-70 prints have "... remarkable clarity and definition of detail whose color is among the most stable and fade resistant in existence."[17]

Using a large-format version of its Polacolor ER peel-apart film, Polaroid has for some years offered for sale life-size replicas of paintings in the collection of the Museum of Fine Arts in Boston.[18] Prices for the replicas, which are framed and intended for display, range from $120 to more than $1,000. This author's tests show that the light fading stability of the prints is very poor (see Chapter 3).

### *Consumer Reports* Publishes Article Saying Kodak's PR-10 Instant Color Prints Have Very Poor Light Fading Stability

In November 1976, *Consumer Reports* magazine published an article that compared the light fading stability of the newly introduced Kodak Instant Print Film PR-10 and Polaroid SX-70 prints.[19] The magazine used high-intensity light fading tests and concluded that the light fading stability of the Kodak product was far inferior to Polaroid SX-70 prints. This apparently caught Kodak quite by surprise because a test report like this had never before appeared in a general-circulation publication.

In spite of the fact that Kodak's own — secret — light-fading tests agreed in general with the conclusions reached by *Consumer Reports*, Kodak's public relations people denounced the article and said that the high-intensity light fading tests used by the magazine were not valid and that "the entire tone" of the article was "misleading and blown out of proportion." According to Kodak, "the stability of Kodak instant prints is entirely satisfactory when such prints are handled, displayed, or stored in the usual variety of home and office situations ..."[20]

As shown on page 138 (see the last entry in Table 3.3), this author's low-level, long-term light fading tests revealed that displayed Kodak PR-10 Instant color prints had extremely poor light fading stability — by far the worst, in fact, of any color print material ever tested by this author. If anything, the *Consumer Reports* article understated just how poor the light fading stability of Kodak PR-10 instant prints actually was.

Kodak was forced to withdraw its ill-fated instant print films and cameras from the market in 1986 after losing a historic patent infringement suit brought against the company by Polaroid. In the end, Kodak was ordered to pay Polaroid a total of $924,526,554 — nearly $1 billion! — in damages and interest; Kodak's total losses from its foray into instant photography probably exceeded $2 billion.

### The Museum World and the General Public Become More Aware of – And Alarmed by – the Poor Permanence of Color Prints and Films

In what can be viewed as a landmark event that helped alert the museum world to the magnitude of the color stability problem and the need to better care for their collections, the International Museum of Photography at George Eastman House, in Rochester, New York, presented a "Colloquium on the Collection and Preservation of Color Photographs" in 1975. This was the first event of its type in the United States (earlier, in 1973, a conference on color preservation sponsored by the Royal Photographic Society was held at the Victoria and Albert Museum in London).[21]

In a letter of invitation to those attending the meeting, which was not open to the public, William Jenkins, a George Eastman House staff member and the organizer of the conference, wrote:

> As you may know, the International Museum of Photography has been concerned for some time with the difficulty of collecting color photographs. We have collected dye transfer and

carbro prints believing these to be relatively permanent, but our policy has been to refrain from acquiring the less stable materials such as "Type C" prints.[22] [Note: In current usage, "Type C print" is a generic term used to refer to a Kodak Ektacolor print or other chromogenic print made from a color negative.]

George Larson, a key figure in stability research at Eastman Kodak, and Charleton Bard, who, during the 1980's, became Kodak's regular speaker on the subject of color stability, represented Kodak at the conference. Larson and Bard, for the first time, gave some basic room-temperature dark-keeping stability data for the current Kodachrome and Ektachrome films. The meeting was marked by some strong denunciations of Kodak for its secrecy policies and for the very poor image stability of many of its color products. The renowned portrait photographer, Arnold Newman, said at the conference:[23]

> Millions and millions of people have taken color wedding pictures, vacation pictures, and family snapshots. What's going to happen to these pictures in 25 years? They're going to disappear.

Newman, who showed the group a selection of severely faded Ektachrome transparencies he had taken some years earlier of President John F. Kennedy, also expressed alarm about the fate of color portraits:

> These things are carefully hung on walls and they are expected to last. The great American public doesn't know it, but it is buying junk.
> They [Kodak and the other manufacturers] are going to find that the public is going to start getting angry in about 8 to 10 years from now when all these personal pictures begin to fade.

Eastman House later changed its policy of not collecting Kodak Ektacolor prints (a potentially embarrassing situation in light of the fact that this is by far the largest selling print material produced by Kodak, the museum's most important benefactor); the collection now includes a sizable number of recently acquired Ektacolor prints.

Refrigerated storage was one of the major recommendations to emerge from the 1975 conference. With the acquisition of the 3M-Sipley Collection in 1976, Eastman House possessed the most valuable collection of historical color processes in the United States. Many of these early color photographs have already seriously deteriorated because of improper storage in the past, and the damage is becoming worse with each passing year.

In spite of the immense value of these photographs, many of which were made by color processes of which examples exist in no other collection in the United States, Eastman House did not include a refrigerated vault in its new $7.4-million archive building completed in 1988. At the time this book went to press in 1992, Eastman House continued to store its priceless collection of color photographs and motion pictures under improper conditions, without refrigeration.

October 1975

New York City photographer Arnold Newman complaining about his severely faded Process E-1 Ektachrome transparencies at the "Colloquium on the Collection and Preservation of Color Photographs" sponsored by George Eastman House in Rochester, New York in October 1975. Listening to Newman's complaints is Charleton Bard (right), a Kodak research scientist who worked on color image stability problems for the company.

Neither Ilford, the manufacturer of Ilfochrome (then called Cibachrome and, at the time of the Eastman House Conference, the world's most stable color print material), nor Polaroid or Fuji was invited to attend the 1975 Eastman House conference.

## Other Important Preservation Conferences Soon Followed

Concern about the instability of color materials and the desire to learn more about how to better care for collections of color photographs and motion pictures in museums and archives led to many other preservation conferences and symposia. Many of the articles on color stability and preservation published during the past 20 years were based on presentations given at these meetings.

## The 1976 American Association for State and Local History Seminar in Madison, Wisconsin

In May 1976 the American Association for State and Local History (AASLH) sponsored a seminar on the "Use of Historical Photographs." Organized by George Talbot,

Courtesy of NASA (Photograph AS11-40-5947)

In this Ektachrome photograph by NASA astronaut Neil Armstrong, Edwin E. Aldrin, Jr. deploys a seismic experiment package on the surface of the moon during the historic July 1969 Apollo 11 mission. In the background is the lunar module in which the two astronauts descended from lunar orbit to a landing on the moon. The mission was the first time that human beings had set foot on the moon.

the meeting took place at the State Historical Society of Wisconsin in Madison, Wisconsin. This author and Klaus B. Hendriks of the National Archives of Canada were among the speakers; the processing and care of both black-and-white and color photographs in an institutional setting were discussed. The great increase in life afforded color photographs and motion pictures by humidity-controlled cold storage was emphasized.

Allan B. Goodrich, audiovisual archivist at the John Fitzgerald Kennedy Library in Boston, Massachusetts, was one of those attending the seminar; at that time, the Kennedy Library had not yet been completed and Goodrich had been thinking about how best to preserve the library's extensive collection of color materials from the Kennedy era. Goodrich had read a little-noticed 1970 article on color motion picture film storage by Peter Z. Adelstein and co-workers at Eastman Kodak entitled "Preservation of Motion Picture Color Films Having Permanent Value,"[24] which included a small graph that, for the first time, gave predictions for the number of years it would take for a 10% dye loss to occur with representative Kodak color motion picture films stored at temperatures down to 20°F (–6.7°C).

This article and the discussions about cold storage that took place at the AASLH seminar in Madison convinced Goodrich that it was indeed possible to preserve the Kennedy color negatives, color prints, and motion pictures indefinitely. At the time, the prevailing view among most museum curators and archivists was that "all color fades" and nothing could be done to stop it. Because of the image-stability problem, many curators and museum people had simply written off color photography altogether.

October 1987

The original Ektachrome EF and MS films used by the astronauts for photography on the historic Apollo mission to the moon on July 16–24, 1969, together with original color still photographs and motion pictures from other space missions, are permanently preserved at 0°F (–18°C) and 20% RH at NASA headquarters in Houston, Texas. As part of the most sophisticated color film preservation effort in the world, a complete set of color duplicates is stored in a second 0°F (20% RH) facility in Houston, and a third set is kept in a 0°F (20% RH) vault at White Sands, New Mexico.

In October 1979 the Kennedy Library began operation of a humidity-controlled cold storage vault maintained at 0°F (–18°C) and 30% RH to permanently preserve the Kennedy collection. This was the first humidity-controlled, 0°F photographic storage facility in the world, and it has helped encourage many other collecting institutions and motion picture studios to construct cold storage vaults to preserve their holdings (see Chapter 20).

## The "Stability and Preservation of Photographic Materials" Session at the 1978 SPSE Annual Conference in Washington, D.C.

In an event that could be considered the beginning of the modern era of the photographic preservation field — in which scientific investigation of the complex deterioration processes affecting photographic materials over time came

to the forefront — a special session on the "Stability and Preservation of Photographic Materials" was included in the program of the annual conference of the Society of Photographic Scientists and Engineers (now known as the Society for Imaging Science and Technology, or IS&T) in Washington, D.C. in May 1978.[25] This special session on preservation, which was the first of its kind at an SPSE meeting, was chaired by Klaus B. Hendriks of the National Archives of Canada.

The meeting included a presentation by Robert J. Tuite of Eastman Kodak on color image stability that contained significant new information about the stability of Kodak color materials and the accelerated test methods employed by Kodak.[26]

This author's presentation at the SPSE meeting included data which, for the first time, showed that there could be significant reciprocity failures with color print materials in accelerated light fading tests; in the talk, this author also proposed limits for dye loss, color imbalance, and stain formation in color print materials.[27] The meeting was an important first step by the photography industry toward becoming more open about the stability problems of color film and print materials.

Although most of Klaus Hendriks' research at the National Archives of Canada since he began his work there in 1975 has centered on the conservation of historical and modern black-and-white materials, his work in organizing numerous conferences and symposia for the Society of Imaging Science and Technology and other organizations has been an valuable contribution to the field of color preservation. Through internships in the conservation laboratories at the National Archives of Canada, Hendriks has helped train numerous individuals now working in the photographic conservation field.[28] Over a period of many years, Hendriks and his staff assembled *Phocus*, a bibliographic data base for photography conservation that is now the largest such on-line resource in the world. Hendriks is the author of the chapter on preservation in the 1989 book *Imaging Processes and Materials – Neblette's Eighth Edition*.[29]

### The 1978 Conference on Color Permanence at the International Center of Photography in New York City

In May 1978, the International Center of Photography (ICP) in New York City sponsored a 2-day conference entitled "The Permanence of Color — Technology's Challenge, the Photographer's and Collector's Dilemma." The conference focused on color stability problems in fine art photography and in photojournalism; this author served as chairperson of the event. A number of experts in the field, including representatives of Polaroid and Ilford, gave presentations at the conference. Eastman Kodak was invited to take part but declined to attend.

### Establishment of the Photographic Materials Group of the American Institute for Conservation in 1979

Since its founding in 1979, one of the most active organizations in the photographic conservation field has been the Photographic Materials Group of the American Institute

for Conservation.[30] Usually meeting twice a year (the group sponsors a program at each annual conference of the American Institute for Conservation and also meets separately once a year at different locations around North America), the diverse membership of the Photographic Materials Group consists of practicing conservators, researchers in the conservation field, curators, and others responsible for the care of photographic collections.

The Photographic Materials Group (PMG) meetings have become a major venue for the exchange of conservation-related information, and each year the organization publishes a bound volume of collected papers that have been presented at the group's gatherings. A number of these papers are cited elsewhere in this book.

### The 1980 American Film Institute and Library of Congress Cold Storage Conference

In 1980 the American Film Institute and the Library of Congress sponsored a conference in Washington, D.C. on "Cold Storage of Motion Picture Films" that helped increase awareness of the importance of low-temperature storage in the motion picture industry and in film archives.[31] Attending the conference on behalf of noted film director Martin Scorsese was Mark del Costello, who made an appeal for support of Scorsese's campaign to make improved color stability a high-priority goal for Kodak, Fuji, and Agfa-Gevaert.[32] Following the conference, this author began serving as a volunteer technical advisor on color stability-related issues to Scorsese and his staff.

At a meeting in Martin Scorsese's New York City apartment suite on July 14, 1980, Scorsese and his assistants Donna Gigliotti and Mark del Costello met with Ken Mason and Tony Bruno of Kodak's Motion Picture Division to discuss Scorsese's demands that Kodak (a) disclose the stability characteristics of its existing color motion picture

July 1980

Martin Scorsese, the director of **Cape Fear** (1991), **The Age of Innocence** (1993), and other noted films. Scorsese's film preservaton campaign helped to persuade Kodak and Fuji to develop the longer-lasting motion picture color negative and color print films that were introduced by both companies beginning in 1982. Scorsese has also encouraged the major Hollywood film studios to devote more time and money to film preservation — and to improve the storage conditions they provide for their film libraries (see discussion in Chapter 9 and Chapter 20).

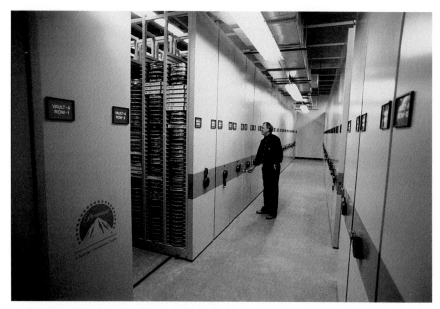 

October 1992 (2)

The color film storage vault in the Paramount Pictures Film and Tape Archive, located on the Paramount studio lot on Melrose Avenue in Hollywood, California. The color film vault, one of nine vaults in the high-security building, is kept at 40°F (4.4°C) and 25% RH. The multi-million-dollar facility went into operation in 1990. Shown here in the color film vault, which is equipped with movable shelving to conserve space, is Robert McCracken, a supervisor in Archive Operations.

A roll of the original camera negative from Francis Ford Coppola's 1974 classic, **The Godfather, Part II**. The film, which won six Academy Awards, starred Robert DeNiro, Robert Duvall, Diane Keaton, and Al Pacino.

films and (b) replace current films with longer-lasting products. With the weight of the entire entertainment motion picture industry behind him, Scorsese was able to convince Kodak that these issues had to be addressed.

In August 1980, only a month after the meeting, Kodak announced that color film and print stability data would be made public. The information became available in May 1981. In October 1981 Kodak announced that it was abandoning all of its existing motion picture print films and replacing them with Eastman Color Print Film 5384 (35mm) and 7384 (16mm); in dark storage these new films were about ten times more stable than the films they replaced. Fuji Photo Film Co., Ltd. soon followed with substantially more stable motion picture color negative and print films.

### The 1982 *Fugitive Color* Exhibition and Symposium at the University of Michigan

In January 1982 the University of Michigan in Ann Arbor, Michigan sponsored a national invitational exhibition of contemporary color photography to focus attention on the shift from black-and-white to color photography in the fine art world and the resulting problem of "fugitive color." (As applied to works of art, the term "fugitive" means that a paint, watercolor, fabric dye, or other medium has poor stability, especially when exposed to light on display.) Most of the photographs in the exhibition were printed on Kodak Ektacolor 74 RC Paper.

This author contributed an essay to the *Fugitive Color* exhibition catalogue[33] entitled "The Problems of the Ektacolor Print System." The essay began with the statement:

> The problem with Kodak Ektacolor prints is simple: they fade. The prints not only fade when

they are on display and exposed to light (one might even be tempted to forgive the product if this were its only fault); much worse, Ektacolor prints also fade in the *dark*. How fast they fade depends on the storage temperature and relative humidity.

. . . In 25 to 30 years [of storage in the dark] the prints will have suffered a visible loss of contrast and a serious color shift toward red-yellow because of cyan dye fading; the whites in the prints will have significantly yellowed. And that is when the prints are kept in the *dark* except for occasional viewing; if the prints have the misfortune of being displayed for 25 to 30 years, the condition of the images could be far worse.

. . . To be sure, there will still be recognizable images there, but they will not be the same images the artist had created. In the tradition of the art world, where one can find Rembrandts in pristine condition after hundreds of years of constant display, 25 to 30 years is not a very long time. In diverse medium collections such as that of the Museum of Modern Art, one would be unlikely to find *any* type of artistic media with worse dark keeping properties than Kodak Ektacolor RC prints. Even 18th-century watercolors, some of which fade quite rapidly on exposure to light, generally have very good dark keeping stability.

Accompanying the exhibition was a symposium on the stability problems of color prints and films. This author spoke on behalf of the exhibition organizers, and Charleton Bard, a color stability research scientist at Eastman Kodak, gave a presentation on the problem from Kodak's perspective. Sitting in the symposium audience was reporter

Marty Killeen, who was working on a feature on color fading for the CBS-TV show *Walter Cronkite's Universe.* The show was broadcast nationwide on August 31, 1982. Charleton Bard, this author, and Iowa portrait and wedding photographer Max Brown, who was plagued by irate customers bringing faded Ektacolor RC prints back to his studio demanding free reprints (see Chapter 8), appeared on the program to present their disparate views on the color fading problem.

## Seminars on the Preservation of Photographs at the Rochester Institute of Technology

In September 1977 the Rochester Institute of Technology (RIT) in Rochester, New York sponsored the first of its semi-annual seminars on the "Restoration and Preservation of Photographic Images." Not only were these seminars popular among people in museums, archives, and industry who were responsible for the care and management of photographic collections, but they also served as an ad hoc twice-a-year gathering for many of the speakers, including this author, who were active in the newly emerging field of photographic preservation. The early RIT seminars were much-anticipated events and featured a free and enthusiastic exchange of information and viewpoints between the seminar speakers themselves and the always-interesting attendees.

The seminars were cancelled amid controversy in 1981 after it was revealed that Kodak had secretly pressured RIT to cancel this author's invitation to speak on the stability and preservation of color photographs at a seminar scheduled to take place in August 1980.[34] Kodak was displeased with this author's critical comments concerning the image stability of its color films and print materials, especially Kodak's extremely unstable PR-10 instant print film. (Kodak's instant print films and cameras were withdrawn from the market in 1986 after a federal court ruled that Kodak had infringed on Polaroid patents; Kodak was ordered to pay Polaroid $925 million in damages.)

The last of the seminars took place in March 1981. Several years later the seminars resumed — with the discussions at first restricted to black-and-white photography. This author has not been invited back to speak at RIT.

## The Image Permanence Institute Is Established at the Rochester Institute of Technology

One positive outgrowth of the RIT preservation seminars was the establishment in 1986 of the Image Permanence Institute (IPI) at the Rochester Institute of Technology.[35] Directed by James M. Reilly, the Institute is jointly sponsored by RIT and the Society for Imaging Science and Technology (IS&T). Reilly had been a regular speaker at the RIT preservation seminars and, initially working on his own, had become the world's leading authority on the technological history and preservation of albumen prints and other 19th-century processes. Reilly's book, *Care and Identification of 19th-Century Photographic Prints*, published by Eastman Kodak in 1986, is the definitive reference on the subject.[36]

IPI's research on protective polysulfide treatments for the silver images in microfilms and other types of black-

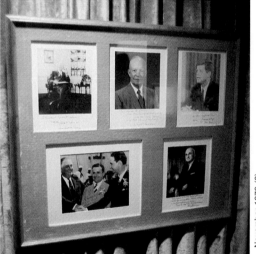

November 1979 (2)

Treasured Ektacolor portraits of U.S. presidents fade too. Shown above as they appeared in 1979 in an exhibit at the Lyndon Baines Johnson Library and Museum in Austin, Texas, these very faded, personally inscribed portraits had been given to President Johnson by five former presidents: Herbert Hoover, Dwight D. Eisenhower, John F. Kennedy, Franklin D. Roosevelt, and Harry S. Truman. The framed group of photographs had been displayed in a small conference room next to the Oval Office in the White House from 1963 until 1969, during Johnson's term in office. The five portraits are said to have been among Johnson's most treasured possessions. The Johnson Library installed the exhibit in 1974; it was removed in 1981, and the faded portraits are now in room-temperature storage. Johnson died in 1973.

Examination of the very faded portrait of Herbert Hoover at the upper left indicates that the print was made with fiber-base Ektacolor paper. The center portrait of Eisenhower is a Kodak Dye Transfer print; the image has suffered from considerable yellow dye fading. The portrait of Kennedy, at the upper right, is another Ektacolor print. At the lower left is a hand-tinted black-and-white print of Roosevelt. The portrait of Truman at the lower right appears to have been made with an Ektachrome paper, although this identification is not certain.

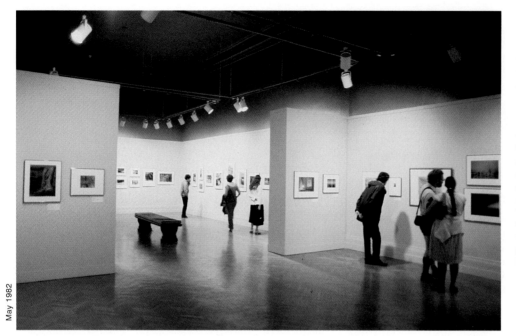

May 1982

**Color as Form: A History of Color Photography** exhibition at the Corcoran Gallery of Art in Washington, D.C. in 1982. Organized by the International Museum of Photography at George Eastman House, this was the first major exhibition of color photography to be densitometrically monitored to quantify fading or staining that might have occurred during the course of the exhibition. Copy transparencies were used for Autochrome plates and certain other fragile items in the exhibition.

and-white materials and its investigations of the stability of polyester, cellulose triacetate, cellulose nitrate, and other cellulose ester film-base materials when stored at various temperatures and relative humidities have been of major importance in the preservation field. IPI has built upon earlier research to better understand the relationship between relative humidity in storage and the deterioration of silver images and film base materials. IPI's findings have placed renewed emphasis on the substantial increases in longevity of these materials afforded by low-temperature and low-humidity storage. IPI also has an ongoing research program to investigate the effects of air pollutants on the stability of black-and-white and color materials.

James Reilly, Peter Adelstein, Douglas Nishimura, and others on the staff of IPI have been active participants in the work of a number of American National Standards Institute (ANSI) subcommittees concerned with stability testing and preservation. Adelstein, who retired from Eastman Kodak in 1987, presently serves as chairman of ANSI Subcommittee IT9, which has jurisdiction over all of the ANSI standards related to the permanence of imaging materials and systems, including magnetic tape, magnetic disk, and optical disk image-storage systems.

Most of IPI's initial funding was provided by Eastman Kodak and other companies in the photographic industry, although at the present time, grants from institutional and government sources constitute the primary support for IPI's activities. IPI also conducts materials testing for private companies under contract.

Policy for the Image Permanence Institute is set by the Board of Advisors, which is made up of representatives from the funding companies in the photographic industry, RIT, a number of collecting institutions, IS&T, and several private firms that supply storage and display materials. As a matter of policy, IPI does not publish comparative evaluations of the stability of commercial products (e.g., color films and papers), nor does it permit companies that contract its services to use IPI test data for such comparisons.

## Fine Art Museums Begin to Respond to the Problems Posed by Color Photographs

Almost immediately after the fine art photography world had finally embraced color photography as an art form in its own right in the late 1970's, museum curators, private collectors, and a new generation of photographers working in color began asking questions about how long color prints could safely be displayed.

Some wondered if Kodak Ektacolor color prints actually faded in the dark. Others would collect nothing but Kodak Dye Transfer prints, hearing that they would last forever. Some museum curators and collectors, fearing that their investments would depreciate as the prints faded, would not collect color photographs at all. (The tenor of the time was nicely captured in Nancy Stevens' essay "The Perils and Pleasures of Collecting Color," which appeared in the May 12, 1979 issue of the *Saturday Review* magazine.)

Among fine art museums, a three-part strategy to deal with the color print fading problem gradually emerged. The first step is to obtain from the photographer two identical copies of each color photograph chosen for acquisition. This approach provides an "expendable" copy for display purposes, for use as a study print, and for loan to other institutions for exhibition. The second "preservation copy" is kept in the dark under the best storage conditions available. A major benefit of the two-print approach is that the condition of the "expendable" print can easily be assessed at any point in time by a simple side-by-side visual comparison with the "preservation" print.

The Museum of Modern Art in New York City and the Art Institute of Chicago are among the museums that have instituted a two-print acquisition program. Both museums have found that photographers working in color are almost always supportive of the museums' efforts to preserve their work for posterity and are happy to provide the second copy at a sharply reduced "lab price" (the actual cost of making the print). The Museum of Modern Art, which is

May 1982

The Art Institute of Chicago, which owns an extensive collection of color photographs, was the first fine art museum to implement an ongoing densitometric monitoring program for the color and black-and-white prints in its collection (see Chapter 7 for print monitoring procedures).

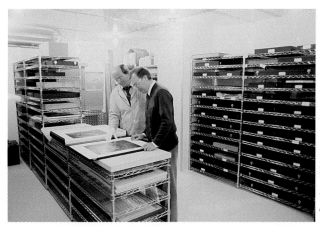

October 1987

The Art Institute was also the first fine art museum to provide cold storage for its collection of color photographs. Shown here examining color prints in the vault, which was constructed in 1982, are David Travis, curator of photography, and Douglas G. Severson, conservator. When stored at normal room temperature, Ektacolor prints from the 1970's and early 1980's have poor dye stability and high rates of yellowish stain formation. With few fine art museums having cold storage facilities, many of the Ektacolor prints preserved in the Art Institute's vault are believed to be the **only** examples of these images existing anywhere in the world that look essentially the same today as they did when they were made.

generally credited with launching the modern era of fine art color photography with the 1976 exhibition of William Eggelston's color photographs curated by John Szarkowski, director of the Department of Photography, issued the statement reproduced below in 1984:

### The Museum of Modern Art
#### New York

#### Statement to Photographers
#### Who Work in Color

It is now well known that with a few exceptions color print materials show a noticeable fading or color shift within as little as ten to twenty years when stored under normal room temperature and humidity conditions, even in the dark. Most such works in the Museum's Collection, prints up to 20 x 24 inches, are now stored at about 30°F [–1.1°C] and 35% relative humidity. These conditions will substantially increase the life of the prints.

However, these same photographs also fade or change color when, on exhibition, they are exposed to light. Since it is our purpose not only to preserve but also to show the pictures we collect, we propose the following:

When we decide to purchase a color print in unstable materials, we will ask to buy two prints, one at the artist's price, the other at the presumably much lower "lab" price, or what it costs to make the print. The Museum will agree to regard the two prints as equivalent versions of a single work of art, and will so record them. Neither print ever will be sold. Both prints will be placed in cold low-humidity storage. One will be available for exhibition and loan; the other will be kept in effect as a back-up, until such time as the first is judged to have faded significantly. This solution is not perfect, but it will help to resolve the conflict between our goals of preserving the Collection and making it known through exhibition here and elsewhere.

The second preservation step being taken by enlightened fine art museums is to provide humidity-controlled cold storage for their color prints and other materials with problematic dark storage stability. In the case of the Museum of Modern Art, a low-humidity refrigerator is now employed (see Chapter 19). The Art Institute of Chicago constructed a large, two-part, humidity-controlled cold storage vault in 1982 for housing its entire photography collection; color materials are kept in the colder of the two vault sections. The National Gallery of Canada in Ottawa began operation of a cold storage vault for its extensive fine art collection in 1988 (see Chapter 20).

The third preservation step now being employed by fine art museums is the electronic monitoring of the fading and staining that may occur over time with the color and black-and-white prints in their collections (see Chapter 7). Periodically, an electronic densitometer is used to measure the red, green, and blue densities at selected locations on each print. A measurement location map is prepared for each print, and records are kept of all density readings.

These procedures allow detection of any significant fading or staining that occurs over time, and if the changes exceed certain predetermined limits, the print in question is taken off display and is retired to the cold storage vault. Both the Art Institute of Chicago and the National Gallery of Canada have instituted monitoring programs for their collections. Monitoring is particularly important for prints that have no second "preservation copy" in cold storage.

This three-part preservation strategy allows fine art museums to collect color photographs made with virtually any color material — no matter how unstable it may be — and preserve the prints in essentially unchanged condition for the far distant future.

Former President Dwight D. Eisenhower speaking at a press conference at Grinnell College in Grinnell, Iowa in May 1965. As with other U.S. news events of the time, television crews filmed the press conference with Eastman Ektachrome Video News Film, a 16mm reversal film. Eisenhower, who served as president of the United States from 1953 until 1961, died in 1969.

Scenes such as the above were soon to end. By the close of the 1970's, the motion picture camera had all but disappeared in the television news field, replaced by compact ENG (electronic news gathering) television cameras made by Sony and other manufacturers. This was the first major market in which electronic systems totally replaced traditional color photography.

## With the Invention of Television in the 1920's, Image Making Has Been Gradually Shifting from Traditional Photography to Electronic Systems

Beginning in 1956, with the introduction by the Ampex Corporation of the 2-inch quadruplex video tape recorder, the first practical video tape recorder for television,[37] traditional silver-halide-based black-and-white and color photography began a steady transition toward electronic systems for recording and preserving moving images.

For the advent of electronic *origination* of images, one must go back another 50 years — to the early 1900's — when a number of farsighted inventors in Europe and the United States involved themselves in trying to solve the vexing problems of "photographing" and transmitting images electrically — an exciting new concept that was called "television" (a word that has been credited to a Frenchman named Perskyi, who used the French word "télévision" in documents prepared for the 1900 Congres Internationale d'Electricité).[38]

By the mid-1920's, the time had come for the introduction of television to the general public. The following is excerpted from an account of the history of television by Richard S. O'Brian and Robert B. Monroe that was published in the *SMPTE Journal* in July 1976:[39]

Stimulated by the ready public acceptance of radio broadcasting, it was inevitable that work would be undertaken to develop a working television system. Two inventive individuals, independently, but more or less simultaneously, undertook this mission: John Logie Baird, a Scottish engineer, in England, and C. Francis Jenkins, an independent inventor, in the U.S.A. Jenkins had achieved success in designing the first practical projector for motion-picture film in the 1890's and had made numerous contributions to motion-picture equipment design and to later development of still-picture transmission (wire or radio photos) technology. His approach to television was as a means of extending the motion picture into the home or conversely of en-

abling wired or wireless transmission to theaters from a central production location.

. . . Both Baird and Jenkins appear to have succeeded in transmitting small, silhouette images contemporaneously, in 1925, [with] Jenkins actually making the world's first radio transmission of moving "shadow graphs" across the Anacostia River near Washington, D.C. on 13 June 1925. Baird had achieved silhouette picture transmission just a few weeks earlier, giving public demonstrations in a London department store during April 1925. The January 1926 demonstration by Baird is, however, generally recognized as the first in which gradations of tone scale in the moving

Amateur home movies, most of which were made with 8mm reversal color film, became the second major market in which traditional silver-halide-based photography was totally displaced by electronic systems. Exploding in popularity during the 1980's, the now-ubiquitous camcorder offers "instant" moving images with sound (and with no chemical processing) at far less cost and trouble than the earlier movie cameras and projectors. Shown here taping with their 8mm camcorder is the Clark and Teresa Winter family, at home in their New York City apartment.

images made it possible to recognize facial features and expressions, despite the very coarse scanning structure used at the time. Line counts of 16, 24, 30, 48, 60, and in a few years, as high as 240, were subsequently used as refinement of mechanical and optical components was achieved.

. . . Experimental television broadcasting, using mechanical scanning, soon began in the U.S. The first, and now barely remembered introduction of television broadcasting to the public was under way. The first license, W3XK, went to Jenkins in 1927 for a visual transmitter located near Washington, D.C.; other stations followed. In 1927, Dr. Ernst Alexanderson at General Electric began experimental television transmission over W2XAD, Schenectady. [By the next year, the pioneering Schenectady, New York TV station was broadcasting rather ambitious television productions that included television's first drama, *The Queen's Messenger*, a three-camera production, the sound portion of which was broadcast over sister-station WGY.]

In 1928, RCA started operating an experimental 250-watt television station W2XBS, from 411 Fifth Avenue in New York City. By 1929, twenty-two experimental television licenses had been issued in the U.S. and portions of the radio spectrum between 2.0 and 2.95 MHz had been set aside for experimental transmissions.

In Germany and in England, experimental television broadcasting was also under way. In 1929, arrangements were made between the BBC and the Baird Television Company for regular experimental transmission of television pictures from the London station. These early BBC television transmissions took place for one-half hour periods, five days a week, and had a definition of 30 lines and a frame repetition frequency of 12½ frames per second.

In addition to this broadcasting schedule, Baird seemed intent on anticipating and exploring every possible television application. In May 1927 he demonstrated the transmission of television signals by telephone line between London and Glasgow. In February 1928, he transmitted the narrow-band television signals between London and New York, and to the S.S. Berengaria in mid-Atlantic, by shortwave radio. By 1930 Baird had demonstrated color television, 3-dimensional television, theater projection (of 30-line images!), infrared television pickup (called "Noctovision"), and had made television recordings on phonograph records. In June 1932 he transmitted the Derby from Epsom Downs on closed-circuit television to a capacity paying audience at the Metropole Cinema, Victoria, London, thus inaugurating theater pay-television!

It was the 1923 patent application for an all-electronic television system developed by Dr. Vladimir K. Zworykin, a Russian immigrant working for Westinghouse in the United States, that launched the modern era of television. Zworykin's system, which was demonstrated in 1924, employed an electronically scanned camera imaging tube (the Iconoscope) and a cathode-ray tube (CRT) for viewing in a TV receiver.

The Zworykin patent also covered the use of electronic flying-spot scanning for converting still-camera slides and motion pictures to television images. In 1929, Zworykin joined RCA to continue his work on advanced television systems and camera imaging tubes.

© 1967 by Robert Hodierne

Most network television coverage of the Vietnam war was done with 16mm motion picture cameras and Ektachrome color reversal film. In this scene, photographed in 1967 about 15 miles north of Saigon, television crews film the last words of a dying North Vietnamese soldier. The Ektachrome motion picture films of the time have poor image stability (which was often made worse by hurried processing and washing) and, with few exceptions, are steadily deteriorating in non-refrigerated storage in television news archives around the world.

By 1940 television had advanced to the point where nationwide commercial broadcasting was ready to begin. In May 1941 the Federal Communications Commission, acting on the recommendations of the National Television Systems Committee (NTSC), a group of 168 specialists from the radio and television industry, established a set of 22 standards that covered all technical aspects of monochrome television broadcasting, based on 525 picture-scanning lines.

## Color Television Finally Gains Widespread Acceptance in the 1960's

In 1953 the FCC, acting on the recommendations of a second National Television Systems Committee, set standards for black-and-white compatible color television broadcasting; using 525 picture-scanning lines, this is the system that is still with us today. (PAL and SECAM, which are the primary German and French broadcast standards in Europe, are adaptations of the NTSC scheme but employ 625 picture-scanning lines.)

RCA began manufacturing color television receivers in 1954, and by the end of 1955 the company offered an extensive line of color television sets. The high cost of color television receivers, the limited amount of color programming available, and the notion held by many people that black-and-white television images were adequate served to discourage the public from buying the new color receivers. At the end of 1956, less than 1% of households in the United States had purchased color television sets.

It took another 10 years for color television to really catch on with the public. By 1967 CBS and ABC had joined NBC in converting all operations to color, and by 1970 the entire U.S. broadcasting industry had fully embraced color. Today, the vast majority of televisions sold are color units.

The Sony Betamax home video cassette recorder (VCR), introduced in 1974 (and obsolete by 1990, having lost out in

February 8, 1988

**Julia and Julia**, a historic 1987 Italian production starring Kathleen Turner and Sting, was the first full-length feature to be shot entirely with high-definition television cameras instead of with motion picture film. After editing, the video image was transferred to motion picture color negative film (via three electronically printed B&W intermediate films) and released on standard color motion picture print film for projection in theaters (shown above is the Varsity Theatre in Des Moines, Iowa). Sony HDTV cameras and video recorders were used for the production, which was "filmed" by cinematographer Giuseppe Rotunno.[40] At the time this book went to press in 1992, **Julia and Julia** remained the only major theatrical feature to have been originated in HDTV; a variety of practical problems, including lack of easily portable HDTV cameras and image resolution that is inferior to that of film, have discouraged more widespread use of HDTV in the theatrical entertainment industry.

February 7, 1988

An advertisement for **Julia and Julia** that appeared in the **New York Times** in 1988. Produced by RAI (Radiotelevisione Italiana), the "film" joins the 1935 Technicolor 3-strip film **Becky Sharp** and the 1951 Canadian Eastman Color film **Royal Journey** as the first feature-length theatrical productions to adopt a new technology marking an epochal change in the way color moving images are recorded.

the market to the competing VHS system) enabled consumers to record their favorite programs for later viewing and — in a little-anticipated development — launched the huge worldwide pre-recorded videocassette business.

### High-Definition, All-Digital Television Broadcast Standards for the United States Are Expected to Be Issued by the FCC by the End of 1994

With a modest screen size — and viewed at normal distances — most people have come to accept the 525-line television picture, established more than 50 years ago in 1941, as having "adequate" image quality. With increasingly popular large-screen and projection television, however, the shortcomings of the 525-line picture (or the 625-line system used in Europe) are readily apparent.

A visually and aurally more sophisticated public, which quickly embraced the laser-read, non-contact optical audio CD because of its scratch-free, pristine sound and its claims of lasting "forever" without wearing out regardless of how many times it is played, has begun to expect better image quality in television as well. Magazines, books, and even newspapers are offering ever-better color reproduction. Color computer monitors now typically have far better image resolution than current 525-line television systems.

By the end of 1994, it is expected that the Federal Communications Commission will issue new regulations setting standards for an all-digital, high-definition television (HDTV) color broadcasting system for the United States. These new broadcast standards and the digital HDTV cam-

eras and televisions, digital signal compression technology, HDTV videotape and laser-disk players and recorders, CD-ROM-based video game units, and the interactive, high-capacity wire and fiber-optic cable systems that will become available during the remainder of the decade are certain to accelerate adoption of electronic imaging and transmission systems in many areas of still photography.

September 1992

Sony HDTV analog television receivers drew large crowds at the Photokina trade show in Germany in 1992.

October 1992

Vast quantities of videotape from television productions are in storage around the world. Shown above is a section of the videotape library stored in the Paramount Pictures Film and Tape Archive in Hollywood, California. Paramount Pictures, which inspects all of its videotapes about every 4 years, has copied all of its analog videotapes onto digital videotape. Because of frequent videotape format changes and consequent equipment obsolescence, the long-term preservation of video materials presents far more difficult problems than is the case with the preservation of color motion picture films in cold storage.

## The Merging of Still Photography with Digital Imaging Systems

For a variety of reasons, electronic imaging systems have been much slower to become accepted in still photography than has been the case in the moving-image field where film is now all but dead in most parts of the business.

When the Sony Mavica still video camera was introduced with great fanfare in 1981, there was considerable speculation that traditional silver-halide-based photography would soon be a thing of the past. But consumers were quick to

realize that the pictorial quality of the 525-line images produced with the expensive camera was far inferior to that of traditional photography, and market acceptance of the Mavica was much less than Sony had expected. Most people have little interest in viewing silent still-camera images on a television set — a fact that Kodak faces in its effort to sell the Photo CD system in the amateur snapshot market.

Although the Mavica camera could produce small prints that were suitable for some applications, the poor resolution of the images meant that it was impossible to make satisfactory enlargements for display purposes. Cameras such as the $10,000 Kodak DCS 200 Digital Camera produce images that may be adequate for applications such as newspaper photography, but they still fall short of the image quality obtained with traditional cameras and films. (A single 35mm ISO 100 color negative frame may contain 18 megabytes or more of digital data — which is more data than the fully formatted text of this entire book — and to equal this level of image quality with an all-electronic camera at reasonable cost is well beyond the capability of current technology.)

The availability of high-resolution film scanners, increasingly powerful and affordable desktop computers, high capacity data storage systems (the Kodak Photo CD being a prominent example — see page 56), and software such as Adobe Photoshop has served to bring the many benefits of digital image processing and transmission to photographs originated with traditional color films. To many people, in fact, this combination of traditional photography and digital image processing has become the definition of "digital imaging."

During the remainder of the 1990's, the merging of traditional photography with digital image processing, storage, and transmission systems will rapidly expand, especially in publishing-related businesses (see page 46) and photo labs where digital imaging offers the greatest practical and economic benefits. At the same time, the use of digital still cameras will continue to increase in applications where they offer a compelling advantage. It is expected that when improved digital cameras become available in the mid-1990's, newspaper photography will be the first major branch of the field to abandon traditional silver-halide-based photography.

February 17, 1982

The Sony Mavica, the first still video camera, was announced in Japan in late 1981. Shown here holding a Mavica during a demonstration at the SPSE Photofinishing Symposium in Las Vegas, Nevada in February 1982 is Klaus B. Hendriks, director of conservation research at the National Archives of Canada. The Mavica camera produces color images in the standard 525-line analog television format.

September 1992

The Kodak Professional DCS 200 Digital Camera is built around a Nikon 35mm autofocus camera body. Instead of film, the camera uses a CCD (charge-coupled device) image sensor; the images are recorded on a small hard disk drive in the base of the camera. Introduced in 1992, the $10,000 camera is shown here being demonstrated at the Photokina trade show in Germany.

This high-resolution, all-electronic photograph was made by Bob and Lois Schlowsky with a Hasselblad 553ELX camera equipped with a Leaf Digital Studio Camera back. Made by Leaf Systems, Inc. (a subsidiary of Scitex Corporation, Ltd.), the digital back costs about $36,000. The image is captured with a 1.2 x 1.2-inch CCD (charge-coupled device) area array with 2048 x 2048 pixels producing a 12.6 megabyte color file. The camera is connected by cable to a Macintosh computer with 64 MB of RAM; the image files are down-loaded to the computer after each exposure. The separations used to print the image on this page were made directly from a copy of the original digital file supplied on a SyQuest removable hard disk. To achieve maximum resolution, a monochrome CCD is used in the Leaf Digital Camera back; color photographs are produced with sequential exposures through red, green, and blue filters. Because of this, the system can be used only for still-life color photographs. Bob and Lois Schlowsky, who operate a commercial studio in Weston, Massachusetts, use the digital camera and computer system for nearly 90 percent of their studio work.[41]

Lois and Bob Schlowsky in their digital studio.

## In an Age of Digital Imaging and Electronic Printmaking, What Constitutes a "Photograph"?

While there has never been a truly precise definition of what is — and what is not — a photograph, it has traditionally been accepted that a photograph: a) has an image that is formed on a material as a direct consequence of exposure to light and b) has a continuous-tone image structure. By this definition, images that are printed by offset lithography, such as the 175-line screen illustrations in this book, for example, do not qualify as photographs. Rather, they are considered to be *reproductions* of photographs. Notions of limited quantity also enter into people's thinking about the subject: a 35mm color slide, a black-and-white negative, or a color negative is usually a one-of-a-kind object, and only a small number of prints are generally made from a specific negative or transparency.

The introduction in recent years of thermal dye-transfer prints (e.g., Kodak Ektatherm prints) and other high-quality, "photorealistic" digital color printing methods has challenged the traditional concepts of what a photograph is. High-resolution electronic still cameras, such as the Leaf Digital camera discussed on the previous page, further cloud the issue. Upon close examination, the traditional definitions of what constitutes a photograph were actually never very adequate. Kodak Dye Transfer prints, for example, are *not* made as a consequence of direct exposure to light (Dye Transfer paper is not light-sensitive, and the prints are made under bright room illumination). Yet Dye Transfer prints have long been accepted as being among the highest-quality color photographs.

Traditional silver-halide-based photographic images are not truly "continuous tone." Instead, they have a random, irregular grain structure. (In fact, an ordered screen pattern is often much less noticeable than an irregular grain structure.) To cite an extreme example, if one compares the unsharp and grainy color prints from a 1980's Kodak Disc camera with the high resolution images from a Leaf Digital camera and printed by the extremely sharp UltraStable and Iris ink jet processes (see pages 49–54), it becomes very difficult indeed to maintain that blurry Disc camera 8x10-inch Ektacolor prints are legitimate photographs while the exquisitely sharp and beautiful 20x20-inch UltraStable and Iris color prints are not.

It is time to set the whole issue aside and instead think in terms of *visual image quality* and *image permanence*. How an image was made should be a secondary consideration.

September 1992 (2)

Metrum FotoPrint digital color printers produce 300 dpi "continuous-tone" prints with traditional RA-4 color papers.

Kodak Ektatherm XL 7700-series digital printers, one of which is shown here at the Photokina trade show in Germany in 1992, produce "continuous-tone" 200 dpi "photorealistic" thermal dye-transfer color prints from digital image files. Thermal dye-transfer (dye-sublimation) printers supplied by Kodak and other manufacturers cost between $10,000 and $25,000.

December 1979

Kodak Dye Transfer prints are made by successively rolling three "matrix films" (which have been soaked in acidified cyan, magenta, and yellow dye solutions) into contact with the print surface. The matrix films have a gelatin layer that varies in thickness according to image density — the thicker the gelatin, the more dye it carries and transfers to the print.

1992 – Courtesy of Fuji Photo Film Co., Ltd.

The images of Fuji-Inax Photocera photographs have a screen pattern that can be observed under magnification. Made with a ceramic support, Photocera photographs are fired at high temperatures to fuse the pigment image to the base. Fuji claims the photographs are permanent, even when displayed for many years outdoors in sunlight and rain.

The Linn Photo wholesale lab near Cedar Rapids, Iowa receiving its first batch of film of the night. With overnight processing and delivery for all of Iowa, the lab's operations begin in the afternoon and continue until early the next morning. Linn Photo was acquired by Qualex Inc. in 1992.

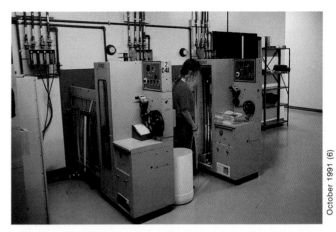

Of the thousands of rolls of film received by the lab each night, about 95 percent are Kodak, Fuji, and other C-41 compatible color negative films in the 35mm and, to a much lesser extent, 110 and 126 formats (Kodak Disc film has almost disappeared from the market). The film is spliced together in long rolls for processing in the machines shown above.

## At Least Until the Year 2010, Amateur Photography Will Probably Change Very Little, and Traditional Color Films and Papers Will Continue To Be Used

There is no technology on the horizon — even the distant horizon — that can provide the image quality of color prints made with 35mm autofocus cameras and color negative films which could even approach the low cost of this system. For as long as people want to have prints to look at, to send to friends and relatives, and to display in homes and offices, traditional photography will continue to be popular.

In recent years, Kodak, Fuji, and Konica have all been acquiring independent labs to protect their color paper markets. Qualex Inc., a joint venture of Kodak and Fuqua Industries Inc., is now the world's largest photofinisher. When Qualex acquired Linn Photo in 1992, Agfacolor paper was promptly replaced with Ektacolor paper. The only other change most customers noticed was that Qualex stopped returning negatives in the protective, high-density polyethylene sleeves that Linn had supplied for a number of years.

After processing, the spliced rolls of film are printed with Agfa MSP printers. Density and color-balance settings are determined by the computerized printers, each of which can expose between 15,000 and 20,000 prints per hour.

The self-contained minilabs now common in shopping malls and other locations are used in this wholesale lab for remakes and reprint orders.

With many millions of color prints produced each year, a tremendous amount of paper is used. These pallets contain hundreds of rolls of Agfacolor paper.

Rolls of exposed paper are processed in a six-strand Agfa RA-4 processor. After cutting, the prints and their negatives are put in customers' envelopes.

October 1991 (6)

The October 19, 1992 issue of the **San Francisco Examiner**. The newspaper usually runs 10 to 20 color pictures and 40 to 50 B&W photographs in its five daily editions.

October 1992 (3)

Staff photographer Kim Komenich (left) and reporter Greg Lewis edit film from a week-long assignment in Los Angeles for a follow-up story on the riot that erupted in April 1992 following the acquittal of four white Los Angeles police officers who had been charged with beating black motorist Rodney G. King. As with most other metropolitan newspapers, color negative film is used almost exclusively.

## With Its 100-Year-Old Darkrooms Replaced by a Fuji Minilab, a Nikon Film Scanner, and Six Macintosh Computers Running Adobe Photoshop Software, the *San Francisco Examiner* Entered the Digital Age

In October 1989, using Apple Macintosh computers and an early version of Adobe Photoshop color image-editing software that had been written by the now-legendary programmers, brothers Tom and John Knoll, the *San Francisco Examiner* became the first large metropolitan newspaper in the United States where the photographers not only took pictures but also learned to scan color negatives to create digital image files for loading into the networked Macintosh computers; to perform sophisticated corrections of the color balance, contrast, and color saturation of their images; and to output color separation files which are used in preparing the cyan, magenta, yellow, and black printing plates for the paper's presses.

Pictures and caption information are reviewed on computer screens by the newspaper's editors, and selected photographs are electronically sized, cropped, and placed in position together with text and graphic elements in pages composed electronically on the newspaper's more than 20 networked computers with Quark XPress software. Color prints are no longer needed.

According to photo editor Chris Gulker, a technology-oriented individual who was responsible for the early implementation of film scanners and image-processing computers at the *Examiner*, it is now possible to get on press with color pictures of late-breaking news events in as little as 40 minutes after exposed film arrives in the *Examiner's* photo department.

The changes at the *Examiner* since 1989 in the way images from color negatives get to the printed page dramatically illustrate the rapidly expanding role of digital systems throughout the worldwide publishing industry.

Photo editor Chris Gulker processes color negative film with the **Examiner's** washless Fuji minilab. The total dry-to-dry processing time is about 12 minutes.

Photo editor Chris Gulker scans color negatives into the **Examiner's** Macintosh computer network with a Kodak Film Scanner. The **Examiner** also uses Nikon scanners. Once a negative has been scanned, it is put into storage.

Gulker discusses a story with photographer Fran Ortiz while Ortiz adjusts color balance, density, saturation, and contrast and eliminates dust spots on an image with Adobe Photoshop software. The **Examiner's** photographers are responsible for handling their own photographs on the computers to prepare them for publication.

Fully composed digital pages with photographs in place are output to separation film on Linotronic and Autologic imagesetters. The films are used to make flexographic printing plates for the newspaper's high-speed presses.

Like most other major newspapers, the **Examiner** receives photographs from all over the world via satellite; the photographs are downloaded into the Associated Press Leafdesk Digital Darkroom image-processing computer system, shown here. The Leafdesk is manufactured by Leaf Systems, Inc.

With film scanners and digital image-processing systems in place, it becomes possible to transmit publication-resolution color images anywhere in the world via satellite links, fiber-optic networks, computer data links, and even with cellular telephones. Photographers working in the field can process film locally and transmit scanned color images and caption information to their newspapers. (Many of the photographs published in newspapers and magazines during the 1992 Summer Olympics in Barcelona, Spain were processed in on-site minilabs and transmitted to publications around the world by photographers equipped with portable film scanners and Apple PowerBook computers.)

At the *Examiner* and at most other newspapers, the last step remaining before an all-electronic system is achieved is the origination of the picture itself. With computer systems already in use, electronic still cameras such as the Kodak DCS 200 digital camera, which has a CCD sensor in place of film and is built around a conventional Nikon camera body, provide direct digital input of color images that *can* be of surprisingly good quality. Use of electronic cameras eliminates the processing and scanning steps required for color film; in addition, pictures taken with electronic cameras can be transmitted directly to the newspaper from remote locations over phone lines or with cellular phones.

At the time this book went to press in late 1992, however, *Examiner* photographers were not making regular use of electronic cameras. Using the Kodak DCS 200 as an example of a state-of-the-art digital camera, photo editor Gulker cited a number of reasons why photographers were reluctant to give up traditional cameras and film.[42]

Among the drawbacks of the DCS 200 are: a) it is unable to take pictures faster than once every 2½ seconds, which is much too slow for most newspaper photography; b)its CCD array is smaller than a 35mm frame, and this increases the effective focal length of the camera's standard Nikon lenses by a factor of 2.5X, which can make wide-angle photography difficult; c) with a maximum capacity of 50 images on its internal hard disk, the camera must frequently be downloaded to a computer, which requires much more time and trouble than changing rolls of film with a conventional camera; d) the resolution and overall picture

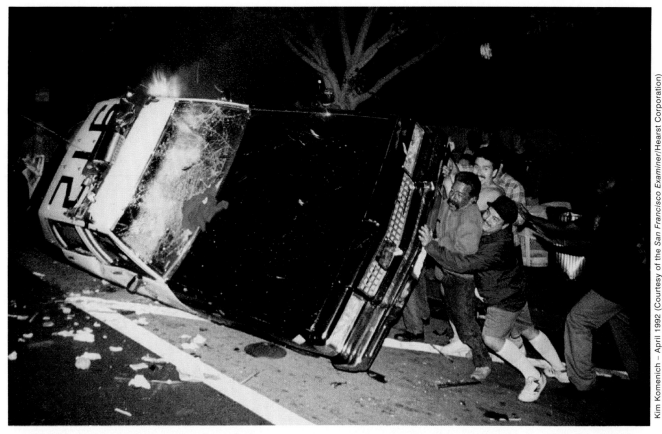

Kim Komenich – April 1992 (Courtesy of the *San Francisco Examiner*/Hearst Corporation)

A photograph taken during the Los Angeles riots in April 1992 by Kim Komenich. The violence began immediately after the acquittal in a California state court of four white Los Angeles police officers who had been accused of using excessive force in the March 3, 1991 arrest of Rodney G. King, a black motorist who had been stopped for speeding. The brutal beating was captured on videotape with a Sony 8mm camcorder by an amateur who witnessed the event; the tape has been repeatedly broadcast around the world. For this book, the photograph above was reproduced from 4-color separations generated from a digital file supplied by the **Examiner**. From the moment the original 35mm color negative was scanned in the **Examiner's** photo department, the entire reproduction chain to the point of exposing the printing plates for this book at the printer in Kingsport, Tennessee was entirely digital; a traditional color print was never made.

quality of the images do not match traditional 35mm color negative film; e) long-term archiving of the digital images is a problem; and f) at a cost of about $10,000, the DCS 200 digital camera is a major budget item.

Most newspaper photographers value the image resolution of 35mm film, knowing that they can make high-quality enlargements of their most important photographs even if the reproduction quality of newspaper printing could in most cases be satisfied with lower-resolution images.

Digital cameras are certain to become better, faster, and less expensive, however, and Gulker predicts that "by 1995 or 1996, film may well be dead at the *Examiner* and other major newspapers."

In 1989, when photographers became familiar with how easy it was to manipulate images with Photoshop, some expressed ethical concerns about the new technology. Like most other newspapers, however, the *Examiner* has implemented a policy that strictly forbids doing anything to an image that alters its content and accuracy. Only routine dust-spotting; correction of color balance, contrast, and saturation; and minor dodging and burning are permitted. Distracting elements in a picture, such as intruding power lines or birds in the background, may not be removed.

October 1992

Komenich prepares to make an Ektatherm print of a photograph from his personal stock file of former Philippines president Ferdinand Marcos and his wife Imelda. Fully dust-spotted and corrected with Photoshop, the images, along with caption information, are stored on a rewritable 600 MB optical disk and can easily be printed when requested. Komenich won a Pulitzer prize in 1987 for his coverage of the Philippines revolution that forced Marcos from office.

An UltraStable Permanent Color print of a family group portrait by the noted photographer David B. LaClaire of LaClaire Portraiture in Grand Rapids, Michigan. Lasting far longer than conventional color prints, UltraStable Permanent Color prints are expected to become widely used in the upper end of the portrait, wedding, and fine art markets. The prints not only have appeal as family heirloom portraits but will also be used for portraits of presidents, prime ministers, and other government officials, as well as for photographs of writers, artists, movie stars, and other culturally and historically important individuals.

## The UltraStable Permanent Color Process for Making Extremely Long-Lasting Pigment Prints

To a greater or lesser extent, all of the organic dyes used to form the images in conventional color films and prints gradually fade when exposed to light. Even Ilford Ilfochrome and Kodak Dye Transfer prints, which are exceedingly stable when stored in the dark, will fade to an objectionable degree after relatively few years of display. In long-term display, no current color material with a dye image can even approach the stability of the silver image of a carefully processed black-and-white photograph made on fiber-base paper (only fiber-base prints can be included in this comparison because, for the reasons discussed in Chapter 17, the life of displayed black-and-white RC prints may fall considerably short of that of fiber-base prints).

So how can a truly permanent color print be made? The answer is to do what Louis Ducos du Hauron, the French pioneer of color photography, did when he made the first real color prints in the 1870's, and that is to form the color image with *pigments* instead of dyes. Ducos du Hauron used a three-color adaptation of the then well-known carbon process to make his color prints. In those days, long before the

This 1877 photograph of Agen, France by the prolific French inventor and photographer Louis Ducos du Hauron is one of the first photographic color prints ever made. Using separate pigmented-gelatin layers to form the image, the process is the historical predecessor of the UltraStable process.

Soaking the laminated pigment sheet.

Peeling off the plastic carrier sheet.

January 1991 (5)

After exposure with separation negatives, the cyan, magenta, yellow, and black pigment layers are applied one at a time to a polyester or paper support.

Unhardened pigmented gelatin is removed in a warm-water bath.

With all four image layers applied, the finished print is rinsed with water.

development of the modern, easy-to-process chromogenic print (e.g., Ektacolor) with its lovely but all-too-fleeting organic dye image, making a print with separate pigmented-gelatin color layers was the only method available.

In the 1930's and 1940's, the tricolor carbro process (a variation of tricolor carbon) was frequently used for glamorous portraits of Hollywood stars, and lush tricolor carbro advertising photographs from this era can be found in the collections of George Eastman House, the Smithsonian, and other institutions. By the late 1950's, however, the color pigment processes had died out, first being replaced with the easier-to-manage Kodak Dye Transfer process, and later

with Ektacolor, Cibachrome (now called Ilfochrome), and other inexpensive and conveniently processed materials.

But none of the modern color print materials were stable enough to satisfy Charles Berger. A fine art photographer who had published several books of photographs and whose work was in the permanent collection of the Museum of Modern Art in New York City, Berger was frustrated with the lack of anything available on the market with which he could make permanent color prints. By 1980, after several years of experimentation, Berger had developed a modern, pin-registered, high-resolution version of the classic tricolor carbon process. Berger not only made the process simpler to use — although the printmaking procedure remains a relatively complex task — but, more importantly, he came

An UltraStable print of poppies and azaleas photographed by Charles Berger in 1976. An accomplished artist and inventor who wanted long-lasting color prints for his own work, Berger made this print in 1992.

March 1991

Charles Berger mixing a pigmented-gelatin emulsion for a test coating at Kilborn Photo Products Inc. in Cedar Rapids, Iowa. Working with Berger is John DaSilva, an emulsion chemist who is director of research at Kilborn.

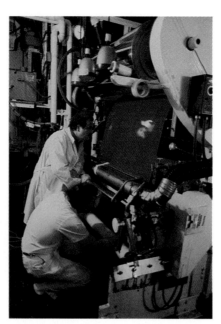

March 1991 (3)

The thick gelatin emulsion coatings are slowly dried in the dust-free, humidity- and temperature-controlled drying alley at Kilborn. Because the UltraStable emulsions are sensitive only to UV radiation, mixing, coating, and drying operations can be conducted under yellow safelights. The prints can also be made under UV-filtered illumination. Kilborn Photo Products, a little-known company that has been producing photographic products in Cedar Rapids, Iowa since 1895, is one of the oldest photographic manufacturers in the world.

Emulsion technician Steve Hynek and Charles Berger mixing gelatin, magenta pigment, a chromium-free sensitizer, and other emulsion components.

Coating the magenta emulsion on a transparent polyester carrier sheet.

up with cyan, magenta, yellow, and black pigments that had extremely good light fading stability. The pigments are similar to those used in automobile paints, which must be able to tolerate years of outdoor sun exposure under the harshest conditions. These materials were produced by the Polaroid Corporation under the Polaroid Permanent-Color name.[43] As shown by the accelerated test examples reproduced on page 14, the stability of these prints is extremely good.

When Polaroid declined to actively market the materials, Berger, living in Santa Cruz, California, joined forces with Richard N. Kauffman, a long-time environmentalist, photographer, and skilled tricolor carbro printer (Kauffman is the chairman of the California-based H. S. Crocker printing company), to work on easier-to-use, pre-sensitized materials employing non-toxic sensitizers and pigments. UltraStable Permanent Color materials, which can produce prints with outstanding color reproduction and extraordinary sharpness, are the result of this collaboration.[44]

The image stability of UltraStable prints is discussed in Chapter 3, beginning on page 121. The initial UltraStable materials, introduced in 1991, used a non-toxic organic yellow pigment that proved to be significantly less stable in light fading tests than expected, based on data supplied by the pigment's manufacturer. New materials made with a more stable, lead-free, metal-type yellow pigment were introduced in late 1992, but test results for the new pigment were not available at the time this book went to press.

Making UltraStable prints requires full-size, high-resolution, screened separation negatives, and the cost of the separations is the principal expense in making a print. Exclusive of separations, the costs of materials are quite low: materials for a 16x20-inch print total less than $25. Having prints (and the required separations) made by a lab can be expensive, however, with a 16x20-inch UltraStable print costing $500 or more (duplicate prints cost much less). Labs that offer UltraStable prints are listed on page 293.

A photograph of novelist Eudora Welty by William Eggleston. The UltraStable print was made by Robert Liles. An exhibition of 50 of Eggleston's UltraStable prints is to be shown at the Robert Miller Gallery in New York City in October 1993.

February 1992

A pioneer in the use of high-resolution color ink jet printers in the fine art field is Nash Editions. Located near Los Angeles in Manhattan Beach, California, Nash Editions was founded by British-born Graham Nash of the legendary 1960's rock group Crosby, Stills, Nash & Young. An accomplished photographer and collector, Nash was drawn to the ink jet process as a means of printing images that he had worked on with Adobe Photoshop software on his Apple Macintosh computer. Shown here are Nash Editions staff members (left to right) Jack Duganne, R. Mac Holbert, and Graham Nash.

## High-Resolution Ink Jet Color Prints Produced from Scanned Photographic Originals, Computer-Generated Images, and Other Digital Sources

One of the most promising of the rapidly advancing direct digital color printing technologies is high-resolution color ink jet printing. The best of the current generation of ink jet printers are the Iris printers manufactured by Iris Graphics, Inc. of Bedford, Massachusetts (Iris Graphics is a subsidiary of the Scitex Corporation Ltd., which is headquartered in Herzlia, Israel).

Capable of printing "photorealistic" color images on paper, polyester, cloth, and most other materials that will accept water-base inks, Iris printers have a resolution of 300 dpi (dots per inch). However, unlike most laser printers and low-cost desktop ink jet printers, the overlapping cyan, magenta, yellow, and black image dots laid down by an Iris printer are built up with from 0 to 31 microscopic droplets for each of the four colors. This unique 4-color variable-size dot structure (which does not have the rosette pattern usually found in 4-color printing) produces images that are far sharper and have much smoother tonal gradation than the images obtained from fixed-dot-size 300 dpi printers. Iris claims its printers have an "effective visual resolution of approximately 1,500 dpi."

When viewed without magnification, Iris ink jet images can have the appearance of traditional photographic color prints. In fact, because of the controls offered by Adobe Photoshop or other digital image processing software that is routinely used prior to printing, Iris ink jet prints are often qualitatively *better* than traditional color prints. Digital images scanned from photographic originals can easily be adjusted for contrast, color saturation, and color balance. Curve imbalances are simple to correct. (In a practical sense, alteration of contrast, color saturation, and curve balance is not possible with traditional color printing. Digital images can also be dodged, burned-in, dust-spotted, and have scratches filled in with a finesse that is absolutely impossible with traditional darkroom color printing.)

Although the Iris printers are expensive — the Model 4012, which makes prints in sizes up to 10x17 inches, costs $39,000 and the Model 3047, which makes prints in sizes up to 34x46 inches, sells for $123,000 — the materials costs for a print are less than for any other high-resolution color imaging process. The cost of the ink and paper for a 34x46-inch print can be as little as $12 (printing time of about 45 minutes). The cost of the ink and paper for an 8.5x11-inch print can be less than $1 (printing time of about 4 minutes).

Unfortunately, at the time this book went to press in late 1992, the ink sets available from Iris had very poor light fading stability. Even when protected with a sharp-cutting ultraviolet filter, the prints had a predicted display life of less than 3 years when evaluated with this author's standard test procedures (see **Table 3.3** on page 138 in Chapter 3). The Iris prints proved to be far less stable than Ilfochrome, Ektacolor, and other traditional color prints.

Iris Graphics has not made any claims for the light fading stability of prints made with the standard ink sets that were available at the time this book went to press in 1992, saying that the company would commit only to a display

Iris ink jet printers lay down the cyan, magenta, yellow, and black images in a single pass with the print material attached to a rapidly rotating drum. The leading band of the image printed by the cyan ink jet, which slowly moves across the image from left to right, is clearly visible.

Graham Nash and Jack Duganne detach a completed monochrome print from one of the Iris 3047 ink jet printers at Nash Editions. This particular image is a black-and-white self-portrait of Nash which was made during the period when he performed with Crosby, Stills, Nash & Young.

February 1992 (6)

Bottles of the water-base inks employed in the Iris ink jet printers. Initially designed for graphic arts proofing, the standard Iris inks have very poor light fading stability. High-stability inks for fine art and other display applications are expected to become available by the end of 1993.

Duganne and Holbert work on an image with Photoshop running on a Macintosh computer with visiting New York City fashion photographer George Holz. Prints can be made from scanned transparencies and negatives or directly from a variety of Macintosh and IBM file formats.

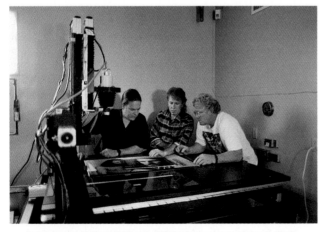

A high-resolution flatbed CCD scanner custom-built by Photometrics, Ltd. is used by Nash Editions to input images from color prints, paintings, and other art work. The scanner can accommodate originals of up to 4 x 4 feet.

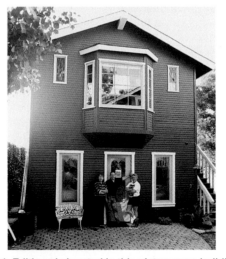

Nash Editions is located in this picturesque building not far from the Los Angeles International Airport.

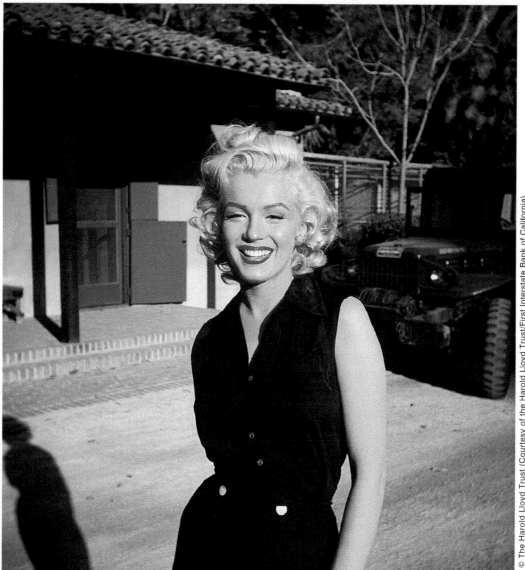

An Iris ink jet print of movie actress Marilyn Monroe. Photographed by silent screen star Harold Lloyd, this previously unpublished picture was taken in 1952 while Monroe was visiting Lloyd's lavish Green Acres estate for a screen test. Monroe died from an overdose of sleeping pills in 1962 at the age of 36. Printed by Nash Editions, the Iris ink jet print was made from one side of a Kodachrome transparency stereo-pair that was scanned with a high-resolution scanner to produce a digital file for the Iris printer. Contrast adjustments and elimination of dust spots were done with Adobe Photoshop software on a Macintosh computer system. As would be expected, based on data obtained in accelerated dark fading tests with Kodachrome film, the transparency was still in excellent condition — after 40 years of storage — at the time this print was made. The image, which was free of yellowish stain, had brilliant highlights and minimal fading.

life of "one to two years, with incidental, interior lighting."[45] When stored in the dark, however, the color images are essentially permanent; this author's tests indicate that the prints, when made on 100% cotton fiber paper or other stable material, have very little tendency to form yellowish stain over time. Because the inks used in Iris printers are water-soluble, a number of coatings are available for protecting the images from water damage.

Since their introduction in the late 1980's, the Iris printers have been employed primarily for graphic arts proofing, where image stability is generally not an important consideration. With the selection of suitable ink colorants, however, the ink jet process has the potential of producing highly stable color prints. In theory, any colorant that has the dielectric properties required by the Iris imaging system — and that can pass through the extremely narrow, 10-micron diameter ink jet nozzles employed in the Iris printers — could be used in an ink formulation.

After the highly publicized 1991 introduction of Iris prints in the fine art photography field by Nash Editions, Iris Graphics realized that there was a potentially large market for their printers outside of the traditional graphic arts proofing area, and the company set about developing a much longer-lasting ink set for fine art and other long-term display applications. Iris plans to introduce the new high-stability inks by the end of 1993.

Having Iris prints made is not inexpensive, although the cost of the prints can vary greatly depending on the supplier,[46] the size of the print, the type of paper desired, whether a protective coating is applied to the print, and the amount of computer time required for making alterations and corrections of the digital image. At the time this book went to press, Nash Editions charged $0.70 per square inch with a minimum cost of $400 (up to 24x24-inches) and a maximum of $700 for a 34x46-inch print (additional prints are about 50% less). Some firms offer straight prints from customer-supplied digital files at moderate cost: Image Transform Ltd. of Ankeny, Iowa produces 34x46-inch Iris prints on various papers, including Arches or Rives 100% cotton fiber watercolor papers, for $175 for the first print.

A large-format print emerging from a Xerox/Versatec liquid-toner electrostatic color printer. Used in the Cactus and Onyx Graphics digital printing systems, the Versatec units produce low-cost color prints in sizes up to 54 inches wide and 15 feet or more in length.

### Color Electrophotography Is One of the Most Promising Technologies for Making Long-Lasting, High-Quality Color Prints at Moderate Cost

Liquid-toner and dry-toner electrophotographic color printers can utilize a wide variety of colorants to form images and, with respect to color stability, this gives these systems a considerable — if not yet fully realized — advantage over the traditional chromogenic and silver dye-bleach color print processes.

Color prints made with Canon Color Laser copier/printers, for example, are approximately twice as stable as Kodak Ektacolor prints according to this author's accelerated light fading tests with glass-filtered fluorescent illumination (see **Table 3.3** on page 137). A Canon color print typically costs only $3 to $5.

Although the image quality of prints made with Canon Color Laser copiers does not equal that of traditional color prints, the Canon prints are often satisfactory for proofing and are also suitable for many business and commercial applications.

Xerox/Versatec color printer/plotters, which serve as the output devices for the Cactus (Fairfield, New Jersey) and Onyx Graphics (Salt Lake City, Utah) digital printing systems, have become popular for producing large-format color prints for commercial display and advertising purposes. Although the image quality of these prints also does not equal that of traditional color photographs, the prints nevertheless are suitable for many purposes. Preliminary tests with "standard" Cactus prints indicate that the prints have fairly good light fading stability; prints made with the special toner set supplied by Cactus for outdoor display are probably much longer lasting.

The 3M Digital Matchprint liquid-toner electrophotographic graphic arts proofing system provides a prototype for a high-quality, high-stability digital color printmaking system. The $300,000 device can produce an 18x27-inch color print at 2,540 dpi on most types of paper in 30 minutes or less from a digital image file (the cost of materials for a print is low). Small prints can be output much more quickly. Although currently available toners were formulated to match graphic arts printing inks, and permanence was not an important consideration, high-stability toners could easily be developed for the system (see the discussion of the mid-1960's 3M Electrocolor process on page 27).

September 1992 (2)

Xerox/Versatec color printer in a system supplied by Onyx Graphics (note containers of liquid toners in base).

1992 – Courtesy of 3M Company

If high-stability colorants were to become available for the 3M Digital Matchprint graphic arts color proofing system, this process would be suitable for producing long-lasting color prints of excellent quality at low cost.

## Despite Their Great Practical Utility, Photo CD's, CD-ROM's, and Magnetic Digital Image Storage Systems Are Not Recommended for the Long-Term Preservation of Photographically Originated Images

The September 1990 announcement of the Kodak Photo CD system, which was placed on the market in the summer of 1992, marked a historic turning point in the evolution of photography and, for the first time in the general market, raised questions about the long-term usability of photographic images stored in digital form. The Photo CD system, in which digitized images are stored on low-cost, write-once optical discs of the same physical format as the popular audio compact disc (CD), includes several components: a) high-speed CCD scanners which digitize images on color negative films, transparencies, and prints; b) computer workstations which convert the digitized data to Kodak's Photo YCC color space, make adjustments in color balance and density, and create an image file using a hierarchical file format and data-compression scheme developed by Kodak; and c) a laser disc writer developed by the Netherlands-based electronics giant Philips which writes the image file to a CD (a complete Kodak system costs $100,000 or more).

Kodak Photo CD Portfolio authoring software to be released in 1993 will allow individuals using a variety of scanners and computers to write image files in the Kodak Photo CD format using a Kodak CD disc writer (about $6,000).

The number of images that can be recorded on a Photo CD depends on the maximum image resolution selected; typically, each image requires about 4.5 Mbytes of disc space so approximately 100 images can be stored on a single disc (at present, the optical CD is the only viable, low-cost storage medium available that can accommodate the huge size of high-resolution color image data files). The ingenious hierarchical file structure allows images to be accessed in a number of different resolutions (e.g., low resolution for viewing on an ordinary color television and high resolution for printing in magazines and books) without the need to store redundant data for each of the available image resolutions. The discs can be read by a CD-ROM XA multi-session drive and can be viewed on a television with a Kodak or other Photo CD-compatible disc player. The Photo CD system is not the only way to record images on CD's (or other media), but it is the first system to bring together all of the components in a unified manner. The proprietary Kodak Photo CD file format and associated software are the heart of the system. Kodak has licensed the Photo CD system to other manufacturers including Fuji, Konica, and Agfa.

The Photo CD system is initially being directed at both the amateur snapshot market and a wide variety of professional applications in desktop and high-end publishing, stock photography, and medical imaging. Although there is considerable doubt that the Photo CD will be successful in the amateur field (having negatives routinely transferred to Photo CD's at a cost of more than $20 a roll is prohibitively expensive for most people, and for looking at family images on television, it is generally much more satisfying and certainly far less expensive to use a video camcorder and enjoy moving images complete with sound), the availability of high-resolution scans of color negative and transparency images for between $2 and $5 each is a revolution in the publishing field. Photo CD images can be imported into a computer running Adobe Photoshop or other image-processing soft-

November 1991

James H. Wallace, Jr., director and curator of Photographic Services at the Smithsonian Institution in Washington, D.C., describes the department's computer and digital imaging equipment to visitors from the ANSI subcommittee on the stability of color images. The Photographic Services department distributes hundreds of images on CompuServe, America Online, GEnie, and Internet on-line computer information services. At the time this book went to press in 1992, more than 30,000 downloads had occurred since the department began offering the no-cost service in November 1990. The digital images are scanned from color transparencies and color negatives; the originals are preserved in a cold storage vault maintained at 40°F (4.4°C) and 27% RH (see photograph on page 633).

ware and, after color and density corrections and image retouching are completed, separation files can be output to an imagesetter to produce fully corrected separations at a previously unheard-of low cost. The images can also be output to a film recorder to create photographic "second originals," employed in multimedia applications, transmitted to remote locations, or used to make high-quality color prints with thermal dye transfer, high-resolution ink jet, electrophotographic, or traditional color photographic papers.

Photo CD's and other types of optical disc and magnetic image storage systems can enable commercial and museum collections to reduce or eliminate handling and shipping of precious photographic originals.[47] A copy of the digital image file can be stored in a separate location to provide a backup should the originals be destroyed by fire or other catastrophe. Creating an electronic visual data base makes it possible for an institution to place photographic originals in cold storage while at the same time maintaining visual access to the images. The Photographic Services department at the Smithsonian Institution has implemented a comprehensive image access and preservation program for its collection that can serve as a model for others.[48]

Although using Photo CD's or other optical or magnetic media for the long-term preservation of photographically originated images may seem appealing, there are at present serious, unresolved problems related to the continued reliability of such systems in the future (see page 6). These concerns include the stability of the actual media (at the time this book went to press, Kodak had released only limited data about the long-term readability of its Photo CD's[49]) and, more importantly, the complete lack of assurance of future availability of hardware and software necessary to read, decompress, and access images on Photo CD's, CD-ROM's, and other types of optical and magnetic media.[50–52]

## Notes and References

1. Edwin H. Land, "Selected Letters to Shareholders," a chapter in **Selected Papers on Industry**, Polaroid Corporation, Cambridge, Massachusetts, 1983, p. 27. The quotation is part of a letter from Land to Polaroid shareholders that originally appeared in the **1976 Polaroid Corporation Annual Report**. Land, who died in 1991, was the founder and chairman of the board of Polaroid.

2. Susan Roman, "PDNews," **Photo District News**, Vol. IX, Issue XIV, December 1989, p. 18.

3. Eastman Kodak Company, "Merrett T. Smith," **Kodak Studio Light**, Issue No. 1, 1986, p. 7. Published by Eastman Kodak Company, 343 State Street, Rochester, New York 14650.

4. Mrs. Lloyd Karstetter, interview with this author, Reedsburg, Wisconsin, February 19, 1980. Karstetter came to this author's attention after she had returned a number of very faded Ektacolor prints to Fehrenbach Studios in Reedsburg and asked the studio to replace the prints at no cost. Fehrenbach Studios believed that because of misleading advertising and poor product quality, Eastman Kodak bore the responsibility for the cost of replacing the faded prints. Citing the disclaimer concerning color dye fading that appears on every box of Kodak color film and paper, Kodak refused to cover the replacement costs. In 1982, after complaints to the Wisconsin Attorney General's office and the Federal Trade Commission in Washington, D.C. brought no results, Fehrenbach Studios and another Wisconsin professional photographer filed a $3.7-million lawsuit against Kodak. The lawsuit never reached trial (see Chapter 8).

5. Eastman Kodak Company, **Gift Certificate Program — Radio Spots,** Kodak Publication PP10-8H. In 1982, responding to a request from the Wisconsin Attorney General's office, which had informed Kodak that advertisements and publications such as this were in probable violation of Wisconsin's consumer fraud laws, Kodak changed the wording in this ad from "Take A Moment Out Of Time . . . And Make It Last Forever," to "Take A Moment Out Of Time . . . And Make It Last For Years To Come." The Kodak publication number for the ad copy remained the same; neither the original nor revised version is dated.

6. Joel Meyerowitz, **Cape Light**, Museum of Fine Arts, Boston, and Little, Brown and Company, Boston, Massachusetts, 1978. See also: Joel Meyerowitz, **A Summer's Day**, Times Books in Association with Floyd A. Yearout, New York, New York, 1985.

7. Mark A. Fischetti, "The Silver Screen Blossoms Into Color" (Special Report on Video Processing), **IEEE Spectrum**, Vol. 24, No. 8, August 1987, pp. 50–55 (published by the Institute of Electrical and Electronic Engineers, Inc., 345 East 47th Street, New York, New York 10017; telephone: 212-705-7555).

8. Peter Hay, **MGM: When the Lion Roars**, Turner Publishing, Inc., One CNN Center, Atlanta, Georgia 30348, 1991, p. 327. By the end of 1990, Turner Broadcasting System had spent more than $1 billion for the black-and-white and color motion pictures that make up its film library. According to Hay, Ted Turner ". . .ended up with what he always wanted — the richest film library in the world, including its crown jewel, **Gone With the Wind**. Told repeatedly that he had paid far too much for old movies, the owner of Turner Broadcasting System once explained his decision to a reporter: 'How can you go broke, buying the Rembrandts of the programming business when you are a programmer?'"

9. Leslie Bennetts, "'Colorizing' Film Classics: A Boon or a Bane?", **The New York Times**, August 5, 1986, pp. 1 and 21.

10. Leslie Bennetts, see Note No. 9.

11. For a concise description of the chromogenic process and other traditional photographic methods of color image formation, see: Peter Krause, "Color Photography," Chapter 4 in **Imaging Processes and Materials – Neblette's Eighth Edition** (edited by John M. Sturge, Vivian Walworth, and Allan Shepp), Van Nostrand Reinhold Company, New York, New York, 1989.

12. Eastman Kodak Company, **Evaluating Dye Stability of Kodak Color Prints – Prints on Kodak Ektacolor Plus Paper**, Kodak Publication CIS No. 50-4, Eastman Kodak Company, Rochester, New York, February 1985.

13. Gert Koshofer, **Farb Fotografie – Book 1**, Verlag Laterna magica, Munich, Germany, 1981, p. 171. Koshofer reports that Kodak described the Azochrome silver dye-bleach color print process and showed sample Azochrome prints made from Kodachrome transparencies in Chicago in August 1941.

The 1941 Azochrome print by Albert Wittmer from the collection of the International Museum of Photography at George Eastman House that is reproduced in this book on page 25 was included in the exhibition **Color As Form – A History of Color Photography** that opened at the Corcoran Gallery of Art in Washington, D.C. on April 10, 1982 (see page 17 of the exhibition catalogue published by George Eastman House in 1982). Later shown at Eastman House in Rochester, the exhibition was organized by George Eastman House, with John Upton serving as guest curator.

14. Paul C. Spehr, "Fading, Fading, Faded – The Color Film Crisis," **American Film**, Vol. V, No. 2, November 1979, pp. 56–61. See also: Bill O'Connell, "Fade Out – Remember the Glorious Color of Films Gone By? It May Soon Be Only a Memory – For the Prints Are Fading Fast," **Film Comment**, Vol. 15, No. 5, September–October 1979, pp. 11–18. See also: Harlan Jacobson, "Old Pix Don't Die, They Fade Away – Scorsese Helms Industry Plea to Kodak," **Variety**, Vol. 299, No. 10, July 9, 1980, pp. 1, 28–29. See also: Richard Patterson, "The Preservation of Color Films – Part I," **American Cinematographer**, Vol. 62, No. 7, July 1981, pp. 694ff; and Richard Patterson, "The Preservation of Color Films – Part II," **American Cinematographer**, Vol. 62, No. 8, August 1981, pp. 792ff.

15. Vsevolod Tulagin, Robert F. Coles, and Richard Miller, **Permanent Reproductions**, United States Patent No. 3,172,827, granted March 9, 1965 (filed April 18, 1960), and **Photoconductography Employing Organic Onium Cation**, United States Patent No. 3,172,826, granted March 9, 1965 (filed April 18, 1960).

16. Gert Koshofer, **Farb Fotografie – Book 1**, Verlag Laterna magica, Munich, Germany, 1981, p. 173.

17. Polaroid Corporation, "This Polaroid SX-70 Photograph Is Part of the Collection of the Museum of Modern Art," 2-page advertisement in **The New Yorker**, May 1977. The ad was illustrated with an SX-70 photograph by Lucas Samaras; the donation of the print to the Museum by an obscure arts foundation was facilitated by the New York advertising agency that prepared the Polaroid ad. At the time the ad featuring the Samaras SX-70 print appeared, it is believed that the Museum had only one or two other SX-70 prints in its collection.

18. Anon., "Fine Art, Via Polaroid," **The New York Times**, February 15, 1990, p. C3.

19. **Consumer Reports** staff, "Instant-Picture Cameras," **Consumer Reports**, pp. 622–625, November 1976.

20. William S. Allen, general manager, Consumer Markets Division, Eastman Kodak Company, letter to Dealers in Kodak Products, November 9, 1976. The letter stated in part:

"There have been published reports critical of the stability of prints made with Kodak instant cameras and film. Kodak considers these reports to be misleading. The company has stated repeatedly that the stability of Kodak instant prints is entirely satisfactory when such prints are handled, displayed, or stored in the usual variety of home and office situations. . . .

"It should be noted that the performance of a color print exposed to direct sunlight or to high-intensity fluorescent light is *not* indicative of its performance when the print is displayed or stored in the usual way by amateur picture-takers.

When Allen wrote the letter, Kodak had extensive light fading data on PR-10 and was well aware that the prints were far less stable than any other color print material on the market; the company also knew that, under typical display conditions in the home or office, the prints would fade significantly in less than a year's time and that in most cases, the prints would become severely deteriorated after only 4 or 5 years of display. See: John Stewart, "Kodak Finds Its Instant Prints Fade More," **Democrat and Chronicle**, Rochester, New York, June 3, 1977. See also: John Stewart, "Expert's Tests Show Light Fades Color Photos — Don't Hang Them on the Wall," **Democrat and Chronicle**, Rochester, New York, March 22, 1979.

21. The Colour Group of the Royal Photographic Society sponsored a symposium on **The Conservation of Colour Photographic Records** at the Victoria and Albert Museum, London, England, September 20, 1973. Among the presentations were: "The Keeping Properties of Some Colour Photographs," by C. H. Giles and R. Haslam [University of Strathclyde]; "On the Resistance to Fading of Silver-Dye-Bleach Transparencies," by R. Bermane [Ciba-Geigy Photochemie Ltd.]; and "The Light Stability of New Polaroid Colour Prints," by H. G. Rogers, M. Idelson, R. F. W. Cieciuch, and S. M. Bloom [Polaroid Corporation]. Eastman Kodak did not take part in this important early conference. Proceedings of the symposium were published in 1974 by the Royal Photographic Society, and a number of the presentations later appeared as articles in the Society's journals.

22. William Jenkins, assistant curator for 20th Century Photography, International Museum of Photography at George Eastman House, letter dated September 9, 1975 to attendees of the October 17, 1975 "Colloquium on the Collection and Preservation of Color Photographs." Participation at the meeting by Kodak apparently convinced the company to include, for the first time, at least some information on the stability of color transparency and color negative films in **Storage and Care of Kodak Color Films**, Kodak Publication No. E-30, January 1976. Little of the often-heated discussion that took place at the conference ever became public because Arthur Goldsmith and Ed Meyers from **Popular Photography**, Ed Scully of

**Modern Photography**, and other members of the press who attended the event were asked to withhold publication of stories about the meeting until the official **Proceedings** of the conference were released by George Eastman House. The promised **Proceedings** were never published and, as a result, this early and important conference was never covered in the press. Since its founding in 1947, Eastman House has received a substantial portion of its funding from the Eastman Kodak Company, either directly or through the Eastman Charitable Trust. The yearly contribution from the Trust alone has often amounted to more than $1 million.

23. Dan Meinwald, "Color Photographs: Must They Always Fade?", **Afterimage**, November 1975 (published by the Visual Studies Workshop in Rochester, New York).

24. Peter Z. Adelstein, C. Loren Graham, and Lloyd E. West [Eastman Kodak Company], "Preservation of Motion-Picture Color Films Having Permanent Value," **Journal of the SMPTE**, Vol. 79, No. 11, November 1970, pp. 1011–1018. This article contained a graph showing predicted times for a 10% density loss of the cyan dyes of two unidentified Kodak motion picture color negative and print films stored at a wide range of temperatures. This small graph was the first public acknowledgment by Kodak that it had developed the now well-established Arrhenius multiple-temperature accelerated test method with which predictions for dark fading and dark staining rates of color films and prints can be obtained for normal room temperatures, cold storage temperatures, or any other desired temperature. This was a major breakthrough in the evaluation and preservation of color films and prints (see Chapter 2). The Arrhenius dark storage test method is also specified in American National Standards Institute, Inc., **ANSI IT9.9-1990, American National Standard for Imaging Media – Stability of Color Photographic Images – Methods for Measuring**, American National Standards Institute, Inc., New York, New York, 1991. Copies of the Standard may be purchased from the American National Standards Institute, Inc., 11 West 42nd Street, New York, New York 10036; telephone: 212-642-4900 (Fax: 212-398-0023).

25. Klaus B. Hendriks, chairperson, session on the **Stability and Preservation of Photographic Materials**, at the annual conference of the Society of Photographic Scientists and Engineers, Washington, D.C., May 1, 1978. Presentations were given by Klaus B. Hendriks [Public Archives of Canada], "The Challenge of Preserving Photographic Records"; Timothy F. Parsons [Eastman Kodak], "To RC or Not To RC"; Robert J. Tuite [Eastman Kodak], "Image Stability in Color Photography"; Martin Idelson [Polaroid], "Polacolor, Polacolor 2, and SX-70 Prints"; Henry Wilhelm [East Street Gallery], "Light Fading Characteristics of Reflection Color Print Materials"; and Stanton Clay [Ilford], "Light Fading Stability of Cibachrome."

   Hendriks also served as chairperson of the **International Symposium: The Stability and Preservation of Photographic Images**, Public Archives of Canada (renamed the National Archives of Canada in 1987), Ottawa, Ontario, August 29 — September 1, 1982, sponsored by the Society of Photographic Scientists and Engineers. Among the presentations were: Robert F. W. Cieciuch, "Stability of Polaroid Integral Color Film Images" and "Light Stability of Polacolor 2 and Polacolor ER Images and Its Maximization"; Henry Wilhelm, "Tungsten Light Fading of Reflection Color Prints"; and Charleton C. Bard and Paul M. Ness, "The Effects of Post Processing Handling on the Image Stability of Kodak Ektacolor Prints."

   In addition, Hendriks served as chairperson of the **Second International Symposium: The Stability and Preservation of Photographic Images**, Public Archives of Canada, Ottawa, Ontario, August 25–28, 1985, sponsored by the Society of Photographic Scientists and Engineers. Among the papers presented at the conference was: Kotaro Nakamura, Makoto Umemoto, Nobuo Sakai, and Yoshio Seoka [Fuji Photo Film Co., Ltd.], "Dark Stability of Photographic Color Print from the Viewpoint of Stain Formation." This important paper described the "low-stain" magenta couplers invented by Fuji and first used in Fujicolor Paper Type 12 (Process EP-2) introduced in 1985.

26. Robert J. Tuite [Eastman Kodak Company], "Image Stability in Color Photography," **Journal of Applied Photographic Engineering,** Vol. 5, No. 4, Fall 1979, pp. 200–207.

27. Henry Wilhelm, "Light Fading Characteristics of Reflection Color Print Materials," abstract in the 31st SPSE Annual Conference Program [abstracts], **Journal of Applied Photographic Engineering**, Vol. 4, No. 2, Spring 1978, p. 54A.

28. Klaus B. Hendriks, together with Brian Thurgood, Joe Iraci, Brian Lesser, and Greg Hill of the National Archives of Canada staff, is the author of **Fundamentals of Photographic Conservation: A Study Guide**, published by Lugus Publications in cooperation with the National Archives of Canada and the Canada Communication Group, 1991. Available from Lugus Productions Ltd., 48 Falcon Street,

Toronto, Ontario, Canada M4S 2P5; telephone: 416-322-5113; Fax: 416-484-9512.

29. Klaus B. Hendriks, "The Stability and Preservation of Recorded Images," Chapter 20 in **Imaging Processes and Materials – Neblette's Eighth Edition** (edited by John M. Sturge, Vivian Walworth, and Allan Shepp), Van Nostrand Reinhold Company, New York, New York, 1989.

30. The Photographic Materials Group of the American Institute for Conservation (AIC) was founded in 1979. The first meeting, organized by Jose Orraca, was held at the University of Delaware in Newark, Delaware, August 20, 1979; the charter members of the group were Gary E. Albright, David E. Kolody, Jose Orraca, Mary Kay Porter, Siegfried Rempel, James Reilly, Henry Wilhelm, and Chris Young. For further information contact: American Institute for Conservation, Suite 340, 1400 16th Street, N.W., Washington, D.C. 20036; telephone: 202-232-6636.

31. Lawrence F. Karr, ed., **Proceedings – Conference on the Cold Storage of Motion Picture Films,** American Film Institute and Library of Congress, Washington, D.C., April 21–23, 1980.

32. See: Harlan Jacobson, "Old Pix Don't Die, They Fade Away — Scorsese Helms Industry Plea to Kodak," **Variety**, Vol. 299, No. 10, July 9, 1980, pp. 1, 28–29. This was a major article on the poor image stability of Kodak motion picture color negative and print films; the writer described film director Martin Scorsese's campaign to pressure Kodak into producing improved film stocks. See also: "Signers of No Fade Petition to Kodak Span All Industry Ranks," **Variety**, Vol. 299, No. 10, July 9, 1980, p. 29. See also: Robert Lindsey, "Martin Scorsese's Campaign to Save a Film Heritage," **The New York Times**, October 5, 1980, pp. 19ff. See also: Patricia O'Brian [Knight News Service], "Movies (and Snapshots) Are Losing Their Color," **San Francisco Chronicle**, May 11, 1980. This article also appeared under various titles in many other newspapers. See also: Jack Garner, "Films Fade – Director Protests; Kodak's 'Working on It'," **Democrat and Chronicle**, Rochester, New York, May 13, 1980, pp. 1C, 2C. See also: Richard Harrington, "Old Movies Never Die – They're Just Fading Away," **The Washington Post**, July 20, 1980.

33. David Litschel, editor, **Fugitive Color** (exhibition catalogue with essays by Diane Kirkpatrick and Henry Wilhelm, with an introduction by David Litschel), University of Michigan, Ann Arbor, Michigan, 1982. This author's essay was entitled "The Problems of the Kodak Ektacolor Print System." Published by the School of Art, University of Michigan, Ann Arbor, Michigan 48109.

34. On July 22, 1980 Herbert Phillips, director of the Graphic Arts Research Center at the Rochester Institute of Technology, telephoned this author to retract a previously extended invitation to speak at the "Preservation and Restoration of Photographic Images" seminar scheduled to take place August 25–27, 1980. This author had been a speaker on color photography at six previous RIT seminars on preservation and was listed as a speaker in the RIT brochure for the August 1980 seminar. Phillips informed this author that RIT "wanted some new material" for the program and had asked Kodak to give a presentation similar to the talk Kodak planned to present on August 12, 1980 at the Professional Photographers of America convention in Atlanta, Georgia.

   The actual reason for the cancellation of this author's invitation to speak was Kodak's displeasure with his presentations on color image stability at the previous six RIT seminars in which Kodak's policy of keeping image stability data secret was criticized; criticisms were leveled at Kodak's extremely unstable PR-10 instant print film; and advertisements by Kodak and Polaroid in which misleading claims were made about color image stability were also discussed. This author had obtained, from an anonymous source in Rochester, an internal Kodak memorandum dated May 13, 1980 which described a secret meeting between Allie C. Peed, Jr., director of Publications and Photo Information in Kodak's Consumer/Professional and Finishing Markets Division (at the time, on behalf of the Eastman Kodak Company, Peed was also serving as president of the Society of Photographic Scientists and Engineers), and Lothar K. Englemann, dean of Graphic Arts and Photography at RIT. The memorandum stated in part:

   ". . . Mr. Wilhelm will not be invited to be a program participant in future seminars. Mr. Hendrix [Dr. Klaus B. Hendriks of the Public Archives of Canada] will be invited, but, if he chooses not to come without Mr. Wilhelm, he will be dropped."

   Peed concluded his memorandum by saying ". . . if this one [the seminar] doesn't come off better than the previous one I think we have no alternative but to withdraw any Kodak support on the basis that we don't want our name associated with a poorly run seminar." In the August seminar, Kodak supplied seven out of the 19 speakers, at no cost to RIT. A front-page story by Richard Whitmire which appeared in the July 29, 1980 edition of Rochester's **Times-Union**

newspaper, entitled "Did Kodak Silence Critic? RIT Denies Pressure Led to Cancellation of Seminar Speaker," included this account of the situation:

"Asked if he knew who sent the letter to Wilhelm, Peed said, 'No, and I'd be glad to pay you if you could tell me. We have a bit of an internal investigation going on here to find out. We're trying very hard to put a finger in the dike.'

"Peed did not hesitate to describe his unhappiness with Wilhelm. 'Our difficulty with him is that he has assigned to himself a role of critic of Eastman Kodak products, for reasons unknown to us,' he said.

"'The question was whether we could continue to give support to an activity being used by someone to attack us.'

"But Peed denied Kodak was pressuring RIT to drop Wilhelm. When questioned about the last paragraph of his letter, Peed said, 'Well, I guess it depends on your definition of pressure. I think we were just being pragmatic in describing a condition we find unacceptable.'

"Contacted yesterday, Englemann refused to discuss his conversation with Peed. 'That is nobody's business,' he said."

The matter received considerable press and television coverage in Rochester in the following weeks. An editorial entitled "Kodak, RIT and Academic Freedom" that was published in the July 31, 1980 issue of the **Times-Union** said, in part:

"In the matter of the disinvited seminar speaker, Eastman Kodak Co. seems to have challenged the concept of academic freedom and Rochester Institute of Technology seems to have submitted cravenly.

"... It's good of Kodak to interest itself in RIT's seminars, and wise of RIT to seek Kodak's advice. But the interests of Kodak are not the same as the interests of photo specialists who are drawn to an academic seminar.

"Kodak ought to answer its critics, not try to silence them. RIT ought to serve students as best it can, and jealously guard its academic independence. Both ought to understand and respect the role of the other."

On August 15, after this author traveled to Rochester and retained an attorney with the intention of suing both RIT and Kodak in addition to seeking an injunction which would force RIT to reinstate the speaking invitation, RIT agreed — out of court — to permit this author to speak at the seminar. The agreement was reached 3 days after Kodak announced in Atlanta, Georgia that the company would be making color stability information public for its current and future products.

For an account of the RIT incident, see: Richard Whitmire, "Did Kodak Silence Critic? — RIT Denies Pressure Led to Cancellation of Seminar Speaker," **Times-Union**, Rochester, New York, July 29, 1980, p. A1; Anne Tanner and Dick Mitchell, "Kodak Critic Ponders Legal Action After Canceled Talk," **Democrat and Chronicle**, Rochester, New York, July 30, 1980, p. D8; "Kodak, RIT and Academic Freedom," editorial, **Times-Union**, Rochester, New York, July 31, 1980, p. A6; Richard Whitmire, "Kodak Fight Won't Fade — Wilhelm Demands Reinstatement as RIT Speaker," **Times-Union**, Rochester, New York, August 8, 1980, p. B1. Richard Whitmire, "RIT Re-Invites Kodak Critic," **Times-Union**, Rochester, New York, August 18, 1980; "Wilhelm to Speak," **Democrat and Chronicle**, Rochester, New York, August 19, 1980; "RIT Makes Amends," editorial, **Democrat and Chronicle**, Rochester, New York, August 20, 1980, p. A18; "Fade Out, Fade In," part of "The Year That Was: 1980," **Times-Union**, Rochester, New York, January 3, 1981, p. 5.

See also a series of articles by Anthony Bannon: "Part I: Priceless Prints Deteriorating — 'Living Color' Dying Out in Old Photos," **The Buffalo News**, Buffalo, New York, August 16, 1980; Anthony Bannon, "Part II: Photography 'Nader' Fighting Film Industry," **The Buffalo News**, Buffalo, New York, August 17, 1980; Anthony Bannon, "Part III: Kodak Defends Stability of Its Film," **The Buffalo News**, Buffalo, New York, August 18, 1980; Anthony Bannon, "Part IV: Cold, Darkness Are Necessary to Preserve Photos," **The Buffalo News**, Buffalo, New York, August 19, 1980; Anthony Bannon, "Kodak Program on Color Fading Is Announced," **The Buffalo News**, Buffalo, New York, August 31, 1980, p. A9. See also: John Bremer, "Wilhelm Feuds with Kodak over Seminar," **Grinnell Herald-Register**, Grinnell, Iowa, August 28, 1980, p. 1.

See also: Cindy Furlong and Adam Weinberg, "The Imperfect Miracle — Wilhelm Reinstated at RIT Seminar, Kodak Shifts on Color," **Afterimage** (published by the Visual Studies Workshop, Rochester, New York), October 1980, p. 3.

See also: John Thompson, interview with Henry Wilhelm concerning Kodak's involvement in the controversy surrounding Wilhelm's cancellation and later reinstatement as a speaker at the Rochester Institute of Technology Seminar on the preservation of photographs.

Segment aired on the evening news of **WHEC** television (CBS — Channel 10), Rochester, New York, August 26, 1980. See also: Marty Bucksbaum, interview with Henry Wilhelm concerning the problems of fading color prints and the controversy surrounding Wilhelm's being dropped and later reinstated as a speaker at the Rochester Institute of Technology seminar on the preservation of photographs. The segment aired on **WXXI** television (PBS — Channel 21), Rochester, New York, August 28, 1980.

See also: Thom O'Connor, "Why Henry Wilhelm Took On Kodak," **New York Photo District News**, Vol. III, Issue I, Sec. II, November 1982, pp. 1ff; and Thom O'Connor, "Print Permanence — How Long Is Forever?", **New York Photo District News**, Vol. III, Issue I, Sec. II, November 1982, p. 66.

RIT has long cultivated ties between the school and the photographic and graphic arts industries and governmental agencies with a zeal that would embarrass most colleges and universities. The driving force behind these intertwining relationships has been the school's often-stated desire to obtain lucrative contracts for research projects and other revenue-producing services.

In 1980, at the time of the cancellation incident, M. Richard Rose was serving as president of RIT. Rose took early retirement in 1992 "... in the wake of controversy last year over his, and the school's, links with the Central Intelligence Agency." (from an article by Jennifer Hyman, "RIT Picks Its Next President, **Democrat and Chronicle**, Rochester, New York, May 19, 1992, page 1). RIT's new president is Albert J. Simone, formerly president of the University of Hawaii.

For an account of the RIT-CIA controversy, see the long series of articles by Jennifer Hyman that appeared in Rochester's **Democrat and Chronicle** newspaper beginning on April 27, 1991, with a story entitled "RIT Students Protest President's CIA Work," (p. 1B–2B) and that ran through the remainder of 1991 and continued into 1992. Among the **Democrat and Chronicle** articles were: "RIT Advises CIA to Plan for Future – Report Espouses Economic Espionage" (May 19, 1991); "Secret RIT Study Bashes the Japanese" (May 24, 1991); "CIA Vein Runs Deep Inside RIT – '85 Memo Spelled Out Formal Ties" (June 2, 1991); "CIA Had a Free Hand: RIT Official – Agency Ran Its Own Shadow Management" (June 11, 1991); "Many Feel CIA Ties Taint RIT's International Efforts – Foreign Educators Grow Wary of School" (June 30, 1991); "The RIT-CIA Connection" (June 30, 1991). See also: "CIA Report on Japan Economy Creates Furor at Institute," **The New York Times**, June 5, 1991, p. B10. See also: William Glaberson, "Soul-Searching at a University Over C.I.A. Links," **The New York Times**, June 20, 1991, p. A1 and A11. See also: M. Kathleen Wagner, "Wariness of the CIA Lingers at RIT Forum," **Democrat and Chronicle**, Rochester, New York, September 23, 1992, pp. 1B–2B.

35. Image Permanence Institute, Rochester Institute of Technology, Frank E. Gannett Memorial Building, Post Office Box 9887, Rochester, New York 14623-0887; telephone: 716-475-5199 (Fax: 716-475-7230).

36. James M. Reilly, **Care and Identification of 19th-Century Photographic Prints**, Kodak Publication No. G-2S, Eastman Kodak Company, Rochester, New York, 1986. See also: James M. Reilly, **The Albumen & Salted Paper Book — The History and Practice of Photographic Printing 1840–1895**, Light Impressions Corporation, 439 Monroe Avenue, P.O. Box 940, Rochester, New York 14603-0940, 1980.

37. Hiroshi Sugaya, "The Past Quarter-Century and the Next Decade of Videotape Recording," **SMPTE Journal**, Vol. 101, No. 1, January 1992, pp. 10–13.

38. Richard S. O'Brien and Robert B. Monroe, with contributions by Charles E. Anderson and Steven C. Runyon, "101 Years of Television Technology," **SMPTE Journal**, July 1976 (reprinted in the **SMPTE Journal**, Vol. 100, No. 8, August 1991, pp. 606–629).

39. Richard S. O'Brien and Robert B. Monroe, with contributions by Charles E. Anderson and Steven C. Runyon, see Note No. 38, pp. 610–611.

40. Nora Lee, "HDTV: The Artists Speak" (Electronic Imagery), **American Cinematographer**, Vol. 68, No. 9, September 1987, pp. 85–90.

41. Lois Schlowsky, "Digital Vision: Birth of a Filmless Photography Studio," **Photo-Electronic Imaging**, Vol. 35, No. 11, November 1992, pp. 31–33. (Schlowsky Photography and Computer Imagery, 73 Old Road, Weston, Massachusetts 02193; telephone: 617-899-5110; Fax: 617-647-1608.)

42. Chris Gulker, photo editor of the **San Francisco Examiner**, interviews with this author during August–November 1992. For a detailed description of how the **Examiner** uses Adobe Photoshop to prepare scanned color negative images for publication, see: Jane Hundertmark, "Picture Success," **Publish**, Vol. 7, No. 7, July 1992, pp. 52–58.

43. The Polaroid Corporation began working with Charles Berger in early 1985, and pigment films were successfully coated in March of that year (see: Polaroid Corporation, "Color for Centuries," **Instants**,

Vol. 4, No. 2, Polaroid Corporation, Cambridge, Massachusetts, 1986, p. 4). At the time, Berger's printmaking materials were known as the ArchivalColor materials. Development work continued and in February 1987, Polaroid announced that it would market the materials worldwide. In June 1987, however, Polaroid abruptly announced that development work had ceased and that the company had decided not to market the ArchivalColor materials. Later, Polaroid announced it would make the existing materials available on a contract basis, under the Polaroid Permanent-Color name, but that further development would not be undertaken. Ataraxia Studio, Inc., 3448 Progress Drive – Suite E, Bensalem, Pennsylvania 19020 (telephone: 215-343-3214) was established to make prints using the Polaroid-manufactured materials (see: Linda Tien, "Lasting Impressions – At Ataraxia Studio, Images Are Made to Stand the Test of Time," **Specialty Lab Update**, published by the Photo Marketing Association International, March 1992, pp. 1 and 4). At the time this book went to press in 1992, however, commercial production of prints at Ataraxia Studio had not begun, and production print samples were not available for image stability and physical stability testing.

44. A number of articles have been written about the UltraStable process. See, for example: John Durniak, "Color Almost Too Good To Be True," **The New York Times**, December 6, 1992, p. Y27; and: Mark Wilson, "A Color Process That Won't Fade Away," **The Boston Sunday Globe**, May 17, 1992. See also: Spencer Grant and Elizabeth Forst, "Carbro Printing: Back to the Future," **Photo District News**, Vol. XII, Issue II, February 1992, pp. 98–100; and: William Nordstrom, "In Search of Permanence: 500-Year-Life UltraStable Color Photographs," **Professional Photographer**, Vol. 119, No. 2159, April 1992, pp. 34–36; and: David B. LaClaire, "Marketing UltraStable Portrait Prints," **Professional Photographer**, Vol. 119, No. 2159, April 1992, p. 36.

45. Joe Matazzoni, "Outputting Fine Color From the Desktop – In the Tradition of Fine Arts Printers, A Handful of Color Houses Are Producing Limited Edition Iris Prints From Digital Files," **Step-By-Step Graphics**, Vol. 8, No. 5, September–October 1992. Donald R. Allred, Ink and Media manager at Iris Graphics, Inc., was quoted in the article concerning the light fading stability of Iris prints.

46. Firms offering high-resolution Iris ink jet prints produced from digital image files (and from photographic originals) for the fine art and commercial display markets include: **Nash Editions**, P.O. Box 637, 1201 Oak Avenue, Manhattan Beach, California 90266 (telephone: 310-545-4352; Fax: 310-545-8565); **Image Transform Ltd.**, 2309 West First Street, Ankeny, Iowa 50021 (telephone: 515-964-0436; Fax: 515-964-3914); **Harvest Productions**, 911 Champlain Circle, Anaheim Hills, California 92807 (telephone: 714-281-0844; Fax: 714-281-2920); and **DiGiColor**, 1300 Dexter Avenue North, Seattle, Washington 98109 (telephone: 206-284-2198; Fax: 206-285-9664).

47. Christine Heap, "Photo Negative Database at the U.K.'s National Railway Museum," **Advanced Imaging**, Vol. 8, No. 2, February 1993, pp. 36–39.

48. Jim Wallace, "Considerations Regarding the Long-Term Storage of Electronic Images," **Journal of Electronic Imaging**, Vol. 2, No. 1, January 1993, pp. 35–37.

49. Eastman Kodak Company, **Kodak Photo CD Permanence Questions and Answers**, Eastman Kodak Company, Communications and Public Affairs, December 18, 1991.

50. National Archives and Records Service, **Strategic Technology Considerations Relative to the Preservation and Storage of Human and Machine Readable Records** (White Paper prepared for the National Archives and Records Service by Subcommittee C of the Committee on Preservation), July 1984.

51. John C. Mallinson, "Archiving Human and Machine Readable Records for the Millenia," **Second International Symposium: The Stability and Preservation of Photographic Images** (Printing of Transcript Summaries), the Society of Photographic Scientists and Engineers, Springfield, Virginia, pp. 398–403, 1985. (The symposium was held August 25–28, 1985 in Ottawa at the National Archives of Canada.) See also: John C. Mallinson, "Preserving Machine-Readable Archival Records for the Millenia," **Archivaria**, No. 22, Summer 1986, pp. 147–152. See also: John C. Mallinson, "On the Preservation of Human- and Machine-Readable Records," **Information Technology and Libraries**, Vol. 7, No. 1, March 1988, pp. 19–23.

52. John C. Mallinson, "Magnetic Tape Recording: History, Evolution and Archival Considerations," chapter in **Proceedings of the International Symposium: Conservation in Archives**, pp. 181–190. The symposium was held May 10–12, 1988 in Ottawa and was sponsored by the National Archives of Canada and the International Council on Archives. The proceedings were published by the National Archives of Canada, 1989. Copies of the proceedings are available from the International Council on Archives, 60 rue des Francs-Bourgeois, 75003 Paris, France.

## General References

American National Standards Institute, Inc., **ANSI IT9.9-1990, American National Standard for Imaging Media – Stability of Color Photographic Images – Methods for Measuring**, American National Standards Institute, Inc., New York, New York, 1991.

Brian Coe, **Colour Photography – The First Hundred Years, 1840–1940**, Ash & Grant Ltd, London, England, 1978.

Jacob Deschin, "Color Print Permanence: 20 Experts Testify on Where It's At Today," **35-mm Photography** (Ziff-Davis Publishing Company, New York, New York), Summer 1975, pp. 4–10 and 114–120.

Eastman Kodak Company, **Conservation of Photographs** (George T. Eaton, editor), Kodak Publication No. F-40, Eastman Kodak Company, 343 State Street, Rochester, New York 14650, March 1985.

Ralph M. Evans, **Eye, Film, and Camera in Color Photography**, John Wiley and Sons, New York, New York, 1959.

Harvey V. Fondiller, "Will Your Color Live Longer Than You Do?" **Color Photography 1973**, Ziff-Davis Publishing Company, New York, New York, 1973, pp. 82–87, 128.

Joseph S. Friedman, **History of Color Photography** (originally published in 1944), Focal Press, Ltd., London, England, 1968.

Grant Haist, **Modern Photographic Processing – Volume 2**, John Wiley and Sons, New York, New York, 1979.

Robert Hirsch, **Exploring Color Photography**, Second Edition, Brown & Benchmark Publishers, Madison, Wisconsin, 1993.

R. W. G. Hunt, **The Reproduction of Colour in Photography, Printing and Television**, Third edition, Fountain Press, London, 1975.

David Kach, "Photographic Dilemma: Stability and Storage of Color Materials," **Industrial Photography**, Vol. 27, No. 8, August 1978, pp. 28ff.

Judith Kahn, "Fleeting Images," **The Museum of California**, The Oakland Museum, Vol. 6, No. 6, May–June 1983, pp. 16–18.

Gert Koshofer, **Farb Fotografie**, (Books 1, 2, and 3), Verlag Laterna Magica, Munich, Germany, 1981.

Gert Koshofer, **Color — Die Farben Des Films**, Wissenschaftverlag Volker Spiess GmbH, Berlin, Germany, 1988.

C. E. Kenneth Mees, **From Dry Plates to Ektachrome Film — A Story of Photographic Research**, Ziff-Davis Publishing Company, New York, New York, 1961.

Stephen R. Milanowski, "Notes on the Stability of Color Materials," **Positive**, 1980–81 (published by the Creative Photography Laboratory, Massachusetts Institute of Technology, Cambridge, Massachusetts); reprinted in 1982: Stephen R. Milanowski, "Notes on the Stability of Color Materials," **Exposure**, Vol. 20, No. 3, Fall 1982, pp. 38–51.

Edwin Mutter, **Farbphotographie – Theorie und Praxis**, Springer-Verlag, Vienna, Austria and New York, New York, 1967.

Luis Nadeau, **Encyclopedia of Printing, Photographic, and Photomechanical Processes** (Volumes 1 and 2), 1989. Published by Atelier Luis Nadeau, P.O. Box 1570, Station A, Fredericton, New Brunswick, Canada E3B 5G2.

Paul Outerbridge, **Photographing in Color**, Random House, New York, New York, 1940.

Bob Schwalberg, "Color Preservation Update," **Popular Photography**, Vol. 89, No. 1, January 1982, pp. 81–85, 131.

Bob Schwalberg, with Henry Wilhelm and Carol Brower, "Going! Going!! Gone!!! – Which Color Films and Papers Last Longest? How Do the Ones You Use Stack Up?," **Popular Photography**, Vol. 97, No. 6, June 1990, pp. 37–49, 60. (Publishing director Herbert Keppler and editorial director Jason Schneider assisted with the article.)

Ellen Ruppel Shell, "Memories That Lose Their Color," **Science 84**, Vol. 5, No. 7, September 1984, pp. 40–47 (published by the American Association for the Advancement of Science, Washington, D.C.).

Louis Walton Sipley, **A Half Century of Color**, The Macmillan Company, New York, New York, 1951.

John M. Sturge, Vivian Walworth, and Allan Shepp, editors, **Imaging Processes and Materials – Neblette's Eighth Edition**, Van Nostrand Reinhold Company, New York, New York, 1989.

Gail Fisher-Taylor, "Colour – A Fading Memory?" **Canadian Photography**, January 1979, pp. 10–11.

Gail Fisher-Taylor, "Interview: Henry Wilhelm," **Photo Communique**, Vol. 3, No. 1, Spring 1981, pp. 2–21.

Edward J. Wall, **The History of Three-Color Photography** (originally published in 1925), Focal Press, Ltd., London, England, 1970 .

Henry Wilhelm, "Color Print Instability," **Modern Photography**, Vol. 43, No. 1, February 1979, pp. 92ff. (Peter Moore, the senior editor of the magazine, assisted with preparation of the article.)

Henry Wilhelm, "Color Photographs and Color Motion Pictures in the Library: For Preservation or Destruction?", chapter in **Conserving and Preserving Materials in Nonbook Formats** (Kathryn Luther Henderson and William T. Henderson, editors), University of Illinois Graduate School of Library and Information Science, Urbana-Champaign, Illinois, pp. 105–111, 1991.

# 2. Accelerated Tests for Measuring Light Fading, Dark Fading, and Yellowish Stain Formation in Color Prints and Films

Prints made on paper currently available will fade, and badly, over a relatively few years. *Not so with color prints made on Konica SR Paper.* The rich color and details in these pictures will show virtually no signs of fading in 100 years. Our advanced emulsion technology enhances dye stability. In fact, accelerated aging tests show that dye images will retain more than 70% of their original density for 100 years or longer under normal album storage conditions.[1]

Konica Corporation advertisement in *Professional Photographer,* October 1984

The introduction of Konica Color PC Paper Type SR in April 1984 was a landmark in the history of color photography for a number of reasons. Konica Type SR paper, which Konica also calls "Century Print Paper" and "Long Life 100 Paper," was the first of a new generation of color negative papers to have a long-lasting cyan dye (cyan dyes with poor dark fading stability were the weak link in Kodak Ektacolor papers and all of the other chromogenic papers on the market at the time). In addition, the new Konica paper and a companion stabilizer used without a final water wash made possible the now-ubiquitous "washless" minilab, which can be easily installed in any location because no water supply or waste-water drain is required. (Surprisingly, Type SR prints processed with the Konica "washless" stabilizer are even more stable than the same prints given the previously mandatory wash in running water.)

In another important first for the photography industry, Konica's advertisements and technical literature for the new paper included data from predictive accelerated dark fading tests and touted the paper's superior image stability as its principal advantage over color papers made by Kodak, Fuji, Agfa, and 3M. With the introduction of Type SR paper and "washless" processing, Konica focused attention on the permanence issue in a way that had not been done before, and forced the entire photographic industry to accept image stability as a legitimate component of overall product quality.

---

**Recommendations**

See Chapter 1 for a comprehensive list of the longest-lasting color films and print materials, based on overall light fading, dark fading, and dark staining performance.

---

Accelerated light fading and dark fading tests played an essential role in the research and development effort that led to Konica Type SR paper, the outstanding Fujicolor SFA3 color negative papers introduced in 1992, and all other color papers and films on the market today. Konica relied heavily on accelerated image stability tests in its research on "washless" stabilizers for prints and films. How such tests are performed is the subject of this chapter.

## Color Image Fading and Staining

The deterioration over time of color photographic images is characterized by overall loss of dye density; shifts in color balance caused by unequal fading of the cyan, magenta, and yellow dyes that make up the image (in any given color material, the three dyes virtually never fade at the same rate); changes in contrast; loss of detail; and overall staining (almost always yellowish in color).

In addition, color photographs may crack, delaminate, be attacked by fungi and other microorganisms, or suffer from scratches, abrasions, fingerprints, and other physical deterioration. Cracking of RC paper generally is initiated by exposure to light on display and occurs most commonly when an RC print is physically stressed by fluctuating relative humidity. Light-induced cracking frequently is found in RC prints from the late 1960's and the 1970's. Especially in mounted prints, RC paper cracking can be caused by widely fluctuating relative humidity alone (even when the prints are stored in the dark).

Color image deterioration, which stems from the *inherent* instability of the organic dyes (and unreacted dye-forming couplers) employed in most color photographs, can be separated into seven principal categories:

1. **Light fading caused by exposure to light and ultraviolet radiation during display or projection.** Absorption of visible light and UV radiation by the image dye molecules causes them to break down into colorless compounds and/or stain products (usually yellowish). Although it may be possible to chemically restore the silver image in a faded black-and-white photograph, there is no known way to chemically restore the dye image of a color photograph once it has deteriorated.

   The rate of light fading is specific to each type of color print or color film and is a function of the intensity of the illumination and the duration of exposure. With most modern color print materials, the wavelength distribution of the illumination is not nearly as important as the intensity of the illumination. With some materials, high ambient relative humidities can increase the rate of light fading. Light fading is not something that suddenly happens to a print; it is a gradual process that

Carol Brower – August 1983

Accelerated light fading tests provide data for predicting the image life of color print materials displayed under a variety of conditions in homes, offices, and public buildings. Henry Wilhelm is shown here checking the illumination level in a low-level, long-term, 1.35 klux (125 fc) incandescent tungsten test that simulates display conditions in museums and archives. Conducted in a special temperature- and humidity-controlled room in the Preservation Publishing Company research facility, the tests employ forced-air cooling to maintain 75°F (24°C) and 60% RH at the sample plane. These tests, which are believed to constitute the first long-term investigation into the effects of low-level tungsten illumination on color photographs, were started in 1982 and had been in progress for more than 10 years at the time this book went to press in 1992.

begins the moment a print is exposed to light on display. Short of total darkness, there is no minimum light level below which light fading does not occur.

The light fading stability of current materials varies over a wide range, with some materials being *far* more stable than others. For any given product, the cyan, magenta, and yellow image-forming dyes each have different fading characteristics, and this results in progressive changes in color balance as fading proceeds over time.

Most current color print materials, including *all* current color negative papers made by Fuji, Kodak, Konica, and Agfa, have a UV-absorbing emulsion overcoat and, largely for this reason, UV radiation is not a major factor in the fading of these prints when displayed under normal indoor conditions. Instead, it is visible light that is the principal cause of image deterioration. Some products, however, including Kodak Ektatherm thermal dye transfer color print paper used with Kodak's XL 7700-series digital printers, do not have a UV-absorbing overcoat and fade much more rapidly when significant UV radiation is present.

2. **Light-induced yellowish stain formation.** In most kinds of color prints and transparencies, dye fading is accompanied by formation of low-level yellowish stain, which is most readily apparent in the highlight areas of the image. For most current products, light-induced staining is a relatively minor problem compared with the fading of the cyan, magenta, and yellow image dyes themselves.

3. **Dye fading that occurs in dark storage.** Dark fading stability also is specific to each type of color film and print material; some products are much more stable than others. The cyan, magenta, and yellow dyes in a given material usually have significantly different rates of dark fading and, as fading progresses over time, this results in an ever-increasing change in color balance. For a given material, the rate of dark fading is a function of temperature and, usually to a lesser extent, relative humidity. (Unlike the case with black-and-white materials, pollution is generally not a major factor in color film and print fading.) Dark fading is a slow but inexorable process that begins the moment a color film or print material emerges from the processor.

Dark fading and light fading are entirely separate phenomena. In Kodak Ektacolor paper, for example, magenta is the most stable of the three image dyes in dark storage, but it is generally the *least* stable when exposed to light. Dark fading proceeds in combination with light fading when prints are displayed.

4. **Dark-storage yellowish stain formation.** With Ektacolor paper and most other modern chromogenic print materials, yellowish stain that forms over time during dark storage is likely to be a more serious problem than is the fading of image dyes in the dark. Progress is being made, however, and current Fuji color papers, including Fujicolor Paper Super FA Type 3, Fujicolor Professional Paper SFA3 Type C and Type P, and Fuji-

chrome Paper Type 35, employ recently developed low-stain magenta couplers that have sharply reduced the rate of yellowish stain formation in dark storage for these products. Konica Color QA Paper Type A5, introduced on a limited scale in Japan in 1990, also employs a new type of low-stain magenta coupler.

Some non-chromogenic materials that employ preformed image dyes, including Ilford Ilfochrome (called Ilford Cibachrome, 1963–91), Kodak Dye Transfer, and Fuji Dyecolor, are, for most practical purposes, permanent in the dark and exhibit no significant fading or staining even after prolonged storage under adverse conditions. Although almost all types of color photographs suffer from light fading, it is generally true that only chromogenic materials are subject to inadequate dye stability and excessive yellowish stain formation in dark storage.

**When color prints made on *current* materials are displayed under typical conditions in a home or office, light is almost always the most significant factor in the fading and staining that occur over time, with dark fading and staining making a much smaller contribution to overall image deterioration.**

5. **Choice of processing method.** Whether a material is processed in the "washless" mode with a stabilizer as the final bath, or is processed with a water wash, can make a significant difference in the rate of yellowish stain formation in dark storage and also, usually to a lesser extent, in the rate of dye fading. To give one example, Konica Color Paper Type SR has a much lower rate of stain formation along with somewhat better dark storage dye stability when processed in the "washless" mode with EP-2 chemicals and Konica Super Stabilizer (most minilabs now employ "washless" processing) than it does when the same paper is processed with EP-2 chemicals and a water wash (a water wash is standard practice in commercial labs and in large-scale photofinishing labs).

Both types of processing are considered "normal," and both are common throughout the world. But because the differences in the rates of stain formation are so great with Konica Type SR paper, separate stability data must be reported for each type of processing. Increased rates of fading may also result from the use of "non-standard" processing chemicals (e.g., the substitution of color developing agent CD-4 for the recommended CD-3 in the KIS Ultra-X-Press minilab color print process to shorten processing time of Ektacolor paper greatly reduces the paper's light fading and dark fading stability).

6. **Processing shortcomings.** Regardless of the processing method selected, decreased dye stability and/or higher stain levels may be expected with improperly replenished or contaminated processing chemicals, omission of the recommended stabilizer bath from the C-41 and E-6 processes, inadequate washing, etc. Such processing faults can adversely affect image stability — sometimes catastrophically — when materials are kept in the dark and/or are exposed to light.

7. **Image fading, staining, and physical deterioration caused or exacerbated by postprocessing treatments.** Light fading stability and/or dark storage stability may be adversely affected by application of print lacquers (see Chapter 4), retouching colors, print "texturizing" treatments, high-pressure canvas mounting, and other postprocessing treatments. In most cases, the stability of a color print is at its best if no postprocessing treatments are applied.

## The Need for Accelerated Tests

In most applications (projected color slides and photographs displayed outdoors in direct sunlight are notable exceptions), modern color materials fade and stain too slowly to evaluate their stability characteristics within a reasonable time under the non-accelerated conditions of normal display and storage. With most current materials, many years or decades of "natural aging" would be required before meaningful data could be obtained, and by that time the information would be of little value to most people.

Photographers, photofinishers, color labs, and other consumers need to know the stability characteristics of a color material *before* they buy it in order to select the most stable material available that otherwise meets their needs. Indeed, the primary concern of most photographers is the film or paper they are using at the moment or are contemplating using in the near future. Nothing can be done to improve the inherent stability characteristics of color photographs already taken (although knowledge about the stability characteristics of older materials is valuable in attempting to provide proper storage conditions).

As a fundamental part of research and development, manufacturers of color materials have a constant need to evaluate quickly the stability of new dyes and emulsion additives that may be included in future film and print materials. Any change or improvement in processing procedures must be evaluated in terms of its effect on image stability before being introduced into the marketplace.

In the years before 1980, Kodak and the other manufacturers of color materials generally conducted image stability tests only for internal product development and were careful to keep the information secret from the public. More recently, stability-related claims have become commonplace in advertising new products and in technical literature (especially for color papers). Obviously, if such claims are to be made, reliable stability data must already be in hand before new products are introduced.

## Types of Accelerated Stability Tests

Various accelerated tests have been devised that attempt to simulate in only weeks or months the fading and staining that will occur during many years of normal display and storage. High-intensity light fading tests expose a print to light that is many times brighter than normal indoor illumination levels, and high-temperature dark fading tests, usually with controlled relative humidity, speed up the fading and staining that would gradually take place during many years of storage in the dark at normal temperatures.

Current accelerated fading tests treat light fading and dark fading separately. Although data from both types of tests can be correlated to try to predict their combined effects during very long-term display under low-level lighting conditions, such correlation can be difficult. This was especially true with older chromogenic materials, such as Ektacolor 74 RC paper (1977–85), that had relatively poor dark fading stability. With these products, dark fading could make a significant contribution to the total fading occurring in displayed prints.

With current print materials that have better dark fading stability, most of the fading that takes place during long-term display will be caused by light, thereby simplifying stability predictions. With Ilford Ilfochrome (called Ilford Cibachrome, 1963–91), Kodak Dye Transfer, and Fuji Dyecolor, all of which have preformed dyes that are exceedingly stable in dark storage, essentially all the image deterioration observed during long-term display can be attributed to the effects of light.

UltraStable Permanent Color prints and Polaroid Permanent-Color prints, both of which employ extremely stable color pigments in place of the organic dyes found in other color materials, are a special case. The pigment images are so stable that in a practical sense they do not fade or stain during prolonged display or when kept in the dark. The white polyester base of UltraStable and Polaroid Permanent-Color prints is also extremely long-lasting. Thus, the stability of the gelatin carrying the pigments — rather than the pigments themselves — will probably determine the eventual life of these prints. With such extraordinarily stable color photographs, even highly accelerated light fading tests must continue for many years before meaningful image-life predictions can be obtained.

## Comparative Tests and Predictive Tests

Accelerated light fading and dark fading tests fall into two broad categories:

**Comparative tests** compare the stability of one product with another under accelerated conditions but do not attempt to indicate how long it will take (e.g., in years) for a certain degree of fading or staining to occur during display or dark storage under normal conditions.

**Predictive tests** attempt to predict the number of months or years of display or dark storage under normal conditions (or other specified temperatures and relative humidities) that a product will last before a specified amount of fading or staining occurs. The predictions obtained from such tests can of course also be used to compare one product with another.

Because of reciprocity failures in high-intensity accelerated light fading tests, and because the temperature dependence of the fading may vary with different dyes, predictive tests may not be reliable when based on a single accelerated test condition. For this reason, predictive tests necessarily are more complex than comparative tests, and if predictive tests are to have validity, predictions made with representative products must be verified with data obtained under normal display and storage conditions. To accumulate such "natural aging" data, however, generally takes many years.

November 1985

American National Standards Institute Subcommittee IT9-3 worked for nearly 12 years to complete **ANSI IT9.9-1990, American National Standard for Imaging Media – Stability of Color Photographic Images – Methods for Measuring.** The subcommittee is shown here meeting in Grinnell, Iowa, in November 1985 in a room provided by Grinnell College.

## American National Standards Institute (ANSI) 1969 Standard for Color Stability Tests

The first ANSI standard for color stability test methods, *ANSI PH1.42-1969, American National Standard Method for Comparing the Color Stabilities of Photographs,*[2] was published in 1969. It was based on work done at Kodak during the 1950's and 1960's and described a single-temperature comparative dark fading test and several comparative light fading tests for color film and print materials.

*ANSI PH1.42-1969* never achieved wide application and during the 1980's it was more or less abandoned by Kodak, other manufacturers, independent labs, and this author, all of whom developed improved image stability tests to meet their own requirements. Over time the methods of reporting data also evolved along different lines at each of the manufacturers and the few independent labs conducting stability tests, with the result that it has often been difficult if not impossible to compare data from one manufacturer or independent lab with another.

## The New ANSI IT9.9-1990 Color Stability Accelerated Test Methods Standard

In 1991, *ANSI PH1.42-1969* was replaced by *ANSI IT9.9-1990, American National Standard for Imaging Media – Stability of Color Photographic Images – Methods for Measuring.*[3] This new Standard, which received final approval by ANSI in 1990, specifies a predictive Arrhenius test for dark storage stability and five comparative tests for light fading stability.

For the predictive dark storage test, the new Standard specifies a complex, multi-temperature, controlled-humidity Arrhenius test that provides a much more complete assessment of dark storage changes and can yield a prediction, in years, of how long it will take for a specified density loss, color balance shift, or stain level to occur at any selected temperature, including, of course, "normal room temperature." As with the single-temperature tests in *ANSI PH1.42-1969,* data from Arrhenius tests can be used to rank the stability of various products.

Neither the old nor the new Standard specifies limits of acceptability for dye fading, color balance shift, or stain formation. Although the new Standard makes use of a set of limits (called "image-life end points" in the Standard) for illustrative purposes, the values given are *not* part of the Standard, and this is clearly stated in the document. Determining a set of limits for a particular application (e.g., professional portrait and wedding photography, amateur snapshot photography, fine art photography in museum collections, or commercial display in stores, airports, and other public areas) is left entirely to the user.

For several reasons, this is not a very satisfactory situation. With no agreement as to how much fading, color balance change, and staining can be tolerated in common applications, different people using the Standard likely will come up with highly divergent image-life predictions for a particular product stored or displayed in exactly the same

December 1978

Subcommittee IT9-3 has gathered every 6 months since the first meeting, which took place at the National Geographic Society in Washington, D.C. in December 1978. With the new IT9.9-1990 Standard approved by ANSI, the group continues to meet to work on the next revision of the Standard. Shown here is Howell Hammond of Eastman Kodak, the first chairperson of the subcommittee, leading a meeting at the National Geographic Society. Meeting at various locations in the U.S. and Canada, the group has often had opportunities to visit museum and archive collections.

way. This will make it difficult to compare product stability data from different testing labs, and could result in confusion for everyone.

Furthermore, because of marketing considerations, manufacturers will tend to select liberal limits for their published image-life predictions to make it appear that their products have a very long display and storage life. For competitive reasons, a manufacturer of a color paper that develops high levels of yellowish stain over time, for example, likely will select a much higher limit for d-min stain than will a manufacturer with a more stable product that does not have a serious staining problem.

Despite the lack of specific fading and staining limits, the Standard *does* specify a common format for reporting data and requires that the values chosen by the user for all fading, color balance change, and staining limits be listed. This is a significant advance and should result in a great deal more image stability data being disclosed for color films and papers than has been the case.

The new Standard is the result of almost 12 years of work by a task group with the following members:

Peter Z. Adelstein – Image Permanence Institute
John H. Auer – Agfa Corporation
Charleton C. Bard – Eastman Kodak Company
Ronald Cieciuch – Polaroid Corporation
Milton Ford – National Geographic Society
Remon Hagen – Ilford AG [Switzerland]

Howell Hammond (Chairperson) – Eastman
      Kodak Company
Klaus B. Hendriks – National Archives of Canada
Donald R. Hotchkiss – 3M Company
Thomas J. Huttemann – Eastman Kodak Company
Martin Idelson – Polaroid Corporation
Haruhiko Iwano – Fuji Photo Film Co., Ltd. [Japan]
Junichi Kohno – Konica Corporation [Japan]
David F. Kopperl – Eastman Kodak Company
Peter Krause – Ilford Photo Corporation
Shinichi Nakamura – Konica Corporation [Japan]
Eugene Ostroff – Smithsonian Institution
A. Tulsi Ram – Eastman Kodak Company
James M. Reilly – Image Permanence Institute
Rudolf Tromnau – Agfa-Gevaert AG [Germany]
James H. Trott – National Geographic Society
Henry G. Wilhelm (Secretary) – Preservation
      Publishing Company
Richard Youso – National Archives and
      Records Administration

With Howell Hammond of Eastman Kodak serving as chairperson, the first meeting of the task group took place at the National Geographic Society in Washington, D.C. in December 1978, and the group has met twice a year ever since. This author joined the task group at its inception in 1978 and has served as its secretary since 1985.

The final draft of the new Standard was approved by the

ANSI Board of Standards Review in August 1990, and the Standard was published in November 1991.

Even after completion and publication of *IT9.9-1990*, the ANSI task group (now called ANSI Subcommittee IT9-3) continues to meet every 6 months and is working on the next revision of the Standard. Some of the original subcommittee members have since retired or have been transferred by their employers to other responsibilities; at the time this book went to press in late 1992, ANSI Subcommittee IT9-3 consisted of the following individuals:

Peter Z. Adelstein – Image Permanence Institute
Donald R. Allred – Iris Graphics, Inc. (Scitex Corp.)
John H. Auer – Agfa Corporation
Thomas Craig – National Geographic Society
Ronald Cieciuch – Polaroid Corporation
Edgar Draber – Agfa-Gevaert AG [Germany]
Walter Fontani – 3M Company
David J. Giacherio – Eastman Kodak Company
Remon Hagen – Ilford AG [Switzerland]
Klaus B. Hendriks – National Archives of Canada
Haruhiko Iwano – Fuji Photo Film Co., Ltd. [Japan]
Junichi Kohno – Konica Corporation [Japan]
Masato Koike – Dai Nippon Printing Co., Ltd. [Japan]
David F. Kopperl – Eastman Kodak Company
Peter Krause – Ilford Photo Corporation
Robert E. McComb – Library of Congress
Mark McCormick-Goodhart – Smithsonian Institution
Mark Ormsby – National Archives and
　　　　　Records Administration
Eugene Ostroff – Smithsonian Institution
Steven Puglia – National Archives and
　　　　　Records Administration
A. Tulsi Ram – Eastman Kodak Company
James M. Reilly – Image Permanence Institute
Charles H. Schallhorn (Chairperson) – Eastman
　　　　　Kodak Company
Idalee Tierney – Eastman Kodak Company
Sarah Wagner – National Archives and
　　　　　Records Administration
James H. Wallace, Jr. – Smithsonian Institution
Henry G. Wilhelm (Secretary) – Preservation
　　　　　Publishing Company

With members from the U.S., Japan, Germany, Canada, and Switzerland, this was the first ANSI photographic task group to have a truly international representation.

In 1993 the new ANSI Standard will, with some modification, be issued as an ISO International Standard (published by the International Organization for Standardization, a worldwide federation of national standards institutes headquartered in Geneva, Switzerland).

## Accelerated Light Fading Tests

By using light levels that are much more intense than those encountered in normal display conditions, accelerated light fading tests attempt to simulate in a short time the effects of light on prints during long-term display. For example, for a given amount of fading, a print displayed in normal indoor lighting conditions should last 20 times longer than a print subjected to an accelerated test under

a light level 20 times more intense. In other words, according to the "reciprocity law" on which accelerated light fading tests are based, the total amount of radiant energy (intensity x time) to which a print is exposed should determine the amount of fading. This concept is similar to doubling a camera shutter speed (from $1/250$ to $1/500$ second, for example) and opening up the lens aperture one $f$-stop (from $f$8 to $f$5.6): the exposure of the film is the same.

Comparative accelerated light fading tests have been used extensively by Fuji, Kodak, Konica, Agfa, and Polaroid, and five such tests are described in *ANSI IT9.9-1990*.

## Reciprocity Failures in Light Fading and Light-Induced Stain Formation

Since the mid-1970's, one of this author's principal interests has been the relationship of fading and light-induced stain formation in high-intensity accelerated tests with the fading and staining that occurs in color prints exposed to much lower light intensities for correspondingly longer periods of time — that is, the validity of the light-fading reciprocity law.[4] An understanding of the relationship between high- and low-intensity fading and staining behavior is crucial if the data obtained in high-intensity tests are to be relevant for predicting the fading and staining rates of prints on long-term display in homes, offices, and museums.

This author's investigations have shown that most color materials exhibit at least some "reciprocity failure" in light fading or light-induced stain formation in high-intensity, short-term tests. That is, a color print or transparency material may fade or stain a different amount when exposed to high-intensity illumination for a short period than it does when exposed to lower-intensity illumination for a longer period — even though the total lux-hour light exposure (intensity x time) and the temperature and relative humidity are the same in both cases. Color slides also are subject to reciprocity failures in accelerated projection tests. As discussed in Chapter 6, intermittent projection can produce much more fading than continuous projection for the same total illumination time. The duration of each projection and the interval between projections are important variables; some color slide films exhibit much larger reciprocity failures than others.

*ANSI IT9.9-1990* specifies a predictive Arrhenius test for dark storage stability, discussed later, but offers only single-intensity comparative tests for light fading stability. Because of the uncertainties posed by reciprocity failures in high-intensity, short-term tests, the Standard does not permit extrapolation of accelerated test data for making "years of display" predictions under normal home or office display conditions.

Predictive "years of display" estimates of light fading stability have in the past been published only infrequently, although Fuji has been publishing "years of display" estimates for Fujichrome Type 34 and Type 35 reversal papers since 1987 and, more recently, for Fujicolor Super FA papers.[5] These predictions are based on single-intensity accelerated tests. In 1988, Ilford[6] and, to a much more limited extent, Kodak[7] also started publishing single-intensity light fading data in the form of predictive "years of display" estimates.

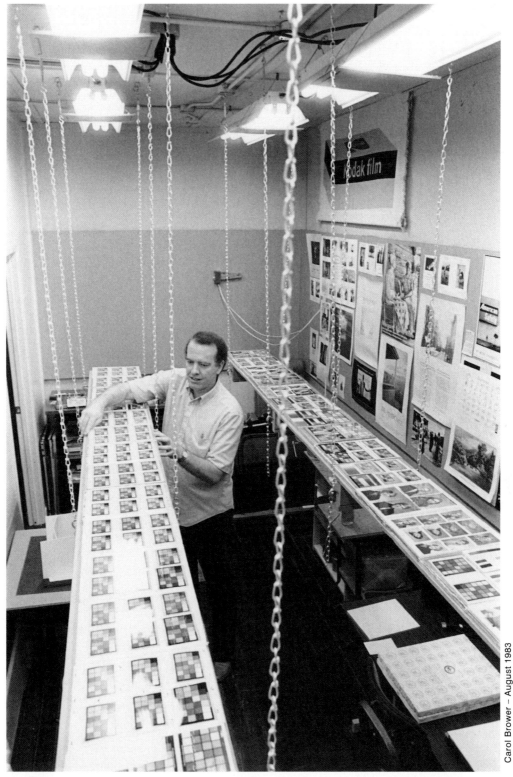

Carol Brower – August 1983

The low-level, long-term, 1.35 klux fluorescent illumination test facility at Preservation Publishing Company. Tests here began in 1977 and had continued for more than 15 years at the time this book went to press in 1992. Data from these tests are compared with data from short-term, high-intensity fluorescent tests to investigate light fading and light-induced staining reciprocity failures in color print materials. Identical samples of each print material are exposed to bare-bulb illumination uncovered, covered with glass sheets, and covered with Plexiglas UF-3, a sharp-cutting UV filter. Maintained at 75°F (24°C) and 60% RH, and with the same illumination intensity as is used in the 1.35 klux tungsten test, the samples allow a direct comparison to be made between the long-term effects on color prints of the two types of illumination.

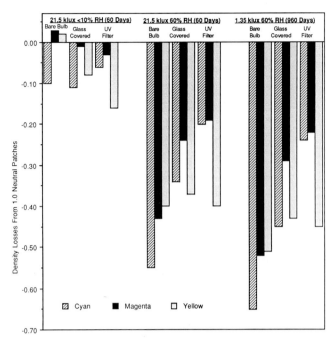

**Figure 2.1** Humidity effects, spectral dependence, and reciprocity failures in the fading of Polacolor ER instant color prints. The prints received the same total klux-hour light exposure under the three test conditions. When the moisture content of the prints was very low because of heating by the nearby fluorescent lamps in the high-intensity 21.5 klux test, the fading was markedly reduced compared with the 21.5 klux temperature- and humidity-controlled test where the relative humidity at the sample plane was maintained at 60%. In low-intensity 1.35 klux tests, the fading of all three dyes increased somewhat further because of reciprocity failures.

This book marks the first comprehensive effort — even if not always conclusive — to treat accelerated light fading data in a predictive manner when dealing with color print and color slide materials. That such image-life predictions could even be attempted was made possible by the availability of a sizable amount of data from long-term, low-intensity 1.35 klux tests that could be compared with high-intensity 21.5 klux data for representative products.

### Early Evidence of Reciprocity Failures in Accelerated Tests with Color Prints

In 1976–77, when this author's initial light fading tests on prints were in progress, several apparent discrepancies were noted between outdoor tests in direct sunlight and much lower intensity indoor tests with fluorescent lamps. These early tests were conducted on Kodak Ektacolor 37 RC, Polaroid Polacolor 2, Kodak Instant Print Film PR-10 and Polaroid SX-70 prints. The Polacolor 2 prints appeared to be relatively more stable than Ektacolor 37 RC prints in direct sunlight tests than they were when framed and hung on this author's office wall (the Polacolor 2 prints were overmatted and, when the overmat was lifted, visual evidence of image fading was apparent much sooner than with the Ektacolor prints).

Since the most obvious differences between these two

test conditions were spectral energy distribution and light intensity, the influence of both of these variables was investigated. In the initial phase of the work, a densitometer was not available and this author was forced to rely on visual analysis by comparing faded prints with identical unfaded prints.

After the discovery that placing a sheet of ordinary glass over an Ektacolor 37 RC print exposed to sunlight or (more significantly) fluorescent light substantially improved the print's cyan dye stability, the work was expanded to include print samples covered with both glass and Plexiglas UF-3 ultraviolet-absorbing acrylic sheet. At that time, this author did not have temperature- and humidity-controlled high-intensity test equipment; consequently, the crucial importance of moisture in the light fading of Polacolor 2 was not fully appreciated (emulsion moisture content proved to be relatively unimportant with Ektacolor and most other chromogenic papers insofar as light fading is concerned). Much of what this author initially attributed to "light fading reciprocity failure" was in fact caused by the low moisture content of the Polacolor 2 prints that resulted from heating by the intense infrared and visible light of direct, outdoor sunlight.

Nonetheless, these early findings, even if misleading, did prompt this author to begin a systematic investigation of the separate roles of light intensity, wavelength distribution, time, emulsion moisture content, and sample temperature. The results of these investigations for one print material, Polacolor ER, are shown in **Figure 2.1** (Polacolor ER is an updated, lower-contrast version of Polacolor 2 and gives somewhat improved color and tone-scale reproduction. With respect to **Figure 2.1**, the older Polacolor 2 product has generally similar light fading behavior).

Comparisons of light fading data from a variety of color print materials covered with glass and Plexiglas UF-3 ultraviolet-absorbing acrylic sheet clearly showed that with Ektacolor and most other types of color print materials displayed in normal indoor conditions, visible light was a much more important factor in light fading than was UV radiation, contrary to what had been suggested in some of the literature.

### Reciprocity Failures in Accelerated Light Fading Tests Can Lead to Faulty Assessments of Image Stability

This author's research indicates that with nearly every type of color print, high-intensity light fading tests (e.g., at 21.5 klux) can be expected to produce *less* overall fading, and *less* yellowish stain, than the equivalent light exposure spread out over the months and years of normal display (**Table 2.1**). And because each of the cyan, magenta, and yellow image dyes in a given type of print has a specific response to high-intensity light, not only is the overall amount of fading usually greater in long-term display, but the relative amount of fading of each dye is also unequal; with most color papers, this results in a different degree of image color balance change (**Figures 2.2 and 2.3**). In extreme cases, even the direction of color balance change can be altered.

Some types of prints exhibit much greater "reciprocity failure" — differences in fading and staining in tests with

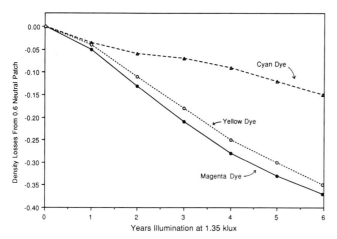

**Figure 2.2** Light fading of Kodak Ektacolor Plus Paper over a 6-year period in a 1.35 klux fluorescent test (print covered with glass). In this moderately accelerated test, the yellow dye faded much more rapidly than it did in a high-intensity 21.5 klux test with the same total light exposure, resulting in a different and visually more severe color balance shift toward cyan (also see **Figure 2.3**).

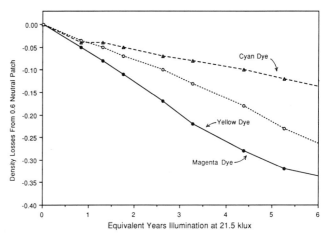

**Figure 2.3** Light fading of Kodak Ektacolor Plus Paper in a high-intensity 21.5 klux test. Although the test time was much shorter, the total klux-hour light exposure was the same as in adjacent **Figure 2.2**. The yellow dye suffered a significant reciprocity failure in the 21.5 klux test, producing a markedly different color balance change than in the long-term 1.35 klux test.

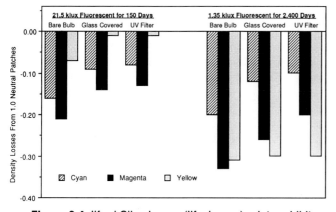

**Figure 2.4** Ilford Cibachrome (Ilfochrome) prints exhibit large reciprocity failures in light fading; the effect is most pronounced with the yellow dye, which faded far more in the long-term, low-level 1.35 klux test than it did in a much shorter high-intensity 21.5 klux test. The Cibachrome cyan dye was greatly affected by the strong 313 nm UV emission of the fluorescent lamps while the fading of the yellow dye showed little spectral dependence in the 1.35 klux test.

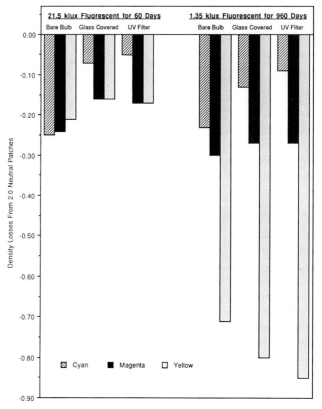

**Figure 2.5** Some chromogenic papers have large reciprocity failures. The yellow dye in Agfacolor Type 589 paper (1981–83) faded far more in long-term, low-level 1.35 klux tests than it did in high-intensity 21.5 klux tests. Interestingly, the print shielded from UV radiation with a Plexiglas UF-3 filter exhibited more yellow dye fading than the print exposed to bare-bulb illumination.

high-intensity light — than others. Ilford Ilfochrome (Cibachrome) prints fade significantly faster when exposed to the same amount of light in long-term, low-intensity tests than in shorter, high-intensity tests. The Ilfochrome yellow dye in particular exhibits markedly different behavior in the two test conditions, with far greater fading taking place in the long-term, low-intensity test (**Figure 2.4**).

Although there are exceptions (e.g., the now-obsolete Agfacolor Type 589 color paper, as shown in **Figure 2.5**), the cyan, magenta, and yellow dyes in chromogenic prints such as Ektacolor, Fujicolor, Konica Color, and Agfacolor typically exhibit much less of a reciprocity failure, and Kodak Dye Transfer prints show this effect hardly at all (al-

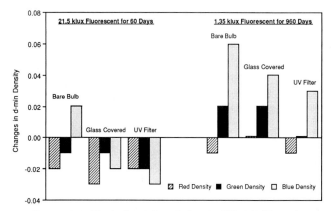

**Figure 2.6** The yellowish stain level of Kodak Ektacolor 74 RC paper (initial type, 1977–82) was significantly higher in the 1.35 klux test, although with this product, as well as with most other color negative papers, the magenta dye fading that occurred during the test was visually much more objectionable than the yellowish stain.

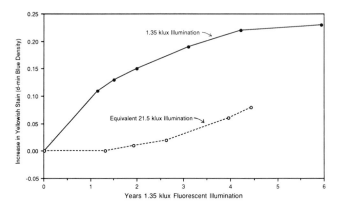

**Figure 2.7** In every chromogenic paper studied by this author, higher levels of d-min yellowish stain occurred in 1.35 klux illumination than in short-term 21.5 klux illumination (with the same total light exposure in both cases). As shown in this graph, Agfacolor Type 7i paper (1984–85) suffered a dramatic increase in yellowish stain level in the low-level test.

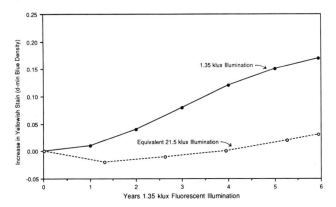

**Figure 2.8** Kodak Ektacolor Plus Paper (1984—) suffered a significant yellowish stain reciprocity failure in this author's high-intensity 21.5 klux test. To a greater or lesser degree, every chromogenic paper studied exhibited similar behavior, leading to the conclusion that high-intensity tests are meaningless for evaluating the tendency for a color paper to form light-induced yellowish stain.

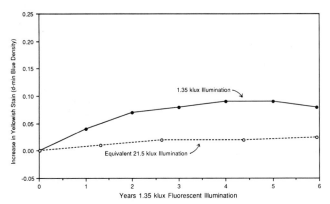

**Figure 2.9** Although Konica Color Paper Type SR (1984—) exhibited significant yellowish stain formation reciprocity failure, the magnitude of the failure was less than that of any other color negative papers tested. These samples were given normal EP-2 processing with a water wash.

though the ambient relative humidity can have a significant effect on the light fading rate of Dye Transfer prints).

As shown in **Figures 2.6, 2.7,** and **2.8,** light-induced yellowish stain formation can also be subject to pronounced reciprocity failures. Konica Color Paper Type SR is noteworthy in its low staining reciprocity failure compared with most other chromogenic papers (**Figure 2.9**).

A generally accepted explanation for at least some of the reciprocity failures that occur in accelerated light fading of color prints is that atmospheric oxygen is involved in the dye fading mechanisms, and during high-intensity light fading, oxygen may be depleted, to a greater or lesser extent, at the sites of the image dye molecules, resulting in a slowing of photochemical reactions. Oxygen availability may be further hindered by low humidity, which sharply reduces the permeability of gelatin to atmospheric oxygen. The dependence of the light fading of chromogenic yellow and magenta dyes on oxygen availability was suggested by

Robert Tuite of Eastman Kodak in 1979[8] and was further investigated by Yoshio Seoka et al.[9] and Toshiaki Aono et al. of Fuji in 1982.[10]

The slow diffusion of deterioration by-products *out* of the gelatin emulsion may also be a factor in light fading and light-induced staining reciprocity failures.

As there is a need to know — at least in an approximate way — the stability characteristics of color materials in order to select the most stable product otherwise suitable for the intended application, the use of short-term accelerated light fading tests is unavoidable. As long as the potential shortcomings of the tests are known and the behavior of different types of materials in long-term tests with low-level illumination is understood, high-intensity tests can provide a great deal of information. The tests also offer guidance concerning permissible display times, the possible benefit to be gained by UV filters, and the potential influence of relative humidity on light fading stability.

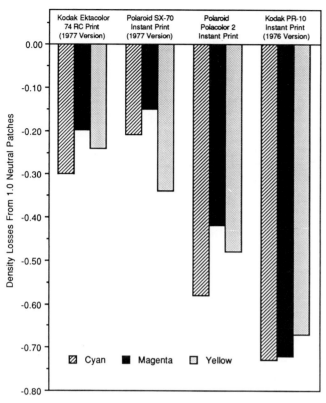

**Figure 2.10** The fading that occurred in four types of color prints after 8 years of display in this author's kitchen (prints exposed to indirect daylight and bare-bulb fluorescent illumination) was similar to that which occurred in 1.35 klux tests.

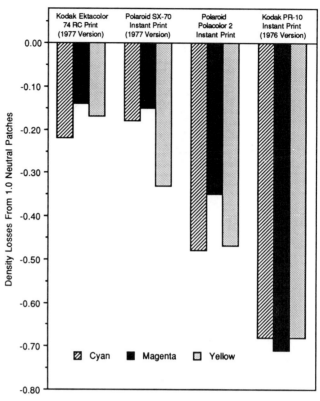

**Figure 2.11** After 8 years of display in a bedroom (indirect daylight and low-level tungsten illumination) in this author's home, the four types of color prints showed a fading pattern similar to that which occurred in the kitchen.

## Correlation of Accelerated Test Results with Fading and Staining That Occur in Normal, Long-Term Display Conditions

It is critically important for persons involved in image stability testing to periodically study the fading and staining behavior of both framed and unframed prints in long-term display under normal conditions (**Figures 2.10, 2.11, and 2.12**) and to attempt to relate this information with results from accelerated fading tests. If fading and/or staining patterns (e.g., the direction and degree of color balance change, level of stain formation, etc.) are significantly different, the accelerated test procedures must be called into question and efforts must be made to improve the tests.

For those working in the image stability field, accelerated tests can take on a life of their own, and a conscious effort is required to keep informed about what is actually happening to color photographs in storage and on display in homes, offices, and institutions around the world.

## RC Base-Associated Image Fading and Yellowish Staining

This author's investigations indicate that in addition to fading caused by the effects of light on the image dyes themselves, displayed color prints made on RC (polyethylene-resin-coated) papers may suffer from direct or indirect chemical attack of the image dyes, the results of which

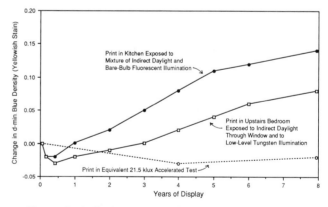

**Figure 2.12** During 8 years of home display, Ektacolor 74 RC prints (initial type, 1977–82) exhibited significantly greater d-min yellowish stain levels than they did in equivalent 21.5 klux tests. The higher stain level in the print displayed in the kitchen can probably be attributed to two factors: exposure to airborne contamination from food cooking on the kitchen stove and the bare-bulb fluorescent illumination in the room.

can render them more susceptible to light fading and/or cause greatly increased rates of dark fading and staining. Research on this phenomenon is continuing, but the evidence obtained to date suggests that this degradation of dye stability and the increased rates of yellowish stain for-

*(continued on page 75)*

## Table 2.1   Reciprocity Failures in Accelerated Light Fading and Light-Induced Staining of Color Prints

**Accelerated light fading tests at 21.5 klux (2,000 fc) and 1.35 klux (125 fc) with prints given the same total light exposure (intensity x time) in both conditions. Glass-filtered Cool White fluorescent illumination at 75°F (24°C) and 60% RH. Initial densities of 1.0 with full d-min corrected densitometry.**

**Test duration of up to 8 years (2,920 days)**

**Light Fading Reciprocity Failure Factor (RF Factor)** is a numerical representation of the difference in fading rate between 21.5 klux high-intensity and 1.35 klux low-intensity test conditions; the RF Factor is computed by dividing the density loss at 1.35 klux by the density loss at 21.5 klux. An RF Factor of 1.0 indicates that the particular dye suffered no measurable reciprocity failure; that is, the dye faded the same amount in both the high-intensity and low-intensity test conditions.

Illumination at 21.5 klux is 16 times more intense than at 1.35 klux. To equalize the amount of light to which the prints were exposed in both conditions, test times at 1.35 klux were 16 times longer than for the 21.5 klux test. The densitometric data given here were fully corrected for any minimum-density increases (stain) that occurred in the course of these tests.

Extrapolations made from high-intensity test data to predict print fading and staining rates at the low illumination levels found in normal indoor display conditions will probably be reasonably accurate for print materials that have low RF Factors (e.g., 1.5 or lower for the image dye that is the least stable in the 21.5 klux tests). Color print materials with RF Factors greater than approximately 1.5 likely will have a significantly shorter useful life when displayed for long periods under normal indoor illumination conditions than is predicted by short-term, high-intensity accelerated light fading tests.

**Boldface Type** indicates products that were being marketed in the U.S. and/or other countries when this book went to press in 1992; the other products listed had either been discontinued or replaced with newer materials.

| Chromogenic Prints: | 21.5 klux (2,000 fc) Density Losses | 1.35 klux (125 fc) Density Losses | Reciprocity Failure Factor (RF Factor) | Chromogenic Prints: | 21.5 klux (2,000 fc) Density Losses | 1.35 klux (125 fc) Density Losses | Reciprocity Failure Factor (RF Factor) |
|---|---|---|---|---|---|---|---|
| **Konica Color PC Paper Type SR** **Konica Color PC Paper Professional Type EX** (EP-2 process with water wash) | 90-Day Test | 1,440-Day Test | RF Factor | **Ektacolor Plus Paper** **Ektacolor Professional Paper** (EP-2 process with water wash) | 90-Day Test | 1,440-Day Test | RF Factor |
| **Cyan Loss from 1.0 Neutral:** | −0.09 | −0.13 | 1.4 | **Cyan Loss from 1.0 Neutral:** | −0.08 | −0.12 | 1.5 |
| **Magenta Loss from 1.0 Neutral:** | −0.23 | −0.23 | 1.0 | **Magenta Loss from 1.0 Neutral:** | −0.23 | −0.31 | 1.4 |
| **Yellow Loss from 1.0 Neutral:** | −0.11 | −0.19 | 1.7 | **Yellow Loss from 1.0 Neutral:** | −0.14 | −0.33 | 2.4 |
| **Cyan Loss from Cyan Patch:** | −0.12 | −0.21 | 1.8 | **Cyan Loss from Cyan Patch:** | −0.11 | −0.18 | 1.6 |
| **Magenta Loss from Magenta Patch:** | −0.38 | −0.40 | 1.1 | **Magenta Loss from Magenta Patch:** | −0.42 | −0.51 | 1.2 |
| **Yellow Loss from Yellow Patch:** | −0.15 | −0.22 | 1.5 | **Yellow Loss from Yellow Patch:** | −0.24 | −0.55 | 2.3 |
| **Minimum-Density Yellowish Stain:** | +0.03 | +0.09 | [Stain: +0.06] | **Minimum-Density Yellowish Stain:** | +0.00 | +0.11 | [Stain: +0.11] |
| **Konica Color PC Paper Type SR** **Konica Color PC Paper Professional Type EX** (processed with Konica Super Stabilizer in a "washless" Konica minilab) | 90-Day Test | 1,440-Day Test | RF Factor | Ektacolor 74 RC Paper Type 2524 Ektacolor 78 Paper (EP-2 process with water wash) | 90-Day Test | 1,440-Day Test | RF Factor |
| **Cyan Loss from 1.0 Neutral:** | −0.10 | −0.16 | 1.6 | Cyan Loss from 1.0 Neutral: | −0.09 | −0.20 | 2.2 |
| **Magenta Loss from 1.0 Neutral:** | −0.19 | −0.22 | 1.2 | Magenta Loss from 1.0 Neutral: | −0.27 | −0.35 | 1.3 |
| **Yellow Loss from 1.0 Neutral:** | −0.11 | −0.23 | 2.1 | Yellow Loss from 1.0 Neutral: | −0.16 | −0.31 | 1.9 |
| **Cyan Loss from Cyan Patch:** | −0.14 | −0.25 | 1.8 | Cyan Loss from Cyan Patch: | −0.12 | −0.35 | 2.9 |
| **Magenta Loss from Magenta Patch:** | −0.38 | −0.40 | 1.1 | Magenta Loss from Magenta Patch: | −0.48 | −0.59 | 1.2 |
| **Yellow Loss from Yellow Patch:** | −0.17 | −0.37 | 2.2 | Yellow Loss from Yellow Patch: | −0.27 | −0.54 | 2.0 |
| **Minimum-Density Yellowish Stain:** | +0.00 | +0.04 | [Stain: +0.04] | Minimum-Density Yellowish Stain: | +0.00 | +0.07 | [Stain: +0.07] |

| Chromogenic Prints: | 21.5 klux (2,000 fc) Density Losses | 1.35 klux (125 fc) Density Losses | Reciprocity Failure Factor (RF Factor) |
|---|---|---|---|
| Ektacolor 37 RC Paper Type 2261 (EP-2 process with EP-3 Stabilizer) | 90-Day Test | 1,440-Day Test | RF Factor |
| Cyan Loss from 1.0 Neutral: | −0.12 | −0.20 | 1.7 |
| Magenta Loss from 1.0 Neutral: | −0.24 | −0.35 | 1.5 |
| Yellow Loss from 1.0 Neutral: | −0.22 | −0.45 | 2.1 |
| Cyan Loss from Cyan Patch: | −0.14 | −0.30 | 2.1 |
| Magenta Loss from Magenta Patch: | −0.41 | −0.56 | 1.4 |
| Yellow Loss from Yellow Patch: | −0.37 | −0.80 | 2.2 |
| Minimum-Density Yellowish Stain: | +0.01 | +0.10 | [Stain: +0.09] |

| Kodak Ektachrome 2203 Paper | 90-Day Test | 1,440-Day Test | RF Factor |
|---|---|---|---|
| Cyan Loss from 1.0 Neutral: | −0.14 | −0.32 | 2.3 |
| Magenta Loss from 1.0 Neutral: | −0.23 | −0.37 | 1.6 |
| Yellow Loss from 1.0 Neutral: | −0.21 | −0.37 | 1.8 |
| Cyan Loss from Cyan Patch: | −0.16 | −0.40 | 2.5 |
| Magenta Loss from Magenta Patch: | −0.49 | −0.75 | 1.5 |
| Yellow Loss from Yellow Patch: | −0.44 | −0.81 | 1.8 |
| Minimum-Density Yellowish Stain: | +0.03 | +0.15 | [Stain: +0.12] |

| Fujicolor Paper Type 8901 (EP-2 process with water wash) | 90-Day Test | 1,440-Day Test | RF Factor |
|---|---|---|---|
| Cyan Loss from 1.0 Neutral: | −0.10 | −0.16 | 1.6 |
| Magenta Loss from 1.0 Neutral: | −0.21 | −0.26 | 1.2 |
| Yellow Loss from 1.0 Neutral: | −0.13 | −0.30 | 2.3 |
| Cyan Loss from Cyan Patch: | −0.16 | −0.25 | 1.6 |
| Magenta Loss from Magenta Patch: | −0.43 | −0.50 | 1.2 |
| Yellow Loss from Yellow Patch: | −0.23 | −0.54 | 2.4 |
| Minimum-Density Yellowish Stain: | +0.03 | +0.09 | [Stain: +0.06] |

| Fujicolor Paper Type 8901 (EP-2 process with EP-3 Stabilizer) | 90-Day Test | 1,440-Day Test | RF Factor |
|---|---|---|---|
| Cyan Loss from 1.0 Neutral: | −0.09 | −0.17 | 1.9 |
| Magenta Loss from 1.0 Neutral: | −0.20 | −0.36 | 1.8 |
| Yellow Loss from 1.0 Neutral: | −0.16 | −0.73 | 4.6 |
| Cyan Loss from Cyan Patch: | −0.13 | −0.24 | 1.9 |
| Magenta Loss from Magenta Patch: | −0.40 | −0.57 | 1.4 |
| Yellow Loss from Yellow Patch: | −0.28 | −1.07 | 3.8 |
| Minimum-Density Yellowish Stain: | +0.02 | +0.14 | [Stain: +0.12] |

| Agfacolor PE Paper Type 7i | 90-Day Test | 1,440-Day Test | RF Factor |
|---|---|---|---|
| Cyan Loss from 1.0 Neutral: | −0.10 | −0.22 | 2.2 |
| Magenta Loss from 1.0 Neutral: | −0.33 | −0.46 | 1.4 |
| Yellow Loss from 1.0 Neutral: | −0.22 | −0.43 | 2.0 |
| Cyan Loss from Cyan Patch: | −0.11 | −0.30 | 2.7 |
| Magenta Loss from Magenta Patch: | −0.60 | −0.70 | 1.2 |
| Yellow Loss from Yellow Patch: | −0.26 | −0.57 | 2.2 |
| Minimum-Density Yellowish Stain: | +0.06 | +0.23 | [Stain: +0.17] |

| Chromogenic Prints: | 21.5 klux (2,000 fc) Density Losses | 1.35 klux (125 fc) Density Losses | Reciprocity Failure Factor (RF Factor) |
|---|---|---|---|
| Agfacolor PE Paper Type 589 | 60-Day Test | 960-Day Test | RF Factor |
| Cyan Loss from 1.0 Neutral: | −0.07 | −0.17 | 2.4 |
| Magenta Loss from 1.0 Neutral: | −0.23 | −0.48 | 2.1 |
| Yellow Loss from 1.0 Neutral: | −0.21 | −0.57 | 2.7 |
| Cyan Loss from Cyan Patch: | −0.10 | −0.17 | 1.7 |
| Magenta Loss from Magenta Patch: | −0.62 | −0.72 | 1.2 |
| Yellow Loss from Yellow Patch: | −0.30 | −0.72 | 2.4 |
| Minimum-Density Yellowish Stain: | NA | NA | — |

| 3M High Speed Color Paper Type 19 | 60-Day Test | 960-Day Test | RF Factor |
|---|---|---|---|
| Cyan Loss from 1.0 Neutral: | −0.10 | −0.19 | 1.9 |
| Magenta Loss from 1.0 Neutral: | −0.16 | −0.37 | 2.3 |
| Yellow Loss from 1.0 Neutral: | −0.12 | −0.45 | 3.8 |
| Cyan Loss from Cyan Patch: | −0.12 | −0.22 | 1.8 |
| Magenta Loss from Magenta Patch: | −0.30 | −0.74 | 2.5 |
| Yellow Loss from Yellow Patch: | −0.21 | −1.14 | 5.4 |
| Minimum-Density Yellowish Stain: | NA | NA | — |

## Silver Dye-Bleach and Dye-Imbibition Prints:

| Ilford Ilfochrome Classic Prints (called Cibachrome II Prints, 1980–91) (P-3 process – glossy polyester base) | 183-Day Test | 2,920-Day Test | RF Factor |
|---|---|---|---|
| Cyan Loss from 1.0 Neutral: | −0.11 | −0.16 | 1.5 |
| Magenta Loss from 1.0 Neutral: | −0.19 | −0.32 | 1.7 |
| Yellow Loss from 1.0 Neutral: | −0.04 | −0.32 | 8.0 |
| Cyan Loss from Cyan Patch: | −0.14 | −0.19 | 1.4 |
| Magenta Loss from Magenta Patch: | −0.32 | −0.54 | 1.7 |
| Yellow Loss from Yellow Patch: | −0.20 | −0.72 | 3.6 |
| Minimum-Density Yellowish Stain: | +0.00 | +0.00 | [Stain: +0.00] |

| Kodak Dye Transfer Prints ("standard" Kodak Film and Paper Dyes) | 90-Day Test | 1,440-Day Test | RF Factor |
|---|---|---|---|
| Cyan Loss from 1.0 Neutral: | −0.09 | −0.13 | 1.4 |
| Magenta Loss from 1.0 Neutral: | −0.06 | −0.07 | 1.2 |
| Yellow Loss from 1.0 Neutral: | −0.18 | −0.19 | 1.1 |
| Cyan Loss from Cyan Patch: | −0.16 | −0.23 | 1.4 |
| Magenta Loss from Magenta Patch: | −0.10 | −0.10 | 1.0 |
| Yellow Loss from Yellow Patch: | −0.27 | −0.40 | 1.5 |
| Minimum-Density Yellowish Stain: | −0.04 | −0.02 | [Stain: +0.00] |

| Fuji Dyecolor Prints (dye transfer type) | 90-Day Test | 1,440-Day Test | RF Factor |
|---|---|---|---|
| Cyan Loss from 1.0 Neutral: | −0.06 | −0.13 | 2.2 |
| Magenta Loss from 1.0 Neutral: | −0.06 | −0.09 | 1.5 |
| Yellow Loss from 1.0 Neutral: | −0.26 | −0.30 | 1.2 |
| Cyan Loss from Cyan Patch: | −0.10 | −0.19 | 1.9 |
| Magenta Loss from Magenta Patch: | −0.13 | −0.13 | 1.0 |
| Yellow Loss from Yellow Patch: | −0.81 | −0.85 | 1.1 |
| Minimum-Density Yellowish Stain: | −0.00 | −0.00 | [Stain: +0.00] |

*(continued)*

| Dye Diffusion-Transfer Prints: | 21.5 klux (2,000 fc) Density Losses | 1.35 klux (125 fc) Density Losses | Reciprocity Failure Factor (RF Factor) |
|---|---|---|---|
| **Polaroid Polacolor ER Prints (Types 59; 559; 669; and 809)** | 60-Day Test | 960-Day Test | RF Factor |
| Cyan Loss from 1.0 Neutral: | −0.34 | −0.45 | 1.3 |
| Magenta Loss from 1.0 Neutral: | −0.24 | −0.29 | 1.2 |
| Yellow Loss from 1.0 Neutral: | −0.37 | −0.43 | 1.2 |
| Cyan Loss from Cyan Patch: | −0.43 | −0.60 | 1.4 |
| Magenta Loss from Magenta Patch: | −0.38 | −0.39 | 1.0 |
| Yellow Loss from Yellow Patch: | −0.40 | −0.42 | 1.1 |
| Minimum-Density Yellowish Stain: | −0.07 | −0.05 | [Stain: +0.00] |
| **Polaroid 600 Plus Prints**<br>**Polaroid Type 990 Prints**<br>**Polaroid Autofilm Type 330 Prints**<br>Polaroid Spectra Prints<br>Polaroid Image Prints (Spectra in Europe) | 60-Day Test | 960-Day Test | RF Factor |
| Cyan Loss from 1.0 Neutral: | −0.25 | −0.25 | 1.0 |
| Magenta Loss from 1.0 Neutral: | −0.24 | −0.25 | 1.0 |
| Yellow Loss from 1.0 Neutral: | −0.26 | −0.32 | 1.2 |
| Cyan Loss from Cyan Patch: | −0.38 | −0.39 | 1.0 |
| Magenta Loss from Magenta Patch: | −0.50 | −0.49 | 1.0 |
| Yellow Loss from Yellow Patch: | −0.26 | −0.30 | 1.2 |
| Minimum-Density Yellowish Stain: | −0.13 | −0.13 | [Stain: +0.00] |
| **Polaroid Autofilm Type 339 Prints**<br>**Polaroid High Speed Type 779 Prints**<br>Polaroid 600 High Speed Prints | 60-Day Test | 960-Day Test | RF Factor |
| Cyan Loss from 1.0 Neutral: | −0.25 | −0.29 | 1.2 |
| Magenta Loss from 1.0 Neutral: | −0.14 | −0.19 | 1.4 |
| Yellow Loss from 1.0 Neutral: | −0.27 | −0.34 | 1.3 |
| Cyan Loss from Cyan Patch: | −0.33 | −0.40 | 1.2 |
| Magenta Loss from Magenta Patch: | −0.23 | −0.24 | 1.0 |
| Yellow Loss from Yellow Patch: | −0.34 | −0.45 | 1.3 |
| Minimum-Density Yellowish Stain: | −0.02 | −0.01 | [Stain: +0.00] |
| Kodak Ektaflex Prints (1981–1988) | 60-Day Test | 960-Day Test | RF Factor |
| Cyan Loss from 1.0 Neutral: | −0.20 | −0.18 | 0.9 |
| Magenta Loss from 1.0 Neutral: | −0.27 | −0.37 | 1.4 |
| Yellow Loss from 1.0 Neutral: | −0.16 | −0.21 | 1.3 |
| Cyan Loss from Cyan Patch: | −0.22 | −0.19 | 0.9 |
| Magenta Loss from Magenta Patch: | −0.25 | −0.33 | 1.3 |
| Yellow Loss from Yellow Patch: | −0.17 | −0.18 | 1.1 |
| Minimum-Density Yellowish Stain: | −0.00 | −0.00 | [Stain: +0.00] |

mation are probably caused by oxidants or other degradation products generated, after long-term exposure to light and UV radiation, by the titanium dioxide-pigmented polyethylene layer coated between the emulsion and paper core of RC prints. (As discussed in Chapter 17, a similar mechanism involving light and titanium dioxide-pigmented polyethylene may be responsible for the light-induced silver image discoloration that has occurred in many black-and-white RC prints.)

Because this type of light-induced "dark fading" and light-induced "dark staining" has to date been observed *only* in color prints made on RC papers, it is tentatively called "RC base-associated fading and staining." It is characterized by relatively large density losses in both high-density and low-density areas of the image. The density loss as a function of original density more closely resembles the approximately equal percentage losses throughout the density range characteristic of dark fading than it does the usual type of light fading in which visual changes are concentrated in lower-density portions of the scale. As shown in **Figures 2.13** and **2.14**, Ektacolor 74 RC prints made in 1978 and tested by this author showed drastic changes when kept in the dark for 10 years after being subjected to accelerated light fading tests. Identical prints that had not been exposed to light exhibited comparatively little fading and staining during this period of storage in the dark.

RC base-associated fading and staining are usually not apparent in short-term, high-intensity accelerated light fading tests. However, in long-term display under more moderate lighting conditions — particularly when prints are framed under glass or plastic sheets that restrict the exchange of air next to the emulsion surface — this kind of deterioration can substantially shorten the life of a print. This author believes that RC base-associated fading was a major factor in the rapid and severe fading observed in many displayed Kodak Ektacolor 20 RC, 47 RC, 30 RC, 37 RC, and 74 RC prints made between 1968 and 1977.

Examples of apparent RC base-associated fading and staining observed by this author showed quite different effects among the various RC color papers manufactured since 1969, and even the same brand and type of paper may exhibit different kinds of fading effects depending on the year it was made (**Table 2.2**). Use of Kodak Ektaprint 3 Stabilizer (and apparently some other low-pH stabilizers) instead of a final water wash can increase the tendency for prints to exhibit RC base-associated fading. To date this author has observed apparent RC base-associated fading effects in chromogenic color papers made by Kodak, Agfa, Fuji, and 3M.

It is possible that long-term exposure of the RC color prints to light results in a further lowering of the emulsion pH, which in turn could increase the rate of "dark fading," especially of the pH-sensitive yellow dyes used in most chromogenic color papers.

Lending support to the notion that the RC base itself is the principal cause of RC base-associated fading is a comparison of the long-term light fading behavior of Konica Color Paper Type SR, coated on an RC base, and Konica Color Paper Type SR (SG), which is coated on a solid polyester base. After 8 years of exposure to low-level, glass-filtered 1.35 klux fluorescent illumination, the yellow dye in the RC-base print had faded significantly more than was

the case with the yellow dye in the polyester-base print (**Figure 2.15**). This gave the RC-base print a decidedly bluish appearance, which was especially noticeable in high-density areas of the image. The emulsions of both Konica products are identical, and they received identical EP-2 processing with "washless" Konica Super Stabilizer. The prints were covered with glass for the duration of the tests. In short-term, high-intensity 21.5 klux glass-filtered fluorescent tests, no difference whatever was observed in the fading behavior of the two types of Konica prints.

In a further example, as shown in **Figure 2.16**, serious yellow staining occurred in Ilford Cibachrome II RC prints during the course of several years of dark storage after an accelerated light fading test, but not in Cibachrome II polyester-base prints under identical conditions.

In terms of accelerated light fading tests, RC base-associated fading and staining is a very troubling phenomenon.

It injects potentially large uncertainties into predictions of color print life based on short-term accelerated tests.

## "Framing Effects" in Light Fading with Prints Framed under Glass or Plastic Sheets

Studies with a variety of chromogenic color negative papers have shown that framing or enclosing these prints with glass or plastic sheets can have a significant effect on fading and stain formation when certain of these materials are displayed for long periods under typical indoor illumination levels. This phenomenon is probably related to the light-induced RC base-associated fading and staining discussed above.

The manner of processing (e.g., a water wash, use of a low-pH stabilizer, etc.) may have a pronounced influence on the rate of dye fading of these framed and displayed

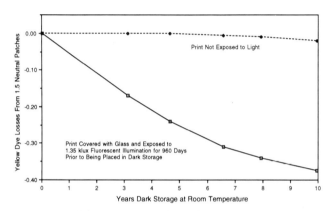

**Figure 2.13** Light-induced "dark fading" of Ektacolor 74 RC paper (initial type: 1977–82), processed with Kodak EP-3 chemicals including EP-3 Stabilizer, a low-pH "stabilizer" which is used as a final rinse prior to drying. After exposure to light for 960 days, the print was placed in the dark. Dramatic fading of the yellow dye occurred during the next 10 years in the dark and was still continuing in 1992. An identical print that was never exposed to light suffered negligible yellow dye fading during 10 years of storage in the same environment (75°F and 60% RH).

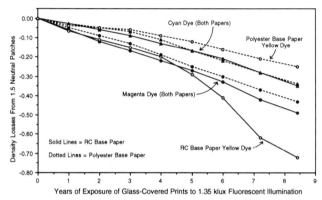

**Figure 2.15** In a comparison of the long-term light fading behavior of Konica Type SR paper on RC base and polyester base, the yellow dye in the RC-base print faded significantly more than did the yellow dye in the polyester-base print. The RC base itself is believed to be the principal cause of the increased rate of dye fading observed in this example. The prints had received identical EP-2 processing with Konica "washless" stabilizer. The prints were covered with glass during the 8½ years of exposure to low-level 1.35 klux fluorescent illumination.

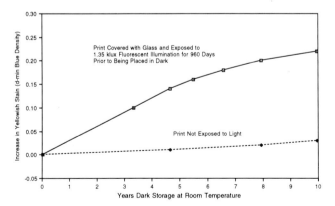

**Figure 2.14** Light-induced "dark staining" of Ektacolor 74 RC Paper (initial type: 1977–82). Yellowish staining occurred at a much more rapid rate after a print was exposed to light for 960 days and then placed in the dark than it did in an identical print that was never exposed to light. Both prints were stored in the same environment.

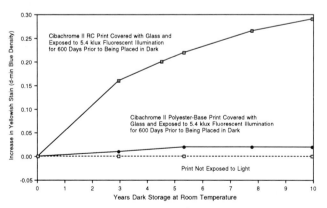

**Figure 2.16** Ilford Cibachrome II RC paper suffered a large increase in yellowish stain during dark storage after a period of light exposure. Only negligible staining occurred with the glossy, polyester-base version of Ilford Cibachrome II (Ilford Cibachrome was renamed Ilford Ilfochrome in 1991).

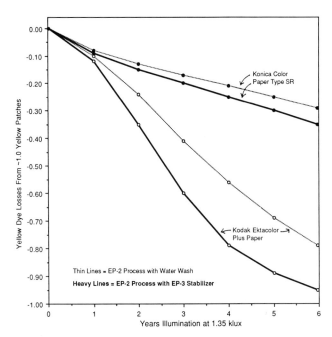

**Figure 2.17** Use of Kodak Ektaprint 3 Stabilizer (a low-pH stabilizer) has a deleterious effect on the light fading stability of the yellow dye in Kodak Ektacolor Plus and Ektacolor Professional papers. Konica Color Paper Type SR was much less affected by EP-3 Stabilizer. This effect is subject to significant reciprocity failures and did not occur in this author's high-intensity 21.5 klux test.

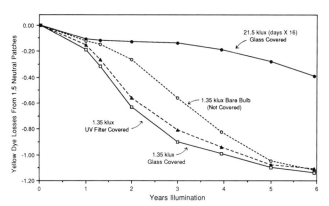

**Figure 2.18** The "framing effect" (also called the "enclosure effect") in a chromogenic paper. The yellow dye in Fujicolor Type 8901 paper (1984–86), processed with Kodak Ektaprint EP-3 chemicals which include a low-pH stabilizer as the final rinse, faded more rapidly when covered with a glass or plastic sheet than it did when the print was not covered and was freely exposed to circulating air. This framing effect is subject to large reciprocity failures and generally does not occur in short-term, high-intensity tests.

print materials (**Figure 2.17**). Most commonly the "framing effect" in chromogenic prints is manifested by an increase in yellow dye fading in particular and, unlike what is generally observed with light fading, is most noticeable in high- and maximum-density areas of a color image. The disproportionate loss of yellow dye eventually causes the image to suffer a pronounced blue shift in color balance. An example of the "framing effect" with Fujicolor Paper Type 8901 (processed with EP-3 Stabilizer) is shown in **Figure 2.18**. To a greater or lesser degree, Ektacolor and most other chromogenic papers are also affected in this manner.

The framing effect has been observed in prints framed directly against glass and in prints that are separated from the framing glass by a cardboard overmat. In a 3-year test conducted by this author with prints in a 1.35 klux fluorescent test, the fading rates of a number of color negative papers were compared when: **a)** prints were resting on an aluminum-foil-covered board and covered with a glass sheet but not sealed with tape along the edges; **b)** placed between a glass sheet and a piece of 4-ply, 100% cotton-fiber mat board and sealed along the edges with tape; and **c)** placed between two sheets of glass and sealed along the edges with tape. For the papers tested, the fading rates for all conditions were quite similar.

Experience has shown that the framing effect generally is subject to large reciprocity failures in high-intensity light stability tests; therefore, long-term tests with illumination intensities of 1.0 klux or lower should be employed to meaningfully evaluate this phenomenon. Although the framing

effect has been studied principally in chromogenic prints, other types of materials possibly are affected similarly.

A test frame devised by this author that can be used to evaluate the framing effect in color papers is described in *ANSI IT9.9-1990* in Annex D, pages 26–27 (the Standard uses the term "enclosure effects" to describe what this author calls the "framing effect").

## Percentage Dye Density Losses in Light Fading as a Function of Original Density

An important difference between dark fading and light fading is that dark fading usually involves an approximately equal *percentage* loss of density throughout the density range of the print (**Table 2.3**). That is, if a dark, high-density area of a print loses 30% of its density, a low-density highlight area of the print will usually lose about the same percentage of density. This means that while the contrast of the dye image becomes lower — and the image becomes lighter overall — both shadow and highlight detail are retained in approximately equal percentages as dark fading progresses.

With light fading, the situation is very different, and with many kinds of prints it can be characterized by more or less equal loss in *density units* throughout the density range (**Table 2.4**). Because highlight areas of a print have a low dye density to begin with, relatively little exposure to light on display can significantly reduce apparent detail in these low-density areas of the image.

For example, in a typical wedding photograph, the detailed areas of a white wedding dress typically have a density of about 0.20 to 0.35, of which about 0.10 can be attributed to the RC paper base itself. This means that the white cloth of the wedding dress is depicted by a dye density of only 0.10 to 0.25, and it takes relatively little exposure to light on display to cause this small amount of image dye to

fade completely. The result is still a photograph of a white dress, but the sense of richness, detail, texture, and weave in the cloth is gone, while higher-density portions of the image remain relatively unchanged. These density-loss characteristics of light fading and dark fading are also described in Annex A of *ANSI IT9.9-1990.*

Most chromogenic print materials, both color negative papers and reversal papers for printing transparencies, have light fading patterns similar to that of Kodak Ektacolor 74 RC. Ilford Ilfochrome prints (called Cibachrome prints, 1963–1991) also follow this general behavior in light fading, although in accelerated tests, the rate of yellow dye fading increases after prolonged exposure to light, causing the relative percentage losses of dye to shift over time. In early stages of the tests, the yellow dye is more stable than either cyan or magenta, but after extended exposure the yellow becomes the least stable of the three.

Some other types of prints, notably dye diffusion-transfer prints such as Kodak Ektaflex (1981–88) and Polaroid Polacolor ER, have light fading characteristics as a function of image density that more closely resemble the kind of uniform percentage losses associated with dark fading. Particularly when light fading reaches an advanced stage, this results in washed-out shadows and gives these prints a very different — and usually inferior — appearance from prints made on Ektacolor and similar papers that have faded the same amount in middle-density areas.

## The Importance of Starting Density in Light Fading Tests

Study of many faded color prints of pictorial scenes indicates that the density range of about 0.45 to 0.6 generally shows the most noticeable fading after exposure to moderate amounts of light. For this reason, this author has employed a starting density of 0.6 (approximately 0.5 above d-min with current color negative papers) for

## Table 2.2  Light Fading Patterns of 1,384 Kodak Ektacolor RC Portraits

Iowa high school class composites made with individual prints; Ektacolor RC paper processed between 1970 and 1974.  Prints examined in January 1980.

| | | | Number of Faded Prints and Direction of Changes in Color Balance | | |
| School Name | Class Year | RC Cracks | Cyan | Yellow | Magenta |
|---|---|---|---|---|---|
| Adel Community High School | 1971 | yes | 78 | – | – |
| Central Decatur Community School | 1971 | – | 70 | – | – |
| Maxwell Community School | 1971 | yes | 27 | – | – |
| North Polk | 1971 | – | 51 | – | – |
| Waukee Community School | 1971 | yes | 46 | – | – |
| Woodward Granger Community High | 1971 | – | 47 | – | – |
| Adel Community High School | 1972 | – | – | 63 | 14 |
| Central Decatur Community School | 1972 | yes | – | 75 | 6 |
| Clark Community School | 1972 | yes | – | 55 | 30 |
| New Monroe | 1972 | – | – | 48 | 6 |
| Madrid Community High School | 1972 | yes | – | 38 | 4 |
| Southwest Warren Community School | 1972 | yes | – | 41 | 6 |
| Van Meter Community School | 1972 | yes | – | 19 | 4 |
| Waukee Community School | 1972 | yes | 30 | – | – |
| Central Decatur Community School | 1973 | – | – | – | 65 |
| Dallas Community School | 1973 | – | 1 | – | 26 |
| Deerfield Community School | 1973 | – | – | – | 46 |
| Madrid Community High School | 1973 | – | – | – | 61 |
| North Polk | 1973 | – | – | – | 49 |
| Southwest Warren Community School | 1973 | – | – | – | 60 |
| Van Meter Community School | 1973 | – | – | – | 32 |
| Waukee Community School | 1973 | – | – | – | 24 |
| Woodward Granger Community High | 1973 | – | – | – | 51 |
| Central Dallas Community School | 1974 | – | – | – | 25 |
| Deerfield Community School | 1974 | – | – | – | 37 |
| Maxwell Community School | 1974 | – | – | – | 29 |
| Stuart-Menlo Community School | 1974 | – | – | – | 63 |
| Waukee Community School | 1974 | – | – | 2 | 57 |
| Totals: | | – | 350 | 339 | 695 |

**Note:** RC cracking was common on prints processed through 1972 (types which faded toward cyan or yellow); however, it can be assumed that prints processed during years after 1972 (generally types which faded in the magenta direction) would also develop RC cracks at some point in the future if placed on permanent display.

In general, the prints were actually processed late in the calendar year preceding the "Class Year."  For example, prints listed under the 1972 Class Year were for the most part processed in late 1971.  Some, however, were taken and processed later, and this probably accounts for the mixed fading pattern observed in many of the 1972 Class Year composites.

**Table 2.3   Percentage Losses of Cyan Dye in Kodak Ektacolor 78 and 74 RC Papers Resulting from Dark Fading**

90 days in the dark at 144°F (62°C) and 45% RH
(Data from neutral patches)

| Starting Density above d-min | Density Loss at End of Test | Percent Density Loss |
|---|---|---|
| 0.20 | − 0.11 | − 45% |
| 0.30 | − 0.14 | − 47% |
| 0.40 | − 0.19 | − 48% |
| 0.50 | − 0.24 | − 48% |
| 0.60 | − 0.28 | − 47% |
| 1.00 | − 0.46 | − 46% |
| 1.50 | − 0.72 | − 48% |

**Table 2.4   Percentage Losses of Magenta Dye in Kodak Ektacolor Plus and Professional Papers Resulting from Light Fading**

60 days under 21.5 klux (2,000 fc) illumination
(Data from neutral patches)

| Starting Density above d-min | Density Loss at End of Test | Percent Density Loss |
|---|---|---|
| 0.20 | − 0.13 | − 65% |
| 0.30 | − 0.14 | − 47% |
| 0.40 | − 0.15 | − 38% |
| 0.50 | − 0.15 | − 30% |
| 0.60 | − 0.15 | − 25% |
| 1.00 | − 0.15 | − 15% |
| 1.50 | − 0.14 | − 9% |

determining the image life of displayed prints for "Home and Commercial" applications, and a starting density of 0.45 for "Museum and Archive" applications.

The *ANSI IT9.9-1990* Standard specifies that a density of 1.0 above d-min be used for both light fading and dark fading tests; this value was selected for reasons of industry tradition, convenience (using the same value for both light fading and dark fading tests), and simplicity (for reflection prints, a simple ½ d-min correction is adequate at a density of 1.0).

This author strongly believes, however, that because of the disproportionate loss of density in low-density areas of color prints and slides that have been subjected to light fading, a starting density of 0.6 (0.5 above d-min) gives a much better correlation with the visual assessment of light fading in portraits, wedding photographs, and most other types of pictorial scenes. For a given set of fading and color-balance change criteria, using 0.6 for light fading also correlates better with the visual assessments of image degradation in dark-faded prints that have changed to approximately the same degree, as determined from a starting density of 1.0. (The previous *ANSI PH1.42-1969* Standard specified that *two* densities, 1.0 and 0.5, be used with color prints and color slides.)

If a starting density of 1.0 is used for both light fading and dark fading, and the same set of change limits is used for both, the result is likely to be an unrealistically optimistic assessment of the light fading stability of a color print material. To give an example, if one were to select a 30% dye loss limit from a starting density of 1.0 (which Konica and some others have adopted for published dark fading predictions) and apply this "acceptability limit" to light-faded prints, there would be severe fading and loss of detail in low-density portions of the color images. Portraits and wedding photographs that have light-faded to this de-

gree would be unacceptable to most people.

Particularly in dark fading, where density losses are often accompanied by significant levels of yellowish stain, the starting density that is chosen can have a major influence on the assessment of color balance changes. An example of this for a color negative paper is shown in **Figure 2.19**.

## Light Fading of Neutral Gray Areas versus Pure Cyan, Magenta, and Yellow Areas

Another characteristic of light fading with most papers is that parts of an image containing relatively pure cyan, magenta, or yellow colors fade more rapidly than the colors do when they are combined in a gray scale. In fact, with some print materials, a pure color patch can fade two or three times more rapidly than when the other two colors are present in equal amounts to form a neutral gray; the increased fading rates of pure magenta image areas in Ektacolor and similar chromogenic papers are often striking (**Figure 2.20**). In these papers, the magenta dye layer is below the cyan dye, which apparently absorbs a considerable amount of the wavelengths that contribute to magenta fading. The presence of the yellow dye layer below the magenta layer also offers some protection to the magenta dye because the yellow absorbs some wavelengths that would otherwise be reflected back from the base and cause magenta fading.

Prints that have a more or less homogeneous mixture of the three dyes in a single layer, such as the dye-diffusion-transfer processes like Polacolor ER and the now-obsolete Kodak Ektaflex print materials, and Kodak Dye Transfer prints, generally exhibit this effect less than materials such as Ektacolor and Ilfochrome, which have the image dyes isolated in distinct layers.

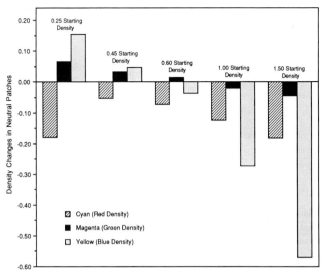

**Figure 2.19** As shown here in Agfacolor Type 8 Paper (AP95 washless process), yellowish stain that occurs in dark storage can have a pronounced effect on perceived color balance. The degree and direction of color balance change generally vary as a function of density.

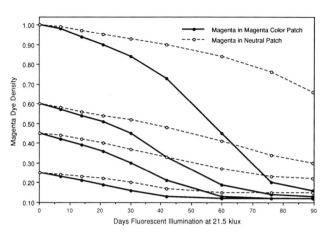

**Figure 2.20** In light fading, with most color papers, pure cyan, magenta, and yellow dye patches fade much more rapidly than when all three dyes are present in approximately equal amounts in a neutral patch. The effect was especially pronounced with the magenta dye in the now-obsolete 3M High Speed Color Paper shown here. In dark fading, most products exhibit little if any difference in the rates of fading of pure colors and colors in neutral patches.

## Light Fading of Skin Colors

It is apparent that the mostly magenta and yellow dye mixture reproducing the light and dark colors of human skin behaves differently than gray patches or separate cyan, magenta, and yellow colors in response to light. Comparisons of the light fading stability of light and dark skin colors in both EP-2 and RA-4 compatible color negative papers are given in Chapter 3. Because of the importance of skin-tone reproduction in portraits, this author plans to further study the visual responses to fading and staining of representative flesh-tone colors with the aim of devising a set of criteria limits specifically for these colors.

## Types of Accelerated Light Fading Tests

A good light fading test simulates actual conditions of display as closely as possible. The temperature and relative humidity conditions and the wavelength distribution of the light source should all match the display condition one would like to simulate. Ideally, the *intensity* of the test illumination should also be the same as the actual display condition, and the alternate light/dark (day/night) periods encountered in most display situations should be duplicated. However, the stability of most current color materials requires test periods of many years before useful fading and staining limits are reached, and for this practical reason, accelerated tests must be employed to study light fading stability.

The three principal light sources for illuminating photographs are fluorescent light, indirect daylight through window glass, and incandescent tungsten light. Each of these light sources has a distinctly different spectral distribution and ultraviolet content, and because of this, each type of illumination has a different fading and staining effect on

each dye of each of the many different color print materials. In addition, extremely intense tungsten halogen illumination is used in slide projectors (projector-caused fading of color slides is discussed in Chapter 6), and some photographs are subjected to extremely intense, direct outdoor sunlight.

*ANSI IT9.9-1990* specifies illumination sources, wavelength distribution, and intensity for all five of these illumination conditions:

> These tests are intended to simulate common use conditions. Selection of the appropriate test should be based on the conditions of intended use. In most homes, for example, indirect daylight through window glass is the principal illumination causing displayed photographs to fade. (The low-intensity illumination provided by incandescent tungsten lamps in homes usually contributes very little to the deterioration of color photographs. Fluorescent lamps, however, which generally provide more intense illumination than tungsten lamps, are increasingly found in homes. When fluorescent lamps are present, they may make a significant contribution to the fading of displayed prints.) In offices and public buildings, fluorescent lamps are usually the primary source of illumination. Photography exhibits in galleries, museums, and archives are most often illuminated with standard incandescent tungsten lamps or quartz-halogen tungsten lamps. Exposure to direct sunlight is the principal cause of fading in color print materials used outdoors (e.g., billboards, outdoor displays, and identification badges).

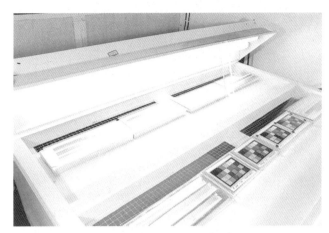

This high-intensity 21.5 klux (2,000 fc) fluorescent test allows rapid evaluation of new color papers as soon as they become available. Shown here with the lamp fixtures raised so that the print samples can be seen, the test set-up employs high-velocity forced-air cooling to maintain 75°F (24°C) and 60% RH at the sample plane. Uncovered (bare-bulb), glass-covered, and Plexiglas UF-3 covered print samples, which are mounted on aluminum foil-covered boards, are moved forward every 24 hours to a new location under the lamps so that all samples receive equal illumination during the course of the test. This equipment was designed and constructed by this author in 1983.

## Accelerated Fluorescent Tests

This author uses two types of accelerated fluorescent light fading tests. One is a short-term, high-intensity test with an illumination intensity at the sample plane of 21.5 klux (2,000 fc). The other is a long-term, low-intensity test with an illumination intensity at the sample plane of 1.35 klux (125 fc). Standard single-phosphor Cool White fluorescent lamps are employed; because of their low cost and high energy-efficiency, Cool White lamps are by far the most common type of fluorescent lamp worldwide.

In both tests, the sample-plane temperature is 75°F (24°C) and the relative humidity 60%. The tests are conducted in temperature- and humidity-controlled rooms. Because of the heating effect of the fluorescent lamps in the high-intensity 21.5 klux test (the lamps are only about 2 inches from the sample plane), high-velocity forced-air cooling is required to maintain the proper temperature and relative humidity in the samples.

To determine the sensitivity of materials to UV radiation, identical samples are exposed to: a) direct, bare-bulb illumination; b) glass-filtered illumination with standard window glass covering the sample; c) UV-filtered illumination with Rohm and Haas Plexiglas UF-3, a sharp-cutting UV filter. Bare-bulb fluorescent illumination exposes prints to the ultraviolet 313 nanometer mercury vapor line emission of the fluorescent lamps; this can greatly increase the fading rate of one or more dyes in Kodak Ektatherm prints (and most other electronic "hardcopy" print materials), Kodak Dye Transfer prints, Polacolor 2 and Polacolor ER prints, and other materials manufactured without a UV-absorbing emulsion overcoat. Ordinary window or framing glass effectively absorbs this harmful wavelength. Plexiglas UF-3 absorbs essentially all ultraviolet radiation; virtually all of the fading that occurs with this filter in place can be attributed to the effects of visible light.

The high-intensity 21.5 klux test is a short-term test which with most products runs about 4 months; the test provides data very quickly and allows evaluation of new color papers shortly after samples become available. This test was extensively used for the color paper image-life predictions and product comparisons in Chapter 3.

The long-term, low-intensity 1.35 klux fluorescent test has 1/16 the illumination intensity of the 21.5 klux fluorescent test, and test periods run between 5 and 10 years for most products. Unlike the high-intensity 21.5 klux test, the 1.35 klux test gives a good measure of the level of yellowish stain that might occur during normal, long-term display. By comparing 1.35 klux data with data from the 21.5 klux test, an indication of a product's tendency toward reciprocity failures in light fading can be obtained. Data from the long-term 1.35 klux test were absolutely critical for this author to be able to give "years of display" predictions for current products with reasonable confidence.

The 1.35 klux test produces a reasonably good simulation of the fading and staining that can be expected in long-term display under normal home and office conditions; this would be this author's primary light fading test were it not for the 3- or 4-year test periods most current color papers require to reach this author's fading limits. By the end of 3 years, some products are no longer even on the market!

An illumination intensity of 6.0 klux is specified for the accelerated fluorescent test in the *ANSI IT9.9-1990* Standard. This intensity is a good compromise between short-term, high-intensity tests that yield data quickly and long-term, low-intensity tests that better simulate normal display conditions. With current color papers, this author's fading limits should be reached in 6 months to a year with the ANSI 6.0 klux test.

## Tungsten Illumination Tests

This author's long-term 1.35 klux incandescent tungsten test is intended to simulate display conditions commonly found in museums and archives. Although 1.35 klux is about four times more intense than the 300 lux illumination level recommended by this author for display of color photographs in museums (see Chapter 17), data from the 1.35 klux accelerated test allow reasonably accurate image-life predictions to be made for color prints displayed under museum conditions.

The tungsten test has shown that extra UV protection (e.g., a Plexiglas UF-3 filter) is of little or no value when prints are displayed under tungsten illumination. Tungsten illumination has an undeservedly good reputation as being safe for color prints. In fact, in this author's tests, some materials — including Cibachrome (Ilfochrome), the now-discontinued Agfachrome-Speed material (**Figure 2.21**), and Kodak Instant Print Film PR10 — faded more rapidly under 1.35 klux tungsten illumination than they did under 1.35 klux fluorescent illumination.

With all three of the materials mentioned above, the cyan dye suffered significantly greater fading under tungsten illumination than under fluorescent, and this can probably be explained by the fact that the peak absorption of

cyan dyes is in the red portion of the spectrum and, at any given lux intensity, tungsten illumination has much greater energy in the red wavelengths than does fluorescent illumination. (To match the sensitivity of the human visual system, a luxmeter has its peak sensitivity in the green portion of the spectrum and does not fully take into account the differences in red or blue energy in different types of illumination.) Because red wavelengths have such low photochemical activity, this author was surprised that these wavelengths had such a pronounced effect on the fading rates of the cyan dyes in the three materials.

One of the difficulties in accelerated light fading tests with incandescent tungsten lamps is that the high infrared (IR) output of the lamps makes it difficult to maintain this author's standard 75°F (24°C) and 60% RH conditions at the sample plane. Because of this problem, this author has not even attempted to run an incandescent tungsten test at 21.5 klux. *ANSI IT9.9-1990* specifies an intensity of 3.0 klux for its incandescent tungsten test.

## Indoor Daylight Tests

This author's indoor daylight test is run under illumination from a large, north-facing glass window. The illumination intensity is about 0.78 klux averaged over a 24-hour period; the accumulated light exposure is measured with a Minolta integrating lux-hour meter. Duplicate print samples are tested under window glass and Plexiglas UF-3 filters.

Averaged over a 24-hour period, 12 months a year, the intensity in this north-daylight test is approximately 0.78 klux. This test is useful primarily to determine what improvement, if any, is afforded by framing prints with UV-absorbing filter material. This test was started in 1983. As with this author's other light fading tests, this test is maintained at 75°F (24°C) and 60% RH. In the center of the sample area is the sensor of a Minolta integrating lux-hour meter which is in place year-round to measure the accumulated light received by the samples.

The tests typically run for a period of several years. When close to a window, north daylight has relatively high UV and blue light components, so this is a good test to show what protection is afforded by a UV filter. Farther from a window, indoor daylight illumination usually has a much lower UV content because of absorption by wall, floor, and ceiling surfaces.

*ANSI IT9.9-1990* specifies an intensity of 6.0 klux for the indoor daylight test. To obtain better repeatability than is possible with a test using actual daylight, the Standard specifies a filtered xenon arc illumination source that is a reasonable simulation of north daylight; the required wavelength distribution is given in the Standard.

## Outdoor Sunlight Tests

This author has not routinely conducted light fading tests in direct, outdoor sunlight. However, a 100-klux simulated outdoor sunlight test with a xenon arc illumination source is provided in *ANSI IT9.9-1990*.

## "Standard" Display Conditions for Predictive Tests

Based on measurements of illumination intensity in a wide variety of display situations (**Table 2.5**), this author selected 450 lux (42 fc) for 12 hours per day as the standard home and office display condition on which to base the "years of display" image-life predictions for color papers given in Chapter 3. For incandescent tungsten illumination in museums and archives, 300 lux (28 fc) for 12 hours per day was selected. In display situations where the daily klux-hour light exposure is either greater or less than these "standard" illumination conditions, it is a simple matter to recalculate the image-life predictions so that they correlate with actual display conditions.

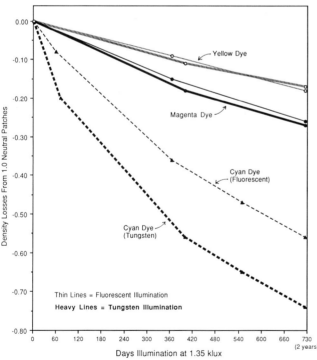

**Figure 2.21** In the now-obsolete Agfachrome-Speed print material (1983–85), the rate of cyan dye fading is significantly greater under glass-filtered tungsten illumination than under glass-filtered Cool White fluorescent illumination of the same klux intensity. For the cyan dye in Agfachrome-Speed, the same relationship also held true for samples exposed to bare-bulb illumination and for samples covered with a Plexiglas UF-3 ultraviolet filter.

**Table 2.5   Survey of Lighting Conditions in Display Areas** (1977–1988)

Summary of Table 17.1 in Chapter 17

|  | Illumination Intensity | |
| Location | Median Level | Average Level |
|---|---|---|
| A. Museums and Archives | 215 lux (20 fc) | 1,057 lux (98 fc) |
| B. Commercial Galleries | 430 lux (40 fc) | 549 lux (51 fc) |
| C. Public Buildings (e.g., offices, libraries, hospitals, and airports) | 1,325 lux (123 fc) | 3,686 lux (342 fc) |
| D. Homes | 635 lux (59 fc) | 3,213 lux (299 fc) |
| A, B, C, and D grouped together: | 375 lux (35 fc) | 1,808 lux (168 fc) |

## Much More Research on Accelerated Light Fading Procedures Is Required

When employing accelerated light fading data to make predictions of print life under typical long-term display conditions, errors introduced by reciprocity failures, RC base-associated fading, and other factors are, in most cases, probably significantly greater than the possible errors in the accelerated test procedures described here. It is obvious that a much better understanding of the actual behavior of photographs during long-term display at low light levels is needed if accelerated light fading tests are to have greater predictive value. For example, the long-term effects on low-intensity light fading of relative humidity, temperature, framing under glass, and coating prints with lacquers all need to be investigated with each of the many different color print materials.

## Test Methods to Determine Dark Fading and Staining Characteristics of Color Materials

This author's tests of color print and color film dark storage stability, reported in **Tables 5.5a** through **5.9** in Chapter 5, were performed according to the general outline described in *ANSI PH1.42-1969, American National Standard Method for Comparing the Color Stabilities of Photographs*. Although replaced by *ANSI IT9.9-1990* in 1991, this was the applicable Standard when these tests were conducted.

For the basic accelerated dark fading test, *ANSI PH1.42-1969* specified a temperature of 140°F (60°C) and 70% RH. According to the Standard, "This condition is used to simulate results which occur with long-term storage." The Standard also specified a test at 100°F (37.8°C) and 90% RH to simulate tropical storage conditions.

Experimental work by this author in the late 1970's suggested that the 70% RH level at 140°F was too severe. With Kodachrome film and Cibachrome prints, the test produced unaccountably rapid dye fading and exudation of sticky substances (probably coupler solvents) on the emulsion

surfaces of incorporated-coupler films and prints. In the case of Polaroid SX-70 prints, the test conditions led to severe reddish-yellow stain formation. These kinds of image deterioration were of a nature that this author had never observed in photographs in actual, long-term storage under less severe conditions (even in the tropics, where relative humidities frequently are higher than 70%). For this reason, this author adopted a more moderate level of 45% RH and a temperature of 144°F (62°C). These test conditions were employed for the data reported in Chapter 5; they were also used for the comparisons of dark storage stability of color films and color print materials published by Bob Schwalberg, this author, and Carol Brower in the June 1990 issue of *Popular Photography* magazine.[11]

At the outset of these investigations in 1977, this author set the test ovens at 140°F (60°C) as specified by *ANSI PH1.42-1969*. With the aid of more precise temperature measurements at the sample desiccator locations in the ovens, it was later determined that the actual temperature was 144°F (62°C), so it was decided to continue using this temperature to make all test data comparable.

The relative humidity was maintained by placing test samples in sealed glass desiccator jars containing a saturated sodium dichromate solution in a compartment at the bottom. The saturated sodium dichromate solution (containing an excess of sodium dichromate so that some of the salt remained undissolved) maintained the air inside the desiccators at a relative humidity of 45% at a temperature of 144°F (62°C).[12]

With representative products, tests were also conducted at 75% RH using a saturated sodium chloride solution in the desiccators. Although this author has little confidence in the 75% RH data in terms of what might be expected to happen under real-world storage conditions, several conclusions were reached: in dark storage, high humidities cause some dyes to fade much faster, but other dyes are

Carol Brower – August 1983

This author's single-temperature dark fading tests are performed in precisely controlled ovens with a temperature of 144°F (62°C). Desiccator jars with a saturated sodium dichromate solution in the bottom maintain a relative humidity of 45%. These tests were started in 1983, and Cibachrome (Ilfochrome) prints, Dye Transfer prints, and a few other materials with exceptional dark fading stability have remained in the ovens since that date. This author plans to acquire new humidity-controlled ovens for Arrhenius testing in 1993.

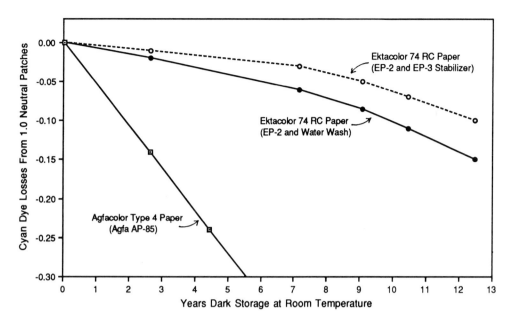

**Figure 2.22** Data from room-temperature dark storage of Ektacolor 74 RC paper (initial type, 1977–82) and Agfacolor Type 4 paper (1974–82). The storage temperature was 75°F (24°C) and the relative humidity 60%. As can be seen, the dark storage stability of the cyan dyes in these papers is poor, with Agfacolor Type 4 paper suffering catastrophic fading in only a few years. The accumulation of natural aging data is an essential part in any long-term testing program. Comparisons between natural aging data and accelerated test data are the only way that predictions based on accelerated tests can be verified.

little affected, and high humidities sharply increase yellowish stain formation in incorporated-coupler chromogenic materials such as Kodak Ektacolor paper and Ektachrome film. Ilford has reported that high-humidity tests (above 60% RH) conducted at high temperatures may cause physical deaggregation (resulting in a loss of optical density) in the azo dyes in Ilfochrome (Cibachrome).[13] Similar dye deaggregation is not believed to occur at normal storage temperatures, and for this reason, accelerated dark fading tests at high humidities will produce misleading results with Ilfochrome.

In some cases, a material is so unstable (or enough time is available) that non-accelerated, real-time tests at normal room temperature are possible within a reasonable length of time (**Figure 2.22**). The now-discontinued Agfacolor Type 4 paper is an example; when stored in the dark in this author's office at 75°F (24°C), sample prints suffered a 20% cyan dye loss in 1,175 days (3.2 years). In an accelerated test at 144°F (62°C), a 20% cyan density loss occurred in 9 days. From this, one could draw the cautious conclusion that this author's accelerated test increased the rate of fading about 130 times. The number of years required for a 10% cyan dye loss to occur in Kodak Ektacolor 74 RC prints kept in the dark at 75°F (24°C) showed a similar relationship with data from this author's accelerated tests reported in Chapter 5.

This means, for example, that Kodak Ektacolor Plus paper, which reached a 20% cyan dye loss after 230 days at 144°F (62°C) and 45% RH in this author's test, would be expected to last approximately 80 years at 75°F (24°C) and 45% RH before the same degree of fading occurred. This is in good agreement with Kodak's Arrhenius prediction of 76 years for the paper. (Kodak's published data for Ektacolor Plus show that the yellow dye is slightly less stable than the cyan dye; that this author's tests showed cyan to be the least stable can probably be attributed to an older method of d-min correction that was used by Kodak.) Comparison of this author's data for a number of other Kodak film and print materials with Kodak's Arrhenius data for these products yielded a generally similar relationship.

The single-temperature tests in *ANSI 1.42-1969* were intended for comparing products in terms of their dye stability and their tendency to form yellowish stain during dark storage; these tests could also help evaluate different modes of processing (such as the effects of a washless stabilizer on color print stability), or the effects of post-processing treatments such as print lacquers. Although these single-temperature tests indicated, in a general way, how one product compared with another in terms of overall dye stability, they were not able to predict how many years under a specified storage condition (e.g., at normal room temperature) a product would last before losing a given amount of dye density. Single-temperature tests also do not provide a good assessment of changes in color balance (caused by the image dyes fading at different rates), nor does the indicated rate of yellowish stain formation necessarily relate to the rate of dye fading that would occur at room temperature.

## The Arrhenius Test: A Predictive, Accelerated Dark Fading and Dark Staining Test Method

The dark fading test specified in the *ANSI IT9.9-1990* Standard is a *predictive* test based on the now well-known Arrhenius equation formulated in the late 1800's by Swedish physicist and chemist Svante August Arrhenius (1859–1927) to describe the relationship between temperature and the rate of simple chemical reactions.[14] Arrhenius received a Nobel prize in chemistry in 1903 for his electrolytic dissociation theory; he was the author of works on biological chemistry, electrochemistry, physical chemistry, and astronomy.

The Arrhenius equation was applied in the 1950's by Fred H. Steiger[15] of the Rohm and Haas Company in Philadelphia, Pennsylvania and others in accelerated aging studies of fabric dyes, anti-static treatments, curing rates of plastics, the deterioration of rubber, and the life of polyester-glass laminates.[16,17]

Steiger described the Arrhenius equation as follows:

Arrhenius expressed the effect of temperature on the rate of reaction by the expression

$$\frac{d \ln k}{dT} = \frac{E}{RT^2} \qquad (1)$$

where k is the rate constant of the reaction, R is the universal gas constant, T is the absolute temperature and E is an equation constant. If E is assumed to be independent of temperature, the above expression may be integrated to

$$\ln K = -\frac{E}{RT} + I \qquad (2)$$

where I is an integration constant.

The constant E represents the heat of activation or the energy required to convert unreactive molecules to "active" ones. This quantity may be determined by plotting ln K against l/T since equation 2 shows the slope of such a plot to be –E/R. The integrated form of the Arrhenius equation is used most frequently to calculate the heat of activation of a reaction.

The phenomenon of aging, which we attribute to inanimate items, may be treated as a single chemical or physical reaction or a series of reactions of that item with itself or its environment. Since the rate of most of these reactions is dependent on temperature, it is possible to use the Arrhenius equation to solve problems involving the aging of materials.

The Arrhenius equation was first applied to the study of the dark fading of color photographic materials by George W. Larson and his co-workers at Eastman Kodak in the 1960's. The first publication of image stability data based on an Arrhenius test was by Peter Z. Adelstein, C. Loren Graham, and Lloyd E. West of Eastman Kodak in an article entitled "Preservation of Motion-Picture Color Films Having Permanent Value," in the November 1970 issue of the *Journal of the SMPTE*.[18] Tucked away in the article was a small graph showing predicted times for a 10% density loss of the least stable dye (cyan) of samples of an unidentified Kodak motion picture color negative and motion picture print film stored at a wide range of temperatures.

Although it went almost unnoticed at the time, this small graph represented a major breakthrough in the evaluation and preservation of color materials. The data represented in the graph provided the rationale for the construction of low-temperature, humidity-controlled storage facilities for the long-term preservation of color films and prints at museums such as the John F. Kennedy Library, the Art Institute of Chicago, the Peabody Museum at Harvard University, and at NASA in Houston, Texas (see Chapter 20).

In 1980 Charleton Bard, George Larson, Howell Hammond, and Clarence Packard of Eastman Kodak published an article describing the application of the Arrhenius test at Kodak in detail,[19] and this article provided the basis for the Arrhenius dark storage test that appears in the *ANSI IT9.9-1990* Standard. **Figure 2.23** illustrates how Arrhenius test data are graphically plotted by Kodak to yield dark storage

Svante Arrhenius (1859–1927), the Swedish physicist and chemist whose study of the influence of temperature on the rate of chemical reactions provided the theoretical foundation for the predictive, accelerated dark aging test that now bears his name. In 1903 Arrhenius was awarded a Nobel prize for his work in chemistry. (Photograph courtesy of the Swedish Information Service)

predictions in terms of "years of storage" at a specific temperature (for actual products, Kodak generally has published only the upper of the two graphs).

Reproduced in **Figure 2.24** is the original dark storage stability graph published by Konica in April 1984 for Konica Color Paper Type SR paper. The graph was based on Arrhenius test data, and this was the first time that such data for a color product had been included in nontechnical advertising and promotional publications.

In Arrhenius tests, the rate of stain formation and the fading characteristics (dependence of fading on temperature) of each dye are determined separately, and this allows prediction of color-balance changes as well as meaningful evaluation of stain growth and how stain will affect color balance. To date, however, none of the manufacturers have reported data on color-balance changes as influenced by stain formation. And, with the exception of Fuji for its low-stain Fujicolor Super FA and SFA3 color negative papers (**Figure 2.25**) and Fujichrome Type 34 and Type 35 color reversal papers, none of the manufacturers have disclosed data on yellowish stain formation for their respective products during dark storage.

Since the publication of Arrhenius test data for Konica Type SR paper in 1984, other manufacturers, notably Fuji and Agfa, have also published Arrhenius data for their color

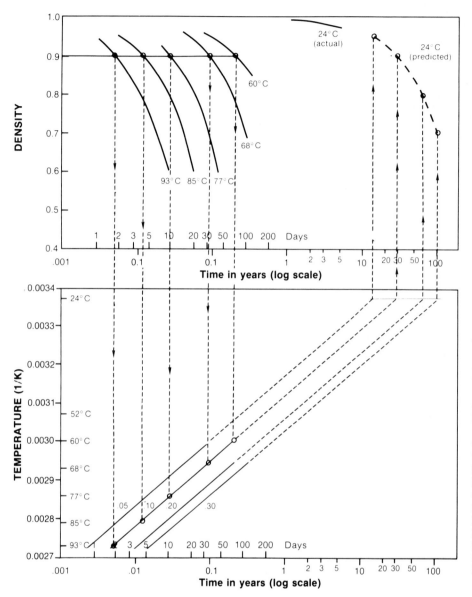

**Figure 2.23** An Arrhenius plot generated by Eastman Kodak using data obtained in five accelerated dark fading tests, each employing a different temperature but the same relative humidity. This illustrative plot is based on yellow dye fading data from a Kodak product. Similar Arrhenius plots can also be produced for cyan and magenta dye fading, and for d-min stain growth. Data for yellow dye fading (reproduced in the upper left) serve as the starting point for this illustration of the method of projecting high-temperature keeping data to predict long-term keeping at lower temperatures. The first step in making the prediction is to replot the original data from the upper left on a new plot with the reciprocal of the absolute temperature on the vertical scale (solid lines at lower left). The downward arrows show how one density level is replotted (0.90 density retained corresponds to 0.10 dye loss) to record the data points that determine the straight line representing constant dye density loss. The same method is used to establish the other straight lines representing 0.05, 0.20, and 0.30 density loss. Extending the straight-line plots (dashed lines) to the 24°C (75°F) line gives an estimate of the time that it would take at 24°C (75°F) to reach the corresponding density level (dye loss). The predicted dark keeping can also be shown on the density-time plot (upper right) to correlate with actual keeping data. (From: **Dye Stability of Kodak and Eastman Motion Picture Film**, Kodak Publication DS-100, May 29, 1981. Reproduced with permission of Eastman Kodak Company.)

print papers. Kodak published detailed Arrhenius data for most of its color films, color papers, and color motion picture films in the early 1980's, but more recently the company has returned to a policy of non-disclosure regarding the stability of most of its products.

Although Arrhenius tests show that the dependence of fading on temperature differs to some degree with different dyes in different products, it is nonetheless possible to average data from a wide range of products and come up with a general relationship between temperature and rate of fading. Kodak has published a number of such generalized estimates and they have been plotted in **Figure 20.1** (page 696) in Chapter 20. Such plots allow determination of an approximate "fading rate factor" for any storage temperature of interest. This in turn allows storage-life estimates to be made for a particular product kept in cold storage if a room-temperature estimate (75°F [24°C]) for the product is available. This is how the image-life predictions for Kodak products stored at various temperatures

given in Chapters 9, 19, and 20 were derived.

Running Arrhenius tests is complex and requires four or more precision, humidity-controlled ovens; the high cost of the equipment has kept the tests from being performed except by the major photographic manufacturers. Independent laboratories are beginning to acquire the necessary equipment and expertise to run the tests, however, and in 1986, B. Lavedrine, C. Trannois, and F. Flieder at the Centre de Recherches sur la Conservation des Documents Graphiques in Paris published results from Arrhenius tests on Kodak, Fuji, and Agfa-Gevaert negative and reversal motion picture films.[20]

More recently, the Image Permanence Institute at the Rochester Institute of Technology began conducting Arrhenius tests with color materials on a consulting basis and for grant-funded research projects. (It is against the policy of IPI to routinely publish stability comparisons of color products. Like RIT itself, IPI has received substantial funding from Eastman Kodak, and this has imposed certain re-

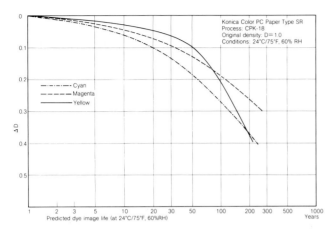

Figure 2.24 Reproduced here is the original dark storage dye-stability graph for Konica Color Paper Type SR published by Konica in April 1984. Based on data obtained in Arrhenius tests, this graph marked the first time that such stability data were included in consumer-oriented advertising. Using a 30% dye loss criterion, Konica was able to claim that Type SR prints would last more than 100 years in album storage under normal conditions. (From: **Konica Technical Data Sheet – Konica Color PC Paper Type SR**, Konica Pub. No. TDSK-213E, April 1984. Reproduced with permission of Konica Corporation.)

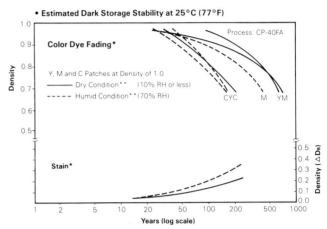

Figure 2.25 Arrhenius tests can be used to predict dye fading and yellowish stain formation in terms of "years of storage" at specified temperature and humidity conditions. Predictive data for yellowish stain formation were first published by Fuji in 1987 for Fujichrome Paper Type 34; in 1988 similar data were published for Fujicolor Paper Super FA and Fujicolor Color Professional Paper Super FA. Stain data were also published for Fujicolor Paper Super FA Type 3 (shown here), introduced in 1992. (From: **Fuji Film Data Sheet – "Fujicolor Paper Super FA Type 3,"** Fuji Ref. No. AF3–723E, January 1992. Reproduced with permission of Fuji Photo Film Co., Ltd.)

strictions on IPI in terms of what the institute can do and what it will publish.)

This author hopes to acquire the necessary equipment for Arrhenius testing in 1993.

## Precision and Accuracy of Arrhenius Tests

The general validity of Arrhenius test procedures has been confirmed by comparisons that have been made between Arrhenius predictions and the fading and staining that actually occurred with a variety of color films and papers stored under normal room-temperature conditions for many years by Kodak and the other major manufacturers. Kodak in particular has accumulated extensive natural aging data on the company's color films and papers. Kodak's Long Range Testing Program monitors densitometry changes over time in samples of hundreds of products stored at 75°F (24°C) and 40% RH, and at 79°F (26°C) and 60% RH. In addition, freezer samples for checking densitometer calibration and for visual reference are preserved at –10°F (–23°C).[21]

This author has a more modest long-range monitoring program for samples of color prints and films stored in the dark at normal room temperatures. These tests were started in 1978 and already have yielded much useful data on color print dye fading and d-min yellowish stain formation; dark fading curves for Agfacolor Type 4 and Ektacolor 74 RC color papers are presented in **Figure 2.22**. The tests have also provided rough "years of storage" correlations with this author's single-temperature accelerated test data included in Chapter 5. Densitometer check samples of selected materials are preserved under refrigeration.

Many potential variables can be encountered when running an Arrhenius test; for accurate and repeatable results, every aspect of the test procedure must be controlled precisely. In a 1986 presentation on application of the Arrhenius procedure for testing color papers,[22] Charleton C. Bard of Kodak said:

> The sources of variability are many; some of the principal ones being paper manufacture, process, sensitometry, densitometry, incubation conditions, data processing, and the actual number of data points used to prepare the Arrhenius plot. [It is best] to repeat, independently, the test procedure many times (e.g., more than 10 times). Unfortunately, for the very stable papers currently available, this procedure takes a lot of time. Thus, it is quite probable that while this long test procedure is under way, the product being tested is no longer for sale.

Based on the experience of the Image Stability Technical Center at Kodak, Bard offered some estimates of the precision and accuracy of Arrhenius predictions for color prints:

> For a dye that has a predicted time of up to 30 years to lose 10% of its density when stored in the dark at the specified conditions (such as 24°C/40% RH), the predicted time (30 years) is probably reliable to no more than ± 6 years (± 20%).
> For a dye that has a predicted time of about 100 years to lose a specified amount of density,

May 22, 1991

Precision temperature- and humidity-controlled ovens are used for incubating film and print samples in Arrhenius tests. Because products must be tested for long periods at a minimum of four different temperatures (typically 55°, 65°, 75°, and 85°C), and perhaps two or more relative humidity levels, a large number of ovens may be required. Suitable ovens cost between $3,000 and $10,000 each. Shown here are the test ovens at the Image Permanence Institute at the Rochester Institute of Technology in Rochester, New York. James Reilly, director of IPI, is checking samples of Ilford Cibachrome (Ilfochrome) micrographic film and other color microfilms undergoing Arrhenius testing.

the true value of the time could be as low as 50 years and as high as 200 years.

Therefore, for a very stable paper, >50 years for a 10% dye loss, the best statement that usually can be made is that for album keeping, the print will remain acceptable for more than a century (at 24°C, 40–60% RH). Of course, to be absolutely certain of the validity of this statement, we will have to wait for more than a century.

### Increased Fading Rates With Color Motion Picture Films Stored in Standard Film Cans

All of the dark storage dye stability data given in this book were based on Arrhenius tests conducted with free-hanging film samples exposed to circulating air. Research disclosed by A. Tulsi Ram et al. of Eastman Kodak in late 1992 showed that storing films in sealed or semi-sealed containers (e.g., vapor-proof bags and standard taped or untaped metal and plastic motion picture film cans) could substantially increase the rates of dye fading and film base deterioration.[23] Therefore, the estimates given in this book for color motion picture films probably *considerably* overstate the actual stabilities of the films when they are stored in standard film cans under the listed temperature and humidity conditions. For further discussion of this topic, refer to Chapter 9.

### Relative Humidity Levels for Accelerated Dark Storage Tests

What is the best relative humidity for conducting dark storage tests? Ideally, accelerated tests should be run at the same humidity level in which photographs are stored and displayed; this varies considerably depending on geographic location and season of the year. New Orleans, Louisiana, situated on the coast of the Gulf of Mexico, is much more humid than Phoenix, Arizona, located in the desert in the southwestern United States. No comprehensive study has been published about worldwide, population-based, *indoor* relative humidity, but what information is available strongly suggests that the worldwide average is above 60%, since the majority of the world's population lives in tropical or subtropical areas.

A 1981 Kodak study of the environmental conditions in two "typical" homes in Rochester, New York found that the indoor relative humidity ranged from 31% to 74%, with the year-round average of the two homes being 54%.[24] Because Rochester is a northern city with a long winter (indoor relative humidities are generally low during cold months), the average relative humidity would be expected to be higher in much of the country.

The *ANSI IT9.9-1990* Standard "recommends" a relative humidity of 50% for the Arrhenius tests, although the user of the Standard may select a different humidity level if the expected storage condition is higher (or lower) than 50% RH:

Because the effects of humidity on image stability can differ markedly from one product to another, it is useful to evaluate its effect. This is done by means of a series of temperature tests carried out at different relative humidities. If the relative humidity during storage is expected to be significantly lower than 50% RH, such as in an arid climate, or significantly higher, as in a tropical climate, the relative humidity selected for the test should correspond to the climate. However, at relative humidities above 60%, especially at the high temperatures employed in accelerated tests, misleading results may be obtained because of difficulties in maintaining constant moisture levels and because of abrupt changes in the physi-

cal properties of some components of photographic image layers, such as gelatin. Furthermore, the combination of high temperature and high relative humidity may cause changes that are not typical of a photograph's behavior under normal storage conditions.

This author believes that 60% is probably the single most representative relative humidity for stability tests, and this level — or two levels: 60% and 40% — will probably be adopted by this author for future work (60% RH has been used satisfactorily for many years in this author's accelerated light fading tests — see Chapter 3). Konica has used 60% RH for most of its published Arrhenius data (**Figure 2.26** shows the influence of relative humidity on the dye fading of Konica Type EX and Type SR papers). Fuji has run Arrhenius tests at <10% RH and at 70% RH, and Arrhenius predictions for Fuji products stored at both of these humidity levels are given in **Table 5.12** in Chapter 5 (these two humidity levels apparently were chosen based on *ANSI PH1.42-1969*).

Most data published by Kodak are based on 40% RH tests, although Kodak also routinely runs tests at 60% RH.[25] Reporting data for two relative humidities is helpful because this gives a clear indication of the humidity-dependence of fading and staining for a material. The dark fading rates of some dyes are greatly increased by high-humidity storage, while other dyes are little affected. It is to Kodak's advantage to use 40% instead of 60% RH for its published predictions of product life because with some products (e.g., color negatives with yellow dyes that are highly humidity-sensitive) the fading rate will *double* when the humidity is increased from 40% to 60%.

## At What Point Are the Fading and Staining of a Color Print "Objectionable"?

Light-caused fading and staining of a color print on display are slow but steady processes that start immediately when the print is hung on a wall or placed in a frame on a desk. The rate and nature of image deterioration are functions of the inherent stability of the print material; the intensity, duration, and spectral distribution of the light used to illuminate the print; whether or not the print is framed; and the ambient temperature and humidity.

What constitutes objectionable fading and/or staining of a print is a highly subjective matter, and individuals may have sharply different opinions as to what is acceptable and what is not. And it is not simply a matter of how much of the cyan, magenta, and yellow image dyes has been lost: some pictorial scenes show fading and staining much more readily than others. Pictures with large areas of near-neutral low- and medium-density areas show fading effects much more than high-contrast scenes consisting mostly of saturated colors and large, dark areas. People are more sensitive to changes in the color rendition of flesh tones, blue skies, concrete roads and sidewalks, fried chicken, green grass, and other colors with which they are familiar — the so-called "memory colors" — than they are to the colors in abstract scenes and pictures of things like painted houses and cars, which could plausibly be any of a variety of colors.

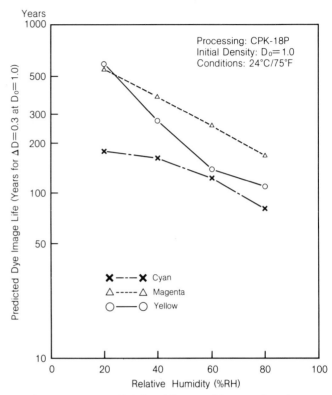

**Figure 2.26** In high-humidity conditions, color photographs generally fade faster and form higher levels of yellowish stain than they do when stored under more moderate conditions. Shown here are Arrhenius predictions for 20%, 40%, 60%, and 80% RH for Konica Color PC Paper Professional Type EX (Type EX has the same stability characteristics as Konica Color PC Paper Type SR). Most of the dye stability data published by Konica to date have been for 60% RH, but it is likely that Konica and the other major manufacturers will in the future adopt 50% RH for published data because this is the value recommended by **ANSI IT9.9–1990**. (From: **Konica Technical Data Sheet – Konica Color PC Paper Professional Type EX**, Konica Pub. No. TDSK–231E, February 1987.)

With most color materials, light fading is characterized by a disproportionate amount of dye fading in the lower density portions of the image. This results in a loss of highlight detail while the darker parts of the image may appear to be unchanged. In the case of a white wedding dress, the sense of texture and weave in the cloth is usually conveyed by a very low-density image (typically about 0.20 to 0.35) and can be totally lost after only a relatively short period of display. With a photograph of this type, it is difficult to know if the print *ever* had significant highlight detail — that is, was it once a good print which is now somewhat faded, or was it just a poor photograph to begin with?

Perceptions of fading can be closely intertwined with the image quality of a print when new. Obviously, if a print is made with an overly green color balance, it will be difficult to tell if it shifts a bit further toward green as a result of magenta dye loss during light fading because the image quality of the print is objectionable whether or not it has faded.

Serious photographers usually want the very best visual print quality they can get.  For photographers who make their own prints, it can be quite instructive to study color balance and density differences between the final print made from a particular negative and the closest rejected trial print.  Although the types of changes that occur when a color print fades — especially the losses of highlight detail caused by light fading — are visually more complex than simple color balance and density variations, print comparisons of this type will furnish a good indication of the kinds and magnitudes of print quality deviations the photographer considers unacceptable.

For photographers selling quality work, there are many reasons why similar image-quality standards for evaluating new prints should also be used to determine when a print has faded an "objectionable" amount.  This is not to say that a print no longer has any value and should be disposed of when fading has progressed beyond this point, or that the customer is even consciously aware of the fact that the print has faded.  But it does mean that the photographer considers the print to have changed beyond a point where he or she would want to sell it if it were new.  The print has lost the richness and clarity that the photographer worked so hard to obtain, and while the customer may not be able to define what if anything is wrong with the image, the perception will grow that there is nothing really special about the quality of the image.  At this point, if an unfaded comparison print is available, the average person will immediately see the difference — and will have a strong preference for the unfaded print.

Eventually, the fading will reach a point where the customer is consciously aware of the fact that "something is wrong" with the print and — if the customer considers the image important — may even take it back to the photographer to ask for a replacement.  Examination of faded prints returned to a number of portrait studios clearly indicates that most people do not return prints until they have become severely faded and discolored; however, it is likely that the relatively small number of faded prints that actually get returned represent only the tip of the iceberg of conscious or subconscious customer dissatisfaction.  As long as a person in a portrait can still be recognized, the picture will probably continue to have some value to a loved one even if it is seriously faded and discolored.

Kodak and other manufacturers have often tried to justify the inadequate stability of their products by claiming that the average person will tolerate a significant amount of fading and still consider a print to be acceptable — as long as an unfaded print is not available for side-by-side comparison.[26]

While this may be true, it avoids the central issues of image quality and suggests that people should be content with mediocre photographs.  For the serious photographer, it is not a question of what deficiencies in color prints people will tolerate but how to deliver a product that will convey a lasting feeling of exquisite tone and color reproduction.

For a museum collection, *any* clearly visible deterioration should be considered objectionable if it can be seen when a print in perfect condition is compared side by side with the print that has been displayed.  The intent here is to preserve the color photograph in an essentially unchanged state so that the viewer can have the experience of looking at exactly the same image the artist originally created.

The feelings of luminosity, clarity, and color intensity — which in many scenes can exist right along with very subtle tonal gradations and color variations — of a carefully printed Ektacolor print can be considerably diminished by even a small amount of fading and overall yellow staining.

## Image-Life Limits for Fading and Staining of Color Prints

After examining a large number of prints made on a variety of color print materials and which had faded as a result of exposure to light on normal long-term display, and prints which had faded under controlled conditions during accelerated light fading tests, this author developed two sets of criteria with limits for losses of density, changes in color balance, and stain formation.  The initial work on these two sets of image-life criteria was done in 1978.[27]

In formulating these sets of image-life criteria, this author devoted considerable study to a group of six photographs printed from medium-format Kodak color negatives on Kodak Ektacolor 74 RC Paper — consisting of individual and family portraits and two representative wedding photographs — which had been incrementally faded using accelerated light fading and dark fading procedures.  These prints were typical of high-quality portrait and wedding photographs made by professional photographers in the U.S.  One of these negatives was subsequently selected to make carefully matched prints on nearly every chromogenic color negative print paper available in the U.S. since 1980 — including color negative print papers manufactured by Kodak, Fuji, Konica, Agfa, Mitsubishi, and 3M.

One set of image fading and staining limits, which is intended for general use, allows a fairly large degree of fading and color balance change to occur before the limits are reached.  The other set of criteria specifies much smaller density losses and deviations in color balance and is intended for critical museum and archive applications.

These sets of criteria limits are weighted in an attempt to account for the differing human visual sensitivities to losses of cyan dye (red density), magenta dye (green density), and yellow dye (blue density).  With most pictorial scenes, fading of the magenta dye is more obvious than the same degree of fading of the cyan dye.  People are much more tolerant of the fading of yellow dye than they are of losses of cyan and magenta; likewise, a much greater degree of yellow stain can be accepted than would be the case if the stain were of another color.  Yellow contributes very little to the perception of image detail, contrast, or the sense of light and dark; however, the amount of yellow dye present has a significant effect on the hue and "warmth" of a photograph and is a critical component of skin-tone reproduction.

Unequal losses of cyan, magenta, or yellow dyes that result in changes in color balance are much more noticeable than density losses when all three dyes have faded approximately the same amount.  For this reason, both of these sets of image-life criteria limits (end points) allow greater overall dye fading than density loss imbalances among the three dyes.

## General Home and Commercial Use

For general home and commercial applications, color prints will be considered to have faded and/or stained an objectionable amount when the *first* limit (end point) has been reached in any of the following image-life criteria, as determined from changes measured in gray-scale densities of 0.6 and 1.0, and in d-min (white) patches:

### Absolute dye density loss (stain-corrected):

Loss of cyan dye (red density) . . . . . . . . . . . . . . . .  25%

Loss of magenta dye (green density) . . . . . . . . . .  20%

Loss of yellow dye (blue density) . . . . . . . . . . . . .  35%

### Color imbalance (not stain-corrected):

Color imbalance between cyan dye (red density) and [minus] magenta dye (green density) . . . . . . . .  12%

Color imbalance between magenta dye (green density) and [minus] cyan dye (red density) . . . . . . . . . . . .  15%

Color imbalance between cyan dye (red density) and [plus or minus] yellow dye (blue density) . . . . .  18%

Color imbalance between magenta dye (green density) and [plus or minus] yellow dye (blue density) . . . . .  18%

### Change limits in minimum-density areas (clear whites), expressed in density units:

Change [increase] in red or green density . . . . . . .  0.06

Change [increase] in blue density . . . . . . . . . . . . .  0.15

Color imbalance between red and green densities  0.05

Color imbalance between red and blue densities . . .  0.10

Color imbalance between green and blue densities  0.10

## Critical Museum and Archive Use

For museum and archive applications (and also for important commercial and documentary photographs, where color and tone reproduction are critical), color prints will be considered to have faded and/or stained an objectionable amount when the *first* limit (end point) has been reached in any of the following image-life criteria, as determined from changes measured in gray-scale densities of 0.45 and 1.0, and in d-min (white) patches:

### Absolute dye density loss (stain-corrected):

Loss of cyan dye (red density) . . . . . . . . . . . . . . . .  9%

Loss of magenta dye (green density) . . . . . . . . . . . .  9%

Loss of yellow dye (blue density) . . . . . . . . . . . . . .  13%

### Color imbalance (not stain-corrected):

Color imbalance between cyan dye (red density) and magenta dye (green density) . . . . . . . . . . . . . .  7%

Color imbalance between cyan dye (red density) and yellow dye (blue density) . . . . . . . . . . . . . . . . .  11%

Color imbalance between magenta dye (green density) and yellow dye (blue density) . . . . . . . . . . . . . . . . .  11%

### Change in minimum-density areas (clear whites), expressed in density units:

Change [increase] in red or green density . . . . . . .  0.04

Change [increase] in blue density . . . . . . . . . . . . .  0.08

Color imbalance between red and green densities  0.03

Color imbalance between red and blue densities . . .  0.04

Color imbalance between green and blue densities  0.04

Because 0.45 was chosen as the principal measurement point in the "Museum and Archive" criteria set, the difference between the "Museum and Archive" and "Home and Commercial" sets of criteria is greater than might be supposed for chromogenic print materials such as Kodak Ektacolor paper. For these products, the lower the initial density is, the sooner a given percentage of dye loss is reached in light fading (unlike dark fading, where the percentage loss tends to be equal throughout the density scale). With light fading of dye-diffusion transfer materials such as Polaroid Polacolor ER, this may not be true, and, quite to the surprise of this author, some of these prints reached a density loss criteria limit at an initial density of 0.6 or 1.0 sooner than they did at 0.45.

For museum and archive collections, this author believes that the suggested criteria limits should be considered the maximum amount of image change that can be tolerated; with many kinds of pictorial content, differences will be clearly visible when an identical — but unfaded — print is compared with a print that has been displayed long enough to reach one of the suggested "Museum and Archive" criteria limits. Museum curators may want to adopt a more restrictive set of criteria for their collections.

## The ANSI Test Methods Standard Does Not Specify Limits for Fading and Staining

The new *ANSI IT9.9-1990* Standard includes a set of image-life criteria (called "color photograph image-life parameters") that do not specify change limits (called "end points" in the Standard). According to the Standard:

> The image-life parameters listed are the critical characteristics that have practical significance for the visual degradation of color images; however, the numerical end points given here [in the Standard] are only illustrative. The

subcommittee that produced this standard was not able to specify broadly applicable "acceptable" end points because the amount of image change that can be tolerated is subjective, and will vary with the product type and specific consumer or institutional requirements. Each user of this standard shall select end points for the listed parameters which, in that user's judgment, are appropriate for the specific product and intended application. Selected end points may be different for light and dark stability tests.

The set of criteria in *ANSI IT9.9-1990* also does not make provision for selecting *different* limits for cyan, magenta, and yellow dye losses, or for *different* limits for different directions of color balance change. In the future, ANSI may adopt a set of specifications for what constitutes "acceptable" fading and staining for color print and film materials.

At the time this book went to press in 1992, no one yet had published Arrhenius predictions based on the set of image-life parameters specified in *ANSI IT9.9-1990*. Since 1984, Konica has used a simple "30% loss of the least stable image dye" limit on which to base its claim of a 100-year dark storage life for Konica Color Paper Type SR (also called "Century Print Paper" and "Long Life 100 Paper" in Konica's promotional literature for the paper). This is a fairly large loss in dye density and results in a significant color shift toward magenta. Especially with Type SR paper processed with a normal water wash, the dye loss is accompanied by a high level of yellowish stain. One could speculate that Konica's principal motivation in selecting the large, 30% density loss figure was so that the claim of a 100-year print life could be made.

## Eastman Kodak's Guidelines for Color Image Fading

In a March 1991 Eastman Kodak publication entitled *Evaluating Image Stability of Kodak Color Photographic Products,*[28] the company issued the following dye-loss guidelines (from a 1.0 neutral patch) for prints, transparencies, and other color materials that are directly viewed (these guidelines do not apply to color negative materials):

• **0.10 Dye Loss** (remaining density 0.90)
  A 10% dye loss is only observable in a critical side-by-side comparison with an unfaded sample of the same image.

• **0.20 Dye Loss** (remaining density 0.80)
  A 20% dye loss is observable in a critical evaluation of the image by itself by someone familiar with the original quality of the image.

• **0.30 Dye Loss** (remaining density 0.70)
  A 30% dye loss is sufficient that most observers are aware that the image has faded and has less quality. However, since this is a very subjective evaluation, losses beyond 30% may continue to be acceptable depending on the intended use of the photographic material or the nature of the image.

Kodak went on to say: "These are only general guidelines, and assume some neutral and some non-neutral fading. Neutral fading (equal fading of different colors) is far less evident than non-neutral fading (unequal fading of colors). The most extreme case is where fading of one dye in the material is significantly different from the fading of the other two dyes."

Following Konica's lead, Kodak has in a few instances also based claims of a 100-year+ life for Ektacolor paper stored in the dark on a 30% loss of the least stable image dye.

## ANSI Abolishes the Term "Archival," Replacing It with "LE Ratings" for B&W Films

In 1990, ANSI Committee IT9, which has jurisdiction over ANSI standards pertaining to physical properties and permanence of photographic materials and other imaging media, voted to abolish the long-standing "archival" designation in ANSI standards for black-and-white films and in standards concerned with storage conditions for photographic materials.

For films, ANSI replaced the "archival" designation with Life Expectancy ratings (LE ratings), which are given as "years of useful life" under specified processing and storage conditions. Definitions for these new terms are included in *ANSI IT9.1-1991, American National Standard for Imaging Media (Film) – Silver-Gelatin Type – Specifications for Stability*[29] (the wording given here is tentative and may be somewhat altered in the published version of the Standard):

> **Archival Medium.** A recording material that can be expected to retain information forever so that it can be retrieved without significant loss when properly stored. However, there is no such material and it is not a term to be used in American National Standard material or system specifications.
>
> **Life Expectancy (LE).** The length of time that information is predicted to be retrievable in a system under extended-term storage conditions. (Note: The term "Life Expectancy" is a definition. However, the actual useful life of film is very dependent upon the existing storage conditions [see *IT9.11*].)
>
> **LE Designation.** A rating for the "life expectancy" of recording materials and associated retrieval systems. The number following the LE symbol is a prediction of the minimum life expectancy in years for which information can be retrieved without significant loss when stored under extended term storage conditions, e.g., LE–100 indicates that information can be retrieved after at least 100 years storage.
>
> **Extended-Term Storage Conditions.** Storage conditions suitable for the preservation of recorded information having permanent value.
>
> **Medium-Term Storage Conditions.** Storage conditions suitable for the preservation of recorded information for a minimum of ten years.

In *ANSI IT9.1-1991,* the maximum LE rating for black-and-white films with a cellulose ester (e.g., cellulose triacetate) base is set at 100 years when the film is kept under Extended-Term storage conditions, and the maximum LE rating for polyester-base films is 500 years.

If ANSI subcommittee IT9-3, the group responsible for the *ANSI IT9.9* color stability test methods Standard, is able to come to agreement on what constitutes "acceptable" levels of fading and staining for color prints and films, and can also define a set of standard storage and display conditions, the concept of LE ratings could be expanded to include color materials.

## Densitometric Correction for Minimum-Density Yellowish Stain

In this author's tests, most types of prints developed some yellow stain density as a consequence of exposure to light, but in almost no case was a minimum-density (stain) criterion the first limit to be reached. In accelerated dark fading tests, the minimum-density change limits were often reached very quickly, but Ilford Cibachrome (Ilfochrome), Kodak Dye Transfer, and Fuji Dyecolor prints developed little if any stain density during these light fading tests.

For determining absolute density loss of the cyan, magenta, and yellow dyes, this author has "d-min corrected" (also called "stain-corrected") all densitometric data prior to analysis. That is, increases in red, green, or blue density measured at d-min have been *subtracted* from the all densities above d-min. If stain density were not subtracted, it would, to the degree that stain has occurred, mask the dye fading that has actually taken place. For example, a yellowish d-min stain causing a blue density increase of 0.08 could make a medium-density yellow dye appear not to have faded at all when in fact it lost 0.08.

While it is true that the human eye does not "subtract" stain density in this way (a person looking at a print sees the visual combination of the image dye and stain), it is essential that stain be subtracted for meaningful analysis of density loss. Otherwise, it would be of *benefit* for a print to develop stain density because this would lessen measured dye fading. In this author's sets of image-life fading limits, losses of absolute density can be thought of as "information" losses, measured as losses of image detail and contrast.

The concept of stain-correcting (d-min correcting) data makes the assumption that stain measured at d-min occurs to the same degree throughout the density range of the print. Unfortunately, this assumption is not always justified; some types of photographs (e.g., Polacolor 2 prints) generate more stain in high-density areas than at d-min.

Stain in chromogenic prints is caused mostly by "print-out" of unused magenta coupler, and logic would dictate that in high-density portions of an image, most of the magenta coupler has been converted to image dye and therefore less stain should be present. However, with a conventional densitometer, stain density cannot be distinguished from dye density, except by inference from changes observed at d-min, and for this reason we have no recourse except to base corrections on d-min measurements.

It is obvious that even with its shortcomings, d-min corrections made in this manner are better than simply not stain-correcting density data at all. One certainly does not want to reward a print material for stain! It is believed that most of the product-fading information published by Kodak and the other major manufacturers has been derived from d-min corrected data (Kodak has not generally published stain characteristics for prints and films stored in the dark).

Determining color imbalances is another matter, however, and based on study of many moderately faded (and stained) pictorial prints, it is apparent that much better visual correlation is obtained when densitometric data are *not* d-min corrected. Shifts in color balance toward yellow, for example, are accentuated by yellow stain, and this is visually most apparent in low-density portions of the image. At the critical densities between about 0.35 and 0.60, stain is frequently a major determinant of perceived color shift (shown previously in **Figure 2.19**).

In the tests conducted by this author to help formulate the criteria sets described here, changes in pure cyan, magenta, and yellow patches were also measured and analyzed, although fading limits for these separate colors were not included in either the "Museum and Archive" or "Home and Commercial" criteria limits. When these colors also exist in a print in equal amounts to form a neutral gray, the pure colors often fade much faster than they do in a neutral gray area. The significance of this is very scene-dependent and can be difficult to interpret; for example, a "blue" sky on a print typically consists mostly of cyan dye, much of which can be lost and still leave a blue sky, even if it is a lighter shade of blue.

The particular relationship of pure-color versus gray-scale fading also differs with each type of print material, and this author feels that a great deal more study is required if meaningful limits are to be assigned. In general, the analysis of gray-scale fading appears to be the best single indicator of the overall light fading performance of a material.

How much and what kind of image fading and staining are objectionable, and defining the "useful" life of a displayed color print, are topics that are certain to be discussed and argued about for years to come. Although much effort has gone into determining the two sets of criteria limits given here, they are obviously not the last word on the subject. Statistical studies need to be done to better evaluate the responses to faded images by people of different backgrounds and cultures. Variation of tolerance to yellowish print stain among individuals in different parts of the world is a highly interesting aspect of this subject and certainly merits further investigation.

This author expects that these criteria will be modified in the future as more experience is gained with faded prints made on the broad range of color products now on the market; it is also possible that separate sets of criteria should be devised for dark-faded prints and transparencies because this type of deterioration has some significant visual differences from fading and staining caused by light fading.

The selection of a particular percentage of density loss, beyond which fading will be considered objectionable, will always be somewhat arbitrary. Given the variety of pictorial scenes, the different fading characteristics of the many types of print materials in use, and the variations in indi-

John Wolf – July 1980

Henry Wilhelm taking density readings from print samples that have been undergoing accelerated light fading tests. Since this work began in 1977, this author has made more than one million individual densitometer readings. At first, as was the case when this photograph was taken in 1980, the data were manually transcribed into notebooks. Since 1983, however, the data have been downloaded electronically from Macbeth and X-Rite densitometers to a Hewlett-Packard HP-125 computer for recording, d-min correction, and analysis according to the sets of image-life criteria described in this chapter. To facilitate this work, a number of computer programs were written for this author by June Clearman, a mathematician and programmer.

vidual responses to faded photographs, it would be difficult to say that a minimum-density color imbalance of 0.06 between yellow and magenta is acceptable while a 0.08 color imbalance is not. Yet, in some cases, that small 0.02 variation in acceptability can result in a large difference in the stability ranking of a product.

In spite of these limitations, the two sets of image-life criteria given here can be quite helpful in comparing the image stability of one product with another, and in making predictions of how long a particular type of print can be displayed before objectionable fading occurs. The criteria correlate reasonably well with visual perceptions of faded color images, and this author believes they represent a significant improvement over past methods of evaluating the fading and staining of color photographs.

## Densitometers for Measuring Fading and Staining

Photographic densitometers are electronic instruments that measure the optical density of photographic materials. Transmission densitometers are used with transparent films, and prints are measured with reflection densitometers. The instruments have long been employed in the photographic industry for research and development work, process control, and other purposes.

Color densitometers have separate filters, or "channels," that measure the densities of the cyan, magenta, and yellow dyes that form the images in most color materials. In what is sometimes confusing to those not familiar with color densitometry and the subtractive system of color image formation, the cyan dye is measured with a red filter (because cyan dye absorbs light primarily in the red portion of the spectrum) and changes in cyan dye density are often referred to as "red density" changes. The same holds true for magenta dye density changes ("green density"

changes), and yellow dye density changes ("blue density" changes).

During the course of this work, which had its beginnings in 1976, this author has used ESECO, Macbeth, and X-Rite densitometers. More than one million individual density readings have been made by this author during this 16-year period. Especially in research conducted over long periods of time, a number of potential problems with densitometers may arise.

To maintain accuracy of the system, especially when densitometer filters are replaced (or, a much more critical matter, when the entire instrument is replaced with a new model), it is *essential* that representative color print and film samples be preserved in a freezer at 0°F (–18°C) or colder. These "freezer check" samples can be withdrawn from cold storage from time to time to verify instrument calibration. Any deviations from the original readings made with these samples can be used to make numerical corrections to current readings. This subject is discussed in greater detail in Chapter 7, and is also discussed in *ANSI IT9.9-1990*.

## Computer Acquisition and Processing of Densitometer Data

When this author acquired his first densitometer and began doing systematic research on color stability in 1977, each reading had to be transcribed by hand into notebooks. This not only was tedious and time-consuming but also required constant double-checking to keep transcription errors to a minimum. (If a mistake is made and a number is incorrectly entered into a notebook, it is usually difficult to detect, and if it happens to be detected, it is usually impossible to precisely correct after the fact.)

During the course of a test, densitometer readings from each individual sample may be taken ten or more times.

Bob Schwalberg – October 1989

This author, his son David Wilhelm, and Carol Brower discussing some of the test data accumulated over the years. Data files are stored on computer disks, and hardcopy printouts (shown here in ring binders) are generated by computer after each sample has been read with a densitometer.

With each sample, which consists of a photograph of a Macbeth ColorChecker color test chart, four readings (through the red, green, blue, and visual densitometer filters) are made from 11 of the patches in the ColorChecker image. Included among the patches that are measured are a 6-step gray scale; cyan, magenta, and yellow patches; and light and dark skin tone patches. In addition, a reading is made from a separate clear d-min (white) patch. This comes to a total of at least 480 individual densitometer readings per sample. To improve the reliability of the whole testing procedure, a minimum of three replicate samples are run for each product under each test condition. Over the years this has involved thousands of samples and well over one million individual density readings.

After the data are recorded, there remains the task of determining at exactly what point the limit for each of the previously described fading and staining criteria has been reached. Because the test samples do not have precise 1.0 or 0.6 (or 0.45 for "museum and archive" applications) neutral density patches from which to report changes in red, green, and blue densities, it is necessary to mathematically interpolate the desired densities from adjacent patches that are both higher and lower in density than the target densities. Additionally, the density loss criteria require that data be corrected for yellowish or other stain that

develops in d-min areas over the course of a test.

With an ever-increasing number of product samples being added to this author's testing program, the amount of work involved soon became so overwhelming that it could not continue without computerizing the entire data acquisition, d-min correction, and criteria analysis process.

Over a period of several years, beginning in 1983, June Clearman, a mathematician and computer programmer who at the time worked at the Robert N. Noyce Computer Center at nearby Grinnell College, wrote a series of programs to run on this author's Hewlett-Packard HP-125 computer to handle all of the necessary data recording and analysis tasks (see **Appendix 2.1** on page 99 for a description of some of the mathematical procedures employed in these programs). Both the Macbeth TR-924 and X-Rite 310 densitometers used by this author were hardwired directly to the HP-125 computer using interface routines written by Clearman, and this eliminated the need for manual transcription of data into notebooks.

Special programs were written to enter into the computer the densitometer data that had been transcribed in notebooks during the previous 6 years. Keyboarding and verifying the accumulated notebook data were a major undertaking, but this transcription permitted d-min corrections, density scale interpolations, and criteria analysis to

be done by computer with the data from the older products and proved to be a very valuable addition to this author's product-stability database.

Today, these data files are stored on about 200 floppy disks. To avoid data loss in the event of fire or tornado (most of the town of Grinnell was destroyed by a tornado in 1882, and a tornado hit the edge of town in 1978), a complete backup set of data disks is kept in a safe deposit box in a Grinnell bank. In addition, hardcopy printouts in binders are kept for all of the data. In the future, the whole system will be transferred to Apple Macintosh computers and additional programs will be written for Arrhenius testing and other data-handling and analysis needs.

## Processing of Test Samples

When Kodak, Fuji, and other manufacturers test color films and papers, their samples have received optimal processing and thorough washing under carefully controlled laboratory conditions. This is done both to show the products to their best advantage and to be sure that tests will be repeatable over time (that is, to eliminate processing variations as a consideration).

In the real world of replenished processing lines, hurried lab schedules, and efforts to keep chemical and water costs to a minimum, conditions frequently are not so well controlled, and image stability can suffer. In some cases, processing shortcomings such as chemical exhaustion, excessive carryover of processing solutions from one tank to the next, inadequate water flow in wash tanks, or omission of a stabilizer bath have resulted in drastic reduction in image stability.

In recent years, a number of companies have entered the photographic processing chemicals market, generally supplying chemicals at lower cost than do Kodak, Fuji, and the other major manufacturers. What effects that processing chemicals from these outside suppliers might have on long-term image stability is not known. Some companies, in an effort to shorten processing time or reduce the number of processing steps, have substituted color developing agents, eliminated stabilizer baths, and taken other shortcuts that could adversely affect image stability. For predictable results, it is recommended that only chemicals from the major materials manufacturers (i.e., Kodak, Fuji, Agfa, and Konica) be used for processing test samples. Processing recommendations, replenishment rates, wash flow, and temperature specifications should be followed to the letter.

Most labs try to retain tight control on color developer activity — that is, to reduce any process deviation resulting in image-quality losses that can be visually assessed immediately after processing. But other processing problems, such as too-diluted (or omitted) C-41 or E-6 stabilizer baths, excess bleach/fix carryover, or inadequate washing, may not manifest themselves until years later.

In an attempt to represent the real world of good-quality, replenished-line processing, all C-41 color negative films, E-6 transparency films, and Kodachrome films in this author's testing program were processed by the Kodalux Processing Services of Qualex, Inc. Eastman Kodak owns almost half of Qualex (the former Kodak Processing Laboratories are now part of Qualex), and Kodak chemicals are used

Carol Brower – September 1983

Carefully processed print samples for testing are produced in the Preservation Publishing Company darkroom. Most of the prints have been processed with a Kodak Rapid Color Processor (Model 11) equipped with a precision, electronically controlled temperature regulator. Processing chemicals are freshly mixed, used only once, and then discarded. Prints are thoroughly washed, both front and back.

exclusively. Because of Kodak's close involvement with Qualex, it was assumed that the labs pay close attention to proper chemical replenishment and washing, and the consistency of stability data obtained from the same type of film processed at different times by Kodalux suggests that this is, at least for the most part, true.

In order to obtain closely matched pictorial prints for reproduction in this book, for use in articles, and for corresponding Macbeth ColorChecker[30] test samples for densitometry, EP-2 and R-3 compatible papers were processed by this author with Kodak chemicals in a Kodak Rapid Color Processor (Model 11) which has been fitted with a precise electronic temperature regulator. Each test print was made with fresh chemicals (Kodak Ektaprint EP-2 Stop Bath was used between the developer and bleach/fix), and the prints were carefully washed.

Processed Cibachrome samples were furnished by Ilford in Switzerland, and additional samples were processed by this author. Kodak Dye Transfer prints were made in several different New York City labs. Fuji Dyecolor prints were made by Fuji in Japan. UltraStable Permanent Color prints and Polaroid Permanent-Color prints were supplied by Charles Berger, the inventor of both processes.

Konica, Fuji, and Agfa RA-4 compatible paper samples

were processed by their respective manufacturers from test negatives furnished by this author; in most cases, print samples processed with a water wash and with a washless stabilizer in a minilab were made available. Kodak declined to furnish processed samples of its Ektacolor RA-4 papers to this author, so these prints were obtained from several different one-hour labs using Kodak minilabs and Kodak RA-4 chemicals. In addition, sample prints made on Ektacolor Supra, Ektacolor Portra, and Ektacolor Portra II papers were obtained from several top-quality professional labs in 1991 and 1992.

Exactly what constitutes "typical" or "normal" processing cannot be specified at this time. Also unknown is how the stability of each of the vast number of different film and print materials on the market is affected by different types of processing chemicals and by process deviations — some products are obviously more sensitive to improper processing than are others. Yellowish stain formation during dark storage appears to be particularly affected by processing and washing conditions; a sobering study on this topic was presented in 1986 by Ubbo T. Wernicke of Agfa-Gevaert entitled "Impact of Modern High-Speed and Washless Processing on the Dye Stability of Different Colour Papers."[31]

This author has accumulated a large store of unprocessed color paper, transparency films, and color negative films in refrigerated storage so that, if necessary, additional work can be done in the future with materials that are no longer being manufactured.

# Notes and References

1. Konica Corporation, full-page advertisement, **Professional Photographer,** Vol. 111, No. 2069, October 1984, p. 20.

2. American National Standards Institute, Inc., **ANSI PH1.42-1969, Method for Comparing the Color Stabilities of Photographs** [reaffirmed 1981], American National Standards Institute, Inc., New York, New York, 1969. The Standard was based largely on an article by three Kodak researchers, David C. Hubbell, Robert G. McKinney, and Lloyd E. West, "Method for Testing Image Stability of Color Photographic Products," **Photographic Science and Engineering,** Vol. 11, No. 5, pp. 295–305, September–October 1967. In August 1990, **ANSI PH1.42-1969** was replaced by **ANSI IT9.9-1990,** listed below.

3. American National Standards Institute, Inc., **ANSI IT9.9-1990, American National Standard for Imaging Media – Stability of Color Photographic Images – Methods for Measuring,** American National Standards Institute, Inc., New York, New York, 1991. Copies of the Standard may be purchased from the American National Standards Institute, Inc., 11 West 42nd Street, New York, New York 10036; telephone: 212-642-4900 (Fax: 212-398-0023).

4. Henry Wilhelm, "Reciprocity Failures in Accelerated Light Fading and Light-Induced Staining of Color Prints," presentation at the **Third International Symposium on Image Conservation** [see: **Advance Printing of Paper Summaries,** p. 11], sponsored by the Society for Imaging Science and Technology (IS&T), International Museum of Photography at George Eastman House, Rochester, New York, June 18, 1990. See also: Henry Wilhelm, "Reciprocity Effects in the Light Fading of Reflection Color Prints," 33rd SPSE Annual Conference Program [abstracts], **Journal of Applied Photographic Engineering,** Vol. 6, No. 2, April 1980, p. 58A. This author's first findings on light fading reciprocity failures were contained in a 1978 presentation entitled "Light Fading Characteristics of Reflection Color Print Materials," given at the annual conference of the Society of Photographic Scientists and Engineers, Washington, D.C., May 1, 1978, in a conference session organized by Klaus B. Hendriks of the National Archives of Canada and entitled "Stability and Preservation of Photographic Materials" (see: 31st SPSE Annual Conference Program [abstracts], **Journal of Applied Photographic Engineering,** Vol. 4, No. 2, Spring 1978, p. 54A).

5. Fuji Photo Film Co., Ltd., **Fujichrome Paper Type 34,** Fuji Film Data Sheet (Color Reversal Papers), Ref. No. AF3-638E (89.7-OB-5-6), July 1989, p. 6. See also: Fuji Photo Film Co., Ltd., **Fujichrome Paper**

**Type 35,** Fuji Film Data Sheet (Color Reversal Papers), Ref. No. AF3-718E (92.1-OB-3-1), January 1992, p. 7. See also: Fuji Photo Film Co., Ltd., **Fujicolor Professional Paper Super FA,** Fuji Film Data Sheet (Color Negative Papers), Ref. No. AF3-661E (90.2-OB-10-1), February 1990, p. 7. See also: Fuji Photo Film Co., Ltd., **Fujicolor Paper Super FA Type 3,** Fuji Film Data Sheet (Color Negative Papers), Ref. No. AF3-723E (92.1-OB-5-1), January 1992, p. 7.

6. Ilford Photo Corporation, **Mounting and Laminating Cibachrome Display Print Materials and Films,** (Technical Information Manual), Cat. No. 7929-RMI 895M, 1988, p. 6.

7. Stanton Anderson and Ronald Goetting, "Environmental Effects on the Image Stability of Photographic Products," **Journal of Imaging Technology,** Vol. 14, No. 4, August 1988, pp. 111–116. This article contains a graph showing the predicted fading of Kodak Ektacolor Plus Paper in "display years," based on an illumination intensity of 100 lux for 12 hours per day (Fig. 24, p. 113). The 100-lux level was adopted in **Image-Stability Data: Kodachrome Films,** "Reference Information from Kodak," Kodak Publication E-105, March 1988. Kodak also used the 100-lux level in: Eastman Kodak Company, **Evaluating Image Stability of Kodak Color Photographic Products,** Kodak Publication CIS-130 (Current Information Summary), Eastman Kodak Company, 343 State Street, Rochester, New York 14650, March 1991, p. 5. These publications have not been widely distributed and this author is not aware of any general consumer or professional Kodak publications making an image-life prediction, expressed in "display years," based on data from accelerated light fading tests.

8. Robert Tuite, "Image Stability in Color Photography," **Journal of Applied Photographic Engineering,** Vol. 5, No. 4, Fall 1979, pp. 200–207.

9. Yoshio Seoka, Seiiti Kubodera, Toshiaki Aono, and Masato Hirano, "Some Problems in the Evaluation of Color Image Stability," **Journal of Applied Photographic Engineering,** Vol. 8, No. 2, April 1982, pp. 79–82. This article was based on a presentation given at the 1980 **International Conference on Photographic Papers,** William E. Lee, chairman, sponsored by the Society of Photographic Scientists and Engineers (SPSE), Hot Springs, Virginia, August 11, 1980.

10. Toshiaki Aono, Kotaro Nakamura, and Nobuo Furutachi, "The Effect of Oxygen Insulation on the Stability of Image Dyes of a Color Photographic Print and the Behavior of Alkylhydroquinones as Antioxidants," **Journal of Applied Photographic Engineering,** Vol. 8, No. 5, October 1982, pp. 227–231.

11. Bob Schwalberg, with Henry Wilhelm and Carol Brower, "Going! Going!! Gone!!! – Which Color Films and Papers Last Longest? How Do the Ones You Use Stack Up?", **Popular Photography,** Vol. 97, No. 6, June 1990, pp. 37–49, 60. With a circulation of approximately one million copies, **Popular Photography** is the world's most widely read photography magazine.

12. Arnold Wexler and Saburo Hasegawa, "Relative Humidity-Temperature Relationships of Some Saturated Salt Solutions in the Temperature Range of 0° to 50℃," **Journal of Research of the National Bureau of Standards,** Vol. 4, No. 4, July 1954, pp. 19–25. See also: D. S. Carr and B. L. Harris, "Solutions for Maintaining Constant Relative Humidity," **Journal of Industrial Engineering Chemistry,** Vol. 41, 1949, pp. 2014–2015.

13. Armin Meyer and Daniel Bermane, "Stability and Permanence of Cibachrome Images," **Journal of Applied Photographic Engineering,** Vol. 9, No. 4, August 1983, pp. 121–125.

14. Svante August Arrhenius, **Zeitschrift fur physikalische Chemie,** Vol. 4, 1889, p. 226.

15. Fred H. Steiger, "The Arrhenius Equation in Accelerated Aging," **American Dyestuff Reporter,** Vol. 47, No. 9, May 5, 1958, pp. 287–290.

16. A. E. Juve and M. G. Schoch, Jr., **ASTM Bulletin,** No. 195, 1954, p. 54.

17. C. P. Doyle, **Modern Plastics,** Vol. 33, No. 7, 1956, p. 143.

18. Peter Z. Adelstein, C. Loren Graham, and Lloyd E. West, "Preservation of Motion-Picture Color Films Having Permanent Value," **Journal of the SMPTE,** Vol. 79, No. 11, November 1970, pp. 1011–1018.

19. Charleton C. Bard, George W. Larson, Howell Hammond, and Clarence Packard, "Predicting Long-Term Dark Storage Dye Stability Characteristics of Color Photographic Products from Short-Term Tests," **Journal of Applied Photographic Engineering,** Vol. 6, No. 2, April 1980, pp. 42–45.

20. B. Lavedrine, C. Trannois, and F. Flieder, "Etude experimentale de la stabilite dans l'obscurite de dix films cinematographiques couleurs," **Studies in Conservation,** Vol. 31, No. 4, November 1986, pp. 171–174.

21. Stanton Anderson and Robert Ellison, "Natural Aging of Photographs," **Journal of the American Institute for Conservation,** Vol. 31, No. 2, Summer 1992, pp. 213–223.

22. Charleton C. Bard [Eastman Kodak Company], "Clearing the Air on the Stability of Color Print Papers," presentation at the **SPSE Fourth International Symposium on Photofinishing Technology** [see ab-

stract in: **Program and Paper Summaries,** p. 9], Las Vegas, Nevada, February 10–12, 1986. Sponsored by the Society of Photographic Scientists and Engineers (SPSE). See also: Stanton I. Anderson and David F. Kopperl [Eastman Kodak Company], "Limitations of Accelerated Image Stability Testing," presentation at **IS&T's Seventh International Symposium on Photofinishing Technology,** Las Vegas, Nevada, February 3–5, 1992, sponsored by the Society for Imaging Science and Technology (IS&T). See also: D. F. Kopperl, R. J. Anderson, R. Codori, R. Ellison, and B. V. Erbland [Eastman Kodak Company], "Quality Improvements and Control Procedures at the Image Stability Technical Center," **Journal of Imaging Technology,** Vol. 16, No. 5, October 1990, pp. 198–202.

23. A. Tulsi Ram, D. Kopperl, R. Sehlin, S. Masaryk-Morris, J. Vincent, and P. Miller [Eastman Kodak Company], "The Effects and Prevention of 'Vinegar Syndrome'," presented at the **Annual Conference of the Association of Moving Image Archivists**, San Francisco, California, December 10, 1992.

24. Stanton I. Anderson and George W. Larson, "A Study of Environmental Conditions Associated with Customer Keeping of Photographic Prints," **Journal of Imaging Technology**, Vol. 13, No. 2, April 1987, pp. 49–54. See also: Stanton I. Anderson and Richard J. Anderson, "A Study of Lighting Conditions Associated with Print Display in Homes," **Journal of Imaging Technology**, Vol. 17, No. 3, June–July 1991, pp. 127–132.

25. Eastman Kodak Company, **Evaluating Dye Stability of Kodak Color Products,** Kodak Publication No. CIS-50, January 1981, and subsequent CIS-50 series of dye-stability data sheets through 1985; **Kodak Ektacolor Plus and Professional Papers for the Professional Finisher,** Kodak Publication No. E-18, March 1986; **Image-Stability Data: Kodachrome Films,** Kodak Publication E-105, March 1988; **Image-Stability Data: Ektachrome Films,** Kodak Publication E-106, May 1988; **Image Stability Data: Kodak Color Negative Films (Process C-41),** Kodak Publication E-107, June 1990; **Dye Stability of Kodak and Eastman Motion Picture Films,** Kodak Publication DS-100 and DS-100-1 through DS-100-9, Eastman Kodak Company, Rochester, New York, May 1981.

26. Donald A. Koop [Eastman Kodak Company], "A Relationship Between Fading and Perceived Quality of Color Prints," presented at the **Second International Symposium: The Stability and Preservation of Photographic Images,** at the Public Archives of Canada (renamed the National Archives of Canada in 1987), sponsored by the Society of Photographic Scientists and Engineers (SPSE), August 27, 1985.

27. Preliminary color print fading and staining parameters and limits for "acceptable" change were first proposed by this author in a 1978 presentation entitled "Light Fading Characteristics of Reflection Color Print Materials," given at the **31st Annual Conference of the Society of Photographic Scientists and Engineers,** Washington, D.C., May 1, 1978, in a conference session organized by Klaus B. Hendriks of the National Archives of Canada and entitled "Stability and Preservation of Photographic Materials" (see: 31st SPSE Annual Conference Program [abstracts], **Journal of Applied Photographic Engineering,** Vol. 4, No. 2, Spring 1978, p. 54A). A more complete description of the fading and staining limits was included in an article by this author entitled "Monitoring the Fading and Staining of Color Photographic Prints," **Journal of the American Institute for Conservation,** Vol. 21, No. 1, 1981, pp. 49–64.

28. Eastman Kodak Company, **Evaluating Image Stability of Kodak Color Photographic Products,** Kodak Publication CIS-130 (Current Information Summary), Eastman Kodak Company, 343 State Street, Rochester, New York 14650, March 1991, p. 8.

29. American National Standards Institute, Inc., **ANSI IT9.1-1991, American National Standard for Imaging Media (Film) – Silver-Gelatin Type – Specifications for Stability,** American National Standards Institute, Inc., New York, New York, 1991, p.8. Copies of the Standard may be purchased from the American National Standards Institute, Inc., 11 West 42nd Street, New York, New York 10036; telephone: 212-642-4900 (Fax: 212-398-0023).

30. The Macbeth ColorChecker chart may be purchased from photographic suppliers or from the Macbeth Division, Kollmorgen Instruments Corporation, 2441 N. Calvert Street, Baltimore, Maryland 21218; telephone: 301-243-2171. For a technical description of the specific colors provided in the Macbeth ColorChecker see: C. S. McCamy, H. Marcus, and J. G. Davidson, "A Color Rendition Chart," **Journal of Applied Photographic Engineering,** Vol. 11, No. 3, Summer 1976, pp. 95–99.

31. Ubbo T. Wernicke, "Impact of Modern High Speed and Washless Processing on the Dye Stability of Different Colour Papers," **International Symposium: The Stability and Conservation of Photographic Images: Chemical, Electronic and Mechanical,** Bangkok, Thailand, November 3–5, 1986. The symposium was sponsored by the Society of Photographic Scientists and Engineers (SPSE) and the Department of Photographic Science and Printing Technology, Chulalongkorn University, in collaboration with Kodak (Thailand) Limited. See also: Heinz Meckl and Gunter Renner, "Stabilizing Bath for Colour Paper: Problems and Solutions," **Fifth International Symposium on Photofinishing Technology and Marketing,** sponsored by the Society for Imaging Science and Technology (SPSE), Chicago, Illinois, February 25–26, 1988. See also: Shigeru Nakamura, Masakazu Morigaki, and Hiroyuki Watanabe [Fuji Photo Film Co., Ltd.), "Photoprocessing Factors Affecting Color Image Stability," presentation at **IS&T's Seventh International Symposium on Photofinishing Technology,** Las Vegas, Nevada, February 3–5, 1992. Sponsored by the Society for Imaging Science and Technology (IS&T).

## Additional References

P. Z. Adelstein and J. L. McCrea, "Dark Image Stability of Diazo Films," **Journal of Applied Photographic Engineering,** Vol. 3, 1977, pp. 173–178.

Eastman Kodak Company, **How Post-Processing Treatment Can Affect Image Stability of Prints on Kodak Ektacolor Paper,** Kodak Publication CIS-62, Eastman Kodak Company, Rochester, New York, February 1982. The material in this publication is based on a presentation by Paul M. Ness, Professional Photography Marketing, and Charleton K. Bard, Image Stability Technical Center, Eastman Kodak Company, given at the February 28, 1982 meeting of the Wisconsin Professional Photographers Association, Oconomowoc, Wisconsin. See also: Paul M. Ness and Charleton C. Bard, "Help Color Prints Last – The Effects of Post-Processing Treatments on the Dye Stability of Prints on Kodak Ektacolor Paper," **Professional Photographer,** Vol. 109, No. 2038, March 1982, pp. 27–28.

Eastman Kodak Company, "Dye Stability – Kodak Scientists Discuss Practical and Theoretical Duration," **Professional Photographer,** Vol. 109, No. 2038, March 1982, pp. 22–26.

Eastman Kodak Company, **Image Stability Technical Center,** Kodak Brochure No. M7L044, Eastman Kodak Company, Rochester, New York, January 1988.

Larry F. Feldman, "Discoloration of Black-and-White Photographic Prints," **Journal of Applied Photographic Engineering,** Vol. 7, No. 1, February 1981, pp. 1–9.

Etsuo Fujii, Hideko Fujii, and Teruaki Hisanaga, "Evaluation on the Stability of Light Faded Images of Color Reversal Films According to Color Difference in CIELAB, Journal of Imaging Technology, Vol. 14, No. 2, April 1988, pp. 29–37; see correction of two tables in "Errata," **Journal of Imaging Technology,** Vol. 14, No. 3, June 1988, p. 93.

Klaus B. Hendriks, together with Brian Thurgood, Joe Iraci, Brian Lesser, and Greg Hill of the National Archives of Canada staff, **Fundamentals of Photographic Conservation: A Study Guide,** published by Lugus Publications in cooperation with the National Archives of Canada and the Canada Communication Group, 1991. Available from Lugus Productions Ltd., 48 Falcon Street, Toronto, Ontario, Canada M4S 2P5; telephone: 416-322-5113; Fax: 416-484-9512.

Souichi Kubo [Chiba University], **Shashin Kogyo,** Vol. 50, No. 513, pp. 10–11 and 46–51, 1992. See also related article: "Color Paper Dye Fade Has Been Reduced In Half — Quality Improvement of Color Couplers — Konica Has Completed the Change-Over," **Nikkei Sangyo Shinbun** [Japan Industrial Newpaper], September 12, 1992, p. 5.

Noboru Ohta, "Color Reproduction in Reflection-type Color Prints," **Journal of Applied Photographic Engineering,** Vol. 2, No. 2, Spring 1976, pp. 75–81.

J. E. Pinney and W. F. Voglesong, "Analytical Densitometry of Reflection Color Print Materials," **Photographic Science and Engineering,** Vol. 6, No. 6, 1962, pp. 367–370.

S. J. Popson, "A Comparison of Densitometers, Reflectometers, and Colorimeters," **Printing** (TAPPI Journal), March 1989, pp. 119–122.

Tadahisa Sato, Masakazu Morigaki, and Osamu Takahashi [Fuji Photo Film Co., Ltd.], "New Type Color Paper with Exceptional Dye Image Stability – Fujicolor Paper Super FA Type 3," presentation at **IS&T's Seventh International Symposium on Photofinishing Technology,** Las Vegas, Nevada, February 3–5, 1992. Sponsored by the Society for Imaging Science and Technology (IS&T).

Yoshio Seoka and Yasuo Inoue, "Effects of Temperature, Humidity and Spectral Property of Exposure Light on Yellowing of Color Prints," **The Second SPSE International Conference on Photographic Papers,** Vancouver, British Columbia, Canada, July 22–25, 1984.

Henry Wilhelm, "Color Print Instability," **Modern Photography,** Vol. 43, No. 1, February 1979, pp. 92–93, 118ff. This was an expanded version of: "Color Print Instability: A Problem for Collectors and Photographers," **Afterimage** (a publication of Visual Studies Workshop, Rochester, New York), Vol. 6, No. 3, October 1978, pp. 11–13, and "Color Print Permanence – A Problem for Collectors," **Print Letter** [Switzerland], No. 17, October 1978, pp. 10–12.

*(Chapter 2 – Appendix 2.1 on following pages)*

# Appendix 2.1 – Methods of Computer Analysis of Densitometer Data

**By June Clearman**
Programmer/Analyst

The programming of the automatic transfer of densitometer readings to a computer for storage on magnetic disks, the calculation of the various curves, and the application of image-life criteria required several assumptions and simplifications. The reading of a new sample with a stepwise visual scale (either a gray scale and/or a step wedge of cyan, magenta, yellow, or other selected colors) could yield values that were not necessarily the same as the readings for any other new sample, or even the same as another copy of a particular sample. Although these steps were roughly arranged in an exponential (or logarithmic) progression, so that there was a temptation to fit a smoothed exponential curve to the data, there was really no logical reason to do so. The reason for wanting to fit a curve at all rather than to deal only with the discrete points of the readings was for the purpose of comparison among samples. One could make immediate comparisons by following, on different samples, what happens from an initial density reading of, for instance, 0.6 at specific intervals of elapsed time. In our judgment, the densitometer, with proper checking, could be trusted, within its range, for greater accuracy than the process producing the samples, or the assumption of a logarithmic progression. Therefore, any method for assuming values between the actual steps on the scale would have to be an interpolation between actual data points rather than a smoothed curve-fit method. That decision led to the next decision, which was the choice of an interpolation technique.

## Interpolation Methods

The simplest way to interpolate between two points is by joining them with a straight line. That method appears to involve no assumptions about the data beyond the initial assumption that the known points are accurate. However, if one were to join the end points only of a set of points, or the endpoints and the midpoint, such lines would probably miss all the intervening points somewhat, and we would realize that straight-line interpolation indeed is making an assumption about the shape of a curve within any interval. Furthermore, any straight-line joining of data points on a graph shows abrupt changes of direction from point to point, so that each recorded point represents a discontinuity in the curve. Even just intuitively, we wish to reject such discontinuities. One feels that a proper joining of half the recorded points should yield a curve not substantially different from one using all the points or from one using twice the number of recorded points (if we only had them). Probably the best, and simplest, method of accomplishing a smooth joining of readings taken at nonregular intervals is a method called "spline fitting," which will be explained below.

Our initial readings of a sample have the actual recorded data from our stepwise visual scale, to which we have arbitrarily assigned integer values corresponding to the order of the steps. That is, a value of 1 has been assigned to the step value of the least dense patch of the graduated visual scale, 0 to a clear minimum-density patch if such exists, and so forth. Using these values as the independent variable, and interpolating between the readings associated with these points, we then can say that a particular value of densitometer reading would exist at a particular non-integer value of the independent variable, if we can simply accept the reality of such a step as 1.55 or 2.68 (i.e., a step placed somewhere on a graduated scale between any two known steps). Then if, for instance, we find one of our desired initial densities yielding a step value of 2.68, on a second, or any subsequent, reading we may ask, given the density values at step 2 and step 3, what would the density at step 2.68 be, had we such a step. We are essentially reversing the process we used for the first reading. Instead of looking for the step value that corresponds to a particular density, we are now looking for what density value we should have been able to read had we arranged physically to have such a step value. This reversal of the interpolation process must, of course, use the same basic procedure as the initial interpolation, except that here, instead of trying to find the particular value on the step scale that represents a desired density value, we are looking for the density value that would be yielded by that particular step value. This reversal of procedure makes for a degree of simplification.

On the original reading, besides solving for the values needed to do the interpolation, we needed a search procedure on the interpolation curve to find, within a programmed degree of accuracy, the particular density values we had decided would be useful for comparisons. We have adopted a binary search technique, which simply means that starting with a known interval, we examine the midpoint and, from it, determine which half interval contains the desired value. A recursion of this method, given a continuous monotonic curve, quickly yields an interval sufficiently small for any desired degree of accuracy.

## Determining Failure Points for Image-Life Parameters

Application of the various image-life criteria to the successive sets of readings presents yet another situation where the spline-fit technique seemed to be a relatively simple and sensible way to arrive at a value of elapsed time that we knew must occur between any two actual sets of readings. Theoretically, the actual shape of the curves of density against time should be derivable from the chemistry involved. Practically, however, this is much too complex, encompassing as it does the chemistry of the particular photographic material and the chemistry of any subsequent image-deterioration effects — effects of the support material, staining, light sources, temperature, relative humidity, and so forth. So here again we must settle for an assumption that the actual density readings are the most accurate thing we have and that any attempt to connect the curves should be relatively smooth and continuous, but not a curve fit that departs from the actual data on some least squares or other error-tolerance scheme unless there are a sufficiently large number of readings to clearly define the curve shape.

Any such scheme implies the choice of a curve form, preferably one derived from the actual physics or chemistry of the phenomena under examination. This might be a polynomial expression, or exponential, or one or another transcendental expression. The choice of any one of them would require justification in terms of the physical and chemical processes involved. Therefore, we attempted to use spline fitting here also. However, in many cases where the density change was very small over relatively long time periods, or where the curve changed direction very quickly over short periods, we felt that a straight line might be as essentially correct an interpolation as any other method.

The problem of numerical accuracy, for instance, where a density change of only 0.02, for example, occurs over a period as long as perhaps 185 days is such that one can say very little about the exact spot where the change was 0.01. The computer was therefore programmed to yield both spline-fit and straight-line values. (Straight-line values were used for determining the criteria failure points reported in this book; spline-fit and other methods of curve smoothing as applied to irregular fading curves are a subject of continuing study.) It should be noted that, regardless of whether the criteria were applied to a single curve or were imbalance criteria involving the ratios between two curves, the fit and search routine was applied to the curves themselves, and not the ratios.

## The Spline-Fit Curve Smoothing Method

This interpolation method was named after a handy drafting device. Consisting of a flexible lead core encased in rubber, a spline can be bent to meet many points and produce a graph with a continuous slope and curvature.

What we do is solve for any point within any pair of adjacent points by using a third-degree polynomial, unique to each interval, that is determined in such a way that it passes through the end points of the interval and matches up each such interval, with the polynomials for the inter-

vals on each side, maintaining continuous first and second derivatives through the endpoints. This means that the slope at any interval endpoint $(p_k, y_k)$ is the same whether we compute it from the left using the interval $[p_{k-1}, p_k]$ or from the right using the interval $[p_k, p_{k+1}]$. These conditions would uniquely determine every polynomial for all intervals, except that at the first and last points we have nothing to match. This means that we are missing two conditions to complete our interpolation process. One solution is to require that the second derivative at each end point be a linear extrapolation of the second derivative at the neighboring points (i.e., the third derivatives are constant for $p_1$ and $p_2$ and for $p_{n-1}$ and $p_n$, i.e., $y'''_1 = y'''_2$ and $y'''_{n-1} = y'''_n$). Other endpoint methods could be used to determine the two missing conditions for a complete system of $n$ equations in $n$ unknowns.

# 3. Light Fading Stability of Displayed Color Prints

## Light-Induced Cracking of RC Papers: Is It Still a Problem with Color Prints?

. . . part of the reason the Cabinet project was done with photographs instead of the traditional oil paintings was that Smith was able to convince White House officials that the photographic papers such as Kodak Ektacolor Professional Paper offer improved image stability. In addition, photography offers quick results at a fraction of the cost of oil painting. So a 30" x 40" photograph taken by Smith and printed on Kodak Ektacolor Professional Paper now hangs at the entry of every Cabinet member's office on Capitol Hill.[1]

From an interview with Merrett T. Smith in *Kodak Studio Light* magazine, Issue No. 1, 1986

A Gregory Heisler photo of New York City Mayor Edward I. Koch may wind up as Koch's official portrait in City Hall. Unlike the Mayor's predecessors, whose portraits are both painted and formal, Koch is looking rather relaxed and candid in this color photo. The photo, taken for the June 11, 1989, *New York Times Sunday Magazine*, was Heisler's first assignment to shoot Koch. The Art Commission, which decides on all art works in city buildings, still must approve the photo. "I'm excited," says Heisler, who thinks the concern of the Art Commission is that of archival quality — whether a photograph will last as long as a painting.[2]

"PDNews" by Susan Roman
*Photo District News*
New York City
December 1989

Shooting a portrait on color negative film and making prints with Ektacolor paper may indeed offer quick results at a fraction of the expense of an oil painting (a 30x40-inch sheet of Ektacolor paper costs only about $6.00), but there are other reasons that most people prefer a color photograph to a painting. The realism of a good color photo-

graph — an authentic frozen moment of history — is something that a painting can never achieve. People love color photographs! But one thing an oil painting *does* have, and an Ektacolor print does not, is permanence on long-term display.

How long do prints made with the many different types of color negative papers last on display? How much longer will Fuji's precedent-setting Fujicolor SFA3 papers last than Kodak's Ektacolor papers? How does the light fading stability of Kodak Ektatherm thermal dye transfer prints compare with that of Fujicolor and Ektacolor prints? What is the best color negative paper for valuable portraits and wedding photographs? What are the longest-lasting materials for printing color transparencies? Has the light fading stability of Ektacolor or Fujicolor prints improved much over the past 20 years?

Is tungsten illumination less harmful to color prints than fluorescent? Does UV protection help? Compared with "conventional" color print materials, how much longer will a more costly UltraStable Permanent Color print, Polaroid Permanent-Color print, or EverColor Pigment color print last? The answers to these and other light fading stability questions are the subject of this chapter.

### Light Fading Is Now a More Serious Problem Than Dark Fading

In the 1970's and early 1980's, it could be debated which was the more serious problem with color papers: poor dark fading stability or poor light fading stability (yellowish stain formation in dark storage was not much of a worry then because the most pressing problem was poor dye stability). Some color negative papers had very poor dark fading stability indeed, and one paper, the previously mentioned Agfacolor Type 4 paper (sold worldwide from 1974 until 1982), had such astonishingly poor cyan dye dark storage stability that by the time this chapter was written in 1992, all known examples of Type 4 prints had faded to an ugly reddish shadow of their originally colorful images.

Although the Ektacolor papers of the same era were much more stable than Agfacolor Type 4 paper, in dark storage the cyan dye was also the least stable of the three image dyes in Ektacolor prints (and most other EP-3 and EP-2 papers during this period), and it was the inadequate stability of the cyan dye that effectively limited the life of Ektacolor prints in dark storage.

That situation changed with the historic introduction of Konica Color PC Paper Type SR in April 1984. (Type SR paper, which was still on the market when this book went to press in 1992, is also called Konica "Century Paper" and Konica "Long Life 100 Paper.") Type SR paper was the

---

> **Recommendations**
> See Chapter 1 for a comprehensive list of the longest-lasting color films and print materials, based on overall light fading, dark fading, and dark staining performance.

Carol Brower – October 1990

Wedding portraits printed on Fujicolor Professional Paper Super FA Type P being inspected at H&H Color Lab by printing department supervisor Steve Tuggle. H&H, a leading professional portrait and wedding lab located near Kansas City in Raytown, Missouri, switched from Ektacolor Portra paper to Fujicolor paper in 1990 because of the superior light fading stability of the Fuji product. The change in color paper was made after a poll mailed to more than 700 H&H customers showed that the great majority wanted their wedding photographs and portraits printed on the longest-lasting color paper available, even if that meant changing from Kodak to Fuji as the paper supplier (see Chapter 8).

first of a new generation of color negative papers to feature an improved cyan coupler which, during processing, produced a new high-stability cyan dye. This improved cyan dye made the overall dark storage dye stability of the new Konica paper far better than that of any previous color negative paper. In August 1984 Kodak followed with Ektacolor Plus paper, which, like Konica Type SR paper, employed a new high-stability cyan dye. A few months later Agfa and Fuji announced their own similarly improved color negative papers, and these new products (which included Ektacolor Professional Paper as a replacement for Ektacolor 74 RC Paper in portrait and wedding markets) became generally available in 1985.

In addition to heralding greatly improved dark storage dye stability, the introduction of Konica Type SR paper accomplished three important breakthroughs:

1. For the first time in the history of color photography, image stability became an important competitive consideration. Konica's advertisements for Type SR paper, which claimed a 100-year album storage life for the prints, marked the first time that a color negative paper had *ever* been promoted on the basis of image stability. Kodak, Agfa, and Fuji all were forced to respond. Before the introduction of Konica Type SR paper, image stability data were for the most part kept secret by Kodak and the other manufacturers, and most purchasers of color paper were totally ignorant of the stability characteristics of the products they bought.

2. The improved dark storage dye stability of Konica Type SR paper and similar chromogenic papers made by Kodak, Agfa, and Fuji shifted the emphasis from dark storage *dye stability* to the problem of gradual formation of *yellowish stain* in prints kept in the dark. Not only is the stain objectionable in its own right, but it also contributes to a change in color balance toward yellow. It became a question of what is the most objectionable visual change when these papers are stored in the dark for long periods (with most color print materials, light-induced stain formation during long-term display is less severe than stain that occurs in dark storage).

Yellowish stain formation in dark storage has been a clearly recognized but little-discussed problem with in-

March 1990

An exhibition of Tina Barney's large Ektacolor prints at the Museum of Modern Art in New York City in 1990. Barney uses a view camera with large-format color negative film. Represented by the Janet Borden Gallery in New York, some of Barney's prints have sold for over $10,000.

corporated-coupler chromogenic materials ever since the first Kodacolor prints appeared in 1942. However, it was not until Fuji introduced Fujichrome Paper Type 34, a low-stain paper for printing transparencies, in 1986 (replaced with Type 35 paper in 1992) and Fujicolor Super FA low-stain papers for printing color negatives in 1989 (replaced with Fuji's advanced Fujicolor SFA3 papers in 1992) that concern about dark-storage stain problems really came into the open. Konica introduced its first low-stain paper, Konica QA Color Paper Type A5, in Japanese markets in 1990. Compared with Kodak Ektacolor and most other papers currently on the market, these new Fuji and Konica papers have greatly reduced rates of stain formation. Fuji has emphasized this advantage in promoting the papers, and the company has also discussed the topic in a number of technical papers (see Chapter 5).

With the current generation of color prints, dark-storage stain formation is finally being acknowledged as a significant problem — a problem that in many cases is even more serious than dye fading itself. The new *ANSI IT9.9-1990* color stability test methods standard published by the American National Standards Institute[3] requires that d-min stain and d-min color balance changes be reported along with dye stability and color balance data, and this should focus much greater attention on the subject of dark-storage stain behavior.

3. Almost all current color papers feature high-stability cyan dyes (at the time this book went to press in 1992, the only exceptions were several of Kodak's Ektachrome papers which still have a cyan dye with poor dark-storage stability of the type abandoned by Fuji, Konica, and Agfa by the mid-1980's), so the principal image stability concern now is the light fading stability of color papers on display. As Klaus Gerlach of Agfa said in 1985, following the introduction of Agfacolor Paper Type 8, "In terms of dye or image stability, we consider the dark fading issue as resolved; improvements in light stability are in progress."[4] Color prints now last *much* longer when stored in the dark than they do when exposed to light on display.

## On Display, Some Types of Color Prints Last Far Longer Than Others

The deterioration of displayed color print images is characterized by shifts in color balance caused by unequal fading of the cyan, magenta, and yellow image dyes; loss of color and detail (especially in highlight areas); changes in

1979

Fluorescent illumination is used in most offices, schools, and other public places. Illumination intensities of 500 to 2,000 lux are common; in display cases, where photographs are often displayed for extended periods, much higher intensities can be found. Because of their high energy-efficiency and low cost, single-phosphor "Cool White" lamps are by far the most popular type of fluorescent lamp. In some fluorescent-illuminated offices, photographs are exposed to the bright light for only short periods; for example, **LIFE** magazine photographer Alfred Eisenstaedt is shown here in his office at Time Warner Inc. in New York City selecting images for an exhibition of his photographs. When color prints are displayed under such lights for many years, however, severe fading eventually will result.

image contrast; and overall low-level yellowish stain formation. Light-faded color prints characteristically have a washed-out, off-color appearance. Such prints have lost their original richness, brilliance, and sparkle.

The light-fading of a color print is a slow but steady process that begins immediately when the print is hung on the wall or placed in a frame on a desk. Other considerations being equal, the rate of light fading of a particular type of color print is determined by the *inherent* dye stability characteristics of the paper, i.e., those built into the material by the manufacturer.

Even though all types of color prints are subject to light fading, grouping every type of color print together and stating simply that "all colors fade" ignores the very large differences in dye stability among currently available products. Some materials are *much* more stable than others. As shown by UltraStable Permanent Color prints and Polaroid Permanent-Color prints, it is possible to make color prints with high-stability color pigments that, in a practical sense, do not fade at all: that is, under normal conditions of display, the prints will probably retain excellent quality color images for five hundred years or more.

## Image Fading and Discoloration Caused by Print Lacquers, Retouching, and Other Post-Processing Treatments

Color prints often are lacquered after processing. Treatment with lacquers obscures surface defects caused by corrective spotting and retouching; helps protect the surface from abrasion, scratches, and fingerprints; modifies emulsion surface gloss characteristics; and, probably most importantly, allows prints to be framed directly against glass without danger of the emulsion sticking or "ferrotyping" to the glass under humid conditions. Lacquering is especially popular among portrait and wedding photographers and is often combined with various surface texturing treatments because many photographers believe this enhances the value of a print to the customer.

According to Kodak, depending on the particular type of lacquer and the manner in which it is applied, these products are capable of accelerating both light fading and dark fading of Ektacolor prints and can under some circumstances produce severe yellow staining.[5] At the time this book went to press in 1992, this author was not aware of

January 1982

Art galleries and museums are among the few places where tungsten lamps are the only source of illumination. In this exhibition of Ilford Cibachrome (Ilfochrome) prints by the late photographer Hans Namuth at Castelli Gallery in New York City, the lamps were mounted on the gallery's high ceiling at a steep angle to the framed prints to minimize surface reflections.

any commercial print lacquer that did not contain at least one ingredient identified by Kodak as potentially harmful. To date, Kodak's published information on print lacquers concerns only the effects of lacquers on Ektacolor prints and may not apply to other types of color prints. No other studies of the effects of lacquers on image stability have been published.

This author believes that some types of abnormally rapid dye fading in displayed prints are actually caused at least in part by RC base-associated fading (see Chapter 2) and cannot be attributed solely to lacquers. However, the use of currently available print lacquers adds a significant unknown element in attempting to determine the long-term dye stability of a print. Thus, when possible, print lacquers — including those containing UV absorbers — should be avoided. (Lacquers and other print coatings are discussed in more detail in Chapter 4.)

Retouching dyes can both accelerate localized image dye fading and make normal print fading more obvious because they may fade more slowly or more quickly than the print's image dyes. As a portrait fades during display, facial wrinkles and blemishes, skillfully smoothed over by retouching when the print was new, begin to stand out in stark relief because of these differences in fading rates, and the picture can assume a ghastly appearance. (Re-

touching materials and procedures are discussed in more detail in Chapter 11.)

It is an unfortunate fact that the more a customer pays for a print, the more likely it is to have been subjected to retouching, lacquering, canvas mounting, texturizing, or other post-processing treatments, any of which can reduce the dye stability of the print.

## How to Interpret the Light Fading Stability Tables in This Chapter

The color print image-life predictions given in the tables at the end of this chapter were based on data obtained in accelerated light fading tests using Cool White fluorescent illumination, incandescent tungsten illumination, and north daylight illumination. For the fluorescent and tungsten illumination tests, color prints were subjected to three different tests: **(1)** "Bare-Bulb" tests in which there was no glass or plastic sheet between the light source and test prints, **(2)** "Glass-Covered" tests conducted with a sheet of glass placed on top of the test prints, and **(3)** "UV-Filtered" tests in which a sheet of Rohm and Haas Plexiglas UF-3, a sharp-cutting ultraviolet filter that absorbs virtually all UV radiation and even some short-wavelength blue light, was placed on top of the test prints.

Carol Brower – November 1986

Henry Wilhelm speaking with associate curator Matthew Postal (right) about the effect of illumination intensity on perceived color print quality at the 1986 exhibition of Ektacolor prints by Len Jenshel at the Laurence Miller Gallery in New York City.

The glass and UF-3 sheets were in direct contact with the surface of the prints.  For the indirect north daylight tests, prints were covered with either glass or Plexiglas UF-3 sheets, spaced about ⅛-inch above the surface of the prints, with free air circulation between the glass or Plexiglas and the print.

In addition to illumination intensity and spectral distribution, a number of other factors can influence the life of a print on display.  These include "framing effects" (also called "enclosure effects") with prints framed under glass or plastic, RC base-associated fading and staining, and dark fading and dark storage staining that may occur concurrently with light-induced changes during prolonged display under low-level illumination (see Chapter 2 for discussion of RC base-associated fading and "framing effects" with displayed prints).

Changes in dye stability and/or stain characteristics can also be brought about by application of print lacquers or other coatings, retouching effects, and other factors such as choice of processing chemicals and/or failure to adhere to recommended processing and washing procedures.  Separately or in combination, all of these factors can have an effect — most often an adverse effect, and sometimes a catastrophic effect — on color image stability.

In the tables the products are listed in order of their "Glass-Covered" stability rankings, as determined by the

tests.  For the important group of current Process RA-4 compatible color negative papers (**Table 3.1a** on page 131) and current Process EP-2 compatible color negative papers (**Table 3.1b** on page 132), at least three replicate samples were tested in all three light exposure conditions, and the experimental error was estimated to be ± 5%.  For the other tables, the experimental error is somewhat greater, especially in cases where the limiting image-life parameter was a color imbalance between two dyes, rather than a density loss of a single dye.

## Illumination Intensity Is Generally Much More Important Than the Spectral Distribution of the Light Source

In reviewing the data presented in this chapter, it will become apparent that for most modern color print materials, the spectral distribution of the illumination source has relatively little effect on fading rates.  Far more important is the *intensity* of the illumination.  There are some exceptions to this — Kodak Ektatherm thermal dye transfer prints being a notable example — but in general, for a given illumination intensity, no great differences in fading rates will be noted when prints are illuminated with different types of commonly encountered indoor light sources (e.g., fluorescent lamps and incandescent tungsten lamps).

1977

George Eastman House in Rochester, New York is an example of an older museum where some areas are illuminated with both daylight through window glass and tungsten lamps. To maintain the architectural integrity of the historic building, the windows cannot be covered. When this photograph was taken in 1977, this upstairs room was used to exhibit photographs from the Eastman House collection. After the completion of the adjacent Eastman House Archives Building in 1988, Eastman House was renovated and this room is no longer used to exhibit photographs from the permanent collection.

### The Most Important Conclusions: Which Color Print Materials Last Longest

The color print image-life predictions presented in this chapter are based on accelerated test data with non-lacquered, correctly processed prints. Because of the previously mentioned factors, prints on actual long-term display under typical home and office conditions may fade more rapidly than predicted by these tests. Because of the reciprocity failure trends noted with two-intensity testing, RC base-associated fading, and "framing effects" during long-term display (see Chapter 2), there appears to be little chance that prints would last longer than predicted under the specified illumination conditions. To the extent that these image-life predictions could be in error, it is most likely that they somewhat *overestimate* the stability of the various types of color prints.

These uncertainties aside, the most important conclusions from these tests are, within each class of color print material (e.g., color negative paper, color reversal paper, instant color prints, etc.), which type of color print likely will last the longest when displayed. For professional wedding and portrait photographers, or commercial photographers who sell prints for long-term display as wall decor, it

is only good ethics — and certainly good business — to give customers the longest-lasting color prints possible.

For operators of color labs, the choice of color papers will matter a great deal to at least some customers. For competitive reasons, and to minimize the chance of clients eventually bringing faded prints back and demanding free replacement prints, the most economical strategy is to use the most stable materials available. Otherwise a lab's business image will suffer, long-standing customers may leave, and potential new clients will never walk in the door.

### What Are "Normal" Display Conditions?

The illumination intensity, spectral distribution, and duration; the temperature and relative humidity in the display area; and the method of framing or mounting that constitute "normal" display practice cover such a wide range (see **Table 17.1** in Chapter 17) that the concept of "normal display conditions" should be approached with caution.

The three most common indoor illumination sources are: **(1)** indirect daylight that has passed through window glass; **(2)** fluorescent lamps — most commonly "Cool White" lamps — that may or may not be covered with a UV-absorbing glass or plastic diffuser; and **(3)** incandescent tungsten

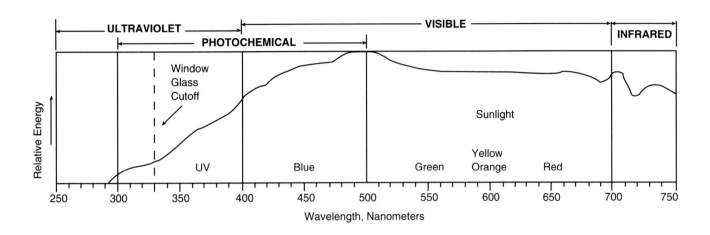

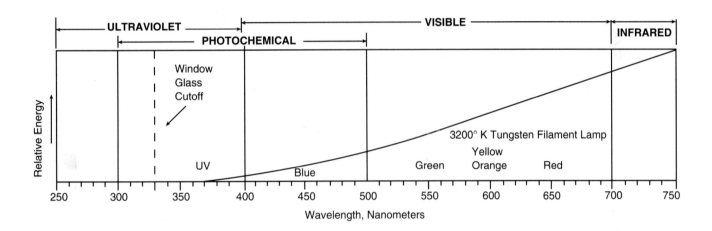

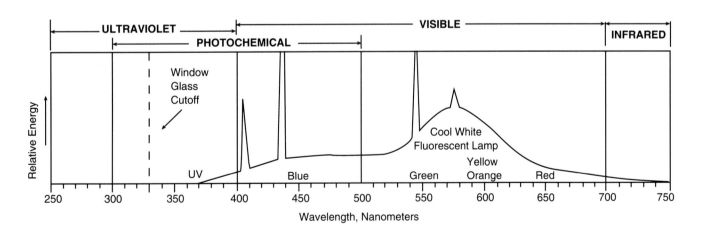

**Figure 3.1**   The spectral energy distribution of sunlight illumination, incandescent tungsten lamps, and Cool White fluorescent lamps. Mercury vapor line emissions from the low-pressure mercury arc in fluorescent lamps produce the irregular energy peaks characteristic of these lamps. At a given illumination intensity (measured in lux units), the very different spectral distributions of these three light sources produce surprisingly similar fading rates with Ektacolor, Fujicolor, and other types of modern chromogenic color papers, all of which have effective UV-absorbing emulsion overcoats. (Sources: Rohm & Haas Publication PL-612c and General Electric Company)

Back-illuminated color transparencies and translucencies (e.g., Kodak Duratrans, Fuji Fujitrans, and Ilfochrome Translucent Display Film) are a popular form of advertisement for hotels, rental car agencies, and other services catering to travelers at airports. In this example at the Tampa, Florida airport, the intense 24-hour-a-day fluorescent illumination caused severe fading of those images which had been displayed for extended periods.

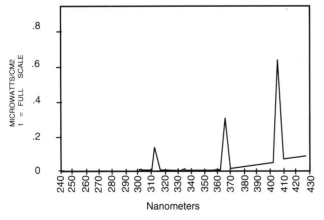

**Figure 3.2** The 313 nanometer mercury vapor emission of bare-bulb fluorescent lamps may appear to be of relatively low energy, but it can have a devastating effect on the dye images of Kodak Ektatherm prints and other color print materials that lack a UV-absorbing overcoat. A sheet of ordinary window glass or framing glass placed between a fluorescent lamp and a color print will protect the image from the harmful 313 nm emission — glass and most types of plastics effectively absorb UV radiation below 330 nm. (Source: General Electric Company)

lamps. Typical spectral distributions for these three illumination sources are given in **Figure 3.1**. These and other illumination sources are described in detail in *ANSI IT9.9-1990, American National Standard for Imaging Media – Stability of Photographic Images – Methods for Measuring.*[6]

Of particular importance with fluorescent lamps is the ultraviolet mercury vapor line emission at 313 nanometers, shown in **Figure 3.2**. Although in terms of relative power distribution the energy of this UV emission may appear to be low, it has a devastating effect on color prints that lack an effective UV-absorbing emulsion overcoat. The effect of ultraviolet radiation on color print fading is discussed in more detail below.

The "years of display" image-life predictions given in **Tables 3.1a** through **3.6** (pages 131 through 144) are based on two "standard" display conditions, as determined by this author. One display condition is for homes, offices, and commercial locations, and the other is for tungsten-illuminated museum and archive display areas.

For homes, offices, and commercial locations, an intensity of 450 lux (42 fc) for 12 hours a day has been adopted by this author.[7] This illumination level is not greatly different from the 500 lux (46.5 fc), also for 12 hours a day, adopted by Fuji for reporting "years of display" image-life predictions for Fujicolor Paper Super FA Type 3, one of Fuji's

The United States Declaration of Independence, which is housed at the National Archives in Washington, D.C., is displayed with extremely low intensity tungsten illumination in an effort to minimize further fading. The Declaration (1776), the Constitution (1787), and the Bill of Rights (written in 1789 and ratified in 1791), which are displayed in the main rotunda of the National Archives, are protected with bullet-proof glass and a yellow filter material that absorbs UV radiation and most blue light. (See page 244 in Chapter 7 for discussion of the computer-based monitoring system employed by the National Archives to detect further ink fading, flaking, or other changes in the 200-year-old documents.)

November 14, 1989

family of Fujicolor SFA3 papers introduced in 1992. (Fuji's "years of display" extrapolations were based on data obtained from very high-intensity, 85-klux xenon arc tests.) According to Fuji:

> Since in common domestic situations sunlit areas may be as bright as 1000 lux or more during the day and drop to 300 lux in the evening and at night, storage conditions are usually designated to be at an average of 500 lux of light exposure for a period of 12 hours per day.[8]

Fuji selected an even higher illumination level on which to base "years of display" predictions for Fujichrome Paper Type 35, a reversal paper for printing color transparencies, introduced in 1992: "Type 35 paper is designed for indoor display under high average illumination conditions of 1000 lux for a period of 12 hours a day."[9]

Employing data obtained from very high intensity (100 klux) cycling xenon arc tests, Ilford has chosen three illumination conditions for "years of display" image-life predictions for Ilfochrome prints (called Cibachrome prints, 1963–91) displayed indoors:[10]

**Indoors/1**   Normal conditions, protected from direct sunlight at least 7 feet from a window (i.e., living rooms, offices, and museums: 45–55% RH, light intensity approximately 500 lux for 12 hours per day).

**Indoors/2**   Medium conditions, protected from direct sunlight (i.e., under spotlights in galleries and exhibits. Averaging 1000 lux for 12 hours per day).

**Indoors/3**   Extreme conditions, high humidity and direct sunlight for half the day (i.e., near indoor swimming pools and aquariums. Averaging 2500 lux for 12 hours per day).

To date, Eastman Kodak has, for the most part, avoided making predictive "years of display" image-life estimates for color prints based on specified illumination conditions. In 1988, in the first such instance, Kodak published an article in the *Journal of Imaging Technology* which included a small graph showing the predicted fading of Kodak Ektacolor Plus Paper expressed in "years of display" based on

an illumination level of 100 lux for 12 hours per day.[11] In a general discussion of accelerated test methods, the 100-lux level was adopted by Kodak in *Image-Stability Data: Kodachrome Films,* "Reference Information from Kodak," Kodak Publication E-105 (March 1988).[12] This publication has not been widely distributed and this author is not aware of any other Kodak publications making an image-life prediction, expressed in "years of display," based on data from accelerated light fading tests.

In the display of color prints in homes, offices, and museums, lighting conditions similar to this author's standard display conditions are commonly encountered; however, display situations frequently have much more intense illumination and/or are illuminated for longer than 12 hours per day — either or both of which would correspondingly shorten the image life of a color print. In other cases, prints are displayed under much lower light levels and/or are illuminated for fewer hours each day than specified in this author's "standard display condition" of 450 lux for 12 hours per day.

It is a simple matter to convert the color print image-life predictions given in this chapter to other display conditions by measuring the light intensity in the display area with an illuminance meter (the Minolta Illuminance Meter is a good instrument for this purpose), determining the average number of hours of illumination each day, and then making the appropriate calculations.

## Fluorescent Illumination for Accelerated Light Fading Tests

For a variety of reasons, fluorescent illumination has become the "standard" light source for accelerated light fading tests. Fluorescent lamps provide fairly high-intensity illumination with relatively little heat; this makes it easier to maintain the proper temperature and relative humidity in accelerated test equipment. Compared with daylight-simulating xenon arc light sources, fluorescent lamps provide stable, energy-efficient, evenly distributed, and low-cost illumination. More importantly, fluorescent lamps are by far the most common light source in offices, educational institutions, stores, and public buildings. Fluorescent lamps are increasingly found in homes, especially in Japan and in other countries that stress energy conservation.

All current chromogenic color papers are made with UV-absorbing emulsion overcoats and are little affected by the UV radiation present in even bare-bulb fluorescent illumination (**Figure 3.3**) or indoor daylight that has passed through window glass (**Figure 3.4**).

For testing current chromogenic papers, glass-filtered fluorescent illumination provides

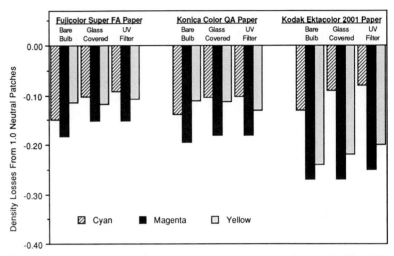

**Figure 3.3** All modern color negative papers are manufactured with a UV-absorbing emulsion overcoat that protects the image dyes from damaging ultraviolet radiation present in fluorescent lamps, daylight, and some other sources of illumination. The fading that occurs in displayed prints is caused almost entirely by visible light, and additional UV protection is of little if any benefit. Prints are effectively protected even from the UV radiation of bare-bulb fluorescent lamps, most of which have a high-energy UV emission at 313 nm that produced rapid fading in earlier color negative papers without a UV-absorbing overcoat. In this graph, the Fuji, Konica, and Kodak color papers were exposed to Cool White fluorescent illumination in an accelerated test at 21.5 klux for 100 days; the temperature at the sample plane was maintained at 75°F (24°C) and the relative humidity at 60%.

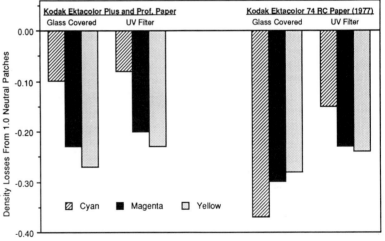

**Figure 3.4** Two generations of Kodak Ektacolor paper exposed to north daylight through window glass. The illumination intensity, averaged over a 24-hour period, was 0.78 klux. The temperature was 75°F (24°C) and the relative humidity 60%. Because the print samples were close to a north-facing window, with almost no light reflected from walls or ceilings (which tend to absorb UV radiation), this is a "worst-case" indoor display situation in terms of UV radiation and short-wavelength blue light. With Ektacolor Plus and Professional papers (1984—), which are made with an effective UV-absorbing overcoat, a sharp-cutting UV filter (Rohm & Haas Plexiglas UF-3) afforded little more protection than ordinary window glass. With Ektacolor 74 RC paper (initial type: 1977–82), which did not have a UV-absorbing overcoat, the fading of the cyan dye was reduced by more than 50% when protected by UF-3. This paper, like most other color negative papers of the era, has a UV-absorbing interlayer that protects the magenta and yellow dye layers. Unannounced, Kodak added a UV-absorbing overcoat to Ektacolor 74 RC paper in early 1982; Konica, Fuji, and Agfa incorporated this feature in their color papers by 1984–85.

a reasonable approximation — in terms of dye fading and light-induced yellowish stain formation — of the indirect, glass-filtered daylight illumination found in homes.

In 1990, Stanton Anderson and Richard Anderson of Eastman Kodak reported that the "typical" daytime indoor illumination in homes (away from windows) was very different from what had been expected: "The characteristic curve contains most of its energy at the longer wavelengths. . . . In direct contrast to sunlight, there is little content at the shorter wavelengths (UV radiation and blue light) but much yellow and red light of lower energy."[13]  They found that the shorter-wavelength radiation was largely absorbed by floor coverings, paint on walls and ceilings, furniture, and draperies.  They suggested that glass-filtered fluorescent or tungsten illumination provides a closer match to typical indoor illumination than do the filtered xenon arc light sources that have often been used in the past for testing the light fading stability of color prints.

There are many types of fluorescent lamps (e.g., Cool White, Warm White, Cool White Deluxe, Daylight, etc.), all of which have different spectral energy distributions.  However, according to the General Electric Company, more than 70% of the fluorescent lamps in the U.S. are of the "Cool White" type, and for this reason Cool White lamps were used in the tests reported here.  The *ANSI IT9.9-1990* Standard also specifies Cool White lamps for the 6.0 klux accelerated fluorescent light fading test (the now-obsolete *ANSI 1.42-1969* color stability test methods Standard called for Cool White Deluxe lamps).

To date, nearly all of the light fading stability data reported by Eastman Kodak have been based on 5.4 klux (500 fc) accelerated tests[14] employing fluorescent illumination filtered with acrylic plastic panels to absorb the potentially damaging 313 nm UV emission of fluorescent lamps (ordinary window or framing glass also absorbs this wavelength).

The 313 nm wavelength emitted by bare-bulb fluorescent lamps caused rapid cyan dye fading in pre-1982 Ektacolor papers, which, like most other color papers of the time, were manufactured without UV-absorbing emulsion overcoats.  The bare-bulb 313 nm emission also causes rapid fading of the cyan dye in Kodak Dye Transfer prints, and it greatly increases the fading rate of Ilfochrome prints (called Cibachrome prints, 1963–91).  Neither Ilfochrome nor Dye Transfer prints have a UV-absorbing overcoat.

Kodak Ektatherm prints and other types of thermal dye transfer prints tested by this author also do not have effective UV protection of the image dyes, and bare-bulb fluorescent illumination has a devastating effect on these prints (see **Figure 3.5**).  When the Kodak Photo CD system was commercially introduced in the summer of 1992, Ektatherm prints were the only type of print initially available for reproducing images from the Photo CD's.  The Photo CD Index Prints supplied with each Kodak Photo CD as "contact sheets" for visual reference to the images recorded on the Photo CD are also Ektatherm prints.

## Light Fading Stability of Current Color Negative Print Papers

During 1990, according to estimates provided by *Photofinishing News,* amateur photographers in the United States alone took nearly 17 billion photographs; of these, about

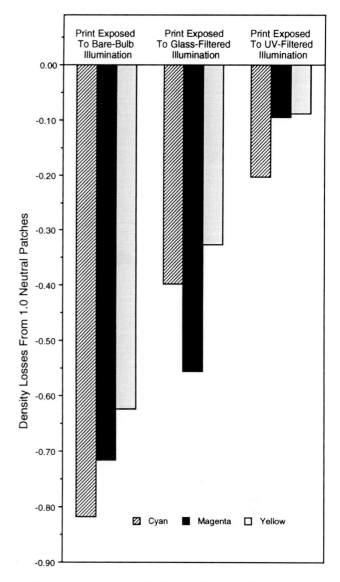

**Figure 3.5**  As shown in this 100-day 21.5 klux accelerated fluorescent light fading test, the image dyes of Kodak Ektatherm prints and other types of thermal dye-transfer (dye-sublimation) prints that lack a UV-absorbing overcoat are strongly affected by even the low-level ultraviolet radiation present in glass-filtered fluorescent illumination. The light fading stability of the prints is greatly increased by the use of Plexiglas UF-3 or other effective UV-absorbing filter.

98% were in color.  Black-and-white photographs constituted just a little over 2% of the market.[15]  Color slides accounted for only about 5% of the photographs taken by amateurs, and Polaroid instant color prints, which have steadily declined in popularity in recent years, had about 2% of the market.

With over 15 billion exposures in 1990, color negative films constituted the lion's share of the total amateur film market in the U.S. and accounted for 90% of all amateur photographs made.  The popularity of ordering "twin prints" from each negative, along with sales of reprints and enlargements, pushed the total number of prints made from

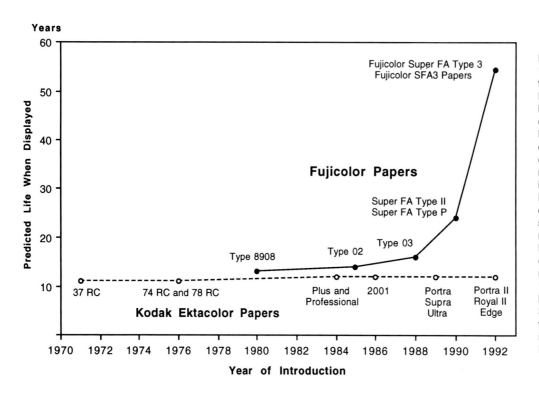

**Figure 3.6** Beginning in 1980, successive generations of Fujicolor EP-2 and RA-4 compatible papers have exhibited steadily increasing light fading stability, with current Fujicolor SFA3 papers having an estimated display life of more than 50 years according to this author's tests. Kodak's Ektacolor papers, on the other hand, have shown negligible improvements in light fading stability since the introduction of Ektacolor 37 RC Paper more than 20 years ago in 1971. When exposed to light on display, Fujicolor SFA3 papers last more than **four times longer** than current Ektacolor papers (e.g., Ektacolor Portra II Paper).

amateur color negatives to 20 billion. (The amateur market for prints from slides was estimated to be only about 24 million prints — less than 1% of the total number of amateur color prints made in 1990.)

Not only are color negative papers the easiest and fastest to process and by far the lowest cost of all color print materials — every aspect of their design is dictated by the requirements of mass production snapshot photofinishing — but virtually all professional color portraits and wedding photographs, even the most expensive, are printed with these papers. So to the 20 billion prints made from amateur color negatives, one can add another billion or so prints made from color negatives in the professional market. In addition, most of the color photography for newspapers is now done with color negative films, with prints made on color negative papers (or with negatives scanned and entered directly into electronic prepress systems without making prints).

The majority of fine art color prints purchased by museums and private collectors are also made with color negative papers. Most photographers making fine art color photographs prefer the wide exposure latitude of color negative films, and the smooth tonality, often subtle color rendition, and the speed and simplicity of making prints from color negatives. Similar results are much more difficult to obtain with prints made from color transparencies. From all of this, it is easy to see why color negative papers are *by far* the most important part of the color print market.

### Process RA-4 Papers Will Soon Replace Process EP-2 Materials

Kodak introduced fast-processing Ektacolor 2001 paper and Process RA-4 chemicals when the company entered the rapidly expanding minilab market in 1986. (In the face

of intense competition from Japanese and European manufacturers, Kodak left the minilab equipment market at the end of 1989.) Ektacolor 2001 and other Process RA-4 compatible papers have a silver chloride emulsion that allows processing in approximately half the time required for Process EP-2 papers (such as Ektacolor Professional Paper), which have slower processing silver bromide emulsions. Until 1988, Ektacolor 2001 was restricted mainly to the minilab market, where the fastest possible processing is essential. Ektacolor 2001 Paper was replaced by Ektacolor Edge Paper in 1991.

In addition to reduced processing times, silver chloride papers and RA-4 chemicals offer a number of other advantages, including lower chemical replenishment rates, reduced water use, no benzyl alcohol in the color developer (which allows easier mixing, less tar formation, and reduced environmental impact), and greater process stability. In the case of the Ektacolor RA-4 papers, at least, less silver is required than with Kodak's EP-2 papers, and this lowers manufacturing costs (Kodak sells the two types of papers for the same price, however).

Outside of the minilab field, the conversion from EP-2 papers to RA-4 papers was at first slow, in part because photofinishing labs were reluctant to purchase all new processing machines or to get involved with expensive conversions of existing equipment (most labs did not want to deal with RA-4 and EP-2 chemical mixing and storage at the same time, and the conversion to RA-4 from EP-2 became sort of an all-or-nothing affair). Speed of processing generally is less important for large photofinishers than it is for minilab operators.

Commercial labs did not want to change until a full complement of RA-4 materials was available (labs supplying Duratrans translucent polyester-base display material did not want to maintain a separate EP-2 line for just one

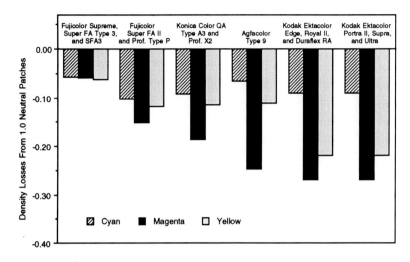

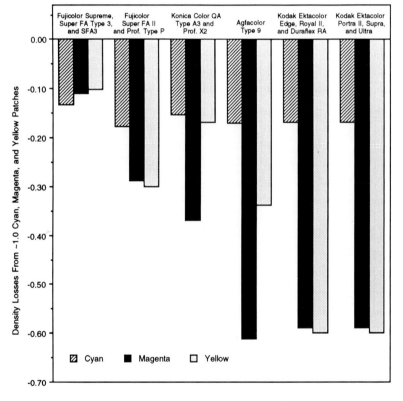

**Figure 3.7** Process RA-4 compatible color negative papers compared by density losses from 1.0 neutral patches. Print samples were covered with glass and exposed to 21.5 klux fluorescent illumination in accelerated light fading tests conducted at 75°F (24°C) and 60% RH. Unless otherwise noted, all of the graphs in this chapter are based on this high-intensity, 100-day test. This light exposure is equivalent to 26 years of display under this author's "standard display condition" of 450 lux for 12 hours per day. The new type of high-stability magenta dye employed in the Fujicolor SFA3 papers faded much less than the magenta dyes in the other papers, and this in turn resulted in significantly less color balance shift to green or green/yellow as fading progressed. The new "low-stain" magenta coupler in Fujicolor SFA3 papers also has much lower rates of yellowish stain formation in dark storage than the magenta couplers used in Kodak, Agfa, and most Konica papers.

**Figure 3.8** Process RA-4 compatible color negative papers compared by density losses from ~1.0 cyan, magenta, and yellow color patches. Note that while the light-fading stability of the cyan dyes of the various products is fairly similar, the stabilities of the magenta and yellow dyes differ significantly, with the Kodak Ektacolor papers being, overall, the worst of the group. Although not included here, the image stability of Mitsubishi RA-4 compatible papers is similar if not identical to that of the Konica papers (Konica supplies key emulsion components to Mitsubishi for use with its papers).

product). By early 1989 Fuji, Konica, and Agfa all had introduced RA-4 photofinishing papers, and early latent-image keeping problems with Ektacolor RA-4 papers had been adequately resolved. Outside of the minilab market, however, the move from EP-2 to RA-4 was still proceeding fairly slowly. With Kodak's introduction of a complete line of RA-4 materials in late 1989, and with lower-contrast RA-4 "professional" papers and translucent polyester-base display materials also available from Fuji and Konica, an industry-wide changeover to RA-4 began in earnest in 1990. By the end of 1994, it is likely that many of the EP-2 papers available when this book went to press in 1992 will have been discontinued.

For photofinishers wishing to continue using processing equipment designed for Process EP-2, Kodak introduced Process RA-4ECM, which allows Ektacolor Edge and other Kodak RA-4 papers to be processed with the longer EP-2 process cycle. In 1990, as part of the company's broad competitive policy of maximum market segmentation, Kodak introduced Ektacolor Royal Paper (later replaced by Royal II paper) into the general minilab and photofinishing markets (the paper was actually introduced in 1989, but at first it was used only in the Kodak Create-A-Print 35mm Enlargement Center). Ektacolor Royal II Paper has a thicker RC base and a somewhat higher-gloss surface than other Ektacolor papers; the image stability of Royal paper is the same as for the other Ektacolor RA-4 papers. In 1990, to compete directly with Ektacolor Royal Paper, Fuji introduced Fujicolor Supreme paper, a thick-base, high-gloss version of Fujicolor Paper Super FA paper.

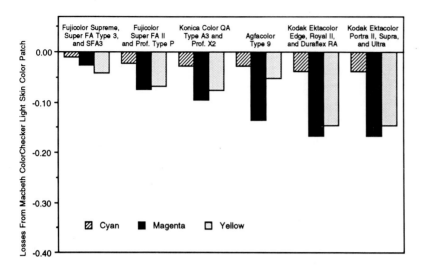

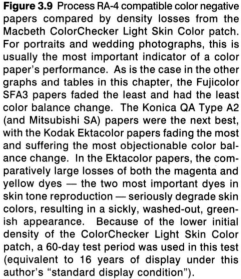

**Figure 3.9** Process RA-4 compatible color negative papers compared by density losses from the Macbeth ColorChecker Light Skin Color patch. For portraits and wedding photographs, this is usually the most important indicator of a color paper's performance. As is the case in the other graphs and tables in this chapter, the Fujicolor SFA3 papers faded the least and had the least color balance change. The Konica QA Type A2 (and Mitsubishi SA) papers were the next best, with the Kodak Ektacolor papers fading the most and suffering the most objectionable color balance change. In the Ektacolor papers, the comparatively large losses of both the magenta and yellow dyes — the two most important dyes in skin tone reproduction — seriously degrade skin colors, resulting in a sickly, washed-out, greenish appearance. Because of the lower initial density of the ColorChecker Light Skin Color patch, a 60-day test period was used in this test (equivalent to 16 years of display under this author's "standard display condition").

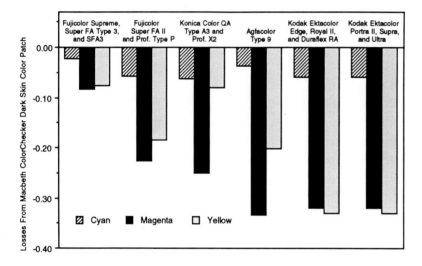

**Figure 3.10** Process RA-4 compatible color negative papers compared by density losses from the Macbeth ColorChecker Dark Skin Color patch. This color is representative of the skin color of dark-skinned individuals. Most portraits, whether of light-skinned or dark-skinned people, have important areas of low-density highlights, and pictorial quality is adversely affected if these highlight areas fade or suffer significant color balance changes.

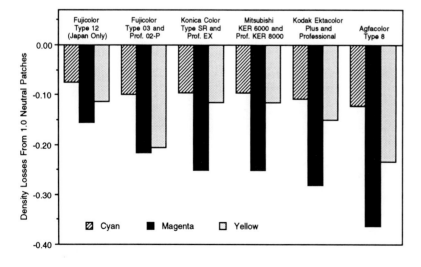

**Figure 3.11** Process EP-2 compatible color negative papers compared by density losses from 1.0 neutral patches. As with the RA-4 compatible papers discussed previously, the print samples were covered with glass and exposed to 21.5 klux fluorescent illumination for 100 days in accelerated light fading tests conducted at 75°F (24°C) and 60% RH. This light exposure is equivalent to 26 years of display under this author's "standard display condition" of 450 lux for 12 hours per day. Fujicolor Type 12 paper (1985—) marked the first use of one of the high-stability, low-stain magenta couplers developed by Fuji for color papers.

## Comparative Light Fading Stability of Current Process RA-4 Papers for Printing Color Negatives

Introduced in February 1992, Fujicolor Paper Super FA Type 3 and a higher-contrast version called Fujicolor SFA3 Type C for commercial labs are by far the best, longest-lasting RA-4 compatible color negative papers available. Fuji planned to introduce a lower-contrast "professional" version of the papers, tentatively named Fujicolor SFA3 Professional Portrait Paper, around the end of 1992. Fujicolor Supreme paper has also been upgraded to have the same precedent-setting image stability characteristics of the other SFA3 papers.

When exposed to light on display, the Fujicolor SFA3 papers will last *more than four times longer* than Ektacolor Edge, Ektacolor Portra II, Supra, Ultra, and the other Kodak RA-4 papers, as shown in **Figure 3.6** and in **Table 3.1a** (page 131). All of these papers proved to be magenta-dye-limited (with this author's visually-weighted fading limits, the magenta dye was considered to be the least stable of the three image dyes).

All of the RA-4 Ektacolor papers listed in **Table 3.1a** had essentially identical light fading stability; the image-life predictions given here were based on tests with Ektacolor Portra II Paper, which was introduced in 1992 as a replacement for Ektacolor Portra Paper. Portra II was the latest version of Ektacolor paper available to this author for testing at the time this book went to press in late 1992.

The major advance in light fading stability of the Fujicolor SFA3 papers was made possible by a new type of high-stability, low-stain coupler that forms a magenta dye of greatly increased resistance to light fading and also has greater color purity. The resistance to light fading is further increased by special stabilizers incorporated into the emulsion of SFA3 papers.[16] The new Fuji magenta-dye-forming coupler has markedly reduced rates of yellowish stain formation when the prints are in dark storage, and, in terms of stain formation, Fuji reports that it makes little difference whether the prints are processed in the "washless mode" with Fuji washless stabilizer, or are given a water wash.

The magenta-dye-forming coupler employed by Kodak in its RA-4 and EP-2 Ektacolor papers has been little improved since the introduction of Ektacolor 37 RC paper in 1971; the magenta dye has poor light fading stability, and the unreacted magenta coupler has a pronounced tendency to form yellowish stain when the prints are in dark storage. With current RA-4 and EP-2 Ektacolor papers, dark storage stain formation is a more serious problem than dark storage dye fading.

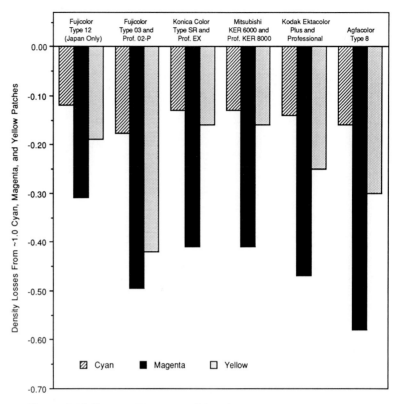

**Figure 3.12** Process EP-2 compatible color negative papers compared by density losses from ~1.0 cyan, magenta, and yellow color patches. Fujicolor Type 12 paper has the best light fading stability among the papers; however, for a number of reasons, Fujicolor Type 12 paper has not generally been marketed outside of Japan. Among the papers available in the U.S. and Europe, Konica Color Type SR papers are recommended as the best of the EP-2 products.

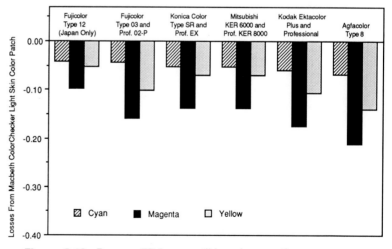

**Figure 3.13** Process EP-2 compatible color negative papers compared by density losses from the Macbeth ColorChecker Light Skin Color patch. For portraits and wedding photographs, this is usually the most important indicator of a color paper's performance. The Konica (and Mitsubishi) papers are recommended as the best among available EP-2 papers and, in terms of overall stability, are significantly better than Kodak Ektacolor Plus and Professional papers. Because of the lower initial density of the ColorChecker Light Skin Color patch, a 60-day test period was used in this test (equivalent to 16 years of display under this author's "standard display condition").

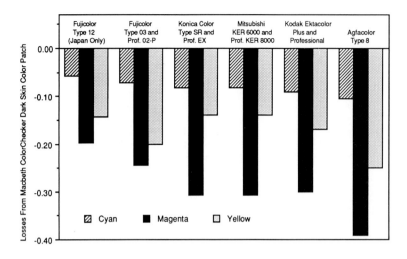

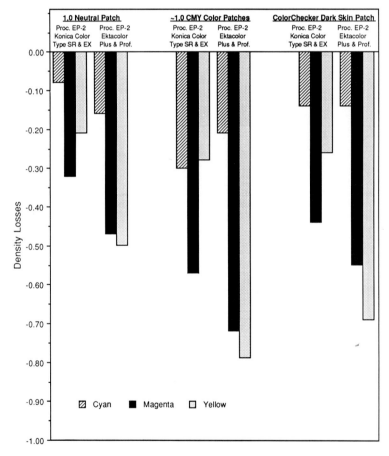

**Figure 3.14** Process EP-2 compatible color negative papers compared by density losses from the Macbeth ColorChecker Dark Skin Color patch. This color is representative of the skin color of dark-skinned individuals. Most portraits, whether of light-skinned or dark-skinned people, have important areas of low-density highlights, and pictorial quality is adversely affected if these highlight areas fade or suffer color balance changes.

Although not as good as the Fujicolor SFA3 papers in either dark storage (yellowish stain) or light fading stability, Konica Color QA Paper Type A3 and its lower-contrast "professional" counterpart, Konica QA Paper Professional Type X2, are this author's second recommendation among the RA-4 papers.

**Figures 3.7** and **3.8** compare the light fading stability of neutral and color patches with the current RA-4 papers. The superiority of the Fujicolor SFA3 papers over Ektacolor, Konica Color, and Agfacolor papers is obvious. The stability of the magenta dye in Fujicolor SFA3 papers closely matches that of the cyan and yellow dyes, thus minimizing color balance changes as fading progresses.

Of particular importance for portrait and wedding photographers is the performance of a color paper in terms of the fading of skin tones (see **Figures 3.9** and **3.10**; to this author's knowledge, this is the first publication of a comparison of color papers based on the stability of skin colors). Again, the superiority of the Fujicolor SFA3 papers over Kodak's Ektacolor papers is obvious. As light fading progresses, the disproportionate fading of the magenta dye in Ektacolor papers imparts an ever more sickly, greenish appearance to skin tones. This is especially apparent in light skin tones because of their low initial density.

Because of the superior performance of the Fujicolor SFA3 papers, both when exposed to light on display and when kept in dark storage, the papers are particularly recommended for portrait, wedding, photo-decor, and fine art photography — markets where long-lasting prints are a must.

## Comparative Light Fading Stability of Current Process EP-2 Papers for Printing Color Negatives

As discussed previously, Process EP-2 papers are being phased out in favor of faster-processing RA-4 papers. The papers listed in **Table 3.1b** (page 132) are probably the last of their kind; with the market moving rapidly toward RA-4 papers, it is unlikely that any new EP-2 papers will be introduced in the future.

**Figures 3.11** and **3.12** illustrate the light fading stability of neutral and color patches for the EP-2 papers. Compared with Ektacolor Plus

**Figure 3.15** Konica Color PC Paper Type SR and Kodak Ektacolor Plus Paper compared in a 6-year, 1.35 klux test with fluorescent illumination. The sample area was maintained at 75°F (24°C) and 60% RH, and the print samples were covered with glass. In this test, Konica Type SR paper performed much better than did Ektacolor Plus. Because of light-fading reciprocity failures, which are more pronounced with the Ektacolor paper than with the Konica paper, the disparity between the two products is greater than indicated by short-term, high-intensity 21.5 klux tests. Particularly noteworthy is the substantially increased fading of the Ektacolor yellow dye in the 1.35 klux test compared with the 21.5 klux test. The low-intensity 1.35 klux test more closely approximates normal indoor display conditions than does the short-term, 21.5 klux test.

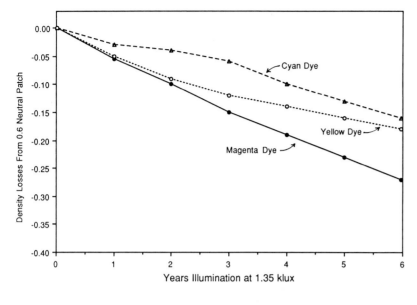

**Figure 3.16** Konica Color Type SR and Type EX papers exposed to glass-filtered Cool White fluorescent illumination for 6 years in a low-level, 1.35 klux accelerated light fading test. With a relatively small change in color balance, the overall light fading stability of Konica Type SR and Type EX papers was better than that of any other Process EP-2 compatible papers tested.

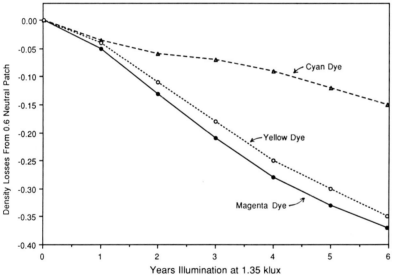

**Figure 3.17** Kodak Ektacolor Plus and Ektacolor Professional papers exposed to glass-filtered Cool White fluorescent illumination for 6 years in a low-level, 1.35 klux accelerated light fading test. Note the more rapid fading of the magenta and yellow dyes, and the greater change in color balance, compared with that of Konica Type SR and Type EX papers (see above **Figure 3.16**). Generally similar data were obtained with prints exposed to bare-bulb fluorescent illumination and with prints covered with sheets of Plexiglas UF-3, a sharp-cutting acrylic UV filter.

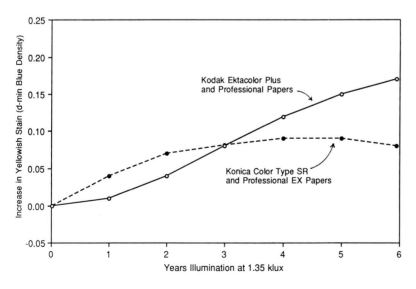

**Figure 3.18** D-min yellowish stain formation in Konica Color Type SR and Ektacolor Plus papers compared in a 6-year, 1.35 klux test with fluorescent illumination. At the end of 6 years, the Ektacolor print had developed approximately twice the stain level of the Konica Type SR print. Because of pronounced stain-formation reciprocity failures, high-intensity tests offer little useful information on the light-induced staining tendency of chromogenic color papers. It should be noted, however, that dye fading, and not stain formation, is the most serious problem for displayed prints made with current papers.

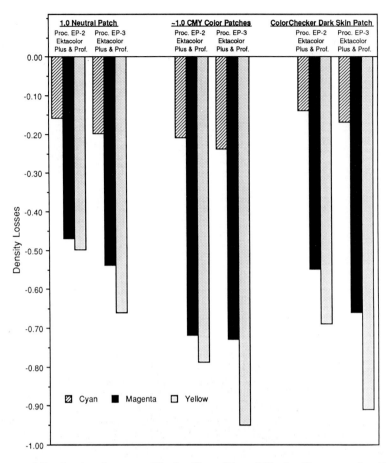

**Figure 3.19** The light fading behavior of Ektacolor Plus prints processed by two different methods. In 6-year, glass-covered 1.35 klux fluorescent tests, yellow dye fading increased when prints were processed with Ektaprint EP-3 Stabilizer as a final rinse. This loss of yellow dye stability, which is particularly objectionable in skin-tone colors, exhibits large reciprocity failures in short-term, high-intensity (e.g., 21.5 klux) tests. Use of EP-3 Stabilizer was generally phased out after Ektacolor Plus Paper was introduced in 1984. EP-3 Stabilizer, which both increases cyan dye stability and reduces yellowish stain formation with Ektacolor papers in dark storage, was extensively used with Ektacolor 37 RC paper (1971–78) and Ektacolor 74 RC paper (1977–86). Unfortunately, EP-3 Stabilizer significantly reduced the yellow dye stability of these papers when displayed. The yellow dye in Konica Type SR paper is not similarly affected by EP-3 Stabilizer or other low-pH stabilizers such as Konica Super Stabilizer.

and Professional papers, Konica Type SR and Konica Professional EX papers demonstrate improved performance. This is particularly important for reproduction of light skin tones, as shown in **Figure 3.13**. Dark skin color stability is shown in **Figure 3.14**. The superiority of the Konica Color PC Paper Type SR and Professional EX papers over Ektacolor Plus and Ektacolor Professional paper becomes even more apparent in 6-year, low-level 1.35 klux tests, as shown in **Figure 3.15** through **Figure 3.18**.

One of the interesting findings of this author's long-term, low-level 1.35 klux tests is that with Ektacolor Plus and Professional papers, the yellow dye exhibited significant reciprocity failure and faded much more with equivalent illumination than it did in high-intensity 21.5 klux tests. In comparing **Figure 3.19** with the Ektacolor Plus data in **Figures 3.11**, **3.12**, and **3.14**, it can be seen that the color balance shift was more extreme in the 1.35 klux condition. Furthermore, as shown in **Figure 3.19**, when Ektacolor Plus and Professional papers were processed with EP-3 Stabilizer, the fading of the yellow dye (and resultant color balance change) was even more pronounced. Konica Type SR and Professional EX, on the other hand, exhibited much less of a reciprocity failure of the yellow dye in the 1.35 klux tests, and a more pleasing flesh tone color balance was maintained.

Except for limited sales under the name Fujicolor Mini-lab Paper, Fujicolor Paper Type 12 has not been available outside of Japan. This was the first Fuji paper to use one of Fuji's high-stability, low-stain magenta couplers, and it is the predecessor of Fuji's outstanding SFA3 papers. Fuji-color Type 12 paper was not supplied to the general U.S. market because, according to Fuji, Kodak and some other non-Fuji EP-2 developers produced unacceptable color-crossovers when the developers were mixed with certain types of water.

Even though Fujicolor Paper Type 03 and Professional Type 02-P had somewhat better light fading stability, this author recommends Konica Color Paper Type SR and Professional Type EX as the best of the EP-2 papers because the Konica papers had significantly better dark storage stability, particularly when processed in the washless mode with Konica Super Stabilizer.

## Comparative Light Fading Stability of Discontinued Color Negative Papers

Most of the papers included in **Table 3.1c** (page 133) are EP-2 products, although some RA-4 papers are represented. One of the most striking findings is that very little improvement in the light fading stability of Ektacolor papers has been made since the introduction of Ektacolor 37 RC Paper in 1971 — over 20 years ago! The same general type of magenta dye continues to be used by Kodak in its current RA-4 and EP-2 papers. One improvement that can be seen in Ektacolor papers, however, is the UV-absorbing emulsion overcoat that appeared unannounced in Ektacolor 74 RC Paper in early 1982. The initial type of Ektacolor 74 RC Paper, which did not have a UV-absorbing overcoat, exhibited very rapid cyan dye fading when exposed to illumina-

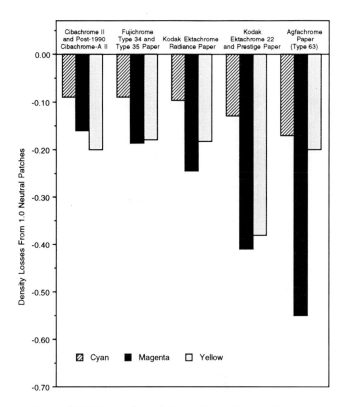

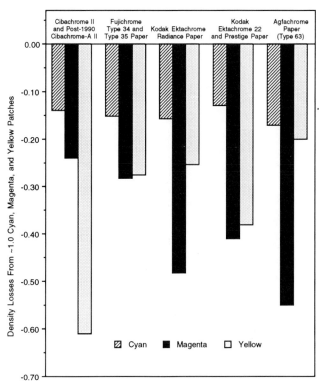

**Figure 3.20** Papers for printing color transparencies compared by density losses from 1.0 neutral patches. As with the color negative papers discussed previously, the Process R-3 Fujichrome, Ektachrome, and Agfachrome print samples were covered with glass and exposed to 21.5 klux fluorescent illumination for 100 days in accelerated light fading tests conducted at 75°F (24°C) and 60% RH. Because of the large reciprocity failures exhibited by Ilford Cibachrome materials (renamed Ilford Ilfochrome in 1991) in short-term, high-intensity tests, the Cibachrome II samples were exposed to an equivalent total light exposure at 1.35 klux for 5 years (1,825 days), also at 75°F (24°C) and 60% RH. This light exposure is equivalent to about 30 years of display under this author's "standard display condition" of 450 lux for 12 hours per day. It is important to note that the relative performance of these papers when measured at a neutral density of 1.0 may differ from that when the density is measured at the visually more critical density of 0.6 which was employed in determining the image-life limits reported in **Table 3.2** on page 135.

tion with a significant UV content (e.g., bare-bulb fluorescent lamps or bare-bulb quartz halogen lamps in fixtures with no glass covers). In indoor north daylight tests, with the light passing through a north-facing window, the benefit of the UV-absorbing overcoat is significant. All chromogenic color negative and color reversal papers are now made with UV-absorbing overcoats.

## Comparative Light Fading Stability of Papers for Printing Color Transparencies

The comparative stability of materials for printing color transparencies is given in **Table 3.2** (page 135) and in **Figures 3.20** and **3.21**. Among conventional, easy-to-process

**Figure 3.21** Papers for printing color transparencies compared by density losses from ~1.0 cyan, magenta, and yellow color patches. The large loss of yellow dye in the Ilford Cibachrome II (Ilfochrome Classic) print in this 1.35 klux test is not evident in short-term, high-intensity tests. In spite of comparatively large losses of the yellow dye in the pure yellow patch, this author nevertheless rates the overall light-fading stability of Ilfochrome as the best of all easily processed materials for printing color transparencies. Of the various image-life parameters employed by this author in evaluating color prints, the human eye is least sensitive to losses in yellow and near-yellow colors (see discussion in Chapter 2).

color print materials, Ilford Ilfochrome materials (called Cibachrome, 1963–1991) are the only products that can be considered to be absolutely permanent (with essentially zero stain levels) in dark storage at normal room temperatures. Here we see the great advantage of the Ilfochrome preformed dye system over the chromogenic process.

If Ilford would develop an improved-stability, negative-printing version of Ilfochrome, which is well within the realm of silver dye-bleach technology, this new product would be enormously successful in the portrait, wedding, commercial display, and fine art fields.

Beginning with several of the new Ilfochrome Rapid print materials for Process P-4 announced during 1991 and 1992, Ilford introduced a new type of magenta dye that is said to have somewhat improved light fading stability compared with the previous magenta dye. Because both the cyan and yellow dyes remain unchanged from previous Ilfochrome (Cibachrome) print materials, the new magenta dye will probably have little effect on the image-life predictions given for Ilfochrome materials in **Table 3.2** (page 135) and **Table 3.4** (page 139). Ilford reports that the dark

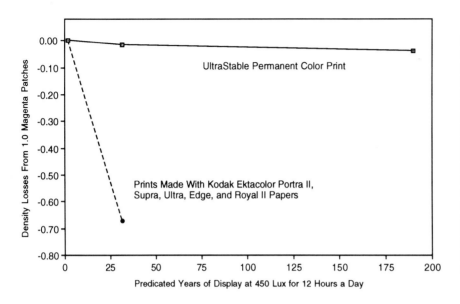

**Figure 3.22** The predicted light-fading stability of Polaroid Permanent-Color prints compared with Kodak Ektacolor prints. Polaroid Permanent-Color prints employ color pigments that are far more resistant to light fading than the organic dyes in Ektacolor and other traditional color prints. UltraStable Permanent Color prints, which also employ high-stability pigments, have cyan and magenta pigments with light fading stability that is similar to that of Polaroid Permanent-Color prints. The "improved-stability" non-toxic (lead-free) metal-type yellow pigment to be introduced in early 1993 for the UltraStable process is expected to have light fading stability that is similar to that of the cadmium yellow pigment in Polaroid Permanent-Color prints.

fading stability of the new magenta dye is "as outstanding as it was for the older magenta dye."

As shown in **Figures 3.20** and **3.21**, Fujichrome Type 35 paper is by far the best choice among Process R-3 reversal papers. With its good dye stability and low stain level in dark storage together with good light fading stability, this is the slide-printing counterpart to Fujicolor SFA3 papers for printing color negatives. It should be noted, however, that although Fuji SFA3 and Type 35 papers have similar dark storage stability, SFA3 paper is much more resistant to light fading on display. For that matter, the light fading stability of Fujicolor SFA3 paper is significantly better than that of current Ilfochrome prints!

Kodak Ektachrome Radiance Paper, introduced in 1991 as the successor to Ektachrome 22 Paper, falls considerably short of Fujichrome Type 35 paper in both light fading stability and dark storage stability. In particular, the rates of yellowish stain formation in dark storage are far higher with Ektachrome Radiance papers than with Fujichrome Type 35 papers.

Kodak's Ektachrome Copy Paper, which was still on the market at the time this book went to press in 1992, has a cyan dye with very poor dark fading stability. Ektachrome Copy Paper is a relic from an earlier era of color papers and should be strictly avoided.

### Comparative Light Fading Stability of Pigment Color Prints

The estimated image life of displayed pigment color prints is given in **Table 3.2** (page 135). To a greater or lesser degree, all of the organic dyes used to form the images in conventional color films and prints gradually fade when exposed to light. Even Ilford Ilfochrome and Kodak Dye Transfer prints, both of which are exceedingly stable when stored in the dark, will fade to an objectionable degree after relatively few years of display.

(In long-term display, no current color material with a dye image can even approach the stability of the silver image of a carefully processed black-and-white photograph made on fiber-base paper).

### UltraStable Permanent Color Prints and Polaroid Permanent-Color Prints

To make a color photograph that can withstand hundreds of years exposure to light on display, UltraStable Permanent Color prints[17-19] and Polaroid Permanent-Color prints[20] employ highly stable cyan, magenta, yellow, and black pigments instead of the organic dyes used by other types of color photographs to form the image. The pigments are similar to those in automobile paints, which must be able to survive years of outdoor sun exposure under the harshest conditions. The prints are made on long-lasting polyester-base materials.

Both UltraStable and Polaroid Permanent-Color materials were developed by Charles Berger of Ben Lomond, California. The Polaroid materials are manufactured by the Polaroid Corporation under contract with commercial users and are not sold in the general market.

UltraStable materials, which have a number of improvements over the earlier Polaroid Permanent-Color materials, are supplied by UltraStable Color Systems, Inc. of Santa Cruz, California.

When made properly, UltraStable prints are extremely sharp and have excellent color and tone reproduction. Prints can be made from existing prints, color negatives, or transparencies. Because separation negatives the size of the final image are required, having the prints made is fairly expensive. A 16x20-inch UltraStable print may cost $500 or more for the first print; additional copies are less. (The UltraStable process is described in detail on pages 49–51.)

This author has employed various tests, including a 6-year, high-intensity 21.5 klux accelerated fluorescent test, to evaluate the stability of Polaroid Permanent-Color pigment prints.[21] Because UltraStable Permanent Color materials with the "improved-stability" yellow pigment (to be introduced in early 1993) were not available when this book went to press, test data for these materials could not be included. (Long-term tests were done with prototype materials having a different, less light-stable yellow pigment.)

What information that is available, however, leaves no doubt that UltraStable prints made with the "improved-

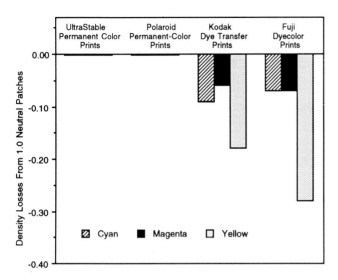

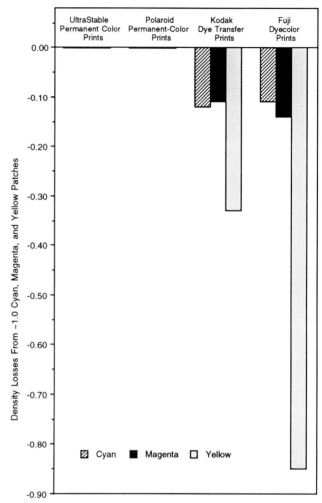

**Figure 3.23** A comparison of UltraStable Permanent Color prints (based on the estimated stability of the new yellow pigment to be introduced in early 1993) and Polaroid Permanent-Color pigment prints with Kodak Dye Transfer and Fuji Dyecolor prints by density losses from 1.0 neutral density patches. In this accelerated test, the prints were covered with glass and exposed to 21.5 klux fluorescent illumination for 100 days. Dye Transfer and Fuji Dyecolor prints employ preformed dyes to form the image; while the prints are subject to light fading, they are essentially permanent in dark storage (see Chapter 5). All four of these processes require black-and-white separation films that are the same size as the final prints; because of this, they are considerably more labor-intensive and costly than Fujicolor, Ektacolor, Agfacolor, Konica Color, Ilfochrome, and other easy-to-process materials.

**Figure 3.24** A comparison of UltraStable Permanent Color prints (based on the estimated stability of the new yellow pigment to be introduced in early 1993) and Polaroid Permanent-Color pigment prints with Kodak Dye Transfer prints and Fuji Dyecolor prints by density losses from ~1.0 cyan, magenta, and yellow patches. (The test conditions were the same as those employed in **Figure 3.23**.) Fujicolor Dyecolor prints, which are made by a method which is similar to that used with the Kodak Dye Transfer Process, are produced by the Fujicolor Services lab in Osaka, Japan and are not available outside of Japan.

stability" yellow pigment and Polaroid Permanent-Color prints are far more stable than any other type of color print on the market (**see Figures 3.22** through **3.24**). Under typical indoor display conditions, it is expected that both types of prints should last for 500 years or more before noticeable fading or staining occurs. The prints also have extremely good dark storage stability.

The stability of the color pigments in UltraStable and Polaroid Permanent-Color Prints is such that the display life of the prints probably is not limited by fading, but rather by cracking (which most likely would be caused by fluctuating relative humidity) of the pigment-containing gelatin image layers, by instability of the gelatin after years of exposure to light, by adhesion failures between the gelatin and white polyester support material, or by the eventual failure of the polyester support itself.

The comparative light fading characteristics of UltraStable Permanent Color Prints (made with the "improved-stability" yellow pigment introduced in early 1993), Polaroid Permanent-Color Prints, Kodak Dye Transfer Prints, and Fuji Dyecolor prints are shown in **Figures 3.23** and **3.24**.

## EverColor Pigment Prints

In late 1992 the EverColor Corporation of El Dorado Hills, California announced the EverColor process for making long-lasting pigment color prints.[22] The EverColor process is a high-stability modification of the AgfaProof graphic

arts proofing process which employs silver-halide gelatin emulsions that contain cyan, magenta, yellow, and black pigments. EverColor plans to offer the prints commercially in early 1993.

In succession, each layer is mechanically transferred onto a polyester print support sheet with an AgfaProof automated transfer machine. Following transfer, the sheet is dried in an AgfaProof dryer. The print sheet is then exposed through the appropriate screened separation negative in a low-wattage graphic arts contact printer. Following exposure, the print sheet is run through an AgfaProof processing machine which develops the image in a "tanning developer" that hardens the gelatin in proportion to image density, immerses the print in a bleach/fix bath to remove the developed silver image, and then washes off

unhardened pigment-containing gelatin in a warm water bath to reveal the color image. The print is then dried in an AgfaProof dryer, and the process is repeated for each of the remaining three colors to complete the print.

The AgfaProof system was designed as a graphic arts proofing process, and as such the cyan, magenta, yellow, and black pigments normally employed by Agfa have been selected to precisely match 4-color printing inks; light fading stability was not a consideration. The EverColor Corporation contracted with Agfa to coat special emulsions that are formulated with carefully selected high-stability color pigments.

The EverColor process appears to have all of the needed characteristics for making very long lasting, high-quality prints at reasonable cost. The image quality of AgfaProof graphic arts proofs is very good, and the process is highly reproducible. In the future, with the incorporation of high-speed silver halides in the emulsions, it would appear that the materials could be direct-written by a laser scanner output device. This would eliminate the expense of making full-size separations and would lower the cost of making the prints when only one or two copies are required.

Based on limited information on the pigments provided by Bill Nordstrom of the EverColor Corporation, this author has included EverColor prints in **Table 3.2** (page 135). It must be emphasized, however, that at the time this book went to press in late 1992, this author had not had the opportunity to test EverColor prints. Indeed, at the time of this writing, this author had not even seen an EverColor print. Nevertheless, it was felt that the reader would want to know about the EverColor process, and for that reason it is included here.

At the time this book went to press in 1992, Nordstrom was producing UltraStable prints through his firm, Color Prints by Nordstrom. He has indicated that his company will probably continue to supply UltraStable prints on request after the EverColor process goes into production.

### Fuji-Inax Photocera
### Ceramic Color Photographs

Fuji-Inax Photocera ceramic color photographs (see page 44) are a joint development of Fuji Photo Film Co., Ltd. and Inax Corporation, a major Japanese producer of ceramic tiles and bathroom fixtures. The photographs are available only in Japan through Fujicolor Processing Service.

The Photocera process, which was introduced in 1991, employs inorganic pigments to print images on ceramic substrates which are fired at very high temperatures. The resulting "photographic ceramic tile" is permanent in the dark and is also unaffected by light, rain, seawater, and fire; in addition, the images are very resistant to surface abrasion. Intended markets for Fuji-Inax Photocera color photographs include heirloom gifts, outdoor signs in zoos and parks, and portraits for memorials and gravestones. Samples of Photocera photographs were not received in time for test results to be included in this book. However, test data made available to this author by Fuji leave little doubt that Photocera photographs are *extremely* long lasting. Fuji calls the photographs "quasi-eternal."

Photocera photographs, which have screened images, can be printed from any type of photographic original and are available in a variety of sizes from 2½ x 3½ inches ($260 for the first print, less for additional copies) to 24 x 31 inches ($5,820 for the first print, less for additional copies).

### Fresson Quadrichromie Pigment Prints

Fresson Quadrichromie pigment color prints are made in France by Atelier Michel Fresson. The Fresson lab, located near Paris,[23] has been producing limited quantities of Quadrichromie prints since 1952. The materials to make the prints are not available to the public.

### Comparative Light Fading Stability of Color Prints Made by Thermal Dye Transfer, Canon Laser Copier, Iris Ink Jet, and Other Processes

Among the color print materials and processes listed in **Table 3.3** (page 137) are a number of new technologies for making color prints that have emerged during the last 10 years and are now beginning to make serious inroads in the photography field. Probably foremost among them is the thermal dye transfer process, which is being employed in digital desktop thermal printers made by Kodak, Sony, Hitachi, and other manufacturers to produce fairly high-quality "photorealistic" color prints. Ektatherm prints, which are made with the Kodak XL 7700-series digital printers (costing between $18,000 and $25,000), are perhaps the most prominent example of this technology. With the commercial introduction of the Kodak Photo CD system in the summer of 1992, Ektatherm prints will be the only type of print initially available from the Photo CD's; in addition, the Photo CD Index Print supplied with each Kodak Photo CD as a "contact sheet" visual reference to the images recorded on the disc will be an Ektatherm print.

Unlike conventional color materials such as Ektacolor and Fujicolor prints, Ektatherm and other thermal dye transfer papers do not have a UV-absorbing overcoat. The image dyes in Ektatherm prints are adversely affected by UV radiation, and in display situations where significant UV radiation is present, such as with bare-bulb fluorescent illumination, the prints fade much more rapidly than they do when protected from UV radiation (see **Figure 3.5**). Because thermal dye transfer materials use preformed dyes or pigments to form the color image, the stability of the images could probably be significantly improved in the future with the selection of more stable colorants.

Ink jet printing, in which color images are formed by spraying millions of tiny ink droplets in precise position onto paper, has found significant application in the graphic arts field for direct proofing of the digital data from laser or CCD scanners. Because of the ability of ink jet printers to make large prints on almost any sort of paper or other support material, there has been significant interest in the technology in the fine arts field (see pages 52–54 for discussion of the use of Iris ink jet printers for making fine art prints at Nash Editions in California). Unfortunately, at the time this book went to press in late 1992, all of the ink sets available for use in Iris ink jet printers had very poor light fading stability.

Image-life predictions for the standard Iris ink set are given in **Table 3.3** (page 137); also tested was an ink set made by American Ink Jet, which proved only somewhat

A Polaroid SX-70 color print made in 1973 that has developed internal image-receiving layer cracks. Early SX-70 prints (1972–76) are frequently found to have developed such cracks, especially if they have been stored in very dry conditions.

A magnified view of the image cracks, which form in the upper layers of the print's internal structure. The transparent polyester sheet that covers the top of the print is not affected by the internal cracking and remains intact.

Image-receiving layer cracks are often easier to detect in light areas of an SX-70 image. Unlike the light-induced cracks found in RC prints, light apparently plays no role in the formation of image-receiving layer cracks in SX-70 prints.

more stable than the Iris inks, and an ink set supplied by Siemens, which was even less stable than the Iris inks. It is hoped that a much more light-stable ink set can be developed for ink jet printing; the process has much to offer from an aesthetic and functional point of view, especially for large display prints.

Two ink set supplied by Stork Bedford B.V. for Stork ink jet printers were also tested, but the light fading stability of these inks proved to be little better than the Iris ink set.

Electrophotographic or xerographic color prints, all of which use preformed colorants to form images, show great promise as a means of making stable color prints. Using a Canon Color Laser Copier, for example, photographs of sufficient quality for proofs, business presentations, and short-run publications can be produced quickly and at low cost. The light fading stability of Canon color copies is much better than that of Ektacolor prints, but not as good as that of Fujicolor SFA3 prints.

## Polaroid Instant Color Prints

As shown in **Table 3.3** (page 137), Polaroid Spectra and Polaroid 600 Plus prints also have poor light fading stability. Polaroid Spectra film was replaced with Spectra HD (High Definition) film in 1991; samples of Spectra HD were not available in time for 1.35 klux test data to be included in this book; however, the image stability of Spectra HD prints is believed to be similar to that of previous Spectra prints.

When displayed, Polaroid Spectra, 600 Plus, and SX-70 prints fade significantly faster than typical chromogenic papers. The dyes in Polaroid instant prints are extremely stable in dark storage. The problem with these prints is that in dark storage at normal room temperatures, they develop an objectionable yellowish overall stain in a relatively short period. In non-accelerated (real-time) tests,

the stain levels exceeded this author's d-min stain limits in only a few years. The stain is produced by slow migration of non-image dyes and/or other chemical constituents residing in the lower layers of the tightly sealed Polaroid print package.

In 1992 Polaroid introduced the Vision 95 system in Europe, a smaller format camera and film employing an improved version of the Spectra HD print emulsion. In 1993, "Vision 95" cameras and film will be introduced in the United States and other parts of the world under different names. A Polaroid spokesman told this author that the light fading stability of Vision 95 prints is expected to be essentially the same as that of Spectra and Spectra HD prints. The spokesman also indicated that Vision 95 prints have a somewhat reduced rate of yellowish staining in dark storage; however, specific stain data for Vision 95 prints were not available from Polaroid or independent laboratories at the time this book went to press.

Polaroid color prints have no usable negative (like daguerreotypes, each exposure produces a unique image). If important pictures have been made on these materials, the best policy is to make two copies on a more stable print material (Polaroid itself offers good-quality copies, made on Fujicolor color negative paper, at reasonable cost). Keep one copy in the dark and display the other.

Polaroid peel-apart prints (e.g., Polacolor ER and Polacolor 2) do much better in dark storage than Spectra and other Polaroid integral prints because in the peel-apart prints, the negative layer (with its unused image-forming dyes and other chemicals) is stripped away after processing. However, these prints have poor light fading stability and should be displayed with caution. Copies should be made for long-term display.

Beginning with the introduction of SX-70 prints in 1972, Polaroid has made numerous misleading claims about the

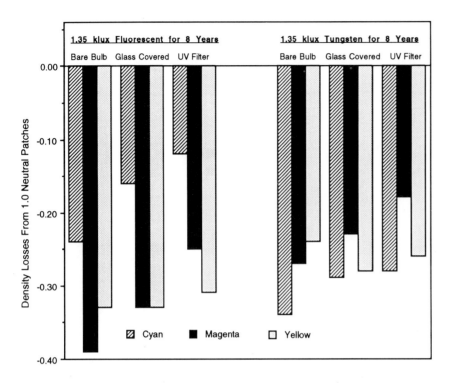

**Figure 3.25** A comparison of glossy, polyester-base Ilford Cibachrome II (Ilfochrome Classic) prints in an 8-year test with 1.35 klux fluorescent and 1.35 klux incandescent tungsten illumination by density losses from 1.0 neutrals. Note that the cyan dye faded more under tungsten illumination than it did under fluorescent illumination. Using this author's image-life fading and color balance change limits, and a starting density of 0.6, the tungsten-illuminated print actually reached its first image-life limit sooner than did the fluorescent-illuminated print (see **Table 3.5**).

dye stability of its materials.[24–26] For example, in a two-page advertisement that appeared in *Newsweek* and a number of other national magazines, Polaroid said:

> The photographer is Marie Cosindas. The medium is Polaroid's Polacolor Land film. The result is the remarkable photograph at the right, "Dolls," a work of art recently acquired by the Museum of Fine Arts in Boston. Now, Polacolor 2 film has the same unique metallized dyes found in Polaroid's SX-70 film. It has the same exceptional clarity and stability. And its brilliant colors are among the most permanent and fade resistant ever developed in photography. Polacolor film is used by amateur, professional and scientific photographers throughout the world. Polaroid, the choice of the artist in the creation of her art.[27]

The Polaroid Corporation even operates a service called the Polaroid Museum Replica Collection, which reproduces works of art in the Boston Museum of Fine Arts collection on large-format Polacolor ER film and offers the lacquered, mounted, and framed prints to the public. The Polaroid Museum Replica Collection will also reproduce works of art for private individuals. There is no mention of the poor light fading stability of these expensive prints, and no cautions whatever are given concerning the fading that inevitably will occur in the course of long-term display.[28]

There are signs, however, that Polaroid is beginning to take a more realistic public stance regarding the image stability of its color print materials. In a technical data sheet for Polacolor 64 Tungsten instant print film, dated January 1992, Polaroid stated: "Photographs can be damaged by, and must be protected from, the effects of light."[29] Polacolor 64 Tungsten, introduced in 1992, is a tungsten-balanced derivative of daylight-balanced Polacolor ER instant print film.

## Internal Image-Receiving Layer Cracking of Polaroid SX-70 Instant Prints

The cracking of the internal image-receiving layer that has occurred in many Polaroid SX-70 prints made during the 1970's is another example of an entirely new type of print material having a completely new type of deterioration. Cracking of this type, in which the internal image layer cracks but the polyester cover and backing sheets are unaffected, has not yet been observed in Fuji instant prints (available only in Japan) or the now-obsolete Kodak instant prints.

Apparently caused by low and/or widely fluctuating relative humidity, the cracking of SX-70 prints does not appear to be influenced by the presence or absence of light unless the light is accompanied by significant heating of the print (which occurs if the print is subjected to direct sunlight, for example). There is no accepted accelerated test for SX-70 cracking. Polaroid has declined to release the details of the tests it uses to evaluate the problem, although the company has said that improvements were made in SX-70 prints around 1980 and that the prints are no longer subject to cracking except under extreme conditions.

Because unacceptable levels of yellow stain can occur after only a few years of storage under normal conditions (see Chapter 5) and because catastrophic internal image-layer cracking is a possibility, this author does not recommend Polaroid Spectra HD prints (called Polaroid Image prints in Europe), Polaroid 600 Plus prints, or SX-70 prints for other than short-term applications. Polaroid instant color prints have no negative from which a new print can be made when the original deteriorates.

## Comparative Light Fading Stability of Color Prints Illuminated Under Incandescent Tungsten Lamps

**Table 3.4** gives image-life predictions for prints illuminated with incandescent tungsten lamps. This is of primary interest to museums and archives where display areas are usually illuminated solely with tungsten lamps. In this table, both the strict set of "Critical Museum and Archive Use" criteria, which allows very little change in image characteristics, and the more tolerant set of "General Home and Commercial Use" criteria have been included to make display-life extrapolations from the accelerated test data (see Chapter 2).

To report image-life predictions for color prints displayed with incandescent tungsten illumination in museums and archives, this author has adopted an illumination intensity of 300 lux (28 fc) for 12 hours a day. This is a higher illumination level than many conservators recommend, but this author feels that this is the minimum level acceptable for proper viewing of photographs, especially color photographs.

There is no minimum "safe" illumination for color photographs below which fading does not take place, and this author believes that it is better to provide adequate illumination for museum exhibits and at the same time to regularly monitor the fading/staining of the color photographs in the collection. Fading and staining must not be allowed to progress beyond pre-set limits.

Display of originals will have to be restricted in any event, and, where it is deemed acceptable from a curatorial point of view, facsimile color copy prints can be substituted for long-term or "permanent" display while the originals are preserved in cold storage. (The reader is referred to Chapter 7 and Chapter 17 for further discussion of this sometimes controversial subject.)

Because incandescent tungsten illumination has a low UV and blue content (the most photochemically active wavelengths) it has often been recommended that color prints be displayed with tungsten illumination to minimize image fading. This author's tests indicate that for equal illumination intensities, the fading rates observed for many types of prints are not substantially different with tungsten or fluorescent illumination. In fact, as shown in **Table 3.5** (page 142), Ilford Ilfochrome Classic prints (formerly called Cibachrome II prints), and the now-obsolete Agfachrome-Speed and Kodak PR10 instant prints, along with several other materials, actually faded more rapidly under tungsten light than they did with fluorescent.

In the case of Ilford Ilfochrome Classic, as shown in **Figure 3.25**, the cyan dye faded significantly more under tungsten illumination than it did under fluorescent illumination of the same 1.35 klux intensity in 10-year, low-level tests. The most likely explanation for this is the proportionally higher red content in tungsten illumination than in Cool White fluorescent light. Although the photochemical energy of red light is low, it is apparently sufficient to cause fading of the Ilfochrome cyan dye, which has its primary absorption in the red portion of the spectrum. This also appears to be true of the cyan dyes in the now-obsolete Agfachrome-Speed and Kodak PR10 instant prints.

Most of the light to which displayed photographs are exposed in homes and offices is either indirect daylight through window glass or light from fluorescent fixtures. In other than museum display, tungsten light is usually of such low intensity and/or hours of duration that its contribution to the overall light fading of a print is relatively small.

The surprising conclusion of these incandescent illumination studies, as shown in **Table 3.5** (page 142), is that in most cases color prints fade at about the same rate under fluorescent and tungsten illumination of the same lux intensity. There are some differences in fading rate and the direction and degree of color balance change, but the magnitude of these differences is generally small (e.g., refer to the data in **Table 3.5** for Konica Color PC Paper Type SR and Kodak Ektacolor Plus and Professional papers).

Tungsten halogen lamps (also called quartz halogen lamps) are increasingly found in museums, galleries, commercial buildings, and homes. Tungsten halogen lamps have become popular because they operate at a somewhat higher color temperature than incandescent lamps and therefore produce a "whiter" light (see discussion in Chapter 17). Halogen lamps also last longer and use less electricity than incandescent lamps.

To withstand their high operating temperature, halogen lamps are made with a quartz bulb instead of the glass bulb used in incandescent tungsten lamps. Quartz is transparent to much shorter wavelengths than is glass, and for this reason bare-bulb halogen lamps emit significant energy in both the long- and short-wavelength ultraviolet region. Such UV radiation can be very damaging to color photographs (especially Kodak Ektatherm and other types of color materials that lack a UV-absorbing overcoat). For this reason, halogen lamps should always be fitted with a protective glass or plastic cover that will absorb UV radiation below about 330 nm.

Recent studies have shown that exposure to bare-bulb tungsten halogen illumination may also increase the risk of skin cancer in humans.[30] Covering the lamps with a sheet of glass or plastic to absorb short-wavelength UV radiation apparently eliminates such risk.

## Comparative Light Fading Stability of Color Prints Illuminated with North Daylight

**Table 3.6** (page 143) gives the relative stability of many types of color prints exposed to north daylight through window glass. With the prints located close to the window, this is a "worst-case" display situation. North daylight contains a significantly higher percentage of blue light and UV radiation than either tungsten or glass-filtered fluorescent light.

In comparing the image-life predictions in this table with the predictions given in **Tables 3.1b** and **3.1c**, and **Tables 3.2** and **3.3**, it can be seen that north daylight illumination is in most cases more harmful to color prints than is either fluorescent or tungsten illumination. This is true even when prints exposed to north daylight are shielded from ultraviolet radiation with a UV-absorbing filter. Because the average illumination intensity in this north daylight test was only 0.78 klux (averaged over a 24-hour period), much longer test periods were required than was the case with the high-intensity 21.5 klux fluorescent tests re-

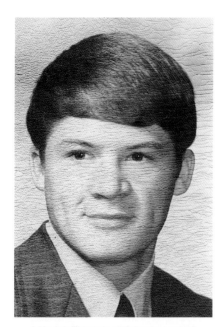

A Kodak Ektacolor RC (resin-coated) print that has suffered light-induced cracking of the thin white RC layer coated on the paper core of the print beneath the emulsion. The RC layer is made of polyethylene pigmented with titanium dioxide. This print, which was made in 1970, developed the cracks after only about 6 years of display under normal conditions in a home. The print had been dry mounted and framed under glass. (Original color photograph by Max Brown)

A magnified view of part of the cracked print. By the time the cracks appeared, the print had also showed significant fading. Like most professional portraits, this print had been lacquered. Similar Ektacolor prints from the time that had not been lacquered have in many cases also suffered light-induced RC layer cracking. This author has observed similar light-induced RC cracking in Agfacolor, Ektachrome, and Cibachrome RC prints made from about 1974 until the early 1980's.

That prolonged exposure to light was the cause of the cracking of this print is evident in this magnified view of the edge of the print: the cracking of the RC layer stopped where the edge of the print was protected from light by a frame. Black-and-white RC prints may also develop light-induced cracking of the RC layer; in addition, they may suffer from light-induced discoloration and fading of the silver image (see discussion of the problems of B&W RC prints in Chapter 17).

ported earlier in this chapter. Reciprocity failures probably contributed to the shorter image-life predictions for many of the materials in the north daylight test. In addition, because an integrating lux-hour meter was available for measuring the accumulated illumination only during the last few years of this 10-year test, there is some uncertainty about what the average illumination actually was during the early years of the test.

The north daylight test does, however, provide valuable information on the stability of one type of print versus another under this display condition; the test also indicates the possible effectiveness of an ultraviolet filter in slowing the rate of fading.

In most display situations, the relative percentage of UV radiation is less than what the prints were exposed to in this north daylight test because UV radiation is largely absorbed by most painted surfaces, walls, ceilings, and floors, which reflect to the print a significant portion of incident illumination. Because of this, the actual effectiveness of UV filters in normal display conditions will probably be less than indicated by this test.

Eastman Kodak has used filtered Cool White Deluxe fluorescent light as the illuminate for most of its published data on print fading, saying, "It's the type of energy to which most prints displayed in public buildings will be sub-

jected. Simulated daylight sources have more UV than a print is likely to see in most applications."

## Light-Induced RC Paper Cracking — A Serious Problem with Early RC Color Papers

The introduction in September 1968 of Kodak Ektacolor 20 RC Paper — the first quick-processing RC (polyethylene-resin-coated) paper sold in the general consumer market — also introduced an entirely new type of deterioration: the embrittlement and subsequent cracking of the titanium dioxide-pigmented polyethylene layer as a result of exposure to even low-level light during normal display (for additional discussion of the structure of RC papers and light-induced RC paper cracking, see Chapter 17).

Many of these early RC prints developed cracks after only a few years of display — something that Kodak became aware of even before the first RC papers were put on the market. Previous fiber-base papers such as Ektacolor Professional Paper, which took much longer to process, wash, and dry than do "waterproof" RC papers, were not subject to this type of cracking. (Fiber-base color prints could, however, develop emulsion cracks as a consequence of cycling relative humidity during storage and/or display. Such cracks, which are not light-induced, are different from the cracks found in RC papers.)

February 1981

The rapid cracking and fading of Ektacolor RC prints in the 1970's presented a major problem for professional portrait and wedding photographers.  Here, Robert and Bernice Fehrenbach of Fehrenbach Studios in Reedsburg, Wisconsin discuss the problem with photographers at their "Faded and Cracked Photographs" booth during the 1981 annual convention of the Wisconsin Professional Photographers Association, held in Milwaukee, Wisconsin.  On the table are a selection from the many hundreds of faded and cracked Ektacolor RC prints that disgruntled customers had returned to portrait studios in Wisconsin, Minnesota, North Dakota, and South Dakota.  The Fehrenbachs, who founded the Committee on Faded and Cracked Photographs of the Wisconsin Professional Photographers Association, had previously circulated a petition asking Kodak to improve the stability of its color films and papers.  They were also involved in a class-action lawsuit against Eastman Kodak regarding these issues (see Chapter 8).

During the 1970's, Kodak made a number of improvements in the RC paper base which lengthened the time a print could be displayed before cracks started to develop. By about 1977 Kodak started to manufacture RC paper with a polyethylene stabilizer incorporated into the conventional paper core in the center of the RC paper structure; over time the stabilizer diffuses into the adjacent polyethylene layers, thereby significantly increasing their resistance to embrittlement and cracking.

Kodak will not say when this improvement was actually introduced, but it is assumed that by 1980 all general-purpose Kodak color and black-and-white RC papers had been converted to the new RC base.

As yet there is no ANSI standard for testing the physical stability of RC papers, but an American National Standards Institute subcommittee is developing a new black-and-white print stability standard that will include an accelerated test procedure for black-and-white RC prints; the test method should also be applicable to color RC prints. The new ANSI standard is expected to be published in 1994.

Kodak has described a test the company has been using since the 1970's for evaluating the stability of RC papers in which the effects of light are accelerated by increasing the temperature of the test prints.[31] Unfortunately, the applicability of such tests to the many different types of RC papers now on the market has yet to be confirmed by independent laboratories.

At the time this book went to press, Fuji, Agfa, Ilford, Mitsubishi, Konica, and other manufacturers had not published any details of their RC-base test procedures; how the RC papers supplied by these companies compare to each other and to Kodak papers is not yet known.  It is probable that there are significant differences in the stability characteristics of these papers.

## Compared with the Problem of Dye Fading in Displayed Color Prints, RC Base Cracking Is No Longer A Serious Concern

Considering the fact that the color image dyes in all current chromogenic RC prints are subject to light fading during the course of display, available data indicate that, under normal indoor display conditions, significant dye fading will have occurred well before there is any likelihood of cracks developing in the RC paper base. In other words, unlike the situation with some of the earlier RC papers, light-induced RC base cracking is no longer the weakest link in the overall stability of these products (although only long-term testing and experience in the coming years with prints on display and stored in a variety of environments can confirm this). This author's single-temperature accelerated dark storage tests with a variety of recent RC color papers indicate that the dark storage stability of these RC support materials is reasonably good.

Given the choice, however, this author recommends polyester-base print materials such as Fujiflex SFA3 Super-Gloss Printing Material over their RC-base counterparts when maximum stability is desired. A polyester base also avoids the potential problem of RC base-associated fading and staining that has afflicted some chromogenic RC color papers. As the dye stabilities of color print materials are improved — and the images last longer on display and/or when stored in the dark — the demands on the stability of the RC base will also increase.

Ilford Ilfochrome materials are supplied both on a low-cost, RC base and on a more expensive and highly stable glossy, solid polyester support. Given the potentially extremely long life of these prints when stored in the dark, it is recommended that the polyester-base types of Ilfochrome be used if long-term storage is contemplated.

Furthermore, the long-term display characteristics of the present Ilfochrome RC base are not now known, and if maximum stability is desired, the polyester-base types of Ilfochrome are recommended. RC-base Cibachrome II prints (now called Ilfochrome Classic prints) made in 1980 which were tested by this author developed serious overall yellowish stain after several years of storage in the dark after a moderate accelerated light fading test; the polyester-base version of Cibachrome II was not affected in this manner and remained free of stain (see Chapter 2).

## Notes and References

1. Eastman Kodak Company, "Merrett T. Smith," **Kodak Studio Light,** Issue No. 1, 1986, p. 7.
2. Susan Roman, "Koch's Official Portrait: A Photo," PDNews, **Photo District News,** Vol. IX, Issue XIV, December 1989, p. 18.
3. American National Standards Institute, Inc., **ANSI IT9.9-1990, American National Standard for Imaging Media – Stability of Color Photographic Images – Methods for Measuring,** American National Standards Institute, Inc., New York, New York, 1991. Copies of the Standard may be purchased from the American National Standards Institute, Inc., 11 West 42nd Street, New York, New York 10036; telephone: 212-642-4900 (Fax: 212-398-0023).
4. "Agfa Committed To Finishers, Gerlach Says," **Photo Weekly,** Vol. 30, No. 10, April 15, 1985, p. 12.
5. Eastman Kodak Company, **How Post-Processing Treatment Can Affect Image Stability of Prints on Kodak Ektacolor Paper,** Kodak Publication CIS 62, February 1982. The material in this publication is based on a presentation by Paul M. Ness, Professional Photography Marketing, and Charleton Bard, Image Stability Techni-

cal Center, Eastman Kodak Company, given at the February 28, 1982 meeting of the Wisconsin Professional Photographers Association, Oconomowoc, Wisconsin.
6. American National Standards Institute, Inc., see Note No. 3, p. 16.
7. Bob Schwalberg, with Henry Wilhelm and Carol Brower, "Going! Going!! Gone!!! – Which Color Films and Papers Last Longest? How Do the Ones You Use Stack Up?", **Popular Photography,** June 1990, Vol. 97, No. 6, pp. 37–49, 60. The article included Wilhelm's "years of display" image-life predictions for color print materials based on the 450 lux for 12 hours per day "standard display condition" that is used in this book.
8. Fuji Photo Film Co., Ltd., **Fujicolor Professional Paper Super FA,** "Fuji Film Data Sheet – Color Negative Papers," Ref. No. AF3–661E (90.2-OB-10-1), February 1990, p. 7. The same "500 lux for 12 hours a day" display condition was also used by Fuji in making image-life predictions for its improved-stability Fujicolor Super FA Type 3 (SFA3) papers, introduced in 1992: **Fujicolor Paper Super FA Type 3,** "Fuji Film Data Sheet – Color Negative Papers," Ref. No. AF3-723E (92.1-OB-5-1), January 1992, p. 7.
9. Fuji Photo Film Co., Ltd., **Fujichrome Paper Type 35,** "Fuji Film Data Sheet – Color Reversal Papers," Ref. No. AF3-718E (92.1-OB-3-1), January 1992, p. 8. Fuji had earlier used the same "1,000 lux for 12 hours a day" display condition in making image-life predictions for Type 34 paper, introduced in 1986: **Fujichrome Paper Type 34,** "Fuji Film Data Sheet – Color Reversal Papers," Ref. No. AF3-638E (89.7-OB-5-6), July 1989, p. 6.
10. Ilford Photo Corporation, **Mounting and Laminating Cibachrome Display Print Materials and Films,"** (Technical Information Manual), Cat. No. 7929-RMI 895M, 1988, p. 6.
11. Stanton Anderson and Ronald Goetting [Eastman Kodak Company], "Environmental Effects on the Image Stability of Photographic Products," **Journal of Imaging Technology,** Vol. 14, No. 4, August 1988, pp. 111–116. This article contains a graph showing the predicted fading of Kodak Ektacolor Plus Paper in "display years," based on an illumination intensity of 100 lux for 12 hours per day (Figure 24, p. 113).
12. Eastman Kodak Company, **Image-Stability Data: Kodachrome Films,** Kodak Publication E-105, March 1988, Eastman Kodak Company, Rochester, New York 14650. Although this publication is primarily concerned with the image stability of Kodachrome film, it also discusses test methods for both films and prints. See also: Eastman Kodak Company, **Evaluating Image Stability of Kodak Color Photographic Products,** Kodak Publication CIS-130, March 1991.
13. Stanton I. Anderson and Richard J. Anderson [Eastman Kodak Company], "A Study of Lighting Conditions Associated with Print Display in Homes," paper given at the **SPSE Sixth International Symposium on Photofinishing Technology,** Las Vegas, Nevada, February 20, 1990, "Advance Printing of Paper Summaries," pp. 80–81; published by The Society for Imaging Science and Technology (IS&T), 7003 Kilworth Lane, Springfield, Virginia 22151; telephone: 703-642-9090; Fax: 703-642-9094.
14. Eastman Kodak Company, **Evaluating Dye Stability of Kodak Color Products,** Kodak Publication No. CIS-50, January 1981, and subsequent CIS-50 series dye-stability data sheets through 1985; **Kodak Ektacolor Plus and Professional Papers for the Professional Finisher,** Kodak Publication No. E-18, March 1986.
15. Photofinishing News, Inc., "Photo Processing – North and South America," **The 1991 International Photo Processing Industry Report,** Chapter 2, p. 1 (1991). Photofinishing News, Inc., Suite 1091, 10915 Bonita Beach Road, Bonita Springs, Florida 33923; telephone: 813-992-4421; Fax: 813-992-6328.
16. Tadahisa Sato, Masakazu Morigaki, and Osamu Takahashi [Fuji Photo Film Co., Ltd.], "New Type Color Paper with Exceptional Dye Image Stability – Fujicolor Paper Super FA Type 3," presentation at **IS&T's Seventh International Symposium on Photofinishing Technology,** Las Vegas, Nevada, February 3–5, 1992. Sponsored by IS&T – The Society for Imaging Science and Technology. See also: O. Takahashi, T. Sato, K. Hasebe, N. Furutachi and T. Ogawa [Fuji Photo Film Co., Ltd., Japan], "New Type Color Print Paper with an Improved Color Saturation and Dye Image Stability – Fujicolor Paper Super FA," paper given at the **SPSE Sixth International Symposium on Photofinishing Technology,** Las Vegas, Nevada, February 20, 1990, "Advance Printing of Paper Summaries," pp. 68–70; published by The Society for Imaging Science and Technology (IS&T), 7003 Kilworth Lane, Springfield, Virginia 22151; telephone: 703-642-9090; Fax 703-642-9094.
17. William Nordstrom, "In Search of Permanence: 500-Year-Life UltraStable Color Photographs," **Professional Photographer,** Vol. 119, No. 2159, April 1992, pp. 34–36.
18. David B. LaClaire, "Marketing UltraStable Portrait Prints," **Professional Photographer,** Vol. 119, No. 2159, April 1992, p. 36.

19. Spencer Grant and Elizabeth Forst, "Carbro Printing: Back to the Future," **Photo District News**, Vol. XII, Issue II, February 1992, pp. 98–100.  See also: John Durniak, "Color Almost Too Good to Be True," **The New York Times**, December 6, 1992, p. Y27.  See also: Mark Wilson, A Color Process That Won't Fade Away," **The Boston Globe**, May 17, 1992.

20. Linda Tien, "Lasting Impressions – At Ataraxia Studio, Images Are Made to Stand the Test of Time," **Specialty Lab Update** (published by the Photo Marketing Association International, Jackson, Michigan), March 1992, pp. 1 & 4.

21. Henry Wilhelm, "The Light-Fading Stability of Polaroid Permanent-Color Prints," presentation at the **Third International Symposium on Image Conservation**, sponsored by The Society for Imaging Science and Technology (IS&T) and held at the International Museum of Photography at George Eastman House, Rochester, New York, June 17–20, 1990.

22. EverColor Corporation, 576 Powers Drive, El Dorado Hills, California 95762; telephone: 916-933-3403.

23. Atelier Michel Fresson, 21 rue de la Montagne Pavee, 91600 Savigny-Orge, France; telephone: (33)-1-996-1260.

24. Polaroid Corporation, **The First Thirty Years, 1948–1978: A Chronology of Polaroid Photographic Products**, Polaroid Catalog C7 TS/DA, December 1979.

25. H. G. Rogers, M. Idelson, R. F. W. Cieciuch, and S. M. Bloom [Polaroid Corporation], "Light Stability of New Polaroid Colour Prints," The **Journal of Photographic Science,** Vol. 22, 1974, pp. 138–142. This paper was presented at a symposium on "The Conservation of Colour Photographic Records" organized by the Colour Group of the Royal Photographic Society on September 20, 1973 in London, England.

26. Polaroid Corporation, "This Polaroid SX-70 photograph is part of the collection of the Museum of Modern Art," two-page advertisement that appeared in several magazines, including **The New Yorker,** Vol. 53, No. 11, May 2, 1977.

27. Polaroid Corporation, "This Polaroid Polacolor photograph was acquired by Boston's Museum of Fine Arts for its permanent collection. . .", two-page advertisement that appeared in a number of magazines, including **Newsweek**, May 9, 1977, and **Scientific American**, Vol 239, No. 2, August 1978.

28. Polaroid Corporation, "The 'Private Works' of John Singer Sargent," **The Polaroid Museum Replica Collection**, promotional literature postmarked July 23, 1987.

29. Polaroid Corporation, **Polacolor 64 Tungsten Instant Print Films**, Polaroid Publication No. PP1401 (PID#1B5582), January 1992, p.6.

30. Warren E. Leary, "New Study Offers More Evidence Linking Cancer to Halogen Lamps," **The New York Times**, April 16, 1992, p. A12.

31. T. F. Parsons, G. G. Gray, and I. H. Crawford, "To RC or Not To RC," **Journal of Applied Photographic Engineering,** Vol. 5, No. 2, Spring 1979, pp. 110–117.

## Additional References

Etsuo Fuji and Hideko Fuji, "Evaluation of the Stability of Thermal Dye Transfer Video Prints by Accelerated Fading Tests," **Journal of Imaging Science and Technology**, Vol. 36, No. 1, January–February 1992, pp. 29–36.

Klaus B. Hendriks, together with Brian Thurgood, Joe Iraci, Brian Lesser, and Greg Hill of the National Archives of Canada staff, **Fundamentals of Photographic Conservation: A Study Guide**, published by Lugus Publications in cooperation with the National Archives of Canada and the Canada Communication Group, 1991.  Available from Lugus Productions Ltd., 48 Falcon Street, Toronto, Ontario, Canada M4S 2P5; telephone: 416-322-5113; Fax: 416-484-9512.

( **Tables 3.1a** through **3.6** on following pages)

## Table 3.1a Comparative Light Fading Stability of Current Process RA-4 Compatible Papers for Printing Color Negatives

**All of these papers were available at the time this book went to press in 1992.**

Predicted years of display to reach "Home and Commercial" image-life fading limits for color prints displayed in home and office locations illuminated 12 hours a day at 450 lux (42 fc) with Cool White fluorescent lamps. With these color papers, all of which have effective UV-absorbing emulsion overcoats, generally similar behavior may be expected with indirect daylight and incandescent tungsten illumination in typical indoor display situations. These predictions are based on equivalent light exposures in accelerated tests at 21.5 klux (2,000 fc) at 75°F (24°C) and 60% RH.

Initial neutral density of 0.6 with full d-min corrected densitometry. Letters inside parentheses ( ) following number of years indicate the first image-life fading limit reached: (–C) = cyan dye; (–M) = magenta dye; (–Y) = yellow dye. (C–M) means, for example, that the color-balance change limit between cyan and magenta was reached first, with the magenta dye fading more than the cyan dye.

| Type of Color Paper | Predicted Years of Display | | |
| --- | --- | --- | --- |
| | Prints Covered With Glass | Prints Covered With UF-3 Ultraviolet Filter | Prints Not Covered (Bare Bulb) |
| **Fujicolor Paper Super FA Type 3** | 54.4 (–M) | 57.3 (–M) | 38.2 (–M) |
| **Fujicolor SFA3 Professional Portrait Paper** | | | |
| **Fujicolor Professional Paper SFA3 Type C** | | | |
| **Fujicolor Supreme Paper SFA3** | | | |
| **Fujiflex SFA3 Super-Gloss Printing Material** [polyester] | | | |
| **Fujicolor Peel-Apart Paper SFA3** | | | |
| **Fujicolor Thin Paper SFA3** | | | |
| ("Fujicolor Print") | | | |
| (1993— for low-contrast SFA3 Professional Portrait Paper) | | | |
| (1992— for other papers) | | | |
| **Fujicolor Prof. Paper Super FA Type P** | 24.0 (–M) | 24.8 (–M) | 20.5 (–M) |
| (1991–93) (low-contrast professional portrait paper) | | | |
| **Konica Color QA Paper Type A3** | 17.5 (–M) | 17.7 (–M) | 16.9 (–M) |
| **Konica Color QA Paper Professional Type X2** | | | |
| **Konica Color QA Super Glossy Print Material Type A3** [polyester] | | | |
| **Konica Color QA Paper Peelable Type A3** | | | |
| (Konica Color "Century Paper" or "Century Print") | | | |
| (Konica Color "Long Life 100 Print") | | | |
| (1991—) | | | |
| **Mitsubishi Color Paper SA 2000** [improved] | 17.5 (–M) [tentative] | 17.7 (–M) [tentative] | 16.9 (–M) [tentative] |
| **Mitsubishi Color Paper SA 5000 Pro** [improved] | | | |
| (papers are believed to be identical to Konica Color QA Type A3 and X2 papers) | | | |
| (improved types: 1992—) | | | |

| Type of Color Paper | Predicted Years of Display | | |
| --- | --- | --- | --- |
| | Prints Covered With Glass | Prints Covered With UF-3 Ultraviolet Filter | Prints Not Covered (Bare Bulb) |
| **Ilford Ilfocolor Deluxe Print Material** [polyester] | 17.5 (–M) [tentative] | 17.7 (–M) [tentative] | 16.9 (–M) [tentative] |
| (ILRA.1K high-gloss polyester-base print material manufactured by Ilford in Switzerland with emulsion components supplied by Konica; stability is believed to be similar if not identical to Konica Color QA Super Glossy Print Material Type A3.) | | | |
| (1991—) | | | |
| **Agfacolor Paper Type 9** | 15.3 (–M) | 15.9 (–M) | 15.2 (–M) |
| **Agfacolor Paper Type 9i** [improved] | | | |
| ("Agfacolor Print") | | | |
| (1988–92 for Type 9; 1992— for Type 9i) | | | |
| **Konica Color QA Paper Type A5** | 13.2 (–M) | 13.2 (–M) | 12.7 (–M) |
| (Konica Color "Century Paper" or "Century Print") | | | |
| (Konica Color "Long Life 100 Print") | | | |
| (1990—) (initially available only in Japan) | | | |
| **Kodak Ektacolor Edge Paper** | 12.1 (–M) | 12.8 (–M) | 11.9 (–M) |
| **Kodak Ektacolor Portra II Paper** | | | |
| **Kodak Ektacolor Royal II Paper** | | | |
| **Kodak Ektacolor Supra Paper** | | | |
| **Kodak Ektacolor Ultra Paper** | | | |
| **Kodak Duraflex RA Print Material** [polyester] | | | |
| ("Ektacolor Print") | | | |
| ("Kodalux Print") | | | |
| (1991— for Ektacolor Edge and Royal II) | | | |
| (1992— for Ektacolor Portra II) | | | |
| (1989— for other papers) | | | |

# Table 3.1b Comparative Light Fading Stability of Current Process EP-2 Compatible Papers for Printing Color Negatives

All of these papers were available at the time this book went to press in 1992. It is likely that many of these papers will have been discontinued by the end of 1994 in favor of faster-processing RA-4 papers.

Predicted years of display to reach "Home and Commercial" image-life fading limits for color prints displayed in home and office locations illuminated 12 hours a day at 450 lux (42 fc) with Cool White fluorescent lamps. With these color papers, all of which have effective UV-absorbing emulsion overcoats, generally similar behavior may be expected with indirect daylight and incandescent tungsten illumination in typical indoor display situations. These predictions are based on equivalent light exposures in accelerated tests at 21.5 klux (2,000 fc) at 75°F (24°C) and 60% RH. Initial neutral density of 0.6 with full d-min corrected densitometry.

| Type of Color Paper | Predicted Years of Display | | |
| --- | --- | --- | --- |
| | Prints Covered With Glass | Prints Covered With UF-3 Ultraviolet Filter | Prints Not Covered (Bare Bulb) |
| **Fujicolor Paper Type 12** **Fujicolor "Minilab Paper"** ("Fujicolor Print") (Type 12 paper generally is not available outside of Japan) (1985—) | 21.3 (–M) | 22.4 (–M) | 21.0 (–M) |
| **Fujicolor Paper Type 03** **Fujicolor "Minilab Paper"** **Fujicolor Professional Paper Type 02-P** **Fujicolor Paper Type 02-C** **Fujicolor HR Printing Material** [polyester] ("Fujicolor Print") ("Fujicolor SuperGloss Print") ("Fujicolor HR Super Deluxe Print") (1988—) | 15.8 (–M) | 16.8 (–M) | 14.3 (–M) |
| **Konica Color PC Paper Type SR** **Konica Color PC Paper Prof. Type EX** **Konica Color PC Paper Type SR (SG)** [polyester] **Konica Color PC Paper Peelable Type SR** (Konica Color "Century Paper" or "Century Print") (Konica Color "Century ProPrint Type EX") (Konica Color "Long Life 100 Print") (Konica Color "Peerless Print") (in Japan, Konica Color Paper Type SR was originally called Sakuracolor PC Paper Type SR) (1984 [April]— for Type SR) (1984 [July]— for Type SG) (1987— for Type EX) (1988— for Peelable Type SR) | 13.1 (–M) | 13.1 (–M) | 12.1 (–M) |
| **Mitsubishi Color Paper KER Type 6000 Super** **Mitsubishi Color Paper KER Type 8000 Pro** (papers are believed to be identical to Konica Type SR and EX papers) (1985— for Type 6000 Super) (1989— for Type 8000 Pro) | 13.1 (–M) | 13.1 (–M) | 12.1 (–M) |
| **Ilford Colorluxe Print Material** [polyester] (IL.1K high-gloss polyester-base print material is manufactured by Ilford in Switzerland using emulsion components supplied by Konica; the stability of the Ilford product is believed to be similar if not identical to Konica Color Paper Type SR [SG] polyester-base print material.) (1990–) | 13.1 (–M) | 13.1 (–M) | 12.1 (–M) |
| **Kodak Ektacolor Plus Paper** **Kodak Ektacolor Plus Thin Paper** **Kodak Ektacolor Professional Paper** **Kodak Duraflex Print Material** [polyester] ("Ektacolor Print") ("Kodalux Print") (formerly "Kodacolor Print") (1984 [August]— for Ektacolor Plus) (1985— for Ektacolor Professional) | 11.8 (–M) | 11.7 (–M) | 11.7 (–M) |
| **Agfacolor Paper Type 8** [improved] **Agfacolor Paper Type 8 ML** ("Agfacolor Print") (1986—) | 11.5 (–M) | 11.7 (–M) | 11.7 (–M) |

## Table 3.1c Comparative Light Fading Stability of Discontinued Process EP-2, EP-3, and RA-4 Compatible Papers for Printing Color Negatives

Predicted years of display to reach "Home and Commercial" image-life fading limits for color prints displayed in home and office locations illuminated 12 hours a day at 450 lux (42 fc) with fluorescent lamps. These predictions are based on equivalent light exposures in accelerated tests at 21.5 klux (2,000 fc) at 75°F (24°C) and 60% RH. Initial neutral density of 0.6 with full d-min corrected densitometry.

Additional "dark fading" changes that slowly occur with many of these papers during normal long-term display are not considered in these predictions. In particular, the fading observed in displayed prints made with Agfacolor PE Paper Type 4 paper usually consists largely of "dark fading" changes, with light fading making a much smaller contribution to the total change. Agfacolor Type 4 paper, in use from 1974 until 1982, has astonishingly poor dark fading stability.

| Type of Color Paper | Predicted Years of Display | | |
| --- | --- | --- | --- |
| | Prints Covered With Glass | Prints Covered With UF-3 Ultraviolet Filter | Prints Not Covered (Bare Bulb) |
| Fujicolor Paper Super FA Type II<br>Fujicolor Supreme Paper<br>Fujicolor Professional Paper Super FA Type C<br>Fujiflex SFA Super-Gloss Printing Material [glossy polyester base]<br>("Fujicolor Print") (RA-4)<br>(1990–92 for Super FA Type II)<br>(1990–92 for Supreme)<br>(1991–92 for Super FA Type C)<br>(1991–92 for Fujiflex SFA) | 24 (–M) | 25 (–M) | 21 (–M) |
| Fujicolor Paper Super FA<br>("Fujicolor Print")<br>(initial type: 1989–90) (RA-4) | 24 (–M) | 25 (–M) | 21 (–M) |
| Konica Color QA Paper Type A2<br>Konica Color QA Paper Professional Type X1<br>Konica Color QA Super Glossy Print Material Type A2 [glossy polyester base]<br>Konica Color QA Paper Peelable Type A2<br>(Konica Color "Century Paper")<br>(Konica Color "Century Print")<br>(Konica Color "Long Life 100 Print")<br>(1988–92 for Type A2) (RA-4)<br>(1990–92 for other papers) | 17 (–M) | 18 (–M) | 17 (–M) |
| Konica Color QA Paper Type A<br>(Konica Color "Century Paper")<br>(Konica Color "Century Print")<br>(Konica Color "Long Life 100 Print")<br>(initial type: 1988–89) (RA-4) | 17 (–M) | 18 (–M) | 17 (–M) |

| Type of Color Paper | Predicted Years of Display | | |
| --- | --- | --- | --- |
| | Prints Covered With Glass | Prints Covered With UF-3 Ultraviolet Filter | Prints Not Covered (Bare Bulb) |
| Mitsubishi Color Paper SA 2000<br>Mitsubishi Color Paper SA 5000 Pro<br>(Mitsubishi "Speed Access" Paper)<br>(Mitsubishi "Rapid Access" Paper)<br>(papers are believed to be identical to Konica Color QA Type A2 and X1 papers)<br>(initial type: 1989–92 for SA 2000) (RA-4)<br>(initial type: 1990–92 for SA 5000) | 17 (–M) [tentative] | 18 (–M) [tentative] | 17 (–M) [tentative] |
| Mitsubishi Color Paper KER Type 1000 SA<br>(Mitsubishi "Speed Access" Paper)<br>(Mitsubishi "Rapid Access" Paper)<br>(paper is believed to be identical to Konica Color QA Paper Type A)<br>(1988–89) (RA-4) | 17 (–M) [tentative] | 18 (–M) [tentative] | 17 (–M) [tentative] |
| Ilford Colorluxe Print Material [polyester]<br>(SP-729s high-gloss polyester-base print material manufactured by Ilford in Switzerland using emulsion components supplied by Konica; the stability of the Ilford product is believed to be similar if not identical to Konica Color QA Super Glossy Print Material Type A2.)<br>(initial type: 1990–91) (RA-4) | 17 (–M) [tentative] | 18 (–M) [tentative] | 17 (–M) [tentative] |
| Fujicolor Paper Type 02<br>Fujicolor "Minilab Paper"<br>Fujicolor Professional Paper Type 01-P<br>Fujicolor HR Printing Material [glossy polyester base]<br>("Fujicolor Print") (EP-2)<br>(1985–88) | 14 (–M) | 15 (–M) | 14 (–M) |

## Table 3.1c (continued from previous page)

| Type of Color Paper | Predicted Years of Display | | |
|---|---|---|---|
| | Prints Covered With Glass | Prints Covered With UF-3 Ultraviolet Filter | Prints Not Covered (Bare Bulb) |
| Kodak Ektacolor 74 RC Paper Type 2524; Kodak Ektacolor 78 Paper Type 2524 ("Ektacolor Print"; "Kodacolor Print") (1982–86) (EP-2) | 10 (–M) | 10 (–M) | 9 (–M) |
| Agfacolor PE Paper Type 8 ("Agfacolor Print") (initial type: 1984 [October]–86) (EP-2) | 10 (–M) | 9 (–M) | 8 (–C) |
| Agfacolor PE Paper Type 7i ("Agfacolor Print") (1984–85) (EP-2) | 10 (–M) | 10 (–M) | 9 (–M) |
| Agfacolor PE Paper Type 589i; Agfacolor PE Paper Type 7 ("Agfacolor Print") (1983–85) (EP-2) | 8 (–M) | 8 (–M) | 8 (–C) |
| 3M Professional Color Paper Type 25; 3M High Speed Color Paper Type 19 (1978–88; 3M ceased manufacture of color paper in 1988) (EP-2) | 8 (–M) | 9 (–M) | 5 (Y–C) |
| Agfacolor PE Paper Type 5 ("Agfacolor Print") (1977–82) (Agfa AP-87) | 7 (–M) | 7 (–M) | 3 (M–C) |
| Agfacolor PE Paper Type 589 ("Agfacolor Print") (1981–83) (EP-2) | 6 (–M) | 7 (–M) | 5 (–M) |
| Agfacolor PE Paper Type 4 ("Agfacolor Print") (this paper has extremely poor dark fading stability) (1974–82) (Agfa AP-85) | 6 (–C) | 7 (–C) | 5 (–C) |

| Type of Color Paper | Predicted Years of Display | | |
|---|---|---|---|
| | Prints Covered With Glass | Prints Covered With UF-3 Ultraviolet Filter | Prints Not Covered (Bare Bulb) |
| Fujicolor Paper Type 8901 ("Fujicolor Print") (1984–86) (EP-2) | 14 (–M) | 14 (–M) | 13 (–M) |
| Mitsubishi Color Paper KER Type 7000 Pro (paper is believed to be identical to Konica Type EX paper) (1985–89) (EP-2) | 13 (–M) | 13 (–M) | 12 (–M) |
| Kodak Ektacolor 2001 Paper; Kodak Ektacolor Portra Paper; Kodak Ektacolor Royal Paper ("Ektacolor Print"; "Kodalux Print") (1986–91 for Ektacolor 2001) (RA-4) (1989–91 for Ektacolor Royal) (1989–92 for Ektacolor Portra) | 13 (–M) | 13 (–M) | 12 (–M) |
| Fujicolor Paper Type 8908 ("Fujicolor Print") (1980–84) (EP-2) | 13 (–M) | 13 (–M) | 9 (Y–C) |
| Fujicolor Paper FA ("Fujicolor Print") (1988–89) (RA-4) | 12 (–M) | 12 (–M) | 12 (–M) |
| Konica Color PC Paper SIII; Sakuracolor PC Paper SIII ("Agfacolor Print") (1983–84) (EP-2) | 11 (–M) | 11 (–M) | 4 (Y–C) |
| Sakuracolor PC Paper SII ("Agfacolor Print") (1978–83) (EP-2) | 11 (–M) | 10 (–M) | 5 (Y–C) |
| Kodak Ektacolor 74 RC Paper ("Ektacolor Print"; "Kodacolor Print") (initial type: 1977–82) (EP-2) | 11 (–M) | 11 (–M) | 4 (M–C) |
| Kodak Ektacolor 37 RC Paper Type 2261 ("Ektacolor Print"; "Kodacolor Print") (1971–78) (EP-3) | 11 (–M) | 11 (–M) | 4 (M–C) |

## Table 3.2   Comparative Light Fading Stability of Silver Dye-Bleach; Chromogenic Reversal; Dye-Imbibition; and UltraStable, EverColor, and Polaroid Permanent Color Pigment Print Materials

Predicted years of display to reach "Home and Commercial" image-life fading limits for color prints displayed in home and office locations illuminated 12 hours a day at 450 lux (42 fc) with fluorescent lamps. These predictions are based on equivalent light exposures in accelerated tests at 21.5 klux (2,000 fc) at 75°F (24°C) and 60% RH. Ilford Ilfochrome (formerly called Cibachrome) and Fresson Quadrichrome prints were tested at 1.35 klux (125 fc) at 75°F (24°C) and 60% RH, as described below.   Initial neutral density of 0.6 with full d-min corrected densitometry.

Test duration of up to 12 years (4,380 days).

**Boldface Type** indicates products that were being marketed in the U.S. and/or other countries when this book went to press in 1992; the other products listed had been either discontinued or replaced with newer materials.

| (T) = For printing color transparencies<br>(T+N) = For printing either color transparencies or negatives<br><br>Type of Color Print Product | Predicted Years of Display | | |
|---|---|---|---|
| | Prints Covered With Glass | Prints Covered With UF-3 Ultraviolet Filter | Prints Not Covered (Bare Bulb) |
| **UltraStable Permanent Color Prints** (T+N)<br>(pigment color process) [polyester & fiber-base]<br>(UltraStable Permanent Color Process)<br>(improved yellow pigment type: 1993—) | >500 (—)<br>[tentative] | >500 (—)<br>[tentative] | >200 (—)<br>[tentative] |
| **Polaroid Permanent-Color Prints** (T+N) [polyester]<br>**Ataraxia Studio Collectors Color Prints**<br>(pigment color process) [polyester]<br>(1989—) (Polaroid Permanent-Color Process) | >500 (—)<br>[tentative] | >500 (—)<br>[tentative] | >200 (—)<br>[tentative] |
| **Fuji-Inax Photocera Color Photographs** (T+N) [fired pigment color process) [ceramic support]<br>(initially available only from Fujicolor Processing Service in Japan)<br>(1991—) (Fuji-Inax Ceramic Color Process) | >500 (—)<br>[tentative] | >500 (—)<br>[tentative] | >500 (—)<br>[tentative] |
| **EverColor Pigment Color Prints** (T+N) [polyester]<br>(A high-stability version of the AgfaProof Process marketed by the EverColor Corporation.)<br>(1993—) (EverColor Pigment Color Print Process) | (new product – test data not available) | | |
| **Fresson Quadrichromie Prints** (T+N)<br>(pigment color process) [fiber base]<br>(available only in France)<br>(1952—) (Fresson Color Print Process) | 225 (–M) | >225 (—) | 100 (–M) |
| Agfachrome CU 410 Color Prints (T)<br>[pigmented triacetate base]<br>(Abandoned by Agfa, this was an outstanding example of the silver dye-bleach process.)<br>(1970–73) (Agfachrome Process 60) | 88 (M–Y) | 134 (–M) | 43 (M–Y) |

| (T) = For printing color transparencies<br>(T+N) = For printing either color transparencies or negatives<br><br>Type of Color Print Product | Predicted Years of Display | | |
|---|---|---|---|
| | Prints Covered With Glass | Prints Covered With UF-3 Ultraviolet Filter | Prints Not Covered (Bare Bulb) |
| Kodak Dye Transfer Prints [fiber-base] (T+N)<br>(high-stability Kodak MX-1372 yellow dye and paper with UV-absorbing overcoat trade-tested in 1988–89)<br>(The paper and yellow dye proved difficult to work with and Kodak decided not to market the materials.) | 50 (–M) | 54 (–M) | 50 (–M) |
| **Kodak Dye Transfer Prints** [fiber-base] (T+N)<br>(Kodak Film and Paper Dyes)<br>(1946—, with minor changes) | 32 (M–Y) | 21 (C–Y) | 8 (M–C) |
| **Ilford Ilfochrome Classic Prints** (T)<br>Ilford Cibachrome II Prints<br>Ilford Cibachrome-A II Prints [improved type]<br>**Fuji CB Prints** (material supplied by Ilford)<br>(P-3, P-3X, P-30, and P-30P) [polyester and RC]<br>(Although Ilfochrome "Pearl" semi-gloss and glossy-surface RC prints have dye stability that is similar to Ilfochrome high-gloss polyester-base prints, the RC prints are subject to RC base cracking and image yellowing, and therefore are not recommended for long-term applications.)<br>(1980–91 for Cibachrome II)<br>(1989–91 for "improved" Cibachrome-A II)<br>(1991— for Ilfochrome Classic) | 29 (–M)* | 33 (C–Y)* | 21 (–M)* |
| **Fujichrome Paper Type 35** (T)<br>**Fujichrome Copy Paper Type 35H**<br>**Fujichrome Super-Gloss Printing Material** [polyester]<br>("Fujichrome Super Deluxe Prints") [polyester]<br>(1992—) (R-3) | 19 (–M) | 19 (–M) | 14 (–M) |

**Table 3.2 (continued from previous page)**

(T) = For printing color transparencies
(T+N) = For printing either color transparencies or negatives

| Type of Color Print Product | Predicted Years of Display | | |
| --- | --- | --- | --- |
| | Prints Covered With Glass | Prints Covered With UF-3 Ultraviolet Filter | Prints Not Covered (Bare Bulb) |
| Fujichrome Paper Type 34 (T) Fujichrome Copy Paper Type 34H Fujichrome Super-Gloss Printing Material [polyester] (1986–92) (R-3) | 19 (–M) | 19 (–M) | 14 (–M) |
| **Fuji Dyecolor Prints** [fiber-base] (T+N) (dye transfer type process) (available only in Japan) (1970– ) (Fuji Dyecolor process) | **17 (C-Y)** | **16 (C-Y)** | **7 (M-Y)** |
| Ilford Cibachrome-A II Prints (T) [polyester and RC] (Although Cibachrome "Pearl" semi-gloss and glossy-surface RC prints have dye stability that is similar to Cibachrome high-gloss polyester-base prints, the RC prints are subject to RC base cracking and image yellowing, and therefore are not recommended for long-term applications.) (initial type: 1981–89) (P-30) | 16 (–M)* | 21 (C-Y)* | 14 (–M)* |
| Ilford Cibachrome-A Prints (T) [pigmented triacetate base] (1975–81) (P-12) | 16 (–M)* | 19 (–M)* | 11 (–M)* |
| Fujichrome Paper Type 33 (T) (1983–86) (R-3) | 16 (–M) | 17 (–M) | 15 (–M) |
| **Kodak Ektachrome Copy Paper** (T) Kodak Ektachrome HC Copy Paper Kodak Ektachrome Thin Copy Paper Kodak Ektachrome 22 Paper [initial type] Kodak Ektachrome Prestige Paper [glossy polyester base] (Not recommended: these Ektachrome papers have very poor dark fading stability compared with Fujichrome, Konica Chrome, Agfachrome, and Ektachrome Radiance Process R-3 papers.) (1984–90 for initial type of Ektachrome 22) (1986–91 for Ektachrome Prestige) (1984–92 for Ektachrome HC Copy and Thin) (1984– for Ektachrome Copy) (R-3) | **15 (–M)** | **15 (–M)** | **14 (–M)** |
| **Kodak Ektachrome Radiance Paper** (T) **Kodak Ektachrome Radiance Select Material** [glossy polyester base] **Kodak Ektachrome Radiance HC Copy Paper** **Kodak Ektachrome Radiance Thin Copy Paper** (1991– for Radiance and Radiance Select) (R-3) (1992– for Radiance HC Copy and Thin Copy) | **14 (–M)** | **14 (–M)** | **13 (–M)** |

(T) = For printing color transparencies
(T+N) = For printing either color transparencies or negatives

| Type of Color Print Product | Predicted Years of Display | | |
| --- | --- | --- | --- |
| | Prints Covered With Glass | Prints Covered With UF-3 Ultraviolet Filter | Prints Not Covered (Bare Bulb) |
| Kodak Ektachrome 22 Paper [improved] (T) (improved type: 1990–91) (R-3) | 14 (–M) | 14 (–M) | 13 (–M) |
| Kodak Ektachrome 2203 Paper (T) (1978–84) (R-100) | 14 (–M) | 14 (–M) | 13 (–M) |
| **Konica Chrome Paper Type 81** (T) (1989– ) (R-3) | (test data not available, but probably has light fading stability similar to that of Konica Color QA Paper Type A3) | | |
| Fujichrome Reversal Paper Type 31 (T) (1978–83) (R-100) | 10 (–M) | 12 (–M) | 11 (–M) |
| **Agfachrome Paper CRN** [Type 63] (T) **Agfachrome High Gloss Material CRP** [polyester] **Agfachrome Copy Paper CRH** (1984–90 for initial types) (1990– for "improved" types) (R-3) | **10 (–M)** | **11 (–M)** | **10 (–M)** |
| Kodak Ektachrome 14 Paper (T) (1981–85) (R-100) | 8 (C-Y) | 7 (C-Y) | 5 (C-Y) |
| Kodak Ektaflex PCT Color Prints (T+N) (dye-diffusion transfer process) (Kodak Ektaflex Process) (1981–88) | 7 (C-M) | 7 (C-M) | 6 (C-M) |
| Agfachrome Reversal Paper CU 310 (T) (1979–84) (R-100) | 5 (–M) | 6 (–M) | 5 (C-M) |
| Kodak Ektachrome RC Paper Type 1993 (T) (1972–79) (R-5) | 5 (–M) | 4 (–M) | 3 (–C) |
| Agfachrome-Speed Color Prints (T) (single-sheet dye-diffusion process) (Agfachrome-Speed Process) (1983–85) | 2 (M-C) | 2 (M-C) | 2 (M-C) |

\* Because of their large reciprocity failure factors (RF Factors) in high-intensity accelerated light fading tests, Ilford Ilfochrome (Cibachrome) prints were illuminated with a lower intensity of 1.35 klux (125 fc) for periods of up to 10 years; this lower intensity illumination better simulates the performance of Ilfochrome prints in normal display conditions and also affords a more valid comparison with most current chromogenic print materials, which generally exhibit much smaller RF Factors than does Ilfochrome.

## Table 3.3 Comparative Light Fading Stability of Polaroid, Fuji, and Kodak Instant Color Prints; Canon and Kodak Digital Copier/Printer Color Prints; Color Offset Printing; Mead Cycolor Prints; and Thermal Dye Transfer Prints and Ink Jet Color Prints for Digitized Pictorial Images and Computer-Generated Images

Predicted years of display to reach "Home and Commercial" image-life fading limits for color prints displayed in home and office locations illuminated 12 hours a day at 450 lux (42 fc) with fluorescent lamps. These predictions are based on equivalent light exposures in accelerated tests at 1.35 klux (125 fc) at 75°F (24°C) and 60% RH for photographic instant color prints, and 21.5 klux (2,000 fc) at 75°F (24°C) and 60% RH for the other materials listed (marked with an *). Initial neutral density of 0.6 with full d-min corrected densitometry. With Mead Cycolor prints, the stain limit was reached before any of the dye-fading limits. With Stork ink jet color prints, pure magenta and yellow colors faded unusually rapidly compared with the fading of more neutral colors, and this lowered the rankings of the Stork prints.

Test duration of up to 6 years (2,190 days).

**Boldface Type** indicates products that were being marketed in the U.S. and/or other countries when this book went to press in 1992; the other products listed had been either discontinued or replaced with newer materials. Kodak, which introduced its first instant cameras and film in 1976, was forced to abandon the instant photography field in 1986 after a federal court found that Kodak had infringed on Polaroid patents.

| | Predicted Years of Display | | |
| --- | --- | --- | --- |
| **Type of Color Print Product** | Prints Covered With Glass | Prints Covered With UF-3 Ultraviolet Filter | Prints Not Covered (Bare Bulb) |
| 3M Electrocolor Prints [continuous-tone, liquid-toner electrophotographic color process] (Abandoned by 3M, this was an outstanding example of the liquid-toner color electrophotographic process.) (1965–66) (3M Company, St. Paul, Minnesota) | 28.0 (–M) | Data Not Available | 26.0 (–M) |
| **Canon Color Laser Copier Prints\*** [scanned, electronically produced prints] [Xerographic plain-paper digital color copier/printer; test prints made in 1989.] | 25.0 (C–M) | 40.0 (C–Y) | 7.8 (C–M) |
| **Kodak ColorEdge Digital Copier Prints\*** [scanned, electronically produced prints] [Xerographic plain-paper digital color copier/printer; test prints made in 1992.] | 19.7 (C–Y) | 23.1 (C–Y) | 15.7 (C–Y) |
| **Kodak Ektatherm Color Prints\*** [scanned, electronically produced prints] (Thermal dye transfer color prints made with Kodak XL 7700 Digital Printer; test prints made in 1992.) | 11.5 (M–C) | 23.3 (M–C) | 4.5 (–C) |
| Polaroid 600 High Speed Prints [continuous-tone instant photographic prints] (Because of high levels of yellowish stain that form over time in normal dark storage, Polaroid 600 prints are not recommended for other than short-term applications.) (1981–88) | 11.0 (–M) | 12.0 (–M) | 12.0 (–M) |

| | Predicted Years of Display | | |
| --- | --- | --- | --- |
| **Type of Color Print Product** | Prints Covered With Glass | Prints Covered With UF-3 Ultraviolet Filter | Prints Not Covered (Bare Bulb) |
| **Polaroid SX-70 Time-Zero Prints** [improved] **Polaroid Type 778 Time-Zero Prints** [continuous-tone instant photographic prints] (Because of high levels of yellowish stain that form over time in normal dark storage, Polaroid SX-70 Time-Zero and Type 778 prints are not recommended for other than short-term applications.) (improved type: 1980—) | 11.0 (–M) | 12.0 (–M) | 12.0 (–M) |
| Polaroid SX-70 Prints [improved] [continuous-tone instant photographic prints] (improved type: 1976–79) | 10.0 (M–Y) | 11.0 (M–Y) | 11.0 (M–Y) |
| Polaroid SX-70 Time-Zero Prints [continuous-tone instant photographic prints] (initial type: 1979–80) | 6.0 (–M) | 7.0 (–M) | 6.0 (–M) |
| **Polacolor 2 Prints (Types 88; 108; 668; 58; and 808)** [continuous-tone instant photographic prints] (The images of Polacolor 2 prints suffer a yellowish color shift that may become objectionable after only a few years of dark storage under normal conditions; because of this, Polacolor 2 prints are not recommended for fine art or other critical applications.) (1975—) (peel-apart prints) | 6.0 (–M) | 5.0 (C–Y) | 4.0 (–M) |

## Table 3.3 (continued from previous page)

| Type of Color Print Product | Predicted Years of Display | | |
| --- | --- | --- | --- |
| | Prints Covered With Glass | Prints Covered With UF-3 Ultraviolet Filter | Prints Not Covered (Bare Bulb) |
| Kodak Trimprint Instant Color Prints [continuous-tone instant photographic prints] (1983–86) | 4.1 (–M) | 4.6 (–M) | 4.0 (–M) |
| Polaroid 600 Plus Prints / Polaroid Autofilm Type 330 Prints / Polaroid Type 990 Prints / Polaroid Spectra Prints / Polaroid Image Prints (Spectra name in Europe) [continuous-tone instant photographic prints] (Because of high levels of yellowish stain that form over time in normal dark storage, Polaroid Spectra prints, Image prints, and 600 Plus prints are not recommended for other than short-term applications.) (1986–91 for Spectra) (1988— for other prints) | 4.1 (–M) | 4.2 (–M) | 3.5 (–M) |
| Polaroid Spectra HD Prints / Polaroid Image Prints (Spectra HD in Europe) [continuous-tone instant photographic prints] (Because of high levels of yellowish stain that form over time in normal dark storage, Polaroid Spectra HD prints are not recommended for other than short-term applications.) (1992—) | 4.1 (–M) [tentative] | 4.2 (–M) [tentative] | 3.5 (–M) [tentative] |
| Polaroid Vision 95 Prints (name in Europe) / Polaroid " ? " 95 Prints (name in Asia) / Polaroid " ? " 95 Prints (name in North & South America) [continuous-tone instant photographic prints] (The internal structure of Vision 95 prints is basically the same as that of Spectra HD and 600 Plus prints; however, the rate of formation of yellowish stain that occurs over time in dark storage is said by Polaroid to be "somewhat reduced" compared with that of Spectra HD and 600 Plus prints. The names Polaroid will use for Vision 95 products in non-European markets were not available at the time this book went to press.) (1992— for Vision 95 products sold in Germany) (1993— for Asia, North and South America, and other markets) | 4.1 (–M) [tentative] | 4.2 (–M) [tentative] | 3.5 (–M) [tentative] |
| Polaroid Polacolor ER Prints (Types 59; 559; 669; and 809) [continuous-tone instant photographic prints] (1980—) (peel-apart prints) | 3.7 (M–Y) [tentative] | 2.8 (M–Y) | 3.7 (–C) |
| Polaroid Polacolor 64T and 100 Prints [continuous-tone instant photographic prints] (1992—) (peel-apart prints) | 3.7 (M–Y) [tentative] | 2.8 (M–Y) [tentative] | 3.7 (–C) [tentative] |

| Type of Color Print Product | Predicted Years of Display | | |
| --- | --- | --- | --- |
| | Prints Covered With Glass | Prints Covered With UF-3 Ultraviolet Filter | Prints Not Covered (Bare Bulb) |
| Polaroid Polacolor Pro 100 Prints [continuous-tone instant photographic prints] (1993—) (peel-apart prints) | (New product: test data not available, but probably has light fading stability similar to that of Polacolor ER prints.) | | |
| Stork Ink Jet Color Prints (Standard ink set)* [scanned, electronically produced prints] (Ink jet color prints made with a Stork Bedford B.V. ink jet printer and the Stork #1010 "Standard" graphic arts ink set; test prints made in 1992.) | 3.6 (–M) | 4.4 (–M) | 2.0 (–M) |
| Stork Ink Jet Color Prints (Reactive Dyes ink set)* [scanned, electronically produced prints] (Ink jet color prints made with a Stork Bedford B.V. ink jet printer and the Stork "Reactive Dyes" ink set; test prints made in 1992.) | 3.5 (–Y) | 4.0 (–Y) | 3.1 (–Y) |
| Fuji FI-10 Instant Color Prints [continuous-tone instant photographic prints] (1981—) (available only in Japan) | 2.6 (Y–C) | 2.8 (Y–C) | 2.4 (Y–C) |
| 4-Color Offset Printed Images* [screened, photomechanical prints] (Cyan, magenta, yellow, and black 4-color process inks typical of those used in color offset printing of books and magazines; samples printed in 1990.) | 2.5 (C–Y) | 2.5 (C–Y) | 2.5 (C–Y) |
| Iris Ink Jet Color Prints (Standard ink set)* [scanned, electronically produced prints] (Ink jet color prints made on 100% cotton fiber paper with an Iris Graphics, Inc. 3047 printer using the "Standard" Iris ink set; test prints made in 1992.) | 2.5 (C–Y) | 2.5 (C–Y) | 1.7 (C–M) |
| Mead Cycolor Prints* [continuous-tone photographic prints] (Mead Imaging Corporation microencapsulated acrylate image color prints made with a Noritsu QPS-101 Cycolor Slideprinter; test prints made in 1988.) | 2.5 (C+Y) | Data Not Available | 1.1 (C+Y) |
| Fuji 800 Instant Color Prints [continuous-tone instant photographic prints] (1984—) (available only in Japan) | 2.1 (M–C) | 2.1 (M–C) | 2.0 (M–C) |
| Sony Mavigraph Still Video Color Prints* [scanned, electronically produced prints] (Thermal dye transfer prints made with Sony UP-5000 ProMavica Color Video Printer; test prints made in 1989.) | 1.2 (–M) | 1.7 (–M) | 0.6 (–M) |
| Kodak PR10 Instant Color Prints [continuous-tone instant photographic prints] (initial type: 1976–79) | 0.5 (M–C) | 0.5 (M–C) | 0.6 (M–C) |

## Table 3.4  Comparative Light Fading Stability of Color Prints Illuminated with Incandescent Tungsten Lamps

Predicted years of display to reach "Home and Commercial" and "Museum and Archive" image-life fading limits for color prints illuminated 12 hours a day at 300 lux (28 fc) with incandescent tungsten reflector flood lamps. Predictions based on equivalent light exposures in accelerated tests at 1.35 klux (125 fc) at 75°F (24°C) and 60% RH. Initial neutral density of 0.6 ("Home and Commercial") and 0.45 ("Museum and Archive") with full d-min corrected densitometry.

Test duration of up to 10 years (3,650 days).

**Boldface Type** indicates products that were being marketed in the U.S. and/or other countries when this book went to press in 1992; the other products listed had been either discontinued or replaced with newer materials.

* Indicates print materials with poor dark fading stability. In most cases, the performance of these prints in actual long-term display will be worse than indicated by these accelerated light fading tests, which, because of their comparatively short duration, generally do not account for the contribution of dark storage to overall print fading and staining.

Com: "Home and Commercial" Fading Limits
Mus: "Museum and Archive" Fading Limits

| Type of Color Print Product | Predicted Years of Display | | |
| --- | --- | --- | --- |
| | Prints Covered With Glass | Prints Covered With UF-3 Ultraviolet Filter | Prints Not Covered (Bare Bulb) |
| **Ilford Ilfochrome Classic Prints** <br> Ilford Cibachrome II Prints <br> Ilford Cibachrome-A II Prints [improved type] <br> **Fuji CB Prints** (material supplied by Ilford) <br> (P-3, P-3X, P-30, and P-30P) [polyester and RC] <br> (Although Ilfochrome "Pearl" semi-gloss and glossy-surface RC prints have dye stability that is similar to Ilfochrome high-gloss polyester-base prints, the RC prints are subject to RC base cracking and light-induced yellowing, and therefore are not recommended for long-term applications.) <br> (1980—91 for Cibachrome II) <br> (1989—91 for "improved" Cibachrome-A II) <br> (1991— for Ilfochrome Classic) | Com: 25 (M–C) <br> Mus: 4 (–C) | 29 (M–C) <br> 6 (–C) | 17 (Y–C) <br> 4 (–C) |
| Fujicolor Paper Type 8901* <br> (1984–86) | Com: 24 (–M) <br> Mus: 9 (–M) | 24 (–M) <br> 9 (–M) | 23 (–M) <br> 7 (–M) |
| **Konica Color PC Paper Type SR** <br> **Konica Color PC Professional Type EX** <br> **Konica Color PC Paper Type SR (SG)** [polyester] <br> (Konica Color "Century Prints") <br> (Konica Color "Century Paper") <br> (Konica Color "Century ProPrint Type EX") <br> (Konica Color "Peerless Prints") <br> (1984 [April]— for Type SR <br> (1984 [July]— for Type SG) <br> (1987— for type EX) | Com: 24 (–M) <br> Mus: 9 (–M) | 23 (–M) <br> 9 (–M) | 21 (–M) <br> 7 (–M) |

Com: "Home and Commercial" Fading Limits
Mus: "Museum and Archive" Fading Limits

| Type of Color Print Product | Predicted Years of Display | | |
| --- | --- | --- | --- |
| | Prints Covered With Glass | Prints Covered With UF-3 Ultraviolet Filter | Prints Not Covered (Bare Bulb) |
| **UltraStable Permanent Color Prints** [polyester] <br> (pigment color process) [polyester] <br> (UltraStable Permanent Color Process) <br> (improved yellow pigment type: 1993— ) | Com: >500 (—) <br> Mus: >500 (—) <br> [tentative] | >500 (—) <br> >500 (—) <br> [tentative] | >500 (—) <br> >500 (—) <br> [tentative] |
| **Polaroid Permanent-Color Prints** <br> **Ataraxia Studio Collectors Color Prints** <br> (pigment color process) [polyester] <br> (1989— ) (Polaroid Permanent-Color Process) | Com: >500 (—) <br> Mus: >500 (—) <br> [tentative] | >500 (—) <br> >500 (—) <br> [tentative] | >500 (—) <br> >500 (—) <br> [tentative] |
| **Fujicolor Paper Super FA Type 3** <br> **Fujicolor Supreme Paper SFA3** <br> **Fujicolor SFA3 Professional Portrait Paper** <br> **Fujicolor Professional Paper SFA3 Type C** <br> **Fujiflex SFA3 Super-Gloss Printing Material** [polyester] <br> ("Fujicolor Print") <br> (1992/93— ) (RA-4) | Com: 105 (–M) <br> Mus: 40 (–M) <br> [estimated] | 105 (–M) <br> 40 (–M) <br> [estimated] | 80 (–M) <br> 35 (–M) <br> [estimated] |
| **Kodak Dye Transfer Prints** [fiber-base] <br> (Made with "standard" Kodak Dye Transfer Film and Paper Dyes and "standard" Kodak Dye Transfer Paper.) <br> (1946—, with minor modifications) | Com: 48 (M–Y) <br> Mus: 9 (–C) | 46 (M–Y) <br> 12 (–Y) | 33 (–C) <br> 6 (–C) |
| **Fuji Dyecolor Prints** [fiber-base] <br> (dye transfer type) <br> (Fuji Dyecolor process) <br> (1970— ) (available only in Japan) | Com: 29 (M–Y) <br> Mus: 11 (–Y) | 31 (M–Y) <br> 12 (–Y) | 22 (M–Y) <br> 11 (–Y) |

## Table 3.4 (continued from previous page)

### (Left portion)

Com: "Home and Commercial" Fading Limits
Mus: "Museum and Archive" Fading Limits

| Type of Color Print Product | | Predicted Years of Display | | |
|---|---|---|---|---|
| | | Prints Covered With Glass | Prints Covered With UF-3 Ultraviolet Filter | Prints Not Covered (Bare Bulb) |
| Kodak Ektacolor Edge Paper<br>Kodak Ektacolor Portra II Paper<br>Kodak Ektacolor Royal II Paper<br>Kodak Ektacolor Supra Paper<br>Kodak Ektacolor Ultra Paper<br>Kodak Duraflex RA Print Material [polyester]<br>Kodak Ektacolor 2001 Paper<br>Kodak Ektacolor Portra Paper<br>Kodak Ektacolor Royal Paper<br>("Ektacolor Print")<br>("Kodalux Print")<br>(formerly "Kodacolor Print")<br>(1986–91 for Ektacolor 2001) (RA-4)<br>(1991— for Ektacolor Edge and Royal II)<br>(1992— for Portra II)<br>(1989—for other papers) | Com:<br>Mus: | 24 (–M)<br>9 (–M)<br>[estimated] | 23 (–M)<br>9 (–M)<br>[estimated] | 24 (–M)<br>9 (–M)<br>[estimated] |
| Fujicolor Paper Type 8908*<br>(1980–84) | Com:<br>Mus: | 24 (–M)<br>9 (–M) | 24 (–M)<br>8 (–M) | 22 (–M)<br>9 (–M) |
| Fujichrome Reversal Paper Type 31*<br>(1978–83) | Com:<br>Mus: | 24 (–M)<br>7 (–M) | 24 (–M)<br>6 (–M) | 22 (–M)<br>6 (–M) |
| Konica Color PC Paper SIII*<br>(1983–84) | Com:<br>Mus: | 23 (–M)<br>8 (–M) | 22 (–M)<br>8 (–M) | Data Not Available |
| Ektacolor Plus Paper<br>Ektacolor Professional Paper<br>("Ektacolor Print")<br>("Kodalux Print")<br>(formerly "Kodacolor Print")<br>(1984 [August]— for Ektacolor Plus)<br>(1985— for Ektacolor Professional) | Com:<br>Mus: | 21 (–M)<br>9 (–M) | 23 (–M)<br>9 (–M) | 21 (–M)<br>9 (–M) |
| Kodak Ektachrome 2203 Paper*<br>(1978–84) | Com:<br>Mus: | 19 (–M)<br>8 (–M) | 21 (–M)<br>8 (–M) | 19 (–M)<br>8 (–M) |
| Kodak Ektacolor 74 RC Paper*<br>("Ektacolor Print")<br>("Kodacolor Print")<br>(initial type: 1977–82) | Com:<br>Mus: | 19 (–M)<br>6 (–M) | 19 (–M)<br>6 (–M) | 19 (–M)<br>6 (–M) |
| Kodak Ektacolor 37 RC Paper Type 2261*<br>("Ektacolor Print")<br>("Kodacolor Print")<br>(1971–78) | Com:<br>Mus: | 19 (–M)<br>6 (–M) | 17 (–M)<br>5 (–M) | 19 (–M)<br>6 (–M) |

### (Right portion)

Com: "Home and Commercial" Fading Limits
Mus: "Museum and Archive" Fading Limits

| Type of Color Print Product | | Predicted Years of Display | | |
|---|---|---|---|---|
| | | Prints Covered With Glass | Prints Covered With UF-3 Ultraviolet Filter | Prints Not Covered (Bare Bulb) |
| Agfacolor PE Paper Type 7i*<br>(1984–85) | Com:<br>Mus: | 17 (–M)<br>6 (–M) | 19 (–M)<br>6 (–M) | 14 (–M)<br>5 (–M) |
| Kodak Ektacolor 78 Paper Type 2524*<br>Kodak Ektacolor 74 RC Paper Type 2524*<br>("Ektacolor Print")<br>("Kodacolor Print")<br>(1982–86) | Com:<br>Mus: | 17 (–M)<br>4 (–M) | 17 (–M)<br>5 (–M) | 17 (–M)<br>4 (–M) |
| Kodak Ektachrome 14 Paper*<br>(1981–85) | Com:<br>Mus: | 17 (–M)<br>3 (–M) | 16 (–M)<br>3 (–M) | 17 (–M)<br>3 (–M) |
| Agfacolor PE Paper Type 589i*<br>Agfacolor PE Paper Type 7*<br>(1983–85) | Com:<br>Mus: | 14 (–M)<br>5 (–M) | 16 (–M)<br>6 (–M) | 14 (–M)<br>6 (–M) |
| Agfacolor PE Paper Type 5*<br>(1977–82) | Com:<br>Mus: | 11 (–M)<br>4 (–M) | 11 (–M)<br>4 (–M) | 11 (–M)<br>4 (–M) |
| Agfacolor PE Paper Type 589*<br>(1981–83) | Com:<br>Mus: | 9 (C–Y)<br>4 (–Y) | 9 (C–Y)<br>4 (–M) | 9 (C–Y)<br>4 (–Y) |
| Agfacolor PE Paper Type 4*<br>(This paper has extremely poor dark fading stability.)<br>(1974–82) | Com:<br>Mus: | 9.0 (–C)<br>3.1 (–C) | 11.0 (–C)<br>3.1 (–C) | 9.0 (–C)<br>2.3 (–C) |
| **Polaroid High Speed Type 779 Prints**<br>**Polaroid Autofilm Type 339 Prints**<br>Polaroid 600 High Speed Prints<br>(Because of high levels of yellowish stain that form over time in normal dark storage, Polaroid Type 779 and Type 339 prints are not recommended for other than short-term applications.)<br>(1981–88 for Polaroid 600)<br>(1981— for other prints) | **Com:**<br>**Mus:** | **8.0 (M–Y)**<br>**2.7 (M–Y)** | **10.0 (M–Y)**<br>**2.9 (M–Y)** | **8.0 (M–Y)**<br>**3.1 (M–Y)** |
| **Polaroid 600 Plus Prints**<br>**Polaroid Autofilm Type 330 Prints**<br>**Polaroid Type 990 Prints**<br>Polaroid Spectra Prints (Image Prints in Europe)<br>(Because of high levels of yellowish stain that form over time in normal dark storage, Polaroid Spectra prints, Image prints, and 600 Plus prints are not recommended for other than short-term applications.)<br>(1986–91 for Spectra) | **Com:**<br>**Mus:** | **8.0 (–M)**<br>**2.8 (–M)** | **8.0 (–M)**<br>**2.6 (–M)** | **7.0 (–M)**<br>**2.4 (–M)** |

(Table 3.4 continued on following page . . .)

## Table 3.4 (continued from previous page)

| Com: "Home and Commercial" Fading Limits<br>Mus: "Museum and Archive" Fading Limits<br><br>Type of Color Print Product | Predicted Years of Display | | |
|---|---|---|---|
| | Prints Covered With Glass | Prints Covered With UF-3 Ultraviolet Filter | Prints Not Covered (Bare Bulb) |
| **Polaroid Spectra HD Prints**<br>**Polaroid Image Prints** (Spectra in Europe)<br>(Because of high levels of yellowish stain that form over time in normal dark storage, Polaroid Spectra HD prints and image prints are not recommended for other than short-term applications.)<br>(1991—) | **Com: 8.0 (−M)**<br>**Mus: 2.8 (−M)**<br>[tentative] | **8.0 (−M)**<br>**2.6 (−M)**<br>[tentative] | **7.0 (−M)**<br>**2.4 (−M)**<br>[tentative] |
| Polaroid SX-70 Prints [Improved]<br>(1976–79) | Com: 7.0 (C−Y)<br>Mus: 3.3 (C−Y) | 7.0 (C−Y)<br>3.4 (C−Y) | 7.0 (C−Y)<br>2.9 (C−Y) |
| Kodak Ektaflex PCT Color Prints<br>(1981–88) | Com: 5.7 (−M)<br>Mus: 2.3 (−M) | 5.7 (−M)<br>2.3 (−M) | 5.0 (−M)<br>1.7 (−M) |
| Kodak Trimprint Instant Color Prints<br>(1983–86) | Com: 4.6 (−C)<br>Mus: 1.4 (−C) | 4.6 (−C)<br>1.4 (−C) | 4.6 (−C)<br>1.1 (−C) |
| **Polaroid Polacolor 2 Prints**<br>**(Types 88; 108; 668; 58; and 808)**<br>(The images of Polacolor 2 prints suffer a yellowish color shift that may become objectionable after only a few years of dark storage under normal conditions; because of this, Polacolor 2 prints are not recommended for fine art or other critical applications.)<br>(1975—) | **Com: 3.6 (M−Y)**<br>**Mus: 2.2 (−Y)** | **3.3 (M−Y)**<br>**2.1 (C−Y)** | **3.5 (M−Y)**<br>**2.1 (−Y)** |

| Com: "Home and Commercial" Fading Limits<br>Mus: "Museum and Archive" Fading Limits<br><br>Type of Color Print Product | Predicted Years of Display | | |
|---|---|---|---|
| | Prints Covered With Glass | Prints Covered With UF-3 Ultraviolet Filter | Prints Not Covered (Bare Bulb) |
| **Polaroid Polacolor ER Prints**<br>**(Types 59; 559; 669; and 809)**<br>(1980—) | **Com: 3.4 (M−Y)**<br>**Mus: 2.4 (−Y)** | **3.3 (M−Y)**<br>**2.1 (C−Y)** | **2.9 (M−Y)**<br>**1.8 (−Y)** |
| **Polaroid Polacolor 100 Prints**<br>**Polaroid Polacolor 64T Prints**<br>(1992—) | **3.4 (M−Y)**<br>**2.4 (−Y)**<br>[tentative] | **3.3 (M−Y)**<br>**2.1 (C−Y)**<br>[tentative] | **2.9 (M−Y)**<br>**1.8 (−Y)** |
| **Polaroid Polacolor Pro 100 Prints**<br>(1993—) | (New product: test data not available, but probably has light fading stability similar to that of Polacolor ER prints.) | | |
| **Fuji FI-10 Instant Color Prints***<br>(1981—) (available only in Japan) | **Com: 1.7 (Y−C)**<br>**Mus: 0.6 (−C)** | **1.6 (Y−C)**<br>**0.6 (−C)** | **1.4 (Y−C)**<br>**0.6 (−C)** |
| **Fuji 800 Instant Color Prints***<br>(1984—) (available only in Japan) | **Com: 1.2 (M−C)**<br>**Mus: 0.5 (M−C)** | **1.2 (M−C)**<br>**0.5 (M−C)** | **1.1 (M−C)**<br>**0.5 (M−C)** |
| Kodak PR10 Instant Color Prints*<br>(initial type: 1976–79) | Com: 1.2 (−C)<br>Mus: 0.4 (−C) | 1.4 (−C)<br>0.4 (−C) | 1.1 (−C)<br>0.4 (−C) |
| Agfachrome-Speed Color Prints<br>(1983–85) | Com: 1.2 (M−C)<br>Mus: 0.5 (M−C) | 1.1 (M−C)<br>0.5 (M−C) | 1.0 (M−C)<br>0.4 (M−C) |

## Table 3.5   Color Print Fading: Tungsten vs. Fluorescent Illumination

Predicted years of display to reach "Home and Commercial" image-life fading limits for color prints displayed in home and office locations illuminated 12 hours a day at 450 lux (42 fc). These predictions are based on equivalent light exposures in Cool White fluorescent and incandescent tungsten accelerated tests conducted at 1.35 klux (125 fc) at 75°F (24°C) and 60% RH. Initial neutral density of 0.6 with full d-min corrected densitometry.

Test duration of up to 10 years (3,650 days).

Boldface Type indicates products that were being marketed in the U.S. and/or other countries when this book went to press in 1992; the other products listed had been either discontinued or replaced with newer materials.

Tung: Tungsten Illumination Test
Fluor: Fluorescent Illumination Test

| Type of Color Print Product | | Predicted Years of Display | | |
|---|---|---|---|---|
| | | Prints Covered With Glass | Prints Covered With UF-3 Ultraviolet Filter | Prints Not Covered (Bare Bulb) |
| **Ilford Ilfochrome Classic Prints** Ilford Cibachrome II Prints (1980–92 for Cibachrome II) (1992— for Ilfochrome Classic) | Tung: Fluor: | 17.0 (Y–C) 29.0 (–M) | 20.0 (M–C) 33.0 (C–Y) | 12.0 (Y–C) 21.0 (–M) |
| **Konica Color PC Paper Type SR** **Konica Color PC Paper Prof. Type EX** (1984 [April]—) | Tung: Fluor: | 16.0 (–M) 15.0 (–M) | 15.0 (–M) 15.0 (–M) | 14.0 (–M) 13.0 (–M) |
| Kodak Ektacolor 74 RC Paper (initial type: 1977–82) | Tung: Fluor: | 10.0 (–M) 9.0 (–M) | 11.0 (–M) 9.0 (–M) | 10.0 (–M) 4.2 (Y–C) |
| **Kodak Ektacolor Plus Paper** **Kodak Ektacolor Professional Paper** (1984 [August]—) | Tung: Fluor: | 14.0 (–M) 12.0 (–M) | 15.0 (–M) 13.0 (–M) | 14.0 (–M) 11.0 (–M) |
| Agfacolor PE Paper Type 4 (1974–82) | Tung: Fluor: | 6.0 (–C) 6.0 (–C) | 7.0 (–C) 7.0 (–C) | 6.0 (–C) 5.0 (–M) |
| Agfacolor PE Paper Type 5 (1977–82) | Tung: Fluor: | 7.0 (Y–M) 7.0 (–M) | 7.0 (C–M) 8.0 (–M) | 7.0 (–M) 6.0 (Y–C) |
| Agfacolor PE Paper Type 589 (1981–83) | Tung: Fluor: | 6.0 (C–Y) 5.0 (C–Y) | 6.0 (C–Y) 5.0 (C–Y) | 7.0 (C–Y) 7.0 (–M) |
| **Polaroid High Speed Type 779 Prints** **Polaroid Autofilm Type 339 Prints** Polaroid 600 High Speed Prints (1981–88 for Polaroid 600) (1981— for other prints) | Tung: Fluor: | 5.0 (M–Y) 11.0 (–M) | 6.0 (M–Y) 12.0 (–M) | 5.0 (M–Y) 10.0 (–M) |

Tung: Tungsten Illumination Test
Fluor: Fluorescent Illumination Test

| Type of Color Print Product | | Predicted Years of Display | | |
|---|---|---|---|---|
| | | Prints Covered With Glass | Prints Covered With Ultraviolet UF-3 Filter | Prints Not Covered (Bare Bulb) |
| **Polaroid 600 Plus Prints** **Polaroid Autofilm Type 330 Prints** **Polaroid Type 990 Prints** Polaroid Spectra Prints Polaroid Image Prints (Spectra in Europe) (1986–91 for Spectra) (1988— for other prints) | Tung: Fluor: | 5.0 (–M) 4.1 (–M) | 5.0 (–M) 4.2 (–M) | 4.4 (–M) 3.5 (–M) |
| Polaroid SX-70 Prints [improved] (1976–79) | Tung: Fluor: | 6.0 (C–Y) 10.0 (M–Y) | 6.0 (C–Y) 10.0 (M–Y) | 6.0 (C–Y) 11.0 (M–Y) |
| Kodak Ektaflex PCT Color Prints (1981–88) | Tung: Fluor: | 4.0 (–M) 7.0 (C–M) | 4.0 (–M) 7.0 (C–M) | 3.5 (–M) 6.0 (C–M) |
| **Polaroid Polacolor ER Prints** **(Types 59; 559; 669; and 809)** (1980—) | Tung: Fluor: | 2.0 (M–Y) 3.7 (M–Y) | 2.1 (M–Y) 2.8 (M–Y) | 1.8 (M–Y) 3.7 (–C) |
| Kodak PR10 Instant Color Prints (initial type: 1976–79) | Tung: Fluor: | 0.8 (–C) 2.0 (–C) | 0.9 (–C) 2.0 (–C) | 0.8 (–C) 2.0 (–C) |
| Agfachrome-Speed Color Prints (1983–85) | Tung: Fluor: | 0.8 (M–C) 2.0 (M–C) | 0.8 (M–C) 2.0 (M–C) | 0.6 (M–C) 2.0 (M–C) |

## Table 3.6  Comparative Stability of Color Prints Illuminated with Diffuse North Daylight Through Window Glass

Predicted years of display to reach "Home and Commercial" image-life fading limits for color prints displayed close to a window in home and office locations and illuminated for 12 hours a day with north daylight having an average intensity of 450 lux (42 fc). Predictions based on equivalent light exposures in accelerated north daylight tests with an average light intensity (over a 24 hour period) of about 0.78 klux (75 fc) at 75°F (24°C) and 60% RH. Initial neutral density of 0.6 with full d-min corrected densitometry.

Test duration of up to 10 years (3,650 days).

**Boldface Type** indicates products that were being marketed in the U.S. and/or other countries when this book went to press in 1992; the other products listed had been either discontinued or replaced with newer materials.

| Type of Color Print Product | Predicted Years of Display | |
| --- | --- | --- |
| | Prints Covered With Glass | Prints Covered With UF-3 Ultraviolet Filter |
| **Ilford Ilfochrome Classic Prints** | **9.5 (–M)** | **16.0 (–M)** |
| Ilford Cibachrome II Prints | | |
| **Fuji CB Prints** (material supplied by Ilford) (P-3, P-3X, P-30, and P-30P) [polyester and RC] (Although Ilfochrome "Pearl" semi-gloss and glossy-surface RC prints have dye stability that is similar to Ilfochrome high-gloss polyester-base prints, the RC prints are subject to RC base cracking and image yellowing, and therefore are not recommended for long-term applications.) (1980–91 for Cibachrome II) (1991— for Ilfochrome Classic) | | |
| **Konica Color PC Paper Type SR** | **9.0 (–M)** | **9.6 (–M)** |
| **Konica Color PC Paper Prof. Type EX** (1984 [April]— for Type SR) (1987— for Type EX) | | |
| **Kodak Dye Transfer Prints** ("standard" Kodak Dye Transfer Film and Paper Dyes) (1946—, with minor modifications) | **8.3 (M–C)** | **6.3 (M–Y)** |
| Fujicolor Paper Type 8901 (1984–86) | 7.4 (–M) | 9.6 (–M) |
| **Kodak Ektacolor Plus Paper** | **7.1 (–M)** | **7.6 (–M)** |
| **Kodak Ektacolor Professional Paper** (1984 [August]— for Ektacolor Plus) (1985— for Ektacolor Professional) | | |
| Kodak Ektacolor 37 RC Paper (1971–78) | 6.5 (–M) | 8.2 (–M) |

| Type of Color Print Product | Predicted Years of Display | |
| --- | --- | --- |
| | Prints Covered With Glass | Prints Covered With UF-3 Ultraviolet Filter |
| Kodak Ektacolor 78 Paper Type 2524 Kodak Ektacolor 74 RC Paper Type 2524 (1982–86) | 6.3 (–M) | 6.9 (–M) |
| Konica Color Paper SIII (1983–84) | 5.8 (Y–C) | 8.6 (–M) |
| Kodak Ektacolor 74 RC Paper (initial type: 1977–82) | 5.7 (–M) | 7.3 (–M) |
| Fujicolor Paper Type 8908 (1980–84) | 5.5 (Y–C) | 8.6 (–M) |
| Kodak Ektachrome 14 Paper (1981–85) | 5.4 (–M) | 7.4 (–M) |
| Agfacolor PE Paper Type 7i (1984–85) | 5.0 (d-min: C+Y) | 6.1 (–M) |
| Fujichrome Reversal Paper Type 31 (1978–83) | 4.9 (–M) | 7.7 (–M) |
| Kodak Ektachrome 2203 Paper (1978–84) | 4.9 (–C) | 6.5 (–C) |
| **Fuji Dyecolor Prints** (dye transfer type) (1970— ) (available only in Japan) | **4.6 (M–Y)** | **5.4 (C–Y)** |
| Agfacolor PE Paper Type 589i Agfacolor PE Paper Type 7 (1983–85) | 4.2 (–M) | 5.4 (–M) |

## Table 3.6 (continued from previous page)

| Type of Color Print Product | Predicted Years of Display | |
|---|---|---|
| | Prints Covered With Glass | Prints Covered With UF-3 Ultraviolet Filter |
| Ilford Cibachrome-A Prints (1975–81) (P-12) | 4.2 (–M) | 8.9 (M–Y) |
| 3M Profesional Color Paper Type 25 / 3M High Speed Color Paper Type 19 (1978–88) | 4.0 (–M) | 5.7 (–M) |
| Agfacolor PE Paper Type 5 (1977–82) | 3.5 (–M) | 3.8 (–M) |
| Agfacolor PE Paper Type 589 (1981–83) | 3.4 (C–Y) | 2.6 (C–Y) |
| Kodak Ektaflex PCT Color Prints (1981–88) | 3.2 (–M) | 3.2 (–M) |
| Polaroid SX-70 Prints [improved] (1976–79) | 3.0 (M–Y) | 2.7 (C–Y) |
| Kodak Trimprint Instant Color Prints (1983–86) | 2.8 (–M) | 3.0 (–M) |
| Kodak Ektachrome RC Paper Type 1993 (1972–79) | 2.6 (–M) | 2.5 (–M) |
| **Polaroid 600 Plus Prints / Polaroid Autofilm Type 330 Prints / Polaroid Type 990 Prints** / Polaroid Spectra Prints / Polaroid Image Prints (Spectra in Europe) (Because of high levels of yellowish stain that form over time in normal dark storage, Polaroid Spectra prints, 600 Plus prints, and other Polaroid products using the Spectra emulsion are not recommended for other than short-term applications.) (1986–91 for Spectra) (1988— for other prints) | **2.5 (–M)** | **3.1 (–M)** |
| **Polaroid Spectra HD Prints** (Spectra in Europe) / **Polaroid Image Prints** (Spectra in Europe) (Because of high levels of yellowish stain that form over time in normal dark storage, Polaroid Spectra HD prints are not recommended for other than short-term applications.) (1991—) | **2.5 (–M)** [tentative] | **3.1 (–M)** [tentative] |

| Type of Color Print Product | Predicted Years of Display | |
|---|---|---|
| | Prints Covered With Glass | Prints Covered With UF-3 Ultraviolet Filter |
| **Polaroid High Speed Type 779 Prints / Polaroid Autofilm Type 339 Prints** / Polaroid 600 High Speed Prints (Because of high levels of yellowish stain that form over time in normal dark storage, Polaroid 600, Type 779, and Type 339 prints are not recommended for other than short-term applications.) (1981–88 for Polaroid 600) (1981— for other prints) | **2.1 (M–Y)** | **2.0 (M–Y)** |
| Agfacolor PE Paper Type 4 (This paper has extremely poor dark fading stability.) (1974–82) (Agfa AP-85) | 1.8 (–C) | 3.3 (–C) |
| **Polaroid Polacolor 2 Prints (Types 88; 108; 668; 58; and 808)** (The images of Polacolor 2 prints suffer a yellowish color shift that may become objectionable after only a few years of dark storage under normal conditions; because of this, Polacolor 2 prints are not recommended for fine art or other critical applications.) (1975—) | **1.8 (–C)** | **1.7 (C–Y)** |
| **Fuji FI-10 Instant Color Prints** (available only in Japan) (1981—) | **1.6 (Y–C)** | **2.1 (Y–C)** |
| Polaroid SX-70 Time-Zero Prints (initial type: 1979–80) | 1.6 (M–Y) | 1.3 (M–Y) |
| **Fuji 800 Instant Color Prints** (available only in Japan) (1984—) | **1.3 (M–C)** | **1.3 (M–C)** |
| **Polaroid Polacolor ER Prints (Types 59; 559; 669; and 809)** (1980—) | **1.2 (M–C)** | **1.6 (M–Y)** |
| Agfachrome-Speed Color Prints (1983–85) | 0.8 (M–C) | 1.1 (M–C) |
| Kodak PR10 Instant Color Prints (initial type: 1976–79) | 0.6 (–C) | 1.0 (–C) |

# 4. The Effects of Print Lacquers, Plastic Laminates, 3M Photogard, and UV-Absorbing Plastic Filters

## The Myth of UV Protection for Ektacolor, Fujicolor, and Similar Color Prints

As for the results of my experiment [with McDonald UV-absorbing print lacquer], I detected no difference in the degree of fading between the surface of the print which was not sprayed, and the surface area that was sprayed twice.... I have concluded that if a "UV inhibitor" does exist at all, its only value is as a promotional sales tool [for the lacquer manufacturers].[1]

Marty Rickard
*Professional Photographer*
January 1990

One of the most persistent beliefs in photography is that color print fading is caused primarily by exposure to ultraviolet radiation, and not by the effects of visible light. A 1970 Kodak publication stated: "Ultraviolet radiation in the illumination source is the chief cause of fading in color photographs."[2] Therefore, so the logic went, all one had to do to prevent fading of displayed color prints was to filter out UV radiation.

Since the early 1980's, however, Ektacolor, Fujicolor, Konica Color, Agfacolor, and most other modern color papers have been manufactured with a protective UV-absorbing emulsion overcoat on top of the image layers. Because of this built-in protection, almost all of the fading that occurs in these papers under normal display conditions — even when the prints are exposed directly to the UV-rich illumination of bare fluorescent lamps — is caused by visible light. Covering a print with an additional UV filter, or spraying it with a UV-absorbing lacquer, will do little if any good in reducing the rate of fading during display.

As discussed in Chapter 3, a good method for assessing the possible benefit of UV filtration for a particular type of color print is to test the material when it has been covered with Plexiglas UF-3, a sharp-cutting ultraviolet filter that removes virtually all UV radiation and even some short-wave blue light. UF-3 can be considered a "perfect" UV filter. If little improvement is noted with UF-3, one can be confident that other UV-filtering products will be of little or no benefit.

Unannounced, Kodak began manufacturing Ektacolor paper with a UV-absorbing emulsion overcoat around 1981, and this effectively eliminated the adverse effects of UV radiation in nearly all display conditions (see **Figure 4.1**). Other manufacturers now have also added this additional

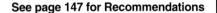
**See page 147 for Recommendations**

**Figure 4.1** Kodak Ektacolor Plus prints (Ektacolor Professional, Ektacolor Edge, Ektacolor Portra II, Ektacolor Supra, and Ektacolor Ultra prints have similar fading characteristics) and earlier Ektacolor 74 RC prints exposed to north daylight for a period of 1,250 days (3.5 years). With the prints located only a few feet from a large north-facing glass window (average intensity over a 24-hour period of 0.78 klux), this is a worst-case indoor display situation. With Ektacolor Plus, the glass-covered print faded only slightly more than the print covered with Plexiglas UF-3, a sharp-cutting UV filter that absorbs virtually all UV radiation and even some short-wavelength blue light. Current Ektacolor papers and similar products made by Fuji, Konica, and Agfa are manufactured with an effective UV-absorbing emulsion overcoat (as well as one or more UV-absorbing layers within the emulsion), so framing such prints with a UV-filtering material offers little if any additional protection. Until the early 1980's, Ektacolor 74 RC paper and similar color negative print papers supplied by other manufacturers were made without a UV-absorbing emulsion overcoat, and the cyan dye in particular was adversely affected by illumination sources with a high UV content.

protective layer. When this book went to press in 1992, Ilford Ilfochrome (called Cibachrome, 1963–1991), Polaroid Polacolor peel-apart prints, Fuji Dyecolor, and Kodak Dye Transfer were the only traditional color print materials not incorporating a UV-absorbing emulsion overcoat.

Kodak Ektatherm Electronic Print Paper, a thermal dye transfer paper supplied by Kodak for use with its electronic digital and video printers, does not have a UV-absorbing overcoat and suffers devastating fading when illuminated with direct, bare-bulb fluorescent lamps. When Ektatherm prints are displayed in this manner, ordinary window glass affords a considerable improvement in image stability. And, as discussed in Chapter 3, Ektatherm

October 1990

H&H Color Lab, located near Kansas City in Raytown, Missouri, is a leading Midwest lab serving professional portrait and wedding photographers. As is the case with most professional portrait labs, H&H's customers usually request lacquering on larger-size prints. Shown here is print sprayer Tom White lacquering a color print. H&H was the first professional wedding and portrait lab in the U.S. to switch from Kodak Ektacolor paper to Fujicolor paper. The change in color papers, which took place in 1991, was made because of the much better image stability of the Fuji product (see Chapter 8).

prints are an example of a print material for which a UV-absorbing filter such as Plexiglas UF-3 offers a further, significant improvement in light fading stability compared with covering the prints with glass.

Thermal dye transfer and ink jet "electronic" print materials supplied by other manufacturers also are made without a UV-absorbing overcoat. The same holds true for prints made with a Canon Color Laser Copier (a xerographic color copier), which have very good image stability — much better than that of Ektacolor prints — when framed under glass. But when the Canon color prints are exposed to bare-bulb fluorescent lamps, both the cyan and magenta colorants suffer markedly increased fading rates, and under this condition, the overall light fading stability of the prints is inferior to that of Ektacolor prints.

## Print Lacquers

Portrait and wedding photographers frequently coat color prints with a spray lacquer (currently available photographic lacquers generally are made with transparent cellulose nitrate [nitrocellulose] plastic dissolved in a mixture of solvents, plasticizers, and, in many cases, matting agents; a thin, hard layer of the plastic remains after the solvents evaporate). Lacquers come with a number of different surface gloss characteristics — from a very flat matte finish to a brilliant high gloss. Print lacquers are supplied both in aerosol cans for easy spray application and in larger bulk containers for commercial paint-spraying equipment; brush application is not recommended.

Special lacquers are available which, after drying, have surface characteristics unlike current photographic papers. McDonald Pro-Tecta-Cote Florentine, applied over coats of conventional or textured lacquers, dries with a reticulated (cracked) surface intended to simulate old and deteriorated oil paintings. Other "special effects" lacquers, such as McDonald Pro-Texture Lacquer, can produce simulated brush strokes on the surface of a print.

In addition to physically protecting a print from fingerprints, moisture, and physical damage during handling, lacquering covers the retouching and spotting work often done on prints sold by professional photographers. Heavy retouching and air-brushing usually result in changes in print surface gloss in the area where the retouching was done (sometimes a matte lacquer is applied first to provide a "toothed" surface receptive to pencil retouching), and a final coat of lacquer will cover the retouching and provide a uniform surface to the print.

Perhaps the most compelling reason for using print lacquers is to permit color prints to be framed directly against

# Recommendations

- **Plastic laminating films:** If a protective surface coating for prints is needed (e.g., for large display prints where framing under glass may not be practical), pressure-sensitive plastic laminating films made by Coda, Inc. and MACtac Permacolor are recommended (laminating films supplied by other firms were not tested and therefore cannot be recommended at this time). Laminates must be applied after retouching and spotting are completed. With Ektacolor, Fujicolor, and similar color negative print papers displayed in typical indoor conditions, there probably is no worthwhile benefit to be gained from ultraviolet-filtering laminating materials.

- **Laminating proved better than lacquering in this author's tests.** For coating Ektacolor prints, none of the print lacquers tested performed as well as the plastic laminating films made by Coda, Inc. and MACtac Permacolor. (The Sureguard-McDonald 900-series non-cellulose-nitrate lacquers introduced in 1992 were not available in time to be evaluated before this book went to press.) Although not tested, liquid surface-texturing finishes generally contain the same potentially harmful ingredients as lacquers and therefore cannot be recommended.

- **If a lacquer must be used, Lacquer-Mat lacquers and the new Sureguard-McDonald 900-series non-cellulose-nitrate lacquers introduced in 1992 tentatively are recommended.** This author's accelerated aging tests showed that older McDonald lacquers and probably all Sureguard brand lacquers will yellow over time to an unacceptable degree; for this reason, these lacquers should be avoided. (Sureguard brand lacquers should not be confused with the new Sureguard-McDonald 900-series lacquers introduced in 1992. Both product lines are now supplied by Sureguard Inc., although the company has indicated that the Sureguard brand will probably be discontinued in favor of the Sureguard-McDonald products in the future.) With Fujicolor prints, Ektacolor prints, and most other types of modern print materials displayed in typical indoor conditions, no worthwhile benefit is afforded by UV-absorbing lacquers. To minimize the likelihood of emulsion penetration by lacquer solvents that could cause increased rates of fading and staining when color prints are displayed or are stored in the dark, Lacquer-Mat, Sureguard-McDonald, and other print lacquers should be applied when the ambient relative humidity is as low as possible — never

higher than 50%. If the ambient relative humidity is higher than 50%, lacquering should be avoided entirely and plastic laminating films used instead.

- **A proven-safe color print lacquer is needed.** A new type of print lacquer that is harmless to Fujicolor, Ektacolor, Konica Color, Agfacolor, and other chromogenic prints, even when applied in high-humidity conditions, is urgently needed (lacquers are comparatively inexpensive, so it is unlikely that they will be replaced with plastic laminating films in the cost-conscious portrait and wedding business). The lacquer itself should be stable and should not yellow upon prolonged exposure to light. The lacquer should be supplied in glossy, semi-gloss, and matte formulations.

- **3M Photogard:** 3M Photogard offers no worthwhile protection against color print fading when Ektacolor and similar prints are displayed in typical indoor conditions; in fact, tests have shown that prints coated with Photogard may fade **more rapidly** than uncoated prints. Because of this, Photogard is not recommended for professional portraits or other photographs intended for long-term display. However, because of the excellent physical protection afforded to prints by Photogard due to its resistance to abrasion, damage caused by water and other liquids, fungus growths, etc., Photogard tentatively is recommended for coating amateur snapshots, especially in the tropics and other humid areas. Photogard is also recommended for coating **duplicate** slides that must be handled frequently (e.g., in academic slide libraries). Valuable original color slides or negatives should **never** be coated with 3M Photogard.

- **KSH UV-absorbing plastic sheets:** With Kodak Ektacolor Professional Paper in accelerated fluorescent light fading tests, KSH-UVF Picture Saver Panels offered no significant reduction in fading rates when compared with glass-covered prints. The KSH UV-absorbing plastic sheets produced no worthwhile advantage even when compared with prints exposed directly to bare-bulb fluorescent illumination.

- **Do not lacquer or laminate valuable prints.** Fine art prints and important historical photographs should **never** be laminated, lacquered, treated with Photogard, or coated with any other material.

glass without the danger of the emulsion sticking to the glass during periods of high relative humidity. A separating overmat is thus unnecessary. To many photographers, this advantage alone justifies the small cost of lacquering prints. Some commercial processing labs routinely lacquer prints for customers at no extra cost; other labs have a small charge for this service — typically about $0.50 for an 8x10-inch print.

Collectively, print spotting, retouching, texturing, and lacquering are often referred to as print enhancement. Professional portrait and wedding photographers frequently

do all of these things in an effort to increase a print's perceived value to the customer. Unfortunately, the image stability of these "enhanced" prints is anything but enhanced. Either separately or in concert, all of these treatments can have an adverse effect on Ektacolor Portra II (RA-4), Ektacolor Professional (EP-2), or similar chromogenic color prints and further reduce the already inadequate stability of these photographs. Ironically, the ordinary drugstore snapshot, or the "non-enhanced," low-cost portrait taken by one of the mass-market operations working out of a discount store, likely is more permanent!

## Kodak's Lacquering Recommendations

For many years, Eastman Kodak recommended lacquering for both black-and-white and color prints. This 1970 statement is typical of the advice given in many Kodak publications:

> You can enhance and protect the appearance of Ektacolor prints by coating them with one of a number of lacquers available from photo dealers. These lacquers are made especially for photographic use.
>
> . . . Lacquering helps protect the surface from abrasions, finger prints, atmospheric contaminants, humidity, and dirt. You can clean a lacquered print by wiping it with a damp cloth.[3]

In Kodak's 1979 book *Preservation of Photographs*, the company said:

> Print lacquers provide physical protection from fingerprints and act as a moisture barrier. The use of a lacquer will also help prevent the emulsion of a print from sticking to glass or a material used as an overlay or for interleaving. Since lacquer formulations vary, only a lacquer designed for photographic applications should be used.[4]

However, in 1980 Kodak abruptly stopped advocating lacquers for color prints and said: "Lacquering of prints is not recommended for optimum print stability."[5] On February 28, 1982, at the annual conference of the Professional Photographers of Wisconsin, held in Oconomowoc, Wisconsin, Kodak delivered a major presentation on the adverse effects of print lacquers and other post-processing treatments on Ektacolor RC prints. The results were published by Kodak later that year.[6] The company identified several types of accelerated dye fading that could be caused by lacquers. Kodak attributed most of the problems to the solvents in print lacquers and cited alcohols, esters, ketones, and carbitols as solvents that are capable of penetrating moist gelatin, and, through a variety of chemical reactions, reducing Ektacolor dye stability and causing prints to turn blue, develop cyan spots, turn red, or develop yellowish stains. Both light fading and dark-storage stability can be affected — in some cases severely.

At the time of this writing in 1992, this author knew of no commercially available print lacquer that did not contain solvents that are potentially harmful to Ektacolor, Fujicolor, and other chromogenic color prints. At the time this book went to press in 1992, all of the print lacquers supplied by the two major U.S. manufacturers — Sureguard Inc., and Lacquer-Mat Systems, Inc. — all contained at least one of these potentially harmful ingredients.

McDonald print lacquers were for many years the most popular brand of lacquer sold in the U.S. In 1989, Sureguard Inc., of Grand Prairie, Texas, acquired marketing rights to the entire McDonald print lacquer line from McDonald Photo Products, Inc., another Texas company, and Sureguard continues to market these products under the McDonald name in addition to its previous line of Sureguard lacquers. With its two brands of lacquers, Sure-

guard Inc. claims it now has more than 80% of the total U.S. print lacquer market.

In 1992 Sureguard introduced the Sureguard-McDonald Pro-Tecta-Cote 900-series of non-cellulose-nitrate print lacquers which the company claims significantly reduced yellowing during aging when compared with that of the firm's previous lacquers. This improved formulation was not extended to the Sureguard line of lacquers, which the company has indicated will probably be discontinued in the future. This author did not have opportunity to evaluate the new Sureguard-McDonald 900-series lacquers before this book went to press. However, it is likely that the elimination of cellulose nitrate from the lacquer will indeed improve the performance of the lacquers, and this author tentatively recommends the new Sureguard-McDonald lacquers in addition to the Lacquer-Mat lacquers that are discussed in this chapter.

Although the Lacquer-Mat lacquers available at the time this book went to press in 1992 contained cellulose nitrate, they did *not* employ UV absorbers which, in accelerated tests with earlier McDonald and Sureguard lacquers, apparently were responsible for increasing the rate of yellowing during aging. Pending further tests, this author tentatively recommends both Lacquer-Mat lacquers and the new Sureguard-McDonald 900-series lacquers.

On inquiry to Kodak by this author, the company refused to recommend a particular lacquer for Ektacolor prints; Kodak would not even reveal which lacquer proved the least harmful in its tests. (It should be noted, however, that in Kodak's 1987 book *Photographic Retouching*, which was written for Kodak by former Kodak retouching expert Vilia Reed, it is stated: "There are lots of brands of photo lacquers on the market. You should use only lacquer that is designed for photographic use. The brand that I like best is Lacquer-Mat. . . ."[7])

Around 1984, Kodak apparently concluded that photographers and labs were going to continue to use print lacquers on a large scale regardless of the warnings of potential harm to prints, so the company adopted a new public position on the matter. Briefly stated, Kodak resumed recommending the practice of lacquering Ektacolor prints while at the same time attempting to legally insulate itself from complaints that could result from increased fading, yellowing, localized discoloration, or other problems. According to a 1985 Kodak pamphlet:

> Applying print lacquers . . . modifies the sheen of the surface, or provides a variety of surface textures. You can also use lacquers to provide physical protection from fingerprints or protection from moisture. Since not all lacquers may be compatible with the emulsions of Kodak papers, use only lacquers designed for photographic prints. Since formulations of lacquers can change, you should reevaluate them from time to time.[8]

Kodak offered advice on lacquering procedures, saying:

> If you plan to lacquer prints, observe the following guidelines so that you'll have the best chance for maintaining the dye stability of prints:

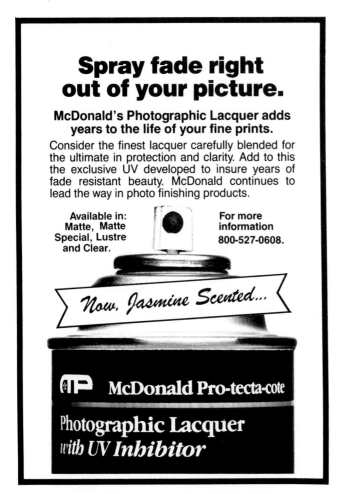

An advertisement for McDonald UV-absorbing print lacquer that appeared in a number of professional photography magazines in 1984.

1. Dry prints thoroughly before lacquering. (If you wait for a time after processing and drying before you lacquer a print, the emulsion can absorb water from humid air. If necessary, redry the print in a heated mounting press or with a hair dryer.)

2. Use only lacquers with solvents based on hydrocarbons and chlorinated or fluorinated hydrocarbons.

3. Apply multiple light coats of lacquer instead of one thick coat.

4. Lacquer in a dust-free, well-ventilated area with a relative humidity of 50 percent or less.

5. Don't let lacquered prints come into contact with glass in a frame. Don't seal prints in a tight enclosure if the lacquer contains any peroxide-forming solvents. (Don't let any prints come into contact with glass, because they can stick to it.)[9]

Despite repeated inquiries by this author, Kodak declined to identify even a single print lacquer based on "hydrocarbons and chlorinated or fluorinated hydrocarbons"

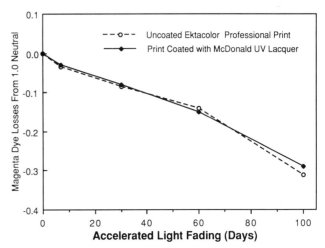

**Figure 4.2** An Ektacolor Professional print coated with McDonald UV-absorbing lacquer and an uncoated print were exposed to bare-bulb fluorescent illumination in a 21.5 klux accelerated light fading test. The UV-absorbing lacquer offered no protection against image fading (fading of the magenta dye is shown here because it is the least stable of the three image dyes when the prints are exposed to light on display).

(this author is not aware that any exist) and also declined to describe how a photographer could go about evaluating a lacquer to determine its suitability for color prints.[10]

Even Kodak's 1985 museum-oriented book *Conservation of Photographs* recommended the use of print lacquers, stating:

> A large percentage of professional color portrait prints are lacquered. The technique is commonly used to enhance the print's visual appearance, to protect the print from physical degradation such as soiling, scratching or abrading, or to provide a surface with tooth when retouching is required.[11]

The book went on to say:

> Print lacquers provide physical protection from fingerprints and fungus attack, and they act as a temporary moisture barrier. The use of a lacquer will also help prevent the emulsion of a print from sticking to the glass or whatever material that is used as an overlay, matt or an interleaving. Since lacquer formulations vary, only a lacquer designed for photographic applications should be used.[12]

Since Kodak has described the ingredients for a "safe" lacquer, one might wonder why Kodak simply doesn't produce a line of suitable print lacquers and solve the whole problem. Indeed, according to an official at one large lacquer supplier, Kodak almost did just that: "Around 1984 we were approached by Kodak with an offer to sell us drums of a lacquer which they said was okay. This was a high-gloss lacquer and most of what we sell has a matting agent in it [to produce semi-gloss and matte surfaces]. But Kodak wouldn't certify it if we added a matting agent and they

said they weren't interested in producing a matte lacquer. They then dropped the whole thing." (Until the early 1970's, Kodak supplied Kodak Print Lacquer in gloss and matte versions; both were said to have been thoroughly tested by Kodak with black-and-white and color prints, and this author has been unable to learn why these apparently excellent products were discontinued.)

The lacquer company official, who wished to remain unnamed, went on to say, "At the current state of the market I don't think there is any product from any supplier that meets Kodak's requirements. We have even sent samples of our lacquers to Kodak for evaluation, but they won't tell us if they are good or bad." He said his company was concerned about potential problems with its current lacquers but saw no ready solutions. "Our chemists are worried about the toxicity of chlorinated hydrocarbons and we have not been able to make satisfactory nitrocellulose lacquers with hydrocarbons alone. We tried acrylics but had adhesion problems with Ektacolor prints. Kodak tells photographers to lacquer their prints but also tells them that Kodak won't be responsible if anything goes wrong. We get the blame and that leaves us in a pretty tough spot."

## UV-Filtering Print Lacquers

In 1982 McDonald International, Inc. (which, at that time, had not yet been acquired by Sureguard Inc.) marketed an ultraviolet-absorbing lacquer known as McDonald UV Pro-Tecta-Cote print lacquer, which was claimed by an outside consultant hired by the company to "extend the life of a color print six to eight times." McDonald went on to say that "If it only doubles the life of the color print, it will be in demand by every photographer who cares about his valuable product."[13] One advertisement for the new lacquer showed a very faded Ektacolor print that had been displayed for more than 10 years alongside a new print made from the original negative and implied that if the new UV-absorbing lacquer were used, the new print would remain unfaded after 10 years of display. The advertisement went on to say, "The hottest topic in professional photography today is color print stability. Everyone is talking about color print fading . . . especially the photographer whose reputation is on the line. McDonald is concerned enough that we spent a lot of time and research dollars to develop a UV inhibitor for lacquer that really works."[14]

In tests conducted by this author on Ektacolor Professional Paper coated with the McDonald UV-absorbing lacquer, no improvement in image stability was observed, even with direct, bare-bulb fluorescent light in which the 313 and 365 nanometer mercury vapor emission lines were not absorbed by a glass or plastic sheet (see **Figure 4.2**). Tests done with lacquered prints made on the earlier Ektacolor 74 RC Paper, Type 2524 gave similar results. Prints coated with the UV-absorbing lacquer performed no better in light fading tests (even with direct fluorescent light) than did prints coated with a previous McDonald lacquer that did not contain a UV absorber.

In 1983 Sureguard Inc. marketed Ultra Screen UV-absorbing lacquer,[15] similar in purpose to the McDonald product. In tests conducted by this author, this lacquer also gave no improvement in dye stability of either Ektacolor Professional Paper or the earlier product that it replaced, Ekta-

A 1985 photography magazine advertisement for Sureguard UV-absorbing lacquer.

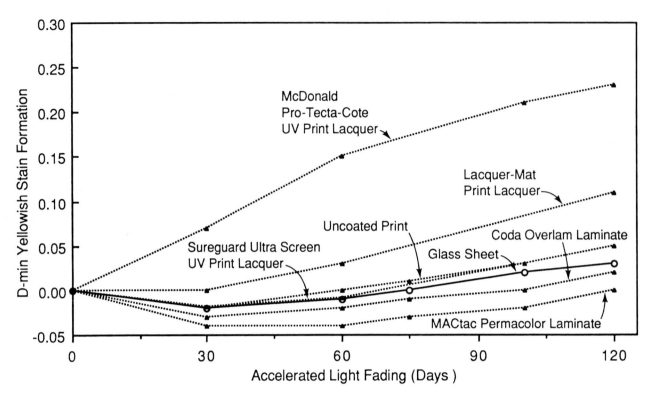

**Figure 4.3**  Yellowing of lacquer-coated and laminated Ektacolor Professional prints exposed to bare-bulb 21.5 klux fluorescent illumination in a temperature- and humidity-controlled light fading test.  Note in particular the pronounced yellowing that occurred in the print with the McDonald UV-absorbing lacquer that was available at the time these tests were conducted (see page 148 for discussion).

color 74 RC Paper, Type 2524.  The yellowing of lacquered and laminated prints illuminated with direct, bare-bulb fluorescent lamps is shown in **Figure 4.3**.

Lacquer-Mat lacquers do not contain ultraviolet absorbers; like the other lacquers, the Lacquer-Mat lacquer tested by this author offered no improvement in light fading stability of Ektacolor Professional Paper.  But, as shown in **Figure 4.4**, the Lacquer-Mat lacquer performed much better in accelerated dark storage tests than either the McDonald or Sureguard lacquers available at the time these tests were conducted; in particular, the Lacquer-Mat lacquer yellowed far less than the other two products.  (As noted previously, these tests did not include the Sureguard-McDonald Pro-Tecta-Cote 900-series non-cellulose-nitrate lacquers introduced by Sureguard Inc. in 1992.  These new lacquers probably will yellow less than previous McDonald and Sureguard lacquers.)  In preparing sample prints for the tests reported here, all of the lacquers were applied in two coats, in the manner recommended by their respective manufacturers.  In the spraying area, the temperature was 70°F (21°C) and the relative humidity 60% (prior to the application of lacquer, the prints were pre-conditioned for several weeks under these conditions).

Short-term accelerated tests probably do not give an accurate indication of what might actually occur with lacquered prints in normal long-term display and storage; in particular, the kinds of disproportionate dye fading and yellowing which have been attributed to the effects of print lacquers by Kodak, and which have on occasion been observed by this author in prints on long-term display and in

normal album storage in the dark, appear to be impossible to duplicate accurately with short-term accelerated tests.  However, the results of this author's accelerated tests convincingly show that no improvement in the stability of Ektacolor and similar prints may be expected from lacquering, formulated with or without UV absorbers.

More meaningful dark storage staining and fading data can be obtained using the multi-temperature Arrhenius accelerated test method specified in *ANSI IT9.9-1990, American National Standard for Imaging Media – Stability of Color Photographic Images – Methods for Measuring.*[16]

Kodak has indicated that the relative humidity of the air where the lacquer is applied (and consequently the moisture content of the print emulsion) can be a major influence on the effect the lacquer may eventually have on the stability of the print.  Kodak suggests a relative humidity of 50% or lower, but the photographer or processing lab will rarely if ever have control over the ambient humidity.

Lacquer-Mat, Sureguard, and McDonald lacquers (including the new Sureguard-McDonald Pro-Tecta-Cote 900-series lacquers introduced in 1992) all contain solvents which, according to Kodak, could be harmful to Ektacolor and similar chromogenic color prints, especially if the lacquers are applied in humid environments.  Because of this concern, it would seem wise to avoid lacquers entirely.  Lacquer fumes are also quite toxic if inhaled, and it is essential that prints be lacquered in an explosion-proof spraying hood with proper high-velocity ventilation that exhausts outdoors.  If it is deemed necessary to apply a protective coating to a print, a pressure-sensitive plastic laminate,

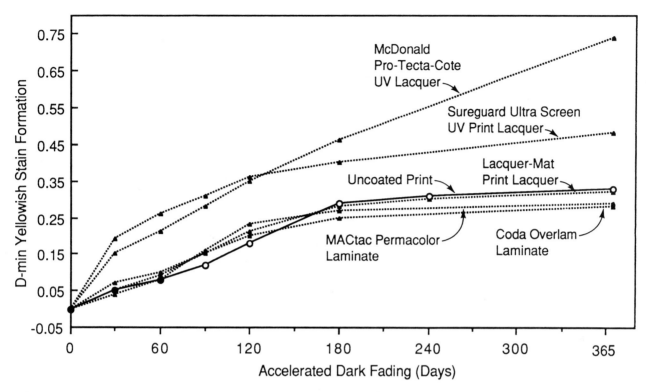

**Figure 4.4** In an accelerated dark storage test conducted at 144°F (62°C) and 45% RH, Ektacolor prints coated with the McDonald and Sureguard lacquers available at the time these tests were conducted (see discussion on page 148) yellowed significantly more than prints covered with plastic laminating films or coated with Lacquer-Mat lacquer.

described below, appears to be a much better choice at present. If, for reasons of economy or other considerations, a lacquer must be used, this author's accelerated tests indicate that Lacquer-Mat lacquers are a better choice than either Sureguard or McDonald lacquers.

There is obviously a need for a safe, non-yellowing, and rapid-drying print lacquer that can be applied without difficulty in a wide range of humidity conditions. Such a lacquer would have to be carefully tested for its effects on light fading and dark-storage image stability of Ektacolor, Fujicolor, Konica Color, Agfacolor, Ilfochrome, and other common print materials (each type of print would have to be tested individually because interactions between a lacquer formulation and different print materials can vary).

There would be a considerable market for a lacquer proven to be both harmless to photographic materials and long lasting without gradual yellowish discoloration.

### Pressure-Sensitive Plastic Laminates

Only since around 1980 have pressure-sensitive plastic laminates become popular in the commercial photography field. Previously, laminates were more likely to be found protecting and making tamper-proof such small photographic items as drivers' licenses and identification badges. The transparent plastic laminate coverings, coated with a pressure-sensitive adhesive, are similar in appearance to large sheets of Scotch tape and are applied with pressure rollers without heat. Pressure-sensitive laminates are now frequently used to physically protect display prints hung in

food stores, restaurants, and public buildings. Such prints are usually large, and it is too expensive or otherwise impractical to frame them under glass. It is also easier and quicker to laminate a large print with an electrically powered applicator than it is to apply two or more coats of spray lacquer. Laminates, like lacquers, are available in glossy, semi-gloss, and matte surfaces.

In the U.S., most glossy-surface laminates are made with polyester (e.g., DuPont Mylar or ICI Melinex), while in Europe both polyester and polypropylene are used. Semigloss and matte-surface laminates are generally made of polyvinyl chloride (PVC) containing a low level of plasticizer, although other plastics are also employed. From a stability point of view, polyester would appear to have some advantages over PVC. Pressure-sensitive acrylic adhesives with UV stabilizers are used with most if not all currently available laminating products.

Although pressure-sensitive laminates are moderate in cost, they are considerably more expensive than spray lacquers, and this has limited the popularity of laminates outside of the commercial display field; in particular, laminates are less common in wedding and portrait markets, where lacquers have had wide popularity for many years.

One of the leading suppliers of pressure-sensitive laminates is MACtac PermaColor of Stow, Ohio.[17] MACtac's products, which include pressure-sensitive "cold-mounting" adhesives, were initially marketed under the MACtac CoolMount name. In 1984 the name was changed to Permacolor after MACtac acquired the assets of the defunct PermaColor Corporation, which in 1983 had unsuccessfully

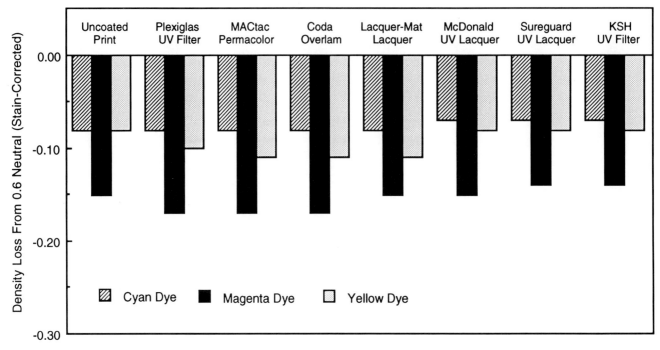

**Figure 4.5** Laminated and lacquered Ektacolor Professional prints exposed to high-intensity 21.5 klux bare-bulb Cool White fluorescent illumination for 60 days in an accelerated light fading test (circulating air at the surface of the prints was maintained at 75°F [24°C] and 60% RH). When compared with the uncoated print, none of these products offered any worthwhile protection against light fading. The somewhat increased magenta dye fading that was measured in the print covered with a Plexiglas UF-3 ultraviolet filter and the prints laminated with MACtac and Coda plastic films is an artifact of the reduced stain levels that occurred in these prints and is not considered significant.

attempted to market small, UV-filtering, hermetically sealed frames for color prints under the Permacolor name. (The frames produced by PermaColor were claimed to reduce fading of Ektacolor prints, although in this author's tests they proved ineffective in this regard.) MACtac's PermaGard laminating materials have been extensively advertised in trade publications. Company literature says: "The Permacolor System is the result of years of research and testing. America's premier scientific method for preserving image color. . . ."[18]

Although at the time the company was unable to furnish any test data to show that PermaGard products reduced the rate of print fading, there was no lack of enthusiasm about the effectiveness of the products. According to Jack McClintock of MACtac, "We are now beginning to look at extending the life of a print to within archival limits."[19]

Pressure-sensitive laminating materials are also available from a number of other firms, including Seal Products Incorporated (Seal Print Guard and Sealeze Print Shield-UV); Coda, Inc., which sells its products under the Coda Overlam name;[20] Drytac Corporation; and Ademco-Seal, Ltd.[21] Both MACtac and Coda laminates are popular in the U.S., and this author selected these for evaluation.

In this author's accelerated fluorescent light fading tests with Ektacolor Professional Paper, neither Permacolor PermaGard nor Coda Overlam offered any meaningful protection against light fading, even when compared with an uncoated Ektacolor Professional print exposed to direct, bare-bulb fluorescent illumination (**Figure 4.2**). Prints laminated with these products yellowed less than lacquered prints in these light fading tests (**Figure 4.3**), however.

In dark aging tests, the laminated prints exhibited fading and staining behavior that was generally similar to uncoated Ektacolor Professional prints. However, the laminated prints were substantially more stable and developed much lower stain levels than prints lacquered with the Sureguard or McDonald lacquers included in these tests. The Lacquer-Mat coated prints were only slightly less stable than the laminated prints. The Coda and Permacolor laminating materials included in these tests were obtained from their respective manufacturers in 1987.

Overall, this author's tests suggest that Coda and MACtac laminating materials probably are not harmful to Ektacolor prints. Although this author's tests showed that neither MACtac PermaGard nor Coda Overlam reduced the rate of light fading of Ektacolor prints, data from Ilford indicate that these products may offer substantial protection to Ilfochrome prints in many display situations.[22]

## MACtac's Published Light Fading Data

In early 1987 MACtac published the results of accelerated light fading tests involving Kodak Ektacolor Plus Paper laminated with MACtac PermaGard IP-7000, a glossy polyester laminating film containing an ultraviolet absorber. "Both protected and unprotected panels were then placed in a xenon arc Weatherometer to artificially accelerate the fading process. The panels were exposed under high-intensity UV light for 359 hours at 120°F (50°C)."[23] The test indicated that the PermaGard laminate markedly reduced the fading rates of both the cyan and magenta dyes of the Ektacolor Plus print (the yellow dye faded in approximately

Carol Brower – June 10, 1987

A practical application of plastic laminating films is the protection of photographs displayed outdoors from rain and dirt. Measuring 30x50 feet and said to be the world's largest backlit photographic billboard, this Kodak installation over the main entrance to the Marriott Marquis Hotel in New York City's Times Square features color prints made with Kodak Duratrans translucent print material that has been laminated on both sides with MACtac plastic laminating films. In outdoor applications, UV-absorbing laminating films probably offer some reduction in the rate of fading, but even at best the prints have a relatively short life. The prints on this billboard are changed at regular intervals.

the same manner in both the laminated and unprotected samples).

A xenon-arc Weatherometer of the type employed for the MACtac tests is designed to simulate the spectral distribution of direct outdoor sunlight and is essentially useless in predicting the behavior of a print material displayed indoors. The MACtac tests may be useful for simulating outdoor display, but they are simply not relevant to indoor display under normally encountered illumination conditions — including direct sunlight through window glass or bare-bulb fluorescent lamps. (This author was surprised by the greater loss of cyan than magenta dye shown in the MACtac tests — in outdoor display of an unprotected Ektacolor print in direct sunlight, this author would have expected the magenta dye loss to exceed that of the cyan dye.)

## Kodak Recommends Laminates as Safer Than Print Lacquers

Laminates contain no solvents and thus avoid the principal problems of print lacquers. Eastman Kodak has generally recommended laminating materials as being less

harmful to color prints than lacquers, saying: "In the cases for which we have long-term results, we have seen no adverse effect."[24] This author's tests support Kodak's recommendations in this regard. Kodak also says, "Laminates provide excellent protection from fungus and bacterial attack, moisture, dirt, and harmful gases." For outdoor display of Ektacolor papers and Duratrans "day-night" print material, Kodak advocates the use of UV-absorbing laminates applied to both sides of the prints. Kodak cautions, however, that the life of color prints displayed outdoors (an increasingly common mode of advertising) will be relatively short, regardless of the steps taken to protect the prints. The reader is referred to the Kodak booklet *Backlit Displays with Kodak Materials*[25] for an informative discussion of both indoor and outdoor display of Duratrans Display Material.

## KSH UV-Absorbing Polystyrene Framing Sheets

Also of no benefit in reducing the light fading of Ektacolor Professional prints exposed to fluorescent light in tests by this author are the UV-filtering KSH-UVF Picture

Klaus B. Hendriks – 1980

A 3M Company billboard on the back of a bus in Ottawa, Canada.  Like many 3M advertisements for Photogard (a UV-absorbing transparent coating for photographs), this ad claims that there is "no fading" in color prints coated with Photogard.  Had this been true, it would have been a most sensational development in the color photography field!  In reality, as discussed in this chapter, displayed prints coated with Photogard may fade even **faster** than uncoated prints.

UVF Picture Saver Panels supplied by ICI Acrylics, Inc., of St. Louis, Missouri.[26]  A KSH brochure says that this product "Protects the beauty and extends the life of treasured photographs, prints and works of art!" and is illustrated with comparison prints (made on an unidentified paper) that had been exposed to 600 hours of UV radiation (of unspecified intensity and spectral distribution).

### 3M Photogard Film and Print Coatings

Photogard Film Protector and Print Protector, coatings marketed by the 3M Company, have been described as a "polymerized silane, 100% solids formulation that is cured by ultraviolet radiation in a few seconds."[27]  The coatings are thin, optically clear, colorless, and flexible; unlike lacquers, Photogard contains no solvents that might penetrate color print and film emulsions.

A UV-cured film-coating liquid that is similar to Photogard, but lower in cost, was introduced in 1987 by the Dacar Chemical Company of Pittsburgh, Pennsylvania, and is supplied by CPAC, Inc. under the ImageGARD name.  In 1988 3M initiated a lawsuit against Dacar claiming an infringement on 3M patents.  The case was settled by the two companies in 1990, and 3M granted Dacar a royalty-bearing license to manufacture and market Dacar's coatings

both in the U.S. and internationally.  Dacar in turn dropped its legal challenge of the validity of 3M's patents.

No information could be obtained regarding the long-term effects of Dacar ImageGARD (or Dacar REZCOAT, a related product) on color films and prints, and, at the time this book went to press, this author had not tested the coatings nor been able to compare their long-term performance with that of 3M Photogard.  Therefore, until comprehensive tests can be completed, the Dacar coatings cannot be recommended.

Photogard must be applied with special equipment in a controlled environment, and has thus far been limited to photofinishing operations and to the production of motion picture release prints and microfilm work copies.  In the photofinishing field, coating negatives with Photogard Film Protector is claimed to eliminate the need for negative sleeves ("sleeveless finishing").  Negatives are cut and inserted into customer print envelopes without sleeves or other physical protection, thus, it is said, saving labs time and money.

Since retouching and spotting must be done before the coating is applied, it is unlikely that Photogard will find significant acceptance for coating prints in the high-quality portrait, wedding, and commercial photography fields. 3M says that without special ultrasonic cleaning, Photo-

A 3M Photogard sheet-coating machine at Duggal Color Projects, Inc., shown here in a 3M press release photograph. Duggal is a leading New York City custom lab. Believing it had been deceived by 3M with respect to the light fading protection offered by Photogard, Duggal abandoned the coating service soon after it was inaugurated in 1982 and later filed a lawsuit against 3M. The case was settled out of court for an undisclosed amount.

gard cannot be applied to Agfachrome transparency films or Agfacolor negative films because they have a silicone coating.

Four types of Photogard coating equipment are available: (1) roll-film coaters for coating negatives, slides, and motion picture films; (2) roll-paper coaters for coating color or black-and-white RC or polyester-base prints in roll form; (3) sheet coaters for coating prints or films in sheet form; (4) strip coaters for coating individual short rolls of film (in a minilab, for example).

Automatic coaters for applying Photogard to rolls and sheets of film and paper are manufactured by CPAC, Inc.,[28] Nord Photo Engineering,[29] and CJ Laser Corporation.[30] Automatic coaters are not inexpensive; for example, the CPAC FilmCOAT 35 machine for 16mm and 35mm film sells for about $30,000. (The CPAC FilmCOAT M7040, a small, manually operated applicator for individual rolls of film, is available for about $2,000.) At the time Photogard was first introduced, the 3M Company supplied coating equipment; however, 3M discontinued making the equipment some years ago (a number of 3M machines are said to still be in operation).

In promoting Photogard, 3M has cited five characteristics of the coating that are claimed to contribute to the preservation of color prints:

1. **Protects against color fading.** In a Photogard Print Protector promotional brochure, 3M asserted that uncoated prints subjected to a fading test (unspecified) faded considerably, while "no fading" occurred in a Photogard-coated print. Other 3M literature indicates that

the company based its claims on tests with direct sunlight and a xenon-arc Atlas Fadeometer. For its published pictorial examples, 3M apparently used 3M High Speed Color Paper, a now-obsolete paper that had exceedingly poor dark fading stability.

2. **Protects against spills and smudges.** Because the Photogard coatings are unaffected by common solvents at room temperatures and do not readily absorb grease, ink, oils, etc., prints can be cleaned with a cloth moistened with water or solvents. The ability to wet-clean the prints lessens the need for putting glass over displayed prints.

3. **Resists abrasion.** The coatings have exceptional abrasion resistance compared with conventional lacquer coatings or uncoated photographic emulsions. In this respect, Photogard is indeed clearly superior to any lacquer or plastic laminate on the market.

4. **Resists fungus.** 3M has reported that Photogard coatings have high resistance to fungus growth. In this respect, the coatings are probably at least equal — and probably superior — to conventional lacquer coatings.

5. **Has anti-static properties.** The coatings are claimed to greatly reduce dirt accumulation and other consequences of static electricity build-up in conditions of low relative humidity.

3M Photogard has been used at one time or another by a number of large-scale photofinishers in the U.S. and abroad,

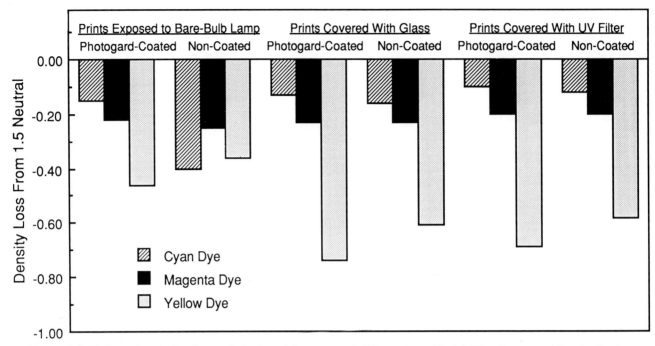

**Figure 4.6** Photogard-coated and uncoated color prints compared. When exposed to 1.35 klux fluorescent illumination for 960 days (2.6 years) in a low-level accelerated light fading test, the yellow dye of the Photogard-coated prints in every case faded more than the yellow dye of the uncoated prints. The color prints in the test were made with now-obsolete 3M High Speed Color Paper. The disproportionate fading of the yellow dye in Photogard-coated prints observed in this long-term test did not occur in short-term, high-intensity tests in which the prints received the same total light exposure (circulating air at the surface of the prints was maintained at 75°F [24°C] and 60% RH in both tests).

including Brown Photo, Living Color Labs (a division of Genovese Drugstores, Inc., headquartered in Melville, New York), and Far East Laboratories, a Tokyo processing lab that coats Photogard on Ektacolor paper, selling the prints under the "Live" name and claiming reduced fading rates.

One professionally oriented lab that installed Photogard sheet-coating equipment is Duggal Color Projects, Inc., of New York City. Baldev Duggal, president of the firm, said at the inauguration of the Photogard service in 1982, "The 3M Photogard coating is one of the landmarks in the history of photography. It gives a lasting image quality to a piece of photo art, and this will add a whole new dimension to our business."[31] Duggal intended to market this service to well-known photographers and institutions such as the Museum of Modern Art "to permanently preserve their color prints." Duggal based his claims about Photogard on information supplied to him by the 3M Company. Duggal's Photogard service was an immediate market failure and was discontinued shortly after it was announced. In June 1983, Duggal filed suit against the 3M Company, claiming $207,500 in damages.[32] The case was settled out of court and never went to trial. According to Duggal: "I wanted to take 3M to the cleaners, but they offered us a damn good settlement so we accepted it."[33]

### Light Fading Characteristics of Photogard-Coated Prints Made on 3M Color Paper

**Figure 4.6** compares Photogard-coated and uncoated 3M High Speed Color Paper printed with neutral gray patches

of an initial density of 1.5; the prints were exposed to three spectral conditions. In the direct, bare-bulb fluorescent exposures, the Photogard coating offered significant protection to the cyan dye; the loss of red density was much higher for the uncoated print under the test conditions. The 3M paper in these tests did not have a UV-absorbing emulsion overcoat (this paper, which is no longer manufactured, does have a UV-absorbing layer under the cyan layer, between the cyan and magenta layers, but it does not protect the cyan dye from UV radiation). A glass filter will effectively absorb the short-wavelength UV radiation, resulting in substantial improvement in the stability of the cyan dye in the 3M paper.

When Photogard-coated and uncoated 3M prints were exposed to glass-filtered fluorescent light, quite different behavior was observed. While the cyan dye of the Photogard-coated print faded less than the cyan dye of the uncoated print, the yellow dye of the Photogard print faded more, producing significantly greater overall color imbalance of the three image dyes resulting from unequal fading rates in the Photogard-coated print.

The greater fading of the yellow dye when the prints were covered with a sheet of glass cannot be accounted for by the fact that direct fluorescent light causes yellow stain formation (print-out of unreacted magenta coupler), which replaces the blue-light absorption of some of the faded yellow dye. There also appears to be a chemical bleaching of the yellow dye in Photogard-coated prints. This possibly is caused by reactions involving the somewhat photoreactive pigmented polyethylene layer on top of the RC paper support, next to the yellow dye layer (in a Photogard-coated

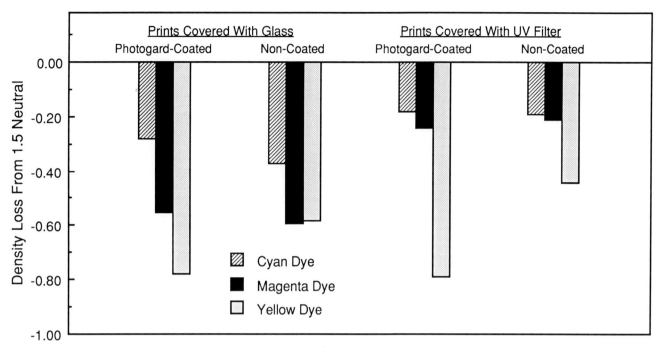

**Figure 4.7** When Photogard-coated prints were exposed to north daylight through window glass (average intensity over 24 hours of 0.78 klux) for 1095 days (3 years) the yellow dye faded significantly more than did the yellow dye of uncoated prints. This was also true of the prints protected from UV radiation by Plexiglas UF-3.

print, the emulsion is "sealed" between the RC base and the Photogard coating, and this might serve to accentuate this type of yellow dye fading). In all three spectral conditions of this author's tests, the changes in blue density were greater in the Photogard-coated prints than in the uncoated prints.

Glass-filtered fluorescent light generally provides a better indication of how prints will behave on display in homes (indirect daylight filtered by window and/or framing glass) and in offices (fluorescent light filtered by glass or plastic light diffusers and/or framing glass) than any other common light source.

Long-term tests indicate that the Photogard coating reduces fading of the cyan dye but somewhat increases the fading rate of the yellow dye in 3M prints exposed to indirect daylight (through window glass); the uncoated glass-filtered print maintained the best color balance during fading (see **Figure 4.7**). In other words, in tests that are a reasonable simulation of normal print display conditions, Photogard not only failed to offer protection against dye fading in 3M color paper but was actually detrimental.

In published information on Photogard, 3M has selected high-UV test conditions and particular products (3M color paper or older versions of Ektacolor RC papers) which, in combination, make Photogard appear to significantly reduce light fading rates despite the fact that neither the test conditions nor the papers being tested are likely to be found in normal print display situations.[34] This author believes that 3M is aware of the inadequacies of its test procedures; nevertheless the company was continuing to make misleading and irrelevant claims about Photogard. For example, in the January 1987 issue of the prestigious *SMPTE Journal,* Ashwani K. Mehta, manager of Photogard products at 3M, stated: "For color prints under direct sunlight

illumination, or as tested in a fadeometer that simulates direct sunlight illumination, a 6X improvement in cyan dye stability is achieved by the incorporation of UV absorbers in the Photogard coating."[35]

3M is a high-technology company, and, given its sophisticated technical resources, it is very difficult to understand why the company has persisted in citing data from irrelevant accelerated tests using a color paper that is no longer even sold in the U.S. and advertising that Photogard offers substantial protection against color print fading when in fact it does not. In some instances, 3M has even gone so far as to say that Photogard "stops fading" altogether. This is perhaps a case of marketing people running amok, having so long ago lost sight of the realities of the product they are promoting that their often-repeated claims have assumed a life of their own.

With respect to Photogard, the following conclusions can be drawn from the data presented in this chapter and from performance data supplied by 3M:

1. Photogard offers excellent abrasion resistance, and a coated print can easily be cleaned should it become soiled with fingerprints, oily dirt, etc. Photogard's abrasion resistance is greatly superior to that of uncoated print emulsions and of prints coated with lacquers or pressure-sensitive laminates.

2. Under display conditions typically found in homes and offices, Photogard offers little if any protection against light fading. With 3M color paper and probably some other types of color prints, Photogard actually somewhat increases the rate of light fading on long-term display. Under high-UV light sources — such as direct sunlight, unfiltered fluorescent light, or direct expo-

A CJ Laser Corporation B-1114 sheet-coater for Photogard. The $12,000 unit, distributed by CPAC, Inc., can handle prints and films up to 11x14 inches. Once Photogard is applied to a print or film, there is no known method for removing the coating without destroying the photograph. If a particle of dirt or lint should become embedded in the coating, it cannot be removed; this is one reason Photogard should not be applied to valuable original films or prints.

A FilmCOAT M7040 strip-coater for applying Photogard to individual rolls or short strips of 35mm and other roll films. Made by CPAC, Inc. and costing about $2,000, the unit is aimed at minilab markets. One worthwhile application of Photogard is to coat scratched negatives; as long as a scratch does not penetrate the image layers of a film, Photogard can reduce or even eliminate the effect of base or emulsion-side scratches when prints are made.

sure in xenon-arc Fadeometers — and if prints are not covered with framing glass or plastic, Photogard will reduce the fading rates of most older color papers. However, for current products such as Ektacolor, Fujicolor, Konica Color, and Agfacolor papers, all of which have an effective UV-absorbing layer over the three image dye layers, Photogard offers little if any additional protection against light fading, even under high-UV display conditions such as direct illumination with bare-bulb fluorescent lamps.

3. Since Photogard contains no solvents, it probably does not reduce or otherwise disrupt the inherent dye stability of chromogenic prints, such those on Ektacolor papers. Currently available lacquers contain solvents and other ingredients that can harm chromogenic prints; damage from lacquers is especially likely to occur if they are applied in thick coats and/or in conditions of high relative humidity.

4. Because neither spotting and retouching colors nor lacquers will properly adhere to the surface of a Photogard coating, all spotting and retouching must be completed before a print is coated. If additional spotting or retouching is necessary after a print has been coated, a new print will have to be made, since Photogard cannot be removed. Portrait and advertising photographers in particular should be aware of this drawback to Photogard.

5. Like lacquers, Photogard will allow prints to be framed directly against glass without a spacing overmat.

6. Photogard offers excellent protection against fungus growth on emulsion surfaces if prints are stored or displayed in humid environments. Typically, fungus becomes a problem when prints are stored for prolonged periods in warm climates with relative humidities above 70%, such as in some southern areas of the U.S. or in the tropics.

7. Photogard is claimed by 3M to reduce dust attraction and other problems associated with static electricity when the relative humidity is low. Simple observation indicates that Photogard does indeed reduce static build-up.

8. Because of the danger of permanently sealing in dust or other dirt on original negatives, transparencies, and motion pictures, and the possibility that Photogard could adversely affect the image stability of these products, Photogard should not be applied to valuable original material.

9. Photogard should not be applied to valuable color or black-and-white RC or fiber-base prints, such as those in museum collections, because of uncertainties about the aging properties of various types of prints coated with Photogard and because of the danger of permanently sealing dust, lint, or other dirt to the surface of the prints. Once applied, Photogard cannot be removed from a print or film by any known method.

## Useful Applications for 3M Photogard

Photogard's most valuable characteristics are its abrasion, moisture, and fungus resistance, and its ease of cleaning. Photogard appears to be well suited for roll-coating working copies of microfilms, microfiche, motion picture prints, intermediate motion picture printing negatives, and expendable color negatives (such as those in mass-market portrait and school-picture operations). In addition, a Photogard coating on duplicate slides that are to be distributed to academic slide libraries or similar institutional collections would eliminate the need for expensive glass mounting.

Photogard is also beneficial as a coating for amateur snapshot color prints — with the clear understanding that although the coating offers substantial physical protection to the emulsion of the prints, it will not improve — and may even reduce — the light fading stability of the prints. The fungus protection offered by Photogard is of great value when prints have to be stored or displayed in high-humidity areas, especially in the tropics. Likewise, coating amateur negatives with Photogard can be of substantial benefit in humid areas.

A number of mass-market and school-portrait finishing labs, including School Pictures Inc. of Jackson, Mississippi, treat color negatives with Photogard immediately after processing and drying and have reported that the protection against scratches resulting from rough handling, dust, and static offered by the coating substantially reduces the time required for spotting finished prints. The money saved more than pays for the cost of applying Photogard, even though the negatives are generally disposed of soon after printing.

## Notes and References

1. Marty Rickard, "An Ounce of Prevention?", **Professional Photographer,** Vol. No. 2132, January 1990, p. 48. Rickard described his experiments as follows: "To find out how effective these [UV-absorbing] additives are in slowing the fading process, I selected a vividly-colored 8x10 print and sprayed a portion of the surface with one heavy coat of the protective spray, another portion with two thick coats, and left a third area unprotected. To provide a control area on the print, I covered the center where all three test areas converged with a heavy 1¼-inch metal washer. This area was not exposed to light. On December 16, 1987, I placed the experimental print in the south window of my studio and left it there until August 16, 1989 – a period of 20 months. As for the results of my experiment, I detected no difference in the degree of fading between the surface of the print which was not sprayed, and the surface that was sprayed twice. (If there **is** a difference, it would take a scientific color measuring device to detect it)." The identity of the print lacquer used in Rickard's tests was not given in the article, but was later confirmed to be a McDonald's lacquer by Rickard's studio in New Sharon, Iowa.
2. Eastman Kodak Company, **Printing Color Negatives,** Publication No. E-66, Eastman Kodak Company, Rochester, New York, September 1970, p. 41.
3. Eastman Kodak Company, see Note No. 2, p. 41.
4. Eastman Kodak Company, **Preservation of Photographs,** Publication No. F-30, Eastman Kodak Company, Rochester, New York, August 1979, p. 35.
5. Eastman Kodak Company, **Storage and Care of Kodak Color Materials,** Publication No. E-30, Eastman Kodak Company, Rochester, New York, revised December 1980.
6. Eastman Kodak Company, **How Post-Processing Treatment Can Affect Image Stability of Prints on Kodak Ektacolor Paper,** Kodak Pamphlet No. CIS-62, Eastman Kodak Company, Rochester, New York, 1982. See also: Eastman Kodak Company, **Conservation of Photographs** (George T. Eaton, editor), Kodak Publication No. F-40, Eastman Kodak Company, Rochester, New York, March 1985, p. 66.
7. Vilia Reed, **Photographic Retouching,** Kodak Publication No. E-97, Eastman Kodak Company, Rochester, New York, August 1987, p. 103. See also: Vilia Reed, **The Fuji Professional Retouching Guide,** Fuji Photo Film U.S.A. Inc., 1992. Instructional videos which cover retouching color negatives and color prints are also available for use in conjunction with the book. Available from Fuji Photo Film U.S.A. Inc., 555 Taxter Road, Elmsford, New York 10523; telephone: 914-789-8201 (toll-free: 800-755-3854).
8. Eastman Kodak Company, **Finishing Prints on Kodak Water-Resistant Papers,** Kodak Publication No. E-67, September 1985, p. 1.
9. Eastman Kodak Company, see Note No. 8, p. 2.
10. Henry Wilhelm, letter to Henry Kaska, director, public information, Corporate Communications, Eastman Kodak Company, October 29, 1986.
11. Eastman Kodak Company, **Conservation of Photographs** (George T. Eaton, editor), Kodak Publication No. F-40, March 1985, p. 66.
12. Eastman Kodak Company, see Note No. 11, p. 108.
13. McDonald International, Inc., **Information Sheet on UV Pro-Tecta-Cote Lacquer,** 1982.
14. McDonald International, Inc., "In 10 Years. . .This. . . Or This? Introducing a New UV Pro-Tecta-Cote Lacquer from McDonald," advertisement in **Professional Photographer,** Vol. 109, No. 2045, October 1982.
15. "Color Print Fading is a Hot Topic," advertisement for Sureguard Photo Print Lacquers in **Studio Photography,** Vol. 19, No. 8, August 1983, p. 16. (Sureguard, Inc., Photo Lacquer Division, 2350 114th Street, Grand Prairie, Texas 75050; telephone: 214-647-9049).
16. American National Standards Institute, Inc., **ANSI IT9.9-1990, American National Standard for Imaging Media – Stability of Color Photographic Images – Methods for Measuring,** American National Standards Institute, Inc., 11 West 42nd Street, New York, New York 10036; telephone: 212-642-4900; Fax: 212-302-1286.
17. MACtac products were previously sold under the CoolMount name; MACtac is a division of Morgan Adhesives Company. Permacolor Permagard IP-7000 pressure-sensitive laminate material was used in this author's accelerated tests; the material was obtained in March 1985.
18. MACtac Permacolor, **The Magic of Photography,** promotional brochure published by MACtac Permacolor Division, Morgan Adhesives Company, 1985.
19. Jack McClintock, "Eye On The Future," **Permaviews,** Spring 1985, published by MACtac Permacolor Division, Morgan Adhesives Company, Stow, Ohio, p. 4.
20. Coda, Inc., Overlam products were among the first pressure-sensitive laminating materials to be marketed for photographs.
21. Ademco-Seal mounting and laminating products are manufactured by Ademco-Seal Ltd., Chester Hall Lane, Basildon, Essex SS14 3BG, England; telephone: 011-44-268-287-650.
22. Ilford Photo Corporation, **Mounting and Laminating Cibachrome [Ilfochrome] Display Print Materials and Films,** (Technical Information Manual), Cat. No. 7929-RMI 895M, 1988. Available from Ilford Photo Corporation, West 70 Century Road, Paramus, New Jersey 07653; telephone: 201-265-2000 (toll-free: 800-631-2522). See also: Remon Hagen, "Further Improvements in the Permanence of Cibachrome Materials Under Adverse Display Conditions," **Journal of Imaging Technology,** Vol. 12, No. 3, June 1986, pp. 160–162.
23. MACtac Permacolor, "UV-Resistance – Accelerated Weathering Tests," **Permaviews,** Winter 1986–1987, published by MACtac Permacolor Division, Morgan Adhesives Company, Stow, Ohio, p. 3. See also: Mike Spidare [MACtac Permacolor], "Cold Mounting Films: A New Era in Image Marketing," Photo Lab Management, Vol. 9, No. 8, August 1987, pp. 59–61.
24. Eastman Kodak Company, see Note No. 8, p. 2.
25. Eastman Kodak Company, **Backlit Displays with Kodak Materials,** Kodak Publication No. E-84, Eastman Kodak Company, Rochester, New York, July 1986.
26. K-S-H, Inc., **KSH-UVF Picture Saver Panels,** product brochure published in 1982 by K-S-H, Inc., K-S-H Industrial Division, St. Louis, Missouri. (K-S-H, Inc. is now part of ICI Acrylics, Inc., 10091 Manchester Road, St. Louis, Missouri 63122; telephone: 314-966-3111 (toll-free: 800-325-9577). The UV-absorbing polystyrene Picture Saver Panels continue to be sold under the KSH-UVF name.)
27. A. K. Mehta, D. R. Hotchkiss, and J. F. Kistner, "Photogard Technology," presentation at the **International Symposium: The Stability and Preservation of Photographic Images,** sponsored by the Society of Photographic Scientists and Engineers at the Public Archives of Canada, Ottawa, Ontario, Canada, August 31, 1982. As yet, no stability data on color prints coated with Photogard have been published by researchers outside of the 3M Company.
28. CPAC equipment for applying 3M Photogard is sold under the FilmCOAT name; the machines were introduced in 1986. CPAC, Inc., 2364

Leicester Road, Leicester, New York 14481; telephone: 716-382-3223.

29. Nord Photo Engineering (a subsidiary of Photo Control Corporation), 4800 Quebec Avenue North, Minneapolis, Minnesota 55428; telephone: 612-537-7620.

30. CJ Laser Corporation, 3035 Dryden Road, Dayton, Ohio 45439; telephone: 513-269-0513. The firm supplies the B-1114 sheet coater ($12,000) for prints and films in sizes up to 11x14; it can coat about 150 8x10-inch prints per hour.

31. 3M Company, **Duggal Color Projects and Genovese Drug Stores Offer 3M's Photogard Protective Coating,** 3M Company Press Release PH 82-205, November 29, 1982 (For Release: December 2, 1982), p. 2. 3M Photo Color Systems Division, 3M Company, 3M Center, St. Paul, Minnesota.

32. Duggal Color Projects, Inc. (Plaintiff), against Minnesota Mining and Manufacturing Company (Defendant). Case Index No. 4911-84, filed in the Supreme Court of the State of New York in June 1983. A transcript of the case may be obtained from: Supreme Court of the State of New York, County Clerk's Office, 60 Center Street, New York, New York 10007; telephone: 212-374-8300.

33. Baldev Duggal, president, Duggal Color Projects, Inc., telephone discussion with this author, December 11, 1986.

34. 3M Company, "U.V. Fade Study on Kodak Color Paper With and Without Photogard," **3M Data Sheet,** PE-PUVFS-K(52.25)R [1982], Photographic Products Division, 3M, 223-2SE 3M Center, St. Paul, Minnesota 55144. Included in the data sheet: "The minimum benefit of Photogard on Kodak Color Paper [Ektacolor 74 RC], under the conditions tested and using the end point criteria defined, is to extend the paper's life by a factor of 4 (Photogard Factor = 4X). Other factors, such as dark fade and fade in normal light should also be considered in the overall evaluation of fading in color print papers." See also: 3M Company, "U.V. Fade Study on 3M Color Paper With and Without Photogard," **3M Data Sheet,** PE-PUVFS(22.25)R1 [1982]. Graphs from the two 3M data sheets were included in: "3M Protective Coating," **Journal of Applied Photographic Engineering,** Vol. 9, No. 5, October 1983, p. 152A.

35. Ashwani K. Mehta, "Photogard Technology" [synopsis of a presentation at the 128th conference of the Society of Motion Picture and Television Engineers, held October 24–29, 1986 in New York], **SMPTE Journal,** Vol. 96, No. 1, January 1987, p. 131. See also: Martin Hershenson, "Photogard — A Tough Finish For Half-A-Century," **Photographic Processing,** Vol. 22, No. 8, August 1987, pp. 26ff. Apparently quoting 3M test data, Hershenson reported:

"Photogard has the ability to increase protection against the damage caused by ultra-violet light. (A serious cause of dye fading).

"Two brands of color paper were incorporated into the test parameters. Accelerated tests were performed for overall stability. In particular, the ever fickle cyan dye came under close scrutiny.

"The evaluation was done using a xenon arc as the light source, operating in the range of 760 nanometers. The tests would determine how many hours of exposure to so rich a source in UV it would take to reach a 30% dye loss. Brand A color paper when untreated exhibited the loss in only 110 hours. The same brand of paper which had been safeguarded with the protective coating required 600 hours to show the same degree of change.

"Paper Brand B was also impressive. Here the numbers for the untreated sample were 160 hours of exposure to the xenon arc, as compared with the Photogard coated paper which took over 700 hours to exhibit a 30% dye loss. 3M makes no claims of any improvement in light or dark keeping." (This last statement, apparently a disclaimer offered by 3M, is given without further explanation.)

See also: Martin Hershenson, "Prints and Slides Protected — 3M Claims its Photogard Process Can Protect Your Originals From Almost Anything . . . Even Hot Chicken Soup!!! Does it Really Work?", **Modern Photography,** Vol. 50, No. 8, August 1986, pp. 24, 80.

## Additional References

Anon., "Film and Paper Coating Primer," **Photo Lab Management,** Vol. 8, No. 7, July 1986, pp. 24–26. (Article about 3M Photogard.)

Toshiaki Aono, Kotaro Nakamura, and Nobuo Furutachi, "The Effect of Oxygen Insulation on the Stability of Image Dyes of a Color Photographic Print and the Behavior of Alkylhydroquinones as Antioxidants," **Journal of Applied Photographic Engineering,** Vol. 8, No. 5, October 1982, pp. 227–231.

Eastman Kodak Company, **Encyclopedia of Practical Photography,** Vol. 9, American Photographic Book Publishing Company, Garden City, New York, 1978, pp. 1481–1487.

Eastman Kodak Company, **How to Use Kodak Print Lacquer for Matte or Glossy or Textured Surfaces,** Pamphlet No. J–26, minor revision August 1968.

Eastman Kodak Company, "General Information for Print Lacquer Users," **Tips – Technical Information for Photographic Systems,** Vol. 10, No. 5, October–November 1979, p. 11.

Eastman Kodak Company, **Preparing Large Color Prints on Kodak Ektacolor 37 RC Paper,** Kodak Pamphlet No. E-54, minor revision September 1975.

Kris Fehrenbach, "Preserve Your Portrait Photography – Archivally Framed Photos Last Generations," **Professional Photographer,** Vol. 114, No. 2107, December 1987, pp. 37–39.

Kathy Hubbard, editor, "L.A.C.S. (Lacquer-Associated Cyan Spotting)," **The Meisel Forum,** Vol. 11, No. 1, Meisel Photochrome Corporation, Dallas, Texas, 1980.

Paul M. Ness and Charleton C. Bard, "Help Color Prints Last," **Professional Photographer,** Vol. 109, No. 2038, March 1982, pp. 27–29.

Allan Tyndell, "Print Spraying," **Professional Photographer,** Vol. 108, No. 2028, May 1981, p. 48.

# Suppliers

**3M Home & Commercial Care Division**
Bldg. 223-3N-05
3M Center
St. Paul, Minnesota 55144-1000
  Telephone: 612-733-6864
  (Supplier of 3M Photogard
  Film and Photo Protector)

**CPAC, Inc.**
2364 Leicester Road
Leicester, New York 14481
  Telephone: 716-382-3223

**CJ Laser Corporation**
3035 Dryden Road
Dayton, Ohio 45439
  Telephone: 513-296-0513

**Nord Photo Engineering**
4800 Quebec Avenue North
Minneapolis, Minnesota 55428
  Telephone: 612-537-7620

**MACtac Permacolor**
4560 Darrow Road
Stow, Ohio 44224
  Telephone: 216-688-1111
  Toll-free: 800-323-3439 (outside Ohio)

**Coda, Inc.**
194 Greenwood Avenue
Midland Park, New Jersey 07432
  Telephone: 201-444-7755

**Lacquer-Mat Systems, Inc.**
1302 East Washington Street
P.O. Box 24
Syracuse, New York 13201
  Telephone: 315-471-4037
  Toll-free: 800-942-2223

**Sureguard Inc.**
2350  114th Street
Grand Prairie, Texas 75050
  Telephone: 214-647-9049
  Toll-free: 800-662-2350 (outside Texas)
  (Sureguard Inc. distributes Sureguard-
  McDonald Pro-Tecta-Cote print lacquers
  and related products in addition to the
  firm's line of Sureguard lacquers.
  Sureguard acquired marketing rights
  for the McDonald product line in 1989.)

# 5. Dark Fading and Yellowish Staining of Color Prints, Transparencies, and Negatives

Shortly before his death, Arthur Rothstein visited the Library of Congress where the 8x10 Ansco transparencies are stored on which he shot most of his food assignments. Because of the instability of the emulsion dyes, he said the transparencies had faded beyond recognition or usefulness.[1]

Casey Allen
*Technical Photography*
April 1988

Once a color photograph has been properly processed, the most important factors in determining the useful life of a color film or color print are the *inherent* dye stability and resistance to stain formation during aging that have been built into the product by its manufacturer. While it is true that even the most unstable materials can be preserved almost indefinitely in humidity-controlled cold storage, only a small fraction of one percent of the many billions of color photographs made around the world each year will ever find their way into a cold storage vault. (In 1990, more than 20 billion photographs were made in the U.S. alone — and of that number, more than 90% percent were shot on color negative film and printed on Kodak Ektacolor paper or similar chromogenic color negative print papers made by Fuji, Konica, or Agfa.[2,3])

Sadly, even many important museums do not yet provide cold storage for their color photograph collections. At the time this book went to press in 1992, the International Museum of Photography at George Eastman House in Rochester, New York, the Metropolitan Museum of Art in New York City, the Corcoran Gallery of Art in Washington, D.C., and the Division of Photographic History at the Smithsonian Institution in Washington, D.C. were among those institutions that did not yet have cold storage facilities. Even the National Geographic Society, which during the years since its founding in 1888 has amassed a large and historically significant color photography collection, stores its photographs without refrigeration in its Washington, D.C. offices. The *National Geographic* magazine, which published its first offset-printed color photograph in the July 1914 issue (the original was an Autochrome plate by Paul Guillamette), was a true pioneer in the publication of photographs in color and in 1920 became the first magazine to have its own in-house color processing laboratory.

---

### Recommendations
See Chapter 1 for a comprehensive list of the longest-lasting color films and print materials, based on overall light fading, dark fading, and dark staining performance.

---

The vast majority of color photographs are kept in homes and offices under whatever conditions are provided for the people who live or work there. If air conditioning is available — and in most of the world it is not — it is for the comfort of people, and not to prolong the life of photographs. How long a particular color photograph will last depends, more than anything else, on the inherent stability of the film or paper with which it was made. Some materials are *much* more resistant to fading and formation of yellowish stain than others.

While a photographer must consider many things in selecting a film or print material for a particular application, it only makes good sense to choose the most stable products available from those that otherwise meet the photographer's requirements. For example, Kodak's tungsten-balanced Vericolor II Professional Color Negative Film Type L has a far shorter dark storage life than Fujicolor 160 Professional Film L. Agfacolor XRS 1000 Professional Film is much less stable in dark storage than are Fujicolor Super HG 1600, Kodak Gold 1600, Kodak Ektapress Gold 1600, and Kodak Ektar 1000 films.

Fujichrome Paper Type 35 for printing transparencies is much more stable in dark storage — and when displayed — than Kodak Ektachrome Radiance and Radiance Select papers. Longer-lasting still are Ilford Ilfochrome (called Cibachrome, 1963–1991) polyester-base print materials and color microfilms, the only easily processed color materials on the market that are essentially *permanent* in dark storage (they should last 500 or more years without significant fading or staining when kept in the dark under normal room temperature conditions).

### Dark Fading and Staining versus Light-Induced Fading and Staining

This chapter deals with the fading and staining that may occur when color film and print materials are stored in the absence of light — that is, in the dark. (Throughout this book, dark fading and dark staining are often combined under the term *dark fading stability*.) Dark fading of course is not *caused* by darkness (light fading, on the other hand, is caused by light and UV radiation). Dark fading simply refers to the fading and staining that take place in a color material during storage when light is not present.

Given the inherent dark fading stability characteristics of a particular material, the rate of dark fading and staining is determined primarily by the ambient temperature and, usually to a lesser extent with modern materials, by relative humidity. Air pollution and contamination from unsuitable storage materials can also play a part in the deterioration of color photographs, but these factors are usually much less important. (The delicate silver images of black-and-white photographs, on the other hand, can be

1979

Thomas Beecher, a staff member at the Library of Congress in Washington, D.C., and Beverly W. Brannan, curator of documentary photography in the Prints and Photographs Division of the library, examine color transparencies in the **Look Magazine** collection. The **Look** collection was donated to the library after the magazine ceased publication in 1971. A wide variety of films dating back to the first Kodachrome films of the mid-1930's are found in the collection. As is the case with most other magazine and picture agency files from this period, many of the transparencies were made on Ansco and Ektachrome films which, because of their very poor dark fading stability in room temperature storage, have suffered substantial image deterioration. (Since this photograph was taken in 1979, the color materials in the **Look** collection have been moved to the library's humidity-controlled cold storage facility in nearby Landover, Maryland.)

extremely sensitive to air pollutants and other environmental contaminants.)

Improper processing of color materials can also impair image stability; for example, use of non-recommended, exhausted, or contaminated chemicals, inadequate washing, omission of the proper stabilizer bath when one is called for, and so forth.

Unless noted otherwise, the data presented in this book are based on careful processing with the manufacturers' recommended chemicals. In the real world of hurried lab production and efforts to keep chemical and wash water costs to a minimum, processing often is less than it should be, and image stability can and does suffer — sometimes catastrophically.

Actually, the slow but inexorable chemical processes involved in "dark fading" and "dark staining" continue whether or not a color photograph is exposed to light on display or during projection. Light fading is a separate process altogether. When a color photograph is exposed to light on display, both light fading and dark fading occur simultaneously. The fading and staining that afflict a pho-

tograph over time are in fact a combination of these two basic types of deterioration.

Given the commonly encountered conditions of prints on display, it may be assumed, at least with modern materials, that the fading observed over time has been caused primarily by light. An Ektacolor print, for example, will last far longer when stored in the dark than it will on display. In other words, under normal conditions, the light fading stability of most types of color prints is substantially inferior to their dark fading stability.

Light fading and dark fading also differ in the way that they affect the appearance of the image. In light fading, a disproportionate loss of density occurs in the lower densities and highlights. Visually dark parts of an image can remain more or less intact while lighter areas can become totally washed out. With modern materials, light-induced stain formation (distinguished from light-induced fading) is of less concern when prints are displayed than is staining when the prints are stored in the dark. In dark fading, highlight detail is not lost but an overall color shift occurs, caused by the cyan, magenta, and yellow dyes fading at

different rates, and is exacerbated by an ever-increasing level of yellowish stain. In addition, there is both an overall loss of contrast and a discoloration caused by stain that is most objectionable in highlight and low-density areas (see Chapter 2 for further discussion).

A further feature of dark fading versus light fading is that a dye with good stability in the dark may be comparatively unstable when exposed to light. In Kodak Ektacolor papers, for example, the magenta dye is the most stable of the three dyes in the dark, but is the *least* stable in light under typical indoor display conditions.

## Improvements Have Been Made in Dark Fading Dye Stability

In the late 1970's, the dark fading stability of both color negative films and papers was so poor that it prompted Ed Scully, in his column in *Modern Photography* magazine, to write:

> Those using color-negative material should know that theirs isn't the most permanent color vehicle. It's bad enough that prints [in albums] are destroyed by leaching polyvinyl chloride, but what's worse is that color negatives will also deteriorate. Those "moments to remember" won't be able to be recaptured unless something's done about them *now*. My recommendation: have reprints made from those negatives you really want, wrap them for freezing in a plastic/foil combination and put them into the freezer. You know, that's a hell of a sad testimony to our photographic technology.[4]

But, as is evident in the product stability tables that follow, significant improvement in the dark fading stability of most types of color print materials has been made during the past 10 years. With the introduction in 1984 of Konica Color PC Paper Type SR (also known as Konica Century Paper), the first of the new generation of chromogenic color negative print papers, Konica achieved an approximately five-fold increase in dark fading stability over the Kodak, Fuji, and Agfa papers available then. Now, in fact, for Ektacolor and Agfacolor papers, it is no longer dye fading but rather yellowish stain formation that is the main image stability problem when the prints are stored in the dark. Fujicolor and Fujichrome papers utilize new types of "low-stain" magenta couplers that afford them much lower rates of stain formation in dark storage than Kodak, Agfa, and most Konica papers.

Most (but not all) color negative and transparency materials have also been improved greatly in terms of dark fading stability. The Kodak Gold Plus color negative films on the market today, for example, are much more stable than the corresponding Kodacolor films of the early 1980's.

These dye stability improvements led Klaus Gerlach of Agfa-Gevaert to say in 1985: "In terms of dye image stability, we consider the dark fading issue as resolved; improvements in light stability are in progress. With our latest generation color paper [stored in the dark] you can still see yourself after 200 years."[5,6] This author does not agree with that assessment. Although you still might be able to

see yourself in 200 years if the print is stored in the dark, you won't look very good; fading and staining of the Agfacolor print will be substantial. But Gerlach's point was not completely off the mark — compared with color print papers available for the early 1980's and before, today's color papers have been significantly improved.

It appears likely that further significant improvements in dark storage dye stability and reduction in stain levels can be achieved with chromogenic materials. Recent gains in image stability in Fujichrome Type 35 paper for printing transparencies and Fujicolor Super SFA3 papers for printing color negatives — which this author considers to be by far the best chromogenic papers produced to date — are a major step toward the goal of low-cost chromogenic prints that will remain essentially unchanged after 100 years of being stored in the dark under normal conditions. But a chromogenic print that can retain all of its original brilliance after *100 years of display* is, at least for now, beyond the reach of the photographic industry.

Of Kodak Ektacolor papers, for example, the current Ektacolor Portra II, Ektacolor Supra, Ektacolor Ultra, Ektacolor Edge, and Ektacolor Professional papers have only marginally better light fading stability under normal indoor display conditions than do prints made on Ektacolor 37 RC paper, introduced in 1971. That is more than 20 years with very little progress in light fading stability on the part of Kodak.

In spite of significant light fading stability improvements made by Fuji since 1986 — the light fading stability of the new Fujicolor Super SFA3 chromogenic papers is *much* better than that of Kodak Ektacolor papers — the chromogenic process may never prove adequate for permanent display in museums, public buildings, or homes. Alternative methods of print production (e.g., color pigment prints made by photographic or electrophotographic means, thermal dye transfer prints or ink jet prints with high-stability colorants, or prints made with an improved version of the silver dye-bleach process) may be the only solution to the light fading problem.

## In Terms of Dark Fading Stability, the History of Color Materials Is Not Pleasant

The extremely poor dark fading stability, combined with very high levels of yellow-orange stain formation, of all Kodacolor prints produced by Kodak from 1942 until the process was improved in 1953 has resulted in a total loss of the first great era of amateur color prints; this author does not know of a single example of the many millions of Kodacolor prints made during this period that is still in good condition.

For more than 30 years, from 1946 when Ektachrome was introduced until improved Process E-6 films became available in 1976–1977, the Kodak Ektachrome sheet and roll films widely used by professional photographers had extremely poor dark fading stability. Many museum and commercial collections have large numbers of severely faded Process E-1, Process E-2, and Process E-3 Ektachrome transparencies, while most Kodachrome transparencies from this period remain in good condition.

The combination of high temperature and high relative humidity can be particularly devastating to some materi-

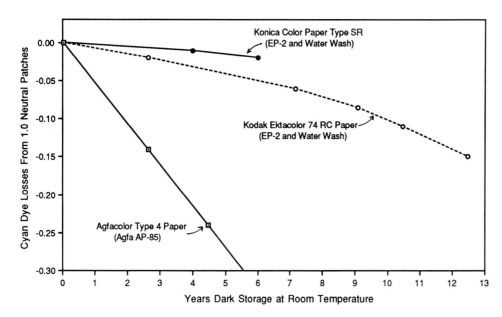

**Figure 5.1** In dark storage, the cyan dyes in chromogenic papers traditionally have been the least stable of the three dyes. Cyan dye fading of three papers stored at room temperature (75°F [24°C] and 60% RH) is shown here. Agfacolor Type 4 paper (1974–1982) had extremely poor cyan dye stability, with 20% dye fading occurring in about 4 years when optimally processed and in a much shorter time with commercial processing in many instances. The cyan dye stability of Kodak Ektacolor 74 RC paper (1977–1986) was much better than that of the Agfacolor paper, but not nearly as good as that of Konica Color Type SR (1984—), the first of a new generation of color negative papers with improved cyan dark storage stability.

als, such as the Ansco and GAF transparency films (manufactured from the late 1930's until GAF abandoned the photography business in 1977) and the Agfachrome 64 and 100 films (1976–1983), all of which used the so-called Agfa-type dye-forming couplers.

Prints made in the late 1970's and early 1980's on the now-infamous Agfacolor PE Paper Type 4 have exhibited extremely poor dark fading stability; some Agfacolor PE Paper Type 4 portraits in this author's collection have suffered more than 60% cyan dye loss in less than 4 years of dark storage in an air-conditioned room kept at 70°F (21°C). *The dark fading rate of these prints is so rapid that it can greatly exceed the rate of light fading in normal display conditions.*

Historically, the most widely used chromogenic print materials such as Kodak Ektacolor 37 RC and 74 RC papers have been poor in *both* regards; these prints are doomed to steadily deteriorating color quality whether put on display or kept in an album in the dark (see **Figure 5.1**).

### Recommendations of the Best Color Film and Print Materials

Recommendations for the most stable, longest-lasting products in the different categories of film and print materials are given at the beginning of Chapter 1. Other than for color negatives, which normally receive negligible light exposure during printing and are otherwise stored in the dark, these recommendations take into account both light fading and dark fading stability and consider the possible visual significance of yellowish stain formation that occurs during long-term dark storage and/or during or after prolonged display of most chromogenic color materials.

The recommendations are based on this author's short- and long-term accelerated tests, on dark fading data obtained from the manufacturers (which is reported later in this chapter), and on examination of large numbers of color photographs of various types that have been stored and displayed under a wide variety of "normal" conditions in homes, offices, public buildings, and museums and archives.

The light fading stability of color prints is discussed in Chapter 3. Projector-caused fading of color slides (a specific type of very rapid light fading) is covered in Chapter 6. Recommendations for color motion picture films are given in Chapter 9.

### Test Methods to Determine Dark Fading and Staining Characteristics of Color Materials

Accelerated test methods for color stability are discussed in detail in Chapter 2, and the reader is advised to consult the sections on accelerated dark fading tests in order to better understand the comparative and predictive tests employed to produce the data reported in this chapter. This author's tests, reported in **Table 5.5a** through **Table 5.9** (pages 180 through 194), are *comparative* tests and were performed according to the general outline described in *ANSI PH1.42-1969, American National Standard Method for Comparing the Color Stabilities of Photographs.*[7] This Standard, which was in effect at the time most of the tests reported here were conducted, has been replaced with *ANSI IT9.9-1990, American National Standard for Imaging Media – Stability of Color Photographic Materials – Method for Measuring.*[8]

In the accelerated dark fading test described in *ANSI PH1.42-1969*, a temperature of 140°F (60°C) and 70% RH are specified. According to the Standard, "This condition is used to simulate results which occur with long-term storage." The Standard also specifies a test at 100°F (37.8°C) and 90% RH to simulate tropical storage conditions.

In this chapter, products are ranked according to the number of days required for a 20% loss of the least stable dye to occur from an initial density of 1.0 when the products are subjected to an accelerated dark storage test at 144°F (62°C) and 45% RH. This is a rather simplistic approach to evaluating the dark storage stability of color materials, but the more complex color balance change and d-min change limits used in the light fading tests in Chapter 3 could not be employed here because, in the case of this author's data, there is considerable uncertainty about

the relative rates of dye fading and stain formation in single-temperature tests.

With most chromogenic materials in dark storage, yellowish stain formation can have a profound influence on color balance changes. Most commonly, the stain exaggerates color imbalances that occur between the yellow and cyan or magenta dyes, but sometimes the stain will help make up for, or "mask," a disproportionate loss of yellow dye. In such a situation, a small amount of yellowish stain can, overall, actually be visually beneficial.

To evaluate d-min stain formation, the number of days to reach a d-min color imbalance of 0.10 during accelerated testing, as well as the actual yellowish stain increase after 180 days (6 months) in the tests, are reported in **Tables 5.5a** through **5.7 (pages 180–188)**, and in **Table 5.9** (page 193). The d-min color imbalance figures are always followed by the letters "C+Y," which means that the color imbalance occurs on the cyan/yellow axis (that is, between red and blue densities). Note that for both the 20% dye fading data and d-min color imbalance (C+Y) stain data, the greater the number of days required to reach the limit, the more stable is the product. For the 180-day d-min blue density (yellowish stain) increase, however, the *lower* the number, the more resistant to stain is the product.

Condensed versions of many of these tables were published in the June 1990 issue of *Popular Photography* magazine in a cover story by Bob Schwalberg with Carol Brower and this author.[9] This article marked the first time that significant, comparative stability data — including dark storage d-min stain characteristics — had been reported for color photographic products.

Both the manufacturers' data and this author's data that are presented in this chapter are best seen as a beginning effort to compare the image stability of current and past color materials. To give more meaningful evaluations, Arrhenius data must be reported for the full set of image-life parameters specified in Table 9 of *ANSI IT9.9-1990,* preferably for two different relative humidity conditions (e.g., 40% and 60% RH). The light-fading data presented in Chapter 3 and the projector-fading data for color slides given in Chapter 6 are in many respects much more complete.

Because of uncertainties in how data derived from the single-temperature accelerated dark fading tests specified in *ANSI PH1.42-1969* and reported here relate to the actual performance of film and print materials kept under normal storage conditions, the rankings of various products should be considered only approximate when they have fairly close failure times in these accelerated tests. When test data show wider gaps between products, there is reasonable confidence that the more stable one will also be the more stable during long-term storage under normal conditions.

The closer an accelerated test temperature is to actual storage conditions, the more reliable the product rankings will be. The recommended temperature of 140°F (60°C) in *ANSI PH1.42-1969* will produce a 20% density loss of the least stable dyes of most chromogenic products in a year or less; a lower temperature would be better, but test periods would become prohibitively long. In this author's tests, materials with extremely good dark fading stability, such as Ilford Ilfochrome (Cibachrome) and Dye Transfer, have

shown negligible fading and, in the case of Ilford Ilfochrome, no measurable staining following a full 9 years of aging at 144°F (62°C) — one can only guess how many years it might take to reach a 20% density loss! Visually, the Cibachrome prints could not be differentiated from prints that had been stored at normal room temperature for 9 years. Even when compared side by side, no fading or color shift could be detected, and no staining whatever occurred, front or back!

## Predictive Arrhenius Tests to Evaluate the Dark Storage Stability of Color Materials

The Arrhenius dark storage stability test, specified in *ANSI IT9.9-1990,* is a complex multi-temperature test which allows predictions to be made of the number of years required for specified amounts of dye fading, change in color balance, and stain formation to occur when materials are stored in the dark under normal room temperature and relative humidity conditions (e.g., 75°F [24°C] and 60% RH) or when kept at some other temperature and relative humidity conditions. The Arrhenius test is described in more detail in Chapter 2. At the time this book went to press, this author did not yet have the temperature- and humidity-controlled ovens necessary to conduct Arrhenius tests, but he hoped to acquire the equipment during 1993.

Arrhenius data obtained from the various manufacturers, listed in alphabetical order in **Tables 5.10** through **5.17,** are reported on pages 195 through 209. These predictions are given for a 20% loss of the least stable dye when

**ANSI IT9.9-1990, American National Standard for Imaging Media – Stability of Color Photographic Images – Methods for Measuring** specifies a predictive, multi-temperature Arrhenius test for evaluating dark storage stability. The Standard also specifies a number of comparative light fading tests for different display conditions.

the film or print material is stored at 75°F (24°C).

Unfortunately, with the exception of Fuji for its low-stain Fujichrome Type 35 and Fujicolor SFA3 papers (and Fuji's earlier Type 34 and Super FA papers), the manufacturers did not disclose predictions for yellowish stain formation, and with many of these products (e.g., Kodak Ektacolor papers) yellowish stain formation is a more serious image stability problem than is dye fading in dark storage. In addition, the manufacturers did not all adopt the same relative humidity level for their tests, and this somewhat limits the comparability of these data.

## Dye Fading versus Yellowish Stain Formation

Prior to the introduction in 1984 of Konica Color PC Paper Type SR, with its greatly improved dark storage dye stability, stain formation in chromogenic prints generally had not been a major concern. Until that time, the cyan dyes in color negative papers had such poor dark fading stability that cyan fading, with a resulting color-balance shift toward red, was the weakest link. Now, however, with improvements in dye stability, stain has become a major concern. Particularly with color prints kept in the dark, yellowish stain formation during long-term storage is often visually more objectionable than dye fading itself. Stain robs color images of their sparkle and brilliance, giving them a dull, muddy look.

The current emphasis on stain behavior in dark storage came about in part because in the late 1970's Kodak replaced the final, low-pH stabilizer in the EP-3 process with a somewhat extended wash and renamed it the EP-2 process. EP-3 stabilizer greatly reduced the rate of stain formation in Ektacolor paper in dark storage. Without this stabilizer, Ektacolor Plus and Professional papers processed with EP-2 chemicals and a water wash have a worse stain problem than did the EP-3 processed Ektacolor 37 RC and 74 RC papers of the 1970's.

In a 1985 presentation entitled "Dark Stability of Photographic Color Prints from the Viewpoint of Stain Formation," Kotaro Nakamura, Makoto Umemoto, Nobuo Sakai, and Yoshio Seoka of Fuji Research Laboratories showed that Fujicolor Process EP-2 prints subjected to a short-term accelerated dark fading test exhibited relatively little dye fading, but yellowish stain was quite apparent. The Fuji researchers concluded that Arrhenius tests were valid for predicting the rate of stain formation in normal storage conditions. The authors stated:

> In contrast to the arguments on dark fading, especially on cyan fading, in recent years, the importance of stain generation seems to have been overlooked . . . . The authors think that for extending dark storage life, the problem of yellow stain must be solved.[10]

The principal cause of yellowish stain formation in Ektacolor and other types of chromogenic prints with similar magenta dye couplers has been attributed by Robert J. Tuite of Kodak[11] and others to discoloration of unreacted magenta coupler; the amount of magenta coupler that remains after processing is inversely proportional to the amount of magenta dye present in an image. Kodacolor prints

from the 1940's and early 1950's now show this problem to the extreme.

Historically, stain formation during dark storage has been a problem with all chromogenic materials except Kodachrome. (From its inception in 1935, Kodachrome has been an "external-coupler" product in which the color-forming dye couplers are placed in separate cyan, magenta, and yellow developer solutions, instead of being anchored in the film emulsion itself. After processing and washing, no unreacted couplers remain in Kodachrome; for this reason the film remains completely free of stain, even after prolonged storage under adverse conditions.)

Advances have been made, however, and Fujicolor SFA3 and Fujichrome Type 35 papers exhibit markedly reduced levels of stain during aging compared with color papers made by Kodak and Agfa. Most color papers made by Konica still exhibit high stain levels in dark storage; however, in 1990, Konica introduced Konica Color QA Paper Type A5 in Japan, which, like the improved Fuji papers, has significantly reduced rates of yellowish stain formation.[12]

In 1990, Fuji included an Arrhenius projection for dark storage stain formation in a technical brochure for its new Process RA-4 compatible Fujicolor Paper Super FA Type II,[13] and a similar graph for the improved Fujicolor SFA3 papers introduced in 1992 is reproduced here as **Figure 5.2**. Fuji also has published similar data for Fujichrome Paper Type 34 and Type 35 papers.[14]

Fuji is to be praised for publishing this information — the first time a manufacturer has provided such data. The graph shows that, if one were to adopt the stain/color balance limit of 0.1 proposed by this author (see Chapter 2), the stain limit for Fujicolor SFA3 paper would be reached after approximately 45 years of storage at moderate humidity levels, compared with over 100 years for the 20% dye fading limit to occur; in this case cyan is the least stable dye.

**Figure 5.3** shows the reduction in yellowish stain achieved in Konica Color QA Paper Type A5, introduced in Japanese markets in 1990, when compared with Konica Color QA Paper Type A2. (With respect to stain, Konica Type A3 paper is similar to Konica Type A2 paper.)

As part of his long-term testing program, this author periodically measures the fading and staining of color paper samples kept in the dark under normal room temperature storage conditions of 75°F (24°C) and 60% RH. That most color papers do indeed develop significant levels of yellowish stain in normal, non-accelerated storage is clearly evident in **Figure 5.4**. Kodak Ektacolor Plus and Professional papers and Agfacolor Type 8 paper (all EP-2 papers) had reached this author's critical "Museum and Archive" limit in less than 4 years. This author's more tolerant "Home and Commercial" d-min color imbalance limit for these papers will probably be reached in less than 15 years.

**Figure 5.5** shows the yellowish stain increase for a number of RA-4 color papers in this author's single-temperature accelerated test at 45% RH. The superiority of the "low-stain" Fujicolor Super FA papers is clearly evident in this comparison.

In all cases with chromogenic papers, high relative humidity in the storage environment significantly increases the rates of yellowish stain formation (see **Figure 5.6**).

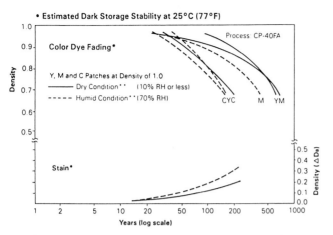

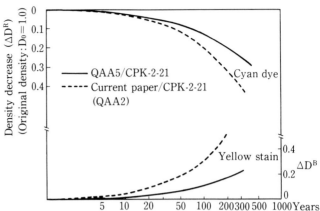

**Figure 5.2** An Arrhenius plot for Fujicolor Paper Super FA Type 3 (one of Fuji's SFA3 papers), introduced in 1992, showing both dye fading and d-min yellowish stain formation. Predictions are given for storage in the dark at 77°F (25°C) and 70% RH and in very dry (<10% RH) conditions. Both stain formation and dye fading, especially yellow dye fading, are significantly increased by high relative humidity. Fujicolor SFA3 papers and Fujichrome Type 34 and 35 papers employ new types of "low-stain" magenta dye couplers, and these products have much lower stain levels in dark storage than competing papers made by Kodak and Agfa. (Fuji data from: **Fujicolor Paper Super FA Type 3**, Fuji Publication No. AF3–723E, January 1992. Reproduced with permission.)

**Figure 5.3** An Arrhenius plot for Konica Color QA Paper Type A5 (QA A5 paper) showing both dye fading and d-min yellowish stain formation. Predictions are given for storage in the dark at 75°F (24°C) and 60% RH. Compared with Konica Type A2 and Type A3 papers (QA A2 and QA A3), the rate of yellowish stain formation has been considerably reduced. Type A5 paper, which was introduced in Japanese markets in 1990, is the first Konica paper to utilize a "low-stain" magenta coupler. (Konica data from: "The Development of Konica QA Paper Type A5," **Konica Technical Report**, Vol. 5, January 1992, pp. 25–29. Reproduced with permission.)

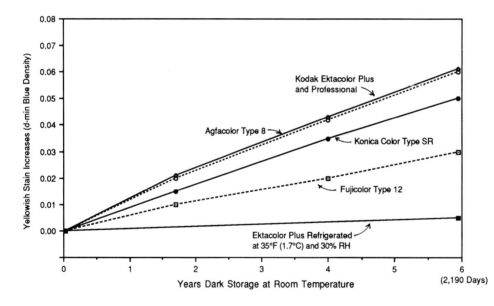

**Figure 5.4** Yellowish stain formation in room-temperature dark storage (75°F [24°C] and 60% RH) was significantly reduced in Fujicolor Paper Type 12, introduced in 1985, and available primarily in Japanese markets. This was the first color negative paper to employ improved, "low-stain" magenta dye couplers. Long-term, room-temperature data are not yet available for Fujicolor SFA3 papers introduced in 1992, but accelerated aging data indicate that the rates of stain formation are as low or lower for these papers.

As shown in **Figure** 5.7, yellowish stain formation in dark storage usually has a pronounced effect on perceived color balance; the effect is visually most apparent in low-density areas of an image (e.g., at densities below 0.5).

Although dye stability **Tables 5.5a** through **5.7** and **Table 5.9** include stain-formation data, insufficient information is available to use these data with any assurance as part of the ranking of products given in this book. Likewise, evaluation of color imbalances could not be done. At this stage, it is simply not possible to evaluate color prints and trans-

parencies for dark fading and staining with the full set of image-quality criteria used to rank color prints for light fading stability in Chapter 3. For the same reason (with the exception of the data published by Fuji for Fujicolor SFA3 papers and Fujichrome Type 35 papers), the absence of Arrhenius stain data from Kodak, Agfa, Konica, and 3M has precluded stain growth and color imbalance as major considerations in evaluating Arrhenius storage-life predictions by these companies.

What information is available, however, strongly sug-

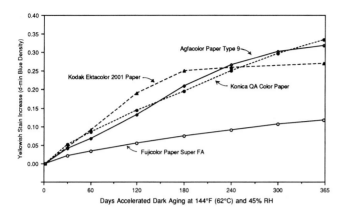

**Figure 5.5** A comparison of yellowish stain formation in four Process RA-4 compatible papers in an accelerated dark storage test conducted at 144°F (62°C) and 45% RH. All of the papers were processed with the manufacturers' chemicals in "washless" minilabs using a stabilizer as the final rinse. The substantial reduction of yellowish stain in Fujicolor Super FA and SFA3 papers is one benefit of the new "low-stain" magenta coupler employed by Fuji in the new papers. In addition to reducing stain, the new coupler produces magenta dye with better color purity and far better light fading stability than the magenta dye in Kodak Ektacolor and other color negative papers.

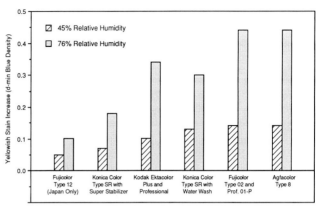

**Figure 5.6** Stain formation of six Process EP-2 compatible papers in an accelerated dark aging test at 144°F (62°C). Data are given for 45% RH and 76% RH. The superiority of Fujicolor Paper Type 12 (1985–) processed with a water wash is readily apparent. This paper employs a "low-stain" magenta coupler and was the first Fuji paper to incorporate this major improvement.

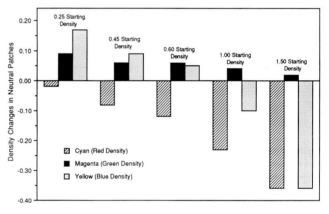

**Figure 5.7** Color balance changes in chromogenic papers result from a combination of image dye fading and yellowish stain formation. As shown in this accelerated aging test at 144°F (62°C) and 45% RH, the effect of stain on Ektacolor 2001 Paper (1986–91) is most pronounced at low densities and in d-min areas (Ektacolor Portra II and other Ektacolor papers have similar stain characteristics). With typical pictorial scenes, a density of about 0.6 (about 0.5 above d-min) is the most critical in terms of color balance changes.

gests that many of the predictions of dark storage print life published by Kodak and other manufacturers that have omitted yellowish stain behavior, both in and of itself and with respect to the influence of stain on color balance changes, are too optimistic.

Kodak certainly recognizes that clear, bright "whites" are an important aspect of print quality. In a 1992 advertisement for Ektacolor Edge paper that appeared in *Photographic Processing* magazine and other trade publications, Kodak said:[15]

> When it comes to building your business, new Kodak Ektacolor Edge paper delivers cutting-edge advantages. It features a new, larger backprint for greater brand identity, plus sharp color and "whiter" whites created by improved, fresh D-min characteristics.

Like other advertisements for Ektacolor and Ektachrome papers, nothing was said about the d-min staining characteristics of the papers during storage and display.

Two methods can help reduce stain in chromogenic materials. One approach is to do what is done in "washless" minilabs and add a stain-reducing stabilizer to the standard water-wash EP-2 and RA-4 processes — in other words, return to EP-3 (with a new stabilizer designed specifically for current papers). The third processing bath would cost little and would probably reduce water consumption, but this approach has a major drawback in that current water-wash processors would have to be modified to accommodate the stabilizer bath, and processing time would be increased.

It is unlikely that most large photofinishers and custom processing labs would readily make this change. A further

drawback is that low-pH stabilizers such as EP-3, which are effective in reducing dark-storage stain (see **Table 5.1**), also tend to reduce the light fading stability of the yellow dye in chromogenic color papers (see Chapter 2).

**EP-3 stabilizer should NOT be used on Ektacolor Plus or other current papers; to do so may have an adverse effect on dark and/or light fading stability, particularly of the yellow dye. Only stabilizers specifically recommended by a paper or film manufacturer for its particular products should be used. For example, do not use Konica Super Stabilizer with Ektacolor papers. At present, EP-2 or RA-4 "process-compatibility" does not extend to washless stabilizers.**

The second approach to reducing yellowish stain is to employ new types of "low-stain" magenta couplers, as Fuji has done with Fujicolor SFA3 color negative papers and Fujichrome Type 35 reversal papers.[16] (As mentioned earlier, unreacted magenta couplers that remain in a chromogenic paper after processing are the principal source of yellowish stain that forms over time.)

Fujicolor Paper Type 12, introduced in 1985, primarily in Japanese markets, and Fujichrome Paper Type 34, introduced in 1986, were the first chromogenic papers to employ low-stain magenta couplers.[17] Konica has also utilized a low-stain magenta coupler in Konica Color QA Paper Type A5, introduced in Japan in 1990. This is really the only satisfactory solution to the stain problem because the Fujicolor, Fujichrome, and Konica Color papers either may be given a water wash following processing or may be treated with a "washless" stabilizer as a final rinse, as is now usually the case in minilabs. Furthermore, the reduction in stain levels afforded by the new low-stain magenta couplers is significantly greater than that of papers with conventional magenta couplers processed with EP-3 stabilizer or a similar, low-pH stabilizer.

The coupler technology, dye stability, reduction in stain level, and improvements in color reproduction in Fujicolor Super FA papers have been described in a 1990 paper entitled "New Type Color Print Paper with an Improved Color Saturation and Dye Image Stability — Fujicolor Paper Super FA," by O. Takahashi, T. Sato, K. Hasebe, N. Furutachi, and T. Ogawa,[18] and in a 1992 paper entitled "New Type Color Paper with Exceptional Dye Image Stability — Fujicolor Paper Super FA Type 3",[19] by Tadahisa Sato, Masakazu Morigaki, and Osamu Takahashi.

The "low-stain" coupler technology and other improvements in Konica Type A5 paper have been described by Makoto Kajiwara, Toyoki Nishijima, and Noboru Mizukura in a report entitled "The Development of Konica QA Paper Type A5," published by Konica in 1992.[20]

The magenta dyes produced by the new magenta dye-forming couplers in current Fujicolor SFA3 papers for printing color negatives (and Fujichrome Type 35 papers for color transparencies) have significantly better light fading stability and also have better reproduction of reds, purples, pinks, and blues than do the older types of magenta dyes found in Ektacolor, Ektachrome, and most other papers.

## Processing of Test Samples

When Kodak, Fuji, and other manufacturers test their products, they use samples that have received optimum processing and thorough washing under carefully controlled laboratory conditions. This is done to show the products to their best advantage and to ensure that tests will be repeatable over time (that is, to eliminate processing variations as a consideration).

In the real world of replenished processing lines, hurried lab schedules, and efforts to keep chemical and water costs to a minimum, things frequently do not turn out so well. In some cases, as shown in **Figure 5.8**, processing shortcomings can have disastrous effects on image stability.

In recent years, a number of companies have entered the photographic processing chemicals market, generally supplying chemicals at lower cost than do Kodak, Fuji,

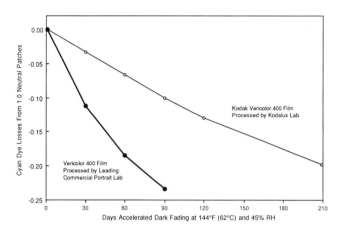

**Figure 5.8** Processing shortcomings can have an adverse effect on dye stability and on rates of yellowish stain formation. In this example, the cyan dye in Kodak Vericolor 400 (a Process C-41 color negative film) had much worse stability when the film was processed by a leading commercial and portrait lab located in the southwestern U.S. than the same film did when processed by the Qualex Kodalux lab in Findley, Ohio.

Agfa, and Konica. What effects processing chemicals from these outside suppliers might have on long-term image stability are not known. Some suppliers, in an effort to shorten processing times or reduce the number of processing steps, have substituted color developing agents, eliminated stabilizer baths in the C-41 and E-6 processes, and taken other shortcuts that adversely affect stability. For predictable results, it is recommended that only chemicals from Kodak, Fuji, Agfa, and Konica be used. Processing recommendations, replenishment rates, wash flow, and temperature specifications should be followed to the letter.

Most labs try to retain tight control on color developer activity — that is, to reduce any process deviation resulting in image-quality losses that can be visually assessed immediately after processing. But other processing problems, such as too-diluted (or omitted) C-41 or E-6 stabilizer baths, excess bleach-fix carryover, or inadequate washing, may not manifest themselves until months or years later.

The photograph studio at the Metropolitan Museum of Art in New York City discovered rapid and irregular magenta dye fading in a large number of Ektachrome transparencies processed by an outside lab in New York between 1982 and 1987.[21] The transparencies, most of which were in the 8x10-inch format, were of paintings, sculptures, and other artifacts in the museum's collections and had looked perfect when they were received from the lab. (The Metropolitan's photograph studio is a large operation that produces between 3,000 and 5,000 large-format color transparencies a year.) Many other Ektachromes from the same period have not faded prematurely, and none processed before 1982 exhibit the problem; all were stored in the dark under the same conditions.

After investigation, the cause of the premature and irregular fading and streaking was attributed to low solution level in the E-6 stabilizer tank in the processor or, possibly in some cases, omission of the stabilizer altogether.

In an attempt to represent the real world of good-qual-

ity, replenished-line processing, all C-41 color negative films, E-6 transparency films, and Kodachrome films in this author's testing program were processed by the Kodalux Processing Services of Qualex, Inc. (see Chapter 2). Eastman Kodak owns almost half of Qualex (the former Kodak Processing Laboratories are now part of Qualex), and Kodak chemicals are used exclusively. Because of Kodak's close involvement with Qualex, it was assumed that the labs pay careful attention to process control, and the consistency of stability data obtained from the same type of film processed at different times by Kodalux suggests that this is, at least for the most part, true.

In order to obtain closely matched pictorial prints for reproduction in this book, for use in articles,[22] and for corresponding Macbeth ColorChecker test samples for acquiring densitometer data, EP-2 and R-3 papers were processed by this author with Kodak chemicals and a Kodak Rapid Color Processor Model 11 fitted with a precise electronic temperature regulator (see Chapter 2). Each test print was made with fresh chemicals (Kodak Ektaprint EP-2 Stop Bath was included between the developer and bleach-fix), and the prints were properly washed.

Processed Cibachrome samples were furnished by Ilford in Switzerland, and additional samples were processed by this author. Kodak Dye Transfer prints were made in several different New York City labs. Fuji Dyecolor prints were supplied by Fuji. UltraStable Permanent Color prints and Polaroid Permanent-Color prints were supplied by Charles Berger, the inventor of both processes.

Konica, Fuji, and Agfa RA-4 compatible paper samples were processed under carefully controlled conditions by their respective manufacturers from test negatives furnished by this author. In most cases, prints processed with a water wash and duplicate prints processed with the particular manufacturer's washless stabilizer were supplied. Kodak declined to furnish samples of processed Ektacolor RA-4 prints, so prints made with Ektacolor Portra, Portra II, and Supra papers were obtained from several leading commercial labs. In addition, samples of Ektacolor 2001 paper were obtained from a number of 1-hour labs using Kodak minilabs and Kodak RA-4 chemicals.

Exactly what constitutes "typical" or "normal" processing cannot be answered at this time. Also unknown is how the stability of each of the vast number of different film and print materials on the market is affected by different types of processing chemicals and by process deviations (some are obviously more sensitive to improper processing than are others). Both cyan dye stability and yellowish stain formation during dark storage appear to be particularly affected by processing and washing conditions. A sobering study in this regard was presented in 1986 by Ubbo T. Wernicke of Agfa-Gevaert, entitled "Impact of Modern High-Speed and Washless Processing on the Dye Stability of Different Colour Papers."[23]

## Dark Fading and Staining of Color Negative Print Papers

In terms of market share, chromogenic papers for printing color negatives are by far the most significant type of color print material. Current Process RA-4 compatible color negative papers are listed in **Table 5.5a (page 180)**.

Clearly the best of the current RA-4 papers are the Fujicolor SFA3 papers introduced in 1992. Of special importance to portrait and wedding labs is Fujicolor SFA3 Professional Portrait Paper (tentative name), which Fuji planned to make available in the U.S. during 1993. The light fading stability of the Fujicolor papers are unsurpassed among color negative papers, and the resistance of the papers to dark fading and dark storage yellowish stain formation is equalled only by Konica Color QA Paper Type A5.

But unlike Konica Type A5 paper and most of the other color papers tested by this author, the rates of dye fading and yellowish stain formation of the Fujicolor SFA3 papers in dark storage were almost identical when the prints were given a water wash or when they were treated with the recommended stabilizer in a washless process.

In this author's dark fading tests, the overall dye stability of Kodak Ektacolor Portra II Paper was better than that of other current Ektacolor papers and the previous Portra paper (in the single-temperature, 45% RH tests, the yellow dye and the previously less stable cyan dye had almost identical stability). Unfortunately, however, Portra II proved to have the same unacceptably high rates of yellowish stain formation in dark storage found in Portra and other Ektacolor papers. In addition, the poor light fading stability of Portra II paper remains unchanged and is no match for the much longer lasting Fujicolor SFA3 papers.

Current Process EP-2 compatible color negative papers are listed in **Table 5.5b** (page 181), with obsolete products listed in **Table 5.5c** (page 183). A comparison of the pre-1984 materials in **Table 5.5c** with current materials clearly shows the dramatic improvements in dye stability in most products that began with the introduction in 1984 of Konica Color PC Paper Type SR (also called Konica "Century Paper"). A Konica ad for the new paper appearing in *Professional Photographer* magazine read in part:

> Prints made on paper currently available will fade, and badly, over a relatively few years. *Not so with color prints made on Konica SR Paper.* The rich color and details in these pictures will show virtually no signs of fading in 100 years. Our advanced emulsion technology enhances dye stability. In fact, accelerated aging tests show that dye images will retain more than 70% of their original density for 100 years or longer under normal album storage conditions.[24]

A few months after the introduction of Konica Type SR paper, Kodak followed with Ektacolor Plus Paper, a similar EP-2 product having a cyan dye with improved stability. Konica Type SR paper is even better when processed in the "washless" mode with Konica washless stabilizer; stain levels are greatly reduced with the stabilizer. Type SR paper is superior to Kodak Ektacolor Plus and Professional papers in both dark fading and light fading, and for this reason it is the recommended EP-2 product.

When Ektacolor Plus paper is processed in KIS Ultra X Press chemicals, substituting CD-4 developing agent for the normal CD-3 developing agent to increase the speed of processing, a significant reduction in both light and dark fading stability occurs; for this reason the KIS process should be avoided.

## Table 5.1 Comparison of Plain Water Wash and Final Treatment in Kodak Ektaprint 3 Stabilizer on the Dark Fading and Staining Behaviors of Selected Process EP-2 Compatible Papers for Printing Color Negatives

### Accelerated Dark Fading Tests at 144°F (62°C) and 45% RH

**Boldface Type** indicates products that were being marketed in the U.S. and/or other countries when this book went to press in 1992; the other products listed had either been discontinued or replaced with newer materials. Initial neutral density of 1.0 with ½ d-min corrected densitometry.

| Type of Color Print Paper | Plain Water Wash | | Final Treatment in Kodak Ektaprint 3 Stabilizer | |
|---|---|---|---|---|
| | Days for 20% Loss of Image Dye | Stain Increase After 90 Days | Days for 20% Loss of Image Dye | Stain Increase After 90 Days |
| **Agfacolor Paper Type 8** [improved] | **370 (–C)** | | **365 (–C)** | |
| **Agfacolor Paper Type 8 ML** | **>500 (–M)** | | **>500 (–M)** | |
| | **355 (–Y)** | **+0.11Y** | **170 (–Y)** | **+0.07Y** |
| **Konica Color PC Paper Type SR** | **300 (–C)** | | **365 (–C)** | |
| **Konica Color Paper Professional** | **>500 (–M)** | | **>500 (–M)** | |
| **Type EX** | **>500 (–Y)** | **+0.13Y** | **>500 (–Y)** | **+0.07Y** |
| **Mitsubishi Color Paper KER** | | | | |
| **Type 6000 Super** | | | | |
| **Mitsubishi Color Paper KER** | | | | |
| **Type 8000 Pro** | | | | |
| **Kodak Ektacolor Plus Paper** | **230 (–C)** | | **260 (–C)** | |
| **Kodak Ektacolor Prof. Paper** | **>500 (–M)** | | **500 (–M)** | |
| | **>480 (–Y)** | **+0.12Y** | **140 (–Y)** | **+0.07Y** |
| Fujicolor Paper Type 02 | 155 (–C) | | 230 (–C) | |
| Fujicolor Professional Paper | >500 (–M) | | >500 (–M) | |
| Type 01-P | >500 (–Y) | +0.14Y | 175 (–Y) | +0.07Y |
| **Fujicolor Paper Type 12** | **130 (–C)** | | **180 (–C)** | |
| **Fujicolor "Minilab Paper"** | **>500 (–M)** | | **>500 (–M)** | |
| | **>500 (–Y)** | **+0.07Y** | **190 (–Y)** | **+0.04Y** |
| Fujicolor Paper Type 8908 | 55 (–C) | +0.23Y | 115 (–C) | +0.06Y |
| Konica Color (Sakuracolor) PC Paper SIII | 50 (–C) | +0.14Y | 95 (–C) | +0.08Y |
| Kodak Ektacolor 74 RC Paper Type 2524 Kodak Ektacolor 78 Paper Type 2524 | 36 (–C) | +0.11Y | 60 (–C) | +0.09Y |
| Kodak Ektacolor 37 RC Paper Type 2261 | 31 (–C) | +0.16Y | 52 (–C) | +0.10Y |
| Kodak Ektacolor 74 RC Paper | 27 (–C) | +0.14Y | 52 (–C) | +0.08Y |

## The Effects of Low-pH EP-3 Stabilizer on the Dark Fading Stability of Process EP-2 Prints

In a series of experiments to determine the effects on dark storage stability of a "generic" low-pH stabilizer, this author treated various papers with the now-obsolete Kodak Ektaprint EP-3 stabilizer after washing. The results of these tests are shown in **Table 5.1**. The stabilizer increased cyan dye stability and at the same time reduced stain levels in all of the older papers; with current papers, however, all products except Konica Type SR paper suffered a marked reduction in yellow dye stability. Konica Type SR paper showed an even greater reduction in stain when processed with Konica Super Stabilizer (see **Figure 5.9**). With the exception of Type SR paper, all of the EP-2 papers tested — including Ektacolor Plus and Ektacolor Professional papers — also exhibited significantly increased yellow dye fading in low-level, long-term light fading tests.

## Stability of Papers for Printing Color Transparencies

Most of the products listed in **Table 5.6** (page 185) are intended for printing from color transparencies; the Polaroid Permanent-Color, UltraStable Permanent Color, and EverColor pigment color processes along with the Kodak Dye Transfer process can also be used to make prints from color negatives or to make copies of existing prints. When compared with even the best of the chromogenic papers, the dark storage superiority of the preformed-dye systems, as exemplified by Ilfochrome (called Cibachrome, 1963-91), is clearly evident in this table and in **Table 5.12** (page 193). The preformed-dye products have extremely good dark fading stability and develop little or no stain. A comparison between Ilfochrome and Kodak Ektachrome Copy Paper (introduced in 1984 and still on the market at the time this book went to press in 1992) and the initial version of Ektachrome 22 Paper (1984–91) is a study in extremes.

Among the Process R-3 compatible papers, the Fujichrome Type 35 papers are clearly the longest lasting, both in terms of dye stability and resistance to stain formation. The Fujichrome papers are greatly superior to Kodak's Ektachrome Radiance and Radiance Select papers.

Fujichrome Type 35 paper was introduced in 1992 as a replacement for Type

34 paper. There was not enough time to complete tests on the new Type 35 paper before this book went to press. However, Fuji has informed this author that the dye stability and resistance to yellowish stain of Type 34 and Type 35 papers are identical (the improvements in Type 35 paper had to do with color and tone reproduction, and did not affect image stability). For this reason, the data given for Type 34 and Type 35 papers in **Table 5.6** are identical.

When this book went to press in 1992, Ektachrome Copy Paper still employed one of the pre-1984 types of highly unstable cyan dyes that does not approach the stability of the cyan dye in Fujichrome Type 34 and Type 35 papers.

### Instant Color Prints and Thermal Dye Transfer, Ink Jet, and Other Print Processes for Digitized and Computer-Generated Images

As shown in **Table 5.7** (page 187), the dyes in Polaroid instant prints are extremely stable in dark storage. However, when discussing the stability of Polaroid SX-70, Spectra, and Polaroid 600 Plus prints, dark storage dye stability is only part of the story. The problem with these prints is that in dark storage at normal temperatures they develop an objectionable overall yellowish stain in a relatively short time. In non-accelerated, real-time tests, the stain levels exceeded this author's limits in only a few years (see **Table 5.2** and **Figure 5.10**). The stain is produced by slow migration of non-image dyes and/or other chemical constituents residing in the lower layers of the tightly sealed Polaroid print package.

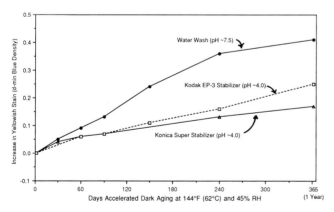

**Figure 5.9** Yellowish stain formation in Konica Color PC Paper Type SR prints is similar when they are processed with Kodak EP-3 Stabilizer or with Konica Super Stabilizer. In common with other Process EP-2 compatible papers, Type SR paper has a significantly higher stain rate when a final water wash is employed in place of a low-pH stabilizer.

## Table 5.2  Stain Formation in Polaroid Spectra Prints and Other Polaroid Integral Instant Color Prints Stored in the Dark at Normal Room Temperature and Relative Humidity Conditions

**Initial Densitometry: 24 Hours After Processing**
**Test Duration of Up to 10 Years (3,650 Days)**

**Boldface Type** indicates products that were being marketed in the U.S. and/or other countries when this book went to press in 1992.

| Type of Print | Days to Reach "Museum" d-min Color Imbalance Limit | Years to Reach "Commercial" d-min Color Imbalance Limit |
|---|---|---|
| Polaroid Spectra Prints (1986–91) Polaroid Image Prints (Spectra in Europe) **Polaroid 600 Plus Prints** (1988—) **Polaroid Type 990 Prints** **Polaroid Autofilm Type 330 Prints** | **16 (C+Y)** | **3.0 (C+Y)** |
| **Polaroid High Speed Type 779 Prints** **Polaroid Autofilm Type 339 Prints** Polaroid 600 High Speed Prints (1980–88) | **12 (C+Y)** | **0.3 (C+Y)** |
| **Polaroid SX-70 Time-Zero Film** (1979—) **Polaroid Type 778 Time-Zero Prints** | **32 (C+Y)** | **0.4 (C+Y)** |
| Polaroid SX-70 Film [improved] (1976–79) | 31 (C+Y) | >10.0 (C+Y) |

In 1991, Polaroid introduced a sharper and finer-grain Spectra film called Spectra High Definition film (Spectra HD film); however, a company official informed this author that the new film was not markedly improved in terms of its tendency to form yellowish stain in dark storage.

In 1992, Polaroid introduced the Vision 95 system in Europe, a smaller format camera and film employing an improved version of the Spectra HD print emulsion. In 1993, "Vision 95" cameras and film will be introduced in the United States and other parts of the world under different names. A Polaroid spokesman told this author that Vision 95 film has somewhat reduced rates of yellowish staining in dark storage; however, specific stain data for Vision 95 prints were not available from Polaroid or independent laboratories at the time this book went to press.

Polaroid Spectra and Polaroid 600 Plus prints have poor light fading stability. When displayed, these prints fade significantly faster than typical chromogenic papers. Polaroid color prints have no usable negative (like daguerreotypes, each exposure produces a unique image). If important pictures have been made on these materials, the best policy is to make two copies on a more stable print material. (Polaroid itself offers good-quality copies made on chromogenic paper at reasonable cost.) One of these copies should be kept in the dark and the other may be displayed.

Polaroid peel-apart prints (e.g., Polacolor ER and Polacolor 2) last much longer in dark storage than Spectra and other Polaroid integral prints because the negative layer with its unused image-forming dyes and other chemicals is

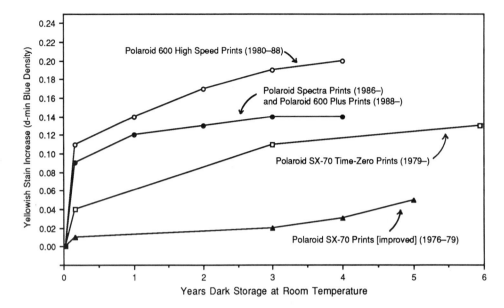

**Figure 5.10** Polaroid Spectra and other Polaroid integral instant color films develop significant yellowish stain during normal, room-temperature storage at 75°F (62°C) and 60% RH. Earlier Polaroid SX-70 [improved type] prints exhibited much lower stain levels. The sharper and finer-grain Spectra HD film introduced in 1991 is reported by Polaroid to have yellowish stain characteristics that are similar to the earlier Spectra film.

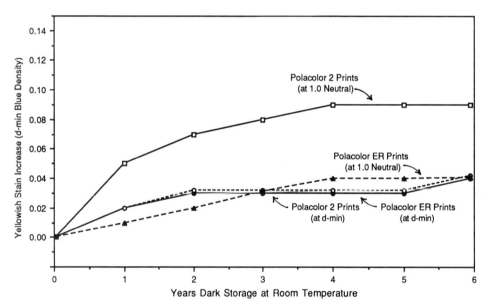

**Figure 5.11** Polaroid Polacolor 2 and Polacolor ER peel-apart prints have generally better stain characteristics than Polaroid integral prints. With Polacolor 2 prints, higher levels of stain occurred at higher image densities (e.g., 1.0) than at d-min, and this resulted in a yellowish color-balance shift that was readily visible.

stripped away after processing (see **Figure 5.11**). Polacolor 2 prints, however, may exhibit pronounced color balance shifts in higher density areas of the image, despite relatively little change at d-min.

Polacolor ER and Polacolor 2 peel-apart prints have poor light fading stability and should be displayed with caution. Copies should be made for long-term display.

Kodak Ektatherm thermal dye transfer prints did not do well in these dark fading tests. When the Kodak Photo CD system was commercially introduced in the summer of 1992, Ektatherm prints were the only type of print initially available for reproducing images from Kodak Photo CD's. The Photo CD Index Print supplied with each Kodak Photo CD as a "contact sheet" for visual reference to the images recorded on the Photo CD was also an Ektatherm print.

Kodak declined to supply Arrhenius data for Ektatherm prints, and it is not known whether these prints undergo abnormally rapid image deterioration when subjected to high-temperature accelerated tests. There is concern that when thermal dye transfer materials are subjected to sustained temperatures above a certain point, the image dyes may migrate or undergo physical changes within the structure of the print in a manner that will never occur at more moderate temperatures.

Preliminary tests with high-resolution color ink jet prints made with ink sets supplied by Iris Graphics, Inc. and Stork Bedford B.V. indicate that the prints have extremely good dark storage stability with no tendency to form yellowish stain if they are made on stable support materials. However, as discussed in Chapter 3, the light fading stability of the ink sets supplied by these two manufacturers at the time this book went to press in 1992 was very poor.

One reassuring finding of this author's research is that the inks used in ordinary 4-color offset magazine and book printing are extremely stable in dark storage (in spite of the fact that the light fading stability of most magenta and

yellow inks is very poor). Color images printed on good-quality paper will in most cases far outlast the photographic originals from which they were made. Most modern alkaline-buffered coated book papers are reasonably stable, and are fairly resistant to yellowing with age.

## Stability of Color Negatives

As shown in **Tables 5.8a** (page 189) and **5.8b** (page 191), the dark fading stability of most color negative films has been substantially improved in the last 10 years. (In general, light fading is not a relevant factor with color negatives; light exposure in the enlarger is insignificant, even when making many prints from a negative.) As a group, the Kodak and Konica 400-speed and faster films, together with Kodak Vericolor III film and Fujicolor Super HG, HG 400, and Super G films rated the best in these tests.

Numerous considerations go into making a choice about which film is best for a particular job, and a photographer may decide to select a less stable film to gain some other advantage. Fujicolor Reala, which has excellent color and tone reproduction and gives exceptionally good results with difficult-to-photograph fluorescent illumination, is a case in point. Although photographers may choose a somewhat less stable color negative film such as Reala, the very worst products, such as Kodak Vericolor II Professional Film Type L, Vericolor Internegative Film 6011, and Agfacolor XRS 1000 Professional Film, should be strictly avoided.

Because color negatives are not viewed directly, but rather are used to make prints, analysis of color negative fading (and the ramifications of d-min stain or density losses) in the future will be based on the effects they have when printed. A certain amount of negative density loss and color imbalance can be satisfactorily adjusted for during printing, but more severe negative deterioration cannot.

Historically, both still camera and motion picture color negative films have had particularly poor dark fading stability — the logic being, one might suppose, that most color negatives are printed soon after processing so that fading of the negative in later years will not matter in most cases. The introduction of Kodacolor HR Disc Film in 1982 (soon followed by Kodak Vericolor III Professional Film) signaled a major advance in the stability of color negatives: the disc film had a new cyan dye-forming coupler, which produced a cyan dye of greatly increased stability. Improved-stability cyan dyes, combined with improved yellow dyes, have now been incorporated into most Kodak color negative films, both still and motion picture. Poor-stability Kodak color negative films, which have not yet been replaced with improved products, include Vericolor II Professional Film Type L and Vericolor Internegative Film.

## Stability of Color Transparencies

The comparative dark storage stability of color transparency films is given in **Table 5.9** (page 193). Kodachrome clearly is the most stable transparency film in dark storage; the film is especially outstanding in terms of its total freedom from yellowish stain, even after extended aging. In spite of Kodachrome's unequaled dark storage stability, it has the worst projector-fading stability of any slide film on the market.

Among Process E-6 films, Fujichrome and Ektachrome had generally similar overall dark storage stability in these tests. Both types of film developed relatively high levels of yellowish stain, and it is stain, not dye stability, that is the most significant image stability problem with these and other E-6 films. It is expected that in the future, "low-stain" magenta couplers related to those presently employed in Fujicolor and Fujichrome papers will be utilized in Process E-6 color transparency films. Such an improvement would greatly reduce yellowish stain formation in dark storage and would substantially increase the useful dark storage life of both Fujichrome and Ektachrome films.

It should be noted that in Arrhenius test data made available to this author by Eastman Kodak (see **Table 5.13**), the more recent "Group II" Ektachrome films, including Ektachrome 64T and 320T films, "Plus," "HC," and "X" films, have much improved yellow dye stability compared with the older "Group I" types of E-6 Ektachrome. In fact, in Kodak's Arrhenius tests, the improved Ektachrome films have somewhat better *dye stability* than Kodachrome film! However, Kodak did not supply stain data for either the new or older Ektachrome films, and it is likely that by the time the least stable dye fades 20%, the films will have developed a very high stain level.

With twice the projector-fading stability of either the new or older Ektachrome films, Fujichrome has the best projector-fading stability of any color slide film (see Chapter 6). For this reason, Fujichrome is this author's primary recommendation among color slide films.

The very poor stability of the Kodak Process E-3 Professional Ektachrome films was one of the most disheartening findings of this author's tests. These films were in wide use among professional advertising and fashion photographers throughout the 1960's and up until the films were replaced by Process E-6 Ektachrome films in 1976–1977. The E-3 films had far worse stability than their "amateur" Process E-4 Ektachrome counterparts, a fact that Kodak withheld from photographers during the period these films were being marketed. Most photographers were equally unaware of the greatly superior dark fading stability of Kodachrome film over any of the Ektachrome films available during this period.

## Color Microfilm

The extraordinary dye stability and total freedom from yellowish stain of Ilford Ilfochrome Micrographic Film (formerly Cibachrome Micrographic Film) during long-term accelerated tests are shown at the end of **Table 5.9** (page 194) and in **Figures 5.12** and **5.13**. Ilfochrome is made with a polyester base that is far more stable than the cellulose triacetate base used with most other color films. This author believes that when stored under typical museum and archive conditions, Ilfochrome Micrographic Film will likely outlast the silver images of conventionally processed black-and-white microfilms.

Accelerated test data as well as examination of historical silver dye-bleach color prints strongly suggest that the dye images of Ilfochrome Micrographic Film are much more resistant to the effects of peroxides and other airborne contaminants than are the very fine-grain silver images of black-and-white microfilms.

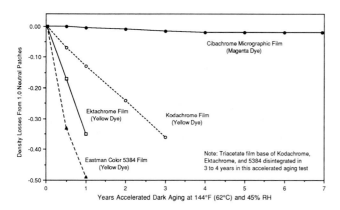

**Figure 5.12** As shown in this accelerated aging test at 144°F (62°C) and 45% RH, Ilford Ilfochrome (formerly Cibachrome) Micrographic Film has extremely good dark storage stability compared with that of Kodachrome film, Ektachrome film, and Eastman 5384 color print film. Ilfochrome Micrographic Film, which is made with an extremely long-lasting polyester base, is probably more stable in typical storage conditions than conventionally processed black-and-white microfilm with silver images.

## Manufacturers' Arrhenius Predictions for a 20% Dye Loss (Fading) in Color Materials

In August 1980, after considerable pressure from influential movie directors and professional portrait and wedding photographers, Kodak announced that the company would begin to publish stability data for its products. A compilation of these and other Kodak data[25] is given in **Table 5.13**, which begins on page 201. Unpublished Kodak data for earlier products are given in **Table 5.14** (page 204). Similar tables and data from the other manufacturers, listed in alphabetical order in **Tables 5.10** through **5.17**, which can be found on pages 195 through 209.

Kodak has also published estimates of the effect of storage temperature on dye fading rates (see **Table 5.3**), based on data from typical Kodak products, and these estimates can be used to calculate approximate storage times for temperatures other than the 75°F (24°C) used in **Tables 5.13** and **5.14**. The effect of relative humidity on the fading rates of certain humidity-sensitive yellow chromogenic dyes is given in **Table 5.4**. The estimates in **Tables 5.3** and **5.4** can also be applied in a general way to other manufacturers' color film and print materials.

With recent color negative films, Kodak has chosen to list films in "image stability categories," and to give predictions of dark storage stability in terms of a range of years that will encompass all of the films in a certain category, rather than give dark storage predictions for each type of film separately. For example, Kodak Vericolor III, Vericolor 400, Ektapress Gold 400, Kodak Gold 400, and Ektar 1000 film are all included in a category of films that Kodak predicts will last from 38 to 65 years before suffering a 20% loss of the least stable image dye when kept in dark storage at 75°F (24°C) and 40% RH. This does not mean that a specific film will last from 38 to 65 years under these conditions, but rather that the various films included in the group, which may differ in terms of their actual image stability, all will fall within this range.

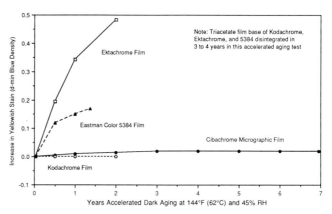

**Figure 5.13** Ilford Ilfochrome (Cibachrome) Micrographic Film developed negligible yellowish stain in a test at 144°F (62°C) and 45% RH. Kodachrome film, an external-coupler chromogenic film, had no stain formation during the test, but the cellulose triacetate base of the Kodachrome disintegrated after 3 years in the test.

Note that the predictions in **Table 5.13** and **Table 5.14** (pages 201–204) are based on storage at a relative humidity of 40%; in many places the yearly average indoor relative humidity will be higher than this, with 60% probably being more typical of the major populated areas of the world. A 60% RH could increase the overall fading rates of many products, particularly those in which the yellow dye is the least stable, by a factor of two or more. The new *ANSI IT9.9-1990* Standard recommends that dark storage tests be performed at 50% RH, and it is likely that Kodak and the other manufacturers will adopt this level in the future.

Konica employed 60% RH for the 20% dye loss predictions for its products in **Table 5.15** (page 205). With Konica color negatives in particular, in which the humidity-sensitive yellow dye is the least stable of the three image dyes, the higher humidity level may have reduced the predicted number of years for a 20% dye loss by as much as 50% versus what would have been predicted if Konica had adopted the 40% RH test condition used by Kodak and Agfa.

It should also be noted that since the introduction of Konica Color PC Paper Type SR in 1984, Konica has used a 30% dye loss criterion for evaluating its color print materials. The Konica claim of a "100-year" life for the prints in dark storage was based on Arrhenius predictions that a 30% loss of the least stable dye would not occur until more than 100 years had passed, when the prints were kept in the dark under normal room temperature conditions.

Konica has given the following predictions for years of storage required for a 30% loss of the least stable dye (cyan) for its color papers processed with a *water wash* (data for yellowish stain formation was not disclosed):

Konica Color QA Paper Type A5 . . . . . . . . 230–270 years

Konica Color QA Paper Type A3 . . . . . . . . 230–270 years

Konica Chrome Paper Type 81 . . . . . . . . 230–270 years

Konica Color QA Paper Type A2 . . . . . . . . . . . 130 years

Konica Color QA Paper Type A . . . . . . . . . . . . 130 years

Konica Color PC Paper Type SR . . . . . . . . . . 130 years

Konica Color PC Paper Type EX . . . . . . . . . 130 years

## Table 5.3 Effect of Temperature on Dye Fading Rates at 40% Relative Humidity*

| Storage Temperature | Relative Storage Time |
|---|---|
| 86°F (30°C) | ½X |
| 75°F (24°C) | 1X |
| 66°F (19°C) | 2X |
| 55°F (13°C) | 4X |
| 45°F (7°C) | 10X |
| 40°F (4°C) | 16X |
| 32°F (0°C) | 28X |
| 14°F (–10°C) | 100X |
| 0°F (–18°C) | 340X |
| –15°F (–26°C) | 1000X |

* Derived from: Charleton C. Bard et al., "Predicting Long-Term Storage Dye Stability Characteristics of Color Photographic Products from Short-Term Tests," **Journal of Applied Photographic Engineering**, Vol. 6, No. 2, April 1980, p. 44 (with permission). Fading rates of many dyes can be significantly greater when stored where relative humidities are higher than 40%.

## Table 5.4 Effect of Relative Humidity on Fading Rates of Certain Kodak Chromogenic Yellow Dyes*

| Relative Humidity | Relative Dye Fading Rate at a Specified Temperature |
|---|---|
| 60% | 2X |
| 40% | 1X |
| 15% | ½X |

* Derived from: Charleton C. Bard et al., "Predicting Long-Term Storage Dye Stability Characteristics of Color Photographic Products from Short-Term Tests," **Journal of Applied Photographic Engineering**, Vol. 6, No. 2, April 1980, p. 43 (with permission).

Fuji, following one of the test specifications in the earlier *ANSI PH1.42-1969* color stability test Standard, gave 20% dye loss predictions for both 70% RH and <10% RH in **Table 5.11** (pages 197–198). As can be seen, the overall dye stability of Fujicolor and Fujichrome papers is little influenced by the level of relative humidity, while the yellow dyes (the least stable dyes) in Fujicolor negative and Fujichrome transparency materials fade significantly faster at the higher, 70% RH level than they do at <10% RH.

The Arrhenius tests employed by Kodak and the other manufacturers were performed according to the general procedures described by Charleton C. Bard, George W. Larson, Howell Hammond, and Clarence Packard in a 1980 article, "Predicting Long-Term Dark Storage Dye Stability Characteristics of Color Photographic Products from Short-Term Tests."[26] With some modification, this test has been adopted in the recent *ANSI IT9.9-1990* Standard for color stability test methods.

When reviewing the Kodak estimates and the data supplied by the other manufacturers in **Tables 5.10** through **5.17** (pages 195–209), keep in mind that dark storage predictions have a significant margin for error. Reporting on a 1986 presentation by Charleton Bard of the Eastman Kodak Company,[27] Klaus B. Hendriks wrote:

> Bard noted that the accuracy of the Arrhenius test is quite good. . . . However, the precision of the Arrhenius test for predicting 0.3 density loss (from an initial 1.0 density) is less reliable. To improve this situation would require a

very large number of tests to be conducted for five or more years, using samples with different coatings produced under varying conditions of exposure and processing, and taking into account variations in densitometry and data analysis. According to Bard, claims that a given product will not lose 30 percent of any dye in 100 years at 24°C [75°F] and 40 percent RH may mean that such dye loss could occur as early as within 50 years or as late as in 200 years for an individual measurement. Furthermore, for a 30 percent loss of a dye there is the possibility that a decrease in density no longer accurately reflects the chemical degradation of the dye. The formation of colored decomposition products of the degraded dye may destroy the linear relationship between density and fate of the dye.[28]

Agfa has indicated that, based on its experience with the Arrhenius test, the dark storage predictions given for its products in **Table 5.10** (pages 195–196) may have a margin for error as high as 50%.

Indeed, several of the manufacturers made available to this author, data from Arrhenius tests they conducted with competitors' products (in sharing these data with this author, it was requested that they not be published). In examining these data, it was apparent that in many cases significantly different image-life predictions were obtained with a given product, depending on who conducted the Arrhenius test. Also, keep in mind that with the exception of Fuji with its low-stain Fujicolor and Fujichrome papers, none of the manufacturers supplied stain predictions for their papers and that with Kodak, Agfa, and most Konica print materials, yellowish stain in dark storage is a more serious problem than is dye fading. This, combined with the different humidity levels employed in the tests by different manufacturers, may make it difficult to make a precise comparison of the various manufacturers' products.

In spite of these uncertainties, however, the 20% dye loss predictions given in **Tables 5.10** through **5.17** are still very useful in comparing one product with another. These

dye loss (fading) predictions also provide information that
is vital if one is to determine what storage temperature is
required for a given type of color film or print material to
be preserved for extended periods (e.g., for 500 or 1,000
years). It is expected that in the future, when the major
manufacturers and independent laboratories begin pub-
lishing Arrhenius fading and yellowish stain data in the
manner specified in *ANSI IT9.9-1990*, and the tests are
conducted at the 50% RH level recommended in the Stan-
dard, more meaningful comparisons of the dark storage
stability of various products will be possible.

# Notes and References

1. Casey Allen, "Arthur Rothstein: A Man For All Seasons," **Technical Photography,** Vol. 20, No. 4, April 1988, p. 39.
2. Photofinishing News, Inc., "Photo Processing – North and South America," **The 1991 International Photo Processing Industry Report,** Chapter 1, p. 1 (1991). Photofinishing News, Inc., Suite 1091, 10915 Bonita Beach Road, Bonita Springs, Florida 33923; telephone: 813-992-4421; Fax: 813-992-6328.
3. "Consumer Markets: Photofinishing," **The 1990–91 PMA Industry Trends Report,** Photo Marketing Association International, Jackson, Michigan, September 1990, pp. 14–21.
4. Ed Scully, "Ed Scully on Color," **Modern Photography,** Vol. 41, No. 8, August 1977, pp. 47–48.
5. Edith Gordon, "Quality Has Top Priority in Agfa-Gevaert Planning," **Photo Weekly,** Vol. 30, No. 10, April 15, 1985, p. 13.
6. "Agfa Committed To Finishers, Gerlach Says," **Photo Weekly,** Vol. 30, No. 10, April 15, 1985, p. 12.
7. American National Standards Institute, Inc., **ANSI PH1.42–1969, American National Standard Method for Comparing the Color Stabilities of Photographs,** American National Standards Institute, Inc., 11 West 42nd Street, New York, New York 10036; telephone: 212-642-4900 (Fax: 212-398-0023).
8. American National Standards Institute, Inc., **ANSI IT9.9-1990, American National Standard for Imaging Media – Stability of Color Photographic Images – Methods for Measuring,** American National Standards Institute, Inc., New York, New York, 1991. Copies of the Standard may be purchased from the American National Standards Institute, Inc., 11 West 42nd Street, New York, New York 10036; telephone: 212-642-4900 (Fax: 212-398-0023). This author has been a member of the ANSI subcommittee that wrote this Standard since the work began in 1978; in recent years he has served as secretary of the subcommittee.
9. Bob Schwalberg, with Henry Wilhelm and Carol Brower, "Going! Going!! Gone!!! – Which Color Films and Paper Last Longest? How Do the Ones You Use Stack Up?", **Popular Photography,** Vol. 97, No. 6, June 1990, pp. 37–49, 60. With a circulation of approximately one million copies, **Popular Photography** is the world's largest photography magazine.
10. Kotaro Nakamura, Makoto Umemoto, Nobuo Sakai, and Yoshio Seoka, "Dark Stability of Photographic Color Prints from the Viewpoint of Stain Formation," **Second International Symposium: The Stability and Preservation of Photographic Images** (held at the National Archives of Canada, Ottawa, Ontario, Canada), sponsored by the Society of Photographic Scientists and Engineers, Springfield, Virginia, August 25–28, 1985, p. 381.
11. Robert J. Tuite [Eastman Kodak Company], "Image Stability in Color Photography," **Journal of Applied Photographic Engineering,** Vol. 5, No. 4, pp. 200–207, Fall 1979.
12. Souichi Kubo [Chiba University], **Shashin Kogyo,** Vol. 50, No. 513, pp. 10–11 and 46–51, 1992. See also related article: "Color Paper Dye Fade Has Been Reduced In Half – Quality Improvement of Color Couplers – Konica Has Completed the Change-Over," **Nikkei Sangyo Shinbun** [Japan Industrial Newpaper], September 12, 1992, p. 5.
13. Fuji Photo Film Co., Ltd., **Fujicolor Paper Super FA Type II,** Fuji Film Data Sheet Ref. No. AF3–662E, February 1990. See also: **Fujicolor Professional Paper Super FA,** Fuji Film Data Sheet Ref. No. AF3–661E, February 1990.
14. Fuji Photo Film Co., Ltd., **Fujichrome Paper Type 34,** Fuji Film Data Sheet Ref. No. AF3–638E, July 1989.
15. Eastman Kodak Company, "Now Kodak Gives You The Competitive Edge," advertisement on the back cover of **Photographic Processing,** Vol. 27, No. 12, December 1992.
16. Kotaro Nakamura, Makoto Umemoto, Nobuo Sakai, and Yoshio Seoka, see Note No. 10, pp. 381–387.
17. Akio Mitsui, Nobuo Furutachi, Takeshi Hirose, and Yoshinobu Yoshida [Ashigara Research Laboratories, Fuji Photo Film Co., Ltd.], "On the New Fujichrome Paper – Fujichrome Paper Type 34," Abstract, **SPSE Second International Symposium: Photofinishing and Minilab Technology,** Cologne, Germany, September 8–9, 1986.
18. O. Takahashi, T. Sato, K. Hasebe, N. Furutachi, and T. Ogawa, "New Type Color Print Paper with an Improved Color Saturation and Dye Image Stability – Fujicolor Paper Super FA," paper given at the **SPSE Sixth International Symposium on Photofinishing Technology,** Las Vegas, Nevada, February 20, 1990, "Advance Printing of Paper Summaries," pp. 68–70; published by The Society for Imaging Science and Technology (IS&T), 7003 Kilworth Lane, Springfield, Virginia 22151; telephone: 703-642-9090; Fax 703-642-9094.
19. Tadahisa Sato, Masakazu Morigaki, and Osamu Takahashi, "New Type Color Paper with Exceptional Dye Image Stability – Fujicolor Paper Super FA Type 3," presentation at **IS&T's Seventh International Symposium on Photofinishing Technology,** Las Vegas, Nevada, February 3–5, 1992. Sponsored by The Society for Imaging Science and Technology (IS&T), 7003 Kilworth Lane, Springfield, Virginia 22151; telephone: 703-642-9090; Fax 703-642-9094.
20. Makoto Kajiwara, Toyoki Nishijima, and Noboru Mizukura, "The Development of Konica QA Paper Type A5," **Konica Technical Report,** Vol. 5, January 1992, pp. 25–29.
21. Barbara Bridgers, manager of the photograph studio at the Metropolitan Museum of Art, New York City, letter to this author and telephone discussion, October 1987.
22. Bob Schwalberg, et al., see Note No. 9.
23. Ubbo T. Wernicke [Agfa-Gevaert AG], "Impact of Modern High Speed and Washless Processing on the Dye Stability of Different Colour Papers," **Proceedings of the International Symposium: The Stability and Conservation of Photographic Images: Chemical, Electronic and Mechanical,** organized by the Society of Photographic Scientists and Engineers and the Department of Photographic Science and Printing Technology, Chulalongkorn University, Bangkok, Thailand, November 3–5, 1986.
24. Konica Corporation, full-page advertisement, **Professional Photographer,** Vol. 111, No. 2069, October 1984, p. 20.
25. **Evaluating Dye Stability of Kodak Color Products,** Kodak Publication No. CIS-50, January 1981, and subsequent CIS-50 series of dye-stability data sheets through 1985; **Image-Stability Data: Kodachrome Films,** Kodak Publication E-105, 1988; **Image-Stability Data: Kodak Ektachrome Films,** Kodak Publication E-106, 1988; **Image-Stability Data: Kodak Color Negative Films (Process C-41),** Kodak Publication E-107, June 1990; **Evaluating Image Stability of Kodak Color Photographic Products,** Kodak Publication No. CIS-130, March 1991; **Kodak Ektacolor Plus and Professional Papers for the Professional Finisher,** Kodak Publication No. E-18, March 1986; **Dye Stability of Kodak and Eastman Motion Picture Films** (data sheets); Kodak Publications DS-100-1 through DS-100-9, May 29, 1981, and other published and unpublished Kodak sources.
26. Charleton C. Bard, George W. Larson, Howell Hammond, and Clarence Packard [Eastman Kodak Company], "Predicting Long-Term Dark Storage Dye Stability Characteristics of Color Photographic Products from Short-Term Tests," **Journal of Applied Photographic Engineering,** Vol. 6, No. 2, April 1980, pp. 42–45. See also: A. Tulsi Ram, D. Kopperl, R. Sehlin, S. Masaryk-Morris, J. Vincent, and P. Miller [Eastman Kodak Company], "The Effects and Prevention of 'Vinegar Syndrome'," presented at the **1992 Annual Conference of the Association of Moving Image Archivists,** San Francisco, California, December 10, 1992. (See Chapter 9 for further discussion of this topic.)
27. Charleton C. Bard [Eastman Kodak Company], "Clearing the Air on the Stability of Color Print Papers," presentation at the **SPSE Fourth International Symposium on Photofinishing Technology** [see abstract in: **Program and Paper Summaries,** p. 9], Las Vegas, Nevada, February 10–12, 1986. Sponsored by the Society of Photographic Scientists and Engineers (SPSE). See also: Stanton I. Anderson and David F. Kopperl [Eastman Kodak Company], "Limitations of Accelerated Image Stability Testing," presentation at **IS&T's Seventh International Symposium on Photofinishing Technology,** Las Vegas, Nevada, February 3, 1992. Sponsored by The Society for Imaging Science and Technology (IS&T). See also: Stanton Anderson and Robert Ellison [Eastman Kodak Company], "Natural Aging of Photographs," **Journal of the American Institute for Conservation,** Vol. 31, No. 2, Summer 1992, pp. 213–223.
28. Klaus B. Hendriks, "The Stability and Preservation of Recorded Images," **Imaging Processes and Materials** (Neblette's Eighth Edition), edited by John M. Sturge, Vivian Walworth, and Allan Shepp, Van Nostrand Reinhold, New York, New York, 1989, p. 656.

# Table 5.5a  Comparative Dark Fading and Yellowish Staining of Current Process RA-4 Compatible Papers for Printing Color Negatives

Number of Days Required for a 20% Loss of the Least Stable Image Dye in Accelerated Dark Fading Tests at 144°F (62°C) and 45% RH

All of the papers listed were available at the time this book went to press in 1992. Initial neutral density of 1.0 with 1/2 d-min corrected densitometry.

| Type of Color Paper | Days for 20% Loss of Least Stable Image Dye | Days to Reach d-min Color Imbalance of 0.10 | Yellowish Stain (Blue Density) Increase After 180 Days |
|---|---|---|---|
| **Fujicolor Paper Super FA Type 3**<br>**Fujicolor Supreme Paper SFA3**<br>**Fujicolor SFA3 Professional Portrait Paper**<br>**Fujicolor Professional Paper SFA3 Type C**<br>**Fujiflex SFA3 Super-Gloss Printing Material** [polyester]<br>**Fujicolor Peel-Apart Paper SFA3**<br>**Fujicolor Thin Paper SFA3**<br>("Fujicolor Print")<br>[processed with Fuji CP-40FA (RA-4) chemicals and water wash, or with Fuji CP-40FA Stabilizer in washless minilab] (1993— for SFA3 Professional Portrait Paper) (1992— for other papers) | 380 (–C) | >500 (C+Y) | +0.05Y |
| **Konica Color QA Paper Type A5**<br>(Konica Color "Century Paper")<br>(Konica Color "Century Print")<br>(Konica Color "Long Life 100 Print")<br>[processed with Konica CPK-20QA (RA-4) chemicals and water wash]<br>(1990—) (initially available only in Japan) | 360 (–C) | 615 (C+Y) | +0.07Y |
| **Konica Color QA Paper Type A3**<br>**Konica Color QA Prof. Paper Type X2**<br>**Konica Color QA Super Glossy Print Material Type A3** [polyester]<br>**Konica Color QA Paper Peelable Type A3**<br>(Konica Color "Century Paper" or "Century Print")<br>(Konica Color "Long Life 100 Print")<br>[processed with Konica CPK-20QA (RA-4) chemicals and water wash]<br>(1991—) | 360 (–C) [estimated] | 75 (C+Y) [estimated] | +0.28Y [estimated] |
| **Mitsubishi Color Paper SA 2000**<br>**Mitsubishi Color Paper SA 5000 Pro**<br>(papers are believed to be identical to Konica Color QA Type A3 and X2 papers) (improved type: 1992—) | 360 (–C) [tentative] | 75 (C+Y) [tentative] | +0.28Y [tentative] |

| Type of Color Paper | Days for 20% Loss of Least Stable Image Dye | Days to Reach d-min Color Imbalance of 0.10 | Yellowish Stain (Blue Density) Increase After 180 Days |
|---|---|---|---|
| **Ilford Ilfocolor Deluxe Print Material**<br>(RA.1K high-gloss polyester-base print material manufactured by Ilford in Switzerland using emulsion components supplied by Konica; the stability of the Ilford product is believed to be similar if not identical to Konica Color QA Super Glossy Print Material Type A3.)<br>(1992—) | 360 (–C) [tentative] | 75 (C+Y) [tentative] | +0.28Y [tentative] |
| **Agfacolor Paper Type 9**<br>**Agfacolor Paper Type 9I** [improved]<br>("Agfacolor Print")<br>[Agfa AP-94 (RA-4) chemicals and water wash]<br>(1988— for Type 9; 1992— for Type 9I) | 305 (–C) | 90 (C+Y) | +0.21Y |
| **Kodak Ektacolor Portra II Paper**<br>("Ektacolor Print")<br>(1992—) | 295 (–C) | 80 (C+Y) | +0.28Y |
| **Konica Color QA Paper Type A5**<br>(Konica Color "Century Paper" or "Century Print")<br>(Konica Color "Long Life 100 Print")<br>[processed with Konica CPK-20QA (RA-4) chemicals and Konica Super Stabilizer in Konica washless minilab]<br>(1990—) (initially available only in Japan) | 275 (–Y) | >700 (C+Y) | +0.06Y |
| **Kodak Ektacolor Edge Paper**<br>**Kodak Ektacolor Royal II Paper**<br>**Kodak Ektacolor Supra Paper**<br>**Kodak Ektacolor Ultra Paper**<br>**Kodak Duraflex RA Print Material** [polyester]<br>("Ektacolor Print" and "Kodalux Print")<br>(1991— for Ektacolor Edge and Royal II)<br>(1989— for other papers) | 190 (–C) | 80 (C+Y) | +0.26Y |
| **Fujicolor Prof. Paper Super FA Type P**<br>(1991–93) (low-contrast professional portrait paper) | 155 (–C) | 315 (C+Y) | +0.07Y |

## Table 5.5b Comparative Dark Fading and Yellowish Staining of Current Process EP-2 Compatible Papers for Printing Color Negatives

Number of Days Required for a 20% Loss of the Least Stable Image Dye in Accelerated Dark Fading Tests at 144°F (62°C) and 45% RH

All of these papers were available at the time this book went to press in 1992. It is likely that many of these papers will have been discontinued by the end of 1994 in favor of faster-processing RA-4 compatible papers.

Initial neutral density of 1.0 with 1/2 d-min corrected densitometry.

| Type of Color Paper | Days for 20% Loss of Least Stable Image Dye | Days to Reach d-min Color Imbalance of 0.10 | Yellowish Stain (Blue Density) Increase After 180 Days |
|---|---|---|---|
| **Agfacolor Paper Type 8** [improved]<br>**Agfacolor Paper Type 8 ML** (for minilabs)<br>("Agfacolor Print")<br>[EP-2 process with water wash]<br>(1986—) | 360 (–Y) | 90 (C+Y) | +0.23Y |
| **Konica Color PC Paper Type SR**<br>**Konica Color PC Paper Prof. Type EX**<br>**Konica Color PC Paper Type SR (SG)** [polyester]<br>**Konica Color PC Paper Peelable Type SR**<br>(Konica Color "Century Paper")<br>(Konica Color "Century Print")<br>(Konica Color "Century ProPrint Type EX")<br>(Konica Color "Long Life 100 Print")<br>(Konica Color "Peerless Print")<br>(In Japan, Konica Type SR paper was originally called Sakuracolor PC Paper Type SR) [processed with "improved" Konica Super Stabilizer in Konica washless minilab]<br>(1984 [April]—for Type SR)<br>(1984 [July]—for Type SG)<br>(1987—for Type EX)<br>(1988—for Peelable Type SR) | 315 (–C) | 160 (C+Y) | +0.11Y |
| **Ilford Colorluxe Print Material**<br>[polyester base]<br>(IL.1K high-gloss polyester-base print material manufactured by Ilford in Switzerland using emulsion components supplied by Konica; the stability of the Ilford product is believed to be similar if not identical to Konica Type SR [SG] polyester-base print material)<br>[EP-2 process with water wash]<br>(1990—) | 300 (–C) | [tentative] | +0.28Y [tentative] |
| **Konica Color PC Paper Type SR**<br>**Konica Color PC Paper Prof. Type EX**<br>**Konica Color PC Paper Type SR (SG)** [polyester]<br>**Konica Color PC Paper Peelable Type SR**<br>(Konica Color "Century Paper")<br>(Konica Color "Century Print")<br>(Konica Color "Century ProPrint Type EX")<br>(Konica Color "Long Life 100 Print")<br>(Konica Color "Peerless Print")<br>(In Japan, Konica Type SR paper was originally called Sakuracolor PC Paper Type SR)<br>[EP-2 process with water wash]<br>(1984 [April]—for Type SR)<br>(1984 [July]—for Type SG)<br>(1987—for Type EX)<br>(1988—for Peelable Type SR) | 300 (–C) | 75 (C+Y) | +0.28Y |
| **Mitsubishi Color Paper KER Type 6000 Super**<br>**Mitsubishi Color Paper KER Type 8000 Pro**<br>(papers manufactured by Konica and are believed to be identical to Konica Type SR and EX papers)<br>[EP-2 process with water wash]<br>(1985—for Type 6000 Super)<br>(1989—for Type 8000 Pro) | 300 (–C) | 75 (C+Y) | +0.28Y |
| **Kodak Ektacolor Plus Paper**<br>**Kodak Ektacolor Plus Thin Paper**<br>**Kodak Ektacolor Professional Paper**<br>**Kodak Duraflex Print Material** [polyester]<br>("Ektacolor Print")<br>("Kodalux Print")<br>(formerly "Kodacolor Print")<br>[EP-2 process with water wash]<br>(1984 [August]—for Ektacolor Plus)<br>(1985—for Ektacolor Professional) | 230 (–C) | 75 (C+Y) | +0.25Y |

Table 5.5b (continued from previous page)

| Type of Color Paper | Days for 20% Loss of Least Stable Image Dye | Days to Reach d-min Color Imbalance of 0.10 | Yellowish Stain (Blue Density) Increase After 180 Days |
|---|---|---|---|
| **Fujicolor "Minilab Paper"** (Fujicolor Paper Type 03) ("Fujicolor Print") [processed with Fuji Stabilizer in Fuji washless minilab] (1988—) | 170 (–C) | 150 (C+Y) | +0.13Y |
| **Fujicolor Paper Type 03** **Fujicolor "Minilab Paper"** **Fujicolor Prof. Paper Type 02-P** **Fujicolor Paper Type 02-C** **Fujicolor HR Printing Material** [polyester] ("Fujicolor Print") [EP-2 process with water wash] (1988—) | 155 (–C) | 110 (C+Y) | +0.20Y |
| **Fujicolor Paper Type 12** **Fujicolor "Minilab Paper"** ("Fujicolor Print") [EP-2 process with water wash] (Type 12 paper is generally not available outside of Japan) (1985—) | 130 (–C) | 200 (C+Y) | +0.11Y |
| **Not Recommended:** | | | |
| **Kodak Ektacolor Plus Paper with KIS Ultra X Press processing chemicals** ("Ektacolor Print") [processed in KIS Magnum Pro Minilab with KIS Ultra X Press chemicals] (Ektacolor Plus paper processed in this manner has reduced light and dark fading stability compared with Ektacolor Plus processed with the standard EP-2 process.) | 105 (–C) | Data Not Available | Data Not Available |
| **Agfacolor Paper Type 8 with Agfa AP-95 processing chemicals** ("Agfacolor Print") [processed with Agfa AP-95 "rapid" process with AP-95SB Stabilizer in Agfa washless minilab] (Agfacolor Paper Type 8 processed in this manner has reduced light and dark fading stability compared with Type 8 paper processed with the standard EP-2 process and water wash.) | 105 (–Y) | 50 (C+Y) | +0.21Y |

# Table 5.5c   Comparative Dark Fading and Yellowish Staining of Discontinued Process EP-2, EP-3, and RA-4 Compatible Papers for Printing Color Negatives

**Number of Days Required for a 20% Loss of the Least Stable Image Dye in Accelerated Dark Fading Tests at 144°F (62°C) and 45% RH**

By the time this book went to press in 1992, these papers had been either discontinued or replaced with newer materials. Initial neutral density of 1.0 with 1/2 d-min corrected densitometry.

| Type of Color Paper | Days for 20% Loss of Least Stable Image Dye | Days to Reach d-min Color Imbalance of 0.10 | Yellowish Stain (Blue Density) Increase After 180 Days |
|---|---|---|---|
| Konica Color QA Paper Type A2 / Konica Color QA Paper Prof. Type X1 / Konica Color QA Super Glossy Print Material Type A2 [polyester] / Konica Color QA Paper Peelable Type A2 (Konica Color "Century Paper" or "Century Print") (Konica Color "Long Life 100 Print") [processed with Konica CPK-20QA (RA-4) chemicals with Konica Super Stabilizer in Konica washless minilab] (1988–92 for Type A2) (RA-4) (1990–92 for other papers) | 360 (–C) | 82 (C+Y) | +0.20Y |
| Mitsubishi Color Paper SA 2000 / Mitsubishi Color Paper SA 5000 Pro (Mitsubishi "Speed Access" Paper) (Mitsubishi "Rapid Access" Paper) [processed with Mitsubishi Speed Access chemicals in washless minilab] (papers are believed to be identical to Konica Color QA Type A2 and X1 papers) (initial type: 1989–92 for SA 2000) (RA-4) (initial type: 1990–92 for SA 5000) | 360 (–C) [tentative] | 82 (C+Y) [tentative] | +0.20Y [tentative] |
| Konica Color QA Paper Type A (Konica Color "Century Paper") (Konica Color "Century Print") (Konica Color "Long Life 100 Print") (initial type: 1988–89) (RA-4) | 360 (–C) | 82 (C+Y) | +0.20Y |
| Mitsubishi Color Paper KER Type 1000 SA (Mitsubishi "Speed Access" Paper) (Mitsubishi "Rapid Access" Paper) (paper is believed to be identical to Konica Color QA Paper Type A) (1988–89) (RA-4) | 360 (–C) [tentative] | 82 (C+Y) [tentative] | +0.20Y [tentative] |
| Ilford Colorluxe Print Material [polyester] (SP-729s high-gloss polyester-base print material manufactured by Ilford in Switzerland using emulsion components supplied by Konica; the stability of the Ilford product is believed to be similar if not identical to Konica Color QA Super Glossy Print Material Type A2.) (1990–91) (RA-4) | 360 (–C) [tentative] | 82 (C+Y) [tentative] | +0.20Y [tentative] |
| Mitsubishi Color Paper KER Type 7000 Pro (paper is believed to be identical to Konica Type EX paper) (1985–89) (EP-2) | 300 (–C) | 75 (C+Y) | +0.28Y |
| Fujicolor Paper FA ("Fujicolor Print") [processed with Fuji CP-40FA (RA-4) chemicals and CP-40FA Stabilizer] (1988–89) (RA-4) | 200 (–C) | 130 (C+Y) | +0.16Y |
| Kodak Ektacolor 2001 Paper / Kodak Ektacolor Portra Paper / Kodak Ektacolor Royal Paper ("Ektacolor Print") ("Kodalux Print") (formerly "Kodacolor Print") [Ektacolor 2001 paper processed with Kodak RA-4 chemicals and RA-4NP Stabilizer] (1986–91 for Ektacolor 2001) (RA-4) (1989–91 for Ektacolor Royal) (1989–92 for Ektacolor Portra) | 200 (–C) | 75 (C+Y) | +0.25Y |
| Agfacolor Paper Type 8 ("Agfacolor Print") [EP-2 process with water wash] (initial type: 1984 [October]–86) (EP-2) | 200 (–Y) | 65 (C+Y) | +0.27Y |

## Table 5.5c  (continued from previous page)

| Type of Color Paper | Days for 20% Loss of Least Stable Image Dye | Days to Reach d-min Color Imbalance of 0.10 | Yellowish Stain (Blue Density) Increase After 180 Days |
|---|---|---|---|
| Fujicolor Paper Super FA Type II / Fujicolor Supreme Paper / Fujicolor Professional Paper Super FA Type C / Fujiflex SFA Super-Gloss Printing Material [polyester] ("Fujicolor Print") [processed with Fuji CP-40FA (RA-4) chemicals and CP-40FA Stabilizer in Fuji washless minilab] (1990–92 for Super FA Type II and Supreme) (RA-4) (1991–92 for Super FA Type C, and Fujiflex SFA) | 190 (–C) | 315 (C+Y) | +0.07Y |
| Fujicolor Paper Super FA ("Fujicolor Print") [processed with Fuji CP-40FA (RA-4) chemicals and CP-40FA Stabilizer in Fuji washless minilab] (initial type: 1989–90) (RA-4) | 190 (–C) | 315 (C+Y) | +0.07Y |
| Fujicolor Paper Type 02 / Fujicolor Professional Paper Type 01-P / Fujicolor HR Printing Material [polyester] ("Fujicolor Print") [EP-2 process with water wash] (1985–88) (EP-2) | 155 (–C) | 110 (C+Y) | +0.20Y |
| Agfacolor Paper Type 8 [improved] ("Agfacolor Print") [Processed with "old type" Agfa AP-92SB Stabilizer; the "improved" AP-92SB Stabilizer introduced in 1988 avoids the reduction in yellow dye stability that resulted from the original AP-92SB Stabilizer. The dark fading stability of Type 8 paper is now probably similar to that of Agfacolor Type 9 paper listed in Table 5.1a.] (1986–89) (EP-2) | 120 (–Y) | 120 (C+Y) | +0.19Y |
| Fujicolor Paper Type 8901 ("Fujicolor Print") (1984–86) (EP-2) | 80 (–C) | 95 (C+Y) | +0.31Y |
| Kodak Ektacolor 74 RC Paper Type 2524 / Kodak Ektacolor 78 Paper Type 2524 ("Kodacolor Print") ("Ektacolor Print") [EP-3 Process with EP-3 Stabilizer] (1982–86) (EP-2 or EP-3) | 60 (–C) | 115 (C+Y) | +0.19Y |
| Fujicolor Paper Type 8908 (1980–84) (EP-2) | 55 (–C) | 60 (C+Y) | +0.30Y |
| Kodak Ektacolor 74 RC Paper ("Kodacolor Print") ("Ektacolor Print") [EP-3 Process with EP-3 Stabilizer] (initial type: 1977–82) (EP-2 or EP-3) | 52 (–C) | 110 (C+Y) | +0.18Y |
| Kodak Ektacolor 37 RC Paper Type 2261 ("Kodacolor Print") ("Ektacolor Print") [EP-3 Process with EP-3 Stabilizer] (1971–78) (EP-3) | 52 (–C) | 90 (C+Y) | +0.19Y |
| Konica Color (Sakuracolor) PC Paper SIII (1983–84) (EP-2) | 50 (–C) | 66 (C+Y) | +0.33Y |
| Sakuracolor PC Paper SII (1978–83) (EP-2) | 50 (–C) | 66 (C+Y) | +0.30Y |
| Agfacolor PE Paper Type 7i ("Agfacolor Print") (1984–85) (EP-2) | 50 (–C) | 30 (C+Y) | +0.24Y |
| Agfacolor PE Paper Type 589i / Agfacolor PE Paper Type 7 ("Agfacolor Print") (1983–85) (EP-2) | 45 (–C) | 52 (C+Y) | +0.30Y |
| Agfacolor PE Paper Type 589 ("Agfacolor Print") (1981–83) (EP-2) | 45 (–C) | 75 (C+Y) | +0.26Y |
| Kodak Ektacolor 74 Paper Type 2524 / Kodak Ektacolor 78 RC Paper Type 2524 ("Kodacolor Print") ("Ektacolor Print") [EP-2 process with water wash] (1982–86) (EP-2 or EP-3) | 36 (–C) | 98 (C+Y) | +0.28Y |
| Agfacolor PE Paper Type 5 ("Agfacolor Print") (1977–82) (Agfa AP-87) | 30 (–C) | 37 (C+Y) | +0.16Y |
| 3M Professional Color Paper Type 25 / 3M High Speed Color Paper 19 (1978–88; 3M ceased manufacture of color paper in 1988) (EP-2) | 27 (–C) | 22 (C+Y) | +0.34Y |
| Agfacolor PE Paper Type 4 ("Agfacolor Print") (this paper has extremely poor dark fading stability) (1974–82) (Agfa AP-85) | 6 (–C) | 125 (C+Y) | +0.13Y |

# Table 5.6 Comparative Dark Fading and Yellowish Staining of Silver Dye-Bleach; Chromogenic Reversal; Dye-Imbibition; and UltraStable, EverColor, and Polaroid Permanent Color Pigment Print Materials

**Number of Days Required for a 20% Loss of the Least Stable Image Dye or Pigment in Accelerated Dark Fading Tests at 144°F (62°C) and 45% RH**

**Test duration of up to 9 Years (3,285 Days)**

**Boldface Type** indicates products that were being marketed in the U.S. and/or other countries when this book went to press in 1992; the other products listed had been either discontinued or replaced with newer materials. Initial neutral density of 1.0 with 1/2 d-min corrected densitometry.

(T) = For printing color transparencies
(T+N) = For printing either color transparencies or negatives

| Type of Color Print Product | Days for 20% Loss of Least Stable Image Dye or Pigment | Days to Reach d-min Color Imbalance of 0.10 | Yellowish Stain (Blue Density) Increase After 180 Days |
|---|---|---|---|
| **UltraStable Permanent Color Prints** (T+N) [pigment color process] [polyester & fiber-base] (UltraStable Permanent Color Process) (improved yellow pigment type: 1993—) | >3,285 (—) [tentative] | >3,285 (—) [tentative] | +0.00Y |
| **Polaroid Permanent-Color Prints** **Ataraxia Studio Collectors Color Prints** (pigment color process) [polyester] (T+N) (Polaroid Permanent-Color Process) (1989—) | >3,285 (—) [tentative] | >3,285 (—) [tentative] | +0.00Y |
| **Fuji-Inax Photocera Color Photographs** (fired pigment color process) [ceramic] (T+N) (initially available only from Fujicolor Processing Service in Japan) (1991—) (Fuji-Inax Ceramic Color Process) | >3,285 (—) [tentative] | >3,285 (—) [tentative] | +0.00Y |
| **Ilford Ilfochrome Classic Prints** (T) **Ilford Ilfochrome Rapid Prints** **Fuji CB Prints** (material supplied by Ilford) Ilford Cibachrome II Prints Ilford Cibachrome-A II Prints [initial type] Ilford Cibachrome-A II Prints [improved type] Ilford Cibacopy Materials (P-3, P-3X, P-30, P-30P, P-22, and P-4) [polyester and RC] (Although Ilfochrome "Pearl" semi-gloss and glossy-surface RC prints have dye stability that is similar to Ilfochrome high-gloss polyester-base prints, the RC prints are subject to RC base cracking and light-induced image yellowing, and therefore are not recommended for long-term applications.) (1980–91 for Cibachrome II) (1981–89 for "initial type" Cibachrome-A II) (1989–91 for "improved type" Cibachrome-A II) (1991— for Ilfochrome Classic and Rapid) | >3,285 (—) | >3,285 (—) | +0.00Y |

(T) = For printing color transparencies
(T+N) = For printing either color transparencies or negatives

| Type of Color Print Product | Days for 20% Loss of Least Stable Image Dye or Pigment | Days to Reach d-min Color Imbalance of 0.10 | Yellowish Stain (Blue Density) Increase After 180 Days |
|---|---|---|---|
| **EverColor Pigment Prints** (T+N) [pigment color process] [polyester] (EverColor Pigment Color Print Process) (A high-stability version of the AgfaProof Process marketed by the EverColor Corp.) (1993—) | (new product – test data not available) | | |
| **Kodak Dye Transfer Prints** (T+N) (Kodak Film and Paper Dyes and fiber-base Kodak Dye Transfer Paper) (1946—, with minor modifications) | >3,285 (—) | >3,285 (—) | +0.02Y |
| **Fuji Dyecolor Prints** [fiber-base] (T+N) (dye transfer type process) (available only in Japan) (1970—) (Fuji Dyecolor process) | >3,285 (—) | >3,285 (—) | +0.02Y |
| Agfachrome-Speed Color Prints (T) (single-sheet dye-ciffusion process) (1983–85) (Agfachrome-Speed Process) | >3,285 (–M) | >3,285 (—) | +0.00Y |
| Kodak Dye Transfer Prints (T+N) (discontinued MX-1119 yellow dye available in the early 1980's) [fiber-base] | >3,285 (—) | 1,300 (C+Y) | +0.05Y |
| Kodak Dye Transfer Prints (T+N) [fiber-base] (high-stability Kodak MX-1372 yellow dye and No. 45203 Dye Transfer receiver paper with UV-absorbing overcoat trade-tested in 1988–89) (The paper and yellow dye proved difficult to work with and Kodak decided not to market the materials.) | >3,285 (—) | 150 (C+Y) | +0.13Y |
| Ilford Cibachrome-A Prints (T) [pigmented triacetate base] (1975–81) (P-12) | >1,460 (—) | >1,460 (—) | +0.04Y |

## Table 5.6 (continued from previous page)

| (T) = For printing color transparencies (T+N) = For printing either color transparencies or negatives — Type of Color Print Product | Days for 20% Loss of Least Stable Image Dye or Pigment | Days to Reach d-min Color Imbalance of 0.10 | Yellowish Stain (Blue Density) Increase After 180 Days |
|---|---|---|---|
| Agfachrome CU 410 Color Prints (T) [pigmented triacetate base] (Outstanding example of the silver dye-bleach process that was abandoned by Agfa.) (1970–73) (Agfachrome Process 60) | >1,460 (—) | >1,460 (—) | Data Not Available |
| Kodak Ektaflex PCT Color Prints (T+N) (dye-diffusion transfer process) (Kodak Ektaflex Process) (1981–88) | 1,050 (–M) | 300 (+M) | +0.07Y |
| **Fujichrome Paper Type 35** (T) **Fujichrome Copy Paper Type 35H Fujichrome Super-Gloss Printing Material** [glossy polyester base] ("Fujichrome Super Deluxe Prints") [polyester] (1992—) (R-3) | **370 (–C)** | **270 (C+Y)** | **+0.08Y** |
| Fujichrome Paper Type 34 (T) Fujichrome Copy Paper Type 34H Fujichrome Super-Gloss Printing Material [glossy polyester base] ("Fujichrome Super Deluxe Prints") [polyester] (1986–92) (R-3) | 370 (–C) | 270 (C+Y) | +0.08Y |
| **Konica Chrome Paper Type 81** (T) (1989—) (R-3) | (test data not available, but probably has light fading stability similar to that of Konica Color QA Paper Type A3) | | |
| **Kodak Ektachrome Radiance Paper** (T) **Kodak Ektachrome Radiance Select Material** [glossy polyester base] **Kodak Ektachrome Radiance HC Copy Paper Kodak Ektachrome Radiance Thin Copy Paper** (1991— for Radiance and Radiance Select) (1992— for Radiance HC and Thin Copy) (R-3) | **180 (–C)** | **140 (C+Y)** | **+0.16Y** |
| Kodak Ektachrome 22 Paper [improved] (T) (improved type: 1990–91) (R-3) | 170 (–C) | 110 (C+Y) | +0.20Y |
| Fujichrome Paper Type 33 (T) (1983–86) (R-3) | 85 (–C) | 90 (C+Y) | +0.20Y |
| Fujichrome Reversal Paper Type 31 (T) (1978–83) (R-100) | 85 (–C) | 75 (C+Y) | +0.28Y |
| **Agfachrome Paper CRN** [Type 63] (T) **Agfachrome High Gloss Material CRP** [glossy polyester base] **Agfachrome Copy Paper CRH** (1984–90 for initial types) (1990— for "improved" types) (R-3) | **63 (–C)** | **Data Not Available** | **Data Not Available** |
| Kodak Ektachrome RC Paper Type 1993 (T) (1972–79) (R-5) | 60 (–C) | 39 (C+Y) | +0.20Y |
| Kodak Ektachrome 14 Paper (T) (1981–85) (R-100) | 53 (–C) | Data Not Available | Data Not Available |
| Kodak Ektachrome 2203 Paper (T) (1978–84) (R-100) | 42 (–C) | 120 (C+Y) | +0.12Y |
| Agfachrome Reversal Paper CU 310 (T) (1979–84) (R-100) | 35 (–C) | Data Not Available | Data Not Available |
| **Kodak Ektachrome Copy Paper** (T) Kodak Ektachrome HC Copy Paper Kodak Ektachrome Thin Paper Kodak Ektachrome 22 Paper [initial type] Kodak Ektachrome Prestige Paper [polyester] (Not recommended: these Ektachrome papers have very poor dark fading stability compared with Fujichrome, Konica Chrome, and Agfachrome Process R-3 compatible reversal papers.) (1984–90 for initial type of Ektachrome 22) (1986–1991 for Ektachrome Prestige) (1984–92 for Ektachrome HC Copy and Thin) (1984— for Ektachrome Copy) (R-3) | **28 (–C)** | **72 (C+Y)** | **+0.26Y** |

## Table 5.7　Comparative Dark Fading and Yellowish Staining of Polaroid, Fuji, and Kodak Instant Color Prints; Canon and Kodak Digital Copier/Printer Color Prints; Color Offset Printing; Mead Cycolor Prints; and Thermal Dye Transfer and Ink Jet Color Prints for Digitized Pictorial Images and Computer-Generated Images

### Number of Days Required for a 20% Loss of the Least Stable Image Dye in Accelerated Dark Fading Tests at 144°F (62°C) and 45% RH

Test duration of up to 6 years (2,190 days).

**Boldface Type** indicates products that were being marketed in the U.S. and/or other countries when this book went to press in 1992; the other products listed had been either discontinued or replaced with newer materials. After losing a patent infringement suit initiated by Polaroid, Kodak was forced to abandon the instant photography field in 1986. Initial neutral density of 1.0 with 1/2 d-min corrected densitometry.

| Type of Color Print Product | Days for 20% Loss of Least Stable Image Dye | Days to Reach d-min Color Imbalance of 0.10 | Yellowish Stain (Blue Density) Increase After 180 Days |
|---|---|---|---|
| 3M Electrocolor Prints (T+N) [continuous-tone, liquid-toner electrophotographic color process] (Abandoned by 3M, this was an outstanding example of the liquid-toner color electrophotographic process.) (1965–66) (3M Company, St. Paul, Minnesota) | >2,190 (—) | >2,190 (—) | +0.03Y |
| 4-Color Offset Printed Images [screened, photomechanical prints] (Cyan, magenta, yellow, and black 4-color process inks typical of those used in color offset printing of books and magazines; samples printed in 1990.) | >2,190 (—) [estimated] | >2,190 (C+Y) [estimated] | +0.02Y |
| **Polaroid Polacolor ER Prints (Types 59; 559; 669; and 809)** [continuous-tone instant photographic prints] (1980—) (peel-apart prints) | >2,190 (—) | 57 (C+Y)* | +0.15Y* |
| **Polaroid Polacolor 64T Prints** **Polaroid Polacolor 100 Prints** **Polaroid Polacolor Pro 100 Prints** [continuous-tone instant photographic prints] (1992/93—) (peel-apart prints) | >2,190 (—) [estimated] | 57 (C+Y)* [estimated] | +0.15Y* [estimated] |
| **Polacolor 2 Prints (Types 88; 108; 668; 58; and 808)** [continuous-tone instant photographic prints] (The images of Polacolor 2 prints suffer a yellowish color shift that may become objectionable after only a few years of dark storage under normal conditions; because of this, Polacolor 2 prints are not recommended for fine art or other critical applications.) (1975—) (peel-apart prints) | >2,190 (—) | 30 (M+Y)* | +0.20Y* |
| Kodak Trimprint Instant Color Prints [continuous-tone instant photographic prints] (separated from backing) (1983–86) | >2,190 (—) | 220 (C+Y) | +0.09Y |
| Kodak Trimprint Instant Color Prints [continuous-tone instant photographic prints] (not separated from backing) (1983–86) | >2,190 (—) | 48 (C+Y) | +0.13Y |
| Polaroid SX-70 Prints [improved] [continuous-tone instant photographic prints] (1976–79) | >2,190 (—) | (see text for discussion) | |
| **Polaroid SX-70 Time-Zero Prints** **Polaroid Type 778 Time-Zero Prints** [continuous-tone instant photographic prints] (Because of high levels of yellowish stain that form over time in normal dark storage, Polaroid SX-70 Time-Zero and Type 778 prints are not recommended for other than short-term applications.) (improved type: 1980—) | >2,190 (—) | (see text for discussion) | |
| **Polaroid High Speed Type 779 Prints** **Polaroid Autofilm Type 339 Prints** Polaroid 600 High Speed Prints [continuous-tone instant photographic prints] (Because of high levels of yellowish stain that form over time in normal dark storage, Polaroid Type 779 and Type 339 prints are not recommended for other than short-term applications.) (1981–88 for Polaroid 600) (1981— for other prints) | >2,190 (—) | (see text for discussion) | |

## Table 5.7 (continued from previous page)

| Type of Color Print Product | Days for 20% Loss of Least Stable Image Dye | Days to Reach d-min Color Imbalance of 0.10 | Yellowish Stain (Blue Density) Increase After 180 Days |
|---|---|---|---|
| **Iris Ink Jet Color Prints** [scanned, electronically produced prints] (Ink jet color prints made on 100% cotton fiber paper with Iris Graphics, Inc. 3047 printer using the "Standard" Iris ink set; test prints made in 1992.) | **>1,095 (—)** [estimated] | **>1,095 (C+Y)** [estimated] | **+0.01Y** |
| **Stork Ink Jet Color Prints** [scanned, electronically produced prints] (Ink jet prints made with a Stork Bedford B.V. ink jet printer using both the "Standard" and "Reactive Dyes" ink sets; prints made in 1992.) | **>1,095 (—)** [estimated] | **>1,095 (C+Y)** [estimated] | **+0.01Y** [estimated] |
| **Polaroid 600 Plus Prints** / **Polaroid Autofilm Type 330 Prints** / **Polaroid Type 990 Prints** / Polaroid Spectra Prints / Polaroid Image Prints (Spectra name in Europe) [continuous-tone instant photographic prints] (Because of high levels of yellowish stain that form over time in normal dark storage, Polaroid Spectra prints, 600 Plus prints, and other Polaroid products using the Spectra emulsion are not recommended for other than short-term applications.) (1986–91 for Spectra prints) (1988— for other prints) | **>1,095 (—)** | **(see text for discussion)** | |
| **Polaroid Spectra HD Prints** (Spectra in Europe) [tentative] / **Polaroid Image Prints** (Spectra in Europe) [continuous-tone instant photographic prints] (Because of high levels of yellowish stain that form over time in normal dark storage, Polaroid Spectra HD prints, Image prints and other Polaroid products using the Spectra HD emulsion are not recommended for other than short-term applications.) (1992—) | **>1,095 (—)** [tentative] | **(see text for discussion)** | |
| **Polaroid Vision 95 Prints** (in Europe) / **Polaroid " ? " 95 Prints** (name in Asia) [tentative] / **Polaroid " ? " 95 Prints** (name in North & South America) [continuous-tone instant photographic prints] (The internal structure of Vision 95 prints is basically the same as that of Spectra HD and 600 Plus prints; however, the rate of formation of yellowish stain that occurs over time in dark storage is said by Polaroid to be "somewhat reduced" compared with that of Spectra HD and 600 Plus prints. The names Polaroid will use for Vision 95 products in non-European markets were not available at the time this book went to press.) (1992— for Vision 95 products sold in Germany) (1993— for Asia, North and South America, and other markets) | **>1,095 (—)** | **(see text for discussion)** | |
| Kodak Kodamatic Instant Color Prints [continuous-tone instant photographic prints] (1982–86) | 1,400 (–M) | 36 (C+Y) | +0.14Y |
| **Canon Color Laser Copier Prints** [scanned, electronically produced prints] (Xerographic plain-paper digital color copier/printer; test prints made in 1989.) | **>730 (—)** | **>730 (C+Y)** | **+0.03Y** |
| **Kodak ColorEdge Copier Prints** [scanned, electronically produced prints] (Xerographic plain-paper digital color copier/printer; test prints made in 1992.) | **>730 (—)** [estimated] | **>730 (C+Y)** [estimated] | **+0.03Y** [estimated] |
| **Polaroid Polacolor Prints** [initial type] [continuous-tone instant photographic prints] (1963–75) (peel-apart prints) | >500 (—) | >500 (C+Y) | +0.03Y |
| **Mead Cycolor Prints** [continuous-tone instant photographic prints] (Mead Imaging Corporation microencapsulated acrylate image color prints made with a Noritsu QPS-101 Cycolor Slideprinter; test prints made in 1988.) (1988—) | **>500 (—)** | **500 (C+Y)** | **+0.06Y** |
| **Fuji 800 Instant Color Prints** [continuous-tone instant photographic prints] (1984—) (available only in Japan) | **470 (–M)** | **55 (C+Y)** | **+0.20Y** |
| **Fuji FI-10 Instant Color Prints** [continuous-tone instant photographic prints] (1981—) (available only in Japan) | **300 (–M)** | **160 (M+Y)** | **+0.19Y** |
| **Kodak PR10 Instant Color Prints** [continuous-tone instant photographic prints] (initial type: 1976–79) | 250 (–M) | 90 (C+Y) | +0.14Y |
| **Kodak Ektatherm Color Prints*** [scanned, electronically produced prints] (Thermal dye transfer color prints made with Kodak XL 7700 Digital Printer; test prints made in 1992.) | **65 (–C)** | **80 (C+Y)** | **+0.21Y** |
| **Sony Mavigraph Still Video Prints*** [scanned, electronically produced prints] (Thermal dye transfer prints made with Sony UP-5000 ProMavica Color Video Printer; test prints made in 1989.) | **6 (–C)** | **Data Not Available** | **Data Not Available** |

* **Note:** Heat-accelerated dark fading tests may not give a meaningful indication of the long-term stability of thermal dye transfer prints of this type — see text.

# Table 5.8a Comparative Dark Fading Stability of Current Color Negative Films

## Number of Days Required for a 20% Loss of the Least Stable Image Dye in Accelerated Dark Fading Tests at 144°F (62°C) and 45% RH

These films, which were available in the U.S. and/or other countries when this book went to press in 1992, are all compatible with Kodak Process C-41. Dye losses measured from an initial neutral density of 1.0 above d-min with full d-min corrected densitometry.

| Type of Color Negative Film | Days for 20% Loss of Least Stable Image Dye |
|---|---|
| **Kodak Vericolor III Professional Film, Type S** (1983—) <br> **Kodak Ektacolor Gold 160 Professional Film** (1986—) <br> **Kodak Ektacolor GPF 160 Professional Film** (1991—) <br> (In the U.S., Ektacolor GPF is sold only in 8-exposure 35mm rolls) | 215 (–Y) |
| **Kodak Vericolor 400 Professional Film** <br> **Kodak Ektacolor Gold 400 Professional Film** (1988—) | 200 (–Y) |
| **Kodak Ektapress Gold 1600 Professional Film** (1988—) <br> **Kodak Ektar 1000 Film** (1988—) <br> **Kodak Gold 1600 Film** (1991—) | 200 (–Y) |
| **Konica Color SR-G 3200 Professional Film** <br> **Konica Color GX3200 Professional Film** (1989—) | 180 (–C) |
| **Konica Color Super SR 400 Film** <br> **Konica Color Super DD 400 Film** <br> **Konica Color XG400 Film** <br> **Polaroid HighDefinition 400 Color Print Film** (Polaroid HighDefinition 400 film is made by Konica in Japan; it was introduced in Europe in 1990, and in the U.S. in 1992.) (1990—) (1992— for XG400 film, which is sold in Japan) | 180 (–C) [tentative] |
| **Kodak Ektapress Gold 400 Professional Film** (1988—) | 175 (–Y) |
| **Kodak Gold Plus 400 Film** (1992—) <br> **Kodak Gold II 400 Film** (name in Europe) | 175 (–Y) |
| **3M ScotchColor 100 Film** (Although this film is labeled by 3M as "Made in U.S.A.," it is actually manufactured in Italy by a subsidiary of the 3M Company, St. Paul, Minnesota.) (improved type: 1990—) | 145 (–Y) |
| **3M ScotchColor 200 Film** <br> **Polaroid OneFilm Color Print Film** (ISO 200) (Although these films are labeled by 3M and Polaroid as "Made in U.S.A.", they are actually manufactured in Italy by a subsidiary of the 3M Company, St. Paul, Minnesota.) (improved type: 1990—) | 145 (–Y) [tentative] |
| **3M ScotchColor 400 Film** (Although this film is labeled by 3M as "Made in U.S.A.," it is actually manufactured in Italy by a subsidiary of the 3M Company.) (improved type: 1991—) | 145 (–Y) [tentative] |
| **Konica Color Super SR 200 Film** (U.S.A. market only) <br> **Konica Color Super SR 200 Professional Film** (1990—) | 140 (–Y) [tentative] |
| **Kodak Ektar 100 Film** (1991—) | 130 (–Y) |
| **Fujicolor Super G 100 Film** <br> **Fujicolor Super G 200 Film** <br> **Fujicolor Super G 400 Film** (1992—) | 130 (–Y) [tentative] |
| **Fujicolor Super HG 100 Film** <br> **Fujicolor Super HG 200 Film** <br> **Fujicolor Super HG 400 Film** <br> **Fujicolor Super HG 1600 Film** (1989–92 for Super HG 200 and 400) (1990–92 for Super HG 100) (1990— for Super HG 1600) | 130 (–Y) |
| **Fujicolor HG 400 Professional Film** (1991—) | 130 (–Y) [tentative] |
| **Konica Color Impresa 50 Professional Film** (1991—) | 110 (–Y) [tentative] |
| **Konica Color Super SR 100 and Super DD 100 Films** <br> **Konica Color Super SR 200 Film** <br> **Konica Color Super DD 200 Professional Film** <br> **Polaroid HighDefinition 100 and 200 Color Print Films** (Polaroid HighDefinition 100 and 200 films are made by Konica in Japan; they were introduced in Europe in 1990, and in the U.S. in 1992.) (1990—) | 110 (–Y) [tentative] |
| **Kodak Kodacolor VR 100, VR 200, and VR 400 Films** (Kodacolor VR films are still manufactured by Kodak in Europe and are sold worldwide.) (1983—) | 110 (–Y) |

**Table 5.8a  (continued from previous page)**

| Type of Color Negative Film | Days for 20% Loss of Least Stable Image Dye |
|---|---|
| **Agfacolor XRC and XRG 400 Films** (1988—) **Agfacolor XRS 400 Professional Film** (1989—) | 100 (–Y) |
| **Fujicolor 160 Professional Film S** **Fujicolor 160 Professional Film L** (1985—) | 90 (–Y) |
| **Kodak Ektar 25 Film** (1988—) **Kodak Ektar 25 Professional Film** (1989—) | 90 (–Y) |
| **Fujicolor Reala Film (ISO 100)** (1989—) | 85 (–Y) |
| **Kodak Ektapress Gold 100 Professional Film** (1988—) | 85 (–Y) |
| **Kodak Gold Plus 100 Film** **Kodak Gold II 100 Film** (name in Europe) (1992—) | 85 (–Y) [tentative] |
| **Kodak Gold Plus 200 Film** **Kodak Gold II 200 Film** (name in Europe) (1992—) | 85 (–Y) [tentative] |
| **Kodak Vericolor HC Professional Film** (1987—) | 85 (–Y) |

| Type of Color Negative Film | Days for 20% Loss of Least Stable Image Dye |
|---|---|
| **Agfacolor XRC and XRG 100 Films** (1988—) | 75 (–Y) |
| **Agfacolor XRS 100 Professional Film** **Agfacolor XRS 200 Professional Film** (1989—) | 75 (–Y) |
| **Agfacolor Ultra 50 Professional Film** **Agfacolor Optima 125 Professional Film** **Agfacolor Portrait 160 Professional Film** (1990—) | 75 (–Y) [tentative] |
| **Agfacolor Optima 200 Professional Film** (1992—) | 75 (–Y) [tentative] |
| **Agfacolor XRC and XRG 200 Film** (improved type: 1992—) | 75 (–Y) [tentative] |
| **Agfacolor XRS 1000 Professional Film** (1984—) | 45 (–C) |
| **Kodak Vericolor II Professional Film, Type L** (1974—) | 30 (–C) |

# Table 5.8b  Comparative Dark Fading Stability of Discontinued Color Negative Films

### Number of Days Required for a 20% Loss of the Least Stable Image Dye in Accelerated Dark Fading Tests at 144°F (62°C) and 45% RH

All films are compatible with Kodak Process C-41 unless otherwise noted.
Dye losses measured from an initial neutral density of 1.0 above d-min with full d-min corrected densitometry.

| Type of Color Negative Film | Days for 20% Loss of Least Stable Image Dye |
|---|---|
| Kodak Kodacolor Gold 1600 Film (1989–91) | 200 (–Y) |
| Konica Color SR-V 3200 Professional Film (1987–89) | 180 (–C) |
| Konica Color SR-V 400 Film / Konica Color GX400 Film (1987–89) | 180 (–C) |
| Konica Color SR-G 400 Film / Konica Color GX400 Film (1986–89) | 180 (–C) [tentative] |
| Polaroid HighDefinition 400 Colour Print Film (Polaroid HighDefinition 400 film was made by Konica in Japan and was marketed in Europe and Australia.) (1989–90) | 175 (–Y) [tentative] |
| Kodacolor Gold 400 Film ("Improved") (1991–92) | 175 (–Y) |
| Kodacolor Gold 400 Film ("Improved") (formerly Kodacolor VR-G 400 Film) (1987–89) | 175 (–Y) |
| Kodacolor VR-G 400 Film / Kodacolor Gold 400 Film (Kodacolor VR-G 400 was introduced in January 1986, and then almost immediately withdrawn; a new version was introduced in September 1987.) (initial type: 1986–87) | |
| Konica Color SR-G 200 Film / Konica Color GX200 Film / Konica Color GX200 Professional Film | 140 (–Y) |
| Polaroid HighDefinition 200 Colour Print Film (Polaroid HighDefinition 200 film was made by Konica in Japan and was marketed in Europe and Australia.) (1989–90) | |
| Konica Color and Sakuracolor SR-V 100 Film / Konica Color SR-V 200 Film / Konica Color GX200 Professional Film (initial type: 1986–90) | |
| Kodak Ektar 125 Film (1989–91) | 130 (–Y) |
| Fujicolor Super HRII 100 Film / Fujicolor Super HRII 1600 Film (1989–90) | 120 (–Y) |
| Fujicolor Super HR 100 Film / Fujicolor Super HR 200 Film / Fujicolor Super HR 400 Film / Fujicolor Super HR 1600 Film (1986–89) | 115 (–Y) |
| Konica Color SR-V 100 Film (improved type: 1987–89) | 115 (–C) |
| Konica Color SR 200 Film / Sakuracolor SR 200 Film (initial type: 1983–86) | 115 (–C) |
| Konica Color SR-G 100 Film / Konica Color GXII 100 Film | 110 (–Y) |
| Polaroid HighDefinition 100 Colour Print Film (Polaroid HighDefinition 100 film was made by Konica in Japan and was marketed in Europe and Australia.) (1989–90) | |
| Kodacolor VR 1000 Film (1984–89) | 105 (–Y) |
| Kodak Gold 100 Film (1991–92) / Kodak Kodacolor Gold 100 Film (1986–91) (formerly Kodacolor VR-G 100 Film) | 85 (–Y) |
| Kodak Gold 200 Film (1991–92) / Kodak Kodacolor Gold 200 Film (1986–91) (formerly Kodacolor VR-G 200 Film) | 85 (–Y) |
| Agfacolor XRC and XRG 200 Films (initial type: 1989–92) | 75 (–Y) |

## Table 5.8b (continued from previous page)

| Type of Color Negative Film | Days for 20% Loss of Least Stable Image Dye | Type of Color Negative Film | Days for 20% Loss of Least Stable Image Dye |
|---|---|---|---|
| **Discontinued Films with Comparatively Poor Stability** (listed in alphabetical order) | | **Discontinued Films with Comparatively Poor Stability** (listed in alphabetical order) | |
| Agfacolor XRS 100 Professional Film<br>Agfacolor XR 100 Film<br>Agfacolor XR 200 Film<br>Agfacolor XRS 200 Professional Film<br>Agfacolor XRS 400 Professional Film<br>(1983–89) | | Konica Color SR 100 Film<br>Konica Color SR 200 Film<br>Konica Color SR 400 Film<br>Konica Color SR 1600 Film<br>(same for equivalent Sakuracolor films)<br>(1984–87) | |
| Fujicolor HR 100 Film<br>Fujicolor HR 200 Film<br>Fujicolor HR 400 Film<br>Fujicolor HR 1600 Film<br>(1983–86) | | Konica Color SR Professional Film Type S<br>Sakuracolor SR Professional Film Type S<br>(1985–89) | |
| Fujicolor F-II Film (1974–83)<br>Fujicolor F-II 400 Film (1976–83) | | Polaroid Supercolor 100 Print Film<br>(Initial type of Polaroid Supercolor film made by Agfa and sold in Spain and Portugal beginning in 1987.)<br>(1987–89) | |
| Ilford Ilfocolor HR 100 Film<br>Ilford Ilfocolor HR 200 Film<br>Ilford Ilfocolor HR 400 Film<br>(Ilfocolor films made by Agfa were marketed from March 1987 to May 1988.)<br>(same as Agfacolor XR films) | **All films in this group:** 30 to 60 days  (–C) | 3M Scotch HR 100 Film<br>(Although this film was labeled by 3M as "Made in U.S.A.," it was actually manufactured in Italy by a subsidiary of the 3M Company, St. Paul, Minnesota.)<br>(initial type: 1986–90) | **All films in this group:** 30 to 60 days  (–C) |
| Kodacolor 400 Film (1977–84)<br>Kodacolor II Film (1972–84)<br>Kodacolor-X Film (1963–74) (Process C-22) | | 3M ScotchColor 200 Film<br>3M Scotch HR 200 Color Print Film<br>Polaroid OneFilm Color Print Film (ISO 200)<br>(Although these films were labeled by 3M and Polaroid as "Made in U.S.A.," they were actually manufactured in Italy by a subsidiary of the 3M Company, St. Paul, Minnesota.)<br>(initial type: 1986/89–90) | |
| Kodak Ektacolor Professional Film, Type S (1956–63) (Process C-22)<br>Kodak Vericolor II Professional Film, Type S (1974–83)<br>Kodak Vericolor Commercial Film, Type S (1979–86) | | 3M ScotchColor 400 Film<br>3M Scotch HR 400 Color Print Film<br>(Although these films were labeled by 3M as "Made in U.S.A.," they were actually manufactured in Italy by a subsidiary of the 3M Company, St. Paul, Minnesota.)<br>(1986–91) | |

## Table 5.9   Comparative Dark Fading and Yellowish Staining of Color Transparency Films

**Number of Days Required for a 20% Loss of the Least Stable Image Dye in Accelerated Dark Fading Tests at 144°F (62°C) and 45% RH**

**Test Duration of Up to 7 Years (2,555 Days)**

**Boldface Type** indicates products that were being marketed in the U.S. and/or other countries when this book went to press in 1992; the other products listed had been either discontinued or replaced with newer materials. Initial neutral density of 1.0 with full d-min corrected densitometry.

| Type of Color Film | Days for 20% Loss of Least Stable Image Dye | Days to Reach d-min Color Imbalance of 0.10 | Yellowish Stain (Blue Density) Increase After 180 Days |
|---|---|---|---|
| **Kodachrome 25, 64, and 200 professional and amateur films; Kodachrome 40 Type A Film** (1974—) (K-14) | **580 (-Y)** | **>1,200 (—)** | **+0.00Y** |
| Kodachrome II and Kodachrome-X films Kodachrome II Professional Type A Film (1961-74) (K-12) | 320 (-Y) | >1,200 (—) | +0.00Y |
| **Kodak Ektachrome 64T and 320T, "Plus" and "X" professional films, and Ektachrome "HC" amateur films** (64X and 64T; 1991—; 100X: 1990—; 400X: 1992—; 100 Plus and HC: 1988—; 50 HC: 1990—; 400 HC and 320T: 1992—) (E-6) | **225 (-C)** | **60 (C+Y)** | **+0.28Y** |
| **Kodak Ektachrome professional and amateur films, and Ektachrome duplicating films** (not including the "Group II" 64T and 320T, "Plus," "HC," and "X" films listed above) (1976—) (E-6) | **210 (-C)** | **80 (C+Y)** | **+0.19Y** |
| **Fujichrome professional and amateur films, and Fujichrome duplicating films** (not including Fujichrome Velvia Prof. Film) (initial types: 1983-88/89) (E-6) (improved types: 1988/89/92—) | **185 (-C)** | **45 (C+Y)** | **+0.24Y** |
| **Polaroid Professional Chrome Film 64T and 100D films** (These 4x5-inch format films are made for Polaroid by Fuji in Japan.) (1987—) (E-6) | **185 (-C)** | **45 (C+Y)** | **+0.24Y** |
| Fujichrome 100 and 400 films (initial types: 1978-84) (E-6) | 185 (-C) | 50 (C+Y) | +0.26Y |
| GAF 64, 200, and 500 Color Slide films (1969-77) (GAF Process AR-1) | 180 (-Y) | 365 (C+Y) | +0.07Y |
| Agfachrome 64 and 100 films (Agfa Process AP-41) (1976-83) | 180 (-Y) | >600 (C+Y) | +0.02Y |
| **Konica Chrome R-50, R-100, R-200, and R-1000 professional films** (1990—) (E-6) | (Data Not Available) | | |
| **Konica Chrome RD100 Color Reversal Film Polaroid HighDefinition 100 Chrome Film** (Polaroid HighDefinition 100 Chrome Film is made for Polaroid by Konica in Japan and is marketed in Europe and Australia.) (1986/89—) (E-6) | (Data Not Available) | | |
| **Agfachrome RS 50 Plus and RS 100 Plus Professional films and Agfachrome CT 100 Plus Film** (1992—) (E-6) | **140 (-Y)** [tentative] | **150 (C+Y)** [tentative] | **+0.10Y** [tentative] |
| Agfachrome RS 50 and RS 100 Professional films and Agfachrome CT 100 Film (improved types: 1988-92) (E-6) | 140 (-Y) | 150 (C+Y) | +0.10Y |
| **Agfachrome RS 200 Professional and Agfachrome CT 200 films** (improved types: 1988—) (E-6) | **140 (-Y)** | **150 (C+Y)** | **+0.10Y** |
| Agfachrome RS 200 Professional and Agfachrome CT 200 films (initial types: 1983-85) (E-6) | 140 (-Y) | 24 (C+Y) | +0.31Y |
| **Fujichrome Velvia Professional Film** (1990—) (ISO 50) (E-6) | **135 (-Y)** | **90 (C+Y)** | **+0.14Y** |

## Table 5.9 (continued from previous page)

| Type of Color Film | Days for 20% Loss of Least Stable Image Dye | Days to Reach d-min Color Imbalance of 0.10 | Yellowish Stain (Blue Density) Increase After 180 Days |
|---|---|---|---|
| Kodak Ektachrome-X Film<br>Kodak High Speed Ektachrome Film<br>Kodak High Speed Ektachrome Film Type B (Tungsten) (1963–77) (E-4) | 120 (–C) | 90 (C+Y) | +0.16Y |
| **3M ScotchChrome 100, 400, 800/3200, and 640T films**<br>**Polaroid Presentation Chrome Film** (100) (1988— ) (E-6)<br>3M Scotch 640T Color Slide Film (1981–89)<br>(Polaroid Presentation Chrome Film is made for Polaroid by the 3M Company) (although these films are labeled by 3M and Polaroid as "Made in U.S.A.," they are actually manufactured in Italy by a 3M subsidiary.) | **95 (–C)** | **70 (C+Y)** | **+0.21Y** |
| **Polaroid PolaChrome Instant Slide Film**<br>(Because of very poor stability in humid storage conditions and formation of severe, irregular stain during projection, this film is not recommended for other than short-term applications.)<br>(1983— ) (Polaroid instant process) | **90 (–C)** | **80 (C+Y)** | **+0.14Y** |
| **Agfachrome RS 1000 Prof. Film**<br>Agfachrome RS 50 Prof. Film<br>Agfachrome RS 100 Prof. and CT Films (1984–88) (E-6) | **75 (–Y)** | **210 (C+Y)** | **+0.07Y** |
| Ilford Ilfochrome 50 Color Slide Film<br>Ilford Ilfochrome 100 Color Slide Film<br>(Ilfochrome slide films made by Agfa were marketed in 1987–88.) (E-6)<br>Polaroid Superchrome 100 Slide Film<br>(Initial type of Polaroid Superchrome film made by Agfa and sold in Spain and Portugal in 1987–88.) (E-6) | 75 (–Y) | 210 (C+Y) | +0.07Y |

| Type of Color Film | Days for 20% Loss of Least Stable Image Dye | Days to Reach d-min Color Imbalance of 0.10 | Yellowish Stain (Blue Density) Increase After 180 Days |
|---|---|---|---|
| Agfachrome 200 Professional Film (initial type: 1982–84) (E-6) | 70 (–C) | 12 (C+Y) | +0.53Y |
| Fujichrome R-100 Film (1968–73) (E-4) | 55 (–C) | 50 (C+Y) | +0.18Y |
| **3M ScotchChrome 1000 Film** (1988— )<br>3M Scotch 1000 Color Slide Film (1983–88)<br>3M Scotch 100 Color Slide Film (1984–88)<br>3M CRT 100 Color Slide Film (1985–88)<br>Polaroid Presentation Chrome 35mm Film (1985–88) (E-6)<br>(Although these films were labeled by 3M and Polaroid as "Made in U.S.A.," they were actually manufactured in Italy by a 3M subsidiary.) | **45 (–C)** | **140 (C+Y)** | **+0.09Y** |
| Kodak Ektachrome Professional films (sheet and 120 roll films) (1959–77) (E-3) | 13 (–C) | 25 (C+Y) | +0.28Y |
| **Color Microfilm** | | | |
| **Ilford Ilfochrome Micrographic Film, Type M and Type P**<br>(called Ilford Cibachrome Micrographic Film, 1984–91)<br>(1984— ) (Ilfochrome Process P-5) | **>2,555 (—)** | **>2,555 (—)** | **+0.01Y** |

# Table 5.10 Predicted Dark Fading Stability of Agfa Color Print Materials, Color Negatives, and Transparencies (from Data Supplied by Agfa-Gevaert and Based on Arrhenius Accelerated Dark Fading Tests)

**Estimated Storage Time for a 20% Loss of the Least Stable Image Dye for Storage in the Dark at 75°F (24°C)**

(Note: Predictions Are for Storage at 40% RH)

**Boldface Type** indicates products that were being marketed in the U.S., Germany, and/or other countries when this book went to press in 1992; the other products listed had been either discontinued or replaced with newer materials. These estimates are based on initial cyan, magenta, and yellow densities of 1.0 with full d-min corrected densitometry. These estimates are for dye fading only and do not take into account the gradual formation of yellowish stain. With print materials in particular (e.g., Agfacolor Type 8 and Type 9 papers), the level of stain may become objectionable before the least stable image dye has faded 20%.

(N) = For printing color negatives
(T) = For printing color transparencies

| Color Papers and Display Films: | Estimated Years of Dark Storage for 20% Loss of Least Stable Dye |
|---|---|
| **Agfacolor Paper Type 9** (N) (RA-4 compatible paper processed with Agfa AP-94 chemicals and Agfa AP-94SB Stabilizer in Agfa "washless" minilab) (1988—) | **120** (–Y) [tentative] |
| **Agfacolor Paper Type 9** (N) (RA-4 compatible paper processed with Agfa AP-94 chemicals and water wash) (1988—) | **120** (–Y) [tentative] |
| **Agfacolor Paper Type 9i** [improved] (RA-4) (N) (RA-4 compatible paper processed with Agfa AP-94 chemicals and water wash) (1992—) | (not disclosed) |
| **Agfacolor Paper Type 8** [improved] (EP-2) (N) (processed with Agfa AP-92 [EP-2] chemicals and water wash) (1986—) | **120** (–Y) |
| **Agfacolor Paper Type 8** [improved] (EP-2) (N) (processed with Agfa AP-92 [EP-2] chemicals and "improved" Agfa AP-92SB Stabilizer in Agfa "washless" minilab) (1986—) | **120** (–Y)* |
| **Agfacolor Paper Type 8** [improved] (EP-2) (N) (processed in Agfa AP-95 rapid-process chemicals with "improved" Agfa AP-95SB Stabilizer in Agfa "washless" minilab) (1992—) | (not disclosed) |
| Agfacolor Paper Type 8 (EP-2) (N) (initial type: 1984) | 120 (–Y) |
| **Agfatrans and Agfaclear Display Films** (EP-2) (N) (1989—) | **120** (–Y) |

(N) = For printing color negatives
(T) = For printing color transparencies

| Color Papers and Display Films: | Estimated Years of Dark Storage for 20% Loss of Least Stable Dye |
|---|---|
| **Agfachrome Paper CRN** [Type 63] (R-3) (T) | **85** (–C) |
| **Agfachrome High Gloss Material CRP** [polyester] | |
| **Agfachrome Copy Paper CRH** | |
| **Agfachrome Overhead Film CRF** (1990—) | |
| Agfachrome Reversal Paper Type 63 (R-3) (T) | 85 (–C) |
| Agfachrome CR 410 High-Gloss Reversal Material [polyester] | |
| Agfachrome Reversal Copy Paper | |
| Agfachrome Overhead CRF Reversal Material (1984–90) | |
| **Process C-41 Compatible Color Negative Films:** | |
| **Agfacolor Ultra 50 Professional Film** | (not disclosed) |
| **Agfacolor Optima 125 Professional Film** | |
| **Agfacolor Portrait 160 Professional Film** (1990—) | |
| **Agfacolor Optima 200 Professional Film** (1992—) | (not disclosed) |
| **Agfacolor Optima 400 Professional Film** (1992—) | (not disclosed) |
| **Agfacolor XRC and XRG 100 Film** | **30** (–Y) |
| **Agfacolor XRC and XRG 400 Film** (1988—) | |
| Agfacolor XRC and XRG 200 Film (1989–92) | |

**Table 5.10 (continued from previous page)**

| Process C-41 Compatible Color Negative Films: | Estimated Years of Dark Storage for 20% Loss of Least Stable Dye | Process E-6 Compatible Color Transparency Films: | Estimated Years of Dark Storage for 20% Loss of Least Stable Dye |
|---|---|---|---|
| **Agfacolor XRC and XRG 200 Film** (improved type: 1992—) | (not disclosed) | Agfachrome RS 50 Professional Film (improved type: 1988–92) | 55 (~Y) |
| **Agfacolor XRS 100 Professional Film** **Agfacolor XRS 200 Professional Film** **Agfacolor XRS 400 Professional Film** (1989—) | **30 (~Y)** | **Agfachrome RS 50 Plus Professional Film** (1992—) | (not disclosed) |
| Agfacolor XR 100 Film Agfacolor XR 100i Film [improved] Agfacolor XR 200 Film Agfacolor XR 400 Film (1983–89) | 15 (~C) | Agfachrome RS 100 Professional and CT Films (improved type: 1988–92) | 55 (~Y) |
| | | **Agfachrome RS 100 Plus Professional and CT Films** (1992—) | (not disclosed) |
| Agfacolor XRS 100 Professional Film Agfacolor XRS 200 Professional Film Agfacolor XRS 400 Professional Film (1984–89) | 15 (~C) | **Agfachrome RS 200 Professional and CT Films** (improved type: 1988—) | **55 (~Y)** |
| | | Agfachrome RS 50 Professional Film Agfachrome RS 100 Professional and CT Films (1984–88) | 32 (~Y) |
| Agfacolor XRS 1000 Professional Film (1984–1989) | 15 (~C) | Agfachrome RS 200 Professional and CT Films (initial type: 1983–85) | 30 (~Y) |
| | | Agfachrome RS 200 Professional and CT Films (improved type: 1985–88) | 30 (~Y) |
| **Agfacolor XRS 1000 Professional Film** (improved type: 1989—) | (not disclosed) | Agfachrome RS 1000 Professional Film (1987–92) | 30 (~Y) |
| | | **Agfachrome RS 1000 Professional Film** (improved type: 1992—) | (not disclosed) |

\* According to Agfa, "The stability of Agfacolor Type 8 Paper stabilized in fresh AP-92SB is slightly better than normally washed material. This situation can change somewhat after the solution has become seasoned. This situation is not specific to [Agfa] color paper and chemistry, but instead it is common to all color papers and stabilizers." Use of the initial version of Agfa process AP-92 stabilizer in "washless" processing resulted in a reduction in the stability of the yellow dye in Agfacolor Type 8 paper; an improved stabilizer formulation that corrected this shortcoming was introduced in 1988.

## Table 5.11    Predicted Dark Fading Stability of Fuji Color Print Materials, Color Negatives, and Transparencies (from Data Supplied by Fuji and Based on Arrhenius Accelerated Dark Fading Tests)

**Estimated Storage Time for a 20% Loss of the Least Stable Image Dye for Storage in the Dark at 75°F (24°C) (Note: Predictions Are for Storage at <10% RH and 70% RH)**

**Boldface Type** indicates products that were being marketed in the U.S., Japan, and/or other countries when this book went to press in 1992; the other products listed had been either discontinued or replaced with newer materials. These estimates are based on initial cyan, magenta, and yellow densities of 1.0 with full d-min corrected densitometry. These estimates are for dye fading only and do not take into account the gradual formation of yellowish stain. With earlier types of Fuji print materials (e.g., EP-2 compatible Fujicolor papers), the level of stain may become objectionable before the least stable image dye has faded 20%.

(N) = For printing color negatives
(T) = For printing color transparencies
(T+N) = For printing either transparencies or negatives

| Color Papers and Display Films: | Estimated Years of Dark Storage for 20% Loss of Least Stable Dye | |
|---|---|---|
| **Fujicolor Paper Super FA Type 3** (RA-4)(N) | 120 (–C) [<10% RH] | 100 (–C) [70% RH] |
| **Fujicolor Supreme Paper SFA3** | | |
| **Fujicolor SFA3 Professional Portrait Paper** | | |
| **Fujicolor Professional Paper SFA3 Type C** | | |
| **Fujiflex SFA3 Super-Gloss Printing Material** [polyester] | | |
| **Fujicolor Peel-Apart Paper SFA3** | | |
| **Fujicolor Thin Paper SFA3** | | |
| (RA-4 compatible paper processed with Fuji CP-40FA chemicals and Fuji washless stabilizer or with water wash) (1993— for Prof. Portrait Paper; 1992— for other papers) | | |
| Fujicolor Paper Super FA Type II (RA-4) (N) | 80 (–C) [<10% RH] | 70 (–C) [70% RH] |
| Fujicolor Supreme Paper | | |
| **Fujicolor Professional Paper Super FA Type P** | | |
| Fujicolor Professional Paper Super FA Type C | | |
| Fujiflex SFA Super-Gloss Printing Material [polyester] | | |
| (RA-4 compatible paper processed with Fuji CP-40FA chemicals and Fuji washless stabilizer or with water wash) (1991–92 for Super FA Type C, and Fujiflex SFA) (1990–92 for Super FA Type II and Supreme) (1991–93 for Prof. Super FA Type P) | | |
| Fujicolor Paper Super FA (RA-4) (N) | 80 (–C) [<10% RH] | 70 (–C) [70% RH] |
| Fujicolor Paper FA | | |
| (RA-4 compatible papers processed with Fuji CP-40FA chemicals and stabilizer in Fuji "washless" minilab) (1989–90) | | |
| Fujicolor Paper Super FA (RA-4) (N) | 80 (–C) [<10% RH] | 70 (–C) [70% RH] |
| Fujicolor Paper FA | | |
| (RA-4 compatible papers processed with Fuji CP-40FA chemicals and water wash) (1989–90) | | |

(N) = For printing color negatives
(T) = For printing color transparencies
(T+N) = For printing either transparencies or negatives

| Color Papers and Display Films: | Estimated Years of Dark Storage for 20% Loss of Least Stable Dye | |
|---|---|---|
| **Fujicolor Paper Type 03** (EP-2) (N) | 60 (–C) [<10% RH] | 50 (–C) [70% RH] |
| **Fujicolor "Minilab Paper"** | | |
| **Fujicolor Professional Paper Type 02-P** | | |
| **Fujicolor HR Printing Material** [polyester] | | |
| Fujicolor Paper Type 02 | | |
| Fujicolor Professional Paper Type 01-P | | |
| **Fujicolor Paper Type 12** (EP-2) (N) | 60 (–C) [<10% RH] | 50 (–C) [70% RH] |
| **Fujicolor "Minilab Paper"** | | |
| **Fujicolor Minilab Paper** (EP-2) (N) | 60 (–C) [<10% RH] | 50 (–C) [70% RH] |
| (processed with Fuji Stabilizer in Fuji washless minilab) | | |
| **Fujitrans Super FA Display Material** (RA-4) (N) | 80 (–C) [<10% RH] | 70 (–C) [70% RH] |
| **Fujitrans Display Material** (EP-2) (N) | 60 (–C) [<10% RH] | 50 (–C) [70% RH] |
| **Fujichrome Paper Type 35** (R-3) (T) | 120 (–C) [<10% RH] | 100 (–C) [70% RH] |
| **Fujichrome Copy Paper Type 35H** | | |
| **Fujichrome Printing Material** [polyester] | | |
| ("Fujichrome Super Deluxe Prints") [polyester] (1992—) | | |
| Fujichrome Paper Type 34 (R-3) (T) | 120 (–C) [<10% RH] | 100 (–C) [70% RH] |
| Fujichrome Copy Paper Type 34H | | |
| Fujichrome Printing Material [polyester] | | |
| ("Fujichrome Super Deluxe Prints") [polyester] (1986–92) | | |
| Fujichrome Reversal Paper Type 33 (R-3) (T) | 25 (–C) [<10% RH] | 20 (–C) [70% RH] |
| (1983–86) | | |

## Table 5.11 (continued from previous page)

(N) = For printing color negatives
(T) = For printing color transparencies
(T+N) = For printing either transparencies or negatives

| | Estimated Years of Dark Storage for 20% Loss of Least Stable Dye |
|---|---|
| **Color Papers:** | |
| **Fuji CB Prints** (T)<br>(Ilford Ilfochrome materials supplied under the Fuji name in Japan)<br>(1970—) | (see Ilford Ilfochrome data in Table 5.12) |
| **Fuji Dyecolor Prints** (dye transfer type) (T+N)<br>(1970—) (available only in Japan) | (not disclosed)* |
| **Fuji-Inax Photocera Color Photographs** (T+N)<br>(fired pigment color process with ceramic support)<br>(Fuji-Inax Ceramic Color Process)<br>(1991—) (initially available only in Japan) | "quasi-eternal" |
| **Fuji Colorcopy Paper AP** (direct positive paper) (T)<br>(Fuji AP-NM, AP-SG, AP-SGR, and AP-T materials for Fuji Colorcopy AP System)<br>(1988—) | 100 (–C) [<10% RH]<br>80 (–C) [70% RH] |
| **Fuji Colorcopy Paper AP** (negative print paper) (N)<br>(Fuji AP-NP and AP-NPR materials for Fuji Colorcopy AP System)<br>(1988—) | 80 (–C) [<10% RH]<br>70 (–C) [70% RH] |
| **Fuji Pictrography Color Prints** (T+N)<br>(silver-sensitized hybrid thermal dye transfer process for printing digitized color images)<br>(1990—) | (not disclosed) |
| **Instant Color Prints:** | |
| **Fuji FI-10 and Fuji 800 Instant Color Prints**<br>(1981— for Fuji FI-10; 1984— for Fuji 800)<br>(available only in Japan) | (not disclosed) |
| **Process C-41 Compatible Color Negative Films:** | |
| **Fujicolor Super G 100 Film**<br>**Fujicolor Super G 200 Film**<br>**Fujicolor Super G 400 Film**<br>(1992—) | stability is "similar" to Fujicolor Super HG films |
| Fujicolor Super HG 100 Film<br>Fujicolor Super HG 200 Film<br>Fujicolor Super HG 400 Film<br>**Fujicolor Super HG 1600 Film**<br>(1990— for Super HG 1600; 1989–92 for other films) | 70 (–C) [<10% RH]<br>20 (–Y) [70% RH] |

| | Estimated Years of Dark Storage for 20% Loss of Least Stable Dye |
|---|---|
| **Process C-41 Compatible Color Negative Films:** | |
| **Fujicolor Reala Film** (ISO 100)<br>(1989—) | 70 (–C) [<10% RH]<br>20 (–Y) [70% RH] |
| **Fujicolor HG 400 Professional Film**<br>(1991—) | 70 (–C) [<10% RH]<br>20 (–Y) [70% RH] |
| **Fujicolor 160 Professional Film S**<br>**Fujicolor 160 Professional Film L**<br>**Fujicolor HR Disc Film** | stability is "similar" to Fujicolor Super HG films |
| Fujicolor Super HR 100 Film<br>Fujicolor Super HRII 100 Film<br>Fujicolor Super HR 200 Film<br>Fujicolor Super HR 400 Film<br>Fujicolor Super HR 1600 Film<br>Fujicolor Super HRII 1600 Film | 70 (–C) [<10% RH]<br>20 (–Y) [70% RH] |
| Fujicolor HR 100 Film<br>Fujicolor HR 200 Film<br>Fujicolor HR 400 Film | 14 (–C) [<10% RH]<br>9 (–C) [70% RH] |
| Fujicolor HR 1600 Film | 20 (–C) [<10% RH]<br>15 (–Y) [70% RH] |
| **Fujicolor Internegative Film IT-N**<br>(1988—) | 70 (–C) [<10% RH]<br>20 (–Y) [70% RH] |
| **Process E-6 Compatible Color Transparency Films:** | |
| **Fujichrome Velvia Professional Film** (ISO 50)<br>(1990—) | 150 (–Y) [<10% RH]<br>40 (–C) [70% RH] |
| **Fujichrome 50D Film**<br>**Fujichrome 64T Film**<br>**Fujichrome 100D Film**<br>Fujichrome 400D Film (1984–92)<br>Fujichrome 400D Film (improved type: 1992—)<br>Fujichrome 1600D Film<br>**Fujichrome Duplicating Films**<br>(1983/88/92—) | 150 (–C) [<10% RH]<br>40 (–C) [70% RH] |

* This author's tests indicate that the dark stability of Fuji Dyecolor prints is extremely good and is similar to that of Kodak Dye Transfer prints (i.e., longer than 600 years at 75°F [24°C] and 40% RH; see Table 5.13). Also like Dye Transfer prints, Fuji Dyecolor prints are essentially free from stain formation, even after prolonged storage in the dark or display under adverse conditions.

## Table 5.12 Predicted Dark Fading Stability of Ilford Color Print Materials, Color Negative Films, and Slide Films (from Data Supplied by Ilford and Based on Arrhenius Accelerated Dark Fading Tests)

**Estimated Storage Time for a 20% Loss of the Least Stable Image Dye for Storage in the Dark at 75°F (24°C)**

**(Note: Predictions Are For Storage at 40% RH)**

**Boldface Type** indicates products that were being marketed in the U.S. and/or other countries when this book went to press in 1992; the other products listed had been either discontinued or replaced with newer materials. Ilford is a subsidiary of the International Paper Company, an American company headquartered in Purchase, New York. These estimates are based on initial cyan, magenta, and yellow densities of 1.0 with full d-min corrected densitometry. Unlike chromogenic materials, Ilfochrome prints and microfilms (called Cibachrome prints and microfilms, 1963–91) can be expected to remain virtually free of stain even after prolonged storage.

| Silver Dye-Bleach Materials for Printing Color Transparencies: | Estimated Years of Dark Storage for 20% Loss of Least Stable Dye |
|---|---|
| **Ilfochrome Classic Deluxe Print Material** (CPS.1K) <br> Cibachrome II Print Material (CPS.1K) <br> [high-contrast, high-gloss polyester-base material] <br> (Process P-3, P-3X, P-30, and P-30P) <br> (Cibachrome II: 1980–91) <br> (Ilfochrome Classic: 1991— ) | **"more than 500"** * |
| **Ilfochrome Classic Deluxe Print Material** (CM.1K) <br> [medium-contrast, high-gloss polyester-base material] <br> (Process P-3, P-3X, P-30, and P-30P) (1992— ) | **"more than 500"** * |
| **Ilfochrome Classic Deluxe Print Material** (CF.1K) <br> Cibachrome II Print Material (CF.1K) <br> [low-contrast, high-gloss polyester-base material] <br> (Process P-3, P-3X, P-30, and P-30P) <br> (Cibachrome II: 1980–91) <br> (Ilfochrome Classic: 1991— ) | **"more than 500"** * |
| Cibachrome II Print Material (CRC.44M) <br> ["Pearl" semi-gloss RC paper] <br> (Process P-3, P-3X, P-30, and P-30P) <br> (Cibachrome II: 1980–92) | "more than 500" * |
| **Ilfochrome Classic Print Material** (CPM.1M) <br> [medium-contrast glossy RC paper] <br> (Process P-3, P-3X, P-30, and P-30P) (1992— ) | **"more than 500"** * |
| **Ilfochrome Classic Print Material** (CPM.44M) <br> [medium-contrast "Pearl" semi-gloss RC paper] <br> (Process P-3, P-3X, P-30, and P-30P) (1992— ) | **"more than 500"** * |
| **Ilfochrome Classic Print Material** (CPH.1M) <br> [high-contrast glossy RC copy paper] <br> (Process P-3, P-3X, P-30, and P-30P) <br> (1992— ) | **"more than 500"** * |

| Silver Dye-Bleach Materials for Printing Color Transparencies: | Estimated Years of Dark Storage 20% Loss of Least Stable Dye |
|---|---|
| **Ilfochrome Classic Translucent Display Film** (CT.F7) <br> Cibachrome II Display Film, Translucent Base (CLF7) <br> [for back-lighted displays] <br> (Process P-3, P-3X, P-30, and P-30P) <br> (1980–92 for Cibachrome Display Films; 1992— for Ilfochrome) | **"more than 500"** * |
| **Ilfochrome Classic Clear Display Film** (CC.F7) <br> Cibachrome II Display Film, Transparent Base (CTD.F7) <br> [for back-lighted displays] <br> (Process P-3, P-3X, P-30, and P-30P) | **"more than 500"** * |
| **Ilfochrome Classic Clear Display (OHP) Film** (COH.F7) <br> Cibachrome II Overhead Transparency Film (COHP.F7) <br> [for overhead transparencies and back-lighted displays] <br> (Process P-3, P-3X, P-30, and P-30P) | **"more than 500"** * |
| **Ilfochrome Rapid Deluxe Print Material** (RLL.1K) <br> [high-gloss polyester-base material] <br> (1991— ) (Process P-22 and P-4) | **"more than 500"** * |
| **Ilfochrome Rapid Print Material** (RPL.1M) <br> [glossy RC paper] <br> (1991— ) (Process P-22 and P-4) | **"more than 500"** * |
| **Ilfochrome Rapid Print Material** (RPL.44M) <br> ["Pearl" semi-gloss RC paper] <br> (1991— ) (Process P-22 and P-4) | **"more than 500"** * |
| **Ilfochrome Rapid Print Material** (CCO.1M) <br> [high-contrast glossy RC copy paper] <br> (1991— ) (Process P-22 and P-4) | **"more than 500"** * |
| **Ilfochrome Rapid Print Material** (CCO.1K) <br> [high-contrast glossy polyester-base copy material] <br> (1991— ) (Process P-22 and P-4) | **"more than 500"** * |

## Table 5.12 (continued from previous page)

| Material | Estimated Years of Dark Storage for 20% Loss of Least Stable Dye |
|---|---|
| **Silver Dye-Bleach Materials for Printing Color Transparencies:** | |
| **Ilfochrome Rapid Print Material** (CCO.44M) ["Pearl" semi-gloss high-contrast RC copy paper] (1991—) (Process P-22 and P-4) | **"more than 500"** * |
| **Ilfochrome Rapid Print Material** (CCO.44L) [lightweight "Pearl" semi-gloss high-contrast RC copy paper] (1991—) (Process P-22 and P-4) | **"more than 500"** * |
| **Ilfochrome Rapid OHP Film** (CTR.F7) [overhead transparency film] (1991—) (Process P-22 and P-4) | **"more than 500"** * |
| **Cibacopy RC Papers and Polyester-Base Print Materials** [processed in Ilford Cibacopy and Ilfochrome Rapid Systems KP-30/40, CC-1217Z/E, CC-1012, CC-120/180, as well as other systems employing P-17, P-22, P-222, and P-4 chemicals] (1976–91) | "more than 500" * |
| **Cibachrome-A II Print Material** (CPSA.1K) [high-gloss polyester-base print material] (Process P-30 and P-30P) (1981–89 for "initial type") (1989–91 for "improved type") | "more than 500" * |
| **Cibachrome-A II Print Material** (CRCA.44M) ["Pearl" semi-gloss RC paper] (Process P-30 and P-30P) (1981–89 for "initial type") (1989–91 for "improved type") | "more than 500" * |
| **Cibachrome-A II Print Material** (CF.1K) [low-contrast, high-gloss polyester material] (Process P-30 and P-30P) | "more than 500" * |
| **Silver Dye-Bleach Color Microfilm:** | |
| **Ilfochrome Micrographic Film Type M & Type P** Cibachrome Micrographic Film Type M & Type P [high-resolution color microfilms] (Process P-5) (1984—) | **"more than 500"** * |
| **Chromogenic Materials for Printing Color Negatives:** | |
| **Ilford Ilfocolor Deluxe Print Material** (ILRA.1K) (RA-4) (high-gloss polyester-base print material manufactured by Ilford in Switzerland using emulsion components supplied by Konica; the stability of the Ilford product is believed to be similar if not identical to Konica Color QA Super Glossy Print Material Type A3 — see Table 5.5a and Table 5.15) (1991—) | (not disclosed) |

| Material | Estimated Years of Dark Storage for 20% Loss of Least Stable Dye |
|---|---|
| **Chromogenic Materials for Printing Color Negatives:** | |
| **Ilford Colorluxe Print Material** (SP-729s) (RA-4) (high-gloss polyester-base print material manufactured by Ilford in Switzerland using emulsion components supplied by Konica; the stability of the Ilford product is believed to be similar if not identical to Konica Color QA Super Glossy Print Material Type A2 — see Table 5.5c and Table 5.15) (1990–91) | (not disclosed) |
| **Ilford Colorluxe Print Material** (IL.1K) (EP-2) (high-gloss polyester-base print material manufactured by Ilford in Switzerland using emulsion components supplied by Konica; the stability of the Ilford product is believed to be similar if not identical to Konica Color Type SR [SG] print material — see Table 5.5b and Table 5.15) (1990—) | **(not disclosed)** |
| **Ilford Ilfocolor Deluxe Translucent Display Film** (ITRA.F7) (RA-4) (translucent, polyester-base display material manufactured by Ilford in Switzerland using emulsion components supplied by Konica; the stability of the Ilford product is believed to be similar if not identical to Konica Color Trans QA Display Film Type A3 — see Table 5.15) (1992—) | **(not disclosed)** |
| **Chromogenic Color Negative and Color Slide Films:** | |
| Ilford Ilfocolor HR 100 Film (C-41) | (not disclosed) ** |
| Ilford Ilfocolor HR 200 Film (C-41) | (not disclosed) ** |
| Ilford Ilfocolor HR 400 Film (C-41) | (not disclosed) ** |
| Ilford Ilfochrome 50 Film (E-6) | (not disclosed) *** |
| Ilford Ilfochrome 100 Film (E-6) | (not disclosed) *** |
| Ilford Ilfochrome 200 Film (E-6) | (not disclosed) *** |

* This author's accelerated tests conducted at 62°C (144°F) and 45% RH suggest that Ilfochrome (Cibachrome) images are essentially permanent in dark storage — they are probably even more stable than Kodak Dye Transfer prints (i.e., longer than 600 years for a 20% density loss of the least stable dye when stored at 75°F [24°C] — see Table 5.13). Like Dye Transfer prints, Ilfochrome polyester-base prints remain virtually free from stain formation — even after prolonged storage in the dark or display under adverse conditions (Ilfochrome RC-base prints, however, can develop yellowish stain after exposure to light during extended display).

** These now-discontinued Ilford Ilfocolor HR color negative films were made for Ilford by Agfa-Gevaert in Germany and are believed to have stability characteristics identical to Agfacolor XR films of the same ISO rating (see Table 5.10); these Ilfocolor film were marketed from March 1987 until May 1988. Prior to 1987 Ilfocolor films are believed to have been supplied to Ilford by Konica.

*** These now-discontinued Ilford Ilfochrome transparency films were made for Ilford by Agfa-Gevaert in Germany and are believed to have stability characteristics that are identical to Agfachrome CT films of the same ISO ratings (see Table 5.10); these Ilfochrome films were marketed by Ilford from March 1987 until May 1988. Prior to 1987 Ilfochrome films are believed to have been supplied to Ilford by Konica.

**Table 5.13**   **Predicted Dark Fading Stability of Kodak Color Print Materials, Color Negatives, and Transparencies (Compiled from Published Kodak Data and Based on Arrhenius Accelerated Dark Fading Tests)**

**Estimated Storage Time for a 20% Loss of the Least Stable Image Dye for Storage in the Dark at 75°F (24°C)**

**(Note: Predictions Are for Storage at 40% RH)**

**Boldface Type** indicates products that were being marketed in the U.S. and/or other countries when this book went to press in 1992; the other products listed had been either discontinued or replaced with newer materials. These estimates are based on initial cyan, magenta, and yellow densities of 1.0 with full d-min corrected densitometry. These estimates are for dye fading only and do not take into account the gradual formation of yellowish stain. With print materials in particular (e.g., Ektacolor papers), the level of stain may become objectionable before the least stable image dye has faded 20%.

(N) = For printing color negatives
(T) = For printing color transparencies
(T+N) = For printing either transparencies or negatives
(I) = Instant camera print

| Color Print Materials: | Estimated Years of Dark Storage for 20% Loss of Least Stable Image Dye |
|---|---|
| Kodak Dye Transfer Prints [fiber-base] (T+N) (Obsolete MX-1119 special-order yellow dye available in the early 1980's.) | >1,000 (—) |
| **Kodak Dye Transfer Prints** [fiber-base] (T+N) (Prints made with "standard" Kodak Film and Paper Dyes.) | >600 (–Y) |
| Kodak Dye Transfer Prints [fiber-base] (T+N) (Kodak MX-1372 Yellow Dye trade-tested in 1989 and "standard" Kodak Magenta and Cyan Film and Paper Dyes; MX-1372 Yellow Dye was withdrawn in 1990.) | (not disclosed) |
| Trimprint Instant Color Film (I) | >400 (–M) |
| Kodak Instant Color Film — Trimprint (I) | >400 (–M) |
| Kodamatic Instant Color Film — HS 144-10 (I) | >400 (–M) |
| Kodak Instant Color Film — PR 144-10 (I) | >300 (–M) |
| Ektaflex PCT Color Prints (1981–88) (T+N) | 160 (–M) |
| **Ektacolor Plus Paper** (EP-2) (N) **Ektacolor Professional Paper** **Ektacolor Plus Thin Paper** ("Ektacolor Print") ("Kodalux Print") (formerly "Kodacolor Print") | 76 (–Y) |
| **Duraflex Print Material 4023** [improved] (EP-2) (N) | [76 (–Y)] |
| **Duratrans Display Material 4022** [improved] (EP-2) (N) | [76 (–Y)] |

(N) = For printing color negatives
(T) = For printing color transparencies
(T+N) = For printing either transparencies or negatives
(I) = Instant camera print

| Color Print Materials: | Estimated Years of Dark Storage for 20% Loss of Least Stable Image Dye |
|---|---|
| **Ektacolor Edge Paper** (RA-4 with water wash) (N) **Ektacolor Royal II Paper** **Ektacolor Portra II Paper** **Ektacolor Supra Paper** **Ektacolor Ultra Paper** **Duraflex RA Print Material** [polyester] **Duratrans RA Display Material** **Ektatrans RA Display Material** **Duraclear RA Display Material** Ektacolor 2001 Paper Ektacolor Royal Paper Ektacolor Portra Paper ("Ektacolor Print") ("Kodalux Print") | (not disclosed) |
| **Ektacolor Edge Paper** (RA-4NP with "washless" stabilizer) (N) **Ektacolor Royal II Paper** **Ektacolor Portra II Paper** **Ektacolor Supra Paper** **Ektacolor Ultra Paper** **Duraflex RA Print Material** [polyester] **Duratrans RA Display Material** **Ektatrans RA Display Material** **Duraclear RA Display Material** Ektacolor 2001 Paper Ektacolor Royal Paper Ektacolor Portra Paper ("Ektacolor Print") ("Kodalux Print") | (not disclosed) |

**Table 5.13 (continued from previous page)**

(N) = For printing color negatives
(T) = For printing color transparencies
(T+N) = For printing either transparencies or negatives
(I) = Instant camera print

| Color Print Materials: | Estimated Years of Dark Storage for 20% Loss of Least Stable Image Dye |
|---|---|
| **Ektachrome Radiance Paper** (1991— ) (R-3) (T) | **(not disclosed)** |
| **Ektachrome Radiance Select Material** (1991— ) [polyester] | |
| **Ektachrome Radiance HC Copy Paper** (1992— ) | |
| **Ektachrome Radiance Thin Copy Paper** (1992— ) | |
| Ektachrome 22 Paper [improved type: 1990–91] (R-3) (T) | (not disclosed) |
| **Kodak Ektatherm Color Print Paper** (1990— ) <br> (thermal dye transfer paper used with Kodak <br> XL 7700-series Digital Continuous Tone Printers) | **(not disclosed)** |
| **Kodak Thermacolor Electronic Print Paper** (1989— ) <br> (thermal dye transfer paper used with Hitachi Video Printer) | **(not disclosed)** |
| Ektacolor 37 RC Paper (EP-3 w/stabilizer) (N) <br> ("Ektacolor Print") <br> ("Kodacolor Print") | 20 (–C) |
| Ektacolor 14 Paper (R-100) (T) | 20 (–C) |
| Duratrans Display Material 4022 (EP-2) (N) | 18 (–C) |
| Ektacolor 74 RC Paper (EP-2) (N) <br> Ektacolor 78 Paper <br> ("Ektacolor Print") <br> ("Kodacolor Print") | 16 (–C) |
| **Ektachrome Copy Paper** (R-3) (T) <br> Ektachrome HC Copy Paper <br> Ektachrome Overhead Material | **16 (–C)** |
| Ektachrome Prestige Paper (1986–1991) [polyester] <br> Ektachrome 22 Paper (initial type: 1984–90) | |
| Ektachrome 2203 Paper (R-100) (T) | 15 (–C) |
| **Color Negative and Internegative Films (C-41):** | |
| **Vericolor III Professional Film, Type S** <br> **Ektacolor Gold 160 Professional Film** <br> **Ektacolor GPF 160 Professional Film** <br> (In the U.S., Ektacolor GPF is sold only in 8-exposure 35mm rolls) | **38 to 65 (–Y)** |
| **Vericolor 400 Professional Film** <br> **Ektacolor Gold 400 Professional Film** | **38 to 65 (–Y)** |
| **Vericolor HC Professional Film** | **16 to 28 (–Y)** |
| **Vericolor Copy/ID Film** | **38 to 65 (–Y)** |

(N) = For printing color negatives
(T) = For printing color transparencies
(T+N) = For printing either transparencies or negatives
(I) = Instant camera print

| Color Negative and Internegative Films (C-41): | Estimated Years of Dark Storage for 20% Loss of Least Stable Image Dye |
|---|---|
| **Ektapress Gold 100 Professional Film** | **16 to 28 (–Y)** |
| **Ektapress Gold 400 Professional Film** | **38 to 65 (–Y)** |
| **Ektapress Gold 1600 Professional Film** | **38 to 65 (–Y)** |
| **Ektar 25 Film and Ektar 25 Professional Film** | **16 to 28 (–Y)** |
| **Ektar 100 Film** | **(not disclosed)** |
| Ektar 125 Film | 16 to 28 (–Y) |
| **Ektar 1000 Film** | **38 to 65 (–Y)** |
| Kodacolor HR Disc Film | 43 (–Y) |
| **Kodak Gold Disc Film** (1991— ) <br> Kodacolor Gold Disc Film <br> **Kodacolor VR Disc Film** | **(not disclosed)** |
| **Kodacolor VR 100 Film** <br> **Kodacolor VR 200 Film** <br> **Kodacolor VR 400 Film** <br> (1983— ) | **35 (–Y)** |
| Kodacolor VR 1000 Film | 33 (–Y) |
| Kodak Gold 100 Film (1986–91) <br> (formerly Kodacolor VR-G 100 Film) <br> Kodak Gold 100 Film (1991–92) | 26 (–Y) |
| Kodak Gold 200 Film (1986–91) <br> (formerly Kodacolor VR-G 200 Film) <br> Kodak Gold 200 Film (1991–92) | 16 to 28 (–Y) |
| Kodak Gold 400 Film (1988–91) <br> (formerly Kodacolor VR-G 400 Film) <br> Kodak Gold 400 Film (1991–92) | 38 to 65 (–Y) |
| **Kodak Gold Plus 100 Film** (1992— ) <br> **Kodak Gold II 100 Film** (name in Europe) | **(not disclosed)** |
| **Kodak Gold Plus 200 Film** (1992— ) <br> **Kodak Gold II 200 Film** (name in Europe) | **(not disclosed)** |
| **Kodak Gold Plus 400 Film** (1992— ) <br> **Kodak Gold II 400 Film** (name in Europe) | **(not disclosed)** |
| **Kodak Gold 1600 Film** (1991— ) <br> Kodacolor Gold 1600 Film (1989–91) | **38 to 65 (–Y)** |

*(Table 5.13 continued on following page . . .)*

## Table 5.13 (continued from previous page)

| | Estimated Years of Dark Storage for 20% Loss of Least Stable Image Dye |
|---|---|
| **Color Negative and Internegative Films (C-41):** | |
| Kodacolor 400 Film | 22 (–C) |
| Kodacolor II Film | 14 (–C) |
| Vericolor II Professional Film, Type S | 14 (–C) |
| **Vericolor Internegative Film 6011** | **12 (–C)** |
| **Kodak Commercial Internegative Film** (1993— ) | **(not disclosed)** |
| **Vericolor Internegative Film 4114** (1984-93) | **(not disclosed)** |
| **Vericolor II Professional Film, Type L** | **7 (–C)** |
| Vericolor II Commercial Film, Type S | 7 (–C) |
| **Process K-14 Kodachrome Films:** | |
| **Kodachrome 25 and 25 Professional Films** | **185 (–Y)** |
| **Kodachrome 40 Film 5070 (Type A)** | |
| **Kodachrome 64 and 64 Professional Films** | |
| **Kodachrome 200 and 200 Professional Films** | |
| **Process E-6 Ektachrome Films ("Group II" films introduced beginning in 1988):** | |
| **Ektachrome 100 Plus Professional Film** | **220 (–C)** |
| **Ektachrome 100 HC Film** | |
| **Ektachrome 50 HC Film** | |
| **Ektachrome 64T Professional Film (Tungsten)** | |
| **Ektachrome 320T Professional Film (Tungsten)** | |
| **Ektachrome 64X Professional Film** | |
| **Ektachrome 100X Professional Film** | |
| **Ektachrome 400X Professional Film** | |
| **Ektachrome 400 HC Film** | |
| **Process E-6 Ektachrome Films ("Group I" films introduced beginning in 1978):** | |
| Ektachrome 50 Professional Film (Tungsten) | 105 (–Y) |
| Ektachrome 50 Professional Film, 5018 (Tungsten) | |
| Ektachrome 50 Professional Film, 6018 (Tungsten) | |
| Ektachrome 64 Film | |
| **Ektachrome 64 Professional Film** | |
| **Ektachrome 64 Professional Film, 5017** | |
| **Ektachrome 64 Professional Film, 6117** | |
| **Ektachrome 64 EPV Film (Press and Video Film)** | |
| Ektachrome 100 Film | |
| **Ektachrome 100 Professional Film** | |
| **Ektachrome 160 Film (Tungsten)** | |

| | Estimated Years of Dark Storage for 20% Loss of Least Stable Image Dye |
|---|---|
| **Process E-6 Ektachrome Films ("Group I films):** | |
| **Ektachrome 160 Professional Film (Tungsten)** | 105 (–Y) |
| **Ektachrome 160 Professional Film, 5037 (Tungsten)** | |
| **Ektachrome 200 and 200 Professional Film** | |
| **Ektachrome 200 Professional Film, 5036** | |
| **Ektachrome 200 Professional Film, 6176** | |
| Ektachrome 400 Film | |
| **Ektachrome P800/1600 Professional Film** | |
| **Ektachrome Slide Duplicating Film 5071** | |
| **Ektachrome SE Duplicating Film SO-366** | |
| **Ektachrome Slide Duplicating Film, Type K** | |
| **Ektachrome Duplicating Film 6121** | |
| **Process E-3 and E-4 Ektachrome Films:** | |
| **Ektachrome Infrared Film 2236** (E-4) | **42 (–C)** |
| High Speed Ektachrome Film (E-4) | 30 (–C) |
| High Speed Ektachrome Film Type B (Tungsten) | |
| Ektachrome-X Film | |
| Ektachrome Professional Films (E-3) (sheet and 120 roll films: 1959-77) | 8 (–C) |
| Kodak Photomicrography Color Film 2483 (E-4) | 6 (–Y) |
| **Print Films for Making Slides from Negatives or Internegatives:** | |
| **Eastman Color Print Film 5384** (slide from negative) | **88 (–Y)** |
| **Vericolor Slide Film 5072** (slide from negative) | **18 (–Y)** |
| **Vericolor Print Film 4111** (transparency from negative) | **18 (–Y)** |
| Eastman Color SP Print Film 5383 (slide from negative) | 9 (–C) |

**Note:** The estimates given here have been derived from data in **Evaluating Dye Stability of Kodak Color Products**, Kodak Publication No. CIS-50, January 1981, and subsequent CIS-50 series of dye-stability data sheets through 1985; **Image-Stability Data: Kodachrome Films**, Kodak Publication E-105, 1988; **Image-Stability Data: Kodak Ektachrome Films**, Kodak Publication E-106, 1988; **Image-Stability Data: Kodak Color Negative Films (Process C-41)**, Kodak Publication E-107, June 1990; **Evaluating Image Stability of Kodak Color Photographic Products**, Kodak Publication No. CIS-130, March 1991; **Kodak Ektacolor Plus and Professional Papers for the Professional Finisher**, Kodak Publication No. E-18, March 1986; **Dye Stability of Kodak and Eastman Motion Picture Films** (data sheets); Kodak Publications DS-100-1 through DS-100-9, May 29, 1981; and other published and non-published Kodak sources. The estimate for Process E-3 Ektachrome films is from an article by Charleton Bard et al, (Eastman Kodak) entitled "Predicting Long-Term Dark Storage Dye Stability Characteristics of Color Photographic Products from Short-Term Tests," **Journal of Applied Photographic Engineering**, Vol. 6, No. 2, April 1980, p. 44. The accelerated-test data given in the article were for Ektachrome Duplicating Film 6120 (Process E-3) and is assumed to apply to Process E-3 Ektachrome camera films; Kodak has declined to release dye-stability data for these films.

## Table 5.14   Unpublished Kodak Estimates of Dark Fading Stability for Kodak Color Materials (Applicable to Kodak Products Marketed from About 1960 Through 1977)

**Estimated Storage Time for 10% Loss of the Least Stable Image Dye for Storage in the Dark at 75°F (24°C) (Note: Predictions Are for Storage at 40% RH)**

**Note:** These estimates are for a "just noticeable" 10% loss of the least stable image dye. To compare these data with those in other tables in this chapter, which present estimates for a 20% loss of dye density, the storage times given below should be multiplied by a factor of 2.3. (With many products, the dark fading curve is reasonably linear as fading progresses to the point of a 20% dye loss, and a simple multiple of 2x will be reliable. However, with some products the rate of fading gradually decreases as dark fading progresses, and a 20% density loss will take more than twice the storage time required for a 10% loss.)

The Process E-6 Ektachrome Professional films listed below were the initial versions manufactured in 1976; later versions of the films were significantly improved in dark fading stability, and it is believed that by the end of 1978 or early in 1979 all Kodak Process E-6 Ektachrome professional and amateur films had the same, improved stability. Kodak has not revealed when the improvements were made in each particular type of Ektachrome film, although it has been reported that Ektachrome Slide Duplicating Film 5071 was the first to be marketed with an improved dark fading stability.

These estimates are based on initial cyan, magenta, and yellow densities of 1.0 with full d-min corrected densitometry. These estimates are for dye fading only and do not take into account the gradual formation of yellowish stain. With print materials in particular (e.g., Kodak Ektacolor papers), the level of stain may become objectionable before the least stable image dye has faded 10%.

**21 to 50 Years:**

Kodachrome II Film (Daylight) [Process K-12]
Kodachrome II Professional Film, Type A [Process K-12]
Kodachrome-X Film [Process K-12]
Kodachrome II Movie Film (Daylight) [Process K-12]
Kodachrome II Movie Film (Type A) [Process K-12]

**11 to 20 Years:**

Ektachrome 160 Professional Film 5037 (Tungsten) [Process E-6]
Ektachrome Duplicating Film 6121 [Process E-6]
Ektachrome Slide Duplicating Film 5071 [Process E-6]
Ektachrome-X Film [Process E-4]
High-Speed Ektachrome Film (Daylight) [Process E-4]
High-Speed Ektachrome Film (Tungsten) [Process E-4]
Ektachrome EF Film 7241 (Daylight) [Process ME-4]
Ektachrome EF Film 7242 (Tungsten) [Process ME-4]
Ektachrome MS Film 7256 [Process ME-4]

**6 to 10 Years:**

Ektachrome 50 Professional Film 5018 and 6118 (Tungsten) [Process E-6]
Ektachrome 64 Professional Film 5017 and 6117 (Daylight) [Process E-6]
Ektachrome 200 Professional Film 5036 (Daylight) [Process E-6]
Ektacolor Slide Film 5028 [Modified Process C-22]
Ektacolor Print Film 4109 [Modified Process C-22]

**6 to 10 Years (continued):**

Ektacolor 37 RC Paper ("Kodacolor Print") [Process EP-3]
Ektachrome RC Paper, Type 1993 [Process R-5]
Eastman Color Negative II Film 5247 (1976 improved version) [Process ECN-2]

**Less Than 6 Years:**

Ektachrome Film 6115, Daylight Type [Process E-3]
Ektachrome Film 6116, Type B [Process E-3]
Ektachrome Professional Film (Daylight) EP120 [Process E-3]
Ektachrome Professional Film, Type B (Tungsten) EPB120 [Process E-3]
Ektachrome Duplicating Film 6120 [Process E-3]
Ektachrome Slide Duplicating Film 5038 [Process E-4]
Vericolor S Film [Vericolor Process]
Vericolor L Film [Vericolor Process]
Vericolor II Film, Type S (original version) [Process C-41]
Vericolor II Film, Type L [Process C-41]
Kodacolor-X Film [Process C-22]
Ektacolor Professional Film, Type S [Process C-22]
Ektacolor Professional Film 6101, Type S [Process C-22]
Ektacolor Professional Film 6102, Type L [Process C-22]
Ektacolor Internegative Film 6008 and 6110 [Modified Process C-22]
Eastman Color Negative Film 5254 and 7254 [Process ECN]
Eastman Color Negative II Film 5247 and 7247 (orig. versions) [Process ECN-2]
Eastman Color Print Film 5381 and 7381 [Process ECP]
Ektachrome 40 Movie Film 7262 [Process EM-25]

## Table 5.15  Predicted Dark Fading Stability of Konica Color Print Materials, Color Negatives, and Transparencies (from Data Supplied by Konica and Based on Arrhenius Accelerated Dark Fading Tests)

**Estimated Storage Time for a 20% Loss of the Least Stable Image Dye for Storage in the Dark at 75°F (24°C)**

(Note: Predictions Are for Storage at 60% RH)

**Boldface Type** indicates products that were being marketed in the U.S., Japan, and/or other countries when this book went to press in 1992; the other products listed had been either discontinued or replaced with newer materials. These estimates are based on initial cyan, magenta, and yellow densities of 1.0 with full d-min corrected densitometry. These estimates are for dye fading only and do not take into account the gradual formation of yellowish stain. With print materials in particular (e.g., Konica Color Paper Type SR and Type A3), the level of stain may become objectionable before the least stable image dye has faded 20%.

(N) = For printing color negatives
(T) = For printing color transparencies

| Color Papers and Display Films: | Estimated Years of Dark Storage for 20% Loss of Least Stable Dye |
|---|---|
| **Konica Color QA Paper Type A5** (RA-4) **(N)**<br>(Konica Color "Century Paper" or "Century Print")<br>(Konica Color "Long Life 100 Print")<br>(RA-4 compatible paper processed with Konica CPK-20QA chemicals and water wash)<br>(1990—) (initially available only in Japan) | **160–200 (–C)** |
| **Konica Color QA Paper Type A5** (RA-4) **(N)**<br>(Konica Color "Century Paper" or "Century Print")<br>(Konica Color "Long Life 100 Print")<br>(RA-4 compatible paper processed with Konica CPK-20QA chemicals and Konica Super Stabilizer in Konica washless minilab)<br>(1990—) (initially available only in Japan) | **(not disclosed)** |
| **Konica Color QA Paper Type A3** (RA-4) **(N)**<br>**Konica Color QA Paper Professional Type X2**<br>**Konica Color QA Super Glossy Print Material Type A3** [polyester]<br>**Konica Color QA Paper Peelable Type A3**<br>(Konica Color "Century Paper" or "Century Print")<br>(Konica Color "Long Life 100 Print")<br>(RA-4 compatible paper processed with Konica CPK-20QA chemicals and water wash)<br>(1991—) | **160–200 (–C)** |
| **Konica Color QA Paper Type A3** (RA-4) **(N)**<br>**Konica Color QA Paper Professional Type X2**<br>**Konica Color QA Super Glossy Print Material Type A3** [polyester]<br>**Konica Color QA Paper Peelable Type A3**<br>(Konica Color "Century Paper" or "Century Print")<br>(Konica Color "Long Life 100 Print")<br>(RA-4 compatible paper processed with Konica CPK-20QA chemicals and Konica Super Stabilizer in Konica washless minilab)<br>(1991—) | **(not disclosed)** |

(N) = For printing color negatives
(T) = For printing color transparencies

| Color Papers and Display Films: | Estimated Years of Dark Storage for 20% Loss of Least Stable Dye |
|---|---|
| **Konica Color QA Paper Type A2** (RA-4) **(N)**<br>**Konica Color QA Paper Professional Type X1**<br>**Konica Color QA Super Glossy Print Material Type A2** [polyester]<br>**Konica Color QA Paper Peelable Type A2**<br>**Konica Color QA Paper Type A**<br>(Konica Color "Century Paper" or "Century Print")<br>(Konica Color "Long Life 100 Print")<br>(RA-4 compatible paper processed with Konica CPK-20QA chemicals and Konica Super Stabilizer in Konica washless minilab)<br>(1988/90—) | **80 (–C)** |
| **Konica Color QA Paper Type A2** (RA-4) **(N)**<br>**Konica Color QA Paper Professional Type X1**<br>**Konica Color QA Super Glossy Print Material Type A2** [polyester]<br>**Konica Color QA Paper Peelable Type A2**<br>**Konica Color QA Paper Type A**<br>(Konica Color "Century Paper" or "Century Print")<br>(Konica Color "Long Life 100 Print")<br>(RA-4 compatible paper processed with Konica CPK-20QA chemicals and water wash)<br>(1988/90—) | **70 (–C)** |
| **Konica Color PC Paper Type SR** (EP-2) **(N)**<br>**Konica Color PC Paper Professional Type EX**<br>**Konica Color PC Paper Type SR (SG)** [polyester]<br>**Konica Color PC Paper Peelable Type SR**<br>(Konica Color "Century Paper" or "Century Print")<br>(Konica Color "Long Life 100 Print")<br>(EP-2 compatible paper processed with Konica CPK-18 chemicals and Konica Super Stabilizer in Konica washless minilab)<br>(1984/88—) | **80 (–C)** |

## Table 5.15 (continued from previous page)

**Color Papers and Display Films:**

| | Estimated Years of Dark Storage for 20% Loss of Least Stable Dye |
|---|---|
| **Konica Color PC Paper Type SR** (EP-2) (N) | **70 (–C)** |
| **Konica Color PC Paper Professional Type EX** | |
| **Konica Color PC Paper Type SR (SG)** [polyester] | |
| **Konica Color PC Paper Peelable Type SR** | |
| (Konica Color "Century Paper" or "Century Print") | |
| (Konica Color "Long Life 100 Print") | |
| (EP-2 compatible paper processed with Konica CPK-18 chemicals and water wash) | |
| (1984/88—) | |
| **Konica Color Trans QA Display Film Type A3** (RA-4) (N) | **120–140 (–Y)** |
| (translucent polyester-base version of Type A3 paper) | |
| **Konica Color Clear QA Display Film Type A3** | |
| (clear polyester-base version of Type A3 paper) | |
| (1992—) | |
| **Konica Color Trans Display Film Type SR** (EP-2) (N) | **70 (–C)** |
| (translucent polyester-base version of Type SR paper) | |
| **Konica Color Clear Display Film Type SR** | |
| (clear polyester-base version of Type SR paper) | |
| (1988—) | |
| **Konica Chrome Paper Type 81** (R-3) (T) | **160–200 (–C)** |
| (1989—) | |

**Process C-41 Compatible Color Negative Films:**

| | Estimated Years of Dark Storage for 20% Loss of Least Stable Dye |
|---|---|
| **Konica Color Impresa 50 Professional Film** (1991—) | **20 (–Y)** |
| **Konica Color Super SR 100 Film** | **13 (–Y)** |
| **Konica Color Super SR 200 Film** | **13 (–Y)** |
| **Konica Color Super SR 400 Film** | **15 (–Y)** |
| **Konica Color Super DD 100 Film** | **13 (–Y)** |
| **Konica Color Super DD 200 Professional Film** | **13 (–Y)** |
| **Konica Color Super DD 400 Film** (1990—) | **15 (–Y)** |
| **Konica Color XG400 Film** (1992—) (initially available only in Japan) | **(not disclosed)** |
| **Konica Color Super SR 200 Film** (USA market) | **22 (–Y)** |
| **Konica Color Super SR 200 Professional Film** (1990—) | **22 (–Y)** |
| **Konica Color Professional 160 Film Type S** | **(not disclosed)** |
| **Konica Color Professional 160 Film Type L** (1990—) | |

**Process C-41 Compatible Color Negative Films:**

| | Estimated Years of Dark Storage for 20% Loss of Least Stable Dye |
|---|---|
| Konica Color SR-G 100 Film | (not disclosed) |
| Konica Color GXII 100 Film | |
| Konica Color SR-G 200 Film | |
| Konica Color SR-G 400 Film (1989–90) | |
| **Konica Color SR-G 160 Professional Film** (1989—) | **(not disclosed)** |
| **Konica Color SR-G 3200 Professional Film** (new name: 1989—) | **13 (–Y)** |
| **Konica Color GX3200 Professional Film** (new name: 1989—) | |
| Konica Color SR-V 3200 Professional Film (1987–89) | |
| Konica Color SR-V 100 Film | 33 (–C) |
| Konica Color GX100 Film | (not disclosed) |
| Konica Color SR-V 200 Film | 13 (–Y) |
| Konica Color GX200 Professional Film | |
| Konica Color SR-V 400 Film | 14 (–Y) |
| Konica Color GX400 Film | |
| Konica Color SR 100 Film | 9 (–C) |
| Konica Color SR Professional Film Type S | |
| Konica Color SR 200 Film | |
| Konica Color SR 200 Film (improved type) | 30 (–C) |
| Konica Color SR 400 Film | 85 (–C) |
| Konica Color SR 1600 Film | 89 (–C) |

**Process E-6 Compatible Color Transparency Films:**

| | Estimated Years of Dark Storage for 20% Loss of Least Stable Dye |
|---|---|
| **Konica Chrome R-100 Film** (1986—) | **115 (–C)** |
| **Konica Chrome R-50 KF Film** | **115 (–C)** |
| **Konica Chrome R-100 KS Film** | **115 (–C)** |
| **Konica Chrome R-200 KU Film** | **48 (–Y)** |
| **Konica Chrome R-1000 KX Film** (1990—) (initially available only in Japan) | **(not disclosed)** |

**Note:** In Japan and some other countries, Konica Color films and papers were originally sold under the Sakuracolor brand name. In October 1987 the Sakuracolor name was dropped in favor of the Konica Color name in all markets, worldwide; at the same time the manufacturer, Konishiroku Photo Industries Co. Ltd., headquartered in Tokyo, Japan, changed its name to Konica Corporation.

## Table 5.16 Predicted Dark Storage Stability of Polaroid Color Prints, Color Negatives, and Transparencies (Data Requested from Polaroid Were for Accelerated Tests, Non-Accelerated Tests, and/or Storage at Normal Room Temperature)

Estimated Storage Time for a 20% Loss of the Least Stable Image Dye and a 0.10 d-min Color Imbalance for Instant Materials Stored in the Dark at 75°F (24°C)

(Note: Predictions Were Requested for Storage at 40% RH)

**Boldface Type** indicates products that were being marketed in the U.S. and/or other countries when this book went to press in 1992; the other products listed had been either discontinued or replaced with newer materials.

| Product | Estimated Years of Dark Storage for 20% Loss of Least Stable Dye or 0.10 d-min Color Imbalance |
|---|---|
| **Pigment Color Prints:** | |
| **Polaroid Permanent-Color Print Materials** (Materials for making extraordinarily stable pigment color prints; available on special order from Polaroid.) (1989—) | **(not disclosed)** (see Table 5.6) |
| **Peel-Apart Polaroid Instant Prints:** | |
| Polacolor Instant Prints (1963–75) | (not disclosed) |
| **Polacolor 2 Instant Prints (Types 88; 108; 668; 58; and 808)** (1975—) | **(not disclosed)** |
| **Polacolor ER Instant Prints (Types 59; 559; 669; and 809)** (1980—) | **(not disclosed)** |
| **Polacolor 100 Instant Prints** / **Polacolor 64T Instant Prints** (1992—) | **(not disclosed)** |
| **Polacolor Pro 100 Instant Prints** (1993—) | **(not disclosed)** |
| **Integral Polaroid Instant Prints:** | |
| Polaroid SX-70 Instant Prints (1972–76) | (not disclosed) |
| Polaroid SX-70 Instant Prints (Improved) (1976–79) | (not disclosec) |
| Polaroid SX-70 Time-Zero Instant Prints (initial type: 1979–80) | (not disclosed) |
| **Polaroid SX-70 Time-Zero Instant Prints** / **Polaroid Type 778 Time-Zero Prints** (improved type: 1980—) | **(not disclosed)** |
| **Polaroid High Speed Type 779 Prints** / **Polaroid Autofilm Type 339 Prints** / Polaroid 600 High Speed Instant Prints (1981—) | **(not disclosed)** |
| Polaroid Spectra Instant Prints (1986–91) / Polaroid Image Prints (Spectra in Europe) / **Polaroid 600 Plus Instant Prints** (1988—) / **Polaroid Type 990 Prints** / **Polaroid Autofilm Type 330 Prints** | **(not disclosed)** |
| **Polaroid Spectra HD Instant Prints** / **Polaroid Image Prints** (Spectra HD in Europe) (1991—) | **(not disclosed)** |
| **Polaroid Vision 95 Instant Prints** (name in Europe) / **Polaroid " ? " 95 Instant Prints** (name in Asia) / **Polaroid " ? " 95 Instant Prints** (name in North & South America) (The internal structure of Vision 95 prints is basically the same as that of Spectra HD and 600 Plus prints; however, the rate of formation of yellowish stain that occurs over time in dark storage is said by Polaroid to be "somewhat reduced" compared with that of Spectra HD and 600 Plus prints. The names Polaroid will use for Vision 95 products in non-European markets were not available at the time this book went to press.) (1992— for Vision 95 products sold in Germany) (1993— for Asia, North and South America, and other markets) | **(not disclosed)** |

## Table 5.16 (continued from previous page)

| Polaroid "Instant" 35mm Color Slide Films: | Estimated Years of Dark Storage for 20% Loss of Least Stable Dye or 0.10 d-min Color Imbalance |
|---|---|
| **Polaroid PolaChrome 35mm Slide Film** | **(not disclosed)** |
| **Polaroid PolaChrome High Contrast 35mm Slide Film** | **(not disclosed)** |
| **Process C-41 Compatible Color Negative Films:** | |
| Polaroid Supercolor 100 Print Film<br>(Initial type made by Agfa for Polaroid and sold in Spain and Portugal.) | (not disclosed) |
| **Polaroid OneFilm Color Print Film** (ISO 200)<br>(improved-stability type: 1990— )<br>(Although the film is labeled by Polaroid as "Made in U.S.A.," it is actually manufactured in Italy by a subsidiary of the 3M Company.) | **(not disclosed)** |
| Polaroid OneFilm Color Print Film (ISO 200)<br>(initial type: 1989–91)<br>(Although the film was labeled by Polaroid as "Made in U.S.A.," it was actually manufactured in Italy by a subsidiary of the 3M Company.) | (not disclosed) |
| **Polaroid HighDefinition 100 Color Print Film**<br>(The initial version of this film was introduced in Europe and Australia in 1989; the current version was introduced in Europe and Australia in 1990, and in the U.S. in 1992. The film is made in Japan by Konica — see Table 5.14.) | **(not disclosed)** |
| **Polaroid HighDefinition 200 Color Print Film**<br>(The initial version of this film was introduced in Europe and Australia in 1989; the current version was introduced in Europe and Australia in 1990, and in the U.S. in 1992. The film is made in Japan by Konica — see Table 5.14.) | **(not disclosed)** |
| **Polaroid HighDefinition 400 Color Print Film**<br>(The initial version of this film was introduced in Europe and Australia in 1989; the current version was introduced in Europe and Australia in 1990, and in the U.S. in 1992. The film is made in Japan by Konica — see Table 5.14.) | **(not disclosed)** |

| Process E-6 Compatible Color Transparency Films: | Estimated Years of Dark Storage for 20% Loss of Least Stable Dye or 0.10 d-min Color Imbalance |
|---|---|
| **Polaroid Professional Chrome Film 64 Tungsten** | |
| **Polaroid Professional Chrome Film 100 Daylight**<br>(The 64T and 100D Process E-6 sheet films, which were introduced in 1985, are manufactured for Polaroid by Fuji Photo Film Co., Ltd. in Japan and are believed to have stability characteristics that are identical to Fujichrome transparency films of the same ISO ratings — see Table 5.11.) | **(not disclosed)** |
| **Polaroid 35mm Presentation Chrome Film**<br>(This film is manufactured for Polaroid by the 3M Company in Italy and is believed to be essentially identical to 3M ScotchChrome 100 Film ["improved"]. Earlier versions of Polaroid Presentation Chrome Film were believed to be identical to now-discontinued 3M ScotchChrome 100.) | **(not disclosed)** |
| Polaroid Superchrome 100 Slide Film<br>(Initial type made by Agfa for Polaroid and sold in Spain and Portugal.) | (not disclosed) |
| **Polaroid HighDefinition 100 Chrome Film**<br>(introduced in Europe and Australia in 1989; film is made in Japan by Konica — see Table 5.15.) | **(not disclosed)** |

**Table 5.17  Predicted Dark Fading Stability of 3M Scotch Color Papers, Color Negative Films, and Slide Films (from Data Supplied by 3M Italia and Based on Arrhenius Accelerated Dark Fading Tests)**

Estimated Storage Time for a 20% Loss of Least Stable Image Dye for Storage in the Dark at 75°F (24°C)

(Note: Predictions Are for Storage at 50% RH)

**Boldface Type** indicates products that were being marketed in the U.S., Italy, and/or other countries when this book went to press in 1992; the other products listed had been either discontinued or replaced with newer materials. These estimates are based on initial cyan, magenta, and yellow densities of 1.0 with full d-min corrected densitometry. These estimates are for dye fading only and do not take into account the gradual formation of yellowish stain. With print materials in particular, the level of stain may become objectionable before the least stable image dye has faded 20%.

All 3M Scotch color films — including all those marked "Made in USA" — are actually manufactured in Ferrania, Italy by 3M Italia S.p.A. (a subsidiary of the 3M Company, St. Paul, Minnesota).

(N) = For printing color negatives

| Color Papers, Transparency Films, and Dry Silver Materials: | Estimated Years of Dark Storage for 20% Loss of Least Stable Dye |
| --- | --- |
| 3M High Speed Color Paper Type 19 (EP-2) (N) | 22 (–C) |
| 3M Professional Color Paper Type 25 (EP-2) (N) | 22 (–C) |
| **3M Color Laser Imager Paper and Transparency Film** (EP-2) | **(not disclosed)** |
| **3M Color Laser Imager Paper and Transparency Film** (RA-4) | **(not disclosed)** |
| **3M Dry Silver Color Materials** | **(not disclosed)** |
| **Process C-41 Compatible Color Negative Films:*** | |
| **3M ScotchColor 100 Color Print Film** (formerly 3M Scotch HR 100 Color Print Film) (improved-stability type: 1990—) | **(not disclosed)** |
| **3M ScotchColor 200 Color Print Film** (improved-stability type: 1990—) | **(not disclosed)** |
| **3M ScotchColor 400 Color Print Film** (improved-stability type: 1991—) | **(not disclosed)** |
| 3M Scotch HR 100 Color Print Film (initial type) | 20 (–C) |
| 3M ScotchColor 200 Color Print Film (initial type) 3M Scotch HR 200 Color Print Film | 16 (–C) |
| 3M ScotchColor 400 Color Print Film (initial type) 3M Scotch HR 400 Color Print Film | 12 (–C) |
| **3M Scotch HR Disc Film** (initial type) | **19 (–C)** |

| Process E-6 Compatible Color Slide Films:* | Estimated Years of Dark Storage for 20% Loss of Least Stable Dye |
| --- | --- |
| **3M ScotchChrome 100 Film** (improved type: 1988—) | **(not disclosed)** |
| 3M Scotch 100 Color Slide Film (1987 version) | (not disclosed) |
| 3M Scotch 100 Color Slide Film | 60 (–C) |
| 3M Scotch CRT 100 Film | (not disclosed) |
| **3M ScotchChrome 400 Film** (improved type: 1988—) | **(not disclosed)** |
| **3M ScotchChrome 800/3200 P Film** (1988—) (initially supplied for the European market; the film itself is essentially identical to 3M ScotchChrome 400) | **(not disclosed)** |
| 3M Scotch 400 Color Slide Film (1987 version) | (not disclosed) |
| 3M Scotch 400 Color Slide Film | 47 (–C) |
| **3M ScotchChrome 640T Film** (formerly 3M Scotch 640T Color Slide Film) | **60 (–C)** |
| **3M ScotchChrome 1000 Film** (formerly 3M Scotch 1000 Color Slide Film) | **25 (–C)** |

* Prior to early 1986, Scotch brand color negative and color transparency films were sold under the 3M Color Print Film and 3M ColorSlide Film names (the stability characteristics of the films remained the same when the names were changed). In late 1988 the ScotchChrome name was adopted for all new color transparency films — films that were already on the market were renamed and supplied in the new ScotchChrome style of packaging. In 1990 all 3M color negative films were given the 3M ScotchColor name and a new packaging style was adopted.

End of Chapter 5

# 6. Projector-Caused Fading of 35mm Color Slides

## Fujichrome Films Have the Longest Life When Projected

Projecting a 35mm color slide exposes the image to a concentrated beam of extremely intense light — a Kodak Ektagraphic III projector equipped with the standard 300-watt EXR quartz-halogen lamp has a light level at the film plane of over one million lux (almost 100,000 footcandles), which is equivalent to about *ten times* the illumination intensity of direct outdoor sunlight.[1] The Kodak Ektapro 7000 and 9000 projectors, introduced in 1992, also employ EXR lamps; however, because of an improved mirror design, the Ektapro projectors have about 10% greater film plane illumination intensity than Ektagraphic III projectors. Kodak Carousel and earlier model Ektagraphic projectors equipped with 300-watt ELH quartz-halogen lamps have a light intensity that is only slightly less than that of an Ektagraphic III.

Some special-purpose projectors for large auditorium screens are equipped with powerful xenon-arc lamps which can exceed the light intensity — and fading power — of the standard Kodak projectors by as much as eight times.[2] This can equal *75 times* the intensity of direct outdoor sunlight!

"Projector-caused fading"[3] is a term used by this author to distinguish the deterioration of images caused by slide projection from other types of light fading. The usually intermittent and relatively short total exposure of slides to the extremely intense light and moderately high heat of projection is a unique fading condition to which color prints and negatives are never subjected. During projection, fading takes place at a rapid rate, and it is only because the total projection time of most slides in their lifetimes is relatively short — normally not exceeding 1 or 2 hours — that color slide images manage to survive at all.

The projector-fading and dark fading characteristics of a film often have little relation to each other. For example, Kodachrome films have the best dark fading stability of any type of camera film in the world. However, in this author's projector-fading tests, the situation was quite the reverse, with Kodachrome ranking the worst of all current color slide films. In projector-fading tests, the current Process K-14 Kodachrome films proved even less stable than the previous generation of Process K-12 films (Kodachrome II and Kodachrome-X), which were introduced in 1961 and discontinued in 1974, having been replaced that year by the Process K-14 films Kodachrome 25 and Kodachrome 64.

Assuming that a slide receives at least some projection time, the fading that takes place during its lifetime will be some combination of projector-caused fading and dark fading. The fading of many slides in recent years has been

See page 213 for Recommendations

incorrectly attributed to projection when the primary cause has actually been the poor dark fading stability of the film; this has been particularly true for slides made on unstable motion picture films (such as Eastman Color Print Film 5383 and earlier versions) which were prevalent in educational and slide library markets in the United States from the 1960's until about the end of 1983.

It should never be forgotten that an original color slide is a unique, one-of-a-kind photograph. Like an instant color print, there is no negative from which to make another slide should the original fade, be physically damaged, or be lost. Unless they make their own color prints — and have a firsthand appreciation for the exasperating problems that scratches and dirt cause on reversal prints — most photographers handle their color slides with far less care than they do their black-and-white and color negatives. Minor scratches, surface dirt, fingerprints, and other defects are not nearly as noticeable when slides are projected as they are when the slides are used to make prints for display or color separations for book or magazine reproduction.

For the typical amateur photographer, the projector-fading stability of current slide films appears to be adequate for the usually limited total times of projection; dark fading stability is generally the more important consideration for amateurs. On the other hand, picture agencies, academic slide libraries, teachers, and lecturers are likely to subject slides to repeated and extended projection: 5- to 10-minute projection periods each time a slide is shown are typical for academic art slide libraries, for instance.

Generally speaking, the more valuable a particular slide is, the more likely it is to receive repeated and extended projection. Most photojournalists and stock photographers have slides for which reproduction rights are sold over and over again, year after year. In the hands of editors and art directors, the accumulated projection time may quickly become sufficient to cause subtle losses of image quality — especially in the highlights — and eventually will result in serious image deterioration. Knowledge of the fading rates of slide films will enable the user to obtain projection duplicates before the fading of originals becomes objectionable.

## Light (Not Heat) Is the Primary Cause of Color Slide Fading During Projection

It is primarily light that causes fading when a slide is projected. Because slide films are subjected to projection heat for relatively short durations, projection heat in itself contributes almost nothing to slide fading. For example, an Ektagraphic III projector has a film-gate temperature of about 130°F (55°C),[4] and accelerated dark fading data (see Chapter 5) indicate that no significant fading could

1979

The National Geographic Society in Washington, D.C., like many facilities with important commercial and publication slide collections, houses millions of 35mm color slides (at the time this book went to press in 1992, the Geographic's collection totaled nearly 11 million slides). Ferne Dame, head librarian, describes the Geographic's slide filing system to Klaus B. Hendriks, Director of the Conservation Research Division at the National Archives of Canada. Geographic staff members are urged to keep projection to a minimum — and to avoid exposing slides unnecessarily to light from illuminated editing tables and from room lights when slides sit uncovered on desks. To protect slides from fingerprints and scratching during editing and handling, all slides in the Geographic's working library are kept in Kimac transparent cellulose acetate sleeves.

take place at that temperature during the short total times normally associated with projection. If a slide were projected long enough for heat to have an effect, the resulting light fading would be so severe as to make the heat-induced dark fading inconsequential. High heat may, however, indirectly increase the rate of light fading,[5] and for this reason — as well as to minimize buckling of slides in open-frame cardboard or plastic mounts and to avoid physical damage to the film base and emulsion — projector cooling systems should be in proper working order, and the infrared-absorbing glass filter should never be removed.

There has been a trend in projector design during the past 20 years to increase the light intensity at the film plane while employing infrared-transmitting dichroic lamp reflectors and mirrors, heat-absorbing glass filters, and high-velocity cooling systems to control slide temperature. The introduction of the ELH quartz-halogen lamp in Kodak Carousel and Ektagraphic projectors in 1971 was a major step in this direction. The new 300-watt lamps and associated optical systems provided significantly more intense light at the film plane than did the previous 500-watt incandescent lamp — and, unfortunately, more rapid fading of

slides as well. According to Kodak, the Ektagraphic III has an illumination intensity which is "25% more"[6] than previous Ektagraphic models E-2 through AF-2; in normal use this means that for any given degree of fading, slides will last about 25% longer when projected in the older model Ektagraphic projectors with ELH lamps, and about 30% longer in the older model Carousel projectors that also had ELH lamps but had uncoated condensers in their illumination systems, thereby somewhat reducing their light intensity compared with the Ektagraphic models. The Kodak Ektapro projectors introduced in 1992 provide an additional 10% increase in illumination intensity compared to that in Ektagraphic III projectors.

## What Is the Useful Life of a Projected Slide?

Three factors determine how long a slide can be projected before objectionable fading takes place:

1. **The projector-fading characteristics of the particular slide film.** Current films vary a great deal in their

# Recommendations

## Color Slide Films

- **Fujichrome is best when significant projection of originals is anticipated or when an easily processed E-6 film is required.** During projection, Fujichrome is significantly more stable than any other slide film on the market. Ektachrome (including Ektachrome Plus and HC films, and the new Ektachrome 64T, 320T, 64X, 100X, and 400X films) is the second-choice recommendation. Fujichrome Velvia Professional Film, a very sharp, extremely fine-grain 50-speed film introduced in 1990, fades somewhat more rapidly during projection than other Fujichrome films, but Velvia nevertheless is still more stable than Ektachrome when projected.

- **Kodachrome is best when little or no projection of originals is expected.** In spite of Kodachrome's unequaled dark-storage dye stability and complete freedom from d-min stain, Kodachrome has the worst projector-fading stability of any color slide film currently on the market. Kodachrome is an excellent film if projection can be avoided; but if projection of originals is sometimes a must and time or money prevents routine duplication of originals — or if the complex and time-consuming processing required for Kodachrome is not available and a Process E-6 film is needed — Fujichrome is recommended.

- **Slide films to avoid:** In terms of overall image stability — when projector-fading stability and dark storage stability are considered together — both Agfachrome and 3M ScotchChrome films are inferior to both Fujichrome and Ektachrome films. And when visually compared with Fujichrome, Ektachrome, or Kodachrome, neither Agfachrome nor ScotchChrome distinguishes itself in terms of sharpness, grain structure, or color reproduction; this author can see no compelling reason to recommend their use. Polaroid PolaChrome instant color slides should be strictly avoided unless it is essential to have a quickly processed slide. PolaChrome slides have very poor image quality, the high base density of PolaChrome results in very dark screen images when the slides are projected, and the film suffers from various other practical shortcomings.

- **Duplicating films:** Fujichrome Duplicating Film CDU, which has the same projector-fading and dark-storage stability characteristics as regular Fujichrome camera films, is recommended for duplicating slides. For printing

slides via internegatives, Fujicolor Positive Film LP 8816 is best. Also recommended is Eastman Color Print Film 5384. Agfa CP1 and CP2 color print films have very poor dark fading stability and should be avoided. Kodak Vericolor Slide Film 5072 has relatively poor dark fading stability and should also be avoided if possible. Ilford Ilfochrome (formerly Cibachrome) Micrographic film, which in dark storage is the world's only permanent color film, and also has relatively good projector-fading stability, is unfortunately not yet available in a version with sensitometry suitable for top-quality slide duplication.

## Projection Guidelines

- Never forget that **original** color slides are one-of-a-kind color photographs and should be treated as such. As with daguerreotypes of the 1800's, there is no negative to go back to should an original slide fade, suffer physical damage, or become lost.

- Keep the projection time of original slides or nonreplaceable duplicates to a minimum. For general applications (with Kodak Ektagraphic, Ektapro, and Carousel projectors), the **total** accumulated projection time with Fujichrome should not exceed 5½ hours; with Fujichrome Velvia do not exceed 4 hours; with Ektachrome do not exceed 2½ hours; with Kodachrome do not exceed 1 hour. For particularly important slides — or when image quality is critical — much shorter total projection times should be adhered to (see **Table 6.1**). The accumulated projection time, not the length of a particular projection, is what is important. Lecturers who project certain slides repeatedly should be especially cautious. Project expendable duplicates whenever possible.

- It is the intense light of a projector that causes color image fading; under normal circumstances, projector heat in itself makes a negligible contribution to image fading. (The temperature at the projector film gate should never get so high that buckling, blistering, or other physical damage occurs, however.)

- Unless showing expendable duplicates, avoid high-intensity xenon-arc projectors.

- Glass mounts offer no protection against fading during projection; in fact, glass mounts may somewhat increase the rate of fading.

projector-fading rates (see **Figure 6.1**). Selection of a film usually cannot be based solely on its projector-fading rates; dark fading stability is more important in many applications. Film speed, granularity, sharpness, contrast and color reproduction characteristics, batch-to-batch uniformity, and ready availability of processing are also important considerations.

2. **The intended use of the slide and, subjectively, how much fading can be tolerated.** If the slide is intended only for projection, much greater fading can usually be

tolerated than if the slide is needed for making color prints or for photomechanical reproduction. The pictorial content of a particular slide can also make a great difference in how much fading is acceptable — some types of scenes show fading much more readily than others. Projection of an original slide can, of course, be reduced or avoided by making expendable duplicates for everyday purposes.

3. **The type of slide projector and projector lamp.** With the exception of special high-intensity projectors, this

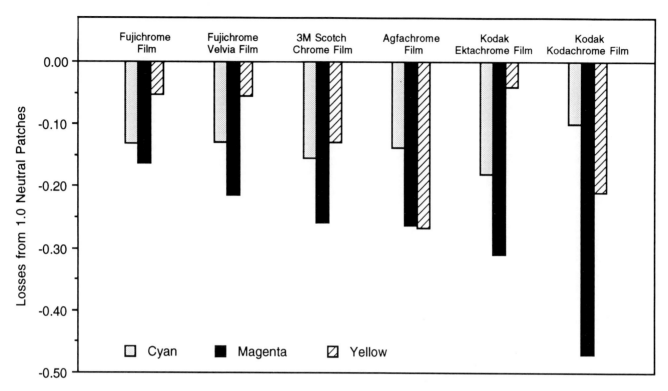

**Figure 6.1**   Fading of magenta dye from an initial neutral density of 1.0 in Fujichrome, Ektachrome, Kodachrome, Agfachrome, and 3M ScotchChrome films. With nearly all of these films, the magenta dye is less stable during projection than either the cyan or yellow dye. The very poor projector-fading stability of Kodachrome is obvious in this comparison.

is not usually as significant a variable as the other two factors listed here. There are important considerations related to the projector, however. For example, operating a Kodak Carousel, Ektagraphic, or Ektapro projector with the lamp-intensity switch in the "Low" position instead of "High" will slow the rate of fading by approximately 30%.

In **Figure 6.1** and other graphs that follow, it should be understood that changes indicated for cyan, magenta, and yellow dyes are actually changes in integral red, green, and blue densities, respectively, as measured by a densitometer. Red density refers to the amount of red light absorbed by the image and is determined primarily by the amount of cyan dye (which absorbs red light) present. Magenta dye primarily absorbs green light, and the amount of magenta present determines green density. Yellow dye absorbs blue light, and the amount of yellow dye (and yellow stain, if any) present determines blue density.[7] For ease of understanding by the reader who may not be familiar with photographic densitometry, this author has in general avoided reference to red, green, and blue densities and instead uses cyan, magenta, and yellow designations.

## Methods of Evaluating Color Slide Fading

This author has developed two sets of criteria to be applied in the computer evaluation of fading and shifts in color balance that result from the projection of slides.[8] One set of criteria is for general amateur and commercial situations where prints are not typically made from the slides and where a fairly large amount of fading can usually be tolerated. For critical commercial and museum applications, a more stringent set of criteria has been chosen. The criteria and method of evaluation are discussed in more detail later.

In developing these criteria, slides made on a variety of films were projected in a Kodak Ektagraphic III projector for 30 seconds, six times each day (a total of 3 minutes a day) during a 140-day period in an attempt to simulate the intermittent short projections, spread out over many months or years, commonly experienced by slides. All of the *current* E-6 and Kodachrome films tested were processed by the Kodalux Processing Services Laboratory (formerly a Kodak Processing Laboratory) in Findlay, Ohio. Kodalux processing is believed to be representative of top-quality, replenished-line commercial processing and, for the purposes of this study, the films are assumed to have optimum image stability (see Chapter 5 for discussion of the influence of processing on image stability).

Older, now-discontinued films were processed by their respective manufacturers. Densitometric data accumulated during the course of the tests were then analyzed by special computer programs in terms of the two sets of criteria. The results of these tests are summarized in **Table 6.1**.

Several negative-positive print films for making slides from original negatives — or in large-quantity slide production from internegatives — are listed in **Table 6.2**. All of these films were exposed and processed by Stokes Imaging Services, Inc., Austin, Texas.[9] Ilford Ilfochrome Micrographic Film (called Cibachrome Micrographic Film,

*(Continued on page 219)*

# Table 6.1   Comparative Stability of Projected Color Slide Films

### Accumulated Times of Intermittent Projection in a Kodak Ektagraphic III Projector to Reach Specified Limits of Density Loss or Color Balance Shift

GE Type EXR Lamp – Projector on "High" Lamp Position – Slides in Open-Frame Mounts

Letters inside ( ) following projection time indicate first limit reached: C = cyan, M = magenta, Y = yellow. For example, (M–Y) means that the color-balance criterion between magenta and yellow was reached, with yellow fading more than magenta; (–C) means the cyan-dye fading limit was reached first. See Chapter 5 for data on the dark-storage stability of these films. Times for slides in Kodak Ektapro projectors are similar to those listed here.

**Boldface Type** indicates films that were being marketed in the U.S. and/or other countries when this book went to press in 1992; the other products listed had been either discontinued or replaced with newer materials.

| Slide Film Type | General Commercial and Amateur Use | Critical Commercial and Museum Use |
|---|---|---|
| **Fujichrome professional and amateur films, and Fujichrome duplicating films** (for Fujichrome Velvia film, see below) (initial types: 1983–88/89) (improved types: 1988/89/92—) [see Note #1] (Process E-6) | **5 hr 20 min (–M)** | **2 hr 25 min (–M)** |
| **Fujichrome Velvia Professional Film** (ISO 50) (1990—) [see Note #2] (Process E-6) | **4 hr 45 min (–M)** | **1 hr 5 min (–M)** |
| **3M ScotchChrome 100, 400, 800/3200, and 640T films** **Polaroid Presentation Chrome Film** (1988—) 3M Scotch 640T Color Slide Film (1981–89) (although these films are labeled by 3M and Polaroid as "Made in U.S.A.," they are actually manufactured in Italy by a 3M subsidiary) [see Note #3] (Process E-6) | **3 hr 30 min (–M)** | **1 hr 20 min (–M)** |
| Kodak High Speed Ektachrome Film Kodak High Speed Ektachrome Film Type B Kodak Ektachrome-X Film (1963–77) [see Note #4] (Process E-4) | 3 hr 30 min (–M) | 1 hr 10 min (–M) |
| Kodak Ektachrome Professional Film EP-120 (120-size transparencies) (1959–77) [see Note #5] (Process E-3) | 3 hr (–M) | 1 hr 10 min (–M) |
| Fujichrome 100 Film Fujichrome 400 Film (initial types: 1978–84) [see Note #6] (Process E-6) | 2 hr 45 min (Y–M) | 1 hr 45 min (Y–M) |
| **Kodak Ektachrome professional and amateur films, and Ektachrome duplicating films** (1976—) [see Note #7] (Process E-6) | **2 hr 40 min (–M)** | **1 hr 5 min (–M)** |
| **Ektachrome 100 Plus Professional Film** **Ektachrome 100HC, 50HC, and 400HC films** (100 Plus and HC: 1988—; 50HC: 1990—; 400HC: 1992—) **Ektachrome 64T, 320T, 64X, 100X, and 400X Professional films** (64X and 64T: 1991—; 100X: 1990—; 320T and 400X: 1992—) [see Note #8] (Process E-6) | **2 hr 40 min (–M)** | **1 hr 5 min (–M)** |
| Fujichrome R-100 Film (1968–73) [see Note #9] (Process E-4) | 2 hr 15 min (–M) | 1 hr 5 min (–M) |
| **Konica Chrome R-50, R-100, R-200, and R-1000 films** (1990—) (generally available only in Japan) [see Note #10] (Process E-6) | **(data not available for these films)** | |

| Slide Film Type | General Commercial and Amateur Use | Critical Commercial and Museum Use |
|---|---|---|
| **Agfachrome RS 50, 50 Plus, 100, 100 Plus, 200, and 1000 professional and CT amateur films** (improved types: 1988/92—) [see Note #11] (Process E-6) | **2 hr (C–M)** | **20 min (C–M)** |
| Agfachrome 64 and 100 films (1976–83) [see Note #12] (Process AP-41) | 1 hr 35 min (–C) | 50 min (–C) |
| Kodachrome II and Kodachrome-X films Kodachrome II Professional Type A Film (1961–74) [see Note #13] (Process K-12) | 1 hr 20 min (C–M) | 30 min (C–M) |
| **Kodachrome 25, 64, and 200 professional and amateur films; Kodachrome 40 Type A** (1974—) [see Note #14] (Process K-14) | **1 hr (C–M)** | **20 min (C–M)** |
| GAF 64, 200, and 500 films (1969–77) [see Note #15] (Process AR-1) | 40 min (M–C) | 25 min (M–C) |
| **PolaChrome Instant Color Slide Film** (1983—) [see Note #16] (instant process) | **(developed severe, irregular stains during test – not recommended for other than short-term applications)** | |

## Notes:

1. Only Fujichrome 50D and 100D Professional films were included in these tests; however, Fuji has indicated that all of the "new type" E-6 professional and amateur Fujichrome films, the first of which were introduced in early 1983, have similar projector-fading and dark fading stability characteristics. The films can be processed in Kodak Process E-6 or Fuji Process CR-56 (Fuji's equivalent to E-6). Fujichrome professional, amateur, and duplicating films are this author's primary recommendation for Process E-6 compatible films.

2. Fujichrome Velvia Professional Film is an ISO-50 Process E-6 (Fuji CR-56) film introduced in January 1990. Velvia is a high-saturation, very sharp, and extremely fine-grain film. The name Velvia was derived from the words "velvet" (smooth, long-scale, and very fine-grain tone reproduction) and "media" (the main market for Velvia is in commercial, advertising, and fashion photography intended for reproduction in printed media). The grain and sharpness characteristics of Velvia are better than Kodachrome 64 and, overall, are approximately equal to those of Kodachrome 25 film, which had long been considered the sharpest and finest-grain color slide film in the world.

3. Only 3M ScotchChrome 100 film was included in these tests; however, 3M ScotchChrome 400 and 800/3200 films probably have similar projector-fading stability. 3M ScotchChrome films formerly were called 3M Scotch Color Slide films; prior to that they were sold under the 3M ColorSlide name. In 1986 the name was changed to Scotch and the film packaging redesigned in an attempt to build stronger identification with the well-known 3M "Scotch" brand (e.g., Scotch tapes). The data given here are for the "improved type" films introduced in 1988.

(At the time this book went to press in 1992, ScotchChrome 640T and 1000 films were still being sold. These films have projector-fading characteristics that are generally similar to the improved 1988 films; however, the 640T and 1000 films have inferior dark fading stability compared with the new films.) Polaroid Presentation Chrome film is a non-instant E-6 film made for Polaroid by 3M; Presentation Chrome is apparently identical to Scotch-Chrome 100 Film. Although labeled "Made in USA," 3M ScotchChrome and 3M Scotch Color Print films in reality are made in Ferrania, Italy by 3M Italia S.p.A. The films are only packaged in the U.S. 3M Italia is a subsidiary of the 3M Company, St. Paul, Minnesota. In spite of the relatively good projector-fading stability of 3M Scotch-Chrome films, they have comparatively poor dark fading stability and are not recommended. By the end of the 6-hour intermittent projection tests with 3M ScotchChrome 640T film, a "greasy" surface residue was observed on parts of the emulsion surface. The nature of this undesirable substance has not been identified, but it likely is coupler solvent or other emulsion addenda. The residue was not apparent on slides projected continuously for 6 hours. The exudation seems to be caused by the combined effects of intermittent projector light and projector heat. A similar-appearing surface residue was noted on Eastman Color Print Film 5384 slides after between 5 and 6 hours of intermittent projection (see Note #1 in Table 6.2).

4. High Speed Ektachrome Film was introduced in April 1959 as a Process E-2 160-speed film; it was converted to Process E-4 around 1966. Ektachrome-X, an ASA 64 film, was marketed in March 1963 as a replacement for the previous ASA 32 Ektachrome film. Although unknown to photographers at the time, these films had

much better dark fading stability than the Process E-3 Ektachrome Professional films widely used by professional photographers until 1977 (see Note #5), when the Process E-3 films were replaced by Process E-6 films (see Notes #7 and #8).

5.  Introduced in 1959, Ektachrome Professional Process E-3 roll and sheet films have extremely poor dark fading stability — the worst of any transparency film tested by this author. Ektachrome Process E-3 120 roll film and sheet films were not supplied by Kodak in the 35mm format. However, the film was included in this study since transparencies made with it are sometimes projected using 120 slide projectors. The Process E-3 professional films replaced the original Process E-1 Ektachrome film introduced in 1946 (a tungsten-balanced Type B version was marketed in 1952). Ektachrome sheet films replaced Kodachrome sheet films that had far better dark fading stability, a fact of which Kodak was well aware but which was withheld from photographers. Process E-3 camera and duplicating films were in widespread use by commercial, advertising, and fashion photographers until the films were replaced with Process E-6 films. Perhaps surprisingly, the "amateur" Process E-4 Ektachrome films, available all through the 1960's and 1970's, were much superior to the "professional" Ektachrome films in terms of dark fading stability.

6.  Introduced by Fuji in 1978, Fujichrome 100 and 400 films were used primarily by amateurs and had a relatively small market in the U.S. The films were replaced by "new type" E-6 compatible Fujichrome films in 1983.

7.  Only Ektachrome Professional 50 Tungsten and Ektachrome 400 film were included in these tests. Kodak Publication CIS No. 50-45 (August 1982) and Kodak Publication E-106 (May 1988) indicate that these two films as well as other amateur and professional Process E-6 films (including Ektachrome 64, Ektachrome 160, Ektachrome 200, and Ektachrome Duplicating Films, but not including Ektachrome 100 Plus, Ektachrome "HC" films, and Ektachrome "X" films), have identical projector-fading and dark fading stability. Early versions of the Process E-6 Ektachrome films, introduced in 1976, were less stable in dark storage than later versions.

8.  Introduced in February 1988, Ektachrome 100 Plus Professional Film has higher color saturation than Ektachrome 100 Professional Film and other older Ektachrome professional films. Ektachrome 100 HC film, also introduced in 1988, is the amateur counterpart of Ektachrome 100 Plus film. Ektachrome 50 HC film was introduced in 1990. Kodak has indicated that the earlier Ektachrome 100 Professional Film will continue to be sold. Ektachrome 64X (1991—), 100X (1990—), 400X, 400HC, 64T, and 320T (1992—) are "warm-balance," high-saturation films with overall color and tone reproduction that are generally similar to those of Fujichrome films.

9.  Fujichrome R-100 was a Process E-4 compatible film intended mostly for the amateur market; manufactured from 1968 to 1973, the film was never widely sold in the United States.

10. Konica Chrome "professional" color transparency films were introduced in late 1990. Konica has sold an ISO 100-speed transparency film in amateur markets in Japan and some other countries since 1976; this film has not been available in the U.S. and this author has not tested the film for projector-fading stability. The Konica Chrome "professional" films also are not available in the U.S. and had not been tested by this author at the time this book went to press in 1992. Unlike Kodak, Fuji, and Agfa — all of which have broad lines of both color negative and color transparency films — Konica has largely focused its efforts on color negative films and color negative papers.

11. Process E-6 compatible Agfachrome RS professional and CT amateur films were introduced by Agfa in 1984–85 as replacements for Agfachrome 64 and 100 films, which could be processed only in Agfa Process 41. The initial versions of the Agfachrome E-6 compatible films had poor dark fading stability. In March 1987 Ilford introduced Ilfochrome 50, 100, and 200 color slide films. These films were made for Ilford by Agfa-Gevaert and apparently were identical to Agfachrome films of the same ISO ratings. Ilford discontinued sale of the films in 1988. Like their Agfachrome counterparts, the Ilfochrome films had comparatively poor dark fading stability. Improved versions of Agfachrome RS and CT films with better dark fading stability were introduced in 1988.

12. Agfachrome 64 and 100 films were direct descendants of the original Agfacolor Neu transparency film introduced in 1936 (this was the world's first incorporated coupler color film and was much simpler to process than the Kodachrome films introduced by Kodak a year earlier in 1935). Agfachrome 64 and 100 films could be processed only with Agfa Process 41; when the Kodak E-6 process came into almost universal use in the late 1970's, the market for the Agfa films became ever more limited. Agfachrome 64 and 100 films have good dark fading stability in low-humidity conditions but fade rapidly in high-humidity accelerated tests. Agfa replaced the films with E-6 compatible Agfachrome RS and CT films beginning in 1984.

13. Process K-12 Kodachrome II Film and Kodachrome II Film, Type A [3400 K tungsten] were introduced in February 1961 as replacements for the modified Kodachrome films placed on the market in 1938. The original daylight Kodachrome 35mm film, introduced in September 1936, and Kodachrome Film, Type A, introduced in October 1936, had very poor dark fading stability, especially in terms of the yellow dye; both the film and processing technique were changed in 1938, and from that date all Kodachrome films have had comparatively good dark fading stability — in addition to almost complete freedom from stain formation. Kodachrome-X, a higher-speed version of Kodachrome II, was introduced in December 1962. The films were widely used by both professionals and amateurs.

14. Considered by Kodak primarily to be amateur slide films, Process K-14 Kodachrome 25 and 64 films were introduced in March 1974 as replacements for Process K-12 Kodachrome II and Kodachrome-X films. A Process K-14 version of Kodachrome 40 Film, Type A was marketed in January 1978. In response to numerous complaints by professional photographers about color balance irregularities and curve crossover problems of the amateur

Kodachrome 25 and 64 films, Kodak introduced Kodachrome 25 Professional Film (and special "professional" processing at Kodak labs) in 1983, and followed with Kodachrome 64 Professional Film in 1984. Kodachrome 200 Professional Film and a 120 roll-film version of Kodachrome 64 Professional Film were introduced in October 1986. All of the Process K-14 Kodachrome films have identical, poor projector-fading stability; but in dark storage Kodachrome films have outstanding dye stability and complete freedom from yellowish stain.

15. GAF 35mm slide and roll-film transparency films, which until 1969 had been sold under the Anscochrome name, were withdrawn from the market in 1977 when General Aniline and Film Corporation decided to abandon its photographic materials business. The GAF films had the worst projector-fading stability of any transparency film tested by this author. These films used the older "Agfa-type" couplers and, in common with other films of this type, have very poor stability in high-humidity accelerated dark fading tests. In low-humidity storage, however, the dark fading stability of these films appears to be reasonably good.

16. Polaroid PolaChrome instant color slide film, an ISO 40 film based on the antiquated additive-screen process,

was introduced in 1983 (PolaChrome High Contrast film was introduced in 1987 for special applications such as photographs of graphs, charts, etc.). Intended for use in conventional 35mm cameras, PolaChrome films can be processed in about 1 minute with a small tabletop processing unit. During the course of these projector-fading tests, PolaChrome instant slides developed severe, irregular yellow stains; non-uniform staining of this type cannot be corrected by adjustments in color balance or exposure during duplication or printing and is one of the worst types of flaws a photographic product can have. Because of the stain problem, coupled with very poor stability in high-humidity accelerated dark fading tests, this film is not recommended for applications requiring other than short-term stability. Had the irregular yellow stains not occurred, PolaChrome film would have been given about a 6-hour projection life based on the "General Commercial and Amateur Use" criteria (with density measurements made in lesser-stained areas of the image). If one were to ignore the stain problem, the projector-fading stability of PolaChrome film is in a general way similar to that of Fujichrome film (it is difficult to compare directly the projector-fading stability of PolaChrome film with conventional films because PolaChrome has a very high base density, and a distinctly different manner of fading and staining).

## Table 6.2   Comparative Stability of Projected Negative-Positive Slide Print Films and Ilford Ilfochrome Color Microfilm

### Accumulated Times of Intermittent Projection in a Kodak Ektagraphic III Projector to Reach Specified Limits of Density Loss or Color Balance Shift

GE Type EXR Lamp – Projector on "High" Lamp Position – Slides in Open-Frame Mounts

Letters inside ( ) following projection time indicate first limit reached: C = cyan, M = magenta, Y = yellow. For example, (M–Y) means that the color-balance criterion between magenta and yellow was reached, with yellow fading more than magenta; (–C) means the cyan dye fading limit was reached first. See Chapter 5 for data on the dark-storage stability of these films. Times for slides in Kodak Ektapro projectors are similar to those listed here.

**Boldface Type** indicates films that were being marketed in the U.S. and/or other countries when this book went to press in 1992; the other products listed had been either discontinued or replaced with newer materials.

| Film Type | General Commercial and Amateur Use | Critical Commercial and Museum Use |
|---|---|---|
| **Ilford Ilfochrome Micrographic Film** (called Ilford Cibachrome, 1984–1991) [see Note #1] (P-5 process) | 7 hr (–C) | 1 hr 40 min (–M) |
| **Vericolor Slide Film 5072** [Eastman Kodak] (C-41 process) | 5 hr (–M) | 1 hr 50 min (–M) |
| **Eastman Color Print Film 5384** (ECP-2A motion picture process) [Eastman Kodak] [see Note #2] | 4 hr 20 min (C–M) | 3 hr 10 min (C–M) |
| Eastman Color Print Film 5383 (ECP-2 motion picture process) [Eastman Kodak] [see Note #3] | 3 hr 30 min (C–M) | 2 hr 15 min (C–M) |
| Gevacolor Print Film 982 (ECP-2A motion picture process) [Agfa-Gevaert] [see Note #4] | 2 hr 30 min (C–M) | 1 hr 45 min (C–M) |

## Table 6.2 Notes:

1. Ilford Ilfochrome Micrographic films are manufactured in Fribourg, Switzerland by Ilford AG (a subsidiary of International Paper Company, headquartered in New York City). The films were introduced in 1984, and from that date until 1991 they were called Ilford Cibachrome Micrographic films. Ilfochrome Micrographic films, which utilize the silver dye-bleach color system, are made on a polyester base. In dark storage, the films are essentially permanent; they should last many hundreds of years without noticeable fading or staining. No other type of color film can even approach the dark storage stability of Ilfochrome Micrographic films. The films are supplied in two versions: Type M, a high-contrast film for copying reflection materials, and Type P, a moderate-contrast film for reproducing transparent originals and for use as a duplicating film. The films are processed by the user in Ilfochrome Process P-5. Ilfochrome Micrographic films are distributed in the U.S. by Microcolor International, Inc., 85 Godwin Avenue, Midland Park, New Jersey 07432; telephone: 201-445-3450. Microcolor also offers various micrographic services including processing of Ilfochrome Micrographic films.

2. Between the fifth and sixth hour of intermittent projection, the Eastman Color Print Film 5384 slide of a Macbeth ColorChecker was noted to have significant amounts of a "greasy" residue on the emulsion side of the film in sections of the high-density parts of the image; the residue probably became apparent prior to the fifth hour of projection, but was not noticed during routine densitometry during which only the base side of the film was visible to this author. The substance has not been identified, but it appears to be coupler solvent or other emulsion addenda. The residue, which smears easily when touched, would create problems with glass-mounted slides. To date, a similar residue has been seen only on 3M Scotch Color Slide 640T and 1000 films (see Note #3 in Table 6.1). The residue on 5384 was not observed in accelerated dark fading tests with the film; the residue seems to be caused by the combined effects of intermittent exposure to projection light and projection heat. Continuous projection for 6 hours did not produce the surface residue. Eastman Color Print Film 5384 was introduced in 1981–82 as a replacement for 5381 and 5383. Eastman 5384 is widely used as a slide print film by low-cost labs offering Eastman Color Negative Film 5247 and 5294 motion picture films respooled in 35mm cassettes for still cameras (use of these negative films in still camera applications is not recommended by this author). Eastman Color 5384 has much better dark fading stability than Vericolor Slide Film 5072, and this author recommends 5384 as a better film for making slides from color negatives, in spite of the projector-caused emulsion exudation observed with 5384.

3. Eastman Color Print Film 5383 has very poor dark fading stability and for this reason was not suitable for color slide production, although it was extensively used for this purpose. 5383 and a similar motion picture print film, 5381, were discontinued in 1983 and replaced by Eastman Color Print Film 5384, which has much better dark fading stability than 5383 and 5381 (see Note #2 above concerning 5384). Eastman Color 5383 was widely used as a slide print film by low-cost labs offering Eastman Color Negative Film 5247 motion picture film respooled in 35mm cassettes for still cameras. Both the negative and resulting slides have very poor dark fading stability.

4. The Gevacolor Print Film 982 in these tests (obtained in 1983) had very poor dark fading stability. In 1984 Agfa-Gevaert introduced a new version of Gevacolor Print Film 982 (the name of the product remained the same). This motion picture print film was replaced with Agfa CP1 print film in 1990 (which was supplemented with Agfa CP2 film in 1992). Information is not available on the projector-fading stability of CP1 and CP2 films, but it is probably similar to the discontinued 982 film tested here. Both CP1 and CP2 have very poor dark fading stability and should be avoided.

---

1984–91), a low-speed (about ISO 1), high-resolution silver dye-bleach color microfilm designed for copying maps and other documents but sometimes also used as a slide film and slide-duplicating film, was also included in this study because of its essentially permanent dark-storage characteristics. This film was processed by Microcolor International, Midland Park, New Jersey.[10]

## Fujichrome Film: The Best Projector-Fading Stability of Any Color Slide Film

In terms of projector-caused fading, this author's tests showed clearly that Fujichrome films are the most stable slide films currently available. When projected, standard Fujichrome films were *twice* as stable as Ektachrome films and more than *five times* as stable as Kodachrome films. In this author's dark-storage tests, standard Fujichrome films and Ektachrome films had similar stability characteristics. Fujichrome Velvia Professional Film, a very sharp and extremely fine-grain 50-speed E-6 film introduced in 1990, is somewhat less stable when projected than standard Fujichrome; however, Velvia is significantly more stable than Ektachrome or Kodachrome. Current Agfachrome RS and CT professional and amateur films, although significantly improved compared with earlier Agfachrome E-6 films, are inferior to Fujichrome and Ektachrome in both projector-fading and in dark storage. (The dark fading characteristics of color transparency films are discussed in Chapter 5.)

For most photographers, Fujichrome and Kodachrome professional films should be the slide films of choice. Fujichrome is available in a comprehensive line of 35mm, 120 roll-film, and sheet-film formats, with ISO speeds from 50 to 1600; Fujichrome films can be processed easily by the user or by any lab offering E-6 processing. In the late 1980's many experienced professional photographers came

to believe that Fujichrome films had generally better color saturation and more pleasing color and tone-scale reproduction than Kodak's analogous Ektachrome films. Thom O'Connor, writing in New York City's *Photo District News* in 1987, said: "Since their introduction in America just three years ago, Fujichrome Professional transparency films have significantly eroded both the professional sales and prestige of Kodak's Ektachrome and Kodachrome emulsions."

In the article, veteran *Time* magazine photographer Bill Pierce, a recent convert to Fujichrome, cited a number of reasons why he and many other top photojournalists had come to prefer the Fuji films:

> Fujichrome has a magical quality. Everywhere I've worked in the past few years, in or out of the country, photographers were using Fuji as an alternative to Ektachrome. Fuji is a warmer film, it's punchier, it has exciting colors, it makes skies majestically blue. Especially on overcast days, it delivers. In the beginning we all used Fuji for pictures that were important to us — of our kids and girlfriends — the pictures that we weren't being paid for. Now Fuji has become a bread-and-butter film.[11]

O'Connor reported, "[P]hotographers are switching from Kodachrome and Ektachrome not because of price differences, fancy packaging, or expensive ad campaigns, but because they simply feel Fujichrome gives better results."

> Photographers and editors at *Time, Playboy, Sports Illustrated,* and the *Los Angeles Times Sunday Magazine* have been favorably impressed by Fuji, and *USA Today* has gone so far as to recommend Fujichrome as the "film of choice" for staff and freelance photographers. "When we assign a photographer," explains Bob Deutsch, *USA Today* staff shooter based in New York, "we talk about Fuji as a film which is superior enough to Kodak to make it our choice. Fuji emphasizes the warm tones, and it's very good with blues outdoors. We prefer the 50-speed film, although I often use the 100-speed film for the extra bit of speed."

The 1988 introduction of Ektachrome 100 Plus Professional Film, and its Ektachrome 100 HC Film amateur counterpart, brought Kodak closer to Fujichrome in terms of color saturation. The "warm-balance" Ektachrome 64X, 64T, 100X, 320T, and 400X professional films introduced during 1990–92 were designed to compete directly with the high-saturation, somewhat "warm" color rendition of the Fujichrome professional films. While the color and tone-scale reproduction gap between Fujichrome and Ektachrome films has narrowed, and some photographers feel that the skin tone reproduction of Ektachrome 64X and 100X films is superior to that of Fujichrome films, the projector-fading stability of the new Ektachrome films has not been improved, and in this respect they remain markedly inferior to Fujichrome films. Where extensive projection might occur, and it is impractical to make expendable duplicates from originals for projection, Fujichrome films are the ob-

vious choice.

In 1993 Kodak will introduce a new series of Ektachrome films that the company claims will have the best speed/grain ratio of any color transparency films in the world (presumably including Kodachrome and Fujichrome Velvia). It is of course possible that the new Ektachrome films also will have improved projector-fading characteristics when compared with that of current Ektachrome films, but no image stability data on the new films were available at the time this book went to press in 1992.

With the exception of a 120 roll-film version of Kodachrome 64 Professional Film, marketed in early 1987, Kodachrome films are currently available only in 35mm, with ISO speeds restricted to 25, 40 (tungsten balance), 64, and 200, and the complicated processing procedure can be carried out only by Kodalux labs and a very small number of commercial labs. Kodachrome 25, 40, and 64 films have very fine grain and excellent image sharpness, and Kodachrome films also have by far the best dark fading stability of any chromogenic color film — transparency or negative. But one must be very careful to restrict the projection of Kodachrome originals; duplicates, preferably on Fujichrome Duplicating Film, should be made when significant projection is a possibility.

## With an Improved Magenta Dye, Kodachrome Could Have the Best Projector-Fading Stability of Any Color Slide Film

Kodachrome is unique among the world's chromogenic color films in that the dye-forming color couplers are in the developer solutions, and are not placed in the film itself during manufacture (see Chapter 1 for a description of the complex Kodachrome processing procedure). It should not be difficult for Kodak to design a new magenta coupler that would produce a magenta dye with better projector-fading stability. Given the good stability of the present cyan and yellow dyes, a sufficiently improved magenta would make Kodachrome the most stable of all color slide films when projected — and Kodachrome is already the most stable color film in the world when kept in the dark.

Apparently believing that Kodachrome was primarily an amateur product that was destined for eventual oblivion, Kodak has made no significant improvements in the Kodachrome K-14 process since it was introduced in 1974 — and this research and development neglect has taken its toll. No other color film in the world has gone for so long without significant improvement. In both color reproduction and projector-fading stability, Kodachrome has fallen behind Fujichrome, Ektachrome, and other E-6 films.

## Short versus Long Projection Times

One important conclusion of this author's research is that — at least for Ektachrome, Kodachrome, Agfachrome, and PolaChrome films — much *more* fading is caused by projecting slides for short, intermittent periods than by long, continuous projections of an equivalent total projection time (as will be discussed later, fading of Fujichrome films is less variable under different projection conditions). Recognition of this slide projection "reciprocity failure" is crucial in developing meaningful projector-fading tests. This

topic is discussed in more detail later.

Kodak and other film manufacturers have frequently advised that slides not be projected for "longer than one minute." This advice is apparently given in an attempt to restrict total projection time, but it has often been interpreted by photographers and other users of slides to mean that disproportionate damage is done by long projections. The most frequent explanation for this belief given to this author is that heat which "builds up" in the slide during long projection causes premature dye fading.

### Glass Mounts versus Open-Frame Mounts

Kodak Ektachrome 50 Tungsten and Kodachrome 25 films were tested in conventional open-frame plastic mounts and in a modern type of plastic-framed glass mount.[12] After 6 hours of intermittent 30-second projections, both types of film appeared to have faded slightly more in the glass mounts (see **Figure 6.2**). The differences in fading between the glass and open-frame mounts were so small as to be within the range of experimental error and are an insignificant factor in deciding which type of mount to use. What was clear, however, was that glass mounts did not *increase* the life of the color image, as has sometimes been suggested. Other types of films possibly may respond differently to projection if they are in glass mounts, and films stored in either a higher or lower relative humidity than the 60% chosen for these tests may also show dissimilar results. The length of each projection and the time inter-

val between projections are probably significant variables. Polyester-tape-sealed glass mounts of the type advocated by Christine L. Sundt of the University of Oregon at Eugene were not included in this study because of the lengthy test periods required to accurately evaluate this type of semi-sealed slide mount.[13]

### Visual Characteristics of Projector-Faded Color Slide Images

When a color slide image fades in a projector, it loses density; undergoes a shift in color balance because of unequal fading rates of the cyan, magenta, and yellow image dyes; and in some cases develops objectionable yellow stains which are most apparent in the highlight areas of the image. In contrast to dark fading, which is characterized by a more or less equal percentage loss of density throughout the density range, the visual effects of light fading are very much concentrated in the lower-density portions of the image. The percentage losses of green density (represented mostly by magenta dye) throughout the density range of a Kodachrome 64 slide after 1 and 6 hours of intermittent projection are illustrated in **Table 6.3**. The disproportionate loss of image dyes in low densities is a characteristic of light fading (and of projector-fading of transparencies) that is recognized in the new *ANSI IT9.9-1990, American National Standard for Imaging Media – Stability of Color Photographic Images – Methods for Measuring*.[14] The topic is discussed in Annex A of the Standard.

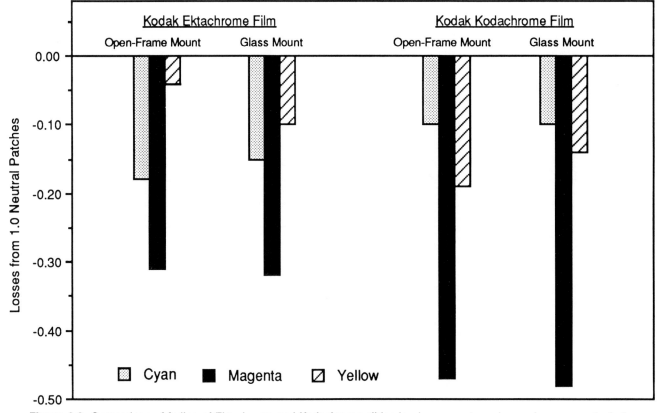

**Figure 6.2** Comparison of fading of Ektachrome and Kodachrome slides in glass mounts and open-frame mounts during intermittent projection. With both films, slightly greater fading took place in the glass-mounted slides.

**Table 6.3    Percentage Losses of Green Density (Magenta Dye)
in Kodachrome 64 Film as a Result of Fading in a Kodak
Ektagraphic III Projector – GE Type EXR Lamp**

Six 30-Second Projections Per Day — Slide Kept in Dark at 75°F (24°C) and 60% RH Between Projections
Neutral-Gray Patches (Base + Fog Density = 0.18)

| Density at Start | Loss After 1 Hour | % Loss | % Loss Minus Base + Fog | Density at Start | Loss After 6 Hours | % Loss | % Loss Minus Base + Fog |
|---|---|---|---|---|---|---|---|
| 0.25 | −0.08 | −32% | −100% | 0.25 | −0.16 | −64% | −100% |
| 0.35 | −0.11 | −31% | −65% | 0.35 | −0.23 | −66% | −100% |
| 0.45 | −0.11 | −24% | −41% | 0.45 | −0.29 | −64% | −100% |
| 0.6 | −0.11 | −18% | −26% | 0.60 | −0.37 | −62% | −88% |
| 1.0 | −0.10 | −10% | −12% | 1.00 | −0.47 | −47% | −57% |
| 1.5 | −0.09 | −6% | −7% | 1.50 | −0.56 | −36% | −42% |
| 2.0 | −0.07 | −4% | −4% | 2.00 | −0.54 | −27% | −30% |
| 2.5 | −0.06 | −2% | −3% | 2.50 | −0.53 | −21% | −23% |
| 3.0 | −0.06 | −2% | −2% | 3.00 | −0.53 | −18% | −19% |

**Note:** These integral green-density values were computer-interpolated based on data from a 10-step
gray scale with a minimum density of 0.21 and a maximum of 3.30.  Measurements were made
with a Macbeth TR924 densitometer equipped with Status A filters.

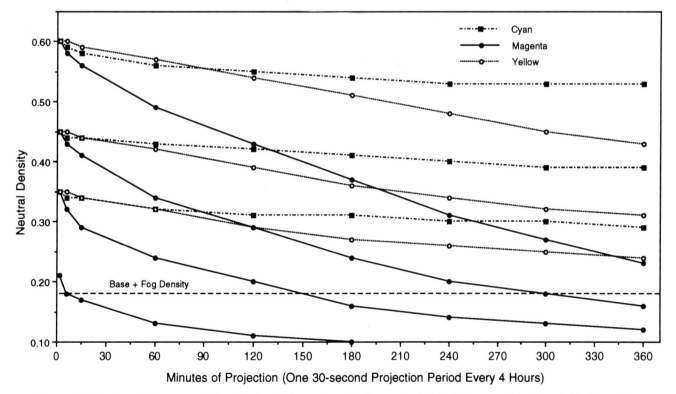

**Figure 6.3** Fading of the magenta dye at selected lower densities in a projected Kodachrome slide.  For clarity, the yellow
and cyan curves in this graph have been omitted at the lowest density.  The disproportionate fading of the magenta dye
causes a marked color shift toward green.  In the low, highlight, and near-highlight densities, even a relatively short
projection time can result in a **total** loss of the magenta image.

In projector-caused fading of Kodachrome films, the magenta dye is significantly less stable than either the cyan or yellow dyes. As fading of the image progresses, ever more serious color-balance shifts toward green, coupled with a loss of detail, occur in low-density and highlight regions of the color image; the color shifts cannot be corrected by means of filter adjustments during printing without causing undesirable color changes in higher-density parts of the image.

**Figure 6.3** shows the progression of fading of Kodachrome 64 starting at an original neutral density of 0.6 and three lower densities. As can be seen, the lower green densities fade very quickly to the base + fog level of about 0.18 (at which point the image detail contained in the magenta dye layer is entirely lost). The base + fog density of most color images consists of the optical density of the film base (typically about 0.05) with the remainder composed of a dye "fog," perhaps with a small of amount of residual sensitizer dye or other stain. The base + fog density of a particular product is considered to be the d-min (minimum density). The dye present in the d-min is of course subject to light fading just like the image itself, and this is why projector-caused fading often results in a density that is less than the original d-min.

At an original density of 0.35, a little over 2 hours of projection is required for the green density of a Kodachrome slide to reach the base + fog level; most slides have important parts of the image with a density of 0.35 or less. At 0.25, in the highlight region, only about 45 minutes of projection is required to reach the base + fog level! The extreme color-balance shifts toward green that occur in the lower densities as Kodachrome progressively fades are readily apparent from the curves in **Figure 6.3**.

How visually obvious these defects are depends not only on how much fading has taken place in all three image dyes but also to a very significant degree on the nature of the image. Scenes with large low-density areas show this effect much more than high-contrast scenes which consist mostly of medium- and high-density areas. A beach scene with large areas of light sand and a gray, overcast sky along with darker areas of muted colors would be particularly sensitive to projector-caused fading. A portrait of a person with light brown or blonde hair may show a shift in color in the lighter portions of the hair, which can be very obvious when compared with the hair in darker areas. Because of the poor stability of the magenta dye versus the cyan dye, Kodachrome films are particularly susceptible to this type of fading.

When slides are viewed in a dark surround, the eye can adapt to shifts in color balance much more readily than is the case when color prints are viewed in a normally lighted room. With many types of scenes, fairly substantial fading and color shifts can take place in a projected slide without the viewer thinking anything is wrong with the image — unless an unfaded image is projected next to or immediately after the faded one. A slightly pink sky in a Kodachrome slide can very quickly shift to a neutral sky — and later to a slightly green sky — as a result of projector-caused fading. If the viewer did not know what the sky looked like in the original slide, this major change in the appearance of the image would probably not be noticed. Multi-image slide shows, in which two or more projectors are operated simultaneously so that images are projected next to each other, or even in edge-to-edge contact, can clearly reveal even slight shifts in color balance in similar scenes.

Low-density color shifts due to moderate projector-caused fading can be partially corrected in the course of duplication or printing by filtration. The appearance of a duplicate made from a faded Kodachrome slide can almost always be improved in this manner, but the image will still suffer from loss of highlight detail. If the best correction is selected for lower mid-tone portions of the image, both lighter and darker portions of the image will continue to have color imbalances — the highlights will be shifted to magenta and the higher-density image areas will have a greenish cast. Once lost through projector-caused fading, highlight detail cannot be restored. Because of this, corrective duplication using contrast-adjusting masks for the faded dyes, such as the procedures suggested by Edwin Wiitala of Eastman Kodak for dark-faded transparencies,[15] has only limited effectiveness with light-faded images.

In the hands of a skilled operator, better success might be had with electronic digital image-processing equipment such as Apple Macintosh computers running Adobe Photoshop, the Kodak Premier Image Enhancement System, or the Agfa Digital Slide Printer. In general, however, restoration of transparencies that suffer from serious light fading is much more problematic than restoration of dark faded transparencies. The general impression one gets from projector-faded images of most slide films is a highlight and mid-tone color shift — with most current films the shift is toward green because the magenta dye fades more rapidly than either the cyan or yellow dyes. With some exceptions, the magenta dyes in chromogenic films and prints have historically had inferior light fading stability compared with cyan and yellow dyes; however, magenta dyes in most products have much better dark fading stability than the other two dyes.

But progress is being made. The second-generation Fujichrome E-6 compatible films introduced in 1983, and improved in 1988, show better retention of neutral color balance in critical lower densities during the course of projector-caused fading compared with any of the Kodak camera slide films on the market at the time this book went to press in 1992. The Process E-6 compatible Agfachrome films introduced in 1984–85, and improved in 1988 and 1992, have greatly improved projector-fading characteristics compared with previous Agfachrome films; nevertheless, they are still not as stable as Fujichrome and Ektachrome films when projected. Correctly exposed or slightly overexposed slides show the effects of fading more readily than darker (underexposed) slides; the overexposed slide has a greater portion of the image contained in the low-density portions of the curve. For best photographic results, of course, slides should be correctly exposed — this is especially important if prints are to be made.

## Criteria for Color Balance Shift and Loss of Density

Two sets of image-deterioration criteria were used in this study.[16] One set allows a fairly large degree of fading and color balance shift to occur before the limits are reached

and is intended for general use where it is not normal practice to make prints from slides. The other set of criteria specifies much less density loss and smaller deviations in color balance; it is intended for critical commercial and museum applications.

## General Commercial and Amateur Use

For general commercial and amateur applications, projected color slides will be considered to have faded an objectionable amount when the *first* limit (end point) has been reached in any of the following image-life criteria, as determined from changes measured in gray-scale densities of 0.6 and 1.0:

Loss of cyan dye (red density) ................... 25%

Loss of magenta dye (green density) ............. 20%

Loss of yellow dye (blue density) ................ 35%

Color imbalance between cyan dye (red density)
    and [minus] magenta dye (green density) ....... 12%

Color imbalance between magenta dye (green density)
    and [minus] cyan dye (red density) ........... 15%

Color imbalance between cyan dye (red density)
    and [plus or minus] yellow dye (blue density) .... 18%

Color imbalance between magenta dye (green density)
    and [plus or minus] yellow dye (blue density) .... 18%

## Critical Commercial and Museum Use

For critical commercial and museum applications, projected color slides will be considered to have faded an objectionable amount when the *first* limit (end point) has been reached in any of the following image-life criteria, as determined from changes measured in gray-scale densities of 0.45 and 1.0:

Loss of cyan dye (red density) ................... 15%

Loss of magenta dye (green density) ............. 12%

Loss of yellow dye (blue density) ................ 20%

Color imbalance between cyan dye (red density)
    and [minus] magenta dye (green density) ........ 8%

Color imbalance between magenta dye (green density)
    and [minus] cyan dye (red density) ............ 10%

Color imbalance between cyan dye (red density)
    and [plus or minus] yellow dye (blue density) .... 15%

Color imbalance between magenta dye (green density)
    and [plus or minus] yellow dye (blue density) .... 15%

Since 0.45 density was selected as the primary measurement point in the "Critical" set of criteria, the difference between the "General" and "Critical" sets of criteria

is greater than might be supposed. Because 0.45 is further down the density scale than 0.6, the effect of any given density loss or color imbalance is — percentage-wise — magnified. The data in **Table 6.1** indicate that while the relationship of the fading times with the two sets of criteria varies among the various films, the "General" criteria typically allow projection two to three times longer than the "Critical" criteria.

Although changes in near-minimum-density areas (the lowest density, or "clear" gray-scale patch) were measured, with most of these film samples the areas were not true minimum densities and thus could not be used for "stain-correction" of the fading data for determining absolute density loss, such as was done with the analysis of light-faded color prints in Chapter 3 and with the accelerated dark fading of films and prints in Chapter 5. In the case of the slide films tested here, stain-correction of the data would probably have made little if any difference in the results. None of the films was yellow-dye-limited (it is with yellow-dye fading that stain formation usually has the most effect), and in any event it is this author's practice *not* to stain-correct data used for color-balance analysis.

A further complication with the stain-correction of data from projected slides is that whatever stain that does take place frequently will be obscured by fading of the relatively high d-min fog levels characteristic of most reversal films. It was also apparent that stain growth in higher-density image areas of Ektachrome and a number of other films was not correctly reflected by d-min changes.

Pure cyan, magenta, and yellow color patches were also measured, but changes in these areas were not included in the criteria limits because this author felt that much more study of a variety of faded pictorial scenes — with slides made on a variety of films — was needed to assign meaningful limits to each of the three image dyes. In most cases, separate magenta and yellow areas faded faster in projection than did the three dyes when combined to form a neutral gray; this is because of the protective effect of one layer on another.

With most films, the cyan layer is coated on the bottom next to the film base, and in projection the cyan dye to a certain extent shields the magenta and yellow dye layers from the light of projection. From looking at many projector-faded slides, it is apparent that the significance of the more rapid fading of the dyes that can take place when they are in separate color patches is *very* dependent on the scene.

This author believes that the sets of criteria given here, which concern only changes in neutral density, are a good reflection of the overall visual changes that take place when slides with typical scenes are projected. Had pure cyan, magenta, and yellow color patches been included in the analysis, the indicated projection times before the first limit was reached would probably have been shortened for some of the films, but in most cases the stability rankings of the various films would have been the same. For example, no realistic method of analysis could rank Ektachrome as being more stable than Fujichrome in projector-caused fading.

Study by this author of many faded slides and color prints clearly demonstrated that the eye is most sensitive to changes in color balance along the magenta/green axis

— this is especially true in near-neutral colors and in the colors of human flesh-tone reproduction. Changes in cyan/red are somewhat less critical in most scenes, and most people are quite tolerant of color shifts along the yellow/blue axis, especially if the direction of change is toward yellow. Yellow dye principally influences the yellow/blue hue of the image and contributes very little to the rendition of image detail and the impression of image contrast — or the sense of light and dark in a scene. Another reason for the acceptance of an excess of yellow, especially in low-density image areas, is that paper, oil paintings, wood, and many other materials gradually yellow with age. Yellowing is thus a key characteristic of what is often referred to as "the patina of age." North American Caucasians often express a preference for a decided excess of yellow — and, to a lesser extent, excess magenta — in the color balance of their portraits. This is the "healthy tanned look."

Both sets of fading criteria give different, weighted values to the cyan, magenta, and yellow image dyes to reflect typical visual responses. The criteria chosen here for slides are this author's attempt to take into account the observed disproportionately rapid low-density and highlight-detail fading due to projection. Various individuals have distinctly different responses to the effects of color fading; in addition, the perception of fading is also highly dependent on the pictorial content of a particular photograph. Much more study needs to be done concerning visual responses to faded slides — both projected in a dark surround and used to make reflection prints.

Since photographers, museum curators, and other visually oriented people are the most likely to be concerned with color stability, the studies should focus on these groups of slide users. Casual observation indicates that the general public usually has a less rigorous notion of what good photographic quality is. However, it has been this author's experience that the average person can be quite discriminating when comparing an even slightly faded print with the same picture in its original state. The fact that a person may accept as adequate a significantly faded picture if no comparison is available may be more an indication of limited familiarity with carefully printed color photographs than it is an indication of lack of visual discrimination. Presented with a selection of color prints of varying quality, the average person's opinions about which prints look the best are usually similar to the views expressed by experienced photographers.

Some people may feel that the criteria given here are too strict and that for general purposes — where the information content of a slide is usually more important than aesthetics and precise color and tone reproduction — significantly more fading can be tolerated. On the other hand, some photographers — especially those who are more concerned with how prints or published reproductions look than they are with the appearance of projected slides — may feel that in at least some respects even the set of criteria intended for critical commercial and museum use is not strict enough.

Indeed, a slide with important areas of the image in the 0.20 to 0.35 density range may exhibit obvious changes in the color balance and density of these low-density areas before it has been projected long enough to reach one or more of the limits specified in this author's "Critical" set of criteria. In the fine art field and other areas of photography that have very high standards for print color and tone reproduction — and where a slide may be printed repeatedly over the years — it would be wise to adopt a policy of *never* projecting originals, especially Kodachrome slides.

Because of the vagaries of a particular emulsion batch of film, exposure conditions, and/or processing of the film, a transparency may be only barely acceptable even in an unfaded condition. If projector-caused fading results in accentuating these defects, only a very short projection time may be needed to push the image past acceptable limits. For example, some of the "amateur" Kodachrome film used by this author in preparing samples for these tests had distinctly low magenta-dye-layer contrast after it was processed by Kodak, resulting in a pronounced green color balance. Projector-caused fading only accentuated the problem. In fact, one could argue that the greater the film/processing/exposure variations experienced with a particular type of slide film, the more strict the fading criteria should be in order to avoid ending up with unacceptable color images.

Unless projector-caused fading of a slide becomes severe, the overall impression of its *brightness* on the screen changes very little. Based on the "General" criteria given here, the increase in projected brightness of a faded slide that has reached the specified limits would typically be equivalent to less than a one *f*-stop increase in camera exposure. A slide that has reached the stricter commercial and museum limits would typically be equivalent to less than a one-half *f*-stop increase in exposure. The fact that the faded image as a whole does not appear to have lost much density can easily obscure the much more significant changes that have taken place in low-density and highlight areas of the image.

While this author's two sets of criteria were arrived at after study of many slides and prints with known amounts of fading and are offered in good faith without bias for or against any particular product, other individuals may have different opinions about the relative values assigned to each dye, the permissible color-balance deviations, and the overall amount of fading that can be tolerated. Whether or not a print is to be made from a slide — or if it is to be reproduced in a magazine or other publication — is an important consideration in any discussion of slide fading. As stated previously, slides that will be used only for projection generally can tolerate much more fading than those that will be reproduced in print form.

Despite the subjective nature of any determination of "acceptable limits of fading," a well-thought-out set of criteria can be effectively employed to *compare* the stability of the various slide films marketed now and in the past. The criteria given here, and the computer programs with which the data were analyzed, are to a significant extent unaffected by inherent color and contrast imbalances within the range found in the films that were tested. This author was indeed surprised by the great irregularities in sensitometric characteristics of most of the films (and in manufacturers' processing); as might be expected, the professional films were much better in terms of consistency and neutral color balance than amateur films. The computer programs and methods of data analysis are discussed in Chapter 2.

## Table 6.4    Projector-Fading and Dark Fading Stability Data Supplied by Eastman Kodak to the Dunlap Society in Washington, D.C. in 1975

| Kind of Film | If Kept in the Dark the Color Should Be Stable for. . . . | If Projected for 15 Seconds with a Tungsten-Halogen Bulb, the Color Should Not Change Until Projected. . . . |
|---|---|---|
| Kodachrome Film [Process K-14] | 50+ years | 250–500 times [1 hr 2 min to 2 hr 5 min] |
| Ektachrome Slide Duplicating Film 5071 [Process E-6] | at least 10–20 years perhaps 20–50 years | 300–500 times [1 hr 15 min to 3 hr 8 min] |
| Ektachrome-X Film [Process E-4] | 10–20 years | 375–1000 times [1 hr 34 min to 4 hr 10 min] |
| Kodacolor Slide Print Film 5028 [Process C-41] | 5–10 years | 500–1000 times [2 hr 5 min to 4 hr 10 min] |
| Ektachrome Slide Duplicating Film 5038 [Process E-4] | 5–10 years | 300–750 times [1 hr 15 min to 3 hr 8 min] |
| Eastman Color Motion Picture Print Film 5381 [Process ECP-1] | 5 years | 400–800 times [1 hr 40 min to 3 hr 20 min] |

## Eastman Kodak's Recommendations for Slide Projection

Kodak has published relatively little on the projection life of color slides. Part of the reason for this is that most amateurs do not project their slides enough to cause objectionable fading, and the company has probably received few complaints about projector-caused fading. In recent years the popularity of slides among amateurs has sharply declined, with most people now showing a strong preference for color prints made from color negatives. However, during the last decade, slide use has grown considerably in the audiovisual area, where slide presentations are frequently employed for education and training purposes and to accompany talks at meetings and conferences. Slides have been consistently preferred in the photojournalism, commercial, and advertising fields — where they are often subjected to repeated and prolonged projection.

The March 1973 edition of Kodak publication E-30, *Storage and Care of Kodak Color Films,* stated:

> The projection life of a color slide depends on the amount of light and heat from the projection lamp falling on the slide and upon the total projection time. Prolonged projection with high-wattage lamps or arc lamps will shorten the life of, and may even distort, the transparencies. Avoid projection times longer than one minute. If long projection times are unavoidable, make duplicate slides of the original and use them for projection purposes.[17]

In common with other Kodak publications of the period, no specific information about the projector-fading or dark fading stability of the company's various films was given.

In the January 1976 edition of *Storage and Care of Kodak Color Films,* Kodak's policy was changed somewhat and this information was offered:

> The dye images most stable to light are those in slides made on Kodak Ektacolor Slide Film 5028, Kodak Ektachrome Duplicating Film 5038, and Kodak Ektachrome Films. Slides made on Kodachrome Film are somewhat less stable, but may be expected to withstand 250 to 500 15-second projections (one projection per minute) in non-arc slide projectors before significant dye fading results.[18]

The Kodak figures of 250 to 500 15-second projections amount to 1 hour 2 minutes to 2 hours 5 minutes total projection time.

In 1975, a researcher in color stability at Kodak supplied the Dunlap Society, an archive and producer of American art and architecture slides and microfiche, with the dark fading and projector-fading characteristics of certain Kodak films the Society was considering for production of slide sets (see **Table 6.4**). This information included the same figures given above for projection life of Kodachrome film, and "300 to 750 15-second projections" (1 hour 15 minutes to 3 hours 8 minutes) for the then-new Process E-6 Ektachrome Slide Duplicating Film 5071. This latter estimate was not contained in any regular Kodak publication,

## Table 6.5  Variations in Projector Lamp Intensity

Intensities of various lamps measured with a Minolta Illuminance Meter, 10 feet from front of lens (Kodak Ektanar C Lens, 127mm, f2.8) of Kodak Ektagraphic III AT projector. Open-frame slide mount (without film) in projector film gate; measurements made in center of frame. Equipment was not available to measure lamp intensities directly in projector film gate. Lamps allowed to stabilize about 20 seconds before measurements were made.

### General Electric EXR Lamps

1) 2,560 lux

2) 2,690 lux          Average: 2,678 lux

3) 2,640 lux          Difference between brightest
                      lamp and average: 8.3%
4) 2,700 lux
                      Difference between dimmest
5) 2,560 lux          and brightest lamps: 12.3%

6) 2,920 lux

### Sylvania EXR Lamps

1) 2,410 lux
                      Average: 2,425 lux
2) 2,440 lux

### General Electric EXW Lamp

1) 3,080 lux

### General Electric EXY Lamp

1) 1,740 lux

however, and was seen by few people outside of the specialized art and architecture slide library field.

Extracting this information from Kodak was a major breakthrough on the part of the Dunlap Society. According to the Society's Isabel Lowery, who obtained the data from Kodak, "We didn't want to repeat the Sandak fiasco and have all our slides turn pink."[19] Lowery was referring to the millions of slides, printed on Eastman Color Print Film (a motion picture print film), that suffered catastrophic cyan and yellow dye loss only a few years after they had been sold by Sandak, Inc. to art slide libraries and other collections all over the world.

Lowery said that when she called Kodak with questions about the stability of various films, she received only vague and generalized cautions about color fading. But the customer service representative she talked to "let slip" the name of a man at the company who worked in research and who "knew about color fading." She called him directly and he supplied her with the information given in **Table 6.4.** Based on this, the Dunlap Society selected Ektachrome Slide Duplicating Film 5071 for making distribution copies of the original slides in its archive. At the time, the Society was about to embark on a major slide-production program funded by the National Endowment for the Humanities;

this was one of the initial activities of the Society's Visual Documentation Program.

In the 1977 and 1984 editions of *The Sourcebook – Kodak Ektagraphic Slide Projectors,* Kodak said:

> For most viewing purposes, pictorial slides made on properly processed Kodak Color Films will be acceptable through 3 to 4 hours of total projection time. This is true when the slides are used in an Ektagraphic or Carousel Slide Projector that is equipped with a tungsten-filament lamp and has unrestricted air circulation, even if the projector is operating with the selector switch set at HIGH.[20,21]

Surprisingly, in this publication Kodak did not distinguish between Kodachrome and Ektachrome slides in terms of projector-caused fading.

More recently Kodak has stopped publishing specific recommendations for "acceptable" projection times. Beginning in early 1982, in answer to individual requests to the company, Kodak started releasing data in the form of graphs showing density loss as a function of projection time for the common slide and print films for still cameras.[22] At first these sheets were accompanied with color prints showing the visual effects of projector-fading and accelerated dark fading tests. About a year later, these prints were discontinued. The graphs are based on one 15-second projection in a Kodak Carousel Projector every 20 minutes; data for up to 720 projections (3 hours total exposure time) are given.

A Kodak spokesman has indicated that the company receives very few requests for this information. This perhaps is not surprising in view of the fact that the company has, to this author's knowledge, never announced the availability of the stability data sheets in any Kodak publication, and they are not listed in the Kodak publications catalog. Very few photographers and archivists were aware that the sheets existed.

In 1988 Kodak quietly published new image-stability data sheets for Ektachrome (not including Ektachrome Plus, HC or X films)[23] and Kodachrome,[24] but as was the case with the data sheets published in 1982, these new publications were not announced and they saw little circulation.

Kodak has apparently decided to publicly minimize the rather large differences between Kodachrome and Ektachrome films in terms of projector-fading stability; and the recommendation on the permissible projection time for Kodachrome film given in the 1976 edition of Kodak Publication E-30, *Storage and Care of Kodak Color Films,* has been dropped in recent editions of E-30 (now entitled *Storage and Care of Kodak Color Materials,* because of the addition of some information on the care of color prints). In the December 1980 edition of E-30, Kodak stated only that "Ektachrome Films . . . withstand the effects of light better than Kodachrome Films." In the May 1982 edition of the same publication, Kodak watered this down a bit further and changed the sentence to read: "Ektachrome Films . . . withstand the effects of light somewhat better than Kodachrome Films."

In 1984, Kodak took the matter of the comparative projector-fading rates of different types of slide films such as

**Figure 6.4**  Light intensity at a projector film gate tends to be higher in the center of a slide than at the corners, and this results in correspondingly greater fading in the center area.  For the data reported in Figure 6.5, density readings were taken at the film-gate locations shown here.

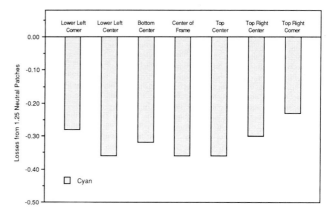

**Figure 6.5**  After 5 hours of continuous projection of a slide with a uniform neutral density of about 1.25 and made with now-obsolete Agfachrome 64 film, density readings were taken at the film-gate locations shown in Figure 6.4.  Note the reduced fading that occurred at the corners of the image due to the fall-off in illumination intensity.

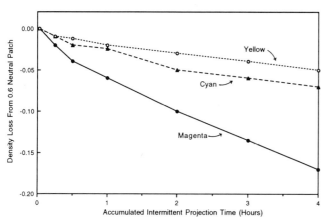

**Figure 6.6**  After some fairly abrupt initial changes, projector fading of Ektachrome film and most other slide films proceeds in a fairly linear fashion as a function of projection time.

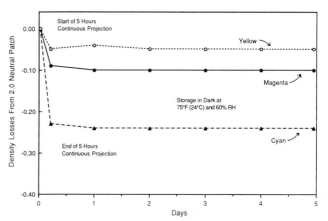

**Figure 6.7**  In this example involving Ektachrome film, image fading occurred essentially simultaneously with exposure to light in a projector; negligible change occurred after the end of the projection period.  Because of massive reciprocity failure during the continuous 5-hour projection period of this particular test, the cyan dye faded more than the magenta (the opposite occurs during normal, intermittent projection).

Kodachrome and Ektachrome one step further and, in a rather astonishing statement, said: ". . . the film type, if it is a photographic film with dye images, does *not* make a significant difference, assuming proper processing and the projector operating at relatively normal room temperatures."[25]

In the 1986 edition of *Kodak Color Films and Papers for Professionals* (Kodak Publication No. E-77), Kodak said: "Color slides are usually projected on a screen by a bright light for several seconds and then returned to storage.  Therefore, the preservation techniques for these materials is much the same as for color negatives."  While cautioning against "prolonged or repeated projections such as might occur in a commercial display," Kodak concluded the discussion by saying, "Kodak transparency film is very stable.  All Kodak slide films are made to be projected, and it is usually not projection that causes image deterioration if reasonable care is taken . . . ."[26]  The previous, 1980 edition of E-77 contained a section that briefly discussed the projector-fading and dark storage stability differences between

Ektachrome and Kodachrome films.[27]  In what appears to signal a major change in Kodak's stance regarding the relative merits of Ektachrome vis-a-vis Kodachrome, this entire section was deleted from the new edition of E-77.

Why Kodak would change its position on such an important matter is open to speculation.  One possibility is that with the introduction of Kodachrome Professional films, and Kodak's renewed emphasis on Kodachrome in the professional market, the company does not wish in any way to disparage Kodachrome in the minds of photographers.  It is also conceivable that, fearing the inevitable unfavorable comparison of the projector-fading stability of *both* Kodachrome and Ektachrome with Fujichrome, Kodak wants to discourage this line of thinking altogether.  Fujichrome is the principal competition for Ektachrome and Kodachrome in the professional market.

## Projector-Fading Test Procedures

For the tests conducted by this author and reported here, each slide was subjected to six 30-second projections each day, with approximately 4 hours between each projection. The tests were carried out over a 140-day period, resulting in a total projection time of 7 hours for each slide (for the less stable films, such as Kodachrome, the tests were ended after 120 days — a total of 6 hours projection for each slide). During the tests the projector was located in a darkened room at a temperature of 75°F (24°C) and a relative humidity of 60%; fans in the room maintained indirect air currents over the projector and slide tray, cooling both fairly quickly after each projection period.

A Kodak Ektagraphic III AT projector, equipped with the standard ANSI Code EXR 82-volt, 300-watt quartz-halogen tungsten lamp (made by General Electric), was used in the tests.[28] Ektagraphic projectors are heavy-duty versions of the popular Kodak Carousel projectors introduced in 1961; in the United States, Carousel and Ektagraphic projectors have achieved practically total domination in educational and commercial markets. The Ektagraphic III projectors were introduced in 1981. The microprocessor-controlled Ektapro projectors introduced by Kodak in 1992 are expected to produce rates of slide fading that are generally similar to that of Ektagraphic III projectors. This author had used a Carousel 750H projector with an ANSI Code ELH quartz-halogen lamp in previous experimental work; an initial study was done in 1979 with a Sawyer rotary projector.

A precise electronic repeat-cycle timer designed by this author was set at 31 seconds to control the Ektagraphic slide-change mechanism; the additional 1 second[29] allowed for the slide-change mechanism to function, giving an actual projection time of 30 seconds. The primary sequence timer controlled a secondary timer set at 0.1 second to provide a short but sustained electrical contact closure to cause the projector to move to the next slide (this simulated a momentary depression of the change button on the hand control). These timers and the projector itself were controlled by a third timer which turned the entire system off after all of the slides had been projected once.

The slide tray was manually returned to the starting position and the bulb checked at the start of each projection sequence to make certain it had not burned out. Experience showed that it was unnecessary to monitor the projection lamp during the course of each sequence; when lamps burned out, they did so without exception within a fraction of a second of a new sequence being started. At the end of a lamp's life, the filaments fail suddenly, apparently due to the initial current surge. Given the relatively short projection time of 20 or 30 minutes for each sequence, the lamps would remain operational throughout this period if they had survived the initial current surge.

To determine the evenness of illumination at the film gate, a full-frame, neutral-density Agfachrome 64 slide was projected for a period of 6 hours. Various locations on the slide (see **Figure 6.4**) were measured with a densitometer; the fading that took place at each of the locations is given in **Figure 6.5**.

A Macbeth ColorChecker was photographed onto the

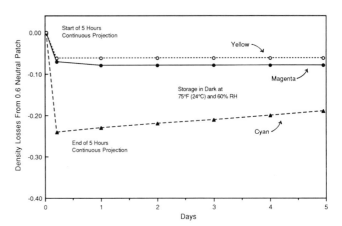

**Figure 6.8** In now-obsolete Agfachrome 64 film, some "regeneration" was noted in the cyan dye during dark storage after a 5-hour period of continuous projection. The yellow and magenta dyes were not similarly affected.

various slide films included in the tests. The critical densities of the gray-scale image were contained in the density steps in the center of the scale, and even though they were on the bottom of the image, they received essentially the same amount of light as the center of the frame. Slides with ten-step gray scales centered in the middle of the frame were included with some of the films.

The projector was operated at the recommended 120 volts (measured with the projector turned on and the lamp on "High"). Kodak states that Ektagraphic projectors will operate satisfactorily in the range of 110 to 125 volts; however, the lamp light intensity — and hence the fading rate — varies considerably with the operating voltage. According to Kodak figures, the ELH quartz-halogen lamp produces 15% more light at 125 volts than it does at 120 volts.[30] At 115 volts, the light level is reduced 12% from that at 120 volts, and at 110 volts, the light level is reduced 25%.

Variations from one lamp to another can also be expected at any given voltage. Robert Beeler of Kodak explained:

> ... there is a good bit of variation in the total illumination and in the evenness of illumination from different lamps. It appears that the lamp manufacturers can make the filaments fairly consistent, but the dichroic [infrared-transmitting] coatings on the reflectors are something else. The total variation usually falls within perhaps ± 10 percent, but sometimes is more. In addition, the coatings are often not perfectly even on the reflector, and this may affect the evenness of illumination at the projector gate. Putting the lamps on an illuminator (preferably with a tungsten light source) will show up differences in the light transmitted by the reflectors, and it is often considerable.[31]

Variations in the intensity of a number of the projector lamps used in this author's study are listed in **Table 6.5**. By the conclusion of the initial phase of this study, when

the majority of the films were tested as a group, a large quantity of lamps had been consumed, and it is assumed that differences in intensity and evenness of illumination were largely averaged out in the course of the tests. For subsequent tests of more recently introduced films, the lamps were individually tested and only those which measured very close to the average intensity of the initial set were included. Only General Electric Type EXR lamps were used in these tests (this was the type of lamp originally supplied by Kodak with the Ektagraphic III projector when it was purchased and is considered to be the "standard" lamp for this projector as well as Kodak's new Ektapro projectors, introduced in 1992).

### Measurement of Density Changes

Many films exhibit relatively rapid losses in density of one or more dyes during the first 5 or 10 minutes of projection; **Figure 6.6** illustrates the changes that took place in a low-density, neutral-gray area of an Ektachrome 50 Tungsten slide. The cause of these initial rapid density losses is not known. It is possible that residual sensitizer dyes remain in the film after processing and that these fade comparatively quickly on exposure to light; however, low-level stains from other sources may be the cause. To a certain extent, fading slows after early projection periods as a consequence of the reciprocity failures in light fading which are discussed in more detail later. To observe these early changes, density measurements were made after 6 minutes of projection time; these were followed with additional measurements after 15 minutes, 30 minutes, and 1 hour. For the remainder of the test, measurements were made after each hour.

Density measurements were taken with a Macbeth TR924 Densitometer equipped with Kodak Status A filters. The densitometer was connected directly to a Hewlett-Packard HP-125 microcomputer which, running the programs described in Chapter 2, processed the data, interpolated preselected gray-scale step values, provided a hardcopy printout, and set up data files on computer disks for storage and later analysis with the sets of fading criteria.

Judging from the instances in which two or more samples of films of the same type were included in the tests, the repeatability of the procedure — including the computations of the criteria analysis program — was reasonably good. As an example, samples of Kodachrome 25 and Kodachrome 64 were tested, with each sample having a distinctly different color balance. The "Critical" museum criteria program predicted 19.5 minutes for the Kodachrome 25 sample to reach the cyan/magenta color imbalance limit, and 19.8 minutes for the Kodachrome 64 sample to reach the same limit. The potential experimental error for samples analyzed with the "General" set of criteria is estimated to be about ± 10%; the potential error is larger for the "Critical" set of criteria.

*ANSI IT9.9-1990, American National Standard for Imaging Media – Stability of Color Photographic Images – Methods for Measuring*[32] specifies correction of densitometric data for changes in d-min densities when measuring density losses in the individual cyan, magenta, and yellow dyes, but not when determining changes in color balance. For the purposes of this study, however, this author felt it was more meaningful in a visual sense to use uncorrected data for *both* density losses and color balance changes. Unlike the blue-density increases (caused by gradual yellowish stain formation) that take place over time with most types of color photographs in dark storage, projection usually causes a *reduction* in d-min densities. Projection of a slide generally does not result in yellowish stain that can be measured in d-min areas and, therefore, this author feels that the usual rationale for making d-min corrections does not apply to projector-fading of color slides.

For most films, projector-caused fading appears to take place virtually simultaneously with exposure to the intense projector light. **Figure 6.7** shows the changes that took place in a neutral-gray, moderately high-density (2.0) area of an Ektachrome 50 Tungsten slide during a period of 5 days in the dark (75°F [24°C], 60% RH) after 5 hours of continuous projection. An initial density reading was made within 15 seconds of the end of the 5-hour projection. No further detectable loss in image density took place during 5 days in dark storage.

However, with an Agfachrome 64 transparency (an obsolete film developed with Agfa Process 41), with an initial density of 0.6, (see **Figure 6.8**), there was a gradual increase in red density during dark storage following the 5-hour projection period, suggesting a "regeneration" of some of the faded cyan dye. An apparent partial regeneration of cyan dye has also been noted with some types of color prints after (or during) exposure to intense light.

Two years after completion of the initial 6- or 7-hour intermittent projection tests (3 minutes projection per day for 120 or 140 days), densities of Fujichrome 100D, Kodachrome 64, Ektachrome 50 Tungsten, and PolaChrome color slides were measured again; none of the films showed significant further density changes. During the 2-year storage period, the slides had been kept in the dark at 75°F (24°C) and 60% RH.

### Reciprocity Failures in Projector-Caused Fading

Accelerated light fading tests for color prints employ high-intensity illumination in an attempt to simulate in a short time the fading and staining that the prints will experience in actual long-term, low-intensity display conditions. For example, exposing an Ektacolor print to fluorescent light with an intensity of 20 klux for 1 month should result in the same amount of fading as if the print were exposed to fluorescent illumination with an intensity of 1 klux for 20 months — in both cases the prints would receive 14,400 klux-hours of illumination. Stated simply, exposure to a bright light for a short period should produce the same amount of fading as exposure to a less intense light for a proportionally longer time.

Unfortunately, as discussed in Chapter 2, most types of color prints fade faster and stain more under long-term, low-intensity illumination than they do when exposed to an equivalent amount of light in short-term, high-intensity accelerated tests.[33] This deviation is known as *reciprocity failure*. There are very few examples of color prints or films that exhibit the opposite relationship — that is, fade

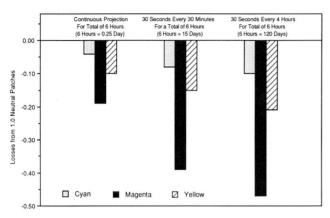

**Figure 6.9** Reciprocity failure in projector fading of Kodachrome film. For a 6-hour total projection time, intermittent projection of 30 seconds every 4 hours produced more than twice the magenta dye loss than that which occurred with continuous projection. In normal, intermittent projection, which is usually spread over a period of many years, it is likely that even greater fading would take place after 6 hours of accumulated projection.

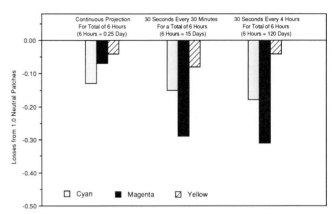

**Figure 6.10** With Kodak Ektachrome films (including the newer "Plus," "X," and "HC" type films, and 64T and 320T films), the magenta dye faded far more in intermittent projection than with continuous projection; the cyan dye was not greatly affected. Note that in continuous projection, the cyan dye faded the most and caused a red color shift. In normal, intermittent projection, the magenta dye fades the most, causing an obvious green color shift.

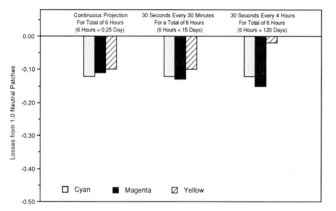

**Figure 6.11** Fujichrome showed very little reciprocity failure (the reduced yellow loss measured during intermittent projection of 30 seconds every 4 hours probably resulted from a compensating stain increase that was not reflected at d-min). These tests show that continuous projection can produce highly misleading comparisons of slide films. With continuous tests, one would erroneously conclude that the stability of Ektachrome was similar to that of Fujichrome.

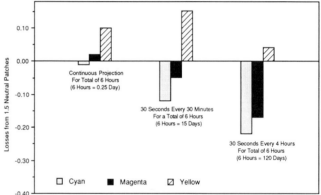

**Figure 6.12** Polaroid PolaChrome instant color slide film also suffered from reciprocity failure in continuous projection. The stability problems of PolaChrome relate more to the discoloration and fading of the silver image layer than with dye stability per se; for this reason, the data presented in this graph produce an incomplete depiction of the stability behavior of the film.

more in high-intensity tests than in low-intensity tests. There are, however, a number of print materials with one or more dyes which, in this author's tests, showed almost identical fading behavior in high- and low-intensity tests; the magenta dyes in Konica Color Paper Type SR, Ektacolor Plus, and Ektacolor Professional papers are examples.

With some types of color prints — Polaroid Polacolor ER, Ilford Ilfochrome (Cibachrome), and the now-obsolete Agfacolor PE Paper Type 589 are examples — reciprocity failures can be quite large. Thus, in normal display conditions, one or more of the image dyes in such prints can fade significantly faster than predicted by high-intensity accelerated tests. These prints can be said to have a large *reciprocity failure,* or *RF Factor.* An RF Factor can be expressed numerically; for example, if the yellow dye of a

certain type of print fades twice as much in a low-intensity test as it does under the same total light exposure in a high-intensity test, the RF Factor of the yellow dye is 2.0 (for those two test conditions). If the yellow dye fades the same amount in both test conditions, the RF Factor is said to be 1.0.

To further complicate matters, the cyan, magenta, and yellow dyes that make up the color image usually have *different* RF Factors, which means not only that the print may fade faster overall under long-term, low-intensity illumination but also that the color shift may be different as well. When evaluating prints with a set of criteria such as those used here, the relationship between the criterion which fails first in a low-intensity test and that which fails first in a high-intensity test can be expressed as an

RF Factor — the print material as a whole can then be said to have a certain RF Factor, under the two given test conditions.

The significance of the RF Factor is that meaningful estimates of fading behavior in long-term use under normal conditions cannot be obtained from high-intensity tests if a print material has a large RF Factor. Stain behavior frequently is also subject to reciprocity failures in high-intensity tests. It is of course possible for a print material to have a large RF Factor and still be relatively stable — Ilfochrome is an example. Likewise, a print material with a small RF Factor may nevertheless have poor light fading stability.

Experimental work by this author in 1980 indicated that projected slides were subject to reciprocity failures in fading that were somewhat similar to the reciprocity failures observed previously in the fading of color prints. In the case of slides, where the light intensity in the projector is essentially a constant, however, the important variables were the length of time of each individual projection and, more significant in terms of the usual short projections for color slides, the length of time between projections. The relative humidity of the air surrounding the slides *between* projections is probably also an important factor, especially when the intervals between projections are short.

To investigate reciprocity failures in projector-caused fading, a number of films were projected under the following three conditions:

1) Continuous projection for a total of 6 hours.

2) Intermittent projection for 30 seconds every 30 minutes, for a total of 6 hours projection over a period of 15 days. Between projections, the slides were quickly re-equilibrated with ambient conditions of 75°F (24°C) and 60% RH.

3) Intermittent projection for 30 seconds every 4 hours, for a total of 6 hours projection over 120 days. Between projections, the slides were re-equilibrated with ambient conditions of 75°F (24°C) and 60% RH.

In every case, projection for intermittent 30-second periods caused greater losses in dye density than did a single continuous projection of 6 hours. The degree of reciprocity failure varied considerably with the type of film. Among conventional color films, the magenta dye of Kodachrome had an RF Factor of 2.5 (**Figure 6.9**), the Ektachrome magenta dye had a very large RF Factor of 4.4 (**Figure 6.10**), and the Fujichrome magenta dye exhibited an RF Factor of only 1.4 (**Figure 6.11**). In the case of these three films, the RF Factors were computed from density losses from an initial 1.0 neutral density; losses measured from "pure" cyan, magenta, and yellow areas generally had even higher RF Factors under these test conditions. For example, based on losses measured from a "pure" magenta with an initial density of 1.0, Ektachrome film had an RF Factor of 6.6 (versus an RF Factor of 4.4 when magenta losses were measured from a 1.0 neutral density). In other words, the "pure" magenta in Ektachrome film faded *6.6 times more* in the intermittent test than it did in the continuous-projection test!

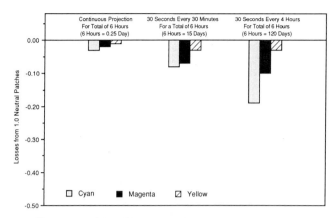

**Figure 6.13** Ilford Ilfochrome (Cibachrome) Micrographic color film suffered large reciprocity failures in continuous projection compared with more normal, intermittent projection. When projected 30 seconds every 4 hours, the special-purpose Ilfochrome film proved to be somewhat more stable than Fujichrome when evaluated according to this author's image-fading criteria.

The apparently reduced fading of yellow dye in Fujichrome film in the 4-hour intermittent condition was caused by low-level yellow stain formation; Ektachrome exhibited similar low-level stain formation in intermittent projection. The stain formation was not observed in either type of film in low-density (e.g., 0.6) or d-min areas. Density measurements detected the stain only in higher-density portions of the images; the stain had little effect on the visual impression of color balance and is considered by this author not to be a significant problem. Further study of this would require the use of a spectrophotometer, which this author did not have available at the time of this research. Neither Ektachrome nor Fujichrome developed significant stain at any density during continuous projection (at least stain was not evident at the lowest density available in the test slides in this study); Kodachrome appeared to be free of stain formation under all projection conditions.

PolaChrome instant color slides (**Figure 6.12**) also showed marked deviations in fading depending on the projection condition, although the total amount of fading, relatively speaking, was not great compared with Ektachrome and Kodachrome. Because PolaChrome slides have an extremely high base density (d-min) of about 0.7, they were measured at a neutral density of 1.5, instead of the 1.0 selected for the conventional films. The *increase* in blue density observed with PolaChrome film was the result of significant yellow stain formation; that the apparent stain was less in the 4-hour intermittent condition can probably be attributed to a complementary fading of the red, green, and blue additive-screen elements in the film.

In intermittent projection, Ilford Ilfochrome (Cibachrome) Micrographic film (**Figure 6.13**) also showed a significant increase in fading rate compared with continuous projection. The now obsolete Agfachrome 64 and 100 films had only a moderate RF Factor under the three projection conditions in this author's tests.

Of particular note was the excellent test performance of Fujichrome film. Either by intention or as a fortunate occurrence related to other aspects of the film's design,

Fuji has managed to mitigate those factors that cause other films to exhibit significant RF Factors. This also underscores the importance of the test method in evaluating projector-caused fading of slide films. Under *continuous projection,* Fujichrome fades at a rate similar to that of Ektachrome film, and the obvious superiority of Fujichrome in normal, intermittent-projection conditions might go unappreciated. In continuous-projection tests, the image stabilities of all the films — with the singular exception of Fujichrome — are greatly overrated compared with what would actually be experienced in normal use.

A possible explanation of the observed reciprocity failures in projector-caused fading is that oxygen plays a role in the light fading of certain dyes. During high-intensity light fading, oxygen is depleted at the sites of the dye molecules, resulting in a slowing of the photochemical reactions. Oxygen availability may be further hindered by low humidity, which lowers the permeability of gelatin to oxygen. This dependence of light fading of magenta and yellow chromogenic dyes on oxygen availability was suggested by Tuite of Kodak in 1979[34] and further discussed by Seoka et al.[35] and Aono et al. of Fuji in 1982.[36] It is also possible that water vapor plays a direct role in the fading of image dyes.

By allowing a significant length of time between projections, the emulsion can equilibrate with ambient atmospheric conditions, and both the moisture and oxygen content of the emulsion can normalize before the next projection, thus increasing the rate of fading.

### Even the Intermittent Tests Reported Here Probably Overestimate the Stability of Slides in Normal Use

Normal use of a slide, of course, does not imply projection for 30 seconds every 4 hours. In actual practice, slides may be projected for 10, 15, or 30 seconds at a time, but in nearly every case, there will be a great deal more time than 4 hours between projections. Days, weeks, months, or even years between showings are more common. Judging from the slope of the fading rates of Kodachrome film, under the three projection conditions in this author's tests, for example, there is no reason to assume that the fading rate would not be even *greater* with shorter projections and/or longer periods between projections. Therefore, the estimates of useful life given by this author in **Tables 6.1** and **6.2** almost certainly *overestimate* the actual stability of the slides under normal use. The magnitude of the error will depend on the particular film; because of the small RF Factors for Fujichrome films, the estimates of stability under normal use for them are probably more meaningful than for the other films.

The undesirable "greasy" surface residue noted on 3M Scotch 640T Color Slide Film (see note in **Table 6.1**) and Eastman Color Print Film 5384 (see **Table 6.2**) after 6 hours of intermittent projection was not found when identical slides were subjected to 6 hours of continuous projection.

The relationships between length of individual projections, the interval between projections, and the influence of relative humidity are probably different for every product, and for each type of dye of a given product. In order to more accurately predict the long-term stability of slide films

under typical intermittent-projection conditions, study of all of these factors is continuing, and this author hopes in the future to publish results from tests with much longer periods between projections.

### Projector-Fading Curves of Slide Films

Projector-fading curves for some of the films included in this study are given in **Figures 6.14** to **6.22**. A starting neutral-gray density of 0.6 was used for all the films. Each slide was subjected to six 30-second projections each day, with approximately 4 hours between each projection. The tests were carried out over a 120-day period, resulting in a total projection time of 6 hours for each slide. The ambient temperature in the test room was 75°F (24°C) and the relative humidity was 60%.

### Eastman Kodak's Test Methods

Reciprocity failures as a consequence of the test method may account for the differences between this author's tests with Ektachrome films and the data reported by Kodak in CIS No. 50–45, August 1982, *Evaluating Dye Stability of Kodak Color Products – Transparencies on These Kodak Ektachrome Films,* and in Kodak Publication E-106 (1988), *Reference Information from Kodak – Image Stability Data: Kodak Ektachrome Films (Process E-6).*[37] Both of these publications indicate that during projector-caused fading of a neutral patch with an initial density of 1.0, the cyan dye (red density) and magenta dye (green density) faded at a similar rate over a 3-hour projection period, while the yellow dye (blue density) faded almost not at all.[38] In this author's tests, the magenta dye in a neutral patch faded significantly faster than the cyan dye, as illustrated in **Figure 6.18**. Continuous projection of Ektachrome film caused the magenta to fade *less* rapidly than the cyan; the magenta dye appears to have a larger RF Factor in projector-caused fading than either the cyan or yellow dye.

Kodak indicated that it used one 15-second projection every 20 minutes (720 projections in a 10-day test period) in a Carousel projector, which is in keeping with the procedure for testing slide-projector fading described in the now-obsolete *ANSI PH1.42-1969, American National Standard Method for Comparing the Color Stabilities of Photographs.*[39] Such a projection sequence can easily be achieved by placing slides in an 80-slide Carousel tray and setting a projector timer for 16 seconds (which allows 1 second for slide changing). As the tray continues to rotate, each slide will be projected once every 20 minutes and will have achieved 720 projections in approximately 240 hours (10 days) of continuous operation.

In a projection situation such as this, where the projector operates continuously, heat from the projector keeps the entire tray of slides warm. This in turn reduces the relative humidity of the air in the vicinity of the slides and maintains the moisture content of the film emulsion at a low level throughout the duration of the test.

Whether Kodak actually applied this method of projecting the slides has not been revealed. In any event, the Kodak test method (one 15-second projection every 20 minutes) did not allow as much time to elapse between projections as in this author's tests; in addition, the Kodak tests

apparently did not allow the film emulsions to regain much moisture between projections, probably contributing to a reduction in fading rates. The resulting reciprocity failures likely account for the differences in results. This author's longer-term tests, with full moisture equilibration at 60% RH between projections, produced more rapid fading of the magenta dye, leading to a significant shift in color balance toward green, while Kodak's tests produced a less noticeable shift toward yellow. In **Figure 6.11,** it can be seen that a projection condition somewhere between continuous projection and the intermittent projection periods employed in this author's tests would produce slower magenta dye fading, resulting in similar fading rates for the magenta and cyan dyes.

The new *ANSI IT9.9-1990, American National Standard for Imaging Media – Stability of Color Photographic Images – Methods for Measuring* specifies a 15-second projection period each hour (a total of 6 minutes of illumination each 24 hours), with the surrounding air having a temperature of 75°F (24°C) and 50% RH. This test cycle falls in between the old *ANSI PH1.42-1969* specification of a 15-second projection every 20 minutes, with an air temperature of 75°F (24°C) and no RH specified (this is the test cycle used by Kodak in the past), and this author's test cycle of a 30-second projection every 4 hours, with an air temperature of 75°F (24°C) and 60% RH.

In 1983 Patrick Young, staff photographer in the Department of History of Art, University of Michigan, reported a projector-fading experiment done with Kodachrome and Ektachrome films (and a now obsolete Agfachrome film) in which slide copies of a Claude Monet painting were projected for periods of 2 minutes (with 2 minutes between projections) for totals of 50 minutes, 100 minutes, and 200 minutes.[40] Significant change was noted in the Kodachrome slide at the end of 200 minutes, but no visually detectable

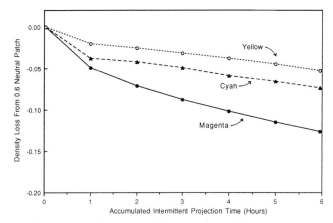

**Figure 6.14** Fujichrome films (except Velvia).

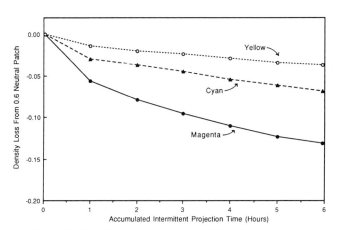

**Figure 6.15** Fujichrome Velvia film (ISO 50).

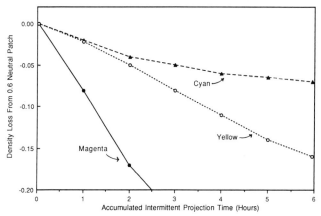

**Figure 6.16** Kodachrome films (all current K-14 types).

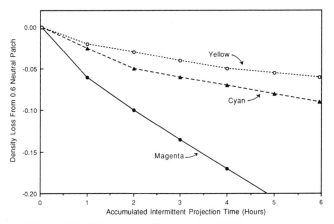

**Figure 6.17** Ektachrome films (current E-6 types, except for Ektachrome Plus, "HC," "X," 64T, and 320T films).

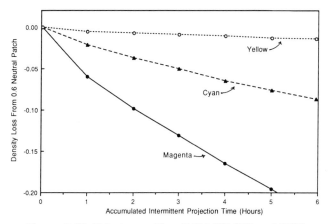

**Figure 6.18** Ektachrome Plus, "HC," "X," 64T, and 320T films (E-6 films introduced by Kodak beginning in 1988).

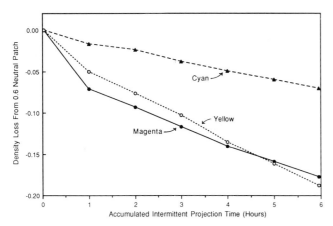

**Figure 6.19** Agfachrome RS film and CT films (E-6 types).

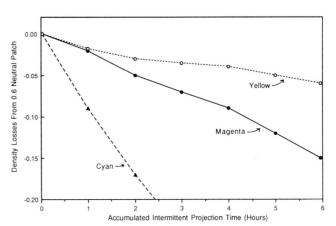

**Figure 6.20** Agfachrome 64 and 100 films (obsolete).

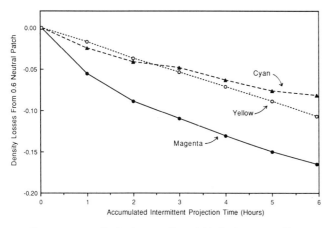

**Figure 6.21** Kodachrome II and Kodachrome-X films (obsolete K-12 types).

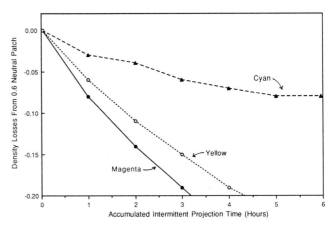

**Figure 6.22** 3M ScotchChrome 100 Film (E-6 type).

color shift was observed in the Ektachrome slide at the end of this time. Favorable reciprocity effects afforded by these test conditions were probably a significant factor in the degree of stability attributed to the Ektachrome slide.

## Problems with Polaroid PolaChrome Instant Color Slides

Introduced in 1983, Polaroid PolaChrome instant color slide film is used in conventional 35mm cameras (a related film, High Contrast PolaChrome, was marketed in 1987 for making high-contrast slides of graphs, charts, etc.). PolaChrome film is developed in about a minute in a separate Polaroid Autoprocess tabletop processor; the slides can be mounted and ready for projection in as little as 5 minutes after exposure. PolaChrome is a modern reincarnation of the additive-screen Autochrome plates and similar color processes popular in the early part of the 1900's. Because of problems inherent in any additive color system, these processes were abandoned soon after Kodachrome and other continuous-tone subtractive color films became available.

PolaChrome utilizes the same imaging technology as the ill-conceived — and quickly abandoned — Polavision instant movie system introduced in 1978. In PolaChrome, the color image is formed by a positive silver image layer which controls light transmission through an extremely

fine series of dyed red, green, and blue lines imprinted on the film base. Deterioration of a PolaChrome image is a complex matter and can involve either the silver layer and the dyed screen elements separately, or *both* at the same time. Being an additive system, the d-min of PolaChrome is very high (about 0.70), and correctly exposed slides have a very dense appearance. When projected, PolaChrome images appear much darker on the screen than conventional slides.

During the course of the 120-day intermittent projection tests, all of the PolaChrome slides developed serious, irregular yellow stains — this was in addition to a more uniform, overall yellow staining. **Figure 6.24** illustrates the changes that occurred in a light skin-tone patch from a Macbeth ColorChecker (the area of the light skin-tone patch developed an especially high stain level on this particular PolaChrome slide). The red and green densities dropped in a fairly orderly fashion, but after a short drop at the very beginning of the test, the blue density increased rapidly, reflecting the formation of yellow stain; the color balance of the skin-tone patch shifted markedly toward yellow.

The stain formation is probably accompanied by some fading of the blue dye; integral densitometry, such as that employed in these tests, cannot distinguish between these two causes of density change. Unlike subtractive films which have relatively clear d-min areas, PolaChrome is an

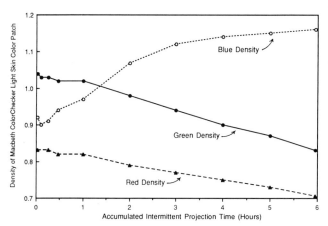

**Figure 6.23** During intermittent projection, PolaChrome instant color slide film developed high levels of yellowish stain — generally in visually objectionable, irregular patterns. The example shown here occurred in the light skin-tone patch of an image of a Macbeth ColorChecker.

additive film with full-density red, green, and blue strips in all areas of the film, making analysis of changes more problematic. Direct comparisons between the fading characteristics of PolaChrome and other films are difficult because of the high base density, compressed density-scale, and other unusual aspects of PolaChrome images.

Because of the *irregular* nature of the yellow stains that occurred in the course of projection, and because PolaChrome images had essentially disappeared by the end of this author's 90-day, high-humidity (144°F [62°C], 75% RH) accelerated dark fading tests, PolaChrome film cannot be recommended for any application requiring more than short-term stability. Irregular stains of this type are virtually impossible to correct in duplication or printing and are one of the most serious flaws that a photographic material can have.

Using continuous-projection tests, Polaroid concluded that PolaChrome slides have very high resistance to projector-caused fading (to this author's knowledge, Polaroid has not published data from intermittent-projection tests):

> All color slides subjected to long periods of projection will eventually fade. Tests under typical projection conditions indicate that PolaChrome slides can be projected two to five times longer than conventional (chromogenic) slide films before exhibiting a similar degree of fading.
>
> A PolaChrome slide projected continuously for 10 hours in a 300-watt projector showed a subtle visual change in some colors. After 20 hours the change was still small enough to be unnoticed unless directly compared to an identical, unprojected slide.
>
> Because of this resistance to fading, PolaChrome film is particularly recommended for slide shows . . . .[41]

Because of its poor image quality, lack of a continuous-tone image, extremely high base density, large grain structure, compressed density range (which reduces the bril-

liance of projected images), slow speed of ISO 40, color-fringing with certain types of scenes, difficulty of making color separations for photomechanical reproduction, poor stability under commonly encountered projection and storage conditions, and other drawbacks, the *only* reason anyone would want to use PolaChrome film is that it can be processed and ready for projection in slightly less than 5 minutes — the only current "instant" 35mm color slide film.

Polaroid has suggested that PolaChrome slides be treated with gold chloride toners to protect the delicate silver image if better stability is desired, especially under less-than-ideal storage conditions.[42] However, it is highly unlikely that many photographers would be willing to get involved in toning and washing the films prior to projection or storage in an effort to improve the stability of the product.

## Notes and References

1. Eastman Kodak Company, **The Source Book – Kodak Ektagraphic Slide Projectors**, Kodak Publication No. S-74, October 1984, p. 153, Eastman Kodak Company, 343 State Street, Rochester, New York 14650; telephone: 716-724-4000. The light intensity at the film plane of an Ektagraphic III projector equipped with an EXR lamp is given as 95,000 footcandles [1,022,200 lux]. See also: Eastman Kodak Company, **Evaluating Dye Stability of Kodak Color Products, Transparencies and Movies on Kodachrome [Films]**, Kodak Current Information Summary CIS No. 50–41, Eastman Kodak Company, June 1982. This publication gives a film-plane intensity of 925 klux (86,000 fc) for a Kodak Carousel projector with a quartz-halogen lamp. The **1982–1983 Kodak Photographic Products Reference Guide**, Kodak Publication No. R-50, states that the then-new Ektagraphic III projectors had "Increased illumination (25% more than Ektagraphic Slide Projector Models E-2 through AF-2)" (p. 70). The coated condensers in Ektagraphic projectors result in about an 8% increase in light intensity at the film plane over Kodak Carousel projectors, which are equipped with lower-cost, uncoated condenser lenses. Kodak Ektapro 7000 and 9000 slide projectors, introduced in 1992, employ the same EXR lamps that are used in Ektagraphic III projectors. According to James Parker, Coordinator of Presentation Technology for Kodak's Professional Imaging Division (telephone discussion with this author, February 19, 1992), an improved mirror design in the Ektapro projectors gives about a 10% increase in film plane illumination intensity compared to that in Ektagraphic III projectors. This author did not have the necessary equipment to be able to directly measure the projector-gate light intensities.

2. The estimated light intensity at the film plane of typical xenon-arc projectors was based on discussions with three makers of such projectors. None had actual data on film-plane light intensity, but expressed the light intensity of their projectors in terms of the percentage increase in screen illumination compared with an Ektagraphic III projector, using the same lens and projection distance. Reciprocity failures at the extreme illumination levels of xenon-arc projectors have not been investigated.

3. This author delivered a talk entitled "Projector-Caused Fading of 35mm Color Slides" at the annual conference of the Society of Photographic Scientists and Engineers, held in Minneapolis, Minnesota, May 5, 1980. This presentation included some data on reciprocity failures in projector-caused fading. Additional research was reported at the **Advanced Studies in Visual Resources Seminar, Production and Preservation of Color Slides and Transparencies**, sponsored by the Department of Art, School of Architecture, and Humanities Research Center at the University of Texas at Austin, Texas, March 27–28, 1981. The proceedings of this landmark seminar were reported by Bob Schwalberg in "Color Preservation Update," **Popular Photography**, Vol. 89, No. 1, January 1982, pp. 81–85, 131. In February 1990, further research was reported in a presentation by this author entitled "The Stability and Preservation of Color Slides: Duplicates for Use, and Cold Storage of Originals Provide the Only Answer," ARLIS–VRA Joint Session, **Conservation and Preservation Issues Beyond the Book: Slides, Microforms, Videodiscs and Magnetic Media**, at the ARLIS (Art Libraries Society of North America) 18th Annual Conference, New York City, February 14, 1990. Comparative projector-fading and dark fading stability data for color slide films were included in: Bob Schwalberg, with

Henry Wilhelm and Carol Brower, "Going! Going!! Gone!!! – Which Color Films and Papers Last Longest? How Do the Ones You Use Stack Up?," **Popular Photography**, Vol. 97, No. 6, June 1990, pp. 37–49, 61. The stability data in the article were condensed from this book.

4. Peter Moore, "The Great Carousel Go-Around," **Modern Photography,** Vol. 45, No. 10, October 1981, pp. 128–133, 172, 176.

5. David C. Hubbell, Robert G. McKinney, and Lloyd West, "Methods for Testing Image Stability of Color Photographic Products," **Photographic Science and Engineering,** Vol. 11, No. 5, September–October 1967, p. 297. This article was the basis for **ANSI PH1.42-1969, American National Standard Method for Comparing the Color Stabilities of Photographs,** American National Standards Institute, Inc., 1430 Broadway, New York, New York 10018; telephone: 212-354-3300. In 1990 **ANSI PH1.42-1969** was replaced by **ANSI IT9.9-1990** (see Note No. 14).

6. Eastman Kodak Company, see Note No. 1.

7. In practice, however, cyan absorbs some green light and contributes to green density; magenta absorbs some red and some blue light in addition to green. Readings taken with a normal densitometer are known as "integral density" measurements and usually equate fairly well with the visual perception of an image. A loss in green density of a gray scale patch is caused mostly by the fading of magenta dye, but losses in the cyan dye may also contribute to the measured losses because of the secondary absorption of the cyan in the green region. Strictly speaking, one cannot say that losses in green density are losses of magenta dye. This is the principal reason that graphs and other data are often expressed in terms of changes in red, green, and blue densities. If yellow stains are present, they will have considerable influence on the blue density readings.

8. A somewhat simplified version of the criteria given here was first proposed by this author in 1978 as part of a presentation entitled "Light Fading Characteristics of Reflection Color Print Materials" at the 31st Annual Conference of the Society of Photographic Scientists and Engineers, May 1, 1978, in Washington, D.C. Preliminary data on reciprocity effects in the light fading of color prints, with specific reference to the light fading characteristics of Polacolor 2 prints, were also discussed during the presentation. Further research by this author was described in a presentation entitled "Reciprocity Effects in the Light Fading of Reflection Color Prints" at the 33rd Annual Conference of the Society of Photographic Scientists and Engineers, held in Minneapolis, Minnesota, May 5, 1980. See also: Henry Wilhelm, "Monitoring the Fading and Staining of Color Photographic Prints," **Journal of the American Institute for Conservation,** Vol. 21, No. 1, Fall 1981, pp. 49–64.

9. Stokes Imaging Services, Inc., 7000 Cameron Road, P.O. Box 14277, Austin, Texas 78761-4277; telephone: 512-458-2201.

10. Microcolor International, Inc., 85 Godwin Avenue, Midland Park, New Jersey 07432; telephone: 201-445-3450.

11. Thom O'Connor, "Pros Winners of Film Wars," **Photo District News,** Vol. VII, Issue II, February 1987, pp. 1, 14, 16, 18.

12. Gepe Double Glass Slide-Binders were used for the glass-mounted slides in the tests reported here. The mounts have plastic frames which snap together, thin aluminum masks that also serve to position the film in the mount, and "anti-Newton's rings" glass on both sides of the mount. Gepe mounts, which are popular in the U.S. and many other countries, are made in Sweden by BiWex. The mounts are distributed in the U.S. by Gepe, Inc., 16 Chapin Road, Pine Brook, New Jersey 07058; telephone: 201-808-9010.

13. Christine L. Sundt, "Mounting Slide Film Between Glass – For Preservation or Destruction?" **Visual Resources,** Vol. II, Nos. 1–2–3, Fall/Winter 1981/Spring 1982, pp. 37–62. See also: Christine L. Sundt, "How to Keep Slide Mounts Clean," **International Bulletin for Photographic Documentation of the Visual Arts,** Vol. 13, No. 2, Summer 1986, pp. 14–15; and: Christine L. Sundt, "Conservation Practices for Slide and Photograph Collections," **VRA Special Bulletin No. 3**, Visual Resources Association, 1989. Sundt, who is continuing the research reported in these articles, currently is curator of the slide collection of architecture and applied arts at the University of Oregon at Eugene.

14. American National Standards Institute, **ANSI IT9.9-1990, American National Standard for Imaging Media – Stability of Color Photographic Images – Methods for Measuring,** American National Standards Institute, Inc., 11 West 42nd Street, New York, New York 10036; telephone: 212-642-4900; Fax: 212-302-1286. This author has served as a member of the ANSI subcommittee that wrote this standard since the group was founded in 1978; in recent years this author has been secretary of the subcommittee. This Standard replaced **ANSI PH1.42-1969** in 1990 (see Note No. 5).

15. Eastman Kodak Company, **Restoring Faded Color Transparencies by Duplication (White-Light Printing Methods)**, CIS No. 22,

Current Information Summary, July 1979, Eastman Kodak Company, 343 State Street, Rochester, New York 14650; telephone: 716-724-4000.

16. Henry Wilhelm, see Note No. 8. The criteria proposed in 1978 were for reflection prints and did not assign weighted values to changes in red, green, and blue densities; in other respects the concept of specified limits for density loss, color imbalances, and stain formation was similar to that discussed here.

17. Eastman Kodak Company, **Storage and Care of Kodak Color Films,** Kodak Publication No. E-30, March 1973, Eastman Kodak Company, 343 State Street, Rochester, New York 14650; telephone: 716-724-4000.

18. Eastman Kodak Company, **Storage and Care of Kodak Color Films,** Kodak Publication No. E-30, January 1976, p. 5. The quoted statement was slightly reworded in **Conservation of Photographs** (George T. Eaton, editor), Kodak Publication No. F-40, March 1985, p. 69, Eastman Kodak Company, 343 State Street, Rochester, New York 14650; telephone: 716-724-4000.

19. Isabel Lowery, the Dunlap Society, telephone discussion with this author, February 15, 1984.

20. Eastman Kodak Company, **The Sourcebook – Kodak Ektagraphic Projectors,** Kodak Publication No. S-74, 1977, p. 59, Eastman Kodak Company, 343 State Street, Rochester, New York 14650; telephone: 716-724-4000.

21. Eastman Kodak Company, **The Sourcebook – Kodak Ektagraphic Projectors,** Kodak Publication No. S-74, October 1984, p. 154. Eastman Kodak Company, 343 State Street, Rochester, New York 14650; telephone: 716-724-4000.

22. Eastman Kodak Company, **Evaluating Dye Stability of Kodak Color Products (**Current Information Summary), Kodak Publication No. CIS No. 50 (1981–1985), Customer Technical Service, Eastman Kodak Company, Rochester, New York 14650. CIS No. 50–41 gives data on Kodachrome films; CIS No. 50–45 gives data on Ektachrome films. Inquiry should be made to Eastman Kodak Company to obtain current image stability data sheets for the particular Kodak products of interest (see Notes No. 23 and 24). The data sheets are usually reissued (and possibly updated) each year. The data sheets for Ektachrome and Kodachrome films referenced by this author were dated 1982. See updated Kodak publication: **Evaluating Image Stability of Kodak Color Photographic Products** (Current Information Summary), Kodak Publication No. CIS-130 (March 1991), Eastman Kodak Company, 343 State Street, Rochester, New York 14650; telephone: 716-724-4000.

23. Eastman Kodak Company, **Reference Information From Kodak – Image Stability Data: Kodak Ektachrome Films (Process E-6),** Kodak Publication No. E-106 (May 1988), Eastman Kodak Company, 343 State Street, Rochester, New York 14650.

24. Eastman Kodak Company, **Reference Information From Kodak – Image Stability Data: Kodachrome Films,** Kodak Publication No. E-105 (March 1988), Eastman Kodak Company, 343 State Street, Rochester, New York 14650; telephone: 716-724-4000.

25. Eastman Kodak Company, see Note No. 21, p. 153.

26. Eastman Kodak Company, **Kodak Color Films and Papers for Professionals**, Kodak Publication No. E-77, March 1986, p. 58. Eastman Kodak Company, 343 State Street, Rochester, New York 14650.

27. Eastman Kodak Company, **Kodak Color Films**, Kodak Publication No. E-77, September 1980, pp. 34–35. Eastman Kodak Company, 343 State Street, Rochester, New York 14650.

28. Because the original Kodak patents for the Carousel projector and tray have expired, anyone can make a projector based on the Carousel design; Telex Communications [formerly Singer] (Caramate Projectors), Elmo (Omnigraphic Projectors), Leitz (Pradolux Projectors), and a number of other companies market projectors of this type that accept the standard Kodak "Carousel" 80- or 140-slide-capacity trays. From a conservation point of view, a noteworthy feature of all of these projectors is that when the rotating tray moves a slide into position for projection, the slide drops by gravity into the projection gate. If the mount is warped or if something else causes the slide to jam, in most cases it either remains in the tray slot or drops part way into the gate and is then usually, but not always, ejected without physical damage. Many other projector designs force a slide into the projection gate, and the slide can be seriously damaged if it should jam on the way in or out of the gate.

29. Eastman Kodak Company, see Note No. 20. For the Kodak Ektagraphic Projectors E-2 through AF-2, the total time required for the slide-change mechanism to function was given as 950 milliseconds, with the projector gate shutter closed 830 milliseconds of that period (p. 39). This author allowed 1 second for changing each slide in the tests described here.

30. Eastman Kodak Company, **Kodak Slide Projector Lamp Data and**

**Light Output Modification,** Publication No. S-80-2, March 1979, Eastman Kodak Company, 343 State Street, Rochester, New York 14650; telephone: 716-724-4000.

31. Robert S. Beeler, Motion Picture and Audiovisual Markets Division, Eastman Kodak Company, letter to this author, February 28, 1980.

32. American National Standards Institute, Inc., see Note No. 14.

33. Henry Wilhelm, "Reciprocity Failures in Accelerated Light Fading and Light-Induced Staining of Color Prints," presentation at the **Third International Symposium on Image Conservation**, sponsored by the Society for Imaging Science and Technology (SPSE) and held at the International Museum of Photography at George Eastman House, Rochester, New York, June 17–20, 1990.

34. Robert Tuite, "Image Stability in Color Photography," **Journal of Applied Photographic Engineering**, Vol. 5, No. 4, Fall 1979, pp. 200–207.

35. Yoshio Seoka, Seiiti Kubodera, Toshiaki Aono, and Masato Hirano, "Some Problems in the Evaluation of Color Image Stability," **Journal of Applied Photographic Engineering**, Vol. 8, No. 2, April 1982, pp. 79–82. This article was based on a presentation given at the **1980 International Conference on Photographic Papers**, William E. Lee, chairman, sponsored by the Society of Photographic Scientists and Engineers (SPSE), Hot Springs, Virginia, August 11, 1980.

36. Toshiaki Aono, Kotaro Nakamura, and Nobuo Furutachi, "The Effect of Oxygen Insulation on the Stability of Image Dyes of a Color Photographic Print and the Behavior of Alkylhydroquinones as Antioxidants," **Journal of Applied Photographic Engineering**, Vol. 8, No. 5, October 1982, pp. 227–231.

37. Eastman Kodak Company, see Notes No. 23 and No. 24.

38. Eastman Kodak Company, **Evaluating the Dye Stability of Kodak Color Products – Transparencies on These Kodak Ektachrome Films** (Current Information Summary), Kodak Publication No. CIS 50–45 (August 1982), Customer Technical Service, Eastman Kodak Company, 343 State Street, Rochester, New York 14650.

39. American National Standards Institute, Inc., see Note No. 5, p. 11, Sec. 3.4, Intermittent Type Slide Projector (50,000 fc) specifies the following test: "A 35 mm slide projector with continuously repeated intermittent exposure of the test specimens is specified. An automatic slide projector with a cylindrical magazine and a 500-watt tungsten lamp is a convenient type of test unit . . . . Each slide is projected for 10 to 20-second intervals. The projector is operated in room conditions, 75°F ±5°F, which will allow the blower to circulate air around the slide and maintain a slide film temperature of less than 160°F. . . ." The Standard, including the slide-fading test, is largely based on a 1967 article by Hubbell, McKinney, and West of Eastman Kodak (see Note No. 5). This now-obsolete Standard did not specify the length of time between each projection, other than saying the projections are "intermittent," and the possibility of reciprocity failures is not mentioned; the relative humidity of the test area is not specified.

40. Patrick Young, "A Comparison of Color Films Used to Photograph Works of Art," **International Bulletin for Photographic Documentation of the Visual Arts**, Vol. 10, No. 2, June 1983, pp. 7–11.

41. Polaroid Corporation, **Polaroid 35mm Instant Slide System,** A Polaroid Book by Lester Lefkowitz, Polaroid Corporation, Cambridge, Massachusetts, and Focal Press, Boston, Massachusetts and London, England, 1985, p. 57.

42. Polaroid Corporation, see Note No. 41, p. 99. Illustrated is an example of a PolaChrome instant color slide stored for 1 year at 68–74°F (20–23°C) and 40–50% RH, and an identical slide stored for 1 year in a "tropical" environment with an average temperature of 80°F (28°C) and an average relative humidity of about 75%. The film stored in the warm and humid environment lost considerable density, with changes taking place in an apparently irregular pattern. Polaroid concluded: "High heat and humidity adversely affect image stability of processed [PolaChrome] film." Especially under less-than-ideal storage conditions, gold chloride toning was recommended to increase the image stability of PolaChrome slides. Gold-toning instructions are available from Polaroid: Technical Assistance, Polaroid Corporation, 784 Memorial Drive, Cambridge, Massachusetts 02139; toll-free telephone: 800-354-3535.

**tems**, pp. 117–123, 1988. Published by the Royal Photographic Society of Great Britain, The Octagon, Milsom Street, Bath BA1 1DN, United Kingdom.

Henry Wilhelm, "Color Photographs and Color Motion Pictures in the Library: For Preservation or Destruction?", chapter in **Conserving and Preserving Materials in Nonbook Formats**, (Kathryn Luther Henderson and William T. Henderson, editors), pp. 105–111, 1991. The book contains the papers presented at the **Allerton Park Institute** (No. 30), sponsored by the University of Illinois Graduate School of Library and Information Science, held November 6–9, 1988 at the Chancellor Hotel and Convention Center, Champaign, Illinois. Published by the University of Illinois Graduate School of Library and Information Science, Urbana-Champaign, Illinois.

## Additional References

Etsuo Fujii, Hideko Fujii, and Teruaki Hisanaga, "Evaluation of the Stability of Light Faded Images of Color Reversal Films According to Color Difference in CIELAB, **Journal of Imaging Technology**, Vol. 14, No. 2, April 1988, pp. 29–37; see correction of 2 tables in "Errata," **Journal of Imaging Technology**, Vol. 14, No. 3, June 1988, p. 93.

Joyce H. Townsend and Norman H. Tennent, "The Photochemical and Thermal Stability of Color Transparencies," **Colour Imaging Sys-**

# 7. Monitoring the Long-Term Fading and Staining of Color Photographs in Museum and Archive Collections

## Similar Procedures Can Be Employed with Black-and-White Prints

Douglas Severson's findings confirm a fact that has long been suspected and dreaded, that is, that the exhibition of photographs is incommensurate with their preservation.

The exhibition Severson monitored [made up of some of the finest photographs in the collection of the Art Institute of Chicago, and sent to Japan for 3 months in 1984] was mounted at the highest level of practice and was of relatively short duration, yet dramatic changes were recorded. The few other monitoring projects which have been conducted show similar results. If one contemplates the probable effects upon the majority of photographs displayed for longer periods, under less controlled conditions without monitoring systems, the implications are sobering.

. . . We must accept the conclusion that we are squandering the largely unrenewable resources of our photographic heritage in an ignorant fashion. It is sadly ironic that this is being done under the banner of promoting the appreciation of photographs.[1]

> Grant B. Romer, Conservator
> International Museum of Photography
> at George Eastman House
> Rochester, New York – September 1986

People go to museums and galleries to see original works of art — whether they are paintings, photographs, drawings, or sculptures. Viewing a *copy* of a 1653 Rembrandt painting — no matter how perfect the copy — is simply not the same intellectual or emotional experience as looking at the original work of art. The desire to see originals certainly extends to color photographs: it is accepted practice to exhibit original color prints despite the fact that exposure to light during display causes gradual image deterioration in the form of fading, changes in color balance, and, with most types of color photographs, formation of low-level yellowish stains.

See page 241 for Recommendations

Compared with most other types of artistic media, color photographs generally fade and/or stain fairly rapidly when exposed to light on display. And, unlike the dyes and pigments in watercolors, paints, and fabrics — almost all of which have very good stability when protected from light and stored under normal room-temperature conditions — most kinds of color photographs slowly fade and develop overall yellowish stains even when kept in the dark.

When the fading of a color print is not severe, it is difficult to visually assess the deterioration of the image over periods of many years, and subtle changes are usually not noticed at all; this is particularly true when the viewer sees the print frequently during the months and years while fading is progressing. Most people have a rather poor recollection of exactly how a color image appeared many years past, and often a person will not have seen a particular faded print in its original and unfaded state. As an example, most people have never seen an albumen black-and-white print from the late 1800's that has not suffered significant image deterioration. The faded and yellowed albumen print has come to be accepted as "normal." People are usually shocked when they first view an albumen print that has remained in pristine condition, with its rich purple-brown tones and wealth of highlight detail with bright, neutral whites.

More extreme is the example of Kodacolor prints from the 1940's and early 1950's; all prints of this type that this author has seen have faded. Worse, the serious loss of image density is accompanied by severe orange-yellow staining. It is no longer possible to view an early Kodacolor print in a state that even remotely resembles its original condition. In a more recent disaster, untold millions of prints made on Agfacolor Type 4 paper in the 1970's have now lost most, if not all, of the cyan dye component of their color images. Even if stored in the dark, these prints now have a ghastly red-yellow appearance.

A moderately faded and/or stained image may evoke feelings that "the image is weak," or "it lacks brilliance," or "something is wrong with it." Most people will, however, be at a loss to describe in specific or quantitative ways the changes that have taken place in the image. Often a person will speculate that the print was never very good, that the highlights were washed out, or that "the color balance was off a bit" when the print was made.

October 1987

Douglas G. Severson, conservator at the Art Institute of Chicago, monitors a color print by Joel Meyerowitz on Kodak Ektacolor 74 RC paper. Severson's monitoring of a selection of photographs from the Art Institute collection that were shipped to Japan for a 9-week exhibition in 1984 showed that some historical photographs suffered significant deterioration even during short-term travel and exhibition. Particularly disturbing was the severe staining that occurred in a number of prints, including a 1919 palladium print by Alfred Stieglitz, an 1892 albumen print by William Henry Jackson, an 1874 albumen print by Julia Margaret Cameron, and an 1857 albumen print by Francis Frith.

# Recommendations

- **What should be monitored:** Museums and archives should monitor all valuable color and black-and-white photographs in their collections. It is particularly important to monitor photographs made with processes that are known to have poor fading and/or staining characteristics (e.g., almost all types of color prints, albumen prints, salted paper prints, and silver-gelatin prints made on printing-out papers).

- **Limits of fading and staining:** The limits given in **Table 7.1** are recommended. With experience, an institution may decide to adopt limits that are different from those given here. In general, museums with fine art collections will tolerate less change than institutions emphasizing historical photographs. Regardless of the type of collection, however, it is best to adopt fairly tight limits of change. Over time, densitometer errors may understate the amount of change that has actually taken place. In addition, the perceived value of many photographs will increase as the years go by, and future caretakers will wish that such prints had been better preserved.

- **Available display time should be used only gradually.** A curator should not use up all of the available display time for a particular print during his or her tenure — as much display time as possible should be left for the future. This means that display of original color prints and other unstable types of prints should be infrequent, and then only for short periods. Between display periods, the prints should be kept in humidity-controlled cold storage. Facsimile color copies should be made for routine display.

- **Facsimile color copies should always be made before a fading or staining limit is reached.** It should be emphasized that with the exceptions of UltraStable Permanent Color prints, Polaroid Permanent-Color prints, and properly processed fiber-base black-and-white prints, photographs cannot be displayed for extended periods without damage. Unless kept in humidity-controlled cold storage, most types of color prints gradually fade and stain even when kept in the dark. Therefore it is simply a matter of time before most photographs will reach one or more of the specified limits of change.

- **Prints believed to have reached a fading or staining limit before the start of monitoring should not be displayed at all.** It may safely be assumed that albumen prints and most other types of historical photographs years ago exceeded the fading and staining limits given here. Most types of color prints that have been displayed or stored in the dark at normal room temperatures for more than 5 or 10 years also have probably exceeded one or more fading or staining limit (Polaroid Spectra prints, Polaroid 600 Plus prints, and Polaroid SX-70 prints generally will exceed the stain limits only a few months after they are made). To prevent further damage, such prints must be kept in cold storage and not displayed. Facsimile copies should be made for display and study purposes.

- **Densitometers:** At the time this book went to press in 1992, Macbeth TR924 densitometers with specially installed Kodak Wratten 92, 93, 94A, and visual 102 filters were recommended. The user should purchase the filters in 5-inch-square sheets from Kodak and forward the filter sheets to Macbeth for installation in the densitometer filter wheels; leftover filter material should be stored in the original Kodak packages in a cool, dry place (if possible, in humidity-controlled cold storage). The normally supplied ANSI Status A and Status M filters have poor stability and are unsuitable for monitoring applications.

- **Long-term densitometer calibration:** At the start of a monitoring program, a new densitometer should be purchased. The densitometer should be reserved for print monitoring and not used for process control or other routine darkroom applications. In addition to the porcelain calibration plaque supplied by the densitometer manufacturer, a Kodak Reflection Densitometer Calibration Plaque should be used to assess changes in spectral response of the instrument. But most important for long-term densitometer calibration are color photographic calibration prints made on each type of color material in the collection; to keep the prints unchanged, they must be preserved in 0°F (–18°C) humidity-controlled cold storage.

With older prints, there is likely to be doubt about the color and tone-reproduction characteristics of the materials with which the prints were made. Ilford Cibachrome prints made on the materials available in the 1970's sometimes have washed-out highlights and look very much like prints subjected to significant light fading; the appearance of such prints is most likely due to excessive contrast and poor tone-scale reproduction of the older Cibachrome materials and is probably *not* the result of light fading. On the other hand, these prints may also have been subjected to

light fading, making evaluation of their condition more difficult. Only rarely is an identical but unfaded print available for a side-by-side comparison with the displayed print.

## Reasons for Monitoring Color Prints

With the singular exception of pigment color prints made by the UltraStable Permanent Color process or the Polaroid Permanent-Color process, a museum cannot responsibly display color photographs for the extended periods

May 1982

The 1982 show **Color as Form: A History of Color Photography** at the Corcoran Gallery of Art in Washington, D.C. was the first photography exhibition to be densitometrically monitored for image fading and staining. Curated by John Upton for the International Museum of Photography at George Eastman House, the show was the first major survey of color photography as an art form. Consisting of vintage prints made by a wide variety of color processes — most with unknown stability characteristics — the exhibition was at the Corcoran for 3 months and was later shown at George Eastman House.

February 1982

Conservation technician Peter Mustardo (left) and conservator Grant Romer monitor a group of color prints in the George Eastman House conservation laboratory. An Electronic Systems Engineering Company Speedmaster TRC-60D densitometer was used for the monitoring project.

May 1982

Lumiere Autochromes and transparencies made by other early processes were copied on Ektachrome sheet film for display in light boxes in the Corcoran exhibition; the originals were deemed too unstable for display.

common with modern fiber-base black-and-white prints. Once this unfortunate limitation of color photography is accepted, the question then becomes: "How long *can* a color print be displayed before objectionable fading takes place?" The purpose of monitoring a print is to provide a quantitative record of the print's original condition and of the complex changes that take place over the months and years of display or storage. Monitoring makes it possible to establish a set of criteria for permissible changes in an image and to do what is necessary to prevent fading and staining from progressing beyond those limits. Monitoring allows prints to be treated individually in terms of display times and light intensities; it permits prints made on the more stable materials such as Ilford Ilfochrome (called Cibachrome, 1963–1991) to be displayed much longer than prints made on less stable materials such as Polaroid Polacolor ER, with the assurance that no print will exceed the predetermined limits of fading.

If a print is made on a material subject to fading and/or staining when stored in the dark, such as Kodak Ektacolor paper, long-term deterioration can be arrested only by placing the photograph in low-temperature, low-humidity storage. At normal room temperatures, dark-storage changes — often referred to as *dark fading* — will continue whether or not a print is on display. Thus, when a print is displayed, the total change that takes place is a complex combination of dark fading/staining and light fading/staining. Light fading is caused by both visible light and ultraviolet radiation. For most types of color prints in normal museum display conditions, image deterioration caused by ultraviolet radiation is much less significant than changes caused by visible light.

Illumination conditions for color photographs vary widely from one museum to another, and even within a given institution (see **Table 17.1** in Chapter 17). Typically, color prints in museums are illuminated with incandescent tungsten lamps of about 2800 K; intensity on the print surface is in the range of 130–430 lux for about 12 hours per day. The small ultraviolet component of the illumination, below about 330 nanometers, is normally absorbed by the glass sheet in the picture frame.

Low illumination levels of about 50 lux (4.7 footcandles) have frequently been recommended for displaying works of art on paper in general, and color photographs in particular.[2] This level is much too low, however, for proper viewing of color prints — indeed, it is much too low for adequate viewing of black-and-white photographs as well. Under low illumination, visual perception of the image is impaired; it may not be possible to see details in darker areas of a print, and perception of color also suffers. Eastman Kodak states: "The intensity of the light source influences that amount of detail that can be seen in a print. For good viewing, a light source should provide an illuminance of 1,400 lux ± 590 lux (130 fc ± 55 fc)."[3] (For further discussion of the relationship between illumination levels and visual perception of color and tone reproduction in photographs, see Chapter 17.)

Inevitably, a compromise must be made between the high illumination levels required for optimal appreciation of a color photograph, the desire for extended display periods, and the need to minimize fading. For museum appli-

cations, this author recommends glass-filtered incandescent tungsten illumination with an intensity of about 300 lux (28 fc). Tungsten illumination of this intensity should also be available in darkrooms, print study rooms, and other areas where color prints are evaluated.

With many common types of color photographs, such as prints made on Kodak Ektacolor, Fujicolor, Konica Color, and Agfacolor chromogenic papers (sometimes incorrectly called "Type C" papers) manufactured prior to 1985, dark fading reactions may predominate when the prints are displayed under low-level tungsten light; low-level tungsten illumination on the order of 50 lux (4.7 fc) may result in little if any gain in print life with these materials.

In April 1984, Konica Color Paper Type SR (also known as Konica Century Print Paper) was introduced; Type SR paper was the first of a new generation of chromogenic color negative print papers with significantly improved dark fading stability. By the end of 1985, Kodak, Agfa, and Fuji had also introduced similar papers with improved dark fading stability. With these new papers, unfortunately, the light fading stability and the tendency toward stain formation on display and in dark storage were only marginally better than previous papers.

At the time this book went to press in 1992, stain formation with Kodak Ektacolor and most other chromogenic print materials in dark storage was a more serious problem than dye fading itself. The only exceptions to this are Fujichrome Type 34 and Type 35 papers (introduced in 1986 and 1992) for printing color transparencies, Fujicolor Super FA and Fujicolor SFA3 papers for printing color negatives (introduced in 1990–92), and Konica Color QA Paper Type A5 (introduced in Japan in 1991). These papers have markedly reduced rates of dark-storage stain formation compared with similar products made by Kodak and Agfa.

Because dark fading reactions in displayed prints are much less of a factor with current papers, longer display times under low-level illumination are possible. Nevertheless, this author believes a higher illumination level is necessary to properly view color prints.

Extrapolations based on fading and staining observed in high-intensity accelerated light fading tests often underestimate the amount of deterioration that actually occurs during long-term display under normal conditions (called "reciprocity failure," this characteristic of light fading and light-induced staining is discussed in Chapter 2), and estimates of long-term fading and staining rates in dark storage currently are not available for many of the numerous types of color print materials found in museum and archive collections. It is therefore usually quite difficult to predict accurately the rates at which changes will take place for a given color print. Current color print materials manifest an extremely wide range of differences in light fading, dark fading, and stain formation characteristics.

## Procedures for Monitoring Prints

To determine what changes take place over a period of months or years, it is necessary to monitor a color print — that is to periodically measure the color and optical density of a print directly. Alternatively, the changes can be measured indirectly with a "fading monitor" made of the

same type of color print material as the photograph in question and subjected to the same light, temperature, and relative-humidity conditions. Measurements of a print or fading monitor are made with an accurate electronic color densitometer designed for photographic applications. The quantitative data thus obtained can indicate at what point in time small — but visually significant — changes have taken place so that the photographer or custodian knows when to retire the original print to cold storage, substituting copy prints for study and display purposes. **Table 7.1** shows the quantitative limits of "tolerable" fading, shifts in color balance, and stain formation suggested by this author for critical museum and archive applications.

Because of reciprocity failures in light fading, the complex relationship between dark fading/staining and light fading/staining of the dye sets in the many types of color photographic materials, and variables having to do with processing or the materials themselves (many of these factors are not well understood), measurement of the total light exposure received by a print by means of Blue Wool Fading Standards, NBS Fading Papers, integrating photometers, and so forth will generally not indicate accurately the degree of deterioration of a color photograph during long-term display and/or dark storage.

The general procedures described here for monitoring color prints can also be applied to color transparencies, color motion picture films, color negatives, and so forth. Black-and-white silver-gelatin photographs, albumen prints, salted paper prints, and other types of monochrome photographs can also be monitored in a manner similar to that used for color photographs.[4] Likewise, yellowing and other forms of visual deterioration in works of art on paper and in other paper objects can be monitored during long-term display and storage. The measurement techniques are applicable in documenting changes in objects after conservation treatments, too.

Changes in watercolors and paintings can also be measured with a densitometer, but because of the wide variety of colorants in paints, a spectrophotometer may have to be employed[5] in addition to, or in place of, a color photographic densitometer to ensure accuracy. Color photographic images are composed of cyan, magenta, and yellow colors that have spectral absorption peaks within a fairly narrow range; photographic densitometers are designed to measure colors with these spectral characteristics.

Although the concept of predetermined limits of change is directly applicable to paper objects, watercolors, paintings, and so forth, the limits selected for these media will probably differ from those suggested here for color photographs. Still, it is important to measure quantitatively and record the visual characteristics of all objects of these types so that any changes in future years can be determined with reasonable accuracy.

## The National Archives Document Monitoring System for the "Charters of Freedom"

In 1987 the National Archives and Records Administration in Washington, D.C. installed a sophisticated electronic document monitoring system designed to detect and quantify changes in the condition of the United States Declaration of Independence (1776), the Constitution (1787), and the Bill of Rights (written in 1789 and ratified in 1791).

Known collectively as the "Charters of Freedom of the United States," the parchment documents have suffered significant ink flaking and other deterioration over the years because of mishandling and poor storage and display conditions. The Declaration of Independence is in particularly poor condition, with the ink inscriptions now deteriorated so much as to be almost unreadable. In the early years the Declaration traveled frequently and was stored and displayed in a number of different locations. The document suffered partial ink loss during an ink-transfer copying process in the early 1800's. Further damage is believed to have occurred in the late 1800's, particularly during the period of 1877 to 1894 when it was displayed at the old State-War-Navy building in Washington, D.C. and was subjected to intense daylight illumination from a large window across from the display cabinet.

Since 1952, in an effort to minimize further deterioration, the documents have been housed at the National Archives building in bullet-proof, helium-filled display cases fitted with yellow filters that absorb wavelengths below about 500 nanometers; the documents are displayed under low-level tungsten illumination.

With the Archives' new document monitoring system, a high-resolution electronic camera with a scanning charge-coupled device (CCD) sensor and computerized image-analysis system are used to record a series of 30-millimeter-square digitized images (1024 x 1024 pixels) from selected areas of the documents once each year.[6] After the images are recorded, the image analysis system electronically compares the new images with images made in previous years. Even minute changes in the physical condition or reflectance of the ink inscriptions and the parchment upon which the documents are written can be detected. As an example of the kinds of things that can be monitored, on the first page of the Constitution the first "e" of "We the people . . . " has partially flaked off, and the letter is being monitored yearly to detect any further degradation.

The imaging camera is mounted on a 3-ton optical bench with solid granite risers supported by four nitrogen-filled cylindrical legs to eliminate ground vibrations from road traffic and a nearby subway. The system was designed to image the documents through the glass cover sheets of the display cases, thus making it unnecessary to open the helium-filled cases.

Technologically related to the electronic remote-imaging devices employed in space satellites for intelligence gathering, Earth survey work, weather forecasting, and in-space telescopes, the Archives' electronic camera and associated computer system were designed by the Jet Propulsion Laboratory at the California Institute of Technology in Pasadena and constructed by Perkin-Elmer Corporation. The Jet Propulsion Laboratory is associated with the National Aeronautics and Space Administration (NASA). The system cost $3.4 million and took 5 years to develop.

Although designed specifically for monitoring textual documents, the system could be adapted for detecting changes in the physical condition (e.g., surface cracking and flaking) and the staining and fading of photographs, oil paintings, pastels, watercolors, and other works of art.

November 14, 1989

In the central rotunda of the National Archives and Records Administration building on Constitution Avenue in Washington, D.C., long lines of people wait to see the United States Declaration of Independence (1776), the Constitution (1787), and the Bill of Rights (written in 1789 and ratified in 1791). Because of inadequate care during the 1800's, the 200-year-old documents have suffered serious deterioration. In particular, the ink inscriptions on the Declaration of Independence are now faded so badly that they are almost unreadable.

November 20, 1991

Mark Ormsby, a physicist with the Archival Research and Evaluation staff of the U.S. National Archives, is shown with the Archives' sophisticated $3.4 million computer-based document monitoring system designed to detect physical and visual changes in the U.S. Declaration of Independence, the Constitution, and the Bill of Rights. Although designed specifically for monitoring textual documents, the equipment will be used experimentally to monitor some of the photographs in the National Archives' vast collections.

November 20, 1991

Mounted on a 3-ton optical bench, the unit's electronic camera utilizes a scanning charge-coupled device (CCD) sensor to produce high-resolution digitized images of one or more 30-millimeter-square ($1^3/_{16}$ inch) sections of the object being monitored. A computer-controlled mechanism precisely positions the CCD camera. Scanning time required for each image is about 5 minutes.

November 20, 1991

Located in a room next to the electronic CCD camera, a computerized image-analysis system compares the initial digitized images of a document with images made in subsequent years and detects any changes in physical or optical properties that have taken place (e.g., ink flaking, movement of ink and dust particles, or tear propagation in the parchment on which the documents are written).

## Photographic Densitometers

Reflection densitometers suitable for color and black-and-white print monitoring are available from the Macbeth Division of Kollmorgen Instruments Corporation, X-Rite, Inc., and a number of other firms.[7] The Macbeth TR924 Color Transmission/Reflection Densitometer, specially equipped by Macbeth with Kodak Wratten filter numbers 92 (red), 93 (green), 94A (blue), and 102 (visual), is at present this author's primary recommendation for print-monitoring applications. The Status A and M filter sets normally supplied by Macbeth are not acceptable because these filters have proven to be very unstable and likely will require replacement every 3 or 4 years; problems with densitometer filters are discussed in detail later in this chapter.

To ensure maximum life of the instrument, a densitometer for print monitoring should not also be assigned to other functions, such as photographic process control. In general, readings are taken with the red-green-blue filters; the 102 (visual) filter is not necessary when monitoring most types of color prints, although it should be used *in addition* to the color filters for monitoring monochrome prints. Density data should always be recorded in the standard red-green-blue sequence to avoid confusion.

Basic to any monitoring system is a calibration procedure that assures the continued accuracy of the densitometer or other measuring instrument as well as the comparability of measurements even after old equipment has been replaced by new instruments of different design. Maintaining accuracy of the system for hundreds or thousands of years will require careful planning as well as the very-long-term preservation of color photographic calibration standards in an unchanged state by means of humidity-controlled cold storage. As discussed later, preserved color photographic calibration standards are likely to provide more accurate densitometer calibration than would be possible from porcelain plaques or stable pigment standards, which usually have only two or three neutral densities and which have spectral characteristics different from those of the cyan, magenta, and yellow dyes in color photographs.

## Direct Monitoring of Color Prints

Of the two methods described in this chapter for monitoring the fading and staining of color prints, institutions generally will choose to measure image changes directly on the prints. Separate fading monitors are useful chiefly for research in cases where the fading monitor's unique ability to distinguish between light-induced changes and dark-storage deterioration can provide important information in the design of better storage and display facilities.

The difficulties involved in preparing and using fading monitors, as well as the fact that monitors cannot be made for print materials that are no longer commercially available, will limit their routine application for indirect monitoring of pictorial color prints in institutional collections. In many cases it may be impossible to identify precisely the type of color material on which a print was made. There may also be uncertainty as to how an original print was processed and washed — this is especially true today, with ever more frequent introduction of new products and the proliferation of processing chemistries supplied by various manufacturers for "washless" and conventional processing of Ektacolor, Fujicolor, and similar papers. To be accurate, a separate fading monitor must be made with materials processed and washed exactly as was the print being monitored. These and other requirements will generally restrict the application of fading monitors to contemporary color prints, where the monitor's gray patches can be made at the same time as the print. A valuable color print should, if possible, be monitored directly from time to time, even when it is accompanied by a separate fading monitor.

## Polyester Overlays to Locate the Densitometer Head on the Print

It is not possible to measure image density accurately when a print is framed under glass, so such a print should be removed from the frame when density readings are to be made. To avoid direct contact of the densitometer head with the surface of the print, and to provide an exact record of the densitometer reading locations on the print, a thin, matte-surface *polyester* overlay sheet[8] must be prepared for each print (cellulose acetate or polyvinyl chloride sheets are not satisfactory because curling and dimensional instability are potential problems), with the print image locations traced on the sheet so that the densitometer head can be registered accurately on the image during each series of readings. The matte surface of the polyester sheet accepts ink and pencil lines readily; ink will not adhere to the surface of ordinary clear polyester and may smear or wear off. This author has found that polyester sheets with one matte side and one glossy side are more satisfactory for this application than sheets with both sides matte. The sheet should be cut about 2 inches larger than the print in both dimensions; space on the edges is available for writing identification data, date of preparation, and other information. The polyester sheet material should be 3 or 4 mil (0.003 or 0.004 inch) thick for general applications; thinner material is adequate for prints 8x10 inches and smaller.

The corners of the print image and the densitometer head locations must be precisely marked on the overlay sheet using a technical pen with a medium point and a suitable stable black ink.[9] The glossy side of the polyester sheet is placed down, against the surface of the photograph; the matte side of the sheet is on top. All ink markings and notations should be on the matte side. Great care should be taken to keep ink away from the photograph. It is usually satisfactory to mark the densitometer head locations by tracing the outer edges of the densitometer base plate onto the polyester sheet; in addition, at each location, a dot of ink should be placed on the polyester sheet in the center of the densitometer reading aperture to aid in locating the holes to be cut later. After all of the densitometer head locations have been selected and marked, the polyester sheet should be removed and a hole about ½ inch (1.3 cm) in diameter should be cut at each reading location.[10]

All ink markings on the overlay sheet should be completed before cutting any holes; otherwise, the pen point might accidentally slip through a hole and deposit ink on the photograph. To avoid confusion, the overlay sheet should be marked (e.g., "Top," "Bottom") to indicate proper orientation. The sheet should bear a serial number that identi-

Density measurements of a color print are read with a Macbeth TR924 densitometer (left).  Data are transmitted by the densitometer to this author's microcomputer (center) and recorded on disk (right).  The computer is programmed to analyze data in terms of specified densitometric limits of change.

fies the print, and densitometer calibration data should be recorded in a notebook made of reasonably stable paper.

The overlay sheet must remain in exact registration with the print during all readings; smooth-surfaced weights placed on the edges of the sheet will help keep it in position.  Because of localized density variations in most color prints, subsequent readings must be taken at precisely the same locations as the original readings if the measurements are to be meaningful.  When densitometer heads are changed, a method must be devised for positioning the new head using the old tracings.  The importance of taking future readings at the *exact* locations of the original readings cannot be overemphasized — accurate data cannot otherwise be obtained.  The person taking the readings should test his or her technique by seeing whether readings by a second person produce identical results.

As an alternative to marking the densitometer head locations on the overlay sheet with ink, Douglas G. Severson, conservator at the Art Institute of Chicago, has suggested locating the point at which a reading is to be taken and then cutting a round hole in the sheet which is slightly larger in diameter than the reading aperture of the densitometer.  Severson has found a #7 ($^{13}/_{64}$-inch) leather punch of the type manufactured by C. S. Osborne & Company to be satisfactory.[11]  After marking the locations of each hole

with a dot of ink, the polyester sheet is flipped over and placed on a sheet of Masonite; the punch is struck with a hammer to cut the holes.  Severson cautions that to avoid scratching the delicate print surface, the holes must be punched from the *bottom* side of the sheet so that the slightly rough edges of the holes lift away from the print rather than toward it.  To take readings, the densitometer head reading aperture is centered over each hole.

## Making Density Readings

Work areas should be clean, and cotton gloves should be worn by the operator to avoid putting fingerprints on the photographs.  A sheet of bright white mount board or opaque white glass should be placed on the work table and prints placed on this white surface while densitometer readings are made.  Since most print support materials transmit some light, the reflectance of the surface beneath a print may have a significant effect on densitometer readings made in low-density areas of a photograph.  For example, readings taken on a dark work surface will usually indicate somewhat higher densities than readings taken on a white work surface; such discrepancies may be quite large with albumen prints and other types of photographs made on thin paper supports.  The same type of work surface should

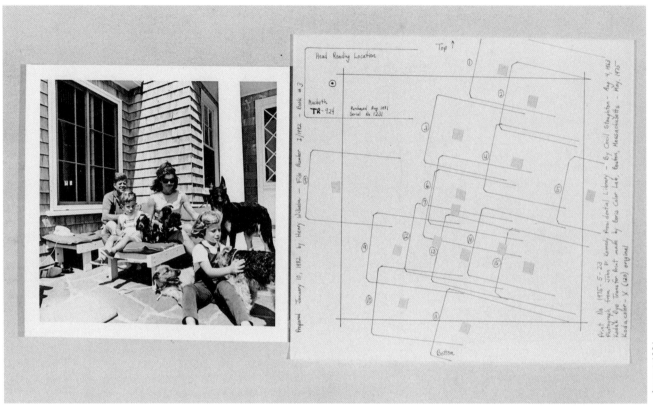

A color print is shown here with a matte-surface polyester overlay sheet marked with the densitometer head locations. The Kodak Dye Transfer print, with an image size of 10 x 10 inches, is of the John F. Kennedy family; it was taken August 4, 1963 by Cecil Stoughton. The original Ektacolor negative is preserved in humidity-controlled cold storage at the John F. Kennedy Library in Boston, Massachusetts.

be used for making all readings, and densitometer readings of the work surface itself should be recorded each time the work surface is changed.

Density readings through the red, green, and blue densitometer filters (which respectively indicate changes in cyan, magenta, and yellow dyes) should be made at minimum-density (white) locations, low-density locations of about 0.45, and maximum-density locations. Normally, readings in each density range should be taken in at least three locations (for a total of at least nine reading locations), and the readings should always include near-neutral (gray) colors, assuming such colors are present. Some of the readings should be taken near the top of the print, where the intensity of illumination during display is usually somewhat higher than it is near the bottom. If possible, fairly large areas of uniform tones should be selected for reading locations. In many photographic images, however, such areas may not be present, so a large number of readings will be required for accurate representation. After readings have been taken, the polyester overlay sheets should be stored *flat* in polyester sleeves[12] or in high-quality paper envelopes.

When prints are subject to light fading on display, it is particularly important that low-density (approximately 0.35 to 0.60) areas be carefully monitored, as dye losses in the low-density areas will be much greater proportionally than dye losses in high-density areas (see **Table 7.2**). This relationship between dye loss and density is typical of many types of color print materials; however, some types of prints, such as Polaroid Spectra prints (called Polaroid Image prints in Europe), Polaroid 600 Plus prints, and Polaroid SX-70 prints, develop overall yellowish stain during storage which may obscure fading of yellow image dye in low-density areas. With these prints, density losses resulting from light fading may be larger — even on a percentage basis — than losses in lower-density portions of the image.

With dark fading, unlike light fading, most types of color prints exhibit dye losses that are more or less proportional throughout the density range of the color image. Prints which have faded in dark storage do not suffer the loss of highlight detail that is characteristic of prints which have faded because of exposure to light.

## Cautions

Although a fading monitor or direct monitoring of an original color print will give an accurate indication of dye fading and stain formation, it may or may not indicate the physical deterioration that can occur in the print. Common examples of physical deterioration include cracking of the top polyethylene and emulsion layers of RC (polyethylene-resin-coated) prints, cracking of emulsions on fiber-base prints, and cracking of the internal image-receiving layer or formation of small "snowflakes" in Polaroid SX-70 prints from the 1970's. Retouching and corrective "dust spotting" may produce irregular fading or staining such as

The reading position of the densitometer head is indicated by an ink tracing of the head's base on a polyester overlay sheet.

August 1981

the orange discolorations sometimes seen on Kodak Ektacolor prints. Storage in conditions of high humidity can result in fungus growth on print emulsions. All prints should be carefully examined on a regular basis so that any physical defects or other irregularities can be documented and photographed for future reference.[13]

## Fading Monitors for Color Prints

Use of a separate fading monitor allows indirect measurement of the changes that take place in a color photograph. The colors and tones in conventional color photographs are obtained by varying the concentrations of cyan, magenta, and yellow image dyes which are in three or more emulsion layers coated on the surface of the support material — the same three dyes form all of the different colors in a color print. A neutral-gray patch serving as a fading monitor consists of nearly equal concentrations of the three image dyes. A minimum-density patch contains little or no dye.

It is possible to measure changes in neutral-gray patches of minimum density, low density, and maximum density and thereby to obtain a reasonably accurate indication of changes occurring in any area of a color print if the three patches are made on the same print material and are processed in the same way as the original print. A single fading monitor consisting of three patches should be matched with only one color print, and the monitor should be permanently assigned to that print with a serial number.

Potential disadvantages of fading monitors include possible differences in print and monitor fading/staining rates caused by differences in print materials, processing, framing, and other conditions. Furthermore, as noted previously, monitors can be prepared only with print materials and processes which are available in the marketplace;

monitors therefore cannot be prepared for most, if any, older color print materials in a collection. Institutions generally will find it more practical and accurate to monitor their color prints directly and to reserve fading monitors for special situations; for example, in some cases it may be undesirable to remove a print from its frame repeatedly for direct measurements.

Used by themselves, fading monitors can provide important information on the stability behavior of specific color print materials in actual long-term display and storage conditions. Data thus obtained can be compared with changes observed in controlled, accelerated tests. Fading monitors can also function as low-cost "integrating photometers" for estimating accumulated light exposure in a display area over time, although this author believes that the Blue Wool Standards, which are standardized and appear to have little reciprocity failure in accelerated light fading tests, are probably better suited for this application.[14]

## Preparing a Fading Monitor

Three test patches, about ½ x 1¼ inches (1.3 x 3.2 cm) each, should be prepared with the same color print material, processing chemicals, and processing procedures as those used to make the original print. Any variation in processing between the original print and its monitor may affect the fading characteristics of the monitor and may reduce its accuracy. One patch should be minimum density (white), one should be a neutral gray close to 0.45 density, and one should be maximum density (black). The three patches can be optically printed to the proper size on a sheet of print material. As an alternative, entire sheets of material can be printed to the desired density and the sheets cut to the proper sizes after processing.

The three print monitor patches should be mounted, as

An alternate system for locating the densitometer head is preferred by Douglas G. Severson of the Art Institute of Chicago. His method is to punch a small hole that is slightly larger than the densitometer reading aperture at each reading location in the overlay sheet; the small diameter of the holes assures sufficiently accurate positioning of the densitometer head.

October 1987

To position a polyester overlay sheet on a print, Severson marks all four corners with diagonal lines that nearly touch the corners of the image. Chamois-covered weights hold the overlay sheet in place while densitometer readings are made.

indicated in the accompanying photograph, on the same type of board used to mount the photograph being monitored, and should be attached with the same type of adhesive or mounting system. The monitor should be covered with a mat made of the same type of board that overmats and supports the original print. The overmat should have an opening in the center so that only half of the patch is exposed to light; this keeps the light fading and dark fading functions of the monitor separated (the overmat must be opaque — 4-ply mount board is recommended — for the monitor to give an accurate indication of dark fading). The monitor should then be placed in a small frame[15] with the same type of glass or plastic covering and backing materials that were used with its companion print.

Fading monitors for integral instant materials, such as Polaroid Spectra and SX-70 prints, should be prepared by optically printing the three density patches in the center of a sheet of the material. Since cutting or trimming such prints may alter their stability characteristics, fading monitors made on these instant materials should remain intact. Polaroid has made changes in its instant color materials on a fairly frequent basis, and some of these changes have altered the fading and staining characteristics of the prints. One should therefore ascertain that a monitor for an instant color print is actually made on the same material as the companion print.

In the preparation of fading monitors for chromogenic materials, such as Ektacolor papers, every effort must be made to duplicate exactly the processing and washing procedures followed in making the original print. If the original processing conditions are unknown or uncertain, the original print should be monitored directly as well as by a separate fading monitor. Polacolor 2 and Polacolor ER instant prints can be treated in the same manner as conventional color print materials.

If the primary purpose of a monitor is to function as an integrating photometer, Ektacolor, Fujicolor, or a similar chromogenic paper printed with a pure color magenta patch of about 1.0 density is suggested; the magenta dyes of these papers have good dark fading stability, and their rate of light fading is not greatly affected by varying relative humidity or temperature. With current papers, the relative ultraviolet content of the illumination has little influence on the fading rate.

A minimum-density (white) patch should also be included to allow for later "stain-correction" of the magenta patch readings. Fading monitors can be "calibrated" with controlled, accelerated light fading tests; if, for example, a 0.25 density loss is measured in a magenta patch on the monitor, the lux-hour exposure required to produce this amount of fading can be estimated from the exposure time that results in a 0.25 density loss with a magenta patch on the same print material in an accelerated test of known light intensity. When used as integrating photometers, the magenta patches need be read only with the green-density densitometer filter.

## Using a Fading Monitor

A print and its monitor should be kept in the same temperature and relative humidity conditions at all times. When a print is on display, its monitor should be exposed to the same intensity of light of the same spectral distribution for exactly the same length of time. The monitor can be exposed to light in a room separate from the display area only if all conditions are identical. The light level on the monitor can be adjusted by varying the distance of the monitor from the light source; the level chosen should be equal to the light intensity on the *most brightly illuminated* portion of the print. Most gallery and museum display areas do not provide uniform illumination over the entire surface of a print.

If the display areas receive any daylight, it will probably be necessary to place the monitor on the wall adjacent to the print, as it is difficult to obtain identical lighting conditions at all times of the day in a different location. When

the print is shipped to another location (for example, when it is loaned to another institution), the monitor must accompany the print during transit and storage; the print and its monitor must be kept together at all times. The borrowing institution must be instructed as to the proper use of the monitor.

Initially, the densities of the fading monitor should be measured at least once a year to see how much change has taken place; experience with each type of print material and with the dark-storage and display conditions to which the prints are subjected will indicate whether the monitor should be measured more or less frequently.

## Maintaining Long-Term Accuracy of a Monitoring System for Color Prints

The most difficult aspect of a monitoring program is maintaining long-term accuracy of the system; the ultimate success of a monitoring program will depend on the accuracy of initial and future instrument calibrations. Especially in fine art applications, very small changes in the visual characteristics of color prints must be measured accurately over many decades or centuries.

The calibration system must not be affected by changes in color densitometers or in other measuring equipment. It is obvious that present densitometers will become obsolete and will be replaced many times during the next several hundred years with new instruments. Because any two color densitometers may give significantly different readings from the same print samples (**Table 7.3**), the data obtained with one piece of equipment will have to be translated accurately to permit comparisons with readings taken with another instrument.

A specific densitometer should be dedicated for a monitoring program, and it should not be assigned to any other project. Densitometer readings should be taken in an environment with reasonably constant temperature and relative humidity. All photographs to be read should be brought to the work area in which the densitometer is located. The instrument should be allowed to warm up until calibration readings stabilize (with modern densitometers having solid-state sensors, a warm-up period of about 15 minutes should be adequate). Prior to each reading session, the porcelain calibration plaque supplied with the densitometer should be cleaned with Windex or a similar wax-free glass cleaner and then immediately wiped dry with paper towels. Fingerprints or other slight soiling can cause a significant deviation in readings taken on the high-density (black) patch on the plaque. Cleaning should be done in an area away from the densitometer and away from where photographs are stored; should tiny droplets of cleaner spray fall on a print, serious damage to the image may eventually occur.

After the densitometer has warmed up, the unit should be calibrated with the low- and high-density patches on the porcelain plaque, carefully following the manufacturer's instructions. Before density measurements are made of each print (or each fading monitor), the densitometer should be recalibrated ("zeroed") on the low-density (white) patch on the porcelain plaque. With most modern densitometers, it is sufficient to perform the high-density calibration just once at the beginning of the session; experience with a particular instrument will indicate whether more frequent

high-density calibrations are necessary.

Repeated low-density calibrations should be performed even if there is no indication that the instrument is drifting following the initial calibration. Most densitometers have only two figures to the right of the decimal point; when the instrument calibration is checked with the porcelain plaque, the digital readout of such instruments may always indicate 0.04, for example, whereas a densitometer may in fact drift over time between 0.036 and 0.043 — such a drift is not apparent to the operator. It has been this author's experience with several different densitometers that recalibrating a densitometer before reading each print can significantly improve the repeatability of the measurements.

Before each measurement session, or at least once each day the densitometer is used, the accuracy of the instrument should be checked with a Kodak Reflection Densitometer Check Plaque and the readings recorded;[16] this plaque will indicate changes in spectral response of the densitometer that result from fading of the filters or from other causes. The Kodak plaque should be permanently assigned to the densitometer and should be stored carefully between uses.

In addition, measured gray scales and color scales made of each type of color photographic material in the collection should be kept in cold storage at 0°F (–18°C) or lower

October 1987

Severson enters readings into a notebook.

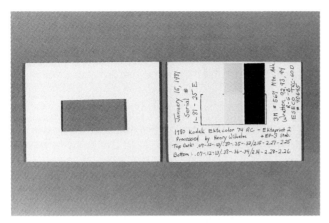

Fading monitor with an overmat. The three pieces of color print material are mounted on the upper center of the board; the mount board and overmat measure 2¹/₂ x 3¹/₂ inches.

1981

Fading monitor covered with a sheet of glass in a small metal frame.

and at a relative humidity of 30–40%; storage at very low temperatures will reduce changes in these photographic calibration standards to a negligible amount during the next 1,000 years or more, according to current estimates based on accelerated test data.[17]

A Macbeth ColorChecker[18] is recommended as a suitable original gray scale and color patch image for preparing the calibration standards for photographic materials; the standards should be printed about 3x5 inches (7.6x12.7 cm), including a border of at least ³/₈ inch (1 cm) to protect the image area. A minimum-density (white) area and all of the color patches, including those with low-saturation colors, should be read and the data recorded. Although the porcelain calibration plaques will generally be adequate for continued calibration of a specific densitometer, they will not necessarily produce accurate readings after an instrument has been repaired or if the filters have faded or been replaced; instrument response may also change if the photodiode or photomultiplier tube light sensor has been replaced. Each dye of each type of color photographic print has a distinct set of spectral absorption characteristics; for this reason, any change in the spectral response of a densitometer will produce different readings from a given photographic sample even if the instrument has been calibrated with the same porcelain plaque.

When the color photographic calibration standards are needed, the packages containing the standards should be removed from cold storage and allowed to reach room temperature before they are opened. After the densitometer has been calibrated with the porcelain plaque, readings should be taken with the color photographic calibration standards and numerical corrections determined for each gray-scale density and color patch of each material; these calibration corrections will ensure continued accuracy of the overall system during the lifetime of the color prints. The photographic calibration standards must be handled with great care, especially when readings are being made with a densitometer, to avoid surface abrasion and other physical damage that could affect the accuracy of readings. As an added degree of protection when densitometer readings are being made, the calibration standard

can be covered with a thin polyester overlay with a reading hole cut in it. Because the calibration standards will be read periodically over the next several hundred years — or perhaps even several thousand years — the need for careful handling cannot be overemphasized.

While other long-term calibration procedures may be devised in the future, this author believes that, at present, long-term system accuracy can be maintained with certainty only by preserving photographic calibration standards for each type of material in a collection. It is presumed that in the near future most institutions with significant color photographic collections will install humidity-controlled cold storage facilities for preserving their color collections; the calibration standards can be kept in these cold storage areas. (See Chapters 19 and 20 for information on refrigerated storage.) If humidity-controlled cold storage is not available, the photographic calibration standards should be carefully double-sealed in suitable vapor-proof envelopes[19] and placed in a regular 0°F (–18°C) household-type or commercial freezer.

## Deterioration of Densitometer Filters and Gradual Drift in Densitometer Response

In an unplanned demonstration of the need for an accurate long-term calibration procedure, this author's Macbeth TR924 densitometer suffered a significant drop in red-density reflection readings in *less than 5 years* after it was purchased in 1981. As an example, for a polyester-base Ilford Cibachrome print stored in the dark as a photographic reference standard (accelerated aging tests indicate that polyester-base Cibachrome prints have extremely good dark fading stability), the densitometer indicated a 0.03 loss in red density from an original neutral density of 1.0 and a 0.02 loss from an original neutral density of 0.60 by the end of the 4-year period. Measurement of a cyan patch with an initial red density of 1.43 indicated a loss of 0.06. In other words, the densitometer indicated that the print had *faded*, when in fact it had not.

That it was the densitometer and not the Cibachrome print that was changing was verified by similar drops in

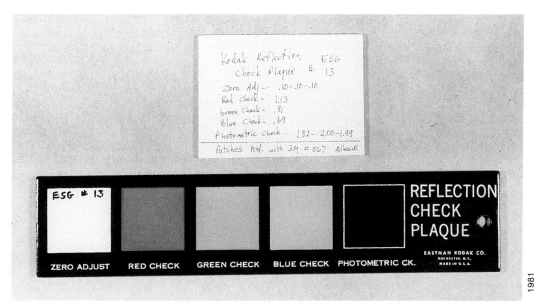

Kodak photographic Reflection Densitometer Check Plaque for detecting changes in the spectral response of a densitometer.

red-density readings from a Kodak porcelain Reflection Densitometer Check Plaque as well as from refrigerated Ektacolor, Fujicolor, Konica Color, and Agfacolor calibration prints. The response of the instrument had been checked frequently over the 5-year period, and no significant change had been detected in either the green- or blue-filter readings. Most of the change in the densitometer's red-filter response took place in the final 6 months of the 5-year period.

The reflection head of this densitometer is equipped with Status A red, green, and blue filters, in addition to a Wratten 102 (visual) filter. The transmission head, which is equipped with both Status A and Status M filters, also suffered significant changes in filter response. Macbeth supplies replacement visual, red, green, and blue filters in a filter wheel that is installed in the densitometer head; thus all the filters are replaced at the same time. Macbeth recommends that new Status A and M filters be installed about every 3 years; but, because of tests in progress, this author was reluctant to do so and kept on using the original filters until the red filter in the reflection head began to deteriorate so rapidly that there was no choice but to replace it.

At that point this author installed a new filter wheel and much to his distress found that the green filter gave readings higher by 0.05 on the green check patch of the Kodak Reflection Densitometer Check Plaque than did the previous Status A green filter (which still gave stable readings). The red and blue filters in the new wheel gave readings on the Kodak Check Plaque that were almost identical to those of the original filters. In order not to upset the green-density readings (the accuracy of which is crucial in the long-term light fading evaluation of magenta-limited papers like Ektacolor), it was decided to remove the red filter from the new wheel and install it in the original filter wheel, leaving the original visual, green, and blue filters in place. The densitometer head was then reassembled and aligned with the reading aperture (taking a densitometer head apart and replacing the filters is not a simple task, and the

reader is advised not to attempt this procedure). The unit checked out well with the Kodak Check Plaque; but it was discovered that for refrigerated *photographic* calibration prints, the new red filter was giving high readings (typically 0.04 higher with 1.0 densities).

When there is a change in response in a print monitoring densitometer, even if the change is only slight, it requires that new readings from ongoing work be corrected, which not only requires additional labor but also increases the potential for error. A most unwelcome complexity!

Status A and M densitometer filters appear to be made with dichroic coatings on one side (to block infrared radiation), and examination of this author's defective red filter showed clearly that this reflective coating had seriously deteriorated, reducing its light transmission and giving it a yellowish, "cloudy" appearance. It is not known how much longer the green and blue filters will last before they also will require replacement; that the red filter was the first to fail may be only a coincidence. It is indeed distressing for one attempting to measure long-term fading of color photographs to find that current densitometer filters are themselves so unstable that they last only 3 or 4 years! The unsatisfactory experience with the Status filters supplied by Macbeth does not necessarily mean that *all* Status filters are unstable; the Kodak "Certified" Densitometer Filter sets AA and MM (the original Status filters) may be more stable; however, Kodak discontinued these filters in 1986.

This author also has an older-model Electronic Systems Engineering Company (ESECO) Speedmaster densitometer equipped with Kodak Wratten 92 (red), 93 (green), 94 (blue), and 106 (visual) filters. Although the unit does not have a computer interface, it continues to be used for a number of tests that were started about 14 years ago. The filters are still giving stable responses once the unit has fully warmed up and is properly calibrated. These four Wratten filters were the "traditional" densitometer filters until the advent of the Status A and M filters, which were designed to have an improved spectral match to chromogenic transparen-

cies and prints (Status A) and chromogenic color negatives (Status M). It should be noted, however, that the spectral characteristics of Status A filters are not well matched to some other types of photographs, including Ilfochrome and Polaroid prints.

In print monitoring and long-term stability research, one is primarily interested in *changes* that take place in a photograph, and the specific spectral characteristics of a set of filters are not nearly so important as the need for filters that will remain absolutely unchanged over time. The Status A and M filters, which are supplied with most current photographic densitometers, are unquestionably the weakest link in their design.

It would be of great benefit if the photographic industry would produce *permanent*, standardized filters for densitometers; it is not unlikely that red, green, and blue technical glasses exist that would be suitable for this purpose.

This author strongly advises that Status A and M filters not be used in monitoring programs; instead, Kodak Wratten 92, 93, 94A, and 102 filters are recommended. These filters can be purchased from Kodak in large sheets (e.g., 125mm, 5-inch, squares), and it is suggested that two sheets of each filter be obtained.[20] These four polyester-base dyed gelatin Wratten filters appear to be essentially permanent in dark storage. In a high-temperature accelerated dark aging test conducted by this author, the filters were subjected to 144°F (62°C) and 45% RH for five years (1987 to 1991) with no significant changes occurring in either their transmission characteristics or in their physical properties. The filters are, however, subject to light fading and fading may occur over time in the course of using a densitometer.

On special order, Macbeth will install Wratten filters cut from sheets in TR924 densitometers.[21] (Not all densitometer manufacturers are willing to install customer-supplied filters in their instruments, and if the reader is contemplating the purchase of other than a Macbeth densitometer, the manufacturer should be consulted prior to making the purchase.) In the transmission head, the 92, 93, and 94A filters should be installed *only* in the Status A filter positions; the Status M filter positions should be blocked with an opaque material.

This author recommends that at the time the densitometer is purchased, five additional transmission and reflection filter wheels fitted with filters cut from the same sheets of filter material be obtained from Macbeth. These filter wheels should be carefully packaged in a completely opaque container to protect them from light, and stored in a cool, dry place. Unused filter material should be kept in the original Kodak packages and also stored in a cool, dry place (if possible, in humidity-controlled cold storage).

When it is determined that one or more filters require replacement, new reflection and transmission filter wheels and the densitometer should be shipped to Macbeth for installation (replacement of filter wheels in a Macbeth densitometer is a complex procedure and should not be attempted by the user). This procedure will eliminate spectral changes in the densitometer filters as a variable in a long-term monitoring program; a 5-inch square of filter sheet contains enough material for at least 24 filter replacements.

At the time of this writing, X-Rite said that the company was not in a position to install customer-supplied filters in its X-Rite 310 Color Transmission/Reflection Densitometer. This is unfortunate because this apparently otherwise excellent densitometer reads and displays density measurements through all four filters simultaneously, thus greatly speeding monitoring operations when the densitometer is connected to a computer or accessory printer. In 1989 Macbeth introduced the Macbeth TR1244, which also reads all four filter channels simultaneously, but because the reflection head of this instrument is attached to the top of the unit and cannot be removed, it is not suitable for monitoring prints.

The X-Rite 310 has the option (in the "10X Mode") of displaying readings with *three figures* to the right of the decimal point; this not only permits somewhat more precise readings, especially when reading low densities and minimum densities, but also allows the operator to more accurately assess drift of the instrument over time. (Because of short-term instrument drift, which unfortunately appears to be inherent with the X-Rite 310, the "10X Mode" does not actually afford a 10X increase in precision; however, with frequent recalibration, the "10X Mode" is somewhat of an improvement over the normal mode with two figures to the right of the decimal point.) At the time of this writing, this author had been using an X-Rite 310 for less than 6 years and could not yet assess the long-term stability of the instrument; however, the X-Rite 310 calibration procedure — which calls for both low-density and high-density calibrations of *each* densitometer filter — appears to give better long-term repeatability than densitometers such as the Macbeth TR924 that allow a high-density (slope) calibration for the visual filter only.

X-Rite has said that in the approximately 8 years the company has been supplying densitometers with Status A and Status M filters, "no deterioration" has been noted with the filters (with a different design than other densitometers, the filters in X-Rite densitometers are sealed to plastic light pipes and photodiodes with epoxy cement and are thus protected on both sides from the atmosphere). Nevertheless, this author recommends that for long-term print-monitoring applications, Status filters also be avoided with X-Rite densitometers. It is hoped that at some point in the future the company will be able to supply 92, 93, and 94A filters with its instruments.

This author has been engaged in discussions with several densitometer manufacturers in an effort to devise a set of permanent filters, and institutions engaged in print-monitoring programs should contact this author for current information.[22]

## Recommended Limits for Deterioration of Color Print Images

Examination of large numbers of deteriorated color prints — including samples that were faded in accelerated light fading and dark-storage tests as well as prints that slowly faded during long-term display and dark storage under normal conditions — has led this author to propose the set of limits for deterioration of color print images given in **Table 7.1**. These limits are for *critical* applications in museums and archives. A number of print materials displayed under a typical tungsten-illuminated museum display condition and

A filter wheel from a Macbeth TR924 densitometer. On special request, Macbeth will install the Kodak Wratten 92, 93, 94A, and 102 filters recommended by this author in place of the normally supplied Status A filters (which are too unstable for long-term print monitoring).

1990

evaluated with these fading and staining limits are included in **Table 3.4** in Chapter 3. For general commercial and home purposes, this author has proposed less stringent limits; these are discussed in Chapter 2 and have been used for most of the light fading comparisons in Chapter 3.

The four groups of criteria that comprise the fading and staining limits describe all of the significant visual changes that can take place in a color print in dark storage and/or during exposure to light and ultraviolet radiation. Such changes include stain formation, changes in overall density and contrast, loss of highlight detail, shifts in color balance, and various combinations of these.

For ease of understanding by persons not familiar with photographic densitometry, the limits for dye fading and color imbalances are specified in terms of changes in the cyan, magenta, and yellow image dyes even though, strictly speaking, the limits should be stated in terms of red, green, and blue density (changes in cyan dye density, for example, are measured with the *red* densitometer filter because the absorption peak of cyan is in the red portion of the spectrum). However, for stain formation at minimum density (where no image dyes are present), the limits are stated in terms of red, green, and blue density (see Chapter 2 for further discussion).

The specific limits given here (e.g., not more than 9% magenta dye [green density] loss is specified instead of, for example, a 10% magenta loss) were selected in part to correlate with actual density units at the target density of 0.45 — a critical density to indicate small changes caused by light fading. A 9% density drop from 0.45 is a loss of 0.04 (0.0405, actually), whereas a 10% loss would be 0.045. Most densitometers give readings to only two decimal places, resulting in uncertainty whether a specified 10% loss should be read as a 9% loss (0.04) or as an 11% loss (0.05). Were it not for this practical consideration, limits

such as 7%, 11%, and 13% would have been given as 8%, 12%, and 14% respectively.

Density losses measured at about 0.45 initial density are of interest primarily in terms of light fading and reflect a loss of image detail, especially noticeable in low-density highlight areas of a photograph. Initial densities of about 0.45 are best for these measurements; however, densities from 0.35 to 0.6 can be used if necessary. Within this range, the limits are given as losses of *density units* (i.e., 0.04 for cyan and magenta dye losses and 0.06 for yellow dye losses), and are *not* calculated from percentage losses (although for reference the percentage losses are given in **Table 7.2**). In a displayed print made on Ektacolor paper, for example, a 0.08 magenta dye loss measured at an initial neutral density of 0.45 will be approximately the same as the magenta losses at 0.35 and 0.6. That is, the losses at all three densities will be 0.08 (or close to that figure), while the *percentage* (and visual) losses at the three densities are quite different — being greatest at 0.35 and least at 0.6.

For evaluation of shifts in color balance, it is necessary to measure changes in near-neutral colors. When subjected to light fading on display, the "pure" cyan, magenta, and yellow colors of most types of color prints fade more rapidly than when all three colors are present in approximately equal amounts (forming near-neutral or gray colors). It is not uncommon for the separate "pure" colors to fade two or even three times faster than when combined to form a neutral gray. On the other hand, a pure magenta can lose considerable density and still be "magenta" — it will simply be a lighter magenta. The same degree of magenta lost from a neutral gray would cause a decided color shift toward green. With most types of pictorial scenes, this author has found it satisfactory to monitor near-neutrals of about 0.45 density. Within the limits suggested in **Table 7.1**, losses of pure yellow, magenta, and cyan col-

ors will not often be visually excessive; many scenes do not even contain significant areas of such colors.

If, however, a photograph contains important areas of relatively pure, saturated colors, and especially if the colors are of a low density to begin with (e.g., a light pink sky), it is certainly appropriate to monitor these areas as well and to apply the same limits as suggested for near-neutral colors. Density losses from saturated colors should be determined using the densitometer filter (or filters) showing the highest initial density; for example, the green filter indicates the highest density for magenta and pink colors. In portraits and other photographs where people are an important part of the scene, flesh tones must also be monitored.

If there is any doubt about the relative significance of density losses measured in different parts of an image, or if a decision has to be made about how much change is tolerable in a particular photograph, it is best to be conservative. If one must err, it is better to allow too little display time than too much. Remember, the intent here is to keep the print as close to its original condition as possible.

With most types of color prints, density losses measured at d-max (maximum density) give a more accurate assessment of dark fading than measurements made at lower densities, such as 0.45. At or near d-max, the limits are given as *percentage losses*, as computed from the actual measured initial densities. Some prints have no high-density dark areas, and in such cases the highest densities available in the print should be chosen for d-max measurements. When monitoring pictorial prints, it is generally not possible to accurately "stain-correct" the density readings based on changes measured in minimum densities (see Chapter 2 for an explanation of "stain-corrected" densitometry). In pictorial prints, true minimum-density areas frequently are not present; if white borders are included, they are generally covered with overmats that shield the borders from exposure to light on display and therefore could be used only for stain-correction of dark fading data.

Separate values are given for blue density *increases* and the resulting color-balance shifts toward yellow caused by the yellow stain that occurs in many materials, particularly in dark storage. Some people feel that a fairly significant degree of yellow stain is tolerable — especially in instant photographs — and they may wish to assign higher numbers to the limits of stain formation and minimum-density color imbalance. Such higher limits would not normally be acceptable, especially in a color imbalance between red and green densities, or even as a loss in blue density (the opposite of a yellow stain).

Yellow stain, however, does not significantly affect the sense of visual image contrast; in addition, so many common materials — such as low-grade book papers — yellow with age that many people have developed a tolerance for this particular type of deterioration. Indeed, for some people, a moderate degree of yellow stain — the "patina of age" — provides assurance that an article is old, and may even impart an added degree of value. Such views have no validity: the goal here is to preserve color photographs in their original condition. The yellow stain formation common to many types of prints is undesirable and should be prevented if at all possible.

Polaroid SX-70, Polaroid 600 High Speed, Polaroid Spectra (Image prints in Europe), and Polaroid 600 Plus prints are almost certain to have exceeded the suggested low-density stain formation limits given in **Table 7.1** even before they arrive in a museum collection. To obtain an approximation of the stain level reached by a particular print, it should be measured in the area of lowest density, and this reading compared with measurements taken from the identical material shortly after processing (initial readings should generally be made about 24 hours after the processing of an instant print).

To further complicate matters, the stain that occurs in these types of Polaroid prints in dark storage is less stable in light fading than the image dyes themselves. For example, when a Spectra print that has developed a low-level yellowish stain during a year or two of dark storage is put on display, the blue density can drop very rapidly.

The limits proposed here allow only for relatively small amounts of deterioration — appropriate to museum and archive collections — and require that the monitoring densitometry be done with a high degree of accuracy. It should be possible to make measurements in low- to medium-density areas with a repeatability of $\pm 0.01$, although in practice a deviation of $\pm 0.02$ may be more realistic. In high-density areas of an image, a repeatability of $\pm 0.03$ to 0.05 should be possible; at high densities, an error of $\pm 0.03$ is of much less consequence than it is at low densities. The *percentage* (and visual) difference of a $\pm 0.02$ error is far greater at a low density than it is at a high density (e.g., a density of 1.80).

One reason for specifying small amounts of permissible change is that densitometer reading errors and/or densitometer calibration errors may result in significantly greater change taking place in the print than indicated by the density readings. For example, with a minimum-density stain color imbalance limit of 0.04, a density measurement error of $\pm 0.02$ could result in an actual color imbalance of 0.06 (usually caused by yellow stain) — a rather noticeable change — before the limit is reached. Setting tight limits on permissible density changes will assure that even with significant densitometer calibration and reading errors, large changes in print condition will almost certainly be detected.

However, even with careful use of a densitometer and precise calibration procedures, the accuracy and repeatability of readings will probably not be as good as one would like, especially if the instrument must be replaced and the new densitometer is calibrated from photographic color print samples kept in cold storage. Accurately detecting small changes in print densities over long periods of time strains the capabilities of even the best equipment currently available; one must expect a certain amount of "noise" in the readings and be content with less than exact repeatability. This is not a perfect system.

Potential difficulties aside, however, careful monitoring of prints is certainly an improvement over past museum practice in which there was no way to know whether, much less how much, a print had faded or stained, even if rather large changes had occurred over the years. Monitoring prints allows one to know when a print has been subjected to excessive display and eliminates the uncertainty of how to properly handle prints made on paper of an unknown type or processed under unknown conditions (more often

## Table 7.1    Recommended Limits of Color Print Fading and Staining for Museums, Galleries, Archives, Artists, and Collectors

**Print density changes should not exceed the following:**

**Overall density losses from near-neutral colors:**

|  |  |  |
|---|---|---|
| Cyan dye (red density) loss from about 0.45: | 0.04 | (9%) |
| Magenta dye (green density) loss from about 0.45: | 0.04 | (9%) |
| Yellow dye (blue density) loss from about 0.45: | 0.06 | (13%) |

Density losses measured at about 0.45 initial density are of interest primarily in terms of light fading and reflect a loss of image detail that is especially noticeable in low-density highlight areas of a photograph. Initial densities of about 0.45 are best for these measurements; however, densities from 0.35 to 0.60 can be used if necessary. Within this range, the limits are given as losses in *density units* (i.e., 0.04 for cyan and magenta dye losses and 0.06 for yellow dye losses) and are *not* calculated as percentage losses.

|  |  |
|---|---|
| Cyan dye (red density) loss from d-max: | 9% |
| Magenta dye (green density) loss from d-max: | 9% |
| Yellow dye (blue density) loss from d-max: | 13% |

With most types of color prints, density losses measured at d-max (maximum density) give a more accurate assessment of dark fading than measurements made at lower densities, such as 0.45. At d-max and near d-max, the limits are given as *percentage losses,* as computed from changes in measured densities. Some prints have no high-density dark areas, and in such cases the highest densities available in the print should be chosen for d-max measurements.

**Cyan-magenta-yellow color imbalances in near-neutral image areas:**

|  |  |  |
|---|---|---|
| Cyan/Magenta (red/green density) imbalance at about 0.45: | 0.03 | (7%) |
| Cyan/Yellow (red/blue density) imbalance at about 0.45: | 0.05 | (11%) |
| Magenta/Yellow (green/blue density) imbalance at about 0.45: | 0.05 | (11%) |

Color imbalances measured at about 0.45 initial density are of interest primarily in light fading. Initial densities of about 0.45 are best for these measurements; however, densities from 0.35 to 0.60 can be used if necessary. Within this relatively low range, it is more practical to determine color imbalances as imbalances in *density units* (i.e., 0.03 between cyan and magenta, and 0.05 between yellow and either cyan or magenta) than it is to calculate them as percentage imbalances. Stain formation frequently contributes to medium- and low-density color imbalances.

|  |  |
|---|---|
| Cyan/Magenta (red/green density) imbalance at d-max: | 7% |
| Cyan/Yellow (red/blue density) imbalance at d-max: | 11% |
| Magenta/Yellow (green/blue density) imbalance at d-max: | 11% |

With most types of color prints, density imbalances measured at d-max (maximum density) are of interest primarily in terms of dark fading. At d-max and near d-max, the limits are given as *percentage imbalances,* as computed from the actual measured densities. Some prints have no high-density dark image areas, and in such cases the highest densities available in the print should be used for d-max measurements. Stain formation generally has little visible effect on d-max color imbalances.

**Minimum-density stain formation:**

|  |  |
|---|---|
| Red Density increase at d-min: | 0.04 |
| Green Density increase at d-min: | 0.04 |
| Blue Density increase at d-min: | 0.08 |

D-min (minimum-density) changes may occur in dark storage and/or as a result of exposure to light on display; an increase in blue density (as a result of yellowish stain) is the most commonly observed change. In some cases, as a result of exposure to light, the minimum density (most commonly red density) will decrease somewhat, instead of increasing. Such losses may be ignored in terms of the stain-formation limits; however, d-min losses will probably contribute to the generally more significant minimum-density color imbalances, the limits for which are given below.

**Minimum-density color imbalances:**

|  |  |
|---|---|
| Red/Green density imbalance at d-min: | 0.03 |
| Red/Blue density imbalance at d-min: | 0.04 |
| Green/Blue density imbalance at d-min: | 0.04 |

D-min (minimum-density) color imbalances may occur in dark storage and/or as a result of exposure to light on display. Minimum-density color *imbalance* limits will almost always be reached before minimum-density increase limits are reached.

Note:  Many pictorial scenes do not have near-neutral colors throughout the density range; readings should be taken from important colors, such as flesh tones, sky areas, etc. Readings may be taken throughout the range of tones in a print, from the lightest to the darkest; however, the emphasis should be on image areas with densities close to d-min, 0.45, and d-max. With Polaroid instant prints, which have higher minimum densities than conventional prints, measurements at about 0.60 may prove to be more useful than measurements at 0.45. A typical print should be monitored in five to ten different locations. Small color (density) imbalances may be visually apparent on prints only in large areas of near-neutral colors.

## Table 7.2 Percentage Losses of Magenta Dye (Green Density) in Kodak Ektacolor Professional Paper in an Accelerated Light Fading Test

21.5 klux (2,000 fc) Glass-Filtered Cool White Fluorescent Illumination
75°F (24°C) and 60% RH at Sample Plane
From Neutral-Gray Patches (Base + Fog Density = 0.10)

| Start | Loss After 60 Days | % Loss | % Loss Minus Base + Fog | Start | Loss After 120 Days | % Loss | % Loss Minus Base + Fog |
|---|---|---|---|---|---|---|---|
| 0.25 | −0.09 | −36% | −60% | 0.25 | −0.10 | −40% | −67% |
| 0.35 | −0.13 | −37% | −52% | 0.35 | −0.18 | −51% | −72% |
| 0.45 | −0.16 | −36% | −46% | 0.45 | −0.24 | −53% | −69% |
| 0.60 | −0.16 | −27% | −32% | 0.60 | −0.31 | −52% | −62% |
| 1.00 | −0.16 | −16% | −18% | 1.00 | −0.36 | −36% | −40% |
| 1.50 | −0.16 | −11% | −11% | 1.50 | −0.35 | −23% | −25% |

than not, this is the case even with prints in museum collections). Being told that a certain print is a "Type C" print means very little in terms of its stability in dark storage or on display!

A color print may be considered to have reached the limit of acceptable deterioration when the *first* of the numerically expressed criteria has been attained. With any given color print material, the particular changes involved depend on the specific conditions of display or dark storage. For example, in Polaroid Spectra, Spectra HD, Polaroid 600 Plus, and Polaroid SX-70 prints stored in the dark, the "minimum-density color imbalance" limit will always be reached first. In Kodak Ektacolor Professional, Ektacolor Plus, Ektacolor Supra, and Ektacolor Portra and Portra II prints on long-term display, the "overall density loss" limit for magenta dye (green density) will likely occur first. When these types of modern Ektacolor prints are stored in the dark at normal room temperature, the prints slowly develop yellowish stain and the "minimum-density color imbalance" limit probably will be reached first.

In Ilford Ilfochrome prints (called Cibachrome prints, 1963–1991) on display under low-level tungsten illumination, the "cyan/yellow color imbalance" limit will probably come first, because of the comparatively inferior light fading stability of the cyan dye in relation to the yellow dye when the prints are displayed under these conditions. (Displayed under low-level fluorescent illumination, the Ilfochrome yellow dye is *less* stable than the cyan dye — the very opposite of what occurs under tungsten illumination!)

Compared with the "10% density loss of one or more dyes at an initial density of 1.0," a criterion which has

sometimes been used in the technical literature of Kodak and a few other manufacturers,[23] the more complex analysis of color image deterioration proposed here correlates much better with visually observed changes. The "10% density loss" criterion also ignores stain formation, which is the principal factor in color image deterioration in materials like Polaroid Spectra and SX-70 prints stored in the dark.

The "30% density loss," upon which Konica, Agfa, and Kodak have based their claims for the 100-year life of their respective color prints kept in dark storage, is *far* too much change to be acceptable for museum and archive collections. In light fading, a 30% dye loss measured at an initial density of 1.0 will result in total destruction of important highlight detail, as well as a severe loss of magenta in low- and medium-density portions of the image. (Other than reporting basic accelerated light fading test data, Konica has made no specific claims for its color papers in terms of how long the prints may be expected to last on display.)

Most photographic manufacturers would prefer a rather broad interpretation of what constitutes "objectionable fading." American manufacturers in particular tend to believe that the general public is particularly tolerant of yellow stain formation and loss of highlight detail common to light fading. By allowing a large amount of change to occur before it is said that a print has reached the end of its useful life, the manufacturers' projections of the average life of a given print material can be greatly extended, and the public's perception of the stability — and quality — of the print material can be influenced accordingly.

This author suggests, of course, that the *limits* of color

## Table 7.3  Response Variations of Four Color Densitometers

Near-neutral patches of various color print materials were read with a Macbeth TR924 densitometer equipped with Status A filters; for ease of interpretation, readings with the other densitometers are given as ± deviations when compared to measurements made with the Macbeth TR924 (this is not to imply that the Macbeth is more accurate than, for example, the X-Rite 310 densitometer). One of the Electronic Systems Engineering Company Speedmaster TRC-60D densitometers was equipped with Kodak Certified AA filters (Status A response), which were discontinued by Kodak in 1986; the other Electronic Systems Engineering Company Speedmaster TRC-60D densitometer was equipped with Kodak Wratten 92, 93, and 94 filters. The ESECO densitometers are of an older design that is no longer manufactured. Each densitometer was calibrated using the porcelain plaque supplied by the manufacturer.

| Type of Print | Macbeth TR924 Status A Filters Red-Green-Blue | X-Rite 310 Status A Filters Red-Green-Blue | ESECO TRC-60D Kodak AA Filters Red-Green-Blue | ESECO TRC-60D Wratten Filters Red-Green-Blue |
|---|---|---|---|---|
| Ektacolor Professional | 0.99  1.02  1.07 | +.03  +.00  −.01 | −.01  +.05  +.04 | +.05  +.07  +.03 |
| Fujichrome Type 34 | 1.35  1.28  1.21 | +.04  +.00  −.02 | +.10  +.06  +.02 | +.01  +.11  +.03 |
| Cibachrome II Glossy | 1.52  1.33  1.16 | −.05  −.01  −.04 | −.39  +.08  +.04 | −.37  +.09  −.01 |
| Kodak Dye Transfer | 1.20  1.27  1.04 | +.03  −.01  +.01 | −.15  +.02  +.00 | −.03  +.08  −.02 |
| ArchivalColor Pigment Print | 0.74  1.02  1.00 | +.00  +.01  −.02 | −.06  +.02  +.02 | −.07  +.08  +.06 |
| Polaroid Spectra | 1.29  1.34  1.56 | +.05  −.01  −.03 | −.07  +.08  −.07 | +.13  +.22  +.09 |
| Polacolor ER | 1.50  1.29  1.23 | +.06  +.02  −.01 | −.17  +.09  −.01 | +.10  +.22  −.02 |

image deterioration given here should not be reached during any single exhibition period and that color prints should not normally be placed on continuous display long enough to reach the limits. Most types of pre-1985 chromogenic color prints, such as Kodak Ektacolor 74 RC prints, will pass these limits of deterioration in less than 10 years, even when kept in the dark at room temperature, because of their poor dark storage stability; this can be prevented only by placing the prints in low-temperature, humidity-controlled storage. Each curator will have to decide how much of the useful life of a print he or she will allow to be consumed during a particular exhibit, or during the curator's tenure, and how much will be left for future curators.

For example, given this set of deterioration criteria, and knowing the stability characteristics of Kodak Ektacolor 74 RC Paper, one could conclude that under moderate tungsten illumination of 300 lux (28 fc) and nominal conditions of 75°F (24°C) and 50% RH, a print made with this now-obsolete paper will have a display-life expectancy of about 6 years; this would allow twelve 6-month exhibitions if the print is kept in cold storage between display periods. If the print is *not* kept in cold storage, but instead is kept at room temperature, the acceptable life would probably be less than 8 years even if it were never exhibited. If the print is put in cold storage between exhibitions, and is displayed for a single 3-month period each 5 years, the final showing of the print could take place about 120 years after the first exhibition. Other print materials (such as those made with many of the early color processes) are much less stable than Kodak Ektacolor 74 RC prints and could tolerate only a small fraction of this total display time.

### Museum Exhibitions of Color Photographs That Have Been Monitored

Grant Romer, conservator of photographs at George Eastman House in Rochester, New York, working in conjunction with this author and Ronald Emerson, at the time a curator at George Eastman House, and John Upton, guest curator at the museum, employed the basic color print monitoring procedures described here for *Color as Form: A History of Color Photography*, an exhibition at the Corcoran Gallery of Art in Washington, D.C. from April 10 to June 6, 1982 and at the International Museum of Photography at George Eastman House from July 2 to September 5, 1982. This was the first exhibition of color photographs to be monitored densitometrically during the display period. (Some of the photographs chosen for the exhibition, including a number of Lumiere Autochrome glass-plate transparencies, were not shown in their original form because of physical problems and/or the potential instability of their color images; instead, color copy prints or transparencies were shown.)

Sergio Burgi, who was in charge of densitometry and data analysis for the exhibition, has reported that whereas none of the photographs reached the set of limits adopted for the project, a number of prints came close to the limits. Among the images that showed significant changes were Kodak Kotavachrome and Minicolor prints from the period 1941–1945 (these prints were made on pigmented cellulose acetate film base using a variation of the external-coupler Kodachrome process — see Chapter 1). During the 4-month period of the display, the photographs had been

exposed to only 110–160 lux (10–15 fc) of tungsten illumination for approximately 10 hours a day. Burgi commented on the results of his examination of the densitometry data:

> In a Kotavachrome print there were some areas with quite a significant loss — which was not necessarily consistent throughout the print. I found some staining and some dye loss going on simultaneously in the print; one area stained a lot.
>
> Some of the prints have already lost 0.02 density and this would increase on further exhibition. It certainly points out that we should think twice about having some of the prints in another exhibition.
>
> However, the recent Ektacolor prints didn't present any significant change and they could certainly tolerate more exhibition time. I plan to go through the data so as to be able to separate the more stable prints from the less stable.
>
> I think monitoring is a very useful method for control of exhibition time — and to reassure us that we are not harming prints by putting them on display.[24]

Burgi said that in general he believes the monitoring procedure gave reliable data, adding, "It can be very accurate if you work carefully." The museum has prints made on a number of materials — including Kodak Dye Transfer, Ektacolor 74 RC, and Ilford Ilfochrome (Cibachrome) — and placed them in freezer storage as aids in future calibration of their monitoring system.

## An Important Illustration of Print Monitoring by the Art Institute of Chicago

In what turned out to be a dramatic illustration of the value of print monitoring, Douglas G. Severson, assistant conservator for photography at the Art Institute of Chicago, monitored 38 prints from the 180 photographs in the 1984 exhibition *The Art of Photography: Past and Present, From the Collection of the Art Institute of Chicago*. The exhibition was put together by David Travis, curator of photography at the Art Institute, and was shown at the National Museum of Art in Osaka, Japan from October 6 to December 4, 1984.

According to Severson, "The selection represented a broad cross-section of photographic history and technique, with prints dating from 1842 to 1982." Among the 38 prints monitored, 13 photographic processes and works by 24 different photographers were represented. The exhibition included Kodak Dye Transfer prints by Eliot Porter, Ektacolor 74 RC prints by Joel Meyerowitz and John Pfahl, and Polacolor 2 prints by Paolo Gioli.

For the Osaka exhibition, the Art Institute placed the following restrictions on display conditions:

1. Temperature: Not in excess of 75°F (24°C).

2. Relative Humidity: 40% RH. A range of 35–55% RH is permitted if rapid changes in humidity are avoided.

3. Light Level: Not to exceed 325 lux (30 footcandles).

4. No sunlight or daylight permitted in exhibition area.

5. No TV or film crew lights permitted.

A calotype negative made by Fox Talbot in the exhibit was covered with brown cloth to protect it from exposure to light except when the cloth was lifted by a person viewing the print.

The prints were away from the Art Institute for a total of 12 weeks, with the actual exhibition lasting 9 weeks. During the exhibition period, the gallery temperature ranged from 56 to 77°F (13–25°C) and the relative humidity was recorded over a range of 39–66%. The photographs were matted with 100% cotton fiber mount board and framed with Acrylite OP-2 ultraviolet-filter acrylic plastic sheet. The exhibit was illuminated with tungsten lamps (presumed not to exceed 325 lux [30 fc]), and no daylight or fluorescent light was present.

Before air shipment of the exhibit to Japan, density measurements were made on the 38 selected prints, and the prints were measured again upon their return to Chicago; the measured density changes are given in **Table 7.4**. Severson made the following observations about the changes that took place in the prints during the time they were away from the Art Institute:

> Overall, of the 38 prints monitored, 17 did not change, 15 changed 10% or less, and 6 changed more than 10%. Of the 13 different processes monitored, only 5 were immune to change and 4 of those are rather unusual or hybrid materials (silver-gelatin being the only common process to remain unchanged).
>
> With regard to albumen prints, the most common type of 19th-century photographic material, several points can be noted. Support can be found here for the notion that the rate of image deterioration in these materials is closely related to their condition. Without exception, the prints in better condition [at the time the exhibit was shipped from the Art Institute] showed more density change than those in poor condition. For instance, the most stained and faded albumen print in the exhibit (#7 by Baldus) was unchanged, while that with the richest tonalities (#14 by Jackson) changed considerably. Also, the pattern of results in prints #10–13 would indicate that staining may appear first in the shadows, where it is the least detectable by the human eye.
>
> Perhaps the most surprising result to be found here is the change that occurred in photograph #21 by Stieglitz. Platinum and palladium prints have a reputation for extreme stability, but this image yellowed considerably in the midtones and shadows. One might assume the change is a yellowing of the paper base due to the acidic nature of the process, but the absence of highlight yellowing tends to contradict that notion. There may be other deterioration mechanisms operating here.

**Table 7.4    Density Changes Measured in Photographs from "The Art of Photography: Past and Present, From the Collection of the Art Institute of Chicago" Following Their Return After a 9-Week Exhibition in 1984 at the National Museum of Art in Osaka, Japan**

Prints monitored by Douglas G. Severson, Assistant Conservator
for Photography, the Art Institute of Chicago

| | Photographer | Date | Process | Original Condition | % Density Change in Shadows | % Density Change in Midtones | Initial d-min Density | d-min Density after Exhibition and Trip to and from Japan | d-min Density Change |
|---|---|---|---|---|---|---|---|---|---|
| 1) | Fox Talbot | 1842 | calotype negative | fair | 0 | 0 | 0.42 | 0.44 | NS |
| 2) | Salzman | 1854 | salted paper print | good | 0 | +6% | 0.24 | 0.25 | NS |
| 3) | Cameron | 1857 | albumen print | fair | 0 | 0 | 0.41 | 0.43 | NS |
| 4) | Cameron | 1874 | albumen print | good | +5% | 0 | 0.31 | 0.31 | NS |
| 5) | Cameron | 1867 | albumen print | good | +7% | +15% | 0.37 | 0.48 | +0.11 |
| 6) | Frith | 1857 | albumen print | good | +7% | +10% | 0.41 | 0.46 | +0.05 |
| 7) | Baldus | 1855 | albumen print | fair | 0 | 0 | 0.27 | 0.28 | NS |
| 8) | LeGray | 1856 | albumen print | fair | 0 | 0 | 0.42 | 0.43 | NS |
| 9) | MacPherson | 1867 | albumen print | fair | 0 | 0 | 0.31 | 0.31 | NS |
| 10) | Bourne | 1865 | albumen print | good | +5% | 0 | 0.36 | 0.36 | NS |
| 11) | Bisson Freres | 1863 | albumen print | good | +5% | 0 | 0.44 | 0.45 | NS |
| 12) | Atget | ND | albumen print | good | +5% | 0 | 0.28 | 0.30 | NS |
| 13) | Watkins | c.1865 | albumen print | excellent | +5% | 0 | 0.25 | 0.26 | NS |
| 14) | Jackson | 1892 | albumen print | excellent | +5% | +15% | 0.21 | 0.29 | +0.08 |
| 15) | O'Sullivan | 1863 | albumen print | good | 0 | –10%* | 0.26 | 0.26 | NS |
| 16) | Fenton | 1856 | dilute albumen | fair | 0 | 0 | 0.33 | 0.34 | NS |
| 17) | Tripe | 1858 | dilute albumen | fair | 0 | 0 | 0.31 | 0.33 | NS |
| 18) | Atget | c.1910 | matte-albumen | good | 0 | –14%* | 0.24 | 0.24 | NS |
| 19) | Atget | c.1910 | gelatin p.o.p. | good | –5% | –10%* | 0.48 | 0.43 | –0.05 |
| 20) | Steichen | 1904 | multiple gum print | good | 0 | 0 | 0.50 | 0.50 | NS |
| 21) | Stieglitz | 1919 | palladium print | good | +15% | +30% | 0.40 | 0.44 | NS |
| 22) | Stieglitz | 1931 | silver gelatin | good | 0 | 0 | 0.18 | 0.18 | NS |
| 23) | Strand | 1928 | silver gelatin | good | 0 | 0 | 0.28 | 0.28 | NS |
| 24) | Hine | 1909 | silver gelatin | fair | 0 | 0 | 0.26 | 0.26 | NS |
| 25) | Hine | 1920 | silver gelatin | fair | 0 | 0 | 0.22 | 0.21 | NS |
| 26) | Meyerowitz | 1978 | Ektacolor 74 RC | excellent | 0 | 0 | 0.14 | 0.14 | NS |
| 27) | Meyerowitz | 1978 | Ektacolor 74 RC | excellent | 0 | +10% | 0.29 | 0.28 | NS |
| 28) | Meyerowitz | 1978 | Ektacolor 74 RC | excellent | –3% | +5% | 0.17 | 0.18 | NS |
| 29) | Pfahl | 1981 | Ektacolor 74 RC | excellent | –5% | 0 | 0.25 | 0.27 | NS |
| 30) | Pfahl | 1980 | Ektacolor 74 RC | excellent | 0 | +5% | 0.18 | 0.18 | NS |
| 31) | Porter | 1951 | Dye Transfer | good | 0 | 0 | 0.32 | 0.33 | NS |
| 32) | Porter | 1963 | Dye Transfer | good | 0 | 0 | 0.45 | 0.42 | NS |
| 33) | Porter | 1967 | Dye Transfer | excellent | –3% | 0 | 0.32 | 0.33 | NS |
| 34) | Porter | 1969 | Dye Transfer | excellent | –6% | 0 | 0.20 | 0.20 | NS |
| 35) | Porter | 1974 | Dye Transfer | excellent | 0 | –20% | 0.62 | 0.62 | NS |
| 36) | Gioli | 1982 | Polacolor 2 | excellent | 0 | 0 | 0.11 | 0.10 | NS |
| 37) | Gioli | 1982 | Polacolor 2 | excellent | +3%,–8% | 0 | 0.11 | 0.10 | NS |
| 38) | Josephson | 1969 | color litho, etc. | good | 0 | 0 | 0.15 | 0.17 | NS |

\* measured at edge of image              **NS = Not Significant**

**Important to Note:**

1) Changes are reported as percentage of initial density in whichever densitometer color channel changed most (generally blue density).

2) Reliability of the readings was estimated quite conservatively, with a margin of error of ± 0.02. Thus, only changes greater than 0.04 were considered significant.

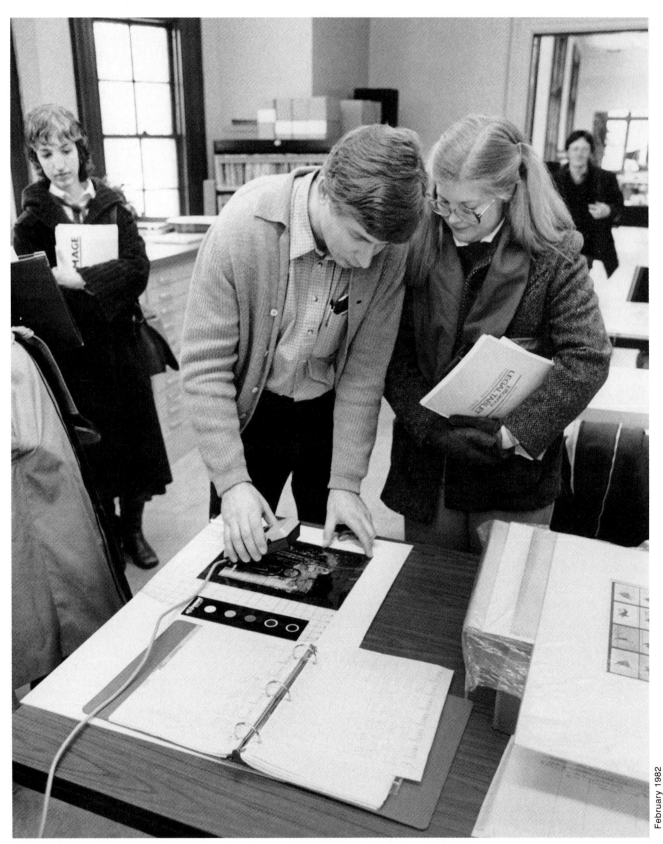

February 1982

David Kolody, a photographic conservator, demonstrates his system of print monitoring at a meeting of the Photographic Materials Group of the American Institute for Conservation in Rochester, New York (see Note No. 4). Kolody has employed the system primarily to measure changes that result from conservation treatments.

The color photographs, on the other hand, may have changed less than one would anticipate, given their reputation for instability. One might also note the inverse relationship of age to deterioration with the five Eliot Porter Dye Transfer prints — the newest print changed most, while the oldest was stable.

. . . One principal conclusion seems inescapable — namely, that some photographs do indeed change when [shipped and/or] exhibited, sometimes in ways that are difficult to understand or predict, and sometimes more than one would anticipate.

. . . This method of print-monitoring can be a very time-consuming and exacting activity. But for those in a position to make decisions or give advice about exhibiting photographs, the information it provides can be extremely useful and important.[25]

Severson noted that according to this author's "Recommended Limits of Print Image Deterioration,"[26] which constitutes a somewhat simplified version of the limits given in **Table 7.1**, "21 of the 38 prints monitored would have exceeded those limits in this one exhibition period."

The total light exposure experienced by the prints during the 9-week exhibition was relatively small, and this author would be surprised if light exposure alone could account for the large changes observed in some of the prints. If low-level air pollutants were present where the prints were exhibited (information about air quality could not be obtained), they could have contributed to the changes that were measured. Because the prints were matted and framed before leaving Chicago, and were exhibited for only a relatively short 9-week period, low-level air pollution was probably not a significant factor, however.

The fading and staining of the prints in this exhibit were more likely caused by the uncontrolled environmental conditions to which the prints were subjected during shipment to and from Japan. Severson reports that "the photographs may have been exposed to excessive or rapidly fluctuating temperatures and humidities in transit. For instance, the baggage compartment of a jet plane can be as cold as –40°F [–40°C], while that of a truck on a hot day can reach as high as 120°F [50°C]. Uncontrolled humidity can be even more damaging, and it is known that the crates in this exhibit experienced at least one major rainfall in the course of their journey. Conditions in transit are always one of the most difficult aspects of any traveling exhibition to control and measure, but they may be a more likely cause of damage than any other even in the full course of the exhibit." The shipping crates themselves may also be implicated in the damage that occurred to the prints; plywood and other common packaging materials are known to evolve formaldehyde vapors and other potentially harmful substances (see Chapter 15).

It should be noted that the large changes noted by Severson in the 1919 Stieglitz palladium print (#21) likely are not representative of what is to be expected with *all* palladium prints under similar exhibition and transit conditions. The fact that the changes did occur with this particular print, however, underscores the importance of monitoring valuable photographs. Particularly with older photographs, merely being able to identify the process does not make it possible to predict how a print will be affected by display and storage. The specific material with which a print is made, its processing, its history of storage (temperature, relative humidity, and exposure to contaminants from storage materials or the atmosphere over the years), prior exposure to light (duration, intensity, and spectral distribution), and so forth, can singly or in combination influence future changes that take place in a given photograph. With further experience in monitoring various types of photographs, it will become apparent which types of prints are particularly vulnerable to damage as a consequence of exhibition or shipment under uncontrolled conditions; but with historical photographs it probably never will be possible to predict with certainty the behavior of a specific print.

When significant changes in a photograph have been noted — for example, in the 1867 Cameron albumen print (#5) and the 1892 Jackson albumen print (#14), both of which suffered substantial image and highlight staining as a result of the trip to Japan — great care must be taken to ensure that no further deterioration takes place. Future display should be restricted (or eliminated, if monitoring indicates that further changes are taking place), and travel outside of the museum should not be permitted. The Art Institute is fortunate in having a temperature- and humidity-controlled storage facility for its collection, and the prints will have the best chance of survival if they remain there — in the dark.

This author considers Severson's study to be an extremely important contribution to our presently limited knowledge about what changes can take place in historical photographs when they are exhibited and/or shipped considerable distances under uncontrolled conditions. Severson's experience with the Osaka exhibition leaves no doubt that the practice of routinely shipping valuable photographs around the country — or around the world — in traveling exhibitions must be carefully re-examined.

Under the direction of conservator John McElhone, the National Gallery of Canada also maintains an extensive monitoring program.[27]

## Notes and References

Note: This chapter is based on an article by this author published in the Fall 1981 issue of the **Journal of the American Institute for Conservation,** Vol. 21, No. 1, pp. 49–64, entitled "Monitoring the Fading and Staining of Color Photographic Prints." This author discussed the design and use of fading monitors and presented a preliminary version of the "Recommended Limits of Color Print Image Deterioration," given in this chapter, as part of a paper entitled "Light Fading Characteristics of Reflection Color Print Materials" at the **31st Annual Conference of the Society of Photographic Scientists and Engineers**, Washington, D.C., May 1, 1978. Additional information on print monitoring was included in a paper entitled "Special Topics: Pigment Color Prints, Fading Monitors for Color Prints, Special Display Techniques, and Cold Storage Facilities," given at the International Symposium on the Conservation of Contemporary Art, sponsored by the National Gallery of Canada, Ottawa, Ontario, July 9, 1980; and in a presentation entitled "Monitoring the Fading and Staining of Color Photographic Prints" at the Summer Meeting of the Photographic Materials Group of the American Institute for Conservation, held as part of the Annual Conference of the American Institute for Conservation, Philadelphia, Pennsylvania, May 31, 1981.

1. Grant B. Romer, "Can We Afford to Exhibit Our Valued Photographs?", **Topics in Photographic Preservation — 1986** (compiled by Maria

S. Holden), Vol. 1, pp. 23–24, 1986. American Institute for Conservation Photographic Materials Group, American Institute for Conservation, Suite 340, 1400 16th Street, N.W., Washington, D.C. 20036; telephone: 202-232-6636; Fax: 202-232-6630. The article was reprinted in **Picturescope,** Vol. 32, No. 4, Winter 1987, pp. 136–137. For a related discussion, see: Paul Lewis, "Preservation Takes Rare Manuscripts From the Public," **The New York Times,** January 25, 1987, p. H1.

2. A review of museum lighting recommendations has been given by Garry Thomson in **The Museum Environment,** second edition, Butterworth & Co., Ltd. (in association with the International Institute for Conservation of Historic and Artistic Works), London, England, 1986, pp. 22–35. A maximum illuminance of 50 lux (4.7 fc) is recommended for "objects especially sensitive to light, such as textiles, costumes, watercolours, tapestries, prints and drawings, manuscripts, miniatures, paintings in distemper media, wallpapers, gouache, dyed leather. Most natural history exhibits, including botanical specimens, fur and feathers." A maximum illuminance of 200 lux (18.6 fc) is recommended for "oil and tempera paintings, undyed leather, horn, bone, and ivory, oriental lacquer." (p. 23).

See also: Stefan Michalski, "Towards Specific Lighting Guidelines," **Preprints of the 9th Triennial Meeting of the ICOM Committee for Conservation,** Dresden, German Democratic Republic, August 26–31, 1990, pp. 583–588. (Published by the International Council of Museums Committee for Conservation, Los Angeles, California.)

See also: James M. Reilly, **Care and Identification of 19th-Century Photographic Prints,** Kodak Publication No. G-2S, Eastman Kodak Company, Rochester, New York, 1986. Reilly concurred with the 50 lux (4.7 fc) recommendation, saying it applies to "all photographic print materials that have exposed paper fibers (salted paper prints, platinotypes, cyanotypes, gum bichromate prints, and carbon prints), to all photomechanical print materials, and to albumen prints. It also applies to all prints that have applied color in any form. Prints with baryta coatings (most gelatin developing-out papers, gelatin printing-out papers, and collodion printing-out papers) may tolerate up to 100 lux (10 foot-candles)." p. 105.

3. Eastman Kodak Company, **Kodak Color Films and Papers for Professionals,** Kodak Publication No. E-77, Eastman Kodak Company, Rochester, New York, March 1986, p. 49.

4. A project to monitor albumen prints was begun in 1979 at the International Museum of Photography at George Eastman House in Rochester, New York by James Reilly, Douglas Severson, and Grant Romer. Both 19th-century and freshly made albumen prints (the latter in the form of gray scales) were included in the project in an effort to better understand the stability characteristics of this type of print. The project was continuing at the time this writing.

David Kolody, a conservator in Stow, Massachusetts, adapted the method of direct monitoring of prints described in this chapter to the routine monitoring of black-and-white photographs, lithographs, watercolors, and etchings. Kolody prepared a polyester overlay sheet marked with a grid consisting of numbered lines drawn ¾ inch (2 cm) apart and with holes cut at each intersection of lines. Density readings can be quickly taken at points of line intersection which correspond to high-density, medium-density, and low-density parts of the image; the line coordinates and density data are recorded in a notebook. Only one overlay sheet is needed in this procedure; the same sheet is used for all of the prints being monitored. Although the pre-drawn grid overlay sheet does not offer the flexibility of being able to locate the densitometer head precisely at any desired point on a print, Kolody believed that the method was adequate for routine monitoring of work before and after conservation treatments. Kolody developed the system in early 1982. He gave a brief demonstration of his monitoring techniques at the Winter Meeting of the Photographic Materials Group of the American Institute for Conservation in Rochester, New York, February 3, 1982, and a more detailed demonstration at the Winter Meeting of the Photographic Materials Group, at the Art Institute of Chicago, January 31, 1983.

Also at the 1983 Photographic Materials Group Winter Meeting, Siegfried Rempel, who at the time was conservator of photographs at the Humanities Research Center (HRC), University of Texas, Austin, Texas, described an ongoing project to monitor calotypes from the HRC collection that were included in the exhibition **Paper and Light — The Calotype in France and Great Britain 1839–1870.** The exhibition was on display at the Art Institute of Chicago from December 15, 1982 to February 13, 1983, after which it traveled to several other institutions.

In 1984 Douglas G. Severson monitored a selection of black-and-white and color prints from the exhibition **The Art of Photography: Past and Present, From the Collection of the Art Institution of Chicago,** which was exhibited at the National Museum of Art in Osaka, Japan from October 6 to December 4, 1984. This monitoring

project is discussed in the text (also see Note No. 25).

5. In 1966, Garry Thomson, scientific adviser to the National Gallery in London, started an investigation of methods to record changes in paintings and arranged for a specially designed spectrophotometer to be built for this purpose; certain paintings are now being measured once every 5 years. See: Linda Bullock, "Reflectance Spectrophotometry for Measurement of Colour Change," **National Gallery Technical Bulletin,** Vol. 2, 1978, pp. 49–56. See also: R. M. Johnson and R. L. Feller, "The Use of Differential Spectral Curve Analysis in the Study of Museum Objects," **Dyestuffs,** Vol. 44, No. 9, 1963, pp. 1–10; and R. L. Feller, "Problems in Spectrophotometry," **1967 London Conference on Museum Climatology,** second edition, Garry Thomson, editor, IIC, London, 1968, pp. 196–197.

6. Alan R. Calmes, "Monitoring the U.S. Charters of Freedom by Electronic Imaging," a chapter in: **Proceedings of the International Symposium: Conservation in Archives,** published by the National Archives of Canada, 1989, pp. 243–251. The Symposium, which took place May 10–12, 1988 in Ottawa, was jointly sponsored by the National Archives of Canada and the International Council on Archives. Copies of the Proceedings are available from the International Council on Archives, 60, rue des Francs-Bourgeois, 75003 Paris, France. See also: Jet Propulsion Laboratory, **Conceptual Design of a Monitoring System for the Charters of Freedom,** JPL Publication 83-102, Jet Propulsion Laboratory through an agreement with the National Aeronautics and Space Administration, California Institute of Technology, Pasadena, California, 1984. See also: Alfred Meyer, "Daily Rise and Fall of the Nation's Revered Documents," **Smithsonian,** Vol. 17, No. 7, October 1986, pp. 135–143.

7. Manufacturers of high-quality photographic densitometers include: Macbeth Division, Kollmorgen Instruments Corporation, P.O. Box 230, 405–417 Little Britain Road, Newburgh, New York 12550, telephone: 914-565-7660; X-Rite, Inc., 3100 44th Street S.W., Grandville, Michigan 49418, telephone: 616-534-7663; and ESECO Speedmaster (Electronic Systems Engineering Company), 1 Eseco Road, Cushing, Oklahoma 74023, telephone: 918-225-1266. Good-quality transmission/reflection densitometers cost between $3,000 and $5,000, depending on the model. Kodak Wratten 92 (red), 93 (green), 94A (blue), and 102 (visual) filters are currently recommended by this author instead of the normally supplied Status A and Status M filters (see discussion in text).

8. Matte-surface polyester (such as DuPont Mylar or Cronar) sheets of a type intended for drafting with technical pens can be obtained from stores that sell drafting and engineering drawing supplies. Matte DuPont Mylar Type EB-11, or other matte polyester with an incorporated matting agent of silicon dioxide or other abrasive material, should be avoided because the abrasive can easily damage the delicate surface of a photograph.

9. Densitometer head locations can be marked with a technical pen (such as a Koh-I-Noor Rapidograph) with a No. 1 point (medium) and a suitable stable black ink (such as Koh-I-Noor Rapidograph "Universal" Waterproof Black Drawing Ink No. 3080-P, Koh-I-Noor Rapidomat Black Ink No. 3074-F, or Higgins Professional India Ink for Film No. 4465 Black).

10. Holes in the polyester overlay sheet are best cut by placing the sheet on a large piece of glass and cutting out a circle with an X-Acto Craft Swivel Knife No. 3241. As an alternative to round holes, square holes may be cut with a straight-blade knife. Be certain that the knife blade is very sharp, and cut the holes carefully to avoid rough edges that might scratch the surface of a print. Holes can also be punched with a suitable leather punch (see Note No. 11).

This author gratefully acknowledges the suggestion by Grant Romer, conservator at the International Museum of Photography at George Eastman House, Rochester, New York, that holes be cut in the polyester overlay sheet. Eliminating the polyester from the densitometer optical path improves the long-term accuracy of this system; it also permits the use of matte-surface polyester, to which ink adheres far better than it does to high-gloss polyester. In the original version of the monitoring system proposed by this author in 1978, readings were made through a clear polyester overlay sheet.

11. The punch used by Douglas Severson at the Art Institute of Chicago is manufactured by C. S. Osborne & Company, 125 Jersey Street, Harrison, New Jersey 07029; telephone: 201-483-3232. The #7 punch cuts a ¹³⁄₆₄-inch hole, which accommodates the ³⁄₁₆-inch head aperture of the Macbeth TR924 and similar Macbeth densitometers. Severson cautions that after marking the polyester overlay sheet, it **must** be inverted for punching so that the slightly rough edges of the hole lift away from the print rather than toward it, to prevent scratching delicate print surfaces.

12. Suitable transparent polyester (DuPont Mylar D or ICI Melinex 516) sleeves which open along one edge so it is not necessary to slide a print or film in and out (thus minimizing the risk of scratching the

surface) are available from: Talas Inc., Ninth Floor, 213 West 35th Street, New York, New York 10001-1996; telephone: 212-594-5791.

13. Documentation photography is most effectively done with color reversal films (recommended is Fujichrome 64T Professional Film [Tungsten] or, as a second choice, Kodak Ektachrome 64T Professional Film [Tungsten]). After processing, the color transparencies can be preserved almost indefinitely by placing them in humidity-controlled cold storage. This author believes that in most cases, color films stored under the proper conditions (0°F [–18°C], 30% RH) will greatly outlast archivally processed black-and-white films stored under typical room-temperature conditions. It is assumed here that an institution engaged in a monitoring program will have cold storage facilities for its collections, densitometer photographic calibration standards, and color documentation photographs.

14. When a fading monitor is used as an "integrating photometer" to study environmental conditions in which photographs are displayed, density losses measured with the fading monitor are correlated with density losses of the same type of photographic material that result from low-level accelerated light fading tests in which the light exposure is known.

The application of photographic materials for "integrating photometers" has been reported by Stanton Anderson and George Larson of Eastman Kodak Company in "A Study of Environmental Conditions Associated with Customer Keeping of Photographic Prints," **Second International Symposium: The Stability and Preservation of Photographic Images,** (Printing of Transcript Summaries), Ottawa, Ontario, August 25–28, 1985, pp. 251–282. Available from: IS&T, Society for Imaging Science and Technology, 7003 Kilworth Lane, Springfield, Virginia 22151; telephone: 703-642-9090.

This author believes, however, that Blue Wool Standard test cards are more satisfactory than photographic materials for use as "integrating photometers." Blue Wool Standard test cards are available from: British Standards Institution, 10 Blackfriars Street, Manchester M3 5DT, England; Beuth-Vertrieb, Burggrafenstr, 4-7, D-1000 Berlin 30, Germany; Japanese Standards Association, 1-24 Akasaka 4, Minatoku Tokyo, Japan. In the U.S. the cards may be purchased from: Talas Inc., Ninth Floor, 213 West 35th Street, New York, New York 10001-1996; telephone: 212-736-7744.

The Blue Wool Standards are described in **BS 1006:1978, British Standard Methods of Test for Colour Fastness of Textiles and Leather,** British Standards Institution, 2 Park Street, London W1A 2BS, England; telephone: 01-629-9000. See also: **ISO 105/ A-1978 Textiles – Tests for Colour Fastness – Part A: General Principles** and **ISO 105/ B-1978 Textiles – Tests for Colour Fastness – Part B: Colour Fastness to Light and Weathering,** published by ISO, 1, rue de Varembe, Case postal 56, CH-1211 Geneve 20, Switzerland; telephone: 41-22-34-12-40. ISO Standards are available in the U.S. from American National Standards Institute, Inc., 11 West 42nd Street, New York, New York 10036; telephone: 212-642-4900; Fax: 212-302-1286. The Blue Wool light-fastness standards (numbered 1–8) should not be confused with the "L Blue Wool Standards," (numbered L2–L9) supplied by the American Association of Textile Chemists and Colorists.

A significant problem with the use of color photographic papers as "integrating photometers" is that new color papers are introduced and older versions discontinued on a fairly regular basis, and this will make long-term continuity difficult. In addition, manufacturers sometimes make unannounced changes in a material and/or its processing, which can affect its stability and possibly its light fading reciprocity characteristics. Because of these uncertainties, each new batch of color paper will have to be retested for "calibration" purposes — a time-consuming process. Unlike photographic papers, the Blue Wool Standards are standardized and should provide good repeatability from year to year. The eight steps of the Blue Wool Standards afford measurement over a very wide range of accumulated exposure and, in this author's tests, the Blue Wool Standards exhibited minimal reciprocity failure in long-term "natural" tests compared with short-term accelerated tests (see Chapter 2). For discussion of the Blue Wool Standards as "integrating photometers" see: Robert L. Feller and Ruth Johnston-Feller, "Use of the International Standards Organization's Blue Wool Standards for Exposure to Light. I. Use as an Integrating Light Monitor for Illumination Under Museum Conditions," **AIC Preprints of Papers Presented at the Sixth Annual Meeting,** Forth Worth, Texas, June 1–4, 1978, pp. 73–80. Also see: Robert L. Feller and Ruth Johnston-Feller, "The International Standards Organization's Blue-Wool Fading Standards (ISO R105)," **Textile and Museum Lighting,** published by the Harpers Ferry Regional Textile Group, 1985, pp. 41–57.

For more accurate measurement of light exposure accumulated over time than is possible with the Blue Wool Standards, various electronic integrating photometers are available. Recommended is

the Minolta Illuminance Meter (Model T-1), a moderate-cost lux/footcandle meter with an integration function, available for about $600 from Minolta Corporation, 101 Williams Drive, Ramsey, New Jersey 07446; telephone: 201-825-4000 (manufactured by Minolta Camera Company, Ltd., 30,2-Chome, Azuchi-Machi, Higashi-ku, Osaka 541, Japan).

15. Inexpensive metal frames of appropriate size can be obtained at many variety stores and, for large-quantity purchases, directly from a manufacturer such as Intercraft Industries Corporation, Chicago, Illinois 60614. Backing materials supplied with such frames should be discarded and replaced with high-quality mounting board.

16. Kodak Reflection Densitometer Check Plaque, Kodak Catalog No. 140-5026, for use with reflection densitometers. For transmission densitometers, obtain a Kodak Transmission Densitometer Check Plaque, Catalog No. 170-1986. Eastman Kodak Company, 343 State Street, Rochester, New York 14650; telephone: 716-724-4000.

17. See, for example: Robert J. Tuite, "Image Stability in Color Photography," **Journal of Applied Photographic Engineering,** Vol. 5, No. 4, Fall 1979, pp. 200–207. For stability information on specific Kodak color materials, see: Eastman Kodak Company, **Evaluating Dye Stability of Kodak Color Products,** Kodak publication CIS No. 50, and CIS No. 50 series data sheets for Kodak color papers, January 1982 and later dates.

18. The Macbeth ColorChecker chart can be purchased from photographic suppliers or from Kollmorgen Instruments Corporation, Macbeth Division, P.O. Box 230, 405-417 Little Britain Road, Newburgh, New York 12550; telephone: 914-565-7660; toll-free: 800-622-2384.

19. Heat-sealable vapor-proof envelopes called Light Impressions Heat Seal Envelopes, which are suitable for storage of photographs in uncontrolled humidity conditions, are available in two sizes from Light Impressions Corporation, 439 Monroe Avenue, Rochester, New York 14607-3717; telephone: 716-271-8960 (toll-free: 800-828-6216). Similar vapor-proof envelopes, called Containers for Freezing Photographic Material, are supplied (minimum purchase of 500 envelopes) by Conservation Resources International, Inc., 8000-H Forbes Place, Springfield, Virginia 22151; telephone: 703-321-7730 (toll-free: 800-634-6932). These heat-sealable envelopes are made with an aluminum-foil vapor barrier which is laminated between sheets of polyethylene and paper; ordinary plastic bags are not suitable.

20. Kodak Wratten densitometer filters in 125mm (5-inch) square sheets may be ordered from Kodak as follows: Visual No. 102 (Catalog No. 166-8318); Red No. 92 (Catalog No. 176-4513); Green No. 93 (Catalog No. 186-0261); and Blue No. 94A (Catalog No. 148-2413). (In 1985 Kodak replaced the traditional Wratten No. 94 densitometer filter with the Wratten No. 94A densitometer filter.) Eastman Kodak Company, 343 State Street, Rochester, New York 14650; telephone: 716-724-4000.

21. Jeanne Boddin, product manager, Macbeth Division, Kollmorgen Instruments Corporation, telephone discussion with this author, December 4, 1986.

22. For current recommendations on densitometers and densitometer filters for photographic print-monitoring applications, contact Henry Wilhelm at Preservation Publishing Company, 719 State Street, P.O. Box 567, Grinnell, Iowa 50112-0567; telephone: 515-236-5575; Fax: 515-236-7052.

23. Robert J. Tuite, see Note No. 17.

24. Sergio Burgi, International Museum of Photography at George Eastman House, telephone discussion with this author, August 5, 1983. Burgi was tentatively using the set of limits previously proposed by this author in an article in the **Journal of the American Institute for Conservation** (see Note No. 26). The limits suggested in that article are a somewhat simplified version of the limits given in this chapter (**Table 7.1**).

25. Douglas G. Severson, "The Effects of Exhibition on Photographs," **Topics in Photographic Preservation – 1986** (compiled by Maria S. Holden), Vol. 1, pp. 38–42, 1986. American Institute for Conservation Photographic Materials Group, American Institute for Conservation, Suite 340, 1400 16th Street, N.W., Washington, D.C. 20036; telephone: 202-232-6636. Slightly revised, the article was reprinted in **Picturescope,** Vol. 32, No. 4, Winter 1987, pp. 133–135.

26. Henry Wilhelm, "Monitoring the Fading and Staining of Color Photographic Prints," **Journal of the American Institute for Conservation,** Vol. 21, No. 1, Fall 1981, pp. 49–64.

27. John McElhone (National Gallery of Canada), "Determining Responsible Display Conditions for Photographs," presentation at The Centre for Photographic Conservation Conference '92: **The Imperfect Image: Photographs their Past, Present and Future,** Windermere, Cumbria, England, United Kingdom, April 6–10, 1992.

# 8. Color Print Fading and the Professional Portrait and Wedding Photographer – What to Do About a Troubling Situation

## Fujicolor SFA3 Papers Are by Far the Longest-Lasting Color Negative Papers Available

### An Upset Customer

Fehrenbach Studios in Reedsburg, Wisconsin has been our photographer for years. We had our wedding pictures taken by them, I had my portrait taken for my husband while he was in the service, and when we had our first baby, we had Fehrenbach Studios take his picture. We were happy with them up to this point — then strange things began to happen to our photographs. My portrait has turned blue and faded to almost nothing. The photo of our son has turned yellow and is fading away. My brother's graduation photo also has turned blue and is faded.

My mother approached Bob Fehrenbach on this matter and he said he would gladly replace these photographs for half price. He also stated that Eastman Kodak does not guarantee that photographs will not fade, and he went on to say that if he replaced all the faded prints that were returned to him free of charge, he would go out of business in a short time. . . .

Needless to say, when our second child was born we found another photographer.

The thing I would like to know is why should we have to pay a second time for something that should have lasted a lifetime.

Eastman Kodak has always contended with their advertising that photographs are lasting memories, once in a lifetime treasures, that keep today alive forever. I do believe a photograph should last longer than 7 years. I wanted to pass our children's baby pictures down to them when they got married, the same as my mother did for me. I have nothing to give them but a faded print.

I do not believe that this is the right way to do business. I feel that I have been cheated because my photographs have not lasted like they were advertised. Would you please look into this matter. . . .[1]

Letter from Mrs. Sharla M. Stanclift
of Reedsburg, Wisconsin to the Office
of Consumer Protection, Wisconsin
Department of Justice, May 16, 1980

## People Expect Their Color Portraits and Wedding Photographs to Last

In no other area of photography is the stability of a color print as important to the customer — and the continued commercial success of the photographer — as it is in the professional portrait and wedding business. Photographs are among the few possessions that the average person would like to hand down to future generations. In the modern era, few individuals have any significant written record of their lives — most people have only photographs, and since the early 1970's, most of these have been color photographs. Indeed, the desire to preserve the memory of important times and events in peoples' lives — childhood, school and college graduations, careers, weddings, children, and families together — is what drives the professional portrait and wedding market. Describing the emotions of people who have survived fires, floods, earthquakes, and other natural disasters, an official of the American Red Cross said: "The items that cause the most grief are photographs. People lose their history when photos are lost."[2]

Probably no one knows the average person's attachment to family photographs better than Eastman Kodak, and the theme of preserving memories has been the basis of nearly all of Kodak's promotional efforts in portrait and wedding markets. A long-running Kodak advertising campaign, keyed to the slogan "For the Times of Your Life," is only the latest example.

Although few people think it necessary to preserve *all* their photographs in pristine condition forever, almost everyone has at least some color photographs that they value and would like not only to keep — and display — during their lifetimes but also to pass on to future generations. Unfortunately, few color photographs from the past 20 or 30 years will survive for future generations — after not too many years of display, many have already deteriorated so seriously that they are now only faded ghost-images of what they originally looked like. The fading of color portraits and wedding pictures affects the rich and famous, the poor and unknown, alike. And, as will be discussed later, the price paid for a portrait or wedding album usually has no bearing on how long the photographs will last.

If a print is made from a color negative on Kodak paper, it doesn't matter whether it costs the customer one dollar or one thousand dollars: they are all printed on one of the

**See page 279 for Recommendations**

October 1990

H&H Color Lab, Inc., a leading professional color lab located near Kansas City in Raytown, Missouri, switched from Kodak Ektacolor paper to Fujicolor paper in 1991 because of the much better color permanence of the Fuji product. H&H was the first major wedding and portrait lab in the U.S. to adopt Fujicolor paper (see pages 280–283). Shown here inspecting Fujicolor test prints coming off a Pako Leader Belt Processor are Sue Cadena, print inspector, and Rob Newbanks, quality assurance manager at H&H. Before making the change to Fujicolor paper, H&H president Wayne B. Haub sent a comprehensive information packet to the lab's customers explaining the stability advantages of Fujicolor paper and asking them whether they felt the lab should switch papers. Matched sets of prints of typical wedding and portrait photographs printed on both Ektacolor Portra and Fujicolor Professional papers were included for the customers to examine. Over 90% of those who responded to the survey said that they wanted H&H to make the change to the longer-lasting Fujicolor paper.

low-cost, poor-stability Ektacolor papers — products conceived and manufactured primarily for amateur snapshot photofinishing. In terms of image stability, there is *no difference* between a top-quality professional portrait printed on Ektacolor Portra II paper, the most expensive of which may cost many hundreds of dollars, and the 35-cent Kodalux (formerly Kodacolor) print made with Ektacolor Edge paper that one picks up at the local drugstore.

## Photographers Complain to Kodak About the Inadequate Stability of Ektacolor Paper

Beginning around 1980, faded color portraits and wedding pictures have been the subject of numerous newspaper and magazine stories.[3] In 1982, Max Brown, a well-meaning Iowa wedding and portrait photographer, went out of business after faded and cracked Ektacolor RC prints from the early 1970's were returned to him by large num-

bers of indignant customers demanding free reprints, and his story was featured on the CBS television program *Walter Cronkite's Universe*. In 1976, Max Brown had sued Eastman Kodak for one million dollars, and in 1982, Wisconsin professional photographers Bob and Bernice Fehrenbach and Robert Germann sued Kodak for $3.7 million.[4]

Both lawsuits claimed that normally framed and displayed prints made with the Ektacolor RC papers supplied by Kodak during the late 1960's and early 1970's suffered extremely rapid image fading and cracking of the RC base. (This author's examination of a variety of Ektacolor prints that had been displayed under typical home and office conditions indicated that these early Ektacolor RC papers were as much as 3 to 5 times *less* stable than the earlier Ektacolor Professional fiber-base paper they replaced.)

Neither the Brown suit nor the Fehrenbach/Germann suit ever reached trial; as a result of well-orchestrated defenses coordinated by Kodak's legal staff in Rochester

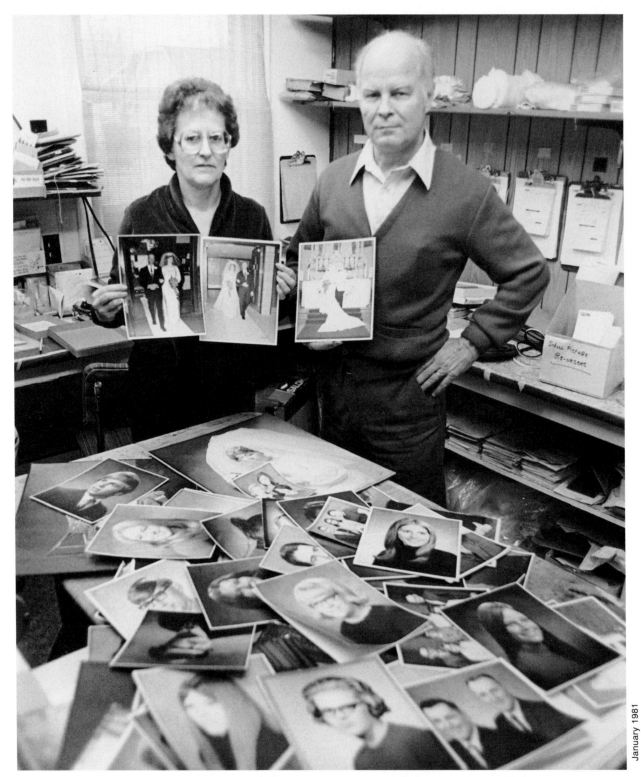

January 1981

Bernice and Robert Fehrenbach of Fehrenbach Studios in Reedsburg, Wisconsin are shown here with some of the more than 100 faded and cracked Ektacolor RC prints, taken between 1969 and 1976, that were brought back to the studio by angry customers.  The three prints held by the Fehrenbachs support their claim that Ektacolor RC prints from the early 1970's faded even faster than the previous Ektacolor fiber-base prints.  The print on the left, an Ektacolor fiber-base print, has faded much less than the two Ektacolor RC prints, even though the fiber-base print was displayed several years longer (all three prints were displayed in identical lighting conditions).  The Fehrenbachs and another Wisconsin photographer, Robert Germann, subsequently sued Kodak for $3.7 million in damages, alleging fraud by Kodak and saying that Kodak advertisements promised the color prints would last "forever."

February 1981

Bernice and Robert Fehrenbach, with their son Thomas, discuss the Ektacolor fading problem at their "Faded and Cracked Ektacolor Print Booth" during the 1981 annual convention of the Wisconsin Professional Photographers Association in Milwaukee, Wisconsin.

— in which the photographers' lawyers were hopelessly outspent and outclassed — Kodak managed to get both cases dismissed on legal technicalities having nothing to do with the issues of color fading, RC-base cracking, or fraudulent advertising. (After Brown's lawsuit was dismissed, he successfully sued his lawyers, Paul Moser, Jr., of Des Moines, Iowa, and Robert L. Huffer, of Story City, Iowa, for legal malpractice; in an out-of-court settlement in 1985, Brown and his wife received $185,000.)

The Fehrenbachs were particularly bitter about the dismissal of their suit before it even had a chance to be argued in court — with a group of four very successful family-operated studios in rural Wisconsin, money was never the main issue with Bob and Bernice Fehrenbach. The Fehrenbachs are people of great integrity who care deeply about their photography and the honest value of the work they do for their customers, many of whom they know on a personal basis. They feel strongly that color prints *should* last forever. In the end they felt deceived and betrayed by Kodak. During the time of the suit, Bernice Fehrenbach often cited a statement made by William A. Sawyer, Jr., vice president and general manager of Professional and Finishing Markets for Kodak:

> Professional photographers have always been extremely important to Kodak; you are our partners in photographic progress. This partnership is much more than the ordinary type of manufacturer-user relationship. Photographers

base their livelihood on Kodak products and stake their reputations on their trust in Kodak product quality each time they accept an assignment or tackle a new photographic challenge.[5]

Acting on behalf of the Committee on Faded and Cracked Photographs of the Wisconsin Professional Photographers Association (WPPA), Bernice Fehrenbach also circulated a petition asking Eastman Kodak to produce color film and print materials with greater stability for professional photographers and requested that Kodak engage in more truthful consumer advertising. The petition was backed by the board of directors of the WPPA and was signed by more than 275 professional portrait and wedding photographers from Wisconsin, Minnesota, North Dakota, and South Dakota. (The Wisconsin petition and Bernice Fehrenbach's cover letter, which were sent to Eastman Kodak, are reprinted in **Appendix 8.1** on page 294.)

## Texas Professional Photographers Protest Kodak's Advertisements

One angry photographer who has had hundreds of badly faded Ektacolor RC prints returned by customers is Zavell Smith, operator of a profitable wedding and portrait studio in San Antonio, Texas. According to Smith, "Nobody has helped me more than Eastman Kodak, but nobody has gotten me in more trouble than Eastman Kodak. And it's not

*(continued on page 273)*

Max Brown, a Story City, Iowa portrait and wedding photographer, in his lawyer's office with a selection of the hundreds of faded and cracked Ektacolor RC prints from the late 1960's and early 1970's that had been returned by disgruntled customers, many of whom demanded that the prints be replaced at no charge. The faded print problem caused Brown to lose many of his lucrative school portrait accounts, and he was forced out of business. Accusing Eastman Kodak of false advertising and misrepresenting the stability of its Ektacolor RC papers, Brown sued the company for $1 million. Because of a technical error by Brown's attorneys, Robert Huffer and Paul Moser, the suit was dismissed in 1980. After losing an appeal to the Iowa Supreme Court, Brown sued his attorneys for legal malpractice; that suit was settled out of court for $185,000.

May 1982

Max Brown being interviewed about his lawsuit against Kodak by Christy Callahan for WHO-TV in Des Moines, Iowa. Waiting to be interviewed is an Iowa assistant attorney general who was in the midst of investigating charges by another Iowa photographer, Edward J. Mulvin, who had filed a complaint with the Attorney General's office concerning premature fading and discoloration caused by Kodak retouching colors and by the application of print lacquers as recommended by Kodak.

January 1981

Brown in front of his former studio in Story City, Iowa. The studio was purchased by photographer Pete Tekippe after Brown went out of business and his bank forced the sale of the property.

February 1982

After the bank foreclosed, Brown's house was sold at auction. Taping the sale was a crew from CBS-TV, which included the event in a segment on the problems of fading color portraits and motion pictures for **Walter Cronkite's Universe**, broadcast nationwide on CBS television. Although both the Brown and Fehrenbach/Germann lawsuits were dismissed in court, they nevertheless had a major impact on Kodak and helped convince the company that it needed to improve the stability of its color negative films and papers. This concern soon resulted in the introduction of Vericolor III film and Ektacolor Plus and Professional Papers — all of which had much improved dark fading stability compared with previous Kodak products.

February 1982

Brown signs the sale papers for his home. Deeply in debt, Brown moved into a small rented house with his two sons and daughter. In the course of the lawsuit with Kodak, Brown and his wife separated. After holding a number of sales jobs to support himself and his children, Brown started a new wedding photography business in 1991 and now lives near Cedar Rapids, Iowa.

1981

Brown in the basement of his home with boxes of Ektacolor and Vericolor portrait and wedding negatives. Before he went out of business, Brown had built a sizable high school portrait operation in central Iowa. As part of his suit against Kodak, Brown had asked Kodak to bear the costs of reprinting the faded prints that had been returned to him by customers.

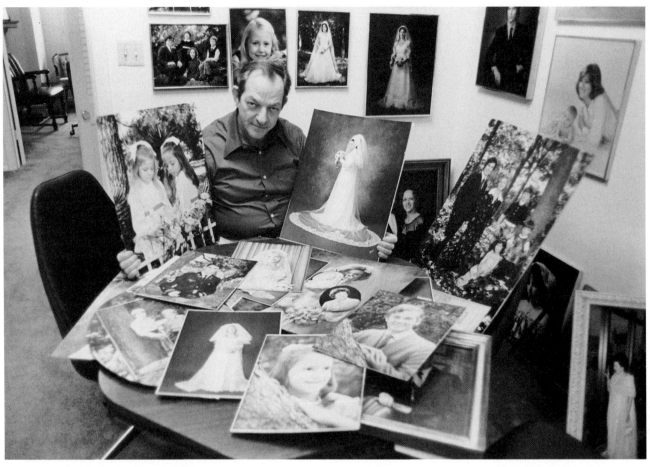

March 1981

Zavell Smith, a San Antonio, Texas photographer, is seen with some of the faded Ektacolor wedding portraits brought back to him by his customers. Upset about the situation, Smith helped organize a petition complaining about the poor image stability of Ektacolor paper and asking Kodak to inform the public of the "true expected life of color materials, and to publicly absolve professional photographers of blame in the fading of color materials available to them." The petition was signed by members of the Texas Professional Photographers Association.

just that we have a color print fading problem with Kodak — we have an industry-wide problem. You can take a trip anywhere in the country, visit any school or public building, and you will see faded color prints."[6] Smith says that many people want faded prints replaced at no cost, but he insists on a charge of 50% of the current price.

Smith attempted to have a "Faded Color Print Booth" at a convention of the Texas Professional Photographers Association but, Smith contended, the idea was blocked by TPPA officials. According to Smith, "They are all scared to rock the boat — they are all scared to talk about faded photographs."

Many of the photographers felt that publicity on the issue could only hurt their businesses because if customers became aware of the truth about the instability of the expensive Ektacolor prints they were buying, they might have their pictures taken by low-cost, mass-market operations instead. Or, they simply might give up having portraits made at all and spend their money on something else with greater perceived value.

The Texas organization did, however, circulate a strongly worded petition complaining about the poor stability of Ektacolor paper and saying that professional photographers

had to bear the brunt of these inadequacies. Stating that in some cases "the reputations of photographers have been severely damaged," the association asked Kodak and other manufacturers for "an advertising policy that will properly inform the public of the true expected life of color materials, and to publicly absolve professional photographers of blame in the fading of color materials available to them." (See **Appendix 8.2** on page 295.)

## Kodak Promises the Federal Trade Commission and the Wisconsin Department of Justice That It Will Stop Knowingly Making False Claims

In addition to citing the extremely poor light fading stability of the Ektacolor RC papers from the 1970's, the Fehrenbach and Germann suit also alleged fraud on the part of Kodak because of the company's advertisements that stated Ektacolor prints would last "forever" or a "lifetime" when in fact Kodak knew very well that the prints would not. Two years before the suit was filed, the Fehrenbachs had complained about Kodak's advertising claims to both the Wisconsin Department of Justice and the Federal Trade Commission in Washington, D.C. After examining Kodak's

advertising materials, an attorney with the Wisconsin Department of Justice informed Kodak that it likely was in violation of Wisconsin's consumer-fraud statutes and wrote the company, "Given the admission by Kodak that its color print materials do not last forever, why are you preparing advertisements in direct contradiction?"[7]

Kodak was asked to submit in writing a promise that it would discontinue any "claim, statements, or advertisements which represent that pictures made from your company's materials will last longer than you are aware is the case."

In August 1980, a member of Kodak's legal staff wrote to both the Wisconsin Department of Justice and the Federal Trade Commission stating that "Kodak has withdrawn all advertisements, brochures, pamphlets, etc. which, taken alone, could imply that an individual print will retain its original appearance 'for a lifetime,' etc."[8] Kodak promised to monitor all such material in the future to ensure that no unsupportable claims were made.

## Kodak Resumes Making Misleading Claims About the Stability of Ektacolor Prints

Kodak adhered to its agreement for a few years, but, by the beginning of 1986, all of that seemed forgotten and Kodak was once again making statements that contained false implications about the permanence of Ektacolor prints. As part of the nationwide "For the Times of Your Life" promotional campaign managed by Paul M. Ness, coordinator of markets development for Kodak's Professional Photography Division, one brochure said:

> A professional portrait can capture the unique personality of each member of your family. Or help you remember special moments in a young child's life. The times that are important to you. You can keep today frozen in time, the memories just as fresh as the day they happened.
> . . . you can have a beautiful family portrait that you'll treasure for a lifetime.[9]

Another 1986 Kodak brochure said: "With professional wedding photography, tradition and good times come to life again and again. . . . let us help you capture the magic of this moment forever."[10] Stated yet another promotional brochure: "Keep today alive. Gather your family together once more for a professional family portrait. It takes only a few moments to capture this special time. The family portrait you take today could be your greatest possession tomorrow."[11]

With the "For the Times of Your Life" advertising campaign still going strong, Kodak described a new brochure in *The Times* newsletter this way: "Citing the sparkle in the eyes of her grandmother on a young woman's wedding day, the stuffer is guaranteed to provoke an emotional response from the viewer. It is designed to build interest in creating heirlooms for generations."[12]

In a 1988 article headlined "A Century of Value Helps Create Priceless Memories," Peter M. Palermo, vice president and general manager of the Consumer Products Division of Eastman Kodak, said:

Precious memories recorded on film are irreplaceable and, therefore, priceless. Pictures which capture once-in-a-lifetime moments have a value that far exceeds the cost of the film and paper they are printed on. Photography allows people to relive their most precious moments forever.

That has been the case for the last 100 years, ever since George Eastman revolutionized photography when he introduced the first snapshot camera in June 1888. "Most photographs are made for the purpose of obtaining a record which cannot be had in any other way," Eastman once said.

. . . One thing hasn't changed. People still take pictures for the same reason they did 100 years ago. It is a natural longing to preserve one's memories so we can make our best moments live forever.[13]

All of this would be great if displayed Ektacolor prints actually would last forever, or even a "lifetime." This would be a wonderful and effective promotion — if only it were true. And Kodak is acutely aware that it is not. To some photographers, all of this may seem like too much nitpicking. But one of the serious consequences of Kodak's continuing to mislead the public and telling people that their proudly displayed color prints will last forever is that in a very real way this reduces the incentive for Kodak to produce a color print material capable of doing just that — preserving priceless memories in brilliant color "forever."

Even if "forever" seems out of reach at the moment to Kodak, the company certainly has the technological capability to produce color negative print papers with light fading and album-keeping (dark fading) stability *far* superior to that of current Ektacolor Portra II Paper and other Ektacolor papers. The slogan for a 1990 Kodak national ad campaign said: "A professional portrait isn't expensive. It's priceless." Assuming this to be true, it only makes sense that Kodak should produce a paper for professional portraits that is better, longer-lasting and, yes, more expensive than the current Ektacolor drugstore photofinishing papers.

## Print Fading Can Affect All Photographers, But the Studio Professional Is Harmed Most

When dealing with faded prints, established studios often feel at a disadvantage to the mass-market portrait operations whose low prices and ambiguous affiliations mean that only rarely will the mass-market photographer be asked to replace a faded print. And a traveling photographer who sets up for a few days at a time in a never-ending series of discount and department stores such as K-Mart, Wal-Mart, and J.C. Penney knows that he or she personally will not have future dealings with the people in the photographs. Even the "permanent" department store studios, such as those operated by CPI Corporation (headquartered in St. Louis, Missouri) in nearly one thousand Sears Roebuck retail stores in the U.S., Puerto Rico, and Canada, have a distinctly anonymous character. Most of these low-cost operations retain negatives for only a short time — if at all — after they are printed.

A photographer named Dennis with Photo Promotion Associates, Inc. visited this author's hometown of Grinnell, Iowa for several days in 1983 to take portraits at a local discount store and told this author: "Our prints will last indefinitely hanging on the wall. We use Kodak paper and that's the best that there is. Very occasionally you get a bad batch of paper and it might fade, but if it does we will replace it. I hear that PCA [a competitor of Photo Promotion] has had some trouble with their pictures turning red, but they don't use Kodak paper." Photo Promotion Associates, based in Monsey, New York, and whose promotional literature contained the Kodak-supplied "We use Kodak paper . . . for a good look" logo, went out of business in 1985.

At the time, PCA International, Inc., a huge portrait operation headquartered in Matthews, North Carolina, was in fact having serious problems with faded prints because from about 1975 until 1982 the company had the distinct misfortune of using Agfacolor Type 4 paper in its processing laboratories.

When PCA chose the Agfa paper, which was made in Germany by Agfa-Gevaert, the company was totally unaware of the astonishingly poor image stability of the product. PCA printed untold millions of portraits of children, adults, and families on Type 4 paper. All of these portraits are now severely faded, whether stored in the dark or displayed, and the photographs cannot be reprinted because the original negatives have long since been discarded.

In 1985 this author examined a selection of Agfacolor Type 4 prints made by PCA. They were less than 6 years old and had never been displayed, but all appeared to have suffered in excess of a 75% loss of cyan dye and had an extreme reddish color shift. Prints that had been displayed during the period were in even worse condition, but most of the deterioration evident in the displayed prints could be attributed to dark fading which took place while the prints were on display — light was not the major factor. Agfacolor Type 4 paper is without a doubt the most unstable color print material of the modern era — no other paper that this author is aware of even comes close to the speed at which Type 4 prints fade in the dark.

Business losses resulting from the exceedingly poor stability of Type 4 paper led to the filing of a nationwide class-action lawsuit in 1985 against Agfa-Gevaert on behalf of labs and photographers all across the U.S. who had used Type 4 paper; the case was settled out of court for an undisclosed sum in 1987.[14] According to court documents, PCA alone purchased more than $45 million of Type 4 paper between 1978 and 1982 (however, apparently because PCA previously had reached a financial settlement with Agfa, PCA was not a party to the class-action suit).

PCA's alarming experience with Agfacolor Type 4 paper also led the company to set up its own image-stability testing laboratory in 1984 so that it could conduct evaluations of color paper. PCA was probably the first major user of color paper anywhere in the world to have an in-house lab to test image stability. In 1985, in a presentation describing the work carried on in the facility, PCA explained that image stability was a subject of increasing concern for the company:

> The quality of portrait image stability is becoming a more important factor in evaluating

overall product quality. Consumers now expect their portraits to not only have good color and composition characteristics, but also to maintain those images for much longer periods of time.[15]

Along with Olan Mills, Inc., Lifetouch, Inc., American Studios, Inc., and CPI Corporation, PCA International, Inc. (the initials stand for Photo Corporation of America) is one of the world's largest child-oriented, mass-market portrait operations, producing many millions of low-cost portraits every year. PCA operates "permanent" studios in department and discount stores and also has hundreds of "mobile" photographers traveling to discount stores, churches, and other locations. PCA is reputed to be the world's largest single consumer of Agfacolor paper; at the time of this writing in 1992, the firm was using Agfacolor Type 9 paper, a product of vastly improved stability compared with the catastrophic Type 4 paper of the 1975–82 period.

This author's tests with Agfacolor Type 9 paper show that it is superior to Ektacolor Portra II Paper (RA-4) and Ektacolor Professional Paper (EP-2) in both light fading and dark fading stability when the fading of flesh tones is compared with the fading of neutral colors. (These colors are deemed by this author to be the most important colors to evaluate in portrait and wedding photographs; the behavior of pure cyan, magenta, and yellow colors is usually less important.) Over the years PCA has used Agfacolor papers primarily because they have been less expensive than Ektacolor paper and most other competing products for large-volume users.

## Discouraged Customers May Abandon Professional Portrait Studios and Give Their Business to Discount Store Photographers

By the mid-1970's, substantial numbers of color prints had been hanging on walls in homes and offices long enough for serious fading to have taken place, and this was when portrait and wedding photographers began to realize the magnitude of their problem. These concerns were heightened when photographers discovered that the Ektacolor RC papers introduced by Kodak beginning in 1968 faded even faster than the previous fiber-base Ektacolor Professional paper — many prints made with the "improved" Ektacolor RC papers during the years from 1968 until about 1976 became severely faded after only 3 or 4 years of display. (Following its long-standing posture regarding color fading, Kodak denied that there were any stability shortcomings with its Ektacolor RC papers and, as Kodak has always done in the past, the company told photographers that there was no cause for alarm.)

In 1981, the Professional Photographers of America sent a list of recommendations on how to deal with the problems of color fading to the organization's 15,000 members (see **Appendix 8.3** on page 296), and some professional photographers felt compelled to supply each of their customers with printed statements acknowledging the instability of color prints and absolving themselves of any liability; an example is the brochure issued by Krider Studios of Lawrenceburg, Indiana, which is reprinted in **Appendix 8.4** on page 297.

November 1982

Portrait photography is now almost universally done in color, and most children's and family photographs are done by mass-portrait operations such as PCA International, Inc. of Matthews, North Carolina. Shown here in 1982, a visiting PCA representative photographs the Charles Kolstad family in a Pamida discount store in Iowa. PCA used Agfacolor Type 4 Paper in the 1970's and early 1980's, and all of the millions of PCA portraits printed on Type 4 paper during that period have now faded to an unsightly red color — regardless of whether they were displayed or kept in the dark.

Photographers were dismayed to realize that every displayed print they had sold in the past, as well as all of those that will be sold in the future, will in time fade to the point where the customer no longer finds them acceptable. Current Ektacolor Portra II, Ektacolor Edge, and Ektacolor Professional papers are more stable than the Ektacolor RC papers from the late 1960's and early 1970's, but in spite of the improvements that have been made, it is a sobering fact that, if displayed, *every* print sold by professional photographers will in a relatively few years lose the special glow it had when new. Sometime between 10 and 30 years — depending on the particular color paper, how brightly the print is illuminated, and whether (and under what circumstances) it was lacquered — the print will fade to such a degree that many customers will find it unacceptable, or at least quite uninspiring.

When that happens, some people will simply put the photograph away, sad to see that it has faded. Others will lose the feeling they once had that professional portraits are valuable heirlooms worth their often high cost. They will have their portraits taken by low-cost department store photographers or by minilab-equipped "one-hour" portrait studios. Some will give up having portraits taken at all. A few will even bring faded prints back to the portrait pho-

November 1982

Like most mass-portrait operations, PCA does not retain negatives for more than a short period. When a print fades, there is no way to make a new one.

tographer and ask for replacements. The better known the photographer — and the longer he or she has been in business — the more likely it is that disgruntled customers will return deteriorated prints.

## For the Established Professional, Even a Little Fading Can Hurt a Lot

Perhaps more insidious for the high-quality and expensive professional is the effect of *subtle* fading and image yellowing that will result after only comparatively few years of display. A print can lose some of its brilliance — the smooth, long-scale tonality that distinguishes really good professional prints made from large-format roll-film negatives from the run-of-the-mill discount store special. The customer in such cases may not be inspired to come back to the studio in the future for another expensive and highly profitable 30x40-inch display print. The image quality lost in the initial stages of fading of a print on display — the partial loss of highlight detail in a wedding gown or a diminished feeling of richness — can be so subtle that even the photographer may not be consciously aware of the changes in the print unless an unfaded print can be compared side by side. But the drop in the customer's perceived value of the photograph can be very real.

## Kodak Likes to Think That the Average Person Is Unconcerned About Even Substantial Color Print Fading

Kodak has maintained that its studies show that the average person is unaware of even substantial amounts of image fading in color prints and therefore professional photographers should have little cause for concern about print fading.[16] It should be noted, however, that the Kodak studies were done without unfaded prints present for comparison, and the participants in the studies did not know the subjects personally and therefore were not familiar with the original color of a spouse's or child's hair, items of clothing, etc.

What Kodak is actually saying is that it believes that the general public is not sensitive to what constitutes a top-quality color photograph and, therefore, it doesn't really matter whether their prints fade. This is quite an amazing viewpoint, coming as it does from the world's largest photographic manufacturer. Rather than promoting image quality, Kodak seems to want to convince photographers — and their customers — that nobody really cares very much what their precious color prints look like.

This author would give the average person a lot more credit than Kodak apparently does. Most people are actually quite sensitive to print quality, especially when they can compare prints side by side. When offered something better, most people quickly recognize it — and want it. The typical home has on display both old and new color prints — often hanging together on a wall or arranged in groups on a table. The side-by-side comparison is there. The worse the prints look (whether because of fading or because the prints were of poor quality to begin with), the less likely it is that their owner will feel inspired to return to the studio and pay to have more pictures taken. Every photographer knows this.

One should recall that earlier Kodak studies showed that most people were going to be happy with the unsharp and grainy images produced by the Kodak Disc camera introduced in 1982; the marketplace proved Kodak wrong on that score (customer dissatisfaction and rapidly declining sales as people switched to Japanese 35mm cameras for their far better image quality led Kodak to abandon the disc camera in 1988), and it will undoubtedly prove Kodak wrong on the color fading issue as well.

Kodak has failed to recognize that a color photograph that can in fact preserve memories forever — or at least for a very long time — is a very appealing product, and something that nearly everyone would like to own. As Charles Lewis, a professional photographer writing in *The Rangefinder* magazine about the color fading problem, said: "Deep down inside, you know that the client expects that portrait to last forever."[17]

Once the general public understands the color print stability problem — and is offered a reasonably priced product that will last substantially longer on display than Ektacolor Portra II Paper or Ektacolor Professional Paper, there is no doubt what the average person will choose.

In the portrait and wedding market, better image stability is simply good business. Kodak doesn't appear to know that. Instead, the company seems to believe that if it spends enough money promoting Kodak paper in television, radio, and print advertising, and keeps suggesting to the public that its color pictures will last forever, people will keep on buying prints made with Kodak paper — even when better color papers are being offered by Japanese or German producers.

Beginning around 1985, trade publications such as *Photo Marketing* and *Photographic Processing* started carrying full-page ads by Konica, Agfa, and Fuji extolling the improved image stability of their color papers; most Kodak ads, on the other hand, said little or nothing about the stability of Ektacolor Paper and instead promoted the Kodak Colorwatch System, a processing quality-control program available from Kodak to processing labs that agree to use "Kodak color paper and Kodak chemicals exclusively." Supported by a multimillion dollar advertising campaign on TV and in magazines and newspapers, Kodak says the program is "designed to drive customers into photofinishing departments identified as members of the Kodak Colorwatch system." The program also includes trade advertising "intended to make every retailer aware of the quality standards you meet."[18]

Many people in the photofinishing business say that the real purpose of the Kodak Colorwatch System is to make drugstores, portrait studios, minilabs, and other retailers fear that if they do not offer prints made on heavily advertised Kodak paper, they will lose customers to studios and processing outlets that do. This in turn is intended to make processing labs fear that if *they* do not use Kodak paper and chemicals, professional photographers and processing retailers may change to a lab that does.

Kodak's attitude is reminiscent of that of the Detroit automakers in the 1960's before Japanese cars began to take a substantial share of the market from them. At the time this book went to press in 1992, Kodak was behind Fuji, Konica, and Agfa in the stability of color prints. And it was Konica — not Kodak — that marketed the first of the

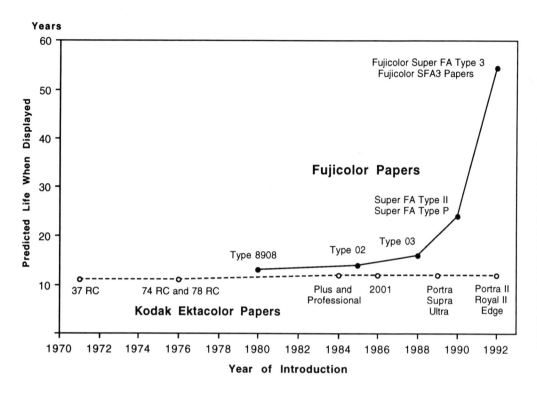

**Years**

Predicted Life When Displayed

Fujicolor Super FA Type 3
Fujicolor SFA3 Papers

**Fujicolor Papers**

Super FA Type II
Super FA Type P

Type 03

Type 8908

Type 02

37 RC

74 RC and 78 RC

Plus and
Professional

2001

Portra
Supra
Ultra

Portra II
Royal II
Edge

**Kodak Ektacolor Papers**

**Year of Introduction**

**Figure 8.1** Beginning in 1980, successive generations of Fujicolor EP-2 and RA-4 compatible papers have exhibited steadily increasing light fading stability, with current Fujicolor SFA3 papers having an estimated display life of more than 50 years according to this author's tests. Kodak's Ektacolor papers, on the other hand, have shown negligible improvements in light fading stability since the introduction of Ektacolor 37 RC Paper more than 20 years ago in 1971. When exposed to light on display, Fujicolor SFA3 papers last more than **four times longer** than current Ektacolor papers (e.g., Ektacolor Portra II Paper).

new generation of color papers with enhanced dark storage stability, Konica Color PC Paper Type SR (also advertised as Konica Century Print Paper) in April 1984, months before Kodak's similar Ektacolor Plus Paper became available to photofinishers as a replacement for Ektacolor 78 Paper.

It was more than a year later, in the middle of 1985, that Kodak finally introduced Ektacolor Professional Paper as a replacement for Ektacolor 74 RC Paper, a product that since 1977 had been the mainstay of the professional portrait and wedding field. Ironically, during that one-year period, low-cost Kodacolor snapshots from the drugstore (printed by Kodak on Ektacolor Plus paper) had far better dark fading stability than the expensive Ektacolor 74 RC prints sold by the best professional studios!

It was also Konica, not Kodak, that in 1984 introduced the first stability-enhancing "washless" stabilizer chemicals and companion minilab for color film and paper; it took 2 more years before Kodak introduced washless processing chemicals. (Kodak entered the minilab market in 1986 with machines manufactured in Japan by Noritsu and Copal. Sales of these and later Kodak-manufactured minilabs were poor, however, and Kodak withdrew from the minilab market in 1989.)

## Fujicolor SFA3 Papers Last Far Longer Than Any Other Color Negative Paper

Supplying prints on the most light-stable color paper available is probably the single most important improvement a professional photographer can make in his or her operation.

At the time this book went to press in 1992, this author's accelerated tests showed that Fujicolor SFA3 papers, RA-4 compatible papers introduced in 1992, had by far the best overall light fading and dark storage stability of any color negative paper. When displayed, prints made on Fujicolor SFA3 papers should last more than *four times* longer than prints made with Ektacolor Portra II Paper and other Ektacolor papers.

(Fujicolor Professional Paper Super FA Type P, introduced in 1991, is approximately *twice* as stable on display as Ektacolor Portra II Paper. Fujicolor Super FA Type P paper will be replaced with Fujicolor SFA3 Professional Portrait Paper [tentative name] in 1993.)

When evaluated with this author's image-life criteria and standard display conditions, the display life of Fujicolor SFA3 prints is estimated to be 54 years; the display life of Ektacolor Portra II prints, on the other hand, is estimated to be only about 12 years. On long-term display, the retention of critical flesh-tone colors is particularly outstanding with the Fujicolor SFA3 papers (see Chapter 3).

When stored in the dark, the Fujicolor SFA3 papers have much better dye stability and far lower rates of brilliance-robbing yellowish stain formation than Ektacolor Portra II Paper and other Ektacolor papers.

As a second choice among RA-4 compatible papers, Konica Color QA Paper Professional Type X2 and Konica QA Paper Type A3 are recommended. Although not the equal of the Fujicolor SFA3 papers in terms of light fading stability, the Konica QA papers are better than Ektacolor Portra II Paper. The best EP-2 compatible papers are Konica Color PC Paper Professional Type EX and Konica Color PC Paper Type SR. This author's accelerated light fading tests indicate that these Konica papers are superior to Ektacolor Professional and Ektacolor Plus papers.

Because of the new magenta dye in the Fujicolor SFA3 papers, they have better color reproduction (especially of

# Recommendations

## For Professional Portrait and Wedding Photographers

- **Choose a lab that uses Fujicolor SFA3 paper.** The single most important thing a professional photographer can do is to use the color paper with the best light fading stability when displayed. At the time this book went to press in 1992, Fujicolor SFA3 papers, including the low-contrast Fujicolor SFA3 Professional Portrait Paper (tentative name) designed for use by portrait and wedding photographers that will be introduced in 1993, had **far better** light fading stability than any other color negative paper on the market. Accelerated light fading tests indicate that, for a given amount of fading, displayed prints made with Fujicolor SFA3 papers will last more than **four times longer** than prints made with Kodak Ektacolor Portra II or Ektacolor Professional papers. In dark storage, the dye stability and yellowish stain characteristics of the Fujicolor SFA3 papers also are **far superior** to Ektacolor papers. With their excellent tone and color reproduction, these breakthrough Fujicolor papers are the primary recommendation for professional portrait and wedding photography; no other color negative paper even comes close to the longevity of the Fujicolor SFA3 papers. Fujicolor SFA3 papers, which are compatible with the RA-4 process, are also the primary recommendation for commercial photography and general photofinishing.

  Two top-quality professional portrait/wedding labs offering prints made with Fujicolor papers are: H&H Color Lab, Inc., 8906 East 67th Street, Raytown, Missouri 64133; telephone: 816-358-6677 (toll-free: 800-821-1305) and LaClaire Laboratories, Inc., 6770 Old 28th Street, S.E., Grand Rapids, Michigan 49546; telephone: 616-942-6910 (toll-free: 800-369-6910). For the names of other labs using Fujicolor papers contact: Fuji Photo Film U.S.A., Inc., Color Paper Dept., 555 Taxter Road, Elmsford, New York 10523; telephone: 914-789-8100 (or call toll-free: 800-526-9030 and ask for Customer Service).

  The second longest-lasting color papers are Konica Color QA Professional Paper Type X2 and its higher-contrast photofinishing counterpart, Konica Color QA Paper Type A3. For labs that have not yet converted to Process RA-4 and are continuing to use the EP-2 process, Konica Color Professional Type EX or Konica Color Type SR papers are recommended.

- **Inform customers about the color fading problem.** Tell customers that Ektacolor, Fujicolor, and similar color prints gradually fade when exposed to light on display, and explain to them the need to keep at least one copy of every important photograph in the dark, in an album or print-storage box. Even in the dark the prints are not permanent, but protected from light, they will last much longer than displayed prints. This not only is a service to your customers that will be appreciated, but will also generate additional print sales.

- **Offer UltraStable Permanent Color Prints, Polaroid Permanent-Color Prints, or EverColor Pigment Prints** as valuable heirloom keepsakes, and promote them for upscale display applications (EverColor is a tentative recommendation). Offer these permanent color prints as an alternative premium product to all segments of the portrait, wedding, and family group market. Regardless of price expectations, customers should be informed of the availability of permanent color prints for those special photographs they would like to display and keep as heirlooms. This can develop into an entirely new and profitable market segment. High-priced photographers serv-

ing the "carriage trade" should furnish permanent color prints exclusively. Permanent color prints should also be used for portraits of government leaders, corporate presidents and board members, and cultural figures, and for other color photographs of historical importance intended for long-term display.

- **Color negative films:** Kodak Vericolor III and Kodak Vericolor 400 professional color negative films are recommended for portrait and wedding photography. These films, which in Europe, Japan, and most other countries are called Kodak Ektacolor Gold 160 Professional Film and Ektacolor Gold 400 Professional Film respectively, have better dark storage stability than any other color negative films designed for portrait and wedding photography. (At the time this book went to press in 1992, Vericolor III was not available in a "Type L" version for tungsten-illuminated exposures. Kodak Vericolor II Type L has extremely poor stability and is even less stable than obsolete Vericolor II Type S film; when a tungsten-balanced color negative film is required, Fujicolor 160 Professional Film Type L is recommended.) Fujicolor Reala (ISO 100), Fujicolor HG 400 Professional Film, and Konica Color Impresa 50 and Konica Color Super SR200 professional films are designed for portrait and wedding photography and have comparatively fine grain with excellent pictorial quality. Although not as stable as Kodak Vericolor III and Vericolor 400 films, the Fuji and Konica films have fairly good stability and are satisfactory alternatives to the Kodak films.

- **Negatives should be retained indefinitely.** If space limitations preclude storage of all negatives, at least keep negatives of sale prints. Inform customers of your policy on negative retention. One reason for retaining negatives (aside from the competitive advantage over mass-market operations, which usually do not keep negatives) is that when improved, more stable print materials become available (and they most surely will), a photographer may be able to generate significant business reprinting older negatives for customers. Negatives should be stored in an air-conditioned room with reasonable relative humidity (always less than 60%). Ideally, all negatives of value — those from which prints have been sold — should be refrigerated according to the recommendations in Chapter 19. It is especially important to refrigerate older and less stable Vericolor, Vericolor II, Ektacolor, Kodacolor-X, and Kodacolor II negatives in order to prevent further image deterioration. Negatives should be stored in uncoated polyester (such as DuPont Mylar D) or uncoated polypropylene top-flap sleeves placed inside of paper envelopes (see Chapter 14).

- **It is best not to lacquer prints.** None of the currently available print lacquers can be recommended without reservation. Likewise, surface-texturing finishes, such as McDonald Pro-Texture, should be avoided. If a protective surface coating is needed (e.g., with large display prints where framing under glass may not be practical), pressure-sensitive laminating films made by Coda, Inc. and MACtac Permacolor are recommended by this author (see Chapter 4). Laminates must be applied after retouching and spotting are completed. With the recommended papers for printing color negatives, no worthwhile benefit is gained from ultraviolet-filtering lacquers or laminating materials; likewise, 3M Photogard offers no additional protection against fading and may in fact cause prints to fade even more rapidly.

- **If a lacquer must be used:** Lacquer-Mat lacquers and the Sureguard McDonald Pro-Tecta-Cote 900-series non-cellulose

nitrate lacquers introduced in 1992 are recommended (see Chapter 4, where addresses of suppliers are also given). With the recommended color papers, no worthwhile benefit is gained from the use of UV-absorbing lacquers.

- **Do not emboss, texture, or canvas-mount prints.** Prints should not be pressure-textured or split through the core for canvas mounting. Either of these operations can cause emulsion and/or RC base cracking, thereby shortening the life of a print.

- **Retouching and spotting:** For wet-brush retouching of color negative print papers, use only Kodak Liquid Retouching Colors. For dry (steam-set) application, use only Kodak Retouching Colors (dry). All other retouching colors on the market should be avoided since the long-term effects of these products on color papers are unknown. Retouching with colored pencils is not possible without first applying a matte "retouch" lacquer to accept the pencil colors, and therefore this method is not recommended.

- **Framing techniques:** Prints should be framed with an overmat to avoid direct contact with glass. An aluminum-foil or polyester-sheet vapor barrier should be placed between the print (or mount board if the print has been mounted) and the backing board in a frame. Prints should be framed under glass (see Chapter 15 for further discussion of framing). With the recommended color negative print papers, no worthwhile benefit is gained from UV-filtering materials such as KSH UV-filtering sheets or Plexiglas UF-3.

- **Wedding albums:** Wedding albums should have pages, or page inserts, made of uncoated polyester (such as DuPont Mylar D); acceptable alternatives are albums with open-frame pages with prints held under page overmats. Probably satisfactory are albums with pages made of untreated polypropylene. Polyvinyl chloride (PVC) and so-called "magnetic" self-stick pages should be strictly avoided, as should all albums made of cheap paper and other low-quality materials. If prints have been lacquered, open-frame, overmatted album pages should be used.

## Recommendations for Manufacturers

- **A high-stability, negative-printing silver dye-bleach print material** (e.g., a more stable, negative-printing version of Ilford Ilfochrome) is urgently needed. In dark storage such a material should be essentially permanent, with no fading or staining occurring in hundreds of years; on display the prints should be at least several times more stable than current Fujicolor SFA3 papers. Because top-quality professional portrait and wedding photographers could clearly differentiate themselves from cut-rate, mass-portrait operations by offering such a premium, high-stability product, a print material of this type would almost instantly find a huge market in the professional photography field.

- **A proven-safe print lacquer is needed.** A print lacquer that is harmless to Ektacolor, Fujicolor, Konica Color, Agfacolor, and other chromogenic prints, even when the lacquer is applied in high-humidity conditions, is urgently needed. The lacquer itself should be stable and not yellow upon prolonged exposure to light; the lacquer should be supplied in glossy, semi-gloss, and matte formulations.

pinks, reds, and purples) than any other color negative paper. (In a practical sense, the color reproduction differences between current Kodak, Konica, and Agfa papers are now so small as to be almost undetectable visually.)

Future competition among papers for printing color negatives will focus on three issues: image stability (especially light fading stability), color reproduction, and price. Kodak is currently at a disadvantage in all three areas.

As shown in **Figure 8.1**, in recent years Kodak has made no significant improvements in the light fading stability of Ektacolor papers. Tests indicate that although the dark fading stability of Ektacolor Professional and Ektacolor Plus papers is much improved over Ektacolor 74 RC and previous Ektacolor RC and fiber-base papers, current Ektacolor Professional, Ektacolor Plus, Ektacolor Portra II, and Ektacolor Supra papers have light fading stability that is only slightly better than Ektacolor 37 RC Paper, introduced in 1971 — more than 20 years ago!

Photographers should try to keep abreast of current information in the field. As professional photographers have more clearly made their needs known, significant competition has developed among Konica, Fuji, Kodak, and Agfa in terms of improving the stability of their respective color papers.

Indeed, this author's current recommendation of Fujicolor papers could change abruptly if Kodak, Konica, or Agfa were to introduce a substantially improved paper for the professional market. But for now, offering color prints on Fujicolor paper can be a definite competitive advantage over studios that stay with Ektacolor paper because, given the option, virtually everyone wants their displayed color prints to last as long as possible.

## H&H Color Lab Switches from Ektacolor to Fujicolor Paper After a Survey of Its Customers Shows Strong Support for the Change

Some labs may fear a loss of business if Kodak paper is abandoned for the superior Fujicolor papers. Photographers may worry that they also could lose business if they stop offering prints on Kodak paper — indeed Kodak's massive advertising campaigns for Ektacolor paper on TV and in magazines and newspapers play on that very fear. But there should be little difficulty in convincing customers that Japanese papers are better than Ektacolor paper. Americans have come to expect superior quality in Japanese products, whether they be cameras, consumer electronics, automobiles, or the many other quality products that Japan is known for.

H&H Color Lab, a leading professional portrait and wedding lab located near Kansas City in Raytown, Missouri,[19] made the change from Ektacolor paper to Fujicolor paper in 1991 after making a detailed study of the comparative merits of each product and conducting a survey of the lab's customers to get their views on the matter.

Despite being convinced that Fujicolor paper was not only a much longer lasting product than Ektacolor paper, and that Fujicolor paper also had visibly superior color and tone reproduction, H&H president Wayne B. Haub was concerned that switching to Fujicolor paper might cause his photographer customers to lose some business, and that this in turn could result in a loss of business for his lab.

February 1992

Wayne B. Haub, president of H&H Color Lab, Inc.

If H&H decided to drop Ektacolor paper, Kodak would prohibit photographers using H&H Color Lab from participating in Kodak's "For the Times of Your Life" promotional program, even if the photographer continued to use Kodak color film.[20]  Wrote Haub in a cover letter that accompanied the H&H survey:[21]

Since the introduction of color into portrait and wedding photography, Kodak has been the undisputed leader in the industry and has become synonymous with quality.  Therefore, many times we have not even considered alternatives and in actuality have limited our choices because of this mindset.  But, in the past decade technology has progressed in quantum leaps in all areas, including the science of emulsion manufacturing.  From the results of our findings, we believe that for the first time in our industry there exists a real choice between chromogenic color paper manufacturers in relation to quality, price, and permanence.

Accompanying the survey sent to H&H customers was an information packet describing the longer life of the Fujicolor prints and a set of matched prints made with both Ektacolor Portra and Fujicolor professional papers.  Of those that responded to the survey, more than 90% voted for changing from Ektacolor to "the longest-lasting paper available."  According to H&H, "an overwhelming majority were pleased with the extended display permanence of the Fuji product . . . and felt the time long overdue to address this important issue."  (See **Appendix 8.5** on page 298.)

In January 1991, H&H switched most of its color print production to Fujicolor paper and, according to Haub, the response among his customers has been very enthusiastic.  In a letter written to H&H,  Mac McKinley of Customcraft Photography in Slidell, Louisiana said:[22]

We received a Profit Pack wedding from H&H last Friday — on the new Fujicolor paper.  Fantastic color!!  We compared the pix with a recent wedding shot in the same church, with the same lighting, done on Ektacolor by your lab — what a tremendous improvement!!  This paper

is superior to Ektacolor, even if it had the same display life.  The bride and groom picked up the album on Saturday and — with no coaching from us — perceived a significant difference in the color saturation and contrast between their wedding pix and our display albums on Ektacolor.  We are now hoping for an early phase-in of the *Super* FA paper in all departments of your lab.  Thanks for taking such good care of your customers (and *our* clients)."

Another H&H customer, Paul McMillian of Van Deusen Photography in Kansas City, Missouri, said:[23]

Since I have been experiencing a problem with my window display prints fading after only a couple of months of display exposure to strong daylight, I was very interested to hear of the Fuji paper's resistance to fading.  Being from the "Show Me" state, I am truly one that must see the results for myself!  I displayed a set of test prints in my southern exposure solarium for several months.  No contest!  The Fuji paper is clearly the longer lasting material, especially when you compare skin tones — the Fuji prints retain their natural look much better.

Commented David Lee of Photography by Lee in Washington, Illinois:[24]

It [Fuji Super FA paper] seems to have excellent contrast without losing shadow detail.  The color is richer with the Fuji paper.  Recent weddings done at churches where earlier work looked dark and muddy, now look brighter and richer . . . a superior product.  I'm thrilled.

H&H was the first major professional portrait and wedding lab in the U.S. to switch from Ektacolor to Fujicolor paper.  H&H president Wayne B. Haub reports that since making the change, business has steadily increased and that the lab has even been forced to temporarily turn away some new customers to keep the lab from expanding so fast that service and product quality might be compromised.  Haub commented to this author that if he decided to change back to Ektacolor Portra II Paper, there would be far more resistance among his customers than he encountered in 1991 when H&H made the change to Fujicolor paper.  Haub says that providing his customers — and their clients — the best and longest-lasting product is simply "the right thing to do."

Haub, who, along with H&H lab manager Ron Fleckal, has made print quality and customer service almost an obsession at the lab, says that the lower cost of Fujicolor paper has allowed H&H to offer its customers a number of services that it was unable to provide in the past and still maintain a competitive price structure.

But, Haub added, if Kodak were to introduce a new Ektacolor paper that had better permanence and image quality than Fujicolor paper, he would promptly switch back to Kodak, despite the higher cost of Kodak's products.

H&H film technician Darryl Owens with rolls of 220 Vericolor and Fujicolor color negative films that have been processed in a Sitte Tischer Divomat MX-24 dip-and-dunk processor. For protection against scratches, dust, and fingerprints, all film is sleeved immediately after processing (films remain sleeved during analyzing and proofing).

October 31, 1990 (4)

Prior to proofing and printing, each negative is coded and carefully video analyzed with the color balance and density values entered into a networked Digital Equipment Corporation VAX computer system running Kodak Accudata software. When the negative is proofed and later printed, the data are used to control printer filtration and exposure times. Shown here is operator Graciella Marshall with a Kodak PVAC Video Analyzer. H&H also uses Bremson Data Systems CVIS digital video analyzers. Proof prints are individually backprinted with the studio name and date, H&H order number, roll and frame number, and negative density and color filtration values.

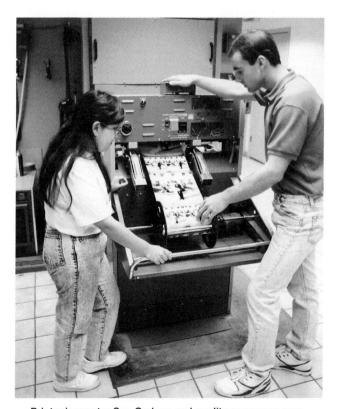

Printer operator Lea Bass printing orders on a Lucht V-7 multi-lens package printer. The daylight printer is loaded with 575-foot rolls of 10-inch Fujicolor paper. H&H also has enlarger stations for prints where custom cropping, dodging, burning, and precise color balance are required.

Printer inspector Sue Cadena and quality assurance manager Rob Newbanks checking Fujicolor prints coming off a Pako Leader Belt Processor Model 2140 which has been modified to run the RA-4 process. H&H uses Fuji-Hunt processing chemicals throughout the lab.

*( H&H Color Lab continued on next page )*

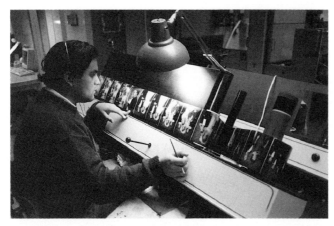

Steve Valenzuela, print spotter/inspector at H&H, checking prints prior to cutting and packaging. All prints from 120/220 negatives are routinely dust-spotted (retouched to remove small dust spots).

H&H devotes considerable effort to make sure all the prints it produces have pleasing color balance and density and are free of dust spots and other imperfections; prints that do not meet H&H's standards are remade. Print inspector Chandra Wilper checks wedding prints prior to packaging and shipping.

Extensive retouching, air brush work, and hand coloring and repair of restoration copies of faded and damaged originals is done for an hourly charge. Artists Dee Myers and Myrna Gamble work on large prints in the retouching department. Negatives can also be retouched to remove blemishes, soften facial wrinkles, etc. As is the case with most wedding and portrait labs, H&H customers usually request lacquering on larger-size prints.

Like most large professional labs, H&H uses computers throughout its operation for order tracking, printer control, pricing, etc. Shown here is quality assurance manager Robert Newbanks with the lab's Digital Equipment Corporation VAX central system. In 1992, the lab began using a high-end Apple Macintosh computer system with a Kodak XL 7700 thermal dye transfer printer for restoration of faded and damaged photographs.

Boxes of Fujicolor professional paper. H&H was the first major professional portrait and wedding lab in the U.S. to switch from Ektacolor paper to Fujicolor paper.

October 31, 1990 (5)

## The Fading Problem Started with the Conversion from Black-and-White to Color

In the mid-1960's, portrait and wedding photographers began the large-scale conversion from black-and-white to color photography. The shift to color had greatly accelerated by the beginning of the 1970's, and by 1975 nearly every studio in the U.S. had changed to color photography. At the time, few photographers realized that in promoting color — and abandoning fiber-base black-and-white prints — they were also giving up a very long tradition of essentially permanent images. Almost none of their customers were aware of the fact that the Ektacolor prints they were buying and displaying would in many cases not survive in acceptable condition for even 5 years. The extremely stable silver image of a properly processed fiber-base black-and-white print was displaced by a very unstable dye image subject to rapid fading when exposed to light on display — and the color prints gradually faded and yellowed even when kept in the dark.

Kodak set the stage for the conversion of the portrait and wedding industry to color when it introduced Ektacolor color negative sheet film in 1947. At that time Kodak would not sell color paper on the open market, so users of the new color negative film had to make prints by the Dye Transfer process. In order to maintain a monopoly in the lucrative Kodacolor amateur processing business, Kodak sold Kodacolor film with processing and printing included in the price; as a result, it was not necessary — nor in Kodak's interest — to sell color printing paper and processing chemicals in the retail market.

As a consequence of antitrust action initiated by the independent photofinishing industry, however, Kodak in 1955 signed a federal court consent decree compelling the company to start selling Kodacolor film without processing included, and to make color paper and chemicals commercially available. Kodak Color Print Material, Type C was introduced in August 1955 (the name was changed to Kodak Ektacolor Paper in May 1958).

In 1963 Ektacolor film, which by then closely resembled Kodacolor amateur film, was introduced in 120 and 620 rolls to supplement the sheet-film formats and, along with the establishment of large photofinishing labs such as Meisel Photographic Corporation of Dallas, Texas, the field rather quickly evolved into the color portrait and wedding business as we know it today.

Even though Ansco had been a leading supplier of black-and-white films and paper to professional photographers, and also had supplied some color materials to the portrait and wedding profession in the form of Ansco color transparency films and Ansco Printon reversal print materials (both of which the user could process), the company quickly lost out when Kodak Ektacolor films and papers became available. The demise of Printon — a material noteworthy for its exceedingly poor light fading stability — was no loss to the field.

Kodak's introduction of Vericolor II film, and the companion C-41 process, in 1972 spelled the end of Ansco's involvement in the professional studio business. The company (which in its later years went under the GAF name) dropped out of photography altogether in the mid-1970's, leaving Kodak with a virtual monopoly in this branch of photography. Commenting on the introduction of Vericolor III in 1983, one writer said:

> The [wedding and portrait] "people market" is predominantly Kodak Vericolor. Kodacolor barely accounted for 1%. Surveys of big "people" labs revealed that the 120 negative market appears to be holding, with an increase in the 220 long rolls, particularly where labs can offer processing without looping. This is a market that is almost 99 and $^{44}/_{100}$ percent pure Kodak. A few labs reported seeing a slight increase in Fuji film, but Fuji 120 is primarily sold in small quantities over-the-counter and does not make its way to the pro labs.[25]

The film picture in the United States remained pretty much the same at the time this book went to press in 1992; Vericolor III and Vericolor 400 films were used by the majority of professional portrait and wedding photographers, although Fuji was beginning to make serious inroads into the market with Fujicolor HG 400 Professional Film (often called Fuji NHG 400 film) and Fujicolor Reala Film.

## Kodak's Policy of "One Paper for All Needs" and Why Professionals Ended Up with Poor-Stability Color Papers Designed for Low-Cost Drugstore Photofinishing

When it was introduced in 1955, Kodak Color Print Material, Type C was essentially the same material used by Kodak in its own photofinishing labs to produce Kodacolor prints. This marked the start of Kodak's supplying the professional trade with print materials in which virtually every aspect of their design was dictated by the price, processing speed, and other competitive requirements of amateur snapshot photofinishing — a segment of the business that consumes far more color paper than professional portrait and wedding photography.

The number of prints produced by the amateur photofinishing industry is awesome. A single large photofinisher, Fox Photo, Inc. of San Antonio, Texas, reported in 1986 that its 20 wholesale photofinishing plants *daily* made more than 2 million Ektacolor prints. Said Fox, "We are proud of the part we have played in the preservation of the memories of our nation and its people." (In 1986, Fox Photo, which has used Kodak paper since its founding in 1905, was offered for sale and was quickly purchased by Eastman Kodak for $96 million, apparently to ensure that Kodak would remain the sole color paper supplier to Fox's photofinishing labs. In 1987, Kodak sold the retail division of Fox back to the previous president of Fox, Carl D. Newton III, for an undisclosed sum; Kodak retained the wholesale labs and they are now a part of Qualex, Inc. — a joint venture between Kodak and Fuqua Industries that is 49% owned by Kodak and 51% owned by Fuqua.)

Kodacolor prints made before 1953 had extremely poor light fading stability and rather quickly developed severe yellow-orange stains whether stored in the dark or placed on display, and Kodak apparently thought that the stability of this product was inadequate for the professional market. Dye Transfer has been available since 1946, but the high

cost and complexity of making Dye Transfer prints kept the demand for the process very small.

Once the Kodacolor staining problem was solved to Kodak's satisfaction, and after the 1955 federal court consent decree forced Kodak to make color paper and processing chemicals commercially available, Kodak proceeded to sell Ektacolor paper in portrait and wedding markets. (Although less severe than it once was, yellowish stain formation during storage is still a problem with current Ektacolor Portra II and other Ektacolor papers; it has the same root cause — staining of unreacted color couplers, principally the magenta dye-forming couplers — as the stain that afflicted the early Kodacolor papers.)

Although there were a number of Ektacolor papers produced during the 1960's — they differed mostly in sensitometric characteristics — the introduction of Ektacolor 37 RC paper in August 1971 finally solidified Kodak's policy of having only one negative-positive color paper for all applications. This continued through the introduction of Ektacolor 74 RC Paper in April 1977 and remained the general Kodak policy until the introduction of Ektacolor 78 paper in 1979. Ektacolor 78 paper was somewhat higher in contrast than Ektacolor 74 RC; however, with respect to image stability, processing characteristics, etc., the two papers were identical. (By the time Ektacolor 78 was introduced, it and virtually all other color papers were on an RC base, and Kodak no longer felt it necessary to include RC in the product name.)

Professional portrait labs for the most part continued to use Ektacolor 74 RC while gradually, over a period of a few years, many amateur photofinishers and some commercial photographers began using Ektacolor 78 paper because its higher contrast provided more "snap" and somewhat higher color saturation. The reasons for this are that small prints often look better with increased contrast and that low-cost amateur cameras have lower-quality and often dirty lenses, both of which tend to reduce the contrast of the color negative image. On the other hand, high-contrast images tend to suffer from loss of both highlight and shadow detail and frequently have a somewhat "harsh" appearance. During the early 1980's, Kodak apparently used the two papers interchangeably in the company's chain of amateur photofinishing labs (Kodak Processing Laboratories).

## The Differences Between Ektacolor "Professional" and Ektacolor "Amateur" Photofinishing Papers

When Ektacolor 78 paper was replaced by Ektacolor Plus paper in 1984, Kodak promoted the new paper primarily as an *amateur photofinishing* product. Ektacolor Professional Paper, the replacement for 74 RC paper, followed about a year later, in June 1985, and this paper is clearly identified by Kodak as a professional portrait/wedding product. Although targeted at different markets, the two Ektacolor papers have identical stability characteristics (while much improved in dark storage dye stability compared with the Ektacolor 78 and 74 RC papers they replaced, the new Ektacolor papers are only *slightly* better in terms of light fading stability).

The only difference between Ektacolor Professional and Ektacolor Plus papers is their sensitometric properties. Stated simply, Ektacolor Plus is about 12% higher in con-

trast than Ektacolor Professional Paper. Logically, the papers could have had the same name, with contrast number designations to distinguish them, as is the usual practice with black-and-white papers.

With the introduction of the faster-processing RA-4 papers, the picture got a little more complex: Ektacolor Edge paper (formerly Ektacolor 2001 paper) is sold in photofinishing markets, while Ektacolor Portra II paper, a low-contrast "professional" product, is supplied for portrait and wedding photography. Kodak also produces higher-contrast Ektacolor Supra (similar in contrast to Ektacolor Plus paper) and the even higher-contrast Ektacolor Ultra paper for the commercial lab market. (Basically these three "professional" Ektacolor papers are simply low-, medium-, and high-contrast versions of the same paper. Were it not for Kodak's desire to segment the market, the three papers would have been supplied the same way black-and-white papers are: with one product name and three contrast grades.) Ektacolor Portra II, Supra, and Ultra all have "Kodak Professional Paper" printed on the backside. In addition, for the minilab market, there is Ektacolor Royal II Paper, which is made with gold-colored backprinting and a somewhat thicker RC base.

Regardless of what name Kodak has given the papers, *all* of the Ektacolor RA-4 papers that were available at the time this book went to press in 1992 had essentially identical light fading and dark storage stability characteristics.

Following Kodak's example, other manufacturers have similar high- and low-contrast versions of their color papers and have also designated their low-contrast products as "professional" papers. Fuji makes Fujicolor Paper Super FA Type 3 and, in 1993, Fuji will introduce low-contrast Fujicolor SFA3 Professional Portrait Paper (tentative name) as an improved-stability replacement for Fujicolor Professional Paper Super FA Type P. Fuji also supplies a higher-contrast paper called Fujicolor Professional Paper SFA3 Type C for commercial labs, and gold backprinted Fujicolor Supreme Paper SFA3 for the minilab market.

Konica markets its products as Konica Color QA Paper Type A3 and Konica Color QA Paper Professional Type X2. Agfacolor Type 9 is currently supplied in a single grade only; the contrast of Type 9 paper falls between that of Ektacolor Portra II paper and Ektacolor Supra paper.

## The Differences Between Process RA-4 and Process EP-2 Compatible Papers

Ektacolor 2001 Paper, the first of the rapid-processing RA-4 papers, was introduced in 1986 as a replacement for Ektacolor Plus Paper in the expanding minilab market (RA stands for "rapid access").

The principal difference between the old and new types of color negative papers is that Ektacolor Edge (originally Ektacolor 2001), Ektacolor Portra II, Fujicolor SFA3, and other RA-4 compatible papers use silver chloride as the light-sensitive silver halide, whereas Ektacolor Plus Paper, Ektacolor Professional Paper, and other process EP-2 compatible papers employ silver bromide. Silver chloride allows faster processing, particularly in the bleach-fix step. Dry-to-dry processing times for RA-4 papers can be under 4 minutes — less than half the time required for the standard EP-2 process. For large operations, the significance

of the decreased processing time is not so much that any particular print is processed more rapidly, but that *twice* the amount of paper can be processed on a machine in a given amount of time, thereby reducing capital equipment costs.

Even faster processing times for silver chloride papers are likely to become common in the future. For example, Agfa has reported an experimental process with a *total* processing time of only 30 seconds!.

Historically, pure silver chloride emulsions were found primarily in slow-speed black-and-white contact papers; while it has long been known that silver chloride emulsions could be processed more rapidly than silver bromide emulsions, it was only since the mid-1980's that silver chloride emulsions were perfected that were both fast enough and had sufficiently good latent image keeping characteristics to be suitable for color enlarging papers.

RA-4 papers also do not require that the color developer contain benzyl alcohol (necessary with the EP-2 process), and this allows much more rapid mixing of the developer concentrate with water to make a working solution.

By the end of 1994, RA-4 compatible papers from Kodak, Fuji, Konica, and Agfa will likely have largely displaced EP-2 compatible papers.

A 1989 Kodak advertisement for Ektacolor 2001 Paper described a number of advantages this paper and the RA-4 process offer over the older Ektacolor Plus Paper (and, by implication, the lower-contrast Ektacolor Professional Paper) and process EP-2:

> How many reasons do you need to switch?
> Take your pick. There are a lot of good reasons for converting to Ektacolor 2001 paper and process RA-4.
> Like the advantage of processing prints in half the time required with yesterday's technology.
> Not that you have to sacrifice quality for speed. In fact, with this combination you get even brighter whites, more brilliant highlights, richer colors, and unsurpassed image stability.
> But the greatest temptation could be new production efficiencies. For instance, greater quality control with increased process stability and outstanding emulsion uniformity. And consider the savings with decreased mixing time and replenishment rates.[26]

With the introduction of Konica QA Paper Type A in early 1988, Konica became the second company after Kodak to market an RA-4 compatible paper (QA stands for "quick access"). Mitsubishi sells Konica QA paper under its own label — called Mitsubishi Color Paper SA (SA stands for "speed access"); the paper is also known as Mitsubishi Rapid Access Paper.

Agfa introduced its Agfacolor Paper Type 9 later in 1988, and Fuji began selling Fujicolor Paper Super FA (FA stands for "fast access") in 1989. Agfa, which historically has offered color papers in only one contrast grade, will in the future probably follow the practice of its competitors and market two or more versions (contrast grades) of Agfacolor paper. (At the time this book went to press in 1992, Agfa did not yet have a "professional" color paper.)

## The Stability of Current Ektacolor Papers Is Still Far from Adequate

The design, processing, cost, and image stability of current Ektacolor papers are still dictated by the requirements of the amateur photofinishing field. Because of increased competition from Fuji, Konica, and Agfa, the constraints imposed by the amateur photofinishing market probably have even more influence on Kodak today than they did when Kodak Color Print Material, Type C was marketed in 1955. Given this situation, it is not surprising that the Ektacolor papers which have evolved over the years have proved so inadequate in terms of image stability. Especially in terms of light fading stability, current Ektacolor papers fall *far* short of the needs of professional photographers.

Indeed, the typical customer buying an expensive professional portrait, or spending more than $1,000 on a set of wedding photographs, would be quite disillusioned to learn that the stability of the prints she or he receives is no better than that of the low-cost Kodalux prints, formerly known as Kodacolor prints, available at the local drugstore. (Kodacolor prints were made by Kodak on Ektacolor paper — there has not been a "Kodacolor" paper for many years.) Worse still is the knowledge that the extensive retouching, lacquering, texturing, and canvas mounting commonly given professional prints can all further reduce the stability of an already inadequate product. Because 35-cent drugstore Kodalux prints have been spared these "image enhancement" treatments, they are almost certain to be *more* stable than professional studio prints!

## Why Prints Made by Mass-Portrait Operations Are Likely More Stable Than the Most Expensive Prints Sold by Well-Known Professionals

Color prints currently supplied by mass-portrait companies such as PCA International, Inc., CPI Corporation (which operates studios in Sears Roebuck retail stores), Olan Mills, Inc. (which has more than 1,100 portrait studios in the U.S. and Great Britain), American Studios, Inc. (which services many Wal-Mart discount stores), and Lifetouch, Inc. are also likely to be more stable than the more expensive prints sold by traditional studios. These prints are rarely lacquered, and retouching, if done at all, never exceeds simple dust-spotting. Olan Mills, having dropped Ektacolor paper in 1988, now uses Konica color paper in its labs. (In this author's long-term light fading tests with critical neutral gray and flesh-tone colors, Konica EP-2 and RA-4 papers proved superior to their corresponding Ektacolor papers, and the Konica papers were also better in dark fading stability.) CPI Corporation uses both Konica and Fujicolor papers in its labs.

Even prints produced in minilab-equipped "one-hour" portrait studios that are rapidly emerging as competitors to the serious studio professional are likely to have better image stability than the far more expensive prints sold by traditional studios. This is particularly true in the case of photographers using Konica minilabs because the papers normally supplied for these minilabs have better light and dark fading stability than Ektacolor papers.

At the time this book went to press in 1992, most of the

high-quality "people labs" supplying the professional wedding and portrait business were still using Kodak papers exclusively, and this too has become a disadvantage to the professional photographer.

## Kodak's R&D Efforts Have Been Stymied by the Company's Fear of the Stability Issue

After discussing Kodak's "single-color-paper-for-all-needs" policy with Kodak officials and many others in the photographic industry, it has become quite obvious how this unfortunate state of affairs came about. To date Fuji, Konica, and Agfa have followed Kodak's example, and none offers a premium, high-stability color paper for professional needs.

The problem actually began more than 50 years ago, with the introduction in 1935 of Kodak's first successful color film, Kodachrome film. For the next 45 years, Kodak kept a tight cloak of secrecy on the stability characteristics of *all* of its color products.

In the early 1940's, when Kodacolor was displacing black-and-white films in the amateur field, and later, when Ektacolor was doing the same in the portrait and wedding business, Kodak was loath to reveal information about color stability out of fear that to do so would discourage customers from switching to the more expensive and profitable color materials. Later, when Ektacolor paper was firmly established in both amateur and professional markets, Kodak did not want to say anything that would give customers in either market reason to question the quality of the product. In spite of the fact that the portrait and wedding markets are big business, by far the largest market for Ektacolor paper is amateur photofinishing.

The way the situation evolved, it would do the company no good to produce a premium, high-stability print material because Kodak's policy of keeping stability data secret would effectively prevent advertising the stability advantages of such an improved material. Because a more stable print material would be more expensive and/or more difficult to process than existing Ektacolor paper, Kodak would be unable to justify the existence of the product if it could not talk about its major virtue: improved stability. And it would be difficult to discuss the stability of one product without talking about them all.

By 1986 it was evident that research and development at Kodak was falling behind both Konica and Fuji in terms of color paper image stability, and with the 1989 introduction of Fujicolor Paper Super FA, Kodak had clearly lost its long-standing leadership position to Fuji. Kodak fell even further behind when Fuji introduced the Fujicolor SFA3 papers in 1992. Kodak has lost the lead not only with papers for printing color negatives but also with process R-3 papers for printing transparencies: both Fujichrome Type 34 paper, introduced in 1986, and Fujichrome Type 35 paper, introduced in 1992, have much better light fading and dark storage stability than Kodak's Ektachrome Radiance and Radiance Select papers, which were introduced in 1991.

## A Premium-Quality, High-Stability Color Paper is Urgently Needed

A number of things can be done to improve the situation for wedding and portrait photographers, as suggested in the **Recommendations** section on pages 279 and 280 of this chapter, but the only real solution is the introduction of new negative-positive color print materials with greatly improved light fading stability. Today's Ektacolor Professional and Ektacolor Portra II papers — and even the new Fujicolor SFA3 papers — are simply not adequate for the requirements of professional photography. These papers, all of which were designed primarily for drugstore photofinishing, have never been adequate. At the very least, a color print material designed for printing color negatives should be essentially permanent when stored in the dark at room temperature. This means not only that the image dyes must not fade over time but also that the prints remain completely free of yellowish stain formation so that whites and delicate highlights retain their original brilliance. When exposed to light on display, the material should be *at least* ten times more stable than the current Ektacolor Portra II Paper. Indeed, the light fading stability of Ektacolor papers has seen little improvement over the past 20 years, and it is *poor light fading stability* that is the major shortcoming of these products.

The greatest concern for the professional photographer is to deliver the most stable color prints possible to the customer. Stable prints reduce the likelihood that a print will be returned in faded condition by a disgruntled customer demanding a free replacement, and, more importantly, mean that the photographer's reputation for top-quality work will not suffer. Few people who have purchased an expensive portrait or family group photo only to find that 5 or 10 years later it has lost its vivid colors, sparkling highlights, and rich, deep shadows will be inclined to give the photographer more business. Faded prints mean loss of repeat business, and this will affect the serious studio professional far more than the low-cost, anonymous mass-portrait operations like PCA International or the CPI Corporation studios in Sears Roebuck stores.

## A More Expensive, High-Stability Color Paper Will Clearly Differentiate the Serious Studio Photographer from the Mass-Portrait Operations

For the serious studio photographer, who may sell a 30x40-inch family portrait for $500 or more, the percentage cost of the color paper to make that portrait is very small. If the cost of a high-stability color paper were to be even several times that of Ektacolor paper, the price impact on the finished print would be minimal (proofing could continue to be done on Fujicolor, Ektacolor, or other low-cost paper). Almost anyone spending $500 for a portrait would be willing, indeed happy, to spend an additional $20 or $25 for a print that they knew would last far longer on display.

Today's more sophisticated consumer looks for quality and value in everything he or she buys, and is willing to pay more to get it. *Image stability* is a key aspect of photographic quality, and after 10 or 15 years of display in the customer's home, image stability will be *the* most important aspect of quality. The photographer's reputation will rest on it.

It is difficult to think of any other type of product where the public is offered but a single quality level. There are inexpensive, utilitarian cars like the Ford Escort and the General Motors Geo; a wide variety of cars are available in

the middle price range; and those who want the best purchase a Mercedes-Benz, BMW, Lexus, Jaguar, Cadillac, Lincoln, or other top-of-the-line vehicle. There are expensive refrigerators and cheap ones. Shoes and clothing come in all price and quality levels. Kodak and the other manufacturers have premium-quality, fiber-base black-and-white papers to complement their less expensive and less stable RC papers, and there is no reason why color photography should not offer a range of price/permanence options.

The availability of a premium, high-stability paper would in the eyes of the public clearly differentiate the serious professional from the mass-market portrait operation. Mass-market companies likely could not afford a significantly more expensive color paper: the low prices paid for their prints, coupled with the large numbers of package prints that are made on speculation but never picked up by customers, make their costs for color paper a comparatively large percentage of their operating expenses.

By not supplying the portrait and wedding business with a special, premium-quality, and high-stability color print paper, Kodak and the other manufacturers have done a major disservice to the photography profession — and to the general public.

Notwithstanding the headline used by Kodak in a series of magazine and newspaper advertisements that began running in 1988 and was continuing in 1992, "A Professional Portrait Isn't Expensive. It's Priceless," Kodak is saying to professional photographers — and to their customers — that expensive professional color photographs deserve nothing better than the Ektacolor paper used to make the lowly 35-cent drugstore Kodalux (Kodacolor) print.

### Ilford Ilfochrome and Kodak Dye Transfer Are Not the Answer to the Fading Problem

Nearly all professional portraits and wedding photographs are made with color negative films because of their superior tone reproduction (the ability to retain both highlight and shadow detail) and their very pleasing flesh-tone reproduction. Prints made from color negatives usually have better overall color quality with lower, more pleasing, contrast than prints made from color transparencies.

Negative films also have far wider exposure latitude than transparency films, and prints made from color negatives are much easier to retouch (scratches and dust spots print lighter than the image) than are color prints made from transparencies, where dust and other defects print darker than the image. These and other advantages of the color negative-positive system in the portrait and wedding field effectively rule out such alternatives as silver dye-bleach Ilford Ilfochrome prints (called Cibachrome prints, 1963–91), which must be made from transparencies. Making an "interpositive" from an original negative and then making an Ilfochrome print from the interpositive not only is expensive but usually gives unsatisfactory results.

Using presently available equipment, it is of course possible to digitize color negatives with a high-resolution scanner and, using electronic reversal to achieve a positive image, output the images on current Ilfochrome silver dye-bleach paper. To make prints from color negatives in this manner would add significant cost to their production and, in any event, the light fading stability of Ilfochrome prints is not

as good as that of Fujicolor SFA3 paper.

Kodak Dye Transfer prints also are inferior to Fujicolor SFA3 prints in terms of light fading stability, and this, coupled with the high cost of Dye Transfer prints, makes them ill-suited for most wedding and portrait applications.

At present, this leaves only the chromogenic print papers such as Fujicolor, Ektacolor, and similar papers made by Konica and Agfa for printing portraits and wedding photographs from color negatives.

### A Silver Dye-Bleach Color Negative Print Process Offers the Best Hope for a Reasonably Priced, High-Stability Color Paper

This author believes that a negative-printing silver dye-bleach paper, similar in concept to Ilford Ilfochrome (called Cibachrome, 1963–1991) except that prints are made from color negatives instead of transparencies, offers the best hope for producing premium-quality, reasonably priced, and easily processed color prints with a substantial increase in light fading stability. Ideally, one would want the light fading stability of such an improved paper to be at least ten times better than that of Ektacolor Portra II and other Ektacolor papers — and this means that the new paper would also have to be much more stable on display than Fujicolor SFA3 paper or Ilfochrome materials.

A major advantage of a negative-printing silver dye-bleach paper is that, when made with a polyester base instead of a less stable and lower cost RC base, it would be genuinely *permanent* when kept in albums or elsewhere in the dark; in normal room-temperature storage, the prints probably would last for more than 500 years without fading and would remain totally free of the yellowish stain that plagues Ektacolor prints in long-term storage.

The technology to produce a negative-printing silver dye-bleach paper has been available for some time: Ciba-Geigy actually demonstrated such a product (called Cibacolor paper) in 1963. In one of the most unfortunate marketing blunders in the entire 150-year history of photography, Ciba-Geigy was unable to recognize the importance of what its scientists had created, and the company's management decided not to commercialize the process.

In 1989 Ciba-Geigy, a huge Swiss pharmaceutical and chemical firm with operations all over the world, sold its Ilford photographic division (with its line of Ilfochrome products) to the International Paper Company, headquartered in Purchase, New York. There is now real hope that Ilford, under its new American owner, will do what Ilford's previous owners failed to do and will develop an improved, more stable, negative-printing version of Ilfochrome. According to Robert Fletcher, former president of Ilford Photo Corporation, "We are looking at how this might be accomplished, but it is much too early to say when such a product might actually become available."[27]

Although currently having no silver dye-bleach products, Agfa-Gevaert is another company with considerable expertise in this technology. Judging from the outstanding light fading stability of Agfachrome CU-410, a silver dye-bleach paper produced by Agfa in the early 1970's, an Agfa negative-printing silver dye-bleach product could be truly outstanding. The light fading stability of the Agfa product was considerably better than that of current Ilfochrome

materials (see Chapter 3.)

In 1982, at a conference of the Society of Photographic Scientists and Engineers held in Rochester, New York, Fuji of Japan gave a presentation on a new technology for negative-printing silver dye-bleach papers[28] and even showed a few color prints made by the process. Rumors about the process have surfaced from time to time, but nothing official has been heard from Fuji since the 1982 conference.

At one time even Eastman Kodak had a silver dye-bleach print material. Known as Azochrome, the material and associated processing chemistry were produced on a limited scale in the early 1940's. The Azochrome process, which was designed for making prints from color transparencies, was never actually marketed and Kodak abandoned silver dye-bleach technology in favor of the vastly inferior but less expensive and easier to process Kodacolor negative paper — the forerunner of today's Ektacolor paper. A number of beautiful Azochrome prints are in the collection of the International Museum of Photography at George Eastman House in Rochester, New York.

When a high-stability silver dye-bleach material for printing color negatives becomes available, a new era will begin for professional portrait and wedding photographers. Not only will they *finally* be able to offer their customers prints that look better than the low-cost Ektacolor prints supplied by their low-cost discount store competitors, but the silver dye-bleach prints will also be absolutely permanent when stored in the dark in albums and will last far longer than Ektacolor prints when displayed.

Most likely, proof prints will continue to be made with Ektacolor, Fujicolor, or similar inexpensive papers; only the enlargements ordered by customers would be printed on the premium-quality and longer-lasting silver dye-bleach material. The higher cost of the silver dye-bleach prints, while probably having relatively little impact on the prices asked of customers by top-quality professionals, will prove to be a significant competitive advantage because the print materials and processing will be too expensive for mass-portrait operations to make available in their low-cost print packages.

At some point in the future, an improved electrophotographic, ink jet, thermal dye transfer, or other direct digital process may offer a more cost-effective, high-stability alternative to a negative-printing silver dye-bleach material. But for now, all of these digital print processes fall short of what is needed in one or more of the following areas: color stability, pictorial image quality, speed of print production, print-size limitations, and cost.

### UltraStable Permanent Color Prints, Polaroid Permanent-Color Prints, and EverColor Pigment Prints: Premium Products for Upscale Markets

For premium-priced display applications, where the very best quality and truly permanent display prints are desired (and cost is a secondary consideration), UltraStable Permanent Color Prints, Polaroid Permanent-Color Prints, and EverColor Pigment Prints are the only choices available.

Unlike Fujicolor, Ektacolor, Ilfochrome, Kodak Dye Transfer, and other color prints that form images with organic dyes, permanent color prints employ extremely stable pigments that, for all practical purposes, do not fade. The

pigments are similar to those used in automobile enamels and other exterior paints.

According to estimates from this author's accelerated light fading tests, UltraStable Permanent Color prints (made with the improved yellow pigment to be introduced in early 1993) and Polaroid Permanent-Color prints are expected to last more than 500 years without perceptible fading or staining when displayed under normal indoor conditions.

These are the most permanent high-quality color prints in the 150-year history of photography — on display, they are *far* more stable than Ilfochrome or any other silver dye-bleach print material that has ever been produced. The prints should last at least as long — and quite possibly longer — than the best "archivally processed" and toned fiber-base black-and-white prints. In short, UltraStable Permanent Color prints and Polaroid Permanent-Color prints are absolutely in a class by themselves!

Permanent color prints can be made from original Fujicolor, Ektacolor, or other prints, or from color transparencies. Most commonly, photographers will supply the lab with a finished Ektacolor print (that has been carefully printed, spotted, and retouched), and a facsimile pigment print will be made from this original. Special high-resolution, laser-scanned color separations are employed in the production of the prints (the complete process, which is fairly complicated, is described in Chapter 1).

The materials and technology for producing these visually outstanding prints were originally developed by Charles Berger, a fine art photographer and inventor working in Ben Lomond, California. Berger and his associates (at the time operating as the ArchivalColor Company) licensed the process to the Polaroid Corporation in 1986, and Polaroid began supplying the cyan, magenta, yellow, and black pigment-coated sheets used to form the color image together with the white opaque polyester base material and basic printmaking instructions in 1989. (Polaroid is acting only as a supplier of Permanent-Color materials; the company does not offer a printmaking service. At the time this book went to press in 1992, only Ataraxia Studio, Inc., located in Bensalem, Pennsylvania, was utilizing the Polaroid-manufactured materials.)

Because of Polaroid's reluctance to continue research and development work on the process, Berger set up his own company, UltraStable Color Systems, Inc., in partnership with Richard N. Kauffman, to continue research on the color pigment process. Sold under the UltraStable Permanent Color name, Berger's new materials offer improved color and tone reproduction, faster and easier print production, and elimination of toxic chemicals from the process. UltraStable materials were introduced on a limited scale in 1991–92; with an improved stability yellow pigment, full availability of the materials was scheduled for early 1993.

EverColor Pigment Prints, supplied by the EverColor Corporation in El Dorado Hills, California, are made with a high-stability modification of the AgfaProof graphic arts proofing system. EverColor plans to introduce the high-resolution, polyester-base prints in early 1993. At the time this book went to press in 1992, this author had not had the opportunity to test the stability of the prints, but information supplied to this author about the structure of the prints and the pigments employed to form the color image sug-

David B. LaClaire – 1992

LaClaire Laboratories, Inc., a top-quality processing lab in Grand Rapids, Michigan catering to wedding and portrait photographers nationwide, planned to offer UltraStable Permanent Color prints in 1993 as a much longer-lasting alternative to the Kodak Dye Transfer prints that the lab has supplied for many years (see Note No. 29 on page 292). In 1991, LaClaire Laboratories switched from Kodak Ektacolor papers to Fujicolor papers because of the better image stability of the Fuji products. According to lab manager Bob Steenwyk, "As a lab, we have an ethical responsibility to offer our customers the longest-lasting prints we can." Shown here with a large family portrait printed on Fujicolor SFA3 paper are Steenwyk and lab technician Jim Nieboer.

gests that the stability of the prints will be very good. (Light fading and dark storage tests will be started as soon as production samples of EverColor prints become available.)

UltraStable Permanent Color prints and Polaroid Permanent-Color Prints initially will be quite expensive — $850 or more for the first copy of a 20x24-inch print.[30] Subsequent copies of a print cost much less. (While still expensive, EverColor Pigment Prints are not expected to cost as much). But even when the photographer's fees are added to the cost of the prints, possibilities will be good for sales in the "upscale" portrait, family group, wedding, executive "boardroom" portrait, fine art, and photo-decor markets. Permanent color prints will have great appeal to families and individuals as heirlooms that can be displayed and handed down for generation after generation.

Such prints are expected to be widely used for portraits of presidents, heads of state and other politicians, and entertainment celebrities — anyone of historical note. Labs planning to offer permanent color prints are listed in the **Suppliers** section on page 292.

With future development, the cost of making permanent, pigment color prints should decrease significantly,

thereby expanding the potential market to a much larger segment of the population.

## "Lifetime" Warranties for Color Prints

Burrell Colour, Inc., a professional color lab in Crown Point, Indiana with associated labs located in seven other states, is one lab that guarantees a free reprint for any color print that fails to last 100 years, whether displayed or not.[31] Burrell, which has used Ektacolor paper exclusively, began offering the guarantee to customers in 1986 even though, according to owner Donald J. Burrell, "all of our competitors think we are out of our minds — they think a lot of prints are going to be coming back."[32]

Burrell says that "we are banking on the idea that people won't put a print in bright light in front of a window and that if a print is hung in your living room, for example, we feel that most living rooms will be remodeled or redecorated within 7 to 10 years and during that time period the photograph will fade so slowly that you wouldn't even notice it. After that time period the person will take the photograph off the wall and put it into a drawer to save it

for history. Being in a dark area, it will last that long [100 years] and we don't see it as a problem. We took our lead from Kodak that the prints would last 100 years when we came out with that announcement."

Burrell knows that prints left on display for "maybe 20 years" will fade, but if they do, "send us the negative and we will reprint it at no charge." Arguing that "the photographer has to give his customer some type of insurance that somebody is going to stand behind a product that cost $200, or $300, or $400, or even $1,000," Burrell said that this is a form of advertising and should be seen as a "satisfaction guarantee" rather than an assurance that every print will actually last 100 years. Some years earlier Burrell offered a free-replacement guarantee for any print that failed to last 5 years,[33] and the effectiveness of that promotion encouraged him to expand the warranty when Ektacolor Professional Paper became available.

Burrell Colour requires that returned prints be accompanied by the original negative and a copy of the Burrell invoice (Burrell suggests that the customer tape the invoice to the back of the framed print to aid in identifying the photograph). Photographs must be "cared for properly" and not be physically damaged. Burrell has not specified how much fading qualifies a print for free replacement, saying that "this is left up to the customer." As part of the guarantee, Burrell will also spot, lacquer, and mount the replacement print in the same manner as the original, at no additional charge.

Most processing labs have been very cautious about print-life warranties, however. They fear that eventually they could be deluged with demands for free reprints. Meisel Photographic Corporation of Dallas, Texas, a large lab serving the commercial, portrait, and wedding markets, at one time offered an all-inclusive free-replacement guarantee for faded color prints. But after Bank Langmore, a professional photographer working out of San Antonio, Texas, asked Meisel to replace a large number of faded prints that he had sold some years earlier to the Minolta Corporation for display in the company's New Jersey headquarters, Meisel abandoned the free-replacement guarantee. According to Langmore, Meisel initially balked at honoring its guarantee for his prints (many of the prints were large and expensive), but he and Meisel eventually reached what Langmore called "a satisfactory settlement." Apparently sobered by that experience, in 1982 Meisel instituted a much more limited guarantee:

> Meisel will reprint at one-half the current price any print five years old or less that has faded severely, even if improperly displayed. Prints over five years old will be reprinted at full charge.[34]

This author believes that "lifetime" or "100-year" color print warranties are not a legitimate form of product promotion — unless customers are clearly informed that these are guarantees of *satisfaction* and are not misled into thinking that displayed color prints will in fact remain in good condition for 100 years. With the exceptions of UltraStable Permanent Color Prints, Polaroid Permanent-Color Prints, and EverColor Pigment Prints, they will not.

The customer *must* also be informed that if the photographer goes out of business, the studio changes hands, or the lab goes out of business or changes ownership, the guarantee probably will be worthless.

Offering a 100-year warranty does have some positive aspects: it likely will make a lab much more conscious of the stability characteristics of the color papers it uses, more careful with processing, spotting, and lacquering, and more receptive to color papers offering improved stability when they become available. A lab offering a 100-year free-replacement warranty is assuming a significant amount of liability (with current Ektacolor Portra II Paper, for example, *virtually all* prints that are displayed for "a lifetime" will end up severely faded), and this can only help increase the concern for product quality and product stability by both the lab and the photographer. A Burrell Colour promotional brochure describing the guarantee said: "The logistics of the Guaranteed for a Lifetime Program are relatively simple but the concept is far reaching. Our part is a total commitment to maintain utmost quality in our products. . . ." (It is worth noting, however, that at the time this book went to press in late 1992, Burrell, a long-time Kodak customer, was using Ektacolor Portra II Paper instead of one of the much longer-lasting Fujicolor papers.)

A photographer offering a lifetime free-replacement warranty has a real incentive to retain and properly care for negatives — and invoices — and this too is a positive aspect of the concept. Print fading aside, organized negative files also offer the potential of selling new prints to old clients when color materials with improved light fading stability become available in the future. Mass-portrait operations normally do not retain negatives for any length of time, and this fact can be turned into a competitive advantage for the established studio professional.

## Notes and References

1. Mrs. Sharla M. Stanclift, letter to the Office of Consumer Protection, Wisconsin Department of Justice, Madison, Wisconsin, May 16, 1980. This was one of a number of complaints about faded prints made on Ektacolor RC papers during the period 1969–1976 that was sent to the Office of Consumer Protection by customers of Fehrenbach Studios and other professional photographers in Wisconsin.

2. Nadine Brozan, "Natural Disaster: Hidden Legacy of Pain," **The New York Times,** June 27, 1983.

3. See, for example: Ellen Ruppel Shell, "Memories That Lose Their Color," **Science 84,** Vol. 5, No. 7, September 1984, pp. 40–47; John Rumsey, "Faded Photos May Cloud Kodak Future," **Times-Union** (Rochester, New York), February 29, 1980, p. 1; Richard Whitmire, "When Pictures Don't Last Forever – Kodak Goes to Great Lengths to Head Off Suit Over Fading Prints," and companion article: "Kodak's Ads Make Fewer Promises," **Times-Union,** November 14, 1980, p. 1; Allen Mundth, "Photographers Challenge Kodak Ads," **Wisconsin State Journal** (Madison, Wisconsin), Section 4, July 7, 1980; David Trend, "Kodak and the Pros – When Memories Get Returned," **Afterimage** (Visual Studies Workshop, Rochester, New York), Vol. 8, No. 6, January 1981; Stephen R. Milanowski, "Notes on the Stability of Color Materials," **Exposure,** Vol. 20, No. 3, Fall 1982, pp. 38–51.

4. Max E. Brown and Corinne R. Brown and Flaire Color Photography Incorporated (Plaintiffs) vs. American Professional Color Corporation and Eastman Kodak Company (Defendants), Case No. 54126, filed August 1976 in the Iowa District Court for Black Hawk County. A transcript of the court proceedings may be obtained from: Iowa District Court for Black Hawk County, Clerk of Court, 316 East 5th Street, Waterloo, Iowa 50703; telephone: 319-291-2482. See also: Bernice Fehrenbach and Robert J. Fehrenbach, d/b/a Fehrenbach Studios, Inc. and Robert Germann, d/b/a/ Germann Photographs (Plaintiffs) vs. Eastman Kodak Company (Defendant), Case No. 82-C-185, filed in 1982 in the United States District Court for the Western District of Wisconsin. A transcript of the court proceedings may be obtained from: United States District Court, Clerk of Court, P.O. Box 432, Madison, Wisconsin 53701; telephone: 608-264-5156.

5. Eastman Kodak Company, **Kodak Studio Light** (Centennial Issue), No. 2, 1980, p. 1; from "Foreword," by William A. Sawyer, Jr., vice president and general manager, Professional and Finishing Markets, Eastman Kodak Company.

6. Zavell N. Smith, telephone discussion with this author, November 19, 1980, and interview with this author in San Antonio, Texas, March 25, 1981.

7. Mark E. Smith, assistant attorney general, Wisconsin Department of Justice, letter to Robert Locker III, Eastman Kodak Company, July 17, 1980.

8. Robert F. O'Connor, Eastman Kodak Company legal department, letter to Mitchell Paul, an attorney with the Division of Advertising Practices, Federal Trade Commission, Washington, D.C., August 1, 1980.

9. Eastman Kodak Company, **Magic.**, brochure in the "For the Times of Your Life" promotional campaign, Kodak Pub. No. P3-703, 1986.

10. Eastman Kodak Company, **How to Advertise and Promote Your Studio – "For the Times of Your Life" Professional Photography Promotion Guide Book,** Kodak Publication No. P3-708, January 1986.

11. Eastman Kodak Company, **Expressions.**, "For the Times of Your Life" promotional brochure, Kodak Publication No. P3-705, 1986.

12. Eastman Kodak Company, **The Times**, Vol. 2, Issue No. 2, 1988, Kodak Publication No. P3-84A, p. 1.

13. Peter M. Palermo, vice president and general manager, Consumer Products Division, Eastman Kodak Company, **Photography 1888– 1988, A Century of Value Helps Create Priceless Memories**, Eastman Kodak Press Release No. NS988798EXP, September 1988.

14. Charley Wise Photography, individually, and on behalf of all others similarly situated, Plaintiff, v. Agfa-Gevaert, Inc., Defendant. Case No. PCA 85-4223-RV, United States District Court, Northern District of Florida, Pensacola Division, filed June 3, 1985. A transcript of the court proceedings may be obtained from: United Stated District Court, Clerk of Court, Rm. 129, 100 N. Talafox Street, Pensacola, Florida 32501; telephone: 904-433-2107. A year before the filing of the class-action suit against Agfa-Gevaert, James Nall of M&A Studios, Mobile, Alabama, had threatened to take legal action against Agfa because of damages he allegedly suffered from his use of Agfacolor Type 4 Paper. Nall had purchased $54,000 worth of Type 4 paper during 1978–1981, and by 1985, according to Nall, "every single picture had turned pink." Nall sought $162,000 in damages; the case was quickly settled out of court for an undisclosed sum.

15. Dave Withington, "A Review of the Testing Methodology for Evaluating Portrait Image Stability," presentation at the 38th Annual Conference of the Society of Photographic Scientists and Engineers (SPSE), Atlantic City, New Jersey, May 15, 1985.

16. Donald A. Koop, "A Relation Between Fading and Perceived Quality of Color Prints," **Second International Symposium: The Stability and Preservation of Photographic Images**, Ottawa, Ontario, August 25–28, 1985, (Printing of Transcript Summaries), pp. 335–349. Available from The Society for Imaging Science and Technology (IS&T), 7003 Kilworth Lane, Springfield, Virginia 22151.

17. Charles J. Lewis, "Preserve Priceless Negatives," (Studio Management Series), **The Rangefinder**, Vol. 33, No. 9, Sept. 1984, p. 55.

18. Eastman Kodak Company, "Develop a Brighter Profit Picture with the New Kodak Colorwatch System," advertisement on the back cover of **Photographic Processing**, Vol. 20, No. 9, September 1985. The Kodak Colorwatch System was originally announced by Kodak in mid-1985 under the name of "The Kodak Masterprint System." Soon after the announcement, the name was changed to avoid possible legal action against Kodak by photofinishers already using the "Masterprint" name.

19. H&H Color Lab, Inc., 8906 East 67th Street, Raytown, Missouri 64133; telephone: 816-358-6677 (toll-free: 800-821-1305); Fax: 816-356-7950.

20. During 1991 and 1992, Terry J. Deglau, Coordinator, Portrait and Wedding Photography, U.S. Marketing Operations, Professional Photography Division, Eastman Kodak Company, sent letters to many of H&H's customers, which said in part (from a letter dated June 17, 1991):

"Consumers expect member studios of 'For the Times of Your Life' to use Kodak professional products in producing their professional portraits. Unfortunately, however, our records indicate that your primary professional lab does not use enough Kodak professional products to be routinely providing your studio with finished packages made with these products.

"If you would like to remain a member of the 'For the Times of Your Life' program, you have two options:

• Request that your professional lab use Kodak professional papers and chemicals for your orders.

• Switch to a lab that will qualify your continued membership in the 'For the Times of Your Life' program.

"Once you have decided how you wish to proceed, please forward a letter detailing your decision to 'For the Times of Your Life,' Eastman Kodak Company, 343 State Street, Rochester, New York 14650-0412. We will quickly review your input and respond in a timely manner."

Kodak took the position that even if a photographer was using Kodak Vericolor professional films exclusively for his or her work, that was not sufficient to continue membership in the "For the Times of Your Life" program. In part because of this stance, increasing numbers of H&H's customers have switched to Fujicolor professional films and stopped using Kodak products altogether.

At one point, after Kodak learned that H&H was considering changing to Fujicolor paper, David P. Biehn, vice president and general manager of Kodak's Professional Imaging Division, visited H&H president Wayne Haub and lab manager Ron Fleckal to try to dissuade them from making the switch. According to Haub, Biehn did not dispute the claim that Fujicolor paper had much better light fading stability than Ektacolor paper, but he nevertheless told Haub and Fleckal that H&H would lose business if the lab dropped Kodak paper. Responding to an invitation from Biehn, Haub later visited Kodak in Rochester, New York for further discussions on the matter. H&H was the first professional portrait and wedding lab in the U.S. to switch from Ektacolor to Fujicolor paper.

21. Letter and survey from H&H Color Lab, Inc. president Wayne Haub to H&H customers, dated September 26, 1990.

22. H&H Color Lab, Inc. "Customer Testimonials," excerpts of letters sent to H&H by its customers concerning their reaction to prints made with Fujicolor paper, 1990.

23. H&H Color Lab, Inc., see Note No. 22.

24. H&H Color Lab, Inc., see Note No. 22.

25. Elizabeth Cunningham, "Product Improvements; New Items; New Film Speeds," **Photographic Processing**, Vol. 18, No. 1, January 1983, p. 35.

26. Eastman Kodak Company, "How Many Reasons Do You Need To Switch?", advertisement in **Photographic Processing**, Vol. 24, No. 1, January 1989, back cover.

27. Robert Fletcher, former president, Ilford Photo Corporation, Paramus, New Jersey, telephone discussion with this author, March 7, 1989.

28. Koichi Nakamura, "Silver Catalyzed Dye Reduction and Its Application as an Imaging Process," presentation at the **35th Annual Conference of the Society of Photographic Scientists and Engineers**, Rochester, New York, May 12, 1982.

29. LaClaire Laboratories, Inc., 6770 Old Twenty-Eighth Street, S.E., Grand Rapids, Michigan 49506; telephone: 616-942-6910 (toll-free: 800-369-6910). In 1993, LaClaire Laboratories plans to introduce UltraStable Permanent Color prints for clients who want a longer-lasting alternative to the Kodak Dye Transfer prints that have been produced by LaClaire for many years. See: David B. LaClaire, "Marketing UltraStable Portrait Prints," **Professional Photographer**, Vol. 119, No. 2159, April 1992, p. 36. See also: John Durniak, "Color Almost Too Good to Be True," **The New York Times**, December 6, 1992, p. Y27. See also: Mark Wilson, A Color Process That Won't Fade Away," **The Boston Globe**, May 17, 1992.

30. At the time this book went to press in 1992, only two labs furnishing UltraStable Permanent Color prints had established prices for the prints. Color Prints by Nordstrom: $350 for 8x10-inch prints; $450 for 11x14; $675 for 16x20; $850 for 20x24; $1,400 for 24x36 (additional prints from the same image are discounted 50% or more, depending on quantity). See: William Nordstrom, "In Search of Permanence: 500-Year-Life UltraStable Color Photographs," **Professional Photographer**, Vol. 119, No. 2159, April 1992, pp. 34–36. Ken Lieberman Laboratories, Inc.: $1,200 for 16x20; $1,400 for 20x24; and $2,200 for 24x36 (additional prints from the same image are discounted 50% or more, depending on quantity). See the **Suppliers** list on page 293 for the addresses of these labs and other suppliers of UltraStable Permanent Color prints and Polaroid Permanent-Color prints.

In 1993, the EverColor Corporation, a company founded by William Nordstrom and Richard H. Carter, plans to sell EverColor Pigment Prints for $150 for 8x10 and $325 for 16x20, with additional prints from the same image available at a substantial discount.

31. Burrell Colour, Inc., "Lifetime Guaranteed Colour Prints – Only from Burrell Colour," advertisement in **The Professional Photographer**, Vol. 113, No. 2092, September 1986, p. 53.

32. Donald J. Burrell, president, Burrell Colour, Inc., telephone discussion with this author, December 5, 1986.

33. Burrell Colour, Inc., "Are Your Color Prints Guaranteed – If Not, What Will You Do?", advertisement in **Studio Photography**, Vol. 18, No. 8, August 1982.

34. George K. Conant III, president, Meisel Photographic Corporation, letter to this author, September 7, 1982.

# Suppliers

## Suppliers of Color Print Materials

**Agfa Corporation**
Professional Products Division
100 Challenger Road
Ridgefield Park, New Jersey 07660
    Telephone: 201-440-2500

**Eastman Kodak Company**
Professional Photography Division
343 State Street
Rochester, New York 14650
    Telephone: 716-724-4000

**Fuji Photo Film U.S.A., Inc.**
Color Paper Department
555 Taxter Road
Elmsford, New York 10523
    Telephone: 914-789-8100
    Toll-free: 800-345-6385

**Konica U.S.A., Inc.**
Professional Products Group
440 Sylvan Avenue
Englewood Cliffs, New Jersey 07623
    Telephone: 201-568-3100

**Polaroid Corporation**
Attn: Mr. Dave Morreale
100 Duchaine Blvd.
New Bedford, Massachusetts 02745
    Telephone: 508-998-5563
    (source of materials and
    instructions for making
    Polaroid Permanent-Color
    Prints; Polaroid itself does
    not make prints)

**UltraStable Color Systems, Inc.**
500 Seabright Avenue
Santa Cruz, California 95062
    Telephone: 408-427-3000
    (source of materials, instruction
    manuals, and workshops on
    making UltraStable Permanent
    Color Prints; UltraStable itself
    does not make prints)

## Lab Producing Color Prints Made With Polaroid Permanent-Color Materials

**Ataraxia Studio, Inc.**
3448 Progress Drive – Suite E
Bensalem, Pennsylvania 19020
    Telephone: 215-343-3214

## Labs Offering Color Prints Made With UltraStable Permanent Color Materials

**EverColor Corporation**
Suite 140
5145 Golden Foothill Parkway
El Dorado Hills, California 95762
    Telephone: 916-939-9300
    Fax: 916-939-9302
    (beginning in 1993, EverColor
    will also offer EverColor
    Pigment Prints – see below)

**LaClaire Laboratories, Inc.**
6770 Old 28th Street, S.E.
Grand Rapids, Michigan 49546
    Telephone: 616-942-6910

**Photographic Arts, Inc.**
70 Webster Street
Worcester, Massachusetts 01603
    Telephone: 508-798-6612

**Robert Liles Photography and Printmaking**
3935 N. Seeley Avenue
Chicago, Illinois 60618
    Telephone: 312-477-8536

**Australian Colour Laboratories**
39 Hotham Parade
Artarmon 2064, N.S.W.
Australia
    Telephone: (61)-2-438-3322
    Fax: (61)-2-437-4328

**Sillages**
Marc Bruhat
91, quai Panhard et Levassor
75013 Paris, France
    Telephone: (33)-1-4584-6713
    Fax: (33)-1-4584-0883

## Labs Offering Color Prints Made With EverColor Pigment Print Materials

**EverColor Corporation**
Suite 140
5145 Golden Foothill Parkway
El Dorado Hills, California 95762
    Telephone: 916-939-9300
    Fax: 916-939-9302

New York City sales representative of EverColor:

**Ken Lieberman Laboratories, Inc.**
118 West 22nd Street
New York, New York 10011
    Telephone: 212-633-0500

# Appendix 8.1 – Text of Cover Letter and Petition Sent to Eastman Kodak by the Wisconsin Committee on Faded and Cracked Photographs

March 11, 1980

Mr. Walter Fallon, Chairman of the Board
Mr. Colby Chandler, President
Eastman Kodak Company
343 State Street
Rochester, New York 14650

Gentlemen:

Enclosed is a petition authorized by the Wisconsin Professional Photographers Association, to be circulated among its members and members of other photography associations in Wisconsin, Minnesota, North and South Dakota.

We as members of these organizations feel that the seriousness of the matter should be brought to your attention, in the form of this petition.

In addition to this petition, many of those signing, indicated the desire for Eastman Kodak to produce a PROFESSIONAL color paper for final prints. Current paper is OK for proofs. A professional paper should be as stable as Kodachrome when stored in the dark, and at least 10 times as stable as current EKTACOLOR 74 RC, WHEN ON PERMANENT DISPLAY.

Most persons quizzed, gave the opinion that they would be interested in paying more for a more durable product, if it meant the permanence would last over a greater period of time.

Thanking you in advance for your consideration.

Sincerely,

[signed]

Bernice Fehrenbach

Committee on Faded and Cracked Photographs
Bernice Fehrenbach, Chairman
Wisconsin Professional Photographers Association
229 N. Walnut Street
Reedsburg, Wisconsin 53959

*(Text of petition signed by approximately 275 professional photographers and sent by the Committee on Faded and Cracked Photographs of the Wisconsin Professional Photographers Association to Eastman Kodak Company.)*

November 1, 1979

Eastman Kodak Co.
Rochester, New York

Gentlemen:

We as Professional Photographers and members of the Wisconsin Professional Photographers Association are confronted with a serious problem with cracked and faded photographs. Our customers do not understand why this has happened and obviously we are blamed for the problem.

We are aware of the disclaimer on any color permanency now made by Eastman Kodak. Nevertheless we must bear the onslaught of irate customers who parade through our doors, demanding their photographs be replaced. We are bearing not only the costs but also the damaged reputation, the failure of the materials have caused. To soothe our wounds, we feel Eastman Kodak should compensate the photographer and color labs, so we can replace the faded and cracked prints, without charge.

Also, we would like the public to become more informed on what can happen to their photographs. Therefore we would like you to issue a statement on color permanency, so we can pass this information on to our customers. We feel it is time we educate the consuming public about color photography.

Sincerely,

Committee on Faded
and Cracked Photographs
Bernice Fehrenbach, Chairman

Note:
The above letter has been approved by the Board of Directors of WPPA, to be sent to Eastman Kodak. The Committee would appreciate your support for this effort by signing the attached petition.

Thank You

# Appendix 8.2 – Petition Sent to the Professional Photographers of America by Members of the Texas Professional Photographers Association

## Petition

July, 1980

To: Board of Directors, Professional Photographers of America, Inc.

We, the undersigned, are members of the Texas Professional Photographers Association, Inc., or other professional photographers in attendance at the Texas PPA summer seminar in Kerrville, Texas, July 5–8, 1980, and are all practicing professionals who sell to the public, or, are engaged in photography in industrial departments.

While it is recognized that color dyes will, in time fade, we believe that the manufacturers of color sensitized materials have inadequately informed the consumers of the United States as to the impermanence of color materials now being manufactured. The consumer has been led to believe that color materials have a long life both in color stability and in physical structure. While manufacturers specifically refuse to warrant their products, even for short periods of time, consumers are not fully informed of this policy and expect long life from the materials, whether amateur products, or professional products produced by professional photographers.

Many professional photographers are bearing the brunt of these inadequacies, and are having to replace photographs that have deteriorated, causing a financial burden on members of this association and other professional photographers, due to no fault of their own, and in some cases the reputations of photographers have been severely damaged.

We are asking the Board of Directors to use the good offices of the Professional Photographers of America to consult with the manufacturers of sensitized materials, advising them of the displeasure of professional photographers, and specifically negotiating an advertising policy that will properly inform the public of the true expected life of color materials, and to publicly absolve professional photographers of blame in the fading of color materials available to them.

If such negotiations with manufacturers should fail, or, statements from manufacturers are inadequate, then it is requested that the Professional Photographers of America, Inc. introduce a plan that will inform the public as to the limits of color materials, and defending the professional photographers from undue blame placed on them.

[signature sheets attached]

Texas Professional Photographers Association, Inc.
Drawer 828
Temple, Texas 76501
Telephone: 817-778-3232

# Appendix 8.3 – Recommendations Concerning Color Film and Print Fading Issued by the Professional Photographers of America for Its Members

Professional Photographers of America, Inc.
1090 Executive Way
Des Plaines, Illinois 60018

Suggestions and Recommendations
On Color Changes in Prints and Films
From the PP of A Education Committee

January, 1981

## I. Suggestions:

A. The breakthrough in color films and printing materials is providing us with photographs that are aesthetic, true to life and provide pleasure and satisfaction.

B. Color negatives and transparencies may in time not be suitable for reproduction.

C. Color prints may fade and deteriorate.

D. Consideration must be given to the role and responsibilities of the professional photographer in using the materials.

   1. The use of the photograph.

   2. It is imperative that the manufacturers' processing and storage recommendations are followed.

   3. Suggestions to the customer should be made in accordance with the instructions from manufacturer in regard to displaying the photograph.

E. Suggested procedures to follow in the photographer/customer relationship:

   1. Explain briefly the nature of the products now available for use.

   2. Explain alternatives – Black and White, Sepia, Oil or Dye Transfer.

   3. Explain negative retention practice followed by your studio.

   4. Determine your charges for reprinting or converting to an alternative.

   5. Post these charges – it should be OK to use percentages of current re-order prices.

## II. Additional protection and suggestions:

A. Photographers should urge manufacturers to continue research and development of better materials to improve dye stability of film and prints. Manufacturers of photographic materials should be encouraged to include specific statements regarding the problem of print and film fade in their advertising and promotional materials.

B. Encourage national and local associations to cooperate with manufacturers in making available materials to be used for customer education.

C. PP of A members may wish to replace deteriorated photographs. If so, they should consider retaining negatives or films ordered as long as the photographer making the original exposure remains in business and the films are printable.

D. Reasonable care should be taken to properly store and identify these original films following recommendations supplied by the material manufacturers.

E. All films and prints may in time deteriorate, lose color saturation and image fidelity. Storage conditions, display and other factors (heat, humidity, UV exposure, etc.) will determine how long a film or print will last. Advise your customers to consult their professional photographer for recommendations on ways of extending the "life" of their photographs.

## III. Recommendations:

A. Explanation cards should be displayed in your studio.

B. The subject of deterioration of the photographic image and materials should be part of the initial contact with the customer.

C. The following PP of A disclaimer is offered for your consideration and possible use. Although this has been developed by PP of A Legal Counsel, we suggest you review the disclaimer with your legal counsel before actual use.

"This studio and/or photographer assumes no responsibility or liability for defects or shortcomings including color changes or instability of the material used and processed in accordance with the manufacturers' specifications. Accordingly, for color film and color prints, the studio and/or photographer disclaims the implied warranties of merchantability and fitness for a particular purpose. For all photographs, whether black and white or color, we also disclaim liability for any consequential or special damages you may suffer, and in no event shall our liability, whether in tort or negligence, in contract or otherwise exceed the actual cost of the material used."

A Photograph is a Treasured Possession
And Should Provide Satisfaction and
Pleasure for Many Years

[Dated December 17, 1980. Some 15,000 copies of this statement were printed and copies were sent to all PP of A members.]

# Appendix 8.4 – Text of Brochure Explaining the Problems of Color Print Fading Supplied to Customers by Krider Studios of Lawrenceburg, Indiana

Krider Studios, Inc. has been in business in Lawrenceburg since May, 1947. We are now photographing our second generation of weddings, and our second and third generations of babies, plus grandparents and great grandparents.

It is because of the many close friendships that we have developed over the years, that we feel we have to be completely honest with our customers about the fading and changing of color of direct color portraits. We can foresee a lost generation of photographs, and we feel it is our obligation to do what we can to preserve as much of our heritage as possible, through photography, for future generations. Portraits are meant to be treasured keepsakes.

Webster defines a photograph as, "A picture made by photography," and photography as, "The art or process of producing images of objects upon a surface sensitive to the chemical action of light etc." We, at Krider Studios, prefer to define a photograph as the recording of an instant from life. These instants from life are recorded for many reasons, but in the case of portraits, because we want to remember, or be remembered. Portraits are meant to be treasured keepsakes.

Because Krider Studios respects your right to know before you buy, we are supplying the following information. We are finding that most materials that are available to professional photographers for taking and printing direct color, are subject to fading and changing of color. The degree of change depends on many variables. We think you should be aware of this, and are offering these alternatives for your consideration.

Since we can print black and white portraits from color negatives, but we cannot print direct color portraits from black and white negatives, your portrait has been taken on color film, unless otherwise specified, for those of you who wish all or a portion of your order printed in direct color. For those of you who wish a more permanent photograph, we can make black and white, brown tone, or oil colored portraits from either color or black and white negatives. We urge you to discuss this with our staff. The decision will be yours.

We retain all of our negatives, and all photographs taken by Krider Studios are covered by a Limited Warranty that states, "The dyes used in color films and prints, like other dyes, may in time change. Neither film nor prints therefore will be warranted against any change in color. If any time, any photographs taken by Krider Studios, Inc. should in any way become lost, stolen or destroyed, the print, or prints, will be replaced to the original purchaser, by Krider Studios, Inc., 215 Walnut Street, Lawrenceburg, Indiana, at 75% of the current reorder price, providing the original negatives are available and in a printable condition. This replacement order will be complete in 60 days."

Damaged or faded photographs must be returned to Krider Studios, Inc. and the charges for reprinting the photographs must be paid in advance. This Limited Warranty is not subject to arbitration, and is provided as a service without legal recourse and extends no further than the terms as they are written.

May we suggest that if you have any treasured photographs that are deteriorating, that now is the time to have them copied and restored before excessive fading occurs. Bring your photographs to Krider Studios, Inc. now for a "no obligation" evaluation.

Krider Studios, Inc.
215 Walnut Street
Lawrenceburg, Indiana 47025

# Appendix 8.5 – Text of 1990 Letter from H&H Color Lab, Inc. to Its Customers Announcing the Change from Ektacolor Portra Paper to Fujicolor Professional Paper

Dear Customer,

In 1990 Kodak introduced the Ektacolor Portra Professional paper and high speed RA-4 chemical process as the new industry standard, and H&H switched to this paper and process in February 1990. Since that time it has been our opinion, as well as many of our customers, that although the chemical process was improved, overall print quality actually declined. Therefore, we began a search for a better product consistent with the H&H objectives of quality, service, and price.

This search led us to a new RA-4 compatible paper manufactured by Fuji, Fujicolor Professional Paper Super FA. We thoroughly tested this paper for many months and in September, mailed test results and sample prints [matched sets of prints made with both the Kodak and Fuji papers] to many of you requesting your opinion. Over 50% of those polled responded to our questionnaire, and the results are as follows:

• 93.9% of the 263 photographers responding voted "YES" that H&H should pursue the best quality product regardless of the manufacturer.

• An overwhelming majority were pleased with the extended display permanence of the Fuji product (nearly twice as long) and felt the time long overdue to address this important issue.

• H&H production employees were unanimous in their positive support for the Fuji paper. They enjoyed the ease with which they could produce accurate color and preferred the overall quality look of the Fuji paper.

Based on our research, our test results, and your "yes" responses, we will be converting at least 85% of our production facilities to the new Fujicolor Super FA paper during January of 1991.

In our questionnaire we welcomed any special comments or observations you wanted to express. Some commented that Kodak has provided support to the professional photographer over the years. We discussed this concern with representatives of Fuji Film USA and they have committed to increasing their support to the professional photographer including increased educational programs and scholarship grants.

Some also expressed a desire to "buy American." Kodak will continue to be a major supplier to H&H. We buy many products from Kodak in the areas of black and white materials, color paper, film, production hardware, and computer software. The channels of communication with our good friends at Kodak are better than ever. We believe they will listen to the demands of the marketplace, and we will see competitive changes in the future!

We all know good and fair competition is healthy for the marketplace. We are witnessing this principle of the American free enterprise system working and benefiting you, the independent studio photographer, and your customer. The lab and the photographer now have both Fuji USA and Kodak working hard to win our business and help us improve our industry.

To those who took the time to study the information and respond in such high numbers, thank you! We especially appreciate the kind words you expressed about H&H. We feel flattered and even more dedicated to provide the finest product in the industry. You have given us a mandate to pursue quality wherever we find it. With Fujicolor Professional Super FA paper, your customers will receive their photographs printed on the best and longest lasting color negative paper available in the world today, and H&H can continue to pursue and provide you with the best balance of quality, service, and price.

Sincerely yours,

Wayne B. Haub, President
December 29, 1990

H&H Color Lab, Inc.
8906 East 67th Street
Raytown, Missouri 64133

Telephone: 816-358-6677
Toll Free: 800-821-1305
Fax: 816-356-7950

# 9. The Permanent Preservation of Color Motion Pictures

## Low-Temperature, Humidity-Controlled Storage of Original Camera Negatives, Color Reversal Originals, Laboratory Intermediates, and Release Prints Is the Only Viable Way to Keep Color Motion Pictures Unchanged for Many Hundreds or Even Thousands of Years

"Nothing really lasts outside the world of art. Most societies are not remembered for their politics or their commerce, but for their composers and artists. America will be remembered for its movies."[1]

Michael Eisner, chairman
Walt Disney Company – April 16, 1982

"For a medium that gives every promise of living forever, the cinema is actually among the most fragile of art forms. It's commonly believed that at least half of all theatrical films made before 1950 have vanished forever. For the silent period (roughly 1893 to 1930), the ratio of lost films may climb to 75 percent or higher.
*"Remodeling Her Husband* (1920), the only film directed by Lillian Gish, is lost. So is *The Divine Woman* (1928), starring Greta Garbo. *The Rogue Song* (1930), a Technicolor feature directed by Lionel Barrymore and featuring Laurel and Hardy, has disappeared with hardly a trace. And so has that snappy, racy, pre-Code comedy *Convention City* (1933), starring Joan Blondell. D. W. Griffith's *That Royal Girl* (1926) with W. C. Fields is among the missing, as are *London After Midnight* (1927) with Lon Chaney, *Cleopatra* (1917) with Theda Bara, *Legion of the Condemned* (1928) with Gary Cooper and Fay Wray, and hundreds upon hundreds of mouth-watering titles from the relatively recent past."[2]

Frank Thompson
*American Film* – August 1991

"I don't know if it's worth trying to prevent further deterioration with most of these films because they are usually in such poor condition when they arrive here."[3]

Stanley Yates, curator
The American Archives
of the Factual Film – 1979

"We are presently presenting the only 35mm print 'in service' of the 1963 Academy Award winner, *Tom Jones,* 'Color by DeLuxe.' The vivid greens that were so vital to the marvelous photography of this film, that remain in the memory of those of us who saw it in 1963, are now just that: a memory. The whole damn thing has turned fire engine red. Tom Jones is now romping across a red countryside under pink skies. Thank you Eastman Kodak."[4]

Jack Tillmany
Gateway Cinema, San Francisco
April 23, 1980

See page 301 for Recommendations

"The visual record of twentieth century America is fading faster than our memories."[5]

Frank Hodsoll, chairman
National Endowment for the Arts
January 14, 1983

"The movie companies are like oil producers. Their backlog, or film libraries, are worth more money in the future, like oil and gas reserves."[6]

Robert Lenzner
*The Boston Globe* – March 1, 1981

"[Not] many people recognized how valuable film libraries would be prior to the commercial success of television during the 1950's and 60's. That created an enormous market for syndicating films. The same process was repeated with the rapid spread of VCR's and laser disk players around the world during the 1980's. Today, there are many new channels of distribution for television programming in the U.S. and in other parts of the world. The privatization of television industries in many countries is creating a demand for more programming. During the remaining 1990's, we anticipate the opening of new markets in developing countries. There are many people all over the world who have never seen thousands of movies and TV programs produced in the Western world.
This doesn't begin to address the future needs of HDTV. As we start to see an increase in the numbers of HDTV sets, VCR's and laser disk players during the 1990's, there will be a demand for software with strong entertainment and production values. The value of assets currently stored in Hollywood's film, videotape and magnetic sound libraries is incalculable. We think it is important for us to assist in protecting those assets."[7]

Joerg D. Agin, vice president
Motion Picture and Television Imaging Division
Eastman Kodak Company
Hollywood, California – May 1992

". . . Disney home video is awash in profits. In 1992 the division will have revenue of $1.1 billion. The arithmetic is simple but remarkable: The *Beauty and the Beast* videocassette carries a suggested retail price of $24.99 and wholesales for about $13.50. With [a record] 20 million units, the revenue to the company will be $270 million. Each videocassette costs about $2 to manufacture and perhaps $2 to market. So Disney's profit is $200 million in the U.S. alone."[8]

Richard Turner
*The Wall Street Journal*
December 24, 1992

October 1992

The color film storage vault in the Paramount Pictures Film and Tape Archive, located on the Paramount studio lot on Melrose Avenue in Hollywood, California. The color film vault, one of nine vaults in the high-security building, is maintained at 40°F (4.4°C) and 25% RH. The Paramount archive, which was Hollywood's first adequate preservation facility for color motion pictures, went into operation in June 1990. Shown here working in the color film vault, which is equipped with movable shelving to conserve space, is Robert McCracken, a supervisor in Archive Operations. McCracken and Bill Weber, director of Operations Resources at Paramount, manage the operation of the multi-million dollar, 40,000-square-foot facility. At the time this book went to press in 1992, Warner Bros. was the only other Hollywood studio to have adequate cold storage facilities for its motion picture library (the new Warner Bros. film archive is described later in this chapter).

"Under [the] agreement, Turner keeps only MGM's 3,000-film library. In effect, Turner is paying $1.2 billion for the library. . . . The company has said it intends to use the MGM films in programming its WTBS station and a possible new cable television network. Ted Turner, chairman and chief executive officer, has said he expects revenue from the MGM library to provide the company with cash flow of about $100 million a year."[9]

> Michael Cieply and John Helyar
> *The Wall Street Journal*
> June 6, 1986

"The problem of color fading in film has reached a crisis point and can no longer be ignored. The instability of Kodak color stock is causing irreparable damage to our films and the films we have made in the past are deteriorating drastically or are irretrievably lost. We must find the solution to this problem, not only to eliminate this threat to present films, but to salvage those made in the past that are not beyond help. Since Eastman Kodak is the single largest manufacturer of color film in the world, and the chief source for motion picture film stock, your company must be held accountable for the color instability flaws inherent in the stock. . . . This existing 'flaw' is destroying our work."[10]

> Martin Scorsese, film director
> Petition sent to Eastman Kodak and signed
> by hundreds of film directors and others
> in the movie industry – June 12, 1980

"Dyes fade, colors fade, but our motion picture heritage is not necessarily threatened by this fact."[11]

> Henry Kaska, spokesman
> Eastman Kodak Company
> April 17, 1981

". . . after only five years the blue is leaving the waters of *Jaws* while the blood spurting from Robert Shaw's mouth gets redder and redder."[12]

> Steven Spielberg, film director
> November 26, 1979

# Recommendations

### • Motion Picture Camera Negative Films

**Recommended as the Longest Lasting:**

*Fujicolor Negative Film F-64, 8510 and 8610*
*Fujicolor Negative Film F-64D, 8520 and 8620*
*Fujicolor Negative Film F-125, 8530 and 8630*
*Fujicolor Negative Film F-250, 8550 and 8650*
*Fujicolor Negative Film F-250D, 8560 and 8660*
*Fujicolor Negative Film F-500, 8570 and 8670*
*Eastman Color Negative Film 7291*
*Eastman EXR 500T Color Negative Film 5296 and 7296*

### • Laboratory Intermediate Films

**Recommended as the Longest Lasting:**

*Fujicolor Intermediate Film 8213 and 8223*

**Should Be Avoided (Very Poor Dye Stability):**

*Eastman Color Reversal Intermediate
    Film 5249 and 7249 (CRI film)*

### • Motion Picture Color Print Films

**Recommended as the Longest Lasting:**

*Fujicolor Positive Film LP 8816 and 8826*

**Secondary Recommendations:**

*Eastman Color Print Film 5384 and 7384*
*Eastman Color LC Print Film 5380 and 7380*

**Should Be Avoided (Very Poor Dye Stability):**

*Agfa Print CP1 Color Print Film*
*Agfa Print CP10 Color Print Film*

## Preservation of Original Camera Negatives, Color Reversal Originals and Duplicates, Laboratory Intermediates, and Release Prints

- **Low-temperature, humidity-controlled storage is the only viable method of permanently preserving color motion pictures.** A temperature of 0°F (–18°C) or lower and a relative humidity of 30% are recommended for the long-term storage of all valuable camera color negatives, color reversal originals and duplicates, laboratory intermediates, and release prints. Extrapolations from accelerated aging tests indicate that color films stored under these conditions may be expected to last for more than a thousand years — essentially forever — with negligible change. Institutions preserving film with humidity-controlled storage at 0°F (–18°C) include the National Aeronautics and Space Administration (NASA) in Houston, Texas (color motion picture film and still photographs made during space flights), the John Fitzgerald Kennedy Library in Boston (color motion pictures and still photographs made during the Kennedy years), and the Jimmy Carter Library in Atlanta, Georgia (color motion pictures and still photographs related to the Carter presidency). The advanced motion picture preservation facility to be completed in 1996 in Gatineau, Quebec by the National Archives of Canada's Moving Image, Data and Audio Conservation Division will also operate at 0°F (–18°C) and 25% RH. It is

particularly important to immediately place in low-temperature storage films that already show evidence of fading, as well as all films that are known to have inherently poor stability. This includes nearly all color films manufactured before 1982–86, as well as some current products. See Chapter 20 for discussion of cold storage facilities.

- **Moderate-temperature, humidity-controlled storage at about 40°F (4.4°C) and 25–40% RH** is satisfactory for preserving unfaded materials made on the comparatively stable film stocks recommended above for periods of perhaps 300 years. The Records Center of Kansas City and National Underground Storage, Inc. of Boyers, Pennsylvania currently offer high-security storage at moderate cost that meets these temperature and humidity requirements. Eastman Kodak will offer rental storage space in its new Hollywood film preservation vaults beginning in 1993; two storage temperatures will be available: 45°F (7.2°C) and 25% RH, and 32°F (0°C) and 25% RH. Other commercial storage facilities are expected to offer similar services in the future. Paramount Pictures constructed a film archive in Hollywood in 1990 in which all of Paramount's color negatives and intermediates are preserved at 40°F (4.4°C) and 25% RH. Warner Bros. opened a large cold storage facility in 1992 which includes color film storage vaults maintained at 35°F (1.7°C) and 25% RH.

- **Packaging films for long-term storage in humidity-controlled cold storage facilities:** Color and black-and-white motion picture films should be placed in "vented" plastic cans (e.g., the vented polypropylene film cans available from the Plastic Reel Corporation of America in Lyndhurst, New Jersey) or in high-quality, vapor-permeable cardboard containers. Because storage in standard metal and plastic film cans (taped or untaped), vapor-proof bags, and other sealed or semi-sealed containers will increase the rates of both dye fading and film-base deterioration with acetate-base films, such containers are not recommended for the long-term storage of motion picture films. To prevent contamination of films stored in "vented" film cans, it is necessary that the air in the storage area be filtered so as to be completely free of dust, lint, or other particulate matter.

- **Storage of film packaged in vapor-proof bags in refrigerated vaults with uncontrolled humidity conditions is not recommended.** Not only could the film be damaged or destroyed because of a small puncture or seal failure that may go unnoticed for years, but the cost of bags, pre-conditioning equipment, and the substantially increased labor required by this approach will in the end cost far more than controlling the humidity in the storage area. In addition, sealed or semi-sealed containers will increase the rates of dye fading and film-base deterioration with acetate-base films.

- **Motion picture films should be stored in a horizontal position,** with not more than eight cans stacked one on top of another.

- **Black-and-white separations (YCM's) are not recommended for the long-term preservation of color motion pictures.** Compared with low-temperature storage of original color negatives, intermediates, and prints, separations are extremely costly, entail potentially large losses of image quality, do not provide a visual reference for density and color balance, will become difficult or even impossible to print satisfactorily in the future when current film stocks are obsolete, and, when stored along with the originals, require four times the storage space of the originals alone. Further, because of the inherently unstable nature of silver images coupled with the limited life of the cellulose triacetate base of most motion picture separation films stored in typical room-temperature conditions, separations will not last nearly as long as original color materials in low-temperature, humidity-controlled storage.

- **If black-and-white separations are made, Eastman Panchromatic Separation Film SO-202 (polyester-base) is recommended.** Under normal storage conditions, the polyester base of SO-202 film will last much longer than the cellulose triacetate base of Eastman Panchromatic Separation Film 5235 (which for many years has been the only separation film used by the major studios). In addition to superior permanence, polyester-base films also have much better dimensional stability than triacetate-base films. This is an important consideration because separations must remain in exact registration if color fringing and loss of image sharpness are to be avoided in future printings.

- **Existing black-and-white separations made from older films are very valuable,** however, because the original color negatives from which they were made almost certainly have faded significantly during storage under typical film-industry conditions. To preserve separations, they should be placed in humidity-controlled (20–30% RH), moderate- or low-temperature storage. Normal room-temperature storage is not satisfactory for long-term storage of cellulose triacetate separations (especially if the relative humidity is above 40% for long periods of time). Pending further investigation, treatment of black-and-white separation films with polysulfide toner, selenium toner, gold chloride toner, or other image-protective treatment could not be recommended at the time this book went to press in 1992.

- **No matter how faded a particular film might be, it should never be written off as a total loss.** However, additional fading must be prevented in order to take best advantage of future digital image enhancement, grain reduction, and color restoration techniques. When severe fading has occurred, computer-aided "colorization" can be done, using the degraded magenta dye image that still survives in most faded motion picture color films as the basis for reconstruction of the color image. (Spectrophotometric analysis of maximum-density, minimum-density, and other parts of even a severely faded color image might yield significant information about the colors that originally were present.)

- **To take full advantage of the improved image quality offered by each new advance in video recording technology and television transmission systems** (digital video recording and analog and digital HDTV — high-definition television — are only the latest examples in a field that has witnessed almost constant technological change since the invention of video recording in 1956), one will have to go back to the photographic original for making video transfers each and every time an improved technology appears. With the widespread commercialization of HDTV during the late 1990's, the entire holdings of film libraries worldwide will once again have to be transferred to tape (and/or optical disk). Image quality demands will be higher than ever, and to deliver the best-quality product at the lowest possible cost, it is essential that negatives, film intermediates, and release prints be preserved in essentially unchanged condition.

- **For now and for the foreseeable future (probably the far distant future),** analog and digital videotapes, optical disks, digital image data tapes (whether or not linked to high-resolution digital film systems), and other digital or analog electronic image-storage systems cannot be considered to be viable alternatives to the long-term preservation of color photographic originals.

- **For the permanent preservation of productions originated on videotape,** the videotapes should be transferred to color negative film, and prints of the best possible quality should be made. The color negative, at least two prints, and the original videotape itself should be placed in low-temperature storage.

- **To prevent total loss of valuable films in the event of earthquake, fire, flood, tornado, theft, damage during transportation or laboratory handling, or other disaster,** the various film elements made during the course of a production should be divided between low-temperature, humidity-controlled facilities at two different geographic locations. For example, one facility should be selected to store the original conformed color negative, duplicate color negative or CRI, sound cut negative and/or magnetic master, any important outtakes, and at least one mint-condition release print (as well as a copy of each foreign-version release print). This facility would serve as a high-security "dead storage" that would not normally need to be accessed; it would be the ultimate backup should a film element in the second facility be lost or damaged. The second storage facility should be close to production and laboratory operations; it is the film elements in this facility that would normally be accessed for television transmission, videocassette and videodisc production, or theatrical re-release. This approach has been followed by NASA for permanent preservation of the color photographs made during the first manned mission to the surface of the moon in 1969, as well as other still photographs and color motion pictures documenting the U.S. space program.

- **Preservation in low-temperature storage of at least two release prints of every version of a film** (i.e., two prints each of both domestic and foreign versions) should be the central focus of all film preservation programs. One print can be used to produce videotape masters directly, and it can also serve as a timing reference print for assessing color balance and density when making new prints or video transfers from duplicate negatives. At some point in the future, because of changes in the characteristics of film stocks or the abandonment of film altogether, it may not be possible to make prints directly from the negatives now in film archives, and the availability of release prints in good condition will become crucial. The other preservation print should be kept in dead storage at a separate geographic location and not touched unless absolutely necessary (i.e., should the other print be damaged or destroyed).

- **Motion pictures in museums, archives, and film libraries should never, ever be projected.** Likewise, prints should not be routinely viewed on Steenbecks or similar equipment. These films must be preserved — saved so they can serve as printing masters for whatever film and electronic reproduction media emerge in the future. The current practice of some of the leading film archives and other collecting institutions around the world of screening original color and black-and-white prints must stop. Original prints are not expendable films to be viewed and thereby damaged for the pleasure of curators and filmgoing audiences who like to see "the real thing."

- **For viewing and study purposes, videotape copies should be made from prints;** for projection, duplicate prints should be made from a color internegative (Eastman Color Internegative Film 5272 is suitable for this purpose).

- **The American Film Institute, in conjunction with the Library of Congress,** should administer carefully designed, low-temperature, humidity-controlled storage facilities at two separate geographic locations for the long-term preservation of color and black-and-white motion pictures and videotapes. Separate areas, isolated from other storage buildings, should be provided for Technicolor nitrate prints and negatives and other nitrate motion pictures. The high-security facilities should offer low-cost storage services for commercial studios, motion picture and videotape libraries, museums, and archives.

## Only In Recent Years Has the Long-Term Value of Film Libraries Begun to Be Understood

It has been only since the mid-1970's, with the advent of large-scale re-release of movies on videocassette, videodisc, cable and satellite TV, and regular network television, that the entertainment film industry has developed a genuine appreciation of the cultural significance — and, much more important to the film studios, the monetary value — of the motion pictures in their film libraries.

In 1991, the U.S. motion picture industry grossed $4.8 billion from the almost one billion movie theater tickets sold in the United States,[13] with additional billions of dollars coming from foreign distribution, licensing to TV, videocassette, video games, and other non-theatrical revenue.

More than 400 feature films released in the U.S. in 1991, not including movies made for television (among the 1991 releases, 150 were from the major studios and 23 films were reissues of earlier productions). There were more than 23,000 motion picture screens in the country, the largest total ever; more than half show first-run features. A typical feature film requires over 8 million feet of color negative and print film, and a major release may require more than twice that much.

According to the entertainment weekly *Variety*, the retail home video market in the U.S. brought in an estimated $3.8 billion to the motion picture studios and other suppliers in 1991.[14] The homevideo business has grown explosively during the past decade; with more than 60,000 outlets in the U.S. that sell or rent videotapes, the gross revenue of the homevideo business is now more than *twice* that taken in by movie theater ticket sales. About 300 million pre-recorded video cassettes were manufactured in 1991.

The majority of the programs on prime-time television are still originated on film. An average one-hour action-adventure television program involves 80,000 feet of color negative and print film; there are about 800 such shows produced each year.

Most motion pictures are now made with color negative films, such as Eastman EXR Color Negative Film 5245, Fujicolor Color Negative Film F-125, and Agfa XT 100 Colour Negative Film, which are in key respects similar to still-camera color negative films such as Kodak Gold and Ektar films, Fujicolor Super HG, and Agfacolor XRS films.

For distribution and projection, the negatives are printed on motion picture "print films" such as Eastman Color Print Film 5384 and similar print films made by Fuji and Agfa. Or, in the case of much of the filming now being done for television, the original camera negative is transferred to videotape for editing and other post-production work and subsequent broadcast.

With video having replaced motion picture film in most commercial, industrial, and educational applications, the market for reversal motion picture films has shrunk substantially in recent years and is now mostly limited to 16mm and 8mm films requiring only a single copy for viewing or a small number of copies for distribution.

Not long ago, a major market for 16mm color reversal motion picture films was television news and documentary production; since the late 1970's, however, virtually all television news footage has been originated on videotape. Among amateurs, the wildly popular video camcorder has made 8mm home movies a thing of the past. Now, many people are having all of their old 8mm home movies transferred to videotape so they can view them on their television screens.

Kodak sells most of the motion picture film used in the United States — industry observers estimate that the company currently has more than 75% of the domestic market. However, Fuji of Japan has been gaining an increasing share of the theatrical and television market in North America and sells a substantial amount of film in Asia and Europe. Agfa-Gevaert is the only other significant producer of color motion picture film in the Western world.

## Making Movies Is Costly, But the Earnings Can Be Immense

Major theatrical films cost a great deal to make — the average production cost for a feature film in 1991 was a little over $26 million, with perhaps an additional $10–15 million to cover advertising and distribution expenses. Some recent films have cost much more: Arnold Schwarzenegger's 1991 science-fiction action movie *Terminator 2* (a Carolco production released by TriStar, a unit of Columbia Pictures, which is in turn owned by Sony Pictures Entertainment) had a record-breaking production cost of around $95 million; the film had grossed more than $200 million in North America by the end of 1991. Of that amount, more than $112 million went back to the studio in rental fees.

The most successful movies can earn a staggering amount: by the end of 1991, Steven Spielberg's 1982 film *E.T. The Extra-Terrestrial* had grossed an estimated $360 million in the U.S. and Canada alone, with many millions more coming in from foreign markets.

By the end of 1991, according to the entertainment publication *Variety*, ten other movies in addition to *E.T.* had grossed more than $200 million from theater ticket sales in domestic markets:[15] *Star Wars* (Fox, 1977) with $323 million gross and earning $194 million in theater rental fees; *Home Alone* (Fox, 1990) with $282 million gross and earning $140 million, which makes the film the top-grossing comedy of all time; *Return of the Jedi* (Fox, 1983) with $264 million gross and earning $168 million; *Batman* (Warner Brothers, 1989) with $251 million gross and earning $151 million; *Raiders of the Lost Ark* (Paramount, 1981) with $242 million gross and earning $116 million; *Beverly Hills Cop* (Paramount, 1984) with $235 million gross and earning $108 million; *The Empire Strikes Back* (Fox, 1980) with $223 million gross and earning $142 million; *Ghost* (Paramount, 1990) with $217 million gross and earning $98 million; *Ghostbusters* (Columbia, 1984) with $214 million gross and earning $133 million; and *Terminator 2* (TriStar/Columbia, 1991) with $204 million gross and earning $112 million in theater rental fees.

Other films from 1991 that did very well at the box office included *Robin Hood: Prince of Thieves* (Warner Bros.) $86 million in rentals at the end of 1991; *City Slickers* (Columbia) $61 million in rentals; the Academy Award winner *The Silence of the Lambs* (Orion) $60 million; *The Addams Family* (Paramount) $55 million; *Sleeping With the Enemy* (Fox) $46 million; *Cape Fear* (Universal) $32 million; *Star Trek VI: The Undiscovered Country* (Paramount) $32 million; *Boyz N the Hood* (Columbia) $27 million; *New Jack*

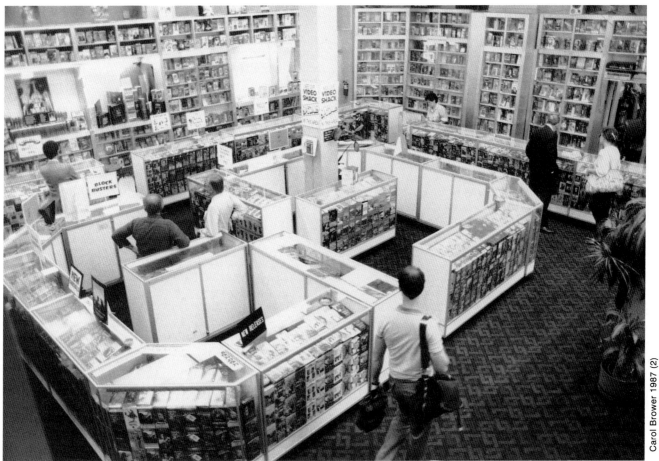

Carol Brower 1987 (2)

With the great majority of the households in the United States now having videocassette recorders (VCR's), the videocassette business has underscored the need to properly preserve color and black-and-white films. Practically every film of note, and many of lesser distinction, have been released on videocassette. Cable and satellite TV have further fueled the demand for old movies. When high-definition television broadcasting, cable, VCR's, and videodisc players become commonplace in the late 1990's, producers will have to go back to their film originals to make new full-frame, high-resolution video transfers; to take full advantage of each major improvement in TV technology, the film-to-tape transfer process will have to be repeated.

*City* (Warner Bros.) $22 million; *Thelma & Louise* (MGM/UA) $20 million; *The Fisher King* (TriStar/Columbia) $18 million; and *JFK* (Warner Bros.) $14 million in rentals at the end of 1991.

Walt Disney estimated that following the 1987 re-release of *Snow White and the Seven Dwarfs,* the film had earned more than $62 million. This was the seventh re-release of the then 50-year-old animated film; Disney has been re-releasing many of its cartoon features on a 7-year cycle (figuring that a new generation of children would be ready to see them) since they were made. Another Disney animated film, *101 Dalmatians,* has earned Disney more than $68 million in theater rental fees since it was first released in 1961, making it the most successful animated film of all time. Many millions of dollars more were earned from videocassette sales.

In a *Variety* story about Disney's 1991 animated feature *Beauty and the Beast,* Charles Fleming reported:

> When "Beauty and the Beast" stops earning money at the box office, it will probably be the industry's most profitable movie of the year.

The Video Shack store near Times Square in New York City is one of the largest videocassette rental and sales outlets in the world. In 1987, for the first time, nationwide revenue from videocassette rentals and sales exceeded that of theater ticket receipts in the United States.

After an estimated production cost of $25 million, and advertising and release costs of another $10 to $15 million, the film will wind up with box office totals of $120 million. That leaves the studio with cash profits, before ancillary markets are taken into account, of about $30 million. When videocassette sales are figured in, and unit sales exceed 10 million, add another $100 million in revenue to [Disney].[16]

*The Rocky Horror Picture Show* (Fox) has earned over $37 million in rentals from its almost continuous midnight showings around the U.S. since its release in 1976.

Most films, of course, do not earn as much as the box office hits, but following or even simultaneous with theater release, expanding aftermarkets such as videocassettes, cable TV, satellite TV, and videodiscs give most major features a very long potential market life. The most popular movies, such as *Casablanca* and *Gone With the Wind,* probably will have an indefinite appeal.

## Motion Picture Films Generally Are Stored Under Poor Conditions

Considering the cost of making and marketing a major feature — and its potential earnings over the years — it is often astonishing to see how poorly most films are cared for. It is difficult to think of another industry that does so little to protect its most valuable assets. Although the major studios generally make black-and-white separation positives (YCM's) from the original color negatives of their most valuable features, only Paramount Pictures and Warner Bros. had adequate cold storage facilities for their film libraries at the time this book went to press in 1992. With only a few exceptions, separations have not been made for television productions, and cold storage is almost never provided for such films.

The great majority of films — whether made for documentary, educational, advertising, scientific, or television news purposes — are stored at normal room-temperature conditions or worse, and their eventual life will be dictated by the dye stability characteristics of the particular film stocks on which they were made.

Since 1894, when Thomas Edison, using cellulose nitrate film supplied by the Eastman Kodak Company, launched the commercial motion picture industry, the story of film preservation has been characterized by incredible neglect on the part of the moviemakers and general disregard for the importance of film-base and color-image stability on the part of Kodak and other manufacturers.

Institutional film archives in the United States — which, like those in most other countries, are ill-equipped and seriously underfunded — have generally done a poor job preserving nitrate film and have lost countless valuable movies through fires and failure to provide proper low-temperature, humidity-controlled storage.

Frank Hodsoll, a former chairman of the National Endowment for the Arts, gave a grim assessment of the situation in the United States:

> I was appalled to learn that one-half of the theatrical films produced before 1952 have al-

ready been irretrievably lost due to decay and neglect. Under present conditions, most of the remaining half will not survive this century.

> Of the 11,000 American feature films produced before 1930, less than one in five have escaped fire, decay, or destruction by other means.

> American films and American television have shaped, influenced, and substantially contributed to American Culture. Many believe that film is perhaps our most significant and most distinctive contribution to international art and culture.

> It is virtually impossible to conceive of a film that does not instruct us in the art, the social perspectives, and the history of a particular period. Every film is a time capsule which tells us how we saw ourselves, and how others saw us, at a point in our past. The disappearance of a film or videotape is therefore not only a loss of an artistic object, it is also partial obliteration of our nation's history.[17]

## For More Than 30 Years, Eastman Color Films Suffered from Very Unstable Color Images

In 1950, almost simultaneously with the introduction of cellulose triacetate "safety base" film as a replacement for the hazardous cellulose nitrate film then being used by the motion picture industry throughout the world, Eastman Kodak launched the first of the Eastman Color Negative and Eastman Color Print films. These films quickly led the way to the mass conversion from black-and-white to color cinematography.

With that change came the demise of the essentially permanent Technicolor imbibition printing process (see Chapter 10) — leaving the industry with Eastman Color negative and print films, which under typical storage conditions had a far shorter life than films made by the Technicolor process.

The color fading problem was made worse by the fact that neither the movie studios nor film archivists had any clear idea of what they were dealing with and how the film had to be stored to preserve it for the future — the fading characteristics of the color films they were using and collecting were a closely held secret of Kodak and the other film manufacturers.

This sad state of affairs continued until the mid-1970's, when a series of events began that ultimately forced Kodak to abandon its policy of secrecy regarding color stability and to announce, in August 1980, that it would release information on light fading and dark-storage stability of its current and future color products. This in turn, for the first time, introduced competition in the area of color image stability among Eastman Kodak, Fuji of Japan, and Agfa-Gevaert of Germany, the major producers of color motion picture stocks in the Western world, and has already led to substantial improvements in the stability of both Kodak and Fuji motion picture print films as well as certain of their color negative products.

An important influence was a major article on the fading of color motion pictures by Bill O'Connell that appeared

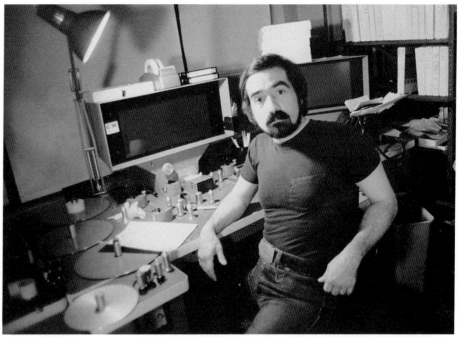

Martin Scorsese, a leader in the drive to preserve color motion pictures, has directed **Mean Streets** (1973); **Alice Doesn't Live Here Anymore** (1975); **Taxi Driver** (1976); **New York, New York** (1977); **Raging Bull** (1980); **The King of Comedy** (1983); **The Color of Money** (1986); **The Last Temptation of Christ** (1988); **Goodfellas** (1990); **Cape Fear** (1991); and **The Age of Innocence** (1993).

July 1980

in the September–October 1978 issue of *Film Comment* magazine. O'Connell began:

> The house lights dim, a hush comes over the expectant audience, and a beam from the projection booth hits the screen. But the old film, so clear in a buff's memory, looks to have deteriorated before his eyes — and memory is not at fault. What was once a color film is now a jarring mixture of faded dyes in a spectrum that runs from dull, muddy pink to deep, garish purple. The sunny, windswept fields of *Oklahoma!* have turned an eerie, strident pink. Marilyn Monroe looks jaundiced. The florid gold and pastel palace in *The King and I* is now a drab, dusky rose.
> . . . Color fading threatens all films, and there is a growing awareness that it has not only reached epidemic proportions but has passed all other problems of film preservation.[18]

The following month, in another important article that appeared in *American Film* magazine, Paul Spehr of the Library of Congress wrote:

> Whatever the aesthetic importance of this basic change in moviemaking [the shift from black-and-white to color], potentially it is a tragedy.
> Why? Because the color dyes used in today's movies are so impermanent that there is little hope that the quality of color we are experiencing today will be passed on to the next generation. The hard, harsh fact is that most of the color films made since the mid-fifties will fade to indistinguishable — or at least undistinguished — shadows of their former glory.

Even the precious negatives from which the films are printed have a limited life expectancy. Under the storage conditions generally in use today, many of these negatives will fade to uselessness within the lifetimes of most of us.[19]

Both the *American Film* and *Film Comment* articles included a brief account of the Technicolor dye imbibition process and showed unfaded Technicolor frames along with severely faded frames from Eastman Color prints.

## Film Director Martin Scorsese Alerts the Entire Film Industry to the Fading Problem

After reading Bill O'Connell's article in *Film Comment,* film director Martin Scorsese wrote a letter to the magazine which said, in part:

> How can we sit back and allow a classic film, *2001: A Space Odyssey,* to fade to magenta? My own work has been severely affected, in that *New York, New York* was made to look like a Technicolor imbibition film. Within five years, its color will have faded beyond any recognition of the original concept, and the film will suffer for that loss. My present film, *Raging Bull,* was shot in black-and-white to avoid the color problem entirely.
> . . . I believe that directors, film students, and the Academy must form a unified front to combat the problem. Through benefits, fundraising, publicity, demonstration of the problem, and if need be, militant action, we must band together to face the issue and solve the problem. I personally offer my services, time, and finances to this cause, in an effort to motivate my colleagues and friends to action.[20]

The July 9, 1980 edition of **Variety,** the entertainment industry publication, featured a front-page story by Harlan Jacobson on the color film fading crisis. The **Variety** story, as well as many others that appeared in newspapers, magazines, and on television worldwide, was inspired by Martin Scorsese's campaign.

In early 1980, Scorsese, with the assistance of Mark del Costello and Donna Gigliotti of his staff and Scorsese's long-time film editor Thelma Schoonmaker, started circulating a petition asking Kodak to make permanent color motion picture film. The petition was sent to directors, actors, actresses, cinematographers, film archivists, and others in the field. Scorsese had a number of ideas for promoting the preservation of films and to pressure Kodak and other manufacturers to make more stable films (see **Appendix 9.1** on pages 343–344 at the end of this chapter).

Scorsese, the well-known director of *Mean Streets* (Warner Bros., 1973); *Alice Doesn't Live Here Anymore* (Warner Bros., 1975); *Taxi Driver* (Columbia, 1976); *New York, New York* (United Artists, 1977); *Raging Bull* (United Artists, 1980); *The King of Comedy* (Fox, 1983); *The Color Of Money* (Touchstone, 1986); *The Last Temptation of Christ* (Universal, 1988); *Goodfellas* (Warner Bros., 1990); *Cape Fear* (Universal, 1991); and *The Age of Innocence* (Columbia, 1993), has many friends in the movie business and the response to his appeal was immediate and overwhelming.

More than 200 people associated with the theatrical motion picture industry signed the petition, including Saul Bass, Bernardo Bertolucci, Peter Bogdanovich, Stan Brakhage, Kevin Brownlow, Ellen Burstyn, Vincent Canby, John Cassavetes, Michael Cimino, Jill Clayburgh, Francis Ford Coppola, Judith Crist, George Cukor, Robert DeNiro, Brian DePalma, Mia Farrow, Federico Fellini, Jane Fonda, Milos Forman, Jodie Foster, Ben Gazzara, Jean-Luc Godard, Elia Kazan, Sergio Leone, George and Marcia Lucas, Sidney Lumet, Leonard Maltin, Malcolm McDowell, Liza Minelli, and Paul Newman.

Also signing were Jack Nicholson, Joseph Papp, Arthur Penn, Sydney Pollack, Otto Preminger, Burt Reynolds, Gina Rowlands, Telly Savalas, Thelma Schoonmaker, Paul Schrader, Steven Spielberg, Mary Steenburgen, Barbra Streisand, Lily Tomlin, Francois Truffaut, King Vidor, Lina Wertmuller, Irwin Winkler, William Wyler, and many other directors, producers, actors, actresses, and film critics.

A letter written by Scorsese accompanied the petition:

To My Friends and Colleagues:
RE: Our Films
Everything We Are Doing Now Means Nothing!

All of our agonizing labor and creative effort is for nothing because our films are vanishing. I am not referring to the terrible problem of black and white film deterioration with which many of you are already familiar, but to something more immediate — FADING COLOR. . . . Working with film stock that is guaranteed to deteriorate in a matter of months is insulting and insane. . . .

Eastman Kodak, through their total monopoly in the United States and many other parts of the world, will be responsible for the destruction of our past and current work. They are betraying us and will have to account for the conscious perversion of the future history of cinema. . . .

The most practical preservation and economic solution is developing a COLOR STABLE FILM. So, if you care about your work and its future, then, for its sake, please lend your name and support. Attached is a letter to Eastman Kodak, petitioning them to take immediate action to rectify the deplorable state of the color film they supply.

. . . As a first step, please join us in signing.[21]

Accompanying the petition, which was sent to Kodak in June 1980, was a "Request for Information," which is printed in full below.[22] This 2-page document had a major impact at Kodak and spurred the company to re-evaluate the importance of good image stability in the design of its color motion picture films.

Scorsese's militant approach and sometimes strident language made many curators and archivists uneasy. Some curators had never really come to grips with color motion pictures from an aesthetic point of view — instead prefer-

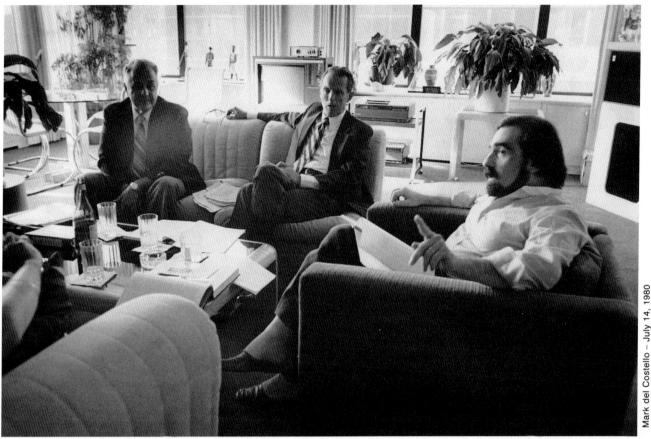

Mark del Costello – July 14, 1980

Pressing his demands that Kodak improve the stability of its color motion picture products and release stability data for all of its color films, director Martin Scorsese and his assistants, Mark del Costello and Donna Gigliotti, met in Scorsese's New York City apartment on July 14, 1980 with Ken Mason and Tony Bruno of Kodak's motion picture division. Scorsese, with the aid of his staff and his long-time film editor, Thelma Schoonmaker, were the leaders in a film-industry effort to force Kodak to address these issues. One month after the meeting, Kodak announced that it would make stability data public. In October 1981, Kodak announced that it was abandoning all of its existing motion picture color print films and replacing them with Eastman Color Print Film 5384 (35mm) and 7384 (16mm). These new films, supplied at no additional cost, were approximately ten times more stable than the films that they replaced. Fuji soon followed with its improved color print film. In 1987, Kodak presented Scorsese with its Career Achievement Award, in recognition of his outstanding achievements as a director and screenwriter.

ring the black-and-white films going back into the silent film era. Most had only a superficial understanding of the fading problem, how it came about, Kodak's part in creating the situation, and what might be done to solve the crisis. Some — who refused to sign the petition — even feared that associating with the Scorsese effort might hinder fund-raising efforts or alienate the film studios that were potential donors of films, money, or both, to their collections. Scorsese's "Request for Information" follows:

June 12, 1980

To: Mr. Walter Fallon, Chairman of the Board
Mr. Colby Chandler, President
Eastman Kodak Company
343 State Street
Rochester, New York 14650

*Request for Information*

1. We would like to have the estimated time of dark storage required for one or more of the color image dyes to

reach a density loss of .10 from an original density of 1.0 when the film is stored in the dark at 75°F and 40% relative humidity for all present and past Eastman Kodak products, including camera negative stock, intermediate film stock and all release print stock.

This information is needed if we (filmmakers, studios, distributors) are to be able to determine the proper storage conditions (temperature and relative humidity) necessary to preserve each of these materials.

Further, the dark fading stability information is necessary if one is to make an intelligent choice among currently available products as to which film stocks and systems will result in the best long term keeping.

Finally, precise stability data is needed for all film stocks, especially the older materials which are no longer manufactured, in order to convince the studios and film archives of the urgent need to install cold storage vaults. Intelligent decisions about cold storage CANNOT be made unless the stability characteristics of each product are known.

Reacting to the outcry over the poor stability of Eastman Color motion picture films, the personnel at the Eastman Kodak booth during the 1980 annual conference of the SMPTE in New York City offered suggestions for proper storage of film and advocated making black-and-white separations.

2. How quickly can a PERMANENT color release print stock be produced, with quality and stability characteristics equal to or better than Technicolor Imbibition prints? A crash program in research and development will be needed, yet we believe that a color stable release print stock is achievable through current technology. The new LF print films, though a welcome improvement, are not stable enough to be acceptable.

3. How much research and development will Eastman Kodak invest into development of color stable pre-print material? For the present, we want all color pre-print material at the dark keeping stability level of E-6 Ektachrome films.

### Kodak Officially Abandons Its Color Stability Secrecy Policy

Along with the petition and its signatories, the above document was probably the single most important factor forcing Kodak two months later to abandon its historic policy of secrecy regarding color stability. (The company, however, continued to keep stability data for its older color films secret, probably because the accumulated information would have made it plain that Kodak had devoted little attention to improving the stability of its products since Eastman color motion picture films were introduced in 1950 — in some cases later products were even less stable than the ones they replaced.)

Kodak also accelerated its efforts to develop new color couplers that would produce more stable dyes in its negative and print films, while at the same time avoiding any significant increase in manufacturing costs — or any major change in processing chemicals. This was important to Kodak since the company feared that even a slight rise in

film costs would cause the company to lose a significant amount of the market to Fuji or Agfa-Gevaert. This was especially true in the highly competitive print film market. Kodak was well aware of the lack of concern about long-term permanence on the part of many movie producers and believed that many studios and labs would choose the cheapest product that produced acceptable images on the screen — regardless of who made it.

Scorsese's campaign received a tremendous amount of publicity in the press, with articles appearing in more than 300 newspapers and magazines in the United States and other countries. A front-page story in the July 9, 1980 entertainment industry weekly *Variety* was headlined: "Old Pix Don't Die, They Fade Away — Scorsese Helms Industry Plea to Kodak." While all the complaints about Kodak's films probably did not cause the company to lose any business, and Kodak repeatedly denied that there really was any problem if negatives "were stored as recommended," Kodak was certainly uneasy about the withering criticisms being leveled at the company and was sensitive to accusations that it was responsible for the loss of much of the world's film heritage.

Despite the fact that some of the charges against Kodak by Scorsese and others which appeared in the press were rather exaggerated — and in some cases actually incorrect — the thrust of the criticisms was valid:

**(a)** the stability of Eastman color motion print films was wholly inadequate;

**(b)** instead of being expendable, as Kodak maintained, prints were generally the only form in which films were being collected by archives around the world;

**(c)** the rapid fading of prints was causing moviemakers a lot of trouble and extra expense and was resulting in many very faded films being shown on television (since it was too expensive to make new prints from faded negatives — or from separations in the few instances where they were available — if the new prints would also fade away in a few years);

**(d)** the dye stability of camera negative and laboratory films was also inadequate, and, since few films would ever be stored under refrigerated conditions, this would result in the loss of the films in only a few more decades (with early Eastman color negatives already being seriously deteriorated);

**(e)** Kodak attached relatively little importance to long-term color stability of its motion picture films;

**(f)** Kodak was doing little to alert the industry to the need for better storage conditions (indeed, Kodak could not even talk about the subject meaningfully because it was keeping stability data secret and would not reveal the fading rate of any particular film at various temperatures and relative humidities).

### Kodak Announces a Much Longer Lasting Color Print Film — Fuji Soon Follows

In October 1981, only a little more than a year after Kodak had received the Scorsese petition, the company suddenly announced that it was going to abandon all of its existing print films and would replace them with a new product, Eastman Color Print Film 5384 (35mm) and 7384

(16mm), which, according to Kodak, had an approximately ten-fold improvement in dye stability. The new print film came into general use in 1982–83.

In the course of the Scorsese campaign, Kodak also adopted a new attitude about the importance of print stability — especially in terms of the newly emerging videocassette and cable and satellite TV markets where only one print in good condition is needed for broadcast or cassette production. In the past, Kodak had maintained that prints were not intended to last long — most were physically worn out after 6 months or a year of theater projection. Kodak was persuaded that long print life was, after all, an important consideration in film design.

A brochure distributed by Kodak at the time the film was announced read, in part:

**5384. A longer print life for your life's work.**

Whatever you do in motion pictures — whether you're involved in producing or distributing — 5384 will mean a longer print life for your life's work.

Prints stored at normal room temperature . . . at about 40-percent relative humidity . . . will provide excellent color pictures that will last for decades. Tests indicate that storage at a lower temperature, such as 55°F [12.8°C], could increase the useful life of your films by as much as five times.

5384. Created so the films in which you invest so much of yourself can live on.

**5384. Eastman's continuing commitment to the motion picture industry.**

Eastman Kodak Company has always appreciated the cultural value of motion pictures. We know what they mean, in America and around the world.

So — while 5384 is new — our commitment to the preservation of motion pictures is long-standing.

We've devoted years to the improvement of color dye stability. All the while we've invested in research. Made recommendations for proper film storage. Developed technical publications and information programs. Maintained a continual dialogue with those who share our commitment: the archivists, the technical societies, and professional associations.[23]

A full-page ad appearing in *American Cinematographer* in July 1983 was entitled "Our Descendants Will See Their Ancestors as We Really Were" and read:

Throughout this ever-changing world, a film-maker wants a production to last decades into the future. You want audiences fifty or more years from now to see your film as it looked originally.

Eastman color print film 5384/7384 makes it possible with its exceptional color reproduction and retention. It is the color release print film intended to last up to a century — even

when stored at normal room temperature (approximately 75 degrees Fahrenheit and 40-percent relative humidity). In fact, when 5384 is carefully stored under recommended conditions (40 degrees Fahrenheit and 40-percent relative humidity), it can last much, much longer.

It is the print film whose color images can look the best and last the longest.

Our new Eastman color print film's unique color images will last for decades so our descendants will see their ancestors as we really were. Just say, "Print mine on Eastman film." Eastman film. It's looking better all the time.[24]

Another ad for 5384, appearing in the January 1984 issue of *American Cinematographer*, read, in part:

Whether you're involved in production or distribution, you'll be pleased to know that the film in which you have invested your time and talent can enjoy longer runs and wider audiences. Decades from now it can still have the crisp, bright colors of its world premiere exhibition. Order it by name — Eastman film.[25]

The new film, and the above ads — nothing like them had ever appeared before in the motion picture industry — ushered in a new era of concern about color film stability and started, for the first time, genuine competition on image stability among Kodak, Fuji, and Agfa-Gevaert.

A copy of Scorsese's petition was also sent to Fuji, and his appeal reportedly spurred the rapid development of new color couplers that would produce significant improvements in the dye stability of Fujicolor negative film (Fujicolor Negative Film A 8511/8521 and Fujicolor High Speed Negative Film AX 8512/8522) along with a new print film, Fujicolor Positive LP Film 8816. Fuji introduced the new films in 1983; many additional improved-stability films have followed since that year.

In 1990 Scorsese, together with noted film directors Woody Allen, Francis Ford Coppola, Stanley Kubrick, George Lucas, Sydney Pollack, Robert Redford, and Steven Spielberg, established The Film Foundation, an organization for promoting and coordinating motion picture preservation and restoration projects.[26]

## A Brief History of Eastman Color Motion Picture Films

Eastman color motion picture films, which were introduced in 1950, trace their beginnings to the Kodacolor amateur still negative and print processes introduced in 1942 (see Chapter 1). Kodak very early realized the practical advantages of a color negative film — instead of a reversal transparency film — for the camera original, and then using the negative to make prints for viewing (paper prints in the case of the Kodacolor system, or "prints" on transparent film for motion picture projection). The negative can be designed for optimum performance in the camera; for example, color negatives are made with low-contrast, multilayer emulsions that have both high-speed and slow-speed layers within the cyan, magenta, and yellow dye-forming

July 1980 (3)

Arnold Schieman of the National Film Board of Canada in Montreal, Quebec, with the original camera negative of the 1951 production **Royal Journey**, a film documenting Princess Elizabeth's tour of Canada. The film was the first feature-length production made on the then-new Eastman Color negative film and print film. When these photographs were taken in 1980, the negative was still being stored under non-refrigerated conditions at the National Film Board. In 1989, the color negative was moved to the National Archives of Canada in Ottawa, and it is now stored at 28°F (–2.2°C) and 28% RH.

Rolls of the original Eastman Color Negative Film, Type 5247 from **Royal Journey**. In 1996, the negative will be moved to the National Archives' new facility in Gatineau, Quebec and will be preserved at 0°F (–18°C) and 25% RH.

Black-and-white separation positives were made from the original color negative, and a new intermediate color negative for producing prints or video transfers can be made from the separations, but at great expense.

layers. This gives color negatives much wider exposure latitude than color reversal films (which have a high-contrast emulsion so that slides have the proper visual appearance when projected on a screen in a darkened room).

With color negatives, extensive corrections can be made for exposure errors and deviations in color balance when color intermediates and prints are made. Modern color negative films have considerable latitude in this respect, and moviemakers put this to good advantage in creating the proper color balance and "mood" for a scene when the film is timed (i.e., when prints are adjusted for color balance and density).

Although the exposure latitude of the early Kodacolor system made it suitable for the ordinary box camera — Kodak knew a wide-latitude color film was needed in order to enter the mass market for amateur snapshots made with non-adjustable cameras — the color reproduction of the prints was poor and not adequate to compete with established motion picture processes such as the Technicolor three-strip camera and imbibition color print system.

The image stability of Kodacolor negatives and prints was also very poor — all of the Kodacolor prints made from 1942 until around 1953 have turned orange and faded to various degrees, whether or not they were exposed to light on display. Although the orange-staining problems were significantly reduced in 1953, the dye-image stability difficulties inherent in the early Kodacolor process were carried directly into the Eastman motion picture color negative and print films.

When Kodak perfected the colored-coupler masking method of color correction in negatives, it was finally able to make a negative-positive system with color and tone reproduction good enough to compete with the Technicolor process. Colored-coupler masking was first included in a commercial product by Kodak in the Ektacolor still camera film introduced in 1947; the technology was applied to Kodacolor amateur negative films soon thereafter. Experience gained with the still color negative films was essential in developing the color negative motion picture film introduced by Kodak in 1950 and the many films that have followed (see film listing in **Table 9.1** on the following page). Eastman Color Print Film, also introduced in 1950, was closely related to the Ektacolor print film put on the market in 1947 at the same time as Ektacolor negative film.

With the introduction of Eastman color negative and print films, it was evident that Kodak was focusing its efforts on essentially the same negative-positive chromogenic processes for both motion picture and still photography; this allowed a concentration of research efforts which benefited both lines of products. As an example, DIR (developer inhibitor releasing) couplers and other improvements in emulsion design which allowed much sharper and finer-grain images than previously possible with color negative films were incorporated into Eastman Color Negative II Film 5247, and into Kodacolor II Film for still cameras, both introduced in 1972.

Although they use different processing chemicals, the current Kodak still and motion picture color negative films are otherwise so similar that some photographers use the motion picture film in their still cameras, printing the images on conventional Ektacolor paper (a practice not recommended by this author).

## Causes of Color Motion Picture Fading

Even after repeated projections, the fading of the dye images in motion picture print films is almost entirely a "dark fading" reaction. Since each frame is exposed to light for only a small fraction of a second during each projection, the total light exposure even after hundreds of projections is so small as to be almost inconsequential.

Dark fading rates are a function of the inherent stability of the organic dye images in a particular film, the temperature of storage, and, usually to a lesser extent, the relative humidity of the storage area. Improper processing and washing can also reduce the stability of a negative or print film — in some cases deviations from recommended processing may result in drastic losses in image stability.

Research disclosed by Eastman Kodak in late 1992 showed that storing films in sealed or semi-sealed containers such as standard taped or untaped metal or plastic film cans (or vapor-proof bags) could significantly increase the rates of both dye fading and film-base deterioration compared with storage in ventilated containers surrounded by circulating air. In a rather controversial recommendation on how to deal with this problem, Kodak suggested packaging films in taped film cans containing a substance that strongly absorbs moisture and acetic acid vapors. This subject is discussed later in this chapter.

When a color negative fades in dark storage, the fading is roughly proportional throughout the full density range of the image. That is, if a 20% loss of density occurs in a low density area of an image (for example, blue density drops from an original density of 1.20 to 0.96), approximately the same percentage will be lost in the maximum density parts of the image (for example, blue density drops from an original density of 2.40 to 1.92). This results in a loss of *contrast* of the blue record (yellow dye image) of the image. While it is possible to correct the overall density of a print made from a faded negative, and to achieve a balanced flesh tone or some other selected color by re-timing the negative for printing, it is *not* possible to correct for the contrast imbalance with normal equipment and procedures.

As the cyan, magenta, and yellow dyes in all current color negative films fade at significantly different rates, severely faded negatives exhibit contrast imbalances that result in off-colored shadows and highlights. With early Eastman Color negatives that have poor-stability cyan and yellow dyes, for example, images generally will print with blue shadows and yellow highlights if the negatives are re-timed to print correctly balanced midtones.

How noticeable negative fading is not only depends on the degree of fading and the resulting contrast imbalance among the cyan, magenta, and yellow dyes, but can also be very scene-dependent. When a print is made from a faded negative, the changes in some scenes are usually more noticeable than are others. The changes in image color balance — especially in detailed highlight and shadow areas — can be particularly distracting as a film cuts from one scene to another.

Re-timing and printing problems are exacerbated when faded film stocks are intercut (e.g., when camera negative film is intercut with a different type of film used for special effects) because different types of film generally have different fading characteristics.

## Table 9.1  Eastman Color Negative, Laboratory Intermediate, and Color Print Films for Motion Pictures

**Boldface Type** indicates a film that was commercially available when this book went to press in 1992; the other products listed had been either discontinued or replaced with newer materials. Under Eastman Kodak's system of film designation, Type 52 films are 35mm or wider camera and laboratory films; Type 72 films are 16mm or narrower camera and laboratory films; Type 53 films are 35mm or wider color print films (printed from color negatives or internegatives); and Type 73 films are 16mm or narrower color print films.

| Camera Negative Films | Year of Introduction |
|---|---|
| Eastman Color Negative Film, Type 5248 (35mm only) | 1952 |
| Eastman Color Negative Film, Type 5250 (35mm only) | 1959 |
| Eastman Color Negative Film, Type 5251 (35mm only) | 1962 |
| Eastman Color Negative Film, Type 5254 (35mm only) | 1968 |
| Eastman Color Negative II Film 5247 (35mm only) [1st version] | 1972 |
| Eastman Color Negative II Film 7247 (16mm only) | 1974 |
| Eastman Color Negative II Film 5247 (35mm only) [2nd version] | 1976 |
| Eastman Color Negative II Film 5247 (35mm only) [3rd version] | 1980 |
| Eastman Color High Speed Negative Film 5293 (35mm only) | 1982 |
| **Eastman Color Negative Film 7291** (16mm only) | **1982** |
| **Eastman Color High Speed Negative Film 5294** and 7294 | **1983** |
| **Eastman Color Negative Film 5247** (35mm only) (name change only; same as 1980 version of 5247) | **1985** |
| **Eastman Color High Speed Negative Film 7292** (16mm only) | **1986** |
| **Eastman Color High Speed SA Negative Film 5295** (35mm only) | **1986** |
| **Eastman Color High Speed Daylight Negative Film 5297 and 7297** | **1986** |
| **Eastman EXR Color Negative Film 5245 and 7245** | **1989** |
| **Eastman EXR Color Negative Film 5248 and 7248** | **1989** |
| **Eastman EXR 500T Color Negative Film 5296 and 7296** | **1989** |
| **Eastman EXR Color Negative Film 5293 and 7293** | **1992** |

| Laboratory Intermediate Films | Year of Introduction |
|---|---|
| Eastman Color Internegative Safety Film, Type 5243 (35mm only) | 1952 |
| Eastman Color Internegative Film, Type 5245 (35mm only) | 1953 |
| Eastman Color Internegative Film, Type 5270 and 7270 | 1956 |
| Eastman Color Intermediate Film, Type 5253 and 7253 | 1956 |
| Eastman Color Internegative Film, Type 5271 and 7271 | **1968** |
| **Eastman Color Reversal Intermediate Film 5249 and 7249** | **1968** |
| Eastman Color Intermediate II Film 5243 and 7243 | 1978 |
| **Eastman Color Internegative II Film 7272** (16mm only) | **1980** |
| **Eastman Color Intermediate Film 5243 and 7243 Improved** | **1986** |
| **Eastman EXR Color Intermediate Film 5244 and 7244** (triacetate); **2244** (polyester) | **1992** |

| Color Print Films | |
|---|---|
| Eastman Color Print Safety Film, Type 5381 and 7381 | 1950 |
| Eastman Color Print Film, Type 5382 and 7382 | 1953 |
| Eastman Color Print Film, Type 7383 (16mm only) | 1959 |
| Eastman Color Print Film, Type 5385 and 7385 | 1962 |
| Eastman Color Print Film, Type 7380 (8mm and Super 8mm only) | 1968 |
| Eastman Color Print Film, Type 7381 (8mm and Super 8mm only) | 1970 |
| Eastman Color Print Film, Type 5381 and 7381 | 1972 |
| Eastman Color SP Print Film, Type 5383 and 7383 | 1974 |
| Eastman Color LF Print Film 5378 and 7378 (7378 was little used; 5378 saw virtually no use) | 1979 |
| Eastman Color LFSP Print Film 5379 and 7379 (7379 was little used; 5379 saw virtually no use) | 1979 |
| **Eastman Color Print Film 5384 and 7384** | **1982** |
| **Eastman Color LC Print Film 5380 and 7380** (low-contrast version of 5384 for TV applications) | **1983** |

## The Original Eastman Color Negative of *Spartacus* Has Faded Beyond Use

When film archivist Robert Harris and his associate Robert Katz became involved with MCA/Universal in the project to restore the epic 1960 film *Spartacus* for its re-release in 1991, it was found that the original Eastman Color negative had faded beyond use:

> Universal took very, very good care of it, but it was thirty years old. The yellow layer was gone; we made some tests with the camera negative and ended up with blue shadows and yellow facial highlights.[27]

Directed by Stanley Kubrick and produced by and starring Kirk Douglas, *Spartacus* was made with a budget exceeding $12 million and employed more than 10,000 people. The film won an Academy Award for color cinematography. At the time it was made, *Spartacus* was the most expensive film ever produced in Hollywood. Writing about the film in the May 1991 issue of *American Cinematographer*, Frank Thompson said "audiences who experienced the dazzling Super Technirama 70 [wide-format] images and brilliant six-track sound have never forgotten the film's impact."

In the restoration of *Spartacus*, Robert Harris, who was also the person behind the 1988 restoration of the 1962 classic *Lawrence of Arabia*, not only had to deal with the problem of the fading of the original color negative, but also had to rebuild the complex six-track soundtrack and reinsert scenes that were "snipped by order of the censors" in 1960. The restored *Spartacus* had a number of theater engagements around the country in 1991, was shown on television, and has been released on videocassette and videodisc.

Fortunately, the black-and-white separations (YCM's) made from the original color negative of *Spartacus* in 1960 still existed in good condition, and they were successfully used to reconstruct an intermediate color negative which in turn was used to make new prints (the existing prints from the 1960's are now severely faded). Except for major theatrical features, separations were never made for most of the movies shot on Eastman Color and similar motion picture color negative film during the past four decades. Good-quality prints can no longer be struck from many of these negatives.

This worldwide cultural and financial tragedy, which grows worse with each day that the films continue to sit in non-refrigerated storage on archive and film library shelves, could easily have been averted *entirely* by simply providing humidity-controlled cold storage. For *Spartacus*, the cost of refrigerated storage for the original color negative during the 30 years dating from when it was made in 1960 until it was re-released in 1991 would have been insignificant compared to what was spent for making and storing separations and in the recent restoration of the film.

## The Profound Influence of Storage Temperature on Color Film Fading Rates

To determine the proper storage temperature for a particular motion picture film, it is first necessary to reach a decision about how long the film could conceivably be of value — and how much image deterioration could be tolerated during that time.

Image-life predictions for a specific type of film stored under various temperature and relative humidity conditions are obtained with the complex, multi-temperature Arrhenius accelerated dark fading test specified in *ANSI IT9.9-1990, American National Standard for Imaging Media – Stability of Color Photographic Images – Methods for Measuring*.[28] The Arrhenius test method is discussed in Chapter 2 and Chapter 5 of this book.

Kodak has released fading-rate data for many of its films, and this information can be used to compute the predicted image-life of the films in storage at normal room temperature (see **Table 9.2**) or at some other temperature. Estimates can also be made concerning the effect of relative humidity on the rate of dye fading. Note that the image-life estimates given in this book for Eastman, Fuji, and Agfa films are based on Arrhenius tests with free-hanging film samples surrounded by rapidly circulating air. As will be discussed later, such tests may considerably overstate the actual stability of a film when it is stored in the closed environment of a standard film can or other sealed or semi-sealed container.

The image-life estimates given in this book for motion picture films are probably reasonably accurate when films are stored in "vented" plastic film cans or in permeable cardboard boxes, as recommended by this author.

Thus far, Kodak has refused to make public stability data for its earlier motion picture films; however, it is known that all of these films have very poor image stability. The fading characteristics of Eastman Color Negative II Film 7247 can be considered representative of early Eastman color negative films, and Eastman Color SP Print Film 5383 is probably typical of the earlier print films.

For this book, Fuji Photo Film Co., Ltd. has furnished estimates for a 10% loss of the least stable dye for its motion picture films, and these are given in **Table 9.3**. Fuji prefers to evaluate color negative films in terms of the loss in *image contrast* of the least stable image dye. According to Fuji, its accelerated tests indicate that current Fuji F-series color negative films could be stored for approximately 180 years at 75°F (24°C) and 40% RH before a 10% loss in image contrast of the least stable dye would occur.

While one can argue that, because of changes in colored coupler masking densities that can occur with color negatives in dark storage and because of density and color corrections that can be made during printing, loss of image contrast is a better approach for the evaluation of color negative deterioration than is using simple "dye loss" data. The "contrast loss" method, however, is not specified in the current ANSI color stability standard.

After repeated requests, Agfa-Gevaert somewhat reluctantly agreed to provide accelerated test data for its color motion picture films for this book, and 10% dye loss estimates are given in **Table 9.4**. Agfa said that its research has indicated that there can be considerable uncertainty in the predictions obtained in Arrhenius tests. Nevertheless, this author believes that the Agfa image-life estimates are useful. They suggest, for example, that Agfa XT 100, improved-type Agfa XT 320, and Agfa XTS 400 color negative films have image stability that is as good or better than

*(continued on page 317)*

**Table 9.2    Unofficial Kodak Estimates for Number of Years Required for the Least Stable Image Dye of Motion Picture Films to Fade 10% from an Original Density of 1.0 When Stored at Room Temperature (75°F / 24°C)***

**Boldface Type** indicates a film that was commercially available when this book went to press in 1992; the other products listed had been either discontinued or replaced with newer materials.

| Camera Negative Films | Years of Storage at 40% RH* | Years of Storage at 60% RH* |
|---|---|---|
| Eastman Color Negative II Film 5247 (1974 version) | 6 (–Y) | 3 (–Y) |
| Eastman Color Negative II Film 5247 (1976 version) | 12 (–C) | NA |
| Eastman Color Negative II Film 5247 (1980 version) | 28 (–Y) | 14 (–Y) |
| **Eastman Color Negative Film 5247** (1985 name change) | **28 (–Y)** | **14 (–Y)** |
| Eastman Color High Speed Negative Film 5293 and 7293 | (not disclosed) | |
| **Eastman Color High Speed Negative Film 5294** | **(not disclosed)** | |
| **Eastman Color High Speed SA Negative Film 5295** | **(not disclosed)** | |
| **Eastman Color High Speed Daylight Negative Film 5297** | **(not disclosed)** | |
| Eastman Color Negative II Film 7247 (1972–1983) | 6 (–Y) | 3 (–Y) |
| **Eastman Color Negative Film 7291** | **50 (–M)** | **NA** |
| Eastman Color High Speed Negative Film 7294 | (not disclosed) | |
| **Eastman Color High Speed Negative Film 7292** | **(not disclosed)** | |
| **Eastman Color High Speed Daylight Negative Film 7297** | **(not disclosed)** | |
| **Eastman EXR Color Negative Film 5245 and 7245** (1989— ) | **22 (–Y)** | **11 (–Y)** |
| **Eastman EXR Color Negative Film 5248 and 7248** (1989— ) | **30 (–Y)** | **15 (–Y)** |
| **Eastman EXR Color Negative Film 5293 and 7293** (1992— ) | (not disclosed) | |
| **Eastman EXR 500T Color Negative Film 5296 and 7296** (1989— ) | **50 (–Y)** | **25 (–Y)** |

| Laboratory Intermediate Films | Years of Storage at 40% RH* | Years of Storage at 60% RH* |
|---|---|---|
| Eastman Color Internegative Film, Type 5271 and 7271 | 5 (–Y) | 3 (–Y) |
| **Eastman Color Internegative Film, Type 7272** | **23 (–C)** | **NA** |

| Laboratory Intermediate Films | Years of Storage at 40% RH* | Years of Storage at 60% RH* |
|---|---|---|
| **Eastman Color Reversal Intermediate Film 5249 and 7249** | **8 (–Y)** | **4 (–Y)** |
| Eastman Color Intermediate II Film 5243 and 7243 | 22 (–C) | NA |
| **Eastman Color Intermediate Film 5243 and 7243 Improved** | **(not disclosed)** | |
| **Eastman EXR Color Intermediate Film 5244 and 7244** (triacetate); **2244** (polyester) (1992— ) | **(not disclosed)** | |

| Color Print Films | Years of Storage at 40% RH* | Years of Storage at 60% RH* |
|---|---|---|
| Eastman Color Print Film 5381 and 7381 | 5 (–C) | NA |
| Eastman Color SP Print Film 5383 and 7383 | 5 (–C) | NA |
| **Eastman Color Print Film 5384 and 7384** | **45 (–Y)** | **23 (–Y)** |
| **Eastman Color LC Print Film 5380 and 7380** (low-contrast version of 5384 for TV applications) | **45 (–Y)** | **23 (–Y)** |

**\*Notes:** The estimates given here should serve only as general guidelines. Estimated times for storage at 75°F (24°C) have been derived by this author from data in **Dye Stability of Kodak and Eastman Motion Picture Films** (data sheets), Kodak Publications DS-100-1 through DS-100-9, May 29, 1981; G. L. Kennel, R. C. Sehlin, F. R. Reinking, S. W. Spakowsky, and G. L. Whittier, "Eastman Color High-Speed Negative Film 5293," **SMPTE Journal,** Vol. 91, No. 10, October 1982, pp. 922–930; K. J. Carl, J. W. Erwin, S. J. Powell, F. R. Reinking, R. C. Sehlin, S. W. Spakowsky, W. A. Szafranski, and R. W. Wien, "Eastman Color Print Film 5384," **SMPTE Journal,** Vol. 91, No. 12, December 1982, pp. 1161–1170; R. C. Sehlin, F. R. Reinking, S. W. Spakowsky, D. L. Clifford, G. L. Whittier, and W. A. Szafranski, "Eastman Color Negative Film 7291," **SMPTE Journal,** Vol. 92, No. 12, December 1983, pp. 1302–1309; and other sources.

The estimates for 60% RH storage are based on Kodak research that showed that the fading rate of typical yellow dyes in Kodak films approximately doubles when the relative humidity is increased from 40% to 60%. Furthermore, the dye stability data given here were based on Arrhenius tests conducted with free-hanging film samples exposed to circulating air. Research disclosed by Eastman Kodak in late 1992 showed that storing films in sealed or semi-sealed containers (e.g., vapor-proof bags and standard taped or untaped metal and plastic motion picture film cans) could substantially increase the rates of dye fading and film-base deterioration. Therefore, the estimates given here for color motion picture films probably **considerably** overstate the actual stabilities of the films when they are stored in standard film cans under the listed temperature and humidity conditions. (See: A. Tulsi Ram, D. Kopperl, R. Sehlin, S. Masaryk-Morris, J. Vincent, and P. Miller [Eastman Kodak Company], "The Effects and Prevention of 'Vinegar Syndrome'," presented at the **1992 Annual Conference of the Association of Moving Image Archivists**, San Francisco, California, December 10, 1992.)

## Table 9.3   Official Fuji Estimates for Number of Years Required for the Least Stable Image Dye of Motion Picture Films to Fade 10% from an Original Density of 1.0 When Stored at Room Temperature (75°F / 24°C)

**Boldface Type** indicates a film that was commercially available when this book went to press in 1992; the other products listed had been either discontinued or replaced with newer materials.  Under Fuji's old system of film designation, type 851 films were 35mm camera color negative films and type 852 films were 16mm equivalents.  Under the current designation system, adopted in 1988, type 85 are 35mm camera color negative films and type 86 are 16mm equivalents.  Type 881 films are 35mm color print films (printed from color negatives or internegatives); type 882 films are 16mm equivalents.

| Camera Negative Films | Years of Storage at 40% RH | Years of Storage at 60% RH |
|---|---|---|
| Fujicolor Negative Film A 8517 and 8527 | 40 (–C) | — (–C) |
| Fujicolor Negative Film A 8511 and 8521 | 100 (–Y) | — (–Y) |
| Fujicolor Negative Film A250 Type 8518 and 8528 | 40 (–C) | — (–C) |
| Fujicolor High-Speed Negative Film AX, 8512 and 8522 | 100 (–Y) | — (–Y) |
| Fujicolor High-Speed Negative Film AX, 8514 and 8524 | 100 (–Y) | — (–Y) |
| Fujicolor Negative Film F-500 8514 and 8524 | 100 (–Y) | — (–Y) |
| **Fujicolor Negative Film F-64 8510 and 8610** | **100 (–Y)** | **— (–Y)** |
| **Fujicolor Negative Film F-64D 8520 and 8620** | **100 (–Y)** | **— (–Y)** |
| **Fujicolor Negative Film F-125 8530 and 8630** | **100 (–Y)** | **— (–Y)** |
| **Fujicolor Negative Film F-250 8550 and 8650** | **100 (–Y)** | **— (–Y)** |
| **Fujicolor Negative Film F-250D 8560 and 8660** | **100 (–Y)** | **— (–Y)** |
| **Fujicolor Negative Film F-500 8570 and 8670** | **100 (–Y)** | **— (–Y)** |

### Laboratory Intermediate Films

| | | |
|---|---|---|
| **Fujicolor Intermediate Film, 8213 and 8223** | **100 (–Y)** | **— (–Y)** |

### Color Print Films

| | | |
|---|---|---|
| Fujicolor Positive Film HP, 8814 and 8824 | 9 (–C) | 8 (–C) |
| **Fujicolor Positive Film LP, 8816 and 8826** | **>50 (–Y)** | **50 (–Y)** |

## Table 9.4   Official Agfa-Gevaert Estimates for Number of Years Required for the Least Stable Image Dye of Motion Picture Films to Fade 10% from an Original Density of 1.0 When Stored at Room Temperature (75°F / 24°C)

**Boldface Type** indicates a film that was commercially available when this book went to press in 1992; the other products listed had been either discontinued or replaced with newer materials

| Camera Negative Films | Years of Storage at 40% RH | Years of Storage at 60% RH |
|---|---|---|
| Agfa XT 125 Colour Negative Film | 10 (–C) | — (–C) |
| **Agfa XT 100 Colour Negative Film** | **35 (–Y)** | **— (–Y)** |
| **Agfa XT 320 High Speed Colour Negative Film** (original type) | **10 (–C)** | **— (–C)** |
| **Agfa XT 320 High Speed Colour Negative Film** (improved type: 1993— ) | **35 (–Y)** | **— (–Y)** |
| **Agfa XTS 400 High Speed Colour Negative Film** (1993— ) | **35 (–Y)** | **— (–Y)** |

### Color Print Films

| | | |
|---|---|---|
| Gevacolor Print Film 982 (original type) | 5 (–C) | — (–C) |
| Gevacolor Print Film 982 (improved type) | 5 (–C) | — (–C) |
| **Agfa Print CP1 Colour Print Film** (triacetate or polyester base) | **5 (–C)** | **— (–C)** |
| **Agfa Print CP10 Colour Print Film** (polyester base) (a triacetate base version of CP10 was planned for introduced in 1993) | **5 (–C)** | **— (–C)** |

that of most Eastman color negative films. The Agfa image-life estimates also indicate that the dye stability of Agfa print films continues to be very poor compared with that of Fuji and Eastman color print films.

## Image-Life Predictions for Long-Term, Humidity-Controlled Cold Storage

Image-life predictions for storage at temperatures lower than 75°F (24°C) are based on research by Eastman Kodak indicating that, compared with room-temperature storage at 75°F (24°C), the fading rates of chromogenic image dyes in typical Kodak films are reduced by a factor of approximately 4.5X when the storage temperature is reduced to 55°F (12.8°C), by a factor of 20X when the temperature is reduced to 35°F (1.7°C), and by a factor of 340X when the temperature is reduced to 0°F (–18°C). As can be seen in **Table 9.5**, low-temperature storage affords a *tremendous* increase in the useful life of color motion picture film. Low-temperature storage not only preserves the dye image itself, it also preserves the film base and the gelatin emulsion. Humidity-controlled cold storage also totally eliminates the possibility of fungus growths on films.

## A 10% Loss of the Least Stable Dye Is the Most Fading That Should Be Tolerated

The image-life predictions given here are based on the number of years that it will take for the least stable of the cyan, magenta, and yellow image dyes in a film to fade 10% (e.g., for the least stable dye to lose 0.10 density from an initial density of 1.0). A 10% dye loss is a useful yardstick for comparing the stability of one film with another, and is a good figure to work with when selecting the appropriate cold storage vault temperature for the long-term preservation of valuable motion picture films.

A 10% dye loss in a color negative is not a great deal of fading, and such a dye loss can generally be corrected by re-timing a negative for printing or producing a new intermediate negative. While one could argue that it is possible to satisfactorily correct for a greater amount of fading in a color negative, this author believes that in a serious preservation program, it is better to take a conservative stance and opt for the least possible change over time. Especially when different film stocks are intercut (e.g., two or more types of camera negative films, special effects films, etc.) — each of which may have a different amount of fading and a different degree or direction of color shift — it is much easier to make a new print that is close to the density and color values of the original production when negative fading is held to an absolute minimum.

In long-term preservation programs, little or no fading should be tolerated in motion picture prints as well. Pulling a print from cold storage and making a videotape or optical disc transfer is a simple task if one has an assurance that color and density are absolutely unchanged from the original, and that there has been no increase in d-min stain level. The color will be brilliant, the highlights clean, and the shadows deep and neutral. As television moves toward fully digital high-definition systems, the demands for image quality will correspondingly increase. What passes as "acceptable" today will not be adequate in the future.

With low-temperature, 0°F (–18°C) storage, color fading ceases for all practical purposes. With most collections, the money and aggravation this will save will in the long run far exceed the costs of cold storage. The older these "like new" motion pictures get, the more valuable they will become.

If one could draw an analogy to the costly process of "colorizing" old black-and-white films,[29] it is much easier and far less expensive to prevent color films from fading in the first place than it is to "restore" or to otherwise attempt to put back the color in a faded film.

## Most Older Color Films in Collections Have Already Faded Much More Than 10%

Probably the most compelling reason for adopting a very tight limit for "acceptable" dye fading in deciding what temperature is required in a long-term cold storage facility is that most films found in film libraries and archives today have already suffered more than a 10% dye loss. With many films, the amount of fading will *far* exceed a 10% dye loss. The reader can appreciate that letting such films fade an additional 20 or 30% — on top of the fading that has already taken place — simply cannot be tolerated. In such situations, *no* additional fading is acceptable. Depending on the degree of fading that has taken place in a particular film, the additional dye loss could very well push the film past the limit where acceptable prints can be made.

With seriously faded films, the additional dye loss could also prevent successful restoration using film-resolution digital intermediate systems or computer-based image-enhancement techniques. When fading passes a certain point, there simply is not enough color information left for adequate separation of the red, green, and blue densities that represent the cyan, magenta, and yellow dye images.

The realization that color motion picture films can be preserved essentially *forever* at moderate cost has convinced an increasing number of film studios, archives, museums, and other collecting institutions to construct humidity-controlled cold storage vaults to protect their holdings. Some of these facilities are discussed in this chapter (also see Chapter 20, *Large-Scale, Humidity-Controlled Cold Storage Facilities for the Permanent Preservation of Color Films, Prints, and Motion Pictures*).

## The Influence of Relative Humidity on Color Film Fading

The image dyes in different films vary in their sensitivity to relative humidity; Kodak has indicated that the rates of fading of some of the yellow dyes in its products approximately double when the relative humidity is increased from 40% to 60%. If yellow is the least stable of the three dyes in a particular film, the life of the film will be correspondingly reduced if the film is stored in a higher relative humidity. As discussed below, high relative humidity also has a very detrimental effect on cellulose triacetate, cellulose nitrate, and other cellulose ester films.

*ANSI IT9.11-1991, American National Standard for Imaging Media – Processed Safety Photographic Film – Storage* specifies a relative humidity level of 20–30% for extended-term storage of both color and black-and-white films.[30]

## Table 9.5   Estimates for Number of Years Required for the Least Stable Image Dye of Eastman Motion Picture Films to Fade 10% from an Original Density of 1.0 in Storage at Various Temperatures and 40% RH*

**Boldface Type** indicates a film that was commercially available when this book went to press in 1992; the other products listed had been either discontinued or replaced with newer materials.

| Camera Negative Films | Years of Storage at 40% RH:* | | | |
|---|---|---|---|---|
| | 75°F (24°C) | 55°F (12.8°C) | 35°F (1.7°C) | 0°F (–18°C) |
| Eastman Color Negative II Film 5247 (1974 version) | 6 | 27 | 120 | 2,000 |
| Eastman Color Negative II Film 5247 (1976 version) | 12 | 55 | 240 | 4,000 |
| Eastman Color Negative II Film 5247 (1980 version) | 28 | 125 | 560 | 9,500 |
| **Eastman Color Negative Film 5247** (1985 name change) | **28** | **125** | **560** | **9,500** |
| Eastman Color High Speed Negative Film 5293 | (not disclosed) | | | |
| **Eastman Color High Speed Negative Film 5294** | **(not disclosed)** | | | |
| **Eastman Color High Speed SA Negative Film 5295** | **(not disclosed)** | | | |
| **Eastman Color High Speed Daylight Negative Film 5297** | **(not disclosed)** | | | |
| Eastman Color Negative II Film 7247 (1974–83) | 6 | 27 | 120 | 2,000 |
| **Eastman Color Negative Film 7291** | **50** | **225** | **1,000** | **17,000** |
| Eastman Color High Speed Negative Film 7294 | (not disclosed) | | | |
| **Eastman Color High Speed Negative Film 7292** | **(not disclosed)** | | | |
| **Eastman Color High Speed Daylight Negative Film 7297** | **(not disclosed)** | | | |
| **Eastman EXR Color Negative Film 5245 and 7245** (1989— ) | **22** | **100** | **440** | **7,500** |
| **Eastman EXR Color Negative Film 5248 and 7248** (1989— ) | **30** | **135** | **600** | **10,000** |
| **Eastman EXR Color Negative Film 5293 and 7293** (1992— ) | **(not disclosed)** | | | |
| **Eastman EXR 500T Color Negative Film 5296 and 7296** (1989— ) | **50** | **225** | **1,000** | **17,000** |

### Laboratory Intermediate Films

| | 75°F (24°C) | 55°F (12.8°C) | 35°F (1.7°C) | 0°F (–18°C) |
|---|---|---|---|---|
| Eastman Color Internegative Film, Type 5271 and 7271 | 5 | 23 | 100 | 1,700 |
| **Eastman Color Internegative Film 7272** | **23** | **105** | **460** | **7,800** |

| Laboratory Intermediate Films | Years of Storage at 40% RH:* | | | |
|---|---|---|---|---|
| | 75°F (24°C) | 55°F (12.8°C) | 35°F (1.7°C) | 0°F (–18°C) |
| **Eastman Color Reversal Intermediate Film 5249 and 7249** | **8** | **36** | **160** | **2,500** |
| Eastman Color Intermediate II Film 5243 and 7243 | 22 | 100 | 440 | 7,500 |
| **Eastman Color Intermediate Film 5243 and 7243 Improved** | **(not disclosed)** | | | |
| **Eastman EXR Color Intermediate Film 5244 and 7244** | **(not disclosed)** | | | |

### Color Print Films

| | 75°F (24°C) | 55°F (12.8°C) | 35°F (1.7°C) | 0°F (–18°C) |
|---|---|---|---|---|
| Eastman Color Print Film 5381 and 7381 | 5 | 23 | 100 | 1,700 |
| Eastman Color SP Print Film 5383 and 7383 | 5 | 23 | 100 | 1,700 |
| Eastman Color LF Print Film 5378 and 7378 | 20 | 90 | 400 | 6,800 |
| Eastman Color LFSP Print Film 5379 and 7379 | 20 | 90 | 400 | 6,800 |
| **Eastman Color Print Film 5384 and 7384** | **45** | **200** | **900** | **15,000** |
| **Eastman Color LC Print Film 5380 and 7380** | **45** | **200** | **900** | **15,000** |

**\*Notes:** The estimates given here should serve only as general guidelines. The predicted times for storage at 75°F (24°C) have been derived by this author from data in **Dye Stability of Kodak and Eastman Motion Picture Films** (data sheets), Kodak Publications DS-100-1 through DS-100-9, May 29, 1981, and other sources (see note in Table 9.2). Predictions for storage at temperatures lower than 75°F (24°C) are based on research by Kodak indicating that, compared with room-temperature storage at 75°F (24°C), the fading rates of image dyes in typical Kodak films are reduced by a factor of approximately 4.5X when the storage temperature is reduced to 55°F (12.8°C), by a factor of 20X when the temperature is reduced to 35°F (1.7°C), and by a factor of 340X when the temperature is reduced to 0°F (–18°C).

Research disclosed by Eastman Kodak in late 1992 showed that storing films in sealed or semi-sealed containers (e.g., vapor-proof bags and standard taped or untaped metal and plastic motion picture film cans) could substantially increase the rates of dye fading and film-base deterioration. Therefore, the estimates given here for color motion picture films probably **considerably** overstate the actual stabilities of the films when they are stored in standard film cans under the listed temperature and humidity conditions. (See: A. Tulsi Ram, D. Kopperl, R. Sehlin, S. Masaryk-Morris, J. Vincent, and P. Miller [Eastman Kodak Company], "The Effects and Prevention of 'Vinegar Syndrome'," presented at the **1992 Annual Conference of the Association of Moving Image Archivists**, San Francisco, California, December 10, 1992.)

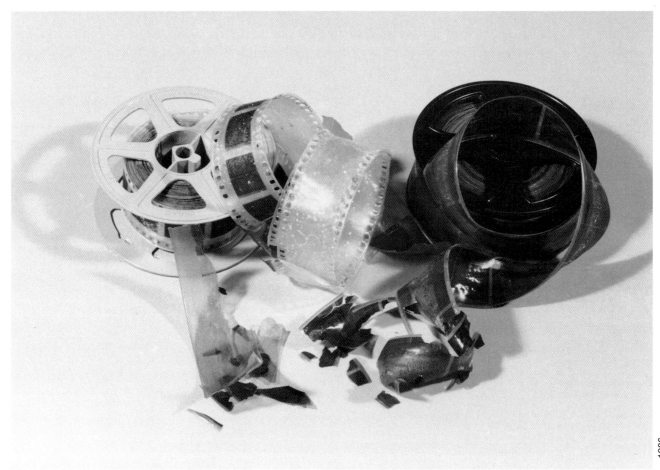

1986

These rolls of Agfa, DuPont, and Gevaert cellulose acetate safety-base microfilm from the 1950's have deteriorated to uselessness. The films are so brittle that they crumble to the touch, and the images on the films are beyond recovery. The decomposing film base smells strongly of vinegar (acetic acid). These films have been stored in Venezuela under semi-tropical temperature and humidity conditions; although the warmth and humidity hastened the decomposition of the films, all cellulose acetate-base microfilms eventually will suffer the same fate unless humidity-controlled cold storage is provided to preserve them. Polyester-base films are expected to last far longer than cellulose triacetate-base films and should be used for all motion picture separations (YCM's) and black-and-white and color microfilms.

Extended-term storage conditions are defined as "Storage conditions suitable for the preservation of record information having permanent value." (Extended-term storage was formerly known as archival storage; beginning in 1991, the word "archival" was being deleted from all ANSI standards as they were revised.) For medium-term storage (storage for a minimum of 10 years), *ANSI IT9.11-1991* specifies 20–30% RH for color films and 20–50% RH for black-and-white films.

Kodak has chosen 40% RH for reporting image stability data for most of its color materials. In most geographic locations, higher average humidity levels are common, and this is especially true in the warmer parts of the world. In addition to 40% RH data, Fuji has also furnished data using a more representative 60% RH storage condition for Fuji-color print films (see **Table 9.3**).

It is interesting to note that unlike most chromogenic yellow dyes, the yellow dye in Fujicolor LP print film shows very little increase in its fading rate when stored at 60% RH compared with storage at 40% RH, according to the Fuji data.

## The Influence of Temperature and Relative Humidity on Film-Base Deterioration

The focus of efforts to preserve color motion picture films has rightly been on the fading of dye images themselves, with film-base stability generally being of much less concern. It has been a question of the weakest link, and, since the introduction of Eastman Color negative and print films in 1950, dye fading unquestionably has been the weakest link.

This is not to say that film-base stability is unimportant. Film-base stability generally is the most critical factor in the deterioration of black-and-white separations (YCM's) which, because of poor dye stability and inadequate storage of virtually all older original color negatives, must now be relied upon for the long-term preservation of many theatrical features.

Also affected are the camera separation negatives made with Technicolor 3-strip cameras, separation interpositives and duplicate negatives made from the original 3-strip negatives, and, of course, those few but priceless full-color Tech-

nicolor dye-imbibition prints that still exist. (Unlike the comparatively unstable dye images in Eastman Color and other chromogenic motion picture films, the color images in Technicolor imbibition prints are essentially permanent in dark storage — see Chapter 10.)

With further improvements in the dye stability of Eastman Color, Fujicolor, and Agfa color motion picture films, it is possible that the stability of the film base could become of concern for these films as well.

Beginning around 1950, when highly flammable cellulose nitrate motion picture film was replaced with cellulose triacetate film, almost everyone in the film industry felt that the long-standing "film base problem" had been finally solved. The many assurances by Eastman Kodak, other manufacturers, and the U.S. National Bureau of Standards that cellulose acetate film base was essentially permanent were based on aging studies dating back a number of years.

Typical was a 1936 study of the comparative aging stability of cellulose nitrate and cellulose acetate films that concluded, based on rather simplistic accelerated aging tests at very high temperatures, that cellulose acetate films were far more stable than cellulose nitrate films:

> The best evidence of the high stability of acetate film is furnished by results of viscosity measurements. When heated for 72 hours at 100°C, the specific viscosity decreased about 2 percent, and after 30 days of aging only 9 percent. With nitrate film, the decrease was 35 percent in 72 hours and 95 percent in 30 days of aging.
>
> While it is not possible to predict the life of acetate film from these results, the data show that chemical stability of the film, with respect to oven-aging, is greater than that of papers of maximum purity for permanent records.[31]

Unfortunately, with the passage of not too many years, cellulose triacetate and other types of cellulose acetate safety-base films kept under normal storage conditions proved in some cases to be no more stable than cellulose nitrate film, and nowhere near as stable as "papers of maximum purity." Within 10 years after Kodak's introduction of cellulose triacetate film, the company received its first field report of the deterioration of this new "permanent" film base material. "This film, from the Government of India, had been stored in a hot, humid climate. Subsequent trade complaints were also from locations where adverse storage conditions could be encountered."[32]

As the years went by, serious deterioration of cellulose acetate safety films was seen in more and more collections; motion picture films, microfilms, and still-camera films were all affected. By the mid-1980's there was serious concern about the problem in the museum and archive fields. The problem became known as the "vinegar syndrome," in reference to the pungent odor of acetic acid present in storage areas and film cans that contain decomposing cellulose acetate-base film (acetic acid, which has a strong and distinct odor, is the principal acidic component in vinegar).

In 1987, David Horvath of the University of Kentucky published a landmark survey of film deterioration in various institutions around the country,[33] and this report confirmed the worst fears of many in the archive community: that is, under commonly encountered storage conditions, cellulose acetate film base could have a far shorter life than previously believed. In short, modern cellulose triacetate film wasn't permanent after all.

This realization, which caused alarm and dismay among those entrusted with microfilm and motion picture collections, prompted a flurry of studies and technical papers by Michele Edge and Norman Allen working at Manchester Polytechnic in England; Eastman Kodak; Agfa-Gevaert; and the Image Permanence Institute in Rochester, New York.

The reader is referred to the many research reports and other publications on the subject by these organizations; particularly valuable is the two-part series of articles by Peter Z. Adelstein, James M. Reilly, and co-workers at the Image Permanence Institute published in the May 1992 issue of the *SMPTE Journal*.[34,35] The articles discuss the findings of the Image Permanence Institute's groundbreaking research on the permanence of cellulose acetate and cellulose nitrate film base, and the influence of temperature and humidity on rates of deterioration. The articles also include relevant references to the work of other researchers in this area.

Among the conclusions of the Image Permanence Institute's research were:[36]

1. The chemical stability of different cellulose ester base films is generally quite similar. There have been reported cases where films from a particular manufacturer, or which were made during a certain time period, have poorer stability. However, there is no evidence to suggest that diacetate, triacetate, or mixed esters have *inherently* different stabilities because of their chemical differences. The often-repeated statement that the obsolete diacetate films are less stable than more recent films is not supported by this study.

2. The stability of cellulose nitrate base film *can be* of the same order of magnitude as cellulose triacetate base films. More work is required to establish whether this is characteristic of most nitrate films now in storage. However, it has been established that cellulose nitrate film in storage will not necessarily degrade faster than other cellulose ester base films.

3. Film archivists should give highest priority for duplication to the film that shows some incipient signs of degradation, regardless of base type. Decisions should not be based solely on the chemical composition of the film base. However, it is recognized that priority should be given to cellulose nitrate films when safety (i.e., flammability) is a concern.

4. The superior chemical stability of polyester base films supports the conclusions of earlier studies.

5. A very significant increase in film life is possible when the storage humidity is lowered below 50% RH. This study is the basis for the recent ANSI recommendation of 20 to 30% RH where extended life of films is desired.

6. The temperature coefficient of improved chemical stability with decreased storage temperature is similar for all cellulose ester films and for all the basic film properties. The use of cold-storage facilities should be considered in order to prolong the chemical stability of valuable and unique photographic films.

February 1989

Some of the many hundreds of film-base specimens tested by the Image Permanence Institute at the Rochester Institute of Technology in Rochester, New York. Groups of film specimens were moisture-conditioned to 20, 50, 60, and 80% RH in a humidity-controlled room prior to being sealed in vapor-proof packages and placed in accelerated aging ovens. Incubations were made at temperatures of 50, 70, 80, 90 and 100°C.

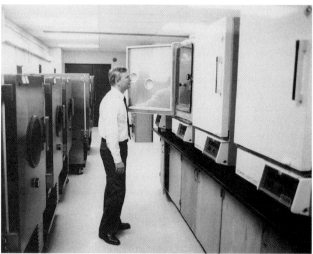

May 1991

James M. Reilly, director of the Image Permanence Institute, checking one of the ovens used to conduct the Arrhenius multi-temperature accelerated aging tests with film-base specimens. The ovens, which have precise temperature and humidity controls, can also be used for accelerated tests with color materials. More than 15,000 measurements were made of the physical properties of the test specimens during the course of the IPI film-base study.

7. The beneficial effects of low-temperature and low-humidity storage are additive. The combination of low temperature and low relative humidity represents the optimum storage condition for cellulose ester base films.

Adelstein, Reilly, and co-workers showed that for typical cellulose ester-base films stored at a given temperature, lowering the relative humidity from 50% to 20% will increase the life of the film 3 to 4 times. Film stored at 80% RH will have only about one-quarter of the life of film stored at 50% RH. The benefit offered by low-temperature storage can be much greater. Lowering the storage temperature from 80°F (26.7°C) to 30°F (−1.1°C) will increase the life of a film approximately 32 times. Lowering the temperature to 0°F (−18°C) is predicted to increase the life of a film more than 200 times over storage at 80°F (26.7°C)!

While reducing the storage relative humidity to the recommended 20–30% level is very beneficial in and of itself, low humidity should not be thought of as a substitute for humidity-controlled cold storage. Preserving cellulose acetate and cellulose nitrate film indefinitely *requires* cold storage. Humidity control alone is perhaps more appropriate for film collections that are financially unable to construct (or rent) cold storage facilities. It will generally be possible to install dry-desiccant dehumidifiers in existing buildings at moderate cost to achieve year-round low humidity (see Chapter 16).

### Storage of Acetate-Base Motion Picture Films in Standard Film Cans Will Increase the Rates of Both Dye Fading and Film-Base Deterioration

In a very important disclosure in late 1992 by A. Tulsi Ram and his co-workers at Eastman Kodak, it was reported that storing acetate-base films in sealed or semi-

sealed containers such as standard taped or untaped metal or plastic film cans (or vapor-proof bags) could significantly increase the rates of both dye fading and film-base deterioration compared with films stored in the open and surrounded by circulating air.[37] It was demonstrated that storage of motion picture films in humid environments was particularly harmful.

There have been a number of reports in recent years pointing to the fact that sealing cellulose acetate and cellulose nitrate films in film cans or other closed containers can accelerate the degradation process by retaining acetic acid vapors and other deterioration by-products which contribute to an autocatalytic acetate film-base deterioration process. But the investigations by Ram and his co-workers at Kodak were the first to show that film-base deterioration by-products could also increase rates of dye fading.

The principal mechanism involved is the evolution of acetic acid vapors from slowly deteriorating cellulose acetate film base which, over time, lowers the pH of the emulsion and that this in turn increases the fading rates of many chromogenic dyes, with the pH-sensitive yellow dyes used in many films being particularly affected. The result, according to Ram and his co-workers, is that the image dyes in color motion picture films packaged in standard metal or plastic film cans or other sealed or semi-sealed containers can fade more rapidly — in some cases, much more rapidly — than is predicted by accelerated dark storage tests with free-hanging specimens using the test procedures specified in *ANSI IT9.9-1990* (see Chapter 2).

To avoid this problem with acetate-base films, Ram and his co-workers recommend packaging films in taped cans with a sodium aluminum silicate "molecular sieve"[38] to absorb moisture, acetic acid vapors, and other gases that could potentially affect dye and film-base stability. Placing an amount of the sodium aluminum silicate molecular sieve

equal to about 2-percent of the weight of the film in the can was recommended. The molecular sieve, which is contained in a tubular Tyvek package that is wrapped around the outside of the film roll (which has been wrapped with a sheet of polyethylene), should be replaced about every 2 to 3 years when the film is stored at room temperature, and every 10 to 15 years if the storage condition is maintained at 35°F (1.7°C) and 20–30% RH. If the relative humidity of the storage area is not maintained at a low level (e.g., 30% RH), the cans should be taped during storage.

Pending the outcome of further studies of the proposed molecular sieve film-storage method — including the costs, labor requirements, and the long-term physical effects on various types of films — it is believed by this author that the increase in the life of color motion picture films that will be obtained with the use of molecular sieves in sealed film cans can be achieved at lower cost and with less labor by storing films in "vented" plastic film cans[39] (or in high-quality, vapor-permeable cardboard boxes[40]) and lowering the storage temperature an appropriate amount.

This author does, however, highly recommend the molecular sieve method to greatly extend the life of B&W separation films (YCM's), sound negatives, microfilms, and other types of B&W and color motion picture films (including nitrate films and Technicolor nitrate-base IB prints) that are stored under non-refrigerated conditions.

Film vaults used to store film packaged in vented film cans or permeable cardboard boxes should be equipped with activated charcoal filtration systems to remove acetic acid vapors and other potentially harmful by-products of film-base deterioration. In addition, air filters should be provided to remove dust, lint, and other particulate matter from the airstream that over time could contaminate films stored in vented film cans.

## Nitrate Film Buried and Abandoned in Yukon Permafrost Preserved for 50 Years

In a dramatic example of the benefits of cold storage (in this case with *no* humidity control whatsoever), over 500 cellulose nitrate motion pictures were buried in the frozen ground of Dawson City in the Yukon Territory in the northwest part of Canada in 1929. When the films were found and dug out of the permafrost in 1978, they were for the most part still in fairly good condition. The discovery was described in the movie business publication *Variety* in 1988:

> The cache included one-reelers, serials, and news films dating from 1903 to 1929. It included some films by famous people and some by people never mentioned in film histories.
>
> All on 35mm nitrate stock, these movies had found their way to the Yukon during the gold rush that started in 1896.
>
> When the gold fever subsided, the reels of film were left behind in the basement of the local Carnegie Library. Then, in 1929, they were used as fill for an open-air swimming pool the town had decided to get rid of.
>
> They remained there until 1978 when workmen found them while breaking ground for a new recreation center.[41]

The recovery and restoration of the films was supervised by Sam Kula of the National Archives of Canada, and the films, many of which exist nowhere else, are now part of the Archives' motion picture collection.

## Low-Temperature, Humidity-Controlled Storage versus Black-and-White Separations

At present there are only two approaches to the long-term preservation of color motion picture images. One method is to make black-and-white silver separations (also called YCM's or Protection Masters) from the original camera color negative and to then rely on these separations for future reconstructions of the color image. The other approach to long-term preservation is to store the original color negative (or reversal film), color intermediates, magnetic masters, sound negatives, and release prints in humidity-controlled cold storage (e.g., 0°F [–18°C] at 30% RH).

When low-temperature storage is used, the making of expensive black-and-white separations is completely unnecessary; in fact, accelerated aging data — and years of experience with black-and-white films — show conclusively that color originals stored at low temperatures will last far longer than silver separations kept in normal air-conditioned room storage.

The availability of color release prints in perfect condition is one of the most valuable aspects of the low-temperature approach to film preservation. A print can be readily accessed for transfer to videotape for television transmission and videodisc production, or for future forms of electronic theatrical release and other applications where only a single top-quality print is required. There will be no laboratory costs for color correcting a faded print, or for making a new composite print from separations or from faded original color negatives or intermediates.

In the event of future theatrical film release, a preserved print can be used as a visual guide for the proper timing (adjustment of overall density and color balance) of new print production. Without a well-preserved original print, there will probably be no way to time new printings — or video transfers — to closely match the way the original film looked when it was made.

## Separations Have Been Recommended Since the Early Days of Color Motion Pictures

The making of black-and-white separations has long been recommended as the best way — or even the only way — to preserve color motion picture images for long periods of time. Graham, Adelstein, and West, writing in the *Journal of the SMPTE* in 1970, said that "This method is the ultimate for long-time preservation of color photographic records although the cost of making black-and-white separations is high."[42] The widespread use of color separations in the motion picture industry had its start with the introduction of the 3-strip Technicolor camera in 1934; this complex camera used three rolls of black-and-white film to make direct separations of moving scenes. The separations were used to prepare gelatin-relief matrix films for printing by the Technicolor dye-imbibition process (see Chapter 10).

Later, separation negatives were prepared in the laboratory from original Kodachrome and Anscocolor mo-

tion picture films as a step in making prints by the Techni-color process. Unfortunately, prior to 1950, virtually all the film stocks supplied to the professional motion picture in-dustry were made on cellulose nitrate supports. Because of dimensional instability, separations made using these older films generally print out of registration unless spe-cial equipment is used to register the separations on a scene-by-scene or even frame-by-frame basis (the use of original cellulose nitrate camera separation negatives in recent restorations of *Gone With the Wind* and other Tech-nicolor dye-imbibition movies is discussed in Chapter 10).

When Eastman Kodak introduced chromogenic East-man Color Negative Film in 1950, separation positives were used for the preparation of duplicate negatives for volume printing on Eastman Color Print Film; initially, no color intermediate films were available from Kodak, so this was the only way duplicate color negatives could be made.

Separation positives have come to be known as YCM's in reference to the fact that one separation is a record of the yellow dye layer of the color negative, the second is the record of the cyan dye layer, and the third is a record of the magenta dye layer. YCM's generally are printed from the original color negative. YCM's are usually timed during printing (after a trial answer print has been made). Some, however, are printed with only one light. Separations are sometimes made from fully-timed color interpositives; in such cases, the separations have negative images and prop-erly are called separation negatives or "RGB" separations.

The Technicolor Corporation made separations from Eastman Color Negative films as a step in making dye imbibition release prints until the process was phased out by the firm in favor of the chromogenic Eastman color print process in the mid-1970's.

After Eastman Color Negative Film came into wide use in the 1960's, it was common practice to make separation positives (YCM's) for major theatrical productions; this was done to have assurance both that a new, duplicate color negative could be prepared for making prints when the original color negative had faded to an unacceptable degree, and to provide an immediate back up for the origi-nal negative should it be physically damaged during labo-ratory printing operations. However, because of the great expense involved in making separations, they have only rarely been made for films other than major theatrical re-leases in the United States and Europe.

Eastman Panchromatic Separation Film 5235, which has been used for many years by the entertainment film indus-try for making separations (YCM's), has always been manu-factured with a cellulose triacetate base. A polyester-base version of 5235 is available as Eastman Panchromatic Sepa-ration Film SO-202; this film, which is far superior to 5235 because of its much better permanence and dimensional stability, has been available since around 1990 and is now supplied by Kodak as a stock item.

One of the unfortunate results of the continued reliance of the major film studios on separations for long-term pres-ervation has been to discourage the construction of low-temperature, humidity-controlled film storage facilities.[43] Since it was believed that in most cases the major films had been preserved, for most studios there has been little incentive to worry about the general state of motion pic-ture preservation.

## The Now-Discontinued NASA Separation Negative Project for Spaceflight Color Films

In 1976, the U.S. National Aeronautics and Space Ad-ministration (NASA) instituted a major project to produce separation negatives for the off-site backup preservation of color transparency films made during manned space flights starting with the first suborbital flight by astronaut Alan Shepard on May 5, 1961, and continuing through the joint Russian-American Apollo-Soyuz mission which took place in July 1975. Other than in the theatrical motion picture industry, the NASA separation project is probably the only large-scale attempt in the U.S. to use separations for backup preservation purposes.

The NASA separation program is described here *not* to encourage the making of separations. Rather, it is to illus-trate just how involved and expensive such procedures can become if one wants to have an assurance that the separa-tions will be usable for high-quality color image recon-structions in the distant future when current film stocks are no longer available.

By 1980, the NASA collection of color films taken during space flights and the historic 1969 landing on the surface of the moon — NASA refers to such films as "flight films" — consisted of about 20,000 feet of 16mm film, about 3,000 feet of 35mm film, 15,000 feet of 70mm film, and about 5,000 feet of 5-inch film. These films included both still and motion picture footage. Black-and-white separations had been made of the bulk of the 1961–1975 footage by the end of 1979.

NASA considers the original space flight films to have extraordinary historical value, and separations were made from the 1961–1975 films as backups should anything hap-pen to the original color transparencies. NASA had kept the original films in moderate-temperature cold storage at about 55°F (12.8°C) and 50% RH during the years following the original space flights. However, upon the realization that much lower storage temperatures were necessary to permanently preserve the films, a new vault was completed in 1982 which is maintained at 0°F (–18°C) and 20% RH.

According to Noel Lamar, formerly with NASA's Image Sciences Division, the decision to make black-and-white separations instead of originally storing the color originals at low temperatures was made for several reasons.[44] Two reasons were that making separations for long-term keep-ing was the usual recommendation given in the literature dealing with this subject, and it was also the recommenda-tion given by Eastman Kodak Company at that time.

An additional consideration was that there was no cer-tainty that the original films would always be kept in cold storage during future years. For example, at the time the separation project was planned, the U.S. National Archives did not have a cold storage facility for color films, and if the space flight originals were handed over to the National Archives, they would have ended up being stored under inadequate conditions. (Regrettably, the National Archives did not include a 0°F [–18°C] storage vault in its new build-ing in College Park, Maryland which is scheduled to open in December 1993.)

Because of the extreme historical importance of the manned space flight photographs, Lamar said that "mor-ally we felt we should make separations" to assure the preservation of the images. NASA also transferred video-

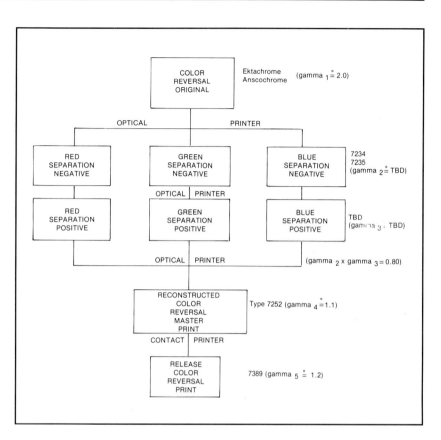

**Figure 9.1** NASA's tentative procedure for reconstructing color images from the black-and-white separation negatives that were made from spaceflight reversal originals in NASA's now-discontinued separation negative program. Because the original color films are stored at 0°F (−18°C), it is unlikely that the polyester-base separation negatives NASA has made will ever be needed. They were produced as an off-site backup for the irreplaceable originals at a time when separations were recommended to protect the images of valuable color originals. Except for test samples, separation positives have not been prepared from the separation negatives because the sensitometric characteristics of future film stocks are unknown. (From: **Black-and-White Separations of Spacecraft Original Film**, Technical Report, by Lincoln Perry, Photographic Technology Division, National Aeronautics and Space Administration, Lyndon B. Johnson Space Center, Houston, Texas, 1975.)

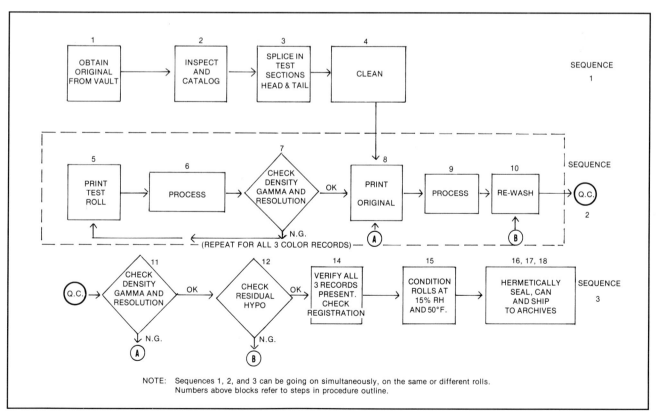

NOTE:  Sequences 1, 2, and 3 can be going on simultaneously, on the same or different rolls. Numbers above blocks refer to steps in procedure outline.

**Figure 9.2**   The flow chart used by NASA for preparation of black-and-white separation negatives from color reversal spaceflight originals. NASA employed an elaborate series of quality control checks to ensure that the density and gamma of the separation negatives were correct and that the films were properly processed and washed.

November 1979

Until 1982, original spaceflight films were stored at NASA in a room maintained at 55°F (12.8°C) and 50% RH. When densitometric measurements of step wedges in the headers of the specially-coated polyester-base Ektachrome EF and MS films revealed that the color images were slowly fading in the 55°F environment, the entire preservation program was re-evaluated and three new 0°F (–18°C), 20% RH vaults were constructed to halt further fading of these priceless records.

tapes generated during the Apollo missions to color film, and separations were then made from these films.

NASA developed a complex two-stage separation procedure which consists of making separation negatives from the color originals and then, at a later date, making gamma-adjusted separation positives from the separation negatives.[45] This procedure avoids the problem of not knowing what gamma and reproduction characteristics of a future reconstruction process will be. The general process is outlined in **Figure 9.1**. The entire reproduction procedure was tested with a number of test examples; however, for most films, only the first stage of the process — the separation negatives — was completed. The remaining steps need not be done until some future time when there may be a reason to reconstruct the color images from separations instead of making duplicates from the color originals.

The separations were made on polyester-base roll films of the same width as the originals; the separation film emulsion is similar to that used in Kodak Panatomic-X still-camera film. NASA used an elaborate quality control program for the making of separations in which process quality, residual chemicals, and registration were carefully checked — the procedures are outlined in **Figure 9.2**. The NASA procedures were more exacting — and far more costly — than the methods used by the theatrical motion picture industry. While most of NASA's separations were made from reversal originals, thus producing a separation negative instead of the separation positive which results

when a separation is made from a color negative, the basic difficulties of reconstructing accurate color images from black-and-white separations with future color films of unknown sensitometric characteristics remain.

After the completion of a 0°F (–18°C) and 20% RH cold storage vault 1982, NASA concluded that making black-and-white separations was no longer necessary, and the separation negative project was discontinued. With two off-site backup sets of duplicates also kept at 0°F (–18°C), NASA now relies on low-temperature storage for the permanent preservation of original spaceflight color films.

## Potential Long-Term Problems with Black-and-White Separations (YCM's)

As current film stocks become obsolete and are replaced with new materials of different sensitometric characteristics, it may be a difficult and costly process to print existing negatives or separations without significant losses in image quality. As an example — even if differential shrinkage were not a factor — separations made with the obsolete Technicolor 3-strip cameras may be incorrectly matched to current color film stocks:

Making new prints of a film photographed by means of the Technicolor three-strip process involves a number of unique problems stemming from the fact that separation elements for such

October 1987

The original Ektachrome EF and MS films used by the astronauts for photography on the historic Apollo mission to the moon on July 16–24, 1969, together with original color still photographs and motion pictures from other space missions, are permanently preserved at 0°F (–18°C) and 20% RH at NASA headquarters in Houston, Texas. Shown here are NASA staff members Frank Zehentner (left) and Terry Slezak preparing to remove an aluminum case containing uncut rolls of color film originals. As part of the most sophisticated color film preservation effort in the world, a complete set of duplicates is stored in a second 0°F (20% RH) facility in Houston, and a third set is kept in a 0°F (20% RH) vault at White Sands, New Mexico.

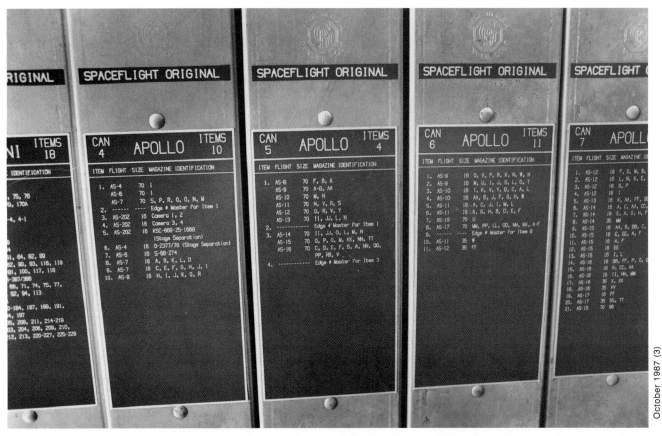

October 1987 (3)

Cans of cataloged rolls of color spaceflight films from the Apollo missions to the moon were placed in waterproof aluminum cases for storage in the Houston vault. Included are the original 70mm Ektachrome color transparencies photographed by astronauts Neil A. Armstrong and Edwin E. Aldrin, Jr. after they landed on the moon on July 20, 1969. Because these films were actually on the surface of the moon, no duplicates or high-resolution digitized copies — no matter how perfect — can ever approach the value of the originals as historic objects. Now stored at 0°F (–18°C) and 20% RH, NASA intends to preserve these films in essentially unchanged condition forever. A plaque left on the moon by the astronauts is engraved: "Here men from the planet Earth first set foot upon the Moon, July 1969, A.D. We came in peace for all mankind."

Signs on the NASA storage vault door warn of the potentially life-threatening carbon dioxide fire extinguishing system. Because the original spaceflight films are never used for routine printing (color internegatives and duplicate transparency printing masters were made from uncut rolls shortly after processing), this is a dead storage vault and is entered only infrequently. NASA operates a sophisticated color processing laboratory in the building where the vault is located, so the original spaceflight films need never leave the high-security facility.

Temperature and relative humidity conditions inside the vault are constantly monitored; alarms will sound to alert NASA staff if preset limits are exceeded.

## Table 9.6    Estimated Cost of Cold Storage Rental Per Year for Motion Picture Film (0°F [–18°C] and 30% RH)*

| | |
|---|---|
| Conformed original color negative — 9 cans (if A and B rolls: 18 cans @ $ 72.00) | $ 36.00 |
| Color interpositive (5243 or 5244) — 9 cans | $ 36.00 |
| Color internegative (5243 or 5244) or CRI (5249) — 9 cans | $ 36.00 |
| Magnetic master — 9 cans | $ 36.00 |
| Sound negative — 9 cans | $ 36.00 |
| Release or answer print (5384) — 9 cans | $ 36.00 |
| Total Per Year: | $ 216.00 |

* 9,000 feet of 35mm film in nine 1,000-foot cans; $30.00 rental per cubic foot per year (7.4 cans per cu. ft.)

## Table 9.7    Cost of Film Elements to Be Put in Cold Storage (9,000-Foot 35mm Feature Film)

| | |
|---|---|
| 1)  Original color negative (A rolls or A and B rolls) | none* |
| 2)  Color interpositive and internegative (5243 or 5244) (also called color "master positive" and color "duplicate negative") | none* |
| 3)  Release print (5384) @ $0.22/ft. (new, non-projected print; part of initial print order) | $ 1,980 |
| Total: | $ 1,980 |

* Costs of original camera negative, color intermediates, magnetic master, and sound negative already covered as a normal expense of film production.

a Technicolor picture were tailored not only to the requirements of the Technicolor system, but also quite often were modified for the specific production. The net result is that the contrast or density of the separations may be inappropriate for printing directly onto current Eastman color stocks. If the contrast of a separation is too high the net result will be that the new color negative will yield contrasty prints which compare unfavorably with a well-preserved imbibition print of the same subject. Duping the separations and adjusting the gamma and density in the process before making the color negative may alleviate the contrast problem, but it will involve other compromises in the image quality which may or may not be considered less desirable.[46]

Other potential problems of silver separations are differential shrinkage of the cellulose triacetate film base (which would cause the images to be printed slightly out of registration) and fading or discoloration of the silver image. Even slight silver image irregularities which occur as a result of fading or staining will result in uneven color reproduction when the separations are printed in future years; such irregularities would likely be difficult or even impossible to correct.

Further, in light of the discussion concerning cellulose triacetate film base degradation earlier in this chapter, it should be noted that the separation film normally used for motion picture work, Eastman Panchromatic Separation Film 5235, is supplied by Kodak on a cellulose triacetate base. An Estar polyester-base version of 5235 is available as Eastman Panchromatic Separation Film SO-202; this film is supplied by Kodak as a stock item and is far supe-

rior to 5235 for separations because of its much better permanence and dimensional stability.

### Costs of B&W Separations versus Cold Storage for Long-Term Preservation

When one compares the high cost of making separations with the relatively low costs of keeping films in low-temperature cold storage, there would appear to be little justification for the continued use of separations for preservation purposes. Using a base rental figure of $30 per year per cubic foot of humidity-controlled 0°F (–18°C) cold storage space in a commercial facility,[47] it would be possible to store all the important elements of a typical 9,000-foot theatrical motion picture for about $216 per year (see **Table 9.6**). As all the elements of a film, except an additional release print, are normally made during the course of production, there is little additional expenditure for the materials to be placed in cold storage (**Table 9.7**).

The costs of producing B&W separation interpositives ("YCM's" or "Protection Masters") and a comparison with the costs of cold storage are given in **Table 9.8** and **Table 9.9**. Black-and-white separation interpositive costs, new color internegative, answer print, and other costs were based on prices quoted by Technicolor, Inc. (Hollywood) in September 1992 and were typical of the prices charged for these services by major motion picture laboratories in Hollywood and New York at the time this book went to press.

In **Table 9.2**, which was discussed earlier in this chapter, estimates based on published Kodak data for a visually detectable dye loss of 10% for many current Kodak motion picture color negative and color print films stored at 75°F (24°C) are given. In **Table 9.5**, corresponding estimates for a 10% dye loss are given for the same films stored at

## Table 9.8 Cost of Motion Picture Film Elements for Preservation by B&W Separation Procedure (9,000-Foot Feature Film)

| | |
|---|---|
| Set of three B&W separation interpositives (YCM's) (SO-202 or 5235) @ $3.71/ft. (additional costs if A and B roll original) | $ 33,390 |
| Additional costs to obtain new print from B&W separations: | |
| Internegative from separations (YCM's) (5243 or 5244) @ $4.70/ft. | $ 42,300 |
| Color print from internegative (5384) @ $1.67/ft. (fully timed answer print) | $ 15,030 |
| Total Cost: | $ 90,720 |

**Note:** Additional prints (5384) @ $1.52/ft. may be required for timing purposes. — $ 13,680

Second color internegative may be required if large numbers of prints are needed for theatrical release. — $ 42,300

## Table 9.9 Comparison of Costs for Cold Storage and B&W Separation Approaches to the Preservation of Color Motion Picture Films

**Cold Storage Approach:**

| | |
|---|---|
| Annual cold storage for release print only | $ 36 |
| Annual cold storage for all elements of a feature film | $ 216 |
| Cost of additional release print for cold storage | $ 1,980 |

**B&W Separation Approach:**

| | |
|---|---|
| Cost of making three B&W separation interpositives (YCM's) | $ 33,390* |
| Cost of making new internegative and single answer print from B&W separation interpositives (YCM's) | $ 57,330 |

\* Does not include cost of storage for separations, magnetic master, and sound negative.

55°F (12.8°C), 45°F (7.2°C), and 0°F (–18°C).

In **Table 9.10**, estimates are given for the number of years various original color film elements could be stored for the cost of making separations, and reconstructing new prints from the separations and sound negatives.

### Optical Disk, Magnetic Tape, and Other Digital Image Storage Systems Are Not Satisfactory Substitutes for Preservation of Film Originals

Many film archivists have long held a dream that someday a "perfect" film preservation system would be devised to allow transfer of color motion picture images onto some sort of extremely high-resolution and essentially permanent digital medium that could be stored under ordinary room-temperature and humidity conditions forever. Such a system, it has been hoped, would give quick access to each and every film stored in huge collections and would be able to produce perfect "film-resolution" transfers or videotape and laserdisc copies of the films on demand — and at low cost.

With the commercial introduction of the Kodak Cineon Digital Film System in 1993, and other "film-resolution" digital intermediate systems, the interest in such a fully digital preservation system is certain to increase.

Although intended for special effects, scene salvage (elimination of scratches), restoration of damaged frames, and image compositing — with the capability of writing the edited digital file on a color photographic intermediate film for seamless intercutting of original negatives — the Kodak Cineon system could conceivably be used to produce "film-resolution" digital tapes or optical disks of full-length color motion pictures. (For an overview of practical applications of digital technology in the motion picture industry, the reader is referred to an article by Bob Fisher entitled "The Dawning of the Digital Age," which appeared in the April 1992 issue of *American Cinematographer*.[48])

Working with the Kodak Cineon system is an expensive proposition. Scanning costs about $6 per frame and writing digital images back to film is an additional $8 per frame. Cineon workstations cost from $250,000 to over $1 million (prices do not include film scanner and film recorder hardware — these services must be contracted from Kodak). Rental of a Cineon facility can cost up to $1,500 per hour.

With approximately 40 megabytes of non-compressed digital data *per frame* (2,600 lines x 3,600 pixels),[49] the file size for 1 second (24 frames) of 35mm Academy aperture color film exceeds 1 gigabyte (one-billion bytes).[50]

A "one-hour" D-1 videocassette holds about 72 Gbytes of digital data; therefore, a full D-1 videocassette can store "film-resolution" data for only about 1 minute of film!

Even if a "film-resolution" digital preservation system for full-length motion pictures eventually becomes a cost-effective alternative to storage of film itself, significant problems remain. Aside from uncertainties about the long-term stability of the various forms of digital magnetic tapes and optical disks in this rapidly changing industry, there is the much more serious problem of *hardware* and *software*

## Table 9.10 Number of Years That a Motion Picture Film Can Be Kept in Cold Storage for Cost Equal to That of Making B&W Separations and Other Film Elements

| | |
|---|---|
| a) All elements in cold storage for cost of separations | 155 years |
| b) All elements in cold storage for cost of separations plus new color internegative and new print | 420 years |
| c) Original negative in cold storage for cost of separations | 930 years |
| d) Original negative in cold storage for cost of separations plus new color internegative | 2,100 years |
| e) Print only in cold storage for cost of separations | 925 years |
| f) Print only in cold storage for cost of separations plus new color internegative and new print | 2,520 years |

obsolescence.[51, 52] One need only to look at the large number of incompatible videotape formats that have been in existence since video recording was commercialized in 1956 by the California-based Ampex Corporation to realize just how serious such problems have become. The reader is referred to two sobering articles on this subject by John C. Mallinson, formerly the manager of research at the Ampex Corporation: "Archiving Human and Machine Readable Records for the Millenia,"[53] and "Magnetic Tape Recording: History, Evolution, and Archival Considerations."[54]

Like color films, videotapes, digital data tapes, and optical disks can probably be preserved for extended periods in low-temperature, humidity-controlled storage. However, the necessary playback equipment *cannot* be maintained in working order indefinitely. Further complicating the long-term digital data preservation picture is the fact that current and near-future digital data compression-decompression software/hardware systems likely will not be supported in future years as improved systems are developed.[55]

Despite the appeal of digital recording systems — which offer the hope of almost limitless re-recording without generational image-quality losses — the industry is nowhere near the time when one could even consider abandoning color originals and color release prints as the primary preservation medium for film-originated productions.

## Humidity-Controlled Cold Storage Facilities for the Permanent Preservation of Valuable Color Motion Picture Films

When it is important to protect major productions and other very valuable footage from catastrophic loss which could occur as a result of earthquakes, equipment failure, fire, theft, or damage during transportation or laboratory handling, the various film elements made during the course of a production should be divided between low-temperature, humidity-controlled cold storage facilities at two different geographic locations.

For example, one cold storage installation should be used to store the original conformed color negative, master positive, duplicate color negative or CRI, sound cut negative and/or magnetic master, and two mint-condition release prints, including a copy of each foreign-version release print (as many as 250 rolls of pre-print elements may be involved in a major production; some classic films have more than 1,000). This remote facility would be used as a high-security dead storage area which would not normally need to be accessed; it would serve as the ultimate backup should a film element in the second facility become lost or damaged.

The second low-temperature storage installation should be close to production and laboratory facilities; it is the color film and sound elements in this facility that would normally be used for videocassette and videodisc production, television transmission, and theatrical re-release.

In the long run, a perfectly preserved release print — which has integral, synchronized sound tracks and the exact scene-by-scene density and color balance called for by the film's director — may prove to be the only readily usable element from current film productions. As digital high-definition television systems evolve in coming years, it will always be desirable — and in many cases absolutely necessary — to go back to the color photographic original in order to obtain the maximum image quality of which each of these new electronic systems will be capable.

Illustrated on the following pages are the color film cold storage facilities at Paramount Pictures, Warner Bros., Turner Entertainment Co. (at the Records Center of Kansas City), the Library of Congress, and the National Archives of Canada. These and other cold storage facilities are also described in Chapter 20, *Large-Scale, Humidity-Controlled Cold Storage Facilities for the Permanent Preservaton of Color Films, Prints, and Motion Pictures.*

## In 1996, the National Archives of Canada Will Open the World's Most Advanced Color Motion Picture Storage Facility

In 1996 the National Archives of Canada plans to open a new film preservation facility near Ottawa in Gatineau, Quebec that will include a large color film storage vault maintained at 0°F (–18°C) and 25% RH for the permanent preservation of the Archives' vast collection of color motion pictures and still-camera photographs.[56] The new installation, which will be operated by the Moving Image, Data and Audio Conservation Division of the National Archives of Canada, will replace a current color film storage vault kept at 28°F (–2.2°C) and 28% RH (see pages 337–338). The new vault will include a sophisticated air-filtration system to remove acetic acid vapors, oxidizing gases, dust, and other contaminants which could harm motion picture film.

The National Archives is the designated repository for films produced by the National Film Board of Canada and other government agencies.

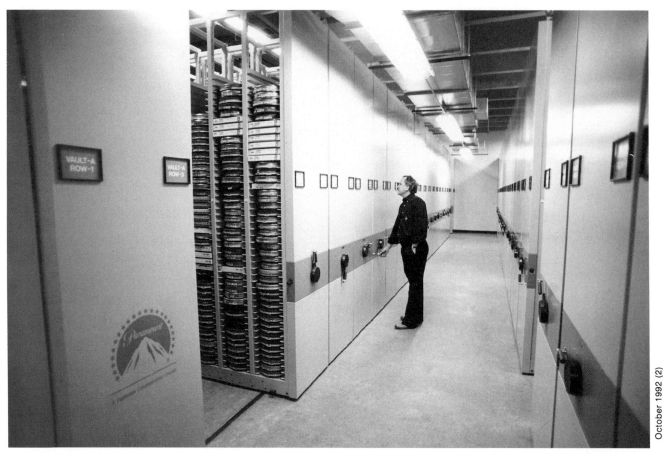

right margin, rotated text: October 1992 (2)

The color film storage vault in the Paramount Pictures Film and Tape Archive, located on the Paramount studio lot on Melrose Avenue in Hollywood, California. The color film vault, one of nine vaults in the high-security building, is maintained at 40°F (4.4°C) and 25% RH. The multi-million dollar facility went into operation in 1990. Shown here in the color film vault, which is equipped with movable shelving to conserve space, is Robert McCracken, a supervisor in Archive Operations.

## The Paramount Pictures Film and Tape Archive: Hollywood's First Modern Humidity-Controlled Cold Storage Facility for Color Film Preservation

In 1990, Paramount Pictures opened a new cold storage facility in Hollywood for preservation of its vast film and video collection. Consisting of nine vaults, which operate at different temperature and relative humidity conditions depending on the film or video elements stored in them, the facility currently houses more than 270,000 rolls of motion picture film, as well as a large amount of videotape from the studio's television productions. The facility, which was built at the behest of former Paramount studio head Frank Mancuso, was designed with enough space to accommodate Paramount's expected film and video production for the next 20 years.

Like most other Hollywood studios, Paramount has a strict policy of dividing the various pre-print elements for a given film between two or more geographic locations. In recent years the Hollywood studios have become acutely aware of the potential for catastrophic loss of their entire collections because of fires, earthquakes, or other disasters. Paramount has been making sets of separations (YCM's) for its feature films since the 1930's, and these are stored in a high-security underground facility in Pennsylvania.

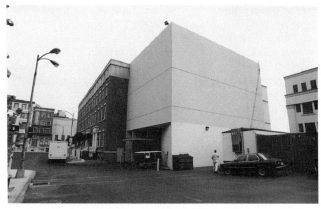

Facing a Hollywood-style re-creation of a New York City street, the front wall of the Film and Tape Archive is covered with a facade of a row of red brick townhouses. The back of the high-security building is covered with Paramount's landmark blue-sky backdrop that has been used in the filming of many movies. Hidden from view within the Archive structure is the refrigeration and air-filtration equipment. The fire- and earthquake-resistant building has its own backup generating system which can supply electrical power for the entire building for an indefinite period in case of a power outage.

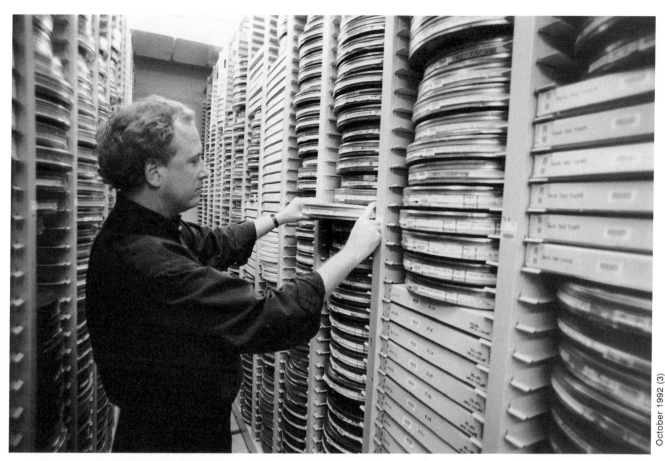

October 1992 (3)

Specially designed shelves hold each roll of film in a separate slot, which simplifies locating a specific roll and avoids the handling difficulties that can occur when rolls are stacked. Paramount has inaugurated a program to repackage films in special, alkaline-buffered cardboard boxes to prevent the gradual accumulation of acetic acid vapors that can occur in regular film cans as a result of acetate film-base decomposition (the "vinegar syndrome"). If acetic acid vapors are not vented or otherwise removed, both dye fading and film-base deterioration can be accelerated. The air in the vault is filtered to remove acid vapors and other contaminants. McCracken is shown here pulling a can containing a roll of the original camera negative from Francis Ford Coppola's 1974 classic, **The Godfather, Part II**. The film, which won six Academy Awards, including Best Picture, Best Director, and Best Screenplay, starred Robert DeNiro, Robert Duvall, Diane Keaton, and Al Pacino.

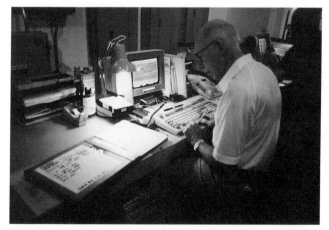

Each roll of film and videotape is bar-coded and tracked with a sophisticated computer-based inventory system. The location of a particular roll can be quickly determined by its slot, rack, row, and vault number. When rolls of film are removed for lab work, the vacated slots are reassigned to incoming rolls by the computer system.

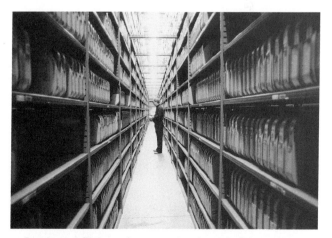

Paramount Pictures has an extensive television output, including **Entertainment Tonight** (the show has more than 100,000 interview and show tapes) and the **Star Trek** series. Shown here is the main videotape vault. Since 1987, all of Paramount's feature films and television productions have been transferred to digital videotape.

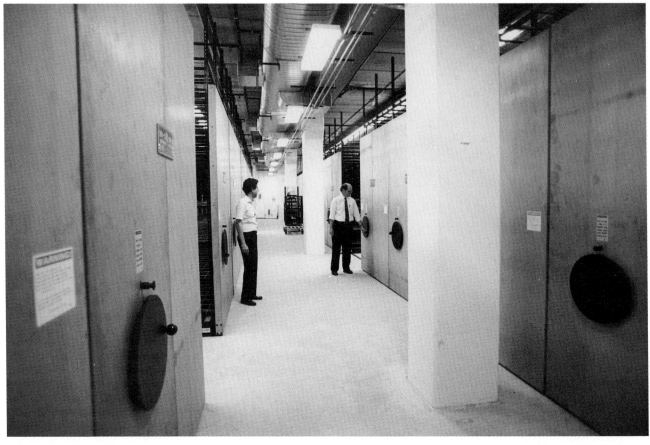

October 1992 (2)

One of the three film storage vaults in the new Warner Bros. high-security motion picture cold storage building on the Warner Bros. studio lot in Burbank, California. The color film vault, which is maintained at 35°F (1.7°C) and 25% RH, and the other vaults were operating and in the final phase of testing when this photograph was taken on October 8, 1992. Warner Bros. began moving its film collection into the vaults a few weeks later. Shown here in the larger black-and-white film vault, which, like the two other vaults in the building, is equipped with movable shelving that permits high-density film loading, are John Belknap, manager of Film Vaults/Assets, and Bill Hartman, manager of Asset Inventory Management and Research in Corporate Film Video Services at Warner Bros. The $9-million cold storage facility was designed under the direction of Peter R. Gardiner, vice president of Operations in Corporate Film Video Services at Warner Bros.

## The Sophisticated Warner Bros. Cold Storage Facility for Color and B&W Motion Picture Films

Warner Bros. opened a new humidity-controlled cold storage facility on its Burbank studio lot in October 1992. One of the three vaults is for color film and is maintained at 35°F (1.7°C) and 25% RH. A second vault is used for separations (YCM's) and other black-and-white films and is kept at 45°F (7.2°C) and 25% RH. The third vault is used to store less-critical duplicate film elements and circulating materials and is maintained at 50°F (10°C) and 45% RH. An advanced air-filtration system is provided to remove acetic acid vapors and other gases resulting from film degradation — and from Los Angeles air pollution.

Warner Bros. is a part of Time Warner Inc. which, with Home Box Office (HBO), a far-flung cable TV system, and extensive publishing operations, is the world's largest entertainment company. In mid-1992 Time Warner inaugurated an experimental 150-channel interactive cable TV service in Brooklyn, New York. In addition to broadcasting a large number of movie titles around the clock, the new system is potentially capable of sending pay-per-view movies to individual subscribers' homes upon request. When such expanded systems are installed on a large scale, it is expected that there will be a tremendous increase in the demand for movie titles and other programming.

The high-security building has only one entrance so that all incoming and outgoing shipments can be carefully checked.

Prior to moving films into the new facility, Warner Bros. instituted a massive program to re-can all of its film in new bar-coded "vented" plastic film cans to prevent the "vinegar syndrome" — the accumulation of acetic acid vapors and other harmful acetate film-base deterioration by-products within the film cans. The building is equipped with a redundant activated charcoal air-filtration system to remove acetic acid vapors, peroxides, formaldehyde, and other potentially harmful substances from the air.

The new facility has a sophisticated air-quality monitoring system to detect the presence of acetic acid vapors, oxidizing gases, and other potentially harmful substances. Air samples are periodically withdrawn from the vaults through small Teflon tubes that are connected to an automated gas-analysis unit. Shown here at a terminal connected to the building's systems-control computer is Ed Cunningham, an engineer with Turner Construction Company, the general contractor for the new facility.

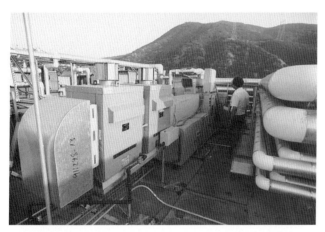

Cargocaire continuous desiccant dehumidifiers and other air-handling equipment for one of the film storage vaults.

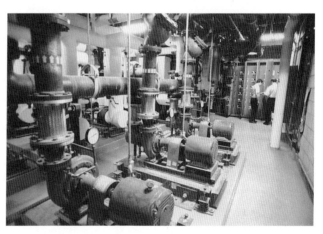

The refrigeration machinery room. To avoid cooling and dehumidification failures, all systems are fully redundant.

The building is equipped with an advanced fire-detection and intrusion alarm system. Access to film vault areas is electronically restricted to certain key personnel.

Haylon gas fire-suppression systems are provided for each of the film vaults in the fire- and earthquake-resistant building. Security systems are monitored 24 hours a day.

October 1992 (6)

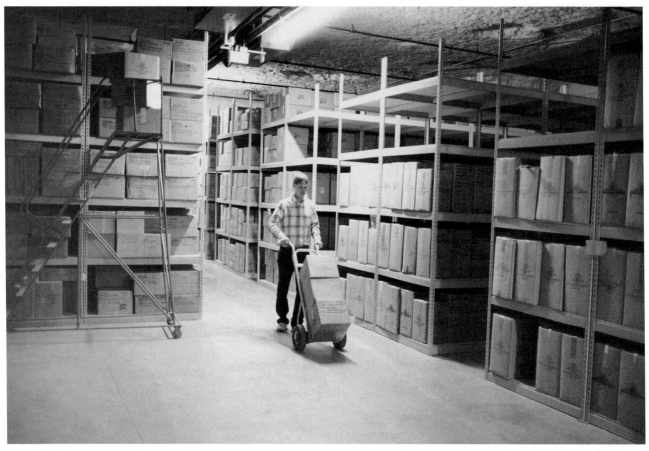

October 1987

Original camera color negatives, color interpositives, YCM's, sound negatives, and other pre-print elements in the Turner Entertainment Co. Film Library are stored in the high-security underground facility operated by the Records Center of Kansas City, located in the rural outskirts of Kansas City, Missouri. Turner Entertainment, which purchased the film library in 1986 at a cost of more than $1 billion, and the major Hollywood studios routinely store backup elements of all their films in remote, high-security facilities to avoid the possibility of a catastrophic loss of their entire collections due to fire, earthquake, tornado, sabotage, civil disturbance, or nuclear attack. When this photograph was taken in 1987, Turner had over 50,000 cans of film in storage in the Kansas City facility. With film, videotape, and computer tape storage vaults kept at 38°F (3.3°C) and 40% RH, the Records Center of Kansas City offers some of the best storage conditions available in a rental facility.

### The Turner Entertainment Co. Backup Film Library at the Records Center of Kansas City

Located in a high-security complex constructed 175 feet below ground in a worked-out section of a huge limestone mine in Kansas City, the Records Center of Kansas City's large refrigerated rental facility is maintained at 38°F (3.3°C) and 40% RH.

Among the materials stored in the underground vault are original color negatives, interpositives, and other color pre-print elements for films in the Turner Entertainment Co. Film Library that was acquired when Ted Turner's Atlanta, Georgia based Turner Broadcasting System Inc. purchased MGM/UA in 1986 for about $1.5 billion (included in the library were most pre-1950 Warner Bros. films, which MGM/UA had acquired in a previous purchase). Turner subsequently sold the MGM Metrocolor film lab and most of the other assets acquired in the purchase; MGM Communications now operates as an independent company.

As the operator of CNN (the worldwide Cable News Network) and WTBS television, a "superstation" that broadcasts nationwide by satellite and over cable systems, Turner was primarily interested in acquiring the more than 2,200 movies in the MGM Film Library. By purchasing the MGM library, such film classics as *Gone With the Wind, Casablanca, The Wizard of Oz, 2001: A Space Odyssey,* and *Ben Hur* became available to Turner for broadcast, sale on videocassette and videodisc, and worldwide syndication to other television broadcasters.

The Turner Entertainment Co. film library has since been enlarged and now includes the RKO domestic market film library. In all, Turner now owns more than 3,300 feature films. The pre-print film elements stored in Kansas serve as a high-security, refrigerated backup for Turner Entertainment's main film library at the company's headquarters in Los Angeles, California. (At the time this book went to press in 1992, Turner did not have cold storage facilities for its film library in Los Angeles.)

The Records Center of Kansas City is a division of Underground Vaults and Storage, Inc., which also operates a deep underground, non-refrigerated film storage rental facility in Hutchinson, Kansas, where Turner Entertainment stores YCM's and other black-and-white film elements.

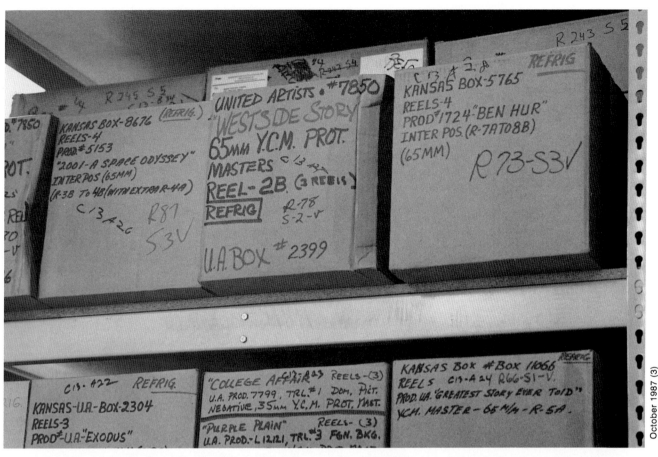

Boxes containing cans of various pre-print film elements stored in the underground Kansas City vault provide a refrigerated, high-security backup for color films kept at the Turner Entertainment Co. headquarters facility in Los Angeles, California. At the time this photograph was taken in 1987, Turner was storing a number of films for United Artists (e.g., **West Side Story** and **Exodus**) under a distribution agreement; these films have since been returned to United Artists.

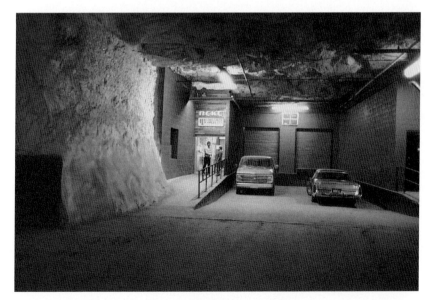

The loading dock and entrance to the high-security Records Center of Kansas City facility, constructed against the side of one of the many massive limestone pillars that were left during mining operations to support the limestone roof of the mine. The Records Center is in the Hunt Midwest Underground complex, which has its own security force and fire department.

Safety-base duplicate black-and-white separations for **Gone With the Wind**. The classic 1939 Technicolor 3-strip film has often been called the crown jewel of the Turner Entertainment collection.

October 1987 (3)

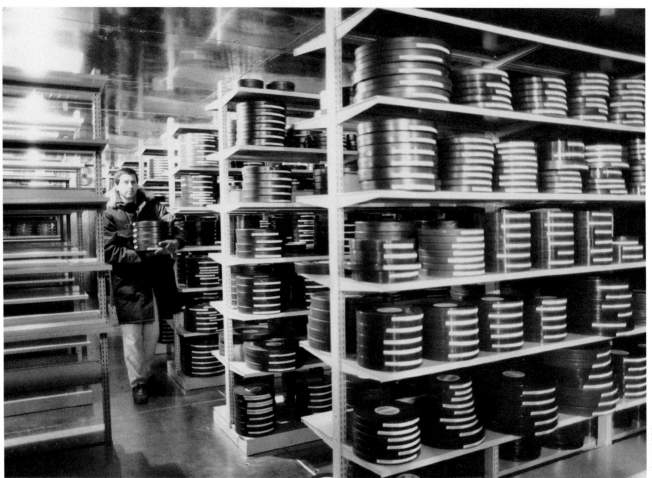

June 1989

The cold storage vault at the National Archives of Canada in Ottawa.  The facility was constructed in 1986 and is maintained at 28°F (–2.2°C) and 28% RH.  Shown here working in the vault, which is used to preserve the Archives' collection of release prints of Canadian feature films and other color motion pictures, is William O'Farrell, chief of Film Conservation and Custody.  O'Farrell wears gloves and a winter coat for protection from the cold.  A new, much larger humidity-controlled cold storage installation will be completed in late 1996 near Ottawa in Gatineau, Quebec; the color film storage vault in the new facility will operate at 0°F (–18°C) and 25% RH.  This will be the most advanced facility of its kind in the world.

## The Advanced Film and Video Preservation Program at the National Archives of Canada

In late 1996, the Moving Image, Data and Audio Conservation Division (Roger Easton, director) of the National Archives of Canada will open a new installation, near Ottawa in Gatineau, Quebec, that will include the world's most advanced large-scale motion picture and color photography preservation facilities.  A large vault maintained at 0°F (–18°C) and 25% RH will be provided for the Archives' vast collection of color and black-and-white motion pictures; the vault will also be used for still photographic materials and to preserve selected paper documents.

Other temperature- and humidity-controlled vaults in the new facility will be provided for storage of audio materials, videotapes, and computer tapes, disks, and other EDP records.  A separate storage area maintained at 65.5°F (18°C) and 50% RH will be used to store oil paintings.  In all, the new building will have eight separate controlled-environment zones, each of which will meet specific requirements for temperature and relative humidity.  A so-

phisticated air-filtration system will keep acetic acid vapors, oxidizing gases, dust, and other airborne contaminants at low levels in all storage areas.

The National Archives serves as a centralized collection for all Canadian government agencies, including the National Film Board of Canada (which does not have its own cold storage facility).  The Archives also has a purchase program for Canadian theatrical feature films.  Release prints normally are supplied, but producers increasingly are asking the Archives to store pre-print elements for safekeeping.  The majority of the color films now in the cold storage vault were acquired through this program.

The National Archives collection includes a sizeable amount of video material in a wide variety of tape formats.  Audio materials, including phonograph records, tapes, and CD's, as well as computer tapes, floppy disks, and optical disks are also collected in ever-increasing quantities.

The Archives' humidity-controlled 0°F (–18°C) facility that will open in 1996 will establish new standards for color and black-and-white motion picture preservation in film libraries, archives, and museums worldwide.

June 1989 (3)

Unlike most film archives, the National Archives of Canada operates a video conservation laboratory equipped with extensive video and film-to-tape transfer equipment. Because of the range of video materials in the Archives' collections, the lab has become what amounts to a museum of video tape recorders, ranging from the Ampex 2-inch quadruplex machines of the late-1950's to the latest digital D-1 and D-2 video tape recorders. Satellite downlinks are provided for around-the-clock taping of television broadcasts from the CBC (the Canadian Broadcasting Corporation) and CTV (the Caldwell Television Network) for the National Archives' collections.

Continuous dry-desiccant dehumidifiers manufactured by Munters Cargocaire (a subsidiary of the Munters Group in Sollentuna, Sweden) are used to maintain 28% RH in the color film vault. Most of the cold storage vaults in the U.S. and Canada use similar Cargocaire dehumidifiers.

Senior film conservator Dennis Waugh with a bar-code reader entering inspection data into a Hewlett-Packard mini-computer terminal. The metal cans of incoming films are replaced with color-coded plastic cans; recently, the Archives has started using "vented" plastic film cans.

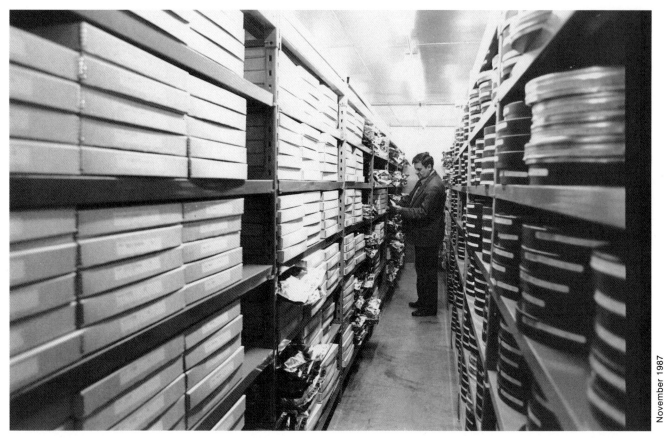

November 1987

The Library of Congress color film storage facility located in Landover, Maryland, just outside of Washington, D.C.  The humidity-controlled vault is maintained at 37°F (2.8°C) and 25% RH.  Shown here in the vault is David Parker, assistant head of the curatorial section of the Motion Picture, Broadcasting, and Recorded Sound Division of the Library of Congress.  Still-camera color photographs, including the color materials in the valuable **Look** magazine collection, are also stored in the color vault.  Several larger vaults for storing black-and-white motion pictures are kept at 55°F (12.8°C) and 25% RH.

## The Library of Congress Cold Storage Facility for Color and Black-and-White Motion Pictures

As the registrar of U.S. copyrights, the Library of Congress receives a release print of virtually every U.S. entertainment film production at no cost.  In addition, the Library's collection includes many films from the American Film Institute, which does not maintain its own storage facilities.  As a result, the Library now holds the most complete entertainment film collection in the country.  (U.S. government film and video productions, including Defense Department materials, are preserved by the National Archives — see description on page 719.)

Because of budget and space constraints, not every film and video production that is registered for copyright is retained by the Library for its research and study collection.  Although most theatrical and documentary films are kept, the Library is more selective about television productions, educational films, and religious material.  At the time this book went to press in 1992, the Library had about 136,000 cans of black-and-white and color film in storage at its Landover, Maryland cold storage facility, which opened in 1978.  Another 197,000 cans of safety-base film were being stored at various non-refrigerated locations.  In addition, 117,000 cans of cellulose nitrate film were being stored at 50°F (10°C) and 30% RH in vaults near the Library's preservation facility at Wright-Patterson Air Force Base in Ohio (see **Appendix 19.1** on page 675).

June 1989

Preserved at the Library's nitrate film storage facility at Wright-Patterson Air Force Base near Dayton, Ohio, is this rare nitrate-base Technicolor imbibition print of the 1944 MGM production **Meet Me in St. Louis**, which was directed by Vincente Minnelli and starred Judy Garland.

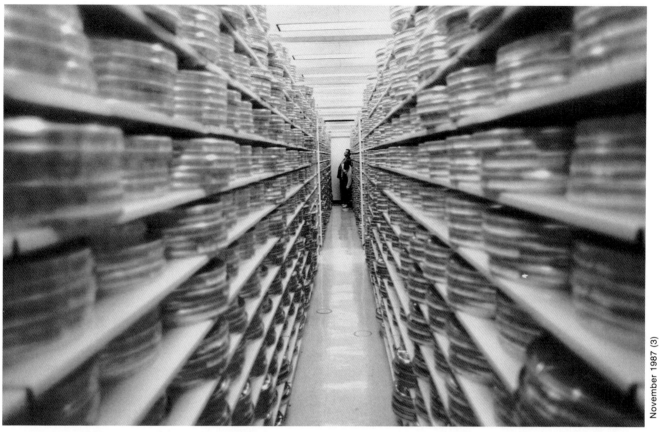

November 1987 (3)

Until around 1970, the Library did not consider preservation to be a primary goal; rather, the films were treated as a reference collection. All of the Library's Eastman Color prints and films made on similarly unstable Gevacolor, Fujicolor, and Ansco Color stocks from the 1950's through the 1970's were not refrigerated, and most have become severely faded. Even today, as pictured here in a storage room in the Library's motion picture division on Capitol Hill in Washington, D.C., thousands of rolls of color motion pictures continue to be stored under room temperature conditions; with new films arriving every day, budget constraints preclude providing cold storage for all of this material.

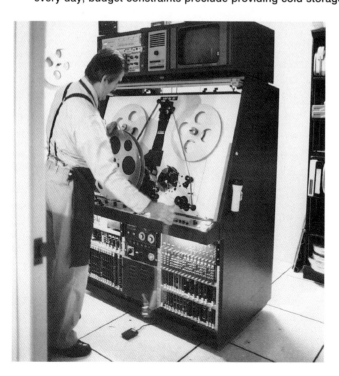

The availability of video releases of most films in recent years has lessened considerably the demand to view motion picture prints in the Library's collection. If a requested title has not been released on video, the Library makes a videotape reference copy. Films are transferred to tape with a Rank Cintel machine (shown in the picture at the left with audio and video lab engineer Paul V. Chrisman). In the picture above, Chrisman and Parker study the color balance of a scene as a tape transfer is being made. After transfer, films are placed in cold storage.

## Notes and References

**Note:** This chapter had its origins in a presentation by this author entitled "A Cost-Effective Approach to the Long-Term Preservation of Color Motion Pictures," at the **123rd Technical Conference and Equipment Exhibit of the Society of Motion Picture and Television Engineers**, Los Angeles, California, October 28, 1981. The use of low-temperature, humidity-controlled cold storage to preserve color motion pictures and cellulose nitrate films was further discussed by this author in "Color Photographs and Color Motion Pictures in the Library: For Preservation or Destruction?", a chapter in **Conserving and Preserving Materials in Nonbook Formats**, (Kathryn Luther Henderson and William T. Henderson, editors), pp. 105–111, 1991. The book contains the papers presented at the **Allerton Park Institute**, sponsored by the University of Illinois Graduate School of Library and Information Science, held November 6–9, 1988 at the Chancellor Hotel and Convention Center, Champaign, Illinois. Published by the University of Illinois Graduate School of Library and Information Science, Urbana-Champaign, Illinois.

1. Ben Stein, "A Studio Head With a Human Face," **The Wall Street Journal**, April 16, 1982, p. 16.
2. Frank Thompson, "Fade Out – What's Being Done to Save Our Motion-Picture Heritage?", **American Film**, Vol. XVI, No. 8, August 1991, pp. 34–38, 46. See also in the same issue: Wolf Schneider, "Film Preservation — Whose Responsibility Should it Be?", p. 2.
3. Stanley Yates, curator, The American Archives of the Factual Film, Iowa State University, Ames, Iowa, interview with this author, 1979.
4. Jack Tillmany, letter to Martin Scorsese, April 23, 1980.
5. Frank Hodsoll, "Film Preservation: A Large Piece of Americana Is Fading Away," **Daily Variety**, January 14, 1983, p. 28.
6. Robert Lenzner, "Hollywood Mystique," **The Boston Globe**, March 1, 1981.
7. Eastman Kodak Company, excerpts from an interview with Joerg D. Agin, vice president and general manager of the Motion Picture and Television Imaging Division of Eastman Kodak Company, **Kodak Press Release ES592149-bNR**, May 1992, p. 4.
8. Ricahrd Turner, "Disney Leads Shift From Rentals to Sales in Videocassettes," **The Wall Street Journal**, December 24, 1992, p. 1.
9. Michael Cieply and John Helyar, "Turner Pact to Sell MGM Assets Boosts Prospects of Broadcaster and 2 Buyers," **The Wall Street Journal**, June 6, 1986, p. 6.
10. Martin Scorsese, cover letter for a petition sent to Walter Fallon, chairman of the board, and Colby Chandler, president, Eastman Kodak Company, June 12, 1980. The letter and petition were accompanied by a list of demands, including that Kodak make more stable motion picture film and that the company make its secret color stability data public. The petition was signed by hundreds of well-known film directors, actors and actresses, producers, film critics, and film curators.
11. Linda Gross, "Any Solution to Film Color Fading Away?", **Los Angeles Times**, April 17, 1981, Part VI, p. 1.
12. Steven Spielberg, letter to Martin Scorsese, November 26, 1979.
13. Claudia Eller and John Evan Frook, "'91 B.O. Down, Spirits Up at Confab," **Variety**, Vol. 346, No. 6, February 24, 1992, p. 5.
14. Marc Berman, "Rentals Reap Bulk of 1991 Vid Harvest," **Variety**, Vol. 345, No. 12, January 6, 1992, p. 22.
15. Gerald Putzer, "'Terminator 2' Takes Ring in $200 Mil Year," **Variety**, Vol. 345, No. 12, January 6, 1992, p. 5.
16. Charles Fleming, "Studios Walking the Bottom Line," **Variety**, Vol. 345, No. 12, January 6, 1992, p. 105.
17. Frank Hodsoll, see Note No. 4.
18. Bill O'Connell, "Fade Out," **Film Comment**, Vol. 15, No. 5, September–October 1979, pp. 11–18.
19. Paul C. Spehr, "Fading, Fading, Faded — The Color Film Crisis," **American Film**, Vol. V, No. 2, November 1979, pp. 56–61.
20. Martin Scorsese, "Letter to the Editor," **Film Comment**, January–February 1980.
21. Martin Scorsese, letter "To My Friends and Colleagues," April 5, 1980.
22. Beginning in April 1980, this author served as a voluntary technical advisor on the stability of color motion picture film to Martin Scorsese and his staff during Scorsese's campaign against fading and helped formulate Scorsese's "Request for Information" sent to Kodak along with the petition on June 12, 1980. This author was to attend a meeting on July 14, 1980 in Scorsese's New York City apartment with Ken Mason and Tony Bruno of Eastman Kodak and Scorsese and his staff. Shortly before the meeting was to take place Kodak informed Scorsese that if this author were present, Kodak would not attend. As a result of Kodak's threat to cancel the meeting, this author went to Scorsese's office and did not attend the gathering. At the meeting, Ken Mason of Kodak indicated that Scorsese's demand that Kodak make public its secret color film stability data would be met by the company.

    See: Harlan Jacobson, "Old Pix Don't Die, They Fade Away — Scorsese Helms Industry Plea to Kodak," **Variety**, Vol. 299, No. 10, July 9, 1980, pp. 1, 28–29. This was a major article on the poor image stability of Kodak motion picture color negative and print films; the writer described film director Martin Scorsese's campaign to pressure Kodak into producing improved film stocks. See also: "Signers of No Fade Petition to Kodak Span All Industry Ranks," **Variety**, Vol. 299, No. 10, July 9, 1980, p. 29. See also: Robert Lindsey, "Martin Scorsese's Campaign to Save a Film Heritage," **The New York Times**, October 5, 1980, pp. 19ff. See also: Patricia O'Brian [Knight News Service], "Movies (and Snapshots) Are Losing Their Color," **San Francisco Chronicle**, May 11, 1980. This article also appeared under various titles in many other newspapers.

    See also: Jack Garner, "Films Fade – Director Protests; Kodak's 'Working on It'," **Democrat and Chronicle**, Rochester, New York, May 13, 1980, pp. 1C, 2C. See also: Richard Harrington, "Old Movies Never Die – They're Just Fading Away," **The Washington Post**, July 20, 1980.
23. Eastman Kodak Company, **Eastman Color Print Film 5384 — The Film to Take You Into the Future**, Eastman Kodak Brochure V3-351, October 1981.
24. Eastman Kodak Company, "Our Descendants Will See Their Ancestors as We Really Were," advertisement in **American Cinematographer**, Vol. 64, No. 7, July 1983, inside back cover.
25. Eastman Kodak Company, "Simply Beautiful . . . Beautifully Simple," advertisement in **American Cinematographer**, Vol. 65, No. 1, January 1984, pp. 8–9.
26. The Film Foundation, 9th Floor, 1619 Broadway, New York, New York 10019; telephone: 212-603-0667 (Fax: 212-245-7281).
27. Frank Thompson, "Spartacus: A Spectacle Revisited," **American Cinematographer**, Vol. 72, No. 5, May 1991, pp. 35–40.
28. American National Standards Institute, Inc., **ANSI IT9.9-1990, American National Standard for Imaging Media – Stability of Color Photographic Images – Methods for Measuring**, American National Standards Institute, Inc., New York, New York, 1991. Copies of the Standard may be purchased from the American National Standards Institute, Inc., 11 West 42nd Street, New York, New York 10036; telephone: 212-642-4900 (Fax: 212-398-0023).
29. See, for example: Lelise Bennetts, "'Colorizing' Film Classics: A Boon or a Bane?", **The New York Times**, August 5, 1986, pp. 1 and 21; "Directors Fight Copyrighting of Tinted Old Films," (Associated Press), **The Des Moines Register**, October 16, 1986, p. 3A; Susan Linfield, "The Color of Money," **American Film**, Vol. XII, No. 4, January–February, 1987, pp. 29ff; and, in a comprehensive review of the technology of the colorization process, Mark A. Fischetti, "The Silver Screen Blossoms Into Color," **IEEE Spectrum**, Vol. 24, No. 8, August 1987, pp. 50–55 (published by The Institute of Electrical and Electronic Engineers, 345 East 47th Street, New York, New York 10017; telephone: 212-705-7555). The cost of "colorizing" a movie may run from $2,000 to $3,000 per minute of film, or a total cost of $200,000 to $300,000 for a typical feature film. During 1990 Turner had 36 films scheduled for colorization at an estimated cost of $9 million; in 1989, 37 films were colorized by Turner, up from 27 in 1988. In addition, Turner planned to spend $1.5 million in 1990 to "recolorize" 25 already colorized films using enhanced computer technology. At the present state of technology, "colorization" is practical only for video transfers although it is expected that in the future, with film-resolution digital intermediate systems and more sophisticated image-processing software, the colorization process could also be used to create high-resolution transfers on color motion picture film that are suitable for theatrical projection.
30. American National Standards Institute, Inc., **ANSI IT9.11-1991, American National Standard for Imaging Media – Processed Safety Photographic Film – Storage**, American National Standards Institute, Inc., New York, New York, 1991. Copies of the Standard may be purchased from the American National Standards Institute, Inc., 11 West 42nd Street, New York, New York 10036; telephone: 212-642-4900 (Fax: 212-398-0023).
31. John G. Bradley, "Stability of Motion Picture Film," **Journal of the Society of Motion Picture Engineers**, December 1936.
32. P. Z. Adelstein, J. M. Reilly, D. W. Nishimura, and C. J. Erbland, "Stability of Cellulose Ester Base Photographic Film: Part I — Laboratory Testing Procedures," **SMPTE Journal**, Vol. 101, No. 5, May 1992, pp. 336–346.
33. David G. Horvath, **The Acetate Negative Survey: Final Report**, University of Louisville, Louisville, Kentucky, 1987. The project was funded by the University of Louisville and the National Museum Act. Copies of the 91-page report may be purchased for $8 (which includes first class postage) from: University of Louisville, Photographic Archives, Ekstrom Library, Louisville, Kentucky 40292; telephone: 502-588-6752.
34. P. Z. Adelstein, J. M. Reilly, D. W. Nishimura, and C. J. Erbland, "Stability of Cellulose Ester Base Photographic Film: Part I – Laboratory Testing Procedures," **SMPTE Journal**, Vol. 101, No. 5, May 1992, pp. 336–346; and P. Z. Adelstein, J. M. Reilly, D. W. Nishimura, and C. J. Erbland, "Stability of Cellulose Ester Base Photographic Film: Part II – Practical Storage Considerations," **SMPTE Journal**, Vol. 101, No. 5, May 1992, pp. 347–353. See also: Karel A. H. Brems [Agfa-Gevaert], "The Archival Quality of Film Bases," **SMPTE Journal**, Vol. 97, No. 12, December 1988, pp. 991–993. In the article, Brems discussed the degradation of cellulose triacetate film base and the "vinegar syndrome." Among his recommendations for storage, Brems included:

    "In film archives, cellulose nitrate-based materials must be stored separately from other materials. Film should be conditioned at 25 to

30% RH at room temperature, sealed air-tight, and stored at as low a temperature as possible, preferably –18°C [0°F].

"The literature concludes that triacetate film base, if not contaminated by other layers or products and if stored under the proper conditions, will last for at least a few hundred years. Recent practical experience in the archival world indicates, however, that in certain circumstances, which cannot be considered extreme, a risk for hydrolysis exists. Therefore, polyethylene terephthalate [polyester] is believed to be a safer choice as a support for film material that will be archived."

35. P. Z. Adelstein, J. M. Reilly, D. W. Nishimura, and C. J. Erbland, see Note No. 32, pp. 336–346.

36. P. Z. Adelstein, J. M. Reilly, D. W. Nishimura, and C. J. Erbland, see Note No. 34, p. 353.

37. A. Tulsi Ram, D. Kopperl, R. Sehlin, S. Masaryk-Morris, J. Vincent, and P. Miller [Eastman Kodak Company], "The Effects and Prevention of 'Vinegar Syndrome'," presented at the **1992 Annual Conference of the Association of Moving Image Archivists**, San Francisco, California, December 10, 1992.

38. Sodium aluminum silicate is available from W. R. Grace & Company, Davison Chemical Division, P.O. Box 2117, Baltimore, Maryland 21203-2117; telephone: 410-659-9000. The material is also available from the Union Carbide Corporation.

39. "Vented" polypropylene film cans are available from the Plastic Reel Corporation of America, Brisbin Avenue, Lyndhurst, New Jersey 07071 (telephone: 201-933-5100). Also: Plastican Corporation, 10 Park Place, P.O. Box 58, Butler, New Jersey 07405 (telephone: 201-838-4363).

40. Suppliers of custom-made, high-quality cardboard film-storage boxes include: Conservation Resources International, Inc., 8000-H Forbes Place, Springfield, Virginia 22151 (telephone: 703-321-7730); The Hollinger Corporation, 4410 Overview Drive, P.O. Box 8360, Fredericksburg, Virginia 22404 (telephone: 703-898-7300); and Light Impressions Corporation, 439 Monroe Avenue, P.O. Box 940, Rochester, New York 14607-0940 (telephone: 716-271-8960).

41. Earl Green, "Canada Restoring 500 Pix Frozen Since 1929," **Variety**, Vol. 331, No. 6, June 1, 1988, p. 48.

42. Peter Z. Adelstein, C. Loren Graham, and Lloyd E. West, "Preservation of Motion-Picture Color Films Having Permanent Value," **Journal of the SMPTE**, Vol. 79, No. 11, November 1970, pp. 1011–1018.

43. Archives for Advanced Media, Inc., 838 N. Seward Street, Hollywood, California 90038 (telephone: 213-466-2454). In 1982 the company attempted to interest clients in the Hollywood area in low-temperature storage (e.g., 0°F [–18°C] at 30% RH); however, the company did not think there was enough potential business to proceed with the construction of such a facility. Archives for Advanced Media offers film and magnetic media storage at about 55°F (12.8°C) and 50% RH. At the time this book went to press in late 1992, to this author's knowledge, there was no commercially available humidity-controlled, low-temperature (0°F [–18°C] and 25% to 35% RH) film storage rental space available anywhere in the world.

44. Noel Lamar, Photographic Technology Division, National Aeronautics and Space Administration, telephone discussion with this author, 1977.

45. Lincoln Perry, **Black-and-White Separations of Spacecraft Original Film**, Technical Report (Contract NASA 9–11500, Task Order HT–133), Photographic Technology Div., National Aeronautics and Space Administration, Lyndon B. Johnson Space Center, Houston, Texas, 1975.

46. Richard Patterson, "The Preservation of Color Films," **American Cinematographer**, Vol. 62, No. 8, August 1981, pp. 792ff.

47. In October 1981, Jack B. Goldman, at the time with Iron Mountain Group, Inc., Boston, Massachusetts, gave this author an estimated commercial storage cost of $18 per year per cubic foot of space for 0°F (–18°C) 30% RH motion picture film storage; this estimate has been increased to $30 per year per cubic foot by this author as an adjustment for inflation. Goldman had conducted a cold storage feasibility study for Iron Mountain Group, Inc. and gave a presentation entitled "A Commercial Service for Low Temperature Color Film Storage" at the 123rd Conference and Equipment Exhibit of the Society of Motion Picture and Television Engineers, Los Angeles, California, October 28, 1981. Because no commercial facility offering 0°F (–18°C), 30% RH storage was in operation at the time of this writing, this author has used the $30 per cubic foot cost as the best available estimate. The actual cost would depend on — among other factors — the size of the facility; a very large facility would have much lower unit costs than a small installation. At the time of this writing, Iron Mountain Group had not constructed a low-temperature facility. Along with Bill Lawler, Goldman left the company to start Archives for Advanced Media, Inc. in Hollywood (see Note No. 43 above).

48. Bob Fisher, "The Dawning of the Digital Age," **American Cinematographer**, Vol. 73, No. 4, April 1992, pp. 70–86.

49. Glenn Kennel, manager of product development, advanced technology products, Motion Picture and Television Imaging Division, Eastman Kodak Company, Hollywood, California, telephone discussion with this author, December 9, 1992.

50. B. Hunt, G. Kennel, L. DeMarsh, and S. Kristy [Eastman Kodak], "High-Resolution Electronic Intermediate System for Motion-Picture Film," **SMPTE Journal**, Vol. 100, No. 3, March 1991, pp. 156–161.

51. P. Z. Adelstein, "Status of Permanence Standards of Imaging Materials," **Journal of Imaging Science and Technology**, Vol. 36, No. 1, January–February 1992, pp. 37–41.

52. National Archives and Records Service, **Strategic Technology Considerations Relative to the Preservation and Storage of Human and Machine Readable Records** (White Paper prepared for the National Archives and Records Service by Subcommittee C of the Committee on Preservation), July 1984.

53. John C. Mallinson, "Archiving Human and Machine Readable Records for the Millenia," **Second International Symposium: The Stability and Preservation of Photographic Images** (Printing of Transcript Summaries), the Society of Photographic Scientists and Engineers, Springfield, Virginia, pp. 388–403, 1985. (The symposium was held August 25–28, 1985 in Ottawa at the National Archives of Canada.) See also: John C. Mallinson, "Preserving Machine-Readable Archival Records for the Millenia," **Archivaria**, No. 22, Summer 1986, pp. 147–152. See also: John C. Mallinson, "On the Preservation of Human- and Machine-Readable Records," **Information Technology and Libraries**, Vol. 7, No. 1, March 1988, pp. 19–23.

54. John C. Mallinson, "Magnetic Tape Recording: History, Evolution and Archival Considerations," chapter in **Proceedings of the International Symposium: Conservation in Archives**, pp. 181–190. The symposium was held May 10–12, 1988 in Ottawa and was sponsored by the National Archives of Canada and the International Council on Archives. The proceedings were published by the National Archives of Canada, 1989. Copies of the proceedings are available from the International Council on Archives, 60, rue des Francs-Bourgeois, 75003 Paris, France.

55. W. Stackhouse (chairman), "Report of the Task Force on Digital Image Architecture," **SMPTE Journal**, Vol. 101, No. 12, December 1992, pp. 855–891. (Note especially the discussion in Sec. 7.4 "Compression Quality Level," pp. 886–887, and in Sec. 7.9 "Audio Quality," p. 889.)

56. The 0°F (–18°C) and 25% RH conditions that will be maintained in the new color film storage facility scheduled to open in late 1996 were recommended by Klaus B. Hendriks, director of the Conservation Research Division of the National Archives of Canada.

## Additional References

Eileen Bowser and John Kuiper, eds., **A Handbook for Film Archives**, Federation Internationale des Archives du Film, Brussels, Belgium, 1980.

Eastman Kodak Company, **The Book of Film Care**, Kodak Pub. No. H-23, Eastman Kodak Company, Rochester, New York, June 1983.

European Broadcasting Union, **Storage of Magnetic Tapes and Cinefilms**, Tech. 3202-E, Technical Centre of the European Broadcasting Union, Brussels, Belgium, August 1974.

FIAF, FIAT, and IASA, **Archiving the Audio-Visual Heritage – A Joint Technical Symposium**, held May 20–22, 1987 in Berlin, Germany. Sponsored by the Federation Internationale des Archives du Film, the Federation Internationale des Archives de Television, and the International Association of Sound Archives, published by Stiftung Deutsche Kinemathek, Berlin, Germany, 1988.

FIAF, **The Preservation and Restoration of Colour and Sound in Films**, Federation Internationale des Archives du Film, Brussels, Belgium, 1981.

Peter Hay, **MGM: When the Lion Roars**, Turner Publishing, Inc. (a division of Turner Broadcasting System, Inc., the parent company of Turner Entertainment Co.), One CNN Center, Atlanta, Georgia 30348), 1991.

Lawrence F. Karr, ed., **Proceedings – Conference on the Cold Storage of Motion Picture Films**, American Film Institute and Library of Congress, Washington, D.C., April 21–23, 1980.

Gert Koshofer, **Farb Fotografie**, (Books 1, 2, and 3), Verlag Laterna magica, Munich, Germany, 1981.

Gert Koshofer, **Color — Die Farben Des Films**, Wissenschaftverlag Volker Spiess GmbH, Berlin, Germany, 1988.

Joseph McBride, "Par Dusting Off Its Heritage, **Daily Variety**, Vol. 277, No. 38, April 27, 1990.

Daniel McKinny, "Networks Keep Pace in Post Race," **American Cinematographer**, Vol. 73, No. 9, September 1992, pp. 44–52.

Munters Cargocaire, **The Dehumidification Handbook – Second Edition**, 1990. Cargocaire Engineering Corporation, 79 Monroe Street, P.O. Box 640, Amesbury, Massachusetts 01913-0640; telephone: 508-388-0600 (toll-free: 800-843-5360); Fax: 508-388-4556.

Patricia O'Brian, "Treasures Lost as Color Film Fades," **Des Moines Sunday Register**, May 18, 1980, p. 6/H.

Richard Patterson, "The Preservation of Color Films – Part I," **American Cinematographer**, Vol. 62, No. 7, July 1981, pp. 694ff; and Richard Patterson, "The Preservation of Color Films – Part II," **American Cinematographer**, Vol. 62, No. 8, August 1981, pp. 792ff.

Roderick T. Ryan, **A History of Motion Picture Colour Technology**, The Focal Press, London, England, 1977.

Curt Sanburn, "The Race to Save America's Film Heritage – Of the 21,000 Movies Made Before 1951, More than Half Are Missing," **Life**, Vol. 8, No. 8, July 1985, pp. 68–80.

Ralph N. Sargent, **Preserving the Moving Image**, The Corporation for Public Broadcasting and The National Endowment for the Arts, Washington, D.C., 1974.

*(See Appendix 9.1 on following pages . . .)*

# Appendix 9.1 – "Outline for a Preservation Strategy," Written by Film Director Martin Scorsese and His Staff in 1980

**An Introductory Word:**

This outline for a Color Preservation Strategy comes as a result of watching and loving films for the past 36 years. In that time I have witnessed the deterioration and sometimes the destruction of most films I have seen. With the introduction of Eastman Kodak color film in 1950, any hope for color stability vanished. All films made in the Eastman color process are about to deteriorate beyond repair. Some have already done so. Methods of restoration are so costly that if a film is not considered important, it is left to die.

The problem of color stability is inherent to the film stock. Eastman Kodak is the world's largest film manufacturer — although they are not entirely to blame in this issue. Other film companies must share responsibility, and filmmakers and filmgoers must recognize the problem and take action to solve it.

**The Problem is not simple, but it can be simply stated:**

1. Unstable film stock.

2. Deterioration of existing films (prints and negatives).

3. A need for research and development of a new print stock equal to or better than Technicolor Imbibition.

4. Research and development of new methods of film restoration.

5. Research and development of new methods of film storage (storage data and more compact film storage).

**The Solution** starts with an understanding of film and our responsibility. We all agree that film is the twentieth century art form — the American art form. But, it is also the immediate reflection of world culture and history. Film must be preserved for man's heritage.

Not only theatrical films, but anthropological and historical still photographs and video — for they record, reflect and shape history. The future will know and judge the past from these records of living time. They must be kept intact. This is the responsibility not only of those who record the past, but of those who furnish the means to do it.

Advancement in technology is so fast that the gap of silence between those who make the images, express ideas or objectively record events and those who have control over the knowledge and status of preserving these materials must be closed. An open dialogue must be established between all members of the industry. Film deterioration is not some esoteric problem of formulas, emulsions, temperature and profit curves. It is a perverse method of

cultural and historical suicide. We've got to fight for the past, for the future.

**No Value Judgments:** All films must be saved. No committees should decide which film lives or dies, whether or not TV commercials are less important than movie trailers. Preserving only commercially successful films, or Academy Award winners and nominees or film festival winners, is a step in the right direction, but far from enough. Very often, as in the case of *The Magnificent Ambersons* or *The Searchers*, it is only time itself which lets a film's true value shine through.

**Creation and Purpose of a New Organization:** A new organization should be composed of representatives of every group in the industry: from studios, producers and actors to museums, archives and universities; from film preservation experts and film manufacturers to experts in advanced technologies. It is important that the group not be affiliated or obligated to any branch of the industry.

The new organization would be a "clearing house" for the diverse branches of the media which:

1. Will establish and sustain an exchange of new ideas.

2. Will learn about the best new technological advancements and educate those concerned about them.

3. Will, with proper counseling and discussion by its expert members, encourage new methods of research and development.

4. Will, through this research and development, begin to work on the color preservation problem and on the deplorable condition of black and white films — old and new.

5. Will explore new methods of film restoration for those nitrate, black and white, imbibition and other films in danger of being lost and discover new forms of materials on which to transfer film elements (negatives, soundtracks, CRI's, YCM's, etc.) which are in danger of destruction. This research will lead also to proper storage of these film elements.

6. Will encourage building of new cold storage vaults, sustaining those that already exist, and establishing the "norm" for the preservation of film elements.

7. We are already aware that most studios and archives have storage facilities that function with varying degrees of efficiency. A "norm" would insure that every

method of storage functions with an equal degree — a maximum degree — of efficiency.

8. Will act as a clearing house for paper materials related to film. These materials, (posters, scripts) can be either stored in a new archive built by the industry, or collected together to form a traveling "archive" for students.

**Perseverance:** The goals outlined in this proposal may seem hopelessly idealistic. Just on the basis of today's advancing technology we know, on the contrary, that they are an attainable reality. But equally important elements are: 1) Our own perseverance. The determination to achieve the best we can, and when we do, not to be content, but to continue to develop new ideas resulting in more sensible, economical and permanent preservation methods and 2) Unity — All branches of the industry must put aside disagreements and unite in this one common cause, which is, after all, a common interest. We must unite to preserve.

**Obstacles:** In the course of taking action we will undoubtedly run into many obstacles which have helped establish this crisis.

**Ignorance and Apathy:** There is never any time for details. When we do find the time, the details are too complicated. So, apathy sets in — "What's the use," "If it's good, it'll survive". The matter is not whether it is good or bad, what great talents we may all be. The matter is knowledge and the survival of these materials themselves. This is not a crusade for self-importance.

Judging from the response we have received from so many branches of the industry it seems that at least a dialogue has begun among us and that indeed, we can all work past self-interest toward a common goal.

**Economics:** It's cheaper to keep the situation the same. The monetary pressures on the studios and distributors — which eventually affect the filmmaker through budget and recoup — force them to be concerned only with the short term goal: get it on the screen with the best quality in the fastest and cheapest way. From a business point of view, what happens after is unimportant. This can mean that if a film is not successful, there is even less chance of its preservation.

If a film is a hit, new Eastman prints will be struck for its re-release. They will look good for a while, but, as in the case of *2001: A Space Odyssey*, only for a while. By 1978, the print revived at the Rivoli Theatre in New York City was pink as a boiled shrimp. It was unwatchable.

It must be understood that whatever the precautions taken by studios and distributors, all films, recent ones and classics, profitable and unprofitable, are obviously in severe danger.

Technological advances are re-shaping and renewing the industry. Digital printing, laser transfers, cable outlets, satellite stations, tapes, videodiscs, all will continue to open new areas where an incredible demand for product — new and old — will be needed. How will the product — especially the older product — be preserved for use? Why ignore preservation and destroy assets?

**Support and Funding: Some initial ideas.**

1. **Individual Initiative.** We can insist on the latest and best methods of preservation — contractually. We can also volunteer one percent of our salaries and profits from the film we're working on to insure that our work is preserved in the way we want. All should contribute: directors and studios, actors, distributors, writers and cameramen.

2. **Studios.** A certain percentage of each film's budget should be used for preservation.

3. **Government Support.** Especially in the case of films where restoration is of most importance, or where rights are in question.

4. **Congressional Action.** Film and its related materials should be declared national archive material to be protected.

**Meetings:** An industry-wide symposium is being planned for the fall of this year [1980] in Los Angeles. Many other meetings will take place before that and the results will be reported to everyone. As a first step, here is a list of questions for Eastman Kodak. We should very much appreciate and anticipate direct and honest answers. [Scorsese's "Request for Information" to Kodak is reprinted on pages 308–309.]

# 10. The Extraordinarily Stable Technicolor Dye-Imbibition Motion Picture Color Print Process (1932–1978)

Except for archival showings, *Gone With the Wind* hasn't looked good theatrically since the last Technicolor prints were struck in 1954; the 1961 reissue was in crummy Eastman Color (the prints faded), and 1967's washed-out "widescreen" version was an abomination.[1]

Mike Clark
"Movies Pretty as a Picture"
*USA Today* – October 15, 1987

In 1939, it was the most technically sophisticated color film ever made, but by 1987 *Gone With the Wind* looked more like *Confederates from Mars*. Scarlett and Rhett had grown green and blue, a result of unstable film stocks and generations of badly duplicated prints. Hair styles and costumes, once marvels of spectral subtlety, looked as though captured in Crayola, not Technicolor.

Not anymore. Turner Broadcasting System, owner of the film, spent two years and $250,000 restoring David O. Selznick's four-hour classic, in time for the film's 50th anniversary this year.

For the restoration of *Gone With the Wind*, Richard May, director of film services at Turner, returned to the original — and highly flammable — nitrate negatives, stored specially at Eastman House in Rochester.

Using as a guide a 1954 Technicolor print approved by the late Mr. Selznick, work began on rephotographing the negatives in early 1987 at YCM Laboratories in Burbank, California.[2]

Max Alexander
"Once More, the Old South
    in All Its Glory"
*The New York Times* – January 29, 1989

While three Hollywood companies rush to produce a new Robin Hood film in head-to-head competition, Turner Entertainment Company stands ready to bring back the definitive film of the saga, Warner Bros.' 1938 Technicolor hit *The Adventures Of Robin Hood*.

Dick May, v.p. of entertainment and film services at Turner Entertainment, says "Give me 10 or 12 substantial bookings and we'll go ahead striking new prints and reissuing the film."

---
See page 347 for Recommendations
---

He notes that the negative used to make existing prints in circulation had worn out [faded].

"That negative dates back to the early '50s when United Artists acquired the film's distribution rights from Warner Bros. in the purchase of the old WB library. Four years ago we at MGM/UA went back to the three-strip Technicolor materials to make a new internegative and now have excellent printing materials. All it takes is a phone call to our lab to make new prints," he says.[3]

Lawrence Cohn
"Turner Eyes '38 *Robin Hood* Redux"
*Variety* – July 25, 1990

## The 45-Year Era of "Permanent" Technicolor Motion Pictures

With the introduction in 1932 of the Technicolor Motion Picture Corporation three-strip beam-splitter camera, which simultaneously filmed separation negatives in register through red, green, and blue filters on three separate reels of black-and-white film, and the companion Technicolor dye-imbibition printer to make full-color prints from the separation negatives, the entertainment film industry in the United States began a 45-year era of color motion pictures with essentially permanent images. Under normal room-temperature storage conditions, the images of Technicolor dye-imbibition motion pictures will probably last for hundreds of years without perceptible changes in color balance, density, or stain level.

According to accelerated dark fading tests conducted by this author, the image stability of triacetate-base Technicolor imbibition prints is *vastly* superior to that of the improved Eastman Color Print Film 5384 and similar "low-fade" Fuji and Agfa-Gevaert color print films which entered the market in 1982–1985. Previous films, such as Eastman Color Print Film 5381 and 5383, and Fujicolor Positive Film HP 8814, had extremely poor image stability — a fact that becomes painfully clear with a visit to any film archive.

Historically, dye-imbibition color images of all types have had extremely good stability when stored in the dark under normal room-temperature and humidity conditions. Light fading is not usually an important factor in the deterioration of motion picture images since the accumulated light exposure on each frame of film — even after hundreds of projections — is not enough to cause significant fading with most types of color films.

The life of a Technicolor dye-imbibition motion picture is limited by the cellulose nitrate or cellulose triacetate base upon which it is made — the color image is far more permanent than is either type of film-base material!

Technicolor three-strip cameras on location in Eureka, California filming the Warner Bros. 1938 feature **Valley of the Giants**. The wide film magazines on the cameras carried three rolls of black-and-white separation negative film. Brilliant color prints were made from the negatives by the dye-imbibition (dye transfer) process in Technicolor's laboratories.

Mac Julian – 1938 (Courtesy of Warner Bros.)

The dye-imbibition color images of both early and more recent Technicolor films are so stable, in fact, that, had they been printed on modern polyester-base film stock instead of the cellulose nitrate or cellulose triacetate film bases available at the time, Technicolor movies would have joined UltraStable Permanent Color Prints, Ilford Ilfochrome (called Cibachrome, 1963–91), Kodak Dye Transfer, Fuji Dyecolor, polyester-base black-and-white films and fiber-base prints that have been treated with a protective toner, and the few other modern photographic materials that are essentially permanent when stored in the dark under normal temperature and humidity conditions.

If cellulose nitrate Technicolor films are properly cared for and not physically scratched and abraded by repeated projection, the useful life of these early films is limited only by the instability of the nitrate film upon which they were printed (nitrate film was used throughout the film industry for both black-and-white and color movies until 1950–52).

The useful life of both cellulose nitrate film and modern cellulose triacetate film is influenced by the temperature and relative humidity of storage, and, to a lesser extent, by how the film is packaged. The lower the temperature and relative humidity, the longer the film will last.

At any given storage temperature, the color images of early Technicolor films are much more stable than the film base itself. Under adverse storage conditions, some nitrate films became unusable after only 20 or 25 years; others remain in very good condition today, more than 50 years after they were made.

Cellulose nitrate motion picture films still in good condition can easily be preserved almost indefinitely in low-cost explosion-proof freezers (a subject discussed in Appendix 19.1 at the end of Chapter 19), or in larger, specially designed humidity-controlled 0°F (–18°C) storage vaults.

In 1950–52, the motion picture industry converted from highly flammable cellulose nitrate-base film stock to less

# Recommendations

**Preservation of Technicolor Dye-Imbibition Motion Picture Prints and Separation Negatives**

• Surviving Technicolor imbibition prints, made on either nitrate or cellulose triacetate safety film, are irreplaceable historical artifacts and must be treated as such.

• Technicolor imbibition prints should never be projected or routinely viewed on Steenbecks or similar equipment.

• For viewing and study purposes, a videotape master and duplicate user tapes should be made from Technicolor imbibition prints. Duplicate motion picture prints should be prepared from a color internegative made from the imbibition prints; Eastman Color Internegative Film 5272 (special order in 35mm) is suitable for this purpose. The internegative can also be used to make videotapes.

• Cellulose triacetate-base imbibition prints, separation negatives, and other preprint materials should be stored in the dark with low relative humidity (20–30% RH) and a temperature of 40°F (4.4°C) or lower. Ideally, triacetate-base materials should be stored at 0°F (–18°C) or lower. Film in tin-plated or painted steel cans should be transferred to plastic or aluminum cans.

• Nitrate-base Technicolor imbibition prints should be wound on cores and stored in untaped film cans in vaults specially designed for nitrate film storage, at a temperature of 0°F (–18°C) or lower and with a relative humidity of about 30%. Nitrate camera separation negatives, master positives, soundtracks, and other preprint materials should be preserved in the same manner. Film in steel cans should be transferred to plastic or aluminum cans.

• If humidity-controlled, low-temperature (i.e., 0°F [–18°C]) storage cannot be provided, nitrate-base imbibition prints should be wound on cores, conditioned to a relative humidity of about 40%, placed in taped plastic or aluminum cans, double-sealed in vapor-proof paper/polyethylene/aluminum-foil bags, and stored in explosion-proof freezers at a temperature of 0°F (–18°C) or lower (for further information on nitrate film preservation, see **Appendix 19.1** at the end of Chapter 19). Nitrate camera separation negatives, master positives, soundtracks, and other preprint materials should be preserved in the same manner.

• With proper handling and storage, original nitrate and cellulose triacetate Technicolor imbibition prints still in good condition can be preserved for hundreds and possibly thousands of years. Technicolor imbibition prints are not expendable films to be viewed and abused for the pleasure of filmgoing audiences who would like to see the "real thing." These films must be preserved in their original form — saved so that they can serve as printing masters for whatever film and electronic reproduction media emerge in the future. The current practice of some of the major film archives and other collecting institutions around the world of screening original Technicolor imbibition prints must stop.

• The American Film Institute, in conjunction with the Library of Congress, should administer carefully designed, low-temperature, humidity-controlled storage facilities at two separate geographic locations for the long-term preservation of color and black-and-white motion pictures and videotapes. Original materials should be stored at one location, with back-up duplicates kept at the other. Separate areas, isolated from other storage buildings, should be provided for Technicolor nitrate prints and negatives and other nitrate films. The high-security facilities should offer low-cost storage services for commercial studios, motion picture and videotape libraries, museums, archives, and individuals (for further discussion of motion picture preservation, see Chapter 9 and Chapter 20).

hazardous cellulose triacetate "safety-base" film. Triacetate film was long believed to be much more stable in storage than cellulose nitrate film, but recent research at the Image Permanence Institute[4] and elsewhere has indicated that cellulose nitrate and cellulose triacetate films have generally similar aging characteristics: triacetate film has a shorter life than once supposed, and cellulose nitrate film can last longer than commonly believed. Low-temperature and low-humidity storage will *vastly* extend the life of both types of film (see Chapter 9).

## Color Image Formation with the Technicolor Dye-Imbibition Process

The Technicolor dye-imbibition process produced color images with preformed acidic cyan, magenta, and yellow dyes in a manner very similar to today's Kodak Dye Transfer (introduced in 1946) and Fuji Dyecolor (introduced in Japan in 1947) print processes for still photography. However, the Technicolor process required complex machinery to print in register all three dye images on complete reels of motion picture film. Technicolor dye-imbibition motion picture prints have sometimes been called dye transfer prints, or IB prints (IB stands for the I.B. Corporation of Cambridge, Massachusetts, which constructed the electrically controlled transfer machines designed by Malcolm H. "Mack" Ames of Technicolor).

The term "imbibition" refers to the absorption and transfer of image dyes from three gelatin relief "matrix" films to a print film. Matrix films printed from the three Technicolor camera separation negatives were developed with a "tanning" developer which selectively hardened gelatin adjacent to the developing silver grains within the emulsion. Following development and chemical bleaching of the silver image, a hot water "wash-off" (at about 130°F [54.5°C]) removed unhardened gelatin, forming gelatin relief images which varied in thickness according to the densities of the different areas of the image. Fixing and drying completed the process. When immersed in a dye bath, the amount of dye absorbed by the matrix film is a function of the gelatin thickness at any given point in the image. Imbibition printing is not a light-sensitive process; the printing procedures are normally carried out in brightly lighted rooms.

Matrices can also be printed directly from Eastman Color and similar chromogenic negatives, as well as from separation negatives printed from Kodachrome and other reversal motion picture color films; this in turn allows production of imbibition prints. Beginning in the early 1950's, Technicolor imbibition release prints were made for many hundreds of motion pictures shot on color negative film.

To make a print, the cyan, magenta, and yellow dyed matrix films were successively placed in brief contact (in exact register) with the emulsion of an unsensitized print film (called a "blank" film), and the gelatin coating on the film absorbed (imbibed, or "drank-up" ) dyes from each of the matrix films. After the introduction of sound films, the "blank" film used by Technicolor was an inexpensive, contact-speed black-and-white film printed with the sound track and developed and fixed in conventional chemicals prior to imbibition printing. The completed full-color motion picture contained both a silver sound track and a dye color image (most early Technicolor prints also contained a low-

density silver "key" image to add depth to the shadows).

Kodak had been closely involved with Technicolor almost from the beginning and produced the separation negative films and matrix films needed in the imbibition process. Prior to about 1940, Kodak Super-XX negative film was used in the camera to film the separation negatives; after that year, Kodak produced a number of special films for Technicolor, and until 1976 Kodak Ltd. of England produced the matrix films for the Technicolor plants in England and Italy. Most of the Technicolor print film was supplied by Eastman Kodak Company.

## The 45-Year Era of "Permanent" Color Motion Pictures Comes to an End

In February 1975, the Technicolor imbibition plant in Hollywood, California was closed and the printing equipment dismantled. Technicolor's overseas imbibition plant in Rome was shut down on June 1, 1978, and the London facility — the last Technicolor imbibition plant — ceased operation on June 14, 1978. "Color by Technicolor" lives on, however. With laboratories in Hollywood, New York City, London, and Rome,[5] the company is now owned by Carlton Communications P.L.C., a British firm that in 1988 purchased Technicolor from its previous owner, MacAndrews & Forbes Group, for $780 million (MacAndrews & Forbes acquired Technicolor in 1983 for $100 million). At the time it was purchased by Carlton Communications, Technicolor was not only the largest motion picture processor in the world but was also the world's largest duplicator of video cassettes for the home video market.[6]

With the its dye-imbibition laboratories closed, Technicolor now processes Eastman, Fuji, and Agfa-Gevaert chromogenic color negative and print films for television and theatrical film producers. The slogan "Color by Technicolor," which for many years has appeared in the title frames of most of the theatrical and television release prints produced by the Technicolor Corporation, simply means that Technicolor laboratories made the prints (and in most cases, also processed the negatives). "Color by Technicolor" no longer refers to any particular motion picture film stock or process; the "Technicolor" name is protected by trademark registration in 84 countries.

At the time of the Technicolor imbibition plant closings, few people in the film industry were aware of the extraordinary image stability of Technicolor dye-imbibition prints. For that matter, not many knew very much about the comparatively poor image stability of Eastman Color prints until 1979, when a series of articles on color stability began appearing in motion picture publications. By then the Technicolor imbibition plants had been dismantled and Technicolor had no interest in reviving the process. This abruptly ended the era of permanent color motion pictures in the United States and Europe.

## Technicolor Builds a New Imbibition Printing Plant in China

Ironically, almost simultaneously with the loss of permanent color motion picture production in the Western world, the People's Republic of China gained the capability. In 1974 the Chinese government contracted with Tech-

nicolor Ltd. in England to have a complete motion picture imbibition printing plant constructed in China. Operation of the plant began in late 1978. The original three-strip Technicolor cameras (discussed later in this chapter) have been abandoned; Chinese films are shot with Eastman Color and other color negative films, and imbibition matrices are prepared from the color negatives.

A delegation of members of the U.S. Society of Motion Picture and Television Engineers (SMPTE) visiting China in 1979 commented on the new imbibition plant:

> The group was impressed by the extreme cleanliness of this facility. . . . A number of reels of the prints were projected for us and we were greatly impressed with the screen color quality. Here was a very new plant, a complicated process, operating correctly and efficiently, and producing a quality product.
>
> . . . Some may wonder why the imbibition or Technicolor process is important in China. It is not used in the United States today, having gradually declined as the use of colorpositive materials increased; so why would the PRC adopt the imbibition system which is virtually obsolete in the United States? We asked this question of our Chinese hosts and the answer makes sense. With the Beijing and Shanghai laboratories now making release prints to be shown throughout all of China, large numbers of prints are made of each subject. Our Chinese friends told us that the print costs on a dye imbibition process in the single subject quantities in which they are made are considerably less than for conventional color positive materials and that the color quality is comparable for both systems.[7]

Most of the equipment supplied to China was new and specially constructed by Technicolor Ltd. to meet Chinese requirements. It has been reported that the equipment is an advanced modification of previous Technicolor printing equipment.[8] The imbibition motion picture process is at its best economic advantage when large numbers of release prints are required and when skilled labor is available at low cost; both of these conditions now exist in China. The normal print run for the Beijing imbibition plant is said to be about 250 35mm copies, with up to 500 copies being made for very popular films; in addition, the lab makes about 1,000–2,000 16mm prints and about the same number of 8.75mm (35mm blank stock slit into four strips) copies for showing in rural areas.[9] China, with an estimated population in excess of one billion people, is a huge market for movies and video productions.

The Chinese now manufacture their own blank stock and matrix film for making release prints in their imbibition plants. Kodak supplies considerable quantities of color negative and intermediate print stocks to China[10] and is said to have supplied matrix stocks before the Chinese started producing their own.

Another large imbibition film laboratory located in Shanghai is equipped with two rotary imbibition transfer machines installed in 1968.[11] These machines, which were designed and built in Russia, have a large dye-transfer wheel about 40 inches (1 meter) in diameter instead of the stainless steel belt found in the Technicolor equipment. The Russian machines require three passes of each film to transfer the cyan, magenta, and yellow dye images.[12] The Soviet Union for many years printed some of its color motion pictures with imbibition transfer machines of this basic design.

## The Beginnings of Technicolor

The Technicolor Motion Picture Corporation was founded in 1915 in Boston, Massachusetts by Dr. Herbert T. Kalmus, Dr. Daniel F. Comstock, and W. Burton Westcott, with financial backing from Boston attorney William Coolidge and his partner C. A. Hight. Kalmus and Comstock were classmates at the Massachusetts Institute of Technology (M.I.T.) and in 1912 formed the engineering company of Kalmus, Comstock & Westcott, Inc. The "Tech" in the Technicolor name was chosen as a tribute to M.I.T.

The first Technicolor processing plants, research laboratories, and equipment shop were built in Boston, but in 1924 Technicolor opened a processing and imbibition printing plant in Hollywood, California. This was followed by the Technicolor Ltd. plant in England in 1937 and the Technicolor Italiana S.p.A. facility in Rome in 1955. Technicolor also operated a plant in Joinville, France (near Paris) for a few years beginning in 1955; the French division was known as Societe Technicolor.

The company's first film, *The Gulf Between*, was produced in 1917 in Florida using a two-color additive process; this was the only film Technicolor made with the additive process. To make the film, Technicolor outfitted a railroad car with a complete processing laboratory and took the car from Boston to Jacksonville, Florida for the production. A single-lens beam-splitter camera was used to shoot the film. The projector for this film had two apertures with red and green filters in front. The two image components on the single piece of nitrate film had to be kept in precise register by the theater projectionist, and difficulties with registration soon caused the process to be abandoned by Technicolor. Kalmus has described the problems that occurred at one of the first public demonstrations of the two-color additive process:

> I was invited by the American Institute of Mining Engineers to give an exhibition of the "revolutionary" Technicolor process at Aeolian Hall in New York City. We were photographing a picture called *The Gulf Between* in Florida. The audience included Mr. Coolidge, Mr. Hight and about 150 others, many of whom were interested in financing the growth of Technicolor. After my enthusiastic preliminary remarks the picture began to appear, and behold there were the most glaring color fringes anyone had ever seen on the screen. The projectionist had failed to register the picture at the outset. This and some further experiences in the theatre with the difficulties of registration in the projection brought about the first deep depression for the then very young company.[13]

## The Cemented-Film Two-Color Process

Developed in 1919, a new method of making color prints consisted of two cellulose nitrate gelatin relief films (similar to the later "matrix" films for transferring dyes to a blank film) cemented together, back-to-back. The relief films were individually dyed with subtractive colors by floating the film on dye baths. This was still a two-color process and as such was quite deficient in color reproduction. The first two-color subtractive motion picture was a Metro Pictures release, *The Toll of the Sea*; the film starred Anna May Wong and was filmed by Technicolor in Hollywood. The first showing of the film was at the Rialto Theater in New York City in November 1922. Public demand for the film quickly exceeded the limited capacity of Technicolor's small laboratory, and the film was not widely distributed until the following year.

Prints of *Toll of the Sea* were manufactured at the original Technicolor pilot plant on Brookline Avenue in Boston; prints cost about $0.27 per foot, which was substantially more than black-and-white prints in those days. The film was quite successful and grossed more than $250,000, of which Technicolor received about $165,000. Even though Metro Pictures distributed the film, Technicolor had acted as producer. In 1923 Technicolor built a second Boston plant with a capacity of about one million feet of release prints per month. In 1924 Metro Pictures became Metro Goldwyn Mayer — better known as MGM — and with the acquisition of United Artists in 1981, the firm became the MGM/UA Entertainment Company.

In 1986 MGM/UA was purchased for about $1.5 billion by Ted Turner's Atlanta, Georgia based Turner Broadcasting System, Inc. As the operator of CNN (the worldwide Cable News Network) and WTBS television, a "superstation" that broadcasts nationwide by satellite and cable systems, Turner was primarily interested in acquiring the more than 2,200 movies in the MGM Film Library (which, by a previous purchase, included most pre-1950 Warner Bros. films). By purchasing MGM, such film classics as *Gone With the Wind, Casablanca, The Wizard of Oz, 2001: A Space Odyssey,* and *Ben Hur* became available to Turner for broadcast, sale on videocassette and videodisc, and worldwide syndication to other television broadcasters. Once MGM/UA was in hand, Turner promptly broke up the company and sold off the MGM movie production unit, the United Artists division (which kept the UA Film Library), the MGM Metrocolor film lab (which was eventually acquired by Technicolor, Inc.), the 44-acre MGM studio lot in Culver City, California, and a number of other MGM/UA assets in order to reduce the massive debt resulting from the purchase.

In the end, Turner Broadcasting, through its Turner Entertainment Co. division, retained only the MGM Film Library, now known as the Turner Entertainment Co. Film Library, at a cost of almost *$1.3 billion!* (The library has since been enlarged and now includes the RKO domestic market film library. In all, Turner now owns more than 3,300 feature films.)[14]

Almost immediately after acquiring the MGM Film Library, Turner became involved in a heated controversy with film directors over Turner's plans to artificially "colorize" over 200 black-and-white film classics, including *Casablanca, The Maltese Falcon, Yankee Doodle Dandy,* and *The Post-* *man Always Rings Twice.* "Colorization" is a computerized video process whereby artists add color on a frame-by-frame basis to a videotape transfer of a black-and-white film. Based on intuition, and perhaps a bit of historical research, the artists decide what colors are appropriate for the background, props, actors' and actresses' clothes, hair, eyes, skin, etc.[15] The resulting "color" videotape is used for television and videocassette release, with the original black-and-white film sent unharmed back to the film vault. It is likely that except for a few of the classics such as *Casablanca,* black-and-white video versions of colorized films generally will cease to be available.

## No Original Print of *Toll of the Sea* Is Known to Exist Today

Incredibly, it appears that not a single complete print of *Toll of the Sea* has been retained anywhere in the world. In late 1985 the UCLA Film, Television and Radio Archives at the University of California at Los Angeles (UCLA), working with YCM Laboratories in Burbank, California, completed a major project to make a new print of *Toll of the Sea* on Eastman Color Print Film 5384. Fortunately, the original camera negatives for most of the film had survived. The missing section — the final 300 feet of the film — was "re-created," using as a guide a written scenario for the film which had been located in the Library of Congress. According to Peter Comandini of YCM Laboratories:

> . . . the scenario told us what the last three or four title cards were supposed to have said and we had an artist, working from a blow-up frame of an original title card, reproduce the backgrounds and the lettering. We shot the title cards on film and we got some shots of some rocks at Malibu that matched frame enlargements of the rocks and the surf in the show. We shot some footage of that two ways. For expediency's sake, we initially shot it on Eastman Color, but it was shot on a second shoot with an original Technicolor two-color camera. We effectively re-created the Technicolor two-color ending with actual two-color Technicolor footage of the waves breaking on the rocks.[16]

## Technicolor Opens Its First Lab In Hollywood

In 1924 the first Technicolor laboratory and camera unit were established on North Cole Avenue in Hollywood. It was necessary to set up this processing operation to supply rush prints to Hollywood filmmakers. Hollywood had become the center of the motion picture industry in the U.S. because the mild climate permitted year-round location filming and because of the tremendous variety of natural scenery (mountains, deserts, forests, an ocean, urban locations, etc.) within a relatively short distance of Hollywood. Another major factor in the early migration of the filmmaking companies to Hollywood was that being in California — far away from the East Coast — made it much easier to evade the Motion Picture Patents Company; this organization, founded in the late 1800's by Thomas Edison, attempted to control all filmmaking companies on the basis of patent rights claimed by Edison's companies.

*Toll of the Sea* was followed in 1924 by the Famous Players-Lasky Corporation production of *The Wanderer of the Wasteland* and by *Ben Hur,* released in 1925 by MGM. One of the most famous two-color films made with the relief films cemented back-to-back was *The Black Pirate,* with Douglas Fairbanks, released by United Artists in 1925. Kalmus has written that at the time this film was made there was considerable skepticism about the desirability of color in motion pictures but that Douglas Fairbanks felt that color would be a great asset in *The Black Pirate:*

> The argument has been that it would tire and distract the eye, take attention from acting, and facial expression, blur and confuse the action. In short it has been felt that it would militate against the simplicity and directness which motion pictures derived from the unobtrusive black and white. These conventional doubts have been entertained, I think, because no one has taken the trouble to dissipate them . . . . Personally I could not imagine piracy without color.[17]

In deciding the type of color reproduction to be used in the picture, Technicolor made test prints for Fairbanks at six different color levels, from slightly more color than black-and-white to "the most garish rendering of which the Technicolor process was then capable." The level of color saturation could be reduced at will by changing the filters on the beam-splitter prisms in the two-color cameras. Color saturation and contrast could also be adjusted by altering the development of the separations, or by changing the composition of the printing dye baths. Controls of this type are possible with any imbibition process, including the Kodak Dye Transfer process for still photography.

*The Black Pirate* cost over one million dollars to make, a considerable sum for a motion picture in 1925, but it was an immediate critical and financial success.

The cemented-film two-color subtractive process eliminated the projection registration problems that plagued the previous two-color additive process; however, the new process had difficulties of its own. The cemented films were easily scratched during projection, and Kalmus described another serious problem:

> As you know, motion picture film, as a result of passing through the heat of the projector and cooling off again, curls or buckles because it has gelatin emulsion on one side and plain celluloid on the other. But with double coated film, with gelatin emulsion on both sides, the direction of this buckling changes from time to time and with each change the picture jumps out of focus during projection in the theatre. And so it became necessary to have men travelling about the country replacing these prints and returning them to our laboratory in Boston where they were put through a debuckling process and reshipped. While we, with special attention, could operate in this manner for a picture or two obviously it was not a commercial process and Technicolor entered into the depths of its second depression.[18]

## The Technicolor Two-Color Dye-Imbibition Process

In late 1927 the cemented film system was replaced by a two-color imbibition process in which separate printing *matrices* were made from the original camera negatives. These relief matrices were soaked in acid dyes, rinsed, and the dyes transferred to a single gelatin-coated "blank" film which had been treated with a dye mordant.

Technicolor developed rapid-transfer dye and mordant systems that permitted relatively high-speed printing and minimized losses in image resolution caused by lateral diffusion of dyes in the gelatin coating of the print stock. In later years Technicolor achieved a dye transfer time of about 18–20 seconds per dye; the transfers were quickened by heating the print film while it was in contact with the matrix films. Several methods of heating the print film and matrix film to speed dye transfer were tried by Technicolor, including radiant heating, hot-air circulation, steam, and electrical induction. By comparison, the transfer time at room temperature is from 2 to 5 minutes for each dye with the current Kodak Dye Transfer process for still prints.

Equipment was designed to hold the Technicolor matrix films in exact register with the positive print film during the dye transfer steps. The print film and dyed matrices were brought together in a warm water bath to eliminate air bubbles between the two films; the films remained under water for about 1 second at the beginning of each of the transfers. The matrix films were held on 35mm-wide stainless steel belts which were just over 205 feet (about 63 meters) long; the belts had coin-silver pins to engage each sprocket hole.

During the transfer steps, the film was placed over the pins in contact with the dyed matrix films; this system enabled exact registration during each of the three transfers and also prevented the matrix film from stretching in the course of repeated printings. One set of matrices could produce many hundreds of release prints before wearing out. A single set of matrices made on the polyester-base matrix film that became available in the late 1960's was capable of producing more than 1,000 release prints. After a dye transfer was completed, the matrix film was washed and dried prior to dyeing for a transfer to another print film; the process was repeated over and over. Technicolor's first transfer machine operated at about 15 feet per minute; by 1975, when the Hollywood laboratory was shut down, improved machines were operating at 330 feet per minute.

Orange-red and blue-green dyes were used in the two-color processes; these subtractive colors produced fairly pleasing reproduction of flesh tones and gave reasonable results with indoor studio filming where costume and set decoration colors could be carefully selected. However, many colors found in natural scenes were not well reproduced, and the deficiencies were obvious in most scenes filmed outdoors. Reds were reproduced as too pinkish and blues were too greenish. Kalmus once said that only "girls and music" in the films helped make the lack of good color reproduction unobtrusive.

It was known from the beginning, of course, that three subtractive colors — cyan, magenta, and yellow — were necessary for proper color reproduction, but the construction of a three-strip camera was far more complicated than

the two-color camera in which a beam splitter exposed two successive frames simultaneously on a single strip of film. Because the camera mechanism pulled down two frames at a time, this two-color camera has sometimes been incorrectly called a two-strip camera. Two printing matrices were prepared from alternate frames of the original camera negative, and because of this the two-color imbibition process is often called the two-strip process. It was not too difficult to adapt the two-color imbibition printing process to a three-color process once the three-strip (three-color) camera was perfected.

## Other Early Color Motion Picture Processes That Competed with Technicolor

During the 1930's and 1940's a number of other color motion picture processes were introduced by a variety of companies in the U.S. and Europe. Most of these were two-color systems and several, including Magnacolor, Trucolor, and Cinecolor, enjoyed significant popularity during the 1940's and even into the early 1950's. Trucolor was a two-color process when it was introduced in 1948; prints were made from bipack or successive frame separations on Eastman Two-Color Print Safety Film, Type 5380, an unusual color-blind incorporated-coupler chromogenic film with an emulsion containing magenta and yellow couplers coated on one side of the film and an emulsion containing cyan couplers coated on the other side. About 3 years later, Trucolor was changed to a three-color process employing DuPont Color Positive Film, Type 275. A few years after that, Trucolor was changed again, and this time used Eastman Color Print Film, Type 5382.

All three versions of Trucolor were processed by Consolidated Film Industries in Hollywood; the process was discontinued about 1958. Consolidated is still a major Hollywood lab and at present processes Eastman, Fuji, and Agfa-Gevaert motion picture films. Many of the Roy Rogers western features released by Republic Pictures (the parent company of Consolidated) were made with the Trucolor process.

Cinecolor was a two-color process used by the Cinecolor Corporation to make release prints for a great number of features and cartoons released by MGM, Paramount, Columbia, United Artists, Universal, and others. In the early 1950's Cinecolor became a three-color process known as Supercinecolor (shot on standard Eastman Color Negative Film), and the Cinecolor Corporation changed its name to the Color Corporation of America; Supercinecolor was abandoned about 1954.

These processes were serious competition for the Technicolor Corporation during the late 1940's. This author is not aware of any stability data on any of these non-Technicolor processes. As with Technicolor, all 35mm movies shot with Cinecolor, Trucolor, and other motion picture processes before about 1951 were made on unstable cellulose nitrate-base film.

It is interesting to note that Technicolor was also involved in research with various other color photography systems, including integral tripack films. Certain elements of U.S. Patent 1,808,584 (applied for in 1921 and issued in 1931), granted to Dr. L. T. Troland of Technicolor, were incorporated in Kodachrome film introduced by Kodak in

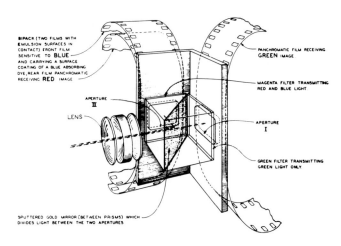

The Technicolor three-strip camera employed a glass prism beam-splitter to expose a green-sensitive negative at one aperture and a bipack consisting of a red-sensitive and blue-sensitive film placed emulsion-to-emulsion. This complex arrangement allowed the simultaneous filming through a single lens of three separation negatives in exact register.

1935. Kodak paid Technicolor royalties, which ultimately amounted to millions of dollars, for rights to certain parts of the Troland patent. Technicolor itself never produced an integral tripack film, although for some productions the company made dye-imbibition prints from a low-contrast version of Kodachrome film, called Monopack film, discussed later in this chapter.

## Technicolor Sound Films Appear

After the introduction of the two-color imbibition process, Technicolor began to produce sound films in which a silver sound track was developed on ordinary black-and-white motion picture print film. The film was then fixed, washed, and treated with a basic 5% chrome-alum solution prior to transferring the three image dyes by imbibition. Silver sound tracks give better sound reproduction than dye sound tracks because silver has a uniform absorption of the wavelengths of light and infrared radiation to which the photocells in traditional projectors are sensitive.

*The Viking,* released in 1928, was the first Technicolor motion picture with music and sound effects. The first "all talking" picture with "live" sound throughout, in addition to music, was *On With the Show,* released by Warner Bros. in 1929; the film featured an all-star cast and sparked tremendous public interest in color films.

Between the years 1929 and 1935, more than 50 films were produced by the two-color imbibition process; these included *The Mystery of the Wax Museum,* a 1933 Warner Bros. release starring Lionel Atwill, and the Samuel Goldwyn-Florenz Ziegfield production *Whoopee,* starring Eddie Cantor. Kalmus has said that these two films may have reached the ultimate color quality possible with the inherently limited two-color process.

Despite the early successes with the two-color imbibition process, Technicolor soon found itself with declining business and renewed financial problems. In 1955, looking back on the two-color period, Kalmus wrote:

1980

Storage vaults for nitrate separation negatives and other preprint film elements on the Walt Disney lot in Burbank, California next to Hollywood.

But after all this was only a two component process which was an attempt to create all shades of colors from two component colors. As everyone knows, to do a good job of this kind three components are necessary. But with sufficient care in the choice of materials, in the choice of colors placed before the cameras, with the make-up, with the amount of sky showing in the scene, etc., etc., it was possible to make wonderful pictures even with this two component method. But when the rush was on and every producer was clamoring to turn his black and white pictures into Technicolor no such care was employed. Some producers spoiled what opportunity they had by insisting upon more and more garish colors in however bad taste. They were out for more color and they wanted plenty of it. And in the rush to meet the demand other defects crept in such as excessive graininess. And so after awhile Technicolor was in its third deep depression. Once the tide set against us we constantly heard producers say "the public doesn't want color," "it detracts from the story," "it hurts the eyes," "it is too expensive," etc. Something had to be done and again Technicolor research and development must come to the rescue. This premature rush to color was doomed to failure simply because Technicolor was then a two color process.[19]

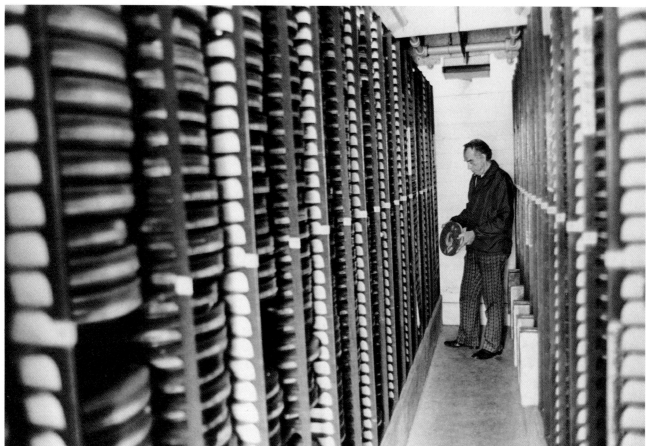

1980

The Disney storage vaults, which are not refrigerated, house the original Technicolor three-strip camera separation negatives from Disney's live-action films, and sequential-frame separation negatives for the studio's cartoons and animated features. All of the nitrate separations have been duplicated on cellulose triacetate black-and-white film and are stored at a separate location.

1980

Original nitrate successive-frame separation negatives from **Snow White and the Seven Dwarfs**, the classic Disney animated feature released in 1937. The film has been released many times since and earned millions of dollars more for Disney in the 1987 re-release, the film's 50th anniversary.

## The Complex Three-Strip (Three-Color) Technicolor Motion Picture Camera

In May 1932, construction of a complex three-strip camera was completed under the direction of J. A. Ball. Costing about $25,000, the camera simultaneously filmed three black-and-white separation negatives through a single lens using a beam splitter in combination with a separable bipack and a single film;[20] the cellulose nitrate-base separation negative films were made for Technicolor by Eastman Kodak. Technicolor rented the cameras to film studios for specific productions; in 1935 the rental fee was about $90 per week. Technicolor also supplied crews trained in the operation of the cameras to help with the filming.

With the development of the three-strip camera, the two-color imbibition printers were modified for three-color printing with newly developed cyan, magenta, and yellow dyes. A fourth neutral-gray "key" developed-silver image made from the green record (magenta) separation negative was included with most of the three-color imbibition prints until the early 1940's. This silver "key" image, known as the "gray" image in Europe, added density and contrast to the shadow areas of the film and increased apparent image resolution (in a manner similar to the "black printer" in book and magazine color printing), and formed frame lines around each frame.

This silver image was discontinued about 1946 because improvements in the matrix film, blank stock, and the magenta, cyan, and yellow dyes made additional shadow density unnecessary. Concurrent with the elimination of the silver image, Bell & Howell (BH) film perforations were changed to Kodak Standard (KS) perforations, which increased projection life of the release prints. In early film clips examined recently by this author, the silver "key" image still appeared to be in very good condition, with no visual indications of sulfiding or other deterioration.

The three-color process gave excellent color and tone reproduction, and was met with immediate enthusiasm. During the years that followed, the image resolution and color reproduction of the process were continually improved. The dyes in the Technicolor imbibition process have better spectral characteristics than dyes available for current negative-positive processes. This gave the prints somewhat better color saturation with lower image contrast.

Technicolor developed a method of controlling the density and color balance of the color image while a film was being printed by means of what the firm called the *wash-back* system. Initially, the degree of dye removal was controlled by variation of the time or temperature of the water bath; beginning in the late 1940's, an improved water-spray method was perfected. After dyeing, the matrix films were rinsed with water from spray-jets; the amount of dye removed from the film prior to transfer could be precisely controlled by adjusting the number of spray-jets activated.

When a completed section of film came out of the dryer following the final dye transfer, it was fed directly into a special projector before being wound on a reel. An operator carefully monitored the projected picture (often with a reference print projected on an adjacent screen) and, over direct-wired telephones, notified machine operators working along individual sections of the processing machines if slight dye density corrections were needed. This allowed accurate control of the color balance of the film and was said to minimize the number of rejected prints.

## The First Full-Color Technicolor Films

The first motion picture produced with the Technicolor three-color process was a Walt Disney cartoon short called *Flowers and Trees;* this film was released in 1932 as part of the Disney *Silly Symphonies* series. Disney had completed nearly half of *Flowers and Trees* in black-and-white when Technicolor showed him samples of the new three-color process. Disney became so enthusiastic about the idea of a full-color cartoon that he abandoned the black-and-white version and had his animation artists start all over in color.

Technicolor made the prints of *Flowers and Trees* in Hollywood, using two-color imbibition equipment modified for three-color printing which had been brought to Hollywood from its Boston laboratories in 1931. The cartoon was a great success and was followed in September 1932 by *King Neptune* and in December 1932 by the Disney cartoon *Santa's Workshop*. These were followed in 1933 by, among others, *Three Little Pigs* and in 1934 by *Funny Little Bunnies* and *Big Bad Wolf*. Disney was so pleased with the color cartoons that the process was used for all the new *Silly Symphonies* and — after *The Band Concert* in 1935 — for the ever-popular *Mickey Mouse* series.[21]

At first, the three-strip camera was used to film cartoons directly from the original art. However, beginning in 1934, Disney Studios started filming cartoons with a specially designed *successive-frame* camera which exposed three film frames in a row through red, green, and blue filters, respectively. A successive-frame camera is simpler to operate and much less expensive than the Technicolor three-strip camera; an ordinary single-strip camera is suitable for this type of filming. The matrix films are prepared by exposing them to each third frame; for example, the magenta dye matrix is exposed only with the green-filter frames. Most black-and-white negative films will not produce the same contrast with the three color records when all three color record films are given the same development; however, the contrast mismatch of the original successive frame negative can be compensated for by adjusting the exposure and development of the individual matrix films.

At the time of this writing, Disney Studios still had single-strip cameras for shooting successive-frame black-and-white negatives of cartoons; however, instead of making imbibition prints, the successive-frame negatives are now used to make color negatives for printing on conventional motion picture print film. The single-strip successive-frame technique is suitable only for static scenes (cartoons are made by photographing large numbers of still drawings, or "cels"). To avoid color fringing when filming moving scenes, all three color records must be exposed at exactly the same time, and it was for this reason that the complex three-strip camera was necessary for general filming.

The first motion picture to include live action filmed by a three-strip camera was the 1934 film *The House of Rothschild*, a black-and-white feature produced by Twentieth Century Pictures, which used three-strip Technicolor for the closing sequence. Also released in 1934, and shot entirely in three-strip Technicolor, was *La Cucaracha*, a famous short film produced by Pioneer Pictures.

## The 1935 Production of *Becky Sharp*

The first full-length three-strip color film was the 1935 Pioneer Pictures production *Becky Sharp,* based on William Makepeace Thackeray's 1848 novel *Vanity Fair* and starring Alan Mowbray and Miriam Hopkins. Released by RKO, the film cost almost one million dollars to make. Rouben Mamoulian, who directed *Becky Sharp,* said this about the use of color in motion pictures:

> For more than 20 years cinematographers have varied their key lighting in photographing black-and-white pictures to make the visual impression enhance the emotional mood of the action. We have become accustomed to a definite language of lighting: low-key effects, with sombre, heavy shadows, express a somberly dramatic mood; high-key effects, with brilliant lighting and sparkling definition, suggest a lighter mood; harsh contrasts, with velvety shadows and strong lights, strike a melodramatic note. [Now] we have color — a new medium, basically different in many ways from any dramatic medium previously known, whether the stage or previous black-and-white pictures. And in color we have not only a new dimension of realism but also a tremendously powerful means of expressing dramatic emotion.[22]

Reflecting the excitement of the advent of full-color movies, a reviewer in the June 14, 1935 *New York Times* commented:

> Science and art, the handmaidens of the cinema, have joined hands to endow the screen with a miraculous new element in *Becky Sharp.* . . . Although its faults are too numerous to earn it distinction as a screen drama, it produces in the spectator all the excitement of standing on a peak in Darien and glimpsing a strange, beautiful and unexpected new world. As an experiment, it is a momentous event, and it may be that in a few years it will be regarded as the equal in historical importance of the first crude and wretched talking pictures. Although it is dramatically tedious, it is a gallant and distinguished outpost in an almost uncharted domain.[23]

Courtesy of UCLA Film, Television and Radio Archives

A production scene from **Becky Sharp.** The RKO feature, released in 1935, was the first feature film shot with the Technicolor three-strip cameras. Despite the artistic and historical significance of the film, not a single complete Technicolor imbibition print has survived from the 448 prints made in 1935. In 1984 the UCLA Film, Television and Radio Archives, working with YCM Laboratories in California, reconstructed the film with various negative and print elements gathered from all over the world. New separations were made, and prints were produced on Eastman Color Print Film 5384 via a color master positive.

## The Resurrection of *Becky Sharp* in 1984

Throughout its history, much of the film industry has been astonishingly lax about the care of its films after production and release. There have been some exceptions, of course, and some producers have devoted considerable effort to assure the survival of their movies — Walt Disney Studios being the most obvious example — but as a whole, the industry has concentrated its attention on current and future productions, adopting a policy of "benign neglect" for everything else. In many instances, the lack of care went beyond simply not providing storage with reasonable temperature and humidity conditions. Almost unbelievably, for many films not a single print or intact negative (or other preprint materials) can be found today. Neither the producers nor collecting archives have managed to retain even one copy!

*Becky Sharp,* which for the second time in 50 years is being called one of the most important films in the history of American cinema, is a case in point. It was left to Robert Gitt of the UCLA Film, Television and Radio Archives and Richard Dayton of YCM Laboratories to resurrect *Becky Sharp* in 1984 by recombining various negative and print elements of the film collected from all over the world. They discussed the fate of the original prints:

> In May of 1935, Technicolor manufactured a total of 448 release prints of the film, 259 for domestic use and 189 for foreign release. As far as can be ascertained, not one of those original nitrate prints has survived. The Technicolor Company, itself, retained a print of only the first ten minute reel for color timing purposes. In 1943, the Whitneys and their company, Pioneer Pictures, sold all rights in *Becky Sharp* to Film Classics, Inc., and at the same time turned over all printing materials on the film. Probably for budgetary reasons, Film Classics decided to reissue the film, not in Technicolor, but in the cheaper to manufacture, two-color, Cinecolor process. Thus, 16mm prints, for non-theatrical purposes, were released of the full-length 84-minute version, while 35mm prints were cut to 66 minutes. In shortening the film, Film Classics removed and junked sections from the magenta and cyan negatives and from the soundtrack negatives. When Film Classics went out of existence in the early Fifties, the film changed hands several times, and by 1958, when television prints were first made, *Becky Sharp* was only available in a black-and-white, 16mm cut version. Since then, miscellaneous reels of the surviving 35mm negative have been lost.[24]

*Becky Sharp* is once again getting rave reviews. Tom Collins, writing in March 1985 in *The Wall Street Journal,* said: "UCLA unveiled a dazzling new version of 'Becky Sharp,' Rouben Mamoulian's witty rendition of 'Vanity Fair.' . . . Over the years, the original sparkle had been lost, not because of the fading that plagues all color pictures today, but by a ghastly transformation into a pallid, washed-out process called Cinecolor. This reduction gave little hint of the glories of the original until the three-year restoration effort by Mr. Gitt and Richard Dayton was put on view."[25]

A fascinating article by Gitt and Dayton describing the reconstruction of *Becky Sharp* was published in *American Cinematographer* in November 1984. Since publication of the article, additional footage from an incomplete, frequently spliced, and badly scratched imbibition print was obtained from the Cineteca Nazionale in Rome, Italy, and this has subsequently been used to improve parts of the UCLA reconstruction of *Becky Sharp:*

> . . . a representative from the UCLA Archives flew to Rome to examine the print, carrying along a letter from Rouben Mamoulian, the film's director. As a result, Dr. Guido Cincotti, head of the Cineteca archives, lent UCLA the Italian copy of *Becky Sharp.* With the assistance of the Library of Congress, arrangements were made to ship the nitrate print by military transport from Rome to the United States.
>
> The fragile and badly worn film was a dubbed version, a real advantage because the images were free of subtitles and could be used to supplement the restoration. UCLA has now integrated the usable sections of the previously missing Technicolor footage into its version. This has allowed fine-tuning of the film's color balance and significant improvement of the color quality of the last reel.
>
> The best news is that this updated version of *Becky Sharp* is expected to be released both theatrically and on videotape during the upcoming months. After decades of being available only on truncated 16mm black-and-white television prints, or much inferior two-color prints, we will finally have opportunity to once again appreciate the film's rich Technicolor look.[26]

More recently, one reel of an original print was found in New Jersey, and parts of this were utilized to improve sections of the soundtrack of the reconstructed film.

In a 1984 interview with Mamoulian about the restoration of *Becky Sharp,* the 85-year-old director commented:

> As Miriam Hopkins and Sir Cedric Hardwicke glide around the ballroom, among the 400 bit players are two young women looking on. One was a sophomore putting herself through the University of Southern California. Her name was Thelma Ryan — but she became better known as Patricia Nixon [the wife of former U.S. President Richard Nixon].[27]

Between 1935 and 1938, a number of well-known films were shot with the three-strip cameras. These included: *A Star is Born,* Janet Gaynor and Fredric March (Selznick International Pictures); *Adventures of Robin Hood,* Errol Flynn, Olivia de Havilland (Warner Bros.); and *Garden of Allah,* Marlene Dietrich, Charles Boyer, Basil Rathbone, Joseph Schildkraut (Selznick International/United Artists). By 1936 Technicolor was producing about 2,750,000 feet (838,000 meters) of three-color release prints per month.

1987

Separation negative masters for **Gone With the Wind** and other color films in the Turner Entertainment Film Library (operated by Turner Entertainment Company, a unit of Turner Broadcasting System, Inc.) are stored in the high-security underground facility operated by the Records Center of Kansas City, near Kansas City, Missouri. Film storage areas are maintained at 38°F (3.3°C) and 40% RH. Only safety base film is accepted for storage at the underground facility.

## *Snow White and the Seven Dwarfs* Released for the Eighth Time in 1987, 50 Years After the Film Premiered in 1937

Walt Disney's classic animated Technicolor feature *Snow White and the Seven Dwarfs,* was released for the eighth time on July 17, 1987, simultaneously opening in 60 countries including the U.S., China, and the U.S.S.R. The Walt Disney Company believes that by the end of 1987 the film had been seen by more than 500 million moviegoers since its premiere in 1939; this, according to Disney, makes *Snow White* "the most popular American film of all time." To enhance this latest re-release, Disney reworked the soundtrack for Dolby Stereo.

Based on a Brothers Grimm fairy tale, *Snow White* was filmed with the successive-frame Technicolor camera and contains images of more than 250,000 drawings, selected from the more than one million drawings that were made for the project. *Snow White* originally cost $1.5 million to make, which was far over budget and at the time a huge sum for making a movie. Writing in *The New York Times* about the movie on the occasion of its 50th anniversary re-release in 1987, film critic John Culhane recounted the film's early history:

In 1934, when Disney announced his intention of making the first feature-length animated cartoon — perhaps costing as much as $250,000 — his sincerest well-wishers told him he was crazy. In the first place, there was a Hollywood truism that fantasies were failures at the box office. In the second place, the public wouldn't sit through so long a cartoon. In the third place, an adult audience wouldn't ever go to see a fairy tale. And in the fourth place, the juvenile audience wasn't large enough to pay for the cost of production.

Disney, who always said that self-confidence was the most important element of success, listened politely and made the feature anyway — at a final cost of $1.5 million in mostly borrowed dollars. *Snow White and the Seven Dwarfs* had its premiere in Hollywood on Dec. 21, 1937, and promptly grossed $8 million in its first release — at the time the most money a film had ever made. It played in 41 countries and soon had soundtracks in 10 different languages.[28]

1987

A box of cellulose triacetate separation negative masters from **Gone With the Wind**; the negatives which are duplicates of the original nitrate negatives shot with Technicolor 3-strip cameras, are stored in the refrigerated high-security underground vault at the Records Center of Kansas City. The originals are now part of the collection of the International Museum of Photography at George Eastman House in Rochester, New York, having been donated by MGM to Eastman House some years ago. The storage conditions provided by the museum for the original camera separations are less than adequate. On the occasion of the film's 50th anniversary in 1989, Turner made new prints from a newly reconstructed internegative printed from the original nitrate camera separations which were made available to Turner by George Eastman House.

To preserve *Snow White,* the original sequential-frame black-and-white cellulose nitrate camera negatives have been duplicated with cellulose triacetate film; for safekeeping, a set of duplicate separation negatives from *Snow White,* together with back-ups of most of Disney's other films, are in the high-security, atomic bomb-proof Underground Vaults & Storage, Inc. facility located more than 600 feet underground in an abandoned section of a salt mine in Hutchinson, Kansas.

Originally imbibition printed by Technicolor, theatrical prints for the latest re-release of *Snow White* were made with conventional chromogenic motion picture print film, printed from duplicate color negatives produced from the black-and-white successive-frame separations.

Disney has traditionally re-released *Snow White* and its other classic animated films every 5 to 7 years — counting on a huge new worldwide audience with every successive generation of children. In only 2 months after the 1987 re-release, the film grossed another $45 million — giving it a total gross to date of about $375 million! The next re-release of *Snow White* is expected to take place around 1993. Disney expects revenues in the coming centuries to be enormous.

## The Preservation of *Gone With the Wind*

Probably the most famous of all the films made with the Technicolor three-strip cameras is the 1939 David O. Selznick production of *Gone With the Wind,* starring Vivien Leigh and Clark Gable. Winner of the first Academy Award for Color Cinematography, the film cost more than $4 million to make — far more than any previous motion picture. At the completion of filming with the Technicolor three-strip cameras, more than one-half million feet of black-and-white separation negative film had been shot. This was edited to a running time of over 3½ hours, quite long by Hollywood standards. *Gone With the Wind* is still the inflation-adjusted top money-making movie of all time, and even in non-inflation-adjusted dollars, the film was the top-grossing movie in history until the 1977 release of George Lucas's *Star Wars.*

In the years since 1939, *Gone With the Wind* has been re-released many times, earning MGM untold millions of dollars (Turner Broadcasting System, Inc., as mentioned previously, purchased the MGM/UA Entertainment Company in 1986, and became the owner of theatrical rights to *Gone With the Wind* along with theatrical and television rights to the more than 2,200 other films in the MGM Film Library). Initially shown on television on the NBC network, the film earned NBC the highest viewer rating ever for a theatrical release when it was aired in 1976. Later, *Gone With the Wind* was licensed to CBS television for 10 years for $37 million. In 1987 Turner Broadcasting acquired television rights to the film from CBS in exchange for an undisclosed amount of cash and a license for some future airings of *The Wizard of Oz.* In 1985 MGM released *Gone With the Wind* on videocassette and videodisc, with the sound track "digitally enhanced" to create a simulated stereo track.

Beginning in 1966, MGM stopped having Technicolor produce imbibition prints of *Gone With the Wind;* instead, MGM made release prints on Eastman Color Print Film from a new color internegative. This was somewhat less expensive than making prints with the Technicolor imbibition process and also allowed the production of a 65mm internegative which was used to print the special 70mm prints for one of the re-releases of *Gone With the Wind.*

MGM made the Eastman color internegatives for *Gone With the Wind* from an Eastman color interpositive which had been printed by separate exposures from the original nitrate camera separation negatives. (MGM Labs, Inc., also known as Metrocolor Film Laboratories, was sold when Turner Broadcasting System, Inc. broke up the MGM/UA Entertainment Company in 1986.)

An advertisement for the newly restored **Gone With the Wind**, which appeared in **The New York Times**, Sunday, January 22, 1989.

At the same time MGM made the new color internegatives, MGM made master positives and duplicate separations from the original nitrate separations with Eastman cellulose triacetate black-and-white film in order to have stable copies of the original black-and-white camera separations for use in future years. The duplicate separations also provided a protection copy in the event of damage to the original separations during subsequent printing operations when the color internegative was made.

## The 1988 Reprinting of *Gone With the Wind* from the Original Nitrate Camera Separations

For the 50th anniversary re-release of *Gone With the Wind,* Turner planned to make new prints from the duplicate separations made by MGM in 1966 from the original nitrate camera separations. But the print quality obtained was often unsatisfactory, so Turner borrowed the original nitrate camera separations from the International Museum of Photography at George Eastman House in Rochester, New York and used these to make a new color interpositive positive which in turn was used to make new duplicate color negatives for release printing. In addition, a new set of duplicate black-and-white separations was made. MGM had donated the original nitrate separations to Eastman House after they were duplicated in 1966.

In an article about the 1988 restoration in *The New York Times,* Max Alexander reported:

> [Turner Entertainment Company] initially planned to restore only the original title sequence in which the words *Gone With the Wind* sweep across the screen. (Later prints used a simpler block title.) Seeing the quality of the restored title "made us hungry for the rest of it," says Mr. Richard May [director of film services at Turner]. "We decided to go with the whole picture."
>
> Using as a guide a 1954 Technicolor print approved by the late Mr. Selznick, work began on rephotographing the negatives in early 1987 at YCM Laboratories in Burbank, Calif.
>
> According to Mr. May, "It had long been thought that the original negatives had shrunk at different rates; in fact the problem was not shrinkage but maladjustment of the prism in the Technicolor camera when it was photographed."
>
> The worst problem came during the Twelve Oaks smoking-room scene early in the film, where the men discuss the impending Civil War. "Rhett has on a tie that's supposed to be a black-and-white check, but it appears as a yellow-cyan and magenta check," says Mr. May, cringing at the thought.
>
> In another scene, he says, "Ashley [Leslie Howard] and Scarlett were silhouetted in front of a window, and he had three noses — different colors."
>
> Correcting the problems was "largely trial and error," sighs Mr. May: "Rephotographing the original at a slightly different relationship to the sprocket holes, hoping that it comes out the same as the other two strips. You're dealing with ten-thousandths of an inch."[29]

The once-again reprinted *Gone With the Wind* opened January 30, 1989 at Radio City Music Hall in New York City at a gala celebration to honor the "World Premiere of the Classic Masterpiece Restored to Its Original Technicolor Splendor." The premiere was co-sponsored by the Museum of Modern Art. During the year, the film was shown in theaters in 41 American cities. Restoration and publicity costs for the 1989 re-release reportedly amounted to about $350,000; the film earned $2.5 million at the box office and sold 220,000 copies of a special 50th anniversary edition videocassette for a total profit of about $7 million.[30]

## Turner Entertainment Company Keeps Back-Up Film Elements in a High-Security Underground Refrigerated Storage Vault in Kansas City

For safekeeping, Turner Entertainment Company stores duplicate three-strip camera separation negatives and color interpositives and internegatives made from the original *Gone With the Wind* in the high-security, refrigerated underground vault operated by the Records Center of Kansas City, Missouri (a division of Underground Vaults &

Storage, Inc.). Located in a leased area of an abandoned section of an underground limestone mine operated by Texas billionaire Lamar Hunt, the Kansas City vault is maintained at 38°F (3.3°C) and 40% RH. The Records Center of Kansas City rents space to a variety of private and governmental clients; the vaults are intended to provide security for valuable films, magnetic media, microfilms, and paper records in the event of tornadoes, floods, civil strife, and even nearby atomic attack.

The original nitrate camera separation negatives from *Gone With the Wind* are in the motion picture collection of the International Museum of Photography at George Eastman House in Rochester, New York. On a hot summer day in 1978 there was a disastrous fire, attributed to spontaneous combustion, in a nitrate film storage facility on the grounds of George Eastman House; 327 features and short films, plus a number of early cartoons, were destroyed. The films were being stored in a building that had no temperature or relative humidity control, no fire detection or fire control equipment, nor any of the other provisions which are generally accepted as necessary for even short-term storage of cellulose nitrate motion picture film.

Fortunately, the *Gone With the Wind* separations were not among the films destroyed in the fire. After the fire, the separations, along with a large number of other nitrate films, were moved to rented space in storage vaults at Wright-Patterson Air Force Base near Dayton, Ohio. The priceless *Gone With the Wind* separations were returned to George Eastman House in 1990 where, at the time this book went to press in October 1992, they were being stored under less than ideal temperature and humidity conditions.

## Cellulose Nitrate Motion Picture Film

Unfortunately, the camera separation negative films, the master positives printed from the original negatives to allow duplicate separations to be made in case the original separations were damaged, and the matrix films produced prior to 1948–1950 were all made on cellulose nitrate base (nitrate films are sometimes called "celluloid" films). The imbibition color release films were also made on nitrate base film during this period. After 1951 all Technicolor camera negatives, master positives, matrices, and release prints were made on cellulose triacetate safety film.

Despite the stability problems associated with cellulose nitrate film and the poor storage conditions in which apparently all of the original Technicolor separation negatives and master positives have been kept, many of those that can still be found are usable for making new duplicate negatives and color prints.

Other than suffering from scratches and other physical abuse, many surviving nitrate imbibition prints are also still in good condition. Thomas Tarr, formerly of Technicolor, has said that it appears to him that the life of cellulose nitrate films with which the early Technicolor movies were made increased as a result of treatment with the acidic dye solutions and/or the mordants used in the process. Tarr reports that many nitrate imbibition prints dating back to the early 1930's remain in excellent condition today, while black-and-white films made during the same period on the same type of nitrate support have suffered more deterioration.[31] Peter Comandini of YCM Laborato-

ries says that in his experience, nitrate films made by DuPont generally have deteriorated much more than Eastman nitrate films stored under similar conditions.[32]

Technicolor normally disposed of cellulose nitrate and later cellulose triacetate printing matrices within 5 or 6 years of the initial printing; new matrices were prepared from the original separation negatives or the original color negative in cases where additional release prints were required after the original matrices had been discarded. Beginning in the 1960's, Technicolor adopted polyester-support matrix films which substantially increased the number of release prints that could be made from a set of matrices; polyester matrix films should remain usable for a great many years to come because the material has excellent dimensional stability during long-term keeping.

The professional motion picture industry was the last branch of photography to abandon highly flammable cellulose nitrate films. Kodak did not even introduce cellulose triacetate "safety" films for the motion picture industry until 1948, and the new films did not come into common use until 1949. Kodak continued to produce 35mm nitrate motion picture film until 1951.

Kodak introduced cellulose acetate "safety" roll film for still cameras in 1908 and has produced cellulose acetate films for the amateur home movie field since 1923. From the very beginning, all Kodak 16mm and 8mm motion picture films have been made on a cellulose acetate safety base because Kodak considered cellulose nitrate film to be too hazardous for home movie use.

The Hollywood motion picture industry preferred working with cellulose nitrate films — and Kodak and other manufacturers continued to produce them — because, compared with early cellulose acetate film, nitrate film had high tensile strength, good flexibility, and good dimensional stability after immersion in processing solutions.

In film industry terminology, films made on cellulose diacetate, cellulose triacetate, cellulose acetate propionate, and polyester supports are often referred to as simply *safety* films. The term "safety" indicates that the films will not burn rapidly; the fire hazards of safety films are approximately the same as of ordinary paper of the same thickness and packaged in the same manner.

If ignited, cellulose nitrate films burn extremely rapidly. Under certain conditions, large quantities of cellulose nitrate film stored without ventilation can spontaneously ignite when sustained temperatures in the storage areas are as low as 120°F (49°C).

It is by no means impossible, however, to preserve cellulose nitrate films that are still in good condition. At a given relative humidity of storage, the rate of deterioration of cellulose nitrate film is approximately *halved* for each 10°F drop in temperature; if the film still is in good condition, it can be preserved almost indefinitely in storage at 0°F (–18°C) or lower. For information on the long-term preservation of cellulose nitrate films in low-cost explosion-proof freezers, see Appendix 19.1 at the end of Chapter 19.

To keep matters in perspective, it should be pointed out that under typical storage conditions cellulose nitrate film is considerably more stable than the color *images* of films such as Eastman Color Print Film 5381 and 5383 which were in use worldwide as late as 1983.

## Identification of Technicolor Imbibition Prints

Technicolor dye-imbibition prints are generally referred to as IB prints or occasionally as *dye transfer* prints. Technicolor imbibition release prints are not marked to distinguish them from the company's prints on Eastman Color and other chromogenic materials; however, *all* Technicolor release prints made from 1928 to about 1955 were made with the imbibition process. All release prints made by Technicolor on nitrate-base films were printed by the imbibition process. By 1949 Technicolor was reportedly printing about one million feet of imbibition release prints per day. By 1954, the company had produced over *four billion* feet of imbibition release prints since its founding in 1915 (most of this footage is no longer in existence).

Beginning in the mid-1950's, Technicolor started producing some release prints on Eastman Color Print Film (by about 1952, dailies from Eastman Color negatives were printed on Eastman Color Print Film), and by mid-1975 all release prints by Technicolor in the U.S. were made on this or similar chromogenic films. In 1977 Technicolor was said to be the largest single commercial customer of Eastman Kodak color motion picture films in the world.

It is sometimes difficult to differentiate Technicolor imbibition prints from Eastman Color Print Films or from other chromogenic color print films such as those made by Ansco, Fuji, Agfa-Gevaert, and Ferrania. Technicolor imbibition prints may also occasionally be confused with prints made by some of the less common color print processes of the 1930–1950's era, such as Supercinecolor or Trucolor (which used DuPont Color Film, Type 275).

Both Eastman Color prints and Technicolor imbibition prints have a slight physical relief image on the surface of the emulsion which corresponds to the optical density. However, the relief image is more pronounced with Eastman Color prints. Older Eastman Color prints have faded and suffered significant red or magenta color shifts unless the prints have been stored at low temperatures. Even the oldest Technicolor three-color imbibition prints, dating as far back as the early 1930's, show little if any color deterioration.

Nearly all the three-color prints until about 1946 have a fourth developed-silver "key" image to add density and contrast to the shadow areas, and these films will exhibit a microscopic grain structure in the middle- and high-density areas. The films usually exhibit a silver neutral-gray area adjacent to the image area of each frame.

Most Technicolor imbibition prints were made on Kodak film stocks and have *Eastman Kodak Nitrate Film* edge-printed in silver on the film (the words "Eastman" and "Kodak" and "Nitrate Film" were normally spaced about 2½ inches [6.4 cm] apart). Safety film made by Eastman Kodak is silver edge-printed with *Eastman Safety Film* or *Kodak Safety Film.*

The 3M Company — and possibly other manufacturers — also made "blank" print stocks for Technicolor during the last years of the imbibition process. If a Technicolor 35mm imbibition print is edge-printed with the "Safety Film" designation, it is certain that it was produced after 1948.

All Technicolor imbibition prints with optical soundtracks have neutral developed-silver soundtracks which do not contain any image dyes. Technicolor never produced 70mm release prints by the imbibition process; these have always been printed on Eastman Color Print Film or similar chromogenic films. Technicolor printed large numbers of 16mm and 8mm release prints by the imbibition process; these prints were normally made on a safety-film stock, although 16mm prints slit from 35mm cellulose nitrate film stock were produced for the armed forces during 1943–44.

## The Demise of the Technicolor Imbibition Motion Picture Process

When dimensionally stable cellulose triacetate films became available, the Technicolor three-strip direct separation system was nearly ideal for making an accurate color record that could be kept for extended periods without the need for cold storage. However, the three-strip camera was a very bulky device and the system was difficult and expensive to operate compared to filming with Eastman Color Negative films and other integral tripack color films in conventional motion picture cameras.

The introduction of Eastman Color Negative Film, Type 5247, a daylight-balanced colored-coupler masked integral tripack, in late 1950 (the film was announced in late 1949) led to a rapid decline in use of the three-strip cameras over the next few years. The last major film shot with Technicolor three-strip cameras was the Ealing Studios production *The Lady Killers,* filmed in 1954 and released in 1955. The separation negatives and printing matrices were processed by Technicolor Ltd. in England; duplicate matrices were shipped to Technicolor in Hollywood for making release prints for U.S. distribution. The last American feature filmed with the three-strip cameras was *Foxfire,* starring Jane Russell and Jeff Chandler, also released in 1955.

At the same time Kodak began producing its color negative film, the company also introduced Eastman Color Print Safety Film, Type 5281 for printing dailies and release prints from the color negatives. In terms of tone and color reproduction, the Eastman Color prints were somewhat inferior to imbibition prints made from camera separation negatives and also to imbibition prints made from Eastman Color Negative Film originals. However, release prints made on Eastman Color Print Film were less costly than Technicolor imbibition prints when relatively small numbers of prints were required.

In the mid-1950's, Eastman Color Print Film was capable of significantly higher image resolution than the then-available Technicolor imbibition prints. The better image resolution of the Eastman prints was a decided advantage when large magnifications were needed for wide-screen theater projection and proved to be crucial when laterally "squeezed" anamorphic wide-screen optical systems came into common use. The quality of color and tone reproduction of Eastman Color Prints was considered adequate by the movie-going public, and the Eastman Color negative-positive system rapidly led to the almost universal adoption of color photography in motion pictures.

Eastman Color Negative Film, Type 5247 (not to be confused with the current Eastman Color Negative Film 5247) and its associated duplicating and print films came into significant use in the general film industry beginning in late 1952. *The Royal Journey,* a 1951 film made by the National Film Board of Canada about the visit to Canada of

Princess Elizabeth, was the first full-length feature produced with the new Eastman Color negative-positive films.

During the late 1940's and early 1950's, Ansco Color gained popularity, particularly at MGM, and this process became serious competition for Technicolor. Ansco Color was a chromogenic reversal process with a low-contrast camera film and a print film of the proper gamma to produce the higher contrast needed for projection. In 1953 Ansco introduced a negative-positive motion picture process. Partially because the Ansco films did not have the colored-coupler masking system used in the Eastman color films to reduce color degradation during successive printing operations, the Ansco system was inferior in color reproduction, and the process failed in the market some years later.

Eastman Color Negative Film, Type 5248, a tungsten-balanced film introduced in 1953, had better image resolution and finer grain than Type 5247. This new negative film, soon joined by various color intermediate and separation films from Kodak and by the improved Eastman Color Print Film, Type 5382, resulted in a complete color motion picture system with higher image resolution and generally lower production costs than the Technicolor imbibition process. This led to further economic distress for the Technicolor Corporation. In 1955 Kalmus said:

> But about 1953 came another development which heralded the fourth serious depression which was to overtake the Technicolor business. I refer to the advent of a new method of photography employing negative of Eastman color negative type which largely superseded the use of Technicolor special 3-strip cameras. And I also refer to the advent of large screen theaters and increased area negatives. The fourth Technicolor process which took care of a very substantial part of the motion picture requirements from 1934 to 1953 was tailored to make prints in the laboratory from Technicolor special 3-strip negative and to be projected on screens not larger than 30 or 35 feet in width. Beginning about 1953 both of these conditions changed and again Technicolor research and development departments had to do something to meet the new demands. And hence we come, in 1955, to the announcement of a fifth Technicolor process, "The Improved New Technicolor Process."

Making Technicolor imbibition prints from Eastman Kodak type negative involved new and special laboratory problems. Continuing to operate with Technicolor Process number 4 resulted in Technicolor imbibition prints with the usual fine characteristic tone scale and color rendering but which lacked something in definition, or visibility. This became increasingly apparent when the industry began generally to use larger area screens in the theatres.

So beginning around 1952–3 the objective of the Research and Development Departments of Technicolor became to improve the definition of its imbibition prints without the loss of any of its other superior characteristics. This work progressed on an emergency basis through a period of about two years until early in May, 1955 I saw on a 50-foot screen in Hollywood a demonstration of AN IMPROVED NEW TECHNICOLOR PROCESS. The 35mm print used for this demonstration embodied all the changes in the imbibition process that Technicolor has been striving for since the advent of Eastman and Ansco color type negative and the advent of large screens in theatres. The result was the most wonderful picture in color made by any process that I have ever seen on the screen from all technical points of view, including sharpness or definition and especially color rendition.[33]

The image resolution of dye-imbibition prints is usually less than the resolution of the printing matrix image because of slight lateral diffusion of the image dyes during the transfer step prior to drying. This type of lateral dye diffusion also takes place with the Kodak Dye Transfer and Fuji Dyecolor processes for still photographs; however, it is not so serious with reflection prints because they are generally viewed without magnification. Close examination of a Kodak Dye Transfer print will reveal the loss of definition caused by dye diffusion; the losses will be obvious if the print is compared with an image of the same original printed on Ilfochrome (Cibachrome) or on Kodak Ektacolor Paper.

Technicolor continued successful marketing of the improved imbibition process until the late 1960's, when popularity of the process started to decline in favor of the generally lower-cost Eastman Color Print Film and similar chromogenic release-print films made by Fuji and Agfa-Gevaert. During this period there was little discussion in motion picture circles of the relative stability characteristics of the various types of print films; because Kodak was still keeping the stability characteristics of its films a secret, and Technicolor decided not to make public what little information it had on the stability of its imbibition prints, the subject did not become a matter of concern at the time.

Thomas Tarr, now retired from Technicolor, says that the introduction of Eastman Color Reversal Intermediate Film, Type 5249 in 1968 (the film was used on a test basis in some labs, including Technicolor, a year or two before 1968) was the crucial factor that led to the end of the imbibition process.[34] Eastman Color Reversal Intermediate Film (CRI film) is a colored-coupler masked reversal film which produces a high-quality duplicate color negative in one operation; before the introduction of this film, labs had to make a duplicate color negative by first producing a color interpositive and then printing the positive on another film to make a duplicate negative. This additional operation was an added expense and, at the time, often resulted in unacceptable losses in reproduction quality.

Major motion pictures are not printed directly from the original camera negative because the negative cannot be replaced if it is damaged by repeated printing operations. For this reason, and to allow for the inclusion of special effects at an intermediate stage, duplicate color negatives are almost always required. Major studios also often make

black-and-white separation positives from the original color negative of major features for protection in the event the original is damaged or fades during storage.

The introduction of the Eastman CRI film made it possible to produce low-cost release prints on improved Eastman Color Print Film that were nearly equal in color and tone reproduction to Technicolor imbibition prints — and that sealed the fate of the imbibition process in the U.S. and Europe. In 1969 Eastman Kodak Company won an Oscar from the Academy of Motion Picture Arts and Sciences for the new reversal intermediate film.

With the 1979 introduction of Eastman Color Intermediate II Film 5243, an improved version of Eastman Color Intermediate Film 5253, designed to make color interpositives and duplicate negatives, many studios are no longer using the CRI film for duplicate negatives from 35mm originals (5249 is still used extensively for 16mm productions). The interpositive duplication method with 5243 is said to give better results than with the CRI film. A further drawback with 5249 is that it fades much more rapidly than 5243 film. In fact, 5249, which has not been significantly improved in terms of stability since its introduction in 1968, is by far the least stable of all current Eastman Color motion picture films.

## Technicolor Imbibition Prints from Color Reversal Films

Release printing by the imbibition method is not restricted to films originally photographed with the three-strip camera or color negative films; the printing method can also be used with color reversal originals by making black-and-white separation negatives.

In 1941 Eastman Kodak manufactured a special low-contrast Kodachrome process film as a camera original reversal film for Technicolor; Technicolor called this product Monopack film. Separation negatives were made from the Monopack original and these were printed by the imbibition process. Monopack could be shot at low cost with conventional cameras, but the color reproduction obtained from the film was inferior to the three-strip camera process. Monopack was first used for outdoor sequences of *Lassie Come Home* (1943), a United Artists release. The first full-length feature shot with Monopack film was *Thunderhead — Son of Flicka,* released by 20th Century Fox in 1945. It was also used for Walt Disney's *True Life Adventure* series. Monopack film was discontinued by Kodak about 1952.

From the late 1940's and continuing through the 1960's, conventional Kodachrome films often served as camera originals for the imbibition process. The 1953 full-length documentary *Conquest of Everest* and the 1958 film *Antarctic Crossing* were both photographed with 16mm Kodachrome. Ansco Color reversal films were also used as original camera films from about 1946 to 1950. Many other types of reversal and negative films were printed by the Technicolor imbibition process; these included Agfacolor, Ferraniacolor, Gevacolor, Ektachrome, etc. Technicolor in England made prints from Russian Sovcolor color negative film for the motion picture *Othello* (1956) and later from the negative of the Russian 70mm production *The Story of the Flaming Years* (1961).

## Technicolor Imbibition Prints Made from Color Negatives

With the decline in popularity of the three-strip camera in the early 1950's, most full-length feature movies printed by the Technicolor imbibition process were filmed on Eastman Color Negative films. Initially, Technicolor made separation positives (YCM masters) from the original color negative; the separation positives were then contact-printed to make separation negatives, and it was from these that the matrix films were printed.

Beginning in 1953, however, printing matrices were prepared from the color negatives with panchromatic matrix film in a manner similar to the printing of still color negatives directly on Kodak Pan Matrix Film in the Kodak Dye Transfer process. Soon after the introduction of the Eastman color negative and print films, Technicolor installed facilities for processing these films. During the early 1950's, Eastman prints were produced only for color dailies that were supplied to the filmmakers; Technicolor continued to make release prints with the imbibition process.

Agfa in Germany had introduced a color negative and color print film for motion pictures in late 1939; the films were used for a number of German productions during the war years. The early Agfacolor negative films did not contain color-correcting masks — Agfa did not begin to produce films with integral masking until about 1953, and at that time it was only a single silver mask.

Kodak did not attempt to enter the professional motion picture field with a negative-positive system until the company perfected its now almost universally adopted colored-coupler masking system in the late 1940's. This masking system was first incorporated in Kodak Ektacolor color negative film introduced in 1947 for still cameras and shortly thereafter in Kodacolor film for amateur photographers; with modifications, Kodak's masking system is now used with nearly all the still and motion picture color negative films in the world today.

One reason Kodak delayed introduction of a chromogenic negative-positive motion picture process was that prior to the development of the colored-coupler masking system, it was not possible to produce release prints that could compete in terms of color and tone scale reproduction with the Technicolor imbibition process. And Kodak was also selling Technicolor most of the film stocks for its productions, so there was limited financial incentive to offer an inferior alternative product.

Following the appearance of Eastman Color Negative Film, Type 5247 in 1950, and Type 5248 in 1953, Technicolor began making large numbers of imbibition release prints from color negatives. The first full-length film printed from Eastman Color Negative Film was *The Lion and the Horse,* released by Warner Bros. in 1952. This process was also used with the first CinemaScope wide-screen film *The Robe,* released in 1953 by 20th Century Fox.

More recently, Technicolor printed such films as *West Side Story* (1961), *My Fair Lady* (1964), *Bonnie and Clyde* (1967), the James Bond film *You Only Live Twice* (1967), *The Godfather* (1972), and *The Godfather Part II* (1974) from color negatives with the imbibition process for 35mm release prints; when wide-screen 70mm prints were required, they were produced on Eastman Color Print Film.

More than 1,000 imbibition prints — amounting to over eight million feet of film — were made of the James Bond film *On Her Majesty's Secret Service,* released in 1969.

*The Godfather Part II* (1974) was the last film made in the U.S. to be imbibition-printed by Technicolor for its initial release. Tarr reports that the last film *reprinted* by the imbibition process in Hollywood before the plant was closed was the 1975 re-release of *Swiss Family Robinson* (Disney, 1960); the prints for the new release were produced from previously made matrix films. The Hollywood plant was closed and dismantled in February 1975; the London and Rome plants were both closed in June 1978.

Tarr reports that Francis Ford Coppola, who directed *The Godfather* and *The Godfather Part II,* had planned to have European 35mm release prints of his 1979 epic about the war in Vietnam, *Apocalypse Now,* imbibition-printed by Technicolor in Rome. However, due to production delays, the film was not completed until after the last of the Technicolor imbibition plants had closed. Coppola is said to have preferred the color and tone reproduction of Technicolor imbibition prints over Eastman Color prints.

When Technicolor closed its imbibition operation in England in 1978, it opened a large new plant to expand its capacity to process and print Eastman negative-positive films. At the end, Technicolor believed that its imbibition process was no longer economically competitive with release prints made on chromogenic films such as Eastman Color, Fujicolor, and Gevacolor (Agfacolor) print films; the superior stability of the imbibition prints was not considered to be a worthwhile market advantage.

## The Outstanding Image Stability of Technicolor Imbibition Prints

In the 1960's and 1970's, it was not uncommon for release prints of a given motion picture to be made both by the Technicolor imbibition process and with Eastman Color Print Film. The instability of Eastman prints can be dramatically illustrated by comparing them with Technicolor imbibition prints of the same film. After 10 to 20 years of storage, the Eastman prints exhibit severe cyan dye loss and have a pronounced red or magenta appearance; the Technicolor imbibition prints appear as perfect in color fidelity as the day they were made.

In 1977, at the Technicolor Motion Picture Corporation office in Hollywood, this author examined original film clips from a large number of early Technicolor imbibition motion pictures made on nitrate film base dating back to the 1935 release *Becky Sharp.* Without exception, the nitrate-base films were in excellent condition and showed none of the yellowing and physical deformation characteristic of the early stages of decomposition in nitrate film. Although original densitometric data are not available for comparison purposes, the dye images of the films appeared to be in uniformly excellent condition, with no obvious color shift or loss of density. The film had been kept in metal cans under normal room-temperature and humidity conditions at the former Technicolor office at 6311 Romaine Street in Hollywood, California. In recent years this office has been air-conditioned to maintain a temperature of about 70°F (21°C).

A non-color-corrected reproduction of an original frame from a cellulose nitrate release print of *Becky Sharp* is reproduced in Chapter 1. The film was imbibition-printed in 1935; still in excellent condition when this book went to press in 1992, the nitrate film was more than half a century old. The film clip had been stored with a large number of other film clips, all about 5 inches long and loosely packed in a metal film can. Because nitric oxides and other decomposition products can more easily escape from loosely packed films, such films may be expected to last longer than films wound tightly on a large reel in a can. In recent years, reproductions of a number of original, unfaded frames from old Technicolor imbibition-printed motion pictures have been reproduced in film periodicals in the United States and abroad.[35,36,37]

Based on the many Technicolor imbibition prints he has examined in recent years, Robert Gitt of the UCLA film archives had this to say about the image stability of the process:

> If you took a Technicolor dye imbibition print and you projected it many times at a drive-in theater and put a lot of light through it, the dyes do fade a little bit — particularly the cyan — although not that badly. But if you are careful with Technicolor imbibition prints, and keep them in the dark and don't show them a lot, they don't seem to fade *at all.* I've never seen one that has faded if properly cared for. It is a remarkably good process. Technicolor imbibition on triacetate base is very, very good.[38]

This author has conducted accelerated dark fading tests with frames from Technicolor imbibition prints made on Eastman cellulose triacetate film; based on density loss and stain formation of other color motion picture films and still materials tested under the same conditions, it could be predicted that Technicolor imbibition images will probably survive hundreds of years with only negligible fading — and with essentially no staining — when stored in the dark. The stability of the imbibition images is far better than the "high-stability" chromogenic print films introduced since 1984, including Eastman Color Print Film 5384 and Fujicolor Positive Film LP 8816. The stability of the Technicolor imbibition images is also far superior to that of Agfa-Gevaert's Agfa Print CP1 and CP10 Colour Print Films.

## Notes and References

1. Mike Clark, "Movies Pretty as a Picture," **USA Today**, October 15, 1987, p. 4D.
2. Max Alexander, "Once More, the Old South in All Its Glory," **The New York Times**, January 29, 1989, p. H13.
3. Lawrence Cohn, "Turner Eyes '38 **Robin Hood** Redux," **Variety**, Vol. 340, No. 3, July 25, 1990, p. 10.
4. P. Z. Adelstein, J. M. Reilly, D. W. Nishimura, and C. J. Erbland, "Stability of Cellulose Ester Base Photographic Film: Part I – Laboratory Testing Procedures," **SMPTE Journal**, Vol. 101, No. 5, May 1992, pp. 336–346; and P. Z. Adelstein, J. M. Reilly, D. W. Nishimura, and C. J. Erbland, "Stability of Cellulose Ester Base Photographic Film: Part II – Practical Storage Considerations," **SMPTE Journal**, Vol. 101, No. 5, May 1992, pp. 347–353. See also: James M. Reilly, Peter Z. Adelstein, and Douglas W. Nishimura, **Preservation of Safety Film – Final Report to the Office of Preservation, National Endowment for the Humanities** (Grant # PS-20159-88),

March 28, 1991, Image Permanence Institute, Rochester Institute of Technology, Frank E. Gannett Memorial Building, P.O. Box 9887, Rochester, New York 14623-0887; telephone: 716-475-5199; Fax: 716-475-7230.

5. In 1992 Technicolor, Inc. was operating four major motion picture film processing laboratories: Technicolor, Inc., 4050 Lankershim Blvd., North Hollywood, California 91608; telephone: 818-769-8500; Technicolor East Coast, Inc., 321 West 44th Street, New York, New York 10036; telephone: 212-582-7310; Technicolor, Ltd., Bath Road, West Drayton, Middlesex UB7 ODB, England; telephone: (081) 759-5432; Technicolor, S.p.A., Via Tiburtina, 1138, 00156 Rome, Italy; telephone: (06) 411-8881.

6. Geraldine Fabrikant, "Technicolor Purchase Is Set by Carlton Communications, **The New York Times**, September 10, 1988, p. Y17. See also: Steve Lohr, "A British Star in TV's Back Room," **The New York Times**, July 3, 1989, p. Y21.

7. William D. Hedden, Frederick M. Remley, Jr., and Robert M. Smith, "Motion-Picture and Television Technology in the People's Republic of China: A Report," **SMPTE Journal**, Vol. 88, No. 9, September 1979, pp. 610–618.

8. Thomas Tarr, Technicolor Corporation, letters to this author and telephone discussions with this author, 1977–1978.

9. D. W. Samuelson, "Filming in China," **American Cinematographer**, Vol. 64, No. 5, May 1983, pp. 25–31.

10. James Manilla, "Manilla in Motion," **Industrial Photography**, Vol. 32, No. 1, January 1983, pp. 8, 42–43.

11. D. W. Samuelson, see Note No. 9.

12. William D. Hedden **et al.**, see Note No. 7.

13. Herbert T. Kalmus, **Your Company Through the Years**, Technicolor Motion Picture Corporation (pamphlet prepared for the directors of the company), 1955.

14. Peter Hay, **MGM: When the Lion Roars**, Turner Publishing, Inc. (a division of Turner Broadcasting System, Inc., One CNN Center, Atlanta, Georgia 30348), 1991, pp. 325–327.

15. See, for example: Lelise Bennetts, "'Colorizing' Film Classics: A Boon or a Bane?" , **The New York Times**, August 5, 1986, p. 1 and 21; "Directors Fight Copyrighting of Tinted Old Films," (Associated Press), **The Des Moines Register**, October 16, 1986, p. 3A; Susan Linfield, "The Color of Money," **American Film**, Vol. XII, No. 4, January–February, 1987, pp. 29ff; and, in a comprehensive review of the technology of the colorization process, Mark A. Fischetti, "The Silver Screen Blossoms Into Color," **IEEE Spectrum**, Vol. 24, No. 8, August 1987, pp. 50–55 (published by the Institute of Electrical and Electronic Engineers, 345 East 47th Street, New York, New York 10017; telephone: 212-705-7555). The cost of "colorizing" a movie may run from $2,000 to $3,000 per minute of film, or a total cost of $200,000 to $300,000 for a typical feature film. During 1990 Turner had 36 films scheduled for colorization at an estimated cost of $9 million; in 1989, 37 films were colorized by Turner, up from 27 in 1988. In addition, Turner planned to spend $1.5 million in 1990 to "recolorize" 25 already colorized films using enhanced computer technology. At the present state of technology, "colorization" is practical only for video transfers, although it is expected that in the future, with the aid of more powerful computers and more sophisticated image-processing software, the colorization process also will be used to create high-resolution transfers on color motion picture film that will be suitable for theatrical projection.

16. Peter Comandini, YCM Laboratories, telephone discussion with this author, December 11, 1985.

17. Herbert T. Kalmus, "Technicolor Adventures in Cinemaland," **Journal of the Society of Motion Picture Engineers**, Vol. 36, No. 6, December 1938, pp. 564–585. This classic article was reprinted in the **SMPTE Journal**, March 1991, pp. 182–190.

18. Herbert T. Kalmus, see Note No. 13.

19. Herbert T. Kalmus, see Note No. 13.

20. J. A. Ball, "The Technicolor Process of Three-Color Cinematography," **Journal of the Society of Motion Picture Engineers**, Vol. 25, No. 2, August 1935, pp. 127–138.

21. David R. Smith, archivist, Walt Disney Archives, Burbank, California, letter to this author, October 8, 1979.

22. Alice Evans Field, **Hollywood, USA**, Vantage Press, New York, New York, 1952, p. 188

23. Fred E. Basten, **Glorious Technicolor – The Movies' Magic Rainbow**, A. S. Barnes and Company, Inc., South Brunswick, New Jersey and New York, New York, 1980, p. 56 (quotation from **The New York Times**, June 14, 1935). Most of the color reproductions from various Technicolor features in Basten's book are not from original Technicolor dye-imbibition film clips; rather they are from Anscochrome or Ektachrome studio publicity stills (or Anscochrome or Ektachrome duplicates made from the originals). Many of these transparencies have seriously faded – their deterioration is in no way characteristic of Technicolor imbibition prints of the same motion pictures.

24. Robert Gitt and Richard Dayton, "Restoring **Becky Sharp**," **American Cinematographer**, Vol. 65, No. 10, November 1984, pp. 99–106. Dayton is with YCM Laboratories (a division of 3-Strip, Inc.), 2312 West Burbank Blvd., Burbank, California 91506-1236; telephone: 818-843-5300. YCM specializes in reproduction from two-color and three-color separation negatives, contrast and balance modification of color films, and reproduction of early optical sound tracks.

25. Tom Collins, "The Reel Thing: Resurrecting 'Lost' Films," **The Wall Street Journal**, March 12, 1985, p. 28; see also: "Colour Revived," **British Journal of Photography**, Vol. 132, No. 6498, February 15, 1985, p. 177.

26. Gregory Lukow, "Lookin' Sharp," **American Film**, Vol. X, No. 9, July–August 1985, p. 9.

27. Peter B. Flint, "Mamoulian's Color Classic Restored – Director Tells of Filming 'Becky Sharp'," **The New York Times**, September 26, 1984.

28. John Culhane, "'Snow White' at 50: Undimmed Magic," **The New York Times**, July 12, 1987, p. H19.

29. Max Alexander, see Note No. 2.

30. Larry Rohter, "New Profits (and Prestige) from Old Films," **The New York Times**, April 25, 1991, p. B1.

31. Thomas Tarr, see Note No. 8.

32. Peter Comandini, YCM Laboratories, telephone discussion with this author, September 1985.

33. Herbert T. Kalmus, see Note No. 13.

34. Thomas Tarr, see Note No. 8.

35. Bill O'Connell, "Fade Out," **Film Comment**, Vol. 15, No. 5, September–October 1979, pp. 11–17.

36. Paul C. Spehr, "Fading, Fading, Faded: The Color Film Crisis," **American Film**, Vol. 5, No. 2, November 1979, pp. 56–61.

37. "Fade to Pink," **Premier**, Vol. 2, No. 3, December 1980, page 7.

38. Robert Gitt, telephone discussions with this author, June 7, 1985 and April 15, 1991.

## Additional References

Adrian Cornwall-Clyne, **Colour Photography,** third edition, Chapman and Hall, London, England, 1951.

Walter R. Greene, "30 Years of Technicolor," **American Cinematographer,** November 1947, pp. 392–393, 410–411.

L. B. K. Happe, "The Technicolor Process," **British Kinematography,** Vol. 35, No. 1, July 1959, pp. 4–9.

Harlan Jacobson, "Old Pix Don't Die, They Fade Away – Scorsese Helms Industry Plea to Kodak," **Variety,** July 9, 1980, pp. 1ff.

Gert Koshofer, "50 Years of Technicolor Motion Pictures," **British Journal of Photography,** December 29, 1967, pp. 1125–1129.

William Poe, "Preservation of Research Sources: Film and Videotape," **Humanities Report,** Vol. 3, No. 10, October 1981, pp. 13–17.

W. E. Pohl, "The Manufacture of 8mm Prints at Technicolor," **Journal of the SMPTE,** Vol. 70, August 1961, pp. 606–607.

Roderick T. Ryan, "Color in the Motion-Picture Industry," **SMPTE Journal,** Vol. 85, No. 7, July 1976, pp. 496–504.

Roderick T. Ryan, **A History of Motion Picture Color Technology,** Focal Press, London, England and New York, New York, 1977.

Wolf Schneider, "Film Preservation – Whose Responsibility Should It Be?" [editorial], **American Film,** Vol. XVI, No. 8, August 1991, p. 2.

Frank Thompson, "Fade Out – What's Being Done to Save Our Motion Picture Heritage?" **American Film,** Vol. XVI, No. 8, August 1991, pp. 34–38 and 46.

Technicolor Motion Picture Corporation, **Technicolor News & Views,** Vol. 17, No. 1, April 1955, and other issues.

# 11. Print Mounting Adhesives and Techniques, Tapes, Rubber Stamps, Pencils, Inks, and Spotting Methods for Color and B&W Prints

Mounting, retouching, lacquering, and other postprocessing treatments can be just as important as fixing and washing in determining the eventual life of a photograph. For example, if properly cared for, a correctly processed fiber-base black-and-white print that has been treated with selenium or sulfur toners to protect the silver image should last many hundreds of years — and perhaps even longer than a thousand years. The same print, however, can be seriously damaged in just a few years if mounted with rubber cement. Prints mounted with contact cement of the kind used to fasten Formica plastic tabletops can suffer serious fading and discoloration of the image in less than a week. Similarly, a heavy rubber-stamp ink impression on the back of a print can transfer to the emulsion of another print, thereby ruining it. Also, the polyethylene layer beneath the emulsion of an RC print can soften and blister if heated too hot in a dry mounting press.

Although a photograph can be ruined because of a single mistake in handling, more often there are a great number of factors involved in the deterioration and eventual destruction of a photograph. With Ektacolor, Fujicolor, Konica Color, Agfacolor, and other chromogenic color prints, the inherent light fading and dark fading stability of the particular brand of print material is the most important consideration. But processing and washing are also important, as are the kind of retouching colors used on a print, whether and how a lacquer is applied, the display light level, and the storage temperature and relative humidity.

With black-and-white prints, the relationship between the many factors involved in sliver image oxidation or sulfiding (fading and discoloration) can be complex; one condition usually influences several others. For example, the rate of print fading caused by residual thiosulfate (fixer) due to inadequate washing as well as the effects of poor-quality mounting materials are both greatly influenced by ambient relative humidity. Also significant are storage relative humidity and temperature, environmental pollutants, contaminants from poor-quality storage materials, whether the print was treated with a selenium or sulfur toner, whether a print-flattening solution was used, and so forth. And there are important — but as yet poorly understood — stability differences between black-and-white fiber-base and RC prints, and even between the RC papers produced by different manufacturers.

There is usually no simple answer to such questions as: "If I choose a cheap mount board instead of a 100% cotton fiber museum board, how much will this shorten the life of a black-and-white print?" Still, if one is aware of the most important factors affecting print life, selects good-quality materials, and exercises reasonable care, making beautiful and long-lasting photographs is relatively simple.

**See page 369 for Recommendations**

## Print Mounting

One of the current controversies in the conservation field is the practice of dry mounting or otherwise permanently attaching a print to a mount board. Before discussing the various issues involved, it will be helpful to consider four separate groups of photographs:

1.  Prints that are inherently extremely stable both during prolonged exposure to light on display and during long-term dark storage under normal temperature and humidity conditions. This group includes correctly processed black-and-white fiber-base prints (both untoned prints and prints treated with selenium or sulfur toners) as well as those relatively few color pigment prints made with the UltraStable Permanent Color process or the Polaroid Permanent-Color process. (Although not as stable as UltraStable or Polaroid Permanent-Color prints, Fresson Quadrichromie prints could also be included in this group.)

2.  Prints that are essentially permanent in long-term dark storage but that are subject to light fading or other deterioration during prolonged display. These include glossy, polyester-base Ilford Ilfochrome prints (called Cibachrome prints, 1963–1991), Kodak Dye Transfer prints, and Fuji Dyecolor prints. Although Ilfochrome RC prints are not physically as stable as glossy, polyester-base Ilfochrome prints, especially in long-term display, the RC prints can be included in this group. Depending on the particular type of black-and-white RC paper, RC prints treated with selenium or sulfur toners, along with some untoned RC prints, could be included in this group if storage conditions are good and relative humidity is low and without major fluctuations.

3.  Chromogenic color prints that are subject to light fading on display but that have fairly good resistance to fading and staining when kept in the dark. Among this group are color prints on Fujicolor SFA3 papers, Fujichrome Type 34 and Type 35 papers for printing transparencies, and Konica Color QA Paper Type A5. Also included are Polaroid Polacolor ER peel-apart instant prints. Ektacolor Portra II, Supra, Ultra, and Edge papers, and Ektacolor Professional and Plus papers; Agfacolor Type 8 and Type 9 papers; and Konica Color QA Type A3, Type X2, and Konica Color Type SR papers also belong to this group, although these papers develop objectionable yellowish stain in dark storage much more rapidly than Fujicolor SFA3, Fujichrome Type 34 and Type 35, and Konica QA Type A5 papers. Either because of fading or staining (or both), this group is not nearly as stable in dark storage as groups 1 and 2 but is substantially better than group 4.

A 1978 exhibition by documentary photographer Lewis Hine (1874–1940) at the Museum of Fine Arts in Boston, Massachusetts. Most photographs in museum collections have been processed, spotted, signed, stamped, and, frequently, mounted by the photographer — often years before the prints are acquired by an institution. Improperly done, any of these postprocessing steps can cause eventual deterioration of the image or the support; if damage does occur, it frequently is impossible to repair.

4. Prints that fade and/or stain fairly rapidly when kept under normal temperature and humidity conditions, whether or not they are exposed to light on display. In this group are virtually all pre-1984 chromogenic color prints, including prints made with Kodak Ektacolor 37, 78, and 74 RC papers. Also included are most types of pre-1991 Ektachrome reversal prints; Polaroid Spectra prints (called Image prints in Europe), Polaroid 600 Plus and SX-70 prints; and Fuji FI-10 and 800 instant color prints. Unless storage conditions and pollutant levels are carefully controlled, and depending on the brand and type of RC paper, untoned black-and-white RC prints could belong in this group.

## Potential Drawbacks of Dry Mounting

The concern about dry mounting centers on the types of prints included in group 1 and, if they are kept in the dark except for short periods of display under low light levels, on the prints in group 2. Under proper conditions, the materials in groups 1 and 2 have a *very* long potential life — many hundreds and possibly even thousands of years. Dry mounting tissues, mount boards, and other materials for storing such prints must have an equally long life, and they must not cause or contribute to fading, staining, or physical deterioration of the prints during the years of display and storage. A mounting adhesive must also maintain the bond between the print and mount board during hundreds of years of fluctuating temperature and relative humidity. These requirements place very stringent demands on a mounting material; none of the products currently on the market were designed with such extremely long-term considerations in mind. Some may in fact be suitable, but at the moment we do not know which are.

Although not nearly as stable as UltraStable Permanent Color, Polaroid Permanent-Color, Ilford Ilfochrome (Cibachrome), and Kodak Dye Transfer prints in dark storage, the color print materials listed in group 3 will probably remain in reasonably good condition for 50 years or more when kept in the dark. Therefore, only high-quality materials should be chosen for mounting and storing such prints.

Following are some of the concerns and unresolved questions about mounting materials and practices:

1. At present there is little published information available on the effects of dry mounting products on the long-term stability of *any* of the various types of color and black-and-white photographs now being produced.

# Recommendations

- **Borders:** Regardless of how a print will be displayed or stored, it should be made with wide borders (1 to 2 inches). If possible, print borders should be left untrimmed.

- **Dry mounting:** Prints in museum and archive collections should not be dry mounted. Likewise, valuable prints purchased by private collectors should not be dry mounted. Expendable Ektacolor portraits, wedding pictures, and other color prints intended for long-term display (where they are destined to slowly fade and stain because of exposure to light) may be dry mounted. **No** black-and-white or color print intended for reproduction should be dry mounted because this will make it impossible to wrap the print around a laser-scanner drum for making color separations, duotones, or halftones.

- **Corner mounting:** Mounting corners made with the appropriate materials are recommended for attaching prints to mounts (see discussion in Chapter 12).

- **Mounting adhesives:** If a print **must** be permanently attached to a mount, Seal Colormount dry mounting tissue is recommended for both fiber-base and RC prints. It is fervently hoped that Kodak will re-introduce the "original" Kodak Dry Mounting Tissue — discontinued in 1974 — which this author considers the finest dry mounting tissue ever made for fiber-base prints. For mounting fiber-base prints, the "original" pre-1974 type of Kodak Dry Mounting Tissue is much superior to the present Kodak Dry Mounting Tissue, Type 2.

  3M Scotch No. 568 Positionable Mounting Adhesive is recommended for polyester-base prints such as Ilford Ilfochrome prints (called Cibachrome prints, 1963–1991), Fujiflex SFA prints, Kodak Duraflex RA prints, and other polyester-base prints. No. 568 is also suitable for mounting RC prints (but not fiber-base prints).

- **Mounting adhesives to avoid:** Rubber cement, contact cement, glues, pastes, mucilage, Kodak Rapid Mounting Cement, self-stick "magnetic" album pages, and most double-sided tapes.

- **Tapes:** In general, no type of tape (or hinge) should be applied directly to a valuable photograph. Gummed fabric tape and 3M Scotch No. 810 Magic Transparent Tape are comparatively stable products that are believed to be satisfactory for use in proximity to photographs. If a pressure-sensitive tape **must** be applied directly to a photograph, Filmoplast P-90 tape, or the widely available 3M No. 810 Scotch Magic Tape (sold in the familiar green plaid dispensers), is suggested.

- **Rubber stamps:** Valuable prints should not be rubber stamped. If fiber-base prints must be stamped, a light impression with a conventional black felt-pad ink is suggested. Pre-inked porous-plastic stamp pads and "pre-inked" rubber stamps should be avoided. For RC and polyester-base prints, Photomark inks and pre-inked Mark II stamp pads supplied by Jackson Marking Products Co. are tentatively recommended.

- **Marking:** Ordinary lead pencils are recommended for writing on the backs (along the borders) of fiber-base prints. For negatives, the backsides of RC prints and polyester-base prints, and the emulsions of all types of prints, black India ink is recommended (Koh-I-Noor Black Rapidomat Ink No. 3074–F in a hollow-point technical pen is particularly satisfactory; applied to a variety of photographs, this ink has performed very well in accelerated light fading and dark storage tests). Felt-tip pens and porous-tip markers are not recommended. If one is determined to use a porous-tip pen, a black Pilot Photographic Marker is suggested.

- **Spotting and retouching colors:** For black-and-white prints, Spotone dye solutions are suggested (with the realization that they are subject to gradual light fading). For Ektacolor, Fujicolor, Konica Color, and Agfacolor prints, Kodak Liquid Retouching Colors are recommended (Kodak Dry Retouching Colors should be used **only** in the dry mode). Ilford Ilfochrome (Cibachrome) prints, should be spotted only with Ilfochrome Retouching Colors. Kodak Dye Transfer prints and Fuji Dyecolor prints should be spotted with the **same dyes** used to make the prints. UltraStable Permanent Color prints and Polaroid Permanent-Color prints should be spotted only with the **same pigments** used to make the prints.

- **Film cleaning solutions:** Pending further information, only Kodak Film Cleaner is recommended.

Meaningful information is also lacking concerning the stability of currently available mount boards during long-term contact with photographs. Dry mounting a photograph adds a significant unknown to the many factors affecting image stability.

2. No meaningful information is available on the long-term stability and adhesion characteristics of *any* currently available mounting adhesive. It is not known for how long and under what storage conditions an adhesive will maintain the bond between the photograph and the mount board or other mounting material. The adhesive bond is subject to stresses every time the relative humidity changes in a storage or display area.

RC and polyester-base prints are dimensionally stable and change very little with fluctuations in relative humidity, whereas the mount board may expand or contract enough to produce significant force; this can place great stress on the adhesive bond. In addition, the polyethylene back of RC prints and the gelatin anti-curl back coating on Ilford Ilfochrome (Cibachrome) prints, UltraStable Permanent Color prints, and Polaroid Permanent-Color prints are more difficult to bond to mount board than is the porous paper base of a fiber-base print. If a print should become partially unstuck due to stresses over many years of storage, it likely will be very difficult to correct the condition.

1987

The advent of laser scanners presents a strong argument against dry mounting photographs. The scanners require that prints be wrapped around a rotating drum — a procedure that would crack and ruin a dry mounted print. Laser scanners such as this German-made Hell Chromagraph CP 341, shown above (and below) being set up by operator Ronald Anderson at Pepco Litho in Cedar Rapids, Iowa, are now almost universally used to make color separations and high-quality black-and-white duotones for book and magazine reproduction. (All of the photographs in this book were separated with laser scanners.)

3. With rotary-drum laser scanners, color separations cannot be made from dry mounted color prints — wrapping a dry mounted print around a scanner drum would crack the print and the mount. Likewise, laser-scanned duotones or halftones cannot be made from dry mounted black-and-white prints. As rotary-drum laser scanners have come into widespread use only during the last 15 years, this is a relatively recent objection to dry mounting. It should, however, be a very serious consideration for museums, archives, historical societies, and anyone else who may have occasion to publish photographs. Scanned high-resolution color separations are also required for making facsimile reproductions with the UltraStable Permanent Color process.

Virtually all color separations are now produced with rotary-drum laser scanners. Many printers and separation firms no longer have the skills or equipment necessary to make color separations using a flat-bed process camera — furthermore, even at their best, camera separations do not equal the quality of good laser-scanned separations. Flat-bed electronic color scanners may in the future replace rotary-drum scanners in the graphic arts field, but for now, dry-mounting poses serious problems when top-quality color separations must be made.

Most high-quality black-and-white duotones are produced with either flat-bed or rotary drum scanners (e.g.,

1987

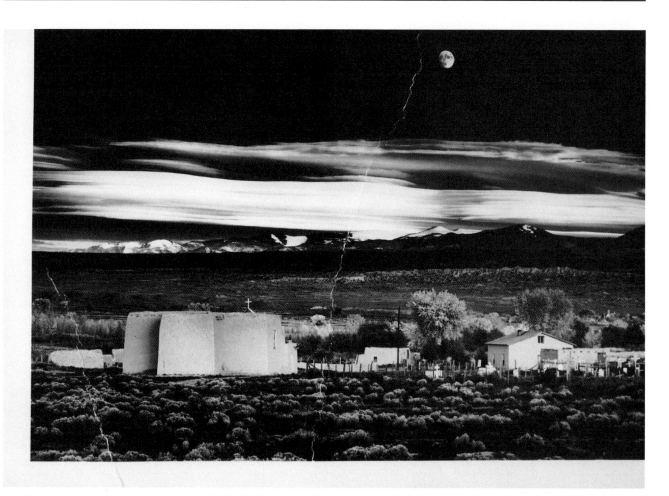

For aesthetic reasons, Ansel Adams (1902–1984) preferred to dry mount his photographs; the prints were trimmed to the edge of the image before being mounted on oversize boards. This dry mounted 1978 print of **Moonrise**, photographed in Hernandez, New Mexico about 1941, suffered catastrophic cracking across the image area when the mounted print was flexed during shipping. **Moonrise** was one of Adams's best-known photographs, and more than 500 prints in various sizes were made during his lifetime; large prints have sold for more than $100,000.

*Yosemite and the Range of Light* and subsequent books by Ansel Adams), and it is probable that in the future most single-impression halftones will also be made with scanners.

4. A wide, untrimmed border on a print affords significant protection to the image from physical and chemical damage. If a print is trimmed to the image area before dry mounting, the edges of the image can easily be chipped or abraded during mounting and handling. Examination of both mounted and unmounted historical photographs clearly shows that chemical attack of the image by airborne pollutants tends to be concentrated near the absorbent edges of a print, and if no borders are present, the image itself will be attacked. Trimming the borders from prints is one of the most damaging practices of traditional dry mounting; the simple solution is to make prints with wide borders (1 to 2 inches) and to leave the protective borders intact when mounting (see Chapter 12).

5. Dry mounted prints cannot be removed from their mounts (and overmats) for compact storage in a frost-free re-

frigerator or humidity-controlled, low-temperature storage vault. Corner-mounted prints, on the other hand, can easily be removed for refrigerated storage. With prints removed, mounts and overmats can be stored safely at room temperature for future exhibition or other purposes. Mounts and overmats are bulky and should not occupy refrigerator space that otherwise could be used for storing photographs.

6. When storage humidity conditions fluctuate from very dry to humid, dry mounted prints are more likely than unmounted prints to suffer emulsion cracks.[1] These cracks are induced by expansion and contraction of the mount board as a result of changes in relative humidity. In this author's experience, stress-induced cracks of this type are more likely to occur with RC prints than with fiber-base prints; *displayed* RC prints are especially prone to stress-cracking because fluctuations in relative humidity produce less dimensional change in the print than in the mount board (these dissimilar expansion characteristics can cause severe stress on a mounted RC print) and because of embrittlement of the emulsion-side polyethylene layer resulting from expo-

A close-up of a deep crack passing near the moon in the Ansel Adams picture. Had the print not been dry mounted, it might have escaped without damage.

A corner of the mount board was also damaged. Had the print been corner-mounted, it would have been a simple process to remove it and install it in a new mount.

sure to light on display. Fiber-base prints, on the other hand, are not nearly so affected by light on display and have a coefficient of humidity-related expansion similar to that of mount board, which tends to minimize stress.

7. A dry mounted print is likely to crack if its mount board is seriously bent or twisted during shipping or handling. However, in historical collections examined by this author, dry mounted prints were usually in better physical condition than unmounted prints; as a group, mounted prints had a much lower incidence of cracked emulsions and damaged corners than did unmounted prints. There is also evidence that dry mounting can help protect the silver image of a fiber-base print from the effects of air pollutants by keeping contaminated air away from the back of the print.

8. The back of a dry mounted print cannot be examined for the photographer's signature — if, in fact, it was signed on the back of the print — or to see possible markings, edition numbers, rubber-stamp impressions, caption information, etc. When contemporary prints are dry mounted, however, the photographer can sign the mount and put other information either on the front or back of the mount board.

9. Prints are frequently dry mounted to boards of irregular and non-standard sizes. Many museums and collectors find it difficult to mat such prints using materials, mat sizes, and board tones standardized for their collections (which enables a uniform presentation of exhibitions — see Chapter 12).

10. At some future time, it might be determined that a dry mounted black-and-white print was fixed or washed incorrectly, or it may be necessary to treat the print with a selenium or sulfiding toner, or some other as-yet-undiscovered image-protective treatment. Better types

of photographic mount boards are certain to become available, and a caretaker may wish to remount prints with the improved board. In addition, as commonly happens, the corners of a mount may become bent or cracked, although the dry mounted print itself may remain in good condition. All these situations would be simple to deal with were it possible to easily replace the mount.

It is one of the tenets of good conservation that a mounting adhesive be removable, or "reversible." Once a print is dry mounted, however, it is difficult to remove it from the mount — and to remove all traces of mounting adhesive from the print — without harming the photograph. This objection to dry mounting can be partially countered with the observation that of the countless photographs produced, only a tiny fraction will ever attain sufficient importance for unmounting to be seriously contemplated; if necessary, a mount can be removed with solvents or by carefully cutting it away from the back of the print (unmounting a valuable print should be done only by an experienced conservator). An alternative to dry mounting is to attach a print to the mount with paper corners (see Chapter 12); it is then a simple matter to remove the print and place it on a new mount.

## How Some Curators and Photographers Regard Dry Mounting

When Minor White established an "Archival Photographic Collection" at the Massachusetts Institute of Technology in 1968, he required that prints purchased for the collection be unmounted. This was probably the first instance of an institution asking that photographers not dry mount their prints. A statement issued at the time read: "For its permanent collection, M.I.T. will buy only unmounted, untrimmed, unbacked prints which have been given archival processing."[2] The first prints acquired for the collection were selected from the 100 prints in the *Light 7* exhibi-

tion, for which photographers had submitted about 3,000 prints.

Many photographers dry mount their prints for aesthetic reasons. They like the perfectly smooth print surface which can be achieved in no other way with fiber-base papers. The late photographer Ansel Adams preferred dry mounting — with the print trimmed to the edge of the image — for a number of reasons, both practical and aesthetic. Noting that some museums and archives favor corner-mounting because it allows the print to be readily removed from the mount, Adams said:

> . . . I find this method gives me a sense of uncertainty, as the edges of the image are not precisely defined, but are imposed by the enlarger easel or by the window of the overmat. In addition, the print is loose, with both surfaces exposed to the atmosphere, and a signature on the overmat is not permanently affixed to the image or its immediate support.[3]

Of the available means of mounting, Adams stated, "I consider dry mounting by all odds the best method. It is clean, dependable, and most unlikely to cause damage to the print."[4]

In Carol Brower's 1982 survey on the care and presentation of photographic prints (see Chapter 12), photographers and curators expressed a number of different views on dry mounting. Many of those who responded to the survey indicated that at one time they had dry mounted their work, but for various reasons abandoned the practice. Photographer Ralph Gibson said, "Years ago, in the 60's it was thought to be good — now I prefer a window mat." Miles Barth, curator of photography at the International Center for Photography in New York City, replied, "Yes, in the past but no longer." Speaking for the Museum of Modern Art in New York City, Susan Kismaric remarked, "From what we understand the controversy surrounding dry mounting has not been resolved. At this moment in time we prefer to overmat work." Grant Romer, conservator at the International Museum of Photography at George Eastman House in Rochester, New York, said that he does not dry mount photographs because he does not want to "tie the life of the print to other materials."

Arnold Newman, the well-known portrait photographer who has for many years dry mounted his photographs, had this to say: "I have prints I mounted back as far as 1938–39 and on — there has been *no* damage. When dry mounted and trimmed to the edge of the image, the print is subject to edge damage unless matted. It is better to print with a wide enough white border to sign on, and then overmat."

## Requirements for Mounting Adhesives Intended for Long-Term Applications

In this author's view, the most serious concern with dry mounting is that we currently have no assurance that *any* dry mounting adhesives or mount boards are suitable for long-term use with photographs. *ANSI PH4.21–1989, American National Standard for Photography (Film) — Thermally Activated Dry-Mounting Adhesive Systems for Mounting Photographs — Specifications* offers no guidance in terms of the stability requirements of a dry mounting product, saying only that the Standard "does not address the archival nature of these mountings, since pertinent data are not available at this time."[5]

None of the manufacturers contacted by this author could supply data from meaningful accelerated aging tests (such as an extended version of the Photographic Activity Test described in *ANSI IT9.2-1991*)[6] done with their products in contact with the various types of common black-and-white and color photographic materials. The long-term effects of light on the adhesives also must be evaluated because a significant amount of light passes through the base of most papers during display. Furthermore, none of the manufacturers indicated that they had performed Arrhenius-type tests to evaluate the long-term stability, bond-retention, and stain characteristics of their products (this is a separate question from how a mounting adhesive or mount board might affect a photograph).

The 3M Company, in a statement that must be commended for its candor, said this about its mounting products:

> 3M's tapes and adhesives form a physical bond to surfaces to which they are applied and are not soluble in water. The bonds that they form can be loosened with solvents or can be reversed with heat but these methods are not without the risk of damage to the art work or surface involved. These methods also leave adhesive residue which must be removed with a solvent.
>
> It is an accepted fact that the application of any adhesive to valuable material will reduce the value of that material. This is true of any valuable, collectible item. It should retain as much of its original form or condition as possible.
>
> . . . We know that most of our adhesive products have an indefinite age life by virtue of our accelerated aging tests and natural aging experience. However, we *do not* have a test that can accurately predict how a product will hold up after 50 to 100 years, for instance. In other words, we cannot *recommend* our products for archival applications.
>
> These products are designed for general purpose use in bonding applications on items of limited value where the bonds should be long aging and permanent. They *are not recommended* for use on art of significant value and considered an investment because (1) the use of full mounting techniques will reduce the value, and (2) the resulting bond may not reverse [be removable] without causing physical damage to the item.[7]

## Accelerated Testing of Dry Mounting Tissues

In 1989, Kimberly Scheneck and Constance McCabe published a preliminary study of a variety of adhesives used in photograph conservation. A number of different test meth-

ods, including the Photographic Activity Test outlined in *ANSI IT9.2-1988,* were employed to evaluate the adhesives. Seal MT5 was the only dry mounting tissue included in the study, and the authors concluded that this product might be damaging to photographs.[8]

In 1991 Nancy Reinhold published an article entitled "An Investigation of Commercially Available Dry Mount Tissues"[9] in which Seal ColorMount, MT5, ArchivalMount Plus, and Fusion 4000 Plus dry mounting tissues were evaluated using: **(1)** the fade and stain detectors specified in the *ANSI IT9.2-1988* Photographic Activity Test, **(2)** a peel strength test using a modified version of the test described in ASTM D-903-49, and **(3)** an accelerated dark aging test to assess the discoloration and yellowing characteristics of the dry mounting tissues.

After analyzing the test data, Reinhold concluded that "Although the dry mount tissues failed the strict criteria for passing outlined by *ANSI IT9.2-1988,* the results of this investigation indicate that there is little evidence to suggest that contact between dry mount tissue and black and white gelatin photographs would be harmful." (See Chapter 13 for discussion of the ANSI Photographic Activity Test and its limitations.) Reinhold also found that there were significant differences in the dark-aging yellowing behavior of the four Seal products, with Seal ArchivalMount Plus tissue yellowing much more than ColorMount, MT5 Plus, or Fusion 4000 Plus (all four of these Seal products will be discussed later in this chapter).

## More Testing Is Needed

As discussed in Chapter 13, it appears that among currently available museum-quality mount boards, quite a few are probably both sufficiently stable and nonreactive with photographic images to be suitable for long-term use. But even among the best and most expensive 100% cotton fiber "museum" boards, there are some that may be unacceptable. James Reilly, who has done considerable research on factors affecting the stability of black-and-white prints, has indicated that some high-quality mount boards are reactive when tested with the *ANSI IT9.2-1991* Photographic Activity Test, causing fading and/or staining of black-and-white prints.

Although Reilly has declined to reveal the identity of the mount boards that proved unacceptable, his findings are cause for serious concern and underscore the need for more comprehensive tests of available products. The extremely long potential life of toned black-and-white fiber-base prints, UltraStable Permanent Color and Polaroid Permanent-Color prints, and dark-stable color materials such as Ilford Ilfochrome (Cibachrome) prints and Kodak Dye Transfer prints places very stringent demands on mounting materials.

The situation can be stated simply: Of currently available mount boards and dry mounting adhesives, there are probably at least a few products that satisfy all known requirements for long-term use with photographs. At the time this book went to press in 1992, however, the suitable products had not been identified, so we have no choice but to rely on mounting materials that have been used for a number of years without any observed problems as well as on practical experience with products for mounting various types of prints. This is an unfortunate state of affairs.

Because the necessary tests are not difficult to perform — meaningful tests with mount boards and mounting adhesives could probably be completed in 2 or 3 years — it is anticipated that the current impasse eventually will be resolved. Both Arrhenius-type dark aging tests and extended versions of the *ANSI IT9.2-1991* Photography Activity Test used with representative color and black-and-white print materials should be employed.

## Dry Mounting Should Be Avoided in Museum and Archive Collections

When dry mounting products and mount boards of proven stability become available, many of the objections to dry mounting will no longer apply. If prints are mounted with borders intact, this author believes that dry mounting with approved materials would be acceptable, and in many instances probably even desirable. Museums and archives, however, should continue to refrain from dry mounting photographs either already in their collections or acquired unmounted in the future.

If a valuable photograph is mounted with dry mounting tissue or other adhesive, it would be worthwhile to mark the back of the mount with the date and name of the product; this information will be invaluable to anyone needing to unmount the print at some future time. This is especially important now because of the great variety of mounting tissues and pressure-sensitive adhesives on the market, with new products being introduced frequently.

Improved dry mounting tissues could probably be made with polyamide or polyvinyl acetate (PVA) thermoplastic adhesives coated on a stable, high-alpha-cellulose tissue-paper core. Both of these adhesives can satisfactorily be removed with solvents. A paper core is necessary because coreless dry mounting "tissues" are difficult to handle and to trim precisely.

Separate types of mounting tissue will probably be needed for fiber-base prints, conventional RC prints, and gelatin back-coated RC and polyester-base prints. Tissues for fiber-base papers should have sufficient "hot-tack" (that is, maintain high bond strength and not become "mushy" while hot) to prevent edge-lift of the mounted print when it is removed from the press. RC papers, on the other hand, *must* be mounted with a low-temperature adhesive to avoid melting the polyethylene coatings on both sides of the paper support. RC prints generally do not have edge-lift problems, and the bond strength of the adhesive when heated in the mounting press can be much less than that required for fiber-base papers.

## Eastman Kodak Dry Mounting Tissue

The first Kodak Dry Mounting Tissue was marketed from 1906 to 1934. In August 1934 Kodak introduced an improved product with better adhesion and requiring less heat; this version of Kodak Dry Mounting Tissue continued in more or less the same form until 1974, when it was abruptly taken off the market and replaced with Kodak Dry Mounting Tissue, Type 2, which was intended only for RC papers. For nearly a year, until the introduction of Kodak Dry Mounting Tissue, Type 2 [Improved] in late 1975, Ko-

dak did not even sell a dry mounting material for fiber-base prints. Type 2 [Improved] remains the current Kodak dry mounting tissue, and, according to Kodak, is intended for both fiber-base and RC prints; the "Improved" designation on product packages and instruction sheets has now been dropped.

When used with fiber-base papers, Kodak's current mounting tissue is, in this author's opinion, distinctly inferior to the Kodak Dry Mounting Tissue marketed until 1974. If the mounting temperature is high enough to obtain a good, overall bond with Type 2, fiber-base prints have a tendency to pull away at the edges immediately after the print is removed from a hot mounting press. This so-called "edge-lift" affects only the outer 1/16 inch or less and results in slightly elevated edges on the print; this not only is aesthetically objectionable but also makes the edge of the print more vulnerable to emulsion chipping and other damage.

In this author's experience, edge-lift is more likely to occur in papers with a strong tendency to curl, such as Agfa Brovira, than it is with Kodak papers such as Polyfiber Paper or Elite Fine-Art Paper, although it is still a problem with these products. The earlier Kodak dry mounting tissue had a sufficiently tacky bond while hot to prevent edge-lift in fiber-base prints. Because of the edge-lift problem, this author believes that Kodak Dry Mounting Tissue, Type 2 fails to meet the adhesion requirements for fiber-base paper as specified in *ANSI PH4.21–1989,* Sec. 3.1.2.

Kodak Dry Mounting Tissue, Type 2 is made of a glassine paper sheet coated on both sides with what appears to be a wax-based adhesive. Glassine paper is not considered a high-stability material and its contact with photographs is specifically advised against in *ANSI IT9.2–1991.* The presence of glassine paper may or may not be important in the context of a dry mounting tissue. Only accelerated aging tests can properly evaluate the overall stability of this product; meaningful test data for Type 2 tissue are not presently available. Kodak has declined to reveal the composition of either the adhesive or core material of its current or previous dry mounting tissues. The adhesive of Type 2 tissue is soluble in toluene; the adhesive of the pre-1974 type of Kodak Dry Mounting Tissue is readily soluble in methylene chloride.

For mounting fiber-base papers, Kodak's pre-1974 Dry Mounting Tissue had, in this author's opinion, the best adhesion characteristics of any dry mounting tissue ever marketed — and this is a view shared by many knowledgeable photographers. The tissue had wide temperature and mounting-time tolerances; consistent mounting results with fiber-base prints were much easier to obtain than is now the case with Type 2 tissue. Kodak recommended a mounting temperature from 200° to 275°F (93° to 135°C); many photographers found that about 240°F (115°C), with a 1-minute press time, worked best. The adhesive nature of the tissue was such that sheets in a package even had a tendency to stick together ("block") during storage at normal room temperature; to prevent this, Kodak interleaved the sheets with thin, pink tissue paper.

Current Ademco dry mounting tissues, discussed later, are interleaved for the same reason. Like a number of other photographers, this author still has a small supply of the pre-1974 Kodak Dry Mounting Tissue reserved for mounting special prints.

To obtain an adequate bond with RC papers, the pre-1974 Kodak Dry Mounting Tissue had to be applied in a narrow temperature range between 210° and 230°F (99° to 110°C); this is dangerously close to the melting temperature of the polyethylene coatings on RC papers. Because mounting presses available in the early 1970's had poor temperature regulation, and were not equipped with dial thermometers to check the setting of the thermostat, photographers often had difficulty using the tissue with RC papers. Damaged prints — or prints that eventually peeled off their mounts because of poor bonds — were common. With current Kodak Dry Mounting Tissue, Type 2, Kodak recommends a press temperature between 180° and 210°F (82° and 98°C); mounting RC prints in this lower temperature range greatly reduces the likelihood of softening or melting the polyethylene layers.

Kodak did not want to market separate mounting products for RC and fiber-base papers and, apparently believing that fiber-base papers would in due time be withdrawn from the marketplace, simply discontinued Kodak Dry Mounting Tissue in 1974. Sources at Kodak have indicated that its pre-1974 dry mounting tissue had been extensively tested for possible deleterious effects on silver-gelatin prints and was considered safe for long-term use even under adverse storage conditions. Kodak has declined to comment on why the product was withdrawn; a spokesman for the company would say only, "There were internal considerations which I'm not at liberty to discuss."[10]

It is believed that Kodak has performed photographic activity tests with its dry mounting tissues in contact with common types of color and black-and-white prints. In addition, it is believed that Kodak has conducted other types of accelerated aging tests to assess the adhesion characteristics of the tissues. On inquiry to the company, Kodak declined to discuss the subject, saying only that a publication on the subject would be issued in the future.[11]

In a 1984 publication, however, Kodak stated:

> For conservation applications, we have evaluated the Kodak Dry Mounting Tissue, Type 2, using the recommended mounting procedure. This material and procedure produces no adverse dye-stability effects with prints made on Kodak Ektacolor Paper. The temperature of the press platen is important in the correct use of dry mounting tissue; too high a temperature can cause serious image degradation. The platen should be kept between 82 and 98°C (180 and 210°F) with regular checks for temperature consistency over time and from point-to-point on the heated surface. A convenient method for doing this is with temperature-sensitive strips that are commercially available.[12]

The performance of Kodak Dry Mounting Tissue, Type 2 in the "conservation mounting" of Ektacolor prints is not particularly meaningful because the Ektacolor RC papers available at the time Kodak made this statement had inherently poor image stability, both on display and when stored in the dark. Adhesives for mounting Ektacolor prints do not have to meet stringent stability requirements because the useful life of these prints is limited.

## Seal Products Incorporated — ColorMount Dry Mounting Tissue is Recommended

Seal Products Incorporated was founded in 1936, and the Connecticut-based company is now the world's largest manufacturer of dry mounting presses and dry mounting materials.[13] Seal acquired Ademco Drimount Ltd. in England in 1987 and, in 1990, the combined firms were purchased by Hunt Manufacturing Company, headquartered in Philadelphia, Pennsylvania. Despite now being owned by the same parent company, Ademco — now called Ademco-Seal Ltd.[14] — and Seal continue to market separate product lines. With the exception of Ademco-Seal's heavy, hardbed dry mounting presses, Ademco-Seal products generally are not available in the United States.

Seal currently has a number of dry mounting products available, including Seal ColorMount, MT5 Plus, Fusion 4000 Plus, Fusion Ultra, MultiMount, and ArchivalMount Plus. Seal also markets a low-temperature, wax-base dry mounting tissue called Fotoflat that is easily removable when heated; it is not recommended for long-term applications with photographs.

Seal MT5 Dry Mounting Tissue — on the market since 1955 and, with a minor formulation change, now called MT5 Plus — is probably the most popular tissue in the United States for mounting fiber-base prints. The MT5 name was derived from the "5-second mounting" advertising slogan when the product was first marketed. MT5 has been recommended for fiber-base papers by *Popular Photography* magazine writer David Vestal and many others.

Asked about tests the company had done to determine possible long-term effects of its products on photographs, Maurice Wilkinson, technical development manager for Seal, replied, "We have not done any serious tests on them. All we would do normally is test the adhesive and the paper for pH." Wilkinson added, "We have had a lot of difficulty about how to test this and generally, when we talk to people about this, we get back about 27,000 different ways to test these things. We have not set up any testing program ourselves." Wilkinson said MT5 Plus is currently made by coating a "wax modified rubber-base adhesive" with a pH of 7.0 on both sides of a thin, white glassine core sheet.[15]

Seal ColorMount tissue has the same adhesive as MT5 Plus coated on a conventional porous paper core (said by Seal to have a pH of 6.9). Seal says the low air-permeability of the glassine core of MT5 Plus tissue prevents it from properly dissipating air bubbles when mounting nonporous polyethylene-coated RC prints, so ColorMount was developed to correct this problem. When ColorMount was originally introduced in 1973, it was made with a different type of wax-based adhesive and was recommended for RC prints only. After ColorMount was modified in 1975, Seal began to recommend it for both RC and fiber-base prints.

Many photographers continue to believe that ColorMount is intended only for RC color prints because it was initially advertised as being exclusively for RC papers and because it has "color" in the name (most color papers are made on an RC base). Since both ColorMount and MT5 Plus are made with the same adhesive, and ColorMount is at least as good and probably better than MT5 Plus for mounting fiber-base prints, it is unclear why Seal continues to produce MT5 Plus.

Ansel Adams began using ColorMount mounting tissue after he could no longer obtain the pre-1974 type of Kodak Dry Mounting Tissue and found the Kodak Type 2 tissue to be unacceptable. Adams continued to mount his prints with ColorMount until his death in 1984.

In 1977 Seal introduced Fusion 4000 mounting adhesive, a thin sheet of EVA-modified polyethylene made without a paper or glassine core. Seal has advertised Fusion 4000 as an "archival" dry mounting product, basing this claim on the fact that the material does not have a paper core, has a pH of 7.0, and therefore is "acid-free" (all the Seal products discussed here have an adhesive pH of 7.0, according to the company). This author does not recommend the product and agrees with David Vestal, who said, "I find paperless dry mounting tissue hard to use cleanly."[16] In 1986 Fusion 4000 was modified and renamed Fusion 4000 Plus dry mounting adhesive.

In 1984 Seal ArchivalMount Archival-Quality Dry Mount Tissue was introduced; prior to its being marketed, Seal spokesman Wilkinson said, "It will incorporate whatever qualities the company can identify as contributing to long-term stability." ArchivalMount Plus is made by coating both sides of an alkaline-buffered tissue paper core with the same EVA-modified polyethylene adhesive used in present Fusion 4000 Plus.

The "Archival-Quality" designation appears to be based on two things: **(a)** the product is made with a neutral-pH adhesive coated on a "acid-free" paper core that is buffered with calcium carbonate, and: **(b)** a print mounted with ArchivalMount can be detached by reheating and pulling the print off the mount while hot; most of the adhesive remaining on the back of the print can, according to Seal, be removed by repeatedly re-mounting the print on sheets of expendable paper and immediately pulling it off while still hot. This author advises against such "hot" methods of unmounting important photographs.

In 1984 Seal ran an advertisement that showed an Edward Weston print "ready for preservation-mounting with ArchivalMount between photo and substrate." The ad said:

> An Edward Weston photograph is too valuable to trust to an ordinary dry mount tissue, it requires extra protection against acid contamination. Now there's ArchivalMount, specially formulated for the preservation-mounting of photographs (including RC's), lithographs, documents, drawings, fabrics and more. . . . It's *absolutely* acid-free. In fact, because it's buffered, it actually *counteracts* the time-damaging acids in paper, substrates and the atmosphere. ArchivalMount is the *only* archival-quality dry mounting tissue. . . .[17]

Despite what seems to have been a sincere attempt on the part of Seal to create an improved product with ArchivalMount Plus, the product appears to have no worthwhile advantages over Colormount. In fact, in the previously discussed accelerated aging tests conducted by Nancy Reinhold, ArchivalMount Plus suffered significantly greater yellowing than did either ColorMount or MT5 Plus.

This author presently believes that, overall, Seal ColorMount is the most satisfactory of the current Seal products

for mounting either fiber-base or RC prints. Because the use of glassine paper in contact with photographs is advised against in *ANSI IT9.2–1991*, this author believes that ColorMount is preferable to MT5 Plus. Furthermore, during mounting, ColorMount is less likely to entrap air bubbles under RC prints than is MT5 Plus. In Europe, Seal Color-Mount is marketed as Ademco-Seal ColourMount.

## "Cold Mount" Pressure-Sensitive Print Mounting Products

Another basic type of dry mounting tissue is the pressure-sensitive adhesive sheet applied without heat. Adhesion occurs on contact at room temperature in a manner similar to that of common pressure-sensitive materials such as Scotch tape. These products are often referred to as "cold mounting adhesives," a term made popular by Coda Inc., of Midland Park, New Jersey, which was one of the first manufacturers to enter this field with its "Cold-Mount" products in the early 1970's.[18] There are now many suppliers of pressure-sensitive mounting materials in the U.S. and other countries.

3M Company, maker of Scotch Brand No. 568 Positionable Mounting Adhesive (PMA) as well as a number of spray adhesives and a heat-activated product for use with dry mounting presses, reported that it has conducted some stability tests with No. 568 and that no harmful effects to either color or black-and-white photographs were observed.[19] Few details concerning the tests have been released. In ongoing tests, according to Roger Jentink of the 3M Company, samples of the adhesive were aged for over 5 years in ovens set at a temperature of 120°F without any evidence of bond failure. At worst, a slight yellowing of the adhesive occurred.[20] This author considers the tests to be encouraging but inconclusive.

3M stated that the adhesive in No. 568 "in no way is similar to the rubber-resin types of adhesives that have earned a bad reputation in the past. They include rubber cement, masking tape and cellophane tape." The No. 568 adhesive, a blend of synthetic polymers, has a pH of 5.4, as determined by a boiling water distillation method. What significance this low pH has for photographs under normal conditions has not been determined. 3M's other products for mounting photographs have adhesive pH values between 6.7 and 7.1; No. 810 Magic Transparent Tape has a stated pH of 6.8.[21]

One theoretical advantage of No. 568 is that after the carrier sheet is stripped off, only a very thin layer of adhesive remains on the print. This eliminates concern about possible adverse affects on photographs of a carrier paper or tissue core. No. 568 PMA, sold in rolls and intended to be applied with the 3M C–35 Applicator (a hand-operated, two-roller cold press), is the same material as the now-discontinued No. 567 Positionable Mounting Adhesive, which was supplied in pre-cut sheets.

Despite the limited accelerated aging tests performed by 3M and the absence of independent test results, this author tentatively recommends No. 568 Positionable Mounting Adhesive for mounting black-and-white and color RC prints and polyester-base prints, but only when a pressure-sensitive adhesive is required. It is also recommended for mounting photographs that have gelatin back-coatings, such as

Ilford Ilfochrome (Cibachrome), UltraStable Permanent Color, and Polaroid Permanent-Color prints. No. 568 adhesive can be removed with solvents. This author does not recommend No. 568 for mounting fiber-base prints.

No. 568 Positionable Mounting Adhesive is the only product this author currently recommends for mounting potentially heat-sensitive instant black-and-white prints such as Polaroid Type 107, 107C, 667, Type 52, etc., and instant color materials including Polaroid Spectra prints (Image prints in Europe), Polaroid 600 Plus, and SX–70 prints, Polaroid Polacolor 2 and Polacolor ER "peel-apart" prints, and Fuji Instant Color prints. It is also convenient in home applications, such as for mounting snapshots in albums.

3M Scotch brand No. 6094 Photomount Spray Adhesive and other aerosol-spray mounting adhesives are not recommended for general applications. The fumes are toxic and the sprays are often messy. Unless one is very careful, spray particles can accidentally fall on the emulsion side of prints, contaminate mount boards, soil hands, etc.

None of the other manufacturers of pressure-sensitive mounting materials could provide this author with meaningful information on accelerated tests with their products; the companies contacted included Morgan Adhesives Company (maker of MACtac Permacolor products, including Permaprint pressure-sensitive mounting adhesive), Seal Products Incorporated (supplier of Sealeze Print Mount products), Coda, Inc., and others.

## Dry Mounting Equipment and Techniques

Dry mounting employs a heat-set tissue instead of the water-based pastes or shellac common in the early days of photography. A more descriptive name for dry mounting that is sometimes used is "hot mounting," a term which also serves to differentiate it from "cold mounting" with the increasingly popular pressure-sensitive adhesives that are applied at room temperature.

To hot-mount a print, a piece of tissue the exact size of a print is placed between the print and the mount board and heated for about a minute in a dry mounting press. The heat softens the wax or thermoplastic adhesive, causing it to bond the print to the mount board. Dry mounting is justifiably popular because (1) it is a relatively simple and quick process, (2) solvents are not released into the air, (3) there is no waiting for adhesives to dry, (4) the print is uniformly bonded over its entire surface, and (5) there is no warping or wrinkling such as can occur with water-based adhesives.

Fiber-base prints are usually somewhat curled or wavy after drying, particularly along the print edges. The pressure and heat of dry mounting will usually flatten the print perfectly, producing an aesthetically pleasing result; this is one of the principal advantages of dry mounting. Also, dry mounting tissue can slow, but not prevent, migration of harmful substances from low-quality mount board to a print. Other than the initial cost of a dry mounting press, it is the least expensive of all mounting methods; dry mounting tissue is much less costly than pressure-sensitive print-mounting adhesives.

Dry mounting presses are available from a number of manufacturers, including Seal Products Incorporated, Bogen Photo Corporation, and Ademco-Seal Ltd. (Ademco equip-

ment is not widely available in the U.S.).[22] The Technal presses sold by Bogen are comparatively inexpensive. For serious work, a press should be equipped with an accurate built-in dial thermometer and a thermostat capable of closely controlling the press temperature.

It is possible to dry mount photographs with an ordinary household iron adjusted to the "synthetic fabric" setting. This author does not recommend this method for any but quick jobs on snapshot-size fiber-base black-and-white prints. It is almost impossible for an iron to produce uniform adhesion for larger prints; the print may appear to be properly mounted, but in time sections of the print may bubble or pull away from the mount. There is also a danger of scorching the print if the iron becomes too hot.

## Make Prints with Wide Borders

Traditional dry mounting practice involves attaching the mounting tissue to the back of the print with a tacking iron and then trimming the entire border off the print, leaving only the image area. The print is then attached to the mount board with a dry mounting press. The edge of a print mounted in this fashion is vulnerable to chipping as well as to discoloration and fading caused by atmospheric pollutants (the effects of which are often most pronounced near the edges of a print). It is much better to make prints with a protective border — at least ¾ inch wide, with 1 to 2 inches recommended — and to leave the border intact when dry mounting. Special four-bladed enlarging easels available from Saunders, Omega/Arkay (Kostiner easels), and other manufacturers allow easy and precise centering of the image when making wide-bordered prints.[23] To avoid later difficulty when overmatting a mounted print, it is vitally important that the image be "square," that is, have parallel sides and perpendicular corners. A high-quality easel with precisely parallel blades is necessary to obtain accurate image positioning and cropping.

After mounting, the print should be overmatted as instructed in Chapter 12. The overmat window can be cut so that it slightly overlaps the edges of the image, thereby completely covering the print border, or the overmat window can be cut somewhat larger so the image "floats," with a portion of the paper border surrounding the image area of the print.

## Use a Cover Sheet When Mounting Prints

A cover sheet should always be placed between the print and the hot press platen to absorb moisture from the print, to prevent the emulsion from sticking, and to keep specks of mounting tissue adhesive off the platen. Cover sheets should have a smooth, absorbent, uncoated surface. Two–ply or 4–ply 100% cotton fiber mount board is excellent for the purpose; a high-quality, heavy artists' paper can also be used. (This author finds mount board or heavy paper cover sheets to be more satisfactory than the silicone-impregnated "release paper" supplied by Seal and other companies. While release papers have a nonstick surface so that adhesive from improperly trimmed prints will not adhere to them, they have no moisture-absorption capacity, and if the humidity is high this can result in an alteration of surface gloss of the print emulsion during mounting.) At the beginning of each mounting session, before any prints are placed in the press, it is good practice to pre-dry the paper or mount board cover sheets by heating them in the press for two or three 30-second periods with the press alternately opened and closed.

Cover sheets should be replaced when even slightly soiled, or if they become contaminated with adhesive from improperly trimmed prints. Particles of adhesive or other dirt on the platen (or the cover sheet) will make tiny indentations in the surface of the print emulsion which are impossible to repair.

## Keep Press, Prints, Boards, and Mounting Area Clean

If a cover sheet is *always* used, the press platen will remain free of bits of adhesive from incorrectly trimmed prints. If tissue adhesive gets on the platen, it can be removed by wiping the platen with a paper towel moistened with an organic solvent such as acetone. This should be done on a *cool* press with adequate ventilation — solvent fumes are toxic. Teflon-coated platens are much easier to clean than uncoated platens. Never try to scrape particles off a platen as this will almost certainly scratch the soft aluminum surface.

The mounting area should be as clean as possible to avoid sandwiching bits of mount board, mounting tissue, or other grit between the print and mount. These particles will cause small but extremely disconcerting surface bumps on the mounted print. The emulsion over these high points is easily abraded during handling, which can result in white spots on the print. Boards should always be dusted off after cutting and again before mounting the print. The need for cleanliness and care when dry mounting prints cannot be overemphasized. The paper cutter and mounting table should be cleaned with a moistened sponge before each mounting session. Formica and similar decorative laminates make excellent table tops — these materials are smooth and easily cleaned and will not melt if a hot tacking iron should touch the surface.

Occasionally, small concentrations of fiber actually occur within a fiber-base photograph itself. Prints should be closely examined from different angles before mounting because a "lump" will become more noticeable after the affected print is mounted.

## How to Determine the Ideal Mounting Temperature

As previously discussed, Seal ColorMount is recommended as the most suitable currently available dry mounting tissue for fiber-base and RC papers. For mounting fiber-base prints, ColorMount should be applied with a press temperature of about 215°F (102°C).

Most older mounting presses have poorly calibrated thermostats, and the press temperature may also fluctuate over a wide range at any given thermostat setting. Current Seal and Ademco presses are available with built-in thermometers and have reasonably accurate temperature controls. Press temperature can be checked with Seal Temperature Indicator Strips, Tempilstiks,[24] and similar products, or with an accurate surface-reading thermom-

eter. A press that is not hot enough will produce a bond with inadequate adhesion (a weak bond is usually not immediately apparent); a press that is too hot can cause print edge-lift, bubbles between the print and mount, and damage to the print and/or mount board.

The peak temperature reached by the mounting adhesive during dry mounting is influenced by several factors, in addition to the press temperature itself (which also varies between the minimum temperature "heater-on" and maximum temperature "heater-off" range of the thermostat that controls the press's electrical heating elements). The thickness of the paper or board cover sheet and the thickness of the print mount board both affect the rate of heat transmission to the dry mounting tissue. The length of time that the print is in the press is another critical factor. The temperature of the print and mount board rise rapidly when the press is closed, but if the mounting time is short — 15 seconds, for example — the print, and mounting tissue behind it, will not have an opportunity to reach the temperature of the press platen.

Some people try to speed up mounting by choosing a very high press temperature coupled with short mounting times. The theory is that, if the print is removed from the press at just the right moment, the rapidly rising temperature of the tissue interface between the print and mount board will have reached the level necessary to effect a good bond but will not yet have become so high that the print is damaged. This is a very risky approach to mounting, especially with RC prints, and is likely to produce erratic results from print to print.

In this author's experience, the most consistent results are obtained by setting the press to the temperature that (1) produces a strong bond with the particular dry mounting tissue, (2) avoids edge-lift, and (3) is safe for the print. The press time should be long enough for the cover sheet, print, and mount board to reach equilibrium with the press temperature. Depending on the size of the mounting press and the thickness of the cover sheets and mount board, a time between 1 and 3 minutes is required. Times less than 1 minute should not be used, even if it appears that bonding is satisfactory after a shorter period. Ansel Adams recommended a 3-minute press time for mounting with Seal ColorMount. His Seal Masterpiece 500T mounting press was set at 210° to 225°F (99° to 107°C), and the print, tacked to its mount board, was placed between two oversize 4–ply mount boards and inserted into the press.

The best way to determine the proper press temperature is to mount a scrap print. Preheat the mounting press for about 20 minutes before the test to allow the temperature to stabilize. Attach the dry mounting tissue to the scrap print so that the tissue does not cover the outer 1½ inches on two opposite sides of the print (e.g., center an 11x11-inch sheet of tissue on an 11x14-inch print). Both 14-inch sides of the print should be trimmed so that the tissue reaches all the way to the edge of the print.

Then tack the print to a mount board that is somewhat larger than the print, place between two *preheated* 4–ply cover sheets, and insert into the press. The print should be kept in the press for the customary mounting time (not less than 1 minute). After removing the print from the press, place it face up on a table, without weights, and allow it to cool completely.

Examine the edges on the long (14-inch) sides of the print to see if there is edge-lift. Then, grasping an unattached end of the print (where there was no tissue), attempt to pull the print from the mount. With a fiber-base print, either the print or mount board paper fibers should tear away, leaving the mounting tissue largely concealed. With an RC print, the tissue should remain attached to the print, and the top layer of paper fibers of the mount board should be torn away. If the print should separate from the tissue, or if the print and tissue separate cleanly from the mount board, the press temperature is not high enough — or, as this author has found to be the case with Ademco Archival Dry Mounting Tissue and some other products, the tissue simply is not capable of adequate adhesion regardless of what temperature is selected.

The test should be repeated several times, with press temperatures both higher and lower than the initial setting, to observe the effects. Be sure to allow the temperature to stabilize each time the setting is changed. When mounting RC prints with Kodak Dry Mounting Tissue, Type 2, the best mounting temperature is about 20°F (11°C) higher than the lowest temperature that produces adequate bonding. With fiber-base prints the ideal mounting temperature is usually about 35°F (20°C) higher than the lowest test temperature at which the adhesive bond is still adequate.

Once the proper mounting temperature is established, and procedures are consistently followed (i.e., use the same temperature, mounting tissue, and type of cover and bottom sheets; allow sufficient preheating time for the press temperature to stabilize; and use *exactly* the same press times), adhesion should be uniformly excellent.

## Step-by-Step Procedures for Mounting Prints

1. Maintain the relative humidity in the mounting room (and in the areas where prints and mount boards are stored) at 40–50%, if possible, both to prevent emulsion damage during mounting and to reduce warping of mounted prints. Avoid mounting on particularly humid days. A room dehumidifier operated in conjunction with an air conditioner will help control humidity.

2. Preheat the mounting press until the temperature has stabilized — typically about 20 minutes. Be certain the temperature is correct for the type of tissue selected.

3. After the press has reached operating temperature, preheat two sheets of *clean,* high-quality, 2- or 4–ply mount board, which are slightly larger than the platen of the press. Alternately open and close the press for several 15-second periods to properly preheat and dry the boards. The two pieces of board will serve as cover and bottom sheets for flattening fiber-base prints (see Step 5) and to protect a print and its attached mount board while they are in the press. When a heated press is idle, leave it open.

4. To avoid fingerprints, wear clean, thin cotton gloves at all times when handling, trimming, and mounting prints. Kodak Cotton Gloves, available in small and large sizes, are suitable.

5. (Skip this step for RC prints.) Flatten a fiber-base print by pressing it between the preheated cover and bottom sheets for about 30 seconds. Remove the print, place it emulsion side down on a clean sheet of mount board, and let it cool. This operation not only helps to remove waves and wrinkles from the print but also shrinks the emulsion and base (by drying them to a low moisture content), which helps to avoid a small strip of dry mounting tissue extending past the edge of the print after mounting. Flattening a print in the press immediately before mounting also helps to reduce warping of the print/mountboard assemblage after mounting. The cover and bottom sheets should remain in the press, with the press open, after the print is flattened.

6. Examine the back of the print to be certain that it is free of dust. Then, place the print face down on a clean surface and attach a sheet of dry mounting tissue to the print with a tacking iron (units with Teflon-coated, "non-stick" surfaces, such as those made by Seal, are best). The tissue should be at least as large as the print, so that it reaches or extends beyond all four edges of the print. "Tack" the tissue in position by gently placing the tacking iron on the center of the tissue and moving it, successively, toward each of the four print edges. Do not go all the way to the edges, however, to expedite later tacking of the tissue (with the attached print) to the mount board. Be careful not to produce wrinkles when tacking the tissue to the print; always draw the tacking iron *away* from the center of the print. To avoid creases or indentations on the print, be sure the tacking iron lies flat on the tissue, and do not apply too much pressure. Placing a silicone- or Teflon-impregnated "release sheet" on top of the tissue while tacking it in place can make proper application easier.

7. With a high-quality rotary- or straight-blade paper cutter, trim off all excess mounting tissue. The print should be image-side up while trimming to avoid scratching the emulsion. If the paper cutter is not equipped with a "hold-down" bar, a perfectly straight length of wood, with a piece of mount board glued along the bottom edge, should be pressed on top of the print close to the blade of the paper cutter during trimming. This will help assure a smooth and accurate cut and minimize the chance of any tissue protruding beyond the edges of the print. This author finds it best to carefully trim about ⅛ inch from the print border on all four edges, along with the tissue; by trimming them together, there is less chance of tissue extending beyond the edges of the print, and the final result has a neater appearance. Unless a print has wide borders and is to be overmatted, it is generally unacceptable for even a tiny sliver of tissue to be visible after mounting. With practice and care while trimming (and humidity control, if necessary), good results are not difficult to obtain.

8. Preheat the board on which the print will be mounted by placing it between the cover and bottom sheets already in the press. After about 30 seconds, remove the board and allow it to cool. Preheat only one board at a time, and attach the print to it as soon as possible after

it has cooled. With some mount boards (or under conditions of low humidity), this step may be skipped. Whichever method results in the least warpage of the mounted print is preferable — experience will be a guide.

9. Precisely position the print on the mount board. Place a weight, such as a 4x4x8-inch block of wood, to which a facing of mount board has been glued, on the center of the print to hold it in position. Lifting one corner of the print at a time, tack the mounting tissue to the mount board by gently touching the tissue with the tacking iron and drawing the tacking iron *away* from the center of the print. Tack the tissue to the board at the two corners nearest you and at one of the opposite corners; this will keep the print in exact position during mounting. Do not let the tacking iron slide off the tissue and onto the mount board; if this happens it will leave a permanent, shiny deposit of adhesive on the board.

10. Partially withdraw the cover and bottom sheets from the press, lift the cover sheet, and carefully insert the mount board with attached print face up. Lower the cover sheet. Holding the cover sheet and bottom sheet together, slide them back into the press.

11. Close the press for exactly 1 minute (or longer if necessary — see text above). Do not guess about the time. If possible, use an interval timer, such as an enlarger timer. If you have to rely on a clock or watch, lower the press handle when the second hand is in the "12" position, so you will not forget when you started.

12. When the press time is completed, open the press, partially withdraw the cover and bottom sheets, lift the cover sheet, and remove the mounted print. Lay it on a table, face up, and immediately place an oversize sheet of clean 4–ply mount board on top of the print. Place a weight (such as a Light Impressions Flat Plate) on top of the cover board for a few minutes, until the print has completely cooled — this will help minimize warpage of the print and mount during cooling. If, after cooling, the mounted print has an objectionable warp, place it between the cover and bottom sheets with the concave side up (i.e., with the edges of the warped board higher than the center) and reheat it in the press for about 20 seconds. Remove from the press, cover, and cool under weight.

If narrow slivers of mounting tissue protrude beyond the edges of mounted prints (this is not of great concern if the print borders will be covered by an overmat), the following procedure suggested by Seal should solve the problem: Before mounting, pre-dry the print (if fiber-base). Tack the tissue to the back of the print and trim off excess tissue (but do not trim any of the print border). Place the print face down on a sheet of clean paper and cover with a sheet of Seal silicone-impregnated "release paper" or similar product. Be certain that the release paper is larger than the print and overhangs all edges. Lay a large sheet of paper or mount board on top of the release paper and place the assemblage in the press for about 30 seconds — this will bond the tissue over the entire print surface. Remove, let

cool, and lift off the release sheet. Then, trim the outer ⅛ inch from all four edges of the print. To tack the print in position on the mount board, place a sheet of heavy paper over the center of the print and lightly press the wide, flat portion of the tacking iron on the cover paper. Leave the tacking iron in one spot and do not slide it on the print.

## Counter-Mounting Prints Back-to-Back to Sheets of Photographic Paper

In some applications, counter-mounting prints to photographic paper has advantages over dry mounting on mount board. Mounting with correctly processed and washed photographic paper eliminates concern about potentially harmful effects of mount board. Print warping or curling will be minimized or eliminated because the print and backing sheet will exert approximately equal curling forces in opposite directions, thus neutralizing any tendency to curl. The emulsion coating on the backing sheet of photographic paper serves the same function as the gelatin anti-curl layer on the backs of sheet films, Ilfochrome (Cibachrome) prints, etc.

A counter-mounted print is thinner than a print mounted on mount board, thus conserving space; this may be especially advantageous if the prints are intended for packaging in a portfolio case. Counter-mounted prints are surprisingly stiff and have the rigidity one might associate with a sheet of hard plastic of equal thickness. The photographer's portrait, historical data, or other information may be photographically printed on the backing sheet; this provides a simple and safe method for attaching considerable supplementary information to the print.

When made with wide borders, a counter-mounted print can easily be attached inside a mat with paper mounting corners (see Chapter 12); the counter-mounted print will stay flat when overmatted and framed. By carefully positioning images, some photographers have made books of counter-mounted prints, with the prints themselves mounted back-to-back without separate backing sheets.

It is recommended, however, that valuable prints not be counter-mounted until a stable and properly tested dry mounting tissue becomes available; once a print is mounted in this fashion, it is almost impossible to unmount. Counter-mounting should be considered only by the photographer who made the print, and it should never be done by museum or archives personnel to prints in their collections.

To further minimize the possibility of curl or warping in counter-mounted prints, prints and backing sheets should be made of the same type of photographic paper — preferably from the same box or emulsion batch. The paper grain of both the print and backing sheet should be in the same direction (e.g., an 11x14-inch print should be backed with an 11x14-inch sheet running in the same direction, even if the print is later to be trimmed to a smaller size, such as 8x10 inches). Double-weight paper should always be backed with double-weight paper, and single-weight prints should be backed with single-weight paper.

Backing sheets should not be exposed to light prior to processing (unless text or other information is printed on them). They should receive the same processing (including immersion in the developer) and washing as the prints; if no image is printed on the backing sheets, however, there

is no need to include Kodak Rapid Selenium Toner or other image-protecting treatment.

Fiber-base prints and backing sheets should be preheated and flattened in a dry mounting press prior to mounting. To keep curl to a minimum, it is essential that both sheets be thoroughly pre-dried *immediately* before mounting. Avoid counter-mounting fiber-base prints on humid days. RC prints do not need to be preheated. A sheet of dry mounting tissue should be tacked in place on the print and excess tissue trimmed off. Position the print back-to-back on the backing sheet so that all edges are aligned. With the print covered by a clean piece of heavy paper, attach the print to the backing sheet by lightly pressing the flat portion of the tacking iron on the center of the cover paper. Cover the print with an oversize sheet of "release paper" and place the assemblage in the mounting press for about 30 seconds. Remove the print and place between two sheets of mount board. When cool, trim the outer ⅛ inch from all four borders of the print and put it back in the press, between two sheets of 4–ply mount board, for 1 minute. Remove the print, place it between two sheets of mount board, and cool it under weight. If the print has an objectionable curl after cooling, try reheating (between two sheets of mount board) in the press for about 15 seconds, with the *convex* side of the curl facing the press platen. Remove the print and cool it as previously instructed.

## Mounting Adhesives to Avoid

Among products which should *never* be considered for mounting photographs are rubber cement, contact cement, and most pressure-sensitive mounting materials and tapes. Rubber cement contains sulfur or other chemicals which will cause fading or discoloration of black-and-white prints. Solvents in the cement may cause staining by transferring dyes in mounting materials to the print; the stains produced are often pink. Contact cement, made by a number of firms, can cause rapid fading of photographs; this is the most harmful adhesive likely to be encountered. Also to be avoided are starch pastes and animal glues.

Kodak Rapid Mounting Cement should be avoided because it contains nitrocellulose (cellulose nitrate), which could decompose over time and damage photographs.

A number of authorities have suggested liquid polyvinyl acetate (PVA) adhesives for use with fiber-base prints as well as with such products as paper envelopes for film and prints. This author has little information on possible long-term physical and chemical effects of these adhesives on black-and-white and color photographs; at present, neither a particular type nor brand can be recommended. As a general rule, however, water-containing adhesives of all types should be avoided with photographs.

## Adhesive Tapes for Use with Photographs

This author suggests that *no* adhesive tape be applied directly to a photograph because staining, fading, deformation, and physical damage may result. Tapes applied to the emulsion side of a photograph are a particular danger. Ordinary cellophane tape and masking tape (both of which have a rubber-base adhesive with poor aging characteristics), "gaffer's" tape, and virtually all other common tapes

should be avoided. Adhesives on these tapes will gradually deteriorate and discolor, become gooey, and soak into paper fibers and photographic emulsions. The tapes can cause typewriting and other inks to bleed. Citing a study by Feller and Encke, Merrily Smith *et al* of the Library of Congress describe the eventual result:

> The adhesive, having permeated the paper, continues to oxidize, and gradually loses its adhesive properties. The carrier may fall off, and the adhesive residues crosslink, becoming hard, brittle, and highly discolored. Once it has reached this condition, the adhesive residue and the stain it has created are very difficult, sometimes impossible, to remove.[25]

Some situations may require using adhesive tape in proximity to photographs, such as attaching overmats to mount boards, paper corners to mount boards, caption information to film envelopes, etc. For these and similar applications this author currently recommends two types of tape: high-quality gummed cloth tape,[26] occasionally referred to as *cambric* tape (gummed cloth tape with a shiny, coated or "glazed" backing — sometimes called Holland tape — should be avoided), and 3M Scotch No. 810 Magic Transparent Tape.

Gummed fabric tape which must be wet when applied (wet with a clean sponge and clean water; licking the tape is not advised because saliva may contain harmful substances) is particularly suited for attaching 4–ply overmats to backing boards. Once in place and dry, the gummed tape remains firmly attached and is therefore a good choice for making flexible hinges. In general, gummed cloth tape should not be applied directly to a fiber-base photograph because the wet gum will, in most cases, cause the print to deform locally and to wrinkle, and because the adhesive, which is likely to be somewhat hygroscopic, may accelerate localized discoloration. This type of tape does have the advantage that it can be removed by soaking it with water. Gummed cloth tape is available in various widths (the most common width being 1 inch) from several companies. See Chapter 12 for more information.

This author believes that Scotch No. 810 Magic Transparent Tape,[27] a cellulose acetate-base tape with a very stable pressure-sensitive adhesive, is suitable for use in proximity to — but not directly on — photographs. The tape is available from office supply stores, drugstores, and other outlets. A roll of the tape can be distinguished from other 3M Scotch tapes by its matte-surface and somewhat milky, translucent appearance. Scotch No. 810 tape is packaged in green plaid boxes and dispensers. Scotch No. 811 Magic Plus Removable Transparent Tape, introduced in 1984, should be avoided for photographic applications.

In some cases, caption sheets or other data must be attached directly to the backs of prints. From what little information is available, No. 810 tape appears to be the most suitable tape for this purpose with both RC and fiber-base prints. There is no doubt that this tape is better than rubber cement, cellophane tape, and pastes which have been used on photographs in the past. It must be emphasized, however, that only limited information is available on the long-term effects of this tape on color and black-and-white photographs. Once applied, the tape is difficult or impossible to remove from paper or photographs. It cannot be removed with water, and the adhesive is not soluble in any of the common solvents.[28] Scotch No. 810 tape recently applied to the back of an RC print can usually be removed by pulling the tape off; however, residues of the adhesive are likely to remain. If tape of any type must be removed from a valuable photograph, a qualified photographic conservator should be consulted.

The 3M Company has supplied the following information about Scotch No. 810 tape. Although not dealing with the long-term effects of the tape on photographs (3M said such tests have not been conducted), the information does suggest that the tape itself has a long life in most applications.

### 3M Company Scotch No. 810
### Magic Transparent Tape

3M No. 810 Magic Transparent Tape is in no way related to cellophane tape, which over the years has been misused for long-aging applications. Cellophane tape has a rubber-resin adhesive which will start to deteriorate within a couple of years and cause the paper staining and discoloration that many people have experienced. No. 810 tape, on the other hand, was originally developed to fulfill the long term applications in which cellophane tape had failed.

No. 810 consists of a cellulose acetate backing and a homogeneous, synthetic acrylic polymer adhesive. Both components are relatively inert and will not discolor or dry out with age. No. 810 also does not contain any fugitive ingredients which will leach into paper. The pH of the tape is 7.0.

The aging properties of No. 810 are somewhat dependent on the surface to which it is applied. If adhered to paper which is in good physical condition and does not contain unstable components, it should last indefinitely.

We have conducted natural aging tests for the 20-plus years that the product has been on the market. Lengthy accelerated aging tests were also run in artificial sunlight and elevated temperatures. None of the tests have indicated that No. 810 will deteriorate or discolor any faster than the paper substrate to which it is adhered.[29]

According to Smith *et al*, however, the adhesive of No. 810 tape can penetrate paper: "The adhesive mass does not typically soak into the paper as rubber-based adhesives do. The acrylic adhesive is, however, subject to cold flow and will penetrate to the degree that paper porosity allows."[30]

Two pressure-sensitive tapes that have been recommended by some conservators for use near photographs are Filmoplast P90, a paper-backed tape, and Filmoplast SH, a cloth-backed tape, both made by the German firm of Hans Neschen, and available in the U.S. from several suppliers.[31] Another tape of this type is the paper-backed Archival Aids Document Repair Tape, sold by the Archival

Aids division of Ademco-Seal Ltd. These tapes, all of which have stable acrylic adhesives, are marketed primarily for book and document repair; no information on possible effects of such tapes on photographs during long-term storage is currently available. Hans Neschen also produces a line of double-sided pressure-sensitive tapes, and a transfer adhesive, under the Gudy O name, which is applied in a manner similar to that described for 3M No. 568 Positionable Mounting Adhesive. Pending availability of meaningful test data, Gudy O products are not recommended for use in contact with photographs.

## Marking and Other Identification

After processing and drying, photographs are often marked to identify the photographer and to indicate the date, location, title, and other information. It is helpful to mark a print with a finding key or file number of the original negative or transparency. Some photographers use a serial number that includes the year, month, and day the photograph was taken, in addition to the roll and frame number. Photographs of historical importance should be marked with as much relevant information as possible; separate caption sheets are sometimes included for this purpose. A caption sheet should be given an identification number which positively identifies it as belonging to a print marked with the same number. Because caption sheets are usually stored with photographs, they should be prepared with high-quality paper that will not harm the photographs (see Chapter 13).

Newspaper clippings should never be stored near or in contact with a photograph. Newsprint has a short life; if the information in a clipping must be retained it should be copied with a *plain-paper* copier, such as a Xerox machine, and the copy filed next to the non-emulsion side of the photograph, with the printed side of the copy placed *away* from the negative or print. A high-quality paper, such as 100% cotton fiber bond paper or Xerox Image Elite Paper (Xerox No. 3R1950), should be used in the copying machine. Plain-paper copying machines employ a thermoplastic powder containing carbon black as a pigment, which is heat-fused to the paper. This author does not have any information about the long-term effects of Xerox images — or those produced by other brands of copiers — stored in contact with photographs, but they probably will not cause any harm if stored as recommended in this paragraph.

Caption information on old mounts or negative envelopes which are being discarded can also be copied on a plain-paper copying machine. A better, but more time-consuming, method of copying caption information is to photograph it and store this supplementary photograph with the original print. Any copy photograph must be properly processed and washed; stabilization prints and Polaroid prints are not acceptable for this purpose.

Pressure-sensitive labels, 3M Scotch Brand Post-it self-adhesive note paper, and similar items should never be attached to either the back or emulsion side of photographs. Although 3M Post-it note sheets are designed to be readily removable, they can leave permanent adhesive deposits on photographs and other paper materials if they remain attached for more than a few weeks.[32] (On hot days, a residue can be deposited almost immediately!)

## Pencils and Pens for Marking Photographs

The only media for marking photographs that this author can recommend at this time are water-base India ink, applied with a technical or fountain pen, and the common "lead" pencil. Pencils have traditionally been made of graphite and carbon black powder mixed with a clay binder. Pencil markings are extremely stable, and in the great many years that pencils have been used to write on photographs, they have not, to this author's knowledge, been reported to cause image deterioration. During the black-and-white era of portraiture, graphite pencils were popular for retouching prints made on the then-common matte-surface papers.

Pencil impressions are not water soluble, so prints marked with pencil can be reprocessed or rewashed with no danger of the writing bleeding or transferring to other prints. One of the great advantages of pencils over rubber-stamp markers and all inks — including so-called "waterproof" India ink — is that there is no danger of pencil lines bleeding or partially (and permanently) transferring to adjacent photographs should they accidentally become water-soaked as a result of broken pipes, floods, etc.

Care should be exercised when writing on the backs of fiber-base prints to avoid producing a physical impression that can be seen on the emulsion side of the print. Before writing, the print should be placed on a smooth, hard, and flat surface. (Mount board is *not* a suitable writing surface because it is too soft.) Apply light pressure with a medium-hard lead pencil that is not sharpened to a point. A standard No. 2½ pencil will suffice; however, a drafting pencil with an HB, H, or 2H lead would be better because softer leads are more likely to create graphite "dust," which, although erasable, smudges easily and can transfer to adjacent paper. Medium-hard lead pencils can be purchased at art supply stores.

Writing on the backs of prints should be restricted to the border areas, if possible, to prevent potential damage to the image area. Keep in mind that all markings will normally be covered if the print is mounted. Serial numbers, captions, and other information should be transcribed to the back of the mount *before* the print is mounted.

Older RC papers, from 1968 to about 1981, are almost impossible to write on with pencils. Most current RC papers have specially treated back-coatings which more readily accept pencil markings; however, it is still difficult to write on RC papers with pencils, and the pressure required to obtain a sufficiently dark line may cause an impression that is visible on the front of the print. India ink in a technical or fountain pen is probably more satisfactory for writing on the backs of RC prints — but be sure to allow adequate drying time before stacking them.

India ink is also recommended for writing on the fronts of prints because most pencil leads will not adhere to the smooth or glossy emulsions currently available.

## India Ink

India ink (also known as Chinese ink when in dry, stick form) has traditionally been made of carbon black with gum arabic as a binder and water as a solvent. The original formulas of India ink were not waterproof; they would

smear when damp and could be washed from paper with water. Most of the commercially available India inks in recent years have been formulated to be waterproof once they have dried. There are no published studies establishing the safety of modern India inks on the many types of photographic materials currently available, and formulas vary with different manufacturers. However, this type of ink has been used on photographs for many years and this author has not observed any instances in which it has caused fading or staining.

Many photographers prefer India ink for marking negatives because the dense black image of the ink prints clearly on contact sheets. India ink adheres to the emulsions of most prints and negatives and to the backs of most current RC papers. The ink does not soak into emulsions and RC coatings (as it does into fiber-base papers); it is necessary, therefore, to allow sufficient drying time to guard against any smearing. Because most of the ink remains on the emulsion or RC surface, and despite being waterproof when dry, some of it will come off if the print is washed.

India ink markings on the back of a fiber-base print may bleed or show though to the front; if these prints must be marked with ink, apply it only at the margins. Lead pencils are preferred for writing on the backs of fiber-base prints.

The back side of Ilford Ilfochrome (Cibachrome) print materials — including Ilfochrome RC materials — is coated with a matte-textured gelatin anti-curl layer which readily accepts pencil, India ink, and light rubber-stamp impressions. The polyester or RC base materials of Ilfochrome prints will prevent any bleed-through of inks, but enough

time must be allowed for any applied ink to dry before handling. It is a good practice to gently blot rubber-stamp impressions on Ilfochrome prints with an absorbent paper towel or, preferably, smooth blotting paper.

Water-base India ink, such as Faber-Castell Higgins Waterproof India Ink (No. 4415), has often been recommended as acceptable for writing on photographic materials. Other suitable inks for writing on the backs of RC prints are Koh-I-Noor Rapidomat Ink No. 3074–F and Koh-I-Noor Universal Waterproof Black Drawing Ink No. 3080–F, although this author has no information on their long-term effects on photographic images. When a graphite pencil is not appropriate, this author prefers the above inks — particularly Koh-I-Noor Rapidomat Ink — to the recently popular felt-tip photographic markers.

## Felt-Tip Pens and Markers

Felt-tip pens and markers are made in two basic types: felt-tip *pens* with odorless, water-base inks that remain water-soluble after drying, and felt-tip *markers* which have rapid-drying, waterproof inks consisting of dyes dissolved in volatile solvents.

Felt-tip pens with water-base inks are often substituted for pencils, ballpoint pens, and fountain pens for general writing applications. More accurately described as "porous-tip" pens, these increasingly common pens are intended for writing on paper; the porous surface of paper readily absorbs the ink, allowing it to quickly "dry" to avoid smearing. The water-base ink solvent actually evaporates

Ansel Adams signed his prints "lightly" with a pencil on the mount board under the lower right corner of the photograph.

# Photograph by Ansel Adams

Route 1     Box 181     Carmel, California 93923

*Moonrise*

*Hernandez, New Mexico*

Print made *Feb. 1978*    Negative made *c. 1941*

A rubber stamp on the back of an Ansel Adams print. The inscription was applied with India ink.

rather slowly, enabling the pens to function after relatively long periods of inactivity with the cap off. These inks are not suitable for writing on photographs; in particular, the nonabsorbent backs of RC prints should not be marked with felt-tip pens because smearing and transfer of ink to adjacent prints will inevitably result. The water-base inks of most felt-tip pens have very poor light fading stability.

Fine-point, porous-tip markers with volatile-solvent-base inks, such as Pilot's Photographic Marker and SC–UF Ultra Fine Point Permanent Marker (Pilot pens are made in Japan and widely available in the U.S.) and Sanford's Sharpie Extra Fine Point Marker, are becoming increasingly popular for writing on photographs, especially on the backs of RC prints. The inks dry rapidly, even on nonporous RC paper and smooth plastic surfaces, and are waterproof when dry.

These markers usually have black ink, but red, green, blue, and other colors are also available. They are often referred to as "permanent" markers by their manufacturers because the inks are waterproof and, in general, have light fading stability that is considerably better than the water-base inks in felt-tip pens.

Pending study of the long-term migration and transfer characteristics of the inks in porous-tip markers, and their potential effects on black-and-white and color photographic images, this author advises that they not be used on any valuable photographs, particularly fiber-base prints. Pilot Photographic Markers are better, however, for writing on

RC prints than either ballpoint pens or pencils, and if India ink is deemed impractical or too time-consuming in a particular application, a Pilot Marker is probably the better choice.

Pilot Photographic Markers and similar markers are recommended for writing on polyester, polypropylene, and high-density polyethylene sleeves and other plastic enclosures provided the ink is on the *outside* of the enclosure, in a position where it cannot directly contact a film or print.

Over long periods of time, especially in conditions of high relative humidity, the ink from such markers may partially transfer from an enclosure or the back of a print or enclosure to another print when they are stacked together.

With porous fiber-base prints, the inks may migrate through a print from the back and into the emulsion. In this author's library there is an example of ink migration through two sheets of paper, leaving a visible impression on a third sheet; the migration took place over a period of about 8 years. The polyethylene layers of RC prints will probably impede ink migration through an RC print, but the danger of transfer from the back of a print to the emulsion of another remains.

This author has seen an example of severe image fading caused by volatile-solvent marker ink applied to the edges of some black-and-white prints made in the mid-1960's; the brand of marker that caused the problem is not known.

Wide-tip volatile-solvent-base ink markers, such as the

Stamp and signature appearing on the back of a black-and-white print by photographer O. Winston Link.

1988

William Christenberry has stamped the backs of his Ekta-color RC Prints with the word "EKTAPRO" (a reference to Ektacolor Professional Paper) to indicate that they were made on post-1985 Ektacolor papers, which are considerably more stable in dark storage than Ektacolor papers marketed before 1985.

Magic Marker, Marks-A-Lot, and El Marko, are intended for writing on both porous and nonporous surfaces. The odor of the ink solvent is usually quite strong. Available in a variety of colors, these markers are handy for addressing packages, making temporary signs, and similar applications; they are *unacceptable* for marking photographs or film and print enclosures.

## Ballpoint Pens

Never use ballpoint pens on photographs because the ink may smear and transfer to other prints and films; this is especially likely to happen when the ink has been freshly applied and/or the relative humidity is high. Ballpoint ink is a particular hazard on the backs of RC prints.

## Wax Pencils

Wax pencils — which are made in red, orange, black, and other colors and are commonly known as *grease pencils* — are often used to indicate cropping lines, to circle images on contact prints for printing, and to give other printing instructions. Wax pencils are not suitable for writing on contact sheets or other photographs intended for long-term keeping.

Ideally, no photographs should be marked with wax pencils because in practice the wax will smear, will get on hands or cotton gloves, negatives, transparencies, and enclosures, and generally will make a mess of working areas. The wax markings never "dry" and can smear and transfer to other prints for years after their original application.

## Retouching Dyes Used as Inks

Spotting dyes, such as undiluted Spotone, may be used in a fountain or technical pen to write on print and film emulsions. Do not blot, but be sure to allow sufficient drying time before handling. As discussed later, Spotone retouching dyes are subject to light fading, and for this reason India ink is preferred.

## Rubber Stamps

Rubber stamps are convenient for marking the backs of prints with a photographer's name and address, an agency name, a copyright notice, etc. The long-term effects of common rubber-stamp inks on photographic images are not known; however, this author has seen a great many old fiber-base prints that have been rubber-stamped with no apparent ill effects unless the print accidentally became wet. If a rubber-stamped print — or one that has been marked with a ballpoint pen — does get wet, however, the results are usually catastrophic — ink will transfer to the emulsions of adjacent prints and can migrate through the base of a fiber-base print and stain the emulsion. These ink impressions and stains may be impossible to remove.

Transfers of rubber-stamp ink can also occur at very high relative humidities, especially if prints have been treated with hygroscopic glossing or flattening agents such as Kodak Print Flattener. Interleaving or placing prints in polyester sleeves will prevent ink transfer.

This author discourages the use of rubber stamps on fiber-base and RC prints intended for long-term keeping. If rubber stamps cannot be avoided despite the possible hazards, impressions should be made with standard inks dispensed from cloth-covered felt stamp pads. The recently introduced "self-inking" stamps and porous plastic stamp pads are undesirable because the inks in these products tend to bleed and print through photographs. This author suggests black ink since it is usually the most permanent color and its opaque quality requires less ink to produce an adequate impression. The less ink needed, the less chance there is of bleeding, print-through, and transfer to another print. Pending further information, regular black stamp-pad ink is recommended over so-called "archival" inks which may be difficult or even impossible to chemically remove from emulsions should the ink transfer from adjacent prints or diffuse through a print after becoming wet. A good procedure to follow when stamping prints is:

Ink the rubber stamp by pressing it on the pad. Then, make an impression on a piece of scrap paper and, without re-inking the stamp, make an impression on the print. Repeat this procedure for each print. This will help avoid excessive inking.

Rubber stamps usually become clogged with dust, lint, and old ink after a period of use. Most rubber stamps can be cleaned simply by rinsing them under a flow of warm water from a faucet. Stubborn cases may require applying a liquid dishwashing detergent directly from the bottle and brushing the stamp with a toothbrush to remove adhered dirt. Kodak Photo-Flo solution or a similar photographic wetting agent can take the place of liquid dishwashing detergent. After treating with any detergent, the rubber stamp should be rinsed with running water and dried by blotting with a paper towel.

Excess base rubber outside the type area may produce unwanted marks when stamping; these extraneous sections can be trimmed away with a razor blade.

So that slight optical "print-through" will not be visually apparent, prints should be stamped in the border areas or behind dark areas of the image. Be sure to allow ample time for the ink to be absorbed by the paper before stacking prints. Interleaving papers should be placed on top of each print as an extra precaution when stacking.

If a print is mounted, the back of the mount board can be stamped; as long as the stamp impression is not too heavy, and another print is not placed against the back of the mount without an interleaving tissue or sheet of polyester between them, there should be no problems. Ansel Adams for many years used rubber stamps on the backs of his mounted prints (insofar as this author is aware, Adams never sold unmounted prints):

> I strongly urge full identification and labeling of all prints. I recommend having a large rubber stamp made up to be impressed on the back of every print mount. The stamp should give full name and address, and also provide spaces for the title of the photograph, the negative date, the printing date, and a statement of reproduction limitation or copyright, if any. Additional stamps can provide copyright notice, return shipment request, intended use (e.g., for reproduction only), etc.[33]

### Stamp-Pad Inks for RC Prints

Normal stamp-pad inks consist of dyes dissolved in a water/glycol solution (or other chemicals similar in function to the glycols). As the ink is absorbed into the paper, the dyes mordant to the paper fibers; the carrier solution is dispersed into the bulk of the paper. Some of the carrier components may gradually evaporate.

Traditional stamp-pad inks have been formulated so that stamps pads will not rapidly dry out. These inks cannot be applied to the backs of RC prints because smearing or ink transfer will occur. The polyethylene layer on RC papers prevents the nondrying ink from being absorbed, and the stamp ink remains on the surface in a "wet" state.

Some stamp-pad inks, such as Sanford's Indelible Black No. 488C,[34] employ a volatile-solvent dye carrier and may be safely applied to polyethylene-coated papers. Sanford suggests a plain cloth stamp pad for this ink. The stamp pad should be kept closed between applications to prevent solvent loss; small amounts of denatured alcohol can be added to the pad should it become too dry. For stamping polyethylene-coated RC papers, Kodak has recommended the fast-drying ink supplied with Bunny's Miracle Kit, a $18 outfit consisting of a bottle of ink, ink remover, stamp pad, and rubber stamp with the word "Original," available from BWS Enterprises in San Marino, California.[35]

Robert E. Mayer, writing in *Photomethods* magazine, recommended the Mark II RC–1000 Stamp Pad System supplied by Wess Plastic, Inc. (a well-known manufacturer of plastic slide mounts).[36] Mayer also suggested the fast-drying Rexton Series–3 stamp-pad ink supplied by Rexton International.[37]

The fast-drying Photomark stamp-pad inks and Photomark pre-inked Mark II "air-tight" stamp pads supplied in a variety of colors by Jackson Marking Products Co. in Mt. Vernon, Illinois[38] were recommended for RC prints by Bill Hurter in an article in *Petersen's Photographic* magazine.

No test data have been published on the long-term effects on color or black-and-white prints of *any* of the above-mentioned products. Until more information becomes available, this author tentatively recommends the Photomark stamp-pad inks and pre-inked Mark II stamp pads supplied by Jackson Marking Products Co. (Jackson also supplies custom-made and standard rubber stamps for photographers in a vast variety of configurations).

Stamp-pad inks may fade as a result of light passing through the print support material while the print is on display. The red ink used in Kodak photofinishing labs to mark the backs of color prints with the Kodak name and the month and year of processing has very poor light fading stability; this author has seen examples which have nearly disappeared after only a few years of display.

### Film Cleaning and Problems with Scratches

Prints will usually have some small white specks in the image area resulting from dust and lint on the negative. The dirt particles block the printing light, resulting in a white or low-density spot. This is a particular problem with high-magnification enlargements. Keeping the darkroom areas clean and free of dust will help reduce the problem, but even the most careful worker will encounter some dust spots. Negatives should be carefully cleaned with a soft brush or can of compressed air or other gas. Unless absolutely necessary, avoid wiping the negative with a cloth or paper towel — even one moistened with liquid negative cleaner — because of the danger of scratching the negative. The negative can be examined for dust by holding it in the negative carrier under the light beam of the enlarger lens. If a large number of prints will be made from a negative, it is helpful to make a test print to determine the location of individual dust particles missed in the initial cleaning. Effort spent in cleaning negatives is usually amply repaid in time saved in spotting prints.

A number of devices are available to clean negatives, including cans of compressed Freon or other gases, brushes,

and brushes containing an ionizing radioactive element to neutralize static electricity which attracts and holds dust. Gas in high-pressure cans, such as Omit and Dust-Off, is fairly effective in removing dust and lint. Staticmaster brushes, made by NRD, Inc.,[39] are the most common radio-active brushes; this author has found them to be only moderately effective in removing dust, however. Much more effective — and more expensive — are the static-neutralizing dust-removal devices available from the 3M Company, Cumming Corporation, Kinetronics Corporation, and a number of other companies.[40] A very effective device is the Model 520 Masterwipe film cleaner sold by the 3M Company. This unit has a slightly sticky nonwoven fabric to pick up dust and incorporates a radioactive strip to ionize the air and remove static charges from the film as it passes through the machine.

Films and prints should be handled by the edges to prevent fingerprints on the image areas. Fingerprints not only show up during printing but may also contribute to long-term chemical deterioration of films and prints. Hands should be washed frequently and, if possible, soft cotton gloves should be worn when handling negatives, transparencies, and prints. Suitable gloves are available from Kodak and other suppliers; they are often worn by motion picture editors to prevent fingerprinting.

Liquid film cleaners can remove some types of adhered dirt, including fingerprints; when such cleaners are absolutely necessary, Kodak Film Cleaner is recommended. However, this author does not suggest liquid cleaners for removing dust since the application of the fluid often adds more dust than is eliminated. This author advises against anti-static liquid cleaners because the long-term effects of the static-neutralizer residues that remain on the film after application are not known. Many anti-static agents are hygroscopic and create elevated surface-moisture levels; this could cause sticking to enclosure materials and other films, and could increase rates of fading and staining.

Films should *never* be rubbed with fingers in an attempt to remove dirt because films are easily scratched; in addition, oils, acids, and salts from the skin may cause future damage to the image.

Negatives, especially old black-and-white films and all color films, should not be washed to remove dirt except in the most severe cases. Most color films other than Kodak Kodachrome are treated with a stabilizer as a final processing step, and the effectiveness of the stabilizer in slowing image-dye fading and staining can be impaired by washing. Old films may develop emulsion blisters or other problems if washed. Cellulose nitrate films should never be washed in solutions containing water because the emulsion may separate from the film base.

Most 35mm films do not have a gelatin coating on the non-emulsion side, and dust, which often preferentially clings to the uncoated surface, may be effectively removed in stubborn cases by lightly wiping the *non-emulsion side* with a clean photographic sponge that has been slightly dampened with water. The sponge should be soaked under running water and then squeezed until reaching the proper dampness. Rinse the sponge between each use to remove accumulated dirt and squeeze it dry. Avoid getting excess water on the negative, and allow any water droplets on the surface of the film to dry before closing the negative car-rier. This procedure cannot be done on some 35mm films, such as Kodak Type 2475 and Type 2485 Recording Films, nor on any sheet or roll film larger than 35mm, because they all have a gelatin anti-curl backing which will soften when damp and cause dirt and sponge particles to adhere.

Black-and-white films with minor surface scratches that have not penetrated the image layer of the emulsion can be treated with Edwal No-Scratch, available from camera stores or directly by mail from Edwal Scientific Products Corporation.[41] This solution, which has approximately the same index of refraction as plastic film base, fills in the scratches during printing. Minor scratch marks can be totally eliminated in most cases. The solution should be applied in a heavy coat over the entire negative.

After printing, the negative and the negative carrier should be washed in a strong solution of a wetting agent, such as Kodak Photo-Flo, to remove the No-Scratch and then rinsed in plain water. Allow the negative to dry on its own, but dry the negative carrier with a paper towel. (Liquid dishwashing detergent is also effective in removing No-Scratch from the negative carrier, but it should not be used on films.) *Under no circumstances* should No-Scratch be allowed to dry on the film, nor should the film be placed in a negative envelope or stored without first being washed and dried.

No-Scratch is not suitable for color films because washing the films after using the product may impair the action of the stabilizer in the processed film, leading to accelerated staining and dye fading. Edwal supplies rather inadequate instructions for this product.

Minor surface scratches on negatives and transparencies are much more apparent on prints made with condenser enlargers than with diffusion enlargers, or on contact prints made with diffuse light sources. For this and other reasons, most photographers will find diffusion enlargers to be more satisfactory for general printing than the more common condenser enlargers. If purchase of a new enlarger is being contemplated, serious consideration should be given to obtaining a diffusion color-head enlarger, which not only serves for color printing but also is excellent for black-and-white printing. In addition, the color-head filters can replace external filters for variable-contrast black-and-white printing.

Scratches may be effectively reduced by using a liquid-immersion film carrier such as those marketed by Carlwen Industries.[42] These special carriers come in a number of different models to fit different enlargers and to accommodate a variety of film sizes. Carlwen supplies a solution called Decalin, made by Eastman Chemical Products, Inc., for use with the film carriers. This solution has a refractive index similar to that of film base. Liquid-immersion film carriers are similar in theory of operation to wet-gate motion picture printers.

Carlwen could not offer any meaningful information on the long-term effects of Decalin on color or black-and-white films; however, the fluid appears to evaporate completely from the film, leaving no residue. Carlwen has reported no problems with the fluid to date. Some professional color processing laboratories routinely use liquid-immersion film carriers when making color separations for Dye Transfer printing or when making internegatives for mural-size enlargements.

## Dyes for Dust-Spotting Prints

Despite diligent efforts to clean negatives, some dust spots will inevitably appear on prints. These spots may be covered and blended in with the rest of the image with dust-spotting dyes, such as Spotone, made by Retouch Methods Company.[43] In spotting, as differentiated from retouching, only marks due to dust, lint, scratches, and other negative defects are removed from a print. Retouching, on the other hand, usually implies a major alteration of the image itself, such as removing wrinkles from a person's face, covering up telephone poles, adding clouds, etc. Retouching black-and-white negatives prior to printing has been a common practice in portrait photography. Photographs of products in catalogs and advertisements are also often retouched or airbrushed (spray-painted with a tiny air- or gas-powered sprayer) to remove unwanted reflections or background details and to emphasize certain details for commercial purposes. Historical photographs should not, however, be retouched or undergo other major types of image alteration, although spotting, color correction, and minor dodging and burning to make up for photographic deficiencies are usually acceptable.

Spotone and other types of liquid dye spotting solutions have become popular because they are easy to apply and do not appreciably change the surface gloss or texture of prints. The dye is absorbed into the emulsion, leaving little or no apparent residue on the print surface. Spotone is available in a number of colors — or off-neutral tones — to match various types of paper. Neutral black No. 3 is suitable for most modern neutral or near-neutral papers. The dyes are usually applied with a very fine watercolor brush. Dark areas can be spotted with the concentrated solution directly from the bottle; the dye can be diluted for application on lighter areas by first dipping the brush in the dye directly from the bottle and then briefly dipping it in a container of water. The density can be checked by brushing a few short lines on a piece of scrap paper. Repeated water dips may be required to obtain very light tones.

When the desired tone is reached, the dye may be applied to the print. With medium to light tones, it is best to choose a dye solution less dense than the surrounding print area so that the spot density can be built up by repeated dabs with the brush. If excessive dye is applied by accident, much of it can be removed by rubbing the affected area lightly with a small piece of a *clean* photographic sponge moistened with clean water. Reserve a special sponge for this purpose. Never use any sponge that might contain chemicals or dirt that could harm the print. Spotting is something of a craft — if you are not experienced with the procedure, you should practice on some expendable prints before working on prints you want to save. Good descriptions of print-spotting techniques are contained in David Vestal's book *The Art of Black-and-White Enlarging*[44] and in the Ansel Adams book *The Print.*[45]

Opaque spotting colors, such as Kodak Spotting Colors, are suitable for covering dark spots on prints, but these pigmented colors will alter the surface gloss and texture where they are applied to the print. The practice of knife-etching to remove dark spots on prints is not recommended, particularly for RC prints, because it pits the emulsion and

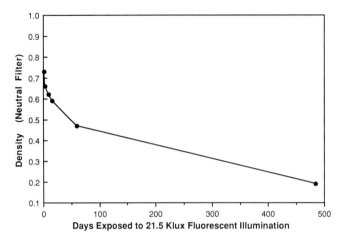

**Figure 11.1** Retouch Methods Company Spotone No. 3 dye applied to a white area of a print and subjected to an accelerated light fading test. The silver images of black-and-white fiber-base prints are essentially unaffected by exposure to light, so as the spotting dye on a print gradually fades during long-term display, spots will gradually reappear. Spotting dyes may also undergo an objectionable color shift after prolonged exposure to light.

may serve as a starting point for flaking and other emulsion damage. Another method of removing dark spots is to chemically bleach them with products such as Retouch Methods Spot-Off; however, the entire print must be refixed, treated with a washing-aid, and washed after any bleaching treatment. It may be difficult or impossible to bleach spots on toned prints or prints treated with image-protective solutions.

This author is not aware of any accelerated test evaluations of the long-term effects of spotting solutions on black-and-white photographs; however, to date this author has not observed any damage that could be attributed to spotting solutions.

Tests conducted by this author with Spotone No. 3 dye, the neutral black dye similar in tone to most current black-and-white papers, indicate that the dye does not have good light fading stability (see **Figure 11.1**). In fact, after 60 days of exposure to high-intensity fluorescent light, the No. 3 dye had faded more than color images on Ektacolor Professional Paper tested for the same period. However, the Spotone dye maintained reasonably good neutrality as it faded, which made the loss of density much less noticeable than it would have been had it shifted in color. In the tests, Spotone retouching dye was brushed on fixed and washed sheets of fiber-base Kodak Polycontrast Paper; several different densities of the dye were prepared. Because correctly processed and toned black-and-white prints are essentially unaffected by exposure to light on display, the original spots on the prints may start to reappear as the dye gradually fades. Retouch Methods reports that the company's basic formulations have remained the same for over 40 years and claims that it has never received a complaint that its products have caused fading or staining.[46] It is of course possible that the fading characteristics of the dyes could be improved by use of more stable dyestuffs.

If spotted prints are reprocessed or rewashed, most of the spotting dyes will be removed, thus requiring respotting

after the print is dry.  If spotting dye is spilled on a print, or if an area is darkened too much by accident, the print should be rewashed to remove the dye.  Most photographers who dry mount prints prefer to spot the prints after they are mounted because the moisture released from the print and mount board when heated during mounting may cause further absorption of the dye into the emulsion and therefore slightly change the apparent dye density.  Of course, a mounted print cannot be rewashed in the event of an overapplication of dye or other accident during spotting.  Make sure you have an uncluttered work area for spotting and place the dye bottle and water container in a safe place — on the upper right side of the print if you are right-handed, on the upper left side if left-handed — where they are not likely to be knocked over.

## Spotting and Retouching Color Prints

Color prints must be spotted with dyes of the appropriate colors, and because the density as well as the color must be matched, the work is much more difficult than black-and-white spotting.  Color spotting and retouching dyes are sold by Kodak, Ilford, and a number of other companies.

Ideally, spotting and retouching colors should have the same light fading and dark-storage stability characteristics as the color print material on which they are applied; in addition, the dyes should not adversely affect image dyes.  The colors must be transparent and easy to apply.  They should also closely match the spectral characteristics of the image dyes to avoid difficulties when color separations are made for photomechanical printing; the colors may "look the same" to the human eye, but may separate differently.

An excellent book on retouching is *The Fuji Professional Retouching Guide*, by long-time retouching expert Vilia Reed.  The book, which was published in 1992 by Fuji Photo Film U.S.A. Inc.,[47] covers retouching techniques for color negatives, color prints, transparencies, and black-and-white films.  Instructional videos on retouching are also available.

Retouching and spotting Dye Transfer prints have traditionally been done with the same dyes used to make the prints; this avoids any problems with stability or spectral differences between image and spotting colors.  With Ektacolor prints and similar chromogenic products, however, the same dyes that form the image are not suitable for spotting, and, as might be expected, there are significant differences in the stability characteristics and other properties of the dye sets.  Apparently, most of the chromogenic dyes in color photographs have very poor stability when dissolved in solutions and applied to emulsions, and this has forced the manufacturers to develop other types of dyes as retouching colors.  Kodak Liquid Retouching Colors and Kodak Retouching Colors (dry) are said to be similar to Dye Transfer dyes and to have light fading characteristics somewhat similar to Ektacolor print images.  The dark fading stability of the retouching colors is believed to be considerably better than that of Ektacolor image dyes.

Retouching dyes may have adverse effects on color print images; that is, contact with retouching colors may cause image dyes to fade or discolor much faster than they otherwise would.  In recent years there has been a significant

problem with Ektacolor 74 RC print discoloration caused by Kodak Retouching Colors (dry).  The rapid image deterioration produced by these dyes was an issue in two lawsuits filed against Kodak; it has also been the subject of numerous complaints by portrait and wedding photographers (see Chapter 8).

For many years Kodak has sold a set of dry retouching colors that can be applied both in the dry mode for lightly coloring large areas of color prints and in the wet-brush mode mixed with a solution of water and Ektaprint 3 Stabilizer for correction of blemishes and dust spots.  The Kodak Retouching Colors were formulated during the era of fiber-base Ektacolor Professional Paper (not to be confused with the RC-base Ektacolor Professional Paper introduced in 1985), which was marketed before the introduction of Ektacolor RC papers in 1968.  Because of changes in the design of the paper and/or processing — or perhaps simply as a result of the change from fiber-base to an RC support — the dry retouching colors in the wet-brush mode have often been associated with severe localized fading and staining on Ektacolor RC prints, which develop a disconcerting orange-red color in areas where the retouching has been done.  This appears to result from a near-total bleaching of the cyan dye layer where the retouching colors have been applied in sufficient concentration to penetrate the emulsions layers.  In this author's accelerated dark fading tests, dry Kodak Retouching Colors used in the wet mode caused rapid cyan-dye fading in Ektacolor 74 RC prints, both when the dyes were moistened with a solution consisting of one part water and one part Ektaprint 3 Stabilizer (working solution) and when moistened with just plain water.

In January 1978 Kodak recommended in some of its technical publications that wet-mode application of its dry retouching colors be discontinued:

> We have received reports of customers having difficulties after using Kodak Retouching Colors on prints made on Kodak Ektacolor 37 and 74 RC Papers.  This difficulty has been in the form of a red-orange staining in areas retouched by the wet-brush technique as outlined in E–70, *Retouching Ektacolor Prints*.
> . . . since all reports have involved the wet-brush retouching technique, we are suggesting that the use of the wet-brush technique be discontinued with Kodak Retouching Colors.[48]

In November 1978 the company announced that, with a modification of the previous wet-brush procedure, Kodak Retouching Colors were safe:

> Tests now indicate that the Kodak Retouching Colors *may* be used successfully in a wet form if the dyes are diluted with a solution of 30 mL of Kodak Rapid Fixer, Part B [the acid hardener] to 970 mL of water.  Note: The working solution should be changed daily.[49]

In late 1981 the company introduced Kodak Liquid Retouching Colors, which can be applied with the wet-brush technique without adverse effects on Ektacolor RC images.  This author's accelerated tests appear to confirm Kodak's

statements that the liquid colors do not harm Ektacolor images. However, the dry Kodak Retouching Colors are still available for dry-dye retouching.

This author recommends *only* Kodak Liquid Retouching Colors for wet-brush retouching and spotting; other brands should not be used on Kodak Ektacolor or Ektachrome papers because there is no published information on their effects on image-dye stability. When having Ektacolor prints made at a commercial lab, be certain that spotting and retouching are done with the Kodak liquid dyes. Kodak took a rather low-key approach in publicizing the potential problems of its dry colors, and it is likely that not all photographers and retouchers have heard about the problems and may be continuing to use the dry colors in the old wet-brush mode. Kodak's 1987 book *Photographic Retouching,* a detailed and generally well-written publication, is vague on this point.[50]

This author also tentatively recommends Kodak Liquid Retouching Colors for Fujicolor, Konica Color, and Agfacolor papers, as well as for reversal papers such as Fujichrome Type 35 paper, Agfachrome paper, and Ektachrome Radiance paper. Kodak Dye Transfer prints should be spotted and retouched *only* with the *same* dyes with which the prints themselves were made.

Spotting color prints made from transparencies presents a special problem because dust, lint, scratches, and other defects reproduce as dark colors or black, instead of as white or light colors when prints are made from color negatives. To correct defects on prints made from transparencies, opaque colors must be applied. As an alternative, the spot can be bleached and then the proper color built up with color dyes.

For retouching Ilford Ilfochrome (Cibachrome) print materials, Ilford supplies a set of transparent Ilfochrome Retouching Colors; these are said to have stability characteristics similar to those of Ilfochrome images. Other retouching dyes, such as the Kodak products, should not be used with Ilfochrome, nor should the Ilfochrome colors be used with other types of color prints. On request, Ilford will supply instructions for selective bleaching of the dyes in Ilfochrome prints for color control or for subsequent spotting with transparent dyes.

Because of the difficulty in spotting color prints made from transparencies, special effort should be made to clean the transparencies before printing. The previously described liquid-immersion negative carriers can be very helpful in reducing the effects of scratches. Transparencies should never be lacquered or coated with other protective substances unless this is done with materials approved by the film's manufacturer and as a part of original processing in a properly equipped lab. Unless extreme precautions are taken, application of lacquer, 3M Photogard, or other coatings will permanently bond dust and lint to the film (see Chapter 4).

## Notes and References

1. Eastman Kodak Company, **Conservation of Photographs** (George T. Eaton, editor), Kodak Publication No. F–40, Eastman Kodak Company, Rochester, New York, March 1985, p. 107.
2. Jacob Deschin, "M.I.T. Starts Archival Photographic Collection," **The New York Times,** April 7, 1968, Sec. II, p. 31. Minor White established the Creative Photography Laboratory at M.I.T. in 1965. The Laboratory was abolished by M.I.T. in 1983, at which time the Archival Photography Collection was turned over to the Department of Architecture. In a statement issued at the opening of the collection, White said, "Until the present time, photographs have been sold to and collected by private individuals and museums, mounted and trimmed, packed and stored with interleaving, more or less carefully, and everyone has been more or less satisfied. Contemporary investigations of the subject of photographic permanence have made it clear that the delicate and sulphur-sensitive photographic emulsion requires special processing and rather elaborate presentation and storage precautions in order to last." The statement continued, "According to the minimum requirements of the new collection, photographs must be fully developed, rinsed in acetic acid stop bath, immersed in two hypo-washes of not more than five minutes each, selenium-toned for protection, washed for up to six hours (when using a wash-shortening preparation, triple the wash time recommended on the bottle), and dried on freshly washed plastic screens. . . . The prints are to be mounted by a narrow paper hinge, top or side, on all-rag stock, such as Strathmore Illustration (light weight) or Bainbridge Museum Stock; finished with a cut-out overmat, also of all-rag stock (no dry mounting) and, to prevent curling, a second fixed and archivally washed piece of unexposed photographic paper should be pasted onto the back of the print with library paste. . . . When prints are offered for the collection, M.I.T. will ask for validated assurance by the photographer that archival processing has been done."
3. Ansel Adams, **The Print,** Little, Brown and Company, Boston, Massachusetts, 1983, p. 145.
4. Ansel Adams, see Note No. 3, p. 148.
5. American National Standards Institute, Inc., **ANSI PH4.21–1989, American National Standard for Photography (Film) — Thermally Activated Dry-Mounting Adhesive Systems for Mounting Photographs — Specifications,** American National Standards Institute, Inc., 11 West 42nd Street, New York, New York 10036; telephone: 212-642-4900; Fax: 212-302-1286.
6. American National Standards Institute, Inc., **ANSI IT9.2-1991, American National Standard for Photography (Processing) — Processed Films, Plates, and Papers — Filing Enclosures and Containers for Storage,** American National Standards Institute, Inc., 11 West 42nd Street, New York, New York 10036; telephone: 212-642-4900; Fax: 212-302-1286.
7. 3M Company, **Product Information — Scotch Brand Adhesives and Tapes Aging Properties,** 3M Publication X–PISA, Professional and Commercial Products Department, 3M Center, St. Paul, Minnesota 55144.
8. Kimberly Schenck and Constance McCabe, "Preliminary Testing of Adhesives Used in Photographic Conservation," **Topics in Photographic Preservation — Volume Three** (compiled by Robin E. Siegel), Photographic Materials Group of the American Institute for Conservation, 1989, pp. 52–61. Available from the American Institute for Conservation, Suite 340, 1400 16th Street, N.W., Washington, D.C. 20036; telephone: 202-232-6636; Fax: 202-232-6630.
9. Nancy Reinhold, "An Investigation of Commercially Available Dry Mount Tissues," **Topics in Photographic Preservation — Volume Four** (compiled by Robin E. Siegel), Photographic Materials Group of the American Institute for Conservation, 1991, pp. 14–30. Available from the American Institute for Conservation, Suite 340, 1400 16th Street, N.W., Washington, D.C. 20036; telephone: 202-232-6636; Fax: 202-232-6630.
10. Henry Kaska, Eastman Kodak Company, Rochester, New York, letter to this author, January 19, 1983.
11. Henry Kaska, see Note No. 10.
12. Eastman Kodak Company, **Post-Processing Treatment of Kodak Ektacolor Papers,** Kodak Publication No. E–176 ("Reference Information from Kodak"), Eastman Kodak Company, Rochester, New York, July 1984, p. 5.
13. Seal Products Incorporated, 550 Spring Street, Naugatuck, Connecticut 06770-9985; telephone: 203-729-5201; Fax: 203-729-5639.
14. Ademco-Seal mounting and laminating products are manufactured by Ademco-Seal Ltd., Chester Hall Lane, Basildon, Essex SS14 3BG, England; telephone: 011-44-268-287-650.
15. Maurice A. Wilkinson, Technical Development Manager, Seal Products Incorporated, telephone discussions with this author, August 26, 1983 and October 3, 1991.
16. David Vestal, **The Art of Black-and-White Enlarging,** Harper & Row, New York, New York, 1984, p. 188. This is an excellent book on making top-quality black-and-white fiber-base and RC prints.
17. Seal Products Incorporated, advertisement entitled "Edward Weston Preserved," **Art Business News,** July 1984. The ad showed a print of Edward Weston's "Two Shells" ready for mounting with Archival-Mount dry mounting tissue.

18. Coda Inc., 194 Greenwood Avenue, Midland Park, New Jersey 07432; telephone: 201-244-7755.

19. Robert E. McCumber, 3M Company, letter to this author, March 24, 1975.

20. Roger Jentink, telephone discussion with Carol Brower, May 16, 1985.

21. 3M Company, see Note No. 7.

22. Seal dry mounting presses are manufactured by Seal Products Incorporated, 550 Spring Street, Naugatuck, Connecticut 06770-9985; telephone: 203-729-5201; Fax: 203-729-5639. Ademco dry mounting presses are manufactured by Ademco-Seal Ltd., Chester Hall Lane, Basildon, Essex SS14 3BG, England; telephone: 011-44-268-287-650. Bogen dry mounting presses are distributed by Bogen Photo Corporation, 565 East Crescent Avenue, Box 506, Ramsey, New Jersey 07446-0506; telephone: 201-818-9500.

23. Precision four-bladed enlarging easels are available from The Saunders Group, Inc., 21 Jet View Drive, Rochester, New York 14624; telephone: 716-328-7800 (800-828-6214); and from the Kostiner Division of Omega/Arkay, 191 Shaeffer Avenue, P.O. Box 2078, Wesminister, Maryland 21158; telephone: 410-857-6353 (800-777-6634).

24. Tempil Division, Big Three Industries, Inc., Hamilton Boulevard, South Plainfield, New Jersey 07080; telephone: 908-757-8300.

25. Merrily A. Smith, Norvell M. M. Jones, II, Susan L. Page, and Marian Peck Dirda, "Pressure-Sensitive Tape and Techniques for Its Removal From Paper," **Journal of the American Institute for Conservation,** Vol. 23, No. 2, Spring 1984, p. 103. The authors cited: Robert L. Feller and David B. Encke, "Stages in Deterioration: The Examples of Rubber Cement and Transparent Mending Tape," **Science and Technology in the Service of Conservation: Preprints of the Contributions to the Washington Congress, 3–9 September 1982, London, IIC, 1982,** pp. 19–23.

26. Suitable gummed cloth tape is available from several sources, including: Talas Inc., Ninth Floor, 213 West 35th Street, New York, New York 10001-1996; telephone: 212-736-7744; and Light Impressions Corporation, 439 Monroe Avenue, Rochester, New York 14607-3717; telephone: 716-271-8960 (toll-free outside New York: 800-828-6216; toll-free inside New York: 800-828-9629).

27. 3M Company, Professional & Commercial Products Dept., 3M Center, St. Paul, Minnesota 55144; telephone: 612-733-1110; toll-free outside Minnesota: 800-328-1600.

28. Merrily A. Smith **et al,** see Note No. 25, p. 105.

29. David S. Lindsey, 3M Company, letter to this author, March 1975.

30. Merrily A. Smith **et al,** see Note No. 25, p. 103.

31. Filmoplast and Gudy O products are manufactured by Hans Neschen, P.O.B. 1340, D–4967 Buckeburg, Germany. In the U.S., the products are distributed by Filmolux (U.S.A.), Inc., 39 Comet Avenue, Buffalo, New York 14216; telephone: 716-873-3480. The products are sold at retail by: Talas Inc., Ninth Floor, 213 West 35th Street, New York, New York 10001-1996; telephone: 212-736-7744; and by: Light Impressions Corporation, 439 Monroe Avenue, Rochester, New York 14607-3717; telephone: 716-271-8960 (toll-free outside New York: 800-828-6216; toll-free inside New York: 800-828-9629).

32. Robin Siegel, "Conservation Implications of Yellow Sticky Tabs," **Topics in Photographic Preservation — Volume Three** (compiled by Robin E. Siegel), Photographic Materials Group of the American Institute for Conservation, 1989, pp. 66–68. Available from the American Institute for Conservation, Suite 340, 1400 16th Street, N.W., Washington, D.C. 20036; telephone: 202-232-6636; Fax: 202-232-6630.

33. Ansel Adams, see Note No. 3, p. 156.

34. Sanford Corporation, 2711 Washington Blvd., Bellwood, Illinois 60104; telephone: 708-547-6650.

35. Fast-drying stamp-pad inks and ink remover for RC papers may be obtained from Bunny West Shepherd, BWS Enterprises, 924 Huntington Drive, San Marino, California 91108; telephone: 818-570-1011. Another ink recommended by Kodak is Kodak No. 85 Ink (Black) and solvent for Eastman Visible Edge Numbering Machine, Eastman Kodak Company, 343 State Street, Rochester, New York 14650; telephone: 716-724-4000.

36. The Mark II RC–1000 Stamp Pad System is available in any of four colors for about $30 from Wess Plastic, Inc., 70 Commerce Drive, Hauppauge, New York 11788-3936; telephone: 516-231-6300; Fax: 516-231-0608.

37. Rexton Series–3 stamp-pad ink for RC prints, which is said to dry in about 3 seconds at room temperature, is available from Rexton International, P.O. Box 412, Collingswood, New Jersey 08108; telephone: 215-533-5148.

38. Jackson Photomark fast-drying stamp-pad inks for RC papers, ink solvent (serves as ink remover and stamp-pad re-activator), and special pre-inked Mark II "air-tight" stamp pads ($16), rubber stamps, and related supplies are available from Jackson Marking Products Co., Brownsville Road, Mt. Vernon, Illinois 62864; telephone: 618-242-1334; toll-free outside Illinois: 800-851-4945. Six Photomark ink colors are available: black, red, blue, green, purple, and brown (this author recommends black ink). On request, Jackson will send a catalog.

39. Staticmaster products, NRD, Inc., Staticmaster Division, 2937 Alp Blvd., Grand Island, New York 14072; telephone: 716-773-7634.

40. 3M Company, Static Control Systems Division, 6801 Riverpace Blvd., Austin, Texas 78726-9000; telephone: 512-984-1200; Cumming Corporation, 9620 Topanga Canyon Place, Chatsworth, California 91311; telephone: 818-882-0551; Kinetronics Corporation, P.O. Box 6178, Sarasota, Florida 43278; telephone: 813-388-2432; toll-free outside Florida: 800-624-3204.

41. Edwal Scientific Products Division of Falcon Safety Products, Inc., 1065 Bristol Road, P.O. Box 1129, Mountainside, New Jersey 07092; telephone: 201-233-5000.

42. Carlwen Industries, Inc., 11008 Fawsett Road, Potomac, Maryland 20854; telephone: 301-469-6671.

43. Retouch Methods Company, Inc., P.O. Box 345, Chatham, New Jersey 07928; telephone: 201-377-1184.

44. David Vestal, see Note No. 16.

45. Ansel Adams, see Note No. 3.

46. Retouch Methods Company, Inc., telephone discussion with this author, 1976.

47. Vilia Reed, **The Fuji Professional Retouching Guide,** Fuji Photo Film U.S.A. Inc., 1992. Instructional videos which cover retouching color negatives and color prints are also available for use in conjunction with the book. Available from Fuji Photo Film U.S.A. Inc., 555 Taxter Road, Elmsford, New York 10523; telephone: 914-789-8201 (toll-free: 800-755-3854).

48. Eastman Kodak Company, **Kodak Tips,** Eastman Kodak Company, Rochester, New York, January–February 1978, p. 12.

49. Eastman Kodak Company, **Kodak Tips,** Eastman Kodak Company, Rochester, New York, November 1978, p. 5.

50. Vilia Reed, **Photographic Retouching,** Kodak Publication No. E–97, Eastman Kodak Company, Rochester, New York, August 1987, pp. 48–55.

## Additional References

W. J. Barrow, "Migration of Impurities in Paper," **Archivum,** Vol. 3, 1953, pp. 105–108.

T. J. Collings, **Archival Care of Still Photographs,** Society of Archivists Information Leaflet No. 2, Society of Archivists, 56 Ellin Street, Sheffield S1 4PL, England, 1986.

Klaus B. Hendriks, together with Brian Thurgood, Joe Iraci, Brian Lesser, and Greg Hill of the National Archives of Canada staff, **Fundamentals of Photographic Conservation: A Study Guide,** published by Lugus Publications in cooperation with the National Archives of Canada and the Canada Communication Group, 1991. Available from Lugus Productions Ltd., 48 Falcon Street, Toronto, Ontario, Canada M4S 2P5; telephone: 416-322-5113; Fax: 416-484-9512.

Laurence E. Keefe, Jr. and Dennis Inch, **The Life of a Photograph,** second edition, Focal Press, Boston, Massachusetts and London, England, 1990.

Eastman Kodak Company, **Quality Enlarging with Kodak B/W Papers,** Kodak Publication No. G–1, Eastman Kodak Company, Rochester, New York, May 1982.

Eastman Kodak Company, **Retouching Black-and-White Negatives and Prints,** Kodak Publication No. O–10, Eastman Kodak Company, Rochester, New York, March 1983.

Raymond H. Lafontaine, "The Lightfastness of Felt-Tip Pens," **Journal of the International Institute of Conservation,** Vol. 4, No. 1, 1979, pp. 9–16.

Library of Congress, **Procedures for Marking Manuscripts,** Preservation Leaflet Series, Office of the Assistant Director for Preservation, Library of Congress, Washington, D.C., July 1, 1976.

Thomas Maffeo, **How to Dry Mount, Texturize, and Protect with Seal,** Seal Products Incorporated, Naugatuck, Connecticut, 1981.

Polaroid Corporation, **Storing, Handling, and Preserving Polaroid Photographs: A Guide,** Polaroid Corporation, Cambridge, Massachusetts, 1983.

James M. Reilly, **Care and Identification of 19th-Century Photographic Prints,** Kodak Publication No. G–2S, Eastman Kodak Company, Rochester, New York, 1986.

# 12. The Handling, Presentation, and Conservation Matting of Photographs

## By Carol Brower

## Introduction

The survival of original photographs requires a solid appreciation of their value. This begins with the photographic manufacturers, who must produce inherently stable color and black-and-white materials. It is then the photographer's responsibility to select the most stable materials available and to process them correctly. Thereafter, proper display and storage, and careful handling, will be required throughout a photograph's existence to prevent otherwise inevitable damage and deterioration.

Making top-quality photographic prints is an exacting process. This chapter is concerned with the intimate physical care of such prints: It tells why it is necessary to provide individual physical protection for valued photographs and illustrates how conservation matting can make an important contribution to both their preservation and presentation. The text is divided into four sections which deal with "Attitudes and Practices," "Aesthetic Considerations," "Mount Boards," and "Mat Construction."

Although general recommendations can be made for the handling, mounting, display, and storage of artistic and historical works on any type of paper, photographic papers require special consideration because of their unique physical characteristics. For example, most photographs cannot be flexed without risking damage to the emulsion, and fingerprints leave their mark more readily on photographs than on most other kinds of paper. Photographic images are very sensitive to contamination by certain kinds of chemicals; therefore, the materials that will come into contact with photographs, or will be used in their vicinity, must be selected very carefully.

Photographic conservation is a relatively new field, and because of the many unanswered questions about the interactions between the various types of photographic materials and mount boards, papers, adhesives, tapes, polyesters, and so forth, few absolute statements can be made as to which materials and practices are best. Sufficient information is available, however, to allow certain recommendations which, when followed with an ever-vigilant attitude of care and caution, can contribute much to preserving photographs.

This chapter is addressed to a wide range of people active in fine art, historical, and professional photography fields; this includes the manufacturers and distributors of the many products used by photographers and those who collect and care for photographs. Unless otherwise noted, quotes are taken from among the 65 individuals who responded in full to this author's survey, "The Care and Pre-

sentation of Photographic Prints" (see **Appendix 12.1**). Although many outside references are cited, this chapter draws chiefly on this author's experience during the past 21 years in providing conservation matting for a colorful segment of the photographic art community centered in New York City.[1]

## Section One: Attitudes and Practices Regarding the Care of Photographs

To a great extent, the value of an object, whether artistic or historical, depends on its physical condition. Obviously, historical photographs are more valuable when in perfect condition, but it is usually possible to obtain from them the desired information despite cracked emulsions, scratches, or fingerprints. With a work of art, however, deterioration changes its very essence, and defects of condition cannot be overlooked.

This author's experiences with fine art photographers, curators, collectors, and dealers have, with some exceptions, revealed a high level of concern about the physical condition of photographic prints and their proper care. More than three out of four respondents to this author's survey said that print condition is usually very important when they are purchasing photographs; another 20% replied that it is very important "sometimes." Only 3 individuals (less than 5%) wrote that it is not very important; those 3 were photographers. Writing in the June 1986 issue of *American Photographer,* Bonnie Barrett Stretch noted the connection between rising prices, print "connoisseurship," and increased concern regarding photographic preservation in the photography art market: "Top dealers are no longer satisfied to get a great image; they want a print to be exceptionally well made, in excellent condition."[2]

In response to another survey question, a significant majority felt that all people who are involved with historical and artistic photographs have a responsibility for their preservation. About 10% said that collectors and museums alone should bear this responsibility. Peter MacGill, Director of the Pace/MacGill Gallery in New York City and a dealer with experience in many areas related to fine art photography, said, "Each time a photograph changes hands, the responsibility for its preservation is passed along with it. All of our photographs receive the best possible care, and every major photograph we sell is accompanied by a written evaluation of its condition, prepared for us by one of the foremost experts in paper conservation, Betty Fiske. Important works must be preserved, otherwise we're not doing our jobs."[3]

Unfortunately, the eventual importance of a photograph or other artwork is usually not evident when it is made. Artist Peter Wilsey commented, "In Leonardo's case, he

---

See page 441 for Recommendations

*Photographs in this chapter were taken by Carol Brower, except where noted.*

July 1987

People of all ages, walks of life, and nationalities visit The Edward Steichen Photography Center at the Museum of Modern Art in New York City. The exhibition above, **William Rau and the Railroad**, was on view from July 2 to September 29, 1987. As was the case with this exhibit, most photographs displayed in museums are conservation matted and framed under glass or Plexiglas acrylic sheet.

probably didn't know that people would still be amazed by *The Last Supper* 500 years after his death. . . . [Also,] sometimes things which were created casually become important later on."

## Growing Concern About the Conservation of Photographs

Photographers alive today benefit from the fact that many people, including photographic manufacturers, are showing increased concern for the stability and preservation of photographs. Museums have become aware of the special procedures necessary to preserve color photographs and some farsighted institutions, including the John F. Kennedy Library, the Jimmy Carter Library, the Art Institute of Chicago, the Historic New Orleans Collection, the Museum of Modern Art in New York City, and the National Gallery of Canada, have installed cold storage facilities to assure the long-term survival of the ever-increasing numbers of color photographs in their collections.

For the first time in history, significant information is now available regarding the long-term stability characteristics of most photographic materials, and many photographers have become aware that among available color print materials some products are much longer lasting than others and that there are significant differences in light fading and dark fading stability. For example, it is well documented that color photographs printed on Kodak Ektacolor 74 RC Paper can fade perceptibly if displayed under common conditions in as little as 3 or 4 years; worse, they suffer significant cyan dye loss and start to shift toward red in less than 10 years even when stored in the dark at room temperatures. (Ektacolor 74 RC Paper was replaced in 1985 with Ektacolor Professional Paper, a product that has significantly better stability in dark storage, but only marginally improved light fading stability — see Chapters 3 and 5.)

It has also been noted that Polaroid Spectra instant prints (called Image prints in Europe), SX-70 prints, Polacolor 2, and Polacolor ER prints have comparatively poor image stability when exposed to light on display.

In recent years many articles in the photographic press have helped publicize the previously little-known fact that Cibachrome (renamed Ilfochrome in 1991) and Kodak Dye Transfer prints are essentially permanent in room-temperature dark storage, and that it is *not* true, as some people think, that "all color photographs fade." UltraStable

Permanent Color Prints and Polaroid Permanent-Color Prints, both of which employ extremely stable pigments instead of the organic dyes used in most other color processes, may be displayed for hundreds of years under typical conditions without noticeable fading.

When individuals were asked in the survey, "In general, do you feel that a photographer should be informed in advance about the stability aspects of the materials he or she intends to use (e.g., potential problems with black-and-white RC papers; potential fading of colored mat boards)?" more than 90% said yes. All 10 individuals representing the conservation field said yes. All 65 respondents had an opinion on the subject, including such written comments as "Of course!" and "Always!" Arnold Newman, the well-known portrait photographer, wrote "Absolutely!"

These feelings were elaborated by Susan Harder, a print curator, dealer, and former Director of the Susan Harder Gallery in New York City, who wrote, "I feel strongly that manufacturers *must* inform accurately (or bear the consequences of misinformation) the purchasers of their products, and give them information as to 'archival' qualities. I also feel strongly that artists, dealers and collectors *must* inform potential buyers, or recipients, about the archival qualities of the pictures, their chemical history, so to say."

Peter Wilsey pointed out, "I think we all wish that Leonardo had painted *The Last Supper* on canvas instead of a wall, but he didn't know what would eventually happen to it."

Henry Wilhelm voiced his conviction that it is vitally important for photographers to be informed of stability factors in advance, but added:

> Aesthetic considerations are very important too. If Vericolor III negatives printed on Fujicolor paper give the kind of luminous color and long-scale tone reproduction the photographer wants, then these materials are probably what should be used. Fujichrome, Ektachrome, or Kodachrome transparencies printed on Cibachrome [Ilfochrome] afford more stable images, but the visual result may not be what the photographer prefers. The photographer should make the final decision as to which materials to use, but it should be an *informed* decision.[4]

Among photographers the degree of concern about stability varies considerably. According to photographer and Professor of Art Thomas Barrow,[5] information about the stability characteristics of the materials used by photographers "does not make much difference to many of them." Miles Barth, Curator of Archives and Collections at the International Center of Photography in New York City, wrote, "Artists and photographers can be stubborn, even when informed." Three-quarters of the people questioned said they know photographers who are not concerned with the quality of mats and other aspects of presentation. *All* photographers participating in the survey, however, said that they wanted to be informed of stability characteristics of the materials they select to use.

Artist Don Rodan shared his thoughts on the subject:

> It is first the artist's responsibility to consider the most permanent materials available

and to store, conserve, and present his or her prints in the most protective manner possible. If the artist takes these concerns seriously, probably his dealer and possibly his collectors will. It has been my experience that many collectors are more concerned with edition size than with the permanence of the image while more recently more (or at least a few) art dealers are encouraging their artists to print on more permanent materials when using color. These issues are related to both business and posterity in varying degrees to each concerned.

Writer, curator, and collector Pepe Karmel expressed similar thoughts:

> As long as a photographer works in a stable medium and follows archival processing procedures, he or she should be free to create without constraints. The collector or curator should try to follow the artist's desires regarding presentation as far as possible and archivally preferable. I think photographers should, however, give more forethought than they perhaps do to the question of unstable media. They have a responsibility — both to themselves and to museums and collectors — to create images that are worth preserving and also capable of being preserved.

## Handling Photographs

After a print has been made, the quality of its presentation and the prospect for its long-term survival ultimately depend on the attitudes of its caretakers. The best and worst of attitudes, as well as ignorance, are reflected in the ways in which photographs are handled.

For example, only 6% of the survey's respondents observed that most people viewing historical and artistic photographs *always* wash their hands before handling prints. This 6% represented major institutions and galleries whose curatorial policies require staff and visitors to do so when using their collections. Unfortunately, most people do not independently elect to wash their hands or to put on gloves before touching photographs. Therefore, where such a curatorial policy exists, it must be actively enforced to be effective. Nearly 80% of survey respondents said that they thought most people were not even conscious of the way they hold photographic prints, matted or unmatted.

Fingerprints, creases, cracks, and scratches are among the most commonly seen forms of physical damage to photographs. Nearly all of these could be prevented by conservation matting, or by enclosing the prints in polyester sleeves, and by always handling them very carefully and only with freshly washed hands. Clean, well-fitting gloves should also be available at all times.

Unfortunately, only five surveyed individuals said that in their experience most people usually wear gloves while handling unprotected prints. Roy L. Perkinson, Conservator at the Museum of Fine Arts in Boston, offered an explanation: "People often feel that gloves make it difficult to handle prints, to study them, and to write information down

# Physical Damage

Photographers spend painstaking energy and enormous amounts of time making fine prints. When a finished print is damaged through careless handling or improper packaging, the photographer suffers regardless of who owns the print. The most common forms of damage include fingerprints, cracked corners, and creases. The all-too-familiar semicircular thumb-crease is caused by holding a print in the wrong place with only one hand or with too much force; single-weight, fiber-base prints and RC prints are particularly vulnerable to this form of damage.

**Cracked Emulsion.** Detail of a double-weight, fiber-base black-and-white print by Lee Friedlander that was damaged in transit when one gallery loaned the unmatted, unmounted print to another gallery.

**Semicircular Thumb-crease.** Detail of an 8x10-inch, double-weight, fiber-base black-and-white print by Harry Callahan that was handled improperly.

**Cracked and Torn Print.** Front and back views of an unmounted double-weight, fiber-base black-and-white print by Tod Papageorge that was damaged inside a standard print drawer in a gallery.

at the same time."[6] Perkinson reported that visitors to the Museum are instructed in advance on the proper handling of prints. More than 95% of the photography collection is overmatted, and no print may be handled directly if it is not overmatted. The Museum uses polyester enclosures for temporary storage of its photographic prints and for permanent housing of a small percentage of the collection.

The habit and skill of wearing properly fitted gloves while handling photographs can be learned and should be a normal procedure in institutions, particularly when working in files where prints are not physically protected by polyester sleeves or mats. Henry Wilhelm said:

> Many people hate to wear these gloves. . . . You have to consider how many times the photograph may be handled if it is going to be kept for the next 500 years. All of the damage adds up very slowly, but eventually it will severely harm the photograph. Unfortunately, the photographs that get handled the most are the most valuable ones, the ones people want to see and use the most.[7]

## Causes and Prevention of Print Damage

When individuals were asked about their experiences with the *causes* and *prevention* of print damage, problems arising from improper handling were significant. For example, Peter Wilsey, artist and a former Light Gallery associate, noted that "customers at Light rendered several prints unsaleable because of their improper handling (No names!) and impatience when viewing." Victor Schrager, photographer and a former director of Light Gallery, said, "People hold prints improperly... by the corners, and with one hand." Photographer and educator Harold Jones[8] emphasized: "People should always use *two hands* to handle *all* photographs."

*Ignorance* was considered the greatest potential threat to photographs after *improper processing* and *improper storage conditions.* "People generally do not know how to handle prints — *plain* and *simple,*" wrote artists' representative Rick Wester. Curator Marvin Heiferman advocates "giving people specific instructions before allowing them to handle prints,"[9] and photographer Allen Schill believes that a good approach to preventing damage involves establishing "environments (galleries, conservation studios, etc.) wherein proper care is the rule, expected of everyone."

This attitude is shared by many people, but, unfortunately, such expectations and "rules" are still unstated or unenforced in most situations. Sculptor, painter, and photographer William Christenberry said, "Insensitivity in handling on the part of most people who deal with photographs causes print damage. I have had less problems with fellow photographers than with curators, dealers, etc." An extreme example of carelessness was cited by publisher Caldecot Chubb: "Someone sat on a Dye Transfer print *in my sight* in a gallery."[10]

The making of a fine print is a painstaking experience for many photographers, but they too can be guilty of mishandling photographs. Photographer Ani Rivera remarked, "As soon as the photographic paper is taken out of its box for exposure under the enlarger, creases, bends, fingerprints, and cracks can occur." After completing prints to their satisfaction, some photographers, such as Dorothea von Haeften and Marie-Claire Montanari, arrange to have the work conservation matted before any other person may handle it. Unfortunately, most people are not as conscientious, and few photographs are in perfect condition by the time they are matted. The vast majority of prints, both old and new, are marred in some way, whether they come from photographers, printers, dealers, or collectors.

## Damage to Prints Sent Out for Publication

In response to one survey question, Helen Levitt replied that when some of her prints were loaned to publishers for reproduction, they came back to her with cracked emulsions but that when the prints were matted beforehand they were returned in their original good condition, although some of the mats were damaged. Harry Callahan indicated that "magazines" had damaged some of his prints. Other photographers shared similar experiences.

Andy Grundberg, writer and a photography critic for *The New York Times,* recognizes the potential hazards of loaning and borrowing prints; for reproduction purposes he makes copy prints and transparencies. Grundberg said,

"At *Modern Photography* where I was picture editor for eleven years, we sometimes had problems with prints sent out for reproduction. Once a batch of originals borrowed from a gallery was ruined when a photostat house made notations on each print with a ballpoint pen. Other prints suffered physical damage from printers, who seemed generally unaware of the value of photographic originals. In recent years I have avoided these problems by not reproducing originals. Quality may suffer but the prints don't."[11]

Unfortunately, it is not always possible to use copies. For example, book publishers often prefer to make halftones and separations directly from original prints. In 1977 and 1978, Michael Hoffman and Carole Kismaric, acting on behalf of the Paul Strand Estate and Aperture, Inc., sent both vintage and modern Paul Strand photographs to this author to be conservation matted before they were sent out to have halftones made for publication. It was believed that the mats would probably be damaged and need replacing but that conservation matting should be done in the usual manner in order to protect the prints from direct handling and potential damage.

Fine art consultant and writer Peter C. Jones pointed out, in addition to the above concerns, that a great many pictures are damaged in shipment, which is "the most vulnerable time for any work of art."

Since highly valued photographs will probably be handled frequently and can also be expected to travel, the expense involved in protecting them is a necessary and worthwhile investment. Use of a collection generally contributes to a greater appreciation of it, but handling and traveling will decrease its value when prints are damaged. Even if they have been duplicated, original prints must be safeguarded at all times because of the loss of image quality and the physical changes inherent in any duplication process. The long-term effects of handling must be considered *well in advance,* and every collector and institution should protect their valued holdings against the hazards of use.

## Conservation Matting as One Way To Protect Prints

Conservation matting is often a good initial step in the overall plan for protecting valuable prints from direct handling and also from some of the consequences of cycling relative humidity, such as print curling and warping. When a collection contains thousands of prints that have not been collected with the primary intention of exhibiting them, however, matting is not practical. Gary Albright, Conservator at the Northeast Document Conservation Center in Andover, Massachusetts, noted, "Mats are only one storage possibility. For many institutions mats are financially out of the question as well as unfeasible for other reasons (large amounts of space required, etc.)." As an alternative to matting, institutions may prefer polyester enclosures which are more economical in terms of cost and space.

Even for temporary and infrequent display of selected prints and documents from within such an archive, however, conservation matting will sometimes be necessary. Every collecting institution should have a conservation matting and framing department or enlist the services of qualified people who can help care for its collection and for prints it has obtained on loan.[12]

Most major museums today have conservation departments staffed by individuals who provide matting and framing for the institutions' holdings and for prints obtained on loan for exhibition purposes. Pictured right is James Iska, Preparator for the Department of Photography at the Art Institute of Chicago, demonstrating archival matcutting in the photographic conservation lab.

February 1983

## The Individual Collector

The individual or "private" collector may elect to have many, if not all, prints matted since the collection will be handled, displayed, loaned, and sold without the restraints common in institutions. For example, the owner may show photographs to guests on a moment's notice, change the selection of framed images displayed on walls in the home or office, lend prints to a curator for exhibition, submit prints to an auction for sale, or supply original and irreplaceable material for publication. In all situations, the collector needs to protect his or her property.

Matting prints, compared with other methods of physical protection, such as enclosing them in polyester, is particularly desirable for the individual collector. Matting can enhance the joy of ownership by encouraging the intimate visual study of the print as a physical object: the print's surface texture and finish, its tones, and its image details may be appreciated without the inevitable loss of clarity caused by polyester enclosures, by the milky translucence of polyethylene bags, or by the normally reflective covering of glass or Plexiglas that is necessary in frames. The viewing of prints is a sensual experience for many people, and mats permit easy visual access to the print while also providing physical protection.

For some people, however, even an open mat hinders full enjoyment. For them, unobstructed viewing must include unobstructed handling, and neither conservation matting nor any other form of physical protection is appropriate. For example, although well-known collector Samuel Wagstaff admitted being more comfortable holding a print protected by a mat or a polyester sleeve than he was holding an unprotected print, he remarked that "it's *much* more fun the naked way." Many people share his view that photographs require tactile as well as visual appreciation.

Every manner of intimate handling is, of course, a privilege which carries with it a responsibility to safeguard the condition of the print. A good approach to satisfying collectors, whose feelings are similar to Wagstaff's, as well as their prints' need for physical protection, is to design and construct mats or enclosures in ways which facilitate the safe removal and replacement of prints.

## Matting and Framing a Personal Collection

Ideally, a print should already be conservation matted at the time it is purchased or borrowed, and more than three-quarters of the survey's respondents who buy photographs said they wanted to receive their prints in mats at the time of purchase.

It cannot be assumed, however, that every professional framer is familiar with the materials or methods required for the proper mounting of photographs, or that framers will always know when mounting is correct and when it is potentially dangerous. In fact, even in museums and galleries, the people responsible for matting and framing can be equally uninformed, or may not be able to apply their expertise in every situation. For example, several private collectors who lend their prints to museums for public display remarked that their conservation mats were discarded and replaced with "new" but poorly constructed mats by borrowers who set out to standardize the presentation of their exhibitions.

Significant time and money are often spent by institutions in well-intentioned efforts to care for prints on loan. However, deadlines, difficulty obtaining proper materials, special requirements, inadequate facilities, and insufficient funding, as well as ignorance, will contribute to poor-quality matting and framing. Furthermore, when there is a high turnover of works, staffs may not be able to correctly mat and frame every print. For example, the following statement appeared in an exhibition and auction announcement distributed by the Milwaukee Center for Photography: "Photographs are sold in the mats in which they exist. MCP does not take any responsibility for the appearance of the mats or for their conformity to proper standards of conservation."[13]

In the general marketplace, countless fine prints have been entrusted to well-meaning framers who have sealed the prints in attractive but unintentionally (and invisibly) destructive units constructed of harmful glues, tapes, and groundwood or other high-lignin-content papers that have led to the works' deterioration, discoloration, or disfigurement. Many framers, gallery personnel, and others have also damaged prints by trimming photographic paper and

original mounts that contained historical information, being tempted for economic reasons to fit prints into existing frames. Damage can also result if hinges are applied to photographs incorrectly or when they are inappropriate. To better judge whether a print has been mounted and overmatted properly, it should be inspected *before* it is framed.

Fortunately, framers are becoming increasingly aware of the need for conservation materials and methods. Most professional framers are willing to discuss their approach to conservation mounting and framing, and will offer their customers a choice from a variety of materials and methods that might be used to mount photographs. The following thoughts were expressed by Thomas Barrow:

> Every artist should have a good knowledge of how his work can be prepared for exhibition. This is particularly true for those in the area of works on paper. The next best thing is to have someone. . . [who] can be trusted implicitly to take the work and make it ready for exhibition. I am certain this will have to be the direction of the future — failing this a great deal of art will be lost to the masking tape-chipboard framers. And the sad thing about that is that the private collector is the biggest loser — the one area that artists really need to have their works thrive, since they support living art more strongly than any institution.

## Private Collections: Two Approaches

Various approaches have been taken to caring for photographic art. The owners of the Jedermann Collection have demonstrated exceptional care for their photographs by matting and framing every print individually, with concern for overall aesthetics as well as for conservation, after studying each photographer's history and intentions. Their house has become a private museum for their photographs, which are carefully integrated with other works of art, including paintings, drawings, sculpture, ceramics, and rare books. The collection is displayed in a combination of controlled incandescent tungsten and UV-filtered indirect daylight illumination. In addition, their house is equipped with elaborate temperature, humidity, and dust controls.

In a different approach, another family of collectors, who also wish to remain anonymous, have conservation matted their large collection of historical and contemporary photographs in nearly all standard sizes. This enables them to keep a minimum number of frames and facilitates the exchange of prints on display for prints in storage. It also encourages the owners to lend their prints frequently to museum curators for public exhibition. Their system ensures that their prints are not only well protected, but are also easily stored, quickly accessed, and promptly displayed when desired — creating, in the rooms of their house, numerous "galleries" of ever-changing exhibits. In their words: "We would like to simplify our system even more. If it were possible to mat and frame every print in *one* suitable standard size, we would do so."

May 1983

Home of the Jedermann Collection . . .

## Section Two: Aesthetic Considerations and Conservation Requirements

### The Function of Presentation

Respect for a photograph is nowhere more evident than in its presentation. To a significant extent, presentation influences the viewer's perception of a picture. Poor presentation can undermine proper appreciation of a photograph as well as of the photographer's intent. In fact, sometimes a picture may not even be noticed or an exhibition may not be viewed in its entirety if the presentation is not carefully planned and skillfully executed. In addition, the kind and degree of attention that a photograph receives often depends on how and where the viewer encounters it. The taking of a photograph is conditioned by the environment in which the photographer lives and works; similarly, an audience's perception of a photograph is affected by the viewing environment. For example, lighting may be inadequate, the pictures may be hung too low on the wall for most viewers, the mats and frames may appear too large, or the pictures may be spaced too closely or too far apart. The glass may be greenish, the mats may have discolored, and the frames may fail to complement the pictures or simply overwhelm them.

Ideas, information, and expressions of beauty that are communicated through the photographic medium are also shaped by the particular process by which the photograph

is made. Just as a watercolor painting of a pear will be different from an oil painting of the same pear, so too will the pear look different if it has been photographed with color negative film and printed on Ektacolor paper or photographed with a transparency film and printed on Ilfochrome. A Polaroid instant color print will produce yet another rendition of the pear. Finally, whatever the selected print material, it will have a different appearance when overmatted, framed, and displayed on a museum wall than when mounted in a photograph album.

Perhaps this should not be the case, but life is full of visually persuasive factors that are introduced intentionally and unintentionally — by creators and caretakers — and affect people both consciously and subconsciously. Without discussing all the various ways in which we are influenced, it should suffice to point out that the manner and form in which a created work is presented preconditions how (and how well) the viewer perceives the image and, to some extent, reshapes the original meaning. In addition, interest in any photograph can be sustained, increased, or diminished depending on how frequently it is viewed. It makes no difference whether it is a privately or publicly held work of art, a historical document, a journalistic photograph, or a family portrait. One has only to ask the following questions to measure the value of a given picture at a given time: Is the work displayed, or is it in storage? What is its physical condition? Who sees it? How often? Does anyone know where it is — or that it even still exists?

In short, if a work is carefully presented, it is more likely to receive proper attention. The attitudes of photographers, curators, and caretakers, therefore, profoundly affect how faithfully preserved are the photographer's original intentions, how a photograph is perceived and received by its audience, and, ultimately, how long a print will remain in satisfactory condition.

### The Photographer's Intent and Curatorial Decisions

Before any specific measures are taken to preserve individual fine art photographs, the photographer's intentions about the presentation of his or her work should be understood. Photographers often have specific ideas on the subject of mounting, and these ideas should be followed whenever possible — particularly because matting and other aspects of presentation may vary considerably when the decisions are left to curators or collectors, among whom a print will change hands many times during its existence.

In addition, because aesthetics and conservation are often interdependent, the photographer who is informed about the stability aspects of different mounting materials and procedures, as well as the stability characteristics of the print materials themselves, would naturally be the preferred final judge regarding both the preservation and the presentation of his work. "Michelangelo and his cohorts knew a great deal about materials — it is part of an artist's *craft*. It does not have to hinder creativity or invention," writer Irene Borger reminds us.

Unfortunately, most photographers are not well enough informed to make aesthetic decisions that will also promote the long-term preservation of their work. Product

May 1983

. . . Johanna in the hallway.

June 1987

View of the Laurence Miller Gallery in New York City as visitors began to arrive to preview the group exhibition **Exposed and Enveloped**, curated by Matthew Postal, in June 1987. Laurence Miller, Director of the gallery, said, "This space was designed to be inviting and to enhance the art I show. Exhibitions such as **Exposed and Enveloped** give us the opportunity to explore the many ways in which a photograph can be used for meaningful expression . . . works that range from the journalistic — for example, Larry Burrows's color photographs of the Vietnam War — to the manipulated and fabricated, such as Gary Brotmeyer's one-of-a-kind photographic collages. This diversity of work and the personalities of the artists that make it are what give me the greatest pleasure in running the gallery."

manufacturers are largely responsible for this because of the frequent absence of accurate and complete information about the stability characteristics of their products. In addition, many people fail to communicate what they know about preservation to others. For example, curators and conservators who safeguard prints and prepare exhibitions are usually aware of a number of suitable mounting methods. They often, however unintentionally, impose their own highly defined values on the mounting by not discussing alternative approaches with the photographer. Not even the photographer can know in advance without careful consideration what will look best and be best for a print. Information about conservation practices and procedures, stability data, available types and sizes of mount boards and frames, restrictions imposed in an exhibition area, financial considerations, and so on should be made available to exhibiting photographers. Collaboration gives everyone an opportunity to share his and/or her particular expertise and can be of value to all. After a plan for mounting, matting, and framing a work has been agreed upon, it should not be altered by anyone without further consultation.

Once in a great while, a curator will create a situation

for which the rules have to be rewritten. One such person is Doris C. O'Neil, Director of Vintage Prints and former Chief of the Life Picture Collection. Starting in 1979 with *LIFE: The First Decade,* O'Neil began organizing museum exhibitions of photographs carefully selected from the many outstanding images taken on assignment for *LIFE* magazine since its beginning in 1936. By having these pictures matted, framed, and displayed in a manner previously reserved for fine art, O'Neil succeeded not only in returning the images to the public and reviving interest in them but also in creating a new audience and a fresh perspective.

## Collaboration

There are many viewpoints regarding the photographer's responsibility toward the presentation of his or her work. Harold Jones remarked, "He or she [the photographer] should be the person to make the decisions. It is the curator's or director's job to work it out from there." Susan Harder felt strongly that "the presentation is the ultimate concern of the owner." Another dealer said, "The artist has to be able to *release* his work to the care and responsibility of

June 1987

While the Mark Klett exhibition of Kodak Dye Transfer, Ektacolor, and black-and-white prints was still hanging at New York's Pace/MacGill Gallery in June 1987, Director Peter MacGill and his staff started planning the next show of Dye Transfer and Ektacolor prints by photographer Joe Maloney. Exhibitions here and at most New York galleries typically run for about one month. MacGill (right) lays out each exhibit at least three times before the actual hanging begins, saying: "We want to arrange the pictures so that there's a visual continuity but not a visual passivity. There shouldn't be a lull in the viewing. The grouping should have impact, like the way Muhammad Ali used to box. He is absolutely my inspiration for hanging shows."

others who know their business. This is *my* gallery and I want to hang exhibitions without interference. I'm not here to be the artist's servant." (This statement was not made in the survey.)

Photographer and photography historian Beaumont Newhall wrote on the subject:

Edward Weston preferred to present his work simply mounted on good quality board, and when we exhibited them at The Museum of Modern Art they were framed without mats. Our Stieglitz collection was originally in the very frames that Stieglitz designed. I built clothlined boxes in which to store them. I think it is the curator's responsibility to respect the artist's judgment. I know how upset Alfred Stieglitz was [some 45 years ago] when the Boston Museum of Fine Arts put all his photographs under uniform size mounts. The very size of a mount was always specified by Paul Strand, down to the millimeter. On the other hand, Cartier-Bresson prefers unmounted prints, and his archive in the

DeMenil Foundation in Houston preserves them in this form.[14]

(Curators and conservators currently associated with the Museum of Fine Arts in Boston informed this author that the Museum's Stieglitz collection is, and has been for at least 20 years, given the individual attention that Stieglitz demanded.)

## Portfolios

If the photographer is directly involved in the production of his or her work, the various elements of a portfolio including the case, the mounts, the overmats, the interleaving paper, the text, and so forth become an authentic extension of the work contained within. Emily Aronson of DEP Editions in New York City recognized this and let the photographers make nearly all decisions regarding the design and format of their own portfolios. For example, in late 1982, she produced the *Trilogy Portfolio* by Ralph Gibson according to the photographer's wishes. It consisted of three individual portfolios of pictures selected from Gib-

son's three books: *The Somnambulist* (1970), *Deja-Vu* (1973), and *Days at Sea* (1975). Gibson made all the aesthetic decisions, including the selection of fabric in three different colors to cover the portfolios. The titles were printed on the spine of the cases as if they, too, were books.

In another example of collaboration, a compromise was reached between photographer Larry Fink, publisher Sidney Singer, and this author regarding the mounting of Fink's portfolio, *Social Graces*.[15] Most of the image sizes are about 14x14 inches on 16x20-inch photographic paper. Because the weight, thickness, and size of each individual portfolio was a critical factor, everyone agreed that the size of the mounts should not exceed 16x20 inches and that the prints would be dry mounted on 16x20-inch pieces of 4-ply 100% cotton fiber board without overmatting. This author recommended that the photographic paper be trimmed approximately ½ inch on each side before dry mounting to provide a recess from the edges of the mount board, thereby protecting the edges of the photographic paper.

Both Fink and Singer objected to the "look." Singer preferred the dry mounting format used by Ansel Adams, Bill Brandt, Edward Weston, and a great many other photographers, so he would have liked Fink's prints mounted in the same manner. This traditional style of dry mounting involves trimming off all the blank borders so that only the image area remains, and then mounting the print in the desired position on a piece of board. The result can be very attractive; however, it exposes the edges of the image and makes them much more vulnerable to damage.

Larry Fink did not accept either format. He disliked the "frame" created by the board around the edges of the photographic paper, and also said that his placement of the image on the photographic paper was important. To remove more than ¼ inch of the "blank" photographic paper, which has a unique surface and is also an integral part of the print, would violate his overall aesthetics.

We all compromised. The prints were trimmed approximately ⅛ inch for the following reasons: **(1)** to match the size of the photographic paper and the dry mounting tissue (manufacturers' standard sizes often vary slightly); **(2)** to prevent the photographic paper from extending beyond the edges of the mounts; and **(3)** to help prevent damage to the edges of the photographic paper.

This style of mounting created more work for Fink because, inevitably, the wide borders surrounding the images of some prints had slight stains, creases, or scratches. Fewer prints would have needed reprinting if they had been trimmed to the edges of the image. It also created more work for Arnon Ben-David and Ani Rivera who did the trimming and mounting, because the narrower the border, the more difficult it is to evenly align all the edges. Fortunately, Singer approaches art with concern for its survival and with the attitude that artists' intentions should be respected and followed whenever possible — and, in Singer's words, "Sometimes when impossible."

Clearly, many people in addition to the artist are usually needed to bring about a project of lasting value.

## Presentation Design and Format

Presentation design and format reflect an individual's, a community's, or a culture's aesthetic preferences at a given time and, like other fashions, are subject to change. For example, before 1970 most displayed artistic photographs were unframed and mounted on card stock or thick hardboards, such as those in Edward Steichen's exhibit, *The Family of Man,* which was shown at the Museum of Modern Art in 1955. During that same period, however, exhibitions at Helen Gee's Limelight gallery also reflected the ideas of individual photographers as well as Gee's own approach to displaying prints. For example, when Gee designed the installation for an exhibition of Ansel Adams's photographs in 1956, the prints were overmatted and displayed under glass, according to Adams's usual practice.

Since the mid-1970's, most photographs in museums and galleries have been exhibited in undecorated cotton fiber board overmats (usually white or off-white) within relatively simple metal or wood frames. In addition, most dry mounted photographs are displayed in the same style frames with overmats or with fillets, which help prevent contact between the prints and the glazing when overmatting is not possible or desired. However, far too many prints continue to be placed directly under glazing without mats or fillets, which is usually the result of a lack of knowledge rather than artistic preference.

Arbiters of matting "style" have debated thin borders around the image versus wide borders, floating the image versus covering the edges of the image, showing a signature versus covering it, bulky mats versus no mats versus delicate mats, single-window mats versus multiple-window mats, white mats versus toned mats, textured mats, tiered mats, ornate mats, and so on — and the variations continue. Even the oval picture in an oval mat and oval frame reappears periodically. As time passes, artists' preferences may also change regarding their earlier mounting formats, or an artist may concede to the style of a period. For example, W. Eugene Smith traditionally preferred his photographs dry mounted to black or dark grey illustration boards, but in the 1970's he followed the advice of gallery director Lee Witkin and allowed his prints to be mounted and overmatted with white museum board.

Philip Katcher wrote that the design of a mat can give a good clue to the age of an image,[16] and William Adair made the following comment on the significance of frames:

> Picture frames may be seen to reflect not only the unique attributes and preferences of individual carvers and, in some instances, individual painters, but the prevailing artistic trends of the period. In so doing, frames merit study for their own sake as a barometer of artistic taste and form, providing a further means to recreate and appreciate the past.[17]

## The Practice of Dry Mounting

The practice of dry mounting is also subject to changing fashions and ideas influenced by concerns both for aesthetic effect and longevity. Respondents to this author's survey were divided between those who liked the way dry mounting looks (23%), those who did not (28%), those who liked it sometimes (43%), and those who had no opinion (5%). Over half thought that dry mounted prints are more vulnerable to damage, whereas 28% thought they are less

The edges of dry mounted photographs are especially vulnerable to damage. This 1934 black-and-white fiber-base print by Imogen Cunningham has been overmatted to prevent additional chipping of the emulsion. When the photographic paper is trimmed to the edges of the image, it is usually better to float the print within the overmat's window rather than cover the edges. This print is floating approximately ¼ inch to prevent putting pressure on the already damaged edges and to show the photographer's signature.

vulnerable and 21% had no opinion. Those active in the field of photographic conservation were as divided on this issue as were photographers, curators, collectors, dealers, and others.

Several individuals who had dry mounted their photographs in the past said that they no longer do. The consensus was that dry mounted prints are more difficult to take care of and that dry mounting obscures many of the physical qualities which distinguish the different print materials (such as paper thickness and flexibility). Dry mounting is generally discouraged by photographic conservators, in part because most dry mounting adhesives are not easily reversible and little is currently known about their long-term effects upon photographs. In addition, dry mounted prints cannot be wrapped around laser scanner drums to make halftones, duotones, and color separations for publications printing — a serious consideration in museum or other important collections. Since laser scanners have come into widespread use only during the last decade, this is a "new" drawback to dry mounting. (See Chapter 11.)

There were, however, many comments in favor of dry mounting. Laurence G. Miller, Director of the Laurence Miller Gallery in New York City, said, "Dry mounting works, such as Ray Metzker's 1966 composite 'Nude [Flashed] Torso,' which is composed of 140 separate prints mounted to a Plexiglas panel, is an excellent way to combine parts into a whole." Peter Wilsey made this remark with regard to edge control: "When cropping is *really* crucial, it helps to dry mount and float, rather than risk losing 1⁄16th of an inch behind the mat." The dry mounting format of Arnold Newman's photographs is familiar to people who know his work firsthand. Newman said, "I have prints I mounted back as far as 1938–39 and on — there has been *no* damage. When dry mounted and trimmed to the edge of the image, the print is subject to edge damage unless matted; better to print with a wide enough white border to sign on and then overmat." Photographer and writer David Vestal wrote, "I've had no bad experiences with dry mounting in . . . thirty years."[18]

In this author's opinion, a dry mounted print usually requires a mat to help protect the edges of the photographic paper from chipping. Matting is especially important if the print is trimmed to the edge of the image. In addition to protecting the edges, a mat minimizes the possibility of surface abrasion and fingerprints, can prevent the emulsion on the raised print from ferrotyping and even adhering to the glass in a frame, and protects the mount itself from damage.

Whatever method of mounting is selected, it will change the appearance of a finished print and affect practical decisions made by the photographer. For instance, prints that are properly dry mounted remain flatter than prints that are not dry mounted. This may be one reason that dry mounted prints are signed on the front more often than unmounted prints.

## The Signature

"A signature is generally regarded as an artist's approval of the final product, and as an indication of authenticity. I only sign things as they leave my hands so that I may edit freely up to that point," said Peter Wilsey.

Although in recent years more photographers have begun to place their signatures directly on the image (e.g., Mark Klett), the majority of photographs are signed just below the image on the blank border, or on the back. In general, it can be assumed that a photographer who signs his or her prints on the front intends the signature to be seen along with the print. Signatures on photographs are often treated differently, however, than signatures on other kinds of art works on paper. For example, when a signature is prominent, such as those of photographers Bill Brandt, Larry Fink, Barbara Morgan, and Edward Weston, curators and collectors frequently cover it with a mat, preferring to see only the photographic image. This seldom happens to a lithograph or a drawing because those media are generally thought to be more compatible with signatures.

A photographer's bold signature can affect the composition of a photograph and often shifts the viewer's focus from the image or adorns it without the photographer having intended to do so. On the other hand, many people find some dominant signatures attractive. For example, pho-

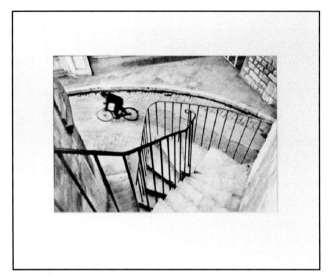 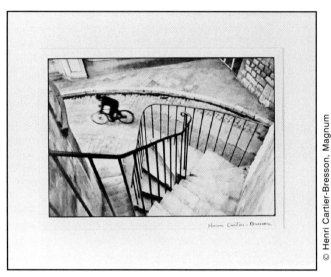

Some photographers print their pictures with narrow black borders surrounding the image. Such prints can be matted in a variety of ways: **(1)** float the entire image and black borders to show a narrow, moderate, or wide portion of the white photographic paper; **(2)** cut the overmat window so that its inner borders are flush with the outer edges of the black borders; **(3)** cover the black borders with the overmat. When the prints are signed, showing or covering the signature becomes the first consideration. The examples show a black-and-white fiber-base print by Henri Cartier-Bresson overmatted to a standard size with the signature and black border covered (left) and with the signature showing (right).

tographer and collector Susan Unterberg said that she prefers, when given the choice, to see a photograph without a visible signature, "unless the signature goes well with the image (i.e., Bill Brandt)."

Ansel Adams's small, lightly drawn signature which appears directly below his large-format photographs of monumental landscapes does not stand out and so it is rarely covered by an overmat. The same is true for Arnold Newman's photographs. Newman, who is best known for his photographic portraits, often dry mounts his black-and-white fiber-base prints on 2- or 4-ply 100% cotton fiber board and then carefully signs them in ink or with a graphite pencil directly below the image on the blank, untrimmed photographic paper, or on the mount board if the paper is trimmed to the edge of the image. Newman places his signature on the right side and the name of the subject and year the photograph was taken on the left. The writing is usually shown when his prints are matted both because it is small and attractive and because it frequently identifies portraits of famous people.

The personal stamps and seals of photographers are often regarded much as signatures. Hans Namuth's seal (applied with white, black, gold, or silver ink) appears either upon or just below the image of his color and black-and-white prints and is adjacent to his signature, which is also upon or directly below the image. In general, Namuth preferred to show these identifying marks; in a situation where the stamp was very close to the edge of the photographic paper, however, he allowed it to be covered in order to protect the edges of the print. Most of Namuth's color work was printed by Michael Wilder on the high-gloss, polyester-base version of professional Cibachrome II, Process P-3 (renamed Ilfochrome in 1990).

Photographers may have strong feelings about whether their signatures should be visible when their prints are

exhibited. Photographer Louis Faurer commented:

> Dependent on esthetic factors and on the artist's script, some signatures flow beautifully and some are ugly. Placing a signature on a photograph and or mat is crucial and important. For example, india ink I found on the white portion beneath the image often is distracting and spoils the entire image. Soft pencil on the photograph or beneath and or on the mat often "works." Grey ink could be experimented with. These suggestions indicate (to me) the vast differences between paintings and photographs.

Beaumont Newhall wrote, "The matter of the signing of prints is most interesting. I agree with [Faurer] that if a print is to be signed, it should be done with a hard pencil that will leave a very light grey impression."[19]

Newhall's interest in this area is also evident in his Aperture monograph *Frederick H. Evans,* in which Evans's great concern with presentation is discussed at length. Most of Evans's prints were mounted on multiple layers of toned or colored drawing papers, which were bordered with carefully ruled lines of light, sepia-colored ink or watercolor. In 1903, when Alfred Stieglitz expressed his disappointment with a shipment of Evans's unmounted prints, Evans replied, "When you come to see them trimmed, all the white margins off, and the picture in a sympathetic colour mount, you will think better of them."[20] The signature and title often appear below the picture within these borders, sometimes accompanied by Evans's familiar impressed monogram.

In such cases, no part of the design which the photographer intended to be seen should be omitted. However,

when a monogram appears isolated on the supporting paper away from the signature and outside the ruled borders, or when a monogram is located in an area that is visually distant from the print (such as those that were mounted on single-weight white weave paper after Evans's death), the monogram may be covered without violating the photographer's intentions, unless originally stated otherwise by the photographer.

Signatures are sometimes covered for consistency when matting prints made by different photographers whose works will be exhibited side by side. For example, one museum curator decided to cover Edward Weston's signature when preparing an exhibition in which none of the other prints were signed on the front. Individual wall labels provided the necessary information.

In general, historians and curators view signatures somewhat differently than dealers. Most historians and curators questioned in this author's survey, said that they wanted to see the photographer's signature when looking at prints in a study collection, although they did not object to the covering of signatures when prints are exhibited. Dealers, however, commonly prefer to show the signatures of prints they display for sale, particularly those of well-known photographers. Marthe M. Smith, former Director of the LIFE Gallery of Photography in New York City, encouraged photographers to sign the photographs she exhibited, most of which were famous images that appeared on the pages of *LIFE* magazine in decades past, thereby giving the photographer due recognition.

Beaumont Newhall wrote, "Personally, as a photographer, I sign my prints only at the request of the client if they are offered for sale. All my exhibition prints are unsigned because it seems to be redundant to appear over and over in one man exhibitions."[21] Newhall also commented, "Occasionally for historical purposes. . . a mat can have one window for the image and one window for the signature. We at George Eastman House did this with the vintage print of H. P. Robinson's 'Fading Away.' Beneath the photograph, about six inches or so below it, someone, presumably the photographer himself, had transcribed a poem by Shelley and this of course was an important part of his presentation."[22]

Some photographers' pictures are accompanied by written material which should never be covered. For example, the titles and texts that Duane Michals creates for (or before?) many of his photographs are not supplementary. They are each, words and picture, an integral part of the other; the writing sometimes even occupies more space than the photographic image. When presenting these pictures, the entire object should be shown.

Before signing (especially if there is uncertainty as to how and where to sign), photographers should give some consideration to how a print will look when matted and framed, especially if it is important that the signature be seen at all times. For example, if a signature is very large, the window opening may need to be made larger than ideal, which sometimes requires an increase in the desired overall size of the mat to allow for adequate borders. This affects the composition of the mounted work and may even disrupt a sequence of prints displayed together on a wall.

In addition, if a photograph is not printed with perfect 90° angles at all four corners, it is especially difficult to cut

a mat window with parallel borders all around the image; this may necessitate covering a signature that would otherwise be shown. When the photographer insists on showing a large signature on a dry mounted print, it may be better to frame the work in a fillet frame without a mat. However, this may require altering the original or preferred mounting procedure. (See Chapter 11 for a discussion of print markers.)

The decision to show or to cover a signature should be made by the photographer — who would ideally be advised by a curator or conservator beforehand of potential problems in matting and framing. This author often recommends "opening" the mat window to show both the signature and the four edges of the photographic image.

## Image Cropping

Image cropping should be initiated and done by the photographer only. The reason for this is obvious. The very act of taking a photograph involves cropping through the lens. While image format is predetermined by the camera, the photographer decides just what to include and what to omit in the frame. After that, a full-frame negative may be cropped in a variety of ways if the photographer wants to further refine the composition of the picture; it can be done at the time of printing, by trimming the finished print (e.g., when dry mounting), and by covering a portion of the image with an overmat.

Every detail of mounting, matting, and framing affects the visual impression of a picture. Cropping, however, actually changes a picture's composition and content. Unfortunately, cropping by people other than the photographer is common practice. For instance, framers are sometimes careless about measuring the windows in overmats. Publishers often prefer to print only a portion of a picture. Damaged and faded borders are frequently covered by overmats at the instructions of curators and collectors, and sometimes such borders are actually trimmed off.

Prints made for exhibition or publication have also been cropped to conform to prevailing moral attitudes. For example, more than 50 years after its exhibition at the Museum of Modern Art, there continued to be controversy over an Andre Kertesz photograph of a nude woman in which the pubic area was cropped out. Writing in 1982 in *The Wall Street Journal,* Raymond Sokolov said, "In Paris in 1933, [Kertesz] experimented with purposely distorted female nudes, surreal masterpieces with a mysteriously erotic charge. Beaumont Newhall would not exhibit one of them at New York's Museum of Modern Art in 1937 until he had bowdlerized it with some depilatory cropping. 'He mutilated my work,' says Kertesz."[23]

Kertesz often recalled the story. Questioned by this author in 1983, Kertesz gave the following details:[24] In 1936 he and his wife, Elizabeth, moved to New York City from Paris, where his reputation as an artist was well established. A few months after their arrival, they were visited at their hotel by Beaumont Newhall, Curator of Photography at the Museum of Modern Art at the time, who wanted to exhibit some of Kertesz's photographs. Kertesz replied, "Very natural. Take your choice." Newhall selected several photographs, among which was Distortion #172. "I wanted long before to exhibit in America. But it was diffi-

© Estate of Andre Kertesz

Distortion #172 by Andre Kertesz in its original composition (left) and a cropped version (right).

cult to find the possibility. Newhall made the possibility. I said, 'I am very glad you are choosing them. In Paris, Germany, and Central Europe they like the Distortions. I hope America likes, too'." In Kertesz's words, Newhall then asked, "Can I cut down the pornographic parts?"[25] Kertesz told this author he was confused by Newhall's question and said that cropping out the pubic area violated the picture as much as it would to crop out the woman's head or hands. "The woman's form is sculptural," stated the artist. Newhall continued to express his wish to exhibit the print. After more than an hour of discussion, Kertesz agreed to provide the museum with a cropped version of Distortion #172. Recalling his feelings during the meeting with Newhall, Kertesz said, "The representative of the big Museum of Modern Art in America talking this way? What can I do? In Paris I was accepted not 100 percent but 1000 percent. But this is America. I feel that I am cutting down my whole possibility here if I say no."

Sources familiar with the situation indicated that the cropping of the Kertesz print was the result of the Museum of Modern Art's policy in the 1930's which prohibited the exhibition of photographs that depicted pubic hair. According to one source who wishes to remain anonymous, the policy was initiated by the trustees of the Museum and was understood by the curators although it may not have existed in written form. Richard Oldenburg, present Director of the Museum, declined to comment on the matter. John Szarkowski, Director of the Department of Photography at the Museum, said, "I was 11 years old, going on twelve, when Beaumont Newhall allegedly 'mutilated' one

of Andre Kertesz's photographs, and it is pointless for me to speculate as to what really happened. I am confident that Newhall would not have changed the cropping of the photograph without Kertesz's permission."[26]

Asked about the incident, Beaumont Newhall said, "As to what you call 'the cropping of the Andre Kertesz photograph' is something I know nothing about. I have no recollection whatsoever of having 'mutilated' one of his prints. There is no way I can prove this, but I can certainly assure you that had such an action been taken in protest I would certainly have recollected it. . ."[27] Newhall went on to say:

> I hardly know a single photographer who does not object to the random cropping of his prints in publications, or for that matter in exhibitions. Cropping by the photographer himself, however, is a different matter. You probably know that Alfred Stieglitz actually advised photographers to crop their prints, and his famous photograph 'Winter on Fifth Avenue' of 1893 shows hardly one-third of the original negative image. . . I feel about cropping just as I do about mounting and framing. It is all important.[28]

Kertesz's Distortion #172 continues to exist in both cropped and uncropped versions; at the time of this writing (1983), according to print dealer Susan Harder, both were available for sale and for exhibition. Some of Kertesz's other negatives, such as Distortions #2, #6, and #76, were also cropped to create more than one variation, and each

of these three images appears in two different compositions among the 126 photographs in Kertesz's book *Distortions*.[29] Distortion #172 appears only once in the book, however, in its uncropped version.

In November 1983, the Pace/MacGill Gallery in New York City mounted an exhibition of Kertesz's Distortions. The show consisted of vintage prints, modern prints made specifically for the exhibit (some newly cropped by Kertesz as recently as September 1983), and of full-frame contact prints which were marked by Kertesz to indicate how they should be cropped. Also included was a modern print of the uncropped version of Distortion #172. Peter MacGill, Director of the Gallery, described the show as "a celebration of Kertesz's joy in working with his Distortions over half a century."[30]

Cropping a picture not only changes its content and alters it aesthetically but, when done by someone other than the artist, it can even legally invalidate a picture. In August 1983, New York State passed a law giving an artist the right to object to the alteration of his or her work and to legally disclaim authorship.[31] The bill stated that:

> . . . no person other than the artist or person acting with the artist's consent shall knowingly display in a place accessible to the public or publish a work of fine art of that artist or a reproduction thereof in an altered, defaced, mutilated or modified form if the work is displayed, published or reproduced as being the work of the artist. . . .[32]

Josh Barbanel reported in *The New York Times:*

> Some experts said the legislation could result in litigation over how a work is framed, how an exhibition is set up and how works are reproduced in a catalog. . . . The law was opposed by the major New York museums, including the Metropolitan Museum of Art and the Museum of Modern Art. It was supported by artists, some of whom complained that it did not go far enough.[33]

Clearly, the right to crop belongs only to the photographer who may, as Kertesz showed us, exercise that right more than once for a given picture and at any time in his life. While a photographer may be influenced or inspired by others throughout the process of making, re-making, or mounting a print — and that includes cropping — the photographer should always feel that he or she has made the decisions that put the work into its final form.

## Preparing Prints for Mounting — Aesthetic Considerations

Mounting materials should be selected not only for correct chemical and material composition but also for their aesthetic qualities. In addition to providing physical protection for the prints, the design and construction of the mounts should be visually harmonizing.

Carefully planned and well-designed presentation contributes to the appreciation of photographic prints, as it does for other media. In general, good presentation design enhances an image without embellishing it, and draws a viewer's attention to the content of the work without at-

tracting attention to itself. In the case of Frederick Evans, however, he *chose* to embellish his work. As mentioned earlier, presentation was of great concern to Evans, who imbued every nuance of it with his attention. For example, he decided to mount one of his portraits of Aubrey Beardsley within a decorative border that Beardsley had drawn for the book *Le Morte d'Arthur*.[34] In his book *Frederick H. Evans,* Beaumont Newhall pointed to Evans's involvement in exhibition design:

> The vertical division of the walls into panels was shocking at a time when little thought was given to the arrangement of photographs on exhibition beyond fitting as many as possible on the allotted wall space. [Ward] Muir was greatly impressed: "The amount of trouble he has taken over the hanging alone is hardly credible. Each picture had to be considered in relation to the others. Its tint, its size, its frame, its mount, its subject — all these were kept in view. Again and again a frame was tried in a certain spot, only to be rejected because the eye of the designer adjudged it to be unsatisfactory. In consequence of this extreme fastidiousness in grouping, every picture has an equal chance to look effective. Not a few of the photographs show up better on the Salon walls than they did when received one by one on selection day. This means that a master-brain has been at work. Each section of the wall is itself a sermon in massing and composition."[35]

Sometimes overstated presentation design can have a negative effect on a viewer. Referring to pioneering images in the 1987 exhibition *Gordon Parks: A Retrospective,* Andy Grundberg wrote in *The New York Times:*

> The show commits. . . crimes in the name of art. Perhaps to make the black-and-white pictures from Life look more imposing, many have been enlarged to 20-by-30 inches, surrounded by black mat board and signed on the image in silver ink. To try to inflate the images to esthetic proportions in this way misses what made them interesting as photographs in the first place, and seriously distorts their original meanings.[36]

When it is not part of the photographer's "creation," presentation design and format should be understated. In any case, it should not compete with a print. That is to say, for example, that a mat and frame are most successful when they are barely noticed — *unless the photographer wants them to be noticed*. Good presentation requires a sensitivity to the individual image and the photographer's intentions, to the print material and the mounting materials, and to the fine details of each as well as to the compatible or incompatible relationships between the various tones, finishes, textures, proportions, and overall composition. Naturally, personal taste is always an important factor. Also, what is noticed at one time or in one place may not be noticed at another time or somewhere else. Furthermore, the exhibition or viewing environment will have a signifi-

cant effect on every other decision. Finally, it is important to remember that there are no absolutes when it comes to the presentation of art.

The following paragraphs illustrate how visual sensitivity to the presentation of photographs can be expressed in the matting and mounting.

Many of Helen Levitt's black-and-white photographs are printed on Agfa Portriga-Rapid Paper. The rich, warm tones and fine details in these prints, qualities that are particularly evident in the dark areas of the images, are enhanced in modest-sized overmats (about 3-inch borders) that are made with a warm-white or beige-toned board which has a smooth, matte finish. A narrow bevel at the edges of the windows — that is, about a 60° bevel cut into a thin board such as 2-ply, or a medium board such as 4-ply, rather than a thick bevel cut into 8-ply board — lessens the contrast between the mat and the image. (The primary function of the bevelled edge is to avoid casting shadows on the photograph where the edges of the image meet the mat. The highlight or shadow on the bevel itself may be narrow or wide depending on the thickness of the board, the angle of the bevel, and the angle of the lighting.)

Ralph Gibson's black-and-white prints made on Agfa Brovira Paper, on the other hand, are often complemented by oversized (borders 4 inches or wider), bright white, smooth-surfaced mats which reflect Gibson's aesthetics. The beveled edges in 4-ply or thicker mats do not conflict with the high-contrast black and white areas that predominate in many of these prints, and, in this author's opinion, provide a better visual balance than 2-ply mats.

Eikoh Hosoe's high-contrast black-and-white photographs are also complemented when matted with a bright white, minimally textured board. Many of his prints, composed of crystalline details between solid expanses of striking blacks and whites, are effectively presented when seen within moderate-size borders in well-crafted window mats.

Two-ply board in a light, warm tone is often the most suitable choice for matting Emmet Gowin's 8x10-inch, contact-printed, toned black-and-white silver-gelatin prints. Four-ply is sometimes too heavy visually, and bright white looks harsh beside the hushed tones in his fine prints. Here again, as with the majority of photographic prints, the mount board should have a smooth, matte finish.

Gowin has strong feelings about what are the correct proportions for mounting his prints and decides just when to deviate from a standard format. For example, many of his prints which look attractive in standard 14x17-inch mats look even better in non-standard mats that are 14x15½ inches. Gowin exercises control in this area both by making many of his own mats and by carefully instructing others who do the matting.

An example of photographs that were successfully presented in a deliberately decorative style, tipped by hand onto mounts of colored card and Japanese tissue, were the facsimile reproductions contained in Alfred Stieglitz's quarterly publication *Camera Work* (1903–17).

When finished prints are not mounted or individually housed in any way, and the photographer — or another person who understands and is intimately involved with the work — is not available, decisions regarding mats, mounts, print cases, and so on will need to be made by other people, who should try to learn the intentions of the photographer.

For example, print dealers might seek the advice of historians and conservators. It is often helpful to study the materials that the photographer had been known to use and to compare them with artists' papers and boards that are currently available.

Sometimes a dealer or curator will go so far as to try to recreate a historical paper. Such was the case when Susan Harder called upon papermakers at Dieu Donne Press & Paper in New York City to prepare an "antique vellum" for mounting the Andre Kertesz contact-printed photographs in the 1982 portfolio published by Harder and the Orminda Corporation.

## Selecting a Board Texture

When preparing artistic photographs for display, it is important to be aware of the surface textures and finishes (e.g., high gloss, semi-gloss, matte, rough, or smooth) of both print materials and mount boards. In general, papers and boards for mounting most photographs should have minimal or subtle surface texture — or texture that is not noticeable — for both aesthetic and conservation reasons.

The surfaces of most photographs are smooth, and a smooth-surfaced mount board is usually more harmonious visually. In fact, most respondents to this author's survey, who notice the surface texture of boards, prefer smooth-textured board for matting and mounting photographs.[37] However, contrasting textures may be exactly what a photographer wants. For example, high-gloss surfaces of print materials such as Ilfochrome polyester-base are simultaneously accentuated by and conflict with a rough-surfaced board. Also, many 19th-century prints are complemented in highly textured mats.

Another factor should be considered when selecting board texture: Smooth-surfaced boards are less likely to scratch or physically alter the surfaces of print materials. Exaggerated board texture can even interfere with the proper mounting of prints, particularly total-surface mounting.

The surface textures of 100% cotton fiber board are generally smooth but vary somewhat among different manufacturers. An experienced worker can often identify a manufacturer's board by its texture alone; it is common, however, for a particular board from the same manufacturer to change slightly from batch to batch. Occasionally, some boards vary significantly from batch to batch.

The visual characteristics of nonbuffered 100% cotton fiber mount boards are comparable to alkaline-buffered 100% cotton fiber mount boards. Generally speaking, for example, the surface textures of nonbuffered and alkaline-buffered Rising Museum Mounting Boards are the same, whereas their texture is usually slightly smoother than the very lightly textured Process Materials Archivart Museum Board and Archivart Photographic Board, both buffered and nonbuffered.

Chemically processed acid-free wood pulp board (e.g., Conservation Board, Conservamat) usually differs very little visually from manufacturer to manufacturer — unless it belongs to one of the lines of composite or markedly textured boards such as Bainbridge Alphamount and Andrews/ Nelson/Whitehead Phase 7 (which was discontinued when the company merged with Crestwood Paper Company to become ANW-Crestwood). So-called conservation board is

usually quite smooth with a matte finish that may have a slight sheen. Light Impressions Exeter Conservation Board has a more pronounced texture with a "lustrous" finish. Neither 100% cotton fiber mount board nor purified wood pulp board manufactured in this country is shiny (as are some high surface bristol boards). However, Atlantis Paper Company in England distributes a specially designed nonbuffered museum board which has a surface closer to a plate-finish bristol.

Several composite boards on the market offer a wide range of textures, most of which are similar to pastel papers; Bainbridge Alphamat and Crescent Rag Mat are examples. Canson Fine Art boards are surfaced with pastel and drawing papers imported from France, and available in the United States from ANW-Crestwood, Morilla Company, Winsor & Newton, Inc., and others.

You will see texture most clearly defined by holding a piece of board perpendicular to a directional light source (at least 4 inches away) so that shadows are cast by the surface formations on the board. Turn the board three times in order to see the texture from four directions. Then inspect the reverse side to see whether the texture looks different. This method of examination exaggerates the texture and facilitates comparisons between different boards.

## Selecting a Board Tone or Color

As discussed in Chapter 13, research indicates that some photographs may be harmed by an alkaline environment. Although this author recommends that nonbuffered boards of neutral pH be used with most photographs, nonbuffered board is not yet manufactured in enough sizes, thicknesses, and tones to satisfy the various requirements of all the people involved in the care and presentation of photographs and certainly not enough to satisfy photographers.

For example, Roy L. Perkinson, Conservator at the Museum of Fine Arts in Boston, said, "The off-white tone of nonbuffered board is not suitable for everything. We are back to the problem faced by artists and curators when there was only one color of museum board available. The Museum uses nonbuffered board for its color prints (less than 5% of the total collection) and wherever off-white is suitable."[38] (Process Materials Archivart Photographic Board was available only in off-white in 1982. Since then, several nonbuffered boards have been introduced in white and/or antique tones by Archivart, Parsons, Rising, and other companies.)

Andre Kertesz also stated the challenge clearly: "Pure white is not good for everything. Pure white is too strong for many pictures. Pictures should go out of the frame, not stay in the frame imprisoned in the white."[39]

Nonbuffered boards must be available in a greater variety of tones and thicknesses if they are to be used more widely to mount photographs. Aesthetic concerns frequently overwhelm concerns for preservation, and buffered boards (and even low-quality boards) are often selected because they provide the desired visual effect. When time and money allow, mats may be lined with thin polyester sheets, as discussed later in this chapter, or the prints themselves may be enclosed in polyester sheets to separate them from potentially harmful board.

The colors and tones of a print are affected by the tones or colors that surround it. Ansel Adams said, "The problem is not necessarily to *match* the color and value of the print, but to select a mount of harmonizing or complementary tonality."[40] In 1965, in preparing his prints for exhibition at Huntington Hartford's Gallery of Modern Art in New York City, Irving Penn "examined every type of mat board available on the market and found that none met his standards for correct color; so all the mats were covered with a white gesso of Penn's choice."[41] (See Chapter 13 for a discussion of the color stability of white, toned, and colored mount boards.)

In general, photographs are not enhanced by brightly colored mount boards. The neutral tones of white, off-white, ivory, beige, and gray are much preferred, although there may be occasions when photographers and even museum curators are attracted to highly colored mount boards for their exhibitions. On the other hand, snapshots and personal photos are often enhanced by lively colored mats and frames.

Most white and neutral tones have some color. For example, off-white can look slightly yellow or slightly pink. An antique-toned board, such as Rising's, can be "pinkish," or, in the case of Parsons' antique board, it can be "greenish." A gray can look "greenish," "bluish," "purplish," "reddish," and so on. The exact tone selected to mount a particular print usually depends on personal preference. A few general guidelines, however, should be noted. For example, untoned black-and-white silver-gelatin prints often appear to take on a blue or green tone when mounted on cream-colored boards. Such boards can also muddle the highlights in black-and-white prints.

Many modern black-and-white prints need a bright white board such as the following cotton fiber boards: *Parsons Brite White Photographic; Archivart White Photographic; Rising White Photomount;* ANW-Crestwood Lenox; James River White; Archivart Extra White; or Strathmore White. Other black-and-white prints look better mounted on neutral gray board, or on a slightly off-white board such as ANW-Crestwood Gemini; *Archivart Off-white Photographic Board;* Miller Shell White; Rising Warm White; or Strathmore Natural. (Note: All the above boards are alkaline-buffered except the four printed in italics, which are nonbuffered.)

Fresson Quadrichromie prints are characterized by their muted colors and low-resolution, "soft-focus" images. An off-white board normally complements their colors whereas a stark white can be noticeably in contrast to them.

When asked what tone of board was preferred for matting and mounting most photographic prints, conservator Mary Kay Porter said that it would depend on the degree of highlight yellowing of the print. This is an important consideration. If the highlight areas of a print are already yellow or will yellow with the passage of time, an off-white or darker board will look better than a bright white board. For example, unlike Dye Transfer and Ilfochrome prints, Ektacolor and Polaroid prints will yellow to varying degrees as they age. In addition, the highlight areas of newly processed Ektacolor prints are not as white as the highlight areas of most Dye Transfer prints.

Color perception by the human eye varies with the type and intensity of lighting. The colors of a print will look brighter as the light intensity increases; in addition, the

colors will look *different* under tungsten, fluorescent, or daylight illumination. Colors and tones may also differ if they are viewed with the light source directly in front, from an oblique side angle, directly from above, or by indirect illumination.

Boards and papers which contain fluorescent brighteners will look different under different lighting conditions in comparison to materials that do not have such brighteners. (Most current photographic papers contain fluorescent brighteners, whereas most cotton fiber museum boards do not.) Under tungsten illumination, however, fluorescent brighteners have very little effect. When photographs themselves contain fluorescent brighteners — as all modern black-and-white prints do — it is more difficult to select the proper tone of mount board.

It is always best to view mounting materials alongside the print to be mounted and, whenever possible, together under the same lighting conditions in which the print will be displayed. (See Chapter 17.)

Another consideration when selecting the most appropriate tone of board is the translucence of the print material. Albumen prints, photogravures on Japanese tissue, and other lightweight prints should be mounted on a backing of very white, smooth board to maximize the brightness of the prints and to enhance the degree to which the details and various tones are visible. An ivory or gray-toned board will make a slightly translucent print appear dull, diminish highlights, and obscure subtle details. However, if writing or printing exists on the back of the print and shows through when the print is placed on white board, the print should usually be mounted on a darker board.

Unfortunately, common framing glass casts a slight green tint and Plexiglas UF-3 (an ultra-violet filtering grade) casts a pale yellow tint over the print and mat. Normal grades of Plexiglas are water-clear without a tint. (See Chapter 15.)

In addition to textures and tones, the tactile qualities, such as structural behavior and responses, tensile and bending strength, further define the character of a given paper or board.

### Becoming Acquainted with a Variety Of Mount Boards and Artists' Papers

Mount boards and artists' papers (for interleaving, making mounting corners, etc.) can be purchased from art supply stores and mail-order companies (see **Suppliers List:** *High-Quality Boards and Papers* at the end of this chapter). One may become acquainted with the variety of available products and their different weights, thicknesses, surface textures, tones, and colors by obtaining samples and sample booklets. Samples are rarely large enough, however, to make an accurate judgment before mounting an individual print or body of work. Whenever possible, boards and papers should be seen, studied, and touched — and compared directly with the work to be mounted — before a final decision is made. As previously discussed, every decision made by the photographer becomes a part of the total work and, if the materials chosen are long-lasting, the mat and/or mount may accompany the photograph throughout its existence.

The quality and selection of mounting materials should be determined at least in part by the stability characteris-

tics of the print itself. For example, with an unstable print material the finest matting materials may not be necessary unless plans are made to replace the displayed print with a duplicate when it has faded or otherwise deteriorated significantly. Unfortunately, in the case of many color photographs, the mounting materials are likely to outlast the useful life of the prints.

## Section Three: The Composition, Marketing, and Use of Mount Boards

The mounting and enclosure papers,[42] plastics, and adhesives that are in contact with photographs during storage and display should be selected with many considerations in mind. From a conservation point of view, the long-term effects of a material on a given photographic material are most important. In addition, knowledge of the composition of each material is essential. Following these, the physical characteristics of the enclosure and mounting materials (such as size, weight, strength, stiffness, and so on) should be evaluated with regard to the individual physical requirements of the print.

Other factors to consider when selecting enclosure and mounting materials and the most appropriate form of physical protection for photographs are:

1. Intended use of the prints (e.g., museum and public exhibition, private display, study collection, traveling exhibition, storage, sale)

2. Short-term vs. long-term conditions (e.g., temporary display vs. permanent display)

3. Available funds

4. Inherent stability characteristics of the photographic material(s)

5. Desired life expectancy of the photographs

6. Aesthetic preferences

7. Estimated frequency of handling

8. Size and location of the display area

9. Available storage space

10. Anticipated expansion of the collection

Not enough is presently known about how most mounting materials affect photographic images, emulsions, and support materials, and it is difficult therefore to know how to best choose from among the many products available. That a mount board or enclosure paper is well made according to the highest standards of the paper industry does not automatically qualify it for safeguarding photographs. In addition, the few existing standards that do apply to the manufacture of papers used with photographs[43] have been subject to debate by conservators and photographic scientists. For example, questions remain about what pH value is optimal for mount boards and enclosure papers for the many different color and black-and-white photographic materials. (See Chapter 13.)

## Board Composition —
## Cotton Fiber And Wood Fiber

Most high-quality mount boards that are specifically intended for photographs are distinguished from other high-quality mount boards only by the absence of alkaline-buffering agents (calcium carbonate and/or magnesium carbonate). These boards are made from the same raw materials as are other solid (i.e., not composite) high-quality mount boards, of which there are two primary types: "museum" board and "conservation" board.[44] Museum board is made from 100% cotton fiber pulp, which usually consists of cotton linters fibers but may be made of rags or of a combination of both (see Chapter 13, page 468).

Conservation board is made from wood fiber pulp which has been cooked, bleached, washed, and extensively refined to remove lignin and other impurities. There are currently no standards defining what is a conservation board. Some composite boards, such as Bainbridge Alphamat, Cardcrafts Astromat, Crescent Rag Mat, and Miller Ultimat, which are alkaline-buffered and made with at least three different papers each, are also referred to in the marketplace as conservation boards.

## Physical Requirements and
## Other Considerations

Board for mounting pictures should meet the following *physical* requirements:

1. Be rigid enough to support its own weight without bending (e.g., standing on any of its four edges against a wall)

2. Have adequate strength to support the selected print(s) without bowing more than slightly when held with two hands at opposite edges

3. Have both the required and desired degree of surface smoothness

4. Have a compact density which favors smooth cutting and sharp, clean bevelling

5. Be reasonably resistant to impact without breaking

6. Be free from warpage

Depending on size, ply, and the intended application, most high-quality mount boards made of rags, cotton linters, and wood pulp usually meet these requirements. Closer examination is required, therefore, to make meaningful comparisons. The best 100% cotton fiber papers and boards are strong yet flexible, whereas the best wood pulp boards are usually less so. (In the case of mount boards, however, superior flexible strength is not as critical as are such factors as chemical inertness, hardness, and smoothness.)[45]

Most currently available conservation boards made of chemically purified wood cellulose are usually quite stiff and can adequately support most prints. These boards, however, do not withstand pressure as well as most 100% cotton fiber boards. During handling and shipping, the corners of conservation boards are somewhat more vulnerable to being crushed on impact. When they are, the damaged area loses all stiffness. Of course, 100% cotton fiber boards are also vulnerable to crushing, but in general, wood pulp board lacks the resilient strength of board made from cotton.

Boards made of chemically purified wood pulp cost approximately ⅓ less than cotton fiber boards; generally, conservation boards can provide the necessary physical protection for many collections and are quite suitable for mounting unstable types of photographs such as most polyethylene-resin-coated (RC) color prints intended for display. For longer-lasting prints, such as correctly processed black-and-white fiber-base prints, cotton fiber boards are recommended.

## Descriptive Terms

Learning the material composition of a mount board and deciding its most appropriate application can be difficult, particularly on the consumer level, because boards are described by many different terms, such as "museum board," "rag board," "mount board," and "conservation board." Chi C. Chen, former Technical Director of Rising Paper Company, ascribed the variety of terms and names for artists' papers and boards in part to the manufacturers' attempts to describe the intended use or a suitable use of a product by naming it, for example, "museum mounting board."

Still, it is often difficult to know what one is purchasing because descriptive names are sometimes not accurate. For instance, James River Ragmount was not made from rags during its last several years on the market. Light Impressions incorrectly describes its mount board by labeling it "Museum Quality 100% Rag Board" when, in fact, the board is made from cotton linters. In another example, Crescent Cardboard Company calls its 100% cotton fiber board, which is made from cotton linters, "Rag Mat 100." Employing the term "rag" to describe a product that does not contain any rags is misleading.

Addressing this concern, Alden W. Hamilton, former Manager of Commercial Development for James River Corporation, remarked that his company did not maintain that its Ragmount was always made from rags. The company simply continued to use the name by which its first 100% cotton fiber mount board became known (when it was made from cotton rags).[46] For several years, until 1985 when the company discontinued marketing boards under its own name, James River Ragmount was made from 100% cotton linters fibers without any rag content.

Contrary to the widespread industry practice of using cotton linters fibers to make museum mount boards, Bainbridge has claimed to be using rags:

> If you prefer working with rag board, then Alpharag board is for you. These archival boards are made with Cotton Rag materials. They are carefully manufactured to an alkaline pH to provide maximum conservation protection. The 100% Cotton Rag composition of Alpharag board is carefully controlled to ensure the greatest strength and cleanest appearance. This board is unique in its use of a high percentage of actual cotton rags, rather than cotton linters.[47]

Is Alpharag board made from 100% cotton rags or a high percentage of 100% cotton rags? According to Bainbridge

Product Manager, Kate McCarthy, Alpharag specifications require 100% cotton rags, but that when suitable rags are in short supply a small percentage of cotton linters may be used. McCarthy said, "We prefer rags to linters because, in our minds, a rag paper is a better product. It is stronger and more durable. The rags used to make our board are purified to the point that there are no dangerous residual chemicals in the final product."[48]

While board made from rags can be superior, because of the additional processing required when rags are used, this author doubts that currently available cotton rags are better than linters in the manufacture of museum boards for photographic applications.

## Cotton and Rag Content

Each company has its own "standards" regarding board composition, which may change because of normal limitations in the industry. For example, many paper companies state that their sources of cotton fiber vary and that they depend on the supply available at a particular time. It is possible, in other words, for a given paper product to be made in January from paper pulps that differ from those used in July. When this author asked paper manufacturers if their cotton sources vary, some said yes and some said no (see Chapter 13, Appendix 2: *Letter to Paper Companies*). Speaking for Rising Paper Company, Chi C. Chen helped to clarify this matter:

> Our suppliers do not vary. *Their* sources, however, vary. We use the same suppliers every time we order cotton. There are a limited number of suppliers — also called "jobbers" — for the paper manufacturing industry and these suppliers go to the same market for their materials. One month they may buy North Carolina cotton, the next time they may buy Texas cotton. Availability of cotton depends upon numerous factors in the market. Nearly all 100% cotton fiber mount boards have been made at some time from combinations of cotton rags and cotton linters fibers although most, if not all, are now made from linters only. The grades of rags and cotton linters can and do vary. For instance, rags come from numerous sources: textile mills, clothing manufacturers, and waste dealers including sources outside the United States. In Africa, rags are collected today by peddlers similar to those with horse drawn wagons in the 19th century that traveled from house to house asking for old clothes. When enough rags and old clothes have been gathered, they are brought to a warehouse where they are sorted and then shipped to various places, including European and United States markets, for use in the paper industry. . . .
>
> If you think papermaking is purely science, it's not. Papermaking is still a great art. There are variables that change every day, every season, every year. The availability and quality of materials, technical information, equipment, skill,

economic conditions, environmental factors, market supply and demand, amount of control over these conditions and factors, aesthetics, time, and inspiration all affect the quality of the final product.[49]

Kurt R. Schaefer, former Manager of Product Development for Strathmore Products Group of the Strathmore Paper Company, remarked: "All Strathmore Museum Mounting Boards and papers are manufactured, tested, and inspected in Strathmore Paper Company Mills. . . . Occasionally our cotton fiber sources vary. . . . Strathmore maintains strict standards for the quality of cotton to be used in its papers, and uses only the best available."[50] According to Marketing and Product Development Manager David Pottenger,[51] Strathmore once processed its own rags. It now purchases cotton rags and cotton linters from the same primary sources as other paper mills. Pottenger explained that cotton rags are rarely used exclusively because they are in such short supply and are generally supplementary to other forms of cotton fibers in paper manufacturing. He said that Strathmore Museum Mounting Board is currently made from 100% cotton linters fibers. Although both cotton rags and cotton linters are used by the company, Strathmore does not use the word "rag" to describe any of its products in its advertising literature. Even Strathmore Bristol, which is always made of cotton rags (because, as Pottenger explained, it is not possible to produce bristol with the same physical characteristics when other forms of cotton are used), is described in its product literature as "100% cotton paper."[52]

The American Paper Institute (API) concurs with the term "100% cotton fiber" for describing papers made entirely from cellulose derived from cotton regardless of the cotton's origin (e.g., linters, textile waste, rags).[53] It is certainly better to use the term "100% cotton fiber" when describing any all cotton fiber paper — even one that is made from cotton rags — than to call a 100% cotton linters paper "all rag"; however, API contributes to the terminological confusion by also sanctioning the term "rag" to describe papers made from cotton linters fibers.[54,55]

The World Print Council draws attention to the problem of terminology regarding cotton fiber paper. It defined "rag content" as:

> A term describing the amount of cotton fiber relative to the total amount of material used in the making of certain kinds of paper. It is expressed as a percentage, such as 100% rag content or 80% rag content. The term, though popular, is losing its meaning since more and more high quality paper is made, not from rag, but from linters.[56]

Except in this last source, use of the term "rag" to describe papers made with non-rag forms of cotton fibers is used throughout the published literature reviewed by this author. With respect to its former place in papermaking terminology, however, the term is archaic. The time has come for paper manufacturers, distributors, and consumers to abandon the term "rag" except for papers actually and consistently made from rags.

## The Museum Board Manufacturing Industry

This author's research revealed that there are only five companies in the United States that manufacture museum mount board. They are: Parsons Paper Company, Rising Paper Company, Strathmore Paper Company, Monadnock Paper Mills, and James River Corporation.

*(Note: Until November 1989, coinciding with the merger of Andrews/Nelson/Whitehead and Crestwood Paper Company, Beckett Paper Company also was a manufacturer of mount board. In 1990, Process Materials Corporation became known as Archivart Division of Heller & Usdan, Inc. and, in April 1991, James River mount board and art papers division came under the control of Custom Papers Group, Inc. The bulk of the writing of this chapter was done in 1983, and references to A/N/W, Beckett, Crestwood, James River, and Process Materials in the following discussion are for the most part left unchanged.)*

Of the five manufacturers, only Parsons, Rising, and Strathmore distribute mount board under their own names. James River and Monadnock operate mills but market their products only through major distributors, who in turn sell to smaller distributors and retailers. It is startling to discover that all of the hundreds of other companies in the mount board business — operating as convertors, distributors, or retailers — sell board produced by one or more of these five manufacturers. Rising and Strathmore are the only two companies among the five whose products are widely recognized by name within the consumer market.

In addition to the five manufacturers, there are several major distributors who label mount board and who are mistakenly thought to be manufacturers. These include: Andrews/Nelson/Whitehead-Crestwood; Archivart Division of Heller & Usdan, Inc.; Cardcrafts, Inc.; The Columbia Corporation; Crescent Cardboard Company; Hurlock Company, Inc.; Light Impressions Corporation; Miller Cardboard Corporation; Morilla, Inc.; Nielsen & Bainbridge; Rupaco Paper Corporation; and University Products, Inc.

Three of the manufacturers (Parsons, Rising, and Strathmore) and four of the major distributors (ANW-Crestwood, Process Materials [Archivart], Light Impressions, and University Products) sell their boards primarily to the museum and fine art markets. Nielsen & Bainbridge, Cardcrafts, Columbia, Crescent, Hurlock, Miller, Morilla, and Rupaco also sell their boards in the museum marketplace but sell more of their products to high-volume framing shops, retail stores, and interior design establishments; these eight distributors are also convertors, which means that they purchase base board from one or more paper manufacturers and then "convert" it into another product, such as a textured composite mat board, by laminating fabric or paper to the two sides of the base board.

There are other companies, such as Howard Paper Mills, Inc. and Mohawk Paper Company, that do not sell boards but manufacture a variety of papers, some of which are laminated to base boards to create matboards and some that are used in conservation work. The importance of knowing which company makes what product becomes more apparent when papers and mount boards are routinely tested to determine their suitability for long-term use with photographs, and the results of the tests are published.

## Proprietary Labeling

Given the terminological confusion and variations in raw materials, the solution to the problem of knowing what constitutes a particular product — and what effect that product can be expected to have on photographs — might seem to be simply to contact the manufacturers and ask them how and with what their boards are made. Unfortunately, the manufacturer may be difficult to identify or reluctant to provide information. For example, many paper companies purchase a particular paper product made by one or more mills and then label it with a name not associated with the true manufacturer(s). This practice, known as "private labeling," is common.

Some convertor-distributors imply in their advertisements that they make board, although in fact they do not. While several distributors "produce" board by assigning specifications ("specs") to a manufacturer, other companies simply purchase board ready-made and sell it as their own; often the same board is given different names by different distributors. At times it is impossible to know with certainty what board is being sold and of what materials the board is composed. Many distributors and retail outlets sell a given type of board made by more than one manufacturer, and when it is cut to small sizes and re-wrapped in plain brown paper, it may even be impossible for them to know which board is what.

Rising Paper Company has a policy of not selling board to distributors who would obscure the Rising label by re-naming, or "de-naming," it. According to Dennis O'Connor, former Marketing Manager of the company, "Rising does not sell board to any convertors or distributors who 'private label' the product or sell it under their own name. If the carton doesn't say 'Rising' then it's not."[57] This policy may be difficult to enforce. For example, samples of board examined by this author showed that Hurlock Company and Miller Cardboard Corporation have both offered Rising boards under their own names, in addition to selling other boards made by other manufacturers. (Hurlock and Miller are convertors and so some of the composite boards they market are their own products in that the "combinations" are unique.)

The conversion of papers and boards into composite products and the shared distribution of one company's product are legitimate activities. The unavailability of accurate product information from the many different companies, however, creates confusion in the marketplace, particularly among photographers and conservators, and those doing research in conservation, who need to know exactly what product they are using, where it is available, and under what name or names.

None of the manufacturers (i.e., Beckett, James River, Monadnock, Parsons, Rising, and Strathmore) were willing to provide this author with information about the distributing companies that market their mount boards under proprietary brand names. Speaking for James River, Alden Hamilton explained that although his company is concerned with needs on the consumer level, as a major manufacturer that operates many mills and produces many paper products, it is primarily merchant-oriented and must, necessarily, protect its customers. In other words, its market

consists almost entirely of convertors and authorized distributors who may and do label, with industry approval, the paper products as their own without identifying the manufacturer. Similar statements were made by spokespersons for the other manufacturers in the United States.

All distributors expressed concern about the publication of such information. One feared that customers would contact the manufacturers directly, thereby cutting into their business. Another worried that customers might doubt the quality of their products. Although these are valid concerns, such information would not displace the traditional and valuable position that distributors maintain in the marketing of boards to retailers.

Although proprietary information could not be obtained from the manufacturers, industry sources revealed that this is a volatile market and one in which many distributors not only put their own labels on mount boards but also readily change mills or employ various mills for the manufacture of a particular paper product — without notifying customers — depending on which company offers the lowest bid, can meet delivery schedules, and can satisfy product specifications at a given time.

Dennis Inch, who has headed the development of archival products at Light Impressions Corporation since 1975, spoke on behalf of his and other companies that engage different mills: "It is necessary to change mills at times because rising prices create competition. In addition, if we stay with one supplier, we have no back-up when the need arises."[58] At various times, therefore, the "same" board will have been made by different manufacturers. Although the basic formula and the applied standards for manufacture may remain the same, when the manufacturing company is different, it is inevitable that there will be some variation in the final product caused by the different machinery, water supply, and other factors.

Until approximately January 1985, the nonbuffered off-white photographic boards sold by both Process Materials (now Archivart) and Light Impressions were made for the two companies by James River. This author believes that Strathmore began to make Process Materials nonbuffered boards some time in 1985; Strathmore had been the manufacturer of Process Materials solid-color museum boards for many years.

In the Light Impressions 1985 catalog, the company no longer listed the off-white photographic board; instead, two "Non-Buffered 100% Rag Boards" (Bright White and Cream) were offered. Examination of a sample of the Bright White board in June 1985 indicated that it was made by either Parsons or Rising, although the company would neither confirm nor deny this. In 1986, the board appeared to be manufactured by Parsons. Industry sources indicated that some of Light Impressions' mount boards were not even bought from manufacturers, but rather from other distributors. Ron Emerson, Technical Assistant and Accounts Manager for Light Impressions, explained the predicament: "We are not trying to hide information from our customers. We are simply unwilling to make a commitment in a situation that is constantly changing."[59]

Other examples of proprietary labeling: the 100% cotton fiber mount boards distributed by Nielsen & Bainbridge and by Crescent Cardboard Company have been made, ac-

cording to each company's specifications, by Parsons in Holyoke, Massachusetts, while Bainbridge Alphamount has been made by James River in Fitchburg, Massachusetts.

Composite boards are frequently assembled from products made by two or more manufacturers. The base boards (core) and surface papers are commonly made at different mills, while the backing papers may be made at yet another mill. The convertor then laminates the three products together, or assigns the task to an outside laminating company. Informed sources reported that James River has manufactured the high-quality white core board for Bainbridge Alphamat, Cardcrafts Astromat, and Miller Ultimat, while Parsons has made the cotton fiber core board for Crescent Rag Mat. This author did not learn who manufactures the surface and backing papers for these boards, but believes the high-stability surface papers on Bainbridge Alphamat and Crescent Rag Mat are made by Strathmore.

There are, meanwhile, different degrees of obfuscation in the area of proprietary labeling. For example, some companies such as A/N/W openly stated that they did not operate paper mills and were, in fact, distributors for papers and boards, some of which were manufactured according to their specifications. Andrews/Nelson/Whitehead distributed many artists' and specialty papers, both domestic and imported, and in nearly every case the papers retained their original names and labels, and their paper samples were accompanied by a listing of over 65 paper mills and manufacturers, titled "Heralding Our Mills." Among the exceptions, unfortunately, were its mount boards and the A/N/W Interleaving Paper.

Looking back, Andrews/Nelson/Whitehead was the first paper company to develop a 100% cotton fiber mount board. In 1928, the company gave their first set of specifications to the Valley Paper Company, which manufactured the board until the late 1960's. For several years after that, the 100% cotton fiber mount boards known as *Gemini* and *W & A* were made at the Rising paper mill. When demand for mount board increased in the early 1970's, Rising Paper Company discontinued making board for Andrews/Nelson/Whitehead and focused on producing its own line of museum boards. Andrews/Nelson/Whitehead retained both the names and the formulas for the two boards — which have, at various times, been made by Beckett Paper Company, James River Corporation, and Monadnock Paper Mills. A/N/W said that their museum board was consistent in quality and composition, and that there were no alterations of the formulas, regardless of the fact that they worked with more than one paper mill, because, according to the company, "each mill adheres strictly to the Andrews/Nelson/Whitehead specifications."[60]

Crestwood Paper Company (which merged with A/N/W in 1989) sells museum, photographic, and conservation boards made by Rising and identifies the boards as such. It also sells other museum-quality boards under the Crestwood brand name. Asked about their board, Vice President Michael S. Ginsburg replied that Parsons was the manufacturer of Crestwood-labeled boards, and said that if customers requested such information, he would provide it: "I'm interested in the customer relationship — not only the sale — and in building a reputation as someone who can be trusted for information about the products I sell."[61]

It is possible that different mills may be manufacturing the above distributors' boards by the time this book has gone to press in late 1992, and that there will continue to be changes afterward.

In contrast to this, there are a few companies, such as Talas (Division of Technical Library Service, Inc.), that do not assign proprietary names to any boards they carry. Talas, an important resource for information about materials and people involved in museum and library conservation work, and the long-time supplier of many related products, sells mount boards made by Parsons and Rising paper companies and identifies the boards as such.

Arno Roessler, President of Paper Technologies, Inc., believes that the consumer should be informed of a board's ingredients and expected performance, but he feels that it is more important to know *with what* and *how* a board is made than it is to know *who* made it. He also pointed out that not only can a distributor change mills and formulas without notifying the consumer, but that mills can also make significant changes within their own range of varying conditions without notifying the distributors. Roessler stressed that experience, expertise, and maximum control over the many stages of papermaking are most important — from setting the specifications to determining composition and special techniques, which may have to be employed to meet all of the requirements for the intended end use. Roessler, who is well-known for his service to the museum and archive community, commented that independent producers such as his company and Process Materials (Archivart) usually have more latitude than manufacturers in setting up specifications and in designing products for specialty markets such as the field of photographic conservation.[62]

Operations in the paper industry are obviously complex and, in some cases, it may be difficult to denounce the practice of private labeling, particularly when the labeled product is unique and not available from any other company under any other name. Proprietary labeling at its worst, however, is a form of deception that usually springs from a fear of competition. Companies should concern themselves less with maintaining exclusivity in the marketplace and concentrate on providing a consistently high quality of services, products, and information and with establishing a credible market for the good of the whole industry. Private labeling in the paper industry — as well as in other industries — does not benefit the consumer and, in the long run, may actually cause considerable harm.

Knowing the specific composition of a paper product is required by those doing conservation research if they are to understand the mechanisms by which a product affects a photographic material. For example, if a particular laminating adhesive proves to be harmful to certain kinds of photographs, it would be essential to know which boards contain that adhesive. In addition, the manufacturer must be identifiable because the information obtained in testing a distributor's board is almost useless if the distributor changes mills. Finally, when complete product information is provided, a photographer is better able to set exacting standards for the materials used in his or her work.

This author recommends, in the case of high-quality mount boards and papers, that every manufacturer and distributor follow the example set by Atlantis Paper Company in England and identify not only the particular paper mill and the converting company (if any) but also provide a list of the product's contents, manufacturing specifications (including a *clearly identifiable* lot number), and photographic reactivity tests. The list should be included with every package. This is discussed at length in Chapter 13.

A print held in a conservation mat with mounting corners.

## Section Four: Constructing a Conservation Mat

Conservation mounting[63] is distinguished from other types of mounting in that its primary purpose is to help preserve the photograph it supports. A conservation mount usually requires an overmat to fulfill this purpose. The unit consisting of the overmat and the mount is called a "conservation mat." This flat enclosure can be opened like a book and contains one or more properly mounted prints; it is made of carefully selected materials including stable, nonreactive adhesives and two or more pieces of high-quality mount board or artists' paper in which one or more windows have been cut to facilitate viewing of the enclosed print or prints.

The making of a conservation mat requires knowledge, attention, skill, and taste in the areas of **(1)** materials, **(2)** construction, **(3)** design, and **(4)** craftsmanship.

1. The **materials** should be chosen first for their composition, which should promote the long-term preservation of the photograph; the boards and adhesives for mounting a print cannot properly be selected until the specific physical, chemical, and aesthetic requirements of the individual print are known.

2. The **construction** of a mat should be determined by the print material's specific structural requirements, so that adequate physical support and protection will be provided during handling, storage, display, and transportation; in addition, the construction should facilitate handling without being cumbersome.

3. The **design** of the mounting should enhance the picture without altering it or being decorative unless this is part of the photographer's intention; in addition, the design should separate the photograph from (or, in some

May 1988

Mario Santiago of Crestwood Paper Company (New York/New Jersey) operates one of the company's two large computerized paper cutting machines. Most major paper distributors have at least one such machine to cut down large sheets and/ or thick stacks of mount board and paper to customers' required sizes. (In October 1989, Crestwood merged with Andrews/Nelson/Whitehead to become ANW-Crestwood Paper Company.)

cases, deliberately connect it to) the surrounding environment. In general, a mat is visually most successful when it is barely noticed.

4. Finally, the quality of the **craftsmanship** should express the feelings and the respect that the photographer and caretaker have for the work.

Although the selection of materials and the construction of a conservation mat are often primarily determined by the need for image preservation and physical protection, and although design and craftsmanship are usually primarily related to presentation aesthetics, *all four areas are interdependent.*

### Purchasing Mount Board

Mount board can be purchased from art supply stores, mail-order companies, and wholesale paper distributors. Board purchased by the individual sheet may cost twice as much or more as that purchased by the carton but, unless the customer is representing an institution or business and purchases a large quantity (average minimum: 25–50 sheets, or one carton), a wholesale distributor is unlikely to accept an order.

Prices are normally discounted according to the quantity ordered. Customers requiring fewer than 25 sheets may purchase board through retail art supply stores and mail-order companies such as Conservation Resources International, Inc., Light Impressions Corporation, Talas, Inc., and University Products, Inc. These companies also accept orders for large quantities of boards and, for some products, may require a minimum order. Manufacturers can supply a list of wholesale distributors (and sometimes of retailers) that sell their products in a particular geographic area. Distributors can provide lists of local retailers. (See **Suppliers List** at the end of this chapter.)

Full cartons of mount board contain 10, 25, 50, or 100 sheets depending on size, ply (thickness), and tone. In the United States, the most common full-sheet sizes of mount board are 32x40 inches and 40x60 inches. Full-sheet sizes are generally determined by the manufacturer or distributor, although in special situations board can be made in sizes specified by the customer. The most common thicknesses available are 2-ply and 4-ply, although some companies offer 1-ply, 6-ply, and 8-ply. One-ply museum board is usually about 12.5 points, or approximately 1/80–1/64 inch thick.[64] The exact thickness measurement of 1-ply varies between different boards and different manufacturers (see **Appendix 12.2:** *Mount Board Thickness*).

### Ordering Board Cut to Size

Mount board is most often sold in full sheets which have to be cut into smaller pieces for use. The term "sheet" refers to full, uncut board or paper as it arrives from the manufacturer or "sheeter" (one who cuts board and paper into industry standard or specified sizes directly from the roll or web). The term "piece" refers to sections of board extracted from full sheets.

Archivart, Light Impressions, Paper Technologies, University Products, and some other distributors sell packages of pre-cut board in standard sizes. Most distributors and mail-order companies have equipment to cut sheets into pieces of requested sizes for a fee based on either quantity or weight of the total order. This service is valuable to users who do not have the capability to cut large sheets or large quantities of board. The quality of their cutting is usually superior to that done by the user. It is not uncommon, however, to receive board that is 1/16 inch larger or smaller in one or both directions and that is cut at an angle which deviates slightly from the 90° standard. Even so, precise cutting of this type is still more likely done by a machine than by hand.

Mount board commonly expands and shrinks in variable-humidity environments, so the cutter may or may not

be responsible for dimensional errors. When requesting the cutting of board to size, state that the board pieces should be *"square and exact"* and *"well-wrapped."*

Also specify at the time of ordering that you want the off-cuts, which are sometimes referred to as "waste." Large off-cuts (e.g., 8x20 inches, 10x40 inches) are excellent tabletop protectors and better suited as a cutting surface than most materials. (For example, Masonite is too hard and dense, and chipboard is too soft. One of the keys to consistently clean, sharp cutting is to cut into the same material that is being cut through.) Small off-cuts are useful as "blotter" surfaces upon which binding tape can be moistened. Some off-cuts may be large enough to be made into small mats.

If more off-cuts (and window cut-outs) accumulate than can be used, contact a local school or an organization such as Materials for the Arts in New York City. Materials for the Arts welcomes all kinds of supplies and distributes the donations to nonprofit educational and cultural organizations that in turn give the materials to children, students, and artists.[65] Whether your surplus is small or large, pass it along to someone who can use it.

## Cutting Board to Size

When planning a "cutting map" (see **Figure 12.1**) and before marking measurements on a full sheet, confirm the overall size of the board. Board may deviate from its designated size by as much as ¼ inch and occasionally more. It is particularly important to check the exact width and length at all four corners — not only in the middle — when cutting a full sheet into equal-sized pieces, such as when dividing one 32x40-inch sheet in half twice to make four 16x20-inch pieces. Planning ahead can prevent unnecessary work and expense later.

## Board Grain

It is sometimes possible to draw up a cutting map that takes grain direction into account. It is widely known that it is easier to cut, tear, and fold paper along its grain than to do so against (across) its grain. The reason for considering grain direction in matmaking, however, is that a board's flexibility is usually greater in one direction, and this will help determine the overall strength of the mount and/or mat. The degree of flexibility for a given piece of board depends on the direction of the grain relative to the board's size and proportions, as well as on the board's thickness, density, and material composition. (High-humidity environments will cause boards to bend more easily.)

Until recently most full sheets of high-quality boards were cut "grain long" by the manufacturer. This means that the grain runs parallel to the longer side. A board that has been cut "grain long" will bend and warp less than the same board with its grain running parallel to the shorter side. In this author's experience, the grain direction of full sheets of 32x40-inch mount board has usually been parallel to the 40-inch side, while the grain direction of 40x60-inch mount board has been consistently parallel to the 60-inch side.[66] Check with the distributor or manufacturer to confirm this, each time board is ordered.

In general, whenever possible, the longer sides of the cut-out board pieces should be parallel to the grain. Con-

**Figure 12.1:** An example of a board map made prior to cutting a sheet of 40x60-inch board. Small pencil marks should be made in two locations for each cut, and not full length lines as pictured above.

sideration of grain direction is especially important when cutting large mats and mats with narrow borders. Sometimes, the strongest construction requires a combination of grain directions, with the backing being "grain long" and the overmat "grain short." This depends on the shape of the mat, the thickness and density of the board, the width of the borders, the placement of the window, as well as the physical characteristics of the print. Unfortunately, in most institutions and frame shops, grain direction cannot usually be taken into account when cutting board to size.

## Standard Sizes

Standard sizes are those that are used most frequently and are most commonly available. In time, some standard sizes may change as dictated both by aesthetics and by economic considerations in the marketplace.

Knowledge of standard sizes is helpful for a variety of reasons. Standardization simplifies storing, packaging, shipping, and display requirements, and usually reduces costs and waste. In addition, standard sizes can play an important role in presentation. For example, it is gener-

ally easier to study a series of related prints that are the same or nearly the same size than it is to study prints of a combination of markedly different sizes and proportions. Claude Minotto, Chief of the Archives Division of the Archives Nationales du Quebec in Montreal, wrote:

> Through careful design and interpretation, an exhibition or a publication can offer the intimacy, the integrity, and the exclusivity of well-selected photographs. "Into the Silent Land" thus proved an amazingly successful journey. Another feature, however, may have accounted partly for the success of that early western photography exhibition: coherence and continuity of image and frame sizes — a standardization of format well understood now by cinematography and television.[67]

On the other hand, some people do not believe that standard sizes are as desirable. Photographer Victor Schrager made the following remark:

> In general, I think it is an excellent thing that care and intelligence contribute to more sensitive and knowledgeable presentation and preservation of photographs. However, there has been a tendency for a "standard" presentation of pictures — from printing and size decisions to matting to exhibition design and conception — which is unimaginative. . . . Preservation does not have to be conservative.

## Checking Board Shipments

Board should be inspected when it arrives to assure that it is in good condition and that it is exactly what was ordered. Board with serious manufacturing defects discovered later will almost always be accepted for exchange, but returns of stock that has been damaged by improper handling will most likely not be accepted by a distributor more than a week or so after delivery.

The same type and brand of board will be slightly different each time it is purchased (if it has been made at different times) because of minor inconsistencies inherent in the paper manufacturing process. There will be subtle variations in surface texture and finish, color, tone, density, flexibility, thickness, and so forth. The differences, however, should not be significant. When absolute consistency is necessary (e.g., portfolio mounting), the entire amount of board needed for a project should be purchased at one time; specify that the board should all come from the same manufactured lot — *not* according to the distributor's lot. Distributors' lots often consist of more than one manufactured lot.

When purchasing board at full retail prices, each sheet should be nearly perfect. When buying board on the wholesale level, expect 1–5% of the stock to have some noticeable *handling* flaws such as minor surface impressions, dents, scratches, clamp marks, fingerprints, occasional stains, and other imperfections caused during handling, cutting to size, packaging, and shipping. Boards with these type of defects are usually the first and last ones in the packages.

## What Sizes Are Standard for Photography?

The standard sizes of mats, frames, and storage cases for photographic prints evolved from the sizes that have long been used in museums for collections of drawings, watercolors, lithographs, and so forth. It was not until the 1970's that widespread consideration was given to the particular sizes and proportions of photographic prints. The standard size of 16x22 inches, which continues to be used by many museums primarily for works of art other than photographs, has been nearly replaced by photographers, curators of photographic collections, and photography dealers with the size of 16x20 inches. Another museum standard size, 14x18 inches, continues to be used to mat and mount photographs, particularly those made from full-frame 35mm negatives and transparencies. In the mid-1970's, 14x17 inches, a size which was not common before 1970, was often requested and is now a common size for matting 8x10-inch contact prints in particular. The 20x24-inch size is usually substituted for the museum standard size of 19x24 inches.

The most frequently used standard sizes for mounting and framing photographic prints are the following:[68]

> 8x10 inches
> 11x14 inches
> 14x17 inches
> 14x18 inches
> 16x20 inches
> 20x24 inches
> 22x26 inches
> 22x28 inches
> 24x30 inches
> 30x40 inches
> 40x60 inches

The following standard sizes are used less frequently:

> 9x12 inches
> 12x14½ inches
> 13x15 inches
> 16x22 inches
> 18x22 inches
> 18x24 inches
> 19x24 inches
> 20x26 inches

In addition, there will occasionally be *manufacturing* defects, which can include splinters, insects, discoloration, separation of plies, defective lamination, structural warping, flaking, feathering, lumps or flocculation (i.e., high-density areas), air pockets, fissures, uneven dye or pigment distribution, and extreme color variations from batch to batch. When more than 10–15% (i.e., 15 or more sheets out of 100) of a shipment is seriously flawed — handling damages and manufacturing defects combined — the entire shipment should be returned to the distributor as soon as possible for exchange or credit. Flawed board should not be used because it compromises the quality of the finished work, whether it shows or not.

Paper companies generally appreciate customers' comments, both favorable and critical, because discussing the problems helps them to provide better quality control, better products, and better service. Chi C. Chen, former Technical Director of Rising Paper Company, said, "Comments, criticism and recommendations from our customers help us to produce mount board that can better satisfy the consumers' needs. The more customers understand about paper, the more comfortable they will feel about using it."[69]

## Opening Packages of Board

If the outside of a newly received package of board is damaged, remove the wrapping entirely. If the board has been significantly damaged, rewrap it in the original wrapping and return it. If the board is not damaged, thoroughly wash your hands and remove at least two sheets or pieces of board from the middle of the package to check its condition, to identify the front and back sides, and to confirm the size, ply, finish, texture, and tone. Then inspect the two outside sheets. Compare the surfaces of sheets in different packages for consistency.

Board should be held to a light source to examine color and clarity (absence or presence of insects, bubbles, etc.). Foreign matter trapped between plies is usually found only when the board is cut through at the defect or if light is projected through the board. A large light box or light table is excellent for finding flaws before cutting. Defects will also show up immediately if one holds a board perpendicular and very close to the open side of a Luxor or similar lamp containing a 100-watt bulb.

## Marking Board to Assure Correct Alignment When Assembling Mats

If the board has passed its first examination, return it to its original position in the package. (Other defects will become evident when the board is selected for use, at which time another inspection should be done. Soiled or damaged wrappings should always be replaced with clean paper.) Using a drafting pencil with a medium-hard lead (i.e., H or 2H is best) that does not have a sharp point, press lightly while drawing a straight line along one side of the open package of board, marking only the outside edge of every piece from the top to the bottom in the same location, which should be either to the left or to the right of the center, or near one corner. Each package of board within a given type, tone, and size should be marked at a slightly different location (but *not* in the center).

The line serves as a guide in matching the overmat board to the backing when the two pieces are taken from the same package. This is often necessary because board is rarely cut with perfect 90° angles at the four corners; a difference between two boards is instantly noticeable when one piece is reversed — or after the binding tape has been applied and the mat is closed. When board is pre-cut to size, a mat should ideally be made of two consecutive pieces from one package. In portfolios, it is important to match the front and back boards closely for the sake of appearance, to speed the process of alignment, and to eliminate potential problems of fitting the mounted prints into cases and frames. One must also make certain that each mat

matches every other mat in size as closely as possible, and no two mats in the same portfolio case should vary in size by more than 1/16 inch.

For general purposes, the refinement of matching fronts and backs in a single mat is not essential provided that the difference between the two boards is not instantly noticeable, or does not exceed 1/16 inch. Also, larger size differences between the overmat and backing board should not exist in mats intended for framing — unless those mats fit properly into the frames and the overmat and backing are aligned along the *bottom* edge of the mat. Individuals with exacting standards, however, will not tolerate more than a 1/32-inch difference between the overmat and the backing in any case, both for aesthetic reasons and because the construction may be compromised, risking damage to certain types of prints in certain situations.

## Labeling Board

Packages of board should be identified on the wrapping paper or on a shelf label. The label should carry a date (e.g., order date or delivery date), the corresponding distributor's invoice number, the manufacturer's lot number, if known, and should identify the manufacturer and distributor as well as the type, size, ply, and color of the board (see **Figure 12.2**: *Diagram of Board Label*).

When board is removed from its packaging, it should be protected in closed cabinets on shelving made of a nonreactive material such as steel with a baked-enamel coating, and its label should appear on its shelf or door. Do not stack boards of different sizes directly on top of each other because surface impressions or bowing may result.

This author's preferred grouping is as follows: First separate board according to type (e.g., alkaline-buffered 100% cotton fiber board, nonbuffered photographic board, conservation board, etc.). Each type should then be separated into tones and colors. Within each tone or color, different sizes should be grouped together and then, within each size, different thicknesses should be separated. If more than one manufacturer is represented, that distinction should be clearly indicated.

All packages of paper and board (whether for printing, mounting, hinging, interleaving, or other purposes) should be stored horizontally on a flat surface at least 2 inches from the floor to keep the packages clean and safe from accidental spills or flooding and to reduce moisture absorption and warping. When horizontal storage is not possible for large cartons of board (32x40 inches and larger), it is recommended that the cartons stand so that the grain runs vertically; to minimize warping, the cartons should be rotated at least every 3 months so that the sides facing the supporting wall are turned around to face outward.

---

6/16/92 #312A-CW / Rising Photomount 20x24 4-W

---

**Figure 12.2:** Sample diagram of a board label. It is helpful in many stages of working to use abbreviations and symbols for identification. For example, the designation "4-W" refers to "4-ply white." Off-white board can be designated "OW."

## Making a Conservation Mat

To make a conservation mat, you will need:

1. A clean, well-lighted area
2. The appropriate boards and papers
3. The appropriate adhesives and tapes
4. A flat, sturdy table or counter
5. Tabletop protection (e.g., expendable mount board)
6. A heavy-gauge, stainless-steel straightedge or T-square
7. A thin, very finely incremented plastic or stainless-steel ruler (preferably Gaebel Model 1057)[71]
8. One or more cutting instruments with sharp blades
9. Extra blades
10. Sharp scissors
11. Drafting pencils with 2H and H leads
12. A pencil sharpener
13. Clean erasers (such as Eberhard Faber Kneaded Rubber and Faber Castell Magic Rub 1954)[72]
14. Clean, soft, undyed, lint-free, cotton wiping cloths or white paper towels
15. An undyed cellulose sponge
16. Clean water in a shallow glass bowl
17. A burnisher
18. A paperweight
19. Interleaving paper
20. Polyethylene bags and packaging materials,[73] or storage case
21. An open mind so that "inventions can develop naturally with the work"[74]

## The Basic Steps

1. Wash hands
2. Apply a fresh, tabletop protector
3. Sharpen pencils and clean tools
4. Clean blades with a disposable paper towel
5. Wash hands again
6. Select the mount board, paper, and tape
7. Inspect the mount board for flaws
8. Measure the print
9. Apply the measurements to the board with a pencil
10. Remove the print from the work area
11. Cut the outer dimensions, if necessary
12. Cut the window in the overmat
13. Erase all measurement markings
14. Burnish all edges, inside and outside, front and back
15. Compare the window with the print for mistakes
16. If necessary, repeat steps 5 through 15
17. Bind the overmat to the backing with the proper tape
18. Copy all information appearing on the back of the print
19. Position the print inside the mat
20. Close the mat to double-check the print's position
21. Place a protective paper on top of the print
22. Place a suitable weight on top of the protective paper
23. Install the print with mounting corners and/or hinges
24. Trim the mounting corners, if necessary
25. Write down the date and what materials were used
26. Either frame the mounted print, or insert interleaving paper between the print and the overmat and place it into a polyethylene bag, a storage case, or a drawer
27. Clean up

## The Working Environment

It is important to separate the two activities of matting and framing since they involve two different and incompatible work environments. Dry mounting is another activity that should be done in its own meticulously clean area. Most paper and board dust created when mats are made does not present a serious threat to photographs since it is not inherently abrasive and is usually easy to remove. (Photographs to be matted or framed should be covered at all times except when they are being inspected, measured, mounted, and installed.) This dust interferes, however, when it clings to glass or Plexiglas during the cleaning and assembling of frames, and during dry mounting procedures.

Frames should be constructed in a well-ventilated and spacious area away from prints and mounting materials. The wood, aluminum, plastic, and glass dust, splinters, and chips that are created when frames are made are extremely harmful to the surfaces of photographic prints, which are very easily scratched. Mount board is also easily damaged in a framing environment. Frames and prints should not be brought together until the frames are completely cleaned, partially assembled, and ready to receive the properly mounted and/or matted prints.

The areas in which matting and framing are done and where materials are stored should be vacuumed every working day. Ideally, they should have a controlled temperature of about 70°F (21°C) with the relative humidity maintained at about 50%. Prints and mounts can warp when they are displayed or stored in an environment with relative humidity that is either higher or lower than the one in which the prints were mounted and framed. The same can occur when prints are mounted and then framed under two different environments.

In 1984, Bark Frameworks, Inc. in New York City installed a climate-controlling system to help maintain moderate temperature and relative humidity levels in its workshop. In 1986, A.P.F., Inc. moved to a new 78,000 square foot facility in the Bronx, New York, which was equipped with environmental controls in the finishing and fitting departments.[70]

Work areas should be well illuminated. If possible, both fluorescent lighting and tungsten incandescent lighting should be available to more accurately determine how each mounted print will look in its intended display environment. Smoking, drinking, and eating in the mounting and framing vicinities should be prohibited at all times.

## Board Size and Thickness: 2-Ply versus 4-Ply, or More

The size, thickness, weight, and flexibility of a print determine the necessary size, thickness, weight, and stiffness of the materials needed to mount and mat it. Also included among the many factors to be considered in selecting board *thickness* are:

1. The print condition

2. The board's ability to properly support a print either as a mount or as an overmat combined with a mount

3. Intended use of the mounted print

4. Available funds

5. Aesthetic preferences

6. Available storage space

7. Overall storing, carrying, and shipping weight

In every case of matting an unmounted print, the backing or support section of the mat should be stiffer and larger than the print material. That is, the mount should be rigid enough — when held at its outer edges with two hands — to hold the print without bending under the weight of the print; the mount should also be rigid enough to support the overmat. In addition, the overmat and mount should always be large enough so that the edges of the print material are not exposed and subject to handling.

For identification purposes, a print on paper that is 8x10 inches to 16x20 inches is considered *medium-size* and a print on paper with measurements outside that range is considered *large* or *small*. (*Mats* that are 11x14 inches to 20x24 inches are considered "medium-size.")

Photographic prints larger than 16x20 inches should not be matted with 2-ply board. Prints that are 16x20 inches should usually be matted with 4-ply board; however, a 2-ply overmat attached to a 4-ply backing on the *long* side is usually secure and unyielding to most sorts of bending which could harm the print. Warped prints of any size should not be matted with 2-ply board on either side.

Many people want a 4-ply overmat because they like the way it looks but try to save money and/or space by using 2-ply board for the backing. A 4-ply overmat should not be attached to a 2-ply backing for any size print because the backing will bend under the weight of the print *because* it is attached to a stiffer and heavier overmat — even during careful handling — and preclude proper support, possibly causing damage to the print inside. In certain situations, however, such as when a print is dry mounted to a board that is the same size as the mat and the three boards will be framed together, a 2-ply backing with a 4-ply overmat may be acceptable.

Most prints that are loaned or sent out on traveling exhibition should be overmatted and backed with 4-ply boards, although sometimes 2-ply overmats attached to 4-ply backings are adequate. A 4-ply overmat is nearly always preferred if a print is to be framed. The thicker overmat will lessen the chance of the print surface contacting, and possibly "ferrotyping," or sticking to, the framing glass. Also, the thicker the mat the greater its effectiveness in minimizing print curl which can result with fiber-base prints over a period of years as a consequence of cycling relative humidity.

## Lightweight Mats

Lightweight mats made with 1- or 2-ply board are often desired for economic, practical, or aesthetic reasons. Board that is 2-ply costs about half as much and is half as thick as the same board which is 4-ply, and it requires less storage space. Lightweight mats may be preferred when weight is a critical factor; they are particularly desirable in cased portfolios and in very large collections.

Sometimes small prints can be matted with a variety of heavyweight artists' papers, which also have the advantage of being available in a very wide range of surface finishes, textures, and tones.

## Designing a Mat

Many measurements must be taken in the course of designing a mat. Before the overall size of the mat can be determined, the following dimensions must be known:

1. The size of the *photographic paper*

2. The size of the *image* on the photographic paper

Given these minimal constraints — that the mat will be larger than the photographic paper and that the mat window will be either smaller, the same size, or larger than the image — there is much room in which to exercise judgment and to express personal taste.

It is important to keep in mind that the composition of a picture can be affected by the design of the mat. Therefore, before any additional measuring is done, the following factors should be considered:

1. The composition of the picture

2. The proportion of the print (e.g., square, square-horizontal, long-horizontal, vertical)

3. Showing or covering the signature

4. Covering the edges of the image, floating the image, or floating the entire sheet of photographic paper

5. If the print will float, the width of the float considered in relation to the composition of the picture and to all vertical and horizontal "bars" in the image (such as poles, doors, stripes, lines, and so forth) as well as to the mat borders

6. If the print will float, whether the print is perfectly square at its four corners

7. The possible overall sizes of the mat

8. The possible mat proportions and directions (i.e., horizontal mat, vertical mat, or square mat)

9. The potential placement of the print (e.g., horizontal print on horizontal mat, horizontal print on vertical mat)

10. The window size relative to the possible mat sizes (e.g., small window in large mat)

11. The potential width of the right and left side borders (which should be equal to each other for mats that have only one window) relative to the potential top and bottom borders

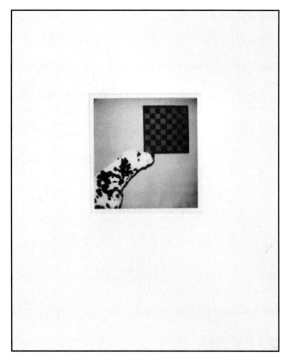

Don Rodan's Polaroid SX-70 color photograph "Cerberus" (of Leo and Toiny Castelli's beloved dalmation, Patrick) was matted twice to better judge the effect of each design. The version on the left is a standard 8x10-inch size, while the version on the right is a 10x10-inch square conforming to the proportions of the original print. (Photograph from **The Greek Myths** [1976–78])

### Selecting a Mat Size

If a standard mat size is desired, the print should be viewed on the three or four most likely standard sizes. For example, an 8x10-inch print could be placed on 11x14-, 14x17-, and 16x20-inch pieces of board. Simply center the print on each of the pieces and see what looks best to you.

If the mat can be a custom size (that is, determined by the unique composition of the particular photographic image and by the personal preferences of the photographer or caretaker), place the print on a board that is about four times larger than the print. Move the print from side to side and from top to bottom to determine the ideal border widths. For the inexperienced eye, it can be difficult to judge the effect, particularly if some part of the photographic paper or image is to be covered in the final design. L-shaped pieces of board, a few inches wide and several inches long, are sometimes helpful as guides.

Another approach is to place the print on the closest "best" standard size board and then make the desired alterations.

When not predetermined by a factor such as an existing frame, the size of the mat is usually a matter of personal taste. Even when selecting from among standard sizes, the photographer or caretaker may prefer narrow borders or ample borders, tall, slender mats or short, wide mats, square mats or vertical mats, and so on.

As indicated, mat size and proportion can affect the composition of an image, and it is possible to maintain the overall balance of a picture, unbalance it, or change the balance simply by increasing or decreasing overall mat size and/or increasing or decreasing individual borders.

### Placement of the Window

After the overall size of the mat has been decided, the location of the window will need to be determined. The border of the mat below the picture will usually appear to be slightly narrower than the top and side borders if all borders are equal in width. To establish a visual balance, therefore, the bottom border should be somewhat wider than the top border. Some people always make the bottom border ½ inch wider than the top border. A perfect balance cannot, however, be set by such rules.

Precise placement always depends on the individual picture image, the already-mentioned considerations, and the ideas of the person(s) involved with the mounting. In addition, two entirely or somewhat different designs may be equally pleasing. For example, some people prefer vertical mats regardless of whether the print is vertical, square, or horizontal. (Paul Strand's horizontal prints are almost always mounted on vertical boards.) No formulas can prescribe invariably ideal placement or perfect design. There may, however, be an existing condition that predetermines or partially controls the design.

For example, a photograph printed on paper that is the same or nearly the same size as the mat predetermines the location of the window. This is always the case if trimming the photographic paper is to be avoided. For this and other reasons, placement of the image on the photographic paper at the time of printing should be determined very carefully.

This is especially important when the photographs have been printed on artists' papers that have distinctive edges. For example, the owners of a portfolio of Edward Steichen

© 1976 Thomas Walther

Thomas Walther's abstraction was photographed in the streets of London and printed by the Fresson Quadrichromie pigment color process. Walther considered two different formats for the print, which was matted to the standard size of 16x20 inches. The horizontal mat emphasizes the image's horizontal composition, while the vertical mat emphasizes the vertical directions of the forms. In one viewer's opinion, the image in the horizontal format appears "content to just sit," while the image in the vertical format appears to be more restless and "ready to move."

photographs, printed by the gravure process on Rives BFK paper with deckled edges, requested that the prints be matted for physical protection. The size of the paper varied from 15⅝x19¾ inches to 15⅝x19⅞ inches. Image sizes varied from small to large, and they were both vertical and horizontal in direction. This author decided to mat the prints with 16x20-inch 4-ply Rising Warm White museum board.[75] It was possible to mat the prints in a standard size close to the paper sizes because all the images were printed in a precise and straight position on the paper.

## Print Borders

When a photograph has not been positioned properly on the paper at the time of printing, it may be possible to compensate for the error when matting. For example, the image can be raised or lowered or straightened in its mat if the photographic paper is smaller than the mat or if trimming of the photographic paper is permitted.

In general, the trimming of print borders should be discouraged.[76] This author recommends that photographers print their pictures so that moderate paper borders of approximately 1–3 inches, and not less than ¾ inch, surround the image area. For example, 8x10-inch images should be printed on 11x14-inch paper. On the other hand, excessive borders — such as, borders wider than 6 inches for large prints — should be avoided. One reason for this is that the larger the paper, the more difficult it is to handle safely. In addition, matting prints which have very large borders often requires trimming off the excess, an operation that risks damaging the print. Dye Transfer prints, however, should have borders that are at least 2 inches wide because approximately ½ inch usually needs to be trimmed

off to remove warped edges. (See further discussion of borders in the section on "Mounting Corner Design.")

Photographs that are to be matted should ideally be printed on paper which is *at least* ½ inch smaller all around than the mat to prevent it from extending outside the mat and to provide space inside the mat for taping down mounting corners. For example, an 11x14-inch image printed on 16x20-inch paper, which will have a 16x20-inch mat will require trimming to safely mat it. Trimming off only ⅛ inch is sometimes sufficient; however, a 1- to 2-inch margin of space between the edges of the print paper and the edges of the mat is much better.

Most enlarging easels have limited or no capability for printing images precisely centered on a sheet of photographic paper; suitable easels which have fully adjustable margins on *all four sides* of the paper are available from The Saunders Group and Omega/Arkay (Kostiner Div.).[77]

In addition to centering photographs, extra care should be taken to assure that the four corners of the print are perfectly square. This is especially important if the print will float in the overmat window or if a minimal amount of cropping is desired.

## Positioning and Measuring the Print

A good ruler is essential for measuring prints. It should be made of stainless steel or plastic, be very thin (shallow depth), have rounded corners, and have finely marked, exact increments. In addition, the ruler should have a small space to the left and right sides of the calibrated scale to facilitate placing and lifting it. An excellent ruler for measuring most window mats is the 24-inch Gaebel Model 1057. (See **Suppliers List** at the end of this chapter.)

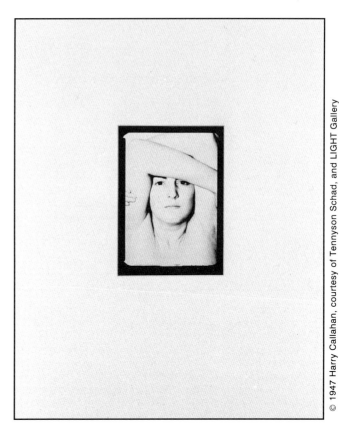

The visual impression of a picture can be changed by the matting. Harry Callahan's photograph of his wife Eleanor can look "delicate, low-key, and light," or "strong, bold, and full of contrast," due simply to covering or showing the black borders around the image.   A totally black border or a very narrow black border would create two other impressions.

Place the front of the board face down in a horizontal or vertical direction depending on which way the mat will be viewed.   Then position the print on the board, either horizontally or vertically.   Do not rest the ruler on the surface of the image but rather place it so that its edge will be alongside an outside edge of the image.   Now measure the width of the image from the left to the right — both at the top of the print and at the bottom.   If any additional area around the print should be visible within the overmat window, add this to the measurements.   Subtract the width of the window from the width of the mat.   Divide the sum by two.   The resulting figure is the width of the right and the left mat borders, which should be equal.

For example, an 8x10-inch horizontal image in a 14x17-inch horizontal mat will have 3½-inch borders at the right and left sides, plus whatever is to be cropped out at the edges of the image (or minus whatever is desired for a float around the image).   If the image will not float and the least amount of cropping is desired, about ¹⁄₃₂ to ¹⁄₁₆ inch should be subtracted from the window size — that is, ¹⁄₆₄ to ¹⁄₃₂ inch will be taken off each of the four sides of the image (and added to the mat borders) when all four corners are at perfect right angles.   It may be necessary to crop out more of the image when corners of the print are not square.

The next measurements, based on the height of the window, are more difficult to determine, as the top and bottom borders should rarely be equal.[78]   Place the print on the board again.   Move the print slightly above center and compare the two side borders with the top and bottom borders.   Does the top border appear narrow or wide?   Does the bottom border appear narrow or wide?   Ideally no border should appear narrow or wide, either considered alone or in relation to the other three sides.   When matting a square print in a vertical mat, however, the bottom border of the mat should obviously be wide, but it should not be disproportionate to the size of the picture or the other three mat borders.   When the top and side borders are correctly proportioned in relation to the print and to the wider bottom border, the overall composition should appear balanced.   The above-described 8x10-inch horizontal image will have a top border of approximately 2¾ inches and a bottom border of approximately 3¼ inches.

## Marking Measurements

It is usually necessary to use pencil marks as a guide for cutting.[79]   All measurements should be marked on the back of the overmat.   Cutting the window should also be done from the back.   A *2H* lead (available, in both wooden pencils or in individual leads for lead holders, where artists' and drafting supplies are sold) is good because it maintains a sharp point without being too hard or too soft.   A sharp point is essential when marking measurements on board because the broad line made by a rounded lead is not an accurate guide for the cutting blade.   Soft leads, such as *B* and softer, do not maintain a point, smear easily, and may leave graphite dust on the board which can be

transferred to fingers and prints. In this author's experience, it is easier to maintain a consistent point with a 2H lead in a mechanical pencil, such as Koh-I-Noor Technigraph 5611 and A.W. Faber Castell Locktite 9500, that are sharpened with a sharpener designed for these pencils. Do not press too hard when marking the board. All measurements should be erased and all eraser crumbs should be brushed off the mat and counter after cutting and before installing the print.

## Cutting the Window

However true it may be that a fine instrument can work well only in the hands of an expert, it is equally true that even an expert cannot perfect his or her craft using inferior tools. To be an expert matmaker, one not only must be patient, exacting, and skilled but also must have well-made and properly maintained equipment, however simple or elaborate.

There are numerous mat cutting instruments and machines on the market. Specific instructions for different cutters are supplied by the respective manufacturers. Some distributors provide individual assistance in setting up elaborate and costly equipment. Unfortunately, it is beyond the scope of this chapter to do a comparative analysis of the many different instruments and machines. The following pages contain practical and detailed information that can be applied in most matting situations. This author bases this writing on extensive experience with the Dexter Mat Cutter and limited experience with a C&H Mat Cutter.

A hand-held mat cutter, such as the Dexter, can cost as little as $15, whereas a mat cutting machine can cost well over $1,000. With an inexpensive cutter such as the Dexter, it is possible to cut excellent mats which can be as good or better than those cut with a more expensive machine. For the individual who wants to make mats on a regular but limited basis with a minimum amount of equipment, the principal investment will be the time and the materials needed to learn the skill.

Never rest an instrument on the surface of a photograph. When measuring a print, place the ruler alongside *without touching* the outer edges of the image. A small extension on each side of the calibrated scale facilitates placing and lifting the ruler.

An excellent ruler for measuring most prints and mats is the 24-inch Gaebel Model 1057 (formerly #608), which is made of stainless steel, is very thin, and has finely marked increments, rounded corners, and the recommended extensions for handling. To take full advantage of this ruler's features, use a mechanical pencil with a very sharp lead.

While getting acquainted with the tools, wasted materials can be minimized by cutting single strokes into narrow scraps of 100% cotton fiber board that is 2- or 4-ply thick (whichever ply you intend to use). When practicing the cutting of windows, start with a piece of board that is at least 16x20 inches. In the center of the board, mark the four corner measurements of a very small window (e.g., 1x4 inches) and cut it. Gradually increase the size of the window by cutting around the previous window in successive ½- or 1-inch increments (e.g., 3x6 inches, 4x7 inches, 5x8 inches, 6x9 inches, 7x10 inches, etc.). Replace the cut-out piece each time so that the cutting instrument will have an even surface upon which to travel.

Because every board responds differently to pressure and to cutting, practice cutting into board that is identical to the one which will be used in making an actual mat. In general, cotton fiber board is more difficult to cut through than wood pulp board. In addition, cutting against (i.e., across) the grain of a board requires more effort than cutting in the direction of the grain. A board's density and thickness also determine the ease of cutting. It is often more difficult to achieve a perfect cut in board which is dehydrated (more common in winter months) or somewhat hydrated (due to storage in a damp environment).

## The Blade

Perhaps the single most important item required to produce a perfectly smooth cut is a sharp blade. Regardless of what cutting instrument is chosen, a dull or broken blade will produce ragged edges, an incomplete incision, an uneven cut, frilling, or tearing — or a combination of these.

The useful life of a blade is determined by many factors, including:

1. Its position in the cutting instrument

2. The density and material content of the board being cut

3. The thickness of the board being cut

4. The amount of pressure exerted in the act of cutting

5. The composition, density, and hardness of the counter-top or table surface

6. The degree of the matmaker's skill

7. The board's moisture content, which is determined by the relative humidity of the environments in which the board is transported, stored, and cut

8. The sizes of the window openings

9. The manufacturing specifications of the blade

Fresh blades, which are usually coated with a film of oil, should be cleaned before use by wiping them with a soft, dry cloth or paper towel. After positioning the wiped blade in the cutter, slowly and carefully pierce a piece of scrap board to remove residual oil and dirt. (If a blade is not cleaned before its first use, the oil and dirt will transfer to the first corner of the mat window and may stain the print resting underneath.) Then test the blade in the scrap board by pushing the cutter several inches both to see how it cuts and to remove any remaining oil. If a properly positioned blade does not make a smooth cut after three runs, discard it. Some new blades are not correctly sharpened and it is impossible to cut perfect mats with them. Hands should be washed immediately after handling a new blade.

Although it is possible to make over 50 windows with just one blade, a blade can be damaged before completing the cutting of just one window. The tip of a blade most commonly breaks because it has been too quickly inserted into the board, or because it hits a hard-surfaced tabletop such as wood, Masonite, or Formica, after cutting through the mount board. As mentioned earlier, mount board off-cuts provide the ideal cutting surface.[80] Cotton fiber boards are usually quite dense, however, and the tip of a blade may break the instant it touches the board if it is not inserted at the correct angle. Therefore, it is important to insert the blade gently and slowly *and* in the direction in which it is pointed.

Care or lack of care in positioning a blade greatly affects its useful life. The best way to calculate protrusion of the blade beyond the thickness of the board before cutting it is to place the cutting instrument, or the cutting section of the equipment, along (outside) one edge of the board. The tip of the blade should extend $1/64$ to $1/32$ inch beyond the thickness of the board it is intended to cut through. If the cutting surface is not absolutely firm and flat, $1/32$ inch will not be sufficient. For example, the tabletop may yield to pressure — moving up and down — changing the relationships between the blade in the cutter and the board, and between the board and the tabletop; as a result, the blade will not cut entirely through the board. If the tabletop is expected to yield to pressure, the blade must be positioned to protrude more than the ideal distance. (This concern does not apply in the case of cutting instruments and machines that have their own attached bases, such as those made by Alto, Art Mate, C & H, Esterly, Fletcher, Holdfast, Logan, Starr-Springfield, and others.)

On the other hand, if a blade extends too far, it either will prevent the mount board from resting evenly on the table or will too deeply penetrate the cutting board under the mat; in the latter case, the tip of the blade may break or it may jam, causing the cutting instrument to jump ahead

or swerve away from the marked measurement. It is nearly impossible to direct the movement of a blade when it is held too firmly and too deeply in the cutting board; it is also extremely difficult to control the cutting and to hold a board in place when the board is not lying perfectly flat on the table. The mount board should be cut through and the cutting board underneath should be only slightly scored. (Avoid cutting into grooves in the cutting surface that have been made previously because they can prevent the blade from cutting a sharp and straight edge in the mat.) When the blade does not completely cut through the mount board, readjust the blade depth — extending it an additional $1/64$ inch or farther — and try to reinsert it exactly as before into the mat's groove. Then "re-cut" the mat, moving the cutter along the *full length* of each partially cut side.

There is a precise point at which the blade should meet the pencil marks both at the beginning and at the end of the cutting. This location varies with each cutting instrument — even within a single manufacturer's model — and also depends on the thickness of a board. When cutting into 4-ply board, the blade of a hand-held cutting instrument should not be inserted exactly where the two lines of the corner meet, but rather approximately $1/32$ inch in front of (before) the line which is perpendicular to the line about to be cut along. Do not stop cutting when you meet the marked corner but go beyond it approximately $1/16$ inch. (Two-ply board requires about half these allowances at both ends.) On the last of four sides, the cutting instrument should be stopped precisely when the tip of the blade enters the starting point of the first cut. A sensitive hand will feel this immediately. Because it can be difficult to know exactly where to stop without underestimating or overestimating the location, it is faster to rely on feeling, aided by observation, while cutting than to try to calculate it in advance.

When an incision is incomplete, some practitioners recommend using a single- or double-edged razor to open it; this is done by turning the board over and working on the front of the overmat.[81] When such working over is necessary, this author prefers to repeat the entire incision starting at the corner and using the original cutting instrument.

## The Metal Straightedge

In addition to sharp blades, a good straightedge is essential to cut mats properly. It should be made of stainless steel, not aluminum or plastic, and it should be longer than most of the mats that will be cut. This author recommends a 36-inch heavy-gauge straightedge (available through most art supply stores) which is relatively easy to handle and control when making mats in a variety of sizes. When it is not lined on the bottom with a thin layer of cork, apply two parallel, full-length strips of tape such as Filmoplast P90 to the underside to help prevent it from skidding.

The straightedge must be placed perfectly parallel to the marked measurements. Care, steadiness, and skill are needed to prevent it from sliding during the cutting. Push the cutter gently along the straightedge; proceed slowly at first to avoid changing the direction of the cut. One can maximize control over both the movement of the cutter and the stationary position of the straightedge by pushing them *against each other* while moving the cutter forward.

A Dexter Mat Cutter rests alongside a stainless steel straight-edge between sides during the cutting of a mat window.

Maintain contact between the cutter and the straightedge at all times — and do not lift the cutter off the board — until the cut is completed.[82]

When an instrument is operated by pushing it forward (e.g., Dexter Mat Cutter) rather than pulling it, the cutting should proceed clockwise for right-handed people. When pulling (e.g., C & H), the cutting direction is counter-clockwise for right-handed people. The Dexter Mini mat cutter, the Dahle Cube Cutter, and the Japanese Olfa mat cutter are small, hand-held bi-directional cutters that can be used by both left- and right-handed people; the Cube and the Olfa can be pushed and pulled because the Cube is square and the Olfa has double-edged "V"-type blades. Many cutters with attached bases and/or straightedges require pulling of the blade, which this author has found to be somewhat more difficult than the pushing required with instruments such as the Dexter.[83]  However, those machines usually have metal bars which hold the mat board in place and control the course of the blade; they are usually equipped with two different cutting heads — one for beveled cuts and one for straight right-angle cuts.

The angle of the bevel (commonly 45° or 60°) is usually predetermined by the cutting instrument. Some machines are adjustable to achieve two different bevels. In the Dexter Mat Cutter, the 60° bevel changes slightly with the thickness of the mount board (the thicker the board, the wider and less acute is the bevel) and may also vary very slightly from instrument to instrument.

### The Binding of a Mat

The tape which connects the front of a mat (the overmat) to the back of the mat (the backing) is usually called the binding or binding hinge. In most circumstances, the overmat should be attached to the backing along the full length of one side with a hinge that folds so that the mat can be opened and closed like a book. Methods which trap a print by adhering the overmat to the backing should be avoided in most cases.

The binding should be on the long side of the mat. The side on the viewer's left should be connected if the mat is vertical, or the top side should be connected if the mat is horizontal.  Square mats may be connected either at the top or along the left side, depending on their size and the grain direction of the board.  The tape should be slightly shorter than the length of the mat: the smaller the mat, the more closely the tape should match the mat length.  When the mat is larger, the tape should not match the length of the mat as closely.  For example, an 8x10-inch mat should have a binding hinge that is approximately 9¾ inches long. A 16x20-inch mat should be bound by tape that is approximately 19 to 19½ inches long. A 22x28-inch mat requires a binding hinge that is approximately 26 to 27 inches long.

During repeated opening and closing of large mats, greater stress is placed on the ends of the tape where the two boards are connected. If the binding covers the entire length of a large mat, the tape will likely become loose or detached at either or both ends. When a large mat is opened frequently, it may be necessary to apply a 2- or 3-inch strip of tape perpendicular to and over each of the two sides of the joint to prevent the binding tape from coming apart.  A mat bound along the short side or bound by a hinge that is too short will not maintain its alignment and may also become detached from the backing. Alignment is critically important when matting dry mounted prints that are trimmed to the edges of the image, particularly when the edges are showing in the window area.

This author primarily uses gummed cambric cloth tape (sometimes called "linen" tape, or Holland tape) for the bindings of 4-ply mats, and Filmoplast P90 tape for the bindings of 2-ply mats.

### Moistening and Applying Gummed Cloth Tape

In the beginning, learning to apply water-activated tape involves learning how to activate the adhesive, how to control the various stages of accretion, and how to determine the strength of the bond. It is also learning how to touch and how to feel. Every adhesive responds differently in different situations with different materials. For example, various batches of a given brand of gummed cloth tape may react differently to water. The adhesive layer may be slightly thinner or thicker, the threads of the cloth may be more or less tightly woven, and the cloth may have slightly more or less sizing. Every variation in the manufacture of a material affects its working behavior. It is easier to master the craft by working consistently with one specific brand of tape; however, experience with one tape and the acquired knowledge of its behavioral characteristics cannot automatically be assumed to apply to other similar tapes used in the same situation.

The most common high-quality tape for binding 4-ply museum board mats is gummed cloth tape which requires moistening with water. Moistening is regulated by the quantity and temperature of water in the applicator (e.g., a sponge) and by the amount of pressure applied. The perfect amount is best determined by touch. Freshly moistened tape should be tacky and should adhere within a few seconds after applying water. At the precise moment it becomes tacky, the tape should "grab" the board as it is placed. It is important to evenly moisten only the surface of the adhesive; the water will then combine with the adhesive layer and activate it without greatly diluting it. The cloth side should not be allowed to get wet. If the tape is

Properly moistened tape.

Dry, unmoistened tape.

Overly moistened tape.

Learning to apply gummed tape requires familiarity with its appearance and feel before, during, and after it has been moistened.

moistened too much, the tape will become limp and the adhesive may be absorbed by the sponge and/or board; tape which is too wet can cause mount boards to warp or deform. If the tape is moistened too little, the adhesive will not combine properly with the water and will not become adherent. The ease or difficulty with which tape adheres is also affected by the temperature and moisture content of the board and the temperature and relative humidity of the working environment.

Before starting to tape, you will need the following:

1. Clean water, preferably distilled; room-temperature or tepid, not cold, water is best for activating the adhesive

2. A shallow, heavy, glass bowl to hold the water (about 1½ inches deep) with sides perpendicular to a flat bottom so that it will not tip over

3. A triangular section of sterile, undyed cellulose sponge that is approximately 50% wider at the base than the width of the tape

4. A clean, dry surface upon which to wet the tape

5. A clean, lint-free, cotton cloth, or sturdy, white paper towel

6. A pointed burnisher

When everything is ready, proceed as follows:

1. With the adhesive side face up and the cloth side face down, place the tape upon a clean surface, at least 1 foot away from the open mat. Some people prefer to moisten tape on a water-resistant surface such as glass, Formica, or Plexiglas; this author prefers small 4-ply mount board off-cuts because they absorb excess water. If right-handed, hold the tape down by placing one finger of the left hand about 1 inch from the top edge of the tape. Squeeze the wet sponge over the bowl to release excess water. Press the sponge upon the top inch of tape. Then lift and pull the tape by its moistened tip, holding the sponge against the tape with moderate pressure to moisten the entire length in one continuous movement. To do this efficiently, pull the tape upward and away from the sponge with one hand while the other hand is pushing the sponge down against the tape. If the pressure varies while the tape is being pulled through, the amount of moisture on the tape will vary, which will prevent it from adhering evenly to the mat. It is usually necessary to immediately remoisten the entire tape, both to add water to sections where the tape is dry and to absorb excess droplets of water before they have diluted the adhesive. A piece of tape that has been moistened so much that the edges of the cloth side are dampened should be discarded. Practicing with one specific type and brand of tape over a period of time will help to develop a better understanding of the skill.

2. The two boards should be positioned side by side, touching, with their inner surfaces facing up and ready to receive the tape at the moment the wet sponge completes its final stroke. Weights can be used to keep the boards in place. With two fingers of each hand, quickly place the

tape lengthwise over the edges where the two boards meet, checking to make sure the width of the tape is equally divided between the two boards. The fingers of the right hand should hold the tape close to the right corner and the fingers of the left hand should hold the tape close to the left corner so that they are diagonally across from each other. Use the visible sections of board which extend at the top and bottom beyond the length of the tape as a guide to correct and parallel placement. As the tape is put down, a slight pull in opposite directions will help to ensure a flat placement and smooth adherence. If the tape is not put down quickly, it may twist, fold, and warp, which will prevent a proper parallel placement.

3. A lintless wiping cloth, such as cotton gauze or S&W Catalog No. 1900 cloth, or a sturdy, white paper towel (such as Bounty or ScotTowel) should be available to immediately apply a firm and even pressure along the length of the tape twice before applying the burnisher. Do not burnish or stroke the tape with your hands.

4. *While closing the mat,* press the point of the burnishing tool against the center of the binding, running it along the inside to help crease the tape. Then check the alignment of the two boards. It is important to complete this operation before the tape dries.

### Alignment of the Overmat and Backing Board

The alignment of the overmat and backing board cannot be changed after the tape "sets" without weakening the mat's binding. A weak binding can cause damage to the print inside the mat in a number of ways. If the print is on very thin paper, the overmat will slide against the print and may cause it to fold or crease at its edges or in the middle. If the print is held in the mat with tab hinges, the shifting overmat may detach the print from its mount. If a fiber-base print is dry mounted and floating within the window, the inside edges of the window may touch the edges of the print and chip the delicate photographic emulsion.

If the overmat and backing boards have not come from the same package of pre-cut board, or when the two pieces are not *exactly* the same size, it is usually necessary to adjust their relative positions before applying tape. Make certain that the overmat and backing are evenly matched along the bottom side — that is, the side upon which the mat would rest if it were framed.

When the larger of the two boards is at least ¹⁄₁₆ inch *larger* than the correct size, the excess should be trimmed off. If the matted print is to be framed and the smaller of the two boards is *less* than the designated frame size by more than ¹⁄₁₆ inch, and the larger board is the correct size, the larger board should *not* be trimmed to match the size of the smaller board because the mat might then be free to move inside the frame. In addition, if the larger board is trimmed, the mat may not fill the entire area that is visible through the glass of the frame.

After aligning the connected boards and before any necessary trimming is done, burnish the outside edges where the mat is hinged both on the front and on the back with a burnisher — such as a printmaker's polished agate or

When binding the overmat to the backing, hold each end of the moist tape by its corners (upper left corner with the left hand, lower right corner with the right hand, or reversed) and give it a slight tug in opposite directions to ensure smooth adherence. Use the visible sections of board that extend beyond the tape ends as guides to parallel placement.

metal burnisher — or with the rounded top edge of a Dexter Mat Cutter. Next, if necessary, trim the uneven border(s). Then burnish the three unhinged outer edges of the mat on the front and on the back, inside and outside.

It is also necessary to burnish the four inside and four outside edges of the *window* because slight ridges are created there during the cutting. Some people like the edges of the window to be rounded; this can be accomplished either by gentle sanding, which results in a flat, "soft" finish, or by strong burnishing, which may cause the rim to be shiny. Care must be taken not to burnish too forcefully if a shiny edge is not desired.

### Bindings as They Relate to Board Thickness

It is best to apply gummed cloth tape to only 4-ply or thicker mount boards because thinner boards usually respond to water-activated tapes by warping. Mats made with lightweight boards may be joined with a high-quality pressure-sensitive tape such as Neschen Filmoplast P90. Make certain there is no space between the boards when they are placed side by side. When connecting or binding a 2-ply overmat to a 4-ply backing, compensate for the difference by resting the 2-ply board upon another piece of 2-ply board to assure an even horizontal plane and to enable the edge of the 2-ply board to rest directly against the higher edge of the 4-ply board. Otherwise, when the mat is closed, a strip of the tape will be exposed which will accumulate dust particles. Pressure-sensitive tapes must be completely and evenly burnished with an *instrument* after they are placed or they will not adhere properly to the board. Never burnish tape with your fingers.

Compensating for differences in board thickness when attaching two pieces of board is necessary regardless of what tape is used. If compensation is not made, the binding will be loose and the overmat may move upon the surface of the mounted print.

## Spaced Bindings for Pre-Mounted Prints

Pre-mounted prints (such as those dry mounted to 4-ply board) require specially constructed mats. First of all, an overmat should not be attached directly to the print's mount, unless it is the photographer's wish to do so. Taping an overmat to the print's mount rather than to a backing board spoils the front of the mount. A backing board also serves to protect the back of the print's mount.

When a pre-mounted print is to be matted the same size as the print's mount — a decision normally made for the sake of maintaining the original proportions — it will be necessary to leave space equal to the thickness of the mount between the two boards when connecting them. For example, Ansel Adams's black-and-white prints are usually dry mounted on standard-size pieces of 4-ply 100% cotton fiber board (e.g., 14x18, 16x20, 22x28 inches), and the mats for Adams's prints are usually matched, as he recommended, to the sizes of the mounts.[84]

To assure that a print dry mounted to a piece of 4-ply board will fit into a mat that is the same size, the overmat and the backing must be separated by a space of approximately $\frac{1}{16}$ inch before the binding tape is applied (about $\frac{1}{64}$ inch more than the thickness of the mount to allow for the tape). This enables the mat to open and close without stress and creates a *flat* three-level tier when the mounted print is inside the closed mat. To prevent the mat from sliding toward the edges of the dry mounted print, it is essential that the space provided at the joint (binding) not be any wider than necessary.

Pressure-sensitive tapes are not suitable for making spaced-bindings because dust particles and dirt will become attached to the exposed section.

## Sectional Fillers

When a mat must be a standard size and the print is pre-mounted on 4-ply or thicker board which matches the mat size in one direction only (e.g., a 13x20-inch mount to be placed in a 16x20-inch mat), a sectional filler must be placed between the overmat and the backing to compensate for the empty space. The binding tape should be applied to the side where the filler is attached to the backing, preferably one of the longer sides, and should be applied to the top of the filler. Sectional fillers may be attached to the backing( before taping) with a variety of materials including Scotch Brand No. 415 tape (a double-sided, pressure-sensitive polyester tape), 3M Positionable Mounting Adhesive No. 568 (also pressure sensitive), or with a stable liquid PVA (polyvinyl acetate) adhesive.

Close-up of a 4-ply mat with a spaced binding accommodating a pre-mounted print.

## The Middle-Mat

When matting a print which is pre-mounted on a piece of 4-ply board that is all around smaller than the mat, a 4-ply "middle-mat" is required to compensate for the size difference. If the overmat and the middle-mat are both attached to the backing with full-length binding hinges, the hinge of the middle-mat should be applied on the side which is opposite the overmat's hinge; in other words, if the mat is vertical, the overmat's hinge to the backing is on the left and the middle-mat's hinge to the backing is on the right. This construction allows the two windows (overmat and middle-mat) to have a complementary closure (i.e., \\_/) rather than a book-format closure. Remember to allow enough space for the middle-mat filling before taping the overmat to the backing. The middle-mat should be the same size as the overmat less approximately $\frac{1}{32}$ inch near the overmat's binding to assure a secure closure of the entire mat. If the middle-mat is completely adhered to the backing (i.e., to form a "sink" mat), it should match the size of the overmat; the overmat may then be hinged directly to the "sink" mat rather than to the backing.

## The "Sink" Mat

If the print's mount is 4-ply or thicker (greater than $\frac{1}{16}$ inch), it is usually necessary to construct a "sink" mat. The term "sink" refers to the recess in which the print will rest, which is surrounded by board attached to the backing. This recessed space is made by cutting an opening in one or more pieces of board, or by applying board strips around the four sides of the print. The depth of the space created should be slightly more than the thickness of the pre-mounted print. The overmat's binding hinge should be attached to the top surface of the "sink," which should be exactly the same overall size as the overmat and backing.

Some prints may be installed into a "sink" mat with pendant hinges that are connected to the backing *under* the middle-mat, "sink" mat, or sectional filler, to permit lifting of the print to view the reverse side. When measuring the overall size of the pre-mounted print, allow an additional space above the print where the hinges will be attached. This space should be at least $\frac{1}{16}$ inch wider than the thickness of the print mount. For example, if a vertical print is 5x7 inches and is mounted on a vertical 8x10-inch 4-ply board, the "sink" should be approximately $8\frac{1}{8}$x$10\frac{1}{8}$ inches; that provides a $\frac{1}{8}$-inch allowance at the top and a $\frac{1}{16}$-inch allowance at both the right and left sides. The bottom edge of the print mount should rest evenly on the bottom edge of the "sink," which should be cut 90° to the surface of the board and then burnished smooth and slightly rounded. The top, right, and left inner edges of the "sink" should be beveled, burnished smooth, and rounded to prevent the edges of the mount from catching, particularly when the print emulsion layer is exposed on the sides (as in the case of flush-mounted prints) and to allow the print to be lifted without resistance at the top edge of the "sink" where the hinges are located. A small inlet may be cut at the bottom edge of the "sink" to more easily lift the pre-mounted print. Sometimes a thin ribbon can be attached to the backing to run under the print and through the inlet to allow the print to be lifted without touching its edge.

Burnishers are necessary both to blunt sharp edges in cut board that can damage delicate print emulsions and to improve the appearance of the finished mat. Pictured above are two examples of printmakers' burnishers: curved, rounded, and polished agate (left) and curved, pointed, and polished metal (right). Bone burnishers are not recommended because they create more friction during movement than either polished agate or metal.

## Paperweights

Before a print is mounted onto the backing, it must be correctly positioned beneath the overmat. When a print is to be corner-mounted, position the print by viewing it through the closed window. Then place a protective piece of 2-ply board or heavy paper — with one of its corners folded up — on top of the print; this protective board or paper should be about ½ inch smaller all around than the window opening so that the overmat can be lifted up without removing it. Now place a clean and smooth weight on top of the protective paper to hold it and the print in place. The weight should have no sharp edges. It should be easy to lift and move, being neither too large nor too heavy (1 to 2 pounds, depending on size). Metal paperweights should be covered with thick, soft, undyed cloth.

Some people use stainless-steel positioning clasps to hold prints in place. Clasps of this type are commonly sold in office supply stores. Although clasps are recommended by some, this author strongly advises against their use because they can easily scratch delicate emulsion surfaces. Fragile prints can be creased, marked, and even folded by these clasps. Those sold by Light Impressions Corporation have well-rounded corners but they can still cause damage if one is not very experienced in using them.

## Installing a Print into a Mat

A photographic print must be held securely in its mat. Traditional methods of securing prints include total-surface adhesion (dry mounting, cold mounting, wet mounting), partial or local attachment (hinges, double-sided tapes, glue), and "free attachment" (mounting corners, Frame Strips, polyester slings, or folders). Every method has its proper application, depending on a multitude of factors.

In the fine art field, many paper conservators recommend hinges to secure a work to the backing of a conservation mat. These are frequently suitable for watercolor paintings, lithographs, pastel and graphite drawings, and some photographic prints on fiber-base paper. The RC (polyethylene-resin-coated) paper or polyester support upon which many photographs are printed, however, cannot be approached in the same manner as other works of art on paper; many water-activated adhesives and tapes may not properly adhere to these types of photographs.

This author recommends, whenever possible, that photographic prints be installed into conservation mats by a method that does not adhere the print, either partially or totally, to the mount or backing board. While this author has not seen examples of carefully done dry mounting that has harmed photographs, it is not generally recommended by photographic conservators. In addition, dry mounted prints cannot be laser-scanned for reproduction purposes. In spite of its shortcomings, however, dry mounting is often desired by photographers for purely aesthetic reasons. (See Chapter 11.)

Possible expansion and contraction of mount boards, combined with the physical responses of different photographic print materials, should be considered before selecting any mounting method. A photograph may buckle, bow, stretch, or tear if it is hinged or installed incorrectly; consideration must also be given to the humidity-induced dimensional changes characteristic of the print and mounting materials when kept in most uncontrolled environments.

## Corner Mounting

Two methods of installing prints into mats are discussed in this chapter: corner mounting and hinge mounting. This author's preferred method of installing most photographic prints into mats is corner mounting. Among the advantages of corner mounting are that the print is not "permanently" attached to the mat, the mat can be replaced more easily if soiled or damaged, the use of adhesives directly on a print is avoided, prints are less likely to slide, and color prints can be removed from mats before being placed in cold storage. Sometimes it is necessary to combine mounting corners with hinges.

Most mounting corners should not fit the print corners too tightly but be placed to allow approximately ¹⁄₆₄ to ¹⁄₃₂ inch — or more for large prints — outside the edges of the prints for slight expansion and contraction of the prints and/or mounts. (Polyester-base photographs, such as glossy

Ilfochrome, Polaroid ArchivalColor, and UltraStable prints, are dimensionally stable and do not change size in response to changes in relative humidity, but allowances should still be made for expansion and contraction of mount boards.) The bottom edges of the two bottom mounting corners, however, should be closer to the bottom edge of the photograph to prevent the print from sliding down during display and handling. Relative humidity conditions and the board's grain direction should also be taken into account.

Mounting corners should be made of high-quality materials appropriate in composition, pH value, weight, texture, and tensile strength, and that have been approved for use as photographic enclosures. (See Chapter 13.) They should be pH neutral, strong, somewhat moisture resistant, lightweight, without color, and not alkaline buffered. The corners should also be designed specifically for the individual print size and type and should be securely attached to the backing of the mat with an adhesive or adhesive tape that also is stable, strong, inert, and has a neutral pH.

Atlantis Silversafe Photostore, available in the United States from Archivart and from Paper Technologies, Inc., is probably the best paper for this purpose.[85] Two other excellent choices are Archivart Storage Paper and Light Impressions Renaissance Paper.[86] Howard Paper Mills alkaline-buffered Permalife papers are not recommended because of continuing questions about the long-term effects of alkaline-buffered papers on photographs.[87]

Transparent corners made of polyester are occasionally suitable for floating prints that would otherwise require hinges. Those distributed by Light Impressions Corporation are pre-scored for folding, but care must be taken to assure both an exact and straight 45° folding in the right direction so that the adhesive is facing out and away from the print. They are narrow in width (7/16 inch), and are thus restricted in use to flat, nonbuckling, small to medium-size prints that are not lightweight, delicate, or flimsy.

University Products, Inc. sells a nearly identical product, See-Thru Archival Mounting Corners, available in three widths (1/2 inch, 5/8 inch, and 7/8 inch). The University Products polyester mounting corners are also restricted in their use to sturdy, flat, medium-weight prints.

Pre-fabricated, easy to use mounting corners named ClearHold, made of transparent polyester with a high-stability pressure-sensitive adhesive backing, are available from Light Impressions.

Frame Strips also hold photographs without applying any adhesive to the prints. Type 423 (flat) and Type 107 (S–shaped), made of "conservation grade" clear polyester, is suitable for mounting lightweight and medium-weight flat prints that do not travel and are not subject to repeated handling. Among the advantages of Frame Strips are that the strips can be cut into very small sizes, they are not visually obtrusive, and prints are easily removed. Among the disadvantages are that Type 423 can scratch delicate print emulsions if one is not *extremely* careful to avoid doing so, and prints too easily shift position when moved. To help prevent scratches when using Type 423, place a piece of thin paper between the Frame Strip and the print emulsion when attaching the strips and before removing the print. Type 107 may be used when mounting prints into 8-ply or thicker mats.

## Mounting Corner Design

The appropriate material, design, and size of a set of mounting corners should be determined by the particular photographic material, the size of the photographic image, and the width of the photographic paper's border around the image. In addition, the thicknesses of the overmat and backing should be taken into account. Any changes in a print's intended display, circulation, and/or storage conditions may create a new combination of requirements.

One important design feature that distinguishes the conservation mounting corner, which this author recommends, from other mounting corners is the *extended base*. (**Figure 12.3** illustrates the correct design and some faulty designs.) When the corners are very large or when a photograph is printed on somewhat translucent paper, or when the image nearly touches the edges of the print material, the extended base should be shorter than usual. The extended base, or "landing pad," ensures proper entry of the print into the mounting corner; without it, the corner of the photograph may slide under the mounting corner. In addition, absence of an extended base creates two other risks: (1) if the photograph is printed on fiber-base paper, the emulsion and baryta layers may become separated from the paper base when the print hits the edge of the corner, and (2) the corners of the print are too easily cracked during insertion because they usually require more bending.

Most handmade and commercially produced mounting corners examined by this author do not have extended bases and/or have a double-thick base created by two overlapping flaps. Such corners are not recommended because of the difficulty reinserting a print after removing it. Those mounting corners that do have extended bases — described and illustrated in various publications — are usually not well designed in that the two "wings," or two sides of the base, are too long and extend into the area directly behind or near the image. If a mounting corner is made of thick paper it may become embossed in the border of the photographic paper or in the image itself. Because of this, mounting corners should be made with paper distinctly thinner than the photographic material, and the corners should not have double-thick bases.

All mounting corners should be designed with consideration for the bending that occurs when inserting and removing prints, as this is the most serious drawback to mounting corners. The size and design of the mounting corner in relation to the size and proportion of the print will determine the location of the bend and its angle. When a mounting corner is too large (i.e., more than 1/2 to 1 percent of the area of the photographic paper), the print may have to be severely bent during removal and re-insertion, thus stressing the various layers of the print. The bending angle should be as obtuse as possible. Mounting corners should not, however, be made smaller than they need to be to properly hold the print. They should be large enough to hold the print securely but small enough to facilitate print removal.

For example, a mounting corner made with 1- to 1 1/8-inch wide strips of paper (resulting in a corner with a side measurement of approximately 1 1/2 inches, creating a 1 1/2-inch "square" with the extended base included) is recommended for most 16x20-inch prints which have a border

**Correct Design**

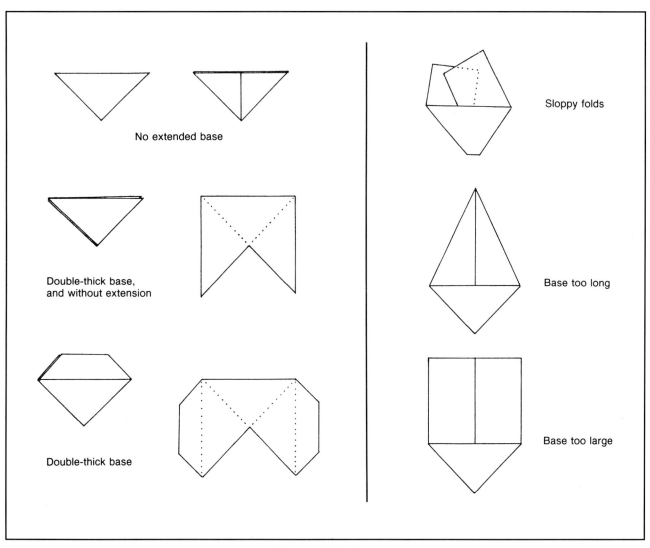

**Incorrect Designs**

**Figure 12.3:** Examples of Mounting Corners

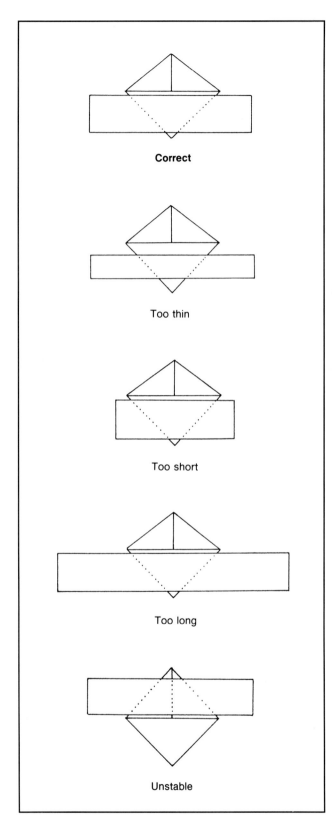

**Correct**

**Too thin**

**Too short**

**Too long**

**Unstable**

**Figure 12.4:** Tape placement over mounting corners. To secure the position of mounting corners in mats, strips of tape should not be too thin, too short, attached to the base rather than the top of the corner, nor should they be divided as shown in **Figure 12.5**.

at least 1-inch wide all around. Strips of paper that are ¾--inch wide will make mounting corners that form an approximately 1-inch "square," a size recommended for most prints on 11x14-inch paper. Mounting corners made with ½ to ⅝-inch wide strips of paper (forming a ¾ to ⅞-inch "square") are recommended for prints on 8x10-inch paper. Polyester prints may require slightly larger corners.

The problem of bending is another reason why photographs should be printed with ample borders. This author recommends border areas that are approximately one-quarter the width and length of the photographic paper for medium-size prints and approximately one-fifth for large prints.

For example, a 1- to 2-inch border is recommended for each side of a small print made on 8x10-inch paper and a border of 3 to 4 inches for a large print made on 30x40-inch paper. Borders of 1½ to 2 inches are recommended for prints on 11x14-inch paper (a good size paper on which to make 8x10-inch contact prints). Borders of 2 to 2½ inches are recommended for prints on 16x20-inch paper.[88,89]

In most situations, mounting corners should be attached to the backing board with small strips of tape (see **Figure 12.4**). This author most often uses gummed cloth tape for attaching paper mounting corners to 4-ply mats, and Filmoplast P90 or other high-quality pressure sensitive tape foe attaching paper corners to 2-ply mats.

### The "Tailored" Mounting Corner

When the image touches or nearly touches the edges of the photographic paper, special alterations must be made in the design of the mounting corner to create what this author calls a "tailored" mounting corner (see **Figure 12.5**). In other words, a small triangular section is cut out of the corner to allow a full view. Tape should be applied over the corner before the cutting out is done, and should be placed so that it will not be divided by the cutting; at least a small section of the tape should be continuous and unbroken, connecting the two sides of the corner. A mounting corner that has tape attached *on the top*, rather than on the base, is stronger and less likely to fall apart. In some situations, tape should be applied in both places.

Before determining how much of the mounting corners need to be cut out, remove the print. Bending of the print can be minimized by removing the first two print corners from two adjacent mounting corners, thereby enabling the remaining print corners to slide out without any bending. Otherwise, three corners must be bent to remove the print. (Caution: Low relative humidity embrittles print emulsions and increases the risk of print damage during bending.)

Close the overmat and mark on the sections of the mounting corners that show near the window corners with a pencil or pin as close as possible to the overmat — about 1/32 inch — without marring the overmat. One small dot on each mounting corner is enough. Naturally, in those rare situations when the print should not be removed from the corners, a pencil — and *not* a pin — must be used to mark the mounting corners. Be careful not to rest any part of your hand on the print. It is essential to protect the surface of the print at all times.

Now open the mat, and place a piece of board into the mounting corner to protect the base during trimming; the beveled corners of 2-ply window cut-outs are ideal for this

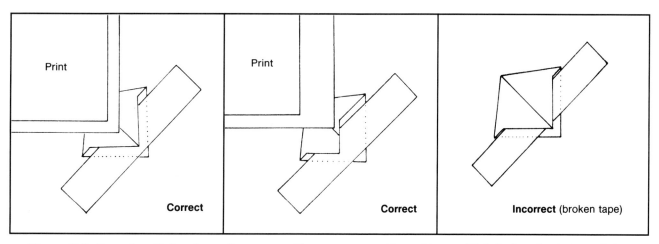

**Figure 12.5:** Examples of tailored mounting corners. These corners are trimmed to permit full viewing of a photograph that has been printed with narrow borders.

purpose. Without pushing it, insert the piece of 2-ply board, with the bevel-side up, as far into the mounting corner as possible. Then cut two strokes into the mounting corner about ¹⁄₁₆ inch outside the mark. This will assure that after the mounting corner has been trimmed the remaining section will be hidden under the overmat. Because most people have more control cutting in one direction (e.g., top to bottom, or left to right), it is often a good idea to rotate the mat before trimming the next corner. Use a fresh protective board each time to reduce the chance of cutting through and into the back of the mounting corner.

When an image has not been centered on the photographic paper during printing but an ample border exists on one to three sides, at least two of the mounting corners will not need to be tailored. Trim as many mounting corners as necessary and re-insert the print.

To more safely guide a print into its mounting corners, a smaller piece of smooth, thin, and somewhat stiff paper may be placed on top of the corner of the print. The "guiding paper" should extend beyond the edges of the print corner by about ⅛ inch, thereby entering the mounting corner first. With a very light push, the corner of the print under the guiding paper will slide into place.

When the print paper is the same or nearly the same size as the mat, and should not be trimmed, the strips of tape which hold the mounting corners down will need to be attached to the back of the mat. These strips should be about twice as long as usual. It is easier to apply the tape if the backing extends a few inches beyond the edge of the tabletop; this extension facilitates immediate folding of the moistened tape around the edge of the board so that it can be attached to the reverse side without lifting the mat.

### Special Procedures with Mounting Corners

When a print is mounted on 4-ply or thicker board, an extra fold should be made on each flap of the mounting corner to form a "box corner." The thickness of the print mount determines just where the two extra folds should be. When tape is applied to attach the box corner to the backing, the tape should follow the folds of the corner against the top and two sides, whether or not the mounted print is flush with the edges of the mat.

If the mount is thick, or if the print and mount are in poor condition, and if flexing presents a serious threat to the print emulsion layer or support — as in the case of varnished or coated prints, Polaroid Spectra prints (called Image prints in Europe), High Speed 600 prints, and SX-70 prints, or prints dry mounted to an embrittled wood pulp board — and the print must be removed from its corners, detach two adjacent mounting corners before removing the print.

In some instances, one or two "doors" which open and close (with pressure-sensitive tape) may be cut into the top mounting corners to facilitate removing the print. It is also possible to provide additional support at the top or bottom edge of a pre-mounted or brittle print with a "pocket" made of a folded strip of polyester, which is shorter than the length of the print or mount.

Removing a fragile print from its corners can be avoided by copying all information that appears on the back onto a separate piece of paper or onto the mat before the mounting corners are taped down. When possible, make two double-sided photocopies on high-quality paper of the front and back of every print. Put one copy in a polyester folder attached to the back of the mat or frame and keep the other copy on file.

### Hinges

Hinging is a common method of installing pictures into mats. While this author prefers to corner-mount most photographs, hinges are sometimes necessary or desired.

For example, when one wants to float a print so that the edges of the paper are visible in the mat, folded hinges that are hidden behind the print are often preferable to clear polyester corners. Also, prints on polyester materials and large prints often require one or more hinges at the top edge of the print in addition to two or four mounting corners, to prevent them from rippling at the bottom corners. (Michael Wilder, a well-known Ilfochrome [formerly called Cibachrome] printer, recommends this method when mounting Ilfochrome glossy polyester prints.)[90]

Although thorough instructions for applying hinges are not given here, some considerations are discussed. First, selection of hinging materials for photographs depends on

the individual print material, the print size, and the intended use of the print. Hinges should have good folding endurance and strength, be thinner than the thickness of the photograph, be sulfur-free and lignin-free, have a neutral pH, and contain no alkaline-buffering chemicals, dyes, or other compounds that might react with the print.

Gummed cloth tape is not suitable for hinging most photographs, most particularly single-weight or other lightweight photographic papers. Japanese tissue paper such as Goyu, Mulberry, and Sekishu are commonly used because they are lightweight and strong. However, these hinging papers are generally attached with water-activated adhesives such as wheat-starch paste and methyl cellulose, which must be applied with extra care because most photographs are physically very sensitive to moisture and, in this author's experience, they can be easily deformed by wet adhesives.

In addition, water-activated tapes and pastes may not properly adhere to polyester and RC prints; special high-stability, pressure-sensitive tapes are often better suited to hinging these prints. Although there are currently no pressure-sensitive tapes or adhesives that have been certified to meet ANSI standards for use with photographs, among the most popular better quality pressure-sensitive tapes are Archival Aids Document Repair Tape, Filmoplast P90, and Scotch Brand No. 415 Double-Sided Polyester Tape. Only time and further research will tell whether these tapes are suitable in long-term photographic applications.[91]

Many conservators recommend the use of liquid adhesives (e.g., wheat-starch paste, rice-starch paste, polyvinyl acetate [PVA], and methyl cellulose) for attaching hinges to photographs and mount boards. Pending further research on their long-term chemical and physical effects on photographs, this author has continued to use pressure-sensitive tapes which, because they are applied without the use of water, avoid potential problems with localized physical deformation in the prints.

T. J. Collings has suggested the use of a heat-set acrylic adhesive to attach paper hinges to prints, thereby avoiding the problems caused by wet adhesives (this author has not had an opportunity to evaluate this method).[92]

The size, weight, and shape of hinges depend largely on the size, weight, shape, and grain direction of the print. Naturally, hinges should be as small as possible to hold the print properly. Hinges that are long and narrow, as well as those that are large and wide, should be avoided. Their shape should be rectangular with no more than one-third of the hinge attached to the back of the print and no less than two-thirds attached to the backing board. Folded hinges should generally be applied vertically at the top of the print. The grain direction(s) of the mount board and the photographic paper, relative both to each other and to the hinges, should be taken into account when making and applying hinges because the board and print may expand and contract, causing the hinges and the print to be stressed.

The advantage of folded hinges is that they are not visible and in most cases they allow easy access to the back of the print. (Hinges also affix a print to its backing so that the print cannot readily be removed.) The disadvantages of folded hinges include:

1. They introduce a double (or triple, if reinforced) layer behind the print which may cause visible physical deformation of the print.

2. They may partially or wholly detach from the print and/ or the backing if the print is lifted incorrectly or hastily, or if the mat falls, risking damage to the loose print.

3. They may not allow for complete lifting of the print if they are not properly applied or if the print has warped edges. (The fold of the hinge should extend about $\frac{1}{64}$ inch or less beyond the edge of the print to facilitate lifting.)

Pendant T-hinges that are adhered correctly are far more secure than folded hinges but can be applied only when the overmat covers the edges of the photographic paper. With a T-hinge there is usually only one layer of hinge material behind the print; this continues above the print to where it is fastened by a cross-piece. The cross-piece should not be more than $\frac{1}{32}$ inch away from the print (unless the print material is at least $\frac{1}{32}$ inch thick). When the cross-piece is farther away, the print is free to move from side to side; this could cause damage to the edges or surface of the print as well as weaken the attachment.

To relieve stress on the edge of a photograph at the T-hinges, 2 small (about $\frac{1}{8}$-inch) incisions should be cut into the cross-piece at each side of the vertical part of the hinge at the sides closest to the print. It is especially important to do this when a print has curled edges.

All hinges should be attached to the top of prints unless the prints are part of a study collection of standard-size mats that are stored in one direction. For example, if the collection is mounted in 16x20-inch mats which are stored standing horizontally (mats resting on the 20-inch sides) and the prints comprise both horizontal and vertical images, vertical prints will require hinging on their left sides. Horizontal prints would be hinged on top as usual.

Hinges should be strategically placed — they should be neither too close to nor too far from the corners of the print; placement depends on the individual print material, its physical characteristics, and its condition. They should be applied first to the back of the print and allowed to set for a brief period under a smooth weight. The adhesive should be "reversible," which means that the hinge and adhesive should be removable without physically or chemically harming the print. *Important:* A print should not be hinged to the window section of a mat nor should hinges be applied to the front of a print except in very special circumstances.

For detailed instructions about hinging documents and works of art on fiber-base papers to mount board, consult the following publications (see also **Additional References**):

1. *The Hinging and Mounting of Paper Objects* (HMS-6), published by the Office of Museum Programs, Smithsonian Institution, 2235 Arts and Industries Building, Washington, D.C. 20560, June 1976.

2. *Conserving Works of Art on Paper,* Roy L. Perkinson, American Association of Museums, 1055 Thomas Jefferson Street, N.W., Suite 428, Washington, D.C. 20007, 1977.

## Mounting and Matting Delicate Prints

Many prints must be handled with "extra care," both when they are unprotected and when they are matted. For example, the paper support of most albumen prints is very thin and direct handling of these prints should be avoided because they may be creased even in the most careful hands.

Albumen prints and other similarly delicate prints that may be subject to curling have been mounted in various ways. One method of safely installing an unmounted albumen print into a conservation mat is to suspend the print inside a polyester folder or sleeve that has been attached to the backing of the mat with hinges and/or mounting corners.[93] Properly done, this method of enclosing the print without "encapsulating" it protects the surface, the support, the edges, the corners, and the image of the print, and facilitates its removal, if desired.

It is also possible to mount a piece of polyester to the backing board behind the print, and then "attach" the print's four corners by inserting them into small, approximately ⅛-inch sections of Frame Strips, Type 423 or Type 107, which self-adhere to the polyester backing. When using Frame Strips, the polyester sheet behind the print should be larger, the same size, or *very slightly* smaller (if the print floats in the mat window) than the print and fully mounted to the backing with a pressure-sensitive adhesive, such as Gudy O or 3M Positionable Mounting Adhesive. This method is best suited for framed prints that will not travel; frequently handled prints should not be mounted this way.

Mounting corners are usually unsuitable for securing delicate prints into mats, unless the prints are enclosed in polyester. When such prints are not mounted by total-surface adhesion, they are often attached to a mat with small folded or pendant hinges. Extra care must be exercised when mounting delicate prints onto lightweight boards. For example, the flexibility of 2-ply mounts can present a problem for very delicate prints (such as albumen prints and photogravures on thin paper). If the backing of a mat is not rigid and is allowed to bend against the photograph, the print may tear in the middle and/or at either or both hinges; or the print may detach and risk being folded or crushed when it moves.

Paper conservators usually recommend that a hinging material not exceed the weight and strength of the paper being hinged into the mat. This author agrees with that and believes that a hinge should be as thin and lightweight as possible, but that a stronger hinge is generally safer than a weaker one, particularly with photographs. In either case, however, no hinging material can prevent damage to a print that is adhered to an unstable, flimsy, or poorly constructed mount.

When very delicate prints must be attached to lightweight mounts, they should be hinged or mounted onto an intermediate support that is somewhat larger than the print — such as 1-ply board, 1 inch larger all around than the print — which will then be secured with mounting corners onto the lightweight backing of the mat. If the mat is flexed, it is unlikely that the mounted print will be released from the corners; more important is that the photograph will not be stressed.

## Polyester Enclosures and Barriers Inside Mats

Folders and sleeves made of thin uncoated polyester sheet (e.g., DuPont Mylar D, or ICI Melinex 516) can isolate prints in their mats and guard against damage. For example, a print can be placed in a 2 or 3 mil polyester folder that is the same size as the print, which may then be installed into a mat with four mounting corners; the unit can be removed and replaced with relative ease and reduced risk of damage to the print.

Another way of protecting prints that should be isolated from their mat environment, when mounting corners are used, is the "sandwich" method. This involves placing the print between two thin sheets of uncoated polyester that are the same size as the print. The polyester sheets and photographic print should be inserted (and removed) *together* into the four mounting corners.

As an alternative to covering the print with a second sheet of polyester that fits into the mounting corners, the print can be covered by overlapping the entire area by ½ inch or more with a polyester sheet that is attached to the backing with a continuous hinge across its top edge. The sheet falls over the print, can easily be lifted, and is held down by the closed overmat. Or, the overlapping sheet may be installed with its own set of mounting corners placed outside the print, thereby facilitating the sheet's complete removal and replacement without handling the print. A window slightly larger than the mat window (and smaller than the print) may be cut into the Mylar cover sheet to create an inner "Mylar mat."

An alternative to isolating the print from its mat, is to isolate the overmat. Before November 1981, when *nonbuffered* 100% cotton fiber mount boards first became available, this seemed to be the most suitable way of separating pH-sensitive color prints from alkaline-buffered boards. In 1980, more than a year before high-quality photographic mount boards were being manufactured, photographer Mitch Epstein's concern for the proper care of his low-pH Kodak Dye Transfer prints prompted him to encourage this author to devise a method of preventing contact between his prints and his alkaline-buffered museum board mats. Four strips of 5 or 3 mil Mylar D were adhered with Scotch Brand Double-Sided Polyester No. 415 Tape to the inside surface of the overmat where it rested against the edges of print. The tape was recessed approximately ¹⁄₃₂-¹⁄₁₆ inch from the inside and outside edges of the mat to minimize the collection of dust particles.

The above methods preventing direct contact between prints and mats are recommended when using boards that do not meet the requirements for photographic storage enclosures; this can occur when a board is selected for purely aesthetic reasons.

## Portfolio Matting

In general, the design and format of a portfolio should be uniform throughout the edition, with a possible exception for the artist's proof prints. Any variance from the overall plan — such as a change of image size or mat size, a difference in materials, an alteration of mat proportions or construction design, and so forth — may be interpreted

June 1987

Laurence Miller, owner of the Laurence Miller Gallery in New York City, and his associate Matthew Postal prepare the **Larry Burrows: Vietnam** portfolio of Kodak Dye Transfer prints for a traveling exhibition. (See Note 96.)

consideration whether the edition is large, small, or one-of-a-kind, such as the carefully arranged selection of prints that a photographer shows to gallery directors. A bulky, heavy, oversized presentation can interfere with appreciation of the photographs by being difficult to handle. On the other hand, it may increase appreciation by demanding more attention, as does the 18-photograph portfolio by Larry Burrows: *Vietnam, The American Intervention 1962–1968,* which weighs over 35 pounds.[96]

When matting and mounting prints for portfolios, consistency in the following areas should be maintained:

1. The board should be exactly the same for every set unless the photographer and publisher have stated otherwise; this means that all board should be ordered at one time and that the distributor should take all of the board from the same manufactured lot so that its overall texture and tone will not vary even slightly.

2. The mat proportions should be the same for multiple prints of the same image.

3. The method by which the prints are installed (e.g., folded hinges, mounting corners) should be the same for all sets; when a change is necessary, the change should not occur within one set (case) of prints in the edition.

4. The overmats and mounts should match each other in size so that they will fit correctly into the portfolio cases.

5. The interior dimensions of cases should be about ⅛ to ¼ inch larger than the overall size of the mounted prints. When the cases are the right size, the prints will be neither difficult to remove nor will they be inclined to move around inside the cases. The required size of the space within a print case depends to some extent on the case's design.

as a mistake or, worse, as lack of care. It is common for photographers to deviate from a rigid standard of print consistency when they allow for some subtle variations of the colors and tones while printing. The publishers of portfolios, however, are usually expected to be consistent insofar as the matting and print cases are concerned.

In some respects, portfolio publication can be compared to limited-edition book publishing, where the quality of the presentation is sometimes as noteworthy as the contents. Presentation can enhance a work of art when its function is considered important or may devalue it when it is viewed simply as necessary packaging. Addressing the Photographic Materials Group of the American Institute for Conservation, Joan Pedzich said, "When a print is carefully presented, we are expressing an attitude which says 'we value this object.'"[94]

Portfolios, like picture books, should permit intimate viewing and should be mounted to facilitate handling and turning of the prints which are, after all, intended to be seen together as a group. Whenever possible, lightweight mounting materials are recommended because the weight of the mounts can greatly increase the weight of the ensemble (see **Appendix 12.2**).[95]

The overall weight of the assemblage is an important

## Interleaving Paper

It is necessary to cover prints in storage with interleaving paper when they are unprotected as well as when they are matted.[97] A proper and clean interleaving paper reduces the possibility of grit and other foreign matter settling on the surface of a print and also helps prevent scratches that can occur when a print and a mount or other print slide against each other. It is especially important to provide interleaving for a mounted print that floats and whose edges are not covered by the borders of a mat. Interleaving paper must be soft and smooth without any abrasive characteristics, which is why certain types of fine tissue are highly suitable.

When cutting interleaving paper for matted prints, it is essential that it be cut to a size that is smaller than the mat but larger than the mat window. The interleaf should be at least ¼ inch smaller on all four sides, but not smaller than the size of the window opening plus the width of 1½ mat borders. This prevents the interleaving paper from slipping toward the mat binding and exposing one or more sides of the print. Ideally, an interleaving paper should be about 1-inch smaller than the mat all around.

In this author's experience, one of the best interleaving papers for photographic prints is #40 Manning 600 Tissue Paper.[98] For years, until 1982, it was available as Troya

Ani Rivera and Arnon Ben-David placing Troya #40 interleaving tissue over each print in Audrey Flack's portfolio of twelve Kodak Dye Transfer photographs published by Sidney Singer in 1983.

1983

#40 Tissue Paper from Andrews/Nelson/Whitehead.[99] The Manning tissue is suitable for interleaving photographs because it is soft, thin, nonabrasive, flexible, strong, nonbuffered, undyed, and semi-transparent (permitting the shapes although not the details in photographs to be identified without lifting the tissue). It is made of cellulose derived from Manila hemp fiber. According to Frank R. Hart, former Marketing Representative for Manning Paper Company (a Division of Hammermill Paper Company), "This is a high hemp containing grade, which has a high degree of purity. Our paper is not alkaline buffered, but is manufactured in a neutral pH range."[100]

In addition to its physical qualities, Troya #40 was reasonable in price. When purchased in a large quantity, each 16x20-inch piece cost less than 25 cents. As with many products, however, prices varied considerably, depending on the source from which the paper was purchased and the costs involved in cutting it.

There are other Manila hemp papers manufactured in England by Barcham Green & Company, Ltd. One is a very fine, semi-transparent, lightweight, nonbuffered paper, called "L" Tissue, that is particularly desirable for interleaving collections where it is important to be able to see details through the interleaf. Distributed in the United States by Andrews/Nelson/Whitehead, "L" Tissue has been sold on the retail level bearing the same name by Light Impressions, and also by Talas under the name of "Green's Tissue." "L" Tissue is similar to Troya #40 except that it is considerably lighter in weight; because of its tendency to slip when not held in place, it is better for matted prints than for loose prints. According to Simon Barcham Green, "L" stands for "lightweight;" his company also makes a "medium-weight" version of "L" Tissue called "M" Tissue, which appears to be a suitable replacement for Troya #40.[101]

Another outstanding interleaving paper made in England and distributed in the U.S. by Archivart and by Paper Technologies, is Atlantis Silversafe Photostore 100% Cotton Fiber paper, available in 27-lb., 54-lb., and 81-lb. basis weight. The 27-lb. weight is preferred by this author for matted prints because it is slightly translucent. The paper was developed "to meet the highest quality standards for the storage of photography [and] is neutral in pH, unbuffered and sulfur-free."[102] When interleaving unmatted prints, the 54-lb. or the 81-lb. weights are generally preferable.

Archivart supplies another fine interleaving tissue called Archivart Photo-Tex Tissue, which is made with 100% cotton fibers, is nonbuffered, and is available in a 40 lb. weight; the company reports that this paper has passed the ANSI Photographic Activity Test. Archivart Photographic Storage Paper is also an excellent product suitable as an interleaf in some situations, although the paper is more commonly used to make negative and print envelopes and folders.[103] Most medium-weight or heavyweight interleaving papers must be handled more carefully because their edges can more easily scratch delicate print surfaces.

Light Impressions Renaissance Paper (80 lb.) and Renaissance Tissue (2.5 mil; 60 g/m$^2$) are two excellent papers also manufactured specifically for use with photographs and textiles that require a neutral pH without any alkaline buffers. The company's catalog advertises that Renaissance "Passes [the] Photographic Activities Test."[104]

Conservation Resources and University Products also sell high-quality nonbuffered interleaving papers. See the **Suppliers List** at the end of this chapter for the addresses of the above companies.

**Note:** *ANSI standards related to the storage of photographs advise against the use of glassine, including so-called "acid-free" glassine.* (See Chapter 13.)

Henry Wilhelm – May 1981

Photographer Mitch Epstein and Carol Brower working together and discussing the details of mounting Epstein's Kodak Dye Transfer prints in 1981 before nonbuffered, neutral pH, museum boards became available.

## Recommendations to Photographers and Caretakers of Photographs

1. Use the most stable photographic materials available and process them correctly.

2. Print all photographs with wide borders and do not trim them, unless absolutely necessary.

3. Print photographs in the center of the paper.

4. Use an enlarger that gives precise 90° print corners with exactly parallel image borders and that centers the image properly on the paper.

5. Dry all prints carefully to avoid warping.

6. Before signing a print, consider how the print will look if matted and framed with the signature showing or covered.

7. Use a graphite pencil or India ink to sign prints.

8. To photographers: Deviate from the above recommendations when it is required by the nature of your work.

9. Mount and overmat valued photographs as soon as possible.

10. Whenever possible, use mounting corners rather than hinges to secure photographs inside mats.

11. Handle all photographs, matted and unmatted, with clean hands; wear clean cotton gloves, if possible.

12. Interleave all stored prints, whether mounted or unmounted, to protect their surfaces.

13. Hold unmounted large and easily bending prints at two corners diagonally opposite from each other, not along the edges at the center.

14. Hold mats with two hands at the outer edges.

15. Do not touch the front of a photograph or a mat.

16. Never open a mat by lifting the inside edge of the window.

17. Open and close mats *slowly*.

18. Do not slide prints or mats against each other.

19. Do not remove a print from its mounting corners if not experienced in doing so.

20. Do not remove a print from its mount and/or corners and leave it loose in the mat.

21. Do not store prints in unsafe envelopes or boxes.

22. Store prints and mats flat on a horizontal surface.

23. Store prints and mats according to size.

24. Do not store large prints or mats on top of small prints or mats.

25. Do not store unmounted and mounted prints together in the same case or envelope.

26. Do not store unmounted color and black-and-white prints in the same case or envelope.

27. Request (and regularly update) information from retailers, distributors, and manufacturers about the stability characteristics of available photographic materials and of the materials that will come in contact with them.

28. Share and discuss such information with those in the field and other interested people.

## Summary

Every effort must be made to protect valued photographs from physical and chemical harm. Careful handling and conservation matting can contribute significantly to preserving the original quality of a print.

Before any mounting procedures are decided upon, the intentions of the photographer should be learned. It is the responsibility of curators, caretakers, collectors, and dealers, to preserve and present photographs according to the photographer's wishes. This task always requires the dedication and cooperation of all people involved, including the photographer.

Few definitive statements can be made about the long-term effects of high-quality mount boards and adhesives on contemporary color and black-and-white photographs. Mounting and enclosure materials should be at least as stable as the photograph to be mounted and should not have any adverse effect on the photographic image, its emulsion, or its support. Mount boards for prints should be sulfur-free, lignin-free, have a high alpha-cellulose content, and, until research shows otherwise, have a neutral pH value without the presence of alkaline-buffering chemicals. If the recommended boards cannot be used, a neutral barrier should prevent contact between unsuitable mounting materials and the photographs. Much more research needs to be done — and the results published with brand names identified — on the interactions between mounting materials and the wide variety of photographic materials.

In the United States, at the time this book went to press in 1992, there were twelve major manufacturers and distributors marketing high-quality boards made specifically for mounting photographs: ANW-Crestwood Paper Company; Archivart Division of Heller & Usdan, Inc.; Conservation Resources International, Inc.; Crescent Cardboard Company; Hurlock Company, Inc.; Light Impressions Corporation; Paper Technologies, Inc.; Miller Cardboard Company; Parsons Paper Company; Rising Paper Company; Talas, Inc.; and University Products, Inc. Regular inquiries should be made to these and other companies about the manufacture, composition, testing, stability characteristics, and appropriate uses of their products.

Manufacturers and distributors should provide with every package or container of paper, board, or other mounting material, a complete list of each product's contents and the manufacturing specifications. Knowing the specific composition of a product and who has manufactured it is essential knowledge for conservators and those doing conservation research if they are to properly understand the mechanisms by which the product affects photographs. In addition, when complete information is provided, and a spirit of openness and cooperation is shared by everyone involved, photographers will be better able to set lasting standards for the materials they use and to produce work that will last.

Where quality in objects — as in life — is to be preserved, thoughtful care is necessary to prevent damage for which there is usually no cure. The photographs properly taken care of now are the ones which will have a chance to survive. In this author's experience, careful handling and conservation matting are two important ways to provide protection and care for valuable and valued photographic prints.

## Acknowledgments

This author expresses her appreciation and gratitude to Sharp Lannom IV, John Wolf, and Henry Wilhelm for their long-standing support in this work.

# Notes and References

## Introduction and Section One

1. Background: Pratt Institute, School of Art and Design, Department of Fine Arts, Brooklyn, New York, 1969–1974 (BFA 1974); first employed to prepare conservation mats by the H. Shickman Gallery in New York City (June to September 1971), and by LIGHT Gallery in New York City (October 1971 to June 1982); associate member of the Photographic Materials Group of the American Institution for Conservation of Historic and Artistic Works (since 1982), and guild member of the Professional Picture Framers Association (since 1985).
2. Bonnie Barrett Stretch, "State of the Art: Big Deals on 57th Street," **American Photographer**, Vol. 16, No. 6, June 1986, p. 22.
3. Peter MacGill, telephone conversation with this author, July 14, 1986.
4. Henry Wilhelm originally outlined his views on the subject in this author's survey in 1982; further comments were added during subsequent discussions between 1983 and 1986.
5. Thomas Barrow is a photographer, curator, historian, and Professor of Art at the University of New Mexico in Albuquerque, and a former Assistant Director of the International Museum of Photography at George Eastman House in Rochester, New York.
6. Roy L. Perkinson, telephone conversation with this author, December 13, 1982.
7. Henry Wilhelm, "Preservation of Black and White Photographs," presentation given at **Preserving Your Historical Records: A Symposium**, The Olmstead Center of Drake University, Des Moines, Iowa, October 20–21, 1978.
8. Harold Jones is a photographer, dealer, former Associate Curator at George Eastman House, first Director of LIGHT Gallery, first Director of the Center for Creative Photography, and Associate Professor and Director of the Photography Program at the University of Arizona in Tucson.
9. Marvin Heiferman is a curator, dealer, author, and the former Director of Photography at Castelli Graphics (1976–1982).
10. Caldecot Chubb is a motion picture producer and publisher of limited-edition photographic books and portfolios.
11. Andy Grundberg, letter to this author, August 30, 1983, and telephone conversation with this author, September 3, 1985.
12. When asked, "Do you recall a situation in which the matting or mounting prevented damage to a photographic print?" 84% of the respondents said yes, 11% said no. Photographer Thomas Barrow, print dealer Monah Gettner, writer Andy Grundberg, framer Keith Knight, and gallery directors Peter MacGill and Laurence Miller all independently commented that they had seen overmats absorb the shock of falls, leaving the prints inside unharmed. "I've witnessed photographs, framed, and unframed but matted, fall off walls with the mats assuming most of the physical damage," wrote Alan B. Newman, who is Executive Director of Photographic Services at the Art Institute of Chicago, Illinois (formerly chief photographer at the Museum of Fine Arts in Boston, Massachusetts, and formerly Assistant Professor of Photography at Pratt Institute and at the New School for Social Research in New York City).
13. Exhibition and auction guide, June 6–10, 1983, Milwaukee Center for Photography, 207 East Buffalo Street, Milwaukee, Wisconsin 53202.

## Notes and References — Section Two

14. Beaumont Newhall, letter to this author, August 29, 1982. In a follow-up letter to this author (January 31, 1985), Newhall also wrote: ". . .regarding Stieglitz's disappointment with the framing/matting of his photographs by the Museum of Fine Arts in Boston. . . . Unfortunately I have no documentation to support my recollection of a conversation with Stieglitz held probably some 45 years ago! I do know definitely that he insisted that his personal presentation of his photographs should be preserved. When I was Curator of Photography at the Museum of Modern Art I acquired a dozen or so prints

from Stieglitz which we had him frame, and we had velvet-lined boxes made for them. . .he was very pleased!"

15. The edition consists of 30 portfolios (plus seven artist's proofs) with 82 different images in each. The negatives were printed on 16x20-inch Agfa Portriga-Rapid Paper. Issue of this portfolio of original prints coincided with the publication of the Aperture book **Social Graces** (1983).

Other examples of collaboration between photographers and publishers in creating portfolios are:
  – **In China** by Eve Arnold, with Castelli Graphics (1980).
  – **Desnudo** by Manuel Alvarez Bravo, with Acorn Editions (1980).
  – **The Seven Deadly Sins** and **The Seven Cardinal Virtues** by Don Rodan, with Castelli Graphics (1981).
  – **Twelve Photographs** by Stephen Shore, with the Metropolitan Museum of Art (1976).
  – **Portraits** by Andy Warhol, with Bruno Bischofberger (1981).
  – **Surrounded Islands** by Christo and photographer Wolfgang Volz, with Hugh Lauter Levin (1984).

16. Philip Katcher, "How to Date an Image from Its Mat," **Photographic Society of America Journal,** Vol. 44, No. 8, August 1978, p. 26.
17. William Adair, **The Frame in America, 1700–1900: A Survey of Fabrication Techniques and Styles,** The American Institute of Architects Foundation, Washington, D.C., 1983.
18. David Vestal, **The Art of Black-and-White Enlarging,** Harper & Row, New York, New York, 1984, p. 186.
19. Beaumont Newhall, letter to this author, July 21, 1983.
20. Beaumont Newhall, **Frederick H. Evans,** Aperture, Inc., Millerton, New York, 1973, p. 18.
21. Beaumont Newhall, see Note No. 19.
22. Beaumont Newhall, see Note No. 19.
23. Raymond Sokolov, **The Wall Street Journal,** December 3, 1982, p. 31.
24. Andre Kertesz, telephone conversation with this author, August 24, 1983.
25. This quote, in Kertesz's words for what Newhall said, was also printed in Janis Bultman's article, "The Up and Down Life of Andre Kertesz," which appeared in the September/October 1983 issue of **Darkroom,** Vol. 5, No. 6, pp. 32–50.
26. John Szarkowski, letter to this author, July 26, 1983.
27. Beaumont Newhall, see Note No. 19.
28. Beaumont Newhall, see Note No. 19.
29. Andre Kertesz, **Distortions,** Alfred A. Knopf, Inc., New York, New York, 1976.
30. Peter MacGill, telephone conversation with this author, September 1, 1983.
31. At the time of this writing in 1983, France, Germany, Italy, California, and Massachusetts also recognized the legal rights of artists to protect the integrity of their works.
32. New York State Assembly Bill No. 5052-C, "Artists' Authorship Rights Act," was signed into law by Governor Mario Cuomo on August 13, 1983.
33. Josh Barbanel, "New York Law Gives Artists Right to Sue to Protect Work," **The New York Times,** August 14, 1983, p. 1.
34. Beaumont Newhall, see Note No. 20, p. 10.
35. Beaumont Newhall, see Note No. 20, p. 17. Ward Muir's quote first appeared in **The Amateur American Photographer,** London, October 2, 1902, p. 273.

Newhall continued the discussion of Evans's concern with presentation: "Evans perfected the type of multiple mounting which was called, inaccurately, the American style because of its popularity with the members of the New American School. The trimmed print was first fastened with dabs of paste at its upper corners to a colored card, usually a subdued gray or tan, hardly more than an eighth of an inch larger in size than the picture. This in turn was mounted on a somewhat larger card of contrasting or harmonizing tint. The process was repeated, sometimes as many as eight times. The result was a series of borders around the photograph. Evans said the technique was 'really an easier way of arriving at the French method of surrounding a drawing by ruling ink lines and filling up some of the spaces between them with faint washes of colour.' Still it was exacting work, for each mount had to be of precisely the proper tint and cut exactly to the right size; it might take from five minutes to half an hour to get a satisfactory combination. [This section was footnoted: **The Photographic Journal,** February 1908, pp. 99–114.] Evans gave a practical course of instruction in mounting in a series of twelve monthly lessons in **The Photogram** magazine for 1904. In each issue there was a reproduction of a photograph, printed on one side only of a supplementary page. This the reader was invited to cut out, and to mount, according to Evans's explicit directions, on the cover paper – which was left unprinted on one side for this purpose. Not all of the cover paper was needed, and the reader was told to save the unused pieces for future les-

sons. Each month's cover was a different tint, so that by December the reader-student had a stock of mounting material, and was able to make an elaborate presentation. In 1908 Evans organized an exhibition of good and bad examples of multiple mounting at the Royal Photographic Society and gave a demonstration." (Beaumont Newhall, **Frederick H. Evans,** Aperture, Inc., Millerton, New York, 1973, p. 17.)

36. Andy Grundberg, "A Pioneer Whose Images Range from the Grim to the Glittery," **The New York Times,** March 1, 1987, Arts and Leisure, Sec. 2, pp. 35 and 37. The Gordon Parks retrospective exhibition was shown at The New York Public Library and the Schomburg Center for Research in Black Culture, both in New York City.
37. Among the 63 respondents who noticed surface texture of mount boards, 76% preferred smooth-textured board for matting and mounting photographs. Only 5% preferred rough-textured boards. Approximately 17% said it depended on the photograph or photographer.
38. Roy L. Perkinson, see Note No. 6.
39. Andre Kertesz, discussion with this author, May 29, 1983.
40. Ansel Adams, "Finishing, Mounting, Storage, Display," **The Print,** New York Graphic Society, Little, Brown and Company, Boston, Massachusetts, 1983, pp. 145–147.
41. Ralph Baum, "Light in the Darkroom: Arranging Exhibits," **Industrial Photography,** Vol. 14, No. 8, August 1965, p. 6.

## Notes and References — Section Three

42. The terms paper and board are sometimes used interchangeably in this text. Because board is usually made with sheets of paper that have been laminated together to create greater strength and thickness, board is sometimes referred to as "paper."
43. American National Standards Institute, Inc., **ANSI IT9.2-1991, American National Standard for Imaging Media – Photographic Processed Films, Plates, and Papers – Filing Enclosures and Containers for Storage.** (This Standard, which replaced **ANSI PH1.53-1986,** includes a new version of the Photographic Activity Test which is based on work done by James M. Reilly and Douglas W. Nishimura at the Image Permanence Institute at the Rochester Institute of Technology in Rochester, New York.) American National Standards Institute, Inc., 11 West 42nd Street, New York, New York 10036; telephone: 212-642-4900.
44. There is a third type of high-quality board, which is a composite board made of de-acidified wood pulp or cotton fiber. Faced with colored papers that have textured or smooth finishes, it is better suited to matting than mounting. This "decorative" board is approximately 4-ply thick and has a bright white core. Bainbridge Alphamat, Crescent Rag Mat (**not** Crescent "Rag Mat 100" ), and Miller Ultimat are examples.
45. Alden W. Hamilton, Manager of Commercial Development for James River Corporation, pointed out that longer cotton fibers and cotton rags are essential in the manufacture of durable papers for such products as bank notes, documents, and paper currency. These papers must be thin, yet have great folding and tearing endurance. In this author's experience, papers used to make mounting corners and hinges also require this kind of physical strength, although to a lesser degree.
46. Alden W. Hamilton, telephone conversation with this author, May 12, 1983. According to Hamilton, James River Ragmount was made from cotton rags until about 1974.
47. This statement by Charles T. Bainbridge's Sons, Inc. (currently Nielsen & Bainbridge) appears in literature published by the company and on folders containing samples of its mount board. Code:1-82-65m.
48. Kate McCarthy, telephone conversation with this author, July 18, 1986.
49. Chi C. Chen, telephone conversation with this author (regarding letters of June 21 and August 4, 1982), March 11, 1983.
50. Kurt R. Schaefer, follow-up letter to this author, July 14, 1982, after July 2, 1982, telephone conversation.
51. David Pottenger, telephone conversations with this author, May 11, 1983 and July 17, 1986. Mr. Pottenger was Marketing Manager in 1983.
52. Strathmore Paper Company, "Strathmore Artists' Paper, 500 Series," Westfield, Massachusetts, no date, p. 3.
53. This information was confirmed by Emily Vinick of the American Paper Institute in a telephone conversation with this author, May 12, 1983. American Paper Institute, 260 Madison Avenue, New York, New York 10016; telephone: 212-340-0600.
54. "Cotton Fiber Content Paper. Paper that contains 25% or more cellulose fibers derived from lint cotton, cotton linters and cotton or linen cuttings. The term is used interchangeably with rag content and cotton content papers."

"Rag Content. A term used interchangeably with cotton fiber content which indicates that a paper contains a percentage of cotton fiber pulp. The cotton fiber content normally used may vary from 25

to 100%." **Dictionary of Paper,** fourth edition, American Paper Institute, Inc., New York, New York, 1980, pp. 116 and 334.

55. Roberts and Etherington gave the following definition for "cotton fiber content papers": "Papers which are made from cellulose fibers derived from COTTON LINTERS, cotton or linen cuttings, and lint cotton. Flax is also sometimes included in this definition. Also called 'rag content paper' and 'cotton content paper.'" Matt T. Roberts and Don Etherington, **Bookbinding and the Conservation of Books,** Library of Congress, Washington, D.C., 1982, p. 67.

56. Glossary, **Paper – Art & Technology,** The World Print Council, San Francisco, California, 1979, p. 117.

57. Dennis O'Connor, undated letter to this author, received September 8, 1983.

58. Dennis Inch, telephone conversation with this author, September 9, 1983.

59. Ron Emerson, telephone conversation with this author, September 23, 1985.

60. Vera G. Freeman, Manager of the Art Paper Department, and Karen L. Crisalli, Assistant Manager of the Art Paper Department (A/N/W), telephone conversations with this author, May and August, 1983.

61. Michael S. Ginsburg, telephone conversation with this author, January 2, 1985.

62. Arno Roessler, telephone conversation with this author, August 20, 1985, and letter to this author, August 28, 1985 in response to author's letter dated August 21, 1985.

## Notes and References — Section Four

63. The terms mount and mat are often used interchangeably in this text. In this author's context, a matted print is always mounted whereas a mounted print is not always matted. When referring to the "mounted print," the print may or may not be matted. When referring to the "matted print," the print is always mounted onto the backing board, which is attached to the overmat. (The print may have been pre-mounted, such as dry mounting, in which case the mount is then mounted into the mat. If the print is loose, it is attached to the mat with either corners, hinges, etc.)

For the sake of brevity, prints are more often referred to as being "mounted" than either "mounted and matted" or "matted" because "mounted prints" refers to both "mounted and matted prints" and to "mounted and unmatted prints." When prints are referred to as "matted," it is to distinguish them from prints that are mounted without overmats.

Most board in the chapter is called mount board, because this author's overmats and mounts are nearly always made from the same board. The term "mat board" is used only when a board is specifically intended for making an overmat and is generally unsuitable for mounting.

64. A "point" is a unit used to measure the thickness of paper and paperboard and is equivalent to $1/1000$ inch; for example, a board which is 55 points thick is $55/1000$ inch thick.

65. Contact: Department of Cultural Affairs, Materials for the Arts, 410 West 16th Street, New York, New York 10001; telephone: 212-841-4100, and 212-555-5924.

66. Pieces of 16x20-inch board are more rigid when the 20-inch sides are taken from the 40-inch sides of the full sheet, provided the board is grain long. Four 16x20-inch pieces, all grain long, can be extracted from a sheet of 32x40-inch board which is grain long.

67. Claude Minotto, "Photograph Bibliography," **Archivaria,** No. 5, 1977–78, p. 138.

68. This author's survey question, "In your experience, what are the most common sizes you have found available for matting and framing photographic prints?" (no sizes were given with the question), received 49 responses and showed that the most common board sizes for mounting photographic prints are:

    1. 16x20 inches (43)
    2. 20x24 inches (30)
    3. 11x14 inches (27)
    4. 14x18 inches (25)
    5. 14x17 inches (23)
    6. 22x28 inches (18)
    7.  8x10 inches (10)
    8. 18x22 inches  (8)
    8. 24x30 inches  (8)
    9. 30x40 inches  (7)
    10. 12x14½ inches (6)
    11. 20x26 inches  (3)
    11. 40x60 inches  (3)

Numbers in parentheses represent the number of respondents who listed that size as standard in their experience.

This striking 1920's portrait is unfortunately all the more dramatic with its torn edges and lost emulsion. Its photographer and history are a mystery. From a private collection.

69. Chi C. Chen, see Note No. 49.

70. See: Jared Bark, "Notes on Framing" (1982) and "More Notes on Framing" (1985) published by Bark Frameworks, Inc., 85 Grand Street, New York, New York 10013; telephone: 212-431-9080.

A.P.F., Inc. has relocated to 320 Washington Street, Mt. Vernon, New York 10053; telephone: 914-665-5400.

71. Gaebel Enterprises, Inc., P.O. Box 6849, East Syracuse, New York 13217; telephone: 315-463-9261; toll-free: 800-722-0342.

72. See: E. J. Pearlstein, D. Cabelli, A. King, and N. Indictor, "Effects of Eraser Treatment on Paper," **Journal of the American Institute for Conservation,** Fall 1982, Vol. 22, No. 1, pp. 1–12. This author prefers kneadable erasers for cleaning mount board because they create fewer particles, or "crumbs."

73. Archivart sells alkaline-buffered wrapping paper: Product Number CP-101-CP, Archivart Acid-Free Wrapping Paper.

74. Arnon Ben-David, telephone conversation with the author, July 30, 1982.

75. The window was made large enough to show the ¼ inch border impression that surrounds the images to create a "double-border." However, impressions or lines in the border area that surrounds a photographic image may also be covered because the mat window also creates a "frame" around the picture.

76. This author was introduced to conservation matting in 1971 by Charles S. Moffett and Norman Leitman at the H. Shickman Gallery in New York City, a private establishment dealing in old master prints, drawings, and paintings. The fragility and difficulty of handling the artworks on paper depended a great deal on whether they had ever been trimmed and whether they were previously matted. Comparison of numerous prints – some trimmed long ago, some trimmed shortly before they reached the gallery, and some never trimmed – helped demonstrate both the reasoning behind and the danger of trimming artwork. It also clearly showed the importance of conservation matting. The torn edges, fingerprints, stains, adhesive residue, and other evidence of improper handling and/or mounting which had occurred during past decades and centuries to some rare and

valuable old master prints and drawings before they arrived in the gallery often detracted from the artwork. Some individuals had responded by trimming off damaged areas. Trimming of artwork is not allowed in the Shickman Gallery because, as I was told, trimming a finished print is itself a further mutilation of the work. A freshly cut edge may appear beautiful, but such beauty is usually short lived, and subsequent handling, new stains, and fresh tears may encourage further trimming. Repeated trimming of artwork brings image areas increasingly closer to areas that are handled directly and therefore makes them more susceptible to damage. In the case of some rare and valuable prints and drawings that had arrived unmatted, it was impossible not to touch the actual art. Conservation matting for such prints was done immediately.

77. Four-bladed easels are sold by The Saunders Group, Inc., 21 Jet View Drive, Rochester, New York 14624; telephone: 716-328-7800 (Master and Heavy Duty Professional Easels), and by the Kostiner Division of Omega/Arkay, 191 Shaeffer Avenue, P.O. Box 2078, Westminister, Maryland 21158; telephone: 410-857-6353; toll-free: 800-777-6634 (Kostiner Adjustable Universal Easels).

78. An exception to this illustrates the importance of considering composition of the image before deciding the mat's design. Some of Val Telberg's photographs such as "City Hanging in the Sky – Le Acrobate" (1951) which pictures five free-floating figures – three dancing women and two sleeping men, all in different positions – are full of movement and "without gravity." This photograph may be hung in any direction, always appearing upside down **and** right-side up. Therefore, the picture is most effectively presented with mat borders that are paired and equal in order to maintain the free-floating feeling.

79. This writer is not experienced in using mat cutting machines, such as the Esterly Speed-Mat Cutter, that do not require marking measurements on board. When this author observed the Esterly Speed-Mat Cutter demonstrated at the Frame-o-rama Convention in New York City in April 1982 and April 1985 by H. F. Esterly, it was accurate in its measurements when adjusted properly. It is essential to take into account any possible inconsistency of outside board dimensions when using such machines and instruments.

80. "Cutting mats" made of rubber-like "self-healing" materials are not recommended for cutting mount board upon. These translucent, green, or blue semi-hard "cutting mats," such as those made by Arttec, Dahle, and Uchida are excellent for cutting individual sheets of thin paper (e.g., mounting corners), but mount boards tend to shift position on them during cutting. If not fastened down, the "cutting mats" themselves will move on a smooth tabletop.

81. This approach is usually successful only when opening any of the eight "sides" where they meet at the four corners. The open incision in the middle of the appropriate side serves as a starting point and a guide for inserting the razor blade and setting the angle before directing its movement to the corner.

82. If the right hand is pushing the cutting instrument, the left hand is holding the straightedge. For right-handed individuals, the elbow and forearm of the right arm, which is moving the hand-held cutter forward, should rest on the straightedge to assist the left hand, which is holding the straightedge in place. (Right and left would be reversed in the case of left-handed individuals.)

83. Two photographers, Rivera Da Cueva and Guta de Carvalho, discovered when purchasing a Dexter Mat Cutter in New York City in November 1982 that the instrument weighed less than previously available models. Experienced in cutting mats with an earlier version, Da Cueva said that the "new" Dexter Mat Cutter was more difficult to control than the earlier model. According to the manufacturer, the metal was replaced with a slightly lighter metal, and the plastic knob on the blade holder was replaced with an aluminum knob, in the late 1970's. In 1984, Dexter returned to using plastic knobs because the aluminum ones were more difficult to adjust.

84. Ansel Adams, see Note No. 40, p. 147.

85. Process Materials Corporation, Technical Bulletin No. CP-197-PH: Atlantis Silversafe Photostore Paper 100% Cotton Fiber, May 1983. This paper was available in 27-lb., 54-lb., and 81-lb. weights. The 54-lb. or 81-lb. papers are suitable for most medium-weight prints.

86. Process Materials Corporation, Technical Bulletin No. CP-195-PH: Archivart Photographic Storage Paper, 75 lbs. (111 g/m²), May 1983; this paper is also available in 80-lb. weight. Light Impressions Renaissance Paper is an 80-lb. text-weight paper with a smooth finish.

87. Howard Paper Mills, the manufacturer of Permalife papers, also makes nonbuffered papers, including Renaissance Paper distributed by Light Impressions Corporation. Howard Paper Mills, Inc., 354 South Edwin C. Moses Boulevard, P.O. Box 982, Dayton, Ohio 45401; telephone: 513-224-1211; toll-free: 800-543-5010.

88. One of the first recommendations about the need for wide borders on photographic prints was made in 1968, when the Creative Pho-

tography Laboratory at the Massachusetts Institute of Technology announced that it would collect only "archivally processed" prints: "Archival prints must be made with a 1 or 2 inch border on all four sides cropped on the easel, then stored and displayed untrimmed beneath overmats." Jacob Deschin, "M.I.T. Starts Archival Photographic Collection," **The New York Times,** April 7, 1968, section 2, p. 31.

89. Eastman Kodak Company has also recommended ample print borders: "Examination of old photographs indicates that those mounted with wide borders often suffer less from atmospheric deterioration due to chemical penetrations at the print edges than those with narrow borders. For this reason, it is desirable to mount prints with borders about 8 cm (3 inches) wide at the top and sides and about 9 cm (3½ inches) wide at the bottom." Eastman Kodak Company, **Storage and Care of Kodak Color Materials** (major revision), Kodak Pamphlet No. E-30, May 1982, p. 6.

90. Michael Wilder, a top-quality commercial color printer, specializes in making Ilfochrome (called Cibachrome until 1990) prints, and has had extensive experience mounting them. Michael Wilder, 3716 Surfwood Road, Malibu, California 90265; telephone: 213-459-0305.

91. See: Merrily A. Smith, Norvell M. M. Jones, II, Susan L. Page, and Marian Peck Dirda, "Pressure-Sensitive Tape and Techniques for Its Removal from Paper," **Journal of the American Institute for Conservation,** Vol. 23, No. 2, Spring 1984, pp. 101–113.

92. T. J. Collings, **Archival Care of Still Photographs,** Society of Archivists Information Leaflet No. 2, Society of Archivists, 56 Ellin Street, Sheffield S1 4PL, England, 1986.

93. James M. Reilly, Director of the Image Permanence Institute at the Rochester Institute of Technology (established by RIT and the Society of Photographic Scientists and Engineers in January 1986), has been conducting research into the effects of enclosure materials on albumen prints. His findings suggest that uncoated polyester sheet is preferable to paper enclosures. See: James M. Reilly, **Evaluation of Storage Enclosure Materials for Photographs Using the ANSI Photographic Activity Test,** (National Museum Act Grant No. FC-309557), March 1984. See also: James M. Reilly, **Care and Identification of 19th-Century Photographic Prints,** Kodak Publication No. G-2S, Eastman Kodak Company, Rochester, New York, 1986, pp. 92–97.

94. Carol Joan Pedzich, Chief Archivist of the Photographic Archives of the International Museum of Photography at George Eastman House in Rochester, New York, addressing the visiting Photographic Materials Group of the American Institute for Conservation, February 1, 1982.

95. For example, fifteen 11x14-inch double-weight black-and-white prints matted to the size of 16x20 inches will weigh approximately the following:

> 4-ply overmat and backing: 12¾ pounds
> 2-ply overmat and backing: 6¾ pounds
> 2-ply overmat and 4-ply backing: 10 pounds

The same 15 prints, when matted with 2-ply overmats and 4-ply backings, will be approximately 1¾ inches thick on the binding side and approximately 1⁷⁄₁₆ inches thick on the opposite side (see **Appendix 12.2: Mount Board Thickness**). The model for these dimensions is the portfolio **Robert Doisneau – 15 Photographs,** published by Hyperion Press Limited in New York City (1979), matted with 2-ply overmats and mounted on 4-ply backings. The weight of the entire portfolio in its case is 15¾ pounds.

96. The portfolio **Larry Burrows: Vietnam, The American Intervention 1962–1968** consists of 18 Dye Transfer prints on 16x20-inch paper, conservation matted with Rising Photomount Museum Board (4-ply, white) – thirteen to the size of 20x24 inches, five to the size of 16x20-inches – and presented in a sturdy, hand-made case, elaborately designed to contain the two sizes. The portfolio was published in 1985 by the Laurence Miller Gallery in New York City, in collaboration with the photographer's son, Russell Burrows.

97. This author's survey included several questions regarding the use of interleaving papers. Of those responding to the survey question: "In general, do you feel that interleaving interferes with the viewing of pictures in galleries or private collections?" 44% said yes and 51% said no. Individuals on both sides commented that interleaving is necessary to protect the surfaces of prints when they are matted and when they are not protected by sleeves or in other ways. Peter MacGill's response to the question was, "No, not at all; it **helps** viewing [because] people learn proper care." Laurence Miller said, "On the contrary – it can increase the viewer's appreciation for a print because it requires people to pause before they look." Unframed prints in the Laurence Miller Gallery and the Pace/MacGill Gallery are protected with interleaving papers.

Most people interested in photography are aware of the need to protect print surfaces. In practice, however, only 53% of those

responding used interleaving paper between loose prints, 35% used it sometimes, and 11% did not interleave loose prints. Regarding the use of interleaving paper over prints inside mats, 54% did, 28% did sometimes, and 18% did not.

98. #40 Manning 600 Tissue Paper may be ordered from Manning Paper Company, P.O. Box 328, Troy, New York 12181; telephone: 518-273-6320. Unfortunately, the minimum order is 5000 pounds. It is hoped that a distributor can be found for this product. As with most of the enclosure papers mentioned in this book, #40 Manning 600 (Troya #40) has not undergone testing with the Photographic Activity Test in **ANSI IT9.2-1991, American National Standard for Imaging Media – Photographic Processed Films, Plates, and Papers – Filing Enclosures and Containers for Storage.**

99. In 1984, Andrews/Nelson/Whitehead began to sell an interleaving paper called Troya #0122, which bears but a slight resemblance to Troya #40. Troya #0122 is a heavier weight and stiffer paper.

100. Frank R. Hart, letter to this author, August 12, 1983.

101. "L" Tissue and "M" Tissue are manufactured by Barcham Green & Company, Ltd. at the Hayle Mill in Kent, England. ANW-Crestwood in New York is the distributor in the United States.

102. Process Materials Corporation, see Note No. 85.

103. Process Materials Corporation, see Note No. 86

104. Light Impressions Archival Supplies Catalogs, Fall 1992 and earlier.

## Additional References

Miles Barth, "Notes on Conservation and Restoration of Photographs," **Print Collector's Newsletter,** May/June 1983, pp. 48–50.

Paul N. Banks, "Matting and Framing Documents and Art Objects on Paper," The Newberry Library, Chicago, Illinois, first published 1968, revised May 1973 and November 1978.

Doris Bry, "An Approach to the Care of Photographs," Sotheby Parke Bernet, New York, New York, 1976.

Anne F. Clapp, **Curatorial Care of Works of Art on Paper,** third revised edition, Intermuseum Conservation Association, The Intermuseum Laboratory, Oberlin, Ohio, March 1978.

Anne F. Clapp, **Curatorial Care of Works of Art on Paper,** fourth revised edition, Nick Lyons Books, New York, 1988.

Francis W. Dolloff and Roy L. Perkinson, **How to Care for Works of Art on Paper,** third edition, Museum of Fine Arts, Boston, Massachusetts, 1979, p. 29.

Eastman Kodak Company, "Finishing and Mounting," in **Quality Enlarging with Kodak B/W Papers – Art, Technique and Science,** Kodak Publication No. G-1, Eastman Kodak Company, Rochester, New York, May 1982.

Eastman Kodak Company, **Preservation of Photographs,** Kodak Publication No. F-30, Eastman Kodak Company, Rochester, New York, 1979.

Eastman Kodak Company, **Conservation of Photographs** (George T. Eaton, editor), Kodak Publication No. F-40, Eastman Kodak Company, Rochester, New York, 1985.

Margaret Holben Ellis, "Matting Drawings for Storage and Exhibition," **Drawing,** Vol. 2, No. 1, May/June 1980, pp. 7–10.

Margaret Holben Ellis, **The Care of Prints and Drawings,** American Association for State and Local History, Nashville, Tennessee, 1987.

Ann Ferguson, **Conservation Framing for the Professional Picture Framer,** Windsor Graphics, Galveston, Texas, 1985.

Grace Glueck, "What's in a Frame? Less and Less at the Modern," **The New York Times,** July 15, 1984, Section 2, pp. 1 and 6.

Per E. Guldbeck, **The Care of Historical Collections,** American Association for State and Local History, third printing, Nashville, Tennessee, 1981.

Judith Harlan, "Hockney Redefines Role of Framer," **Art Business News,** May 1986, pp. 1 and 70.

Robert Heller, "Photography in American Art Museums: A History," **Picturescope,** Vol. 29, No. 3, Fall 1981, pp. 84–90.

Klaus B. Hendriks, **The Preservation and Restoration of Photographic Materials in Archives and Libraries: A RAMP Study with Guidelines,** United Nations Educational, Scientific and Cultural Organization (UNESCO), Paris, 1984.

Klaus B. Hendriks, together with Brian Thurgood, Joe Iraci, Brian Lesser, and Greg Hill of the National Archives of Canada staff, **Fundamentals of Photographic Conservation: A Study Guide,** published by Lugus Publications in cooperation with the National Archives of Canada and the Canada Communication Group, 1991. Available from Lugus Productions Ltd., 48 Falcon Street, Toronto, Ontario, Canada M4S 2P5; telephone: 416-322-5113; Fax: 416-484-9512.

Craig W. Jensen (compiled by), **The Book & Paper Group Annual – Volume 2,** The American Institute for Conservation of Historic and Artistic Works, Washington, D. C., 1983.

Klaus B. Kasper and Rudolf Wanka, "Chemical Formulations and Requirements of Photographic Paper," **Journal of Applied Photographic Engineering,** Vol. 7, No. 3, June 1981, p. 67.

Laurence E. Keefe, Jr. and Dennis Inch, **The Life of a Photograph,** Focal Press (Butterworth Publishers), Boston, Massachusetts and London, England, 1990. The book's first edition was published in 1984.

Stuart A. Kohler, "Archival Photo Corners of Japanese Tissue," **The Abbey Newsletter,** Vol. 6, No. 5, October 1982, pp. 63–64.

Stuart A. Kohler, "How to Make and Use Wheat Starch Paste," **History News,** Vol. 36, No. 7, July 1981, pp. 38–39.

Sue Beauman Murphy and Siegfried Rempel, "A Study of the Quality of Japanese Papers Used in Conservation," **The Book and Paper Group Annual,** Vol 4, The American Institute for Conservation of Historic and Artistic Works, Washington, D.C., 1985, pp.63–72.

Library of Congress, Preservation Office – Research Services, **Matting and Hinging of Works of Art on Paper,** Library of Congress, Washington, D.C., 1981, p. 30.

National Gallery of Canada, Restoration and Conservation Laboratory, **The Care of Prints and Drawings with Notes on Matting, Framing and Storage,** revised edition, National Gallery of Canada, Ottawa, Ontario, April 1981.

Laraine Wright O'Malley, ed., **Mounting Art Work,** Basics & Beyond Series, Commerce Publishing Company, St. Louis, Missouri, 1979.

Joan Pedzich, "Balancing Preservation and Research: Some Principles that Help," **PhotographiConservation,** Vol. 4, No. 2, June 1982, pp. 6–7.

Roy L. Perkinson, **Conserving Works of Art on Paper,** American Association of Museums, Washington, D.C., 1977, p. 4.

Polaroid Corporation, **Storing, Handling and Preserving Polaroid Photographs: A Guide,** Polaroid Corporation, Cambridge, Massachusetts, 1983.

Sandra Powers, "Why Exhibit? The Risks Versus the Benefits," **The American Archivist,** Vol. 41, No. 3, July 1978, p. 297.

Professional Picture Framers Association, **PPFA Guild Guidelines for Framing Works of Art on Paper,** Professional Picture Framers Association, Richmond, Virginia, 1985.

Professional Picture Framers Association, **PPFA Guild Guidelines for Framing Works of Art on Paper** (revised edition), Professional Picture Framers Association, Richmond, Virginia, 1987.

Professional Picture Framers Association, **Survey on Mat/Mount Boards,** Richmond, Virginia, March 1986.

Jeanne Schonberg, "Questions to ask your framer and answers you should get," Tamarind Institute, The University of New Mexico, Albuquerque. Revised by Judith Booth, July 1973.

Bob Schwalberg, with Henry Wilhelm and Carol Brower, "Going! Going!! Gone!!! – Which Color Films and Papers Last Longest?", **Popular Photography,** June 1990, Vol. 97, No. 6, pp. 37–49, 60.

Merrily A. Smith and Margaret R. Brown, **Matting and Hinging of Works of Art on Paper,** A National Preservation Program Publication, National Preservation Program Office, Library of Congress, Washington, D.C., 1981; and, The Consultant Press, A Division of the Photographic Arts Center, New York, New York, 1986.

Otha C. Spencer, **A Guide to the Enhancement & Presentation of Photographs,** Prentice-Hall, Inc. Englewood Cliffs, New Jersey, 1983.

Nathan Stolow, **Conservation Standards for Works of Art in Transit and on Exhibition,** United Nations Educational, Scientific and Cultural Organization, Paris, France, 1979.

Marla Strasburg and Vivian Kistler, **Floorplans for Galleries and Frame Shops,** Columbia Publishing, Akron, Ohio, 1989.

Susan Garretson Swartzburg, ed., **Conservation in the Library – A Handbook of Use and Care of Traditional and Nontraditional Materials,** Greenwood Press, Westport, Connecticut, 1983.

Time-Life Books, **Caring for Photographs – Display, Storage, Restoration** (revised edition), Time-Life Books, Alexandria, Virginia, 1982.

David Vestal, "How David Vestal Mounts and Mats Prints," **Popular Photography,** Vol. 90, No. 9, September 1983, pp. 87–94.

David Vestal, **The Craft of Photography** (updated edition), Harper & Row Publishers, Inc., New York, New York, 1975.

Lee D. Witkin and Barbara London, **The Photograph Collector's Guide,** New York Graphic Society, Little, Brown and Company, Boston, Massachusetts, 1979.

Carl Zigrosser and Christa M. Gaehde, **A Guide to the Collecting and Care of Original Prints,** sponsored by the Print Council of America, Crown Publishers, New York, New York, 1965.

*(See Chapter 12 Appendices and Suppliers List on following pages. . .)*

# Appendix 12.1: Survey

In August 1982, this author sent out survey forms to 86 individuals actively involved with photography. The survey, titled "The Care and Presentation of Photographic Prints," consisted of 131 questions and was conducted to review changing attitudes and practices related to the preservation and presentation of photographic prints. Among those queried were 18 photographers, 14 curators and historians, 13 conservators, 10 print dealers, 6 print collectors, 4 writers, 11 miscellaneous professionals, and 10 "multiple role" people. Although many individuals were involved in more than one area, only 10 were classified as having active multiple roles. For example, Harold Jones, who currently teaches at the University of Arizona, is also well known as a photographer, educator, curator, print dealer, and gallery director.

Of the 72 returned forms, 65 were usable and 7 were unusable (apologies, incomplete). In addition, one person wrote an informative letter to substitute for the incomplete form, 6 people participated in telephone interviews (2 of these had returned unusable forms), and 10 people did not respond. Answers to the questions and all additional comments written in the usable forms were tabulated and yielded an enormous amount of information. Some of the data was used by citing statistics to illustrate various concerns and some of the written comments have been woven into the chapter. Only those individuals who completed the survey forms were included in the statistical tabulations. Those who wrote letters and participated in telephone interviews have been quoted in the text and are referenced at the end of the chapter.

It is hoped that this is only the first of a series of surveys that will be conducted periodically in the coming years. This author would like to thank the following people who participated in this survey:

Ansel Adams
Gary E. Albright, Northeast Document
    Conservation Center
Jared Bark, Bark Frameworks, Inc.
Thomas Barrow, University of New Mexico
Miles Barth, International Center for Photography
Arnon Ben-David
Jane and Larry Booth, San Diego Historical Society
Irene Borger
Harry Callahan
Eleanor Caponigro
Pat Marie Caporaso, Castelli Graphics
William Christenberry
Caldecot Chubb
Mitch Epstein
Louis Faurer
David Fahey, G. Ray Hawkins Gallery
Roy Flukinger, Humanities Resource Center,
    University of Texas
Frances Fralin, Corcoran Gallery of Art
Helen Gee
Monah and Alan Gettner, Hyperion Press Ltd.
Ralph Gibson
Emmet Gowin
Andy Grundberg
Susan Harder
Marvin Heiferman
Marvin Hoshino
Harold Jones, University of Arizona
Peter C. Jones
Pepe Karmel
Andre Kertesz
Susan Kismaric, Museum of Modern Art
Keith Knight, Knightworks
Patti and Frank Kolodny
David Kolody
Helen Levitt
Robert Littman, Grey Art Gallery (presently
    Director of Museo Rufino Tamayo)
Robert Lyons

Peter MacGill, Pace/MacGill Gallery
Jerald Maddox, Library of Congress
Joyce and Robert Menschel
Ronay and Richard Menschel
Laurence G. Miller, Laurence Miller Gallery
National Film Board of Canada
Weston J. Naef, Metropolitan Museum of Art
    (presently Curator of Photography at the
    J. Paul Getty Museum)
Hans Namuth
Beaumont Newhall
Alan B. Newman, Museum of Fine Arts, Boston
    (presently Executive Director of Photographic
    Services at The Art Institute of Chicago)
Arnold Newman
Debbie Hess Norris
Eugene Ostroff, Smithsonian Institution
Merrily Page, Page Imageworks, Inc.
Roy L. Perkinson, Museum of Fine Arts, Boston
Mary Kay Porter
Ani Rivera
Don Rodan
John Rohrback, Aperture, Inc.
Grant Romer, International Museum of Photography
    at George Eastman House
Leo Rubinfien
Gerd Sander, Sander Gallery, Inc.
Allen Schill
Victor A. Schrager
Douglas G. Severson, The Art Institute of Chicago
Frederick Sommer
Eve Sonneman
Joel Sternfeld
Alice Swan
Susan Unterberg
Samuel Wagstaff, Jr.
Thomas Walther
Rick Wester
Henry Wilhelm
Peter Wilsey

## Appendix 12.2: Mount Board Thickness

Museum mount board is available in 1-, 2-, 4-, 6-, and 8-ply thicknesses of which 2- and 4-ply are the most common. One-ply is usually about 12.5 points thick. A "point" is a unit for measuring the thickness of paper and paperboard and is equivalent to $\frac{1}{1000}$ inch. A point measurement is more accurate than a ply measurement because the term "ply" merely means "layer" and not actual thickness. For example, a piece of 4-ply museum board is usually about $\frac{1}{16}$-inch thick, while a different 4-ply paper product, such as a bristol board, may be less than $\frac{1}{32}$-inch thick. Thickness is not an accurate guide to weight since some manufacturers' boards are denser (and consequently heavier) than others of the same thickness.

Following are the approximate thicknesses of single sheets or pieces of museum mount board:

2-ply = $\frac{1}{32}$ inch = 25–30 points
4-ply = $\frac{1}{16}$ inch = 50–60 points

The following examples indicate how the thicknesses of 1-, 2-, and 4-ply mount boards vary among different companies and show some other available thicknesses of mount board (measurements were supplied by the companies in 1985):

*Andrews/Nelson/Whitehead:*
1-ply: 13–14 points
2-ply: 27 points
4-ply: 54 points
6-ply: 81 points

*James River Corporation:*
1-ply: 13 points
2-ply: 26 points
4-ply: 56 points

*Process Materials Corporation:*
2-ply: 25–27 points
4-ply: 50–55 points
60x104-inch museum board: 60 points
6-ply: 85 points

*Rising Paper Company:*
1-ply: 15 points
2-ply: 30 points
Conservamat: 55 points
4-ply: 60 points

In March 1986, the Professional Picture Framers Association in Richmond, Virginia, published its first *Survey on Mat/Mount Boards.* This comprehensive report provides information about numerous boards, and includes a more extensive list of board thickness (see above: **Additional References**).

# Suppliers

## High-Quality Boards and Papers

### A. Manufacturers (museum board)

**Barcham Green & Company, Ltd.**
Hayle Mill
Maidstone, Kent ME15 6XQ
England

**Beckett Paper Company**
400 Dayton Street
Hamilton, Ohio 45011
  Telephone: 513-863-5641

**Custom Papers Group**
(formerly James River-Fitchburg, Inc.)
Old Princeton Road
Fitchburg, Massachusetts 01420
  Telephone: 617-345-2161

**James River Corporation**
(see Custom Papers Group)

**Lydall-Manning Paper Company**
Division of Hammermill Paper Company
P.O. Box 328
Troy, New York 12181
  Telephone: 518-273-6320

**Monadnock Paper Mills, Inc.**
Antrim Road
Bennington, New Hampshire 03442
  Telephone: 603-588-3311

**Papeteries Canson & Montgolfier**
P.O. Box 139
F-07104 Annonay
Cedex, France

**Parsons Paper Company**
Division of NVF Company
Holyoke, Massachusetts 01040
  Telephone: 413-532-3222

**Rising Paper Company**
Division of Fox River Paper Company
295 Park Street
Housatonic, Massachusetts 01236
  Telephone: 413-274-3345

**St. Cuthbert's Paper Mill**
Wells, Somerset BA5 1A6
England
  Telephone: 0749-72015

**Strathmore Paper Company**
South Broad Street
Westfield, Massachusetts 01085
  Telephone: 413-568-9111

### B. Convertors and Distributors

**ANW-Crestwood Paper Co.**
Division of Willmann Paper Co.
315 Hudson Street
New York, New York 10013
  Telephone: 212-989-2700
  Toll-free: 800-525-3196

**Atlantis Paper Company Limited**
No. 2 St. Andrews Way
London, E3 3PA
England
  Telephone: 01-481-3784

## High-Quality Boards and Papers

### B. Convertors and Distributors

**Archivart**
Division of Heller & Usdan, Inc.
7 Caesar Place
Moonachie, New Jersey 07074
  Telephone: 201-933-8100
  Toll-free: 800-333-4466

**The Columbia Corporation**
Artists Supplies Division
Route 295
Chatham, New York 12037
  Telephone: 518-392-4000
  Toll-free: 800-833-1804

**Crescent Cardboard Company**
100 West Willow Road
Wheeling, Illinois 60090
  Telephone: 312-537-3400
  Toll-free: 800-323-1055

**Hurlock Company, Inc.**
1446–48 W. Hunting Park Avenue
Philadelphia, Pennsylvania 19140
  Telephone: 215-324-8094
  Toll-free: 800-341-0142

**Light Impressions Corporation**
439 Monroe Avenue
Rochester, New York 14603
  Telephone: 716-271-8960
  Toll-free: 800-828-6216

**Miller Cardboard Corporation**
75 Wooster Street
New York, New York 10012
  Telephone: 212-226-0833
  Toll-free: 800-888-1662

**Morilla Inc.**
211 Bowers Street
Holyoke, Massachusetts 01040
  Telephone: 413-538-9250
  Toll-free: 800-628-9283

**Nielsen & Bainbridge**
Esselte Business Systems, Inc.
40 Eisenhower Drive
Paramus, New Jersey 07652
  Telephone: 201-368-9191
  Toll-free: 800-631-5414

**Paper Technologies, Inc.**
929 Calle Negocio
San Clemente, CA 92673
  Telephone: 714-366-8799

**Process Materials Corporation**
(see Archivart)

**Rupaco Paper Corporation**
110 Newfield Avenue
Edison New Jersey 08818
  Telephone: 908-417-9266
  Toll-free: 800-336-4736

**Talas, Inc.**
213 West 35th Street
New York, New York 10001-1996
  Telephone: 212-736-7744

**University Products, Inc.**
517 Main Street
Holyoke, Massachusetts 01041
  Telephone: 413-532-9431
  Toll-free: 800-628-1912

### C. Retailers

**Charrette Corporation**
31 Olympic Avenue
Woburn, Massachusetts 01888
  Telephone: 617-935-6000
  Toll-free: 800-367-3729

**Conservation Materials, Ltd.**
1165 Marrietta Way
Sparks, Nevada 89431
  Telephone: 702-331-0582

**Conservation Resources International, Inc.**
8000-H Forbes Place
Springfield, Virginia 22151
  Telephone: 703-321-7730
  Toll-free: 800-634-6923

**Light Impressions Corporation**
439 Monroe Avenue
Rochester, New York 14603
  Telephone: 716-271-8960
  Toll-free: 800-828-6216

**New York Central Art Supply**
62 Third Avenue
New York, New York 10003
  Telephone: 212-473-7705
  Toll-free: 800-242-2408

**Sam Flax, Inc.**
39 West 19th Street
New York, New York 10011
  Telephone: 212-620-3000
  Toll-free: 800-628-9512

**Talas, Inc.**
213 West 35th Street
New York, New York 10001-1996
  Telephone: 212-736-7744

**University Products, Inc.**
517 Main Street
Holyoke, Massachusetts 01041
  Telephone: 413-532-9431
  Toll-free: 800-628-1912

## Conservation Materials

### A. Distributors

**Archivart**
Division of Heller & Usdan, Inc.
7 Caesar Place
Moonachie, New Jersey 07074
  Telephone: 201-933-8100
  Toll-free: 800-333-4466

**Filmolux (U.S.A.), Inc.**
(tapes, adhesives)
4600 Witmer Industrial Estate
Niagra Falls, New York 14305
  Telephone: 716-298-1189
  Toll-free: 800-873-4839

**Paper Technologies, Inc.**
929 Calle Negocio
San Clemente, CA 92673
  Telephone: 714-366-8799

**Seal Products, Inc.**
550 Spring Street
Naugatuck, Connecticut 06770
  Telephone: 203-729-5201
(Contact Seal for information on Ademco products and Archival Aids tapes.)

### B. Retailers

**Conservation Materials, Ltd.**
1165 Marrietta Way
Sparks, Nevada 89431
  Telephone: 702-331-0582

**Conservation Resources International, Inc.**
8000-H Forbes Place
Springfield, Virginia 22151
  Telephone: 703-321-7730
  Toll-free: 800-634-6923

**Light Impressions Corporation**
439 Monroe Avenue
Rochester, New York 14603
  Telephone: 716-271-8960
  Toll-free: 800-828-6216

**Lineco Inc.**
P.O. Box 2604
Holyoke, MA 01041
  Telephone: 413-534-7815
  Toll-free: 800-322-7775

**Talas, Inc.**
213 West 35th Street
New York, New York 10001-1996
  Telephone: 212-736-7744

**University Products, Inc.**
517 Main Street
Holyoke, Massachusetts 01041
  Telephone: 413-532-9431
  Toll-free: 800-628-1912

## Matting / Framing Supplies

(See also Chapter 15.)

### A. Manufacturers

**A.P.F., Inc.** (frames)
320 Washington Street
Mt. Vernon, New York 10553
  Telephone: 914-665-5400
  Toll-free: 800-221-9515

**The C–Thru Ruler Company**
6 Britton Drive
Bloomfield, Connecticut 06002
  Telephone: 203-243-0303
  Toll-free: 800-243-8419

**Dahle U.S.A., Inc.**
6 Benson Road
Oxford, Connecticut 06483
  Telephone: 203-264-0505
  Toll-free: 800-243-8145

**Faber-Castell Corporation**
(drafting supplies)
41 Dickerson Street
Newark, New Jersey 07107
  Telephone: 201-483-4646
  Toll-free: 800-835-8382

**Frame Tek** (frame fillets)
5120-5 Franklin Boulevard
Eugene, Oregon 97403
  Telephone: 503-726-5779
  Toll-free: 800-227-9933

**Frame Strips, Inc.**
(polyester strips for mounting prints)
P. O. Box 1788
Cathedral City, California 92234
  Telephone: 619-328-2358
  Toll-free: 800-448-1163

**Gaebel Enterprises, Inc.** (rulers)
P.O. Box 6849
100 Ball Street
East Syracuse, New York 13217
 Telephone: 315-463-9261
 Toll-free: 800-722-0342

**Innerspace** (frame fillets)
43 E. Lancaster Avenue
Paoli, Pennsylvania 19301
 Telephone: 215-644-9293
 Toll-free: 800-327-9348

**Koh-I-Noor, Inc.**
(pens, drafting supplies)
100 North Street
Bloomsbury, New Jersey 08804
 Telephone: 908-479-4124
 Toll-free: 800-631-7646

## B. Distributors

**Larsen-Juhl**
3900 Steve Reynolds Blvd.
Norcross, GA 30093
 Telephone: 404-279-5319
 Toll-free: 800-221-4123

**Morilla Inc.**
211 Bowers Street
Holyoke, Massachusetts 01040
 Telephone: 413-538-9250
 Toll-free: 800-628-9283

**S&W Framing Supplies, Inc.**
120 Broadway
P.O. Box 340
Garden City Park, New York 11040
 Telephone: 516-746-1000
 Toll-free: 800-645-3399

**United Manufacturers
Supplies, Inc.**
80 Gordon Drive
Syosset, New York 11791
 Telephone: 516-496-4430
 Toll-free: 800-645-7260

## C. Retailers

**Charrette Corporation**
31 Olympic Avenue
Woburn, Massachusetts 01888
 Telephone: 617-935-6000
 Toll-free: 800-367-3729

**New York Central Art Supply**
62 Third Avenue
New York, New York 10003
 Telephone: 212-473-7705
 Toll-free: 800-242-2408

**Sam Flax, Inc.**
39 West 19th Street
New York, New York 10011
 Telephone: 212-620-3000
 Toll-free: 800-628-9512

**Light Impressions Corporation**
439 Monroe Avenue
Rochester, New York 14607
 Telephone: 716-271-8960
 Toll-free: 800-828-6216

**Talas, Inc.**
213 West 35th Street
New York, New York 10001-1996
 Telephone: 212-736-7744

**University Products, Inc.**
517 Main Street
Holyoke, Massachusetts 01041
 Telephone: 413-532-9431
 Toll-free: 800-628-1912

**Westfall Framing, Inc.**
P.O. Box 13524
Tallahassee, Florida 32317
 Telephone: 904-878-3546
 Toll-free: 800-874-3164

## Paper and Mat Cutting Instruments and Machines

(Contact the following companies for the names of distributors and retailers.)

**Alto's EZ/Mat, Inc.**
607 West Third Avenue
Ellensburg, Washington 98926
 Telephone: 509-962-9212

**Carithers International Associates, Inc.**
P.O. Box 16997
Jackson, Mississippi 39236
 Telephone: 601-956-8378

**C & H/Bainbridge**
Nielsen & Bainbridge
50 Northfield Avenue
Edison, New Jersey 08818
 Telephone: 201-225-9100
 Toll-free: 800-631-5414

**Dahle U.S.A., Inc.**
6 Benson Road
Oxford, Connecticut 06483
 Telephone: 203-264-0505
 Toll-free: 800-243-8145

**Dexter Mat Cutters**
Russell Harrington Cutlery, Inc.
44 Green River Street
Southbridge, Massachusetts 01550
 Telephone: 617-765-0201

**H. F. Esterly Company**
Box 890, R.R. 3, U.S. Rt. 1
Wiscasset, Maine 04578
 Telephone: 207-882-7017
 Toll-free: 800-882-7017

**The Fletcher-Terry Company**
65 Spring Lane
Farmington, Connecticut 06032
 Telephone: 203-677-7331
 Toll-free: 800-843-3826

**General Tools, Inc.**
80 White Street
New York, New York 10013
 Telephone: 212-431-6100

**Grifhold** (available from Charrette Corporation and Sam Flax, Inc.)

**Holdfast Mat Cutting
Systems Concept Design**
Box 84, RR 5
Cape Elizabeth, Maine 04107
 (Distributed by Morilla Inc.)

**KeenCut North America**
The Saunders Group
21 Jet View Drive
Rochester, New York 14624
 Telephone: 716-328-7800
 Toll-free: 800-828-6124

**Kutrimmer Cutters**
(see Triumph Paper Cutters)

**Logan Graphic Products, Inc.**
1100 Brown Street
Wauconda, Illinois 60084
 Telephone: 708-526-5515
 Toll-free: 800-331-6232

**Maped S.A.**
B.P. 190
4, avenue des Vieux Moulins
74005 Nancy, France
 (Maped matcutters are distributed
 in North America by Talens C.A.C., Inc.
 and sold through fine art material stores in
 Canada)

**Morilla Inc.**
211 Bowers Street
Holyoke, Massachusetts 01040
 Telephone: 413-538-9250
 Toll-free: 800-628-9283

**Olfa Corporation**
Higashi-Nakamoto 2-11-8
Higashinari-ku, Osaka 537
Japan
 Telephone: 06-972-8101/5
 (Olfa cutters are sold in the
 United States by Charrette
 Corporation and Sam Flax, Inc.)

**Picture Framing
Equipment Company**
5836 North Commerce Plaza
Jackson, Mississippi 39206
 Telephone: 601-956-9894
 Toll-free: 800-221-8592

**Stanley Works**
Tool Division
600 Myrtle Street
New Britain, Connecticut 06050
 Telephone: 203-225-5111

**Starr-Springfield, Inc.**
2610 Prancer Street
New Orleans, Louisiana 70114
 Telephone: 504-392-7905

**Talens C.A.C., Inc.**
2 Waterman Street
Department AT3
St. Lambert, Quebec J4P 1R8
Canada
 Telephone: 514-672-9931

**Triumph Paper Cutters**
Michael Business Machines Corporation
3290 Ashley Phosphate Road
North Charleston, South Carolina 29418
 Telephone: 803-552-2700
 Toll-free: 800-552-2974

**X-Acto**
Subsidiary of Hunt
Manufacturing Corporation
2020 West Front Street
Statesville, North Carolina 28677
 Telephone: 704-872-9511
 Toll-free: 800-438-0977

# 13. Composition, pH, Testing, and Light Fading Stability of Mount Boards and Other Paper Products Used with Photographs

## By Carol Brower and Henry Wilhelm

Mount boards, paper envelopes, and interleaving sheets used with black-and-white and color photographs should meet the following three basic requirements:

1. **Mount boards and paper materials should not cause staining or fading of prints and should not accelerate the rates of deterioration inherent with a given type of color or black-and-white photograph.** The composition, pH, and other characteristics of mount boards and paper products should be determined primarily by what is best for the stability of the particular type of photograph being mounted or stored. For example, with the exceptions of recent Fujicolor and Fujichrome papers, prints made with Kodak Ektacolor Portra II, Ektacolor Supra, Ektacolor Professional, and most other chromogenic papers gradually develop an objectionable overall yellowish stain during normal dark storage at room temperature, and there is evidence that this type of stain formation is accelerated by an alkaline environment. With some of these papers, the dark storage fading rate of the cyan image dye also is accelerated by an alkaline environment (see Chapter 5). Consequently, it is advisable to avoid high-pH, alkaline-buffered, "acid-free" boards and papers with these and similar chromogenic color prints.

    While there is ample evidence that alkaline buffering will enhance the longevity of mount boards and most other paper products, the pH level and the addition of calcium carbonate or magnesium carbonate buffering should be determined not by what is best for the board or paper, but rather by what will maximize the life of the photograph. Pending further study, high-quality mount boards, enclosure papers, and interleaving papers that have a near-neutral pH *without* the presence of buffering agents are recommended for both color and black-and-white photographs. High-quality alkaline-buffered boards and papers *are* believed suitable for platinum and palladium prints.[1]

2. **The long-term physical stability of the mount board or other paper product should be at least equal to that of the photograph used with it.** Since some types of photographs are inherently far more stable and long-

    lasting than others, the stability requirements for boards and papers will vary correspondingly. With color materials, both the type of print and whether or not it will be subjected to light fading during prolonged display will determine the stability requirements of the mount board. With Ilford Ilfochrome prints (called Cibachrome prints, 1963–1991), Kodak Dye Transfer prints, and Fuji Dyecolor prints — which should remain in excellent condition for many hundreds of years when stored in the dark, but which will have a much shorter life if displayed — the intended use of a print will strongly influence the stability requirements of the board chosen to mount it. On the other hand, UltraStable Permanent Color prints (introduced in 1991) and Polaroid Permanent-Color prints (introduced in 1989), both of which are made with extremely stable color pigments instead of the far less stable organic dyes used with other types of color photographs, and properly processed fiber-base black-and-white prints that have been treated with Kodak Rapid Selenium Toner or a sulfiding toner, can be expected to have an exceedingly long life either if exposed to light on display *or* if kept in the dark. Only the most stable boards and other materials should be chosen to mount these prints.

    Physical stability requirements include the following: a mount board must maintain sufficient strength and stiffness to properly support and protect a print throughout its expected life; an interleaving paper must retain its smoothness and flexibility; and a storage envelope must have great folding endurance to withstand repeated opening and closing without breaking.

3. **The brightness and color or tone of a mount board should not change an objectionable amount during its co-existence with a photograph.** The amount of visual change that can be tolerated in a mount board depends on the particular application, and on how critical were the visual criteria for the board when it was originally selected.

    For example, with a fiber-base black-and-white print that has been treated with Kodak Rapid Selenium Toner and that may be displayed for many hundreds of years in a museum collection, the mount board should obviously have much better visual stability characteristics than a board for matting a comparatively short-lived Ektacolor print for display in an office or an Ektacolor family portrait displayed in a home. Even subtle differ-

See page 453 for Recommendations

John Szarkowski, director emeritus of the Department of Photography at the Museum of Modern Art in New York City, studies two photographs by Alfred Stieglitz, both taken in 1935. The print in the foreground remains affixed to the original mount in the original frame that Stieglitz prepared. The print at Szarkowski's left has been remounted, matted, and framed with contemporary materials.

# Recommendations

- **Requirements Vary:** Some types of photographs are far more stable than others (e.g., a carefully processed fiber-base black-and-white print versus a Kodak Ektacolor print), so mount boards and paper products used for storing photographs should be selected accordingly. For the most stable and valuable photographs, the following mount boards and paper are recommended:

- **Nonbuffered 100% Cotton Fiber Mount Boards:**
    *Atlantis 100% Cotton Museum Board (TG Offwhite)*
    *Parsons Photographic Museum Board (White)*
    *Rising Photomount Museum Board (White)*

- **Colored 100% Cotton Fiber Mount Boards:**
    When colored or tinted 100% cotton fiber boards are desired, the following are recommended because their colorants have superior light fading stability (see **Table 13.1**) and because the manufacturers are clearly identified on the packaging. These boards are alkaline buffered (refer to text in this chapter and Chapter 12 for precautions):
    *James River Museum Board (Ivory)*
    *Strathmore Museum Board (Brown)*
    *Strathmore Museum Board (Creme)*
    *Strathmore Museum Board (Gray)*
    *Strathmore Museum Board (Green)*
    *Strathmore Museum Board (Natural)*
    When a black board is required, there should be absolutely no direct contact between the board and the photograph (see Chapter 12). Only one black board on the market is recommended — with reservations — by the authors:
    *Strathmore Museum Board (Black)*

- **Envelope or Interleaving Paper:**
    *Atlantis Silversafe Photostore*

- **Truth in Labeling:** Until adequate information about the composition and manufacturer is provided with the products and in promotional literature, the authors cannot recommend other high-quality boards and papers on the market. For example, a number of products sold by Light Impressions Corporation and the Archivart Division of Heller & Usdan, Inc. would probably be recommended were it not for the fact that the name of the actual manufacturer of each product is unavailable to the consumer.

- **Test Methods:** For testing the suitability of paper products used with color and black-and-white photographs, the "interim test" for nonsilver photographic materials described under Sec. 5.1 of **American National Standard IT9.2-1991** is recommended. The test should be modified to have greatly extended test times and be performed at a more moderate relative humidity than the 86% RH called for in the Standard. In addition, the Sec. 5.1 Photographic Activity Test for black-and-white (silver-gelatin) materials in **ANSI IT9.2-1991** should also be employed. The best method of evaluation is to use the complex, multi-temperature Arrhenius test described in **ANSI IT9.9-1990**, with materials in contact with the particular types of black-and-white or color photographic material of interest. The light fading stability of mount boards should be evaluated with the temperature- and humidity-controlled 6.0 klux fluorescent lamp test specified in Sec. 5.7 of **ANSI IT9.9-1990**.

ences in board tones can be important in the the mats of fine art prints; therefore, in museum or fine art collections, mount boards should always have the maximum color and brightness stability possible. Mount boards should not, however, contain fluorescent brighteners.

In addition, mount boards should have an even greater resistance to yellowing or other discoloration than the photograph's support material. All black-and-white and most color print materials have a layer containing a white pigment (barium sulfate or titanium dioxide) coated between the emulsion and the support or, in the case of RC papers, as a top coating of the base paper itself; this layer can effectively hide yellowing or loss of brightness of the underlying paper support. Because mount boards do not have such coatings, or "anti-yellowing" ingredients, any change in them will be clearly noticeable.

The visual stability of a board may or may not be related to a board's physical stability. These characteristics must be evaluated separately. As shown in **Table 13.1**, many available high-quality colored mount boards have poor light fading stability; some actually fade far more rapidly than Ektacolor and similar chromogenic color prints.

## The Choice of Mount Board Is Only One of Many Factors Affecting the Useful Life of a Photograph

In any discussion of mount boards, it is important to keep in perspective the various intrinsic factors that can limit the useful life of a photograph even before it is mounted. For example, whether or not a black-and-white print has been treated with Kodak Rapid Selenium Toner or other protective toner will probably have much more impact on its life than will the selection of mount board. When a black-and-white print is intended for long-term display, being made on fiber-base paper — instead of RC paper — is of *crucial* importance to insure the maximum longevity of the image. Concern about a safe mount board, therefore, must not overshadow the need to make prints with inherently stable materials and to be certain that they are properly processed.

Of the total number of photographs that are mounted in the United States each year, the majority are Ektacolor, Fujicolor, and similar chromogenic prints supplied by professional portrait and wedding photographers, many of which have been retouched and lacquered; most will be framed and displayed. For these prints, which have a limited useful life on display, the choice of mount board will probably make little or no difference. Light fading, lacquer-associated discoloration and fading, and other forms of deterioration will proceed at essentially the same rates regardless of whether the print is mounted on inexpensive "illustration board," made with a high-lignin-content chipboard base, or with the best 100% cotton fiber museum board. Of course, no harm is done to unstable prints by selecting very high-quality mounting materials. It is better, however, to spend that money to make prints on more stable materials in the first place. The focus of attention should always be on the "weakest link" among the many factors

Carol Brower – July 1987

A visitor to the Museum of Modern Art looks at photographs taken by Alfred Stieglitz in 1935 and 1936. The Museum mounted, matted, and framed the prints with contemporary materials to better protect them during prolonged display. (It was necessary to replace Stieglitz's original frames because they were not sturdy or deep enough to support the weight and thickness of the new glazing, two 4-ply museum boards, and backing.) Although Stieglitz personally overmatted some of his photographs with thin paper mats, the majority of his exhibition prints were mounted in his lifetime on unstable wood-pulp boards without overmats. It was not until the 1970's that high-quality museum boards became widely available and conservation matting came to be viewed as necessary and desirable.

that determine and affect the longevity of a photograph.

In the museum and fine art field, where prints may be kept for hundreds or thousands of years, long-lasting mounting and enclosure materials are critical. Like the original copy of the Declaration of Independence of the United States displayed in the National Archives in Washington, D.C., which will be safeguarded forever despite the fact that it has faded so much during the past 200 years that it is now virtually unreadable, valuable photographs in museums will probably be retained indefinitely regardless of how much their images might deteriorate. It is important, therefore, that mount boards, envelopes, and interleaving papers for such photographs be of the highest quality and stability available.

## Potential Problems with Mount Boards and Other Paper Products

Photographic enclosures and mounting materials have received a steadily increasing amount of attention during the past decade. Commenting on the potentially harmful effects of improper storage materials on black-and-white photographs, photographic chemist George Eaton said:

Many of the materials used for enclosing or "housing" photographic artifacts must be carefully selected. These are primarily paper products. . . . Included are mount boards, envelopes, folders, boxes and cartons, interleaves, file cards, aperture cards. Accessories such as mounting tissues, adhesives, tapes, and adhesive tissues are all suspect.

It is perhaps difficult to believe that many of the materials mentioned above can really cause any deterioration of photographic artifacts. Remember first that the photographic artifact itself has been thoroughly investigated and designed from the viewpoint of image stability from manufacture to processing. Then, it is only reasonable to be equally conscientious in archives to enclose and store under the best possible conditions. A very minute amount of an oxidizing agent released from any material can initiate the image oxidation reaction. It may not be apparent, and it may take months or years before the action of the oxidant becomes obvious.

One example of an image-oxidation-controlled experiment will indicate the insidious nature of the problem. Carefully measured amounts of hydrogen peroxide ($H_2O_2$) were used in an experimental chamber in which the effect on silver could be measured. It was indicated that only one part of $H_2O_2$ in 30 million was required to initiate silver oxidation.[2]

Acknowledging the difficulty of accurately determining the cause of deterioration in many older mounted prints, Eastman Kodak said:

> During the nineteenth century and well into the twentieth century, mount boards did not meet the quality standards of present day products. Because much of the photographic processing done during this time was inferior and left damaging chemicals in the photographs, the degrading effects of these chemicals overshadowed most changes [caused by] the mount board."[3]

Examination of historical photographic collections clearly indicates that mounting and storage materials frequently cause or contribute to fading, staining, and other deterioration. Even today, however, with the widespread availability of information relating to papermaking technology and paper stability, it is difficult to know which materials, from among the many products on the market, to choose for use with photographs. That a mount board or other paper product is well made according to the highest standards of the paper industry does not automatically qualify it for safeguarding photographs. A number of tests have been suggested for determining which mounting and storage materials are safe with photographs; however, these tests have not often been applied outside of the photographic industry, and no study has yet been published which gives specific brand-name recommendations based on the results of such tests.

The need for information on the suitability of specific paper products was emphasized by the findings of a 1984 research project conducted by James M. Reilly at the Rochester Institute of Technology under a grant from the National Museum Act. Using the Photographic Activity Test that was specified in *ANSI PH1.53-1984, American National Standard for Photography (Processing) – Processed Films, Plates, and Papers – Filing Enclosures and Containers for Storage*[4] to study interactions between albumen prints and mount boards, paper, and plastic enclosure materials, Reilly reported that 5 of the 29 "archival" 100% cotton fiber boards and 4 of the 16 "archival" purified wood cellulose boards in the study caused unacceptably high levels of fading and/or staining of the albumen test prints.

Albumen prints, widely made between 1850 and about 1890 and frequently found in museum collections today, have an image consisting of extremely small silver particles in an egg-albumen coating (instead of the modern gelatin emulsion coating). Even though the albumen images are normally gold-toned, these prints have proven to be very susceptible to deterioration caused by sulfur compounds and oxidants such as peroxides, especially under conditions of high relative humidity. Reporting on the results of the tests, Reilly said:

> The plastic enclosures, both non-archival and archival, did very well compared to [paper materials]. It is apparent from this study that problems with storage enclosures center on paper and board products. While there were some harmful papers, boards had the highest incidence of harmful reactions. Boards consistently produced more staining than paper products . . . .
>
> In total, 9 of the 45 archival boards were harmful, 20% of the total. Of these, 4 were colored (3 black and 1 gray). Since 3 out of 3 black mat boards included in this study were harmful, it would be prudent to avoid matting photographs with black mat board until more information can be gained.
>
> Two archival board products (one an off-white rag board, one a white conservation board). . . caused similar and unequalled deterioration, obliterating 5 steps of the gray scale and causing extremely heavy staining . . . . The "standard" [non-archival] mat boards included in this study proved themselves to be entirely unsuitable for photographic storage, causing heavy staining and fading.[5]

Reilly added, "Some of the archival boards seemed to have an ingredient that was really dreadful — it caused terrible staining and terrible fading of albumen prints. Just a real devastation. This was the same kind of thing observed with the binders board [an inexpensive single-ply board made from waste paper and groundwood, used for the core of hardbound book covers] samples, which was all out of proportion to the fact that they were loaded with groundwood. So something else was doing it. Maybe it is something they put in it to hold it together — a laminating adhesive or binding agent or something similar."[6]

In keeping with the Image Permanence Institute's policy of avoiding product brand name identification in comparative product evaluations, Reilly declined to identify the boards and papers included in the tests.

Modern silver-gelatin print materials may be expected to be less sensitive to peroxides and other oxidants than are albumen prints, and color prints respond altogether differently than either albumen or modern black-and-white materials. Nevertheless, Reilly's 1984 studies indicated that there is genuine cause for concern about possible adverse reactions between mount boards and other paper products and modern black-and-white photographs and, by implication, color materials.

With the aid of several grants received in 1984–85,[7] Reilly continued his research; in 1987 he and co-worker Douglas W. Nishimura proposed a new accelerated test for paper enclosure and mounting materials. This new test procedure, which has been adopted as the primary Photographic Activity Test in *ANSI IT9.2-1991, American National Standard for Imaging Media – Photographic Processed Films, Plates, and Papers – Filing Enclosures and Storage Containers,*[8] is discussed below.

## Specifications and Tests for Mount Boards and Enclosure Materials

Five approaches have been suggested in attempting to assure the suitability of paper products for long-term storage of photographs:

1. **Specify paper ingredients — percentage of alpha cellulose, maximum lignin content, type of sizing, laminating adhesives, pH, alkaline reserve, etc. — that will, according to current knowledge, make the paper or board long-lasting and, therefore, by implication, safe with photographs.**

   Unfortunately, this common-sense approach does not go far enough. To be certain that a paper product such as a mount board or storage envelope is suitable for photographic applications, all of the ingredients — and contaminants — that can contribute to fading or staining of the many types of photographs must first be identified. There is currently a lack of knowledge about exactly how the many different constituents in various papers might affect different kinds of photographs; therefore, this approach has been much more successful in producing long-lasting paper products than it has been in guaranteeing that a particular product is safe during long-term contact with photographs. Although factors that affect the aging characteristics of papers have been studied for many years, almost no research on interactions between these products and modern photographic materials has been published.

2. **Test the board or paper product with one of the "silver-tarnishing tests," such as that proposed by Collings and Young;[9] test the product for reducible sulfur;[10] and, during accelerated aging, test for low-level emission of peroxides and other substances that are known to be harmful to silver images.**

   Even though these tests can provide helpful information, they may not properly indicate how an actual black-and-white photographic material will react when stored in contact with the paper product (e.g., the filamentary silver grains embedded in a gelatin emulsion coating may react quite differently than the polished silver plates in the Collings and Young test). In addition, these tests will not indicate the propensity of a paper or board to cause stains on a photographic material, and they also have other limitations, as have been discussed by Hendriks and Madeley[11] and Reilly.[12] Hendriks says: "I strongly advise anybody against the Collings and Young test."[13] These tests are probably of little significance with respect to the storage of color films and prints.

3. **Employing accelerated aging techniques, test the board or paper in contact with whatever photographic materials are of interest to determine whether the paper product causes, or contributes to, staining or fading of the photographic images.**

   While such tests cannot directly indicate *which* constituent of the paper product has caused fading or staining, they do take into account the individual sensitivities of each different type of photographic material and are applicable to both color and black-and-white photographs. Such tests can help rank various boards and other storage materials in terms of their potential harm to a particular type of photograph. The Photographic Activity Test described in Sec. 5.1 of the now-obsolete *ANSI PH1.53-1986* Standard is a simple test of this type (a modified version of this procedure is included in the current *ANSI IT9.2-1991* Standard as an "interim" test for color prints and films and other nonsilver materials). Accelerated aging tests can also provide information about the stability of a mount board or other paper product, both in and of itself and in comparison with the stability of the photographic material stored in contact with it. For color materials in particular, the more meaningful — but more complex and time-consuming — multi-temperature Arrhenius test method included in *ANSI IT9.9-1990, American National Standard for Imaging Media – Stability of Color Photographic Images – Methods for Measuring* should be undertaken for this kind of evaluation.[14,15] The Arrhenius test provides a means of estimating the number of years required for a specified amount of deterioration to take place in a given paper product, and in the photographic material in contact with it, under various storage conditions.

4. **Test storage and mounting materials intended for black-and-white photographs with the colloidal silver test strips developed by Edith Weyde of Agfa-Gevaert in 1972.[16]**

   These silver test strips are very sensitive and, placed in contact with storage or mounting materials, detect products that evolve substances that could attack the finely divided silver images of black-and-white photographs. The test strips are not applicable to color materials. The procedures published in 1972 for using the test strips called for room-temperature tests that extended over a period of months or years; high-temperature, high-humidity, accelerated tests were not described.

5. **Employ the Photographic Activity Test in *ANSI IT9.2-1991* in which Agfa-Gevaert colloidal silver test strips are used to detect boards or papers that could cause fading of the silver images of black-and-white photographs, and in which fixed and washed fiber-base photographic paper is used to indicate storage materials that could cause staining.**

   Proposed by James M. Reilly and Douglas W. Nishimura in 1987 as a replacement for the Photographic Activity Test in *ANSI PH1.53-1986*, this test can be thought of as an accelerated version of Weyde's 1972 procedure (described above) to indicate materials that could cause discoloration and fading of the silver images of black-and-white photographs.[17] The test has been adopted as the primary Photographic Activity Test in *ANSI IT9.2-1991* (replacing *ANSI PH1.53-1986*).

   Unfortunately, the new test is applicable only to black-and-white photographs and is restricted to paper storage materials; also, it is not suitable for evaluating storage and mounting materials used with color photographs, nor is it recommended for testing pressure-sensitive adhesives, non-contact storage materials, or plastic en-

closure materials such as polyethylene, polypropylene, and polyester.[18] The test, which calls for an incubation period of 15 days at 158°F (70°C) and 86% RH, provides little if any information on the potential life of most mount boards or other paper products.

## The ANSI IT9.2-1991 Photographic Activity Test

Approaches 2 through 5 above are more concerned with the effects that a paper product might have on a photographic material than they are with how, or with what, a paper product is made. *ANSI IT9.2-1991, American National Standard for Imaging Media – Photographic Processed Films, Plates, and Papers – Filing Enclosures and Containers for Storage* gives a set of general requirements for suitable photographic filing enclosures (see below) and requires that the enclosure or storage material pass a Photographic Activity Test.

Pointing out that the *ANSI PH1.53-1986* Photographic Activity Test "does not function well in discriminating between marginal and very good materials," and that it is not sensitive enough for other than screening out the most harmful materials, James M. Reilly and Douglas W. Nishimura of the Image Permanence Institute at the Rochester Institute of Technology in 1987 proposed a new test as a replacement for the existing test.

In a demonstration of the shortcomings of the *ANSI PH1.53-1986* Photographic Activity Test, Reilly and Nishimura obtained a 1960's cardboard microfilm box that during long-term storage had caused "redox blemishes" or microspots in the microfilm images. "The box was cut into strips and incubated (at the conditions specified in *ANSI PH1.53-1986*) in contact with processed Kodak AHU 1460 Imagecapture microfilm. After incubation, the differences between the microfilms incubated with the box and the filter paper controls were slight [Whatman Number 1 filter paper was used]. Redox blemishes were not observed on the microfilms incubated with the defective box."[19]

Reilly and Nishimura experimented with various photographic materials in search of a "detector" with sufficient sensitivity to respond in short-term accelerated tests. Kodak Studio Proof Paper, Polaroid instant slide films, fine-grain motion picture films, graphic arts films, Polaroid and conventional black-and-white prints, and other materials were tried. Among the conventional films and prints tested, Kodak Professional B/W Duplicating Film 4168 proved to be by far the most sensitive to contaminants; in this respect, 4168 film was nearly as sensitive as albumen paper. (In 1990 Kodak replaced 4168 Film with a new product, Kodak Professional B/W Duplicating Film SO-339, that is claimed by Kodak to be more stable — and much less sensitive to peroxides and other environmental contaminants.)

Also tested were Agfa-Gevaert colloidal silver test strips, which had been devised by Edith Weyde of Agfa in the late 1960's in the course of an investigation into the causes of the sudden and rapid discoloration and fading that had been discovered among films and paper prints in the government archives in Munich, Germany. At the outset it was believed that oxidizing gases such as peroxides probably caused the blemishes and discolorations, and to detect the source of the oxidants, test strips were made by coating layers of extremely finely divided colloidal silver on polyester film base (the test strips are not a light-sensitive photographic material).

With the help of the test strips, Weyde determined that the plastic index cards made of phenylene-formaldehyde were the principal source of the oxidants attacking the photographs in the Munich archives; the cards had been used in photograph files in the archives for 14 years, and the first signs of discoloration and fading had been noted after about 5 years. The plastic index cards were tested by placing them in contact with the Agfa test strips; discoloration was noted after periods varying from a few months to several years. Freshly manufactured index cards caused discoloration of the test strips much more quickly than did older index cards taken from the archive files. After observing the rates of discoloration of the test strips in situations that had caused photographs to discolor or fade over long periods of time, Weyde drew the "cautious conclusion" that the test strips would exhibit discoloration about 10 times sooner than the first visible deterioration of typical black-and-white photographs.

Since publication of the details of the colloidal silver test strips and test procedures in 1972, the test strips have often been cited as a means of testing the atmospheres of storage areas in museums and archives (in this application, the test strips are left freely hanging in the air in storage rooms — see Chapter 16 for further discussion). Along with the testing of storage materials, this use of the test strips had also been recommended by Weyde.

The Agfa-Gevaert test strips would certainly have seen wide application in museums and archives around the world following Weyde's original 1972 publication; but after the initial supply was exhausted, the strips were no longer available. Agfa did not resume manufacturing the test strips until convinced to do so by Reilly in 1986.

Reilly and Nishimura conducted further experiments with the Agfa test strips in contact with paper envelopes that were known to have caused severe fading to determine the optimum temperature, relative humidity, and test period; 15 days at 158°F (70°C) and 86% RH was selected. Reilly and Nishimura originally conducted the tests at three different relative humidities (75, 86, and 95%), and it is curious to note that at both 75 and 95% RH the filter paper control produced a *greater* density change in the Agfa test strips than did the "known to be harmful" envelope paper. Only at the 86% RH level did the envelope paper prove to be more harmful than the filter paper. Reilly and Nishimura concluded that "unsatisfactory enclosures may manifest themselves by causing significantly *less* fading than the controls, as well as more." This suggests that further evaluation of the test with a variety of materials and test conditions should be done. (It is noteworthy that at the end of the 15-day test period, the Agfa test strips exhibited a substantial drop in blue density even when in contact with inert laboratory filter paper.)

To detect paper storage and mounting materials that may cause staining (as distinct from fading or discoloration), Reilly and Nishimura suggested that samples be aged in contact with unexposed, fixed, and washed Kodak Elite fiber-base photographic paper under the same tempera-

ture and humidity conditions recommended for the Agfa test strips. As with the colloidal silver test strips, filter paper controls serve for comparison purposes. Following incubation for 15 days, the samples are evaluated in three ways: **(1)** visually, **(2)** by stain measurement, and **(3)** by fade measurement. The criteria for passing the tests are given in the ANSI Standard.

The Image Permanence Institute markets test kits consisting of the Agfa-Gevaert colloidal silver test strips, processed Kodak Elite photographic paper strips, and instructions for their use.[20]

In Reilly and Nishimura's line of reasoning, the Agfa test strips have proven to be more sensitive to harmful substances than any other "fine-grain" silver detector. Thus, they argue, if an enclosure paper or other storage material produces changes in the Agfa test strips that are no different from changes observed with inert laboratory filter paper, the storage material should not damage even the most sensitive fine-grain black-and-white photographs (e.g., albumen prints, POP prints, untoned microfilms, untoned Kodak 4168 duplicating film, and untoned black-and-white prints). In this regard the test was a major departure from the Photographic Activity Test given in the now-obsolete *ANSI PH1.53-1986* Standard, which specified that an enclosure paper or other storage material be tested in contact with *each type* of photographic material with which it will be employed. Therefore, the test was able to cover the full range of photographic materials, including color films and prints.

Only further investigation will indicate whether the test developed by Reilly and Nishimura is superior to a modified version (with lower levels of relative humidity and much longer test periods) of the previous *ANSI PH1.53-1986* Photographic Activity Test for mount boards, enclosure papers, and other materials used with modern black-and-white films and prints. The extremely small particles of colloidal silver in the Agfa test strips have a very different microstructure from the far larger and more stable filamentary silver grains of modern (developed-out) black-and-white materials. For this reason, the test strips could possibly misrank enclosure papers and mount boards in terms of how they would actually perform in long-term use under normal conditions with the types of modern black-and-white photographs that presently coonstitute the bulk of most collections.

Pending further evaluation, the authors recommend that for storage materials intended for use with black-and-white photographs, *both* types of tests be performed (the *ANSI PH1.53-1986* test should be conducted for much longer periods than the specified 30 days — see below).

## The Interim ANSI Photographic Activity Test for Mount Boards and Other Paper Products Used with Color Materials

In recognition that there is a need for a photographic activity test to evaluate paper storage materials and mount boards used with color photographs, the following was included in *ANSI IT9.2-1991* as a footnote to the Photographic Activity Test (Sec. 5.1):

This Photographic Activity Test was developed for silver photographic images. For non-silver (e.g., color, diazo) images, a satisfactory test has not yet been established. In the interim, for enclosures intended for use with non-silver photographic images, an additional third detector should be included, consisting of processed samples of the type of photograph to be stored. The general procedures of 5.1.2 and 5.1.3 should be followed, except that evaluation of image changes upon incubation should be appropriate for the detector. Image changes should be no greater than the filter paper control. The incubation conditions specified in 5.1.2 may cause high levels of staining and fading of some color images, which in turn may mask the effects of the enclosure. For chromogenic color print detectors, a suggested incubation test is 60°C, 86% relative humidity.[21]

Except for differences in test temperatures and length of the incubation period, this interim test for non-silver materials is similar to the Photographic Activity Test specified in the now-obsolete *ANSI PH1.53-1986* Standard in which a sample of the paper, mount board, or other storage material and a sample of the photographic material with which it is to be used are placed in contact and subjected to an accelerated dark-aging test for 30 days at 122°F (50°C) and 86% RH. For comparison purposes, an identical sample of the photographic material is aged in contact with a piece of pure, nonreactive laboratory filter paper (e.g., Whatman Number 1 filter paper). "At the end of this test, no visual pattern should be transferred from the enclosure material to the photographic material nor shall the image of the latter be affected. . . . The changes produced by contact with the enclosure material should be no greater than that produced by the film [or print] in contact with a filter paper control, having a pH between 7.0 and 7.7."

The Photographic Activity Test provided in old *ANSI PH1.53-1986* was criticized on a variety of grounds and a number of alternative procedures were proposed. The authors, however, believe that the basic concept of the *PH1.53* test is sound and that its only serious shortcoming is simply that the specified test time of 30 days is far too short — periods much longer than 30 days are necessary to obtain meaningful results with most photographic products. For example, the 30-day test at 122°F (50°C) provides little information about the effects of mounting and storage materials on current color films and prints. With Ektacolor Portra II chromogenic color prints, for example, so little color dye fading will take place during the 30-day test that the influence of a paper or mount board's pH on dye fading cannot be meaningfully evaluated.

With black-and-white photographs, the 30-day test period is probably useless for detecting all but the most harmful materials. With the *PH1.53* test, the authors tentatively recommend a *minimum* test period of 240 days, with longer times for the more stable photographic materials. To properly assess the effects of a board or paper on a highly stable material such as a black-and-white print treated with Kodak Rapid Selenium Toner, the test should be continued

until at least *some* visible change is observed in the filter-paper control sample, however long that might require.

In a high-temperature test such as this, many color materials will give anomalous test results at relative humidities as high as 86%; a lower humidity, 60% for example, would be a better choice in such cases. A lower humidity is also necessary when testing plastic materials (at 122°F [50°C] and 86% RH, gelatin is above its glass-transition temperature and emulsions will soften and stick to most plastic materials).[22]

An especially appealing aspect of the obsolete *ANSI PH1.53-1986* Photographic Activity Test is that *each* different type of color and black-and-white film or print material must be tested individually with *each* enclosure material (such as mount board or interleaving paper); adhesives must also be tested. If a particular material passes the test with a certain black-and-white fiber-base paper, this does not mean that the material is suitable for color materials or, for that matter, a chromogenic black-and-white negative. At the very least, a mount board or enclosure material should be tested with a representative black-and-white fiber-base paper such as Ilford Multigrade FB Paper; a black-and-white RC paper such as Kodak Polycontrast III RC Paper; chromogenic color print materials such as Fujicolor Professional Paper SFA3 Type C and Kodak Ektacolor Portra II Paper; and a representative fine-grain microfilm.

With suitable modification, the authors believe that the *ANSI PH1.53-1986* Photographic Activity Test is the best available "simple" procedure for evaluating mount boards, paper for interleaves and envelopes, and plastic storage products used with the wide range of color and black-and-white photographic materials currently on the market and found in historical collections. Ideally, of course, the multi-temperature Arrhenius procedure described in *ANSI IT9.9-1990* should be applied to the *PH1.53* Photographic Activity Test. Carried on long enough, Arrhenius testing not only will provide valuable information about how a mount board or storage material can affect a particular type of photograph, but also will give an indication of the inherent aging characteristics of the mount board or paper material itself.

## Paper and Mount Board Evaluation Using the IT9.2 Photographic Activity Test

In a practical application of the *ANSI IT9.2* Photographic Activity Test (PAT), in 1988 Douglas W. Nishimura, James M. Reilly, and Peter Z. Adelstein at the Image Permanence Institute used the test to evaluate 90 different mount board, enclosure, and interleaving papers:[23]

> This included 66 commercially available materials that could be considered "archival," not by any strict scientific definition, but because they were sold by suppliers specializing in this line of products. The 66 archival materials included 36 rag [cotton fiber] boards, 9 non-rag boards, and 21 papers, numbering among them were interleaving tissues, Japanese repair tissues, barrier papers, envelope papers,

> glassines, and slip sheets. These materials were obtained from a number of manufacturers and distributors, and are representative of the kinds of products that might be used in archival collections in contact with photographs. Also included were a number of known good and bad "benchmark" materials to put the performance of the archival products in perspective.

> . . . Overall, 29 (44%) of the archival products passed the PAT [*ANSI IT9.2* Photographic Activity Test]. The most common cause of products failing the PAT was mottling (uneven blotchy fading of the colloidal silver detector). Most of these failed products were 2- or 4-ply boards. In all, 25 products (38%) failed the mottling criteria. Mottling represents the presence of local "hot spots" of fading and generally indicates inhomogeneity in an enclosure product.

> . . . The results of this evaluation of 66 commercially available archival products have an important lesson for archive managers: not all enclosures offered in the marketplace are safe to use with photographs. Vague descriptors, such as "acid free" (most of the failed products were so described), do not guarantee inertness toward photographs. In some cases, the high prices paid for "archival" enclosures are actually buying materials more harmful than grocery bags or newsprint.

> . . . The performance of the 66 archival products can be put into perspective by comparing them with the behavior of some of the known good and bad "benchmark" materials also included in this test. This data illustrates that, by and large, photographic [paper enclosure, mounting, and storage] materials have come a long way from the truly dreadful materials that were so common in the past. For example, two 1930s portrait studio folders (one gray and the other dark green) were tested. The prints inside these folders showed fading and mirroring where they had been in contact with the over-mat part of the folder. Both failed all three PAT criteria by large margins. The fading they caused was among the worst of all 90 materials. Their staining was about seven times the maximum acceptable limit, and they were heavily mottled. But it is also important to note that the fourth worst fading performance of all 90 materials was given by an "archival" product, a 2-ply white rag board. Two out of the three Japanese repair tissues tested failed the fading criterion. There appeared to be no difference in product performance related to the presence or absence of carbonate buffering. The interactions between photographic materials and enclosures are obviously more complex and varied than the commonly used archival descriptors, such as "acid free," allow for. An empirical evaluation, such as the PAT, is a vital check for unforeseen harmful effects.

**1.** Strathmore Paper Company has been manufacturing fine artists' papers for nearly a century. The company currently operates four paper mills in Massachusetts, one of which produces museum board. The above photograph and those that follow show white museum board being made at Strathmore's Woronoco Mill No. 1 in October 1987. The Fourdrinier machine pictured on the left — the wet end is in the foreground — is nearly 100 years old and continues to make papers and boards of outstanding quality.

## ANSI Removes the "Archival" Designation from ANSI Standards

In 1990 ANSI decided to remove the "archival" designation from all of the ANSI photographic standards. The rationale for this is explained in the Foreword to *ANSI IT9.11-1991*:[24]

> The term "archival" is no longer specified in American National Standards documents since it has been interpreted to have many meanings, ranging from preserving information "forever" to the jargon meaning [especially in the computer and electronic data storage fields], temporary storage of actively used information. It is therefore recommended that the term "archival" not be used in standards for stability of recording materials and systems.

Processed photographic films are now classified according to the life expectancy or "LE designation," when stored under specified conditions. Terms such as archival processing, archival record film, and archival storage materials, all of which have been widely used in the photography conservation field, are no longer used or endorsed by ANSI.

## ANSI Requirements for Paper Products Used with Photographs

While as yet there is not an ANSI standard that specifically addresses mount boards, the requirements for enclosure papers given in Sec. 3.2 of *ANSI IT9.2-1991* would generally apply:[25]

> Paper that is in direct contact with *black-and-white* photographic material shall be made from high alpha cellulose [e.g., cotton fiber], bleached sulfite, or bleached kraft pulp with an alkali resistance expressed as $R_{18}$ value greater than 87% as determined by the method given in ISO 699:1982. It shall be free from such highly lignified fibers as groundwood, as determined by microscopic analysis and the phloroglucinol spot test. The pH should be between 7.2 and 9.5, as determined by the method given in TAPPI T509su-77. The alkali reserve shall be the molar equivalent to at least 2% $CaCO_3$, as determined by the alkali reserve test described in 5.2. This alkali reserve should be accomplished by the incorporation of an alkaline earth car-

*(continued on page 466)*

**2.** Dry sheets of 100% cotton linters pulp are stored in large bales at the mill, ready for making paper and museum board. Pulp operator Joe Stebbins is separating bales with a forklift truck to move them to the pulper.

**3.** The bales are placed on a slowly moving conveyer belt which drops the pulp into the pulper.

Carol Brower (5) – October 1987

**4.** In this close-up, the pulper (approximately 10 feet in diameter) beats the pulp (furnish) into slurry. Most of the chemical ingredients, such as internal sizing agents, colorants, and alkaline buffers, are added to the pulp at this stage.

**5.** Machine tender Bob Hungerford looks over the wire (the wet end of the machine). A continuous belt made of fine fiber screen vibrates constantly as it moves forward so that the pulp fibers will mesh together and the water will drain away. It is during this stage that the grain direction is formed as the fibers line up in the direction of the flow.

**6.** Hungerford inspects the machine and the stock as the newly formed wet sheet of paper is "lifted" off the screen and transferred to a continuously moving felt belt for drying.

**7.** This close-up view shows the point at which the stock becomes paper.

**8.** The wet sheet of paper (later to become museum board) enters the first set of drying drums.

Carol Brower (6) – October 1987

**9.** Marketing and sales manager Thomas Richards looks over the paper as it comes out of the first set of dryers and enters a bath containing surface sizing chemicals. The paper then enters a second set of dryers (right).

**10.** The paper leaves the dryers and passes through an idle calender stack (which, when operating, produces a very smooth surface on such products as writing papers). A new roll is started the moment the previous roll is finished. The machines do not slow down during this operation, so the back tenders must quickly coordinate the transfer of the continuously running sheet of paper onto another cylinder. Here the crew members observe the next roll as it begins to wind.

**11.** The completed roll of 1-ply museum board, weighing approximately 1,000 pounds, is moved aside during the roll-change operation to make room for the next roll. The machines normally produce one roll every 45 to 50 minutes.

**12.** At the start of a new roll, the machine tender examines a sample of the 1-ply board before it is sent to the laboratory for specification tests (caliper or thickness, basis weight, color, consistency, strength, etc.). Requiring the attention of three separate shifts of workers, the machines run 24 hours a day, 7 days a week producing museum board and numerous other fine papers. The finished roll of 1-ply museum board is pictured on the left.

**13.** When the entire run is completed, the rolls are taken by semitrailers across the Woronoco River to Strathmore's Woronoco Mill No. 2 (above), where they will be pasted together to make 2- or 4-ply board. The semitrailers are pictured on the left.

**14.** David Climo, assistant manager of Woronoco finishing operations, talks with forklift operator Gerald Fillion. This roll of 1-ply museum board is on its way to the pasting machine.

**15.** Pasting operator Kurt Bodendorf removes several outside layers before the rolls are hoisted onto the pasting machine.

**16.** To make 2-ply board, one roll of 1-ply board is suspended above another roll. They unroll together at a rate of about 450 feet per minute. Bodendorf supervises the operation as the lower roll passes through the pasting applicator (lower right).

**17.** Carlos Cruz mixes the sacks of dry starch-based adhesive with water to produce the proper consistency before the adhesive enters the pasting applicator. Starch paste is preferable to animal glues or synthetic adhesives for laminating high-quality boards because it is more stable chemically, does not discolor, and does not contain residual chemicals and acids, which break down the paper fibers.

Carol Brower (5) – February 1988

**18.** The board leaves the applicator (with paste on its surface) and meets the roll above as they enter a series of high-pressure stainless steel rollers (center right), which permanently join the two sheets. The damp 2-ply board is then rolled up again before it is dried.

**21.** When the 2-ply board will be made into 4-ply board, the board passes through the idle cutting machine (left) and is rolled up once again. Back tender Peter McLaughlin starts a new roll by quickly attaching the 2-ply board to its core.

**19.** Close-up view of the stainless steel rollers. The two sheets of 2-ply board can be seen coming together for the first time on the large roller on the left.

**22.** McLaughlin moves the previous roll aside to join other rolls until they can be laminated again. Moisture content must be carefully controlled during each stage of manufacturing, storing, pasting, rolling, drying, re-rolling, and cutting. When the ambient relative humidity is 35 to 50%, the moisture content of the final sheet is approximately 6%.

**20.** Kurt Bodendorf (right) and intern Rick Bergstrom splice the beginning of a recently pasted roll of 2-ply board to the end of the previous roll, which is stalled during its passage through the long row of 19 drying drums (center right).

**23.** Hours later, another shift of workers makes 4-ply board by guiding the rolls of 2-ply board through the same pasting machine.

**24.** Pasting operator Mark Miller checks a roll of 4-ply board as it enters the dryers. Another recently pasted roll (left) will follow. Four-ply board takes about twice as long to dry as 2-ply.

**26.** Back tender Ron Laporte spot-checks one of the sheets.

**25.** The 4-ply board is cut into sheets immediately as it leaves the dryers. Here the sheets are slightly larger than the standard size of 32 x 40 inches (by about ½ inch) to allow for trimming before packaging. The sheets land on a raised skid, which is gradually lowered to floor level by a hydraulic lift until the stack is full.

**27.** Forklift operator Francis Hansen takes the museum board to be weighed. This stack weighs about 1,250 pounds. Afterward, the board will be trimmed to 32 x 40 inches, sorted by hand to remove sheets with surface defects, arranged into groups of 10 or 25 sheets, wrapped in water-resistant paper, and packaged in corrugated cartons for storage in the warehouse before it is sent to distributors.

Carol Brower (4) – February 1988

Carol Brower – October 1987

**28.** Warehouseman Dave Galbert, group leader Dave Christian, and marketing and sales manager Thomas Richards check the inventory of finished products in the Strathmore warehouse. Richards says, "Our paper is inspected every step of the way, from the bales of pulp to the cartons in the warehouse."

bonate or the equivalent. ($MgCO_3$ and $ZnO$ are also being used, which in molar equivalencies correspond to approximately 1.6% reserve.) A minimum of sizing chemicals shall be used, the amount being dictated by the requirements of the end use (enclosures, overwraps, interleaving, etc.). If sizing is used, neutral or alkaline sizing chemicals shall be employed. The material shall essentially be free from particles of metal. Surface fibers that might offset onto photographic layers should not be present. The paper shall not contain waxes, plasticizers, or other ingredients that may transfer to the photographic material during storage. Glassine envelopes shall not be used. The paper shall meet the physical tests required for the particular application. [These include stability (see TAPPI T453su-70), folding endurance (see ASTM D2176-69 [1982] and TAPPI T511su-69), and tear resistance (see TAPPI T414om-82).]

Paper that is in direct contact with processed diazo or *color* photographic materials shall have similar composition to that used for black-and-white material except that the pH shall be between 7.0 and 7.5, and the 2% alkaline reserve requirement shall *not* apply.

To conduct all of the paper quality tests called for in the ANSI Standard is a complex, expensive, and time-consuming task requiring experienced personnel and a well-equipped laboratory. To the authors' knowledge, the only time the complete series of tests has been done on paper enclosure materials was in 1978 when, at the request of Klaus B. Hendriks of the National Archives of Canada (then called the Public Archives of Canada), the Ontario Research Foundation tested seven paper and glassine photographic enclosure materials under a contract with the Public Archives. The report has not been published and Hendriks has declined to identify the products included in the tests, but he has indicated that *none* of the products (which included an alkaline-buffered paper envelope popular in museums and archives) satisfied all of the ANSI requirements.[26] Mount boards were not included in the tests.

Commenting in 1984 on efforts to better formulate specifications and test procedures for mount boards and other paper products, James Reilly said:

I think this is an evolutionary situation where more testing will be done and maybe a narrower definition of requirements will emerge. If there is one bad sizing or laminating adhesive it will be identified sooner or later. The worst types of things that might be in a board

or paper will be identified and a set of specs that are more comfortable for the paper mills will emerge.

But I think generally — in spite of a few really bad products — the overall level of board and enclosure paper quality has improved dramatically over what was common practice just a few years ago, when people, even in museums, would use practically anything. In general, we are just vastly better off now.[27]

## Glassine Paper — Not Recommended

Glassine paper is a thin, very smooth translucent paper used extensively for negative enclosures and sometimes for interleaving purposes. Glassine is made from wood pulps that have been mechanically beaten to have a high degree of hydration, a process which degrades the fibers. Ethylene glycol or other substances are usually added to glassine paper to increase its translucency and flexibility.

In 1967 Eugene Ostroff of the Smithsonian Institution in Washington, D.C. advised against storing photographs in contact with glassine paper, citing its poor stability and additives that "can have a detrimental effect on image stability of adjacent photographs."[28] Based in part on Ostroff's observations, *ANSI IT9.2-1991* specifically warns against glassine envelopes. Eastman Kodak also advises that glassine be avoided, stating in 1985: "With age and dry storage this material tends to become brittle and during subsequent handling may even shatter; conversely in the presence of high temperature and high relative humidity (90°F [32.2°C] and 90% relative humidity), the transparentizers may exude, and on coming in contact with the negative surface, cause ferrotyping."[29]

So-called "archival" or "acid-free" glassine papers likewise are *not* recommended for storing photographs.

## Paper Chemistry: Some Considerations with Regard to Photographic Materials

Many chemicals and additives used during the papermaking process may be deliberately present in the final product, or may exist as residual contaminants. Some of these substances can interact with photographs, causing fading and/or staining of the image and possibly deterioration of the support. For instance, boards and papers may contain acid or alkaline dyes (in addition to bright colors, board tones such as off-white, cream, ivory, antique, etc. are often obtained with dyes), pigments, retention aids, fillers, aluminum sulfate fixative (papermaker's "alum"), internal sizing agents, beater adhesives, bleaches, surface sizing agents, and waxes, as well as metal particles or other contaminants.

Boards colored with dyes commonly contain mordants that affix the dyes to the paper fibers and that help prevent color fading and color migration. Boards colored with pigments, such as Bainbridge Alphamat, have fixatives to hold the pigment particles in place and prevent bleeding. As will be discussed in more detail later, alkaline-buffered boards and papers contain calcium carbonate or magnesium carbonate to neutralize acids that may occur from internal or external sources.

## Laminating and Sizing

Unlike most papers, which are manufactured as single sheets, mount boards usually consist of several layers or "plies" of thick paper; composite boards have thin "facing papers" laminated to the front and back. Both types of boards incorporate adhesives which constitute another possible source of harm to photographs.

Sizing agents are compounds added to paper to reduce the rate of moisture absorption by the fibers, making them somewhat water-resistant. For example, sizing is necessary in writing papers to keep inks from bleeding. Nearly all high-quality papers are sized to some extent (blotter paper is an obvious exception). Sizing can also modify and improve the surface finish of a paper, and can increase its tear-strength.

One reason that *ANSI IT9.2-1991* specifies "neutral or alkaline" sizing chemicals is to preclude the use of the common alum-rosin size, introduced to papermaking in the U.S. about 1830. Rosin is a low-cost by-product resulting from the distillation of turpentine from resinous pine trees. Rosin is essentially an organic acid, insoluble in water until treated with a caustic soda, in a process similar to soapmaking.

In papermaking, rosin size is precipitated on the paper fibers by the addition of aluminum sulfate (papermaker's alum), which has the undesirable result of increasing the acidity of the paper. Rosin in paper also gradually oxidizes and yellows, a process that is accelerated by iron particles from paper-manufacturing machinery, and sometimes from the water used in papermaking.

## Lignin in Paper Products

*ANSI IT9.2-1991* also states that paper products such as negative envelope papers and mount boards used for storing and mounting photographs shall be free of highly lignified fibers, such as groundwood. After cellulose, lignin is the principal component of fibrous plant materials. Lignin is the substance that binds plant fibers together and is largely responsible for the great strength of wood.

When present in paper, lignin yellows on exposure to light and is also unstable in the dark, releasing decomposition products such as peroxides and other potentially harmful substances. This is the main reason why lignin must not be present in paper products intended for the storage of photographs.

Many high-quality papers are now advertised as "lignin-free," in recognition that lignin should not be present. Lignin is more or less completely removed in sulfite-processed wood pulps (bleaching further removes lignin-containing residues), but little or none is removed from mechanically ground wood pulps. Newsprint and the gray chipboard base of many low-cost mount boards contain a high percentage of lignin. In addition to lignin, such groundwood papers usually contain a variety of other potentially harmful substances.

Lignin-containing wood-pulp papers, alum-rosin size, and fiber-degrading chlorine bleaches have all contributed to the sharp decline in the stability of most papers made during the past 150 years — a problem now plaguing libraries and archives the world over.

## Cotton Fiber Versus Wood Pulp

There are two principal types of high-quality mount boards: "museum" board and "conservation" board.[30] So-called "museum" board is made from 100% cotton fiber pulp, which usually consists of cotton linters fibers but may be made from cotton rags or a combination of both. "Conservation" board is made from wood fiber pulp which has been cooked, bleached, washed, and extensively refined to remove lignin and other impurities. Cost and scarcity of cotton pulps have been important factors in the development of high-quality mount boards from refined wood pulps. The cost difference is not great, however, and refined wood pulp boards typically cost only about 20% less than 100% cotton fiber boards.[31] (Lower-quality "standard" boards, made from wood pulps that are not as highly refined as those processed for conservation boards, commonly cost less than half as much as cotton fiber boards.)

With the exception of several nonbuffered, neutral-pH mount boards intended primarily for photographic applications, most museum boards and conservation boards have, since the mid-1970's, been manufactured with the addition of alkaline buffering agents.

Mount board made from 100% cotton fiber differs physically, chemically, and visually from board made from chemically processed wood pulp. First of all, cotton is one of the purest forms of cellulose occurring in nature, being nearly 99% alpha cellulose, whereas typical hardwoods and softwoods are about 50% alpha cellulose.[32,33] The higher the alpha cellulose content in a given fiber, the greater the potential strength of the paper made with it. In addition, the chemical purity of such papers is usually potentially very high because a minimum of refining, processing, and bleaching is required, especially in the case of paper made from cotton linters.

There are two principal types of natural cotton fibers. The longer ones are known as "cotton seed-hair fibers" and the shorter as "cotton linters fibers." The longer and more costly cotton seed-hair fibers are used primarily in the textile industry. When these longer fibers do go into making paper, they are usually purchased in the form of textile cuttings (scraps) or as old rags — hence the terms "rag paper" and "rag board." However, most 100% cotton fiber papers and mount boards are currently made with the shorter cotton linters, and so the descriptive term "rag" is often inaccurate (see Chapter 12).

Cotton linters are likely to be freer of contaminants than reprocessed cotton rags because the latter require more chemical refining. Numerous chemical additives and dyestuffs used in the textile industry are often present in cotton rags and must be removed before they can be made into museum board and other high-quality papers. In addition, rags must be closely examined to guard against contaminating cotton pulp with synthetic materials. In 1967, Eugene Ostroff wrote that "manufacturers find it extremely difficult to purchase rags which do not contain traces of synthetic fibers and various additives intended to impart certain physical attributes, such as added whiteness. Chemical processing, uninjurious to the rag fibers, cannot successfully remove all such foreign matter. In the finished paperboard their long-range storage effects on photographs are unknown."[34]

All refining affects the structure of the cellulosic bond in cotton and wood fibers. For example, the more bleaching required, the weaker a fiber will become. Since both wood fibers and rags require significant refining and purification, they are more difficult to manufacture into high-quality, stable paper products than are pure cotton linters. Few paper mills still have equipment capable of purifying rags for papermaking.

In nearly every case, whether coming from linters or rags, cotton fibers make papers and boards that are physically more durable and resilient, having better strength and folding endurance than do products made from refined wood fibers. However, these qualities are not as crucial in photographic papers and mount boards (which are not normally folded or handled as much) as they are, for example, in a book paper.

It should be possible to make a satisfactory mount board from refined wood pulp which would be as stable as one made from cotton fibers.[35] Fiber-base photographic paper (as well as the paper core of polyethylene-coated RC papers) is itself now made from purified wood cellulose, although this was not always so. In the early 19th century, nearly all photographic prints were made on linen and cotton rag papers, selected from artists' and writing papers available at the time. Inexpensive papers made from ground-wood pulp were introduced around 1840 but, because of their low quality, were unsuitable for making photographs.

By 1850 at least two companies were manufacturing papers specifically for making photographs.[36] Rag papers were sized with starches, albumen, and then gelatin, which resulted in prints with improved contrast and sharper detail. However, as the science of photography advanced, the various requirements for photographic papers were not always met. Problems regarding pulp availability and contamination, unstable sizing agents, papermaking equipment, paper strength (both wet and dry), and paper permanence challenged papermakers and photographers to create better photographic printing papers. According to Kodak, "as the demand for paper of all kinds increased, the supply of suitable rags diminished . . . . Consequently, much of the rag stock that was available did not meet the purity standards required for photographic use. In an effort to solve the problem, Eastman Kodak Company instituted a program of research and development into the possibility of making pure paper from wood pulp."[37]

George Eaton explained why Kodak needed to develop a satisfactory wood cellulose paper: "George Eastman imported the finest rag papers he could obtain from Europe until 1914, when World War I prevented further importation. Eastman Kodak Company then made the highest quality rag paper using rosin sizing," although, as Eaton also noted, the company had difficulty manufacturing the paper and "experienced considerable variability in the product. It was obvious that a source of more uniform raw material was necessary, and a ten-year research program ensued with a paper company to produce a wood cellulose fiber equal in purity to new grown cotton."[38]

By 1926 Kodak was producing photographic base papers containing 50% cotton fiber and 50% purified wood pulp. In 1926–27 Kodak substituted a more stable sodium stearate binder for rosin size. In 1929 a Kodak paper made entirely from wood pulp was judged by the National Bureau of Stan-

dards to be as permanent as the best quality 100% cotton fiber paper,[39] based on the rather simplistic paper permanence tests accepted at the time. Since the 1930's, virtually all Kodak and other fiber-base photographic papers have been manufactured entirely from wood cellulose.

Cost factors undoubtedly played a major part in the decision to develop a satisfactory wood cellulose paper, since such a paper is much less expensive than 100% cotton fiber paper. Over the years, this change has saved Kodak and other manufacturers untold millions of dollars in production costs.

In addition to the general desire for long-lasting prints, the quality of fiber-base photographic paper has traditionally been consistently high because of several requirements unique to photography. The paper must be free of certain common paper contaminants, especially copper, iron, and other metal particles, since these impurities can have adverse effects on the keeping properties of an emulsion prior to processing.[40] The paper must also have good wet-strength properties in order to hold up adequately during developing, fixing, and an hour or more of washing.

With the introduction of polyethylene-coated RC papers in the late 1960's, most of these constraints — which also tended to insure a long-lasting product — no longer applied. Because of this, stability differences between various brands of RC paper appear to be far greater than is the case with fiber-base papers manufactured during the past several decades.

Research and development on all kinds of photographic papers continue in the photographic industry. For example, in 1984, in response to an expanding market for "premium" fiber-base black-and-white papers with high stability and superior image quality — and intense competition from Ilford, Oriental, and Agfa-Gevaert — Kodak introduced Kodak Elite Fine-Art Paper. Information on the stability of the many photographic papers presently on the market, as well as of the relative stability of photographic mount boards and enclosure papers, will probably become increasingly available in the future.

## Fluorescent Brighteners in Prints and Mount Boards

Fluorescent brighteners, sometimes called "optical bleaches," are white or colorless compounds added to many paper products, fabrics, and so forth in order to make them appear whiter and "brighter" than they really are. (Most laundry detergents have added brighteners that mordant to fabrics during washing.) Fluorescent brighteners absorb ultraviolet (UV) radiation, causing the brighteners to fluoresce (emit light) in the visible region, especially in the blue and green portions of the spectrum. If the illumination source contains no UV radiation, fluorescent brighteners are not activated and, comparatively speaking, the paper appears "dull" or subtly lacking in brightness. It is the amount of UV radiation as a percentage of visible light that determines the perceived "brightening" produced by fluorescent brighteners in papers. Therefore, the more UV radiation present, the brighter the paper will appear.

Among common sources of illumination, indirect daylight through window glass has the highest relative UV content. Illumination from glass-filtered fluorescent lamps

and glass-filtered quartz-halogen lamps has a moderate UV content. Incandescent tungsten illumination has the lowest relative UV content of any common light source, but even incandescent lamps emit sufficient UV radiation to activate fluorescent brighteners. If the light source passes through an effective UV filter such as Plexiglas UF-3, not enough UV radiation will be transmitted to affect the brightener. Thus, unfortunately, prints and mount boards with fluorescent brighteners can appear significantly different depending on the exact spectral distribution of the light source.

Because Plexiglas UF-3 absorbs virtually all UV radiation below about 400 nanometers (ordinary glass freely transmits UV radiation in the 330–400 nanometer region of the spectrum, which excites fluorescent brighteners), the yellowish tint imparted by a UF-3 sheet covering a photograph is exaggerated if the print or mount board contains a fluorescent brightener. In other words, assuming that the illumination contains sufficient UV radiation to noticeably activate a fluorescent brightener, the "yellowing" imparted by UF-3 appears to be comparatively greater than it is with a similar print or mount board made without a fluorescent brightener. When photographs covered with glass and with UF-3 are hung side-by-side, the difference in yellowness is quite noticeable.

Another drawback of fluorescent brighteners in mount boards, photographic materials, and artists' papers is that when these products are exposed to light and UV radiation over time, they gradually lose their ability to fluoresce — in effect, the fluorescent brightener "fades." Thus, the paper gradually becomes faintly yellow and less bright in appearance. These problems can be avoided simply by not adding fluorescent brighteners to the paper product in the first place.

The authors have examined most of the cotton fiber mount boards currently available in the U.S. and, fortunately, it appears that fluorescent brighteners are seldom added to them. Boards that did contain significant amounts of fluorescent brighteners were a 4-ply 100% cotton fiber board manufactured in Germany by Felix Schoeller, Jr., GmbH & Co. KG (Schoeller boards are not widely available in the U.S., although they were used during the early to mid-1970's by Ansel Adams for dry mounting his prints) and several samples of 2-ply and 4-ply 100% cotton fiber boards sold in 1982 under private label by University Products, Inc., Holyoke, Massachusetts. Unfortunately, virtually all black-and-white photographic papers now contain fluorescent brighteners. The authors advise against the use of mount boards containing fluorescent brighteners and discourage the practice of adding brighteners to photographic papers.

## The Question of Paper pH

The pH of paper refers to its acidity or alkalinity, measured on a scale of 0.0 to 14.0, with pH 7.0 being neutral. A pH of less than 6.5 is considered acidic, and a pH of more than 7.5 is considered alkaline. Each whole number on the scale represents a difference in acidity or alkalinity of ten times the adjacent whole number. Common book and document papers usually have a pH value within the range of about 5.0 to 7.0, while the pH level of alkaline-buffered

papers is usually about 7.5 to 9.5. Papers with a pH of 6.5 or higher are generally considered to be "acid-free."

Throughout the discussion that follows, it must not be forgotten that pH is only one factor among many which can affect the stability of a photograph. In fact, research by Glen Gray of Eastman Kodak has indicated that pH alone is not even a good indicator of paper stability, particularly with high-quality papers: "Specifications based upon extractable pH levels only cannot properly rank papers for permanence nor can useful life be estimated since several other factors are involved."[41]

The current widespread interest in paper pH was generated chiefly by William Barrow, who conducted research on the stability of paper during the 30-year period prior to his death in 1967. He and other investigators demonstrated that, other factors being equal, papers with a pH below about 5.0 are generally short-lived, while neutral or alkaline papers are more likely to have a very long life.[42] This research led to the manufacture of low-cost, relatively stable papers that are alkaline-buffered with 2% to 3% calcium carbonate or magnesium carbonate by weight and with a resulting pH of about 8.5. One function of the alkaline buffer is to help neutralize the effects of sulfur dioxide and other contaminants absorbed by the paper from acidic inks, polluted air, and other external sources.

Alkaline-buffered papers are becoming common in the publishing field. For example, this book is printed on a high-quality, long-life, alkaline-buffered, coated book paper made by the Glatfelter Paper Company and is expected to survive many hundreds of years. In 1984 the American National Standards Institute issued *ANSI Z39.48-1984, American National Standard for Information Sciences – Permanence of Paper for Printed Library Materials,* which, among other requirements, specifies a minimum pH of 7.5 and a minimum alkaline reserve equivalent to 2% calcium carbonate by weight for uncoated paper used in books and other publications intended for permanent retention (coated papers, such as that used in this book, were beyond the scope of this initial standard).[43] Alkaline buffering appears to be particularly beneficial in increasing the life of low-quality papers on which most paperback books are printed.

In recent years there has been a marked trend toward incorporating alkaline buffering agents into the manufacture of museum mount boards, boxboards, and enclosure papers. Most conservation-quality products on the market are alkaline-buffered. These products are referred to as "acid-free," a confusing term heard so frequently that many consumers have been led to believe that this is the *only* requirement for materials used in long-term contact with films, prints, and other valuable artifacts.

Among early alkaline-buffered paper products were the microfilm and print storage boxes manufactured by the Hollinger Corporation. Alkaline buffering was intended to maintain the stability of the board as it aged, thus lessening the tendency for the box to generate peroxides, which — even at very low-level concentrations — have been shown to cause discoloration and fading of silver images during long-term storage. Untoned black-and-white RC prints and the very-fine-grain images of microfilms are extremely sensitive to peroxides and other such oxidizing gases.

The first widely marketed alkaline-buffered paper was

Permalife, initially produced according to Barrow's specifications by the Standard Paper Manufacturing Company of Richmond, Virginia beginning in 1960. Permalife is a moderately priced bond paper made from refined wood fibers; the trademark was acquired about 1976 by Howard Paper Mills, Inc. of Dayton, Ohio.[44]

With the introduction of Permalife in the document conservation field, archives and museums began storing negative and print collections in envelopes made of Permalife and similar papers. The Hollinger Corporation started producing envelopes of this type in the mid-1970's. Apparently neither the manufacturers nor the customers who requested Permalife envelopes tested them for possible adverse effects resulting from their long-term contact with photographs — it was simply assumed that the more stable an enclosure paper was, the better it was for storing photographs.

Some people, however, working in photographic conservation questioned the acceptance of alkaline-buffered products without testing. In 1976 Walter Clark, a former chemist at the Eastman Kodak Company and a conservation consultant at George Eastman House, wrote, "Special boxes, papers and mount boards are now made of nonacid materials, which were developed from research on permanent papers for books. It is not yet certain that the high degree of alkalinity in these materials is satisfactory in the long run for photographs, especially color pictures, but they offer the best approach at the moment."[45]

In 1978 Klaus B. Hendriks, chief conservation chemist at the Public Archives of Canada (now called the National Archives of Canada) said, "Questions are being asked concerning the most suitable pH of paper envelopes, and it may well be that different photographic records require different pH values of the respective paper enclosures in order to be kept safely."[46] Later in 1978, partially based on results of an investigation into factors influencing the dark fading stability of Ektacolor 37 RC prints, Henry Wilhelm recommended against the use of alkaline-buffered materials with photographs, pending the outcome of further research.[47]

In recent years, various advice has been given regarding pH requirements for photographic enclosures. In 1983 Polaroid Corporation said, "In general, photographs should not be subjected to acidic or highly alkaline substances. Storage envelopes, folders, papers, and so forth, should have a pH between 7.0 and 8.5 (neutral to slightly alkaline)."[48] In 1979, Eastman Kodak recommended that paper products for photographs "should be free of groundwood, alum, or alum-rosin size and have a pH of about 6.5."[49] In a 1982 publication, the company stated, "To be considered for color print mounting, a paper product should be free of ground wood, alum, or alum-rosin size and should have a pH of 7 to 7.5. (A pH of 7 to 9.5 often is considered acceptable for black-and-white print mounting.)"[50] Referring to black-and-white photographs, Kodak spokesman Henry Kaska said, "We simply haven't studied the matter in any depth. The feeling is that image stability isn't particularly affected by the [pH of the] paper that films and prints come in contact with. The question [about pH] arises from time to time, but it hasn't been subjected to the kind of study that would permit us to speak authoritatively on the matter."[51]

In the 1985 book *Conservation of Photographs,* Kodak

recommended a mount board pH value "very close to 7.0 or very slightly higher."[52] Based on an erroneous 1982 article,[53] which incorrectly cited a report by conservator Mary Kay Porter presented at a meeting of the Photographic Materials Group of the American Institute for Conservation (AIC), Kodak went on to say:

> Even though the pH may be within this range [7.0 to 9.0] an excessive amount of buffer can be harmful. One such mountboard contained 10–100 times the average concentration. Color prints stored for only a few months on this material showed considerable damage. A test for total alkalinity could have prevented the loss.[54]

Porter had actually reported on the apparent discoloration, or "staining," of some 19th-century *albumen* black-and-white prints which had recently been overmatted with an alkaline-buffered board. *Color prints were not involved.*

Investigations reported in 1982 by conservator Sergio Burgi, at the time with the International Museum of Photography at George Eastman House, revealed that this type of apparent discoloration of overmatted albumen prints is in reality not a discoloration at all.[55] In the 19th century it was common practice to lightly "tint" the albumen layer of the paper with organic dyes to give bluish-red or yellowish-red hues to the highlights of the prints. Burgi's research showed that these dyes characteristically have poor light fading stability, and when an overmatted albumen print is displayed for sufficient time, the dyes exposed to light in the cutout area of the overmat fade. The edges of the print protected from light by the overmat do not fade. With no record of what the print originally looked like, the unfaded

dye around the edges of the print can easily be misinterpreted as a "stain."

Porter was aware of Burgi's findings but had been told that some of the "stained" albumen prints had never been displayed (an assertion she later came to doubt); she suspected, therefore, that alkaline buffering in the overmat might be the cause of the discoloration, but she was not certain of this. Rather, in her report to the AIC group, she emphasized that materials used by paper conservators were not necessarily satisfactory for photographs and that much more consideration should be given to how mount boards and other paper products react with the silver images of black-and-white photographs. Porter did not discuss color prints or their storage requirements in her report.

## Most Photographs Are Not "Acid-Free"

When contemplating the consequences and benefits of specifying pH in the manufacture of mounting and enclosure materials, it is important to consider the normal pH values of photographs. Ilford has recommended a near-neutral pH for storage materials in contact with Cibachrome prints (renamed Ilfochrome prints in 1991): "The dyes utilized in Cibachrome are at maximum stability in the near neutral range between 6.5 and 6.8 pH. Materials to be placed in contact with the surface of the photograph for long-term storage must be of neutral pH."[56]

While the 1978 version of *ANSI PH1.53* (the predecessor of the current *ANSI IT9.2* Standard) specified buffered papers with a pH between 7.0 and 9.5 for both color and black-and-white photographs, this recommendation was changed in the 1984 and 1986 revisions of the Standard, and separate recommendations are now given in *ANSI IT9.2* for color and black-and-white photographs. For color photographs, nonbuffered paper products with a pH of 7.0 to 7.5 are specified; for black-and-white photographs, the recommendation is essentially the same as in the 1978 version.

Peter Adelstein, chairman of the ANSI subcommittee which developed the new versions of the Standard, said that "the concern was with the enclosure material lasting as long as possible. It could also be argued — though I don't think it is a good argument — that under any adverse conditions, when cellulose acetate materials hydrolyze, they release acid, which, of course, if it were in contact with

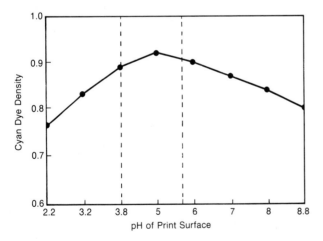

**Figure 13.1** The effect of emulsion pH on the dark fading of the cyan dye in Konica Color Paper Type SR. The prints have been subjected to an accelerated dark-storage test. The optimum stability of the dye occurs in the acidic range of pH 3.8–5.5. While the pH sensitivity of dyes varies considerably among color photographic products, the behavior of this particular dye is typical of the cyan dyes in most chromogenic color photographs; this underscores the concern about storing color prints in contact with alkaline-buffered mount boards and envelopes, which generally have a pH of 8.5 or higher. (Data courtesy Konica Corporation)

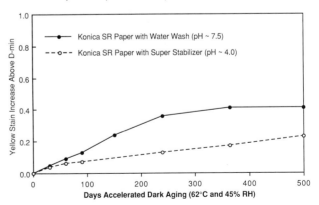

During dark storage, high emulsion pH also contributes to yellowish stain formation with Konica Type SR paper (shown here) as well as Ektacolor and other color negative print papers. (Data from H. Wilhelm)

buffered paper would be good. That is not true with the polyester materials — they don't hydrolyze as easily. However the primary concern was the stability of the enclosure paper; studies with books and documents indicated that these [alkaline-buffered] papers generally would last longer."[57]

Relative to the pH of photographs themselves, George Eaton made the following statement:

> Much has been said and will be said about the acidity or pH of photographic paper base with respect to permanence. Kodak raw stocks for black and white emulsions range in pH from 4.6 to 5.9 but after processing pH increases to a range of 5.5 to 6.6. The gelatin in the emulsion layer helps to stabilize paper acidity at these levels. This slight acidity . . . is not as important a variable to permanence as is the use of highly purified pulp, inert sizing material, and low levels of metallic impurities.[58]

As Eaton pointed out, fiber-base black-and-white prints typically have a pH in the acid range; a random selection of prints from the years 1917 to 1982 had pH levels of from 4.8 to 6.5 when tested by Henry Wilhelm.[59] Ektacolor prints from 1976 to 1982 had pH levels in the 3.5–4.5 range if the prints had been treated with Ektaprint 3 Stabilizer after washing, and about 6.5 if the acidic stabilizer had not been included, as has been the general practice in recent years. (Following the 1984 introduction of the Konica Nice Print "washless" minilab and associated Konica Super Stabilizer solution, color print stabilizers that leave the emulsion in a low-pH condition are becoming popular once again.)

Several samples of fiber-base Kodak Dye Transfer prints tested by Henry Wilhelm had a pH of about 5.0 on the emulsion side. In spite of the fact that Dye Transfer prints have a low pH, accelerated tests and experience over the last 40 years indicate that the paper support (made from highly refined wood cellulose), gelatin layers, and image dyes of the prints are extremely stable. When protected from light, Dye Transfer prints have the most stable images of any color film or print material made by Kodak. If one were to "de-acidify" a Dye Transfer print by immersion in an alkaline solution, the image dyes would bleed or even wash from the print.

The isoelectric point of the lime-processed gelatins (of which photographic emulsions are normally made) is also in the acid range, typically about pH 5.0.[60] The isoelectric point, "which is characteristic of the kind of gelatin, its method of preparation, and the impurities present, is the point at which the gelatin molecule is most tightly coiled because of the equal number of charge attractions. It is the condition of acidity or alkalinity at which the gelatin molecule is least soluble in water."[61] The significance of this, with respect to the long-term stability of photographs, is not known, but it has been suggested that gelatin may be most stable when the pH is near the isoelectric point.

There is no published information on the softening of gelatin stored at high relative humidities as a function of pH or whether the rate of penetration of airborne pollutants into gelatin (which would be most pronounced when storage humidities are high) is influenced by emulsion pH.

Likewise, the long-term effects of pH in terms of gelatin cracking and brittleness are not known. There is also no published information available as to how pH of the gelatin emulsion will be altered when color and black-and-white photographs are in long-term contact with alkaline-buffered paper.

## Examination of Historical Print Collections

Examination of historical print collections indicates that in general the paper supports of both albumen and silver-gelatin prints have remained in reasonably good condition, while the silver images are often significantly deteriorated as a result of poor processing, improper washing, humid storage conditions, contact with reactive storage materials, air pollutants, or fungus growths. This suggests that the focus of attention should be on preservation of the *image* and the gelatin emulsion. Assuming an otherwise high-quality paper stock, the pH should probably be selected to promote maximum stability of the silver or dye image and gelatin emulsion.

In 1982 James Reilly reported that Permalife paper promoted yellowing of freshly made albumen prints in accelerated aging tests, and he advised against storing such prints with alkaline-buffered papers.[62] Reilly's further investigation of the problem revealed that it was probably not the calcium carbonate buffering itself that produced the increased rate of yellowing, but rather it was some other, as yet unidentified, constituent of Permalife paper. Pending further research, however, Reilly said he still believed that, all other characteristics of a particular paper or board being equal, it is best to avoid alkaline-buffered products for storage of albumen prints.[63]

In general, there is apprehension about the effects of alkaline-buffered paper on all color photographs, including chromogenic prints such as Agfacolor, Ektacolor, Fujicolor, and Konica Color. There is particular concern over its adverse effects on dye-imbibition prints, including Kodak Wash-Off Relief prints, Kodak Dye Transfer prints, and Fuji Dyecolor prints.

In 1985 Konica reported findings from research on the effects of emulsion pH on the dark fading stability of Konica color paper: "It is well known that acidic pH is the best condition for keeping prints. When the pH of the print surface is between 4 and 5, the cyan dye fading is at a minimum, and yellow stain is limited."[64] As indicated in **Figure 13.1**, increasing the pH of the emulsion from 5.0 to 8.8 approximately doubles the amount of cyan dye loss under the conditions of the Konica tests. Because of interactions between an alkaline-buffered mount board or other paper product in contact with the emulsion of a color print, the pH of the emulsion may be expected to gradually rise to approximately the level of the buffered paper during long-term storage. Conditions of high humidity will accelerate the rate of change.

Accelerated dark fading tests conducted by Henry Wilhelm indicate that in addition to Konica Color Type SR and Type EX prints, the dark fading stability of Ektacolor 37 RC, Ektacolor 74 RC, Fujicolor Type 8908, and many other chromogenic papers is better (i.e., rates of cyan dye fading and/or yellow stain formation are reduced) when the prints are in a mildly acidic rather than alkaline condition. For

example, with many chromogenic color papers, the rate of yellow stain formation is drastically reduced when the prints are treated with Kodak Ektaprint 3 Stabilizer, which lowers emulsion pH to less than 4.5. (In spite of the reduced stain formation and increased cyan dye stability afforded by Ektaprint 3 Stabilizer, it should not be used with current color papers — see Chapter 2 and Chapter 5.)

Pending further research the authors of this chapter, Brower and Wilhelm, discourage the use of alkaline-buffered mount boards and papers with all color products. (Boxboards are not normally in direct contact with photographic emulsions, and for this reason the authors believe that there is much less cause for concern about possible adverse effects of an alkaline buffering in such products.) As indicated above, different types of photographic materials quite likely have different "ideal" pH conditions for storage. As a practical matter, however, it would be cumbersome and costly to stock, in every size, thickness, and color, alkaline-buffered mount boards and papers for black-and-white photographs, and a separate but equally complete line of nonbuffered boards and papers for color photographs, to meet the specifications of *ANSI IT9.2-1991.* (To meet the requirements of the ANSI Standard, manufacturers of paper envelopes also would have to supply two complete lines of envelopes; at the time of this writing, no manufacturer had indicated a willingness to do so.) It is hoped that there will eventually be a *single* specification — *that takes into account all the many factors affecting both photographic and paper stability, including pH* — for boards, envelopes, and other paper products for mounting and storing all types of important photographs.

Such a specification, however, cannot be formulated in the immediate future. For example, since it is very difficult to realistically simulate the long-term effects of air pollutants on paper products and, in turn, the effects these materials may have on photographs as they both slowly deteriorate, conclusive recommendations regarding pH alone are not expected soon. Until more information is available, the authors recommend nonbuffered 100% cotton fiber boards and enclosure papers when long-term keeping is contemplated, especially for the display and storage of color prints.

Responding to these concerns, in 1982 the Museum of Fine Arts in Boston, and in 1983 the New Orleans Museum of Art, began to mount the color prints in their collections with nonbuffered 100% cotton fiber board. Since then, many other institutions and individuals have begun to do the same.[65]

## Light Fading Stability of Mount Boards

Many mount boards fade or change color during prolonged display, and some are even less stable than Ektacolor and similar color prints when exposed to light. For example, some mount boards eventually lose all color and become white, white boards may turn yellow, a gray board may turn beige, a deep blue board may turn brown, or a dark green board may become light blue. This presents a difficult and often hidden problem for artists, framers, and curators who carefully select the most appropriate and complementary board when mounting a photograph and generally assume that the colors of the mount will remain unchanged.

**Table 13.1** was compiled from more than 300 mount and mat boards made in the United States in 1982 and 1983. (In 1985, Rising Paper Company introduced several new "fade-resistant" colored boards to replace those previously available; the authors repeated the tests for a period of 90 days for these boards. Six tones of museum board introduced in 1985 by Crescent Paper Company were also tested and included in this table.) The boards are divided into five types and subdivided into six color-density groups; the boards are then ranked according to the stability of their original color.

The five categories of board are:

**(1)** 100% Cotton Fiber Boards (solid)
**(2)** Highly Refined Wood Pulp Boards (solid)
**(3)** 100% Cotton Fiber Boards (composite)
**(4)** Highly Refined Wood Pulp Boards (composite)
**(5)** Standard Wood Pulp Boards (composite)

*Solid* boards are consistent in color and fiber on both sides and throughout the middle. *Composite* boards are faced and backed with separate sheets of paper, usually white on the back and a toned paper on the top. The top surface papers frequently have a noticeable texture.

The six color groups are:

**(A)** Whites and Off-Whites   (blue density: 0.03–0.11)
**(B)** Ivories                 (blue density: 0.12–0.20)
**(C)** Light Colors            (visual density: 0.10–0.33)
**(D)** Medium Colors           (visual density: 0.34–0.73)
**(E)** Dark Colors             (visual density: 0.74–1.18)
**(F)** Blacks                  (visual density: 1.30–1.41)

The color groups are determined by the visual or blue filters on a densitometer. Two exceptions are noted in **Table 13.1** with an asterisk. (Red, green, and blue densities vary considerably outside the visual ranges; for ex-

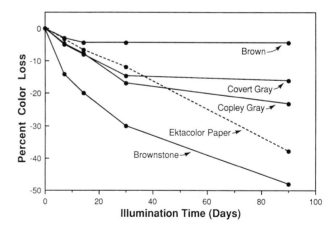

**Figure 13.2** The stability of four mount boards subjected to an accelerated light fading test with 21.5 klux (2,000 fc) glass-filtered Cool White fluorescent lamps. The Rising Brownstone color falls into the authors' "extremely poor" category; Crescent Cardboard Copley Gray has "poor" stability; Crescent Cardboard Covert Gray has "fair" stability; and Strathmore Brown has "good" stability. A Kodak Ektacolor Plus print tested under the same conditions is shown for comparison.

ample, Crescent Cardboard Company's Naples Yellow board has a visual density of 0.15 and a blue density of 0.76.)

In judging the relative stabilities of the boards, the authors observed three types of changes: fading, color shift, and yellowing (darkening). Since the authors did not feel it was possible to quantitatively define acceptable amounts of such changes in this test, each board's relative stability was ranked as being good, fair, poor, or extremely poor according to the authors' visual assessment. Because of the even greater difficulty in defining these four stability categories for white and ivory boards, such boards are listed as having either good stability or poor stability; only severely changed boards (i.e., darkened or completely faded) in these two color groups are described as having extremely poor stability. White and ivory boards with very slight changes were considered to have good stability.

*As a general guideline,* the authors considered colored boards with less than 10% color losses (measured as losses in red, green, and/or blue density) to have good stability; a colored board with a 10–20% loss in color was considered to have fair stability; boards that lost 20–40% of their color were considered to have poor stability; and any board that lost more than 40% of its color or that actually changed color was considered extremely unstable. In general, light-colored and reddish boards achieved lower rankings with somewhat less than these percentage losses, while dark and yellow or greenish boards required greater percentage losses before they were downgraded.

When selecting a mount board, one cannot judge its color stability according to the quality of its fiber or its cost. Many museum boards made of high-quality cotton fiber have remarkably poor color stability while many of the less expensive wood pulp boards have extremely good color stability. Unfortunately, some of the most aesthetically pleasing colored museum boards, such as Crescent Cardboard Company's Rag Mat 100 Antique Tan and Archival Mist, and Rising Paper Company's Gallery Grey, proved to have extremely poor color stability.

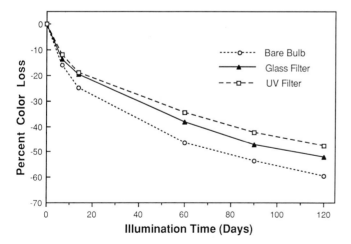

**Figure 13.3** Rising Burnt Orange mount board subjected to an accelerated light fading test with 21.5 klux (2,000 fc) Cool White fluorescent lamps under three different spectral conditions. A Plexiglas UF-3 ultraviolet filter afforded only marginal improvement. In all cases the stability of the board was rated "extremely poor."

Some of the best colors for mounting photographs, such as Crescent's Neutral Gray and the various antique tones offered by most of the represented companies, performed equally poorly in these tests. Only 43% of the dyed 100% cotton fiber museum boards (Type 1) had good color stability while 49% were rated poor or extremely poor. Highly refined wood pulp boards (Type 2) fared the worst, with only 39% having good stability and 53% having poor or extremely poor stability. For whatever reasons, the solid museum and conservation boards had inferior color stability when compared with the three other types of boards. All 28 colors of Crescent Cardboard Company's Rag Mat composite boards (Type 3) had good stability. It was surprising to find that 59% of the lowest-quality, so-called standard or regular boards (Type 5) had good color stability while only 30% had poor or extremely poor color stability. Overall, 60% of all the tested boards had good stability, 7% had fair stability, 15% had poor stability, and 18% had extremely poor stability.

## Manufacturers' Claims About Color Stability Are Frequently Meaningless

Manufacturers have been an unreliable source of meaningful information regarding the color stability of their boards. In the PPFA 1986 Survey on Mat/Mount Boards,[66] most companies cited various lab tests, but the results of these tests cannot be interpreted or applied by most board consumers without further information. For example, Nielsen & Bainbridge Alphamat boards were listed as being tested with the "Fade resistance Carbon Arc Fade-O-Meter (80 hr. ASTM G-25)." This fact is not meaningful to the average framer. Did Crescent Cardboard Rag Mat boards pass, did they fail, or were they simply subjected to the "80-hour fade"? Columbia Corporation provided somewhat more useful information by stating that its Museum Mounting Board 100% Rag "withstands 80 hours Fade-O-Meter exposure without fading." But how is one to know how well a particular board color will hold up compared to another?

Some of the manufacturers' advertising and promotion literature is equally uninformative, and even misleading. Miller Cardboard's specifications for the surface papers of its Ultimat boards included, "Direct dye or iron oxide to ensure bleed and fade resistance," while Rising claimed that its museum and Conservamat boards are "fade resistant." In a letter to the authors (April 25, 1986), Crescent Cardboard Company wrote, "The Crescent Rag Mat Museum Board . . . high quality surface papers are . . . completely fade resistant." While it is true that Crescent's faced "museum" boards proved to have excellent color stability, the company's Rag Mat 100 museum boards were shown to be among the least stable. In a product sample folder, both types of boards are described as "fade resistant," while the Regular Mat Board is said to have surface papers which are "highly resistant to fading."

Although only one Alphamat color (Garnet) faded more than 10% in Carol Brower's tests, Bainbridge overstated the color stability of its Alphamat Board, which it claimed "Offers complete resistance to fade, discoloration, bleeding and deterioration" (1984 Framing Colors and Textures from Bainbridge brochure). Unlike other companies, however, Bainbridge made no claims regarding the fade resis-

*(continued on page 477)*

## Table 13.1 Comparative Light Fading Stability of Mount Boards

### 1. Solid 100% Cotton Fiber Boards

**a. Whites and Off-Whites**

Good Stability:
- LI Non Buffered (same board as Process Materials below)**
- PA Photographic (white)**
- PM Photographic (off-white)**
- RS Photomount (white)**
- ANW Lenox (white)
- ANW Gemini (off-white)
- CC White
- CC White Linen
- JR White
- LI Bright White
- LI Westminster Natural White
- MC Shell White
- N&B White
- PA Brite White
- PA Soft White
- PM Pure White
- PM Off White
- RS White
- STR Natural

Poor Stability:
- CC Off-White
- CC Antique White
- LI Antique White
- MC Off White
- MC Warm White
- MC Ivory
- PA Antique
- PA Warm White
- RS Warm White

Extremely Poor Stability:
- MC White (d)

**b. Ivories**

Good Stability:
- ANW W & A
- JR Ivory
- PM Metropolitan Antique
- Cream
- STR Creme

Poor Stability:
- ANW Antique
- CC Antique White
- CC Antique White Linen
- CC Cream
- CC Cream Linen
- LI Ivory
- N&B Ivory

### 2. Solid Highly Refined Wood Pulp Boards

**a. Whites and Off-Whites**

Good Stability:
- ANW White
- JR Cream
- LI Gallery White
- N&B White
- RS Snowhite
- RS White

Poor Stability:
- MC Acid Free (white)
- PM Extra White

**b. Ivories**

Good Stability:
- PM Ivory
- PM Special Cream

Poor Stability:
- N&B Ivory
- RS Ivory

**c. Light Colors**

Good Stability:
- ANW Seashell

Extremely Poor Stability:
- PM Light Gray (f)
- RS Pearl Gray (f)
- RS Beige (f)
- RS Fawn (f)
- RS Light Green (fc)

**d. Medium Colors**

Good Stability:
- ANW Desert Tan
- ANW Gray-Grey

Fair Stability:
- ANW Blue Granite
- RS Bluestone

Extremely Poor Stability:
- RS Dark Green (f)
- RS Neutral Gray (f)
- RS Mustard* (0.20) (f)
- RS Kraft (fc)
- RS Tan (fc)

**e. Dark Colors**

Good Stability:
- ANW Taupe* (0.67)
- ANW Dark Gray

Fair Stability:
- RS Dark Gray

### 3. 100% Cotton Fiber Boards with Facing Sheets

**a. Whites and Off-Whites**

Good Stability:
- CC Palm Beach White

**b. No Ivories Tested**

**c. Light Colors**

Good Stability:
- CC Chamois Gold
- CC Dawn Gray
- CC French Buff
- CC India
- CC Mist
- CC Pearl
- CC Sand
- CC Sandstone

**d. Medium Colors**

Good Stability:
- CC Bar Harbor Gray
- CC Biscay Blue
- CC Copley Gray
- CC Las Palmas Green
- CC Oak Brown
- CC Pewter
- CC Rust
- CC Storm Blue
- CC Suntan

**e. Dark Colors**

Good Stability:
- CC Avocado
- CC Dark Gray
- CC Newport Blue
- CC Redwood
- CC Russet
- CC Sable
- CC Sepia
- CC Tampico Brown
- CC Williamsburg Green

**f. Blacks**

Good Stability:
- CC Raven Black

### 4. Highly Refined Wood Pulp Boards with Facing Sheets

**a. Whites and Off-Whites**

Good Stability:
- MC Dove
- CC Snowflake
- N&B Photo White
- N&B Talc

**b. No Ivories Tested**

**c. Light Colors**

Good Stability:
- N&B Almond
- N&B Cashmere
- N&B Celadon
- N&B Chamois
- N&B Fairfield White
- N&B Goldenrod
- N&B Heather Mist
- N&B Khaki
- N&B Malacca
- N&B Mimosa
- N&B Moroccan Sand
- N&B Neutral Grey
- N&B Nimbus
- N&B Sea Mist
- N&B Shadow Blue
- N&B Teal Grey

Extremely Poor Stability:
- MC Balique (f)
- MC Beige (f)
- MC Blue Art (f)
- MC Pearl (f)
- MC Tawny (f)
- MC Putty (fc)
- MC Sauterne (fc)

**d. Medium Colors**

Good Stability:
- N&B Adobe Brown
- N&B Annapolis Blue
- N&B Antique Brass
- N&B Arabesque
- N&B Baltic Green
- N&B Brittany
- N&B Burnished Gold
- N&B Calabash
- N&B Cascade Grey
- N&B Catawba
- N&B Chelsea Blue
- N&B Cobblestone
- N&B Dijon
- N&B Emberglow
- N&B Flemish Blue
- N&B Grey Flannel
- N&B Kirkwood

### 5. Standard Board Made of Wood Pulp Core with Facing Sheets

**a. No Whites or Off-Whites**

**b. No Ivories Tested**

**c. Light Colors**

Good Stability:
- CC Antique Buff
- CC Chamois Gold
- CC Cool Gray
- CC Dawn Gray
- CC French Blue
- CC French Gray
- CC French Lilac
- CC Limestone
- CC Madagascar Pink
- CC Mist
- CC Olde Tan
- CC Paris Green
- CC Peach
- CC Pearl
- CC Sauterne

Fair Stability:
- CC Naples Yellow

Poor Stability:
- CC Cameo Rose (fc)
- CC Daffodil (f)
- CC Doeskin (f)
- CC India (f)
- CC Yellow (f)

Extremely Poor Stability:
- CC Diamond Blue (dc)
- CC Sandstone (f)

**d. Medium Colors**

Good Stability:
- CC Azure
- CC Bar Harbor Gray
- CC Blue Gray
- CC Bonanza Gold
- CC Camel
- CC Celery
- CC Dusk
- CC Inca Gold
- CC Las Palmas Green
- CC Mauve
- CC Mist Gray
- CC Moss Point Green
- CC Oak Brown
- CC Oriental Red
- CC Pewter
- CC Redstone
- CC Rust
- CC Saddle Tan
- CC San Fernando Gold
- CC Sand
- CC Stone Gray
- CC Suntan

PA  Ivory
RS  Antique
RS  Cream
RS  Natural
UP  Ivory

**c. Light Colors**

**Good Stability:**
PM  Graytone
PM  Ashtone

**Fair Stability:**
STR  Light Gray (c)

**Poor Stability:**
PM  Peachtone (fc)

**Extremely Poor Stability:**
CC  Antique Tan (fc)
CC  Archival Mist (fc)
CC  Desert Sand (fc)
CC  Neutral Gray (fc)
CC  Olde Ecru (fc)
CC  Vintage Gray (fc)
PA  Grey (f)
PA  Dark Grey (f)
PA  Tan (f)
RS  Gallery Gray (f)
RS  Fawn (f)
RS  Zinc (f)
STR  Pink (fc)

**d. Medium Colors**

**Good Stability:**
MC  Greige (same as Strathmore Gray below)
MC  Jasper (same as Strathmore Green below)
STR  Brown
STR  Gray
STR  Green

**Fair Stability:**
MC  Lapis (same as Strathmore Blue below)
PM  Florentine Tan
PM  French Blue
STR  Blue
STR  Tan

**Poor Stability:**
MC  Sable (c)

**Extremely Poor Stability:**
MC  Sandlewood (fc)
RS  Brownstone (f)

**e. No Dark Colors Tested**

**f. Blacks**

**Good Stability:**
MC  Black
PM  Black
STR  Black

**Extremely Poor Stability:**
PM  Ash Gray (fc)
RS  Brick Red (f)
RS  Burnt Orange (f)
RS  Chocolate (fc)
RS  Deep Blue (fc)

**f. Blacks**

**Good Stability:**
ANW  Black

**Note:** This table was compiled from more than 300 mount and mat boards made in the United States in 1982 and 1983 (see pages 473–478 for discussion). These products and others currently on the market may have very different light fading characteristics.

Letters follow all poor and extremely poor rankings to indicate what type of change was observed: fading (f); color change (c); yellowing or darkening (d). Boards are listed alphabetically in each column according to the manufacturer or distributor and not according to performance. Board color names (capitalized) are those of the associated company. The two colors marked with a single asterisk have a visual density reading outside the above given ranges for their assigned groups. The first four boards on the list (marked with two asterisks) are nonbuffered "photographic" boards.

**Companies represented:**

ANW  Andrews/Nelson/Whitehead
CC  Crescent Cardboard Company
JR  James River Corporation
LI  Light Impressions Corporation
MC  Miller Cardboard Company
N&B  Nielsen & Bainbridge
PA  Parsons Paper Company
PM  Process Materials Corporation
RS  Rising Paper Company
STR  Strathmore Paper Company
UP  University Products Corporation

N&B  Martinique
N&B  Pampas
N&B  Photo Grey
N&B  Pistache
N&B  Sonora
N&B  Spice
N&B  Sultan Sand
N&B  Weathered Oak
N&B  Windsor Tan

**Extremely Poor Stability:**
MC  Green Mist (f)
MC  Gulf Blue (f)
MC  Honey (f)
MC  Mica (f)
MC  Tangerine (f)
MC  Taupe (f)
MC  Moss Green (fc)

**e. Dark Colors**

**Good Stability:**
N&B  Almandine
N&B  Ash
N&B  Brianwood
N&B  Carmine
N&B  Chutney
N&B  Clove
N&B  Dover Grey
N&B  Indigo
N&B  Jasmine
N&B  Regatta
N&B  Sorrel
N&B  Tartan Green
N&B  Tuscan Brown

**Fair Stability:**
N&B  Garnet
MC  Charcoal

**Poor Stability:**
MC  Dark Blue (f)
MC  Navy (f)
MC  Ivy Green (fc)

**Extremely Poor Stability:**
MC  Brick (f)
MC  Russet (f)

**f. Blacks**

**Good Stability:**
N&B  Ivory Black

**Poor Stability:**
MC  Black (f)

**Fair Stability:**
CC  Bimini Blue
CC  Congo Green (c)
CC  Covert Gray
CC  Light Gray
CC  Lime

**Poor Stability:**
CC  Biscay Blue (f)
CC  Copley Gray (f)
CC  Cypress (f)
CC  Ex Light Gray (f)
CC  Gibraltar Gray (f)
CC  Kelly Green (fc)

**Extremely Poor Stability:**
CC  Burnt Orange (f)
CC  Cinnamon (f)
CC  Colonial Orange (f)
CC  Coral (f)
CC  Olive Gray (f)
CC  Persimmon (f)
CC  Pompeian Red (f)
CC  San Vincente
CC  Orange (f)

**e. Dark Colors**

**Good Stability:**
CC  Avocado
CC  Baltic Blue
CC  Dark Gray
CC  Delft Blue*
CC  Las Cruces Purple
CC  Madeira Red
CC  Marine Blue
CC  Newport Blue
CC  Nutmeg
CC  Pyro Brown
CC  Riviera Rose
CC  Russet
CC  Sable
CC  Sepia
CC  Storm Blue
CC  Volcano Blue
CC  Williamsburg Green

**Fair Stability:**
CC  Chinese Red
CC  Chocolate
CC  Dark Green
CC  Ivy Green

**Poor Stability:**
CC  Boulder Brown (f)
CC  Fudge (f)
CC  Malay (fc)
CC  Redwood (fc)
CC  Wine (f)

**Extremely Poor Stability:**
CC  Tampico Brown

**f. Blacks**

**Good Stability:**
CC  Raven Black

**Extremely Poor Stability:**
CC  Smooth Black (fc)

tance or light fastness of its Alpharag or Alphamount boards.

Vera G. Freeman, former manager of the Art Paper Department at Andrews/Nelson/Whitehead, responded to Carol Brower's inquiry on the subject of color stability in a letter dated July 14, 1982: "We do have test data on dye stability, but since it seems to vary with every making, we do not publish such findings in order not to misguide the public."

In promotional literature distributed in 1982 by Process Materials Corporation (which in 1990 became the Archivart Division of Heller & Usdan, Inc.), the company announced: "New . . . acid-free mat board in 14 compatible colors . . . that last." And in 1984: "Archivart Museum Board . . . light-fastness is assured by manufacturing specifications which yield resistance to fading at least five times that of other colored mat boards." Arno Roessler, former president of Process Materials (and currently president of Paper Technologies, Inc.), said in a panel discussion published in the November 1984 *Art Business News:*

> Producing conservation color paper is a complicated process and it depends on the manufacturer because to get it in the alkaline range you use a completely different approach, [you] are restricted, and cannot simply make every color as you please. There are different dyes you can use that lend themselves to making acid-free boards and color . . . . Most good quality colored boards are really pigmented.

Kurt R. Schaeffer, former product planner for Strathmore Paper Company, also responded to inquiry in July 1982: "We conduct a test to determine the fade resistance of our Museum Mounting Board. The test is conducted with an Enclosed Violet Carbon Arc. The industry wide standard considers a 20 hour fade test without any fade to be excellent."

As **Table 13.1** shows, stability can vary considerably within each group even among the best available products, such as Strathmore Museum Boards. It is apparent that a new, standardized test for evaluating the light fading stability of mat and mount boards is required — a test that simulates the spectral distribution of typical indoor illumination conditions. Different levels of stability need to be defined, and limits of acceptability need to be set. As a beginning, the authors recommend adoption of the 6 klux temperature- and humidity-controlled glass-filtered fluorescent light fading test specified in the new *ANSI IT9.9-1990* color stability test methods Standard.[67] Furthermore, because information supplied by the paper manufacturers and distributors is often essentially meaningless to the consumer, manufacturers are urged to provide more reliable (and comprehensible to the average consumer) information with the boards they sell.

### Test Procedures

In preparing **Table 13.1**, Carol Brower exposed boards to high-intensity 21.5 klux (2,000 fc), Philips 40-watt Cool White Fluorescent Lamps (F40CW) with two lamps per fixture for a total of 120 days. The surface temperature of the samples was approximately 85°F (29.4°C) and because of

the heating of the samples, the moisture content can be assumed to have been very low. The board samples were covered with window glass to absorb ultraviolet radiation below about 330 nanometers (the 313 nanometer mercury emission line radiated by the lamps, which can cause greatly increased rates of fading in some dyes used to color mount boards, is completely absorbed by the glass).

Each board was read for density changes in the visual, red, green, and blue spectrum ranges at intervals of 7, 14, 60, 90, and 120 days. A densitometer was used for this study instead of a color difference meter so that the results could be compared to fading data on color photographs. The densitometer was a Macbeth TR924 equipped with Status A filters, which were designed for use with color photographs. Zero density was calibrated on a porcelain plaque supplied by the manufacturer. The potential error of the readings was approximately ± 0.01 for any given measurement; this is of particular importance when judging the relative stability of white, ivory, and very light-colored boards as well as when calculating the changes in all low-density measurements.

### Manufacturers' Efforts to Meet Photography Conservation Requirements

All manufacturers (and major distributors) of high-quality mount boards are aware of at least some of the concerns related to photographic conservation.[68] (See **Appendix 13.1** [Letter to Paper Manufacturers].) At the time of this writing, however, no paper manufacturer had performed tests to determine the effects of its products on even the most common photographic materials nor confirmed that its products meet the many requirements given in *ANSI PH1.53-1986* (essentially the same requirements are specified in the current *ANSI IT9.2-1991* Standard). Chi C. Chen, technical director at Rising Paper Company, said that many paper manufacturers do not believe they have a responsibility to conduct such tests. In Chen's opinion, people who buy the products, and particularly people working in the field of photographic conservation, bear the responsibility for testing them and for recommending specifications to the manufacturer.

Other paper companies concurred with this view. For example, Joseph B. Fiedor, general manager of Crescent Cardboard Company, made the following comment about requests for nonbuffered mount boards:

> We supply what people want. It's a question of demand. For example, our boards were once made without the addition of alkaline-buffering agents. The pH was below 7.0. But in recent years there has been great demand for buffered boards and so we began to add buffering agents. Now we strive for a pH that is above 7.5 at the time of manufacture as demanded by the market. The [future] direction we take will be based first on the research of people such as James Reilly in Rochester.[69]

Speaking for Process Materials Corporation (now the Archivart Division of Heller & Usdan, Inc.), marketing manager Robert Stiff said:

Manufacturers have to be told what the photographic conservation field is looking for. Conservators must initiate specifications for new products — "We need a product that will do this." There has to be a consensus of opinion and then we will try to meet the stated requirements. Naturally that involves testing on our part to know that our products meet those specifications. It's wholly a matter of cooperation between the manufacturers and those in the marketplace.[70]

## Nonbuffered Photographic Storage Paper and Mount Board Made by Atlantis Paper Company: An Enlightened Approach to Meeting Users' Needs

Of all the paper companies producing high-quality mount boards and papers for conservation purposes, the Atlantis Paper Company Limited, located in London, England,[71] appears to be making the greatest effort to address the specific needs of the photographic conservation field. Founded in 1978 by Stuart Welch and David Brown, who at the time were both working artists and teachers in London art schools, Atlantis initially supplied artists, printmakers, and students with papers for watercolor, printing, and drawing.

It is immediately evident from the Atlantis catalog that the company furnishes its customers with a more complete list of product specifications than is usually given by other distributors. According to Atlantis, "The idea of giving information about our products is two fold, one to supply information to the best of our knowledge about the products to assist the conservator in his or her work, and to help educate and relate information about paper, and paper conservation and preservation, to practicing artists and paper users who otherwise have little or no access to information on the materials they use."[72]

In 1983, in response to needs expressed by British paper and photograph conservators Ian and Angela Moor and others in the conservation field, Atlantis introduced Silversafe Photostore, a very smooth, white, nonbuffered 100% cotton fiber paper that is probably the first high-quality paper ever designed specifically for making photographic storage envelopes and enclosures. Available in four different weights, the paper is also intended for interleaving prints and negatives. The paper is Fourdrinier machine-made at St. Cuthbert's Paper Mill, Somerset, England. The paper is presently used as a negative enclosure and interleaving paper by a number of museums, including the J. Paul Getty Museum in Pasadena, California. Atlantis Silversafe Photostore may be ordered directly from Atlantis, or through the Archivart Division of Heller & Usdan, Inc. or Paper Technologies, Inc.[73]

Ian and Angela Moor collaborated with Atlantis in developing the specifications for the paper, which embodies all of the qualities they could identify as important for the long-term preservation of photographs. The specifications for the paper, as given in the 1991 Atlantis catalog, are:

- 100% cotton fiber from purest cotton linters

- Passes Silver Tarnish Tests

- Passes ANSI photographic activity test IT9.2
    Criterion 1: Fading of colloidal silver detector
    Criterion 2: Staining of gelatin/photographic
                    paper detector
    Criterion 3: Mottling of colloidal silver detector

- Sized with neutral curing ketene dimer

- Reducible sulfur: less than 0.2 parts per million

- Qualitative test for chloride – negative

- Gurley test to assess porosity where airflow
  can be beneficial:
    40gsm (before calendering) 3.5 sec;
            (after calendering) 10 sec;
    120 gsm (before calendering) 11 sec;
            (after calendering) 55 sec.
    The higher the figure the less porous the paper
    expressed as sec/100ml/sq. in.

- pH: 6 by cold demineralised extract

- Ash content: 40 gsm 0.025%
               120 gsm 0.019%

- No added alkaline buffering agents

- Supplied long grain

- Smooth surface

- Available in four weights

- White colour, free from Optical Brightening Agents

Atlantis also supplies a line of 100% cotton fiber mount boards under the Atlantis 100% Cotton Museum Board name. In 1985 the company introduced Atlantis 100% Cotton Museum Board TG Offwhite (initially called Heritage Museum Board TG Offwhite) for the mounting and conservation of photographs. "In line with current opinion," according to Atlantis, the board has a pH of about 7.0 at the time of manufacture and is not buffered. Atlantis 100% Cotton Museum mount board stock is sized with the same alkyl ketene dimer sizing agent used in Silversafe Photostore; in addition, the mount boards are "lightly" surface-sized with a modified non-ionic farina starch.

The board plies are laminated with a V.A.E. polymer adhesive, which contains no plasticizer and is about pH 7.0. According to Atlantis, selection of the V.A.E. adhesive was based on the following criteria:

1. Since pH is of primary importance we considered a V.A.E. polymer better than P.V.A. [polyvinyl acetate] since they are less susceptible to hydrolysis and release of acetic acid. As a further precaution the system is neutralized by a small proportion of ½% calcium carbonate to absorb any acetic acid should it be formed, thereby maintaining the neutrality of the glue line. This should not be considered as a normal buffer as we are not looking for an alkaline product.

2. There is a small possibility that any plasticizer present could migrate and adversely affect the material in contact with the board and hence this is avoided by the omission of any plasticizers in the formulation of this adhesive.

3. Chloride and sulfur content should be as low as possible. After coating a layer of the base paper used for the Atlantis 100% Cotton Museum Board with a film of our V.A.E. adhesive, allowing it to dry and then testing directly against the adhesive for Silver Tarnish using a standard test, the results were totally satisfactory: i.e., no tarnish at all. Included in the formula of this adhesive is less than ½% of Ortho Phenyl Phenol which is included as a preservative to prevent mold growth and bug attack. This additive has the advantage that it continues to protect the adhesive from this kind of attack in its dry state after lamination. The formula for the adhesive was arrived at after lengthy discussions with both conservators and adhesive chemists.[74]

Atlantis, unfortunately, has declined to identify either the specific adhesive or its manufacturer, citing "competitive reasons." However, Stuart Welch, a director of the company, commented, "I should say that if it can be shown that a better adhesive exists we would have no hesitation using it. We try to work as closely as possible with conservators and conservation scientists and rely very much on their advice and help to produce the best possible products. All of our fine art and archival products are in a constant state of development according to the ever changing requirements of our customers, and advances in the 'State of the Art' of paper-making technology."[75]

Welch also said that Atlantis would be willing to disclose the name of the adhesive manufacturer to "institutional conservators" if they wrote to Atlantis on their official letterhead and "are able to persuade Atlantis that this information is essential in solving a problem in their work."[76]

Atlantis claims that Atlantis 100% Cotton Museum boards are "light fast," equal to or better than a Blue Wool Scale No. 5 rating. (The authors presently do not have the data necessary to compare the light fading stability of Atlantis 100% Cotton Museum boards with other available white and near-white boards; however, the fact that Atlantis publishes such information is noteworthy.)

Atlantis says that its papers and boards intended for photographic applications are tested with a silver tarnish test at St. Cuthbert's Paper Mill as part of routine quality control. All Atlantis products intended for museum and archive applications are made by St. Cuthbert's "using the pure water source of the River Axe directly as it leaves the underground complex of caves at Wookey Hole, in the Mendip Hills. The pipework throughout the mill is stainless steel ensuring no rust, oxidization or contamination of the water source or stock during the manufacturing process."[77]

## Other Suppliers of High-Quality Boards and Papers

Process Materials Corporation (now the Archivart Division of Heller & Usdan, Inc.) was the first paper company to respond to reservations in the photographic conservation field regarding alkaline-buffered boards. In November 1981, as an outcome of discussions between Arno Roessler (who at the time was president of Process Materials), the authors, and others, the company introduced Archivart Photographic Board: "This board has been manufactured specifically for photographic use, for such applications where the alkaline environment of Archival Quality Matboards is considered to be undesirable. This board comes in an off-white color and is manufactured from selected 100% cotton fiber in the neutral pH range, without any alkaline reserve[78] or buffering."[79,80] According to Archivart, the pH value of Archivart Photographic Board at the time of manufacture is between 6.5 and 7.5, which may be expected to drop somewhat with time as the board is exposed to normal atmospheric conditions.

Archivart regularly publishes technical bulletins, which, along with samples of the products, are sent to anyone who requests them. The company also publishes "discussions" in its *Paper and Preservation* series, invites comments on its literature and products, and has for many years demonstrated an interest in educating and working with its customers. Unfortunately, Archivart has declined to identify the manufacturer of its mount board, and for this reason its use in long-term photographic applications cannot currently be recommended by the authors. The importance of identifying the manufacturing mill of a paper product for conservation purposes is discussed in this chapter and in Chapter 12.

In 1982 Rising Paper Company introduced a white, non-buffered 100% cotton fiber board called Rising Museum Photomount. The company stated, "It is for use with photographic prints where excessive alkalinity should be avoided."[81] The board is made at the Rising paper mill in Housatonic, Massachusetts. Rising Museum Photomount is one of the boards tentatively recommended for photographic applications by the authors.

Parsons Paper Company introduced a line of 100% cotton fiber mount boards in mid-1983. Among them is a nonbuffered 4-ply board called Photomounting Board, which is available in two tones: white and antique. Made at the Parsons Paper Company mill in Holyoke, Massachusetts, Photomounting Board is tentatively recommended by the authors for photographic applications. A/N/W-Crestwood Paper Company in New York City and University Products, Inc. in Holyoke sell the Parsons line of museum and photographic mount boards under their own names.

Process Materials Corporation (now the Archivart Division of Heller & Usdan, Inc.) introduced Archivart Photographic Storage Paper in 1983. Made from wood cellulose, the paper has an exceptionally smooth finish without being shiny, is neutral in pH, is nonbuffered, and is claimed to be sulfur free. Also in 1983, Light Impressions Corporation introduced a nonbuffered, neutral-pH product called Renaissance paper, developed specifically for storing albumen and color prints.[82] Both papers are suitable for making mounting corners and negative envelopes, and also as interleaving papers, depending on the selected weight. However, as neither Archivart nor Light Impressions would identify the manufacturers, the papers cannot be unequivocally recommended.

Conservation Resources International, Inc. supplies a nonbuffered, sulfur-free, high-alpha-cellulose wood-pulp paper called Lig-free Photographic Enclosure Paper that is recommended by the company for "archival photographic enclosures."[83] Conservation Resources has declined to identify the manufacturers of the company's paper and board products.

In 1985, Andrews/Nelson/Whitehead introduced a smooth-surfaced, white, nonbuffered 100% cotton fiber board called Photographic Board, available in 2-ply and 4-ply thicknesses. The company, however, declined to reveal the name of the manufacturer(s) of the board. Later that year Process Materials Archivart Photographic Board became available in white. A comprehensive list of mount board manufacturers and distributors can be found at the end of Chapter 12.

## Summary of Recommendations

### Museum and Archive Collections

Given the lack of unbiased information on which mount boards and papers are most suitable for photographic applications, and on what pH levels are best, the authors believe the safest course for museum and archive collections to follow at present is to choose nonbuffered 100% cotton fiber boards and enclosure papers for all types of important photographs. Until the consequences have been thoroughly investigated, it is probably unwise to subject photographs to a potentially major alteration of normal emulsion and support pH levels, which may occur as a result of prolonged contact with alkaline-buffered materials. It is particularly important to use nonbuffered, neutral-pH boards with color photographs.

Although nonbuffered 100% cotton fiber mount boards are available from a number of distributors, the authors currently recommend only Atlantis 100% Cotton Museum Board TG Offwhite, Parsons Photographic Board (Brite White and, for some applications, Antique), and Rising Photomount Museum Board (White). At present, direct contact between colored boards and photographs should be avoided if possible, and black boards should not be used.

The authors also recommend Atlantis Silversafe Photostore (available directly from Atlantis in England) for interleaving sheets, storage envelopes, and mounting corners, depending on the selected weight and application. [Archivart product manager Robert Stiff said his company supplies a high quality interleaving tissue similar to Silversafe called Archivart Photo-Tex Tissue, which is also made with 100% cotton fibers and is nonbuffered; Stiff said that this paper has passed the ANSI Photographic Activity Test.]

Photographers, conservators, and other individuals may, of course, have specific preferences in paper and board surface characteristics, tone or color, and handling characteristics that will not be met by the recommended products. The user will have to make the final decision about what is best according to his or her specific requirements in each individual circumstance.

The recommendations given here are based on a studied examination of available information (which, unfortunately, includes scant test data that would permit more conclusive evaluations) and represents the authors' best

opinion about which products are most likely to be satisfactory in long-term preservation. As more information becomes available, and new papers and mount boards which meet the strict requirements of photographic conservation are marketed, the range of thicknesses, surface textures, and tones will certainly become broader.

### Black-and-White Photography

When black-and-white prints have been processed correctly (treatment with Kodak Rapid Selenium Toner or other protective toner is recommended) and image permanence is an important consideration, nonbuffered 100% cotton fiber boards and papers are recommended.

It is particularly important to choose good-quality mount board if prints are to be dry mounted or otherwise permanently attached, because it is highly unlikely that the print and board will ever be separated. If museum boards are deemed too expensive, good-quality "conservation" boards may be a suitable option. Because Atlantis, Parsons, Rising, and Strathmore are the only companies to market positively identifiable boards, the authors tentatively recommend their conservation boards despite the fact that they are alkaline-buffered.

Low-cost boards with gray chipboard cores (usually with white facing paper on one side) should be avoided at all times; these and other groundwood boards with a high lignin content are not suitable for even short-term contact with black-and-white photographs. The presence of groundwood can easily be detected with the Tri-Test Spot Testing Kit for Unstable Papers,[84] available from Light Impressions Corporation, the Professional Picture Framers Association, and other suppliers.

With most low-quality mount boards, alkaline buffering is probably an advantage, both for black-and-white and color prints. The authors currently believe that the potential for harm to photographs caused by the alkaline buffer is probably more than offset by the increased life and reduction in harmful emissions from low-quality boards afforded by alkaline buffering. When colored boards are required, the most light-stable boards available should be selected (see **Table 13.1**). At present, black boards should be avoided.

### Color Photography

For most Fujicolor, Ektacolor, Konica Color, and similar chromogenic color prints intended for display, such as those produced by portrait and wedding photographers, the choice of mount board is less important because the useful life of the prints will be limited by the instability of their dye images when exposed to light. The mount board should, of course, maintain adequate stiffness and freedom from warping. The "standard" mat boards supplied by Crescent Cardboard Company, Nielsen & Bainbridge, and others appear to be satisfactory. If colored mount boards are needed, however, those with poor light fading stability should be avoided (see **Table 13.1**).

When color prints are intended for long-term storage without extensive display, they should be mounted on high-stability nonbuffered boards or stored in high-quality envelopes made of nonbuffered paper or uncoated polyester (see Chapter 14).

## Truth-in-Labeling Recommendations

In the case of high-quality mount boards, artists' papers, and other papers for storing or displaying photographs, the authors recommend that every manufacturer and distributor identify the particular paper mill making the product and supply relevant information about the composition and method of manufacture, including any tests done to assure its suitability for photographic applications.

By manufacturing their respective photographic boards at only one mill, Atlantis Paper Company, Parsons Paper Company, and Rising Paper Company avoid a significant source of product variability that results when distributors periodically change paper mills. With "private label" mount boards and other paper products, consumers usually have no idea of where, or by whom, they were made. As one employee at Light Impressions Corporation commented with regard to the company's products, "We jump around among a lot of suppliers — it all depends on price and availability."

Privately labeled mount boards can have two origins. A distributor may purchase a "ready-made" board from a paper mill and then affix its own label. Thus, the board may be identical to that sold by other distributors — all under different names. When a distributor changes suppliers, it usually keeps the same private label name for a different board made by a different manufacturer.

Some distributors have board manufactured according to their own specifications, but may change mills from time to time in response to price and other considerations. Depending on how detailed the specifications are — and how strictly they are adhered to — this may not be much different in practice than simply putting a private label on a "ready-made" product. In all these cases, the customer has no way of knowing which mill made the board and will, in most instances, also be unaware of significant alterations in the specifications, such as a change in laminating adhesives. Perhaps more important is that test results cannot be applied to subsequent batches. For example, when a mount board is subjected to the *ANSI IT9.2* Photographic Activity Test, results may be meaningless if the "same" board is, at one time or another, also made at another mill. The practice of private labeling is discussed at greater length in Chapter 12.

Parsons Paper Company and Rising Paper Company are themselves manufacturers of the products that bear their names. Atlantis Paper Company Limited is a distributor, not a manufacturer; however, all of the Atlantis products intended for photographic conservation are made at the St. Cuthbert's Paper Mill, according to specifications formulated by Atlantis in collaboration with St. Cuthbert's — and the products are clearly marked as such.

The practice of private labeling for the purpose of obscuring the real manufacturer — in order to create the impression that the board or paper is available from only one source — is a disservice to customers and makes meaningful independent evaluation, with the ANSI Photographic Activity Test and other recognized test methods, impossible. The authors strongly disapprove of the marketing of mount boards and papers for which the actual manufacturer, brand name, and complete specifications are not openly stated.

## Information That Should Accompany Every Package of Paper and Mount Board:

1. Distributing or retailing company

2. Manufacturing company and mill location

3. Date of manufacture and manufacturer's lot number

4. Converting company

5. Fiber origin (e.g., cotton fibers, wood fibers)

6. The pH range (including maximum and minimum pH)

7. Percent (reserve) and type of alkaline buffering agent, if used

8. Level of reducible sulfur compounds

9. Tests conducted, if any, to determine photographic image reactivity with color and black-and-white photographs

10. Types and brands of internal and surface sizing agents

11. Type and brand name of laminating adhesives

12. Light fading stability

13. Types of dyes, pigments, and mordants, if used

14. Types of fluorescent brighteners, if any

15. Tests conducted to determine physical strength (e.g., the Mullen test to determine bursting strength, the Elmendorf test to determine tearing strength)

## Notes and References

1. See, for example: Debbie Hess Norris, "Platinum Photographs: Deterioration and Preservation," **PhotographiConservation,** Vol. 7, No. 2, June 1985, p. 1.
2. George T. Eaton, "Photographic Image Oxidation in Processed Black-and-White Films, Plates, and Papers," **PhotographiConservation,** Vol. 7, No. 1, March 1985, pp. 1, 4.
3. Eastman Kodak Company, **Conservation of Photographs** (George T. Eaton, editor), Kodak Publication No. F-40, Eastman Kodak Company, Rochester, New York, March 1985, p. 106.
4. American National Standards Institute, Inc., **ANSI PH1.53-1984, American National Standard For Photography (Processing) – Processed Films, Plates, and Papers – Filing Enclosures and Containers for Storage**, Sec. 5.1, p. 10, American National Standards Institute, Inc., 11 West 42nd Street, New York, New York 10036; telephone: 212-642-4900; Fax: 212-302-1286. This Standard is now obsolete and has been replaced by **ANSI IT9.2-1991** (see Note No. 8 below). The Photographic Activity Test described in **ANSI PH1.53-1984** is different from the primary test specified in **ANSI IT9.2-1991.**
5. James M. Reilly, Evaluation of Storage Enclosure Materials for Photographs Using the ANSI Photographic Activity Test, Final Narrative Report of Accomplishment for National Museum Act Grant #FC-309557 (Administered by the Smithsonian Institution, Washington, D.C.), March 1984. See also: James M. Reilly, Care and Identification of 19th-Century Photographic Prints, Kodak Publication No. G-2S, Eastman Kodak Company, 343 State Street, Rochester, New York 14650, 1986 (pH and other considerations of mount boards and other paper products used with albumen prints, cyanotypes, platinotypes, and other kinds of 19th-century photographs are discussed on pages 93–94).
6. James M. Reilly, Rochester Institute of Technology, telephone discussion with Henry Wilhelm, September 27, 1984.
7. In continuing support of James Reilly's research on improved test

methods for storage materials, Rochester Institute of Technology (RIT) received a grant in 1984 of $15,000 from the National Museum Act (NMA) grant program administered by the Smithsonian Institution. Also in 1984, RIT accepted a grant for $39,750 from the National Historical Publications and Records Commission (NHPRC) for this project. In 1985 RIT received a $72,547 grant from the National Endowment for the Humanities (NEH) for continuation of the research.

In January 1986 Reilly was appointed director of the newly established Image Permanence Institute at the Rochester Institute of Technology, a research laboratory initially funded and presently supervised primarily by Eastman Kodak, Polaroid Corporation, and other photographic manufacturers. The Image Permanence Institute, located at RIT in Rochester, New York, is jointly sponsored by The Society for Imaging Science and Technology (IS&T) and the Rochester Institute of Technology.

8. American National Standards Institute, Inc., **ANSI IT9.2-1991, American National Standard for Imaging Media – Photographic Processed Films, Plates, and Papers – Filing Enclosures and Storage Containers,** American National Standards Institute, Inc., 11 West 42nd Street, New York, New York 10036; telephone: 212-642-4900; Fax: 212-302-1286.

9. T. J. Collings and F. J. Young, "Improvements in Some Tests and Techniques in Photograph Conservation," **Studies in Conservation,** Vol. 21, No. 2, May 1976, pp. 79–84. See also: V. Daniels and S. Ward, "A Rapid Test for the Detection of Substances Which Will Tarnish Silver," **Studies in Conservation,** Vol. 27, 1982, pp. 58–60. Also: S. H. Ehrlich, "Chemiluminescence: A Method for the Determination of Trace Amounts of Hydrogen Peroxide in Photographic Plastics," **Photographic Science and Engineering,** Vol. 28, No. 6, November–December 1984, pp. 226–232.

10. TAPPI Official Test Method T406om-82, **Reducible Sulfur in Paper and Paperboard,** 1982, Technical Association of the Pulp and Paper Industry, P.O. Box 105113, Technology Park/Atlanta, Atlanta, Georgia 30348; telephone: 404-446-1400.

11. Klaus B. Hendriks and Douglas Madeley [National Archives of Canada], "A Comparison of the Collings-Young Test and ANSI PH1.54-1978 Photographic Activity Test," **PMG Newsletter** (newsletter of the Photographic Materials Group of the American Institute for Conservation), No. 3, May 1983, p. 4.

12. James M. Reilly, see Note No. 5, p. 4.

13. R. Scott Williams, "Commercial Storage and Filing Enclosures for Processed Photographic Materials," **Second International Symposium: The Stability and Preservation of Photographic Images,** Ottawa, Ontario, August 25–28, 1985, (Printing of Transcript Summaries), SPSE, The Society for Imaging Science and Technology, 7003 Kilworth Lane, Springfield, Virginia 22151; telephone: 703-642-9090. (Hendriks is quoted on page 29 of the article; his remark took place during a question and answer session following the presentation.)

14. American National Standards Institute, Inc., **ANSI IT9.9-1990, American National Standard for Imaging Media – Stability of Color Photographic Images – Methods for Measuring,** American National Standards Institute, Inc., 11 West 42nd Street, New York, New York 10036; telephone: 212-642-4900; Fax: 212-302-1286. See also: Charleton C. Bard, George W. Larson, Howell Hammond, and Clarence Packard, "Predicting Long-Term Dark Storage Dye Stability Characteristics of Color Photographic Products from Short-Term Tests," **Journal of Applied Photographic Engineering,** Vol. 6, No. 2, April 1980, pp. 42–45.

15. Glen G. Gray, "Determination and Significance of Activation Energy in Permanence Tests," in **Preservation of Paper and Textiles of Historic and Artistic Value,** John C. Williams, ed., Advances in Chemistry Series 164, American Chemical Society, Washington, D.C., 1977, pp. 286–313. Includes a discussion of an Arrhenius test method for paper products and its advantages over previous methods. For application of the Arrhenius test method to black-and-white photographic materials see: D. F. Kopperl, G. W. Larson, B. A. Hutchins, and C. C. Bard, "A Method to Predict the Effect of Residual Thiosulfate Content on the Long-Term Image-Stability Characteristics of Radiographic Films," **Journal of Applied Photographic Engineering,** Vol. 8, No. 2, April 1982, pp. 83–89. For application of the Arrhenius test method to plastic film base, see P. Z. Adelstein and J. L. McCrea, "Stability of Processed Polyester Base Photographic Films," **Journal of Applied Photographic Engineering,** Vol. 7, No. 6, December 1981, pp. 160–167.

16. Edith Weyde, "A Simple Test to Identify Gases Which Destroy Silver Images," **Photographic Science and Engineering,** Vol. 16, No. 4, July–August 1972, pp. 283–286.

17. James M. Reilly and Douglas W. Nishimura, "Improvements in Test Methods for Photographic Storage Enclosures," presented at the

**SPSE 40th Annual Conference and Symposium on Hybrid Imaging Systems,** sponsored by SPSE, The Society for Imaging Science and Technology, Rochester, New York, May 19, 1987 (see **Advance Printing of Conference Summaries,** pp. 150–154).

18. Peter Z. Adelstein, "Update on National and International Permanence Standards," presentation at the **Third International Symposium on Image Conservation,** Rochester, New York, June 18, 1990. The Symposium, which was held at the International Museum of Photography at George Eastman House, was sponsored by The Society for Imaging Science and Technology in cooperation with Manchester Polytechnic (Manchester, U.K.).

19. James M. Reilly and Douglas W. Nishimura, see Note No. 17, p. 150.

20. The enclosure paper and mount board test kit is available from the Image Permanence Institute, Rochester Institute of Technology, Frank E. Gannett Memorial Building, P.O. Box 9887, Rochester, New York 14623-0887; telephone: 716-475-5199; Fax: 716-475-7230.

21. American National Standards Institute, Inc., see Note No. 8.

22. R. Scott Williams, see Note No. 13, p. 21.

23. W. Nishimura, J. Reilly, and P. Adelstein, "Improvements to the Photographic Activity Test in ANSI Standard IT9.2," **Journal of Imaging Technology,** Vol. 17, No. 6, December 1991, pp. 245–252. For the original version of this article, see: James M. Reilly, Douglas W. Nishimura, Luis Pavao, and Peter Z. Adelstein, "Photo Enclosures Research and Specifications," **Topics in Photographic Preservation – Volume Three** (compiled by Robin E. Siegel), Photographic Materials Group of the American Institute for Conservation, 1989, pp. 1–7. Available from the American Institute for Conservation, Suite 340, 1400 16th Street, N.W., Washington, D.C. 20036; telephone: 202-232-6636; Fax: 202-232-6630.

24. American National Standards Institute, Inc., **ANSI IT9.11-1991, American National Standard for Imaging Media – Processed Safety Photographic Film – Storage,** American National Standards Institute, Inc., 11 West 42nd Street, New York, New York 10036; telephone: 212-264-4900; Fax: 212-302-1286

25. American National Standards Institute, Inc., **ANSI IT9.2-1991,** Sec. 3.2, (see Note No. 8). Referenced ASTM test methods can be obtained from the American Society for Testing and Materials, 1916 Race Street, Philadelphia, Pennsylvania 19103; telephone: 215-299-5400. TAPPI publications can be obtained from the Technical Association of the Pulp and Paper Industry, P.O. Box 105113, Technology Park/Atlanta, Atlanta, Georgia 30348; telephone: 404-446-1400.

26. Klaus B. Hendriks, "Tests of Paper Filing Enclosures According to the New ANSI Standard," presented at **Preservation and Restoration of Photographic Images,** a symposium at the Rochester Institute of Technology, Rochester, New York, March 5, 1979.

27. James M. Reilly, see Note No. 6.

28. Eugene Ostroff, "Preservation of Photographs," **The Photographic Journal,** Vol. 107, No. 10, October 1967, p. 311. See also: Eugene Ostroff, **Conserving and Restoring Photographic Collections,** American Association of Museums, 1976, pp. 14–15.

29. Eastman Kodak Company, see Note No. 3, p. 95.

30. There is a third type of high-quality board, which can be described as a decorative composite board. This board is made of de-acidified wood pulp and is faced with colored papers that have textured or smooth finishes on either side of a bright white core. It is intended for making overmats and, when its finish is highly textured, it is unsuitable for mounting or as a backing. This board is usually 50 to 60 points thick (about the thickness of 4-ply board). Bainbridge Alphamat and Miller Ultimat are examples. The authors advise against the use of these boards in direct contact with valuable photographs.

31. For example, the Fall 1992 Light Impressions Corporation **Archival Supplies** catalog listed the following prices per sheet of 32x40-inch 4-ply mount board when purchased in 10-sheet packages:
    **100% Cotton Fiber Boards:**
        Westminster 100% Rag Board (White, Natural, Ivory): $7.80
        Non-Buffered 100% Rag Board (White, Cream): $7.80
    **Purified Wood Pulp Boards:**
        Exeter Conservation Board (White): $6.15

32. Roy P. Whitney, "Chemistry of Paper," **Paper – Art & Technology,** The World Print Council, San Francisco, California, 1979, pp. 36–44.

33. "Cellulose. The chief constituent of the cell walls of all plants and of many fibrous products, including paper and cloth. Cellulose is by far the most abundant organic substance found in nature . . . . The portion of cellulosic material that does not dissolve in a 17.5% solution of sodium hydroxide [at 20°C, under specified conditions] is termed Alpha Cellulose" (p. 49). "Because the permanence of paper depends to some extent on the absence of non-cellulosic materials, the determination of true cellulose (alpha cellulose) gives an indication of the stability of the paper, and therefore its permanence"

(p. 8). From: Matt Roberts and Don Etherington, **Bookbinding and the Conservation of Books,** Library of Congress, Washington, D.C., 1982.

34. Eugene Ostroff, see Note No. 28, p. 311.
35. John C. Williams, "A Review of Paper Quality and Paper Chemistry," in **Conservation of Library Materials,** Gerald Lundeen, ed., **Library Trends,** Vol. 30, No. 2, Fall 1981, p. 207.
36. George T. Eaton, "Photographic Paper Base," **PhotographiConservation,** Vol. 4, No. 1, March 1982, p. 1.
37. Eastman Kodak Company, **Preservation of Photographs,** Kodak Publication No. F-30, Eastman Kodak Company, Rochester, New York, August 1979, p. 4. See also: **Conservation of Photographs** [George T. Eaton, editor], Kodak Publication No. F-40, March 1985, pp. 37–39.
38. George T. Eaton, see Note No. 36, pp. 1 and 6.
39. George T. Eaton, see Note No. 36.
40. A. I. Woodward [Wiggins Teape Ltd.], "The Evolution of Photographic Base Papers," **Journal of Applied Photographic Engineering,** Vol. 7, No. 4, August 1981, pp. 117–120. See also: Klaus B. Kasper and Rudolf Wanka [Schoeller Technical Papers, Inc.], "Chemical Formulations and Requirements of Photographic Paper," **Journal of Applied Photographic Engineering,** Vol. 7, No. 3, June 1981, pp. 67–72.
41. Glen G. Gray, see Note No. 15, p. 312.
42. William J. Barrow, **Manuscripts and Documents: Their Deterioration and Restoration,** second ed., University of Virginia Press, Charlottesville, Virginia, 1972.
43. American National Standards Institute, Inc., **ANSI Z39.48-1984, American National Standard for Information Sciences – Permanence of Paper for Printed Library Materials,** American National Standards Institute, Inc., 11 West 42nd St., New York, New York 10036; telephone: 212-642-4900; Fax: 212-302-1286. "To ensure maximum consistency of test results, it is recommended that suppliers subscribe to some form of comparative test program, such as the CIS-TAPPI Collaborative Reference Service, Collaborative Testing Services, Inc., 8343 A Greensboro Drive, McLean, Virginia 22102" (p. 7).
44. Howard Paper Mills, Inc., 354 South Edwin C. Moses Blvd., P.O. Box 982, Dayton, Ohio 45401; telephone: 513-224-1211. The company makes Permalife papers and has also made the Renaissance nonbuffered paper intended for photographic storage applications and sold by Light Impressions Corporation.
45. Walter Clark, "Techniques for Conserving Those Old Photographs," **The New York Times,** June 13, 1976, Sec. D, p. 40.
46. Klaus B. Hendriks, introductory remarks for the session on "Stability and Preservation of Photographic Records" at the 31st Annual Conference of the Society of Photographic Scientists and Engineers (SPSE) in Washington, D.C., May 1, 1978.
47. Henry Wilhelm, "Preservation of Your Black and White Photographs," presented at **Preserving Your Historical Records: A Symposium,** the Olmsted Center of Drake University, Des Moines, Iowa, October 20–21, 1978.
48. Polaroid Corporation, **Storing, Handling and Preserving Polaroid Photographs: A Guide,** Polaroid Corporation, Cambridge, Massachusetts, 1983, p. 28.
49. Eastman Kodak Company, see Note No. 37, p. 35.
50. Eastman Kodak Company, **Storage and Care of Kodak Color Materials,** Pamphlet No. E-30, Eastman Kodak Company, Rochester, New York, May 1982, p. 7.
51. Henry J. Kaska, director of public information, Eastman Kodak Company, letter to Henry Wilhelm, November 17, 1982.
52. Eastman Kodak Company, see Note No. 3.
53. Anonymous, "What Are the Speakers From the RIT Seminars Doing Currently," **PhotographiConservation,** Vol. 4, No. 2, June 1982, p. 7. (Published by the Technical and Education Center of the Graphic Arts, Rochester Institute of Technology, Rochester, New York.)
54. Eastman Kodak Company, see Note No. 3.
55. Sergio Burgi, "Fading of Dyes Used for Tinting Unsensitized Albumen Paper," presented at **The Stability and Preservation of Photographic Images,** SPSE International Symposium, the Public Archives of Canada (renamed the National Archives of Canada in 1987), Ottawa, Ontario, August 30, 1982.
56. Stanton Clay, "Stability of Cibachrome Materials," presented at a conference on **The Permanence of Color – Technology's Challenge, The Photographer's and Collector's Dilemma** at the International Center of Photography, New York, New York, May 6, 1978; Henry Wilhelm, chairman.
57. Peter Z. Adelstein, Eastman Kodak Company, telephone discussion with Henry Wilhelm, September 3, 1983.
58. George T. Eaton, see Note No. 36, p. 6.
59. The pH levels of the prints were measured by Henry Wilhelm using an Ingold Electrodes, Inc. Flat Membrane Electrode with Four Liquid

Junction Legs for Measurements of Paper, Catalog No. 6147-01, with a Digi-pH-ase pH Meter made by Cole-Parmer Instrument Company.
60. Thomas Woodlief, Jr., ed., **SPSE Handbook of Photographic Science and Engineering,** John Wiley and Sons, New York, New York, 1973, p. 514.
61. Grant Haist, **Modern Photographic Processing,** Vol. 1, John Wiley and Sons, New York, New York, 1979, p. 54.
62. James M. Reilly, Douglas G. Severson, and Constance McCabe, "Image Deterioration in Albumen Photographic Prints," paper presented at a conference of the International Institute for Conservation, Washington, D.C., May 1982; William B. Becker, "New Life for Old Photographs," **Camera Arts,** Vol. 2, No. 2, March–April 1982, pp. 96–98, 102; Debbie Hess Norris, "The Proper Storage and Display of a Photographic Collection," **Picturescope,** Vol. 31, No. 1, Spring 1983, pp. 4–10.
63. James M. Reilly, see Note No. 6.
64. M. Kahn and G. Ayers, "Elimination of Wash Water in Minilab Operations," paper presented at the Society of Photographic Scientists and Engineers (SPSE) **Tutorial Symposium on One Hour Lab Operations and Technologies,** Las Vegas, Nevada, March 26–27, 1985.
65. According to Carol Brower's 1982 survey "The Care and Presentation of Photographic Prints" (see Chapter 12), 35 of 65 queried individuals said that they used nonbuffered, neutral pH boards; however, 19 of the 35 respondents did not answer the question, "If you use nonbuffered, neutral pH boards, who are the manufacturers?" Eight people (out of 65) said they did not use nonbuffered boards. The following numbers of individuals named the corresponding paper companies as suppliers of the "nonbuffered" board they purchase (some people named more than one):
    8 – Process Materials Corporation
      (now the Archivart Division of Heller & Usdan, Inc.)
    7 – Rising Paper Company
    2 – C. T. Bainbridge's Sons, Inc.
      (now Nielsen & Bainbridge)
    2 – Light Impressions Corporation
    1 – Andrews/Nelson/Whitehead
    1 – Crestwood Paper Company
    1 – University Products, Inc.
    Given that only 18 respondents gave the names of "manufacturers" and that only Process Materials and Light Impressions were selling nonbuffered boards in August 1982, the above responses suggest that most people were still unaware at that time of the difference between nonbuffered, neutral pH boards and alkaline-buffered, neutral pH boards.
66. Professional Picture Framers Association, **Survey on Mat/Mount Boards,** March 1986. Professional Picture Framers Association, 4305 Sarellen Road, P.O. Box 7655, Richmond, Virginia 23231; telephone: 804-226-0430.
67. American National Standards Institute, Inc., see Note No. 14. The **ANSI IT9.9-1990** Standard includes a 6.0 klux Cool White fluorescent accelerated light fading test suitable for use with mount boards.
68. Process Materials Corporation was the first company to develop and market a line of "New Products for Photographic Conservation," the title of an ad that first appeared in the **American Institute for Conservation Newsletter,** August 1983. It represented a major step forward in the marketing of such products. (In 1990, Process Materials Corporation, which by then had changed its name to Archivart, was acquired from its then owner, Lindenmeyr Paper Company, headquartered in New York City, by Heller & Usdan, Inc., 7 Caesar Place, Moonachie, New Jersey 07074; telephone: 201-933-8100; toll-free: 800-333-4466.)
69. Joseph B. Fiedor, telephone conversation with Carol Brower, May 18, 1983.
70. Robert Stiff, telephone conversation with Carol Brower, November 25, 1985.
71. Atlantis Paper Company Limited, No. 2 St. Andrews Way, London E3 3PA, England; telephone: 071-537-2727 (to direct-dial from the U.S.: 011-44-071-537-2727); Fax: 071-537-4277 (to direct-dial from the U.S.: 011-44-071-537-4277).
72. Stuart M. Welch, Atlantis Paper Company Limited, letter to the authors, March 21, 1985.
73. Archivart Division of Heller & Usdan, Inc., 7 Caesar Place, Moonachie, New Jersey 07074; telephone: 201-933-8100 (toll-free: 800-333-4466). Paper Technologies, Inc., 25801 Obrero, Suite 4, Mission Viejo, California 92691; telephone: 714-768-7497 and 714-768-7498.
74. Stuart M. Welch, letter to the authors, June 20, 1985.
75. Stuart M. Welch, see Note No. 72.
76. Stuart M. Welch, letter to the authors, September 27, 1985.
77. Atlantis Paper Company Limited, **Fine Archival Papers From St.**

**Cuthbert's England** (1985 product sample book and catalog), and 1991 catalog.

78. Process Materials Corporation, "Paper & Preservation No. 4," Process Materials Corporation, Rutherford, New Jersey, February 1983.

79. Process Materials Corporation, "Technical Bulletin No. CP-186-MB," November 1981 (revised February 1983).

80. Introduced in 1974 by Process Materials Corporation, Archivart Photomount Board, a solid, dark ash-gray board, was described as "an acid-free board, of exceptionally rigid construction, made from selected chemical pulp, buffered against acid deterioration. Developed for the mounting and storage of photographs, this board is also used in picture framing and as a binder's board" (Process Materials Corporation, "Conservation Products," second edition, 1982, p. 5). Because of the presence of the alkaline buffering agents and because of possible confusion with the company's nonbuffered Archivart Photographic Board, Arno Roessler, then president of the company, said in August 1983 that this product was renamed Conservation Board, and is now available in other tones.

81. This statement appears on mount board sample cards distributed by Rising Paper Company.

82. The product description for Renaissance Paper in the Light Impressions 1991 Archival Supplies catalog (p. 60) stated that the paper had passed the **ANSI IT9.2** Sec. 5.1 Photographic Activity Test.

83. Conservation Resources International, Inc., 8000-H Forbes Place, Springfield, Virginia 22151; telephone: 703-321-7730; toll-free: 800-634-6932. Summer–Fall 1991 General Catalog, p. 30.

84. Distributed by the Professional Picture Framers Association in Richmond, Virginia, Tri-Test – A Spot Testing Kit for Unstable Papers contains three solutions for detecting the presence of groundwood and alum, and for distinguishing between acid, neutral, or alkaline paper or board products. These are qualitative tests which are easy to perform and will readily identify poor-quality paper products. The user should be cautioned, however, that a paper product which appears to be satisfactory on the basis of these tests may in fact be quite harmful to photographs because of the presence of sulfur compounds which upon aging produce active oxidants, and of other substances to which the tests do not respond. Originally called the Barrow Spot Test Kit, the tests were devised by William J. Barrow (1904–1967) of the now defunct W. J. Barrow Research Laboratory in Richmond, Virginia (see: W. J. Barrow Research Laboratory, **Permanence/Durability of the Book: VI. Spot Testing for Unstable Modern Book and Record Papers,** Richmond, Virginia, 1969).

The Tri-Test spot testing kit is available from the Professional Picture Framers Association, 4305 Sarellen Road, Richmond, Virginia 23231; telephone: 804-226-0430; toll-free: 800-832-7732. The kit can also be purchased from Light Impressions Corporation, 439 Monroe Avenue, Rochester, New York 14607-3717; telephone: 716-271-8960; (toll-free outside New York: 800-828-6216; toll-free inside New York: 800-828-9629); and Westfall Framing, Inc., P.O. Box 13534, Tallahassee, Florida 32317; telephone: 904-878-3546 (toll-free outside Florida: 800-874-3164).

## Additional References

Helen D. Burgess and Carolyn G. Leckie, "Evaluation of Paper Products: With Special Reference to Use with Photographic Materials," **Topics in Photographic Preservation – Volume Four** (compiled by Robin E. Siegel), Photographic Materials Group of the American Institute for Conservation, 1991, pp. 96–105. Available from the American Institute for Conservation, Suite 340, 1400 16th Street, N.W., Washington, D.C. 20036; telephone: 202-232-6636; Fax: 202-232-6630.

Klaus B. Hendriks, together with Brian Thurgood, Joe Iraci, Brian Lesser, and Greg Hill of the National Archives of Canada staff, **Fundamentals of Photographic Conservation: A Study Guide**, published by Lugus Publications in cooperation with the National Archives of Canada and the Canada Communication Group, 1991. Available from Lugus Productions Ltd., 48 Falcon Street, Toronto, Ontario, Canada M4S 2P5; telephone: 416-322-5113; Fax: 416-484-9512.

Nancy Reinhold, "An Investigation of Commercially Available Dry Mount Tissues," **Topics in Photographic Preservation – Volume Four** (compiled by Robin E. Siegel), Photographic Materials Group of the American Institute for Conservation, 1991, pp. 14–30.

Kimberly Scheneck and Constance McCabe, "Preliminary Testing of Adhesives Used in Photographic Conservation," **Topics in Photographic Preservation – Volume Three** (compiled by Robin E. Siegel), Photographic Materials Group of the American Institute for Conservation, 1989, pp. 52–61.

## Appendix 13.1 – Letter to Paper Companies

In June 1982, Carol Brower sent letters to 23 paper companies and distributors asking the following questions:

1. Which paper mills make your mount boards?

2. What is the pH of your museum mount boards?

3. Are your museum mount boards buffered? If so, with what?

4. Do they have an alkaline reserve? If so, how much?

5. What is the raw material content of your mount boards (cotton fiber, wood cellulose, etc.)?

6. Do your sources of cotton fiber vary?

7. Can you supply information about your laminating adhesives and sizings?

8. Have accelerated aging tests been conducted with your mount boards? If so, could you describe the tests and your findings?

9. Do you manufacture or distribute other high-quality boards and papers that are suitable for use in museums, archives, institutions, and galleries?

10. Do you know how or to what extent your materials are used in the photographic fields?

11. Have tests been conducted with your mount boards in contact with common photographic materials including albumen, silver-gelatin, Ektacolor, Cibachrome [currently called Ilfochrome], Dye Transfer, Polacolor, etc. that would indicate what effects the boards might have in long-term storage?

12. Do you have any test data on the dye stability of your colored or tinted boards when they are subjected to prolonged light exposure?

13. Do you have papers which you recommend for interleaving purposes?

**The following 12 companies responded in writing, although not all of the requested information was provided:**

Andrews/Nelson/Whitehead; Conservation Resources International, Inc.; Crescent Cardboard Company; Crestwood Paper Company; Howard Paper Mills, Inc.; James River Corporation; Light Impressions Corporation; Process Materials Corporation (now the Archivart Division of Heller & Usdan, Inc.); Rising Paper Company; Talas, Inc.; Strathmore Paper Company; and University Products, Inc. In 1985 Atlantis Paper Company Limited of London, England responded in detail to questions from the authors (Atlantis was not sent a copy of the original 1982 letter).

**Letters of apology or referral to other companies were sent by the following 5 companies:**

Buntin Gillies and Company, Ltd.; Conservation Materials, Ltd.; Domtar Fine Papers; Hollinger Corporation; and Rupaco Paper Corporation. (For example, the Hollinger Corporation no longer distributes mount boards, and Eric Schiffman of Rupaco Paper Corporation referred the author to Rising Paper Company for information regarding the Rising Museum and Conservamat boards that Rupaco distributes; Buntin Gillies and Company, Ltd. no longer manufactures mount board.)

Charles T. Bainbridge's Sons, Inc. (currently Nielsen & Bainbridge) and Miller Cardboard Corporation sent promotional literature containing some information about pH and fiber content. Parsons Paper – Division of NVF Company sent a sample package of their Photomounting Board. None of the companies responded with letters.

**The following 3 companies did not respond:**

Beckett Paper Company; Hurlock Bros. Company, Inc.; and Monadnock Paper Mills, Inc. Follow-up telephone calls were made and copies of the letters were sent to the companies, to no avail.

# 14. Envelopes and Sleeves for Films and Prints

## Recommendations

### Enclosure Materials:

- **Recommended:** Uncoated transparent polyester (e.g., DuPont Mylar D and ICI Melinex 516). Also suitable are uncoated polypropylene (e.g., Hercules T500 film) and certain nonbuffered 100% cotton fiber papers (e.g., Atlantis Silversafe Photostore). Probably satisfactory is high-density polyethylene (recommended as the best available low-cost material for amateur photofinishing applications).

- **Should be avoided:** Low-density polyethylene (e.g., Print File, Vue-All, and Clear File notebook pages and sleeves); cellulose acetate (e.g., Kodak Transparent Sleeves); polyvinyl chloride [PVC] (e.g., 20th Century Plastics vinyl notebook pages); surface-treated polypropylene (believed acceptable for slide pages, however); conventional glassine; acid-free glassine; kraft paper and most other common types of paper; matte polyester (e.g., DuPont Mylar EB-11); and synthetic paper-like materials (e.g., DuPont Tyvek).

### Enclosure Design:

- **Recommended:** Top-flap sleeves (preferably made of uncoated transparent polyester; as a second choice, uncoated polypropylene is probably acceptable). These sleeves allow films and prints to be inserted and removed without sliding against the enclosure surfaces, thus avoiding scratches (available from Talas Inc. and Light Impressions).

- **Acceptable:** High-density polyethylene sleeves of the types often used in amateur photofinishing (commonly referred to as "sleeving material"). Although they require that negatives slide against the plastic surfaces during insertion and removal, high-density polyethylene sleeves appear to have minimal tendency to cause scratches and have otherwise proven to be generally satisfactory for applications that require low-cost enclosures.

- **For additional protection:** All sleeved films and prints, either singly or in groups, should be stored in high-quality, top-flap paper envelopes for protection from dust and physical damage, and to allow marking with rubber stamps, pens, etc.

Envelopes, sleeves, and other enclosures for long-term storage of photographs must meet three fundamental requirements:

1. The design of an enclosure — and the surface characteristics of the materials used to make it — must not cause scratches and abrasion to films and prints during storage and use. This requirement is not met by most currently available photographic enclosures because it is necessary to slide films and prints against the enclosure material during insertion and removal.

2. Materials and adhesives used to make the enclosures must not be hygroscopic (attracting moisture from the surrounding air), nor contain any chemicals that could cause, or contribute to, fading or staining of black-and-white or color photographs during the intended storage period. In museum collections, most photographs will be kept for hundreds or thousands of years. Unstable materials, including poor-quality paper, glassine, and polyvinyl chloride (PVC), may over the years produce harmful decomposition products, stick to emulsions, exude gooey plasticizers, or cause other types of damage to photographs.

3. To provide adequate physical protection during the life of a photograph, the materials used to make an enclosure must retain sufficient physical strength and tear resistance for as many years as the photograph inside is to be kept. Because a photograph is likely to be retained even after the image has significantly deteriorated, the enclosure material should have aging characteristics which are at least as good as the photograph's paper or plastic support material.

The requirements for enclosure materials suggest that the relatively few plastics and high-quality nonbuffered papers suitable for making print and film bases logically could also be used to make filing enclosures. If the material is nonreactive and stable enough to be used as a photographic support material, it should be equally satisfactory as an enclosure material.

When storing comparatively unstable films, such as color negatives made with Kodak Kodacolor II and Vericolor II, pre-1989 Agfacolor XRS and XRG, and pre-1992 3M ScotchColor films (which are significantly less stable in dark storage than current Kodak Vericolor III and 400, Ektar, and Kodak Gold Plus; Fujicolor Super HG, Super G, Reala, and Fujicolor Professional 400 and 160; and Konica Super SR, GX, Super DD, and XG films), the permanence

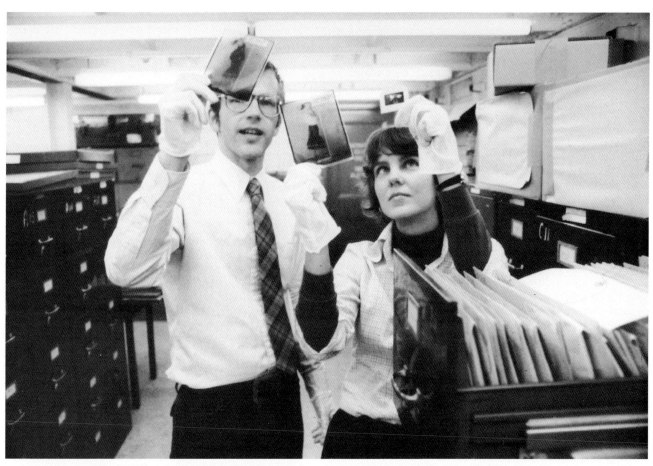

1979

Thomas Beecher, a staff member at the Library of Congress in Washington, D.C., and Beverly W. Brannan, curator of documentary photography in the Prints and Photographs Division of the library, examine color transparencies in the **Look Magazine** collection. The **Look** collection was donated to the library after the magazine ceased publication in 1971. The transparencies and negatives are still in their original, less-than-ideal sleeves and envelopes, although the films likely will be put in new, higher-quality enclosures at some point in the future. Films and prints in most institutional and private collections, however, are destined to remain in their original enclosures for as long as they are kept. To avoid cumulative damage to photographs caused by unsuitable filing materials, it is essential to use safe and long-lasting enclosures right at the outset. (Since this photograph was taken in 1979, the color transparencies in the **Look** collection have been moved to the library's cold storage facility in nearby Landover, Maryland.)

requirements for the enclosure material are in general less stringent than they are for the longer-lasting color films — and, of course, for black-and-white negatives.

Likewise, enclosures for older, less stable color prints such as those made with Ektacolor 37 RC and 74 RC paper, need not be of the same high quality as is required for storage of the much longer lasting Konica Color, Ektacolor, Agfacolor, and Fujicolor papers introduced during 1984–1985, or for storage of the most stable types of prints, including Ilford Ilfochrome (called Cibachrome, 1963–1991), Kodak Dye Transfer, and Fuji Dyecolor color prints, and black-and-white prints, which, when kept in the dark, have the potential to remain in good condition for many hundreds and perhaps even thousands of years. UltraStable Permanent Color prints and Polaroid Permanent-Color pigment prints, which are extremely stable both on display and in dark storage, of course also require very long-lasting storage enclosures.

But regardless of how good or poor the inherent image stability of a particular film or print may be, the enclosure material should not in any way contribute to, or speed up, the deterioration of the image or of the base material. As a practical matter, most photographers and collecting institutions will want to use the same type of enclosure for everything in their collections — and this means that only the very best, most stable enclosures will suffice.

## Avoiding Scratches and Other Damage Caused by Enclosures

A fundamental requirement in the design of any photographic enclosure is that a film or print can be inserted or removed without sliding it against the surfaces of the enclosure material. Sliding a negative in and out of an enclosure will, over time, almost certainly result in scratches; the longer a negative or color transparency is kept — or the more valuable it is — the more likely it is that it will be repeatedly accessed and printed. The more it is handled, the more likely it is to be scratched or otherwise physically damaged.

As any photographer knows who has laboriously attempted to retouch an enlargement printed from a scratched 35mm negative, every possible precaution should be taken to avoid even minor surface scratches on negatives. Scratches on transparencies are especially troublesome because they will show up on prints as black lines which must be chemically bleached before they can be retouched with spotting dyes — a time-consuming and difficult task. Although the enclosure material itself may be soft enough not to scratch delicate gelatin emulsions, particles of dust and grit inevitably become sandwiched between the enclosure and film surfaces. As film is dragged across even a tiny particle of grit, the emulsion or base can be scratched. Stiff plastic enclosure materials are particularly prone to cause grit-related scratches. In this author's experience, PVC enclosures are the most likely to cause scratches on films as they are slid in and out; among plastic materials, high-density polyethylene appears to have the least tendency to cause scratches during use.

Charges of static electricity which can develop as a film or print is inserted and removed from a plastic enclosure — especially in low-humidity conditions — cause an attraction between the film and enclosure, increasing the likelihood of scratches.

An enclosure should be designed so that it can be opened like a book, allowing a film or print to be lifted out without touching the enclosure material. This non-sliding requirement alone eliminates from consideration most of the envelopes, sleeves, and notebook filing pages currently on the market.

Enclosures for negatives, unmounted transparencies, and prints are discussed in this chapter. Although information on PVC, polypropylene, and other plastics used to make 35mm slide pages is included in this chapter, discussion of the practical aspects of these products is found in Chapter 18, *Handling and Preservation of Color Slide Collections*.

### Types of Enclosures

Photographic enclosures have been made with many different paper and plastic materials, and supplied in a vast number of configurations. They can be divided into twelve groups:

1. **High-density polyethylene sleeve for automatic negative sleevers.** Many professional labs, photofinishers, and mini-labs return 35mm negatives in plastic sleeves which are made with edge-sealed negative compartments side-by-side in a row, with one end of each compartment open. Nearly all sleeves of this design are made of translucent, high-density polyethylene, and most are manufactured in Japan. Often imprinted with the name of the photofinisher, the sleeves are now the most common kind of negative enclosure — in the U.S. alone, many millions are used every week. Negatives are cut — most commonly to 4-frame lengths — and inserted into the sleeves with manually operated or high-speed automatic machines. With negatives inside, the sleeves are folded accordion-fashion and placed in customers' print envelopes. Negative strips can also be cut with scissors and manually inserted into the

sleeves. When made of high-density polyethylene (low-density polyethylene is *not* recommended), the sleeves appear to be reasonably satisfactory if kept in a photofinisher's envelope, standard paper letter envelope, or other enclosure to prevent contamination with dust and dirt. The naturally "slippery" and non-clinging surface of high-density polyethylene is much less likely to cause scratches on films than most other types of enclosure plastics. High-density polyethylene sleeves are obviously superior to the open-end yellow paper folders in which negatives are returned to customers by Kodalux photofinishing labs; with an entire roll of negatives cut to random lengths stuffed into each folder, the Kodak folders offer little protection to individual negatives.

2. **Plastic sleeve with uncemented top flap.** Usually made of transparent uncoated polyester, polypropylene, or cellulose triacetate, this sleeve can be opened like a book to allow the film or print to be lifted out, avoiding the possibility of scratches. Both ends are open and adhesives are not used. Used in combination with high-quality top-flap paper envelopes (No. 8 below), this is the recommended design for most applications. Stable and chemically inert uncoated polyester is the best material with which to make these sleeves; "matte" surface polyester such as DuPont Mylar EB-11, which is impregnated with abrasive silicon dioxide, should be avoided. It is *absolutely essential* that the sleeve have very tight and crisp folds to minimize the chances of a film accidentally sliding out of either end of the closed sleeve during handling. Top-flap polyester sleeves used in combination with high-quality top-flap paper envelopes provide the best protection of any currently available filing system. (See **Figure 14.1**.)

3. **Plastic sleeve heat-sealed around uncut roll films.** Similar in appearance to plastic negative tubes, these sleeves consist of two transparent plastic strips (most commonly made of heat-sealable polypropylene) that are sealed on both edges around uncut roll films with special heat-sealing equipment; for protection from dust and scratches during handling in the lab, films are usually sleeved immediately after processing. The cut ends of the sleeves are not sealed and remain open. The sleeves are most commonly used with 120 and 220 roll films but are also applied to 35mm films when customers request that a lab return rolls uncut. The roll-length sleeves with film inside are generally cut with scissors into lengths of the desired number of frames. For protection from dust, cut lengths of sleeved film should be stored in paper envelopes. Once films are removed from the sleeves, this author recommends that the sleeves be discarded and films placed in top-flap polyester or uncoated polypropylene sleeves, also kept inside of paper envelopes. In recent years, hot-seal sleeves have become popular in professional processing labs, especially for housing transparency roll films. Automatic heat-sealing equipment and plastic sleeving material are supplied by Climax, Ltd. and other firms (see **Suppliers** at the end of this chapter). At the time this book went to press, no information was available

on the long-term effects of these sleeves on stored color or black-and-white films, but they are believed to be reasonably safe.

4. **Sleeve with cemented top and bottom seams.** Generally made of transparent cellulose triacetate, polypropylene, polyvinyl chloride (PVC), or polyester, this type of sleeve has traditionally been used for roll and sheet color films. Sometimes referred to as "sheaths," Kodak Transparent Sleeves, made of cellulose triacetate, are of this design. Because the film or print must slide against the surfaces of the enclosure each time it is inserted or removed, there is a significant danger of scratching. The design is not recommended for either long- or short-term applications. Some sleeves with cemented top and bottom seams have one side made of a "matte" translucent plastic to serve as a diffuser when viewing the enclosed transparency or negative. The translucent portion of such sleeves is usually made of low-plasticizer-content PVC, with the transparent front made of either PVC or cellulose acetate. This type of translucent-back sleeve has most frequently been used with sheet transparency films, especially those in the 4x5-inch and 8x10-inch format.

5. **Notebook page.** Once made of glassine, these are now usually made of low-density polyethylene, plasticized polyvinyl chloride (PVC), polypropylene, and, occasionally, cellulose acetate or high-density polyethylene. Intended to be stored in a three-ring binder, the pages are made in a wide variety of configurations, nearly all of which require that a film or print be slid in and out of a pocket or open-ended compartment. Some filing pages are intended to be stored flat, in boxes, and are not punched with ring-binder holes; others fold up into attached paper wallets (some wallet enclosures are made of translucent high-density polyethylene). As a matter of convenience, many photographers expose contact sheets with negatives in the pages even though this results in contact images of reduced resolution. With the exception of polypropylene pages designed for mounted 35mm slides, none of the currently available notebook page enclosures are recommended. Plasticized PVC pages in particular should be avoided.

6. **Negative tube.** Usually made of low-density polyethylene, these are supplied as flattened tubes in long rolls. Intended for 35mm and 120/220 roll films, they are cut to length by the user, leaving both ends open. Because the plastic tubes require that films slide against the surfaces of the tube during insertion and removal, they are not recommended; low-density polyethylene negative tubes in particular should be avoided.

7. **Print and negative "wallet."** Most amateur prints are returned to customers in wallets made of paper, plasticized polyvinyl chloride (PVC), or, less commonly, high- or low-density polyethylene. Wallets are supplied in many configurations but basically consist of a folded envelope with a wide, unsecured top flap that frequently extends to the full depth of the enclosure. Some wallets have a print and negative storage compartment in the

top flap as well as the bottom of the enclosure; PVC wallets are generally made with transparent interiors so that the contents are visible when open. Even though Kodak has frequently advised that plasticized PVC should be avoided for storage of photographs, since 1983 Kodak Processing Labs (now Kodalux Processing Services) have supplied wallets made of this unsafe material with its "premium" Magnaprint 35 Service for oversize 4x6-inch prints from 35mm negatives. Much safer is the yellow two-compartment, heavy-weight paper envelope that Kodak (now Kodalux) has for many years supplied with standard-size prints (one compartment accommodates the prints and the other holds a separate paper folder containing the negatives). This enclosure has a design that combines certain features of a paper wallet with the overall concept of a paper envelope with a protective top flap.

8. **Envelope with protective top flap.** Usually made of paper, this is similar in design to the ordinary mailing envelope. Less common than the envelope without a protective flap, this design is very effective in keeping enclosed films or prints free from dust and dirt. Properly made *with narrow and thinly cemented* edge seams on both sides *(with the two flaps adhered to the outside of the envelope)*, an ungummed top flap, and with a folded, seamless bottom, this type of envelope is ideal for use in combination with top-flap polyester sleeves (No. 2 above). A film or print is first placed in a polyester sleeve, which is then put in the envelope. The transparent sleeve protects the film or print from fingerprints and external chemical contamination during examination, handling, and storage. The paper envelope protects the sleeve and photograph from dust and abrasion and also provides a convenient surface for written information, filing numbers, and rubber-stamp impressions. Up to 10 films or prints in individual sleeves can be placed in each envelope. (See **Figure 14.2**.)

9. **Envelope without protective flap.** Sometimes known as a "jacket," this is the traditional negative filing enclosure. Sealed on three sides, with one end left open, it is usually made of paper, glassine, or high-density polyethylene. (Flat, low-density polyethylene bags, often used for storage of both mounted and unmounted prints, are included in this group.) These envelopes are often made with a thumb-cut at the top to facilitate negative removal. The design has a number of drawbacks and is not recommended for long-term storage applications; in particular, paper or glassine envelopes with a glued seam in the center should be avoided. If for reasons of economy this type of enclosure must be used, edge-sealed high-density polyethylene envelopes appear to have the least potential for harm to films and prints.

10. **Folder.** Usually made of paper or glassine, some folders have a glued seam on one end and some are made with both ends open. Folders are generally made without a top flap. Folders are intended to be placed into envelopes after films or prints are inserted between the two sides of the folder. With the exception of Kodak

(now Kodalux) photofinishing labs, which have for many years returned cut rolls of negatives in a paper folder (some made with a top flap and a glued seam on one end, and others made without a top flap and with both ends open), this type of enclosure is no longer commonly used. Because groups of negatives can easily fall out of the open top and/or open ends of a folder, and little protection from dust and dirt is provided, this type of enclosure is not recommended.

11. **Heat-sealable vapor-proof envelope.** Supplied in a variety of sizes by Light Impressions Corporation, Conservation Resources International, Inc., and several other companies, these special envelopes are made of a paper- or plastic/aluminum-foil/polyethylene laminate; they are similar to the envelopes used by Kodak and other manufacturers to factory-pack sheet films. Because paper and plastics are permeable to water vapor, the aluminum-foil layer is needed to provide a moisture barrier. Intended for protecting color films and prints in cold storage with uncontrolled relative humidity, the envelopes must be replaced each time they are opened. They are not recommended by this author for other than cold storage applications (see Chapters 19 and 20). Envelopes of this type in 4x5- and 8x10-inch sizes were supplied by Eastman Kodak for a number of years; called Kodak Storage Envelopes for Processed Film, they were discontinued by Kodak in 1987, apparently because of lack of demand.

12. **Four-flap paper enclosure.** This is a specialized design of paper enclosure, favored by some museums and archives, especially for storage of glass plates. The plate or negative is placed in the center of the enclosure and the four flaps, each the size of the negative, are successively folded over it. The enclosures are pre-scored for ease of folding. Advantages of the design are freedom from scratching during insertion and removal of the negative, and the absence of potentially harmful glues in the enclosure. Three-flap versions of this enclosure are not recommended. In this author's view, four-flap enclosures are not as satisfactory as top-flap polyester sleeves used in combination with top-flap paper envelopes.

## Plastic Enclosure Materials

A great advantage of transparent plastic enclosures over paper envelopes is that negatives, transparencies, and prints can be viewed without having to remove them from the enclosure. This not only speeds up examination of negative and print files but also helps to avoid fingerprints, scratches, and other sorts of physical damage. With paper enclosures, films and prints must be removed every time they are looked at. During the last decade, the popularity of plastic enclosures has markedly increased, and in most branches of photography they have almost entirely displaced paper and glassine enclosures.

Plastic enclosures can be fabricated easily with high-speed thermal, ultrasonic, or radio-frequency sealing equipment,[1] which eliminates the glues required for paper and glassine envelopes. Many of these glues contain ingredients which can cause discoloration and fading of prints and negatives stored adjacent to cemented seams; such problems can be especially severe when the photographs are stored in humid conditions. Many commonly used glues are hygroscopic and increase localized moisture content of the paper — as well as of films or prints — in the vicinity of glued envelope seams, accelerating fading and discoloration in these areas.

Although plastic enclosures have many advantages, they also suffer from a few drawbacks. They are, for example, difficult to write on; with most types of plastics, only inks from solvent-dye felt-tip markers such as Sanford's Sharpie or Pilot Photographic pens will satisfactorily adhere to the surface. However, if plastic enclosures are inserted into a paper envelope, negative numbers, caption information, and rubber-stamp impressions can easily be put on the outside of the envelope.

Another objection to plastic enclosures is that they tend to develop static electrical charges, which attract and retain dust and dirt, especially when the relative humidity is low. During handling, polyester is particularly likely to develop static charges. This problem can be minimized by keeping darkrooms and other work areas clean and by storing the plastic enclosures in paper envelopes or boxes.

Concern has been expressed that moisture may become trapped in plastic enclosures, and that they are more likely to cause sticking or areas of irregular surface gloss (often called ferrotyping) on the emulsions of films and prints, especially when stored in high humidities. Examination of many commercial and historical collections containing films and prints packaged in glossy acetate sleeves — as well as films stored in groups so that the emulsions are in tight contact with the smooth surfaces of adjacent films — suggests to this author that with polyester and cellulose acetate enclosures, this alleged danger has been greatly exaggerated.

When storage temperatures and humidities are reasonable, and films or prints are not crammed into files or large boxes (or otherwise stored under pressure), there appears to be little likelihood of sticking problems with enclosures made of uncoated polyester, untreated polypropylene, high-density polyethylene, or cellulose triacetate. If, however, photographs must be stored for long periods in conditions of high relative humidity, it is suggested that a sheet of suitable paper, cut to the same size as the film or print, be placed between the enclosure and the emulsion side of the film, or that the film or print be put in a thin paper folder of proper size before placing in the plastic envelope.[2]

This author has observed a number of instances of print and film emulsions sticking to enclosures made of low-density polyethylene, surface-treated polypropylene, and plasticized PVC; for this and other important reasons cited later, it is recommended that these materials be avoided for storage of films and prints.

Kodak has pointed out an additional drawback of polyethylene enclosures:

> . . . if a fire occurred in the immediate vicinity of the storeroom, heat that would not destroy negatives on acetate film base, nor even scorch good-quality paper, might melt polyethylene and thereby damage negatives.[3]

In a disastrous 1982 fire at the Design Conspiracy Color Lab in Oakland, California, many negatives and prints belonging to San Francisco area fine art photographers were destroyed. As salvage efforts revealed, "Some negatives in storage fared reasonably well, although different types of storage containers withstood heat and water with varying degrees of success. Most negatives in plastic [low-density polyethylene and PVC] were lost when the plastic melted onto the film."[4] The low melting temperature of polyethylene and plasticized PVC is an additional reason that these plastics are inferior to polyester for storage enclosures.

## Identifying Polyester, Cellulose Triacetate, and Other Plastic Enclosure Materials

Uncoated polyester and cellulose triacetate are both glass-clear materials and very similar in appearance. They can be differentiated by two simple tests:

1. Using just the fingers, it is almost impossible to initiate a tear in polyester. Cellulose triacetate tears rather easily. In an equivalent thickness, polyester is much stiffer than cellulose triacetate. (If an identified sample is needed for comparison, Kodak Estar Base sheet films are made of polyester.) Most Kodak black-and-white and color 35mm and larger roll films are made with cellulose triacetate.

2. Cellulose triacetate is soluble in certain solvents, such as methylene chloride. When dipped in methylene chloride, the material will become sticky and pieces may become cemented together. Polyester is virtually unaffected by solvents at room temperatures. This test should be done with adequate ventilation since the solvents are toxic to breathe.

Other common plastics for making photographic storage enclosures are low-density polyethylene, high-density polyethylene, and polypropylene, none of which is soluble in methylene chloride. Transparent grades of low-density polyethylene are slightly milky in appearance, very flexible, and can be stretched considerably without tearing or breaking; high-density polyethylene is a milk-white translucent material, somewhat similar in appearance to glassine paper, and stiffer than low-density polyethylene. Polypropylene, which is discussed later, may be hard to distinguish from polyester on the basis of simple tests. As with polyester, it is difficult to initiate a tear in polypropylene. Both plastics tear fairly easily once a tear has been started (by making a small cut with a pair of scissors, for example), but polyester tears with a rough, somewhat jagged edge whereas polypropylene tears with a much smoother edge.[5]

Plasticized PVC is a flexible, glass-clear or translucent plastic, usually of fairly heavy gauge when used for slide notebook pages and, less commonly, to hold negative strips. Heavily plasticized PVC usually has a pronounced odor when held close to the nose. Thin gauges of low-plasticizer-content PVC (used in some cemented top- and bottom-seam sheet film and roll film sleeves) may be difficult to distinguish from cellulose acetate or polypropylene.

## Polyester Film and Print Enclosures – Highly Recommended

Uncoated polyester is, because of several unique attributes, the preferred material for photographic enclosures. A glass-clear plastic technically known as polyethylene terephthalate, polyester is produced by a number of companies in the U.S. and other countries. In the U.S., DuPont Mylar is probably the best-known commercial polyester sheet material (DuPont manufactures over 60 types of Mylar); Eastman Kodak produces polyester film base under the Estar name.[6]

About 25 years ago, polyester began to replace less expensive cellulose triacetate as a film base for some products, especially graphic arts films; because polyester is stiffer than cellulose triacetate of the same thickness, it is particularly well suited for sheet films and reflection print materials. Cellulose triacetate continues to be used as the support material for most 35mm and 120/220 roll films such as Kodak T-Max 400, Tri-X Pan, Vericolor, Ektar, Kodak Gold, and Ektachrome. Polyester is the current base for such products as Kodak Gold Disc film, Kodak Estar Base black-and-white and color sheet films, Ilford Ilfochrome (formerly Cibachrome) Micrographic film, and Polaroid PolaChrome instant color slide film. A special opaque white Melinex polyester base material made by the British firm Imperial Chemical Industries, Ltd. (ICI) is used with Ilfochrome Classic (formerly Cibachrome II) glossy-surface prints, UltraStable Permanent Color prints, Polaroid Permanent-Color prints, and Kodak Duraflex RA Print Material. A similar if not identical polyester material is also the base for Konica Color QA Super Glossy Print Material and Fujiflex SFA Super-Gloss Printing Material. Polaroid Spectra prints (called Polaroid Image prints in Europe), Polaroid 600 High Speed prints, and Polaroid SX-70 prints all have polyester front and backing sheets.

Polyester is an extremely stable and long-lasting plastic. Recently published studies by Kodak indicate that in dark storage Estar polyester film base is at least six times more stable than cellulose triacetate film base and that the physical properties of polyester are predicted to remain unchanged "for several thousand years."[7] The stability advantages of polyester over cellulose triacetate are even greater under adverse storage conditions of high relative humidity. In dark storage, polyester sheet is believed to be more stable than even the best-quality 100% cotton fiber paper; polyester will probably last as long as any type of photograph in existence. Extensive experience with it as a film base, coupled with accelerated aging tests, indicates that polyester is essentially nonreactive with black-and-white and color images, even under extreme temperature and humidity conditions.

In this author's accelerated dark-storage tests at 144°F (62°C) and 45% RH, DuPont Mylar D uncoated polyester sheet and the polyester base materials of Cibachrome (now Ilfochrome) prints, UltraStable Permanent Color prints, and Cibachrome (Ilfochrome) Micrographic Film proved to be far more stable than the cellulose triacetate base materials used with Kodak, Fuji, and Agfa 35mm films; the polyester materials were also much more stable than the fiber-base paper support of Kodak Dye Transfer prints. After 1,000 days (2.7 years) of accelerated aging, the cellulose

triacetate film bases had shrunk, smelled of acetic acid, and had become grossly deformed, while the polyester materials appeared *totally* unaffected.

Uncoated polyester is naturally flexible and contains no plasticizers which might exude or volatilize over time and damage films or prints. Polyester is not affected by most solvents and has a very low rate of moisture transmission, which will partially protect enclosed photographs from rapid fluctuations in relative humidity.

Polyester has a low permeability to gases and thus affords significant protection to photographs from atmospheric pollutants and/or harmful chemicals from materials such as improperly processed photographs or low-quality paper. This feature may be particularly important to museums and archives because of the great variety of photographs — many of which have not been processed and washed correctly — likely to be in their collections. Harmful chemicals from poor-quality mount board and envelopes, as well as from incorrectly processed photographs can migrate through adjacent paper envelopes and contaminate prints and negatives.[8] Polyester is far superior to paper as a chemical barrier between adjacent photographs. Storage in contact with polyester will not alter the pH of a photographic material, an important consideration with some color materials.

Polyester is very tough and tear-resistant — for the same degree of physical protection, it can be used in thinner gauges than cellulose triacetate. Unlike thin cellulose triacetate, polyester sheets lie very flat and do not develop surface ripples or waves, even in large sizes. Any surface ripples in a film or print enclosure can "rock" on the delicate emulsion or base surfaces during storage, producing surface abrasion which can in some cases cause severe damage to a photograph. This is most often seen with sheet film stored in tightly packed vertical files; any dust or other particles of dirt on the film or acetate enclosures will exacerbate the problem.

If enclosures are made of *uncoated* polyester, such as DuPont Mylar D or ICI Melinex 516, there is assurance that they will be photographically safe and perform as expected. Cellulose triacetate, on the other hand, is made in many grades by a number of manufacturers. Most brands probably will not harm photographs, but only those types specifically designed as a film base, such as Kodak Kodacel, may be assumed to be safe.

### Design of Polyester Sleeves

Until recently, polyester was not used extensively to make photographic enclosures because it is somewhat more expensive than cellulose triacetate and it cannot be fabricated with conventional solvent cementing techniques. Polyester also cannot be heat sealed or properly heat folded with conventional fabricating machinery. In the last few years, however, ultrasonic heating equipment which permits effective welding and folding of polyester enclosures has become widely available in the plastics industry. The first commercially available uncemented top-flap polyester film and print enclosures were introduced in 1976 by Talas Inc., in New York City, employing designs suggested by this author (see **Figure 14.1** and **Table 14.1**).

Similar clear polyester sleeves are sold under the Fold

### Table 14.1 Suggested Sizes for Sleeves Made of Uncoated Polyester

| Film or Print Size | | Sleeve Size |
|---|---|---|
| 35mm 4-frame strip | — | 1⅝ x 6¼ inches (4.13 x 15.9 cm) |
| 35mm 5-frame strip | — | 1⅝ x 7¾ inches (4.13 x 19.7 cm) |
| 35mm 6-frame strip* | — | 1⅝ x 9¼ inches (4.13 x 23.5 cm) |
| 120/220 3-frame strip* | — | 2⅝ x 8 inches (6.7 x 20.3 cm) |
| 4 x 5 sheet film or print (10.2 x 12.7 cm) | — | 4⅛ x 5¼ inches (10.5 x 13.3 cm) |
| 5 x 7 sheet film or print (12.7 x 17.8 cm) | — | 5⅛ x 7¼ inches (13 x 18.4 cm) |
| 8 x 10 sheet film or print (20.3 x 25.4 cm) | — | 8¼ x 10⅜ inches (21 x 26.4 cm) |
| 11 x 14 sheet film or print (28 x 35.6 cm) | — | 11¼ x 14⅜ inches (28.6 x 36.5 cm) |
| 16 x 20 sheet film or print (40.6 x 50.8 cm) | — | 16⅜ x 20⅜ inches (41.6 x 51.8 cm) |

**Note:** DuPont Mylar D and ICI Melinex 516 are acceptable uncoated polyester materials. For sizes up to 4 x 5 inches, 2 to 4 mil thicknesses of polyester are suggested. For larger sizes, 4 to 6 mil thicknesses are recommended.

\* Will fit in a standard No. 11 letter envelope or in a file drawer.

Lock name by Light Impressions Corporation. Recent samples of sleeves from Light Impressions were made with tighter folds than sleeves generally supplied by Talas — a significant advantage because tight folds tend to prevent films from slipping out of the ends of the sleeves. Talas sleeves are made of 4-mil (0.004-inch) Mylar D, which is about twice as thick as the Mylar D in those supplied by Light Impressions. This author prefers Light Impressions clear sleeves in 35mm and 120 roll film sizes (because of the tight folds), and Talas sleeves in 4x5-inch and larger print and sheet film sizes (the thicker and more rigid Mylar D in Talas sleeves is a distinct advantage when handling large prints).

Photofile, Inc. and some other firms[9] also supply sleeves made of matte surface "frosted" polyester, such as DuPont Mylar Type EB-11, which is claimed to minimize chances of sticking or ferrotyping. This material contains an incorporated silicon dioxide matting agent which, unfortunately, is a strong abrasive. Tests by this author show that rub-

End View

Side View

**Figure 14.1** Design of a top-flap polyester sleeve. The flap folds over but is not cemented to the main body of the sleeve; this allows the sleeve to be opened like a book. To minimize the possibility of a film or print accidentally sliding out of an open end of a polyester sleeve, it is essential that such sleeves be made with tight folds.

A six-frame 35mm negative strip being inserted into a top-flap polyester sleeve made by Light Impressions Corp.

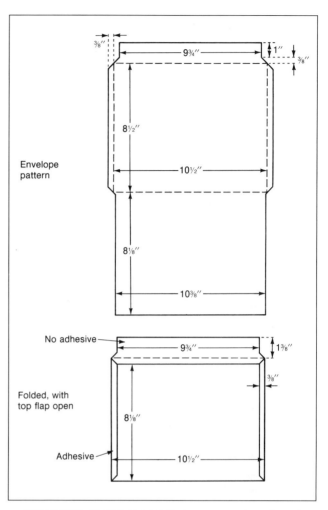

Envelope pattern

No adhesive

Folded, with top flap open

Adhesive

**Figure 14.2** Design of a top-flap paper envelope, based on recommendations given in **ANSI IT9.2-1991**. To avoid contact between a potentially harmful glued seam and the emulsion of a film or print, this type of envelope is designed with narrow glued side seams and without a glued bottom seam.

Six sleeved 35mm color or black-and-white negative strips, comprising a full 36-exposure roll, may be safely stored in a high-quality No. 11 size paper envelope, available from office supply stores.

An 8x10-inch print being placed in a heavy-gauge top-flap polyester sleeve supplied by Talas Inc.

bing the material on the emulsion of a film or print with only slight pressure will severely abrade the surface; "frosted" polyester should be avoided. For some years Light Impressions offered folders and top-flap sleeves in both clear and Mylar EB-11 matte-surface polyester; however, in 1988, the company discontinued the matte-surface products.

Polyester sleeves in either clear or matte surface and having both the top and bottom edges sealed, such as those supplied by Conservation Resources International, Inc. (sold under the Polyweld name) and Photofile, Inc. are not recommended because of the danger to films or prints of scratching during insertion and removal. The "L-sealed" polyester and polypropylene sleeves sold by Conservation Resources also are not recommended. L-sealed sleeves, which are sealed on one short side and one long side (with the other two sides open and without flaps), are, in this author's opinion, not as satisfactory as the top-flap polyester sleeves discussed previously.

Sleeves should be somewhat larger than the photographs they will contain. Fiber-base prints are particularly likely to be larger than the indicated size; for example, an "8x10-inch" print may be as large as 8¼x10³/₈ inches. When fiber-base prints are dried in contact with ferrotype (glazing) sheets or ferrotyping dryer drums, the size of the print will be very close to that of the paper when it is expanded in the wet state. Contact with the ferrotype sheet prevents the print from contracting during drying, as would normally be the case.

Especially when handled frequently, large prints can be protected by inserting a sheet of high-quality 2-ply mount board behind the print in the sleeve to prevent creases and kink marks from occurring in the print. It may also be desirable to tape the top flap to the back of the sleeve after the print is inserted and the sleeve is closed; a stable, pressure-sensitive tape such as Scotch Magic Transparent Tape No. 810, made by the 3M Company, is suitable. This will prevent the sleeve from accidentally falling open during handling and is especially helpful when prints are kept in public files. For access to the print, the sleeve can be opened by cutting the tape at the joint where the edge of the flap meets the back of the sleeve.

For prints that are handled a great deal, such as in gallery print racks, an effective enclosure can be made by placing a print on a sheet of mount board cut to the proper size; a pre-cut sheet of *thin* polyester (thick polyester sheet is almost impossible to fold sharply without special equipment) which overlaps all four edges of the mount board is placed on top and the edges of the polyester are folded and adhered to the back of the mount board with a stable, pressure-sensitive tape such as Scotch Double-Coated Film Tape No. 415, made by the 3M Company. Ready-made enclosures of this type are available from Jerry Solomon Gallery Services, Inc.[10]

The polyester L-Velopes supplied by Lineco, Inc. of Holyoke, Massachusetts are also excellent for storing prints. The sleeves are sealed on two sides and have overlapping flaps on the other two sides, thus affording excellent protection from dust. Once inserted, prints are held securely in place and cannot slide out. L-Velopes are particularly useful when prints are subject to frequent handling.

Polyester sleeves are more expensive than most other types of enclosures; typical prices at the time of this writing were $0.15 for a sleeve designed to hold a 6-frame strip of 35mm film, $0.16 for a 4x5-inch sleeve, and $0.45 for an 8x10-inch sleeve. Prices are less when large quantities are purchased.

Ansel Adams adopted a system of negative storage in which a polyester folder (without a top flap) is wrapped around the negative and then placed in a paper envelope of the appropriate size; negative identification, exposure times, dodging and burning instructions, and other printing information are written on the outside of the envelope.

As yet, no manufacturer has offered a system of filing enclosures consisting of uncemented top-flap polyester (or untreated polypropylene) sleeves with matching high-quality top-flap paper envelopes of the design illustrated in **Figure 14.2**; however, it is likely that these will soon be available.[11] Sizes are needed for 6-frame strips of 35mm film (which are normally stored with six or seven 6-frame strips in one paper envelope) through 16x20 inches for both prints and films.

## Cellulose Triacetate Sleeves — Not Recommended

At the time of this writing, cellulose triacetate sleeves were generally available only in the cemented top- and bottom-seam sleeve design which requires that films and prints slide on the enclosure surfaces when they are inserted and removed. Unlike polyester sheets, which usually remain flat and smooth during storage, thin cellulose triacetate sheets tend to develop wrinkles, waves, and surface cockles during long-term storage. When films or prints are grouped together in files and boxes, these surface distortions may produce localized areas of relatively high pressure on the films which, in combination with sliding or "rocking" of the triacetate on the front and back surfaces of the photograph, can cause abrasion — especially if particles of dust or other dirt are present. Distorted sleeves are also more likely to cause scratches when films and prints are slid in and out. For these reasons, cellulose triacetate is distinctly inferior to polyester as an enclosure material.

At present the only commonly available cellulose triacetate sleeves are Kodak Transparent Sleeves, which are available in several sheet film sizes. They are designed to be only slightly larger than nominal sheet film sizes, presumably so that sleeved films will fit into standard sheet film boxes. Consequently, Kodak sleeves are too small to properly accommodate most paper prints of the same nominal size. Kodak introduced its Transparent Sleeves many years ago; the sleeves are comparatively expensive and appear to have only limited sales.

For many years, Kleer-Vu Industries, Inc. (now Kleer-Vu Plastics Corporation) produced a line of acetate sleeves which included uncemented top-flap designs for 35mm and roll films. In 1983 the firm converted most of its products to polypropylene. Both cellulose triacetate and polypropylene are less expensive than polyester.

NegaFile Systems, Inc., best known for the glassine negative envelopes the company has produced since 1939, also makes cellulose acetate sleeves in sizes 35mm (strip of 6 frames) through 4x5 inches, all in the slide-through design.

In 1984 Paterson Products Ltd. of England introduced a

Over time, sleeves made of thin cellulose acetate, such as Kodak Transparent Sleeves, tend to develop wrinkles or wave-like deformations that can eventually cause damage to film surfaces during handling and storage.

A deformed cellulose acetate sleeve caused severe localized abrasion on both sides of this 4x5-inch Ansco color transparency in the collection of the American Museum of Natural History in New York City.

line of cellulose acetate notebook-page enclosures that have been advertised as "chemically inert to ensure archival storage for correctly fixed and washed negatives." Since the pages require that negatives slide against the thin plastic surfaces of the pages during insertion and removal, however, they are not recommended.

## Untreated Polypropylene Top-Flap Sleeves — Recommended

In 1983 Kleer-Vu Plastics Corporation introduced an extensive line of polypropylene sleeves and notebook-page enclosures marketed under the Pro-Line Protective Enclosures name.[12] Untreated (uncoated) polypropylene is a relatively low-cost material and appears to be the best available substitute for polyester. Untreated "oriented" polypropylene is almost as transparent as polyester. Polypropylene is considered to be a stable and safe plastic; along with uncoated polyester and cellulose acetate, it is one of the plastics recommended in *American National Standard ANSI IT9.2-1991*.[13] According to Kleer-Vu, the untreated polypropylene in Pro-Line sleeves meets the requirements of *ANSI IT9.2-1991*[14] and has been tested in contact with a few black-and-white and color photographic materials using the *ANSI IT9.2* Photographic Activity Test, with no adverse results.[15]

At the time of this writing, Kleer-Vu was supplying 35mm and other roll film sizes only in pre-cut lengths of 40 and 62 inches, which will accommodate full-roll lengths of 35mm and 120 films. The sleeves are also available in uncut 667-foot rolls. Unfortunately, short, pre-cut lengths to accommodate 35mm 6-frame strips or 3-frame strips of 120 film are not available. It is, however, a fairly simple task to cut the sleeves to short lengths with a paper cutter or scissors. Pro-Line sleeves for sheet films and prints are available in sizes ranging from 4x5 to 16x20 inches.

Kleer-Vu Pro-Line polypropylene sleeves are also supplied in cemented top-seam and glued "frosted-back" configurations. The cement in these sleeves is a "specially formulated" hot-melt adhesive, which, at the time of this writing, had not been subjected to the *ANSI IT9.2-1991* Photographic Activity Test. Translucent cellulose acetate is used for the rear sheet of Pro-Line "frosted-back" sleeves. The cemented top-seam sleeves require that films or prints slide against the plastic during insertion or removal and are therefore not recommended.

Although this author has had only limited experience with these new untreated polypropylene products, the *uncemented* top-flap sleeves appear to be suitable for long-term storage of films and prints and can tentatively be recommended as the only satisfactory alternative to the more expensive top-flap polyester sleeves. Pro-Line sleeves are only about one-sixth the cost of similar polyester sleeves. Light Impressions Corporation also supplies top-flap polypropylene sleeves in 35mm through 5x7-inch film formats under the Fold Lock name; the sleeves cost approximately one-half as much as Fold Lock polyester sleeves of the same design.

During 1984 and 1985, a number of companies converted their sleeve and notebook-page enclosure production from cellulose acetate and PVC to polypropylene, and the plastic has become the material of choice in the medium price range (polyester enclosures are the most expensive; polyethylene enclosures are the lowest in cost). Kodak and NegaFile Systems, Inc. appear to be the only major manufacturers in the United States which continue to produce cellulose triacetate sleeves (Kodak Transparent Sleeves are available only in sheet film sizes).

Top-flap polypropylene sleeves in uncut roll film sizes are currently supplied by the Filmguard Corporation of Escondido, California under the Polyguard name. Polyguard sleeves for sheet films are supplied in the top-flap design, and with cemented seams in clear and frosted-back designs. The cemented-seam sleeves are not recommended; likewise, Polyguard Econo-Matte sleeves with a polypropylene front and "frosted" PVC back should be avoided.

National Photo Products Company of Cudahy, California markets polypropylene top-flap sleeves under the

Filmguard Plastar Sleeving name. The sleeves are offered in two thicknesses, which are designated Plastar and Plastar Plus. The company also makes cemented-seam polypropylene sleeves for sheet films; these sleeves should be avoided for long-term applications.

Because Kleer-Vu identifies the manufacturer and type of polypropylene in its sleeves, this author recommends Kleer-Vu products in preference to those of other suppliers; at the time of this writing, none of the other suppliers listed in their product literature the type of polypropylene from which their sleeves were made.

### Surface-Treated Polypropylene Notebook-Page Film and Print Enclosures: Not Recommended Except for Slide Pages

Polypropylene notebook-page enclosures for slides, strips of negatives, and prints are available from a number of companies including C-Line Products, Inc., 20th Century Plastics, Inc., Light Impressions Corporation, Kleer-Vu Plastics Corporation, and Franklin Distributors Corporation. These pages are all made of surface-treated polypropylene. Untreated "oriented" polypropylene cannot be satisfactorily sealed by heat or ultrasonically, which precludes its use in pocket-type notebook-page enclosures.

The surface coatings add a presently unknown element to assessing the suitability of the enclosures. The treated polypropylene may be prone to ferrotyping or sticking to film emulsions in a manner similar to that observed with polyethylene and PVC or present other problems. Indeed, this author has observed sticking of a black-and-white print emulsion to the surface of a polypropylene notebook-page enclosure made by C-Line Products, Inc., which was stored for about 2 years under normal room temperature and humidity conditions.[16] When contacted about the problem, C-

Line offered to replace the enclosure at no charge and readily acknowledged that sticking has sometimes occurred with its polypropylene products:

> The problem of the photographs sticking and the diminished clarity can be traced to the same source. As the polypropylene film is processed by our supplier, they do add a surface coating. The coating acts as a "slip agent," and as an anti-static agent. Both properties are important to us, since too much, or too little coating will greatly affect how the material runs [during manufacture]. The problem you are experiencing is due to too much of the coating, causing the surface to become tacky, and the clarity to be reduced.
>
> By noting a [certain detail of the design], we were able to identify the sample sheet you sent in as a product that was run prior to September 1983. Since then, we have become more selective in the material we will accept, and our suppliers have responded to our needs.[17]

The design of notebook-page enclosures requires that negatives and prints be slid in and out. Because of this drawback — and the potential problem of sticking — polypropylene notebook-page enclosures are *not recommended* for long-term storage applications, except for mounted slides (see Chapter 18).

If, in spite of these problems, the decision is made to use polypropylene notebook page enclosures for negatives and prints, this author currently recommends C-Line products over those of other suppliers, especially those selling pages under their own "private label." C-Line actually manufactures its own enclosures and appears to understand the nature of the sticking problem. The company, working

© Victor Schrager 1979

Over time, surface-treated polypropylene notebook pages and sleeves may stick to print or film emulsions and are therefore not recommended for applications other than storage of mounted slides (slides have recessed mounts which minimize contact and pressure between the film and polypropylene).

In this example, a C-Line polypropylene notebook page stuck to the surface of an 8x10-inch fiber-base black-and-white print after several years of storage in a New York City apartment. The areas of adhesion can be seen clearly when light is reflected off the surface of the page. The photograph, taken by Victor Schrager in 1979, is of the late photographer Andre Kertesz and Carol Brower.

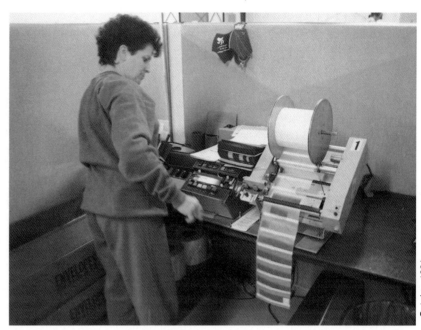

This automatic film sleever at Linn Photo, a large wholesale photofinisher near Cedar Rapids, Iowa, used rolls of low-cost, high-density polyethylene "sleeving material" when this photograph was made in 1991  Such protective sleeving is used by most mini-labs processing color negative film and also by many large-volume photofinishing labs. High-density polyethylene sleeves are clearly superior to sleeves made of low-density polyethylene.  In 1992, Linn Photo was ac-quired by Qualex Inc., which is a joint ven-ture between Eastman Kodak and Fuqua Industries, Inc.   Before being acquired by Qualex, Linn Photo sleeved all negatives before placing them into envelopes together with the prints for return to customers. After Qualex took over, however, sleeving was discontinued and, at the time this book went to press in 1992, the negatives were being stuffed into the envelopes with no protection, leaving them very vulnerable to fingerprints, scratches, and other damage. Qualex is the world's largest photofinisher.

October 1991

with the suppliers of its materials, has taken steps to mini-mize the chances of sticking, and this offers the consumer a measure of assurance that the products will be consis-tent from batch to batch and perform satisfactorily in the future.

Suppliers selling private label polypropylene enclosures, on the other hand, may change the source of their products without notice (usually there is no way to determine who actually made a private label enclosure) and are in a poor position to monitor the long-term performance of what they sell.  When purchasing private label products, the con-sumer is at greater risk.

## High-Density Polyethylene — the Best Low-Cost Enclosure Material

High-density polyethylene is a translucent material, some-what similar in appearance to glassine; it does not have the transparency of polyester, polypropylene, or low-den-sity polyethylene.

High-density polyethylene is a naturally slippery plas-tic, with little tendency to cling, and is normally manufac-tured without the antiblock and slip agents commonly used in low-density polyethylene.[18]  The surface properties of high-density polyethylene and the absence of antiblock and slip agents appear to make it much less likely than low-density polyethylene to stick to or ferrotype photographic emulsions during long-term storage, especially in humid conditions.  This author's experience to date with high-density polyethylene enclosures leaves little doubt that they are superior to conventional low-density polyethylene and surface-treated polypropylene enclosures.

Of all the plastics used for photographic enclosures, high-density polyethylene appears to have the least ten-dency to scratch films and prints when they slide over the material during insertion and removal.  High-density poly-ethylene enclosures have been popular for a number of years in Japan and other humid areas in Asia but have only

recently become widely available in the U.S.  High-density polyethylene sleeves are used by the Fuji photofinishing laboratory in Anaheim, California and by most other high-quality photofinishing companies in the U.S.

At the time this book went to press in 1992, Kodalux photofinishing labs had not yet adopted this type of nega-tive enclosure; instead, Kodalux was returning customer negatives in an open-sided yellow paper folder.

Most currently available high-density polyethylene en-closures are made in Japan or Taiwan and consist of edge-sealed, side-by-side negative compartments with one end of each compartment open for insertion of a negative strip. "Sleeving material," as this type of high-density polyethyl-ene sleeve is often referred to in the photofinishing trade, is supplied in large rolls.  The number of negative compart-ments necessary to accommodate each roll of film is cut from the sleeving roll after the negatives have been cut and inserted by machine; negative strips can also be cut with scissors and manually inserted into the sleeves.  The sleeving material is available for 110, 126, and 35mm film widths in 4-, 5-, and 6-frame lengths; sleeving material for 120 film is also available.

Negatives are cut — most commonly to 4-frame lengths — and inserted into sleeves with manually operated, semi-automatic, or high-speed fully automatic machines mar-keted by Crown Photo Systems, Agfa-Copal, Noritsu, DOI, Labokey, and a number of other firms (see list of **Suppli-ers** at the end of this chapter).  Cost of the machines ranges from about $500 for manually operated sleevers to more than $7,000 for high-speed, microprocessor-controlled models that automatically feed sleeving material, cut negatives to the specified frame-length, insert the strips into individual sleeve compartments, and cut the sleeving after all the negatives from a roll of film have been inserted.

High-density polyethylene sleeving in rolls is probably the least expensive of all film enclosures.  For example, Noritsu America Corporation of Buena Park, California sells a 1,320-foot roll of sleeving material for about $20 with

shipping additional (the minimum order is two rolls). Each roll has 6,000 negative sleeves — sufficient for more than 660 rolls of 36-exposure 35mm film cut into 4-frame lengths, for a cost of only about $0.03 per *roll* of film.

Crown Photo Systems, Inc. supplies sleeving material which is perforated between negative compartments so that they may be separated without cutting. The Crown sleeves have compartments which are about ⅜-inch wider than most other sleeves and have a white stripe along one side of each compartment to accommodate written information. Crown reports that weekly sales of its sleeving material are, on average, sufficient to sleeve more than 5 million rolls of film.

Most suppliers of sleeving material offer an imprinting service for photofinishers and other large-volume users — company names, logos, promotional slogans, and other information can be printed on each sleeve.

Rolls of high-density polyethylene sleeving are not available from traditional camera stores and darkroom materials suppliers. Photographers, however, can purchase rolls of sleeving material directly from one of the suppliers listed at the end of this chapter. A photographer might, for example, want to sleeve a several-year accumulation of unsleeved color negatives which were processed by Koda-lux photofinishing laboratories. When ordering rolls of sleeving, be sure to indicate the number of negative frames (4, 5, or 6 frames) that will be used with the sleeves in order to obtain the correct compartment length.

High-density polyethylene is also used for individual sleeves for negatives and prints. A major distributor in the United States is Reeves Photo Sales, Inc., which sells a variety of low-cost envelopes made of the material under the RPS Plastine Print and Film Preservers name (the same enclosures are also available from Light Impressions Corporation under the Polyethylene Thumb-Cut Envelope name). The envelopes are manufactured in Japan.

Plastine envelopes are edge-sealed on the sides and bottom, with one end open (usually with a thumb-cut to aid in removal of films or prints). The envelopes are supplied in a variety of sheet and roll film sizes, from 2¼x2¼ inches to 20x24 inches. Plastine envelope No. S-00610, which holds a 6-frame strip of 35mm film, and envelope No. S-00620, which accommodates a 4-frame strip of 120/220 film, are superior substitutes for comparable glassine envelopes used by photographers for a great many years. For storage, Plastine envelopes containing the negatives for each roll can be placed in a No. 10 or No. 11 letter envelope available from office supply stores; dates, captions, and other information can be written on the outside of the paper envelope.

Plastine high-density polyethylene envelopes are inexpensive, costing no more than most paper or glassine enclosures. For example, Plastine envelopes which hold a 6-frame strip of 35mm film cost about $45 for a box of 1,000.

Also available from Reeves is a high-density polyethylene fold-up page with attached paper wallet for 35mm and 120 films. Films and prints must be slid in and out of the enclosures. Reeves also supplies Plastine notebook page enclosures made of low-density polyethylene and slide pages made of plasticized PVC (as discussed later, neither low-density polyethylene nor PVC enclosures are recommended).

High-density polyethylene enclosures are a low-cost — and superior — substitute for common kraft paper, glass-

ine, and low-density polyethylene enclosures, but they are not as satisfactory as top-flap polyester or untreated polypropylene sleeves.

At the time of this writing, this author has insufficient accelerated test data and user experience with high-density polyethylene sleeving material to be able to recommend a particular brand. For the reasons discussed below, however, *low-density* polyethylene sleeving material should be avoided. A few suppliers, including NegaFile Systems, Inc., market sleeving material made of low-density polyethylene.

## Low-Density Polyethylene Enclosures — Not Recommended

Low-density polyethylene enclosures first came into widespread use in the U.S. in the mid-1960's with the introduction of Print File Archival Preservers, originated by Print File, Inc. of Schenectady, New York, and now manufactured by Print File, Inc. of Orlando, Florida (a separate company which up until the end of 1987 called itself Photo Plastic Products, Inc. — the Print File, Inc. located in Schenectady is still in operation as one of the many distributors of the enclosures). Low-density polyethylene enclosures are also made by several other companies, including Vue-All, Inc. of Ocala, Florida.

The most common types of low-density polyethylene enclosures are notebook pages designed to contain an entire roll of film cut into strips. Low-density polyethylene is sufficiently transparent to permit contact prints to be made without removing the negatives from the enclosure; however, there is a significant loss of image sharpness of contact prints made in this manner because of light scatter in the semi-transparent polyethylene.

The very low cost of low-density polyethylene (it is the least expensive of all plastics — the primary reason it is used to make garbage bags) and the ease with which it can be heat sealed into multi-compartment enclosures have contributed to the popularity of low-density polyethylene products. However, this author's personal experience and reports received from many users of Print File and similar low-density polyethylene enclosures over the past several years have indicated a serious problem with negative scratches caused by these enclosures. Films must be slid in and out of the enclosures, and small particles of dirt sandwiched between the film and the polyethylene can cause scratches. The problem appears to be most serious with 35mm films, the majority of which do not have gelatin anti-curl backings. In addition, this author has observed negatives ferrotyping and sticking to Print File enclosures after several years of storage in typical storage environments. A reader of *Camera 35* magazine wrote:

> Five years ago I changed from glassine envelopes to polyethylene preserver pages which fit into three-ring binders. Now I've discovered those early negative strips have become *laminated* to the preserver page — despite storage in a constant temp/humidity environment.
>
> On further examination, I've also found that film will be scratched on the acetate side from a single insertion into a previously unused sleeved preserver page.[19]

A close-up view of a Print File low-density polyethylene notebook-page enclosure. Areas of adhesion between a Kodak Tri-X negative and the polyethylene enclosure are clearly evident. This type of adhesion, often referred to as ferrotyping, is most likely to occur in humid environments.

With the negative removed from its sleeve, damage in the form of irregular gloss on the emulsion surface is clearly visible. The sticking occurred after about 5 years of storage under normal conditions in this author's house in Grinnell, Iowa.

There is little in the published literature that suggests *pure* polyethylene could chemically harm photographs stored in the dark; polyethylene, along with polyester, polypropylene, and cellulose triacetate, is one of the plastics recommended in *ANSI IT9.2-1991*. RC (polyethylene-resin-coated) prints are made with a paper core coated on both sides with polyethylene using a hot extrusion process. The manufacture of RC paper has given the photographic industry considerable experience with the stability characteristics of polyethylene and the effects it could have on silver and dye images during long-term aging.

Low-density polyethylene is a naturally flexible material and like polyester does not require the addition of plasticizers to impart flexibility. In practice, however, a number of additives are usually incorporated into the basic polyethylene resin to improve processing and handling characteristics. These include antioxidants, UV stabilizers, antiblock agents, slip agents, pigments, flame retardants, and antistatic additives.

Antiblock agents prevent sheets of polyethylene from sticking together during manufacture and use. Untreated polyethylene sheets have a tendency to "grab" or stick together in the manner that food wraps such as Saran Wrap do. Fine-particle silicas are often used as antiblock agents. Lubricants known as slip agents are added to improve handling in fabrication machinery; slip agents may also serve to reduce blocking and static electricity. Slip agents are incorporated into polyethylene resin during manufacture and migrate to the surface after extrusion, forming a thin, invisible layer that lowers the coefficient of friction. As applied to low-density polyethylene, the term "uncoated" is probably meaningless. This author is not aware of any published research on the long-term physical and chemical effects of the many additives in low-density polyethylene on color and black-and-white photographs.

There have, however, been reports that polyethylene containing BHT (butylated hydroxytoluene), an antioxidant commonly present in polyethylene, has caused white fabrics wrapped in polyethylene to yellow during dark storage.[20] The yellowing has been attributed to a complex reaction involving BHT, moisture, and nitrogen dioxide (a common air pollutant) or other oxides of nitrogen. BHT can diffuse out of polyethylene and be absorbed by adjacent materials. What implications this has for photographic films and prints stored for long periods in polyethylene enclosures is not clear, but it is cause for concern.

The sticking observed with films and prints stored in low-density polyethylene enclosures is probably related to the presence of antiblock and slip agents incorporated in polyethylene during manufacture. The matter is further complicated by the variety of additives employed by the resin manufacturers; polyethylene is made in a vast number of types and grades by manufacturers in many countries. Pigments or other coloring materials added to the nontransparent grades may also have adverse effects on photographs. This author contacted several manufacturers of low-density polyethylene photographic enclosures; none indicated that testing had been done to determine if there are any harmful reactions — or sticking — of their products with common photographic materials, as determined by the *ANSI IT9.2-1991* Photographic Activity Test.

In a 1978 study undertaken by the Public Archives of Canada (renamed the National Archives of Canada in 1987), low-density polyethylene enclosures subjected to the *ANSI PH1.53* Photographic Activity Test adhered to black-and-white film emulsions and became so tightly bonded to most of the print materials tested that the emulsions separated from the paper base when the polyethylene enclosure material was pulled off. The applicability of this test for plastic enclosure materials has been questioned, however, as the 122°F (50°C) temperature and 86% relative humidity test conditions could produce ferrotyping and adhesion that would not occur under more moderate conditions.

Nevertheless, experience over the past 10 years indicates that even under normal conditions, low-density polyethylene enclosures have a pronounced tendency to stick

to emulsions or cause ferrotyping of the emulsion surface; this problem has not been observed with films and prints stored in polyester and cellulose triacetate enclosures under the same moderate temperature and humidity conditions. This author has also noted that print emulsions in contact with low-density polyethylene for only a few months under normal storage conditions absorb unidentified substances from the polyethylene which causes India ink (such as Koh-I-Noor 3080-F Universal Waterproof Black India Ink) to form beads on the print surface and resist absorption into the emulsion.

Because of sticking and numerous other problems observed with these products — and the many unanswered questions concerning their long-term suitability — low-density polyethylene enclosures are not recommended.

## Polyvinyl Chloride (PVC) Enclosures — Not Recommended

Storage of photographs in either plasticized, low-plasticized, or nonplasticized polyvinyl chloride (PVC) is specifically advised against by American National Standard *ANSI IT9.2-1991*.[21] Kodak, Ilford, and Polaroid have also advised that PVC enclosures be avoided.[22,23,24] (It should be noted that despite Kodak's often-repeated recommendations to avoid PVC, since 1983 the company has supplied plasticized PVC print and negative wallets with its Kodalux "premium" Magnaprint 35 Service for oversize 4x6-inch prints. Polaroid has also sold print albums with pages made of plasticized PVC.)

Plasticized PVC has proven to be particularly harmful; it can contaminate, stick to, and even destroy films and prints. Problems are especially severe in humid storage conditions. To make PVC flexible, plasticizers, usually organic compounds, are added in large amounts (40 to 100 parts plasticizer per 100 parts PVC). Particularly when stored in high-humidity conditions, the plasticizers can gradually exude from the PVC, depositing sticky droplets or gooey coatings on photographs. Some types of plasticizers migrate more readily than others; high-humidity conditions appear to greatly increase exudation of the plasticizers. PVC plasticizers can support fungus growth in humid conditions, thereby causing additional damage to stored photographs. (Even under low-humidity conditions, the plasticizers in flexible PVC will cause softening, sticking, and partial transfer of electrostatic copier images, such as those made on Xerox machines.)

Plasticizers commonly used in the manufacture of PVC have a distinct odor, and the plasticizer content of many flexible PVC enclosures is so great that most people can easily smell fumes given off by the material when it is held a few inches from the nose. In addition to the plasticizers that make PVC flexible, antiblock agents, antistatic agents, stabilizers, and other additives are also commonly added to PVC during manufacture.

In a 1985 study of photographic enclosures materials, R. Scott Williams, a conservation scientist at the Canadian Conservation Institute, reported:

> I have examined two cases where slides were damaged by storage in phthalate plasticized poly(vinyl chloride) enclosures. In the first case,

oily droplets were formed on slides. These were identified as phthalate plasticizers identical to those contained in the poly(vinyl chloride) enclosures. When projected, the droplets on the slide are visible as disfiguring spots on the image.

> In the second case, a waxy film formed on slides with protective glass covers. Only slides with glass covers show this phenomenon. Unglassed slides in the same enclosure do not have the waxy film. Analysis of the waxy film showed it to be composed of carboxylate salts of the type used as lubricants or more commonly as heat stabilizers in poly(vinyl chloride), and that these components were also found in the PVC of the enclosure.

> In addition, there is the further, often cited, disturbing possibility that the PVC may degrade to produce acidic hydrogen chloride gas. It is to prevent this degradation that PVC must be highly compounded with additives to inhibit these reactions or to scavenge degradation products before they escape from the plastic.[25]

Flexible PVC is commonly used to make notebook-page enclosures with individual pockets for mounted transparencies. Some of these pages have a "frosted" PVC backing sheet to provide diffused light for viewing the transparencies. The front sides of the pages are usually glass-clear. The pages are normally made of a fairly thick PVC material to maintain rigidity in a notebook.

Beginning in 1977 and running through 1982, a number of articles and letters concerned with the pros and cons of PVC slide pages appeared in *Modern Photography* magazine. It started with a August 1977 column by *Modern* writer Ed Scully:

> All of the conferences [on preservation] I've attended have come to the same conclusion — if the sheet you store your slides or prints in stinks, don't use it. If you insist on handsome products for storing your slides, you will probably get stuck with one of the smelly polyvinyl chlorides that are poison for your color slides or prints.[26]

That brought an angry reply from Robert D. Shipp, president of 20th Century Plastics, Inc., a Los Angeles, California firm which is probably the largest supplier of PVC slide pages in the United States (20th Century Plastics has since introduced an extensive line of polypropylene slide pages). In a letter to the magazine, Shipp complained:

> . . . we feel that Mr. Scully has set forth in a most irresponsible manner false statements concerning such [PVC] products without any basis in fact nor without any empirical or scientific evaluation or collaboration.

> Mr. Scully's article has caused irreparable harm and injury to our company and its reputation and to others like us in the industry. Unless you have proof of the harmful nature of *all*

Polyvinyl Chloride materials, we demand an immediate retraction by Mr. Scully of his editorial article. . . . [27]

In its defense the magazine cited a list of literature references (including *ANSI PH1.43-1971*) which advised against the use of PVC, and concluded:

> It seems to *Modern* that the experts agree that PVC in general theory should be avoided . . . but that 20th Century Plastics has made tests in particular during which time no deleterious effects were noted. (And being practical about it, we searched for, but could not find, a single report anywhere in the world of damage to films, slides or prints caused by PVC.) The choice to use or not use any specific product, as always, thus remains with the purchaser. If and when there is additional information on PVC, pro or con, *Modern* will publish it.

A few months later, in 1980, Paul A. Elias, wrote a letter to *Modern* saying:

> Now that the Great Yellow Father [Eastman Kodak Company] has confirmed what we chemists have been saying for the last several years — that polyvinyl chloride can and does damage slides — how about dropping 20th Century Plastics from your list of advertisers? Do you still need to see dead bodies, or do you now believe because God [Eastman Kodak] said so?[28]

To which the magazine replied:

> Yes, indeed, Mr. Elias, Eastman Kodak's film experts have indicated that they do not recommend polyvinyl chloride sheets for storing transparencies. However, they have not *confirmed* anything! Before we take the stern measures you suggest, it is our considered opinion that we *do* need the "smoking gun" and so far, it hasn't materialized. In short we have yet to see a single set or even one transparency with damage claimed to be from PVC slide storage sheets, and until we do our advertising policy will not be changed.

In August 1981, Herbert Keppler, at the time the editorial director and publisher of *Modern Photography,* finally had the proof that the magazine was looking for:

> While I do not believe for an instant that all PVC pages will harm all slides, I now have what chemists feel is proof positive that some PVC slide storage pages sent me by readers have caused damaged to the slides therein, just as Kodak described. It can and does happen. It would appear that the plasticizer in PVC which contributes to the pages' flexibility, has a tendency to leach out, particularly with humidity, and can damage the slides.

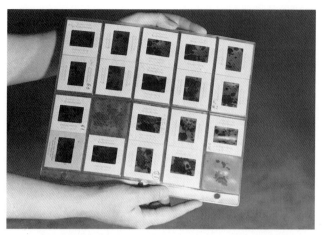

A plasticized PVC slide page in which gooey plasticizer has exuded onto the surface of Kodachrome slides. This page was discovered in the collection of Magnum Photos, Inc.'s New York City office in 1983, before the agency moved and upgraded its facility.

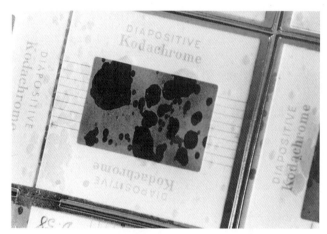

When viewed in light reflected off the surface of the slide page, the slimy droplets of plasticizer on the film and mount surfaces are readily apparent.

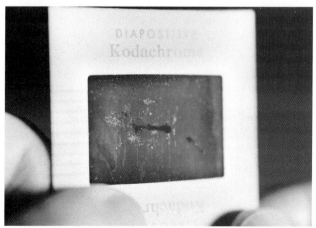

When a slide is removed from the page, image-damaging deposits of gooey plasticizer remain adhered to the film surfaces. Disposable gloves should be worn when removing slides from deteriorated pages to avoid getting plasticizer on one's hands.

A number of PVC page makers have had so-called accelerated scientific tests run by allegedly independent labs proposing to show no slide damage caused by PVC. Few, if any, ran them under humid conditions — and accelerated tests, I feel, are questionable — particularly when paid for by the very ones who hope to be exonerated.[29]

This author's experience with plasticized PVC points to the same conclusion reached by Keppler: namely, that the exudation of plasticizers is the primary problem of flexible PVC, and that high-humidity conditions tend to exacerbate the situation.

In 1983, 20th Century Plastics, Inc. added a number of "archival" polypropylene notebook-page enclosures to its line of products — the pages are sold under the EZ2C Super-heavyweight, EZ2C Heavyweight, and Century-Poly names. At the time of this writing, however, many 20th Century Plastics products continue to be made of plasticized PVC (and the company continued to advertise in *Modern Photography* until the magazine ceased publication and sold its subscription list to *Popular Photography* in 1990).

Also available from 20th Century Plastics and a number of other manufacturers are plasticized PVC enclosures designed to contain negatives, color transparency strips, and prints. They are of similar design to the previously described polyethylene enclosures and permit viewing of the photograph or direct contact printing of negatives through the enclosure (polyethylene enclosures are usually of a thinner gauge and are somewhat milky in appearance; the PVC enclosures are glass-clear).

Practical aspects of slide pages and slide storage systems are discussed in Chapter 18. Chapter 18 also in-

cludes a listing of suppliers of polypropylene slide pages — the only type of slide page recommended by this author. (The 20th Century Plastics EZ2C Super-heavyweight page is this author's primary recommendation for slide pages.)

## DuPont Tyvek — More Testing Needed

Tyvek is a synthetic material made of very thin high-density polyethylene fibers bonded under heat and pressure to make an opaque paper-like sheet. Tyvek and similar materials have been used extensively for high-strength mailing envelopes, protective storage jackets for computer floppy disks, and many other products; for a given weight and thickness, Tyvek is much stronger and tear-resistant than paper. With use, paper appears to generate significantly more dust (composed of bits of paper fiber) than does Tyvek.

In 1972 W. F. van Altena, who at the time was working at the Yerkes Observatory in Williams Bay, Wisconsin, studied the various paper and plastic enclosure materials then being used to store astronomical glass plates. He found problems with all of them but after some investigation, recommended that the most suitable material for such en-

Oozing down the inside of the film washer column, the plasticizer caused severe surface cracking (crazing) of the acrylic plastic.

Exudations of plasticizer are not restricted to PVC slide pages, but can occur with many types of heavily plasticized PVC. After about 15 years of storage in this author's darkroom, this PVC hose began to drip plasticizer onto an acrylic plastic film washer.

© Barbara Morgan

A recent contact print of a 4x5-inch negative made in 1942 that was damaged by being stored in a kraft paper envelope. The portrait, by Barbara Morgan, is of photography historian Beaumont Newhall. Then age 33, Newhall was director of the Department of Photography at the Museum of Modern Art in New York City. The negative was stored for more than 30 years with the emulsion side resting against the glued seam in the center of the envelope. This caused a yellowish stain in the area that was in contact with the seam; when printed, the stain resulted in the light (minus-density) band running through the center of the image. Damage of this type also has been caused by glued seams in glassine envelopes.

© Barbara Morgan

A print from another negative made at the same time and stored in an identical envelope. In this case, the negative was not harmed because the emulsion faced **away** from the glued seam. The negatives had been stored in Morgan's home outside New York City. As in most homes, during the summer months the relative humidity frequently was high; had the negatives been stored in a constant, low relative humidity environment, damage probably would not have occurred. A significant number of Morgan's negatives, including some of her well-known photographs of dancer and choreographer Martha Graham, were damaged by storage in kraft paper envelopes. (Courtesy Barbara Morgan)

velopes was Tyvek.[30] The material can be written on with ballpoint pens, but not with pencils. According to van Altena, Kodak conducted accelerated aging studies with Tyvek in contact with several types of processed color films for 14 and 28 days at 140°F (60°C) and 70% RH, and concluded that the material had no effect on the dye stability of the test films. No tests with silver-gelatin black-and-white materials were reported. Van Altena suggested use of Paisley adhesive No. 47-SU291, a polyvinyl acetate adhesive, for cementing the seams of the envelopes. Tyvek envelopes are now in use at several observatories; however, as yet they are not commercially available in normal roll film and sheet film sizes.

The soft surface of Tyvek appears to minimize the likelihood of scratches when prints and negatives slide against it. Upon further testing of both Tyvek and adhesives for cementing it, the material may prove to be a satisfactory substitute for high-quality paper envelopes for storing photographs. However, until the results of testing of specific, identified grades of Tyvek and suitable adhesives are published, this author suggests that Tyvek enclosures be avoided.

## Paper and Glassine Enclosures —
## Most Are Unsatisfactory

Until the late 1970's, when plastic photographic enclosures became popular, most envelopes and sleeves were made of glassine or brown kraft paper with the seams cemented with various types of adhesives. These materials

are generally unsuitable for long-term storage of photographs, and most older collections have examples of damage caused by glassine or kraft paper enclosures. Glassine is specifically advised against by *ANSI IT9.2-1991* and by Eastman Kodak.[31] So-called "acid-free" alkaline-buffered glassine should also be avoided. The most satisfactory low-cost substitutes for glassine envelopes are high-density polyethylene enclosures, which have been discussed previously.

Particular problems have been noted with paper and glassine envelopes which have a cemented seam in the center. The adhesive, which is often hygroscopic, can cause staining and fading of photographs, especially in humid storage conditions. Because the overlapped seam is two pieces of paper thick, added pressure is placed on the photograph in the seam area when the enclosures are stacked

1987

James Wallace, Jr., director and curator of Photographic Services at the Smithsonian Institution in Washington, D.C., is shown in the Photographic Services' cold storage vault. Older negatives stored in the vault have been removed from their original enclosures and placed in polyester sleeves, which in turn have been put in high-quality paper envelopes.

1987

To speed the resleeving project and also to retain all inscriptions and markings on the original negative envelopes, a Canon office copier that could accommodate 4x5-inch and larger negative envelopes was obtained, and the old envelopes were copied onto the new ones.

or placed tightly in boxes. The localized pressure aggravates problems with the adhesive. Negatives filed in this type of enclosure should have the base side of the film next to the seam to avoid emulsion contact with the adhesive area. Old collections should be examined and the negatives reoriented if necessary so that none of the film emulsions are in contact with the cemented seam. Keeping the relative humidity in the storage area between 25% and 40% will considerably slow deterioration.

*ANSI IT9.2-1991* says the following about adhesives:

> If an adhesive is used, it shall have no harmful effect on the photographic images. The adhesive shall be applied to Whatman Number 1 filter paper and shall pass the photographic activity test outlined in 5.1. . . . Some photographic images can be damaged by adhesives incorporating impurities such as sulfur, iron, copper, or other ingredients that might attack image silver, gelatin, or the paper support of prints. Various adhesives are hygroscopic, thus increasing the possibility of local chemical activity. Pressure-sensitive and ether-linked products should be avoided.
>
> Avoid using rubber-base products such as rubber cement. Not only might they contain harmful solvents or plasticizers, but they might be compounded with photographically damaging sulfur, usually a vulcanizer, accelerator, or stabilizer. Even some "low-desensitizing" or "sulfur-free" rubbers contain sulfur.
>
> If a particular brand of commercially made adhesive is found to be safe for long-term storage purposes, there is no assurance that subsequent batches will contain ingredients of the same purity.[32]

The low-quality paper and glassine with which many enclosures are made can be very damaging to prints and films in long-term storage, especially in humid conditions. Eugene Ostroff of the Smithsonian Institution in Washington, D.C. has described some of the problems:

> The brown kraft negative envelopes traditionally used for storing negatives contain image-damaging ingredients, such as lignin, which generate destructive peroxides. (As we have all observed, kraft envelopes quickly become brittle and disintegrate.) Glassine paper, more fragile than kraft, is made from "hydrated" fibers that enhance translucency and flexing properties, characteristics that are heightened with plasticizers and other additives. Many of these ingredients are impermanent (they volatilize or leach out); the paper becomes brittle and falls apart at the slightest touch. Aside from damaging the image, these degenerative byproducts also might destroy all cataloging information written on the envelopes. Consequently, additional labor costs are incurred by making new entries, refiling, and cleaning debris from the cabinet.[33]

1987

Barbara Whitted, a technician at the NASA Film Repository at the Lyndon B. Johnson Space Center in Houston, Texas, removes negatives and transparencies from their original glassine and acetate sleeves and places the films into new polyester sleeves, which are then inserted into protective paper envelopes. With Whitted is Gary Seloff, curator of visual resources at the Johnson Space Center. The resleeving project involved more than 600,000 items.

James McCord, chief of the photographic laboratories at the Earth Resources Observation Systems (EROS) Data Center in Sioux Falls, South Dakota, reported in 1979 that cemented seams on glassine envelopes caused localized yellow dye loss on Kodak Ektachrome Duplicating Film Type 2447; the yellow dye fading could in some cases be detected in as little as 90 days and was frequently observed within 6 months.[34]   After the problem was detected, the EROS Data Center discarded all the glassine envelopes in its collection and replaced them with paper and Tyvek envelopes.

In 1987, the National Aeronautics and Space Administration (NASA) began a massive project to resleeve the more than 600,000 still photographs that were being stored in glassine and cellulose triacetate enclosures in the collection of color and black-and-white photographs stored at the NASA Film Repository at the Lyndon B. Johnson Space Center in Houston, Texas.   On the advice of Noel Lamar, a consultant working for NASA, polyester folders (without a top-flap), placed in high-stability alkaline-buffered paper envelopes, were adopted for the resleeving project (this is the same method of storage that was used by the late Ansel Adams for his negatives).

General requirements for paper suitable for photographic

filing enclosures are discussed in Chapter 13.   When a paper envelope is made with glued seams, the adhesive must be acceptable when tested by the *ANSI IT9.2-1991* Photographic Activity Test with every type of black-and-white and color material that is to be stored in it.   The reader is also referred to Chapter 13 for a discussion of accelerated tests for paper enclosures, mount boards, and adhesives to be used with black-and-white and color films and prints.

A paper envelope based on the design suggested in *ANSI IT9.2-1991* is shown in **Figure 14.2**.  Only two narrow glued seams are needed — one on each side.  The seams are non-overlapping, and an ungummed top-flap is provided to keep out dust and dirt.  Because a photograph in an envelope usually rests against the bottom, the bottom is folded to avoid a glued seam.  This design results in a smooth interior and provides three uniform thicknesses of paper on the top and both sides, thereby promoting even stacking and minimizing localized pressure on the enclosed film or print.  A nonreactive and nonhygroscopic cement is essential for connecting the seam-flaps to the outside of the envelope; polyvinyl acetate (PVA) adhesives have been recommended by Kodak.[35]  Ideally, this envelope would be used in combination with top-flap polyester sleeves.  At the time of this writing, high-quality envelopes of the ANSI-suggested design and made with tested papers and adhesives were not yet commercially available.

## Encapsulation of Photographs — Sometimes Useful

Photographs may be placed between two polyester sheets which are joined to each other on the edges with special double-sided pressure-sensitive tapes (3M Scotch Double-Coated Film Tape No. 415 is usually recommended for this purpose).[36]  The photograph itself is not in contact with the double-sided tape and can readily be removed by cutting open one edge of the encapsulation.  This technique can be particularly effective if the photograph is fragile.  Some concern has been expressed about the possibility of lateral migration of the adhesive beyond the edges of the double-sided tape; over time the adhesive might contact the edge of the encapsulated print.  Encapsulation has been used extensively at the Library of Congress and other institutions (for detailed instructions on how to encapsulate photographs and documents, refer to *Polyester Film Encapsulation,* published by the Library of Congress[37]).

As an alternative to double-sided pressure-sensitive tape, Jane Booth of the San Diego Historical Society has a method by which she sews two sheets of polyester together with nylon thread on an ordinary sewing machine.[38]  The stitching enables her to quickly make enclosures that are tailored to the size and proportions of individual prints and to the requirements of her files.  It is also possible to make enclosures with multiple compartments for storage of a number of smaller prints.  In addition, potential problems with pressure-sensitive tapes are avoided.

Institutions which encapsulate photographs or fabricate other types of polyester enclosures on a large scale will find an electrically operated sealing machine, such as the Polyweld Model B-50 device sold by Conservation Resources International, Inc., to be very convenient.

# Notes and References

1. Seams of cellulose triacetate sleeves can be cemented with a solvent such as methylene chloride or a cement composed of cellulose triacetate dissolved in methylene chloride or other suitable solvent. Kodak Transparent Sleeves, made of cellulose triacetate, have cemented top and bottom seams. Solvent bonding is probably harmless to photographs kept in such enclosures and avoids the sorts of problems encountered with the glues used in many paper and glassine envelopes.

2. Suitable papers include Atlantis Silversafe Photostore (a 100% cotton fiber paper) and Archivart Photographic Storage Paper, both supplied in the U.S. by Archivart Division of Heller & Usdan, Inc., 7 Caesar Place, Moonachie, New Jersey 07074; telephone: 201-804-8986; toll-free: 800-333-4466. Silversafe Photostore is made by the Atlantis Paper Company, Ltd., No. 2 St. Andrews Way, London E3 3PA, England; telephone: 011-44-71-537-2727. Also believed to be satisfactory is Renaissance Paper, a paper intended for photographic storage applications and supplied by Light Impressions Corporation. All of these papers are nonbuffered and have a near-neutral pH at the time of manufacture. See Chapter 13 for further discussion.

3. Eastman Kodak Company, **Preservation of Photographs,** Kodak Publication No. F-30, Eastman Kodak Company, Rochester, New York, August 1979, p. 31.

4. "Oakland Fire Results in New Storage Ideas," **Newsletter of the Friends of Photography,** Vol. 5, No. 12, December 1982.

5. Thomas O. Taylor, "Identification and Use of Plastic Materials for Photographic Storage," presentation at the American Institute for Conservation Photographic Materials Group Winter Meeting, Philadelphia, Pennsylvania, February 2, 1985.

6. Sleeves should be made of **uncoated** polyester, such as DuPont Mylar D or ICI Melinex 516. Polyester sheet is sold with a wide variety of surface coatings which allow it to be cemented, heat-sealed, or to accept printing inks and dyes or other treatments. Some coatings give the sheets antistatic properties. Many of these coatings are hygroscopic, creating a high surface-moisture level. These coatings may cause the sleeves to stick to each other or to photographs stored in them and may produce chemical damage to photographic images. Sleeves ordered by this author in 1974 were made of a coated polyester — even though uncoated Mylar polyester was specified. The fact that the polyester was coated became apparent when the sleeves started firmly sticking to themselves during storage in this author's darkroom. Fortunately, the problem was discovered before any of the negatives stored in the sleeves were damaged. Mylar D or a similar uncoated polyester film must be specified, and the importance of using an uncoated product should be stressed when purchasing polyester sheet material or when having sleeves made by custom plastics fabricators.

   If it is necessary to have sleeves specially made, emphasize to the fabricator the need for **tight** folds so that the film or print will not have a tendency to slip out of the sleeve during handling. Sleeves made for glass plates should have folds of a much larger radius to properly accommodate the relatively thick plates; these sleeves should not be used for films or prints. A number of plastics fabricators can make sleeves of this type on special order. One firm which has advertised that it is willing to handle small orders for special designs of Mylar D polyester enclosures is the Taylor Made Company, P.O. Box 406, Lima, Pennsylvania 19037; telephone: 215-459-3099.

   See also: "A Clear Connection with the Past," **DuPont Magazine,** Vol. 76, No. 6, November–December 1982, pp. 10–11.

7. P. Z. Adelstein and J. L. McCrea, "Stability of Processed Polyester Base Photographic Films," **Journal of Applied Photographic Engineering,** Vol. 7, No. 6, December 1981, pp. 160–167.

8. W. J. Barrow, "Migration of Impurities in Paper," **Archivum,** Vol. 3, 1953, pp. 105–108.

9. Photofile, Inc. and the Hollinger Corporation, among others, sell polyester sleeves, made with DuPont Mylar Type EB-11 or similar products, which contain a silicon dioxide matting agent. These sleeves are highly abrasive and should be avoided. For a number of years Light Impressions Corporation also sold Mylar Type EB-11 sleeves and folders; the company discontinued EB-11 sleeves in 1988.

10. Pre-made enclosures of this type, with an open top, are available from Jerry Solomon Gallery Services, Inc., 960 North La Brea Avenue, Los Angeles, California 90038; telephone: 213-651-1950; toll-free 800-821-5948. The firm will custom make the design described by this author; a minimum order of 25 enclosures is requested.

11. Light Impressions Corporation supplies a matched set of polyester sleeves, polyester folders, and paper envelopes under the NegaGuard name. However, the envelopes are of an open-top design which allows dust to enter. The basic idea behind the NegaGuard system is sound and it is hoped that the envelopes will be improved.

12. Probably the first supplier of polypropylene photographic enclosures was C-Line Products, Inc. The firm produces surface-treated (coated) polypropylene notebook pages for mounted slides, negatives, and prints in various formats. Certain C-Line products have been sold under private labels by Light Impressions Corporation, Kleer-Vu Plastics Corporation, and others. Kleer-Vu Plastics fabricates its own polypropylene print and film enclosures; C-Line has made Kleer-Vu's slide pages. Polypropylene notebook-page enclosures are not recommended for other than mounted slides.

   Sleeves made of polypropylene and designed to accommodate stereo views and carte-de-visite photographs are available from Russell Norton Photographic Antiques, P.O. Box 1070, New Haven, Connecticut 06504-1070; telephone: 203-562-7800.

13. American National Standards Institute, Inc., **ANSI IT9.2-1991, American National Standard for Imaging Media — Photographic Processed Films, Plates, and Papers — Filing Enclosures and Containers for Storage.** (This Standard, which replaced **ANSI PH1.53-1986,** includes a new version of the Photographic Activity Test which is based on work done by James M. Reilly and Douglas W. Nishimura at the Image Permanence Institute at the Rochester Institute of Technology in Rochester, New York.) American National Standards Institute, Inc., 11 West 42nd Street, New York, New York 10036; telephone: 212-642-4900; Fax: 212-302-1286. See also: American National Standards Institute, Inc., **ANSI PH1.45-1981, American National Standard Practice for Storage of Processed Photographic Plates,** Sec. 3.3, p. 7.

14. American National Standards Institute, Inc., see Note No. 13. The Photographic Activity Test described in the Standard is a relatively simple test which, because of the combination of the elevated temperature and high relative humidity employed, may not be appropriate for the evaluation of plastic storage materials.

15. Lisa Overton, Kleer-Vu Plastics Corporation, telephone discussion with this author, August 31, 1983. When introduced in 1983, Pro-Line sleeves were sold under the Poly-Pro name. The polypropylene sheet used to make Kleer-Vu sleeves is untreated T500 film manufactured by Hercules, Inc. in Wilmington, Delaware. In a letter dated February 9, 1983, Henry K. Graves (district sales manager at the time, Mr. Graves is currently process systems manager) of Hercules, Inc. in Norcross, Georgia, told Kleer-Vu that: "This information is of interest to customers concerned with protection of photographic materials and archival documents. Concern about pH, sulfur content and peroxide level is a result of past problems with glassine, paper and paperboard storage envelopes or containers. Hercules T500 untreated polypropylene films have been tested at an independent test lab and the results were as follows: **(1)** pH — heavy gauge T500 films are neutral and therefore have a pH of 7.0; **(2)** Active Hydrogen — none; this is expected in view of the pH results; **(3)** Peroxide Content — not detectable (limit of detection — 0.015 mcg/cm$^2$); **(4)** Sulfur Content — not detectable (limit of detection — 3ppm); T500 also passes the Photographic Activity Test (**ANSI PH1.53-1978** Section 6.1)." The Photographic Activity Test referred to here is the same as Sec. 5.1 in the 1986 revision of **ANSI PH1.53;** the test apparently was performed only with a limited number of older black-and-white and color materials.

16. The C-Line polypropylene notebook page enclosure which stuck to photographs was stored in a New York City apartment. Situated on the top floor of a non-air-conditioned building, the apartment was hot and humid during the summer months — and cool and dry during the winter.

17. Jack VerMeulen, Quality Control Manager, C-Line Products, Inc., letter to this author, December 12, 1984.

18. Clyde V. Detter, "Films, Polyethylene, High-Density," in **Packaging Encyclopedia & Yearbook — 1985,** William C. Simms, ed., Cahners Publishing Company, Des Plaines, Illinois, 1985, p. 62.

19. Robert Hagle, "A Negative on Filing," letter to the editor in **Camera 35,** Vol. 35, No. 12, December 1980, p. 6.

20. Kenneth C. Smeltz, "Why Do White Fabrics and Garments Turn Yellow During Storage in Polyethylene Bags and Wrappings? — A Growing Problem," **Textile Chemist and Colorist,** Vol. 15, No. 4, April 1983, pp. 17–21.

21. American National Standards Institute, Inc., see Note No. 13.

22. Eastman Kodak Company, see Note No. 3, p. 9.

23. Ilford, Inc., **Ilford Galerie,** Ilford, Inc., West 70 Century Road, Paramus, New Jersey 07652, 1979, p. 16.

24. Polaroid Corporation, **Storing, Handling and Preserving Polaroid Photographs: A Guide,** Publication No. P2064, Polaroid Corporation, Cambridge, Massachusetts, 1983, p. 29.

25. R. Scott Williams, "Commercial Storage and Filing Enclosures for Processed Photographic Materials," **Second International Symposium: The Stability and Preservation of Photographic Images,**

Ottawa, Ontario, August 25–28, 1985, (Printing of Transcript Summaries), IS&T, The Society for Imaging Science and Technology, 7003 Kilworth Lane, Springfield, Virginia 22151; telephone: 703-642-9090. See also: Robert E. Mayer, "Oily Droplets on Slides," (in Images and Answers), **Photomethods,** Vol. 27, No. 9, September 1984, p. 52. For discussion of the possible formation of hydrochloric acid by the decomposition of polyvinyl chloride see: Thomas W. Sharpless, "Corrosion: The Problem of Storage," **The Numismatist,** Vol. 93, No. 10, October 1980, pp. 2450–2454. Also: Ed Reiter, "Little 'PVC' Holders Can Cause Big Problems," (Numismatics), **The New York Times,** January 25, 1981, Sec. D, p. 35.

26. Ed Scully, "Preservation, Duplicating, Temperature Control — Did I Ever Get My Foot in My Mouth in Record Time! Now to Get It Out By Answering Your Letters About Recent Columns," **Modern Photography,** Vol. 41, No. 8, August 1977, pp. 47ff.

27. Robert D. Shipp, "Letter to the Editor," **Modern Photography Magazine,** Vol. 42, No. 1, January 1978, pp. 6, 8.

28. Paul A. Elias, "Letter to the Editor," **Modern Photography,** Vol. 44, No. 8, August 1980, p. 83.

29. Herbert Keppler, "Why Chance Damaging Slides in PVC Pages?", **Modern Photography,** Vol. 45, No. 8, August 1981, pp. 68–70.

30. W. F. van Altena, "Envelopes for the Archival Storage of Processed Astronomical Photographs," **AAS Photo-Bulletin,** No. 1, 1975, pp. 18–19. The article listed two sources for Tyvek envelopes: Mail Well Envelopes, Division of Georgia-Pacific Lumber Company, 5445 North Alston Avenue, Chicago, Illinois 60630, and Coast Envelope Company, 2930 South Vail Avenue, Los Angeles, California 90040. Cost of the envelopes was reported to be similar to that of high-quality paper envelopes.

31. Eastman Kodak Company, **Conservation of Photographs** (George T. Eaton, editor), Eastman Kodak Company, Rochester, New York, March 1985, p. 95.

32. American National Standards Institute, Inc., see Note No. 13.

33. Eugene Ostroff, **Conserving and Restoring Photographic Collections,** American Association of Museums, Washington, D.C., 1976, p. 14.

34. James McCord, EROS Data Center, Sioux Falls, South Dakota, interview with this author during visit to Earth Resources Observation System (EROS) Data Center, December 1979. The EROS Data Center is operated by the U.S. Geological Survey, U.S. Department of the Interior. The two orbiting Landsat satellites and associated systems, which originate many of the images processed by the EROS Data Center, were sold by the U.S. Government on October 18, 1985 to the Earth Observation Satellite Company (Eosat), a joint venture of Hughes Aircraft Company and RCA Corporation (RCA was acquired by the General Electric Company in late 1985).

35. Eastman Kodak Company, see Note No. 31, p. 97.

36. For encapsulation using sheets of uncoated polyester, such as Du-Pont Mylar D, 3M Scotch Double-Coated Film Tape No. 415 is recommended: 3M Company, Industrial Specialties Division, Bldg. 220-7E-01 — 3M Center, St. Paul, Minnesota 55144; telephone: 612-733-8202. This tape is available from many suppliers, including Light Impressions Corporation and Talas Inc. (see **Suppliers** list at the end of this chapter for addresses).

37. Preservation Office of the Library of Congress, **Polyester Film Encapsulation,** Library of Congress, Washington, D.C., 1980.

38. Jane Booth, San Diego Historical Society, telephone discussion with Carol Brower, December 10, 1982.

## Additional References

Joan Agranoff, ed., **Modern Plastics Encyclopedia 1984/1985,** Vol. 61, No. 10A, McGraw-Hill Inc., New York, New York, 1984.

Gary Albright, "Which Envelope? Selecting Storage Enclosures for Photographs," **Picturescope,** Vol. 31, No. 4, Winter 1985, pp. 111–113.

W. F. van Altena, "Report of the Subgroup on the Storage of Astronomical Plates for Archival Purposes," **AAS Photo-Bulletin,** No. 2, 1972, pp. 15–17.

Calvin J. Benning, **Plastic Films for Packaging,** Technomic Publishing Co., Inc., Lancaster, Pennsylvania, 1983.

J. H. Briston and L. L. Katan, **Plastics Films,** 2nd ed., (George Goodwin in association with the Plastics and Rubber Institute), Longman Group Limited, Harlow, England, 1983.

Helen D. Burgess, "Evaluation of Paper Products: With Special Reference to Use with Photographic Materials," **Topics in Photographic Preservation – Volume Four** (compiled by Robin E. Siegel), Photographic Materials Group of the American Institute for Conservation, 1991, pp. 96–105. Available from the American Institute for Conservation, Suite 340, 1400 16th Street, N.W., Washington, D.C. 20036; telephone: 202-232-6636.

T. J. Collings, **Archival Care of Still Photographs,** Society of Archivists Information Leaflet No. 2, Society of Archivists, 56 Ellin Street, Sheffield S1 4PL, England, 1986.

Klaus B. Hendriks, together with Brian Thurgood, Joe Iraci, Brian Lesser, and Greg Hill of the National Archives of Canada staff, **Fundamentals of Photographic Conservation: A Study Guide**, published by Lugus Publications in cooperation with the National Archives of Canada and the Canada Communication Group, 1991. Available from Lugus Productions Ltd., 48 Falcon Street, Toronto, Ontario, Canada M4S 2P5; telephone: 416-322-5113; Fax: 416-484-9512.

Margaret Hobbie, "Paper and Plastic Preservers for Photographic Prints and Negatives," **History News,** Vol. 35, No. 10, October 1980, pp. 42–45.

Dan O'Neill, "Filing Slides and Negs," **Technical Photography,** Vol. 14, No. 9, September 1982, pp. 38, 40, 43.

Debbie Hess Norris, "The Proper Storage and Display of a Photographic Collection," **Picturescope,** Vol. 31, No. 1, Spring 1983, pp. 4–10.

Mary Kay Porter, "Filing Enclosures for Black and White Negatives," **Picturescope,** Vol. 29, No. 3, Fall 1981, p. 108.

James M. Reilly and Douglas W. Nishimura, "Improvements in Test Methods for Photographic Storage Enclosures," presentation at the SPSE (The Society for Imaging Science and Technology) 40th Annual Conference and Symposium on Hybrid Imaging Systems, Rochester, New York, May 19, 1987.

James M. Reilly, Douglas W. Nishimura, Luis Pavao, and Peter Z. Adelstein, "Photo Enclosures Research and Specifications," **Topics in Photographic Preservation – Volume Three** (compiled by Robin E. Siegel), Photographic Materials Group of the American Institute for Conservation, 1989, pp. 1–7. Available from the American Institute for Conservation, Suite 340, 1400 16th Street, N.W., Washington, D.C. 20036; telephone: 202-232-6636.

Mary Lynn Ritzenthaler, "Storage Enclosures for Photographic Materials," (SAA Basic Archival Conservation Program), The Society of American Archivists, **SAA Newsletter,** November 1984.

Lloyd R. Whittington, **Whittington's Dictionary of Plastics,** (Society of Plastics Engineers), Technomic Publishing Co., Inc., Lancaster, Pennsylvania, 1978.

*(Turn Page for Chapter 14 Suppliers List)*

October 31, 1990

A Photech hot-seal plastic sleeving machine in operation at H&H Color Lab under the watchful eye of Darrell Owens, a film processing technician.  H&H, a leading professional portrait and wedding lab located near Kansas City in Raytown, Missouri, processes and proofs up to 2,000 rolls of color negative film a day (mostly in the 120/220 format).  Sleeving is done immediately after processing to protect the film from dust and scratches.  The film is video analyzed, proofed, and shipped to customers without ever removing the film from the sleeves.

# Suppliers

## Envelopes and Sleeves

**Archivart**
Division of Heller & Usdan
7 Caesar Place
Moonachie, New Jersey 07074
    Telephone: 201-804-8986
    Toll-free: 800-333-4466

**Clear File, Inc.**
P.O. Box 593433
Orlando, Florida 32859-3433
    Telephone: 407-851-5966
    Toll-free: 800-423-0274

**C-Line Products, Inc.**
1530 East Birchwood Avenue
P.O. Box 1278
Des Plaines, Illinois 60018
    Telephone: 312-827-6661
    Toll-free: 800-323-6084

**Conservation Resources
International, Inc.**
8000-H Forbes Place
Springfield, Virginia 22151
    Telephone: 703-321-7730
    Toll-free: 800-634-6932

**Filmguard Corporation**
P.O. Box 788
Escondido, California 92033
    Telephone: 619-741-7000
    Toll-free: 800-777-7744

**Hollinger Corporation**
4410 Overview Drive
P.O. Box 8360
Fredericksburg, Virginia 22404
    Telephone: 703-898-7300
    Toll-free: 800-634-0491

**Kleer-Vu Plastics Corporation**
Kleer-Vu Drive
P.O. Box 449
Brownsville, Tennessee 38012
    Telephone: 901-772-5664
    Toll-free: 800-238-6001

**Light Impressions Corporation**
439 Monroe Avenue
Rochester, New York 14607-3717
    Telephone: 716-271-8960
    Toll-free: 800-828-6216

**Lineco Inc.**
P.O. Box 2604
Holyoke, Massachusetts 01041
    Telephone: 413-534-7815
    Toll-free: 800-322-7775

## Envelopes and Sleeves

**National Photo Products Company**
4400 Santa Ana Street
P.O. Box 1038
Cudahy, California 90201
    Telephone: 213-771-1211
    Toll-free: 800-421-6184

**NegaFile Systems, Inc.**
P.O. Box 78
Furlong, Pennsylvania 18925
    Telephone: 215-348-6342

**Photofile, Inc.**
2020 Lewis Avenue
Zion, Illinois 60099
    Telephone: 708-872-7557
    Toll-free: 800-356-2755

**Picture Pocket Corporation**
242 Bingham Drive
San Marcos, California 92069
    Telephone: 619-744-2425
    Toll-free: 800-369-0852

**Print File, Inc.**
1846 South Orange Blossom Trail
Apopka, Florida 32703
    Telephone: 407-886-3100

**Reeves Photo Sales, Inc.**
9000 Sovereign Row
Dallas, Texas 75247-4598
    Telephone: 214-631-9730
    Toll-free: 800-527-9482

**Savage Universal Corporation**
800 West Fairmont Drive
Tempe, Arizona 85282
    Telephone: 602-967-5882
    Toll-free: 800-624-8891

**Talas Inc.**
213 West 35th Street
New York, New York 10001-1996
    Telephone: 212-736-7744

**Taylor Made Company**
P.O. Box 406
Lima, Pennsylvania 19037
    Telephone: 215-459-3099

**20th Century Plastics, Inc.**
P.O. Box 30810
Los Angeles, California 90030
    Telephone: 213-731-0900
    Toll-free: 800-767-0777

**Vue-All, Inc.**
P.O. Box 1690
Ocala, Florida 32678
    Telephone: 904-732-3188
    Toll-free: 800-874-9737

## High-Density Polyethylene Sleeving Material in Rolls; Sleeving Machines

**Agfa-Copal, Inc.**
2605 Fernbrook Lane
Plymouth, Minnesota 55477
    Telephone: 612-553-0366
    Toll-free: 800-866-6692
(Copal sleevers and sleeving material)

**Byers Industries, Inc.**
6955 S.W. Sandburg Street
P.O. Box 23399
Portland, Oregon 97223
    Telephone: 503-639-0620
    Toll-free: 800-547-9670

**CPAC, Inc.**
2364 Leicester Road
Leicester, New York 14481
    Telephone: 716-382-3223

**Crown Photo Systems, Inc.**
P.O. Box 1298
Everett, Washington 98206
    Telephone: 206-339-1518
    Toll-free: 800-228-1518
(Crown sleevers and sleeving material)

**DOI, Inc.**
15 East 42nd Street
New York, New York 10017
    Telephone: 212-661-0876
(DOI sleevers and sleeving material)

**Minilab Specialties, Inc.**
17762 Metzker Lane
Huntington Beach, California 92647
    Telephone: 714-842-0059
    Toll-free: 800-633-8091
(Labokey sleevers and sleeving material)

**Noritsu America Corporation**
69 Noritsu Avenue
Buena Park, California 90620
    Telephone: 714-521-9040
(Noritsu sleevers and sleeving material)

## Hot-Seal Plastic Sleeving and Automatic Application Machines

**Climax, Ltd.**
780 Fort Bragg Road
P.O. Box 399
Willits, California 95490
    Telephone: 707-459-4535
    Toll-free: 800-444-0977
(Climax [Hostert-style] hot-seal sleevers; polypropylene sleeving material)

# 15. Framing Materials, Storage Boxes, Portfolio Cases, Albums, Cabinets, and Shelves

The photo album, storehouse for the treasured memories of many of the nation's 64 million families, often damages the images it holds. The materials and construction of many new imported albums, as well as millions of albums purchased in years past, create a harsh environment for photographic prints, research has shown.

At risk are black and white photographs and the color snapshots that have documented the lives of millions during the last four decades.

"An essential part of many families' heritage is in danger of being lost, and yet few are aware of it," said James M. Reilly, director of the Image Permanence Institute of the Rochester Institute of Technology.

"People think that by putting these family treasures in an album, they're being preserved forever, to be passed down to future generations," said Judith Fortson, the conservation officer at the Hoover Institution of Stanford University in California. "Yet in many cases these albums are helping speed their deterioration."

In some albums, "photographs are ruined much more quickly than they would be if you just left them in a shoe box," said Douglas Severson, a conservator at the Art Institute of Chicago. He is chairman of the photography group of the American Institute for Conservation, the national organization of professional conservators and researchers.

The situation is increasingly serious, said Mr. Reilly, "because the materials in the photo albums are getting cheaper and cheaper" as stores sell low-priced albums imported from the Far East.

The Rochester Institute's most recent research shows that "the level of damage from poor-quality materials is much worse than we had imagined," Mr. Reilly said.[1]

Glenn Collins
*The New York Times*
October 3, 1987

**See page 511 for Recommendations**

## Framing Color and Black-and-White Prints

Displayed photographs should always be framed under glass for protection against physical damage and accumulation of dirt, grease, and insect residues. Tars and other components of cigarette smoke in homes and offices produce yellow and brown stains on unframed and uncovered prints; in poorly ventilated public buildings, severe stains can occur in only a few years. Cooking food generates airborne droplets of oil and grease which travel throughout a home. Photographs, unlike furniture, carpets, and walls, cannot easily be cleaned. Framing under glass can also give prints and mounting materials significant protection against moisture fluctuations as well as oxidizing gases and other air pollutants.

Examination of large numbers of old black-and-white photographs leaves no doubt that proper framing with an overmat — and hanging the framed photograph in an area free from excessively high relative humidity — is one of the best ways to preserve a print. Frames with glass (or Plexiglas acrylic plastic sheet in short-term applications) give prints outstanding physical protection, totally preventing the surface abrasions, dirt, fingerprints, scratches, and cracks often found on older photographs that have not been framed.

With the exception of UltraStable Permanent Color prints and Polaroid Permanent-Color prints, both of which are made with extraordinarily stable color pigments, prolonged exposure to light on display will ruin color photographs — framed or not. Consequently, valuable color prints should not be displayed except for limited periods of time under moderate lighting conditions (such as in short-term museum exhibitions). For extended display, an expendable duplicate or copy print should be obtained and the original color print stored in the dark.

When having professional portraits or wedding pictures made, the customer should be certain to purchase a duplicate (even if in a smaller size) of each print that will be displayed and to store it in the dark. Many portrait photographers dispose of their color negatives within a few years (or *immediately*, in the case of most low-cost department store and school photographers), so it will probably be impossible to have replacement prints made in the future.

## Framing Black-and-White RC Prints: A Word of Caution

Many framed black-and-white RC (polyethylene-resin-coated) prints have become severely discolored and faded after only a few years of display, even though the prints were properly fixed and washed. When RC prints are sealed

1982

Exhibition galleries at the Art Institute of Chicago. Frames provide photographs with a semi-sealed environment that offers excellent protection against dirt, physical damage, and (to some extent) the effects of air pollutants. Carefully chosen frames also enhance the appearance of displayed photographs.

in a frame, oxidants produced by the deteriorating effects of light and UV radiation on the RC base can accumulate inside the frame and attack the silver image, causing either localized or overall yellow or orange-red discolorations. High-humidity conditions accentuate this type of image deterioration. There is also evidence that black-and-white RC papers are more susceptible than fiber-base papers to image discoloration caused by other sources, such as atmospheric pollutants, surface contaminants, or reactive substances in framing and filing materials.

The most important single factor that determines whether — or how soon — a displayed RC print will discolor is the *type of paper* with which the print is made. This author has seen countless prints from the 1970's and early 1980's made with Kodak Polycontrast Rapid RC Paper, Kodak Polycontrast Rapid II RC Paper, and Ilford Ilfospeed Paper which became severely discolored as a consequence of exposure to light on display. Most of these prints had been framed; however, some were simply tacked to a wall and were exposed to the open air. The Corcoran Gallery of Art in Washington, D.C., the Art Institute of Chicago, and the National Archives of Canada in Ottawa, among other well-known institutions, now have black-and-white RC prints in their collections that became severely discolored after only a few years of display and storage; with the passage of

time, it is inevitable that huge numbers of prints worldwide are going to be affected.

Image deterioration of Polycontrast Rapid RC prints is characterized by extreme yellow and orange discolorations and formation of silver mirror-like deposits along density gradient lines (e.g., at the junction of white and black image areas). Some Polycontrast Rapid RC prints have also developed large numbers of small, circular orange-red discolorations (known as redox blemishes, or microspots); previously associated primarily with microfilms and astronomical plates, such defects have not, to this author's knowledge been encountered in any fiber-base prints. Some Polycontrast Rapid RC prints have also suffered from cracking of the emulsion-side RC layer; many Ektacolor RC prints from the late 1960's and early 1970's also have suffered from RC base cracking.

Image deterioration of displayed Ilford Ilfospeed prints is generally characterized by an overall yellow-brown discoloration, which is quite different in appearance from the discoloration seen with Kodak RC prints. Many Ilford RC prints from the late 1970's and early 1980's also suffer from pronounced brownish discoloration of the RC paper base; the discoloration, believed to be caused by developer chemicals incorporated into the paper's emulsion during manufacture, is most obvious on the backside of the prints.

# Recommendations

## Framing Materials

- **Frames:** Aluminum section frames are inert, inexpensive, lightweight, unaffected by moisture fluctuations, and otherwise ideally suited for framing photographs. Stainless steel and brass are also safe, but are expensive and heavy. Wood frames should not be used for black-and-white photographs, although they probably will not harm color prints. Museums and archives should avoid wood frames altogether.

- **Glazing:** Glass and high-quality acrylic plastic sheet (e.g., Plexiglas or Lucite) are recommended for color photographs. UV-absorbing grades of acrylic sheet offer little if any additional protection against light fading for most types of color photographs. Glass — although it is subject to breakage — is less expensive and has much greater resistance to scratching than plastic. Although Plexiglas and other plastics are satisfactory for framing in short-term exhibitions and traveling shows, they should be avoided for long-term use with black-and-white photographs.

- **Prevent contact between prints and framing glass:** Overmats are recommended to lessen the possibility of prints sticking to framing glass or plastic over time.

- **Frame moisture barriers:** Aluminum foil or polyester (e.g., DuPont Mylar or ICI Melinex) should be placed between the mount board and backing board of framed prints, except for black-and-white RC prints; for these, the author tentatively recommends that a vapor barrier be omitted to allow peroxides generated by the RC print base during prolonged exposure to light to gradually diffuse out of the frame. Frames should not be "vented."

- **Backing boards:** Aluminum sheet, high-quality mount board, corrugated polypropylene "cardboard," and Lig-free Type II box board (Conservation Resources International) are recommended. Ordinary cardboard, chipboard, plywood, and Masonite should all be strictly avoided. Fome-Cor and other polystyrene-foam laminate boards are probably satisfactory for backing (and mounting) expendable color prints intended for display, but should be avoided for valuable black-and-white prints.

## Storage Containers

- **Cardboard storage boxes:** Lig-free Type II boxes (Conservation Resources International) are recommended for general storage of prints and negatives. Ordinary cardboard boxes, including those in which photographic manufacturers package and sell their paper, should not be used for other than temporary storage. Wood boxes should be strictly avoided.

- **Portfolio cases and clamshell boxes:** Because all currently available print storage boxes of this type are constructed with low-quality, lignin-containing (and usually acidic) binders board, none can be recommended for long-term storage of black-and-white photographs, although they probably are safe enough for color prints. Several firms, including Portfoliobox and Museum Box Company, can supply custom-made boxes (at extra cost) in which 100% cotton fiber mount board has been substituted for binders board; these boxes should be satisfactory for long-term applications. Pyroxylin-impregnated cover fabrics should be avoided; acrylic-coated fabrics are recommended.

- **Solander boxes:** These boxes are made with wood frames and binders board (usually covered with pyroxylin-coated fabrics) and are not satisfactory for the long-term storage of black-and-white photographs, especially photographs made by some of the historical processes, such as albumen prints. The boxes are probably safe for color prints. Also called "museum cases," these boxes are sold by Spink and Gaborc, Light Impressions, University Products, and others; they are found in most major museum collections. On special order, Spink and Gaborc can substitute 100% cotton fiber mount board for binders board and replace the pyroxylin-coated fabric with an acrylic-coated fabric; the wood frame is still used, however. Should a Solander box be required, this somewhat more expensive box is recommended. Extruded aluminum or an inert plastic such as polypropylene could be used to replace the potentially harmful wood frames in Solander boxes; at the time this book went to press, however, such an improved box was not commercially available.

## Photograph Albums

- **Recommended:** High-quality albums with paper pages and polyester-covered pages are available from Light Impressions, University Products, and Photofile; often referred to as "archival" albums, these fairly high-priced albums appear to be quite satisfactory for museum and other long-term applications. Well-designed but much less expensive albums consisting of good-quality paper pages with Melinex polyester-covered "Picture-Pockets" are supplied by Webway Incorporated under the Webway Family Archival Album name. These expandable albums, many of which have an ample writing area below each print for captions, are available in sizes for 3½ x 5–inch and 4 x 6–inch prints. Webway Family Archival albums are the author's primary recommendation for general home and amateur use for both color and black-and-white photographs. Probably also satisfactory are albums with polypropylene-covered pages available from the Holson Company. Hallmark Cards supplies albums with cellulose acetate pages; these appear to be suitable for small amateur prints.

- **Albums to be avoided:** Albums with self-stick, plastic-covered "magnetic" pages can be extremely harmful and should **not** be used. If, however, one insists on using a self-stick album, the FlashBacks brand photo albums supplied by the 3M Company are recommended by this author as the safest album of this type. Also to be avoided are surface-treated, heat-sealed polypropylene pages (e.g., C-Line, 20th Century Plastics, and Light Impressions notebook pages); pages containing polyvinyl chloride [PVC] (e.g., 20th Century Plastics notebook pages); low-density polyethylene pages (e.g., Print File, Vue-All, and Clear File pages); and albums with pages made of low-grade paper, especially cheap black paper.

## Cabinets and Shelves

- **Recommended construction materials:** Steel or aluminum coated with baked enamel, chrome- or nickel-plated steel, anodized aluminum, and stainless steel. (Baked-enamel-coated steel cabinets, shelves, filing cabinets, and blueprint files of the kind widely sold for office use are generally satisfactory.)

- **Materials to be avoided:** Wood, plywood, particle board, Masonite, Formica-covered plywood, and particle board. If wood must be used, well-dried hardwoods such as maple, birch, and basswood are provisionally recommended.

## Paints

- **Recommended:** Oven-baked enamels and lacquers; latex paints.

- **To be avoided:** Alkyd or other oil-base enamels dried at normal temperatures (not oven-baked).

Carol Brower – 1987

The Museum of Modern Art in New York City displays photographs in a variety of frames, including those made from aluminum, brass, Plexiglas, and various types of wood that has been painted, varnished, or lacquered.

## Among Current Black-and-White RC Papers, Kodak Polymax RC Paper Is Recommended

Polycontrast Rapid RC Paper, introduced in October 1972 (Ektacolor RC paper was introduced in September 1968), was Kodak's first general purpose black-and-white RC paper and is the product that started the trend away from fiber-base papers. Now, the great majority of black-and-white prints are made on RC papers. Kodak has made various improvements in the stability of its RC base materials (and also, apparently, the stability of the silver image itself), and it seems certain the current Kodak black-and-white papers such as Polymax RC Paper and Polyprint RC Paper will last much longer when framed and displayed than the Kodak RC papers from the 1970's and early 1980's. *How long* is not presently known. Nothing has been published on the comparative image stability of framed and displayed black-and-white RC prints.

Kodak has, however, published an article describing improvements made in the stability of Kodak RC base paper (which is related to the stability of the silver image with displayed prints) and has described accelerated test methods used by the company to evaluate the stability of Kodak RC base papers.[2] To date, none of the other major manufacturers of black-and-white RC papers, including Agfa-Gevaert, Fuji, Ilford, Oriental, and Mitsubishi, have published *anything* meaningful concerning the stability of their products.

There is no doubt that for some years Kodak has been aware of the image stability problems of displayed black-and-white RC prints and has devoted considerable effort toward improving the products. Much less is known about how other manufacturers have attempted to deal with these problems, and for this reason, this author recommends Kodak black-and-white RC papers in preference to other brands. Among Kodak RC papers, Kodak Polymax RC Paper and Kodak Polyprint RC Paper are this author's primary recommendations because — unlike Polycontrast III RC Paper and other current Kodak RC papers — Polymax RC and Polyprint RC papers are conventional-emulsion (non-developer-incorporated) papers. Prints made with some developer-incorporated RC papers have developed objectionable brownish stain within the paper base after only a few years of storage following processing, and use of conventional-emulsion RC papers eliminates concern about this particular problem.

The reader is cautioned *not* to apply test data or other information supplied by one manufacturer to the products of another. There likely are large differences in the image and/or RC base stability between the products supplied by the many manufacturers of black-and-white RC papers.

This author concurs with Kodak's suggestion that RC prints intended for display be treated with a protective toner (e.g., Kodak Rapid Selenium Toner or Kodak Poly-

1979

Ektacolor prints by Nicholas Nixon (left) and Stephen Shore (right) displayed in Kulicke welded aluminum frames at the Museum of Modern Art in New York City.

Toner) to help protect the image. Although in recent years treating RC prints with a toner has often been recommended, in practice it is rarely done. People use RC papers because of their speed of processing and drying, and a toner treatment with the required additional wash is an unwanted and time-consuming bother.

This author strongly recommends that fiber-base black-and-white papers be used in preference to RC papers when the longest-lasting prints are desired, especially if the prints are to be displayed for long periods. Ideally, both fiber-base and RC prints should be treated with an image-protective toner. Valuable black-and-white RC prints — especially those made prior to about 1982 — should not be displayed. For a further discussion of light-induced image degradation of black-and-white RC prints and image-protective toners, and for a list of recommended fiber-base papers, see Chapter 17, *Display and Illumination of Color and B&W Prints*.

There is also evidence that under normal display conditions, framing has increased the fading rates of some RC color prints. This phenomenon — one aspect of which this author calls "RC base-associated fading" — appears to have been a major factor in the rapid fading and staining observed in many displayed Ektacolor RC prints made during the early 1970's; this author's tests indicate that under certain processing and display conditions, most of the current, improved RC color prints can be similarly affected (see Chapter 2). Special considerations when framing black-and-white RC prints will be discussed later.

### Frames and Mounting Materials Must Be Inert

All materials used in framing photographs, including backing boards, should meet strict requirements of permanence and chemical inertness. Noncorrosive metals, such as anodized aluminum, aluminum finished with oven-baked enamel, and stainless steel, are ideally suited for frames.

In a discussion of the harmful effects of many common materials on black-and-white photographic images, William Lee *et al.* of Eastman Kodak cautioned:

> . . . until a new material has been evaluated and judged safe for use in storing or filing pho-

tographic products, it would be considered prudent to avoid using it for this purpose. It has been shown that certain materials almost always adversely affect image stability and should be avoided. They are: **(1)** wood and wood products, especially plywood; **(2)** varnish and lacquers, especially those that contain cellulose nitrate; **(3)** untempered hardboard; **(4)** synthetic foam materials, especially expanded polyurethanes; and **(5)** adhesives that emit oxidizing species.[3]

Lee *et al.* recommended that "the manufacturer or vendor must initiate a series of accelerated aging tests designed to predict long-term stability of the photographic product in contact with the packaging or filing material in question." (Refer to Chapter 13 for a description of tests for mount boards and other paper products.) By the late 1980's, a number of manufacturers and distributors of mount boards, paper envelopes, interleaving materials, and photograph storage boxes had begun conducting such tests, at least to some extent, in an effort to evaluate the long-term suitability of their products.

A noteworthy example is Light Impressions Corporation, a large mail-order supplier of conservation materials located in Rochester, New York. In 1990 the firm announced that it had started a testing program for paper products carrying Light Impressions brand names using the Photographic Activity Test (P.A.T.) described in *ANSI IT9.2-1991* to "insure that our papers are safe in contact with photographic materials." According to Light Impressions, it would test "all papers that come in direct contact with photographic emulsions. This would include envelopes, folders and album pages, but may not include boxes and cases unless direct contact with the emulsion is anticipated."[4] The tests were being performed by the Image Permanence Institute in Rochester, under contract with Light Impressions.

### Aluminum Frames

There is a large variety of well-designed aluminum section frames available at moderate prices. Aluminum can be economically extruded into the complex, internally grooved shapes required for mouldings. It is nonreactive with photographs; it is strong and will not warp or become distorted with fluctuations in relative humidity; and it can be anodized or easily finished with safe, oven-baked enamels or lacquers. Aluminum frames are usually constructed of four extruded sections which are secured at the corners with hidden screw-tightened or pressure-fitted hardware. Some of the more expensive aluminum frames are welded and polished at the corners, giving the appearance of one-piece construction. From a conservation point of view, aluminum frames are excellent — they avoid all of the problems inherent with wood frames.

One of the first museum applications of aluminum frames for photographs was in the 1959 Alfred Stieglitz retrospective exhibition at the Museum of Modern Art in New York City; these brightly polished frames were designed by Robert Kulicke of Kulicke Frames, Inc. — later known as A.P.F./Kulicke, Inc., and subsequently called simply A.P.F.,

Inc. — in New York City. The original Kulicke aluminum frame, now known as "The Classic Welded Frame," is still produced by A.P.F., Inc. and is made of either polished aluminum or brass, with welded corners. The frames have a wood strainer (retainer) placed behind the backing board and secured with screws through the sides of the frame to hold the matted print and glass in place.

In 1968 Kulicke began marketing the first design of the now very popular extruded aluminum section frame. Aluminum section frame pieces are sold in pairs in a wide range of lengths and finishes. Almost any size frame can be quickly assembled from two pairs of pieces of the desired length. For example, for a 14x18-inch frame, a pair of 14-inch sections and a pair of 18-inch sections are needed. Most section frames have removable corner hardware and can be taken apart for storage or to reuse the pieces in frames of different sizes. Aluminum section frames are now produced by a number of manufacturers; probably the best known maker of aluminum mouldings is Nielsen & Bainbridge (formerly Nielsen Moulding Design), a division of Esselte Business Systems, Inc., located in Paramus, New Jersey. Nielsen frames are marketed through retail stores as well as by mail-order outlets such as Light Impressions Corporation, and are used by many framing shops.

## Anodized Aluminum Frames

Aluminum frames are supplied with either an anodized, lacquer, or enamel finish. Anodizing is a process of electrolytically forming a thin, nonabsorbent oxide layer on the surface of aluminum. During the anodizing process, the aluminum can be treated with special salt solutions to produce certain permanent "metallic" colors, including black, gray, bronze, gold, and chrome. Organic dyes may also be used to produce colors such as metallic blue, green, red, etc. The dyes are not permanent and will slowly fade on exposure to light and ultraviolet radiation. An anodized finish is resistant to scratches and much easier to clean than the somewhat absorbent "natural" oxide layer formed on untreated aluminum in the course of manufacture and during use. The surface of untreated aluminum easily picks up dirt, oil, fingerprints, etc., which may transfer to photographs and mount boards. Untreated aluminum may be polished to a bright, smooth finish, but, unlike anodized aluminum, the surface must be protected with a clear lacquer to prevent dulling, because the absorbent oxide layer picks up dirt.

## Low-Cost Plated or Painted Steel Frames

Metal frames in small sizes have been sold for home use for many years. These frames, which are usually very inexpensive, are made of rolled steel which has been plated or painted. The frames themselves appear to be satisfactory; however, the mats and backing boards supplied with them are of poor quality and should be replaced.

## Wood Frames

Wood, especially resinous softwoods such as pine and fir, should not be used to frame black-and-white photographs because wood releases peroxides and other harmful substances which, over time, can cause discoloration and fading of silver images.[5] Kodak has said: "Frames made of wood, especially bleached wood, may cause problems. Varnished, stained, or oiled frames should be avoided: there are no known 'safe' wood sealers."[6] Another drawback of wood as a framing material is that it cannot be oven-baked at high temperatures after painting or lacquering.

Examination of historical collections suggests that ordinary wood frames are probably not a major cause of deterioration of fiber-base black-and-white prints. Improper processing and washing, poor-quality mount board, and harmful mounting adhesives appear to be much more significant factors leading to deterioration of framed fiber-base prints. Untoned black-and-white RC prints are another matter, however, and these should never be put in wood frames.

Wood frames do have the advantage of being easy to "seal" on the back side with paper attached with glue or gummed tape to keep out dust, dirt, and insects. Bleached wood frames should never be used because there may be residual bleaching compounds in the wood which can harm photographic images; it may be difficult, however, to determine whether a frame has been made of bleached wood. "Oiled" wood frames should also be avoided.

Wood frames probably do little if any damage to color prints; keep in mind, of course, that displayed color prints will fade as a result of exposure to light regardless of the type of frame. For museum collections, wood frames are not recommended for any type of photograph.

## Hermetically Sealed and Nitrogen-Flushed Frames

Hermetically sealed frames are of obvious benefit for displaying photographs in the tropics or other humid areas (including, for example, bathrooms and kitchens). In 1982 the PermaColor Corporation of Broomall, Pennsylvania introduced an acrylic, hermetically sealed frame under the Photo-Saver name. According to the company:

> The Photo-Saver works in a unique manner by filtering out the most damaging wavelengths of light while simultaneously sealing out the atmospheric elements that catalyze both dark fading and light fading. This concept is an important breakthrough because it is now possible to preserve color prints while they are kept on display. That's what people really want to do, rather than be told to keep their color prints in the refrigerator to preserve color.[7]

PermaColor distributed graphs of accelerated test results and comparison pictorial prints made on Ektacolor 78 Paper (apparently the pre-1982 type that was manufactured without an ultraviolet-absorbing emulsion overcoat, which left the unprotected cyan dye very UV-sensitive); those tests indicated that the frames approximately doubled the stability of the prints compared with glass-covered prints under similar conditions.

When sample frames were provided to this author, they were tested with prints made on Ektacolor 74 RC Paper Type 2524 and a prototype version of Ektacolor Professional Paper (both of these papers were made with an ul-

Carol Brower – 1987

Photographs on display at the Museum of Modern Art in New York City.

traviolet-absorbing emulsion overcoat). The frames were found to provide little protection for these papers.

For the amateur market, the high cost of the frames (e.g., $14.95 for a 5x7-inch frame) proved to be prohibitive. The product could not *stop* the fading of displayed color prints, and since the frames cost more than replacement prints, there was little incentive for the average person to purchase them. Despite extensive advertising, "The frames simply didn't go over in the marketplace," according to Joseph M. Segel, chairman of PermaColor. Segel, the entrepreneur who founded the Franklin Mint (which was subsequently acquired by Warner Communications), liquidated PermaColor in September 1983 and quickly moved on to other ventures. He sold his test equipment, rights to the frames, the laminating films he was developing, and the PermaColor trademark to MACtac (a division of Morgan Adhesives Company) of Stow, Ohio. Re-named MACtac Permacolor, the company currently markets a variety of "cold mount" pressure-sensitive laminating films and adhesives (but not the original PermaColor frames) under the Permacolor name (see Chapter 4).

From time to time it has been suggested that photographs be stored — or framed — in an inert atmosphere in hopes that this would reduce, or even eliminate, color fading. This rests on the theory that light fading cannot proceed without the presence of adequate oxygen and/or water vapor. Pursuing this approach, Light Impressions Corpo-

ration in 1986 circulated a questionnaire to people in the museum and fine art photography fields asking for opinions on a vaguely described frame that this author speculates is a large-format, glass-front aluminum frame with an aluminum sheet backing. The glass is probably edge-sealed to the aluminum backing with silicone rubber or a similar substance after a print has been inserted, and the frame is then flushed with nitrogen to remove all air (the photographer likely would have to send prints to Light Impressions for installation in the frame). It is assumed that such a framing and print installation service would not be inexpensive.

In a letter accompanying the questionnaire, the company said:

> At Light Impressions Corporation we are currently developing a framing and display technique for color photographs that would provide protection from the damaging effects caused by extremes in relative humidity, temperature, atmospheric acidity, and ultra-violet radiation. In addition, our new system would potentially resolve the light-fading problem of color photographic material in a display situation.[8]

Like the earlier PermaColor Photo-Saver frame, a nitrogen-flushed frame would probably be of little benefit for

Photographs in aluminum, brass, Plexiglas, and wood frames side by side at the Museum of Modern Art.

Carol Brower – 1987

Ektacolor and other chromogenic materials;[9] however, data published by Ilford on the protection afforded to Ilfochrome (called Cibachrome, 1963–1991) prints by embedding them in a polyester resin[10] suggests that a moisture-starved, nitrogen-flushed frame would substantially increase the useful display life of Ilfochrome prints. Light Impressions declined to answer questions about the frames and would not supply data in support of its contention that the frames "would potentially resolve the light-fading problem of color photographic material in a display situation." When this book went to press in 1992, nothing further had been heard about the frames.

## Kodak Keeps Data on the Behavior of Its Color Prints in Nitrogen-Flushed Frames Secret

Since about 1982 it has been rumored that Kodak discovered that Dye Transfer prints in nitrogen-flushed frames "simply didn't fade" in accelerated light fading tests. But when asked, Kodak refused to provide data on Dye Transfer prints tested in this manner — and would not even confirm whether such tests had in fact ever taken place.

Lending credence to these rumors was the announcement that on May 19, 1987, David Kopperl *et al.* of Kodak would present a paper entitled "Light Stability of Kodak Color Products Irradiated in Air and Nitrogen" at the annual conference of SPSE, The Society for Imaging Science

and Technology, in Rochester, New York. However, shortly before the conference was to begin, the paper was withdrawn without explanation and the subject has remained shrouded in secrecy.

The behavior of various types of color and black-and-white photographs in nitrogen-flushed frames certainly merits investigation. For example, tests might indicate that the frames can be used for protecting daguerreotypes and photographs made by some of the other early processes. But possible adverse effects of the frames on displayed RC prints of all types — and black-and-white RC prints in particular — should also be carefully studied.

If the frames prove to substantially improve the light fading stability of Kodak Dye Transfer fiber-base prints and Ilford Ilfochrome (Cibachrome) polyester-base prints — and *long-term* testing would be required to confirm this — it will be a very important development, at least for the museum field. If, however, UltraStable Permanent Color or Polaroid Permanent-Color prints become generally available at reasonable cost, the need for such frames would be reduced.

At the National Archives in Washington, D.C., the original copies of the United States Declaration of Independence, the Constitution, and the Bill of Rights are displayed under very low-level tungsten illumination in helium-filled, yellow-filtered, bulletproof display cases (in 1986, the documents survived without damage an attack by a man wielding a hammer).

## Framing Procedures

A stiff backing board should always be placed behind a mounted print in a frame. This serves to keep the mount flat, to prevent punctures through the back, and to keep the back of the mount clean and free of scratches. Some frames are designed with a deeper recess to provide adequate room for a print that is unusually thick or to allow a greater separation space between the print and the glass when a mounted but unmatted print is "floated"; when the print is not unusually thick, or a fillet is not placed within the frame to regulate the space between the glass and the floating print, additional backing material is required to fill up the channel (recess). With most aluminum section frames, such as those manufactured by Nielsen & Bainbridge, spring-steel tension clips are provided for fitting into the four channels of an assembled frame behind the backing material, mat, print, and glass; the clips press the various layers together and help to ensure a tight fit inside the frame.

Frame mouldings should be selected with sufficient depth to accommodate the thickness of all the materials and to have enough space left so the spring clips will not exert too much pressure on the backing board. When a photograph is mounted and overmatted with 4-ply boards, and a moisture barrier sheet and backing board are included, the package may be too thick to fit properly *with the spring clips* in a standard frame moulding such as the Nielsen #11 size, which has a 7/16-inch channel. A moulding with a wider channel, such as the Nielsen #12 with a 5/8-inch channel, is more satisfactory. This author has seen many instances of the spring clips distorting the backing and mount board at the points where the clips contact the backing sheet; it may take several years for this type of damage to manifest itself. This is another reason why a separate, expendable backing board should always be included: to prevent the spring clips from directly contacting — and scratching or distorting — the mount board and print.

It would be a considerable improvement if, with each moulding section, frame manufacturers provided strips about 3/4-inch wide and made of thin aluminum or stainless steel; the metal strips would be placed on the rear edges of the backing board, with the spring clips installed over the strips. The metal strips would prevent board distortion caused by the spring clips and more effectively seal the frame against dust and insects; they would also minimize internal moisture fluctuations when moisture barriers are used between the backing material and the matted photograph.

Where possible, framing should be done in a room separate from matting activities and storage of mount board. After frame mouldings and glass have been cut to size, they must be carefully cleaned before a print and backing board are installed. Aluminum and glass fragments from cutting operations are extremely abrasive and can easily scratch emulsion surfaces or become embedded in the surface of a print. It is important to regulate both matting and framing environments. Smoking, eating, and drinking should be prohibited at all times. Clean and moderate conditions — approximately 70°F (21°C) with a relative humidity of 40–50% — should be consistently maintained to minimize the possibility of putting contaminated and/or moisture-laden materials into a frame, and to minimize later warpage of prints, mats, and backing boards.

## Should Frames Be Sealed, or "Vented"?

It has sometimes been advocated that frames be provided with small holes, or "vents," in the backing material, print mount, and even the overmat of framed prints. Kodak has advised:

> Small air vents should be arranged so that there will be an airflow between the print and the glass. If fumes from a varnished frame are trapped against a print surface, especially an untoned print, some dark areas may develop a red color as black metallic silver grains change to colloidal silver. This is especially likely to happen to prints made on resin-coated [RC] paper.[11]

Kodak did not explain how one would go about venting the cut-out area inside an overmat, and it is not apparent to this author how such holes could be made, short of piercing the print itself (assuming that the overmat extends to the edges of the image, as is normally the case). It might also be inferred from Kodak's statement that vents are not needed with anodized or baked-enamel aluminum frames. Kodak declined to answer this author's inquiries concerning the company's venting recommendation.

Keefe and Inch, in their 1990 book *The Life of a Photograph*, gave another rationale for providing vents:

> A sudden increase in heat — caused, for example, by having the frame hang several hours in direct sunlight — can force moisture trapped in the paper to form vapor. When the frame cools, this moisture condenses inside the frame in liquid form instead of dissolving back into the mat board and print. Water stains result if the moisture cannot escape.[12]

In addition to recommending a polyester or aluminum-foil moisture barrier between the backing board and the print mount, Keefe and Inch suggest providing a small "venting gap" in one corner of the polyester or aluminum foil sheet and, presumably, the backing board.

This author recommends that in general frames *not* be vented. Examination of photographs framed in a variety of ways, and displayed in a wide range of environments, has convinced this author that frames with *overmatted* prints are not subject to moisture condensation on the interior of the framing glass — except, perhaps, in certain extreme circumstances. If a framed print were hanging against a very cold wall in a room with warm and humid air, it is possible that condensation could occur inside the frame (under this condition, moisture condensation would also occur on the surface of the wall itself). In a test, this author placed a framed and overmatted Ektacolor print (which had been preconditioned for several months at 70°F (21°C) and 50% RH) into a freezer at 0°F (–18°C). While in the freezer, the framed photograph was examined every few minutes until the temperature had stabilized. Interior moisture condensation was not observed at any point during this test.

Within the normally encountered range of temperature

and humidity, the edges of the overmat board, and the surface of the print itself, act as a "moisture buffer," rapidly absorbing water vapor from the small amount of air in the overmat cavity should the temperature inside the frame suddenly drop — thereby preventing the relative humidity from becoming high enough for moisture to condense on the framing glass.

While it appears unlikely that actual moisture condensation inside of a frame will occur, *elevated* moisture levels inside a frame can indeed cause other problems when a frame is hanging against a cool wall in a room with warm and humid air. Under these conditions, a "zone" of high relative humidity will be created in the air near the cool wall, especially directly behind a frame where the wall will usually be somewhat colder than wall surfaces which are freely exposed to warm room air. The moisture level inside the frame usually will not become high enough to reach the dew point (where liquid condensation occurs on the cool surfaces), but over time the moisture level can become sufficiently high to cause warping of the print, mount board, and overmat. If the print emulsion should contact the framing glass, ferrotyping or even sticking can occur. Sustained high moisture levels can enable fungus to grow on the photograph or mounting materials. Venting the frame will not help in this situation and may even exacerbate the problem.

Ideally, photographs should not be hung on outer walls in cold climates, especially if the walls are poorly insulated and/or if the building is humidified during cold periods. As will be discussed later, placing an unvented polyester or aluminum-foil moisture barrier between the backing board and the photograph will significantly reduce the likelihood of moisture-caused damage.

The question of frame vents also involves whether the long-term effects of airborne contaminants outside a frame can cause more damage to a photograph than harmful substances existing — or generated — inside a more-or-less sealed frame. Sources of oxidizing gases and other harmful substances inside a frame are mount boards and adhesives, plastic substitutes for framing glass, wood frames (including paint or varnish on wood frames), and, in the case of RC prints exposed to light on display, the titanium-dioxide-pigmented polyethylene "RC" layer beneath the print emulsion. With fiber-base black-and-white prints mounted and overmatted with suitable materials and housed in aluminum frames under glass, this author believes that internally generated contaminants pose much less of a threat than external, airborne pollutants.

## The Best Way to Frame Black-and-White RC Prints Remains Uncertain

At the time of this writing, how best to frame black-and-white RC prints remained an unanswered and troubling question. Tentatively, this author recommends framing black-and-white RC prints using an overmat, but without vents and without a polyester or aluminum-foil moisture barrier. The absence of a moisture barrier will permit slow diffusion of RC-base-generated oxidants through the mounting and backing boards. The absence of vents (actual holes in the mounting and backing boards) affords protection against dirt and insects entering the frame. With

black-and-white RC prints in particular, wood frames should never be used. Black-and-white RC prints intended for display should be treated with Kodak Rapid Selenium Toner or Kodak Poly-Toner or other image-protective solution[13] to help protect the silver image from oxidants produced by the RC base, evolved from framing materials, or entering the frame from external sources (see Chapter 17). Valuable black-and-white RC prints, especially those made before 1982, should not be displayed, even if they have been treated with a protective toner.

## Polyester and Aluminum-Foil Moisture Barriers

For fiber-base black-and-white prints, and unlacquered RC color prints, this author recommends that a nonvented moisture barrier be placed between the print mounting and backing board. With these prints, a moisture barrier should be a normal part of everyday framing — not something that is reserved for "conservation framing." Color prints which have been lacquered probably should not be framed with a moisture barrier, as entrapped fumes evolved from the lacquer over time can be harmful to color images. Lacquering is not advised for black-and-white prints of any type.

If the aluminum-sheet or Lig-free Type II backing materials discussed below are not used as backing materials, a separate polyester or aluminum-foil moisture barrier should be placed between the print mount board and backing board. Thin, uncoated polyester sheet, such as DuPont Mylar D or ICI Melinex 516, is recommended. It may be purchased pre-cut in common framing sizes from Light Impressions Corporation; uncut rolls are available from a variety of sources. Thicknesses of 1 to 3 mils are adequate, though more expensive 5- and 7-mil polyester is easier to handle and provides a somewhat more effective barrier against migration of contaminants.

Aluminum foil sold in food stores is also satisfactory as a moisture barrier; foil intended for use with food has been treated to remove all oil or other dirt accumulated during manufacture. Industrial grades of aluminum foil should be avoided. Aluminum foil is readily available and may be less expensive than polyester in small quantities; if free of pinholes, aluminum foil is a totally impermeable vapor barrier and for framing purposes may be somewhat superior to polyester. On the other hand, some people have expressed concern that, over time, aluminum foil might slightly soil the back of a mount board or might even react harmfully with paper materials, although to date this author has seen no evidence to support either contention. More expensive anodized aluminum foil would lessen the chance of any such problems occurring, however. Both polyester and aluminum foil can easily be cut to size (the same size as the frame backing board) with an ordinary paper cutter. With care, scissors can also be used.

In addition to reducing the infiltration of airborne pollutants, a moisture barrier will greatly slow moisture fluctuations inside a frame. For example, in homes — which virtually never have effective humidity control — the relative humidity may be very high for a period of hours or days when it is raining outside. And as discussed previously, framed photographs hung on outer walls in cool cli-

mates may be in a zone of temporarily elevated relative humidity. A moisture barrier will prevent sudden changes in the moisture content of a print, its mount, and overmat; this in turn will minimize expansion of the boards and photograph, thus reducing the tendency of the mount and overmat to warp. The likelihood of an emulsion ferrotyping or sticking to framing glass will be greatly reduced.

Moisture barriers cannot totally stop moisture penetration, however. Water vapor can enter the frame along the exposed edges of the mount board and overmat inside the frame; in the case of polyester barriers, the plastic itself slowly transmits water vapor. The effect of the barrier is to even out year-round fluctuations in ambient relative humidity so that the moisture content of the print and mount will reflect the average humidity, over a period of several weeks, in the display area. Short periods of very high — or very low — ambient relative humidity will cause little change in the moisture content of the print and mounting materials inside the frame if a moisture barrier is included.

In a test conducted by this author, two 8x10-inch prints, dry mounted on 11x14-inch 4-ply 100% cotton fiber mount board and then overmatted with 4-ply board, were preconditioned in a room with 30% relative humidity for a month. The overmatted prints were then framed under glass in Nielsen #11 aluminum section frames; 4-ply backing boards were placed behind the mounted prints in both frames (the backing boards had also been preconditioned at 30% relative humidity). One print was framed with an aluminum-foil moisture barrier (placed between the backing board and the print mount), the other without.

Micro Essential Laboratory humidity indicator paper strips were placed at several locations inside of each frame, under the glass, to allow continual observation of changes in interior relative humidity (do not try this test with valuable photographs, as the humidity indicator strips will permanently stain anything they are in contact with). The framed prints were then hung in a room with circulating air and a relative humidity of 60%. The relative humidity inside the frame without the moisture barrier rose from 30% to about 45% in 3 days and appeared to reach equilibrium at 60% RH in 5 days. In contrast, the relative humidity inside the frame with the aluminum-foil moisture barrier required 35 days to reach equilibrium with the 60% RH conditions in the room — this is about seven times longer than the frame without the moisture barrier! Thus, moisture barriers can effectively protect a print and its mount against short-term changes in relative humidity.

If the ambient relative humidity is high over long periods of time, such as in the tropics, the moisture level inside a frame with a moisture barrier will, after a few weeks, reach the same level it would if no moisture barrier were present. A moisture barrier is, however, of benefit in most situations, and will also allow display of expendable photographs in locations such as kitchens and bathrooms, where there are periodic — but not sustained — high levels of relative humidity and air pollutants. Of course, a unique or valuable photograph should never be displayed in such areas, even if a moisture barrier is used.

If it is necessary to back framed photographs with low-quality materials, such as corrugated cardboard, chipboard, strawboard, plywood, or Masonite, a polyester or alumi-num-foil moisture barrier serves the additional function of protecting the photograph from harmful chemicals and vapors emitted by the backing material. With low-quality backing materials, the best protection can be obtained by wrapping the backing board with a large piece of heavy aluminum foil such as the "broiler foil" available at food stores (sheet polyester does not handle well as a wrapping because it is difficult to fold sharply). The foil should cover the entire board next to the photograph as well as the edges of the board; the edges may be taped to the outside of the backing board with 3M Scotch No. 810 Magic Transparent Tape. If possible, a single sheet of foil should be used. Care should be taken to prevent punctures or pin holes in the foil during handling.

A polyester or aluminum-foil moisture barrier may be attached along all four edges to the framing glass with a stable polyester tape or 3M No. 810 Magic Transparent Tape — so that the photograph and matting materials are inside a sealed package — following a procedure suggested by the Conservation Center for Art and Historic Affairs.[14] As pointed out by Keefe and Inch, tape seals are particularly useful for traveling exhibitions of photographs: "Inspection of many traveling shows frequently turns up little slivers of glass and glass crumbs that break off edges because of repeated stressing. Tape eases some of this stress and contains the particles so they cannot penetrate the frame's interior."[15]

This author does not recommend taping as a general practice, however, as the tape adhesive will contaminate the edges of the mount board and overmat, and possibly even contaminate the photograph itself if the print extends to the edges of the mount board. And, as previously discussed, this author advises against sealing black-and-white RC and lacquered color prints in frames.

## Paper "Barrier Sheets"

Cotton fiber papers and mount boards, and alkaline-buffered papers such as Howard Permalife, have often been used as "barriers" between photographs and low-quality backing materials. Compared with aluminum foil or polyester, paper products are more expensive and not nearly as effective in preventing migration of potentially harmful chemicals. Barrier papers and boards are totally ineffective in preventing moisture transmission, and this author does not recommend their use.

## Good and Bad Backing Materials

Corrugated cardboard, gray chipboard, strawboard, binders board, plywood, Masonite, extruded polystyrene-foam laminates such as Fome-Cor, and a variety of other potentially harmful materials have traditionally been employed for backing framed photographs. All of these materials are potentially harmful to photographs and generally should be avoided.

With black-and-white prints, one should be especially careful to avoid wood products as well as any paper or board that contains groundwood or lignin, or is acidic. Lignin (a common constituent of low-quality wood pulp paper products) has been shown to produce damaging peroxides and acids during aging. Ordinary corrugated cardboard is

particularly harmful and is unsuitable as a backing material. A number of "acid-free" alkaline-buffered corrugated cardboard sheets are available which have been recommended as backing materials;[16] even if these proved to be stable and nonreactive with photographs — and no test data were available at the time of this writing — corrugated cardboard, in this author's opinion, is not rigid enough, especially for large frames and in high-humidity conditions, to be satisfactory as a backing material.

Acceptable backing materials include high-quality mount board, Lig-free Type II boxboard, natural or anodized aluminum sheets, and — for color prints only — Plexiglas and other acrylic sheets. Glass is also satisfactory for backing framed prints but has the disadvantages of being heavy and easily broken.

For the best economy in general applications, this author recommends alkaline-buffered wood cellulose "conservation board" with a polyester or aluminum-foil moisture barrier. More expensive alkaline-buffered 100% cotton fiber "museum board" is of course also suitable. For backing in frames for both black-and-white and color photographs that have been overmatted and mounted with the appropriate materials, alkaline-buffered mount boards are preferred over nonbuffered boards. (See Chapters 12 and 13 for further discussion of mount boards.) Four-ply boards (about $1/16$ inch thick) are satisfactory for small and medium-size frames; 8-ply boards (at least $1/8$ inch thick) or thicker should be used with large frames to provide needed rigidity.

## Lig-free Type II Boxboard

Lig-free Type II boxboard, introduced by Conservation Resources International, Inc. in 1984, is a relatively new type of paper board which this author believes to be a very good backing material for both black-and-white and color prints. Designed for archival storage boxes, Lig-free Type II is made with a thin sheet of Mylar polyester laminated between a sheet of lignin-free, alkaline-buffered wood cellulose boxboard (with a cream-colored surface) on one side, and white, nonbuffered, near-neutral, lignin-free paper on the other; the polyester sheet acts as an internal moisture barrier and eliminates the need for a separate polyester or aluminum-foil barrier sheet. A PVA (polyvinyl acetate) adhesive is used in the lamination process. Conservation Resources says the board meets ASTM specifications for nontarnishing paper (not more than 0.0008% reducible sulfur)[17] and is nonreactive when tested with the Collings and Young silver tarnishing test.[18] Results of Lig-free Type II tested in contact with photographic materials using the Photographic Activity Test specified in *ANSI IT9.2–1991* were not available. The board is available in two thicknesses, 40 pt. and 60 pt.; the heavier board has about the same thickness and stiffness as 4-ply mount board. Unfortunately, Lig-free Type II board is expensive, costing more than an equivalent size of 100% cotton fiber board with a separate polyester moisture barrier. The white, nonbuffered side of the board should probably face out; keeping the thicker, cream-colored alkaline-buffered side facing the interior of the frame will help minimize warping during periods of fluctuating humidity.

## Aluminum Backing Sheets

Although fairly expensive and difficult to cut smoothly without special metal-shearing equipment, anodized aluminum sheet appears to be the best of all currently available backing materials. It is lightweight, nonreactive, nonsoiling, unbreakable, and rigid. Unlike boards and other paper products, aluminum sheet will not sag or warp with moisture fluctuations and aging (an important advantage with large frames), and it provides an effective barrier against migration of moisture and air pollutants. Aluminum backing sheets also prevent damage to mats and photographs caused by localized pressure of the spring tension clips found in most aluminum section frames. Anodized aluminum sheet is supplied in a variety of thicknesses by a number of manufacturers; an example is the Anoclad sheet made by ALCOA.[19]

Unfinished aluminum, which has not been anodized, is relatively inexpensive and may also serve as a backing sheet; however, it is necessary to place a sheet of aluminum foil, uncoated polyester, or high-quality paper between the unfinished aluminum sheet and the back of a mounted print to prevent the mount from becoming soiled by transfer of small amounts of dirt or oil from the oxidized surface of the aluminum over long periods. Most commercially available natural aluminum sheet products have a residual oil film on the surface left from rolling operations; it is not, therefore, recommended for backing high-quality and valuable prints.

Aluminum sheet in large sizes is difficult to cut flat and smoothly with ordinary tin snips. A bench-mounted sheet metal shear works well, however, and the expense of one should not be excessive for most frame shops or exhibition departments. Hand-operated sheet metal "nibbling" tools may also be used for small jobs. The thickness of the aluminum required will depend on the size of the frame; $1/32$ to $1/16$ inch (0.8 to 1.6 mm) should be sufficient for sizes up to about 20x24 inches.

## Fome-Cor and Other Polystyrene Foam Laminate Boards

Extruded polystyrene-foam laminates such as Fome-Cor, Gatorfoam, Artcor, and Prime-Foam-X are widely used both as backing materials for framed photographs and as substitutes for mount board when mounting black-and-white and color prints. These laminates are very lightweight, easy to cut, and surprisingly rigid for their thickness; foam laminates are especially popular for mounting murals and other large prints. Monsanto Plastics and Resins Company, the maker of Fome-Cor, had this to say about its product:

> We do not recommend that Fome-Cor in its current composition be used in conservation framing in direct contact with works of art. However, the product is suitable for use as a backing material behind an appropriate thickness of conservation ragboard, due to its relatively low acid content. The commercial grade of Fome-Cor has a pH of 5.5–6.5.[20]

Original-type Fome-Core is faced on both sides with bleached white clay-coated kraft paper (kraft paper is a common wood pulp paper produced by the sulfate process). Brown natural kraft paper facings are also available. In 1983 Monsanto introduced Acid-Free Fome-Cor, faced with alkaline-buffered paper, "designed to be used in direct contact with artwork in conservation quality framing, allowing you to remove protective ragboard barriers. By having one backing sheet do the work of two, Acid-Free Fome-Cor can save you as much as 25% of your backing materials cost."[21]

Gatorfoam, manufactured by the Uniwood Division of the International Paper Company, is laminated on both sides with sheets of moisture-resistant, resin-impregnated wood fibers. Concerning the "archival quality" of Gatorfoam as a mounting material for photographs, Uniwood says:

> The pH on the composite panel of Gatorfoam is an average of 5.5 to 6.5. However, pH on the face material is closer to 6.0. While this may seem to be slightly acid, Gatorfoam has been tested and is used by several top museums as mount board for fine prints. If archivability is critical we suggest having tests made to determine acceptability of the panel.[22]

An ad for Gatorfoam which appeared in a number of publications in 1983 said:

> The stability of Gatorfoam makes it especially suitable for mounting fine photographic prints. Its pH is within a safe range for even the most chemically sensitive mounted materials. Several major museums that use Gatorfoam have commented on its ability to keep prints from fading and discoloring.[23]

The pH level of polystyrene-foam laminates is only one of many considerations that determine their suitability for mounting photographs; more important are the possible adverse effects from facing materials, and from aging products of the polystyrene foam core and laminating adhesives. On inquiry from this author, neither Monsanto nor Uniwood had any test data on possible adverse effects their respective products might have during long-term use with photographs; Uniwood could offer no evidence to support its contention that Gatorfoam helped keep prints from "fading and discoloring."[24]

When used to mount black-and-white photographs, Gatorfoam's "resin-impregnated wood fiber" facing sheets are a source of particular concern. William Lee *et al.* of Kodak have claimed that synthetic foam materials and wood products are among "materials that almost always adversely affect image stability [of black-and-white images] and should be avoided."[25] Polaroid Corporation has advised against polystyrene foam (Styrofoam) products such as Fome-Cor, noting that they are among the materials "containing substances that are harmful to photographs."[26]

Artcor, a product of Amoco Foam Products Company, is faced with thin sheets of acrylonitrile-butadiene-styrene (ABS) plastic. Prime-Foam-X, made by ICC Industries,

Inc., is faced with white, clay-coated paper; it is similar in appearance to original-type Fome-Cor.

For Ektacolor, Fujicolor, Konica Color, Agfacolor, and similar chromogenic color prints intended for prolonged display, Gatorfoam, Acid-Free Fome-Cor, Artcor, and Prime-Foam-X appear to be satisfactory as backing or mounting materials. Pending more information on their aging characteristics and potential adverse interactions with silver images, however, these products are not recommended for use in contact with, or near, valuable black-and-white photographs.

## Corrugated Polypropylene Backing Sheets

A relatively new and very inexpensive plastic material that may prove to be a satisfactory backing material is polypropylene "corrugated board." It is a lightweight material with a structure similar in appearance to ordinary corrugated cardboard. Available in a variety of colors, it has found application as a high-quality, moisture-resistant substitute for corrugated cardboard in box manufacture; since it is plastic, a separate moisture barrier would not be needed in framing applications. Polypropylene board is made using extrusion techniques developed in Japan and Europe. Sheet corrugated polypropylene is available from Coroplast, Inc. in Canada.[27] In the absence of accelerated test data, this author does not recommend the material for backing valuable photographs; however, there is no doubt that Coroplast polypropylene board is superior to conventional corrugated cardboard and chipboard products widely used in commercial framing.

## Prints Must Be Separated from Framing Glass

Photographs to be framed should be overmatted to prevent direct contact of the print emulsion with framing glass or plastic sheets. Some frame mouldings are designed to keep the artwork away from the glass by holding them in separate, closely spaced grooves; Nielsen #44 and #55 mouldings are examples. Artwork can also be separated from the glass by specially designed plastic spacers (fillets), such as the Framespace.[28]

Prolonged contact of a gelatin emulsion with glass (especially under pressure) in conditions of high relative humidity may produce sticking or "ferrotyping," which results in irregular areas of altered surface gloss. This appears to be particularly likely to occur with some types of color prints. Studio portrait and wedding photographers usually lacquer color prints in an attempt to prevent them from sticking or ferrotyping when in contact with framing glass. Kodak has recently recommended that even lacquered prints be overmatted to preclude contact with framing glass — both to prevent sticking of the lacquered surface to the glass (which Kodak says can occur, although this author has never seen an example of this) and to minimize yellowing should a color print be lacquered with a product containing ketones or other solvents which produce peroxides on oxidation. Lacquering should be avoided for any black-and-white or color print intended for long-term keeping. Print lacquers and pressure-sensitive laminates are discussed in Chapter 4.

## Plastic and Glass Framing Materials

In general framing, glass is preferred to plastic sheets. Acrylic sheet such as Plexiglas scratches much more easily than glass, and care must be exercised in handling and cleaning. Both DuPont Lucite SAR (Super Abrasion Resistant) acrylic sheet and Rohm and Haas Plexiglas G Ultra-Shield have much greater abrasion resistance than regular grades of acrylic sheet. Especially when the relative humidity is low, acrylics and most other transparent plastics have a pronounced tendency to develop static charges, which in turn attract airborne dust; glass does not have this drawback. Plexiglas and similar acrylic products are also considerably more expensive than glass.

Almost all current color papers, including Ektacolor, Fujicolor, Konica Color, and Agfacolor, are overcoated with an ultraviolet-absorbing layer during manufacture, so in most display situations where the print or illumination source is covered with a sheet of glass, there will be little if any reduction in fading by using ultraviolet-absorbing plastic materials such as the UF-3 grade of Plexiglas acrylic sheet made by the Rohm and Haas Company. (Polycast Technology Corporation Polycast UF-3, DuPont's abrasion resistant Lucite SAR UF-3, and CYRO Industries Acrylite OP-3 appear to have UV-absorption characteristics that are generally similar to Plexiglas UF-3.)[29] Even though Ilford Ilfochrome (Cibachrome) prints do not have an ultraviolet-absorbing emulsion overcoat, this author's long-term 1.35 klux fluorescent light fading tests with the prints showed that the increased protection afforded by UF-3 is relatively small (see **Table 3.3** in Chapter 3).

Plexiglas UF-3 has a slight yellowish tint as a result of the incorporated ultraviolet filter material which absorbs essentially all radiation below 400 nanometers, and, unavoidably, also absorbs some visible blue light in the 400–425 nanometer region. When UF-3 is used for framing, its yellowish tint somewhat changes the appearance of photographs and mat boards; UF-3 will therefore not be acceptable for critical museum applications. Polycast UF-4 and other UF-4 sheets are almost completely colorless; UF-4, however, does not completely absorb UV radiation in the 385–400 nanometer region and is therefore somewhat less effective than UF-3 as a UV filter.

Plexiglas G and other "standard" grades of acrylic sheet typically absorb most UV radiation below about 350 nanometers. Ordinary window and framing glass completely absorbs wavelengths below about 320–325 nanometers. Glass effectively absorbs the 313 nanometer mercury vapor emission line which is radiated by most fluorescent lamps; significant UV radiation at this wavelength is very harmful to color materials that do not have a UV-absorbing emulsion overcoat, such as Ilford Ilfochrome (Cibachrome) prints, Kodak Dye Transfer prints, Fuji Dyecolor prints, Polacolor 2 and ER prints, pre-1983 Ektacolor prints, and Kodak Ektatherm and most types of thermal dye transfer still video or digital electronic hardcopy prints.

Fortunately, glass windows absorb much of the UV radiation present in daylight in the potentially very harmful 300–350 nanometer region. Were it not for this fact, upholstery fabrics, dyed carpets, wallpaper, black-and-white photographs, and many other objects found in homes and offices would not last nearly as long as they do! Fluorescent

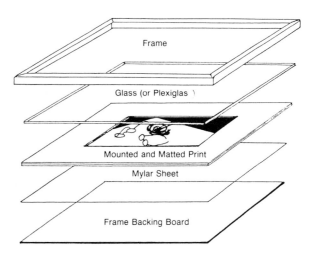

**Figure 15.1** Disassembled Frame

lamps also have a mercury vapor emission at 365 nanometers, which glass freely transmits; however, such long-wave ultraviolet radiation does not adversely affect the overall fading rates of most types of color photographs.

To completely exclude UV radiation from display areas, one can install sheets of Plexiglas UF-3 over windows, fluorescent lamps, quartz halogen lamps, and other light sources which emit significant UV radiation. This eliminates the need to frame prints with UF-3 — they can be framed with glass instead (see Chapter 17). Filtering the light source instead of the prints also avoids the problem of the sometimes disconcerting yellowish tint of UF-3. When UF-3 is used to frame a photograph, light must pass through it once to illuminate the print, and a second time when reflected back to the viewer. This accentuates the yellowish tint of UF-3; the effect is made all the more obvious by unavoidable visual comparison with walls, frames, and other objects in the viewing area which are not covered with UF-3. When the light source itself is filtered with UF-3, the yellowish coloration cannot be detected.

Pending further information, this author does not recommend Plexiglas or other brands of acrylic sheet for long-term use with black-and-white photographs. Acrylic plastics are based on methyl methacrylate and are manufactured using a peroxide-catalyzed polymerization system. The final product may contain residual peroxides and/or unreacted acrylic monomers which over a long period could harm the silver images of black-and-white photographs.

While the long-term effects of acrylic sheet on photographs are not presently known, the work of Weyde,[30] Pope,[31] and others would certainly suggest caution in this area. The problem is complicated by the fact that levels of residual peroxides and unreacted acrylic monomers vary from batch to batch, and some manufacturers of acrylic sheet have lower quality control standards than others. Kodak has recommended that acrylic plastics be avoided;[32] however,

Polaroid Corporation considers them to be acceptable.[33]

Although this author has not yet seen any examples of image deterioration which appear to have been caused by Plexiglas brand acrylic sheet, the long-term display of black-and-white prints with plastic frames or cover sheets made of acrylic, polystyrene, or other currently available clear plastics is not recommended. Products of this type include the Kulicke FK Plastic Frame, WK Warhol Kulicke Frame, Trap Frames, Slip Frames, and frames of similar design made by other manufacturers.

Acrylic sheet is probably satisfactory for short-term contact with black-and-white photographs in situations where breakage of glass might be a problem, such as in traveling exhibitions. Acrylic plastics are also suitable for use with color photographs; color image dyes appear to be much less sensitive to trace levels of peroxides and other chemicals than are silver images.

March 1991

Subjected to widely varying relative humidity (caused by seasonal fluctuations in humidity) over a 25-year period, these photographs gradually became severely curled during storage. The prints were made on single-weight fiber-base Kodak Polycontrast Paper in 1966.

March 1991

Also stored for 25 years, these prints were made on the same type of fiber-base paper and kept under identical conditions, except that the curl has been restrained by storage in a snugly fitting box. For these illustrations, both groups of prints were allowed to equilibrate in an environment with a relative humidity of less than 20%. Even in this very dry condition, the prints that had been kept in the box curled only slightly when they were removed from the container.

For some years, the International Museum of Photography at George Eastman House in Rochester, New York framed salted paper and albumen prints with Plexiglas UF-3 in an effort to reduce the damaging effects of the daylight illumination that was present in many of the museum's display areas at the time.

Textured non-glare glass should be avoided in framing because it reduces visual definition of the image. Also, textured glass must be in direct contact with the photograph, unless the print is lacquered, and this may result in sticking or ferrotyping of the emulsion over time. If textured glass is separated from the photograph by an over-mat, the loss of image definition, contrast, and color saturation will be visually unacceptable.

Some types of non-glare glass are manufactured with a vacuum-deposited, optical anti-reflection coating which functions in a manner similar to the anti-reflection coatings on camera lenses. Unlike conventional non-glare glass, anti-reflection coated glass can be used with overmatted prints with no loss in image clarity.

Suppliers of framing glass with optical anti-reflection coatings include Viratec Tru Vue, Inc. (Tru Vue Museum Glass), and Denton Vacuum, Inc. (Denglas).[34] Both Tru Vue Museum Glass and Denglas are available with UV-absorbing coatings. While specular reflections are largely eliminated by the anti-reflection coatings, the faint glare images from sources of bright light can have a somewhat disconcerting iridescent appearance. In display situations, however, where objectionable glare is present, these special (and fairly expensive) types of glass will markedly improve the appearance of photographs and other works of art.

## Cleaning Glass and Plastic

Glass and plastic sheets must be washed to remove dirt before placement in a frame. After swabbing with a solution of water and a non-ionic detergent such as Ivory Liquid, the sheet should be thoroughly rinsed with warm running water and dried with clean paper towels.

Glass or plastic sheets already in a frame should be removed from the frame for cleaning; otherwise, the cleaning solution could seep under the edges of the frame and contaminate the mount board or photograph. If it is not possible to remove the glass for cleaning, the frame should be laid horizontally on a table. The glass should be wiped with a paper towel which has been moistened (but not soaked) with a non-ionic detergent solution; great care must be taken to prevent any of the cleaning solution from seeping under an edge of the frame. Then — working quickly to prevent any of the cleaning solution from drying on the glass or plastic — all remaining solution should be wiped off with paper towels. Superficial dust can be removed with a soft brush.

Glass cleaners containing ammonia, such as the popular Windex Glass Cleaner with Ammonia-D, should be used with great care because residues of the cleaners can cause serious damage to photographs should some of the solution seep under the edges of a frame or come into contact with nearby, unframed prints. This author has seen a number of Kodak Ektacolor prints which have suffered almost total localized dye loss as a result of contamination with droplets of ammonia-containing glass cleaners.

## General Storage Considerations

For storage, unframed prints and large sheet films should be placed horizontally in flat boxes (preferably about 2 inches deep and never more than 4 inches deep) with drop-fronts or drop-backs. Keeping stacks short and minimizing the weight on prints or films near the bottom of the stacks will lessen the chance of dirt becoming embedded in emulsions, minimize physical damage that can occur when mounts of varying sizes are stored together, and reduce the possibility of ferrotyping under humid conditions if plastic sleeves are used. Prints and films should never be pulled from the center of a horizontal stack; instead, the prints on top of the desired photograph should be lifted off and set aside.

When prints are stored in regular office file cabinets, as is often the case in publication or commercial archives, the photographs should be prevented from curling excessively over time by taking up the free space in each file drawer. Most file cabinets have adjustable metal partitions for this purpose; if possible, partitions in the file drawers should be placed about 8 or 10 inches apart (additional partitions can be purchased from the manufacturer of the file). Prints should be inserted or removed from file drawers by pulling out the entire file, placing it on a work table, and carefully lifting out or inserting the photographs.

Prints and films should never be crammed into sleeves or envelopes that are already in a file cabinet; this will inevitably result in scratches, creases, and cracked emulsions.

## Preventing Excessive Curl in Fiber-Base Prints

Gradually, sometimes over a period of many years, unmounted fiber-base prints can develop excessive curl; the curl is almost always toward the emulsion side of a print and is most acute in single-weight prints. When prints without envelopes or sleeves are stored together — in the drawer of a file cabinet, for example — the entire batch may develop curl as a unit. Aside from the curl characteristics, which are inherent to a given print material, there are two principal factors that affect the amount of curl which ultimately will develop:

1. **Cycling Relative Humidity.** An environment in which the relative humidity cycles over a wide range — from very low to very high — will, over time, cause much more curl to develop in unrestrained fiber-base prints (even if the average RH is very low) than will storage at a more constant relative humidity. Why cycling relative humidity increases the curling tendency in fiber-base prints (and, to a lesser extent, in RC prints and in 35mm and other narrow-gauge films manufactured without a gelatin anti-curl coating on the base side) is not understood; however, there is no doubt that it does. In temperate climates, indoor relative humidity will drop to a very low level in cold periods of the year unless humidifiers are available to increase the moisture level. In warmer parts of the year, on the other hand, indoor relative humidity levels may periodically become very high, even if air conditioners are in operation.

2. **Physical Restraint of the Curling Tendency.** If a fiber-base print is maintained in a flat position by mounting it in an overmat, by placing it in a frame, by storing it in a filled box, or by inserting it into a plastic sleeve (with a reinforcing mount board backing behind the print, if necessary), excessive curl will not develop even if the relative humidity does cycle over a wide range.

In homes and offices in temperate climates, it usually is impossible to maintain a low — and reasonably constant — relative humidity without costly special equipment of the type that only a few museums and archives have at present. It is therefore essential that prints be held flat if excessive curl is to be avoided. This — in addition to protecting photographs from dust, dirt, fingerprints, scratches, creasing, cracking, and other physical damage — is an essential element of a good storage system.

If prints have already developed unacceptable curl, great care should be exercised in attempting to flatten them in order to avoid cracking the emulsion; with valuable prints, an experienced photographic conservator should be consulted.

## Housing Valuable Photographs

Storing unprotected or sleeved prints, negatives, and transparencies in file cabinets or stacked in discarded Kodak paper and film boxes (or those supplied by other photographic manufacturers) is not recommended, particularly for museums, archives, galleries, important commercial and documentary collections, or fine art photographers. To properly store valuable photographs, the following approach is suggested:

1. Place individual prints or films in uncoated polyester or untreated polypropylene top-flap sleeves (see Chapter 14 for discussion of the various types of sleeves and envelopes for storing photographs). The transparent plastic sleeves allow visual examination of prints and films while at the same time preventing fingerprints and scratches on the photographs themselves. The sleeves also prevent transfer of rubber-stamp ink from one print to another and eliminate the possibility of contaminating films and prints with migrating residual thiosulfate and other harmful chemicals from poorly processed photographs that might be present in the box.

2. Sleeved prints and films, either individually or in small groups (e.g., all of the cut strips of negatives from a roll of 35mm or 120 film), should be placed in high-quality paper envelopes to protect them from dust and to provide a place upon which to write the date and other identifying information with a pencil or pen, or to mark with a rubber stamp. The sleeves and paper envelopes also offer a significant amount of physical restraint to fiber-base prints and help prevent them from developing excessive curl over time.

3. For protection against physical damage and dust, and to further physically restrain fiber-base prints so as to keep them flat, the paper envelopes should be placed in suitable boxes. Prints and sheet films larger than 5x7 inches should be stored horizontally in boxes not more

than about 4 inches deep. It is essential that the boxes have drop-fronts or drop-backs to minimize the chance of physical damage to prints when they are removed from the boxes. Prints and films 4x5 inches and smaller (including 35mm and 120 films) may be stored vertically in fixed-front boxes not larger than about 10 inches deep if they are in envelopes. It is important that the boxes be full so that the contents fit snugly and are not allowed to sag or develop curl over time; filler made of high-quality mount board may have to be placed in a box to fill extra space. Pieces of plastic foam should never be used for filler because over time these materials may evolve harmful gases.

4. The boxes should be placed on metal shelves coated with baked enamel — or better still, for additional protection against dust and physical damage, on shelves within closed metal cabinets. Wood fixtures in general, and plywood, particle board, chipboard, and Masonite in particular, should be avoided. For ease of access and to avoid excessive weight on the contents of a box, the boxes should not be stacked on top of one another.

Mounted prints should also be stored in boxes. Mounted prints are not normally placed in sleeves or envelopes; however, the prints should be interleaved as they are placed in the box. This author believes that a smooth, 100% cotton fiber paper, such as Atlantis Silversafe Photostore (see Chapter 13), should be used to interleave mounted prints that do not have overmats. For prints that do have overmats, a sheet of Mylar D or ICI Melinex 516 polyester (or suitable translucent interleaving paper), cut about one inch smaller than the dimensions of the mat, should be placed between the print and the overmat. This will protect the surface of a print while permitting viewing without the need to remove the interleaf sheet.

Storage will be simplified if prints (and the mounts of mounted or overmatted prints) are all of the same size or are segregated into several standard sizes, such as 8x10, 11x14, and 16x20 inches, and if boxes of the appropriate size are used. Small prints tend to slide around during handling if they are filed with larger prints; this is especially true when groups of prints receive rough handling when being shipped. If mixing prints of different sizes cannot be avoided, small or odd-size prints can be protected by placing them in a standard-size sleeve along with a backing sheet of a good-quality mount board (preferably of 2-ply thickness) the same size as the sleeve.

Very large prints should be grouped by size in small stacks and stored horizontally in metal blueprint files or on large shelves within metal cabinets. Large prints require special handling, and no attempt should be made to incorporate them into regular subject or alphabetical files. Cross-reference cards or small copy photographs can be inserted in the regular files, as required.

Contact between different types of photographs (e.g., Fujicolor prints, Kodak Dye Transfer prints, Ilford Ilfochrome prints, black-and-white prints, color negatives, instant prints, etc.) should be avoided; if various types of photographs must be kept together in the same file or box, they should be placed in individual polyester sleeves to prevent migration of chemicals between adjacent films and prints.

Glass photographic plates should be stored vertically, resting on the long edge, in vertical files or in vertically compartmented shelves. Cabinets and shelves for glass plates should be constructed of steel coated with baked enamel, of anodized aluminum, or of other suitable nonreactive and noncombustible materials; wood, plywood, Masonite, particle board, chipboard, Formica, and similar products should be avoided. Great care should be taken that fragile glass plates are not subjected to undue pressure or allowed to slide off shelves. Information on proper storage containers for glass plates may be found in *ANSI PH1.45-1981, American National Standard Practice for Storage of Processed Photographic Plates.*[35]

## Storage Containers

Boxes, cabinets, and shelves for storing photographs should be made of materials which do not chemically react with photographs over long periods, are opaque (to protect the contents from light), do not absorb moisture, are impermeable to gases, do not deteriorate with age, and, if possible, are noncombustible. Suitable materials are stainless steel, heavily chrome- or nickel-plated steel, aluminized steel, aluminum, anodized aluminum, and aluminum or steel coated with oven-baked enamel.[36]

Containers can be molded of a suitable plastic material, such as polypropylene. Any plastic material used in storage environments must have very good aging characteristics and be nonreactive with photographs during long-term storage. Acrylics, unsaturated polyesters (the plastic base for many fiberglass-reinforced articles), and other plastics which may contain residual peroxides should be avoided. Phenolics (such as Bakelite), which may release formaldehyde, should not be used. Decorative plastic laminates (such as Formica) are usually made with a thin melamine-formaldehyde top-sheet laminated to a phenolic base and are unsuitable for storing photographs because both the plastic laminate itself and the contact adhesives that adhere the materials to countertops and cabinets can cause deterioration of silver images. All chlorinated plastics, such as polyvinyl chloride (PVC), should be avoided.

Wood, especially resinous softwoods such as pine or fir, should not be used for containers because wood may release peroxides or other chemicals which, over time, will harm photographs.[37] Well-aged hardwoods, such as maple or birch, are less of a problem, but these too should be avoided if possible. Plywood, particle board, chipboard, Masonite, and other glued or laminated wood products are unsuitable because of potentially harmful substances in the bonding adhesives (most of which are made with formaldehyde as a primary ingredient) and in the wood itself.

## Cardboard Boxes

Most types of cardboard boxes are not satisfactory for long-term storage because cardboard, containing groundwood and lignin, is usually acidic and relatively unstable; decomposition products of cardboard may adversely affect photographs, particularly black-and-white prints. Lignin has been cited as a "powerful cause of fading and staining during long-term storage."[38] A wide variety of glues and pastes — many of which are hygroscopic — are used in

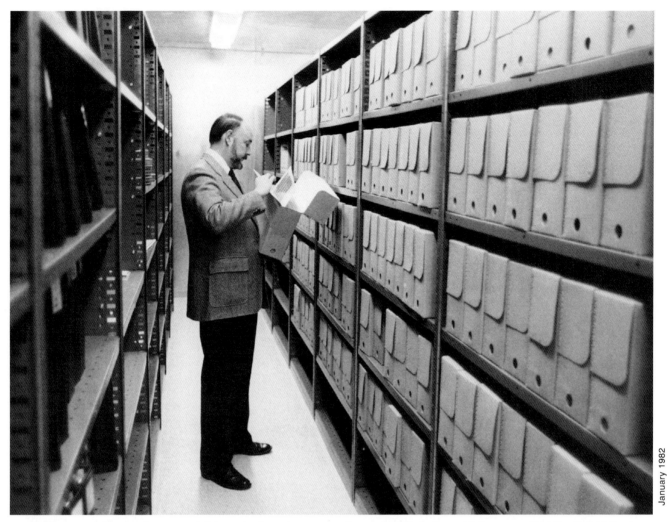

January 1982

Hollinger metal-corner boxes containing negatives, transparencies, and prints in the cold storage vault at the Gerald Ford Library in Ann Arbor, Michigan. Working in the vault is Richard Holzhousen, curator of photography at the library. Administered by the National Archives and Records Administration's Office of Presidential Libraries, the library collection focuses on Ford's years as President of the United States.

cardboard box construction; the effects of these adhesives on photographs are not known. Boxes in which photographic papers and films are supplied by the manufacturers, while probably not harmful for short-term storage, are unsuitable for long-term storage of black-and-white photographs. These boxes have commonly been used by photographers because a ready supply of them is usually available — in proportion to the number of prints processed — and because they precisely fit the common print sizes. Carol Brower has seen dye stains on prints and mounts which have been stored for a few years in these boxes before being delivered to her for matting; for example, a distinct blue and orange staining sometimes occurs on the exposed surfaces and edges of prints when stored inside the familiar orange photographic paper boxes manufactured by Agfa-Gevaert. Agfa removed the dark interior papers sometime after 1983; prints stored in the current boxes are exposed to gray chipboard, which is still unsuitable for long-term storage.

This author tested a variety of photographic paper and film boxes for pH, groundwood content, and presence of alum, using the Tri-Test Spot Testing Kit for Unstable Papers.[39] Of the samples tested, all except some Kodak black-and-white paper boxes of recent years indicated groundwood content and were quite acidic. Kodak has advised: "Cardboard boxes in which unexposed film, plates, and paper are packaged should not be used for enclosure materials. Packaging material which is suitable for unexposed sensitized materials may not be inert to processed materials."[40] It would be extremely helpful if manufacturers supplied film and paper in good-quality boxes made with stable and photographically nonreactive cardboard; the added cost would be slight and the benefits great since so many photographs are stored in these boxes.

## Hollinger Metal-Corner Boxes

Primarily used for long-term storage of documents and photographs in archives and museums, the first boxes of this type were produced in 1954 by the Hollinger Corporation, a packaging and box manufacturer now located in Fredericksburg, Virginia, near Washington, D.C., for the

February 1987

Members of the Photographic Materials Group of the American Institute for Conservation study photographs in the Historic New Orleans Collection during the group's 1987 meeting in New Orleans, Louisiana. Much of the collection is matted, both to enhance the presentation of the photographs and to reduce physical damage during handling and study. Drop-back Solander boxes allow matted prints to be lifted out easily without damage to the edges of the mats. Cotton gloves are made available to all visitors.

National Archives and Records Administration. Originally made with a low-groundwood, nonbuffered cardboard with a pH of about 7.5, and sized with Aquapel, the boxes were fabricated with baked-lacquer-coated steel corners, which avoided glues or pastes. A gray pigment-coated paper with good light-fading stability was bonded to the cardboard to keep the boxes looking "new" with the passing years.

Boxes of this design became commonly known as "The Hollinger Box" and can be found in archives and museums throughout the world. Current boxes supplied by the Hollinger Corporation have the same construction as the originals but are now made with alkaline-buffered cardboard with a stated minimum pH of 8.5. The calcium carbonate buffering agent is dispersed throughout the cardboard; an alkaline-buffered gray facing sheet is laminated to the outside of the box and a buffered white paper to the inside. At the time of this writing in 1992, no test data were available concerning the suitability of Hollinger boxes for long-term storage of photographs. For storage of prints and large sheet films, flat boxes with drop-fronts should always be used; the boxes preferably should be about 2 inches deep, and never more than 4 inches deep.

Boxes similar in physical design to those originated by Hollinger are now supplied by Conservation Resources International, Inc., Light Impressions Corporation, Century Divi-

sion of Pohlig Bros. Inc., and a number of other companies; they are often called "metal-edge" or "metal-corner" boxes.

## Conservation Resources Lig-free Type II Boxes

Probably the best currently available cardboard storage boxes are the Lig-free Type II boxes manufactured by Conservation Resources International, Inc. of Springfield, Virginia. Introduced in 1984, the boxes are made with the previously described Lig-free Type II board, which has a polyester moisture barrier laminated between a sheet of white, nonbuffered, lignin-free paper on the inside and a sheet of alkaline-buffered, lignin-free boxboard with a cream-color facing sheet on the outside. The boxes come in low-cost "fold-up" designs as well as in the traditional metal-corner Hollinger design fabricated with staked metal corners; both designs are free of glued seams. The boxes are also made with a lower-cost, alkaline-buffered, lignin-free boxboard called Lig-free Type I, which does not contain a polyester moisture barrier.

Lig-free boxes are currently available in a number of styles; the Drop Front Print Boxes, Negative Boxes, and Document Cases are best suited to photographic needs. Microfilm storage boxes are also available. Conservation Resources can custom-make almost any style or size of

box on special order. The boxes are moderate in price: the cost of a 11½x14½x3-inch Lig-free Type II drop-front box for 11x14-inch prints is about $6 in quantities of 20, and less for larger quantities. Lig-free Type I boxes of the same size cost about $5, and 2-inch-deep Lig-free corrugated fold-up boxes for 11x14-inch prints are about $3. Lig-free corrugated cardboard is made in two forms: one is alkaline-buffered throughout, while the other is made with one side (and the corrugated core) alkaline-buffered and the opposite side nonbuffered.

Also recommended are the Hollinger-type boxes supplied by Light Impressions Corporation under the names Drop Front, Flip-Top, and Flat Storage Boxes. They are made of TrueCore boxboard, a tan, alkaline-buffered, lignin- and alum-free, wood pulp boxboard which is claimed to contain less than 0.0008% reducible sulfur and to have been tested with the *ANSI IT9.2-1991* Photographic Activity Test. The boxboard does not have a polyester moisture barrier, and the boxes are somewhat less expensive than the previously described Conservation Resources Lig-free Type II boxes.

## Solander Boxes

Many private collectors, museums, and galleries store their fine art photography collections in cloth-covered, wood-framed boxes (cases) with cloth-hinged tops and drop backs, commonly called "solander boxes,"[41] "museum cases," or "print cases." They are almost always black, usually covered with a slightly pebbled, semi-gloss, pyroxylin-impregnated book-binding fabric. The best known manufacturer is Spink & Gaborc, Inc. in Clifton, New Jersey (from its founding in 1911 until 1985, the firm was located in New York City). Similar boxes are also made by Light Impressions Corporation in Rochester, New York; Museum Box Company

February 1987

John Lawrence, curator of the Historic New Orleans Collection, holds a drop-back Solander box. Boxes such as this one are used to store all of the museum's matted prints.

May 1982

Fine art portfolios are presented in custom-made cases, most of which are of the clam-shell design. At Light Gallery in 1982, Carol Brower and Peter Wilsey (former Light Gallery associates) examine Mitch Epstein's 1981 portfolio of six over-matted Dye Transfer photographs. The portfolio cases were made by Lisa Callaway of North Hampton, Massachusetts. Located at 724 Fifth Avenue in New York City, Light Gallery was the world's preeminent contemporary photography gallery from 1971 until the early 1980's, when an abrupt downturn in the market for fine art photographs led to the gallery's closing.

in West Warwick, Rhode Island; Portfoliobox, Inc. in Providence, Rhode Island; Opus Binding Limited in Ottawa, Ontario (not related to Opus Framing, Ltd., another Canadian company); G. Ryder & Co. Ltd. in Milton Keynes, England; Atlantis Paper Company Limited in London, England; and a number of other firms.

Solander boxes have long been used by museums for storage of drawings, lithographs, and other works of art on paper; when these institutions began to acquire photographs, it seemed logical to store them in these boxes as well. Such boxes are fairly expensive (in 1992 a box for 16x20-inch prints cost about $80), attractive, durable, and offer excellent *physical* protection for photographic prints. The lipped lids form an effective seal against dust when the box is closed. The boxes are usually made with a cloth-hinged drop back, which facilitates access to the contents and minimizes the possibility of damage to prints and mounts during handling, and are equipped with two polished nickel-plated clasps and a label holder on the front. Handles are available by special order.

Boxes currently manufactured by Spink & Gaborc are framed with pine wood; the top and bottom are made of binders board, a type of heavy compressed cardboard for covering hardbound books. The exterior of the box is covered with a pyroxylin-impregnated fabric, the edges of which wrap around into the inside of the box. The interior is covered with a shiny, white, clay-coated paper glued to the frame and to the binders board which forms the top and bottom of the box. On request, alkaline-buffered paper can be substituted for the clay-coated paper. The boxes are assembled with glue.

Binders board is a thick, low-cost, single-ply cardboard made from waste paper such as newsprint, scraps of cardboard, etc. Binders board has a high groundwood and lignin content. It contains many impurities and is usually nonbuffered and acidic. Binders board should not be used in photographic storage containers and in particular should be avoided for storage of black-and-white prints. If, for reasons of economy, binders board must be used, the alkaline-buffered Acid-pHree binders board introduced in 1984 by the Davey Company is strongly recommended.[42] The cost of this more stable product is only marginally greater than ordinary acidic, nonbuffered binders board.

Pyroxylin is a plasticized cellulose nitrate plastic (having a lower nitrogen content than highly flammable cellulose nitrate film base) and is commonly used as a lacquer base for coatings on book covers. Pyroxylin and other cellulose nitrate-based plastics are not sufficiently stable for long-term applications; on aging, pyroxylin can evolve nitrogen oxides and other substances which are harmful to black-and-white silver images. William Lee *et al.* have cautioned against their use with black-and-white photographs.[43] Acrylic-impregnated book binding cloth, which is a satisfactory substitute for pyroxylin-impregnated fabric, is available from Industrial Coatings Group, Inc.[44]

On special order, Spink & Gaborc will manufacture boxes with 100% cotton fiber mount board in place of binders board and replace the pyroxylin-impregnated fabric with an acrylic-coated, starch-filled, or plain cloth material (unfortunately, the wood frame is retained); these special boxes are sold at a premium price.

This author is unaware of any tests that have been conducted to determine the long-term effects of storing photographs in Spink & Gaborc boxes. Nor does this author know of any damage to photographs that has been directly attributed to Spink & Gaborc boxes. They are used extensively at the Museum of Modern Art in New York City; George Eastman House in Rochester, New York; the Art Institute of Chicago, and most of the other major fine art photography collections in the United States; however, binders board, wood frames, and various other materials in these boxes are potentially very harmful to silver images. Although the boxes probably present no immediate hazard to photographs, they cannot be recommended for long-term storage of black-and-white photographs, especially in humid locations.

Silver images — particularly the images of albumen prints, silver-gelatin printing-out papers, and contemporary RC prints — can be extremely sensitive to peroxides and other contaminants which, over time, are likely to be evolved from many of the components in Solander boxes. Harmful substances could reach print images either by migration through boards and papers or in a gaseous form. This author believes that of all the materials in a Solander box which have the potential to harm silver images, the acidic, high-lignin-content binders board is the cause for greatest concern. Forming both the top and bottom of the box, the total surface area of the binders board is quite large, and the board is also in very close proximity to the topmost and bottommost photographs stored inside the box. Image deterioration of silver-gelatin microfilms which has been attributed to peroxides evolved from cardboard storage boxes indicates that *all* materials used in the vicinity of silver image black-and-white films and prints must be selected very carefully.[45]

An improved version of the basic box design — in which the wood frame is replaced with extruded aluminum or a suitable plastic such as polypropylene, and with the top and bottom made with either aluminum or alkaline-buffered and lignin-free board, covered with an acrylic-coated fabric, and assembled with long-lasting, nonreactive adhesives — would be a major advance in the photographic conservation field; the internal and external appearance of such an improved box could remain unchanged.

In 1985 Light Impressions Corporation announced that in 1986 it would replace the binders board used in all of their Solander museum cases with a better-quality, alkaline-buffered, lignin-free boxboard; unfortunately, the company abandoned the idea for "practical and economic reasons," and decided to continue using inexpensive, low-quality, high-lignin-content, acidic binders board. Light Impressions did, however, replace the pyroxylin-impregnated fabric covering on its boxes with an acrylic-coated fabric. At a premium price, Light Impressions can also supply custom-made boxes, using materials specified by the customer.

## Portfolio Cases and Clamshell Boxes

Light Impressions Corporation; University Products, Inc., Century Division of Pohlig Bros. Inc., Museum Box Company, Portfoliobox, Inc., G. Ryder & Co. Ltd., and several other companies make a moderately priced box usually called a "portfolio case" or "clamshell box." Extensively used for storing photographs, these boxes are constructed of binders board covered with pyroxylin-impregnated fabric or other book-covering cloth, and lined with paper or synthetic materials such as DuPont Tyvek. They are available in a variety of colors, the most common being gray, black, and brown. The boxes are glued together, and the top, bottom, and drop back are attached with flexible cloth joints; there are no wood frames, and the boxes do not have metal latches. A variation of the design, with a slightly overhanging top and bottom, is known as a "lipped clamshell" box. Detailed instructions on how to make these boxes are contained in a publication from the Library of Congress entitled *Boxes for the Protection of Rare Books – Their Design and Construction.*[46]

There are currently no accelerated test data on the ef-

fects on photographs of the materials that go into the manufacture of these boxes (materials and adhesives vary among manufacturers). Other than the lack of wood frames, portfolio cases are made with materials and construction techniques similar to those found in Solander boxes. While they are probably satisfactory for storing color photographs and likely present no immediate hazard to black-and-white prints, they are not recommended for long-term storage of black-and-white photographs, especially in humid conditions.

In late 1986, as the company did with their museum cases, Light Impressions Corporation replaced the pyroxylin-impregnated fabric covering of their boxes with an acrylic-coated fabric. Announced plans to improve the quality of the board used in the manufacture of the boxes were abandoned, however, and at the time of this writing in 1992 the boxes continued to be made with a low-quality, high-lignin-content, acidic binders board.

## Metal Print-Storage Boxes

In the late 1970's, a steel print box was manufactured by Saxe Archival Systems, a Canadian firm; the box was coated with a heat-cured dry powder finish.[47] Equipped with a hinged drop front and a telescoping lid that lifts off, it was an interesting attempt to make an improved box. Because of the heavy-gauge steel used to make the box, it is heavy and difficult to handle. It is also likely that rust would develop in humid environments should the finish become chipped or scratched. This author finds the Saxe box to be generally unsatisfactory.

Several photographers have had metal boxes custom-made for portfolios. In 1980 Lilio Raymond used a brushed aluminum box for a portfolio entitled *Six Photographs;* the edition was limited to 30 sets and was sold for $1,000 by the Marcuse Pfeifer Gallery in New York City. Joe Maloney had a spray-painted metal box made for his portfolio of ten Kodak Dye Transfer prints published and sold by QED Editions in New York City for $5,000 in 1982.

A print storage box made of aluminum, lined with 100% cotton fiber mount board, and "covered in cloth to make it aesthetically pleasing," was under development by a British firm called Goldfinger Ltd.; unfortunately, the company went out of business in 1985 and the box was never marketed. This approach to box design appears to be sound, however, and it is hoped that in the future some other manufacturer will produce a box of this type.

## Photograph Albums

Paper products in photograph albums should meet the same requirements as mount board, interleaves, envelopes, and any other paper in direct contact with films and prints; additional information on paper quality can be found in Chapter 13.

Photograph albums have traditionally been fabricated from paper of very low quality; usually made with alum-rosin size, these acidic papers often contain significant amounts of lignin from groundwood, and have potentially harmful levels of sulfur. Combined with damaging adhesives, the paper in such albums has caused — or accelerated — the discoloration and fading of countless millions of photographs.

November 1986

Commercial blueprint files are excellent for storing prints (especially large unmatted prints) because they have wide, shallow drawers. Marthe Smith, former director of the Life Gallery of Photography in New York City, and Carol Brower look at Alfred Eisenstadt photographs. The gallery exhibits and sells photographs from the extensive Time Inc. Magazines Picture Collection (part of Time Warner Inc.).

More recently, photograph albums with plastic-covered "self-stick" or "magnetic" pages have become very popular for storing amateur snapshots. As a group, these albums have proven to have very poor aging characteristics and are unacceptable for storing any type of photograph. In a 1987 *New York Times* article about the hazards of poor-quality photo albums, Glenn Collins wrote:

> The worst type of album, conservators say, is the most common one: the so-called magnetic album. It has no magnets, but its cardboard pages grip photographs on a sticky adhesive coating covered by a layer of plastic that is peeled back to position the photos.
>
> In such albums, "the cheap-quality cardboard gives off peroxides that cause yellow staining in the whites of the prints in both black and white and color prints," Mr. [James] Reilly said.
>
> The plastic covering can be harmful not only because it completely seals the photograph in

with cardboard, but because the plastic gives off gases that attack photographic images.

Furthermore, Mr. [Douglas] Severson said, "the strips of adhesive material can be devastating to photographs, transferring themselves to the print." Ms. [Judith] Fortson explained that eventually a bond forms between the adhesive and the photograph, "so you cannot take out the photo without destroying it."

This is by no means the only harmful type of album. Mr. Reilly said the black backing paper that was used in many older albums "is the pits — the paper gives off oxidant gases that attack photo images."[48]

Existing albums of poor-quality materials can best be preserved by storing in refrigerated conditions with low relative humidity (about 30%) and the lowest temperature possible (see Chapters 19 and 20).

Many albums contain valuable written material such as captions to the photographs, and this material should be photocopied if it is decided to remove prints from an album. Unmounting photographs, especially old prints attached with unknown adhesives, is a complex and hazardous procedure and should not be attempted unless adequate equipment and thoroughly experienced personnel are available. It is beyond the scope of this book to discuss unmounting, reprocessing, and restoration of old photographs.

## 3M FlashBacks Brand Photo Albums with Self-Stick Pages

Perceiving that a large market existed for a reasonably safe, easy-to-use photograph album with self-stick pages, in 1991 the 3M Company introduced a line of albums with self-stick pages under the FlashBacks name. These albums utilize a different and much longer-lasting "tacky" adhesive to hold photographs in place than other currently available self-stick albums. 3M cautions, however, that the adhesive, which is similar to that used in 3M's familiar removable yellow "Post-it" note pads, may leave a "slight residue" on the backs of prints.

This author has not tested these albums for the long-term effects they could have on photographs. FlashBacks albums should not be used in museum or archive applications. However, the albums appear to be made of reasonably good quality materials and the pages are made with long-lasting polypropylene cover sheets. For those who insist on using self-stick albums, FlashBacks albums are recommended as the best currently available albums of this type. They are clearly much safer for photographs than the common, low-cost, self-stick "magnetic-page" albums discussed previously.

## Albums with Paper and Polyester Pages

Light Impressions Corporation, University Products, Inc., Century Division of Pohlig Bros. Inc., Photofile, Inc., and a few other suppliers now market "archival" photograph albums with paper pages and polyester-covered pages which, in general, are made with long-lasting and nonreactive materials. These albums, which appear to be suitable for histori-

cal societies, museums, and other long-term applications, are fairly expensive.

Low-cost albums of reasonable quality can be made by using a loose-leaf notebook filled with good-quality artists' drawing paper obtainable at any art supply store. A notebook with a cloth or paper cover is preferable to one made with the currently popular plasticized PVC covers. The artists' paper can be cut to the proper size and holes punched with a standard paper punch. Gummed hole reinforcements should then be applied to the holes. Pencil or India ink should be used to mark the pages. Prints may be attached with mounting corners (see Chapter 12), or with 3M No. 568 Positionable Mounting Adhesive, available from photographic supply stores.

Uncoated polyester notebook page protectors (made from DuPont Mylar D or ICI Melinex 516), available from Light Impressions Corporation and most office supply stores, offer excellent physical protection for album pages; because transparent notebook page protectors are made from a variety of plastics, be certain that those to be placed in photograph albums are fabricated from polyester.

### Webway Family Archival Albums

Moderately priced, well-designed albums consisting of good-quality acid-free and lignin-free paper pages with ICI Melenix polyester-covered "Picture-Pockets" are supplied by Webway Incorporated of St. Cloud, Minnesota under the Webway Family Archival Album name. These albums, which can be easily expanded with low-cost Family Archival refill pages, are available in sizes for standard 3½x5-inch 3R format prints ($18.00) and 4x6-inch 4R format prints ($20.00). Page styles are available both with and without an ample writing space below each print for captions (probably better for most people are the pages with extra writing space, even though these pages accommodate fewer prints than the page style without writing space).

Webway Family Archival albums, which were introduced in 1989, are this author's primary recommendation for general home and amateur storage of both color and black-and-white photographs. For 8x10-inch prints, the Webway Portrait Album is available. Webway supplies other albums under the Classic, Prestige, and Vanguard names; some of these albums are sold with "Press-N-Stick" self-adhesive pages, which should be avoided.

### Albums with Polypropylene and Low-Density Polyethylene Pages

C-Line Products, Inc., 20th Century Plastics, Inc., Light Impressions Corporation, and others sell surface-treated (coated) polypropylene notebook pages with sectioned pockets, similar to those made for slides, to hold a variety of common print sizes. Although surface-treated polypropylene pages are superior to PVC notebook pages, such as those sold by 20th Century Plastics, they are not recommended by this author for long-term storage of valuable photographs; polypropylene pages should be avoided in museum and archive applications. Likewise, polyethylene notebook pages made by Vue-All Incorporated, Print File, Inc., Clear File Inc., and other suppliers are not recommended. For further information, see Chapter 14.

November 1986

Print boxes are stored on steel shelves (coated with baked enamel) at the Museum of Modern Art in New York City. The shelves are open and no box rests on another; this provides ready access to the boxes and the prints. Here, Peter Galassi, now the director of the Department of Photography, removes a print box for study purposes. The photography collection is stored in an environmentally controlled room at 60°F (15.5°C) and 40% RH.

A variety of low-cost consumer albums with polypropylene-covered pages are available from the Holson Company of Wilton, Connecticut. Holson has advertised that its album pages have "No PVC Content." One Holson brochure issued in 1985 shows a faded color print that is claimed to have been stored for 5 years in a PVC album page. Also illustrated is an unfaded print of the same scene which has received "No PVC Exposure." On inquiry to the company, this author was informed that the "unfaded" print was not 5 years old like the "faded" print — it was actually a new print made from the original negative. The faded print stored in the polyvinyl chloride page appears to have suffered a near total loss of cyan dye and, judging from its appearance and the date it was supposed to have been made, this author believes that Agfacolor Paper Type 4 was probably used to make the print.

Agfacolor Paper Type 4 has extremely poor dark fading stability and in 5 years would be expected to fade in this manner, regardless of whether the print was stored in a PVC album page. The Holson Company could not identify

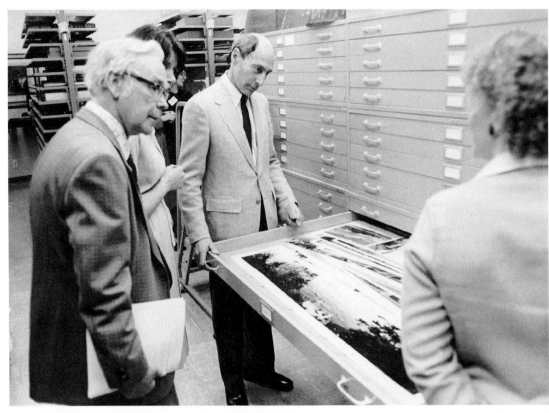

March 1981

Thomas Hill, Peter Krause (center), and other visitors look at large unmounted panoramic prints stored in blueprint files at the Humanities Research Center Photography Collection at the University of Texas in Austin.

the type of paper that was used to make the 5-year-old print.[49] The company did say, however, that the faded print had no backprinting — this precludes it from being an Ektacolor print because all Kodak color paper sold in the U.S. during that period was backprinted to identify it as a Kodak product. Most, if not all, Agfacolor Paper Type 4 imported into the U.S. was not backprinted (watermarked). The new, "unfaded" print was made on Kodak Ektacolor paper.

Regardless of whether a PVC page was the cause of the fading suffered by the print in the Holson brochure, Holson's concern about PVC is justified and the firm's polypropylene-page albums are to be preferred over albums supplied with PVC or poor-quality paper pages. In Holson's product literature, the company does not identify the brand or type of polypropylene in its albums.

Unless plastic-covered pages or plastic page protectors are used, photographs should be mounted on only one side of each album page; if prints are mounted on facing pages, they may catch and damage each other as the pages are turned. In addition, direct print-to-print contact will permit chemicals from poorly processed prints to migrate onto other prints. It is also important to prevent different types of prints (e.g., Kodacolor prints and Polaroid instant prints) from directly contacting each other in the album.

Albums should be kept in a cool, dry place away from strong light. This is especially important if the album contains color photographs. Albums containing lacquered Ektacolor and similar chromogenic color prints from professional wedding and portrait photographers should be opened

several times a year during the first few years after the prints are made to allow lacquer solvent vapors to dissipate; Kodak reports that "Lacquered prints can . . . turn yellow in albums that are tightly sealed, particularly where peroxide forming solvents are present in the lacquer."[50] Prints obtained from drugstores, "one-hour" minilabs, and similar outlets are never lacquered.

## Other Types of Albums

Hallmark Card Shops (operated by Hallmark Cards, Inc. of Kansas City, Missouri) sell several types of photograph albums, some of which are made with overlapping cellulose acetate pages with prints inserted back-to-back, two to a page. These albums appear to be satisfactory for amateur use.

Some albums supplied by the Polaroid Corporation for Polaroid 600 and SX-70 prints require that the prints be flexed during insertion into album page slots. These albums should be avoided because such bending may contribute to eventual cracking of the prints' internal image-receiving layer. Polaroid albums for peel-apart color and black-and-white prints that have pages made of plasticized polyvinyl chloride (PVC) are not recommended for long-term storage of photographs.

## Cabinets and Shelves

Cabinets and shelves should be constructed of steel or aluminum coated with baked enamel, of chrome- or nickel-plated steel, of anodized aluminum, or of stainless steel.[51]

Wood is not recommended, but if it *must* be used, well-dried hardwoods such as maple or birch are preferred. For reasons to be discussed later, plywood and particle board in particular should be avoided. Structural foam plastics and laminated decorative plastics such as Formica should never be used.

ANSI standards concerned with the storage of photographs suggest both "baked-on nonplasticized synthetic resin lacquer" and "baked-on enamel"[52] as suitable finishes for steel cabinets, shelves, and other storage housings.[53] Lacquers containing cellulose nitrate (pyroxylin) should be avoided. Kodak has recommended against both acrylic lacquers and acrylic enamels.[54]

If steel equipment is to be repainted, this author suggests having this work done at a commercial spray-paint shop equipped with drying ovens to produce the proper finish. Some automobile paint shops can do this type of work. Finishes on wood will blister if baked at high temperatures; therefore, water-base latex paints, which do not require baking, are recommended for painting wood shelves and cabinets, as well as walls and other fixtures in galleries and storage areas. Alkyd oil-base paints have been shown to produce peroxides and other vapors which can rapidly discolor black-and-white images. Larry Feldman of Eastman Kodak has reported that unbaked alkyd oil-base enamel continued to evolve harmful fumes for many weeks after the paint was applied; latex paints, however, did not produce harmful fumes in the Kodak tests.[55]

Anodized aluminum is an excellent material for cabinets and shelves, though it is more expensive than baked-enamel-coated steel. Stainless steel is also excellent, but because it is very expensive it is not often chosen for making photographic storage equipment.

A wide range of cabinets, cabinets with shelves, and open shelves made of steel finished with baked enamel are available from office equipment dealers at moderate cost; most are well suited for long-term storage of photographs. Blueprint files, which have many large drawers of shallow depth, are excellent for storing large or odd-sized prints.

For large-volume storage applications, shelving which can be rolled together will save a significant amount of space; the shelves are rolled apart for access.[56] Shelves of this type are particularly helpful in cold storage facilities where space is at a premium.

Cabinets and closed shelves normally do not need ventilation if the prints stored in them are properly processed and the mount board, paper products, and boxes are of high quality. Closed cabinets greatly reduce problems with dust and minimize effects of air pollution. Unventilated cabinets also minimize fluctuations in relative humidity if the humidity in the storage area is not controlled.

If the photographs and associated paper products and boxes are of poor quality, however, there may be some advantage in providing ventilation to allow peroxides and other potentially harmful vapors to diffuse into the surrounding air. Cabinets for storing cellulose nitrate films at room temperature should be adequately ventilated — and if possible should be located in a separate building away from other collections. Ideally, nitrate films should be sealed in vapor-proof containers and stored in special, explosion-proof freezers at a temperature of 0°F (–18°C) or lower (see **Appendix 19.1** in Chapter 19).

## Plywood, Particle Board, and Formica-covered Cabinets and Shelves Should Be Avoided

Margaret A. Leveque, a conservator at the Museum of Fine Arts in Boston, has reported a case in which metal objects in the museum collection corroded within a short period after they were put in new plywood display cases.[57] The source of the problem was identified as formaldehyde from the urea-formaldehyde adhesive that bonded the layers of plywood together; samples of the birch plywood in the cases contained about 7.8% free formaldehyde by weight. Attempts to seal the plywood with three coats of polyurethane varnish and covering the cut edges with strips of hardwood proved to be of little benefit. Ventilation of the display cases also did not solve the problem.

Leveque also reported that tests of the interior environment of veneered wood-particle-board storage cases installed in the newly built Sackler Museum at Harvard University indicated such high levels of formaldehyde that it was decided not to jeopardize museum objects by placing them in the cases; instead, the units were replaced with baked-enamel steel cases.

It has been shown that formaldehyde vapors also are capable of harming black-and-white photographs. In an important article published in 1972, Edith Weyde, a research chemist at Agfa-Gevaert in Leverkusen, West Germany, described a number of chemical processes which the silver images of black-and-white films and prints can undergo during the course of image deterioration:

> When silver coatings are exposed to oxidizing gases, soluble silver salts form in these coatings. . . . These salts are colorless and will remain that way for years if they are protected from intense light exposure and kept in pure air. The only effect of the oxidizing gases is to reduce the density of the images, which is easily overlooked. However, the colorless silver salts are very easily converted to brown, water-soluble compounds, if the air contains traces of certain impurities such as formaldehyde, acids, etc. For example, it is quite sufficient to open a bottle of formaldehyde in the same room to stain these colorless silver salts brown. Light will quickly convert these salts to silver.[58]

The initial reason for Weyde's research was the unexpectedly rapid deterioration of some of the films and prints in the Munich archives. Weyde was able to identify plastic file index cards made of phenylene-formaldehyde as the cause; the cards had been in use at the archives for 14 years, and the first signs of image discoloration had been noted after 5 years.

Formaldehyde solutions have been used as hardeners in black-and-white processing, and it is apparent that newly processed silver images are not adversely affected by short-term exposure to the substance. Older films and prints, on the other hand, are likely to contain at least trace amounts of silver salts due to exposure to oxidizing gases during the course of storage; as a result, the photographs may be subject to discoloration in the presence of formaldehyde. The hazard is probably the greatest for films and prints

which have been subjected to periods of storage under adverse conditions during their history.

This underscores this author's recommendation that museums and archives in particular should strictly prohibit wood, plywood, particle board, chipboard, Masonite, and formaldehyde-containing plastic laminates such as Formica in making boxes, cabinets, shelves, and display cases for storing their collections.

## Notes and References

1. Glenn Collins, "Fading Memories: Albums Damage Photos," **The New York Times,** October 3, 1987, p. 16Y.
2. T. F. Parsons, G. G. Gray, and I. H. Crawford [Eastman Kodak Company], "To RC or Not to RC," **Journal of Applied Photographic Engineering,** Vol. 5, No. 2, Spring 1979, pp. 110–117. See also: Larry H. Feldman [Eastman Kodak Company], "Discoloration of Black-and-White Photographic Prints," **Journal of Applied Photographic Engineering,** Vol. 7, No. 1, February 1981, pp. 1–9. (The Feldman article does not directly address the image deterioration in framed and displayed black-and-white RC prints.) Kodak's most recent advice: **"Displaying Prints:** Prints on black-and-white, resin-coated [RC] papers that may be subjected to intense or extended illumination, exposed to oxidizing gases, or framed under glass or plastic should be treated with toners . . . to extend image life. Toned fiber-base papers continue to be recommended for those applications requiring long-term keeping under adverse storage or display conditions." (From information sheet: **Kodak Polycontrast Rapid II RC Paper,** KP73873f, Eastman Kodak Company, Rochester, New York, August 1981.)
3. W. E. Lee, F. J. Drago, and A. T. Ram, "New Procedures for Processing and Storage of Kodak Spectroscopic Plates, Type IIIa–J," **Journal of Imaging Technology,** Vol. 10, No. 1, February 1984, p. 28.
4. Light Impressions Corporation, **Light Impressions Mid-Summer 1991 Archival Supplies Catalog,** p. 2 (see **Suppliers** list below for Light Impressions' address).
5. See **ANSI PH1.48-1982, American National Standard for Photography (Film and Slides) – Black-and-White Photographic Paper Prints – Practice for Storage,** 1982, p. 6. American National Standards Institute, Inc., 11 West 42nd Street, New York, New York 10036; telephone: 212-642-4900; Fax: 212-398-0023.
6. Eastman Kodak Company, **Conservation of Photographs** (George T. Eaton, editor), Kodak Publication No. F-40, Eastman Kodak Company, Rochester, New York, March 1985, p. 108.
7. PermaColor Corporation, press release, June 1, 1982.
8. Norb J. DeKerchove, product research coordinator, Light Impressions Corporation, Rochester, New York.
9. Toshiaki Aono, Kotaro Nakamura, and Nobuo Furutachi [Fuji Photo Film Co., Ltd.], "The Effect of Oxygen Insulation on the Stability of Image Dyes of a Color Photographic Print and the Behavior of Alkylhydroquinones as Antioxidants," **Journal of Applied Photographic Engineering,** Vol. 8, No. 5, October 1982, pp. 227–231. See also: Kaoru Onodera, Toyoki Nishijima, Shun Takada, and Masao Sasaki [Konica Corporation], "The Effect of Oxygen Gas on the Light-Induced Fading of Dye Images and Staining of Color Photographic Prints," presented at the **Second SPSE International Conference on Photographic Papers,** sponsored by the Society of Photographic Scientists and Engineers, Vancouver, British Columbia, Canada, July 24, 1984.
10. Remon Hagen, "Further Improvements in the Permanence of Cibachrome Materials under Adverse Display Conditions," **Journal of Imaging Technology,** Vol. 12, No. 3, June 1986, pp. 160–162. One company offering rigid plastic encapsulation of Ilfochrome (Cibachrome) and other photographs is: Armourseal, VPB Industries, Albion Mill, Hollingsworth, Hyde, Cheshire SK14 8LS, England; telephone: 01-0475-65226. See also: Attila Kiraly, "The Kiraly Method of Embedding Cibachrome Display Prints for Archival Protection," **Proceedings of the International Symposium: The Stability and Conservation of Photographic Images: Chemical, Electronic and Mechanical,** Bangkok, Thailand, November 3–5, 1986, pp. 139–144. (Available from: SPSE, The Society for Imaging Science and Technology, 7003 Kilworth Lane, Springfield, Virginia 22151; telephone: 703-642-9090.)
11. Eastman Kodak Company, **Quality Enlarging with Kodak B/W Papers – Art, Technique, and Science,** Kodak Publication No. G-1, Eastman Kodak Company, Rochester, New York, May 1982, p. 119.
12. Laurence E. Keefe, Jr. and Dennis Inch, **The Life of a Photograph,** Focal Press (Butterworth Publishers), Boston, Massachusetts and London, England, 1990, p. 179. The venting recommendation was also included in the first edition of the book (p. 165), published in 1984.
13. Eastman Kodak Company, see Note No. 6, pp. 57–58. See also: Eastman Kodak Company, **Printmaking with Kodak Elite Fine-Art Paper,** Kodak Publication No. G-18, Eastman Kodak Company, Rochester, New York, November 1984.
14. Debbie Hess Norris, "The Proper Storage and Display of a Photographic Collection," **Picturescope,** Vol. 31, No. 1, Spring 1983, p. 10.
15. Laurence E. Keefe, Jr. and Dennis Inch, see Note No. 12, p. 182.
16. If economy dictates corrugated cardboard as backing for framed photographs, the best available product is probably Lig-free Corrugated Board, supplied by Conservation Resources International, Inc. (see **Suppliers** list at the end of this chapter).
17. American Society for Testing and Materials, **ASTM D 984–74, Standard Methods of Testing for Reducible Sulfur in Paper,** American Society for Testing and Materials, 1916 Race Street, Philadelphia, Pennsylvania 19103; 1974. Related Standard: Technical Association of Pulp and Paper Industry [TAPPI] Standard Method T 406 Su 72.
18. T. J. Collings and F. J. Young, "Improvements in Some Tests and Techniques in Photograph Conservation," **Studies in Conservation,** Vol. 21, No. 2, May 1976, pp. 79–84.
19. Check with aluminum suppliers in your area (listed in the Yellow Pages of the telephone book). Some industrial suppliers will sell only to large-quantity purchasers. Small or large quantities, including cut-to-size pieces, may be purchased from Lawrence N. Frederick, Inc., 501 East Lake Street, Streamwood, Illinois 60107; telephone: 708-289-8300. This firm also sells anodized aluminum foil.
20. Michael F. Bruton, market supervisor, Fabricated Products Division, Monsanto Plastics and Resins Co., 800 N. Lindbergh Boulevard, St. Louis, Missouri 63166, letter to this author, December 1, 1982.
21. Advertisement in **Photographic Processing,** Vol. 18, No. 6, June 1983.
22. International Paper Company, **Gatorfoam Photo-Mount Use Instruction Sheet,** March 13, 1984, Gatorfoam Laminated Foam Panels, International Paper Company, Uniwood Division, Highway 90, P.O. Box 5380, Statesville, North Carolina 28677.
23. Advertisement in **Photographic Processing,** Vol. 18, No. 9, Sept. 1983.
24. Jay Wynne, technical manager, Gatorfoam Laminated Foam Panels, see Note No. 22, telephone discussion with this author, Oct. 24, 1984.
25. W. E. Lee **et al.,** see Note No. 3, p. 28.
26. Polaroid Corporation, **Storing, Handling, and Preserving Polaroid Photographs: A Guide,** Polaroid Corporation, Cambridge, Massachusetts, 1983, p. 33.
27. Coroplast, Inc., 700 Vadnais Street, Granby, Quebec J2J 1A7, Canada; telephone: 514-378-3995.
28. Framespace spacers are available from Frame Tek, 5120–5 Franklin Boulevard, Eugene, Oregon 97403; telephone: 503-726-5779 (toll-free outside of Oregon: 800-227-9033). Framespace spacers are made of KODAR PETG 6763 plastic, a product of Eastman Chemical Company. The plastic is claimed to contain no "plasticizers or additives which might exude."
29. Rohm and Haas Company, **Ultraviolet Filtering and Transmitting Formulations of Plexiglas Acrylic Plastic,** Plexiglas Design, Fabrication Data, PL–612d, 1979, pp. 2, 3, 5. Rohm and Haas Company, Independence Mall West, Philadelphia, Pennsylvania 19105; telephone: 215-592-3000. Plexiglas UF-3 should not be confused with Plexiglas II UVA which does not contain an ultraviolet absorber. UVA has about the same ultraviolet cutoff point as the standard grades of Plexiglas (which absorb somewhat more UV radiation than ordinary glass). The Plexiglas II series is made to much closer thickness tolerances, and is more expensive, than the standard grades such as Plexiglas G.

Polycast UF-3 and UF-4 are manufactured by Polycast Technology Corporation, P.O. Box 141, Stamford, Connecticut 06904. DuPont Lucite SAR and Lucite SAR UF-3 are manufactured by the DuPont Company, Polymer Products Department, Lucite Sheet Products Group, Wilmington, Delaware 19898. To produce Lucite SAR UF-3 and SAR UF-4 abrasion-resistant sheet, DuPont reportedly applies its proprietary SAR coating to UF-3 and UF-4 acrylic sheet purchased from Polycast Technology Corporation. Licensing and purchasing agreements allow the Rohm and Haas UF-3 and UF-4 trademarks to be used by all three companies. Acrylite OP-2 and OP-3 are distributed by CYRO Industries, Inc., 100 Valley Road, P.O. Box 950, Mt. Arlington, New Jersey 07856; telephone: 201-770-3000.

Plexiglas is supplied with protective paper or polyethylene cover sheets on both sides to prevent scratches during cutting and handling. Plexiglas may be cut with a table saw equipped with a fine hollow-ground plywood blade such as those sold by Sears Roebuck, Rockwell, and others. Production shops cutting large quantities of Plexiglas should use one of the fine-toothed, carbide-tipped blades especially designed for cutting acrylic sheet. These blades, which may cost more than $200 each, are available from several companies, including Forrest Manufacturing Company, Inc., 461 River Road, Clifton, New Jersey 07014; telephone: 201-473-5236. Coarse-toothed saw blades or blades with teeth which have been "set" should not be used because a rough cut and edge chipping will result.
30. Edith Weyde [Agfa-Gevaert AG], "A Simple Test to Identify Gases Which Destroy Silver Images," **Photographic Science and Engineering,** Vol. 16, No. 4, July–August 1972, pp. 283–286.
31. C. I. Pope, "Blemish Formation in Processed Microfilm II," **Journal of Research of the National Bureau of Standards – A. Physics and Chemistry,** Vol. 74A, No. 1, January–February 1970, pp. 31–36.
32. Eastman Kodak Company, **Preservation of Photographs,** Kodak Publication No. F-30, Eastman Kodak Company, Rochester, New York, August 1979, p. 30.

33. Polaroid Corporation, see Note. No. 26, p. 28.
34. Viratec Tru Vue, Inc., 1315 N. North Branch Street, Chicago, Illinois 60622; telephone: 312-943-4200; toll-free: 800-621-8339 (anti-reflection coated glass sold under the Tru Vue Museum Glass name). Denton Vacuum, Inc., 8 Springdale Road, Cherry Hill, New Jersey 08003; telephone: 609-424-1012 (anti-reflection coated glass sold under the Denglas name).
35. American National Standards Institute, Inc., **ANSI PH1.45-1981, American National Standard Practice for Storage of Processed Photographic Plates,** American National Standards Institute, Inc., 11 West 42nd Street, New York, New York 10036; telephone: 212-642-4900; Fax: 212-302-1286. (Note: This Standard eventually will be replaced with a revised version under the ANSI IT9 designation.)
36. American National Standards Institute, Inc., see Note No. 5, p. 6.
37. American National Standards Institute, Inc., see Note No. 5, p. 6.
38. James M. Reilly, **Care and Identification of 19th-Century Photographic Prints,** Kodak Publication No. G-2S, Eastman Kodak Company, Rochester, New York, 1986, p. 93.
39. The Tri-Test Spot Testing Kit for Unstable Papers was previously known as the Barrow Laboratory Paper Test Kit. The Barrow kit was developed by the now defunct W. J. Barrow Research Laboratory in Richmond, Virginia in the 1960's. See: W. J. Barrow Research Laboratory, **Permanence/Durability of the Book: VI, Spot Testing for Unstable Modern Book and Record Papers,** Richmond, Virginia, 1969 (a copy of this publication, with a new cover, is included as an instruction booklet with each Tri-Test kit). The test reagent for detecting groundwood yellows with age and should be replaced as necessary; refrigeration will greatly extend the life of the solutions. The bottle of test reagent for groundwood should be opened slowly, while holding over a sink. Eye goggles and rubber or plastic gloves should be worn. Gas pressure which may have built up inside the bottle over time can cause the solution to bubble over, perhaps with some force, upon opening. The Tri-Test kit is available for about $30 from Professional Picture Framers Association, Inc., 4305 Sarellen Road, Richmond, Virginia 23231; telephone: 804-226-0430. Also available from Light Impressions Corporation and Westfall Framing (see **Suppliers** list at the end of this chapter).
40. Eastman Kodak Company, see Note No. 6, p. 95.
41. "Solander box (Solander book-box portfolio). A more or less elaborate book or document box invented by Dr. Daniel Charles Solander, a botanist, during his tenure at the British Museum (1773–1782).

". . . When properly constructed the Solander box is very nearly dustproof and almost waterproof.

". . . The drop-back Solander is intended to house a book. For document storage, specifically to facilitate removal from the box, a drop-front box may actually be preferable, although in a strict sense it may be argued that such an arrangement is not really a Solander box. Aside from this, however, the drop-back box has a distinct advantage over the drop-front type in that the former imposes virtually no strain on the hinge of the box because it is in a right-angle position when closed and assumes a straight line position when opened."

From **Bookbinding and the Conservation of Books,** Matt T. Roberts and Don Etherington, Library of Congress, Washington, D.C., 1982, p. 243.
42. Davey Acid-pHree binders board is available in six thicknesses, from 0.067 to 0.123 inch, from The Davey Company, 164 Laidlaw Avenue, P.O. Box 8128, Five Corners Station, Jersey City, New Jersey 07306; telephone: 201-653-0606.
43. W. F. Lee **et al.,** see Note No. 3, p. 28.
44. Acrylic-impregnated book cloth with surface physical characteristics similar to pyroxylin-impregnated fabric is manufactured under the Arrestox name (supplied in three thicknesses: A, B, and C) by Industrial Coatings Group, Inc., 220 Broad Street, Kingsport, Tennessee 37660; telephone: 615-247-2131 (toll-free: 800-251-7528). See: Ellen McCrady, "Pyroxylin vs. Aqueous (Acrylic) Coated Cloth," **The Abbey Newsletter,** Vol. 9, No. 3, May 1985, p. 3. Acrylic-impregnated book cloth also is available from: The Holliston Mills, Inc., P.O. Box 1568, Boca Raton, Florida 33429; telephone: 305-392-9934 (toll-free: 800-225-7122).
45. C. I. Pope, see Note No. 31.
46. Margaret R. Brown, comp., **Boxes for the Protection of Rare Books: Their Design and Construction,** Library of Congress, Washington, D.C., 1982.
47. Saxe steel boxes were manufactured by Saxe Archival Systems, P.O. Box 237, Victoria Station, Westmount, Quebec H3Z 2V5, Canada. The boxes were supplied in four standard sizes, 8x10 through 16x20 inches; they were coated with a dry, heat-cured, electrostatically applied polyester finish. A heavy, similarly finished steel plate was available to keep prints flat inside the boxes. For several years, Saxe boxes were distributed in the U.S. by Light Impressions Corporation, Rochester, New York.
48. Glenn Collins, see Note No. 1, p. 16Y.
49. Todd Holson, marketing manager, The Holson Company, telephone discussion with this author, October 1, 1985.
50. Eastman Kodak Company, **Post-Processing Treatment of Kodak Ektacolor Papers,** ("Reference Information From Kodak"), Kodak Publication No. E-176, Rochester, New York, July 1984, p. 5. See also Eastman Kodak Company, Note No. 6, "The Effect of Post-Processing Treatments on Color Image Stability," pp. 66–68.
51. American National Standards Institute, Inc., see Note No. 5, p. 6.
52. Modern finishes are often not clearly distinguished as being lacquers, enamels, or other types of coatings. Lacquers generally refer to thermoplastic materials dissolved in a solvent and capable of drying rapidly to harden films. Cellulose esters, including cellulose nitrate (nitrocellulose), are often used in lacquers; however, many other types of plastics, including vinyls and acrylics, are also used. The clear spray finishes for coating photographic prints are usually true lacquer products (see Chapter 4). These finishes remain soluble in appropriate solvents after drying. Another example of a true lacquer finish is fingernail paint, variously referred to as "polish," "lacquer," and "enamel."

Enamel finishes generally refer to coatings which form a hard film by a curing process (either an oxidation or polymerization reaction) which takes place after most of the solvent has evaporated. Once hardened, these finishes are no longer soluble in common solvents. Baking at temperatures of 180–250°F (82–121°C), or higher, will produce very hard, solvent-free finishes with most alkyd and other oil-base enamels. Baked enamels of this type have traditionally been used to finish steel office equipment, home appliances, and automobiles. Baking ovens on production lines can quickly dry the enamels to a durable finish. The rising cost of energy required to heat ovens and the cost of solvent-recovery equipment for meeting air pollution regulations are causing some industries to change to two-component, catalyst-hardened finishes, which do not require heating and give off little vapor. This author has no data on the long-term effects of these two-component finishes on photographs. Another new type of finish is the heat-fused sprayable powder coating.
53. American National Standards Institute, Inc., see Note No. 5, p. 6.
54. Eastman Kodak Company, see Note No. 32, p. 30.
55. Larry H. Feldman [Eastman Kodak Company], "Discoloration of Black-and-White Photographic Prints," **Journal of Applied Photographic Engineering,** Vol. 7, No. 1, February 1981, pp. 1–9.
56. Spacesaver Corporation, 1450 Janesville Avenue, Ft. Atkinson, Wisconsin 53538; telephone: 414-563-6362.
57. Margaret A. Leveque, "The Problem of Formaldehyde – A Case Study," **Preprints,** of papers presented at the 14th annual meeting of the American Institute for Conservation of Historic and Artistic Works (AIC), Chicago, Illinois, May 21–25, 1986, pp. 56–65. See also: Pamela Hatchfield and Jane Carpenter, **Formaldehyde: How Great is the Danger to Museum Collections?,** Center for Conservation and Technical Studies, Harvard University Art Museum, Harvard University, 1987. (Available from: The Center for Conservation and Technical Studies, Harvard University Art Museums, 32 Quincy Street, Cambridge, Massachusetts 02138; telephone: 617-495-2392.)
58. Edith Weyde, see Note No. 30, p. 283.

## Additional References

Ansel Adams, **The Print,** The New Ansel Adams Photography Series – Book 3, New York Graphic Society, Little, Brown and Company, Boston, Massachusetts, 1983.

W. J. Barrow, "Migration of Impurities in Paper," **Archivum,** Vol. 3, 1953.

Jared Bark, **Notes on Framing,** Bark Frameworks, Inc., 85 Grand Street, New York, New York, 1982.

Jared Bark, **More Notes on Framing,** Bark Frameworks, Inc., 85 Grand Street, New York, New York, 1985.

Helen D. Burgess and Carolyn G. Leckie, "Evaluation of Paper Products: With Special Reference to Use with Photographic Materials," **Topics in Photographic Preservation — Volume Four** (compiled by Robin E. Seigel), Photographic Materials Group of the American Institute for Conservation, 1991, pp. 96–105. Available from the American Institute for Conservation, Suite 340, 1400 16th Street, N.W., Washington, D.C. 20036; telephone: 202-232-6636.

Ctein, "Archival Framing," **Petersen's Photographic Magazine,** Vol. 8, No. 4, August 1979.

Francis W. Dolloff and Roy L. Perkinson, **How to Care for Works of Art on Paper,** third edition, Museum of Fine Arts, Boston, Massachusetts, 1979.

Klaus B. Hendriks, together with Brian Thurgood, Joe Iraci, Brian Lesser, and Greg Hill of the National Archives of Canada staff, **Fundamentals of Photographic Conservation: A Study Guide,** published by Lugus Publications in cooperation with the National Archives of Canada and the Canada Communication Group, 1991. Available from Lugus Productions Ltd., 48 Falcon Street, Toronto, Ontario, Canada M4S 2P5; telephone: 416-322-5113; Fax: 416-484-9512.

Gregory Hill, "The Conservation of a Photograph Album at the National Archives of Canada," **Journal of the American Institute for Conservation,** Vol. 30, No. 1, Spring 1991, pp. 75–88.

Douglas M. Kenyon, **Framing and Conservation of Works of Art on Paper,** Rising Paper Company, Housatonic, Massachusetts, 1981.

Eugene Ostroff, "Preservation of Photographs," **The Photographic Journal,** Vol. 107, No. 10, October 1967, pp. 309–314.

Beverly Solochek, "Framers Putting More Emphasis on Preservation of Art Works," **The New York Times,** January 29, 1981, pp. C1, C6.

David Vestal, **The Art of Black-and-White Enlarging,** Harper & Row, Publishers, Inc., New York, New York, 1984.

# Suppliers

## Welded Aluminum and other Pre-Assembled Frames

**A.P.F., Inc.**
320 Washington Street
Mt. Vernon, New York 10053
  Telephone: 914-665-5400

**A.P.F., Inc.** (uptown showroom)
136 East 70th Street
New York, New York 10021
  Telephone: 212-988-1090

**A.P.F., Inc.** (SoHo showroom)
568 Broadway
New York, New York 10012
  Telephone: 212-925-5444

## Aluminum Section Frames

**ASF American Frame Corporation**
1340 Tomahawk Drive
Maumee, Ohio 43537
  Telephone: 419-893-5595
  Toll-free: 800-537-0944 (outside Ohio)

**Graphic Dimensions Ltd.**
41–23 Haight Street
Flushing, New York 11355
  Telephone: 212-463-3500
  Toll-free: 800-221-0262 (outside New York)

**Light Impressions Corporation**
439 Monroe Avenue
Rochester, New York 14603-0940
  Telephone: 716-271-8960
  Toll-free: 800-828-9629

**Nielsen & Bainbridge Division**
Esselte Business Systems, Inc.
40 Eisenhower Drive
Paramus, New Jersey 07653
  Telephone: 201-368-9191
  Toll-free: 800-342-0124

**Opus Framing Ltd.**
1360 Johnston Street
Vancouver, British Columbia V6H 3S1
Canada
  Telephone: 604-688-0388

**Westfall Framing**
P.O. Box 13524
Tallahassee, Florida 32317
  Telephone: 904-878-3546
  Toll-free: 800-874-3164

## Boxes for Storing Prints and Films

**Conservation Resources International, Inc.**
8000-H Forbes Place
Springfield, Virginia 22151
  Telephone: 703-321-7730
  Toll-free: 800-634-6932 (outside Virginia)

**The Hollinger Corporation**
4410 Overview Drive
P.O. Box 8630
Fredericksburg, Virginia 22404
  Telephone: 703-898-7300
  Toll-free: 800-634-0491 (outside Virginia)

**Light Impressions Corporation**
439 Monroe Avenue
Rochester, New York 14603-0940
  Telephone: 716-271-8960
  Toll-free: 800-828-6216

**Museum Box Company**
1050 Tollgate Road
P.O. Box 1292
West Warwick, Rhode Island 02893
  Telephone: 401-822-1560

**Opus Binding Limited**
356 Preston Street
Ottawa, Ontario K1S 4M7
Canada
  Telephone: 613-236-8743

**Pohlig Bros. Inc.**
Century Division
2419 E. Franklin Street
P.O. Box 8069
Richmond, Virginia 23223
  Telephone: 804-644-7824

**Portfoliobox, Inc.**
166 Valley Street
Building 3–402
Providence, Rhode Island 02909
  Telephone: 401-272-9490

**G. Ryder & Co., Ltd.**
Denbigh Road, Bletchley
Milton Keynes, Buckinghamshire MK1 1DG
England
  Telephone: 01-0908-75524

**Spink & Gaborc, Inc.**
11 Troast Court
Clifton, New Jersey 07011
  Telephone: 201-478-4551

# Suppliers

## Boxes for Storing Prints and Films

**Talas, Inc.**
213 West 35th Street
New York, New York 10001-1996
　Telephone: 212-736-7744

**University Products, Inc.**
517 Main Street
Holyoke, Massachusetts 01041-0101
　Telephone: 413-532-9431
　Toll-free: 800-628-1912 (outside Massachusetts)
　Toll-free: 800-336-4847 (in Massachusetts)

## High-Quality Photograph Albums

**Light Impressions Corporation**
439 Monroe Avenue
Rochester, New York 14607-3717
　Telephone: 716-271-8960
　Toll-free: 800-828-6216

**Photofile, Inc.**
2020 Lewis Avenue
Zion, Illinois 60099
　Telephone: 708-872-7557
　Toll-free: 800-356-2755

**University Products, Inc.**
517 Main Street
Holyoke, Massachusetts 01041-0101
　Telephone: 413-532-9431
　Toll-free: 800-628-1912 (outside Massachusetts)
　Toll-free: 800-336-4847 (in Massachusetts)

**Pohlig Bros. Inc.**
Century Division
2419 E. Franklin Street
Richmond, Virginia 23223
　Telephone: 804-644-7824

## Good-Quality "Consumer" Photograph Albums

**Webway Incorporated**
2815 Clearwater Road
P.O. Box 767
St. Cloud, Minnesota 56302
　Telephone: 612-251-3822
　Toll-free: 800-328-2344

**The Holson Company**
111 Danbury Road
Wilton, Connecticut 06897
　Telephone: 203-762-8661

## The Best Available Self-Stick "Magnetic" Page Photograph Albums

**3M Company**  (FlashBacks Photo Albums)
3M Consumer Stationery Division
P.O. Box 33594
St. Paul, Minnesota 55133
　Telephone: 612-731-6676

## DuPont Mylar D and ICI Melinex 516 (Polyester Sheet)

**Archivart**
Division of Heller & Usdan, Inc.
7 Caesar Place
Moonachie, New Jersey 07074
　Telephone: 201-804-8986

**The Hollinger Corporation**
4410 Overview Drive
Fredericksburg, Virginia 22404
　Telephone: 703-898-7300
　Toll-free: 800-634-0491

**Light Impressions Corporation**
439 Monroe Avenue
Rochester, New York 14603-0940
　Telephone: 716-271-8960
　Toll-free: 800-828-6216

**Spink & Gaborc, Inc.**
11 Troast Court
Clifton, New Jersey 07011
　Telephone: 201-478-4551

**Talas Inc.**
213 West 35th Street
New York, New York 10001-1996
　Telephone: 212-736-7744

**Transilwrap Company**
2615 N. Paulina Street
Chicago, Illinois 60614
　Telephone: 312-528-8000

**University Products, Inc.**
517 Main Street
Holyoke, Massachusetts 01041-0101
　Telephone: 413-532-9431
　Toll-free: 800-628-1912 (outside Massachusetts)
　Toll-free: 800-336-4847 (in Massachusetts)

**Westfall Framing**
P.O. Box 13524
Tallahassee, Florida 32317
　Telephone: 904-878-3546
　Toll-free: 800-874-3164

# 16. The Storage Environment for Photographs: Relative Humidity, Temperature, Air Pollution, Dust, and the Prevention of Fungus

I question whether even a small percentage of the museums in this country are doing anything more than presiding over the steady deterioration of that which they have been instituted to preserve.

*America's Museums: The Belmont Report*[1]
American Association of Museums — 1968

Given the inherent stability characteristics of a particular type of print, slide, or negative — and assuming careful processing and handling — the ultimate useful life of a photograph will be determined by the conditions of storage and display.

The most important decision that must be made is how many years one wants to keep a specific photograph — or an entire collection — in good condition. Nearly every other decision regarding choice of films and papers, processing, negative and print enclosures, display and storage temperature, and relative humidity will revolve around the answer to that question. Once it is decided how long a photograph should be preserved, the stability characteristics of the particular material and processing method used to make the photograph, dictate the conditions under which it must be kept.

As an example, the useful life of Kodak Ektacolor 74 RC prints made during the mid-1970's and early 1980's will be determined by the amount of light they are exposed to on display, the temperature and relative humidity during display, and the temperature and relative humidity of the storage area when the prints are kept in the dark. The inherently poor dark fading stability of Ektacolor 74 RC Paper means that normal room temperatures are much too high if a long life is desired for Ektacolor 74 RC prints.

If prints made on Ektacolor 74 RC Paper are to be kept in good condition for 100 years, and if the approximate light fading and dark fading (and staining) characteristics of the paper are known, it becomes a simple task to calculate how long the prints can be displayed during the 100-year period, and at what refrigerated temperature they must be kept when not on display. (Ektacolor 74 RC Paper and its higher-contrast counterpart, Ektacolor 78 Paper, were replaced with Ektacolor Professional Paper and Ektacolor Plus Paper, respectively, in 1984–1985. Compared with Ektacolor 74 RC, both of these new papers have much better dye stability in dark storage, but they continue to suffer from poor light fading stability. Particularly in dark storage at normal temperatures, the prints will form objectionable yellowish stain over time, and they too must be kept in

humidity-controlled cold storage if they are to be preserved in unchanged condition.)

If it is not desired — or not possible — to keep color photographs in cold storage, then prints must be made with Ilford Ilfochrome (called Cibachrome, 1963–1991), Kodak Dye Transfer, Fuji Dyecolor, UltraStable Permanent Color, or Polaroid Permanent-Color materials — all of which are *extremely* stable when kept in the dark at normal room temperature. Of these, however, only prints made with the new UltraStable Permanent Color (introduced in 1991) and the Polaroid Permanent-Color (introduced in 1989) processes, have sufficient light fading stability to be suitable for long-term display.

Although deterioration characteristics are more difficult to quantify for black-and-white photographs than for color materials, there is ample evidence that a black-and-white photograph may fall far short of its potential life if it is stored in an unsuitable enclosure, if it is kept in contact with a poorly processed print that is contaminated with fixer, or if the surrounding air is humid and/or contains harmful levels of ozone, peroxides, sulfur dioxide, or other pollutants.

The question of how best to store photographic materials is often an economic one: Given a certain amount of available money, would a collection last longer if all old kraft-paper negative and print envelopes were replaced with polyester sleeves, or if a dehumidification system were installed to maintain the relative humidity at 20–30%? Because most prints and many negatives made in past years were not processed properly, nor washed adequately, and have high levels of residual fixer (new enclosures offer little improvement in this case), the greater benefit would almost certainly come from the dehumidification system.

## Keeping Photographs and Films Forever

At least in theory, most museums and archives want to keep their collections in good condition forever, or certainly for a very long — indefinite — time. If an institution collects color photographs, refrigerated storage *must* be provided to preserve most types of color prints and films for the future. It does little good to have a computer-based cataloging system and carefully designed display galleries if color prints and films are going to deteriorate before even the next generation has a chance to view them.

With the notable exception of a small number of institutions — including the John F. Kennedy Library in Boston; the Warner Bros. movie studio in Burbank, California; Paramount Pictures in Hollywood; the Jimmy Carter Library in Atlanta, Georgia; the Art Institute of Chicago; the Moving Image, Data and Audio Conservation Division of the National Archives of Canada in Ottawa, Ontario; the National Aeronautics and Space Administration (NASA) in Houston,

See page 544 for Recommendations

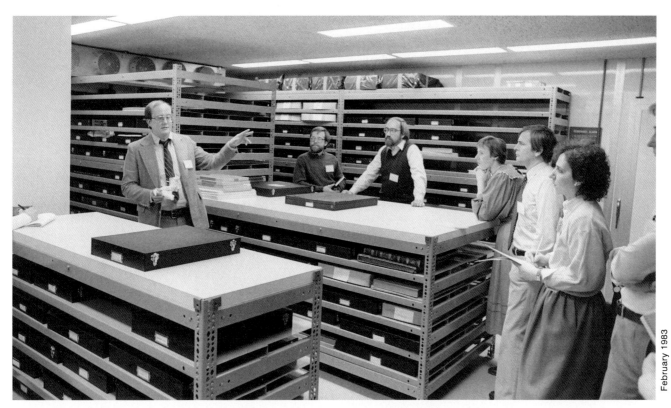

February 1983

The Art Institute of Chicago stores its collection of black-and-white photographs in this humidity-controlled vault at 60°F (15.6°C) and 40% RH; color photographs are preserved in an adjacent cold storage vault maintained at 40°F (4.4°C) and 40% RH. Douglas G. Severson, conservator of photographs at the Art Institute, is shown here describing the facility to visiting members of the Photographic Materials Group of the American Institute for Conservation.

Texas; and the Historic New Orleans Collection in New Orleans, Louisiana — most institutions have not provided adequate storage facilities for their collections of photographs and motion pictures. These shortcomings virtually assure that important parts of their collections will not survive in usable form for future generations — and call into question the very purpose of these institutions.

It is sheer folly to believe that damage to collections resulting from poor storage conditions will be undone in the future using restoration techniques. Even if the technology were available to restore faded, stained, cracked, and otherwise deteriorated black-and-white and color photographs to their original condition, the costs of treating whole collections would be astronomical — far greater than what it would have cost to have taken proper care of the photographs in the first place. For many types of deterioration, such as cracks and discoloration of image silver on black-and-white RC (polyethylene-resin-coated) prints, cracked and delaminated cellulose diacetate safety film negatives, and seriously degraded cellulose nitrate and cellulose acetate motion picture films, effective restoration technology does not now exist at any price.

### Past Neglect at George Eastman House

For many years the photographic storage archives, library, and the "permanent" display galleries on the second floor of the International Museum of Photography at George Eastman House in Rochester, New York had no direct air

October 1987

One of the two vault control panels, located near the vault entrance. The temperature and humidity levels are continuously recorded on circular paper charts. Alarms sound and a fail-safe control system automatically shuts down the vault dehumidifiers and refrigeration compressors if either the temperature or relative humidity deviates beyond pre-set limits. The facility was designed and built by Harris Environmental Systems, Inc.

1976

The print storage archive and library in the attic of the International Museum of Photography at George Eastman House in Rochester, New York. When this photograph was taken in 1976, the archive had no direct air conditioning or humidity control, and storage conditions often were very poor. During summer months the temperature could reach as high as 85°F (29.4°C) with the relative humidity sometimes exceeding 80%.

conditioning or humidity control. Temperatures in the archives and library ranged from 45 to 85°F (7.2–29.4°C), with the relative humidity varying from a low of around 30% to higher than 90%; humidity fluctuations in the archives and display galleries were often quite rapid as outdoor weather conditions changed. Temperature control in the archives and library was improved in 1984 when a new air-conditioning system in the storage area was put into operation, but even then the relative humidity continued to fluctuate beyond an acceptable range. The second-floor display galleries continued without air conditioning until they were closed at the end of 1988.

On a hot afternoon in July 1978, the *original* negatives from more than 300 Hollywood motion pictures in the George Eastman House Collection were lost in a disastrous fire. The cellulose nitrate films were being kept under astonishingly poor conditions in an old concrete building that had no air conditioning, no ventilation system, no sprinkler system, and no fire alarm. The Rochester Fire Department attributed the fire to spontaneous combustion. Most of the estimated one-million-dollar insurance settlement the museum received went to cover operating deficits during the years following the fire; little of the settlement, apparently, was directed toward improving the storage facilities.

Subsequently, it was revealed that in the early 1970's Eastman House buried hundreds of rolls of original MGM

nitrate motion picture negatives on its grounds under what was once one of George Eastman's gardens; all of the films are now presumed to be destroyed. Commenting on the loss, James Card, former director of the film department at Eastman House and the person who supervised the burial, said: "Our vaults were filled to the brim. We had no place to put it. I went to a board of trustees (of Eastman House) meeting and asked that I be allowed to build or rent another vault. They said 'no'."[2] Among the buried and now destroyed films was the original camera negative from *Andy Hardy Meets Debutante* with Mickey Rooney and Judy Garland. Ironically, many of the MGM films that were deemed valuable enough to be spared from the burial were later lost in the 1978 fire.

After a period of uncertainty over whether the museum would even remain in Rochester. At one point, in 1984, the trustees actually proposed *giving* the collection to the Smithsonian Institution in Washington, D.C. But the plan was quickly abandoned because of organized opposition in Rochester and expressions of shock and disgust voiced by influential members of the photography community from around the world, and a fund drive was begun for a new $7.4 million archives building to be constructed adjacent to George Eastman House "to better preserve the vast collection of historical photographs, films, technology and library owned by the Museum." Aided by a $16 million endowment grant

June 1987

Improved storage conditions are provided in the new $7.4 million archives building located adjacent to George Eastman House (shown here in the early stages of construction in June 1987, the archives building was completed at the end of 1988). Plans for an urgently needed cold storage vault for the museum's priceless collection of color photographs were set aside, apparently in an effort to reduce construction costs. To avoid overshadowing George Eastman House itself (originally the home of George Eastman, the founder of the Eastman Kodak Company), two stories of the 60,000-square-foot, three-story archives building were constructed below ground level. The photograph and motion picture collections are stored on the lower two floors.

from Eastman Kodak, the new archives building was completed in 1988. Photograph storage areas in the new facility are maintained at 65°F (18.3°C) and 40% RH, which, for black-and-white photographs, is a significant improvement over the conditions that were present in the old archives in George Eastman House.

The original plans for the new archives building called for a cold storage vault for color photographs (specifications for the vault tentatively were set at 35°F [1.7°C] and 25% RH). But when the new building was completed at the end of 1988, the long-awaited vault was nowhere to be seen. Sadly, despite protests from a concerned conservation staff, plans for the cold storage vault were set aside. At the time this book went to press at the end of 1992, Eastman House continued to store its priceless historical collection of color photographs under woefully inadequate conditions. It is fervently hoped that Eastman House will correct this unfortunate shortcoming in the care of its collections.

## Relative Humidity and Temperature

At any given relative humidity, almost all forms of deterioration of color and black-and-white photographs slow down as the temperature is lowered. If satisfactory humidity levels can be maintained, storage temperatures should be as low as economically possible, and temperatures in display and work areas should be as low as human comfort permits. For black-and-white prints and films stored in the normal temperature ranges found in homes and museums, however, maintaining low relative humidity is usually much more important than reducing the temperature.

Relative humidity is also an important factor in the fading and staining of color photographs, but as long as the humidity does not exceed an upper limit of 65–70% for long periods (which would risk fungus growths), storage temperature is much more significant than relative humidity with most types of color prints, slides, and negatives. As a general rule, the fading rate of color dye images approximately *doubles* with every 10°F (5.6°C) increase in temperature. The dark fading characteristics of color films and prints are discussed in Chapter 5.

For storage of black-and-white films and prints, temperatures not exceeding 70°F (21°C) have often been recommended; for medium-term storage (a minimum useful life of at least 10 years), *ANSI IT9.11-1991*, the American National Standard for film storage conditions, states:

November 1986

The photograph collection at the Museum of Modern Art in New York City is stored in this environmentally controlled room at 60°F (15.6°C) and 40% RH. The facility was constructed in 1984. Ektacolor and other chromogenic color prints are kept at 35°F (1.7°C) and 25–35% RH in the frost-free refrigerator in the back of the room at the far right. Peter Galassi, a curator of photography at the time this photograph was taken, discusses the handling of prints in the collection with Carol Brower. In 1991, Galassi was appointed director of the Museum's department of photography.

Ideally, the maximum temperature for extended periods should not exceed 25°C (77°F), and a temperature below 20°C (68°F) is preferable. The peak temperature for short time periods shall not exceed 32°C (90°F). For color film a storage temperature not exceeding 10°C (50°F) shall be used for proper protection. Short-term cycling of temperature shall be avoided. Cycling of relative humidity shall be no greater than ± 5% over a 24 hour period. Protection may be increased by storing film at low temperature and low relative humidity.[3]

For extended-term storage of black-and-white photographs, *ANSI IT9.11-1991* states:

> Temperatures shall not exceed 21°C (70°F), and added protection may be obtained for all films by low-temperature storage. Low temperature storage improves the stability of both the film base and the image. A storage temperature of 2°C (35°F) or below shall be used for color film. Excellent keeping behavior has been obtained by storing color film at such low temperatures.

## ANSI Replaces the "Archival Storage" Designation with "Extended-Term Storage"

In previous versions of the ANSI storage standards, extended-term storage was referred to as "archival storage." In 1990 ANSI decided to remove the "archival" designation from all of the ANSI photographic standards. The rationale for this is explained in the Foreword to *ANSI IT9.11-1991*:

> The term "archival" is no longer specified in American National Standards documents since it has been interpreted to have many meanings, ranging from preserving information "forever" to the jargon meaning [especially in the computer and electronic data storage fields], temporary storage of actively used information. It is therefore recommended that the term "archival" not be used in standards for stability of recording materials and systems.

Processed photographic films are now classified according to the life expectancy or "LE designation," when stored under specified conditions. Terms such as archival processing, archival record film, and archival storage materials, all of which have been widely used in the photography conservation field, are no longer used or endorsed by ANSI.

# Recommendations

• **Keep photographs cool and dry.** Do not store photographs in basements (too damp) or in attics (too hot).

• **Black-and-white prints and negatives:** Relative humidity in the storage area is the most critical factor in determining the rate of image deterioration. Museums and archives should consider humidity control to be the **number-one priority** for their black-and-white collections — about 30% RH is recommended if cycling between storage and use areas can be avoided (see below); levels higher than 50% RH are unacceptable. For storage of photographs in homes and businesses, the relative humidity should be kept as low as practical, and every effort should be made to prevent the relative humidity from rising above 65% for extended periods.

• **Color films and prints:** Storage temperature generally is the most significant factor in determining the rate of image fading and staining, with relative humidity being comparatively less important than it is with black-and-white photographs. Each 10°F (5.6°C) reduction in temperature will approximately **double** the life of a color material (see Chapter 5). Museums and archives with color films, prints, and motion pictures in their collections **must** provide humidity-controlled cold storage facilities (see Chapter 20). Institutions and photographers with small color collections can keep them in suitable frost-free refrigerators (see Chapter 19).

• **Prevent wide-ranging humidity cycling.** Particularly with fiber-base prints, drastic fluctuations in humidity can cause severe curling. Over time, the curl will become much more pronounced than when prints are stored in a **constant** relative humidity, even if the humidity level is very low. Widely cycling humidity contributes to the cracking of RC prints that have been embrittled as a result of light exposure during display. Cycling humidity can also cause emulsion cracks in fiber-base prints. Ideally, the RH should be maintained within ± 2% of the aim point. Recent studies of emulsion stress and moisture relationships conducted by Mark McCormick-Goodhart of the Smithsonian Conservation Analytical Lab have underscored the dangers to prints and films posed by storage in cycling — or in very low — relative humidities.

• **Environmentally-controlled storage facilities:** Bonner Systems, Inc. is recommended for the design and construction of temperature- and humidity-controlled storage rooms and refrigerated vaults (see Chapter 20).

• **Dehumidifiers:** For museums and archives, Cargocaire automatic dry desiccant dehumidifiers equipped with HEPA filters and incorporated into building heating and cooling systems are recommended (reliability problems have been reported with some older Cargocaire units but improved models were introduced in 1989). Cargocaire is located at 79 Monroe Street, Amesbury, Massachusetts 01913; telephone: 508-388-0600. For small storage areas, home-type dehumidifiers used in conjunction with room air conditioners are satisfactory.

• **Silica-gel:** Bags or cans of silica gel are generally unsatisfactory as a means of humidity control.

• **Hygrometer calibration:** The calibration of mechanical and electronic hygrometers should be checked at least every 6 months and adjusted as necessary. In museums and archives with tightly controlled relative humidity, a single calibration point close to the humidity level maintained in the institution is sufficient.

• **Fungus:** When photographs are stored at the recommended humidity levels (i.e., 30–40% RH), fungus growth will not occur. Kodak Print Flattener, Pako Pakosol, and other hygroscopic print flatteners for fiber-base prints should be strictly avoided because such products can promote fungus growth in humid environments.

• **Air pollutants:** "Safe" levels of airborne pollutants have yet to be established (for black-and-white photographs, the notion of "safe" levels is probably not even a valid concept). Museums and archives should keep pollutant levels as low as practical — oxidants such as peroxides and nitrogen oxides, in addition to sulfur-containing gases, can be particularly harmful to the delicate silver images of black-and-white photographs. The effects of commonly encountered air pollutants on color photographs are not known, but they probably are much less significant than with black-and-white photographs. Efforts to limit concentrations of pollutants are usually of little value if relative humidity cannot be maintained at or below the recommended levels.

• **Agfa-Gevaert colloidal silver test slides:** These inexpensive and compact test slides are uniquely suited for monitoring airborne pollutants that can harm the silver images of black-and-white photographs; museums and archives should place the test slides in all areas in which black-and-white photographs are stored and displayed. The Agfa-Gevaert test slides are available from the Image Permanence Institute, Rochester Institute of Technology, Frank E. Gannett Memorial Building, P.O. Box 9887, Rochester, New York 14623-0887 (telephone: 716-475-5199; Fax: 716-475-7230).

• **Floods:** Valuable photographs should not be stored in locations where there is even a **remote** possibility of flooding. Storage areas should be isolated from water pipes so that water is prevented from reaching any part of the collection if a pipe should burst. Unless special precautions are observed, basement or other below-ground storage is not recommended because of the danger from water damage.

• **Fires:** Buildings and storage rooms constructed of non-combustible materials are recommended. Fire-detection systems should be installed and are particularly important in combustible structures. Water sprinklers should be avoided in photograph storage areas; fire-suppression systems using Haylon gas or newer, environmentally-acceptable substitutes are recommended.

## Low Relative Humidity Is Especially Important in the Storage of B&W Materials

With black-and-white prints and films processed in the normal manner and stored in the typical variety of envelopes and boxes, the relative humidity of the storage area is usually *the* most critical factor in determining the eventual life of the photographs. Maintaining low and reasonably constant humidity should be the number-one priority when designing a storage area for photographs — whether in a large museum or archives, in a valuable commercial collection, or for a serious photographer desiring to keep negatives, slides, and prints in the best possible condition. It is realized, of course, that many businesses — and certainly most amateur photographers — will not be able to justify the cost of a special temperature- and humidity-controlled storage facility.

Nevertheless, the importance of low-humidity storage must be emphasized, and the often-repeated admonition to "store photographs in a cool and dry place" is a good rule to follow. In a home, photographs should not be stored in the basement, where the relative humidity is commonly in the 90–100% range during the warm months of the year, nor in an attic, where temperatures can reach above 140°F (60°C). A first-floor storage location in a home is usually best, with photographs kept off the floor in cabinets or on shelves.

Regardless of the storage temperature, the relative humidity for storage of both color and black-and-white films and paper prints should, ideally, be kept between 20–30%.

During the past several years, research by James M. Reilly and his co-workers at the Image Permanence Institute at the Rochester Institute of Technology, the Eastman Kodak Company, and at other laboratories, as well as data obtained from examination of films stored under a variety of conditions in all parts of the world, has focused attention on the critical role played by relative humidity in both film base stability and silver image stability. Lending considerable urgency to this work is the alarming realization that in all too many cases, cellulose acetate film base and the silver images of both films and prints have deteriorated far more rapidly than had been expected.

## Table 16.1  ANSI-Recommended Relative Humidity and Temperature for Film Storage

| Sensitive Layer | Medium-Term Storage* | | Extended-Term Storage** | |
|---|---|---|---|---|
| | Relative Humidity Range*** | Maximum Temperature | Relative Humidity Range*** | Maximum Temperature |
| Silver-gelatin | | | | |
| Heat-processed silver | | | | |
| Vesicular | 20–50% | 25°C (77°F) | 20–30% | 21°C (70°F) |
| Electrophotographic | | | | |
| Photoplastic | | | | |
| Diazo | | | | |
| Color | 20–30% | 10°C (50°F) | 20–30% | 2°C (35°F) |

 * Medium-Term storage conditions are suitable for the preservation of recorded information for a minimum of 10 years.

** Extended-Term storage conditions are suitable for the preservation of recorded information having permanent value. In previous ANSI standards, extended-term storage conditions were known as "archival" storage conditions; the term "archival" is no longer used in ANSI photographic standards.

*** The moisture content shall not be greater than film in moisture equilibrium with these relative humidities.

Adapted from **ANSI IT9.11-1991, American National Standard for Imaging Media – Processed Safety Photographic Film – Storage**, with permission of the American National Standards Institute, Inc. © 1991. Copies of this Standard may be purchased from the American National Standards Institute, Inc., 11 West 42nd Street, New York, New York 10036; telephone: 212-642-4900; Fax: 212-302-1286.

## Relative Humidity and Deterioration

High relative humidity greatly increases the rates of nearly every type of physical and image deterioration associated with black-and-white photographs. Image oxidation and sulfiding — discoloration and fading caused by residual processing chemicals, contact with unsuitable enclosure and mounting materials, airborne pollutants, migration of chemicals from adjacent improperly processed photographs, fingerprints, etc. — all proceed much more quickly in conditions of high relative humidity. In high relative humidity, the oxygen in air itself can slowly attack silver images.

A landmark 1991 report entitled *Preservation of Safety Film*, by James M. Reilly, Peter A. Adelstein, and Douglas W. Nishimura, working at the Image Permanence Institute at the Rochester Institute of Technology, confirmed that relative humidity plays a determining role in the deterioration rates of cellulose nitrate, cellulose triacetate, and other cellulose ester films:[4]

> Deterioration is *strongly humidity dependent*. The data showed that lowering the RH of the storage environment from 50% to 20% RH will prolong the life of the film from 3 to 10 times, depending on the property measured.
> Deterioration is also *strongly temperature dependent*. Lowering the storage temperature from 68°F [20°C] to 37°F [2.9°C] will increase the overall predicted life of film by a factor of 10 times.
> Optimum storage conditions for film *include both low temperature and low humidity*. Indications are that the benefits are additive, i.e., that the combination of low temperature and low RH is better than either alone.

One of the key findings of the research by Reilly and his co-workers was that, contrary to what has been almost universally accepted in the past, cellulose nitrate and cellulose acetate films have generally similar stability characteristics:

> All of the cellulosic film materials, including *all the acetate safety films* and at least one sample of cellulose nitrate, have the *same general behavior* with respect to deterioration — they can be expected to deteriorate at the same general rate if kept under similar storage conditions. Accepted beliefs that nitrate will necessarily degrade faster than acetate, and that among safety films, that diacetate is much worse than triacetate, are not supported by the data.

Storage in high humidity can produce severe stains on areas of negatives and prints in contact with glued seams of paper envelopes. Conditions of high relative humidity also favor the growth of fungus on gelatin emulsions and can cause gelatin to soften to the point where it can stick, or "ferrotype," to adjacent surfaces of films, to smooth plastic filing enclosures, or to framing glass. High humidity markedly accelerates exudation of greasy plasticizers on the surfaces of polyvinyl chloride (PVC) storage enclosures, and this greatly increases the likelihood of films and prints sticking to plasticized PVC.

High-humidity storage also enhances the tendency of emulsions to stick to polyethylene which has been treated with slip and anti-block agents (low-density polyethylene for making photographic enclosures such as Print File Archival Preserver polyethylene notebook pages nearly always contains these additives — see Chapter 14).

In an important early study of the influence of residual thiosulfate and storage conditions on silver-gelatin image stability, French researchers Pouradier and Mailliet wrote:

> If the photographic document is conserved in a dry atmosphere (relative humidity less than or equal to 50%), the thiosulfate retained is practically inoperative as long as the concentration does not exceed ten milligrams per square decimeter. In contrast, even with a very weak concentration, it becomes one of the factors affecting deterioration when the humidity and temperature of the surrounding environment increase.
> If, during the entire period of the document's required life, it were possible to keep the air of the storage vault unfailingly at low relative humidity, relatively high levels of residual thiosulfate could be tolerated.[5]

Under the accelerated conditions of this study, Pouradier and Mailliet determined that for a given level of silver image deterioration in prints with a low amount of residual thiosulfate, prints kept at 20% RH lasted at least *10 times longer* than prints stored at 70% RH; when larger amounts of thiosulfate remained in the prints, the increase in life afforded by storage at 20% RH became much greater. In some cases, extrapolations from the test data indicated that when significant amounts of thiosulfate were present, prints stored at 20% RH would last more than 100 times longer than similar prints stored at 70% RH. Of course, during long-term storage, other factors — such as air pollutants — may intervene to lessen these differences, but the advantages of low-humidity storage remain very significant. For the price of a dehumidification system to maintain relative humidities in the 20–30% range, the useful life of a collection of black-and white photographs will almost certainly be increased many times over.

In a survey of silver-image deterioration (microspots, or redox blemishes) in microfilm collections, McCamy, Wiley, and Speckman observed:

> The effect of humidity on blemish incidence was quite pronounced. When the maximum humidity was 51 to 60 percent, there were 11 times as many blemished leaders and 19 times as many blemished information sections as there were when the relative humidity was 20 to 50 percent.
> In the arid southwestern part of the United States, Wiley observed a collection of films, in-

cluding several brands processed in many places over a twenty-five year period and stored in cans or paper boxes. The storage temperature was thought to exceed 100°F [38°C] frequently but the humidity was always low. No redox blemishes were found on these films.[6]

Accelerated dark-aging studies conducted by James M. Reilly and Douglas G. Severson in 1980 showed that high-humidity storage is very harmful to albumen prints:

> Primary forms of deterioration were found to be highlight detail loss, overall density loss, image hue changes and the formation of a yellow stain in highlight (non-image) areas. Ambient relative humidity was found to be the principal rate-controlling factor in all these forms of deterioration, with the rate greatly increasing above 60% RH. . . . Processing flaws were found to be of less overall importance in albumen print preservation than environmental conditions during storage.
>   . . . If the minority of albumen prints left in good condition are to be preserved, a clear message from the experimental results is that they must be shielded from moderately high moisture levels.[7]

More recently, in 1990, James M. Reilly and co-workers reported on work at the Image Permanence Institute which showed a dramatic reduction in the degree of microfilm silver image attack by hydrogen peroxide in accelerated tests when the relative humidity was reduced to the 10–30% range.[8]

## Wide Fluctuations in Relative Humidity Should Be Avoided

Short-term humidity cycling should be minimized; ideally, fluctuations should be limited to not more than ± 5% RH. More gradual seasonal variations are probably less critical. Wide fluctuations in relative humidity produce physical stresses which may in time cause base and/or emulsion cracking, delamination, and other forms of physical deterioration; prints on RC (polyethylene-resin-coated) paper appear to be particularly susceptible to this kind of damage. However, examination of historical collections which have been stored for many years in totally uncontrolled humidity conditions indicates that many types of materials can tolerate reasonable fluctuations without obvious physical damage; variations of ± 10% RH probably do little harm. What is more important, especially for black-and-white films and prints, is to keep the average relative humidity at a low level.

Films without anti-curl gelatin back-coatings, as well as paper prints (especially single-weight fiber-base prints), have an obvious tendency to curl in low-humidity conditions, and concern has been expressed that stresses induced by low-humidity storage (caused by unequal coefficients of moisture-associated expansion of the gelatin emulsion layer and paper or plastic support material) may over time cause emulsion cracking or other physical damage. It

has been suggested that storage at a higher humidity (e.g., 50% RH) might be preferable.

This author believes that in most cases the greatly increased stability of the image and support material afforded by low-humidity storage more than offsets the possibility of damage caused by physical stress. Many instances of cracking and other problems attributed to storage in very dry conditions have in fact been caused by *cycling* between very low-humidity indoor air in the cold months of the year and warm, humid conditions in the summer. The catastrophic internal image-receiving layer cracking that has occurred in early Polaroid SX-70 prints appears to have been caused by storage in such conditions; the cracking has destroyed the images of many SX-70 prints made from 1972 until around 1980, when improvements were made in the prints.

## Widely Cycling Relative Humidity Can Cause Extreme Curl in Fiber-Base Prints

It is this author's observation that unless they are physically restrained and held flat — stored in a filled, shallow box or held in place by an overmat, for example — fiber-base prints stored in an environment with widely cycling relative humidity develop much more curl over time than prints kept in a more constant relative humidity (this is true even when the "constant" relative humidity is significantly lower than the lowest level reached in a cycling condition). In cycling conditions, the maximum curl may be reached only after many years of storage. This author currently has no explanation why fiber-base prints react in this manner, and nothing has been published on this subject (see Chapter 15 for further discussion of humidity-related print curl).

Reasonably constant low-humidity storage usually presents few problems. It is realized, of course, that few parts of the world have year-round low-humidity climates, and only museums and other collecting institutions are likely to have funds for the equipment required to maintain constant temperature and relative humidity conditions throughout the year in storage and display areas.

Over a period of years, widely cycling relative humidity can cause severe curling of fiber-base prints.

## The Recommended 20–30% RH Is Usually Found Only in Cold Storage Vaults for Color Motion Pictures and Still-Photographs

Some institutions in arid climates have naturally low average indoor relative humidity, but at the time of this writing this author was unaware of a major museum or archive anywhere in the world that maintains a constant and controlled relative humidity of 30% or lower in general photographic storage areas. It is only in dehumidified cold storage facilities for color photographs and motion pictures — found only in a relatively small number of sophisticated institutions in the U.S. and a few other countries (see Chapter 20) — and in a few black-and-white microfilm storage installations that such a condition is maintained.

In North America, institutions with cold storage facilities that operate at 30% RH or lower include: the John Fitzgerald Kennedy Library, Boston, Massachusetts; the National Aeronautics and Space Administration (NASA) facilities in Houston, Texas (where the huge NASA spaceflight color photography collection is preserved) and in White Sands, New Mexico; Paramount Pictures in Hollywood, California; Warner Bros. in Burbank, California; the Historic New Orleans Collection in New Orleans, Louisiana; the National Archives and Records Administration, Alexandria, Virginia; the Library of Congress in Landover, Maryland; the Library of Congress Film Conservation Center at Wright-Patterson Air Force Base near Dayton, Ohio; the Peabody Museum of Archaeology and Ethnology at Harvard University, Cambridge, Massachusetts; the Human Studies Film Archive, the National Museum of African Art, and the Office of Printing and Photographic Services at the Smithsonian Institution in Washington, D.C.; the Ancient Biblical Manuscript Center at Claremont College, Claremont, California; and the Moving Image, Data and Audio Conservation Division of the National Archives of Canada in Ottawa, Ontario.

In 1982 the Art Institute of Chicago constructed a storage vault to keep its black-and-white photography collection at a relative humidity of 40% and a temperature of 60°F (15.6°C); chromogenic color photographs are stored in a second vault that operates at 40% RH and a temperature of 40°F (4.4°C). The relative humidity is controlled at 35% in the Microtext Masters Storage Room at the Newberry Library in Chicago, Illinois; the microfilm storage area is in the library's sophisticated new bookstack building completed in 1982. The temperature is maintained at 60°F (15.6°C) throughout the structure (the Newberry Library facility is discussed in more detail later in this chapter).

In 1984 the Museum of Modern Art in New York City moved its fine art photography collection into a newly constructed storage room that is maintained at 40% RH and 60°F (15.6°C); the museum stores its collection of chromogenic color prints in a frost-free refrigerator with a relative humidity of 25–35% and a temperature of 35°F (1.7°C).

Storage areas in the new building housing the Center for Creative Photography, completed in 1988, are kept at 60°F (15.6°C) and 40% RH. Located in Tucson, Arizona, the Center is associated with the University of Arizona.

The National Gallery of Canada, which moved into a new building in Ottawa in 1988, maintains 59°F (15°C) and 40% RH in its photograph collections vault; a smaller cold storage vault for chromogenic color prints and films is kept at 39°F (4°C) and 40% RH.

The Canadian Centre for Architecture in Montreal completed a new building in 1988 which provides two storage vaults for its photograph collections — one vault is kept at 40°F (4.4°C) and 40% RH, and the other at 55°F (12.8°C) and 40% RH. The building as a whole is maintained at 70°F (21°C) and 43% RH.

National Underground Storage, Inc., located 220 feet underground in a former limestone mine near Boyers, Pennsylvania (57 miles north of Pittsburgh), maintains 25% RH and about 68°F (20°C) in its high-security microfilm storage vaults. Federal government agencies, including the Social Security Administration, banks, and major corporations from around the world utilize the underground facility to store microfilm, paper records, computer tapes, and motion pictures (a number of major Hollywood movie studios keep backup copies of their motion picture libraries here).

The Granite Mountain Records Vault, which houses a vast collection of microfilmed genealogical records for the Church of Jesus Christ of Latter-Day Saints (popularly known as the Mormon Church), maintains 30–40% RH and about 55°F (12.8°C) in its high-security vault that was tunneled into the side of a solid granite mountain located near Salt Lake City, Utah.

University Microfilms International, Inc., a major microform publisher headquartered in Ann Arbor, Michigan, stores its microfilm masters at 70°F (21°C) and 40% RH.

The color and black-and-white photography collection at the Mystic Seaport Museum in Mystic, Connecticut is stored at 65°F (18.3°C) and 35% RH.

## Measurement and Control of Relative Humidity

In considering various storage arrangements for photographs, it is necessary to have an understanding of the relationship between humidity and the temperature of the air. Relative humidity, expressed as a percentage (%), is simply the amount of water vapor in a body of air at a given temperature compared to the amount of water vapor the air would contain at maximum saturation (100%). Absolute humidity is a measure by weight of the amount of water vapor in a given body of air: for example, 6.4 grams water vapor per kilogram of air. A kilogram of air at sea level at 68°F (20°C) is a volume of 0.84 cubic meter.

The capacity of air to contain moisture increases markedly as the temperature of the air increases. For example, the maximum amount of moisture that air can contain at 50°F (10°C) is 7.1 grams per kilogram of air. At 82°F (27.5°C) the moisture capacity increases to 21.4 grams per kilogram of air, or about three times the capacity of air at 50°F.

This means that within an isolated body of air, when the temperature increases, the relative humidity decreases. Conversely, when the temperature drops in a given body of air, the relative humidity *increases*. This is the most important phenomenon for the photographic archivist to understand because of the rapid damage that can be caused to photographs by high *relative* humidities.

Keep in mind that it is the actual relative humidity of the storage area, and *not* the outdoor relative humidity given by weather forecasters, that is important. Some lo-

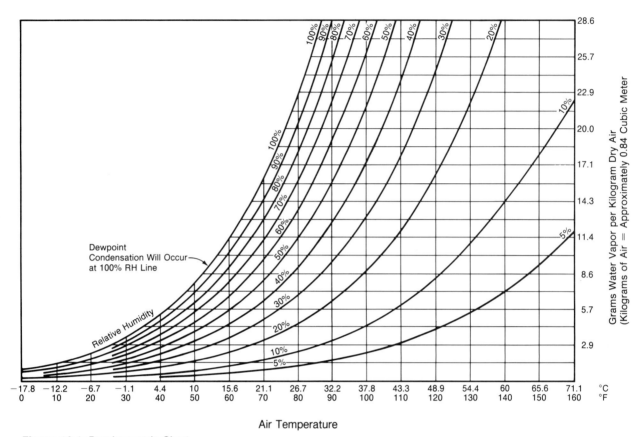

**Figure 16.1**: Psychrometric Chart

cations in the United States with a reputation for being humid in the summer actually have lower relative humidities than cooler areas which are considered to be more comfortable. An example of this is Washington, D.C., which has a mean relative humidity of about 71% during the summer and is famous for being "muggy" and uncomfortable. San Francisco, on the other hand, has a mean relative humidity of about 79% during the same summer period, but the city is not thought of as being humid because the lower summer temperatures make it feel more comfortable.

The relationship between relative humidity, air temperature, and moisture content can be understood most easily with the aid of a psychrometric chart (**Figure 16.1**). Following are a few examples of common photograph storage situations that illustrate the use of a psychrometric chart. As can be seen, the outdoor relative humidity may have little relationship to the actual indoor relative humidity.

**Figure 16.2: The Basement of a Building.** On a typical summer day with an outdoor temperature of 85°F (29°C) and a relative humidity of 60%, outside air enters a cool basement and the temperature of the air drops to 70°F (21°C). The temperature drop causes the relative humidity to rise to near 100%. A basement frequently *adds* water vapor to the air by transmitting moisture from the ground through the walls and floor.

**Figure 16.3: Air-Conditioned Building on a Hot Day.** Outdoor air at 85°F (29°C) and 50% RH is brought into a building by a ventilation system. The outdoor air mixes with cooler air already present in the building, thus lower-

ing the temperature of the outdoor air and causing the relative humidity to rise; however, the effect is reduced by the dilution with the indoor air. The air conditioner will remove some of the moisture by momentarily cooling some of the air to about 55°F (13°C) and condensing excess moisture. Air which has passed over the air conditioner cooling coils will have a relative humidity of about 58% when it warms back up to the room temperature; however, the relative humidity will probably be increased above this level by mixing with the rest of the indoor air.

The final indoor relative humidity depends on a complex set of factors including the outdoor temperature and relative humidity, ventilation rates, building insulation, internal heat load (people, lights, machinery, etc.), moisture added to the air in the building by people and other sources, solar heat load, type of air conditioner, and many others. Often the resulting indoor relative humidity will be in the same range as the outdoor relative humidity even though the temperature indoors is cooler. It is not uncommon, however, for the indoor relative humidity in an air-conditioned building to actually be *higher* than the outdoor relative humidity. This is especially likely to occur during the comparatively cool spring and fall months and during cool nights in the summer (see **Figure 16.4**). As can be seen, the air conditioner must remove substantial quantities of water when cooling the air to maintain even the *same* relative humidity as that of the warmer outdoor air. Advertising for air conditioners often gives misleading information about this. To maintain constant low relative humidity

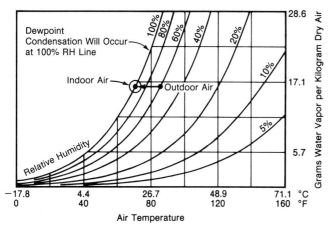

Figure 16.2: The Basement of a Building

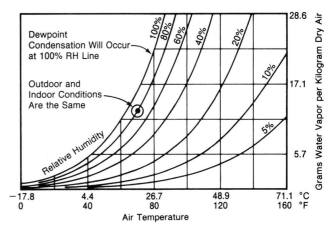

Figure 16.4: Air-Conditioned Building on a Cool Day

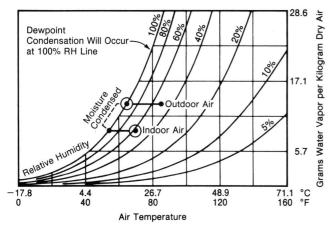

Figure 16.3: Air-Conditioned Building on a Hot Day

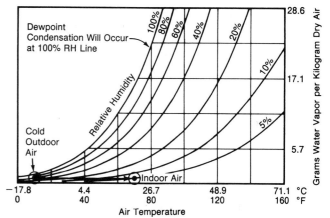

Figure 16.5: Cold Winter Day

inside a building requires special air-conditioning equipment which has provision for dehumidifying air without cooling it. One or more refrigeration-type dehumidifiers of the kind sold for home use may be placed in small rooms of air-conditioned buildings to aid in controlling the humidity.

**Figure 16.4: Air-Conditioned Building on a Cool Day.** On a cool day, such as often occurs during the spring and fall months in the U.S., the outdoor temperature might be 70°F (21°C) with a relative humidity of 80%. Under such conditions, especially if there is a low internal heat load, the air-conditioning system will not be needed to keep the indoor temperature at 70°F (21°C). As a result, the indoor relative humidity will be about the same as the outdoor relative humidity: a high 80%. Accessory dehumidification or air-reheating equipment will be needed to control the humidity level.

**Figure 16.5: Cold Winter Day.** This situation is opposite to that of an air-conditioned building in warm outdoor temperatures. Cold outdoor air at 10°F (−12°C) and 60% RH is warmed up by the building heating system to 70°F (21°C). As a result the relative humidity will drop to below 10% unless moisture is added indoors by humidification equipment. Typical indoor relative humidity found in homes and office buildings on cold days is usually somewhat higher than would be assumed from the psychrometric chart, due to moisture added to the air by people breathing, dishwashing,

etc., but is often in the 10–20% range. When relative humidity cycles between normal (or high) and very low levels, it may cause "spokiness" (wave-like deformations) in rolls of motion picture film, cracking of RC prints, cracking of the internal image-receiving layer of Polaroid SX-70 prints, and base-to-emulsion separation in some types of polyester-base films. Very low and/or widely cycling humidity will cause excessive curling of unmounted or unmatted fiber-base prints, especially those on single-weight paper.

## Devices for Measuring Relative Humidity

Caretakers of photography collections should acquire an accurate relative humidity indicator so that the actual humidity level can be monitored in storage areas. Ideally, as discussed previously, photographs should be stored in conditions of about 30% RH. However, as will quickly become apparent when a humidity indicator is put into service, such low humidity levels usually cannot be maintained except during winter months in temperate climates. One should try to keep the humidity as constant as possible and in no event permit it to exceed 65–70% for long periods. Various types of humidity-measuring devices are available; they differ in design, accuracy, and price. Suppliers of instruments for measuring relative humidity are given at the end of this chapter.

Taylor 9-inch sling psychrometer (Model No. 1328).

## Sling Psychrometers

The sling psychrometer was the first instrument for accurately measuring relative humidity and, when used properly, is still among the most precise. Use of sling psychrometers, however, is rather time-consuming and cumbersome for routine monitoring of relative humidity. They cannot be used for measurements inside of small enclosures such as refrigerators or display cases. Sling psychrometers are satisfactory for calibration of dial hygrometers and other types of mechanical hygrometers.

The sling psychrometer consists of two thermometers mounted on a frame with a handle at one end. Attached to the bulb of one of the thermometers is a cotton wick that is moistened with distilled water before taking a reading. To operate, the handle is gripped in one hand and the thermometer frame is slung around in a circle (hence the name). Moisture in the wet wick (the wet-bulb thermometer) evaporates because of the rapid air motion occurring during rotation of the device, cooling it to a lower temperature. The lower the humidity, the faster the evaporation and the lower the reading of the wet-bulb thermometer.

## Use of a Sling Psychrometer

1. Be very careful when using a sling psychrometer in the vicinity of photographs or other valuable objects, because small drops of water are usually ejected from the moistened wick, especially during the initial period of rotation. The droplets of water can travel across a room 10 feet or more! Do not operate a sling psychrometer in a room containing uncovered photographs on tables or hanging on walls.

2. Thoroughly saturate the wick with water before each reading is made. Moisten the wick only with distilled water; dissolved solids usually present in tap water will adversely affect the accuracy of the instrument. The wick should be replaced should it appear dirty or become stiff.

3. After about 2 minutes of rapid rotation, immediately take a reading from the wet-bulb thermometer. At low relative humidities (e.g., 20–40%), rotation times of up

to 5 minutes will be required to fully depress the wet-bulb reading.

4. Repeat the operation (with the wick remoistened each time) until two or more wet-bulb readings agree at the lowest temperature obtainable. Then compare the wet-bulb and dry-bulb temperature readings with a psychrometric table (normally supplied with a sling psychrometer) and determine the relative humidity. Psychrometric tables that have a separate entry for *each degree* of wet- and dry-bulb temperatures are easier to read accurately than are psychrometric charts.

A sling psychrometer may have limited accuracy when the relative humidity is below about 25%. At high humidities, sling psychrometers are usually quite accurate. At low temperatures, when the wet-bulb temperature drops below freezing (32°F [0°C]), readings are highly uncertain.

Thermometers in a sling psychrometer should be accurate, but much more important than their absolute accuracy is the requirement that both thermometers agree with *each other*. This can easily be checked by removing the cotton wick from the wet-bulb thermometer (if the wick was wet and moisture remains on the thermometer, it should be removed with a clean paper towel) and allowing both thermometers to stabilize at the ambient room temperature. A discrepancy greater than ¼°F (⅛°C) is unacceptable and the unit should be replaced. A 1°F (½°C) discrepancy between the thermometers will result in a 4% error in the indicated relative humidity.

The thermometers must be read carefully — and immediately — after it is certain that the sling psychrometer has been rotated long enough for the wet-bulb thermometer to become fully depressed. An error of ± 1°F (½°C) in reading the wet-bulb thermometer can result in a ± 4% error (high or low) in indicated relative humidity — a range of 8%! If errors are made in reading *both* thermometers, the error in indicated RH may be correspondingly greater. But an accurate instrument operated with care can be expected to produce consistent and reasonably accurate results.

The Assmann psychrometer[9] is a precision instrument operating on the general principles of the sling psychrometer; instead of being whirled in a circle, the Assmann psychrometer has a spring-wound fan to circulate air over the wet-bulb thermometer for up to 8 minutes (at least 5 minutes is recommended). Equipped with individually calibrated mercury thermometers (with a corrected accuracy of better than ± 0.1°C) and infrared radiation shields, Assmann psychrometers cost $350 or more.

Also available are low-cost psychrometers, based on the Assmann design, which have small battery-powered fans to draw air across the wet-bulb thermometer. One model tested by this author, the Psychro-Dyne sold by Environmental Tectonics Corporation (the Psychro-Dyne is similar in most respects to the Belfort Psychron), proved to be reasonably accurate when the relative humidity was above about 40% and when the unit was allowed to operate for several minutes to achieve full depression of the wet-bulb temperature. In this author's judgment, a sling psychrometer such as the 9-inch model made by Taylor Instruments (Catalog No. 1328) is a more accurate instrument and also costs only $65, roughly half as much as the Psychro-Dyne.

June 1983

An Abbeon HTAB-176 dial hygrometer, costing about $135, is shown here in a frost-free refrigerator. When properly calibrated using the procedures outlined in the text, these devices give an accurate indication of relative humidity.

November 1986

A Belfort recording thermohygrograph in the photograph storage room at the Museum of Modern Art. These units, which cost between $500 and $1,000, typically provide a week-long paper chart with a continuous record of relative humidity and temperature.

## Dial Hygrometers

The dial hygrometer gives a continuous direct reading of relative humidity at a glance. If carefully calibrated about every 6 months, the better-quality dial hygrometers are accurate within approximately ± 3% over a range between 20% and 90% RH; if the relative humidity in the location where the instrument will be operating is close to that of the calibration point, the accuracy of a dial hygrometer can be ± 1%. Most dial hygrometers are reliable over a fairly wide temperature range.

It is especially important to calibrate a new dial hygrometer *before* it is put into service. Manufacturers' claims to the contrary, this author's experience is that most hygrometers are in poor calibration by the time they are delivered. Good-quality dial hygrometers have a small calibration screw, accessible from outside the case, which allows the dial to be adjusted.

Although dial hygrometers have a relatively slow response time and, depending on air movement, may require 20 minutes or more to stabilize following an abrupt change in humidity, the rate of response is adequate for most photographic storage applications. The humidity-sensing element of some high-quality dial hygrometers is made of bundled human hair. The hair bundle, one end of which is connected to the dial indicator mechanism, changes in length as a function of the ambient relative humidity. Other good-quality dial hygrometers, such as the popular Abbeon Certified Hygrometers (made by the German firm of G. Lufft Metalabarometerfabrik GmbH and sold under many different brand names in the U.S.), utilize bundles of synthetic fibers instead of hair as the humidity-sensing elements.

The Abbeon Model No. HTAB-176, which has a built-in thermometer and costs about $135, is recommended by this author for monitoring most photographic storage environments, including the inside of frost-free, low-humidity refrigerators. The calibration of the unit should be checked every few months with a sling psychrometer, or with the very accurate saturated-salt procedure described later in this chapter.

Low-cost dial hygrometers, such as those with paper sensing elements and sold in hardware stores for $10 or less, can provide very approximate measurements of relative humidity, but often they will be nonlinear and inaccurate by 20% or more, especially in the low and high ranges of the scale.

## Recording Thermohygrographs

Recording hygrometers (hygrographs) make a continuous paper chart of the ambient relative humidity for a week or longer periods. When equipped with a recording thermometer, which is usually the case, they are called recording thermohygrographs. Some types make disk charts;

A Condar Humidity Meter. These inexpensive units, which regrettably are no longer available, are based on the principle that certain chemical compounds undergo reversible changes in their crystal structure at specific relative humidities, resulting in abrupt changes in the reflection of polarized light. The "bright" square farthest to the right registers the relative humidity. Condar hygrometers do not drift over time and do not require periodic calibration. In fact, the units are accurate enough to be suitable for calibrating other types of hygrometers. Manufacture of Condar hygrometers ceased in 1987.

## Table 16.2 Relative Humidity of Air over a Saturated Sodium Dichromate Solution

| Temperature | Relative Humidity |
|---|---|
| 68°F (20°C) | 55.2% |
| 70°F (21°C) | 54.9% |
| 77°F (25°C) | 53.8% |

Adapted from: Arnold Wexler and Saburo Hasegawa, "Relative Humidity-Temperature Relationships of Some Saturated Salt Solutions in the Temperature Range 0° to 50°C," *Journal of Research of the National Bureau of Standards,* Vol. 53, No. 1, July 1954, pp. 19–25.

others produce linear graphs. Recording thermohygrographs are fairly expensive — usually costing from $500 to more than $1,000. Most thermohygrographs have humidity-sensing elements of bundled human hair or synthetic fibers, although various types of electronic recording instruments are also available. As with dial hygrometers, it is *essential* that the calibration of recording hygrometers be checked at least every 6 months.

Thermohygrographs have become a common fixture in most museums; some museum personnel are so devoted to the instruments that the mere fact that conditions are being constantly monitored may in time overshadow the need to correct the widely fluctuating levels of relative humidity usually reported by the graphs. Thermohygrographs are valuable for recording daily temperature and humidity fluctuations caused by changes in air-conditioning levels between days, nights, and weekends. To save energy many buildings operate at higher temperatures during non-working hours in the summer (or at lower temperatures during off-hours in the winter); such temperature variations normally result in significant humidity fluctuations.

### Electronic Humidity Indicators

Rapidly responding electronic humidity indicators either operate as self-contained, hand-held units or have a humidity probe connected to an indicator unit or chart recorder by a length of electrical wire. These fairly expensive instruments can be made with different types of humidity sensors — the two most common are a special thin-film capacitor in which electrical capacitance changes as a function of relative humidity (a Pope cell), and a sensor in which electrical resistance varies according to the relative humidity (a Dunmore sensor). Associated electronic circuitry computes the dew point or relative humidity from the capacitance or electrical resistance of the sensing element. The hand-held Humi-Chek electronic hygrometers supplied by Rosemont Analytical, Inc. are particularly recommended; available in several models, the units cost between $500 and $900.[10]

A very accurate — and expensive — type of electronic humidity indicator is the dew-point/frost-point hygrometer, whose photocell optically detects formation of dew (liquid condensation) or frost on a polished plate which is slowly cooled by a thermoelectric cooling unit. The relative humidity is computed by comparing the ambient air temperature and the temperature of the polished plate when condensation (or frost) occurs. Electronic instruments with external probes are particularly helpful for monitoring humidity levels inside a refrigerated storage unit from a remote location. Suppliers of electronic humidity indicators are listed at the end of this chapter.

### Humidity Indicator Papers

Paper or other material impregnated with a cobalt salt such as cobalt thiocyanate has the property of progressively changing color from blue to pink as the relative humidity increases through a range from 20% to 80%. One such product, Hydrion Humidicator Paper, is available from Micro Essential Laboratory, Inc.[11] By comparing the color of the paper with a color chart supplied with the product, estimates of relative humidity can be made to within about ± 5% in the humidity range covered by the paper. Not well suited for general humidity monitoring, strips of the low-cost paper do have some unique research applications, such as measuring the relative humidity *inside* a sealed glass slide mount, picture frame, plastic bag, or other closed container. Because the colored salt will contaminate and permanently stain adjacent materials, even migrating through a sheet of paper in only a week or two, these paper indicator strips should *never* be placed in the vicinity of valuable photographs, films, mount boards and mats, etc.

### Calibration of Hygrometers

It is vitally important that mechanical and electronic hygrometers be checked when initially put into operation, and then from time to time after that to guarantee their continued accuracy. As Garry Thomson observed in *The Museum Environment:*

> The hair hygrometer in its eight-day recording form, often combined with a temperature recorder, has become a common sight in museums all over the world, and testifies to a growing awareness of the importance of climate control. . . . Because it can so easily slip out of calibration, either through a jolt or by slow drift, so that its readings are no longer true, there must be hundreds of humidity records stored away in museums which are in fact worthless. Ideally the hair hygrometer should have its calibration checked monthly.[12]

A carefully operated sling psychrometer should be adequate for routine calibration of dial and recording hygrometers (as well as common types of electronic hygrometers) for most photographic storage needs, but there are applications where more accurate calibration is desired. While a precise Assmann psychrometer or electronic dew-point hygrometer could provide a standard for calibration, a simple and very accurate method of calibrating a hygrometer is to place the unit in a sealed container made of glass or transparent plastic and containing a tray with a

1991

Hygrometer calibration with a saturated solution of sodium dichromate. The acrylic case, constructed of ⅜-inch clear Plexiglas acrylic sheet by this author, measures 12x12x6 inches. The sodium dichromate solution is contained in a glass oven dish resting on the bottom of the case. A removable shelf for the hygrometer is provided in the center. The transparent lid, which rests on a foam plastic gasket, allows the user to determine when the hygrometer indication has stabilized (full equilibration may require 2 or 3 days). After noting the exact plus or minus deviation of the hygrometer from the proper reading, the unit is removed from the case and allowed to equilibrate to ambient conditions. The hygrometer calibration screw is then adjusted by the required amount (adjustment right after removal from the calibration case is difficult because the hygrometer reading will start changing immediately to conform to ambient conditions.)

saturated solution of sodium dichromate or certain other salts in distilled water. At a given temperature, the air above the saturated salt solution has a specific, known relative humidity.[13] If properly carried out, sodium dichromate calibrations can be as accurate as ± 1%.

This method is especially suited to calibrating dial hygrometers (several can be placed in the container at the same time if space allows). In this author's experience, a saturated solution of sodium dichromate is especially appropriate for this application because the 55% relative humidity obtained at 70°F (21°C) — see **Table 16.2** — is close to the average humidity found in many museums. Also, the solution is stable during long-term keeping, with no tendency to form crystals which can gradually climb up the walls of the container above the level of the solution.

For greatest accuracy with this method, the hygrometer should be calibrated as closely as possible to the relative humidity in which it will normally be used. For those few institutions that are able to maintain the relative humidity in the recommended 30–35% range, a saturated solution of magnesium chloride is recommended in place of the sodium dichromate solution. This gives a relative hu-

midity of 33.4% at a temperature of 68°F (20°C). For high-humidity conditions (where photographs should not be stored for long periods!), a saturated solution of sodium chloride gives a relative humidity of 75.5% at 68°F (20°C).

The glass tray or dish holding the solution inside the calibration chamber should have as large a surface area as possible, to aid in rapid equilibration after the chamber has been opened. The solution should be mixed with distilled water, and a sufficient amount of the salt added so that a quantity of the salt crystals remains undissolved at the bottom of the tray, with a layer of clear liquid above the undissolved crystals; several days should be allowed for the solution to become fully saturated. A solution depth of about 1 inch is recommended. The solution should be replaced about every 2 years — or sooner if all the salt crystals become dissolved (because of absorption of moisture from humid air), or if all the clear liquid layer should evaporate due to frequent use (or poor container seal) in conditions of low ambient relative humidity.

Calibrations should be performed in a room with a stable temperature, and, if possible, with a relative humidity close to that inside the chamber. After a hygrometer has been

placed in the chamber, at least 6 hours should be allowed for the relative humidity inside the chamber to stabilize; it is good practice to leave the hygrometer in the chamber overnight (assuming the room temperature remains constant) to assure accuracy of the calibration procedure. The hygrometer should be adjusted to the proper humidity *immediately* after it is removed from the chamber. The hygrometer should then be returned to the chamber and allowed to stabilize for a final check of the adjustment. If the relative humidity of the room is significantly higher or lower than that of the chamber, the hygrometer indicator will start to change as soon as the unit is removed from the chamber; this makes proper calibration difficult, and several attempts may be required for accurate adjustment.

This author has found this method of hygrometer calibration to be simple to perform on a routine basis.

It has been suggested that the bundled-hair or synthetic-fiber element of a dial or recording hygrometer be "rejuvenated" every few months by placing a wet cloth around the unit (in order to create a high-humidity environment) for about an hour. After the cloth is removed and the hygrometer has stabilized for 24 hours, the unit is recalibrated. Pending further experience with long-term behavior of these units, this author tentatively recommends that this "rejuvenation" procedure be omitted and that instead the calibration of such hygrometers be checked — and adjusted if necessary — every few months with the units in their normal operating environment.

## Methods of Controlling Relative Humidity and Temperature in Photographic Storage Areas

While it is recognized that many smaller museums — and the majority of photographers — will not be able to justify the cost of equipment necessary to maintain relative humidity in the 20–30% range throughout the year, an effort should be made to keep the relative humidity as close to this ideal as is practical, and conditions which cause widely fluctuating humidity should be avoided. There are several types of equipment available to meet different needs and budget limitations.

### Home Refrigeration-Type Dehumidifiers

Common electric refrigeration-type home dehumidifiers are capable of maintaining *reasonable* humidity levels in room-size storage areas. These units are available from a number of manufacturers and usually cost between $175 and $400, depending on dehumidification capacity (given as "pints of water removed each 24 hours," according to the test method in *ANSI B-149-1*), types of controls, and other features. The more expensive units have built-in humidistats which turn the unit on if the humidity rises above a pre-set level.

The calibration of dehumidifier humidistats should always be checked with an accurate hygrometer since the factory markings are normally inaccurate. Several dehumidifiers may be needed to control the relative humidity in a medium- or large-size room. The capacity of a dehumidifier needed to control a specific room will depend on such factors as the ventilation of the room (if any), moisture introduced through walls and floors such as in a basement,

the size of the room, frequency and duration of door openings, number of people in the room, etc. Checking the humidity level of the room under various conditions will indicate whether the dehumidifier has sufficient capacity.

Home dehumidifiers usually have a container to collect water extracted from the air. Most models automatically stop if the container becomes full, but if this cut-off switch should fail, the unit will continue to operate, causing water to spill over the sides of the container and onto the floor. Because of this hazard, it is essential that photographs stored in a room with a dehumidifier be placed on shelves or in cabinets at least several inches above the floor. Dehumidifiers usually have a provision for attaching a hose from the unit to a drain (keep in mind that the hose may become clogged, which may also result in flooding). It is, of course, best to work out some sort of permanent drain arrangement so that the unit will not have to be emptied frequently and so that the dehumidifier will not shut off because the water container is full. In an upstairs room of a house where no water drain is available, a length of garden hose can be passed through the center of a wall and attached to a ground-level or basement drain.

An air conditioner and dehumidifier together can effectively maintain reasonable levels of temperature and relative humidity. The air conditioner will remove some moisture from the air in the process of lowering the temperature. The dehumidifier will remove additional moisture and also prevent excessive humidity levels on cool days when the air conditioner is not operating. In condensing moisture from the air, the compressor motor gives off additional heat, causing the compressor to operate for longer periods than would otherwise be the case; this further reduces the level of relative humidity in the room. Care must be taken to be sure that the air conditioner does not shut off in a room containing a dehumidifier; without the cooling of the air conditioner, the room temperature can rise quickly. Most dehumidifiers will become clogged with ice if the room temperature drops below about 65°F (18.3°C), so the air conditioner should be adjusted not to cool below this temperature.

Forced-air exhaust — and provision for replacement air — in a storage area for photographs is not usually necessary unless people are working in the room for a significant amount of time. Remember that the more moist air that is brought into the room, the more dehumidification capacity will be required.

Home refrigeration-type dehumidifiers remove moisture by passing room air over refrigerated coils which are at a temperature not much above the freezing point of water. Moisture is condensed on the coils because the temperature of the coils is below the dew point of the air. After passing over the cool coils, the air is reheated by blowing it over the warm coils connected to the high-pressure side of the compressor. A dehumidifier is similar in design to a small air conditioner except that, unlike an air conditioner, the hot air is not exhausted outdoors. The net effect of a dehumidifier is to lower the relative humidity and — because of heat generated by the compressor motor — raise the temperature of a room.

Dehumidifiers are especially helpful in tropical areas for preventing the relative humidity from exceeding 65–70%, the level at which fungus may begin to grow on film

and print emulsions. Many tropical regions experience sustained periods of very high humidity; at the research station that Eastman Kodak once operated in the tropics of Panama, it was reported that daily humidity levels varied between 63% and 100% during the wet season.[14]

## Standard Window Air Conditioners and Special Humidity-Control Models

As previously discussed (**Figures 16.3 and 16.4**), because most air conditioners lower the temperature of air at the same time they remove moisture, the net result is not always a decrease in the relative humidity in a room or building. In fact, when operated during moderately cool days and nights, and under some other common conditions, an air conditioner can actually cause indoor relative humidity to *rise*. Air conditioners dehumidify most effectively not only when it is warm outdoors but also when significant additional heat is generated indoors by lights, people, electrical office equipment, etc. Such conditions increase the operating time of air conditioners, which in turn increases the amount of moisture removed from the indoor air.

Air conditioners that have an "energy saver" switch that turns the fan on only when the cooling compressor is operating generally produce lower relative humidity in a room than do conventional models in which the fan operates all the time (unless the entire unit is turned off). Air conditioners with this feature are preferred for photographic storage areas (they also cost somewhat less to operate).

Some window air conditioners have provision for dehumidifying air *without* cooling and are excellent for temperature and humidity control in photograph storage areas. This type of air conditioner can be identified by a separate humidity-control knob located near the temperature control on the switch panel; in the U.S., several models with independent dehumidifying capability are available from Sears Roebuck and Co.[15] These air conditioners are able to dehumidify air without cooling by switching half of the evaporator coil to the condenser side of the compressor — and half of the condenser coil to the evaporator side of the compressor. Thus, the unit blows cold dehumidified air and warm air into the room at the same time, resulting in the air being at normal room temperature. When these air conditioners operate in the cooling mode, an electric valve in the refrigerant lines switches the coils back to the normal cooling function.

People are sometimes confused about the names identifying the hot and cold coils of an air conditioner. The cold coil is known as the "evaporator" coil even though it *condenses* moisture from the air on the cold surfaces of the coil. The name "evaporator" comes from the fact that the compressed refrigerant (Freon gas) evaporates, or decompresses, in this coil, thus cooling it. The hot coil is known as the "condenser" coil; when Freon in the gaseous state is pumped into the coil by the compressor under sufficient pressure to cause it to become a liquid, considerable heat is given off in the process.

Window-size heat pumps ("reversible" air conditioners) are sold mainly in the warmer southern states for installation in houses without central heating systems. A heat pump operating in its heating mode will not remove moisture from the air, although the relative humidity will usually be lowered by the heating effect.

Keep in mind that most air conditioners cannot operate at room temperatures below about 65°F (18.3°C). At cooler temperatures the cooling coils will become blocked with ice. An exception to this is the type of air conditioner equipped with a water- or brine-filled heat exchanger of the kind usually found in gas-powered units and "chilled water systems" in many office buildings, museums, and other large buildings. These units can be set for a room temperature below 65°F (18.3°C); however, the relative humidity will probably rise to excessive levels without auxiliary dehumidification equipment.

The minimum relative humidity that theoretically can be obtained by air-conditioning systems that do not form ice on the evaporator coils is about 35% with a room temperature of 70°F (21°C). In practice, this low level probably cannot be reached except in very dry climates such as the elevated southwestern parts of the U.S. Minimum obtainable levels of 50–60% RH are more common. To maintain low relative humidities at low temperatures, a desiccation dehumidifier or a "freeze and heat-defrost" system such as that in a frost-free refrigerator/freezer is needed. A brine-spray system to melt ice on cooling coils should *never* be used in an air conditioner that cools storage areas for photographs because significant quantities of spray chemicals may be carried over into the air stream and contaminate the photographs.

## Remote Air Conditioners for Individual Rooms

Standard window air conditioners cannot be operated in rooms which do not have an outside wall. Even when window space is available, many people do not like the appearance of an air conditioner unit sitting in the bottom half of a window. In a central air-conditioning system, the condenser coil and the compressor are located outdoors. Central air-conditioning systems, however, are difficult to install in buildings that do not already have duct-work in place as part of the air-heating system. In such situations a small "remote" air conditioner may be needed. This type of unit has an outdoor compressor-condenser unit connected to an indoor evaporator-blower by a length of refrigerant tubing. It is similar in concept to a large central air conditioner except that the indoor evaporator unit is designed to be mounted on a wall and has its own blower and air filter attached.

Several sizes of these remote air conditioners are manufactured under the name Comfort-Aire Twin Pac Remote Air Conditioning System.[16] The indoor and outdoor units may be separated by up to 19 feet of tubing (8 feet is supplied, and an additional 11 feet may be purchased as an accessory). The units are available in 6,000-Btu/hr, 10,500-Btu/hr, and 15,500-Btu/hr capacities. A hole 2½ inches in diameter must be cut in the wall for the refrigerant and electrical lines to pass through. A hose attached to the indoor evaporator unit carries condensed water to the equipment outdoors. If the indoor unit is in a building at a level lower than the outdoor condenser unit, provision must be made to drain condensed water away from the indoor section to a floor drain; a home basement installation may require the indoor unit to be lower than the outdoor sec-

tion. The refrigerant lines on these remote air conditioners are of the pre-charged, quick-connect type, enabling anyone with a few hand tools to install the units without professional help.

## Air-Conditioning and Dehumidification Systems for Large Buildings

Air-conditioning systems in large buildings function on the same general principles as the previously described home units; both ducted-air and chilled-water systems are common. With a piping system that runs throughout a building, a chilled-water system circulates refrigerated water to thermostatically controlled cooling units which regulate the temperature in individual rooms or in larger areas.

Most large air-conditioning systems have no provision for separately controlling temperature and humidity and are unable to adequately reduce the humidity during cool and moist days of spring and fall in temperate climates; humidity control also usually fails during cool nighttime hours in hot climates. Modern systems usually have a fairly high air exchange (exhausting indoor air and bringing in fresh outdoor air) to keep concentrations of cigarette smoke and other indoor pollutants from becoming too high, but this makes humidity control more difficult and wastes a great amount of electricity. Air exchange rates can be reduced substantially if smoking is prohibited.

Humidity control can be improved if provision is made to reheat the cooled air so that the air conditioner continues to operate on cool days without significantly cooling the building. This procedure requires additional energy. New installations for museums and archives should have separate dehumidification equipment for dehumidifying without cooling. Older equipment can be modified to perform this function. A qualified air-conditioning and heating engineer should be consulted for advice on selecting equipment and the best approach to the particular problems of each situation. The engineer should be informed of the need for *constant* year-round humidity control.

Museums with different types of collections may require different levels of relative humidity in various parts of the building. For example, recommended humidity levels for leather-bound books are significantly higher than the ideal 30% for photographs. If a collection requires a specific relative humidity (and temperature), it may be possible to place it in a separate room or area controlled by auxiliary equipment. The Ohio Historical Society stores microfilm in an isolated area. Such an isolated-area system has been described by Amdur,[17] who suggests that rooms for specialized storage not have any walls, floors, or ceilings along the outside of the building. This will allow the existing air-conditioning and heating system in the building to control seasonal temperature extremes and to provide a first stage of humidity control. Auxiliary equipment for isolated storage areas can draw air from the interior of the building; such equipment need have only minimum capacity. Descriptions and engineering data for various types of air-conditioning and filtration systems appear in publications of the American Society of Heating, Refrigerating and Air Conditioning Engineers (ASHRAE).[18]

As noted in Chapter 19, frost-free refrigerators offer an excellent way to store color materials at low temperatures and low relative humidities. From an economic point of view, it may be less expensive for a museum to purchase a number of frost-free refrigerators than to construct a low-temperature/low-humidity storage vault. The refrigerators may be acquired one at a time if budgets do not permit a large capital expenditure. For example, about one million 35mm color slides could be accommodated in 40 medium-size refrigerators costing about $18,000 at $450 per unit. (Be aware, however, that large prints cannot be accommodated in a refrigerator.)

## Bags or Cans of Silica Gel: a Generally Unsatisfactory Method of Humidity Control

Desiccants are substances which, when dehydrated ("activated"), are highly hygroscopic and have a great affinity for moisture in the air. Activated silica gel is the most common desiccant; anhydrous calcium, commercially available under the Drierite name, is also popular.

When drying or storing photographs with desiccants, great care must be taken to prevent small particles of the desiccant from contaminating films or prints. Calcium chloride, sometimes used as a desiccant, is not suitable for photographic applications because it is very prone to producing dust, liquefies when moist, and is corrosive.

The simplest form of desiccant air dryer is a porous cloth bag filled with silica gel. This is placed in a closed container along with the film or whatever is to be dried. If the silica gel has been "activated" by heating to dehydrate it prior to use, it will absorb nearly all the water in the air (regardless of ambient temperature), lowering the relative humidity of air to *less than 4%*, which is substantially below the safe minimum suggested for photographs.

A widely sold air dryer is the Grace Davison Silica Gel Air-Dryer.[19] This device, a perforated aluminum can containing silica gel, has a blue indicator (probably cobalt chloride crystals), visible through a small window on the top of the can, which turns pink when the silica gel has absorbed a significant amount of water vapor. The Grace Davison Air-Dryer can be reactivated when saturated by placing it in an oven at about 350°F (175°C) for several hours and then letting it cool in a small closed container to prevent moisture absorption during cooling. Because small particles of silica gel can fall through the can perforations and contaminate photographs, this device is not recommended.

Small packets of silica gel are packed with cameras at the factory to minimize the possibility of moisture damage during shipment and storage. However, once silica gel has absorbed enough moisture to reach equilibrium with the surrounding air, it will not absorb additional moisture unless the humidity of the air rises. Small quantities of silica gel have only a limited capacity to absorb moisture.

Because of the problems associated with silica gel, and the difficulty of accurately controlling the final moisture content of materials being desiccated, this author does not recommend the routine use of cans or packets of silica gel for maintaining low levels of humidity where photographs are being stored. They can, however, be helpful when no other means of humidity control are available or when very low moisture levels in sealed containers are desired (such as might be the case when storing daguerreotypes). Re-

member that unless the photographs and silica gel are sealed in a true vapor-proof container — a cardboard box or a file drawer is *not* vapor-proof — the silica gel will continue to absorb moisture from the air until it no longer offers any practical control over relative humidity. Under some conditions, silica gel can lose its ability to absorb additional moisture in less than an hour.

Pre-conditioned in air of a specific relative humidity, silica gel can serve as a "buffer" to help maintain a given humidity level in a sealed display case or other reasonably vapor-proof container for short periods of time.[20] A brand of silica gel known as Art-Sorb, made by Fuji-Davison Chemical Ltd. of Japan and distributed in the U.S. by Conservation Materials, Ltd.,[21] has been advertised as being more effective as a humidity buffer than ordinary silica gel. Also available is a product called Art-Sorb Sheets, which are sheets of polyethylene/polypropylene foam impregnated with Art-Sorb silica gel. The foam-plastic sheets contain about 16% Art-Sorb silica gel by weight and are intended to be cut to size for placement in display cases, shipping crates, etc. Until meaningful test information on the product becomes available, Art-Sorb Sheets are not recommended for use with photographs because of the possibility of harmful emissions from the foam-plastic sheets.[22]

Probably safer are Gore-Tex Silica Tiles, manufactured by W. L. Gore & Associates.[23] The non-dusting 6x6x½-inch tiles are made of moisture-permeable Gore-Tex expanded PTFE (polytetrafluoroethylene) membrane bonded to both sides of an acrylic plastic grid, with silica gel sealed inside.

## Continuous High-Volume Dry Desiccant Dehumidifiers

The principle of drying air with a desiccant has been applied on a massive scale in the form of dehumidification machines made by Cargocaire Engineering Corporation[24] and several other firms.

**Figure 16.6** shows how a Cargocaire desiccant dehumidifier removes moisture from the air by means of a continuous regeneration cycle for the desiccant wheel, which consists of a lithium chloride-impregnated porous structure. As the wheel slowly turns (approximately 6–20 revolutions per hour), humid air passing through the flutes in the wheel is dried. At the same time, a counterflowing stream of hot air passing through the reactivation sector of the wheel removes the moisture picked up by the desiccant, thus allowing continuous dehumidification. Units with wheels impregnated with molecular sieve and silica gel desiccants are also available for special applications.

The desiccant-impregnated wheel dehumidifier was developed by Carl Munters of Sweden in the 1950's, and manufacturing rights were licensed to Cargocaire in the U.S. and to a number of companies in other countries. The Munters Group of Sollentuna, Sweden now owns Cargocaire and most of the other former licensees.

Desiccation dehumidifiers are extensively employed on ocean ships for maintaining proper relative humidities in steel-walled cargo holds (in which relative humidities would otherwise be around 100%) and in industry for environmental control in areas where such humidity-sensitive items as lithium batteries are manufactured. They are also used to control the humidity in underground storage facilities.

Desiccation dehumidifiers are ideal for controlling relative humidity in storage and display areas for photographs kept at normal room temperature — and for humidity control in entire buildings. The units offer more precise control with less energy expenditure than any other type of dehumidifier, and since they operate independently of heating and cooling equipment, the proper relative humidity can be maintained regardless of seasonal or day-to-night variations in outdoor conditions as well as changes in indoor temperature and moisture loads.

Under normal circumstances the dehumidifiers operate without any desiccant particles entering the air stream. However, it is advised that a HEPA (high-efficiency particulate air) filtration system capable of filtering particles down to a size of 0.3 micron[25] be installed in the output duct of the machine to make certain no liquid droplets or dust can enter the air stream into the storage area, should the desiccant regeneration system and the unit's automatic electrical shut-off controls fail, causing the wheel to become saturated with water. In addition, it is absolutely essential that a separate high-humidity shut-off be installed to cut off *all* electrical power to the dehumidifier, air conditioners, and other equipment in the storage area should the relative humidity rise above a pre-set level. The safety equipment must be periodically tested to be certain that it is functioning properly.

In the past, desiccation air-drying machines were not recommended for controlling the relative humidity in photographic storage areas; contamination was a recurring problem with many of the machines having beds of silica gel open to the air stream. The Cargocaire HoneyCombe machine is claimed by the manufacturer to have eliminated the dust problem.

Cargocaire dehumidifiers are made in a variety of sizes for different applications; some models can remove up to 1,500 pounds of water per hour from the air. The machines can be set to control the relative humidity to any level —

1980

A Cargocaire dry desiccant dehumidifier attached to a color motion picture film storage vault (maintained at 25% RH and 37°F [2.8°C]) at the Library of Congress facility in Landover, Maryland, near Washington, D.C.

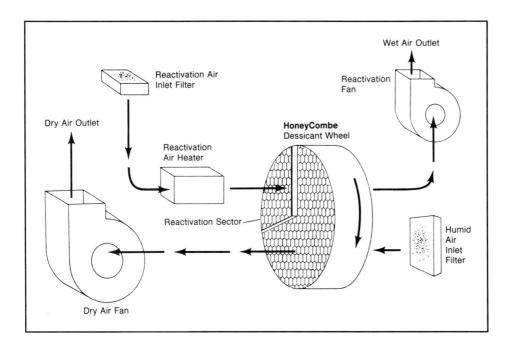

Reactivation Air
Inlet Filter

Wet Air Outlet

Reactivation
Fan

Dry Air Outlet

**HoneyCombe**
**Dessicant Wheel**

Reactivation
Air Heater

Reactivation Sector

Humid
Air
Inlet
Filter

Dry Air Fan

**Figure 16.6** Functioning of
a Cargocaire dry desiccant
dehumidifier.

even as low as 10%. In the larger units, heating is by steam, electricity, or gas; in the smaller units, the reactivation sector is heated electrically. The Cargocaire Model M85-L dehumidifier (about $2,500 including humidistat) has a provision for internally cooling the heated air in the reactivation sector and does not require an outdoor air exhaust; this allows the unit to be located almost anywhere within a building. Cargocaire units in the size range commonly used in photograph cold storage vaults range in price from about $3,500 to $12,000.

Cargocaire offers a special explosion-proof version of its HC-150 dehumidifier that is capable of meeting the building and fire code requirements of most cities and states for electrically powered air-handling equipment which recirculates air in flammable environments. This special unit is recommended for cellulose nitrate film storage vaults.

Continuous desiccant dehumidifiers are currently the only practical and energy-efficient method of maintaining low and precisely controlled humidity at the 0°F (−18°C) or lower temperatures necessary for the long-term storage of most types of color films and prints. Cargocaire units were first used for humidity control of a low-temperature vault for photographic materials at the John Fitzgerald Kennedy Library in Boston, Massachusetts, which opened in 1979.

Cargocaire dehumidifiers are currently in operation in the cold storage facilities at the Warner Bros. movie studio in Burbank, California; Paramount Pictures in Hollywood, California; the Art Institute of Chicago in Chicago, Illinois; the Time Inc. Picture Collection in New York City; the Peabody Museum of Archaeology and Ethnology at Harvard University in Cambridge, Massachusetts; the Library of Congress cold storage facility in Landover, Maryland; the Historic New Orleans Collection, in New Orleans, Louisiana; the National Archives and Records Administration cold storage vaults in Alexandria, Virginia; the Human Studies Film Archive at the Smithsonian Institution in Washington, D.C.; and the Moving Image, Data and Audio Conservation Division of the National Archives of Canada in Ottawa, On-

tario. (See Chapter 20 for further information on large-scale cold storage facilities for color materials.)

## Reliability Problems Reported with Cargocaire Dehumidifiers — Improved Models Introduced in 1989

A number of institutions using Cargocaire dehumidifiers, including the Art Institute of Chicago and the Peabody Museum of Archaeology and Ethnology, have had serious reliability problems with the units. The most frequent failure has involved the electrical reactivation heaters that drive moisture off the rotating lithium chloride-impregnated wheel. At the Art Institute of Chicago, photography conservator Douglas G. Severson reports that during the first 6 years that the units were in operation (the Art Institute's two cold storage vaults were constructed in 1982), the reactivation heaters in the six Cargocaire dehumidifiers were all replaced at least twice.[26] According to Severson, at one point four of the six dehumidifiers were out of operation. But, in spite of the failures, control of the relative humidity levels in the two vaults was never lost because at least one of the dehumidifiers remained functional while the others were being repaired (the units operate in a redundant manner). Severson says that during the first 6 years of operation, no problems whatever were experienced with the vault refrigeration compressors.

The Art Institute vaults are equipped with fail-safe electrical controls that automatically sound an alarm and cut off electrical power to all cooling and dehumidification equipment should the temperature or relative humidity levels drift beyond pre-set limits. If such a failure should occur, the doors to the vaults would be left closed until the interior reached room temperature (during which time the relative humidity inside the vaults would drop somewhat). The photographs stored inside the vaults would be in no danger should such a shutdown occur. Severson says that the fail-safe shutdown controls are tested regularly.

Cargocaire has acknowledged the problems with the reactivation heaters in the dehumidifiers and several redesigned models were introduced in 1989 which, according to the company, should prove to be far more reliable.

## Control of Relative Humidity with Cool-and-Reheat Equipment

Controlling relative humidity in air-conditioned buildings has traditionally been accomplished by heating units — usually electrical — attached to the cool-air ducts coming from the air-conditioning units. The heating units raise the temperature of the air coming from the air conditioners, producing a drop in relative humidity; at the same time, the heaters cause the air conditioners to operate for a longer time without lowering the room temperature below the desired level. Thus, the air conditioners have an increased dehumidification effect on the constantly recirculated air. These systems consume much more energy than desiccant dehumidifiers, and if a low relative humidity is desired — 25% for example — an enormous amount of energy may be required to maintain such a level; with many installations, it will be impossible to reach such a low humidity level even with continuous operation of the cooling and reheating equipment.

When precise regulation at a low level of relative humidity is desired, desiccant dehumidifiers in conjunction with conventional air-conditioning equipment will be much more satisfactory than cool-and-reheat equipment.

## Humidifiers to Raise Relative Humidity

To maintain reasonably constant relative humidity in areas where photographs are stored, it will usually be necessary to add moisture to indoor air in the cold periods of the year in temperate climates.

Humidifiers that eject steam or water mists directly into the air should be avoided in any but the most elaborate systems because they can create localized areas of very high relative humidity and, should the controls fail, will raise the room humidity to near 100%. Evaporation humidifiers which are attached directly to home hot-air heating systems, and which have automatic relative humidity controls that can be set by the user, probably present no great danger and will minimize winter/summer variations in humidity. An accurate hygrometer should be placed in storage areas so that conditions can be checked from time to time. Humidity calibrations on home humidifiers are usually inaccurate. Low-cost evaporation humidifiers for the home can be accurately controlled by separate humidistats available from heating equipment supply outlets.[27] This author has employed simple equipment of this type to control the relative humidity in rooms in which accelerated light fading tests are conducted; the humidity can be maintained at ± 5% or better.

Any large-scale humidification system should have "failsafe" automatic controls to minimize the danger of overhumidification, which could seriously damage photographs in a short time.

When budgets are limited, it almost always best to concentrate available resources on the purchase and operation of *dehumidification* equipment and not be overly concerned about the short periods of the year in cold climates when the humidity may drop below 20%. Generally speaking, high relative humidities are much more harmful to photographs than are low relative humidities.

## Prevention of Fungus on Photographs

Fungus growth on photographs can be prevented by keeping the relative humidity in storage and display areas at less than 65%. This simple advice is given with the realization that in many parts of the world, proper control of relative humidity in commercial buildings and homes where photographs are used and stored may be difficult — or, in a practical sense, even impossible. It is important, however, to clearly understand the relationship between relative humidity and fungus growth, and to provide the best storage conditions that one is able.

In museums and archives, it is imperative that adequate humidity-control equipment be provided in storage and display areas. For a collecting institution to ignore this fundamental requirement for the proper care of photographs is a serious irresponsibility.

Fungus, also called "mold" and "mildew," will not grow in temperatures below the freezing point of water, but may thrive in temperatures slightly above freezing, as many people have observed in their refrigerators. Some forms of fungus flourish in temperatures as high as 131°F (55°C). Most forms of fungus will grow in either light or dark situations. Warm and humid conditions are most conducive to fungus growth, but regardless of the temperature, the humidity must be above 65–70% for sustained periods. Wessel has stated: "Generally it is believed that below 70% relative humidity (RH) there is little opportunity for growth. At 80–95 percent RH most forms grow well; above 95 percent RH growth is luxurious."[28] If fungus has started to grow, it can be arrested by drying the photographs and then storing them in low-humidity conditions.

Fungi require nutrients to grow. Gelatin, the major component in the emulsion of films and prints, is, unfortunately, an *excellent* nutrient for fungi. Indeed, susceptibility to fungus attack is one of the serious shortcomings of gelatin-emulsion films and prints that has never been solved. Alternatives for gelatin have been investigated — and have been substituted for gelatin in a few commercial products such as Kodak Velite contact paper which was marketed in the 1950's — but to date none have been developed which are as satisfactory as gelatin in terms of cost, chemical, processing, physical, and optical characteristics.

Fungus spores are found almost everywhere and will grow if the proper combination of nutrients and humidity is present. Fungus growths frequently concentrate around fingerprints on prints and films due to salts in the fingerprints which create localized moist conditions. Fungus growths often damage areas adjacent to the nutrient surfaces on which they are actually growing; they may surface-etch or otherwise damage film base materials. Insects may be attracted to fungus growths, and they or their excrement may do additional damage to photographs.

Hygroscopic glues and print flattener solutions such as Kodak Print Flattener and Pako Pakosol should be particularly avoided in tropical areas because these materials will increase the fungus problem.

Fungi growing on emulsions usually make the gelatin soluble in water. Therefore, water or solutions containing water cannot be used to clean photographs which have been attacked by fungus. Surface fungus can often be at least partially removed by wiping with a soft cotton swab soaked with Kodak Film Cleaner. Slides should be removed from their mounts before cleaning and returned to new mounts after cleaning.

As long as photographs are kept out of obviously damp places such as basements, fungus is not a major problem in most areas of the United States. In tropical areas, which frequently have high average relative humidities, fungus on photographs is common; in rain forests and other particularly humid areas, fungus often causes catastrophic damage to prints and films.

At the first sign of fungus growth (which might be mistaken for dirt in early stages), measures should be taken to reduce the relative humidity in storage locations. As discussed previously, one or more home-type dehumidifiers placed in storage rooms will generally reduce the humidity to a safe level. In severe conditions, such as tropical areas where both heat and moisture are problems, a suitable frost-free refrigerator will provide an excellent humidity-controlled "micro-climate" for storage of both color and black-and-white photographs. Use of these refrigerators is discussed in Chapter 19.

## Fungicides

In situations where control of relative humidity is impossible, several methods of preventing fungus from growing on photographs have been suggested. These include processing color negatives and prints with a "washless" system incorporating Konica Super Stabilizer as a final bath (the stabilizer has a long-term fungicidal effect and, used with Konica Color Paper Type SR, Konica Color Paper Professional Type EX, and Konica Color QA Paper, is highly recommended for tropical or other humid areas),[29] postprocessing treatment of films and prints with chemical fungicides,[30] treatment of paper envelopes and interleaving papers with fungicides,[31] laminating prints with pressure-sensitive plastic laminates,[32] or coating films and prints with 3M Photogard or a waterproof lacquer (3M Photogard is claimed to provide excellent protection against fungus attack; lacquers, however, may provide only limited protection). See Chapter 4 for discussion of pressure-sensitive laminates, Photogard, and lacquers.

Eastman Kodak has recommended immersion in a 1% solution of zinc fluosilicate and air drying without wiping as the only effective fungicidal treatment suitable for *both* color and black-and-white films and prints.[33] Zinc fluosilicate, however, is extremely toxic and may be fatal if ingested in even very dilute solutions; treated films and prints may also be harmful if licked or eaten and should never be stored in areas where children are present. Rohm and Haas Hyamine 1622 has been cited by Eastman Kodak as very effective in preventing fungus growth on black-and-white photographs, but the company has cautioned that it should *never* be applied to color films or prints.[34] Black-and-white photographs treated with Hyamine 1622 should never be interfiled with color films or prints.

In most situations — even in tropical areas — this au-

thor does not recommend treating photographs with fungicides. A much better approach is to control the relative humidity in areas where photographic materials are stored. If, however, fungicides are applied, treated prints and films should be separated from untreated materials and clearly marked to indicate what type of fungicide was used. If framed or unframed prints are displayed in rooms without humidity control in tropical or other humid areas, the prints should be covered with a suitable pressure-sensitive plastic laminate (see Chapter 4). Fiber-base prints and Ilford Ilfochrome prints (called Cibachrome, 1963–1991), which have a gelatin anti-curl back-coating, should be laminated on both sides.

At one time, Kodak processing laboratories coated Kodachrome transparencies and Kodacolor 35mm negatives with a film lacquer. This practice was stopped in 1970 for reasons that this author has not been able to determine. Kodak films coated with lacquer often have a slightly iridescent appearance when the emulsion side is viewed at an angle to the light. Kodak film lacquer is said to contain a mild fungicide which is safe when applied to color films. This author does not recommend that photographers try to coat their films with lacquers as it is almost impossible to prevent small dust particles from becoming embedded in the lacquer when it is applied; in addition, the dye stability of the films may be impaired.

Edwal Scientific Products Corporation (a division of Falcon Safety Products, Inc.) markets a film-coating product called Permafilm, which the company claims will reduce emulsion scratches, chances of fungus growth, and color dye fading. An Edwal spokesman says the slowing of dye fading is achieved by a reduction of moisture in the emulsion. Edwal has advertised Permafilm as an "almost magic" liquid which, among other things, "makes negatives and movies practically scratch-proof; reduces tearing of sprocket holes." Permafilm definitely does *not* make films scratch-proof, although it may reduce the likelihood of emulsion scratches. This author has no information on the long-term effects of this product on photographs and thus cannot recommend it.

## Insect and Rodent Damage to Photographs

If storage areas are kept clean and free from crumbs and other bits of food — and relative humidity and temperature are maintained at moderate levels — damage to films and prints by insects and rodents is not a common problem. However, if mice and rats are able to enter storage areas, they may chew on paper prints or envelopes to obtain small bits of paper for nest construction. Rodents should not be controlled by keeping pet cats in the storage areas because some cats are fond of sharpening their claws on stacks of prints; they can also damage photographs by climbing on stacks of boxes and knocking them to the floor. Any animal can damage photographic materials with its urine and excrement, causing stains and encouraging fungus growth.

Insects may be attracted to photographic materials, particularly in warm, high-humidity conditions or when fungus is present on the photographs. Roudabush has reported some examples of damage to films and mounted slides by carpet beetle (dermestid) larvae. In a few cases

the larvae damaged film while it was still inside a camera. Damage to mounted slides was usually restricted to an area of the film no more than 9mm from the edge of the cardboard mount. Experiments showed that the larvae needed to have a grip on the edge of the mount in order to chew on the emulsion. Adult carpet beetles do not normally damage photographs. To eliminate infestations of carpet beetle larvae, Roudabush advised:

> Remove all of the transparencies and fumigate the boxes or drawers of slide files with paradichlorobenzene moth crystals. Naphthalene crystals should not be used. With the slides removed and the slide files closed, the paradichlorobenzene crystals should be left in position for several days so that any emerging larvae will be killed. The slides should be dusted with a soft brush or jet of air to remove any eggs or larvae before replacing them in the storage box. Since the vapor of paradichlorobenzene may seriously damage the transparencies by weakening the cardboard base or support, all of the crystals should be shaken out of the slide drawers and the drawers aired before the transparencies are refiled. Tests to date indicate that transparencies will not be damaged if paradichlorobenzene crystals or concentrated vapor from the crystals are not allowed to contact them. It is also recommended that the treatment be repeated periodically and that stored slides be examined regularly for any evidence of damage.[35]

Wessel has listed a number of insects which may attack paper prints, mounting materials, and envelopes: silverfish, cockroaches, bookworms, and termites.[36] Termite damage is often a by-product of the termites' eating of wood or other materials in the same area as the paper. Insects and rodents may be attracted to glues and pastes, especially in high-humidity conditions.

All photographs on long-term display should be framed under glass to protect them from flying insects, such as houseflies, which may land on them and leave deposits of excrement and dirt. Low temperatures and low relative humidities discourage most insects. Keeping storage areas free of dust, lint, and food particles or wrappings (such as candy bar wrappers) will minimize the possibility of insects inhabiting the areas. New photographs from outside sources should be closely examined for insects before they are added to existing collections.

If, in spite of good housekeeping and proper temperature and relative humidity control in storage areas, insect infestations persist and an insecticide must be used, Bard and Kopperl of Eastman Kodak have recommended sulfuryl fluoride as the only fumigant satisfactory for treating photographs (both color and black-and-white).[37] Sulfuryl fluoride, sold under the trade name Vikane, is reported to be effective against "cockroaches, termites, silverfish, ants, spiders, bedbugs, clothes moths, and carpet beetles, but *not* on microorganisms and mold [fungus]. Vikane is not effective against insect eggs, and some authorities recommend a second application 20 days to one year after the

first, depending on the species of the insect."[38] Like all insecticides, sulfuryl fluoride is toxic if excessive amounts are inhaled or ingested; the recommended maximum level of exposure is 5 ppm. Exposure to excessive levels of sulfuryl fluoride "causes abdominal pains, nausea, vomiting, convulsions, chemical pneumonia, lung and kidney damage, and teeth and bone defects."[39] For advice on the safe application of sulfuryl fluoride and fungicides to photographs, Eastman Kodak Company should be consulted.[40]

**Air Pollutants**

Photographs of all types can be adversely affected by air pollutants. The delicate silver images of black-and-white photographs in general — and RC prints and microfilms in particular — are susceptible to low levels of pollutants such as sulfur dioxide, nitrogen oxides, hydrogen sulfide, peroxides, ammonia, formaldehyde, ozone, and paint fumes. Kodak states:

> The severity of attack by various gases in the atmosphere depends on the concentration of the gases, or fumes, on the presence of residual processing chemicals in the materials, and on the levels of temperature and relative humidity. If there are residual chemicals present, moisture alone may precipitate their attack on an image. Since the effects of oxidation on a silver image are similar, regardless of the cause, it is difficult to determine in any particular case to what extent atmospheric conditions were responsible for the deterioration. In most cases there is no single cause of fading and staining of material; the effect is usually due to a combination of several factors.[41]

Fumes from fresh oil-base paints are a potent source of oxidizing gases which can — in only a few days — cause severe fading and discoloration of black-and-white photographs. To be safe, photographs should be removed from freshly painted rooms for at least 6 weeks if an oil-base paint was applied. Tests conducted by Eastman Kodak in which black-and-white fiber-base and RC test prints were placed in a room 5 hours after painting showed that even very low concentrations of oil-base paint fumes were sufficient to cause image discoloration:

> This painted-room test did substantiate laboratory findings in that certain test prints on both fiber-base and resin-coated papers discolored within 7 days. Also, other test prints discolored when placed in the room up to four weeks after painting was completed. Total oxidant concentrations in the painted room never exceeded 30 parts per billion.[42]

The Kodak study determined that hydrogen peroxide is released by oil-base paints in the course of drying, or autoxidative polymerization. Certain types of cosmetics, such as hair sprays, were also said to produce image discoloration. There is substantial evidence that RC prints are in general more susceptible to discoloration and fading

**Table 16.3   National Institute of Standards and Technology Recommendations for Environmental Conditions for Storage of Paper-Based Archival Materials [Not Necessarily Including Photographic Materials]**

Prepared for the National Archives and Records Administration in 1983

| Category of Storage Conditions | 1. | 2. | 3. |
|---|---|---|---|
| Public Access | yes | no | no |
| Duration of Storage | short[a]-long | short[a]-long | long[b] |
| Frequency of access | often | often | seldom |
| Temperature Range | 65–75°F (18–24°C) | 50–55°F (10–13°C) | –20°F (–29°C) |
| Temperature Control[c] | ±2°F (±1°C) | ±1°F (±0.5°C) | ±2°F (±1°C) |
| Relative Humidity Range | 40–45% | 35% | — |
| Relative Humidity Control[d] | ±5% | ±3% | — |
| Gaseous Contaminants $SO_2$ | <1 $\mu g/m^3$ | <1 $\mu g/m^3$ | <1 $\mu g/m^3$ |
| $NO_x$ | <5 $\mu g/m^3$ | <5 $\mu g/m^3$ | <5 $\mu g/m^3$ |
| $O_3$ | <25 $\mu g/m^3$ | <25 $\mu g/m^3$ | <25 $\mu g/m^3$ |
| $CO_2$ | <4.5 $g/m^3$ | <4.5 $g/m^3$ | <4.5 $g/m^3$ |
| HCl Acetic Acid HCHO (formaldehyde) | use best control technology | use best control technology | use best control technology |
| Fine Particles TSP[e] | <75 $\mu g/m^3$ | <75 $\mu g/m^3$ | <75 $\mu g/m^3$ |
| Metallic Fumes | use best control technology | use best control technology | use best control technology |

a) Short-term storage is defined in this table as a wide range of time of storage. Documents may be removed and replaced daily or stored for many years depending on requests for their use.
b) Long-term storage is defined in this table as a time of storage intended to be 50–100 years or more. Documents designated for this type of storage would be those of "intrinsic value" and designated for preservation as long as possible.
c) Temperature should be in the given range and should not vary more than these control values.
d) Relative humidity should be in the given range and not vary more than these control values.
e) Total suspended particulates: the weight of particulates suspended in a unit volume of air when collected by a high-volume air sampler.

**Note:** It may be desirable to provide system capability to achieve lower levels of temperature and relative humidity than the levels given in this table. Some studies tend to indicate that for long-term storage, either or both lower temperature and lower relative humidity may be desirable.

Adapted from: Robert G. Mathey, Thomas K. Faison, Samuel Silberstein, **Air Quality Criteria for Storage of Paper-Based Archival Records,** Center for Building Technology, National Engineering Laboratory, National Institute of Standards and Technology (formerly known as the National Bureau of Standards), Gaithersburg, Maryland, November 1983, p. 22.

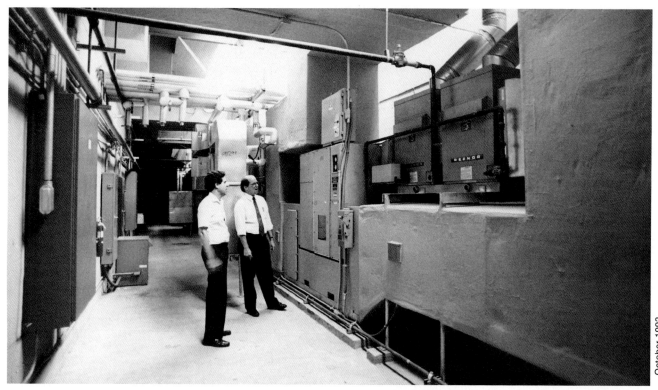

October 1992

Air purification, dehumidification, and refrigeration equipment at the Warner Bros. motion picture archive on the Warner Bros. studio lot in Burbank, California. This multi-million dollar humidity-controlled cold storage facility, which went into operation at the end of 1992, employs a sophisticated computer-controlled air-quality management system to remotely monitor the atmosphere in the storage vaults for the presence of acetic acid vapors (which can evolve from acetate film base during long-term storage) and formaldehyde vapors. The redundant, activated-carbon air-filtration system is designed to remove these gases as well as sulphur dioxide, hydrogen sulfide, peroxides, ozone, acidic fumes (e.g., nitrogen oxides), alkaline gases, and ammonia. In keeping with ANSI film storage recommendations, the relative humidity is maintained at 28%. Shown here with some of the air-quality equipment in the high-security facility are John Belknap, Manager of Film Vaults/Assets, and Bill Hartman, Manager of Asset Inventory Management and Research in Corporate Film Video Services at Warner Bros., a division of Time Warner Inc. (See Chapter 9 for further discussion of the Warner Bros. film archive.)

caused by low-level air pollutants and other contaminants than are fiber-base prints. Print lacquers were found to give little protection against airborne contaminants.

Water-base latex paints reportedly do not release oxidants in amounts that could harm silver images. None of the latex paints included in the Kodak study caused discoloration of prints. On the basis of these findings, it is recommended that storage rooms, exhibition areas, and darkrooms be painted exclusively with latex paint.

Maximum levels of pollutants in areas where photographs are stored have not been established; however, maximum concentrations for art museums have been proposed.[43] As a rule, the level of pollutants should be as low as feasible:

> Great care should be taken to eliminate these gaseous impurities from the long-term storage environment because even very small concentrations may cause extreme damage. Suitable means for removal of gaseous impurities are available, such as air washers operating with treated water for elimination of sulfur dioxide, and activated charcoal for the adsorption of sulfur dioxide and hydrogen sulfide. These require consistent control and, in the case of activated charcoal, proper recycling.[44]

At the request of the U.S. National Archives and Records Administration, the National Institute of Standards and Technology (formerly known as the National Bureau of Standards) made a study of the storage conditions in the National Archives facilities in Washington, D.C. and made recommendations for environmental conditions for storage of paper-based records. Summarized in a 1983 report entitled *Air Quality Criteria for Storage of Paper-Based Archival Records*,[45] the study did not specifically address the requirements of photographic materials; nevertheless, the report provides practical guidelines for conditions in an archive or museum (see **Table 16.3**).

Of particular note is the extremely low temperature of –20°F (–29°C) recommended for long-term storage. Intended for "permanent" preservation of even the most inherently unstable paper-based materials, this temperature is far lower than what has generally been advocated in the past for museum and archive storage.

In most storage and display situations, such as in homes and offices, it will not be economically feasible to install equipment for control of pollutants. The best that can be done is to prohibit cigarette smoking, keep exchange of outside air to a minimum (unless cooking is done on the premise, in which case an exhaust fan to the outdoors

should be placed above the cooking area), and operate air-conditioning equipment on a 24-hour basis during warm and humid periods. Additional humidity control with home-type dehumidifiers will be of benefit.

Equipment to control airborne pollutants in museums and archives is supplied by Purafil, Inc. (see *Suppliers List* at the end of this chapter) and others. Purafil air filtration equipment is used at the International Museum of Photography at George Eastman House and the Library of Congress, among other institutions.

Treating black-and-white films and prints with a solution of Kodak Rapid Selenium Toner, Kodak Poly-Toner, or Kodak Brown Toner affords substantial protection against common air pollutants. James M. Reilly and co-workers at the Image Permanence Institute recommend a polysulfide treatment for maximum protection of microfilm images.[46]

Beginning in 1993, the National Archives and Records Administration in Washington, D.C., acting on the recommendation of Steven Puglia, a photographic preservation specialist at the Archives, will employ the IPI polysulfide image stabilization treatment for all microfilm and other black-and-white films processed at the institution.

### Detection of Harmful Air Pollutants with Agfa-Gevaert Colloidal Silver Test Strips

In 1972, Edith Weyde and associates at Agfa-Gevaert AG in Leverkusen, West Germany published the details of a simple test to determine whether the atmosphere in a storage area contains gases which could harm the silver images of films and paper prints. The method grew out of a project investigating the deterioration of photographs at the Munich Archives. In the 1960's, curators of the Archives had observed brown spots where image silver had been destroyed on prints and films in the collection. Weyde's research into this problem led to the development of colloidal silver test strips:

> To detect very small amounts of oxidizing gases, layers of yellow colloidal silver were used

October 1987

An Agfa-Gevaert colloidal silver test slide, matted and in a small metal frame (without glass), in the photograph storage vault at the Art Institute of Chicago.

which had a grain size of less than 30 nm. These underwent a dark discoloration due to oxidizing gases and only at a very high concentration of the gases did they fade or bleach. This discoloration is due to a change in grain, as shown by electron micrographs. Very fine grains disappear making the average grains coarser.

> ... The colloidal silver layers were superimposed with a lacquer print resembling an Agfa diamond, which protected the silver layer against oxidizing gases. If the air being examined contained oxidizing gases, the area around the diamond darkened which left the symbol light under the lacquer cover.

> The concentration of oxidizing gases in air is usually quite small. The darkening of the test layer takes considerable time. We conclude that, where darkening occurs after weeks or a few months, there will be danger for the archival storage of valuable photographic documents. If noticeable darkening occurs only after one or more years, there does not seem to be serious danger for the silver images stored in vaults or archives.[47]

Weyde, in this important article, went on to describe the two principal applications of the test strips:

> **(a)** Testing for damaging gases given off by a variety of different materials: It has been found that freshly produced plastic packaging or storing materials are very dangerous. Such materials can still be very active, releasing monomer or other compounds used in manufacture, such as polymerization catalysts which are very often peroxides. Of special interest is also the activity of automobile exhaust fumes, which can differ greatly in their composition, depending on a variety of conditions. During the oxidation of hydrocarbons, alkyl radicals are produced which, with oxygen, form peroxide radicals. Additionally these engine exhaust fumes often have an acid reaction, as they contain, among other substances, nitric oxides.

> **(b)** Testing the atmospheres of various rooms: Such colloidal layers of silver are intensely discolored in laboratories, garages, and bathrooms. The results varied for rooms with oil and gas heating systems depending on ventilation. ... In Europe silver images were frequently discolored in photographic shops, particularly in Denmark and Sweden, where the displays were open to the street only. An examination of these localities showed that such shops were usually situated in very narrow streets carrying a volume of traffic, and were often at traffic lights, or near parking lots, and gas stations. In this case the layers of colloidal silver exposed to the air were discolored, often in a matter of weeks.

> ... It was possible to draw the cautious conclusion that color change of the layer of col-

Henry Wilhelm – February 1987

Located on Tchoupitoulas Street in New Orleans, this restored building owned by the Historic New Orleans Collection houses cold storage vaults for black-and-white negatives, color films and prints, and cellulose nitrate negatives. Also in the building are manuscript archives, conservation labs, and administrative offices.

loidal silver occurred about 10 times earlier than the first visible destruction of a photographic layer of silver. Color change of the layer of colloidal silver occurring after a few weeks or months probably indicates an atmosphere which can cause destruction of the silver layers.

Beginning in the early 1970's, small numbers of the colloidal silver test strips were distributed to several institutions in the U.S. with large photographic collections, including the Library of Congress, the National Archives, and the Mississippi State Archives. The Agfa Corporation has reported that several of the test strips placed in collections showed a very rapid response. Upon investigation the source of the problem in one case proved to be ozone and nitrogen oxides generated by a nearby Xerox copying machine, while at another institution the harmful fumes were being given off by the adhesive from recently installed floor tiles. Electrostatic office copying machines and electronic dust precipitators may generate ozone and nitrogen

Alan B. Newman – February 1987

The control panel for the building-wide fire suppression and intrusion alarm system at the Historic New Orleans Collection.

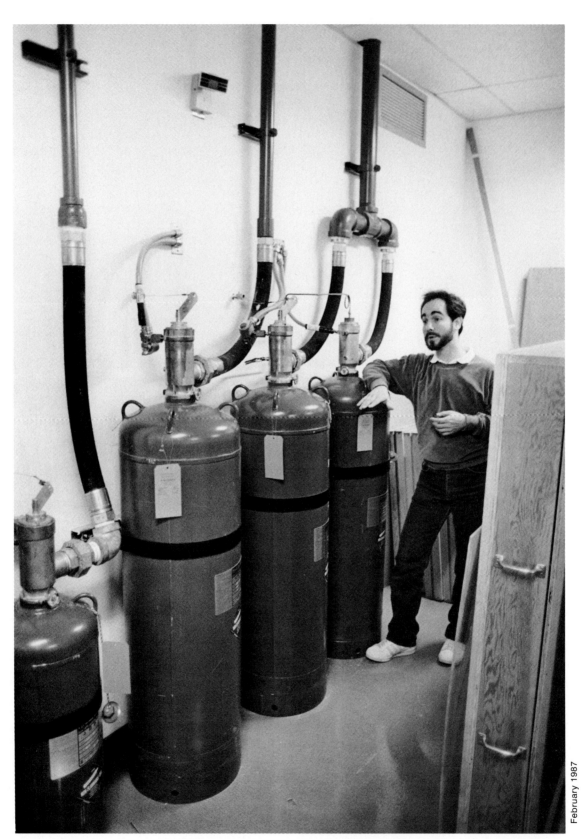

February 1987

Curator John H. Lawrence is seen here with large cylinders of Haylon gas at the Historic New Orleans Collection in New Orleans, Louisiana. Haylon fire-suppression systems are particularly appropriate for photographic storage areas because, unlike water or other liquid and dry chemical fire extinguishers, Haylon gas does not freeze, leaves no residue, and does not harm photographs, paper, or other fragile materials.

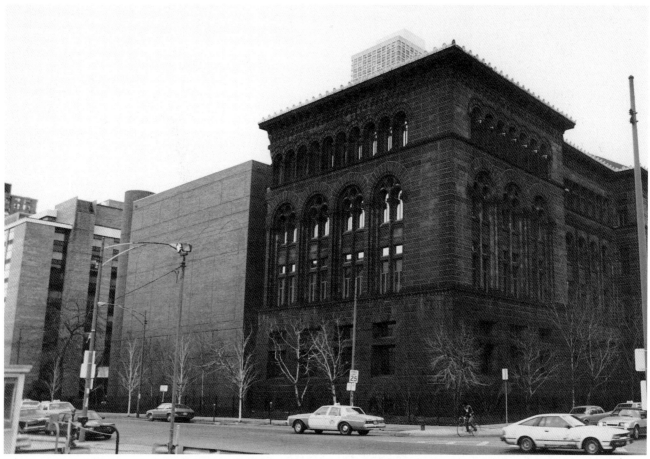

February 1988

The Newberry Library, founded in 1887 in Chicago, is one of the country's leading research libraries. The temperature- and humidity-controlled bookstack building, completed in 1982, is the windowless structure located behind the main library building. Fireproof passageways provide access to each floor from the main library.

oxides; such equipment should not be installed in areas where photographs are stored.

The Agfa-Gevaert colloidal silver test strips are the best means devised to date for monitoring airborne pollutants in areas where photographs are stored in homes, offices, museums, and archives. The test strips are inexpensive and can be placed throughout museums, in storage and display areas, in darkrooms, inside of display cases and frames, and even inside of storage boxes.

After the initial supply of the test strips was exhausted in the early 1970's, they remained unavailable until 1987 when James Reilly, director of the Image Permanence Institute at the Rochester Institute of Technology, persuaded Agfa-Gevaert to resume manufacture of this much-needed item. The test strips may be purchased from the Image Permanence Institute in Rochester, New York.[48]

## Control of Dust

Any photographer who has had to spot or retouch magnified dust specks on enlargements from 35mm negatives knows that dust is almost everywhere and that getting rid of it is difficult. Accumulations of dust may contribute to physical damage of print and film emulsions, especially when photographs are stacked in a pile and surface abra-

sion results from moving them about. Dust-caused scratches on negatives commonly occur when films are slid in and out of plastic or paper enclosures; the dust — sandwiched between the surfaces of the photograph and the enclosure — acts as an abrasive. Reactive dusts can cause localized fading and discoloration on prints and films; a particular danger is the fine dust from dry fixers which may become airborne when the fixer powder is poured into a container for mixing. Unless very well protected, negatives and prints should not be kept in a darkroom for long periods.

Prints and films should be stored in closed containers; with the exception of cellulose nitrate negatives, it is not necessary to ventilate storage boxes and cabinets. In fact, for a number of reasons, ventilation will usually do more harm than good.

Where possible, air filtration systems should be installed in buildings or rooms in which photographs are stored. Electrostatic dust precipitators are not recommended for storage areas because of possible ozone generation which can be very harmful to silver images. Air filtration requirements are given in applicable standards such as *ANSI PH1.48-1982.* A particularly helpful discussion of air filtration equipment has been written by Garry Thomson.[49]

In general the best way to control dust is to practice good housekeeping, to regularly vacuum-clean floors, and

February 1988

Bonnie Jo Cullison working in the master microfilm negative storage room of the Newberry Library. The relative humidity in this room is maintained at 35%, and the temperature at 60°F (15.6°C). Air in the bookstack building is filtered to remove dust, oxidizing gases, and other airborne pollutants.

to wipe the tops of tables and counters with a damp sponge and carefully dry them with paper towels before use with photographs. Food and smoking should be banned from storage and study areas. Windows leading to storage and display areas should be kept closed at all times; air conditioning usually reduces the amount of dust in the air.

## Minimizing the Danger of Fire in Photographic Collections

With irreplaceable collections of photographs that will be kept for hundreds or even thousands of years, the need to prevent fires, or to quickly detect and control them should they occur, cannot be overemphasized. Particularly valuable photographs, such as original camera negatives and preservation release prints from major motion pictures, should be duplicated and the two copies stored in separate geographic locations.

There have been a number of recent fires in major photographic collecting institutions. Most, such as the 1978 fire at the International Museum of Photography at George Eastman House, have been associated with improper stor-

age conditions for cellulose nitrate motion picture films. (For information on the properties and care of cellulose nitrate film, see **Appendix 19.1** at the end of Chapter 19.)

In 1982 there was a fire at the Design Conspiracy Color Lab in Oakland, California which destroyed color negatives and transparencies belonging to a number of well-known photographers, including Stephen Shore, Meridel Rubenstein, Judy Dater, and Richard Misrach. The fire apparently resulted from arson in an adjoining building.

In 1986 the central Los Angeles Public Library, a building that had been cited for fire-safety violations for nearly 20 years, had a major fire that burned out of control for more than 4 hours, injured 46 firefighters, and caused a loss of over $20 million in books alone. None of the photographs in the library's large photography collection were lost in the blaze itself, but the collection suffered extensive water damage.

Whenever possible, noncombustible materials should be used in building construction and in equipping storage and display areas. Smoking should be banned in all museum and archive buildings. Particular attention should be given to electrical wiring, lights, motors, and heating equipment

to make certain that they conform to applicable safety codes. Automatic Haylon-gas fire extinguishing systems offer very effective fire control in many types of storage situations. Water sprinkler systems should be avoided; despite their effectiveness in controlling fires, the water spray and resulting flooding may seriously damage or even destroy a photographic collection.

Most fire-resistant cabinets and safes have walls lined with materials that release water vapor when heated; the evaporation of moisture has a cooling effect which minimizes temperature increases inside the enclosure during a fire. However, the released water vapor increases internal relative humidity to the point where photographs may be seriously damaged.

It is beyond the scope of this chapter to thoroughly discuss fire prevention and control measures. The reader should consult applicable publications of the National Fire Protection Association, Inc.[50] Especially helpful are: *Protection of Museums and Museum Collections – 1980*, NFPA Publication No. 911; *Archives and Records Center – 1980*, NFPA Publication No. 232AM; *Protection of Library Collections – 1980*, NFPA Publication No. 910; and *Detecting Fires*, NFPA Publication No. SPP-28. Also recommended is G.W. Underdown's *Practical Fire Precautions*, 2nd edition.[51]

### Flood and Water Damage

An unfortunate consequence of a fire is damage caused by the water needed to extinguish the fire. The extensive water damage to the photography collection from the 1986 fire at the Los Angeles Public Library and the more than one million books that suffered water damage in the disastrous 1988 fire in the Soviet Union at the Academy of Sciences Library in Leningrad are examples of this.

Ideally, storage containers should be constructed and housed in such a way that water dripping from above will not enter them; metal or plastic motion picture cans sealed with tape and stored flat are an example. With still photographs, other than making certain that photographs are never stored in boxes directly on floors, there are few practical methods of protecting working collections from water damage should there be a major roof leak, burst water pipe, or flood. Efforts can be more profitably directed at preventing water from entering storage and display areas.

Valuable photographs should not be stored in buildings located in known or potential areas of flooding. The consequences to a photographic collection in a flooded museum have been graphically described in *The Corning Flood: Museum Under Water*.[52] An excellent review of procedures for handling water-soaked photographs has been written by Klaus B. Hendriks and Brian Lesser.[53]

A discussion of flood, earthquake, and other hazards related to museum location can be found in *Facing Geologic and Hydrologic Hazards: Earth-Science Considerations*.[54]

More common sources of water damage than natural floods are leaking roofs, burst water pipes, backed-up sewers in basements, etc. Pipes should not pass through storage areas, and the likely consequences of water leaks from nearby plumbing should be carefully assessed. In general, photographs should be stored neither in basements nor in attics or other rooms located just below the building roof. Basements are subject to flooding from backed-up sewers or water leaks during heavy rains. Even if roofs are very carefully maintained, nearly all of them will eventually develop leaks. If one considers all of the accidents, dripping pipes, and leaking roofs that have occurred in a building over the past 25 years, for example, and then contemplates what *might* be expected to happen during the next 500 or 1000 years, the dangers will become obvious. Unlike books, which are usually printed in large numbers of copies, most photographs are unique and cannot be replaced should they be damaged or destroyed.

Preservation librarian Bonnie Jo Cullison and staff member Patrick Morris examine a book in the bookstack building of the Newberry Library. The public is not permitted to enter the stack areas (specific books and manuscripts are brought out upon request). To minimize fading of book bindings and other light-induced damage, stack areas remain in darkness most of the time, with the overhead lights between the shelves turned on by the staff only when necessary. The building is maintained at 60°F (15.6°C) and 45% RH (± 3%).

## Building Design and Environmental Control at the Newberry Library in Chicago

Completed in 1982, the 10-story bookstack addition to the Newberry Library in Chicago, Illinois for housing books, maps, manuscripts, and microfilms is an outstanding example of a thoughtfully designed long-term storage facility. The windowless outer walls of the building, including the roof and basement, have a waterproof and fireproof double-shell construction. Each floor is self-contained and isolated from the others; access is by stairways located in two turrets connected to the building, and through a services building which connects the bookstack to the main library. Elevators, water pipes, and principal electrical power distribution wiring are contained in the services building, isolated from the bookstack building.

To eliminate the possibility of water damage resulting from broken pipes or faulty fixtures, there are no water pipes, bathrooms, or fire-suppression sprinklers anywhere in the bookstack building. Large numbers of ionization smoke detectors are located on each floor. The Special Collections Vault is equipped with a Haylon-gas combustion-suppression system. Smoking is not permitted in the building.

Operating and monitoring the temperature, relative humidity, security, and fire detection systems for each floor is a Johnson Controls JC-85-40 computer-controlled building-automation system :

> Electronic sensing devices located on each level of the bookstack building and in the Microtext Masters Storage Room [where microfilms are housed] signal Field Processing Units. These, in turn, report the temperature and RH to the Central Processing Unit (CPU) in the Building Control Systems Room. There, a CRT and printer make it possible to "call up" this information as well as the status of all the individual components of the heating, ventilating, and air-conditioning system at any time.
>
> At periodic intervals, a printout on the status of any of the field data points is run off. Presently the CPU produces a Trend Log for both temperature and RH, storing readings taken at two-hour intervals and printing them out in a specified format every 24 hours. . . .
>
> High- and low-level limits for all the temperature and RH calibration points have been programmed into the system. If these are exceeded, an alarm is activated at the CRT and, when the library is closed, on a pager worn by the security personnel on duty 24 hours a day. This alarm will sound until it has been acknowledged at the CRT, thus ensuring that the condition is responded to by a trained staff member. A print-out of the alarm condition is produced simultaneously.[55]

Under the guidance of Paul Banks, conservator at the library from 1964 until 1981, rigid specifications were established for temperature, relative humidity, and maximum air pollution levels. The temperature is maintained at 60°F (15.6°C) ± 5°F. The relative humidity is kept at 45% (± 3% on a daily basis, or ± 6% seasonally). Relative humidity in the microfilm storage room is 35% RH, in keeping with storage recommendations for silver-gelatin films. The building is equipped with a three-stage air-filtration system: ". . . an initial particle filter; a second-stage chemisorbent filter (Purafil, Inc.) of pelletized activated alumina impregnated with potassium permanganate, capable of absorbing, adsorbing, and chemically oxidizing gases; and a final, high-efficiency (90–95 percent) particle filter."

Writing about the new bookstack building, Bonnie Jo Cullison, preservation librarian at the library, said: "Being able to prolong the useful life of library materials by maintaining a stable environment is terrific; but the current environmental conditions are actually a compromise. If economic and user constraints could be eliminated, it would be ideal to literally freeze most of the library's materials — theoretically extending their lives indefinitely."[56]

## Notes and References

1. A Special Committee of the American Association of Museums, **America's Museums: The Belmont Report,** Report to the Federal Council on the Arts and the Humanities, October 1968, p. 57. The source of the quote was "a curator of wide experience" who was not identified by name. The quotation was included in a discussion of conservation and restoration in the "Unmet Needs" chapter of the report.

2. Jack Garner, "Buried 'Treasure' at Eastman – 300 Old Films Lie Buried and Decomposing In an Eastman House Garden," **Democrat and Chronicle,** Rochester, New York, August 9, 1984, p. 1. See also: "Originals of 329 Movies Burned – 'Boys Town', 'Strike Up the Band' Destroyed," **Times-Union,** Rochester, New York, May 30, 1978, p. 1.

3. American National Standards Institute, Inc., **ANSI IT9.11-1991, American National Standard for Imaging Media – Processed Safety Photographic Film – Storage,** American National Standards Institute, Inc., 11 West 42nd Street, New York, New York 10036; telephone: 212-264-4900; Fax: 212-302-1286.

4. James M. Reilly, Peter Z. Adelstein, and Douglas W. Nishimura, **Preservation of Safety Film – Final Report to the Office of Preservation, National Endowment for the Humanities** (Grant #PS-20159-88), March 28, 1991, pp. i–ii. Copies of the report are available from: Image Permanence Institute, Rochester Institute of Technology, Frank E. Gannett Memorial Building, P.O. Box 9887, Rochester, New York 14623-0887; telephone: 716-475-5199; Fax: 716-475-7230. See also: P. Z. Adelstein, J. M. Reilly, D. W. Nishimura, and C. J. Erbland, "Stability of Cellulose Ester Base Photographic Film: Laboratory Testing Procedures and Practical Storage Considerations" (Preprint No. 133–3), presentation at the **133rd SMPTE Technical Conference,** Los Angeles, California, October 26–29, 1991. A copy of the preprint may be ordered from the Society of Motion Picture and Television Engineers, Inc., 595 West Hartsdale Avenue, White Plains, New York 10607; telephone: 914-761-1100.

   For a comprehensive discussion of the deterioration of early cellulose acetate safety film see: David Horvath, **The Acetate Negative Survey: Final Report,** University of Louisville, 1987. Copies of the 91-page report may be obtained from the Photographic Archives, University of Louisville, Ekstrom Library, Louisville, Kentucky 40292; telephone: 502-588-6752.

5. Jacques Pouradier and Anne-Marie Mailliet, "Conservation des documents photographiques sur papier: influence du thiosulfate residuel et des conditions de stockage," **Science et industries photographiques,** Vol. 36, 2nd series, No. 2–3, February–March 1965, pp. 29–42.

6. C. S. McCamy, S. R. Wiley, and J. A. Speckman, "A Survey of Blemishes on Processed Microfilm," **Journal of Research of the National Bureau of Standards: A. Physics and Chemistry,** Vol. 73A, No. 1, January–February 1969, p. 83. See also: C. I. Pope, "Stability of Residual Thiosulfate in Processed Microfilm," **Journal of Research of the National Bureau of Standards,** Vol. 67C, No. 1, January–March 1963, pp. 15–24.

7. James M. Reilly and Douglas G. Severson, "Development and Evaluation of New Preservation Methods for 19th Century Photographic Prints," [Report to the National Historical Publications and Records Commission on NHPRC Grant #80-50], National Historical Publications and Records Commission, Washington, D.C., August 1980. See also: James M. Reilly, **Care and Identification of 19th-Century Photographic Prints,** Kodak Publication No. G-2S, Eastman Kodak Company, Rochester, New York, 1986, pp. 82–91; and also: James M. Reilly, Nora Kennedy, Donald Black, and Theodore Van Dam, "Image Structure and Deterioration in Albumen Prints," **Photographic Science and Engineering,** Vol. 28, No. 4, July–August 1984, pp. 166–171.

8. Peter Z. Adelstein, James M. Reilly, Douglas W. Nishimura, and Kaspars M. Cupriks, "Hydrogen Peroxide Test to Evaluate Redox Blemish Formation on Processed Microfilm," **Journal of Imaging Technology,** Vol. 17, No. 3, June–July 1991, pp. 91–98. See also: James M. Reilly, D. W. Nishimura, K. M. Cupriks, and P. Z. Adelstein, "Polysulfide Treatment for Microfilm," **Journal of Imaging Technology,** Vol. 17, No. 3, June–July 1991, pp. 99–107. See also: James M. Reilly, Douglas W. Nishimura, Kaspars M. Cupriks, and Peter Z. Adelstein, "Stability of Black-and-White Photographic Images, with Special Reference to Microfilm," **The Abbey Newsletter,** Vol. 12, No. 5, July 1988, pp. 83–88.

9. One source of an Assmann psychrometer is: Qualimetrics, Inc., 1165 National Drive, Sacramento, California 95834; telephone: 916-928-1000; toll-free: 800-824-5873. (Model 5230 [Celsius thermometers], and Model 5231 [Fahrenheit thermometers]: about $500).

10. Humi-Chek electronic hygrometers are available from Rosemont Analytical, Inc., 89 Commerce Road, Cedar Grove, New Jersey 07009; telephone: 201-239-6200; and from various retail outlets including Light Impressions Corporation, 439 Monroe Avenue, Rochester, New York 14607-3717; telephone: 716-271-8960 (toll-free outside of New York: 800-828-6216; toll-free inside New York: 800-828-9629). The Humi-Chek is supplied in several models, which vary in price from about $400 to about $900.

11. Hydrion Humidicator Paper (Cat. No. HJH-650; about $6.00 for enough paper for 200 tests) is supplied by Micro Essential Laboratory, Inc., 4224 Avenue H, Brooklyn, New York 11320; telephone: 718-338-3618. The paper is also available from a number of outlets including: (Catalog No. 2801) Light Impressions Corporation, 439 Monroe Avenue, Rochester, New York 14607-3717; telephone: 726-271-8960 (toll-free outside New York: 800-828-6216; toll-free inside New York: 800-828-9629).

12. Garry Thomson, **The Museum Environment**, 2nd edition, Butterworth & Co., Ltd., London, England and Boston, Massachusetts (in association with the International Institute for Conservation of Historic and Artistic Works), 1986, pp. 68–69.

13. Arnold Wexler and Saburo Hasegawa, "Relative Humidity-Temperature Relationships of Some Saturated Salt Solutions in the Temperature Range 0° to 50°C," **Journal of Research of the National Bureau of Standards,** Vol. 53, No. 1, July 1954, pp. 19–25.

14. R. W. Henn and I. A. Olivares, "Tropical Storage of Processed Negatives," **Photographic Science and Engineering,** Vol. 4, No. 4, July–August 1960, pp. 229–233.

15. Special air conditioners with provision for independent control of relative humidity are available from Sears Roebuck and Co., P.O. Box 1530, Downers Grove, Illinois 60515-5721 (telephone: 312-875-2500; toll-free: 800-366-3000) and at Sears retail and catalog stores. The Sears 1987 **Cooling Specialog** listed the following models (page 8): Catalog No. 42 BY 75148N – 13,800 Btu/hr model removes up to 138 pints of moisture per day in dehumidifier mode (96 pints in cooling mode), 110–120 volts; Catalog No. 42 BY 75188N – 18,000 Btu/hr removes up to 210 pints of moisture per day in dehumidifier mode (139 pints in cooling mode), 230–280 volts.

16. Heat Controller, Inc., 1900 Wellworth Avenue, Jackson, Michigan 49203; telephone: 517-787-2100 (Fax: 517-787-9341). The company will supply product literature on Comfort-Aire Twin Pac Remote Air Conditioning Systems and the names of dealers in your area.

17. Elias J. Amdur, "Humidity Control – Isolated Area Plan," **Museum News,** No. 6 (Technical Supplement), December 1964, pp. 53–57. See also: Richard D. Buck, "A Specification for Museum Airconditioning," **Museum News,** No. 6 (Technical Supplement), December 1964, pp. 58–60.

18. American Society of Heating, Refrigerating and Air Conditioning Engineers, **ASHRAE Guide and Data Books: Equipment, 1969; Systems, 1970; Applications, 1971.** See also: **ASHRAE Handbook of Fundamentals, 1972,** American Society of Heating, Refrigerating and Air Conditioning Engineers, New York, New York.

19. Grace Davison Silica Gel Air-Dryer, W. R. Grace and Company, Davison Chemical Division, P.O. Box 2117, Baltimore, Maryland 21203; telephone: 301-659-9000. The Air-Dryer units can be obtained from various suppliers including: Light Impressions Corporation, 439 Monroe Avenue, Rochester, New York 14607-3717; telephone: 716-271-8960 (toll-free outside New York: 800-828-6216; toll-free inside New York: 800-828-9629).

20. Garry Thomson, see Note No. 12, pp. 105–112.

21. Art-Sorb silica gel beads, Art-Sorb Sheets, and Art-Sorb Cassettes are distributed in the U.S. by Conservation Materials, Ltd., 1165 Marrietta Way, Box 2884, Sparks, Nevada 89431; telephone: 702-331-0582. The materials are manufactured by Fuji-Division Chemical Ltd., 5th Floor Higashi-Kan, Dia-ni Toyota Building 4-11-27 Meieki, Nakamura-ku, Nagoya-shi, Japan 450; telephone: 052-583-0451; Fax: 052-583-0455.

22. W. E. Lee, F. J. Drago, and A. T. Ram, "New Procedures for Processing and Storage of Kodak Spectroscopic Plates, Type IIIa-J," **Journal of Imaging Technology,** Vol. 10, No. 1, February 1984, p. 28.

23. Gore-Tex Silica Tiles are available from W. L. Gore & Associates, Inc., 3 Blue Ball Road, P.O. Box 1550, Elkton, Maryland 21921; telephone: 301-392-3700.

24. Cargocaire Engineering Corporation, 79 Monroe Street, P.O. Box 640, Amesbury, Massachusetts 01913; telephone: 508-388-0600. Many of the recently built low-temperature photographic storage facilities which incorporate Cargocaire desiccant dehumidification equipment have been constructed by Harris Environmental Systems, Inc., 11 Connector Road, Andover, Massachusetts 01810; telephone: 508-475-0104.

25. Institute of Environmental Sciences, HEPA Filters, IES Recommended Practice (Tentative) No. IES-RP-CC-001-83-T, November 1983. Institute of Environmental Sciences, 940 East Northwest Highway, Mount Prospect, Illinois 60056; telephone: 708-255-1561.

26. Douglas G. Severson, assistant conservator for photography, Art Institute of Chicago, telephone discussion with this author, October 21, 1988.

27. A suitable humidistat for control of evaporation humidifiers is the Honeywell H49A Humidifier Controller manufactured by Honeywell, Inc., Residential Division, 1985 Douglas Drive, Avenue North, Gordon Valley, Minnesota 55422; telephone: 612-542-7204 (humidifier controls). The humidistat can control more than one humidifier at the same time as long as the rated current capacity of the humidistat is not exceeded.

28. Carl J. Wessel, "Environmental Factors Affecting the Permanence of Library Materials," **Library Quarterly,** Vol. 40, No. 1, January 1970, p. 55.

29. S. Koboshi and M. Kurematsu [Konica Corporation], "A New Stabilization Process for Color Films and Prints Using Konica Super Stabilizer," **Second International Symposium: The Stability and Preservation of Photographic Images** (Printing of Transcript Summaries), Ottawa, Ontario, August 25–28, 1985, pp. 351–375. Available from: SPSE, The Society for Imaging Science and Technology, 7003 Kilworth Lane, Springfield, Virginia 22151; telephone: 703-642-9090.

30. Charleton C. Bard and David F. Kopperl, "Treating Insect and Microorganism Infestation of Photographic Collections," **Second International Symposium: The Stability and Preservation of Photographic Images** (Printing of Transcript Summaries), Ottawa, Ontario, August 25–28, 1985, pp. 313–334. Available from: SPSE, The Society for Imaging Science and Technology, 7003 Kilworth Lane, Springfield, Virginia 22151; telephone: 703-642-9090. See also: Eastman Kodak Company, **Prevention and Removal of Fungus on Prints and Films,** Kodak Customer Service Bulletin, Kodak Publication No. AE-22, August 1985; also: Eastman Kodak Company, **Notes on Tropical Photography,** 1970.

31. R. W. Henn and I. A. Olivares, see Note No. 14.

32. Charleton C. Bard and David F. Kopperl, see Note No. 30.

33. Eastman Kodak Company, **Conservation of Photographs** (George T. Eaton, editor), Kodak Publication No. F-40, Eastman Kodak Company, Rochester, New York, March 1985, p. 86. For additional information on the use of fungicides, insecticides, and fumigants with photographic materials manufactured by Eastman Kodak, contact: Eastman Kodak Company, Photo Information, Department 841, Rochester, New York 14650; telephone: 716-724-4000.

34. Charleton C. Bard and David F. Kopperl, see Note No. 30, p. 318.

35. Robert L. Roudabush, "Insect Damage to Color Film," **Photographic Applications in Science, Technology, and Medicine,** Vol. 10, No. 2, March 1975, pp. 28–33.

36. Carl J. Wessel, see Note No. 28.

37. Charleton C. Bard and David F. Kopperl, see Note No. 30, p. 319.

38. Robert F. McGiffin Jr., "A Current Status Report on Fumigation in Museums and Historical Agencies," **Technical Report 4,** Technical Information Service, American Association for State and Local History, 172 Second Avenue North, Suite 202, Nashville, Tennessee 37201 (telephone: 615-255-2971), 1985, p. 7.

39. Robert F. McGiffin Jr., see Note No. 38.

40. For further information on the safe application of sulfuryl fluoride and other fumigants, insecticides, and fungicides on photographic materials manufactured by Eastman Kodak, contact: Eastman Kodak Company, Photo Information, Department 841, Rochester, New York 14650; telephone: 716-724-4000.

41. Eastman Kodak Company, **Preservation of Photographs,** Publication No. F-30, Eastman Kodak Company, Rochester, New York, August 1979, p. 25. See also: Eastman Kodak Company, **Conservation of Photographs** (George T. Eaton, editor), Publication No. F-40, Eastman Kodak Company, Rochester, New York, March 1985.

42. Larry H. Feldman, "Discoloration of Black-and-White Photographic Prints," **Journal of Applied Photographic Engineering,** Vol. 7, No. 1, February 1981, pp. 1–9.

43. Garry Thomson, see Note No. 12, p. 151.

44. American National Standards Institute, Inc., **ANSI PH1.48-1987, American National Standard for Photography (Film and Slides) – Black-and-White Photographic Paper Prints – Practice for Storage,** p. 7. American National Standards Institute, Inc., 11 West 42nd Street, New York, New York 10036; telephone: 212-264-4900; Fax: 212-302-1286.

45. Robert G. Mathey, Thomas K. Faison, Samuel Silberstein, **et al., Air Quality Criteria for Storage of Paper-Based Archival Records,** U.S. National Bureau of Standards, (NBSIR 83-2795), 1983. Available from National Technical Information Service (NTIS), 5285 Port Royal Road, Springfield, Virginia 22161; telephone: 703-487-4660. See also: Alan Calmes, Ralph Schofer, and Keith R. Eberhardt, **National Archives and Records Service (NARS) Twenty Year Preservation Plan,** U.S. National Bureau of Standards, (NBSIR 85-2999), 1985. Also available from National Technical Information Service.

46. James M. Reilly, Douglas W. Nishimura, Kaspars M. Cupriks, and Peter Z. Adelstein, "Polysulfide Treatment for Microfilm," **Journal of Imaging Technology**, Vol. 17, No. 3, June–July, 1991, pp. 99–107. See also: James M. Reilly and Kaspars M. Cupriks, **Sulfiding Protection for Silver Images – Final Report to the Office of Preservation, National Endowment for the Humanities** (Grant #PS-20152-87), March 28, 1991. Copies of the report are available from: Image Permanence Institute, Rochester Institute of Technology, Frank E. Gannett Memorial Building, P.O. Box 9887, Rochester, New York 14623-0887; telephone: 716-475-5199; Fax: 716-475-7230.

47. Edith Weyde, "A Simple Test to Identify Gases Which Destroy Silver Images," **Photographic Science and Engineering,** Vol. 16, No. 4, July–August 1972, pp. 283–286.

48. Agfa-Gevaert colloidal silver test strips are available from the Image Permanence Institute, Rochester Institute of Technology, Frank E. Gannett Memorial Building, P.O. Box 9887, Rochester, New York 14623-0887; telephone: 716-475-5199; Fax: 716-475-7230.

49. Garry Thomson, see Note No. 12, pp. 130–158.

50. National Fire Protection Association, Inc., One Battery March Park, P.O. Box 9101, Quincy, Massachusetts 02269; telephone: 617-770-3000; toll-free: 800-344-3555.

51. G. W. Underdown, **Practical Fire Precautions,** 2nd edition, Gower Press, Teakfield, Limited, Westmead, Farnborough, Hants, England, 1979.

52. Corning Museum of Glass, **The Corning Flood: Museum Under Water,** Corning Museum of Glass, Corning Glass Center, Corning, New York, 1977.

53. Klaus B. Hendriks and Brian Lesser, "Disaster Preparedness and Recovery: Photographic Materials," **American Archivist,** Vol. 46, No. 1, Winter 1983, pp. 52–68.

54. W. W. Hays, ed., **Facing Geologic and Hydrologic Hazards: Earth-Science Considerations,** Geological Survey Professional Paper 1240-B, United States Government Printing Office, Washington, D.C., 1981.

55. Bonnie Jo Cullison, "The Ideal Preservation Building – At One Great Research Library, New Technologies Help House and Preserve the Heritage of Centuries," **American Libraries,** Vol. 15, No. 10, November 1984, p. 703.

56. Bonnie Jo Cullison, see Note No. 55.

## Additional References

Stanton I. Anderson and Robert L. Ellison, "Image Stability of Black-and-White Photographic Products," **Journal of Imaging Technology,** Vol. 16, No. 1, February 1990, pp. 27–32.

Stanton Anderson and Ronald Goetting, "Environmental Effects on the Image Stability of Photographic Products," **Journal of Imaging Technology,** Vol. 14, No. 4, August 1988, pp. 111–116.

Stanton I. Anderson and George W. Larson, "A Study of Environmental Conditions Associated with Customer Keeping of Photographic Prints,"

**Second International Symposium: The Stability and Preservation of Photographic Images** (Printing of Transcript Summaries), Ottawa, Ontario, August 25–28, 1985, pp. 251–282. Available from: IS&T, The Society for Imaging Science and Technology, 7003 Kilworth Lane, Springfield, Virginia 22151; telephone: 703-642-9090.

Bruce B. Bonner, Jr., "The Application of Environmental Control Technology to Archival Storage Requirements," presented at the **International Symposium: The Stability and Preservation of Photographic Images,** sponsored by the Society of Photographic Scientists and Engineers, Ottawa, Ontario, August 30, 1982.

George T. Eaton, "Photographic Image Oxidation in Processed Black-and-White Films, Plates, and Papers," **PhotographiConservation,** Vol. 7, No. 1, March 1985, p. 4.

Stephen Guglielmi, "Will the Gernsheim Collection End Up as 'Pulp'?", **Photographica,** Vol. 12, No. 8, October 1980, p. 9. See also: "Response by Roy Flukinger," and "Statement by Helmut Gernsheim," p. 10. See also: Michael Ennis, "In the Battle Between Helmut Gernsheim and UT No One Is Winning," **Texas Monthly,** July 1979, pp. 164–166.

Klaus B. Hendriks, together with Brian Thurgood, Joe Iraci, Brian Lesser, and Greg Hill of the National Archives of Canada staff, **Fundamentals of Photographic Conservation: A Study Guide,** published by Lugus Publications in cooperation with the National Archives of Canada and the Canada Communication Group, 1991. Available from Lugus Productions Ltd., 48 Falcon Street, Toronto, Ontario, Canada M4S 2P5; telephone: 416-322-5113; Fax: 416-484-9512.

Klaus B. Hendriks, **The Preservation and Restoration of Photographic Materials in Archives and Libraries: A RAMP Study with Guidelines** [PGI-84/WS/1], United Nations Educational, Scientific and Cultural Organization (UNESCO), Paris, France, 1984.

E. Verner Johnson and Joanne C. Horgan, **Museum Collection Storage,** Technical Handbooks for Museums and Monuments 2, United Nations Educational, Scientific and Cultural Organization (UNESCO), Paris, France, 1979.

Raymond H. Lafontaine, **Recommended Environmental Monitors for Museums, Archives and Art Galleries,** Technical Bulletin No. 3, Canadian Conservation Institute, Ottawa, Ontario, July 1970.

Raymond H. Lafontaine, **Environmental Norms for Canadian Museums, Art Galleries, and Archives,** Technical Bulletin No. 5, Canadian Conservation Institute, Ottawa, Ontario, November 1979.

K. J. Macleod, **Relative Humidity: Its Importance, Measurement, and Control in Museums,** Technical Bulletin No. 1, Canadian Conservation Institute, Ottawa, Ontario, May 1978.

Munters Cargocaire, **The Dehumidification Handbook – Second Edition,** 1990. Cargocaire Engineering Corporation, 79 Monroe Street, P.O. Box 640, Amesbury, Massachusetts 01913-0640; telephone: 508-388-0600 (toll-free: 800-843-5360); Fax: 508-388-4556.

John Morris and Irvin D. Nichols, **Managing the Library Fire Risk,** 2nd ed., University of California, Office of Risk Management, Berkeley, California, 1979.

Debbie Hess Norris, "The Proper Storage and Display of a Photographic Collection," **Picturescope,** Vol. 31, No. 1, Spring 1983, pp. 4–10.

Eugene Ostroff, "Preservation of Photographs," **The Photographic Journal,** Vol. 107, No. 10, October, 1967, pp. 309–314.

Eugene Ostroff, **Conserving and Restoring Photographic Collections,** American Association of Museums, Washington, D.C., 1976.

Tim Padfield, "The Control of Relative Humidity and Air Pollution in Show-Cases and Picture Frames," **Studies in Conservation,** Vol. 11, No. 1, February 1966, pp. 8–30.

Royal Ontario Museum, **In Search of the Black Box: A Report on the Proceedings of a Workshop on Micro-Climates Held at the Royal Ontario Museum, February 1978,** Royal Ontario Museum, Toronto, Ontario, 1979.

Nathan Stolow, **Procedures and Conservation Standards for Museum Collections in Transit and on Exhibition,** Technical Handbooks for Museums and Monuments 3, United Nations Educational, Scientific and Cultural Organization (UNESCO), Paris, France, 1981.

Alice Swan, "Conservation of Photographic Print Collections," **Conservation of Library Materials – Library Trends,** Vol. 30, No. 2, Fall 1981, pp. 267–296.

Kenzo Toishi, "Relative Humidity in a Closed Package," in **Recent Advances in Conservation: Contributions to the IIC Rome Conference, 1961,** edited by Garry Thomson, Butterworth & Co., Ltd., London, England, 1963, pp. 13–15.

United States Department of Agriculture, **Condensation Problems in Your House: Prevention and Solution,** Agriculture Information Bulletin No. 373, United States Government Printing Office, Washington, D.C., September 1974.

# Suppliers

## Air Purification Equipment for Museums and Archives

**Purafil, Inc.**
P.O. Box 1188
Norcross, Georgia 30091
 Telephone: 404-662-8545
 Toll-free: 800-222-6367

## Thermometers and Hygrometers: Non-Electronic Mechanical Devices

**Abbeon Cal, Inc.**
123 Gray Avenue
Santa Barbara, California 93101
 Telephone: 805-966-0810
 Toll-free: 800-922-0977

**Belfort Instrument Company**
727 South Wolfe Street
Baltimore, Maryland 21231
 Telephone: 301-342-2626

**Cole-Parmer Instrument Company**
7425 North Oak Park Avenue
Chicago, Illinois 60648
 Telephone: 312-647-7600
 Toll-free: 800-323-4340

**Conservation Materials, Ltd.**
1165 Marietta Way
Box 2884
Sparks, Nevada 89431
 Telephone: 702-331-0582

**Light Impressions Corporation**
439 Monroe Avenue
Rochester, New York 14607-3717
 Telephone: 716-271-8960
 Toll-free: 800-828-6216

**Qualimetrics, Inc.**
1165 National Drive
Sacramento, CA 95834
 Telephone: 916-928-1000
 Toll-free: 800-824-5873

**TCA Taylor Instruments**
280 Kane Creek Road
Fletcher, North Carolina 28732
 Telephone: 704-687-1684
 Toll-free: 800-438-6045

## Electronic Temperature and Relative-Humidity Measurement and Control Equipment

**Belfort Instrument Company**
727 South Wolfe Street
Baltimore, Maryland 21231
 Telephone: 301-342-2626

**E.G&G International, Inc.**
Moisture and Humidity Systems
217 Middlesex Turnpike
Burlington, Massachusetts 01803
 Telephone: 617-270-9100

**General Eastern Instruments Corporation**
20 Commerce Way
Woburn, Massachusetts 01801
 Telephone: 617-938-7070
 Toll-free: 800-225-3208

**Honeywell, Inc.**
Commercial Division
Honeywell Plaza
Minneapolis, Minnesota 55408
 Telephone: 612-870-5200

**Hygrometrix, Inc.**
7740 MacArthur Blvd.
Oakland, California 94605
 Telephone: 415-639-7800

**Johnson Controls, Inc.**
507 East Michigan Street
Milwaukee, Wisconsin 53201
 Telephone: 414-274-4000

**Panametrics, Inc.**
221 Crescent Street
Waltham, Massachusetts 02154
 Telephone: 617-899-2719
 Toll-free: 800-833-9438

**PRG (Preservation Resource Group)**
P.O. Box 1768
Rockville, Maryland 20849-1768
 Telephone: 301-309-2222

**Qualimetrics, Inc.**
1165 National Drive
Sacramento, CA 95834
 Telephone: 916-928-1000
 Toll-free: 800-824-5873

**Rosemont Analytical, Inc.**
89 Commerce Road
Cedar Grove, New Jersey 07009
 Telephone: 201-239-6200

# 17. Display and Illumination of Color and B&W Prints

## The Alarming Light-Induced Image Discoloration and Base Cracking of B&W RC Prints on Long-Term Display

Those serving the needs of collections being heavily used for exhibition face a serious dilemma. On one hand, they are chronicling, aiding and abetting in the systematic destruction of the photographs they are charged to protect by supporting reprehensible exhibition practices. On the other hand, they largely owe their existence to those very exhibition programs.

. . . The current exhibition vogue amounts to a systematic program of accelerating the degradation of our most valued and important photographs. The practice can and must be changed. No doubt there will be many who will claim that such an assessment is too extreme and that the problem is being exaggerated. They will say that we do not have enough information to change our ways. I would say we do not have enough information to maintain them.[1]

> Grant B. Romer, Conservator
> International Museum of Photography
> at George Eastman House
> Rochester, New York – September 1986

## Introduction

Photographs are displayed for many different reasons and in an extremely wide range of lighting conditions — see **Table 17.1**. Whereas modern fiber-base black-and-white prints that have been correctly processed and treated with a protective toner are extremely stable and may be expected to have a very long life under typical conditions of display,[2] the same cannot be said for most kinds of color prints, or for black-and-white prints made on RC (polyethylene-resin-coated) papers.

With the singular exception of color pigment prints made with the new UltraStable Permanent Color process and the Polaroid Permanent-Color process,[3] exposure of color photographs to light during display will cause slow but inexorable fading and staining of the image; visible light and ultraviolet (UV) radiation may also cause cracking and other physical deterioration of the print emulsion and support material. This does not mean that color prints cannot or should not be displayed, but if such photographs are to be preserved for long periods of time, the stability characteristics (including fading rate) of the color print material must be understood. The planned total time of display must be determined with consideration for the intensity and spectral composition of the illumination source as well

---

**See page 577 for Recommendations**

---

as for how much image fading and staining can be tolerated. As discussed in Chapter 7, valuable color prints should be monitored with a densitometer, and visually significant changes in color balance, overall density, and minimum density stain levels should not be permitted to take place.

Display of color prints is inherently detrimental to them, but avoiding display runs counter to the reasons most photographs are made and frequently conflicts with the purposes for which most individuals and museums collect prints.

### The Expendable or Replaceable Color Print

If a color print has no lasting value — or if it can be replaced with a new print after the original has deteriorated — it can be displayed without much caution. Although they may be expensive to replace, decorative prints and murals of the types found in many corporate offices and in public places such as hotel lobbies, restaurants, and airports are usually expendable. Museums, however, do not generally consider their prints to be expendable, even if a faded print could be replaced during a photographer's lifetime.

In some instances it might be possible to obtain replacement color prints for faded baby pictures, high school portraits, wedding photographs, and family portraits from the photographer who took them. Many professional photographers, however, keep negatives for only a relatively short time — often only for as long as experience indicates that reorders might come in. Most of the low-cost "mass-market" portrait operations — such as those that travel from department store to department store, taking photographs only a few days at each location — dispose of their color negatives almost immediately after the selection of prints is made; the cost of filing and storing negatives is prohibitive for these low-overhead, high-volume businesses.

Even if a photographer does keep color negatives, the negatives may be too faded to make satisfactory prints after years have passed. This is especially true if the photographs were made on earlier, low-stability films such as Kodak Kodacolor II, Vericolor II, and Process E-1, E-2, and E-3 Ektachrome films.

### Display of Nonreplaceable Color Prints

When it is desired to keep a color print in good condition for as long as possible, there are limitations on how long the print can be exposed to light on display. Guidelines for the display times of current and many older color print materials are given in Chapter 3. As a general rule, it may be assumed that under typical moderate display conditions, the light fading rate of a given type of color print is approximately proportional to the light intensity on the print. For example, a print displayed for 12 hours a day in

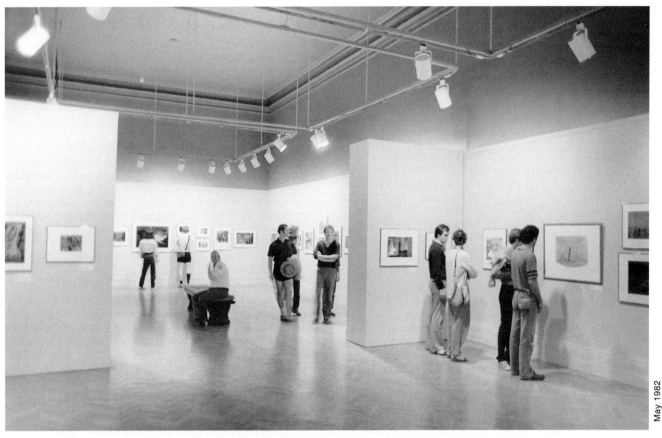

The 1982 exhibition **Color as Form: A History of Color Photography** at the Corcoran Gallery of Art in Washington, D.C. The display area was illuminated with incandescent tungsten lamps with an average intensity of about 170 lux. The first major survey of color photography as an art form, this show was curated by John Upton for the International Museum of Photography at George Eastman House in Rochester, New York. The exhibition opened at the Corcoran for 3 months and was later shown at George Eastman House. With vintage prints made by a wide variety of color processes — most with unknown stability characteristics — this was the first photography exhibition to be densitometrically monitored for image fading and staining.

1,000 lux of light will fade at about twice the rate of a print displayed the same amount of time in 500 lux. Because the human eye has a great ability to adapt to different light intensities, a person is often not aware of the great range of light intensities that usually exist in a room, or in different parts of a building. In museum display of original color photographs, densitometric limits of tolerable color fading should be established and a monitoring program instituted to make certain that prints are not permitted to fade or stain beyond those limits (see Chapter 7).

Some museums have guidelines for exhibition of color and black-and-white photographs which apply to works both in the museum and out on loan. The Museum of Fine Arts in Boston permits a maximum display time of 3 months every 2 or 3 years; if a print has been exhibited in the previous year, the museum will not send it out on loan. The Metropolitan Museum of Art in New York City has a policy of displaying color photographs no more than 3 or 4 months every 5 to 10 years. In the past, the International Museum of Photography at George Eastman House kept a number of its better-known photographs on permanent display; some of the museum's traveling exhibitions were out on loan to a succession of institutions for years at a time. More recently, the museum has been periodically

replacing most of the photographs in its regular exhibition areas with other photographs from the collection so that no print is on constant display.

When purchasing a color print, it may be possible to obtain a duplicate copy at low cost; one print can be displayed with the realization that it will fade over time, while the other can be kept in the dark for preservation purposes. When the displayed print has faded to the point where it is no longer acceptable, a copy print for display can be made from the stored print; the one remaining original print should continue to be kept in the dark under the most favorable conditions possible. For persons making their own color prints, it is a simple matter to produce one or two extra prints for display purposes. In recent years the Art Institute of Chicago has attempted to obtain duplicate prints of the color photographs acquired for its collection so that one print can be used for exhibition and study purposes and the other kept in the dark in the museum's humidity-controlled cold storage facility. The Museum of Modern Art in New York City also attempts to obtain two copies of each of its chromogenic color print acquisitions; one copy is kept in permanent storage in a frost-free refrigerator, and the other is withdrawn from the refrigerator when needed for study or exhibition purposes.

*(continued on page 578)*

# Recommendations

## Display of Color Prints

* **Nonreplaceable color prints.** Unfortunately, with the exception of UltraStable Permanent Color and Polaroid Permanent-Color pigment prints, almost all other types of color photographs exposed to light on display slowly fade over time and will eventually become severely degraded. Valuable or nonreplaceable color prints should never be subjected to prolonged display. The light fading stability of different types of color prints varies over a wide range, with some color prints lasting far longer than others under the same display conditions (see Chapter 3). Only **expendable** color prints having no lasting value, or those for which duplicates are being kept in dark storage, or those for which it is certain that replacement prints can be made in the future, should be subjected to prolonged or "permanent" display.

## Illumination Levels

* **For museums, galleries, and archives.** Approximately 300 lux of incandescent tungsten or glass-filtered quartz halogen illumination is recommended. This author believes that light levels below 300 lux are insufficient for proper visual appreciation of photographs, particularly color photographs. Prints should be displayed with adequate illumination. There is no "minimum" illumination level at which color print fading does not occur. Accumulated display time must be limited to prevent excessive fading. Modern black-and-white fiber-base prints may be displayed at significantly higher illumination levels (e.g., 600 lux or higher) as long as the surface temperature of the prints in black (d-max) areas does not increase more than a few degrees. Heating of prints reduces emulsion and base moisture content, which may in turn cause increased curl and/or eventual cracking, especially in RC prints.

* **For home and commercial applications.** Approximately 450 lux of incandescent tungsten, glass-filtered quartz halogen, or glass-filtered fluorescent illumination is recommended. In many commercial display situations, bright ambient lighting conditions will require significantly higher illumination levels to show photographs to their best advantage.

* **Museums and photographers should adopt a standard illumination level.** A photograph on display should accurately convey the subtleties envisioned by the photographer. To accomplish this, it is essential that the print be evaluated for density and color balance in the darkroom under the same intensity and type of illumination with which it will be displayed in a gallery or museum. It is proposed that galleries, museums, and archives formally adopt the above-recommended 300 lux of incandescent tungsten or glass-filtered quartz halogen illumination against a light, neutral background and that photographers be encouraged to use this illumination condition for evaluating prints.

* **Museums and archives should monitor prints.** Densities at selected image locations on color and black-and-white prints should be measured periodically with an accurate electronic densitometer, and predetermined limits of fading and staining should not be exceeded (see Chapter 7). It is recommended that salted paper prints (ca. 1840–1855) and albumen prints (ca. 1850–1895) never be displayed — not even for short periods.

## Glass and UV-Absorbing Framing Materials

* **UV filters do little to protect most color prints.** With Ektacolor, Fujicolor, Konica Color, Agfacolor, and most other current color print materials displayed in typical indoor conditions, image fading is caused primarily by **visible** light, not by ultraviolet radiation. Ultraviolet filters such as Plexiglas UF-3 do little if anything to increase the life of these color materials, largely because they are manufactured with an effective UV-absorbing emulsion overcoat. One exception is Ilford Ilfochrome print materials (called Cibachrome 1963–1991), which are manufactured without a UV-absorbing overcoat. When Ilfochrome prints are displayed under direct or indirect daylight, framing with a UV filter markedly increases their stability. The improvement is much less for prints illuminated with fluorescent or tungsten light (see Chapter 3).

* **Glass is recommended over Plexiglas and other plastics for most framing applications.** Glass is inexpensive, easy to cut, chemically inert, and resistant to scratches; however, it should not be used for traveling exhibitions or for very large prints where breakage could occur. For these applications, standard clear Plexiglas G is recommended. Displaying prints framed with glass or Plexiglas G adjacent to prints framed with Plexiglas UF-3 can be visually distracting. The light-yellow tint of UF-3 gives white mount boards and low-density areas of photographs a distinctly yellowish, or warm, appearance; prints framed with glass look distinctly different. Furthermore, UF-3 suppresses the effects of fluorescent brighteners that are incorporated in virtually all current black-and-white papers; this has the effect of subtly dulling the appearance of the prints. Even with incandescent tungsten illumination, which has very low UV content, the dulling effect of UF-3 is noticeable.

## Black-and-White RC and Fiber-Base Prints

* **Double-weight, fiber-base papers are strongly recommended.** Current information indicates that fiber-base prints are, overall, substantially more stable than RC prints, especially when displayed for prolonged periods. Fiber-base prints also appear to be less susceptible than RC prints to image discoloration caused by surface contaminants, poor-quality storage materials, and/or commonly encountered levels of air pollutants. Many RC prints made with developer-incorporated papers (e.g., the now-obsolete Ilford Multigrade II RC paper) have, after only a few years of storage, developed serious brownish stain within the paper base itself. RC papers should not be used for historically important photographs, fine art prints, or portraits. Fiber-base prints intended for long-term display or storage should be treated with an image-protective toner (see text). This author considers treatment with a protective toner to be an **essential** part of "archival" processing. Virtually all modern black-and-white papers are made with fluorescent brighteners, which gradually lose activity ("fade") when displayed. Thus, although the image and base of an "archivally" processed fiber-base print are extremely stable, the loss of brightener effect will cause the whites and highlights of the print to lose some of their original brilliance.

* **Display of black-and-white RC prints.** Valuable black-and-white RC prints should never be displayed. Especially when framed under glass or plastic and displayed for prolonged periods, even at low light levels with UV-filtered illumination, black-and-white RC prints may be subject to light-induced oxidation of the silver image, resulting in ugly yellowish or orange-red image discolorations. Black-and-white RC prints are also subject to base and/or emulsion cracking as a result of display.

* **Kodak B&W RC papers are recommended.** If it is decided to use an RC paper, then Kodak Polymax RC Paper and Polyprint RC Paper, both conventional-emulsion (non-developer-incorporated) papers, currently are recommended. There are **substantial** differences in image and base stability of black-and-white RC papers. At the time of this writing, Kodak was the only manufacturer that had published meaningful accelerated aging projections for its RC papers with respect to base cracking, and Kodak also has described the stability benefits afforded by its "stabilizer in the paper core" technology. Until meaningful comparative accelerated aging data are available on the base and image stability characteristics of the RC papers supplied by other manufacturers, Kodak RC papers will continue to be recommended. It is recognized, however, that with the most common methods of drying RC prints, the image and surface quality of most RC papers, including Kodak, may prove visually unacceptable because of "veiling" of the blacks (see below). Should this be the case, Oriental New Seagull Select VC-RP, a variable-contrast paper, and Oriental New Seagull RP, a graded paper, both of which give good results even when dried at room temperature, are probably the only satisfactory alternatives.

* **Ilford RC print processors and dryers are recommended.** The depth of the blacks, the print surface gloss, and the overall visual image quality of Kodak and most other black-and-white RC papers are significantly degraded when the prints are dried at room temperature or dried with conventional hot-air RC print dryers, such as the dryer in the Kodak Royalprint processor (discontinued in 1991). For best results, RC prints should be dried with one of the Ilford infrared print dryers. The stand-alone Ilford 1250 dryer and the dryers incorporated in the Ilford 2240 and 2150 RC print processors all provide excellent results. Also satisfactory is the Kodak Polymax IR processor; introduced in 1991, this is the first Kodak processor to be equipped with an infrared dryer. Unlike the case with RC prints, the images on fiber-base papers are not noticeably affected by the method of drying; fiber-base prints can be dried emulsion-side down on clean, plastic-coated fiberglass screens at room temperature with outstanding results.

* **Valuable RC prints should be treated with an image-protective toner.** Especially if they are to be displayed, valuable black-and-white RC prints should be treated with Kodak Poly-Toner or Kodak Rapid Selenium Toner to help protect the silver image against the peculiar types of discoloration (oxidation) to which RC prints are susceptible. Toner treatment will not, however, increase the resistance of RC papers to cracking.

Instant color photographs, none of which have usable negatives for making new prints, are in most cases not replaceable. In addition, all current Polaroid and Fuji instant color prints have relatively poor light fading stability; valuable instant prints should be displayed for short periods only.

## Display of Black-and-White RC Prints: Caution Is Necessary

Black-and-white RC (polyethylene-resin-coated) papers first became generally available in the United States with the introduction of Kodak Polycontrast Rapid RC Paper in October 1972.[4] RC papers made by Ilford (Ilfospeed and Ilford Multigrade papers), Agfa-Gevaert (Brovira PE Paper, later called Brovira-Speed Paper), and other manufacturers worldwide soon followed. RC papers now constitute the great majority of all black-and-white photographic papers produced. Use of fiber-base papers increasingly is limited to fine art photographers, advanced darkroom hobbyists, and top-quality advertising and commercial photographers (advertising photographers prefer the superior retouching and knife-etching capabilities of fiber-base papers).

Whether because of an appreciation of the superior surface and image qualities afforded by the best fiber-base papers, or perhaps because of a reluctance to adopt an unproven material, fine art photographers in the U.S. and most other countries have — fortunately — thus far almost completely avoided black-and-white RC papers in making prints for exhibition or sale.

RC paper is made by hot-extruding a thin layer of polyethylene on both sides of a fiber-base paper core; clear polyethylene is coated on the back of the print (often the paper core is first printed with the manufacturer's name in light gray ink) and polyethylene pigmented with white titanium dioxide ($TiO_2$) is coated on the emulsion side; the high-reflectance pigmented layer serves the same general function as the baryta layer (composed of barium sulfate suspended in gelatin) in fiber-base prints. The emulsion is coated on top of the pigmented polyethylene layer, leaving the emulsion accessible to developer and other processing solutions.

Because the polyethylene layers render the paper support essentially waterproof, very fast processing, washing, and drying of RC prints are possible. With an automatic processing machine, an RC print can be developed, fixed, washed, *and dried* in as little as 55 seconds; manual processing, including washing in trays and drying with an electric hair dryer, typically takes 8 or 10 minutes. To correctly process, wash, and dry double-weight fiber-base prints, on the other hand, requires a minimum of about an hour. When processing fiber-base prints for maximum permanence, with air-drying on plastic-coated fiberglass screens at room temperature — what is often called "archival processing" — the total time can extend to as long as 12 hours. Speed of processing is the primary appeal of RC papers and is the principal reason they were invented. And unlike fiber-base prints, RC papers have little tendency to curl, even in environments with low or fluctuating humidity .

RC papers should not be confused with print materials coated on ICI Melinex 990, a high gloss, opaque white poly-

ester sheet manufactured by Imperial Chemical Industries (through a complex manufacturing process which forms billions of microscopic "voids" of high refractive index within the polyester structure of Melinex 990, a bright white material is produced without the need for an added pigment such as titanium dioxide). Among current products coated on Melinex 990 (or other closely related high gloss, opaque white polyester support) are Ilford Ilfochrome glossy print materials (semi-gloss Ilfochrome is an RC paper), and special-purpose products such as Fujiflex SFA3 Super-Gloss Printing Material, Fujichrome Printing Material, Kodak Duraflex RA Print Material, Konica Color QA Super Glossy Print Material Type A3, and Agfachrome 410 high gloss polyester color print material for transparencies.

UltraStable Permanent Color prints and Polaroid Permanent-Color prints are also made on an opaque white polyester support; the surface gloss of these prints can vary from a semi-gloss to a fairly high gloss, depending on the formulation of the gelatin used to overcoat the image layers after they have been affixed to the polyester support.

Solid polyester supports are more expensive — but tougher and far more stable during aging — than RC paper supports. Prints made on Melinex 990 have a mirror-like gloss that is much smoother and glossier than the highest gloss surface that can be produced on an RC paper. One drawback of Melinex 990, however, is that it cannot readily be manufactured with other than a high gloss surface. A semi-gloss surface similar to the popular Kodak N surface is not available and this, along with the higher cost of polyester materials, has restricted their use in portrait, wedding, fine art, and most other areas of photography where photographers generally prefer semi-gloss or matte surface papers.

With the exception of a few special-purpose products, black-and-white papers are not presently supplied on polyester supports. This is unfortunate, because if such a print material were properly manufactured, it would avoid most of the stability problems associated with black-and-white RC papers (it would, however, also be more expensive).

Before the invention of RC paper base in the 1960's — and before opaque white polyester supports became available around 1980 — waterproof print supports were made with white-pigmented cellulose acetate (in its transparent form, the same material is used for film base). Beginning in the early 1940's, Kodak Minicolor and Kotavachrome prints (processed by Kodak using the Kodachrome system) were coated on pigmented acetate supports, as was Ansco Printon, a reversal color material for printing slides produced by Ansco from 1943 until 1973. From 1963 until around 1980, Cibachrome print materials were coated on a pigmented cellulose triacetate support. With the introduction of Ilford Cibachrome II materials, the support material was changed to Melinex 990 (in 1991, Ilford changed the name of all Cibachrome materials to Ilfochrome — Cibachrome II became Ilfochrome Classic). Because of processing considerations, all of these color materials required a nonabsorbent support; had this not been the case, a less costly fiber-base support could have been used.

Pigmented cellulose triacetate is a far more stable material than the RC base papers of the 1970's — but it is also more expensive. Kodak had long searched for a low-cost, waterproof substitute for pigmented cellulose triacetate. Kodak wanted a material that cost little more than single-weight fiber-base paper, and after considerable experimentation, the company found it in polyethylene-coated paper. An important reason that polyethylene was chosen for this application is that it is the least expensive of all plastics — which is why it is also the material of choice for garbage bags, plastic milk bottles, and many other inexpensive disposable consumer items.

## Deterioration of Displayed RC Prints

Many framed black-and-white prints made on Kodak Polycontrast Rapid RC Paper and Ilford Ilfospeed [RC] Paper manufactured in the 1970's and early 1980's have, during the course of only a few years of display under normal conditions, suffered catastrophic, irregular gold-like, orange-red, or yellow image discolorations (sometimes called "bronzing") and have developed localized "silver mirror" deposits on the emulsion surface in high-density areas of the image. Sometimes these discolorations are accompanied by large numbers of small, bright orange-red spots, identical in structure to the microspots (also known as "redox blemishes" or "microscopic blemishes") that in the past have been found principally on stored microfilms and astronomical plates. Microspots are also occasionally encountered on conventional camera and motion picture films, glass-plate negatives, and glass lantern slides. But, to the best of this author's knowledge, microspots of this type have *never* been found on fiber-base prints.

The Corcoran Gallery of Art in Washington, D.C., the Art Institute of Chicago, and the National Archives of Canada in Ottawa are among the well-known institutions that have deteriorated black-and-white RC prints in their collections. These prints became severely discolored after only a few years of display and storage; with the passage of time, it is inevitable that huge numbers of RC prints worldwide will be similarly affected.

Judging from the speed at which the images of framed and displayed Polycontrast Rapid RC prints from the 1970's and Polycontrast Rapid II RC prints from the early 1980's can become severely discolored, these papers could certainly be ranked as some of the most inherently unstable black-and-white photographic materials ever to be marketed since the introduction of the first silver-gelatin developing-out papers in the late 1800's. The deterioration of the Kodak RC prints has occurred despite careful processing and washing.

The discolorations which this author has observed in Kodak Polycontrast Rapid RC prints generally are concentrated along density gradients where light and dark portions of the image meet; Polycontrast Rapid RC prints sometimes also have large numbers of orange-red microspots. Deteriorated Ilford RC prints, on the other hand, usually have had a more uniform, overall brownish-yellow image discoloration.

Both Kodak and Ilford RC papers can suffer from microspot formation and surface mirroring; with some prints, the mirroring has become quite extreme. Although all of the deteriorated Kodak RC prints which this author has been able to positively identify were made on Polycontrast Rapid RC Paper and Polycontrast Rapid II RC Paper, it is assumed that Kodabrome RC and other Kodak black-and-white RC papers from the period can be similarly affected.

1981

Fern Bleckner, at the time a conservator at the Corcoran Gallery of Art in Washington, D.C., and Joe Cameron, a photographer and teacher at the Corcoran, examine discolored black-and-white RC prints that had been made on Polycontrast Rapid RC Paper in the mid-1970's. Although the prints had been displayed for only 2 months, they had nevertheless developed serious image discoloration by the time this photograph was taken in 1981. It is not known whether the damage was caused by exposure to light or by air pollutants (or a combination of both). At the time, the Corcoran was not air conditioned, and during warm months windows in the photograph storage area, which is near to a busy Washington street, were open much of the time. Pollutants from automobile exhaust might have been a significant factor in the rapid deterioration that occurred in these unstable prints.

Some Kodak Polycontrast Rapid RC prints also have suffered from severe cracking of the polyethylene-coated support material (cracking has also occurred in many displayed Kodak Ektacolor RC prints from the late 1960's and early 1970's). As discussed below, cracking of the RC support is facilitated by a combination of exposure to light and storage or display in an environment in which the relative humidity fluctuates over a wide range. With the passage of time, it is expected that increasing numbers of these prints will develop cracks. To date, however, image discoloration appears to be a much more serious problem than support cracking in black-and-white RC prints.

Ilford Ilfospeed RC paper was not particularly popular in the U.S. in the 1970's, and this author has encountered only a relatively small number of Ilfospeed RC prints that have been displayed for significant periods (complicating the matter is the fact that Ilford did not imprint the back of the paper with the company's name, so it is often impossible to tell whether a particular print is in fact an Ilford product). This author has not yet encountered a verified Ilfospeed RC print which has developed cracks; however, cracking of Ilford RC prints from this era has been reported in the literature.[5]

## Light-Induced Oxidation and Subsequent Cracking of the Image-Side Polyethylene Layer

Polyethylene plastic has long been recognized as having poor stability when subjected to prolonged exposure to light or ultraviolet radiation. According to a 1974 patent issued to Eastman Kodak for improvements in the formulation of its RC papers:

In the use of such resin coated papers many problems occur, not the least of which relates to the relatively low stability of the resins and, especially polyolefins [polyethylenes], used to coat the paper to achieve the desired wet strength, etc. Such resins [polyethylenes] typically deteriorate quite rapidly due to the action of, for example, ultraviolet light or the oxidative action of photographic printing and developing chemicals. . . . It has therefore become of prime importance that such resinous layers be suitably stabilized against such hazards if they are to be useful in photographic papers.[6]

This small print, made on Kodak Polycontrast Rapid RC Paper from the early 1970's, has developed severe RC base cracks. The print was exhibited for about 5 years in a glass-enclosed display cabinet in the Grinnell College Physics Museum in Grinnell, Iowa. The cabinet was illuminated with bare-bulb Cool White fluorescent lamps. (Print courtesy of Grant Gale, physics professor and curator of the Physics Museum)

A magnified view of the RC base cracking. The fluorescent lamps elevated the temperature inside the cabinet, thus lowering the relative humidity. When the lamps were turned off at night, the humidity returned to the ambient level, and this daily humidity cycling, in combination with the degrading effects of light and UV radiation on the unstable RC base, eventually produced the cracking seen here.

The light-induced deterioration of polyethylene can be greatly accelerated by the presence of white titanium dioxide pigment, incorporated in the top polyethylene layer of RC prints. Titanium dioxide is a photochemically active substance and when exposed to light it can generate an active form of oxygen, which in turn can attack adjacent polyethylene. Although both ultraviolet radiation and visible light can trigger these reactions, study of the display conditions of large numbers of deteriorated RC prints suggests that visible light is, in most cases, the primary cause of the deterioration. In typical indoor display conditions, a Plexiglas UF-3 or other UV filter will probably do little to improve the long-term stability of a black-and-white RC print.

Oxidation of the polyethylene results in gradually increasing brittleness of the plastic and, in conjunction with the physical stresses produced by normal fluctuations in relative humidity (e.g., between 30 and 60%)[7], will eventually cause cracks to form in the image-side polyethylene layer and print emulsion.

Light-induced deterioration of polyethylene and accelerated test methods used by Eastman Kodak to evaluate the cracking tendency of its RC papers have been reviewed in an important 1979 article by Parsons, Gray, and Crawford.[8] The addition of antioxidants and stabilizers to the structure of Kodak RC papers, the change to a less reactive form of titanium dioxide in the emulsion-side RC layer, and other improvements in Kodak RC papers were also described (the article restricted its discussion to the problem of RC print cracking and did not deal with silver-image discoloration of displayed RC prints).

## Light-Induced Destruction of the Silver Images of RC Prints

The peroxides and other oxidants generated in the titanium dioxide pigmented polyethylene layer during long-term exposure to light and UV radiation — in association with by-products of polyethylene degradation (certain emulsion ingredients or other components of the RC paper structure may also be involved) — can progressively attack (oxidize) the adjacent silver image. The eventual result can be severe image discoloration and the formation of "silver mirrors" on the emulsion surface. This apparently is the mechanism responsible for the rapid image deterioration that has been observed in many framed and displayed prints made on early Kodak and Ilford black-and-white RC papers. Unframed prints exposed to light can also be affected. The relative humidity of the display and storage environment appears to be an important variable in these reactions, with high relative humidity substantially increasing the rate of image discoloration. High temperatures undoubtedly also accelerate the rate of deterioration.

Internally generated peroxides and/or by-products of polyethylene degradation may also be implicated in the increased rates of fading that this author has observed in certain types of Ektacolor, Fujicolor, Agfacolor, and 3M color papers when they are framed under glass or plastic on long-term display. With color prints, it is of course a dye image, rather than a silver image, that is affected (see Chapter 2 for discussion of RC-base-associated fading of color prints).

The sensitivity of silver photographic images to even very low levels of peroxides and other oxidants, especially in humid environments, is well established, and logic would suggest that an oxidant level sufficient to degrade and embrittle polyethylene should also be capable of oxidizing the delicate filamentary silver grains which make up the image.

The chemical processes involved in the oxidation and subsequent reduction of the silver image, resulting in the formation of yellow-orange colloidal silver and "silver mirrors," are also generally understood and have been discussed at length in the literature. As described by Larry Feldman of Eastman Kodak,[9] the silver grains forming the image are oxidized by peroxides or some other oxidizing substance to form silver ions. Particularly when the emul-

sion has a high moisture content, the silver ions can physically migrate a short distance from the site of the original silver grains. Through the action of light, or in the presence of various atmospheric contaminants, the silver ions are then reduced to tiny particles of metallic colloidal silver, or converted to silver sulfide (silver sulfide can be formed by reaction with, for example, hydrogen sulfide, a common air pollutant). According to Feldman, "Since these minute particles refract light, groupings of these particles have a characteristic yellow, orange, or red appearance. When concentrated near the [emulsion] surface, the metallic silver or silver sulfide particles can reflect light as a silver mirror."

Changes have been made in the structure of the silver grains in print emulsions in recent years in order to reduce the amount of silver required to produce an adequate black (thus increasing the "covering power" of the silver), and thereby reduce the manufacturers' costs. These changes may also be implicated in the increased susceptibility of some black-and-white RC papers to image discoloration.

## Displayed Black-and-White RC Prints Can Self-Destruct

We have here a very alarming situation — with their built-in ability to generate oxidants during the course of normal display, black-and-white RC prints contain a potentially powerful source of their own destruction. With both the silver image and support material being attacked, this constitutes an entirely new type of photographic deterioration. Although unframed RC prints on display are also subject to light-induced image discoloration, framing an RC print under glass or plastic exacerbates the problem, apparently by preventing the diffusion of oxidants and volatile degradation products into the atmosphere, and away from the silver image. With everything trapped inside the frame, and with the print emulsion sandwiched between the RC support and framing glass, the print is left to "stew in its own juices." (See pages 600–601 for reproductions of RC prints that suffer from light-induced image discoloration.)

Over the years Kodak has carefully avoided discussion of this mode of RC image deterioration, and this author is aware of only one reference — a vague one at that — in Kodak literature to this phenomenon. In the April 1978 revision of *Kodak B/W Photographic Papers*, Kodak Publication No. G-1, it is stated:

> In addition to protecting the paper base from absorption of processing chemicals (thus permitting easier working), the resin [polyethylene] layers restrict the flow of gases. When prints are stored or displayed in a confined atmosphere (such as being framed under glass), any oxidants present may react with the silver grains and result in image discolorations. Such oxidants might result from the environment, residual processing chemicals, adhesives used in frame construction, cleaning agents, or *base degradation* [italics added]. . . .[10]

Although Kodak placed "base degradation" last on its list of potential causes of image discoloration in framed RC prints, this author believes that at least with early Kodak

Polycontrast Rapid RC prints, base degradation is in the great majority of cases the *primary* reason that images have discolored, or will do so in the future if displayed for a sufficient length of time. In the subsequent edition of Kodak Publication No. G-1, released in May 1982, and a later edition published in 1985, all reference to a possible relationship between RC base degradation and image discoloration was deleted.

In May 1978, at a conference on preservation of color photographs at the International Center of Photography (ICP) in New York City, this mode of black-and-white RC image discoloration was discussed by Klaus B. Hendriks.[11] Commenting on the previously discussed statement in the 1978 edition of *Kodak B/W Photographic Papers*, Hendriks dismissed the influence of oxidants originating from the environment or from residual processing chemicals as likely causes of image discoloration in framed RC prints, and said: "First the base degrades and produces some oxidizing agent, and then it will continue to attack itself [and the silver image] because it is enclosed in a glass frame."

Hendriks, who is director of the Conservation Research Division at the National Archives of Canada, said that displaying a framed black-and-white RC print created a "closed system" of deterioration, and he speculated that this could prove to be a serious problem in the years to come. (When the presentation was given in 1978, neither Hendriks nor this author had yet seen an example of image discoloration in the then-new black-and-white RC papers which could definitely be attributed to this mechanism of "self-destruction"; however, a number of Ektacolor RC prints that had developed cracks after less than 10 years of normal display in homes had been encountered.)

David Vestal, a photographer and influential writer who in early 1976 had started a public campaign to alert photographers to the shortcomings of RC papers and to convince Kodak and other manufacturers not to cease production of fiber-base papers, gave a detailed account of Hendriks's presentation in the October 1978 issue of *Popular Photography* magazine in an article entitled, "RC Report: The $TiO_2$ Blues."[12]

## The "Edge Effect" in the Discoloration of Framed and Displayed RC Prints

Supporting the view that image deterioration of framed and displayed Kodak Polycontrast Rapid RC prints can be caused by oxidants generated by the RC paper itself is the nature of the discoloration observed after several years of display in two RC prints made in 1977 by this author. The photographs were taken in the middle of the night of a lumberyard in Grinnell, Iowa going up in flames — the lumberyard was located next door to this author's home (which, fortunately, was spared). These prints were among many made by this author from a box of 8x10-inch Polycontrast Rapid RC Paper purchased in 1974;[13] all of the prints had been carefully processed, washed, and air-dried at room temperature, following Kodak's instructions. The white borders were trimmed from the prints after processing. The prints were dry mounted in the centers of sheets of 11x14-inch, 4-ply, 100% cotton fiber museum mount board (made by the Rising Paper Company). The mounted prints, without overmats, were placed under glass in metal frames.

After less than 5 years of display, severe image discoloration, microspots, and surface mirroring had occurred in medium- and high-density image areas, with the discoloration and mirroring especially pronounced in high-density locations adjoining low-density or white areas of the prints. However, the very outer edges of the prints — extending inward about ¹⁄₁₆ inch — suffered little or no discoloration.

This author believes that this "edge effect" is caused by the oxidants generated by the pigmented polyethylene layer diffusing through the paper core at the outer edges of a print. Passing into the thin air pocket surrounding the edges of the framed print (the thickness of the print kept the mount board slightly separated from the framing glass) and then absorbed by the mount board, the localized concentrations of oxidants at the edges of the print were lower than oxidant levels in the rest of the image area.

In correctly processed and washed fiber-base prints suffering from image deterioration caused by *external* contaminants from polluted air or unsuitable storage materials, it is frequently observed that the discoloration and fading are most severe near the edges of the prints. With framed and displayed RC prints, the opposite is generally true; this is additional support for the theory that the images are oxidized by substances generated within the print structure itself. In the examples of discolored RC prints just cited, the prints showing the "edge effect" had been trimmed after processing and drying, thus eliminating the possibility that edge-penetration of processing chemicals into the paper core of the RC prints was involved.

In view of the fact that the RC print structure has two polyethylene layers, that the prints were mounted on 4-ply, 100% cotton fiber museum mount board (all of which would help protect the image from attack from the back by airborne contaminants), and that the print emulsions were protected from the environment by framing glass, the reduced edge-fading also suggests that contaminants within the frame itself or from the surrounding environment were not a significant factor in the discoloration.

(It is important to note that unframed RC prints may also discolor. Indeed, this author had a stack of prints sitting on a shelf in his office for a number of years, and several Kodak Polycontrast Rapid RC prints among the group discolored where the edges or corners had protruded from the stack and were exposed to light. Fiber-base prints in the stack were unaffected.)

It has been noted by this author that after prolonged exposure to light, most RC papers evolve gases that have a distinct, pungent odor. The odor is especially pronounced if the prints have been framed under glass or plastic. Once the prints have been exposed to light for a sufficient period, emission of these gases can continue for many months, or even years, after the prints are placed in dark storage. The evolution of the gases is probably associated with the slow decomposition of polyethylene. The exact composition of these volatile substances has not been identified.

## Accelerated Light Exposure Tests to Induce Silver Image Discoloration and Base Cracking in RC Prints

In 1986, after examining the nature of the severe image discoloration that occurred with the 1972 "initial type"

Polycontrast Rapid RC prints discussed above, this author subjected a small print made from the same box of paper to a high-intensity 21.5 klux accelerated light exposure test with the expectation of being able to quickly simulate the discoloration. After several months had passed and the test print had been exposed to far more light (intensity x time) than the displayed print could possibly have received during the 5 years that it had been hanging on the wall — and with no sign of discoloration in the test print — it was concluded that the discoloration mechanism must have an extremely large reciprocity failure in light exposure tests. (If no reciprocity failure were involved, increasing the light intensity 25 times, for example, would reduce the length of time for image discoloration to appear by a factor of 25 — see Chapter 2 for a discussion of reciprocity failures as applied to the light fading and light-induced staining of color prints.)

To more systematically investigate the light intensity reciprocity relationship, the influence of UV radiation on image discoloration, and the effects of framing under glass or plastic, this author began a series of tests with samples cut from duplicate prints made in 1977 with paper from the same box that had been used for the 5-year displayed prints. All of the prints had been made during the same darkroom session and had been processed, washed and dried in the same manner. The duplicate prints had been stored in the dark during the 9 years before the tests were started. Each test sample contained a white border and a full range of densities — from a clean white to a deep black.

One group of prints was placed under low-intensity 1.35 klux (125 footcandles) Cool White fluorescent illumination at 75°F (24°C) and 60% RH. Another group was exposed to high-intensity 21.5 klux (2,000 footcandles) illumination, also at 75°F (24°C) and 60% RH (for a description of the test equipment, see Chapter 2). Illumination at 21.5 klux is 16 times more intense than at 1.35 klux. Included were unframed prints exposed to bare-bulb illumination, prints framed with glass (both with and without an overmat), and prints framed with Plexiglas UF-3, a UV-absorbing acrylic sheet.

At the time this book went to press in 1992, the tests had been in progress for 6 years (72 months) and visible deterioration had occurred in most of the prints:

1. **1.35 klux Unframed Print:** After 4 years, significant yellowish discoloration had rather suddenly occurred, and this was most evident in medium and low density areas immediately adjacent to white portions of the image. Unlike the prints that were framed with glass or Plexiglas UF-3, no microspots were evident, although surface "silvering-out" was noted adjacent to the most severely discolored areas. Even after 6 years, no base/emulsion cracking was observed with the unframed print, even though it had been exposed to the relatively high UV content of bare-bulb fluorescent illumination.

2. **1.35 klux Overmatted Glass-Framed Print:** After 1½ years of light exposure, "classic" orange-colored, surface-mirrored microspots were observed (if this author had been experienced in looking for early-stage discoloration, the spots probably would have been noticed sooner). These spots occurred in medium-density areas, adjacent to lower-density parts of the image. After

2⅓ years, the spots had grown in size, but the total number of these "large" spots remained fairly small. In addition, a narrow band of the image, approximately 1.0mm wide, and running along the full length of the adjacent, untrimmed white print border, had become uniformly discolored and surface-mirrored. Under 10X magnification, a large number of very small microspots could be observed in an image area 3mm to 8mm from the print border. After 4 years, significant yellowish discoloration in low- and medium-density areas adjacent to white portions of the image had rather suddenly occurred. Few additional large microspots were noted. After 6 years, this pattern continued with image discoloration becoming more severe; no surface cracking could be detected.

3. **1.35 klux Print Framed in Contact with Glass:** After 1⅔ years, the print had developed large numbers of very small microspots, which were fairly evenly distributed in medium- to high-density areas of the print (the microspots tended to be concentrated along image-density gradients). No discoloration was evident in low-density areas of the image. After 4 years, the print had not developed a discolored area next to the white print border as had occurred with No. 2 above. But, overall, the number of small microspots had increased markedly. None of these spots, however, approached the size of the "large" spots that occurred with the overmatted print. After 6 years, little of the yellowish discoloration noted in the overmatted print was evident.

4. **1.35 klux Print Framed in Contact with UF-3:** After 2⅓ years, the print exhibited a narrow, strongly discolored band immediately adjacent to the untrimmed white print border (identical to that described in No. 2 above) and the print had also developed some small microspots 3mm to 10mm from the border; these spots were concentrated near one corner of the sample. After 6 years, more microspots and discoloration were noted.

5. **21.5 klux Unframed Print:** After 1½ years the print had developed extensive emulsion and/or base cracking (which type of crack could not be determined) in minimum-density (white) and low-density areas. The first cracks probably occurred at an earlier point in the test; but because the cracks were not accompanied by image discoloration, and at that time this author was not consciously looking for cracks, they were not noticed. After 2⅓ years the cracks covered most of the print surface, with only the maximum-density areas still remaining free of cracks. After 4 years, cracking was very extensive and covered all areas of the print. Even after 6 years of illumination, however, and with the print severely cracked, no microspots or other image discoloration could be detected.

6. **21.5 klux Print Framed in Contact with Glass:** After 4 years, the print rather suddenly began to show significant image discoloration in the form of large numbers of distinct microspots. The discoloration was most evident in medium- and high-density areas immediately adjacent to low-density and/or white areas. After 6 years,

this pattern continued with the size and number of microspots and the degree of image discoloration becoming more severe.

7. **21.5 klux Print Framed in Contact with UF-3:** After 2⅓ years, the print had developed a very narrow, strongly discolored band along the full length of the image adjacent to the white print border; the print also exhibited small microspots along an area farther in from the border. Like the 1.35 klux print framed with UF-3, these spots were concentrated near one corner of the print. In fact, after 6 years of light exposure, the pattern of discoloration on these two prints was almost identical — despite the fact that the 21.5 klux print had received 16 times more light exposure than the 1.35 klux print!

The previously discussed *severely* discolored and spotted print that had been normally displayed for 5 years (made on the same paper as the test samples described above), was displayed under Cool White fluorescent illumination with an intensity of about 195 lux — the total display time is estimated to have been approximately 14,300 hours. The print was framed under glass, without an overmat, and for most of the time, the area where it was displayed was air conditioned. The length of time that had passed before the first discolorations occurred in this print is not known.

**Accumulated Light Exposure of Prints:**

Print normally displayed for 5 years = **2,790 klux-hours** (estimated light exposure accumulated during 5 years)

1.35 klux test prints for 6 years = **70,956 klux-hours** (25x light exposure of normally displayed print)

21.5 klux test prints for 6 years = **1,130,040 klux-hours** (405x light exposure of normally displayed print)

## Conclusions Suggested by These Tests

It is clear that to produce the type of image discoloration caused by long-term display under normal conditions with this particular RC paper, accelerated light-exposure tests have an *extremely* large reciprocity failure (although the 21.5 klux test samples had received an estimated 405 times more light exposure than did the severely discolored print that had been displayed under normal conditions for 5 years, the discoloration observed in the 21.5 klux print samples was less pronounced). Therefore, one would have to conclude that — compared with long-term display under normal conditions — short-term, high-intensity tests (at least at room temperature) may in fact do little if anything to accelerate the discoloration process.

These results, together with an investigation of the illumination history of a number of prints that became discolored during normal display, suggest that the threshold level of illumination necessary to initiate the production of oxidants by the titanium dioxide pigmented polyethylene layer may be very low indeed (and that although exposure to UV radiation appears to accelerate the reaction, visible light alone is quite sufficient to initiate and sustain the process).

The fact that, even after 6 years of light exposure, the unframed print in the high-intensity, forced-air-cooled 21.5

klux test had not yet discolored lends considerable support to the theory that the discoloration observed with framed RC prints is brought about primarily by the light-initiated production of oxidizing substances (e.g., peroxides) by the titanium dioxide white pigment in the emulsion-side polyethylene coating of the prints. With unframed prints, these oxidants are free to diffuse into the atmosphere, and away from the print emulsion. With framed prints, the oxidants are to a much greater extent retained within the frame package, forming a destructive microclimate that over time can cause severe discoloration of the silver image.

In the 1.35 klux test, there is much less air circulation over the surface of the print than is the case with the 21.5 klux test, and this is probably the reason that the unframed print in this test began to show discoloration after 4 years, while the 21.5 klux unframed print still had not after 6 years. This correlates well with the patterns of discoloration that have been observed in unframed prints that became discolored after several years of sitting in stacks exposed to light in normal office storage conditions.

For any given type of RC paper, the most critical factors affecting discoloration of the image appear to be the duration of the illumination (regardless of how intense the illumination level might be, prolonged exposure periods are required for this type of light-induced discoloration to occur) and the ambient relative humidity. Examination of discolored prints displayed in tropical countries, humid southern areas in the United States, and in drier regions in the northern United States and in Canada makes it clear that relative humidity is a very important variable: high relative humidity, especially in conjunction with high temperatures, can greatly accelerate the discoloration of displayed black-and-white RC prints.

Exactly why the test prints, which had been exposed to 6 years of high-intensity illumination in accelerated tests, had not discolored as much as did the print that was displayed under normal conditions for 5 years, remains unanswered. All of the prints were made with Kodak Polycontrast Rapid RC Paper from the same box, they had the same image, and they were processed at the same time.

This author can suggest only three things that might account for the more severe discoloration that occurred in the normally displayed print: **(1)** At times during the course of 5 years, the normally displayed print was subjected to relative humidity that was significantly higher than the 60% RH used in the accelerated tests. **(2)** The test prints were stored in the dark for nearly 9 years before they were subjected to the intense illumination of the accelerated tests, and during this period of dark storage subtle changes may have occurred in the silver image (e.g., mild sulfiding of the silver grains that resulted in the image becoming more resistant to oxidation) and/or changes in the RC paper base that rendered the test prints less susceptible to light-induced image discoloration. **(3)** The test prints were exposed to continuous illumination for 24 hours a day, and the normally displayed print was in the dark for approximately 12 hours each day; it is possible that these dark periods in some way accelerated image discoloration.

An important finding of these tests is that there is nothing to be gained (with respect to image discoloration at least) by separating prints from framing glass with an overmat; in fact, in the 1.35 klux tests with framed prints,

the overmatted print was the most severely discolored of the group at the end of 6 years. (Unfortunately, an overmatted print was not included in the 21.5 klux tests.)

It is also worth noting that, after 1½ years of light exposure, the gray Kodak identification (sometimes called a watermark) printed on the back of the RC paper had faded beyond recognition on both the 1.35 and 21.5 klux unframed prints (to avoid disturbing the microclimate inside the sealed frames, the backprinting on the prints framed under glass and UF-3 was not examined). Like the discoloration of the images, the fading of the ink used to backprint the paper also appears to have a large reciprocity failure.

The often irregular patterns of discoloration noted with many RC prints suggests that surface contamination, processing chemical or wash water residues, or print drying irregularities may also influence the rate and visual appearance of the discoloration. An increased number of test samples would be useful in this type of test. The kinds of "clean" extrapolations that can be done with the rates of dye fading in color prints in high-intensity light fading tests are simply not valid when it comes to the discoloration of the silver images of framed black-and-white RC prints.

Observation of displayed RC prints made with more recent Kodak RC papers suggests that they almost certainly have greater resistance to discoloration than the "initial type" Polycontrast Rapid RC Paper evaluated in these tests. But how much better they are and what kinds of accelerated tests can be devised to meaningfully evaluate the tendency for these papers to discolor on long-term display remain unanswered questions. Likewise, the long-term behavior of RC papers made by Ilford, Agfa-Gevaert, Oriental, Fuji, and the many other manufacturers worldwide currently producing RC papers is not known.

## Brownish Base-Staining in Developer-Incorporated RC Papers

In 1983 this author and Carol Brower made many hundreds of prints with Ilford Ilfospeed Multigrade RC paper; all of these prints now exhibit heavy brownish staining within the paper base itself. The discoloration is quite pronounced on the backs of the prints, but is much less apparent on the emulsion side of the prints because of the shielding effect of the white titanium dioxide pigmented polyethylene layer. This type of paper-base staining, which according to Ctein, a well-known photography writer, is caused by the developer incorporated in the paper's emulsion at the time of manufacture,[14] has never been observed with fiber-base papers. Apparently, the longer a developer-incorporated RC paper remains in storage prior to processing, the more severe the brownish stain may eventually become. During storage, the incorporated developer migrates from the emulsion, through the top-side polyethylene layer (and through the backside of the adjacent sheet), and into the fiber-base paper core of the RC paper.

## Inherent Stability Differences Between RC Prints and Fiber-Base Prints

That fiber-base prints are not subject to the types of light-induced deterioration that afflict RC prints can probably be accounted for by two principal factors: **(1)** Barium sulfate — which, unlike titanium dioxide, is not photoreac-

tive — is used as the pigment in the smooth, white baryta layer coated beneath the emulsion in fiber-base papers. (2) Fiber-base papers do not contain polyethylene, which, as mentioned previously, is a plastic long recognized for its poor stability in the presence of light and UV radiation (especially when compounded with titanium dioxide).

The thickness of the gelatin baryta layer in fiber-base papers can accommodate the relatively large amount of barium sulfate required to achieve a bright and opaque white coating. Barium sulfate does not, unfortunately, have a high enough relative reflectance or refractive index to make it suitable as a pigment in the small quantities permitted by the very thin emulsion-side polyethylene layer of RC prints. Of available white pigments, only titanium dioxide appears to have the optical properties required for RC papers. It would, of course, be possible to coat a conventional baryta layer on an RC base paper prior to coating the light-sensitive emulsion, but to do so would significantly increase processing, washing, and drying times — and thereby partially negate the principal advantage of RC papers.

There is also evidence that prints made on early Kodak Polycontrast Rapid RC Paper and Polycontrast Rapid II RC Paper — indeed, possibly *all* black-and-white RC papers — are unusually sensitive to the effects of atmospheric pollutants and/or contaminants in storage materials. In an article published in 1980, Gunter Kolf of Agfa-Gevaert suggested that one of the reasons why silver images on fiber-base papers appear to be more stable than images on RC papers is that the baryta layer and absorbent paper base of fiber-base prints act as a "sump" which absorbs airborne pollutants, contaminants from storage materials, and degradation products such as migrating silver ions, thereby preventing them from becoming concentrated in the emulsion layer, adjacent to the silver image grains.[15] With RC papers, the nonabsorbent polyethylene layer beneath the emulsion prevents migration of harmful substances away from the emulsion and silver image, and this, according to Kolf, can accelerate image discoloration and the formation of "silver mirrors" on the emulsion surface.

Kolf also stated that image silver accelerates the deterioration of the polyethylene layers in Agfa RC papers and that the cracking defect had not been observed in Agfacolor RC prints (this author recently examined a cracked Agfacolor RC print from the mid-1980's). This author has had little firsthand experience with early Agfa RC papers; but in Kodak RC papers from the 1970's, this author has encountered far more cracked color prints than cracked black-and-white prints. These differences possibly could be accounted for by differences in the formulations of Kodak and Agfa RC papers from that era.

Kolf's article was published primarily as a defense by Agfa-Gevaert against a vehement attack on virtually every aspect of RC papers by a group of fine art photographers led by the French photographer and gallery owner Jean Dieuzaide. In a document published by Dieuzaide in 1977 entitled *Appeal for the Preservation of Genuine Photographic Paper Which is Threatened by the Cessation of Production,* it was claimed, among other things, that the silver content of papers had been reduced and that "[RC] papers are of low quality, and tests have proved beyond question that the images fade in 15 years at the latest." It was also stated that "damage through flaking [RC cracking] is un-

avoidable; well-printed reproductions are virtually impossible since the gradations and black tones are insufficient; and [RC papers] are unpleasant to the touch."[16]

During 1977, Dieuzaide and other concerned European photographers collected thousands of signatures on petitions urging the major photographic manufacturers not to discontinue fiber-base papers. The group held two "summit conferences" in France with representatives of Eastman Kodak, Agfa-Gevaert, Ilford, and the French manufacturer R. Guilleminot Boespflug & Cie to discuss the situation. The eventual outcome of Dieuzaide's efforts — and a concurrent campaign in the U.S. led by David Vestal and Arthur Goldsmith of *Popular Photography* magazine — to prevent the demise of "quality" fiber-base papers will be discussed later.

While disputing nearly all of the practical and aesthetic criticisms of RC papers made by Dieuzaide, Kolf did acknowledge that Agfa black-and-white RC papers (and by implication, the RC papers of other manufacturers as well) were less stable than their fiber-base counterparts, both in terms of the permanence of the silver image and the stability of the RC base paper itself. Saying that more research was needed to find ways of retarding or stopping the light-induced deterioration of polyethylene, Kolf suggested that ". . . plastics other than polyethylene should be sought which while possessing the positive virtues of polyethylene exhibit fewer detrimental aging characteristics. So long as this work remains uncompleted, responsible manufacturers will continue to market a broad range of black-and-white baryta papers."

## Kodak's Current Position on RC Papers versus Fiber-Base Papers

In Larry Feldman's previously mentioned article, he described the mechanisms of silver-image deterioration in RC and fiber-base prints and emphasized the damaging effects caused to silver images by peroxides and other oxidants from *external* sources such as oil-base paint fumes. Many readers of the Feldman article have been left with the impression that attack by external oxidants is the primary, if not the only, cause of image deterioration of correctly processed and washed RC prints.

Probably because of legal and marketing considerations at Kodak, Feldman's article made every effort to minimize the often large differences in image and support stability that have been observed in Kodak RC papers and Kodak fiber-base papers marketed in the 1970's (Feldman's article was first presented as a paper at an SPSE conference in 1980); and he did not address the topic of light-induced image discoloration of framed RC prints caused by reactions involving titanium dioxide and/or polyethylene degradation. (In the years since the Feldman presentation, Kodak has remained silent on this subject.) Feldman, however, in a carefully worded paragraph near the end of the article, did *allude* to the possibility of internally caused oxidation of RC images:

> In particular, black-and-white prints on resin-coated paper base that may be subjected to intense or extended illumination, exposed to oxidizing gases, or framed under glass or plastic should be considered for treatment with toners

to extend image life. The toning of prints on fiber-base papers is likewise recommended for those applications requiring long-term keeping under adverse storage or display conditions.[17]

In a masterful attempt to further obfuscate the real cause of image deterioration in early Kodak black-and-white RC prints, the company included the following statement in its 1985 book *Conservation of Photographs*:

> Displayed black-and-white photographic prints on early versions of RC paper base, that were subjected to active oxidants at low concentration could, over a period of time, develop colloidal silver spots. This phenomenon can also occur on fiber-based papers. For some time, Kodak black-and-white papers on RC paper base have incorporated a stabilizer in the paper stock which prolongs the life of prints under display conditions. Nonetheless, treatment with toners is recommended to further extend the life of all black-and-white photographic prints.[18]

The Kodak book carefully avoided mention of the fact that the source of "active oxidants" in displayed prints made on early versions of Kodak RC papers most likely was the RC paper base itself. Especially in light of the admission that "This phenomenon can also occur on fiber-based papers," the statement can only be viewed as an attempt to divert the reader from the reality of the very large stability differences between Kodak fiber-base and RC prints from the early 1970's.

*Conservation of Photographs* also contained a similar, intentionally vague discussion of "emulsion cracking or mosaic cracking" of Kodak fiber-base and RC color prints. According to Kodak, "This effect may occur on either fiber-base or RC prints under adverse display and/or storage conditions."[19] Examples of cracked fiber-base and RC color prints are shown; judging from the amount of fading that has taken place and the nature of the cracks, the RC print appears to date from the early 1970's. The reader is given the impression that Kodak RC and fiber-base papers from this era did not differ appreciably in their tendency to develop cracks. This notion is obviously incorrect; examination of many Kodak RC and fiber-base prints from the 1960's and 1970's leaves no doubt that the RC prints have a far higher incidence of cracking.

## Treating Prints with a Protective Toner to Help Prevent Image Oxidation and Discoloration

Feldman's article suggested treating RC prints (and fiber-base prints) with Kodak Rapid Selenium Toner, Kodak Poly-Toner, or Kodak Sepia Toner to increase their resistance to image discoloration. When a print is treated with Kodak Rapid Selenium Toner, for example, selenium metal — present in the toner solution in the form of sodium selenite — combines with the outer layer of the silver image grains to form silver selenide, a compound that is much more resistant to oxidation than is normal, unprotected image silver (see section below on new research on the protection afforded by various toners).

Feldman's advice to treat RC prints with a suitable toner (which could also be viewed as a legal disclaimer to help protect Kodak against possible lawsuits related to the very poor stability of its early black-and-white RC papers) soon appeared in Kodak RC paper product-information sheets, accompanied by the added recommendation: "Toned fiber-base papers continue to be recommended for those applications requiring long-term keeping under adverse storage or display conditions."[20] More recently Kodak has toned down its warnings; for example, the information sheets packaged with Kodak Polyprint RC Paper and Kodak Polycontrast III RC Paper now say only:

> *Print Storage and Display:* You can use Kodak packaged toners to extend the life of prints which may be exposed to oxidizing gases or subjected to adverse display or storage conditions. Kodak Rapid Selenium Toner, used diluted 1:20 for 3 minutes at 70°F (21°C), provides protection without changing the image color.[21]

The advice to use fiber-base papers for applications involving "adverse storage or display conditions" has now been eliminated on at least some information sheets for Kodak black-and-white RC papers.

It is this author's observation that it is virtually unheard of for a photographer to treat RC prints with a protective toner (or an image-protective solution such as Agfa Sistan or Fuji Ag-Guard). RC papers are chosen for their convenience and speed of processing, washing, and drying. Treatment with a toner requires an additional processing step along with an added wash, neither of which can be accommodated by automatic RC print-processing machines such as the Kodak Polymax processor or the Ilford 2150 or 2240 processors. Most photographers who are interested in permanence — and who might be willing to spend the time required for these additional processing steps — do not use RC papers in the first place.

Because of this, museums or archives should assume that black-and-white RC prints have *not* been treated with a protective toner solution, unless specific information to the contrary is available. In addition, it generally is difficult or impossible to identify the type and date of manufacture of an RC print, particularly if it has been mounted and the backside is not available for examination.

## Kodak Rapid Selenium Toner and Poly-Toner Are Currently Recommended for Both RC and Fiber-Base Prints

For many years it was generally accepted that treatment of silver images with selenium, sulfiding, or gold toners offered substantial protection against peroxides, nitrogen oxides, ozone, and other oxidizing substances that frequently are present in polluted air and that may be evolved from particle board, plywood, wood, paints and varnishes, many types of plastics, poor-quality cardboard and paper, and a long list of other materials.

Selenium toner had been used for decades by the late photographer Ansel Adams to protect and intensify the images of his carefully made prints. This author has long been a vocal advocate of the use of selenium toner, especially for prints. Most contemporary fine art photogra-

phers now routinely treat their black-and-white prints with Kodak Rapid Selenium Toner. In the early 1980's Kodak published a series of articles that demonstrated its effectiveness and advocated its use for both prints and films.[22]

(The prohibitive cost of gold chloride, the key ingredient in gold toners, had long since rendered them little more than a laboratory curiosity — sometimes used as a benchmark with which to compare the image protection afforded by other types of toners.)

In 1988, James M. Reilly and his co-workers at the Image Permanence Institute in Rochester, New York reported that Kodak Rapid Selenium Toner afforded relatively *little* protection against oxidation to the extremely fine grain silver images of microfilms. Sulfiding toners were recommended instead.[23] As explained in a 172-page report on their studies released in 1991:[24]

> Using a criterion of rigorous hydrogen peroxide testing, only gold and polysulfide treatment proved effective enough. Selenium, often recommended, does not protect the low density areas of microfilm. The evidence we have suggests that selenium does not convert the low density areas to silver selenide as readily as middle and high density areas. While the reason for this is not clear, it is a fact, and rules out selenium as a microfilm treatment, though it may function well with photographic papers. Gold and polysulfide protect all density levels; gold, however, is impractical because of its cost and the possible toxicity of the thiourea constituent of the most effective gold treatment formulas. Polysulfide seemed the most practical and effective choice.

For treating both RC and fiber-base papers, this author continues to recommend Kodak Rapid Selenium Toner (to simplify treatment of fiber-base papers, the toner can be mixed directly with Kodak Hypo Clearing Agent). If a greater degree of image protection is desired, Kodak Poly-Toner in a 1:10 dilution for about 2 minutes at room temperature is recommended. This gives a pleasing, near-neutral tone and a noticeable amount of image intensification with many current papers. Use of Poly-Toner with fiber-base papers requires a subsequent treatment with Kodak Hypo Clearing Agent (followed with Kodak Liquid Hardener if emulsion frilling proves to be a problem while the prints are wet), and a 30-minute wash. For RC papers, a 5-minute wash following toning should be adequate.

Kodak may modify Rapid Selenium Toner to improve the image protection it offers. A combination of Rapid Selenium Toner and Kodak Poly-Toner (which contains both selenium and potassium sulfide) might prove adequate.

## Valuable Black-and-White RC Prints Should Not Be Displayed

It must be emphasized that *very little* information has been made public about the specific long-term stability characteristics of current and past black-and-white RC papers supplied by Kodak, Ilford, Agfa-Gevaert, and the other major manufacturers. Essentially nothing is available on the properties of black-and-white RC papers produced by

October 1992

Samples of "original type" Kodak Polycontrast Rapid RC Paper introduced in 1972 undergoing light-exposure tests in this author's temperature- and humidity-controlled high-intensity 21.5 klux fluorescent test unit. When this picture was taken, the tests had been in progress for 6 years and significant light-induced image discoloration and silver "microspot" formation had occurred. Under normal display conditions, a similar degree of image discoloration can occur after far less light exposure, indicating that there is a very large reciprocity failure in accelerated light-exposure testing of black-and-white RC papers.

the many smaller manufacturers in the field. At present it is not possible to suggest "safe" illumination conditions, display times, or even the best framing methods for any Kodak black-and-white RC prints, let alone for the RC papers made by other manufacturers. For these reasons, it is recommended that valuable black-and-white RC prints not be displayed; instead, copy prints should be made for exhibition purposes. Black-and-white RC prints known to date from the 1970's should *never* be displayed, even for short periods.

## Kodak's Early Claims Concerning RC Paper

When RC papers entered the market in the 1960's, they were a distinctly new type of photographic material. As with Polaroid SX-70 prints and some other color products, black-and-white RC prints exhibited entirely new types of image and base deterioration; the peculiar light-induced base cracking and garish image discoloration that soon occurred with RC prints had never been observed with fiber-base prints in the many years that they had been in use. Judging from early Kodak pronouncements about its black-and-white RC papers, the company itself was not fully aware of the stability limitations of the papers prior to introducing them to the market:

> Kodak Polycontrast Rapid RC Paper — medium weight — is the newest paper in the line. This new resin-coated paper, in either F or N surface, has many important advantages. It fixes in two minutes and washes in 4 to save you a lot of processing time. RC papers in F surface provide a high-gloss surface without ferrotyping. Prints lie flat, remain flexible and have long life. . . . Try this new product that offers you so much today.[25]

The above quote is from *Kodak Photographic Papers for the Professional,* Kodak Publication P4-73 (October 1972).

> The big saving in processing time for water-resistant [RC] papers occurs in the washing step. Instead of the minimum of an hour wash for conventional papers . . . a 4-minute wash time is recommended, in which time prints attain optimum stability.[26]
> *Faster and Better B/W Print Processing*
> Kodak Publication G-6 (July 1976)

In the early 1970's, all of this seemed like a panacea to many photographers. To be able to wash an RC print for only 4 minutes and obtain a lower level of residual thiosulfate than could be achieved in a fiber-base print after even 2 hours of washing seemed wonderful. And RC prints could be dried with a perfect gloss in a minute or less. After drying, RC prints stayed *flat*. With machine processing, RC prints could be completely processed, washed, and dried in *less than 60 seconds*, and the result, most photographers were led to believe, was a permanent print. It seemed too good to be true. And, as the unfortunate fate of many of these early black-and-white RC prints now clearly shows, too good to be true it was.

## Evaluating the Stability Characteristics of Current Black-and-White RC Papers

No generally accepted accelerated tests have yet been devised to determine the stability properties of RC papers, and many questions remain unanswered about the tests used to assess the stability of RC base paper. Kodak has revealed only the barest details of how it evaluates the light-induced image deterioration characteristics of these papers.[27] Agfa-Gevaert, Oriental, Mitsubishi, Fuji, and Ilford[28] have disclosed little about their respective test methods, and comprehensive, comparative stability-test data from independent laboratories are not available.

As discussed previously, the light-induced discoloration of framed RC prints is difficult to simulate in accelerated aging tests in a way that can be extrapolated to normal display conditions. There also is evidence that image discoloration may in some instances first manifest itself in the dark *after* a print has been returned to storage following exposure to light on display. Likewise, if deterioration is already visually apparent in a displayed print, it may worsen in dark storage.

No ANSI standards currently exist either for the characteristics of the RC support material itself or for test methods to predict the useful life of the support and/or image in common conditions of display or storage. The current ANSI standards related to the stability of silver images on films do not include any tests which can be used to evaluate the four principal aspects of RC print deterioration: **(1)** susceptibility of the silver image of framed and displayed prints to fading and discoloration caused by oxidants from *internal* sources; **(2)** susceptibility of the silver image to fading and discoloration caused by airborne pollutants, harmful substances in mounting and storage materials, and other *external* sources; **(3)** light-caused cracking and other deterioration of the print support material; and **(4)** print cracking caused — or contributed to — by

fluctuations in relative humidity.

Paper print materials in general have historically been rather neglected by ANSI; in the case of RC papers, the photographic industry — well aware of the stability shortcomings of these materials — has in the past been quite content to leave it that way. In 1980, however, a new ANSI subcommittee was established to develop a test standard for RC and fiber-base papers (this author has been a member of this subcommittee since it began). The meaningful evaluation of black-and-white RC papers using short-term, accelerated tests presents some formidable problems, but it appears that the new standard may be ready for publication in 1993 or 1994.

## RC Papers Are Not All Alike

The reader should be aware that the information Kodak has supplied on the stability of its black-and-white RC papers — incomplete as it is — *cannot* be assumed to apply to RC papers made by Ilford, Agfa-Gevaert, Oriental, Mitsubishi, or other manufacturers (none of whom have published meaningful information on the stability of their respective RC papers). In recent years, some writers in the photographic press,[29] and even some people in the conservation field,[30] have tended to lump *all* black-and-white RC papers together and to assume that whatever claims Eastman Kodak has made about the stability of its RC papers apply to all RC papers, regardless of the manufacturer. Even the information about a particular Kodak RC product may not apply to other RC papers made by Kodak.

Unlike fiber-base black-and-white papers, the basic design of RC papers renders them *inherently unstable* when exposed to light on display. Once the serious stability problems of RC papers had manifested themselves in the early 1970's, and the mechanisms of image and base deterioration were beginning to be understood, the manufacturers made various modifications to the formulations of their RC papers in an attempt to increase their stability. Antioxidants, stabilizers, peroxide scavengers, and other protective substances were incorporated into the RC support material and, apparently, into the emulsion layer itself in an attempt to protect the silver image. These were measures that never had to be considered in the manufacture of black-and-white fiber-base papers.

As a result, modern RC papers have evolved into complex products made with proprietary formulations and manufacturing techniques which vary from one manufacturer to the next; for example, the system of incorporating polyethylene stabilizers into the porous paper core of Kodak RC papers (after manufacture, the stabilizers gradually migrate into the polyethylene layers) is covered by a patent granted to Kodak in 1974 (U.S. patents expire after 17 years). In another, earlier modification, Kodak changed the type of titanium dioxide in its RC papers to a less-reactive form of the pigment — Kodak has declined to reveal exactly when this improvement was made in its products.

Kodak also has refused to say exactly when the "stabilizer in the paper core" improvement was applied to its black-and-white papers; however, this author believes that this new technology appeared around the end of 1978, concurrent with the introduction of Kodak's type "II" developer-incorporated black-and-white RC papers (e.g., Poly-

contrast Rapid II RC Paper and Kodabrome II RC Paper). Because light-induced RC base degradation and image discoloration appear to be caused by the same oxidative reactions, it had been hoped that prints made on these and subsequent Kodak RC papers could tolerate longer display periods than earlier Kodak RC papers before image discoloration became evident. Unfortunately, a number of prints made in 1983 by this author and Carol Brower with Polycontrast Rapid II RC Paper began to exhibit image discoloration after only a few years of display — the resistance of these prints to light-induced discoloration appears not much better than that of the initial 1972 version of Polycontrast Rapid RC Paper.

Black-and-white RC papers sold by the many current suppliers of these materials are *certain* to have different stability characteristics; the differences between RC papers of various manufacturers likely are much greater than stability differences found among fiber-base papers. Further complicating the matter is the common industry practice of purchasing RC base paper from outside suppliers,[31] with the photographic manufacturer doing only the emulsion coating and packaging of the finished product. The source of RC base paper may change in time, and a plant in Europe, for example, may use a different supplier for RC base paper than the same company's factory in Japan.

This author has seen a number of truly dreadful black-and-white RC papers; among them is Forte RC paper manufactured by Photochemical Industry VAC in Hungary. In the course of normal handling and flexing, some samples of the Forte paper exhibited cracking of the backside polyethylene layer immediately after processing — and the prints had not even been displayed! This Forte paper also suffered from extreme edge-penetration and retention of developer and fixer in the course of processing.

It has been reported that thiosulfate and other chemicals retained in the absorbent paper core at the edges of a black-and-white RC print can produce localized image deterioration of an adjacent print when the edge of the print is in contact with the image area of another print during prolonged storage, especially under humid conditions.[32] To a greater or lesser extent, all RC papers are subject to edge-penetration during processing. How much danger this problem poses in normal, long-term storage is not yet known; the degree of edge-penetration varies among different brands of RC paper. Storing black-and-white RC prints in individual polyester sleeves, or trimming the outer ⅛ inch of all four edges of RC prints, will eliminate the possibility of this type of damage.

### The Problem of "Veiling" of the Blacks in RC Prints: The Influence of Drying Method on the Appearance of RC Prints

A frequent and often vociferous complaint about black-and-white RC papers has been that after the prints are air-dried at room temperature, or after they are dried with a home-type electric hair dryer (the most common drying method employed by amateur darkroom workers), the blacks and other high-density portions of the image exhibit a disconcerting "veiling" of the image, and have a grainy "metallic" surface sheen.

This image defect is sometimes called "blooming," "surface backscatter," or "haze," and is especially noticeable on glossy RC papers. The dried prints have a distinctly degraded appearance compared with how they looked when wet during fixing and washing — the deep blacks are simply no longer really deep blacks. The effect is especially acute when a print is viewed at an angle with specular light reflected off the emulsion surface. This visual defect is peculiar to black-and-white RC papers and, in this author's experience, does not occur in any significant way in fiber-base papers. Surprisingly, it also does not occur in *color* RC papers. (Although the surface gloss properties of color RC papers vary depending on how the prints are dried, with a higher dryer temperature usually producing a higher gloss or sheen, the image quality itself is little affected.)

When black-and-white RC papers are dried with an Ilford 1050 RC print dryer[33] — a patented motorized dryer that employs powerful infrared heating elements placed both above and below the print, with a blower to force unheated, room-temperature air over the hot print surfaces to carry evaporating moisture away as the print passes between the heating elements — the degradation or veiling of the blacks in all brands of glossy RC papers is miraculously eliminated. (In 1990, the Ilford 1050 dryer was replaced with the Ilford 1250 dryer, an improved, variable-speed version of the 1050 model; all of the comments concerning the 1050 print dryer that follow are equally applicable to the 1250 print dryer.)

Infrared dryers function differently from conventional hot-air dryers in that in an infrared dryer, infrared radiation absorbed by a print heats it to a higher temperature than the surrounding cooler and comparatively humid air. A hot-air dryer, on the other hand, heats the air passing over a moist print to a significantly higher temperature than that reached by the print itself; the hot air has a very low relative humidity.

The Ilford 1250 RC print dryer, which costs about $1,990, squeegees and dries an 8x10-inch print in about 10 seconds. With a capability of drying two 8x10-inch prints at a time, according to Ilford, this machine can dry about 500 8x10-inch prints an hour. Both the automatic Ilford 2240 print processor ($13,545) and the table-top Ilford 2150 RC print processor ($7,695), which are high-speed machines for processing all types of Ilford, Kodak, and other black-and-white RC prints, have built-in infrared dryers and give the same excellent results as the Ilford 1250 RC print dryer.

### Why the Images of Most RC Papers Are Affected by the Manner of Drying, and Why Fiber-Base Prints Are Not

Exactly why black-and-white RC papers exhibit the veiling problem, and fiber-base papers do not, has not been fully explained. Peter Krause, a former president of Ilford and a leading authority on photographic technology, speculated that several factors may be involved:[34]

• The very thin gelatin emulsion and surface coat of black-and-white RC papers contain latexes and other gelatin additives to impart flexibility and to reduce the tendency to curl in low-humidity environments. These additives cause the emulsion to have very different sur-

Wet RC prints being fed into an Ilford 1050 infrared RC print dryer (the 1050 dryer was replaced with the improved 1250 dryer in 1990). Drying black-and-white RC prints at room temperature, or with conventional hot-air dryers such as found in the now-obsolete Kodak Royalprint and Dektomatic RC print processors, results in degraded, "veiled" blacks (in this author's tests, the only exceptions to this are the Oriental New Seagull RP [RC] papers, introduced in 1988–89, which give good results regardless of how they are dried).

July 1987

In the Ilford 1050 and 1250 RC dryers, electrically heated infrared tubes are placed above and below the print-drying zone. Infrared radiation rapidly heats the print emulsion, and fan-forced, room-temperature air carries the moisture off. In terms of image and surface quality, infrared drying appears to be the only satisfactory way to dry most current RC papers. Infrared dryers similar to the Ilford 1250 are employed in the Ilford 2240 and 2150 RC print processors. The Kodak Polymax IR print processor introduced in 1991 also features an infrared dryer.

## Experiments with Different Methods of Drying RC Prints

This author tried several different drying techniques with glossy (F surface), developer-incorporated papers including Kodak Polycontrast Rapid II RC Paper, Polycontrast III RC Paper, Ilford Ilfospeed Multigrade II RC Paper, Ilford Multigrade III RC Rapid Paper, and Agfa Multicontrast High Speed RC Paper. Conventional-emulsion (non-developer-incorporated) papers included Kodak Polyprint RC Paper (Kodak Polymax RC Paper, introduced in 1992, was not available at the time these tests were conducted), Ilford Multigrade III RC Deluxe Paper, Oriental New Seagull RP Paper, and New Seagull Select VC-RP Paper.

Included in the tests were air-drying at room temperature after careful squeegeeing to remove surface water; drying with a hand-held Gillette Promax 1200-watt hair dryer (this unit cost about $35 and is similar to the hair dryers found in many homes and darkrooms); and drying with an Ilford 1050 RC print dryer ($1,995), which is the predecessor of the Ilford 1250 print dryer. Samples of Polycontrast Rapid II RC prints processed and dried in a Kodak Royalprint Processor Model 417 (discontinued in 1991, the unit last sold for $14,800) and in an Ilford 2240 print processor ($13,545) were also obtained. In addition, Ilford Multigrade II RC prints dried with an Arkay RC-1100 dryer ($800) were examined.

A careful appraisal of image quality and surface characteristics of the prints led to the following conclusions:

face characteristics when rapidly dried under high heat than when slowly air-dried at normal room-temperature conditions.

• Fluorescent brighteners incorporated in a thin coating between the emulsion layer and the RC base tend to migrate to the surface of the emulsion during processing, washing, and drying. (With fiber-base papers, brighteners can be incorporated into both the paper base and baryta layer because barium sulfate, the white pigment used in place of titanium dioxide in fiber-base papers, is a substance that does not strongly absorb UV radiation and thus allows the brighteners to fluoresce.) The presence of even small amounts of a brightener in the image portion of the emulsion or gelatin surface coat can significantly degrade the appearance of the blacks. For reasons that are not entirely clear, rapid drying of RC papers apparently allows less brightener to migrate to the surface than when prints dry more slowly.

• The extruded polyethylene surface of RC base paper has a slightly rough, or "toothed," texture, and this microscopic surface irregularity is imparted to the thin gelatin emulsion and surface coat of the print. High-heat infrared drying melts the moist gelatin the moment before drying is completed, leaving it with a smoother, higher-gloss surface. This results in less light-scattering by the silver image, and thereby increases the apparent density.

Krause said that the paper manufacturers have made improvements in black-and-white RC papers in recent years and that the veiling problem has been reduced. "At one time people just refused to use RC papers because they had such a very strong blooming — you really couldn't get a decent black."[34]

1. With the exception of the Oriental New Seagull RP [RC] papers introduced in 1988–89, air-drying at room temperature (without a fan) produced the worst image quality of all the drying methods. The blacks were significantly degraded, and the surface gloss was somewhat sub-

dued (the reduction in surface gloss was quite pronounced with the earlier Kodak Polycontrast Rapid II RC Paper). Prints fixed in Kodak Rapid Fixer *with* the hardener added appeared slightly worse than those fixed without the hardener. With the exception of the Oriental New Seagull RP [RC] papers, this author considered all of these prints to be visually unacceptable. With respect to the veiling of the blacks and surface gloss characteristics, treating the prints with Kodak Rapid Selenium Toner as part of processing made no obvious difference in the appearance of the prints after drying.

2. Prints dried with the hair dryer (switched to the highest heat level) were hardly better than the prints dried at room temperature; with the exception of the Oriental New Seagull RP [RC] papers, all the papers were deemed visually unacceptable.

3. The Ilford 1050 dryer (replaced by the improved Ilford 1250 dryer in 1990) produced results that were far superior to the above methods on all papers. The blacks appeared to have no veiling whatever, and the surface gloss was very good. While the surface finish of the Oriental New Seagull RP [RC] papers was judged to be best when dried with the Ilford 1050 dryer, the improvement was surprisingly small when compared with Seagull RC prints air-dried at room temperature or with a hair dryer.

4. Prints processed and dried with an Ilford 2240 processor appeared identical to those dried with the Ilford 1050 dryer.

5. The Kodak Royalprint Processor Model 417 produced much better results than drying at room temperature or with an electric hair dryer, but the prints still exhibited some veiling and for this reason were not as good as those processed with the Ilford 1050 dryer or Ilford 2240 processor.

6. With glossy Ilford Multigrade II Paper, the Arkay RC-1100 dryer gave results similar to the Kodak Royalprint Processor — much better than room-temperature drying but not as good as results obtained with the Ilford units. The surface quality of pearl-surface Multigrade II Paper dried with the Arkay RC-1100 dryer was judged significantly inferior to the quality obtained with an Ilford 1050 dryer.

7. Regardless of how a print was originally dried, it could be re-wet and dried with an Ilford 1050 dryer to obtain the same excellent print quality of a print dried immediately after processing and washing. Conversely, prints dried with an Ilford 1050 dryer, Kodak Royalprint Processor, or an Ilford 2240 processor and then re-wet and slowly dried at room temperature had the identical degraded appearance of prints originally dried at room temperature.

This author has been unable to find any published account of the results of different methods of drying RC prints. Given the great differences obtained with different drying methods, this omission in the photographic press is remarkable. Surprisingly, Oriental has not promoted the superior drying characteristics of its RC papers, nor has the company revealed how it managed to solve the veiling problem with prints air-dried at room temperature.

Kodak, Ilford, and Agfa appear to have avoided discussion of this aspect of RC papers for fear that the many photographers who cannot afford to purchase a $2,000 print dryer might become discontented with RC papers. Ilford advertising literature says only that its infrared drying equipment produces "the best gloss in the industry." Kodak avoided the issue completely until 1991, when the company introduced the Polymax IR Processor as a replacement for its Dektomatic Processor. According to Kodak, "The [Polymax] processor is equipped with an infrared dryer that provides higher surface gloss than normal air dryers." Priced at $7,950, this is the first Kodak RC paper processor to use an infrared dryer (apparently licensed from Ilford).

In a conversation with this author, however, Barry Sinclair, Ilford's national marketing manager for monochrome products and systems, said that despite improvements in RC papers during the past few years, "Infrared drying, quite frankly, is still the only way to get a decent gloss."[35] (It may interest the reader that Ilford, an old-line British firm that had its beginnings in 1879, was purchased in 1989 by International Paper Company, a $10 billion American company based in Purchase, New York. Prior to being purchased by International Paper Company, Ilford was owned by Ciba-Geigy, a giant chemical and pharmaceutical firm headquartered in Switzerland.)

Discussing the matter with this author in 1987, *Popular Photography* magazine writer Bob Schwalberg noted that few home darkroom enthusiasts have access to an expensive infrared RC print dryer and, as a result, are "simply unable to make top-quality prints on RC papers because of the veiling of the blacks. Most of them are confused and discouraged by this and wonder if they are doing something wrong." Schwalberg said, "They really don't know what their problem is — their prints just don't look as good as they did with fiber-base papers."[36]

The Oriental New Seagull RP [RC] papers are likely to have great appeal to amateur photographers working in home darkrooms, and who generally do not have expensive infrared print dryers such as the Ilford 1250. These photographers must either air-dry prints or use a hand-held hair dryer to speed the process. The new Oriental RC papers for the first time allow these individuals to produce glossy RC prints with image quality that approaches that of glossy fiber-base papers.

Potential image and RC-base stability problems remain, however, and this author continues to recommend fiber-base papers for fine art prints and for all photographs of potential historical importance.

## Kodak Black-and-White RC Papers, Especially Kodak Polyprint RC Paper, Are Currently Recommended

Since 1974, and perhaps earlier, Kodak has been acutely aware of the stability problems of black-and-white RC papers and apparently has devoted considerable effort toward minimizing them. Kodak has also published *some* meaningful technical information on the properties of its RC papers and in recent years has made an apparently sincere, if low-key, effort to inform photographers of the

benefits afforded to displayed RC prints by protective toners. The other manufacturers have provided consumers with little or no meaningful information about the stability of their RC papers, and comparative data from independent sources are not available.

For these reasons — and if RC paper must be used because of time demands, such as with newspaper photography — this author currently recommends Kodak black-and-white RC papers. If, however, as previously discussed, a photographer does not have access to an Ilford 1250 RC dryer or other expensive RC print processing and drying equipment — and must air-dry prints at room temperature or use an ordinary hand-held hair dryer — the image and surface quality of Kodak RC papers may prove to be unacceptable. Should this be the case, Oriental New Seagull RP Paper and Oriental New Seagull Select VC-RP Paper are the only satisfactory alternatives (of these two Oriental RC papers, New Seagull RP paper, a graded RC paper, is recommended because it is made without a potentially stain-causing incorporated developer).

Included among current Kodak RC papers are:

**Polymax RC Paper** (conventional emulsion)
**Polyprint RC Paper** (conventional emulsion)
**Polycontrast III RC Paper** (developer-incorporated)
**Kodabrome II RC Paper** (developer-incorporated)
**Panalure Select RC Paper** (developer-incorporated)
**Premier II RC Paper** (developer-incorporated)

Kodak Polymax RC Paper and Kodak Polyprint RC Paper are particularly recommended by this author because the absence of an incorporated developer eliminates a possible cause of gradual brownish base-paper staining. The absence of an incorporated developer also allows a greater degree of control during development than is possible with Kodak papers such as Polycontrast III RC Paper (all Kodak RC papers with a "II" or "III" as part of the name are manufactured with a developer incorporated in the emulsion). Kodak Polymax RC Paper and Polyprint RC Paper also have a pleasing neutral image tone when tray processed with Kodak Dektol or a similar developer.

The preference for Kodak RC papers is based on admittedly scant data and could certainly change if any of the other manufacturers or an independent laboratory were to come forward with meaningful comparative test results. This author has made repeated inquiries to the major manufacturers about the stability of their respective products, examined numerous deteriorated RC prints, studied other available information closely, and believes that for now, at least, this is a valid recommendation.

### RC Papers Are Preferable to Fiber-Base Papers for Some Applications

It is recognized that the speed of processing possible with RC papers makes them indispensable in some applications. In newspaper photography, for example, tight deadlines *require* the fastest possible processing of prints. This author recalls the days when he worked as a part-time high school sports photographer for the now-defunct *Washington Daily News* in Washington, D.C. Back then, in the late 1950's and early 1960's, RC papers had not yet appeared. With fiber-base prints, the general practice at the

*Daily News* was to cut Kodak's recommended 1-hour wash time to only a minute or two — in a real rush, prints were sometimes rinsed for just a few seconds in hot water (although available, Kodak Hypo Clearing Agent was never used because the extra processing step was "too much trouble"). The prints were then dunked in a hygroscopic Pakosol "glossing-aid solution" which was always heavily contaminated with fixer from previous, poorly washed prints.

To dry the prints, they were placed on a heated Pako cloth-belt ferrotyping drum dryer with the temperature turned up as high as it would go without scorching the prints. Even if a print happened to become adequately washed (when it was left in the washer while the sports staff went out for a late-night hamburger, for example), it would subsequently reabsorb fixer from the stained and fixer-laden cloth dryer belt when the print was being dried.

In situations like this, RC papers offer a decided advantage, especially with machine processing. The conversion to RC papers means that photographs in newspaper collections will for the most part remain in good condition far longer than they once did. It is suggested, however, that newspapers, magazines, and in-house commercial photo labs using RC papers at least have the *capability* of properly processing and washing fiber-base prints when the need arises for a "special" print, intended for long-term display or for donation to a museum, for example.

### Black-and-White RC Papers Should Be Avoided by Museums, Archives, and Fine Art Photographers

In the fine art field, and for prints intended for museum or archive collections, this author *strongly* recommends that all black-and-white RC papers — including those made by Eastman Kodak — be strictly avoided. Instead, double-weight fiber-base papers, treated with a protective toner, should be selected. This is particularly important in the fine art field or in other applications where prolonged display of prints is even a remote possibility. Treatment of fiber-base papers with an image-protective toner such as Kodak Rapid Selenium Toner or Kodak Poly-Toner is an *essential* part of processing if the prints are to last as long as possible. Recommended high-quality, double-weight fiber-base papers[37] include (in alphabetical order):

**Agfa Brovira Paper**
**Agfa Insignia Fine Art Paper**
**Agfa Portriga-Rapid Paper**
**Agfa Record Rapid Paper**
**Fuji Museum Paper**
**Ilford Galerie FB Paper**
**Ilford Multigrade FB Paper**
**Kodak Elite Fine-Art Paper**
**Kodak Polyfiber Paper**
**Mitsubishi Gekko Paper**
**Oriental New Seagull G Paper**
**Oriental New Seagull Portrait FB Paper**
**Oriental New Seagull Select VC-FB Paper**
**Zone VI Brilliant Paper**

In 1976, apparently responding to concerns about the threatened demise of black-and-white fiber-base papers which had been expressed principally by David Vestal and Arthur

1981

David Vestal in the basement darkroom of his home in Bethlehem, Connecticut.  In a series of articles in **Popular Photography** magazine in the 1970's, Vestal raised serious questions about the stability and image quality of the then-new black-and-white RC papers.  A fine art photographer as well as a writer, Vestal was influential in persuading Agfa, Kodak, and Ilford not to abandon their black-and-white fiber-base papers (in 1976 Agfa-Gevaert had actually announced that it planned to discontinue all of its fiber-base papers).  Vestal's impassioned pleas helped convince Ilford to develop Galerie paper, introduced in 1978 — the first of the new, "premium" fiber-base papers.  Kodak followed with Elite Fine-Art Paper in 1984, and Agfa introduced Insignia Fine Art Paper in 1988.  Other excellent fiber-base papers include Oriental New Seagull G paper, Oriental New Seagull Select VC-FB paper, and Ilford Multigrade FB paper.

Goldsmith in a series of articles, editorials, and a poll of readers' views on the subject in *Popular Photography*,[38] Eastman Kodak said:

> Until extensive testing and natural aging data indicate that prints on resin-coated paper base can be expected to last as long as prints made on conventional paper base, black-and-white photographic paper without a resin coat will be produced by Eastman Kodak Company for those customers requiring long-term keeping under adverse storage or display conditions.[39]

The Kodak statement was printed again in 1978 in *Kodak B/W Photographic Papers*[40] and was also included in *Preservation of Photographs*, published in 1979 by Kodak.[41]

In the 1985 Kodak book *Conservation of Photographs*, the company stated:

> Recently there has been concern over the continued availability of [fiber-base] papers. Concurrent with the manufacture of black-and-

white RC papers, Kodak supplies a number of fiber-base products such as Kodak Elite Fine-Art Paper, Kodak Polyfiber Paper, Kodabromide, and Ektamatic Papers and will continue to provide the best products for photographic conservation purposes for as long as they are needed. Fiber-base papers are preferred for aesthetic reasons among many users of photographic papers.[42]

In their campaign to save fiber-base papers from extinction, Vestal and Goldsmith were concerned not only about the stability limitations of RC papers but also — reflecting the feelings of many of the world's finest photographers — about the decidedly inferior quality of RC papers versus the best fiber-base papers in terms of surface qualities, tone-reproduction characteristics, maximum density, and overall appearance of the image.

For an article published in 1977, Vestal interviewed a number of well-known photographers to get their views on the situation.[43] Ansel Adams told Vestal:

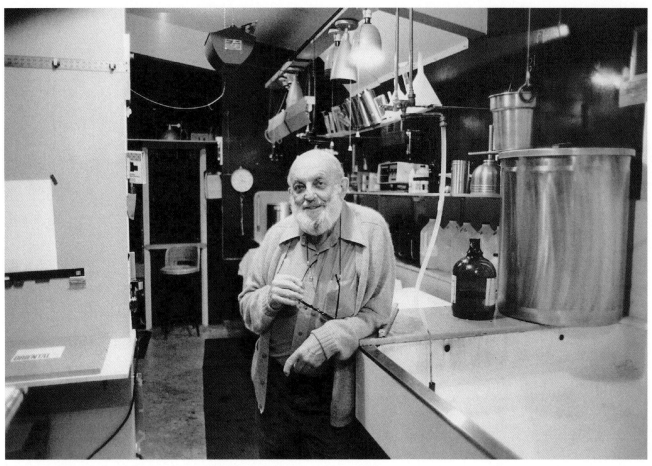

March 1981

Ansel Adams in the well-equipped darkroom in his home in Carmel, California.  Adams was a prolific printer, and with the help of several assistants, he continued to work up until the time of his death in 1984.

There is a definite deterioration in photographic paper.  It is partially surface quality and partially inherent defects.  It is heartbreaking to feel that the manufacturers are cutting down the availability of papers and apparently leading toward ubiquitous plastic-coated sheets.

. . . I am preparing a letter to the manufacturers very strongly protesting the RC papers, largely on the basis of impermanence.

Not only does fine creative work require permanence, but images of news character automatically become history and should be likewise treated archivally.

While my strong feelings about RC papers were substantiated by the telephoned expression of opinion by a person very high in the photographic manufacturing world (*not* Polaroid) [at the time, Adams was serving as a paid consultant to Polaroid], I think it is very important that we be absolutely sure of the permanency factor.  It would do our cause no good at all to find out that we had received bad advice.

W. Eugene Smith said: "If they go to the plastic papers, I think I will give up photography. . . . I'm also limping along with Polycontrast [fiber-base paper].  I can use it, but I don't like it.  The paper is gray, and the surface doesn't have the brilliance it used to.  I can no longer get the feel of cloth in the prints . . . . About the RC paper: it turns my stomach — and you can quote me on that."

Paul Caponigro wrote:

Until roughly 10 years ago, a photographer could print on a wide variety of silver papers with beautiful surfaces and good working characteristics.  Since then, the papers have steadily degenerated.  My own experience is that they are becoming unyielding and difficult to manipulate.

Each year, more of our remaining decent papers lose in quality, while others disappear.  Today the situation is desperate.  A bare minimum of usable papers remains.  For the last six months I have found myself telephoning all over the United States and Canada trying to locate any leftover stocks of good discontinued papers on photo dealers' shelves.

The replacements for the fine silver papers we have known are of course plastic-coated papers.  Blech!  I personally find them affronting: textureless, scaleless, and lifeless.  I am told they will not even last.

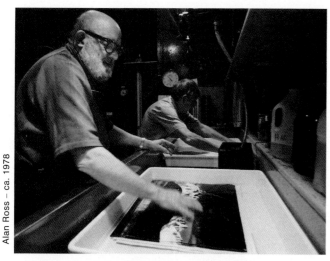

Alan Ross – ca. 1978

Adams popularized the use of Kodak Rapid Selenium Toner to intensify the blacks and darker tones of fine art prints while at same time affording significant protection to the silver image from the damaging effects of air pollutants and other contaminants, thereby giving the prints added permanence.

March 1981

Bottles of Kodak Rapid Selenium Toner in Adams's darkroom. This large store of toner concentrate is evidence of the volume of his print production.

Beauty is an important part of expression and communication. I think it a great pity to lose it, and a sad commentary on the producers of photographic papers that mediocrity and commodity should take precedence over excellence.

At the conclusion of his interview article, Vestal asked the readers of *Popular Photography*, "What do you think? I hope to hear from you, and I hope the photo industry hears from you — in no uncertain terms."

## Ilford Introduces Galerie Paper

The following year, 1978, Ilford introduced Ilfobrom Galerie Paper (now called Ilford Galerie FB Paper), the first of a new generation of expensive, "silver-rich" fiber-base papers intended for those specialized markets for which the best visual quality and longest-lasting black-and-white prints are more important than convenience and price. The paper is supplied in only two surfaces — and only on double-weight paper base.

Ilford's decision to develop and market Galerie paper came in direct response to the campaign by David Vestal in the U.S. and Jean Dieuzaide in Europe to prevent the demise of "quality, high-silver-content" fiber-base papers.

Under the direction of Jacques Regent, Ilford's assistant product manager for monochrome products and systems, work on Galerie began soon after the "summit conference" between Dieuzaide and his supporters and representatives of the photographic manufacturers in the summer of 1977 at the international fine art photography conference in Arles, France.[44] Regent had attended a number of the annual Arles gatherings and had become aware firsthand of the sensitivities and expectations of fine art photographers. Prototypes of Galerie were demonstrated with rave reviews at Arles the following year, and the new paper was formally introduced at the Photokina trade show in Germany in September 1978.

Galerie soon became one of the favorite papers of Ansel Adams, who said: "This is a paper of very high quality which I use extensively. . . . It tones differently from any other paper I have used. Most papers intensify somewhat [in Kodak Rapid Selenium Toner], but Galerie does so to a greater extent, and without the marked color change that occurs with other papers. This ability to acquire some intensification during toning is a rewarding refinement of value control."[45]

In response to the renewed demand for high-quality fiber-base papers, Agfa-Gevaert — which in 1976 had actually announced plans to discontinue all of its fiber-base papers — took steps to correct the poor quality-control that for some years had plagued its popular Brovira and Portriga Rapid fiber-base papers and devoted more effort to marketing these products.

During this period, Oriental New Seagull G Paper, advertised by its Japanese manufacturer as the "World's Finest Baryta Paper for Exhibition Prints," also became popular with many fine art photographers. Brett Weston, whose work has been featured in advertisements for Oriental, said, "Quite simply, the best paper I've ever used." Ansel Adams stated: "This paper has had exceptional quality and consistency. It tones very well in selenium. . . . I have

March 1981

The paper-storage cabinet in the print-finishing room out-side of Ansel Adams's darkroom. When this photograph was taken in 1981, Adams was using Ilford, Agfa-Gevaert, and Oriental papers to make his prints. He had largely abandoned Kodak papers because of their inferior image quality. Discussing the merits of various papers with a visiting photographer is John Sexton, Adams's technical assistant. Sexton later served as a paid consultant to Kodak in the development of Elite Fine-Art Paper, and his photographs appeared in advertisements promoting the product after its introduction in 1984.

found that Seagull Grade 4 gives me a better print of my *Frozen Lake and Cliffs* than I was able to get on Agfa Brovira Grade 6, and the tone is magnificent."[46]

Zone VI Studios, a small mail-order company in Vermont run by Fred Picker, a photographer and workshop teacher, has been importing a premium-quality, double-weight fiber-base paper made by the French firm of R. Guilleminot Boespflug & Cie; the paper is sold under the Zone VI Brilliant name.[47]

## With Well-Known Photographers Abandoning Its Fiber-Base Papers, Kodak Finally Becomes Concerned

During the 1970's, Eastman Kodak had concentrated its efforts in the expanding black-and-white RC and color RC paper markets, and by 1980 found itself in the rather embarrassing position of having the worst fiber-base papers — from an aesthetic point of view — of any major photo-

graphic manufacturer in the world. Serious fine art photographers and top commercial printers had almost entirely deserted Kodak and switched to fiber-base papers supplied by Ilford, Agfa, and Oriental. For much of its long history, Kodak had prided itself on producing "the best of everything," and many Kodak employees seemed genuinely pained by this unexpected turn of events.

It was against this background that Kodak in late 1983 introduced Polyfiber Paper, an improved version of Polycontrast fiber-base paper, and, in 1984, Elite Fine-Art Paper, a premium-quality, premium-priced, graded, "silver-rich" fiber-base paper. Kodak hired John Sexton, a former technical assistant to Ansel Adams and a well-known photographer in his own right, to give the company's emulsion scientists and engineers advice on aesthetic considerations in the design of Elite Paper. Kodak later featured Sexton's photographs in advertisements promoting the new product. Said Kodak:

Our goal with Elite fine-art paper was simple: create the best fine-art black-and-white paper requested by some of the world's best printmakers.

Elite fine-art paper had to be so superior that its very touch stated there was no equal. So before we went to the lab, we went to users like you. People who are very serious about black-and-white photography and have the reputations to go with it. They told us what they wanted in the ultimate paper. We listened. Now, more than two years and untold hours of research and refinement later, we're ready.

Whites and blacks are nothing short of superb. Images are alive. There is a richness of image that cannot be described. It's the brightest paper we've ever made. The emulsion delivers extraordinary exposure latitude: up to 240 seconds to control development. The extra-thick, fiber-base paper is a hefty 13.2 mils — heavier than double-weight. That means easier handling, less curl, better mounting.[48]

Eastman Kodak also stated: "With the recommended processing, Elite Paper has excellent image stability under normal storage conditions — the best of any paper we have made."[49]

## Display Illumination Levels for Photographs

Very low illumination levels of about 50 lux have often been suggested for museum display of light-sensitive objects such as watercolors, textiles, and color photographs; suggested illumination levels for more stable materials such as oil and tempera paintings are about 200 lux.[50] In the 1986 Kodak book *Care and Identification of 19th-Century Photographic Prints*, author James Reilly concurs with the 50-lux recommendation for the more light-sensitive types of 19th-century prints, adding that only incandescent tungsten illumination is acceptable.[51]

Offering the opinion that "photographic prints can be adequately seen and appreciated when illuminated at the 50-lux level," Reilly recommends 50-lux illumination for the display of albumen prints as well as all 19th-century

February 1983

The main exhibition area for photographs at the Art Institute of Chicago employs incandescent tungsten track lights in the center of the room and recessed ceiling lamps along the outside walls. The vertical display panels can be rearranged to accommodate different exhibitions.

photographic print materials that have exposed paper fibers on the image side (among these are salted paper prints, gum bichromate prints, cyanotypes, platinotypes, and carbon prints). For 19th-century prints with baryta coatings, including gelatin printing-out and developing-out papers, and collodion printing-out papers, Reilly suggests that the illumination level not exceed 100 lux. Reilly points out, however, that "these illumination levels have not been experimentally established for each print process, but are extrapolated from the recommendations for works of art on paper and from experience with the individual components of prints rather than from the photographic materials themselves."

Most museums have light-level specifications to which they expect borrowing institutions to adhere; the limit of 50 lux of incandescent tungsten light, UV-filtered daylight, or UV-filtered fluorescent light is commonly specified. Enforcement of lighting specifications is often rather lax, however, and it has been observed that some museums routinely display photographs in lighting levels and environmental conditions which exceed their own lending-policy recommendations; indeed, some museums and archives have not even established formal lighting and environmental guidelines for exhibiting photographs.

Brian Coe — who was curator of the Kodak Museum in Harrow, England before Kodak closed the museum in 1984 and donated its collection to Britain's new National Mu-

seum of Photography, Film, and Television in Bradford — has reported that the Kodak Museum once loaned some vintage Dufaycolour transparencies for a 6-week exhibition in Cologne, West Germany; by the time they were returned they had faded severely.[52] Coe said the transparencies were back-illuminated on light boxes equipped with bright fluorescent lamps.

## 300 Lux Tungsten Illumination Is Recommended for Museums, Archives, and Galleries

This author believes that even under the most favorable viewing conditions, 50 lux is simply too low for proper visual appreciation of most color and black-and-white photographic images. At low illumination levels, details in the darker areas of a print are perceived improperly or in some instances are completely obscured, color saturation is reduced, and the apparent brightness range of the print is lowered. The perception of color in darker parts of a print may be eliminated altogether. In a 1986 publication, Eastman Kodak stated:

The intensity of the light source influences the amount of detail that can be seen in a print. For good viewing, a light source should provide an illuminance of 1,400 lux +/– 590 lux.[53]

However, an illumination level of 1,400 lux — which approximates the most intense illumination ever encountered by this author in a tungsten-illuminated display area — causes fairly rapid fading of most types of color prints and cannot be recommended for museum applications. Examination of color and black-and-white prints on display in a wide variety of museum, gallery, and other display situations has led this author to conclude that, with incandescent tungsten flood lamps which concentrate light in the general area of the displayed prints (and if no windows or other sources of bright light are present), an illumination level of about 300 lux is a good compromise between adequate illumination for viewing and for minimizing the rate of fading. Short of total darkness, there is no level of illumination that is so low that no light fading occurs.

From the point of view of a museum, only UltraStable Permanent Color prints and Polaroid Permanent-Color pigment prints are sufficiently stable to permit permanent display. Fresson Quadrichromie prints, which have some significant shortcomings in terms of sharpness and accurate color reproduction — and which are produced only for a limited clientele in France — are also very stable and can tolerate prolonged display. As yet, however, very few UltraStable, Polaroid Permanent-Color, or Fresson Quadrichromie prints are found in museum collections; the great majority of color photographs are on much less stable materials such as Ektacolor, Fujicolor, Dye Transfer, and Ilfochrome (Cibachrome). For these prints, one should opt for short-term display at light levels high enough for proper visual perception. For the remainder of the time, the prints should be kept in the dark, and, if the material requires it, refrigerated in humidity-controlled conditions.

Infrared heating of prints by tungsten light at a level of 300 lux is not significant in most wall-display situations. Higher levels of tungsten illumination (in excess of 1,000 lux) are usually accompanied by significant infrared heating of the print emulsion and support; this results in dehydration and can produce physical stress in the emulsion which may in time cause cracks or other types of damage. In high-intensity applications, Cool Beam PAR (Parabolic Aluminized Reflector) lamps or special types of low-infrared quartz halogen equipment, or glass infrared filters over conventional lamps, can reduce heating effects by two-thirds or more.

If a luxmeter[54,55] is not available for light-level measurements, a single-lens reflex camera with a through-the-lens meter can be used to indicate the proper light level. Place a white sheet of paper in the same location and plane where prints are to be viewed and adjust the camera's ISO setting to 100 and the shutter speed to $1/30$ second. Locate the camera so the white paper fills the entire viewfinder, being careful not to cast a shadow on the paper. A light intensity of 300 lux will register an exposure of about $1/30$ second at $f$4.0.

Ansel Adams had recommended a light level significantly higher than 300 lux for proper viewing of prints:

> Although personal preference is a factor, I have found illumination levels of 80 to 100 ft-c [860–1,076 lux] at the print position to be agreeable if the walls and general environment are of a middle value.[56]

## Eastman Kodak's Recommendations

Eastman Kodak Company generally recommends display illumination levels of 538 to 1,400 lux for both black-and-white and color prints. Until recently, the fading of color prints as a function of light intensity was not mentioned in most of the company's publications; where it has been discussed, Kodak's recommendations have generally been similar to this advice, given in a 1992 Kodak information sheet for Ektacolor Portra II Paper:

> Evaluate prints under light of the same color and brightness that you will use to view the final prints. A good average viewing condition is a light source with a color temperature of 4000 ± 1000 K, a Color Rendering Index (CRI) of 85 to 100, and an illuminance of at least 50 footcandles (538 lux).
> ... Illuminate prints with tungsten light whenever possible. Display prints in the lowest light level consistent with your viewing needs.
> ... Keep the temperature and humidity as low as possible.[57]

## ANSI Recommendations for Viewing and Exhibiting Color Prints

*ANSI PH2.30-1985, American National Standard for Photography (Sensitometry) – Viewing Conditions – Photographic Prints, Transparencies, and Photomechanical Reproductions* makes illumination recommendations for "judging and exhibiting photographic reflection prints in competitions, salons, and other exhibitions":

> **Illuminance.** The illuminance at the center of the print surface shall be 800 lux +/– 200 lux and the luminance at the edge of the print shall be at least 60% of that at the center.

> **Spectral Power Distribution.** The spectral power distribution should [have] a correlated color temperature between 3000°K and 5000°K. The higher color temperature should be used [if possible]. Light of the same correlated color temperature shall be used for both judging and exhibiting.

> **General Color-Rendering Index.** The general color-rendering index of the light illuminating the prints shall be 85 or greater. . . .

> **Surround.** If the print is not associated with a given surround by a mat or mount, it shall be viewed against a gray background extending beyond the print on all sides at least one-third the print dimension in the same direction. If the print is associated with a given surround by mounting, it shall be judged and exhibited as mounted against a gray background extending beyond the mount on all sides at least one-fourth the mount dimension in the same direction. The surround should be spectrally nonselective and have a reflection density greater than 0.20.

© 1975 by Jan Saudek  (Courtesy of Anne and Jacques Baruch of the Jacques Baruch Gallery, Chicago, Illinois)

This photograph by Jan Saudek, a Czechoslovakian artist, was printed with Kodak Polycontrast Rapid RC Paper in 1976. Introduced in 1972, this was Kodak's first general-purpose black-and-white RC paper. The print was framed under glass and after about 5 years of display it began to develop small reddish-orange spots in the image areas exposed to light (note that the outer edges of the print, which were protected from light by an overmat, are free of discoloration). This type of "self-destructive" oxidation of the silver image is caused by peroxides and other oxidants that are generated in the titanium-dioxide-pigmented polyethylene layer under the emulsion in RC papers; the reaction is initiated by exposure to light (see discussion beginning on page 581). Discoloration of this type does not occur with fiber-base prints. The Saudek print was sold by the Jacques Baruch Gallery, a Chicago gallery established by Jacques and Anne Baruch to exhibit the work of Eastern European artists. The print was returned to the gallery after the discolorations began to appear. By 1980, when the Baruchs learned the full scope of the RC paper problem, the gallery had sold more than 200 of Saudek's Polycontrast RC prints. Sale of the prints was immediately halted, and Saudek, who had printed much of his work from the early 1970's with Kodak Polycontrast RC paper, switched to fiber-base paper.

1983

A magnified view of the reddish-orange colloidal silver "microspots" that were caused by exposure of the Kodak Poly-contrast RC print to light during display.

Henry Wilhelm – October 2, 1977

After 5 years of display, this Kodak RC print had formed reddish-orange "microspots" over its entire surface. The print was made by this author in 1977 with Kodak Poly-contrast Rapid RC Paper purchased in 1974.

Light-induced image deterioration of black-and-white RC prints is usually characterized by reddish-orange or yellowish discolorations that are concentrated along image-density gradients. In the magnified view above, the severe discoloration that occurred on the fire hose on the left side of the picture is clearly evident. Discolored RC prints frequently exhibit surface silver-mirroring, which can be observed by viewing specular reflections from the surface of a print held at an angle to the light source. The photograph, at the left, of a fire that destroyed the Vosburg lumber yard near this author's home in Grinnell was printed with the "initial type" Polycontrast Rapid RC Paper introduced by Kodak in 1972. Sections cut from duplicate prints that had been processed together in 1977 were used in the author's accelerated light-exposure tests described on page 583. These tests revealed that there is an extremely large reciprocity failure in short-term, high-intensity image-discoloration tests with RC papers. Even very low illumination levels can — over a period of several years — be sufficient to initiate the reactions that cause discoloration of the silver image in black-and-white RC prints.

August 1982

The black-and-white portrait (at the right) of Queen Elizabeth II and her husband, Prince Philip, Duke of Edinburgh, was presented to the people of Canada by Queen Elizabeth while she was visiting the country in October 1977 as part of her worldwide Silver Jubilee Tour, which commemorated her 25th anniversary on the throne. After only a few years of display at the National Archives of Canada in Ottawa, the photograph began to exhibit serious orange-brown discolorations in the silver image. In the photograph above (at the far left), studying the print, is Klaus B. Hendriks, the director of conservation research at the National Archives.

The framed and inscribed photograph, which is believed to have been printed with Ilford RC paper in 1976 or 1977 by Her Majesty's Stationery Office in England, was removed from public display because of the light-induced discoloration of the silver image and is now in storage at the Archives.

**Geometry of Illuminating and Viewing.** The lighting and print shall be positioned so that the amount of light specularly reflected toward the eyes of an observer on or near the normal to the center of the print is minimized. This may be achieved by placing the light source or sources 45° off the normal to the print surface.[58]

*ANSI PH2.30-1985* is mostly concerned with illumination factors which influence color and tone perception. The Standard was written primarily for the graphic arts industry, and the illumination recommendations were arrived at apparently without consideration of the deleterious effects high light levels have on the stability of color prints. The section of the Standard quoted above is intended primarily for photography contests and short-term exhibitions and does not directly address the concerns of museums and archives. (It should be noted, however, that at one time ANSI recommended a higher illumination level for exhibit judging and display. The now-obsolete *ANSI PH2.41-1976, American National Standard Viewing Conditions for Photographic Color Prints* specified an illumination level of 1,400 lux,[59] which Eastman Kodak currently recommends for "critical viewing," and which is nearly double the 800 lux recommendation given in the current ANSI Standard.)

The main purpose of *ANSI PH2.30-1985* is to specify "standard" illumination conditions so that everyone involved with a publications project — photographers, art directors, editors, color separators, printers, and buyers of printing — can evaluate under *uniform* illumination conditions the color balance and density of original photographs, pre-press color proofs, and reproductions when a job is on press.

For graphic arts applications, the Standard specifies two illumination and viewing conditions "for critical appraisal of photographic reflection color prints and the comparisons of such prints with the original objects photographed or with reproductions." Light sources with a correlated color temperature of 5000K and a color-rendering index of more than 90 are specified:

**2000-Lux Level.** For critical appraisal of the colors of reflection prints . . . when it is desirable to see detail in the darkest tones . . . the illuminance at the center of the print surface shall be 2000 lux +/– 500 lux as measured with a cosine-corrected illumination photometer.

**500-Lux Level.** For critical appraisal of the tone reproduction and colors of reflection prints . . . when it is desirable to judge the way the print would look in what would be considered a brightly illuminated area in a residence, office, or library, the illuminance at the center of the print surface shall be 500 lux +/– 125 lux, as measured with a cosine-corrected illumination photometer.

Special photograph evaluation areas with illumination conforming closely to the 2000-lux condition specified in the Standard are provided in most graphic arts color separation houses and printing plants. The 500-lux illumination level is often used by color labs for evaluating por-

traits, wedding pictures, snapshots, and other photographs that will be displayed in customers' homes and offices.

## Printing Photographs for Display

It is critical that the light for viewing prints in the darkroom be of the same spectral quality — and intensity — as that in which the prints will be displayed. The relative ultraviolet component of the light source is also important, because of its effect on the fluorescent brighteners incorporated in the base material of all current black-and-white papers (because of UV-absorbing emulsion layers to minimize UV-caused fading, and for other technical reasons, most color print materials do not contain active fluorescent brighteners on the emulsion side). In addition, the "surround," or the walls and other conditions in the darkroom or workroom viewing area, should be of approximately the same brightness and color as that of the intended display area. Eastman Kodak has offered the following suggestions:

**Display Light Level:** The quality of prints made for display must be adjusted for the illumination level under which they will be displayed. The eye has a variable response to tones that depends on the level of ambient illumination.

If a gray scale that has even density steps is viewed under a normal interior light level of 50 to 100 footcandles [538 to 1,076 lux], the eye sees the steps between the light tones as larger than steps between the dark tones. As the light level is reduced, the steps between the darkest steps disappear, while the tone separation between the light steps seems to grow larger. Under very low light levels, such as the light given by a full moon, only the light steps will be visible; all the medium-gray and dark gray steps will look black.

On the other hand, if the gray scale is taken out into the full sun, the separation between two dark steps appears greater, while the tonal separation between the light steps appears to lessen.

This means that prints made for display under high levels of illuminance should have slightly greater densities overall, while prints made for display under relatively low levels of illuminance should be somewhat lighter, overall, than normal.

Good highlight rendition is important in all prints, and especially in prints for high illuminance display. The diffuse highlights should have enough tone so that they will not "wash out" when displayed.[60]

Color prints often appear to have significantly different color values when viewed under incandescent tungsten, fluorescent, or daylight illumination. Some types of materials show this effect more than others. In this author's experience, the appearance of Ilford Ilfochrome (Cibachrome) and Polaroid Polacolor 2 and ER prints in particular can be substantially altered when viewed under different types of light sources; most fluorescent lamps produce particularly

November 1985

Guy Stricherz, Kurt Rowell, and Karen Balogh of CVI Color Lab in New York City. Incandescent tungsten lamps were installed over the print-evaluation area in order to simulate an average museum display condition. CVI specializes in making Kodak Dye Transfer prints for fine art photographers. Most commercial labs evaluate color prints under fairly intense illumination from 5000K wide-spectrum fluorescent lamps, as recommended in **ANSI PH2.30-1985.** This is very different from the lower intensity and lower color temperature of the tungsten illumination found in most museums and galleries.

unpleasant effects. The altered appearance of color prints when viewed under different light sources is related to the spectral absorption characteristics of the cyan, magenta, and yellow dyes in the color image and to the spectral energy distribution of the particular light source. (For a discussion of the influence of different spectral sources on the appearance of oil paintings, see the informative article by Roy S. Berns and Franc Grum entitled, "Exhibiting Artwork: Consider the Illuminating Source."[61]) The image tone of black-and-white prints also varies when viewed under different types of illumination — this is especially true when the prints have been treated with Kodak Rapid Selenium Toner or other toners.

Unlike tungsten lamps and daylight, most fluorescent lamps produce light of irregular spectral distribution marked by a number of energy peaks in the narrow spectral bands of the mercury vapor discharge. The peak output of the widely used Cool White fluorescent lamp is in the green portion of the spectrum, with comparatively little red emission; the lamp also has pronounced mercury vapor emissions at 436 nanometers in the blue part of the spectrum, and at 546 and 578 nanometers in the green region. One result of this is that reds are "dulled" and appear to be much less saturated than when viewed with tungsten, daylight, Chroma 50 fluorescent, Deluxe Cool White fluorescent, or other "full-spectrum" fluorescent illumination.

### Illumination for Evaluation of Prints for Gallery and Museum Exhibition

In the case of prints intended for museum and gallery display, it can be assumed that incandescent tungsten or glass-filtered quartz halogen lamps — usually of the reflector flood type — with a color temperature of 2800–3200K will be used for illumination.

It would benefit both photographers and museums if the major collecting institutions would agree on a "standard"

display condition in terms of intensity, spectral energy distribution, lighting geometry, and characteristics of the surround, so that people making prints could evaluate them in the darkroom under the specified lighting conditions. This would be similar in concept to the previously mentioned *ANSI PH2.30-1985* Standard for the graphic arts and printing industries — though the specified viewing conditions for museums would of necessity be different.

For such a museum standard, this author suggests incandescent tungsten or glass-filtered quartz halogen illumination with an intensity of 300 lux on the surface of prints. Lights should be placed above displayed prints at a 30–45° angle. Windows or other extraneous light sources should be avoided. Walls or other backgrounds in display areas should be of a light, near-neutral, or gray color, with a reflection density of 0.15–0.30. Floors should be darker than walls.

UltraStable Permanent Color prints, Polaroid Permanent-Color prints, and black-and-white fiber-base prints treated with a protective toner (e.g., Kodak Rapid Selenium Toner or Kodak Poly-Toner) could of course be safely illuminated at levels much higher than 300 lux, but since most museum collections consist of photographs made with a wide variety of processes, including albumen and other 19th-century processes, untoned silver-gelatin prints, and many types of contemporary color prints, it usually is impractical to alter the display lighting every time an exhibition is changed.

### The Effect of Display Lighting on Fluorescent Brighteners in Prints

Virtually all current black-and-white photographic papers have fluorescent brighteners added to the paper base (and the emulsion-side baryta coating on fiber-base prints) to give the appearance of added whiteness in many lighting conditions. UV radiation causes these brighteners to

fluoresce in the visible portion of the spectrum, primarily in the blue region. If relatively little UV radiation is present, as is the case with conventional tungsten lamps or with UV-filtered fluorescent or UV-filtered daylight, the prints may appear to be subtly yellowish and less brilliant — somewhat "dull" is a good way to describe it.

The use of fluorescent brighteners in photographic papers is a fairly recent innovation. Ilford and Agfa began incorporating brighteners in their fiber-base and RC papers in the late 1970's, and Kodak started using fluorescent brighteners in RC papers at about the same time. But it was not until the 1983 introduction of Polyfiber paper that Kodak marketed a general-purpose fiber-base paper with a fluorescent brightener (Kodak Ektamatic SC Paper, a fiber-base paper intended for "stabilization" processing, has contained a fluorescent brightener since the mid-1970's, and perhaps earlier). Kodak Elite Fine-Art Paper, introduced in late 1984, also contains a fluorescent brightener. Kodak Polycontrast and Polycontrast Rapid fiber-base papers, which were replaced by Polyfiber paper, did not have fluorescent brighteners. Kodabromide, a graded-contrast fiber-base paper which has been manufactured by Kodak for a great many years, has to this author's knowledge never contained a brightener.

In a study of the effect of washing times on loss of fluorescent brighteners from black-and-white fiber-base and RC papers, Richard J. Henry reported that the brighteners in both types of papers were progressively leached out in the course of washing; depending on the type and brand of paper, the loss of brightener could be considerable with extended washing times.[62]

This author's accelerated light-exposure tests with Kodak Elite Fine-Art Paper also show that the brighteners gradually lose their ability to fluoresce during exposure to light and UV radiation on prolonged display.

Many modern artists' papers used for drawings and watercolors are manufactured with strongly fluorescing incorporated brighteners (in the paper manufacturing industry, fluorescent brighteners are sometimes called *optical bleaches* or *blancophores*).

Most color papers do not have *functioning* fluorescent brighteners in the base paper on the emulsion side because the UV-absorbing layers in their emulsion structure prevents the brighteners from fluorescing; brighteners found in the base paper of most RC color print materials are included only to make the backsides of the prints appear to be a brighter white (or possibly to allow the same RC base paper to be used with both color and black-and-white print materials).

In an attempt to partially compensate for the lack of a fluorescing base material, Kodak Ektaprint 2 Developer and similar color developer solutions for chromogenic papers, such as Ektacolor Professional Paper, contain a fluorescent brightener which mordants to the emulsion during development. Some of the brightener is lost in subsequent processing and washing steps, but enough remains to somewhat brighten the whites of the prints. There are limits to how much brightener can be used in this fashion — since the brightener is diffused into the emulsion itself (and is not located *underneath* the emulsion, as in the case of a base paper with brighteners), too much brightener would degrade the darker colors and blacks of a print.

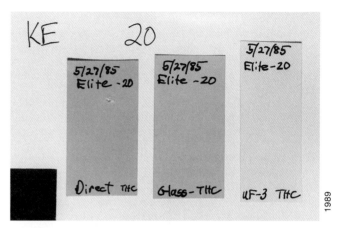

Samples of Kodak Elite Fine-Art Paper subjected to an accelerated fluorescent light test. After 100 days of exposure to 21.5 klux illumination (equivalent to about 25 years of display under average conditions — see Chapter 2), the fluorescent brighteners in the paper had lost considerable activity and the paper appeared perceptibly less brilliant. Of the three samples, the one on the left was exposed to bare-bulb illumination; the sample in the center was covered with glass during the test; and the sample on the right was covered with Plexiglas UF-3, a UV filter. The background is a freshly processed sheet of Elite paper, with full brightener activity. To illustrate the loss of brightness after the 100-day test, the samples were photographed under UV illumination. (Under normal illumination with visible light, the differences do not appear to be nearly as great, but are nevertheless readily discernible.) The development of more stable, longer-lasting brighteners would be a significant improvement in black-and-white papers.

Kodak Dye Transfer prints made with Kodak Dye Transfer Paper do not have UV-absorbing layers but at the time this book went to press in 1992, the paper continued to be manufactured with little or no fluorescent brightener. (In 1988 Kodak trade-tested an "improved" product called No. 45203 Dye Transfer Receiver Paper that incorporated an improved dye mordant for greater image sharpness and also had an effective UV-absorbing emulsion overcoat; however, difficulties in chemically bleaching the dyes in the course of retouching led Kodak to abandon the product.)

The ultraviolet component of a "standard" museum display illumination must be precisely defined — both for conservation reasons and because of the different visual effects various levels of UV radiation have on fluorescent brighteners. Incandescent tungsten lamps emit a relatively small amount of UV radiation and have less of an effect on the fluorescent brighteners found in many artists' papers and photographic materials than daylight or fluorescent illumination (glass-filtered fluorescent lamps have a strong mercury vapor emission line at 365 nanometers which effectively excites fluorescent brighteners).

To further complicate matters, at a given illumination level, glass-filtered quartz halogen lamps typically emit approximately twice as much UV radiation as incandescent tungsten lamps. Thus, the whites and lighter tones of prints made on papers containing fluorescent brighteners, such as Kodak Elite Fine-Art Paper, for example, look noticeably brighter when illuminated with a glass-filtered quartz

halogen lamp than they do when illuminated with a conventional incandescent tungsten lamp of the same color temperature. If the lamps are fitted with Plexiglas UF-3 filters, the fluorescent brightener in the paper will not be activated and the prints will appear the same under both light sources.

Contrary to assertions by Kodak[63] and some others that incandescent tungsten illumination does not contain sufficient UV radiation to activate fluorescent brighteners, this author's examination of prints made on a variety of papers under daylight, fluorescent, and incandescent tungsten illumination left no doubt that tungsten illumination *does* visibly activate fluorescent brighteners. In the tests, some of the papers, including Kodak Elite Fine-Art Paper, contained brighteners while other papers did not. When the tungsten illumination was filtered with UF-3 to remove the ultraviolet component, the reduced "brightness" of the papers containing fluorescent brighteners was readily apparent. The visual appearance of Polycontrast and other non-brightened papers was not affected by the UF-3 filter.

### Display Lighting — Incandescent Tungsten Lamps Are Recommended

Common incandescent tungsten 75-watt (75R30/FL) or 150-watt (150R/FL) internal reflector flood lamps are quite satisfactory for illuminating black-and-white and color photographs. The more expensive heavy-glass, internal-reflector PAR (Parabolic Aluminized Reflector) lamps, available in sizes from 40 watts to 150 watts, are supplied in a variety of beam-spread configurations (including several Cool Beam reduced-infrared types) and are equally satisfactory. With proper fixtures, conventional lamps without built-in reflectors can also be used. At a given level of illumination, incandescent tungsten lamps have a lower ultraviolet output than any other common light source, so there is little necessity for UV filters when using tungsten lamps to illuminate most types of photographs framed under glass.

With most organic materials, other things being equal, ultraviolet radiation and short-wavelength blue light are more harmful than the longer wavelengths in the green and red portions of the spectrum. Because of their relatively low ultraviolet radiation and blue light output, incandescent tungsten lamps are almost ideal from a general conservation point of view. Even though incandescent tungsten illumination has a low color temperature and a decidedly orange-red color balance, most people have lived with tungsten illumination all their lives and generally accept it in homes — as well as in museums.

It should be noted, however, that certain color photographic materials have cyan dyes which fade *more rapidly* when illuminated with tungsten lamps than they do with common fluorescent lamps of the same lux intensity. Ilford Ilfochrome (Cibachrome) print materials, Fuji FI-10 and 800 Instant Color Films, the obsolete Agfachrome-Speed reversal print material (marketed 1983–1985), and the initial versions of Kodak PR10 Instant Prints introduced in 1976 are among those materials that fade more rapidly under tungsten illumination.

For example, in Ilford Ilfochrome print materials, the fading rate of the cyan image dye is significantly increased when illumination comes from tungsten light instead of Cool White fluorescent lamps at the same intensity. That this is true can almost certainly be attributed to the higher relative red light output of tungsten lamps compared with the most widely used fluorescent lamps (e.g., Cool White lamps made by a variety of manufacturers). Cyan dyes have an absorption peak in the red portion of the spectrum; and with the cyan dye in Ilfochrome, this absorbed energy causes fading (UV radiation and other visible wavelengths also contribute to fading of the Ilfochrome cyan dye). Most of the literature concerned with dye fading suggests that the photochemical energy of red light is so low as to cause little or no damage to organic materials; with regard to some of the dyes used in color photography, this belief is obviously not correct. For further discussion of spectral influences on color print fading, see Chapters 2 and 3.

### Quartz Halogen Lamps Are Also Satisfactory If Properly Filtered

Unlike incandescent tungsten lamps, bare-bulb quartz halogen lamps have a very high UV output, extending even below 250 nanometers, and should always be fitted with heat-resistant glass or UV filters. Exposure of skin to high-intensity quartz halogen lamps without a glass filter can cause reddening (sunburn). Even a glass-filtered quartz halogen lamp emits almost twice as much UV radiation in the 350–400 nanometer region as an unfiltered incandescent tungsten lamp. In terms of the deterioration of black-and-white photographs, gelatin, artists' papers, fabrics, and other organic materials, the significance of this difference in UV radiation levels is not yet known. The greater ultraviolet output of glass-filtered quartz halogen lamps is probably of little consequence in terms of the fading rates of Ektacolor, Fujicolor, Konica Color, Agfacolor, and most other current color print materials.

Quartz halogen lamps have tungsten filaments in a quartz envelope containing a halogen along with normal gases to fill the lamp. The lamps are made of quartz rather than glass because the very high internal operating temperatures (generally over 480°F [250°C]) can soften or melt ordinary glass. During operation of the lamp, the hot tungsten filament slowly evaporates; the tungsten vapor combines chemically with the halogen gas which then migrates back to the filament, where the high temperature causes it to decompose, redepositing the tungsten on the filament. This constant redeposition of tungsten on the filament prevents the lamp from darkening (which would occur if evaporated tungsten were deposited on the lamp envelope) and maintains a fairly uniform output and color temperature (typically with a drop of only about 50K) over the life of the lamp.[64] Quartz lamps, however, and most of the fixtures in which they operate, are expensive compared with incandescent tungsten lamps and fixtures.

Quartz halogen lamps last up to twice as long as conventional tungsten lamps, do not suffer a significant drop in light output during the life of the lamp, generate less heat and infrared radiation, and usually use electricity more efficiently. Quartz halogen lamps have a somewhat higher color temperature (typically 3100K) and produce a more visually pleasing light than conventional lamps, emitting a "whiter" light with comparatively greater blue and less red

November 1986

Because of their noticeably "whiter" light, high output, and compact size, quartz-halogen lamps are becoming increasingly popular in commercial galleries and museums. In the LIFE Gallery of Photography in the Time-Life building in New York City, quartz-halogen track lights provide the illumination; in this installation the compact size of the fixtures is of particular advantage because of the restricted ceiling height.

output. These features of quartz halogen lamps have made them appealing for museum display applications, and their use in museums is steadily increasing. The comparative effects of quartz halogen and incandescent tungsten lamps on the deterioration of photographs deserve further study.

## Fluorescent Lamps

Fluorescent lamps consist of a glass tube coated on the inside with fluorescent phosphors, such as calcium halophosphate, and filled with mercury vapor and a small amount of certain other gases. In operation, the mercury arc produces ultraviolet energy which in turn is absorbed by the lamp phosphor, causing it to produce visible light. Not all of the UV radiation is absorbed by the phosphors, however; some of the remainder is absorbed by the thin glass walls of the tube and the rest, along with the visible light, is radiated from the lamp. The total radiation of fluorescent lamps is a combination of visible light emitted by the phosphors and ultraviolet radiation at the mercury

emission lines of 313 and 365 nanometers; visible emission peaks are at 405, 408, 436, 546, and 578 nanometers.

In recent years, fluorescent lamps have almost totally replaced incandescent lamps in offices, schools, grocery stores, etc. because of their efficiency, producing up to four times as much light as tungsten lamps, and a correspondingly smaller amount of heat and infrared radiation, for a given amount of electricity. The reduced heat output of fluorescent lamps lowers air conditioning costs, further reducing costs when outdoor temperatures are warm. Fluorescent lamps also last far longer than tungsten lamps, which results in additional savings.

Although there are many types of fluorescent lamps, the standard Cool White lamps, produced worldwide by manufacturers such as Philips, General Electric, Sylvania, Osram, Toshiba, NEC, and Hitachi, probably account for more than 80% of all fluorescent lamps sold. Some fluorescent lamps, such as the General Electric Chroma 50 and Verilux VLX/M, have a better color rendition. They are made with a mixture of phosphors and rare gases to produce light of more uniform spectral distribution, but they are more expensive and give about 30% less light output for the same electrical consumption compared with standard Cool White lamps. These lamps constitute only a small part of the total market and are found primarily in clothing stores, meat counters in grocery stores, graphic arts firms, printing companies, photographic laboratories, and other settings where good color rendition is important.

In typical lighting installations, fluorescent illumination is usually much brighter than tungsten, with consequent increases in rates of color print fading. Indeed, it is the high level of illumination associated with fluorescent lamps that is their principal drawback; with respect to the fading rates of most color print materials framed under glass, the spectral differences between the two types of light sources are much less important. Because of the high illumination intensities associated with fluorescent lamps, and for a number of other reasons, this author does not generally recommend fluorescent lamps for illuminating photographs on display. Special-purpose fluorescent lamps with improved color rendering properties, or reduced ultraviolet emission, are likewise not recommended for most museum applications.

If fluorescent lamps are used to illuminate uncovered, UV-sensitive color photographs on display, it may be advisable to install a UV filter such as Plexiglas UF-3 over the fixtures, or to place UV-filter plastic tubes[65] over the individual lamps, or, as a last resort, to choose one of the available types of low-UV-emission fluorescent lamps.[66] Most fluorescent lamps have an ultraviolet energy peak at the 313 nanometer mercury vapor emission line; unless absorbed by a glass or acrylic plastic sheet, this UV radiation greatly accelerates fading of most types of color prints manufactured without a UV-absorbing emulsion overcoat.

The 313 nanometer emission does not appear to be particularly strong on the spectral power distribution curves of fluorescent lamps, but at this very photochemically active wavelength, its power is sufficient to have a devastating effect on Kodak Dye Transfer, Polacolor 2, Polacolor ER, pre-1982 Ektacolor prints, pre-1985 Fujicolor and Konica Color prints, and pre-1986 Agfacolor prints. Ultraviolet radiation of fluorescent lamps at the 365 nanometer mer-

cury vapor emission line, which readily passes through glass and most clear plastics, has much less effect on the dyes used in most color photographic materials compared with ultraviolet radiation at the 313 nanometer emission.

In museums and archives, where a variety of photographic and other types of materials may be displayed, it is recommended that UF-3 sheets, cut to the proper size, be installed either above or below the diffusers in all fluorescent light fixtures; this is generally more practical, as well as less expensive in the long run, than installing UV-filter tubes over the lamps, or than purchasing special low-UV lamps. Particular attention should be given to fluorescent lamps in display cases; such lamps are likely to be installed without glass or plastic cover sheets.

## Ultraviolet Radiation and UV Filters

In museums and archives, it is always good practice to keep ultraviolet radiation levels to a minimum in display areas. One should be aware, however, that with most types of color photographs displayed in typical indoor situations, the primary cause of image fading is *visible light*, so UV filters in place of glass, or in addition to glass, will do little if anything to extend the life of the prints. One of the most persistent beliefs in the photography field is that ultraviolet radiation is the primary, if not the *sole* cause of color print fading. This was indeed true with many early color print materials and is reflected in Kodak's 1970 statement that "Ultraviolet radiation in the illumination source is the chief cause of fading in color photographs."[67]

Beginning around 1970, Kodak and most other manufacturers of chromogenic print materials took various steps to mitigate the effects of UV radiation on displayed prints — principally by incorporating one or more UV-absorbing layers into the print emulsion structure — and with most current color print materials UV radiation is no longer the primary cause of fading; rather, it is *visible light* that causes most of the damage. A separate UV filter placed between the light source and prints made on current Ektacolor paper and similar products improves the fading characteristics little if any under most display conditions.

In the early 1970's, Ektacolor 37 RC and similar color negative print papers were made with an incorporated UV-absorbing layer between the topmost cyan dye and the underlying magenta and yellow dyes; this left the cyan dye layer without UV protection and resulted in rapid cyan fading when illuminated with direct fluorescent light or other high-UV light sources. Coating an additional UV-absorbing layer over the cyan dye is a relatively recent innovation. Kodak first added a UV-absorbing overcoat to Ektacolor RC papers about the beginning of 1982. Fuji, Konica, and Mitsubishi added the additional emulsion layer to the new papers they introduced during 1984 and 1985. Agfacolor Type 8 paper manufactured after mid-1986 also incorporated a UV-absorbing emulsion overcoat.

Kodak Dye Transfer prints made with Kodak Dye Transfer Paper do not have a UV-absorbing overcoat, and the cyan dye in these prints fades rapidly under high-UV illumination conditions. Plexiglas UF-3 "overprotects" the cyan dye, causing an increasing color shift toward cyan as fading progresses. Framing the prints with glass appears to give the best protection. This author's tests also suggest

that glass, and not UF-3, is best for framing Polacolor 2 and ER prints.

A few color materials do benefit from the addition of a UV filter; however, in this author's tests, Ilford Cibachrome prints of all types (and presumably the Ilfochrome materials that replaced Cibachrome materials in 1991) showed worthwhile improvement in light fading stability when covered with Plexiglas UF-3. The protection afforded these prints by UF-3 is particularly striking in prints illuminated with north daylight coming through glass windows.

Elimination of UV radiation from illumination sources will somewhat lessen minimum-density yellowing of chromogenic papers such as Ektacolor and Fujicolor; but with most such papers in typical indoor display conditions, the small improvement in stain characteristics afforded by use of a UV filter is not very noticeable — at least not until the print has been displayed for so long that dye fading becomes rather severe. At that point, the presence of excessive stain may make little difference.

In accelerated light fading tests using this author's "General Home and Commercial Use" set of fading and staining limits, none of the current color papers reached the d-min stain or color imbalance limits as a first failure; in every case, dye fading or image color imbalances were reached first. This is not to say that UV filters should never be used, but with current Ektacolor papers, and similar products made by Fuji, Konica, and Agfa, displayed under typical indoor conditions, the benefits, if any, will be small. For further information on the effects of UV filters on the fading and staining of color prints, see Chapters 3 and 4.

Very high levels of UV radiation, such as occur with direct exposure of prints to light from unfiltered quartz halogen or fluorescent lamps (without a sheet of glass either over the lamps or covering the prints), should always be avoided with black-and-white prints, especially RC prints. High UV exposure may contribute to emulsion yellowing, image discoloration, and physical degradation of both the emulsion and paper base. The simple expedient of framing these materials under ordinary glass or acrylic sheet will eliminate the potentially damaging UV radiation at wavelengths below about 320 nanometers.

## Instead of Framing Prints with Plexiglas UF-3, High-UV Illumination Sources Should Be Filtered to Remove UV Radiation

In museums and archives, where photographs, watercolors, paintings, fabrics, and a variety of other potentially sensitive materials may be displayed, it is strongly advised that an effective UV filter, such as Rohm and Haas Plexiglas UF-3 acrylic sheet, or DuPont Lucite SAR (Super Abrasion Resistant) UF-3 acrylic sheet, be permanently installed (indoors) over windows and skylights to keep UV radiation from both direct and indirect daylight to a minimum. As previously discussed, quartz halogen and fluorescent lamps in museums and archives should, in most cases, also be filtered with UF-3.

DuPont Lucite SAR UF-3, Polycast Technology Corporation Polycast UF-3, and CYRO Industries Acrylite OP-3 appear to have UV-absorption characteristics that are virtually identical to Plexiglas UF-3.[68] Contrary to some reports in the literature, the UV-absorption capabilities of

Plexiglas UF-3 do not diminish with age, even after many years of exposure to direct sunlight and outdoor weather.

Whenever possible, it is better to filter illumination sources with UF-3 than to frame photographs with the material. There are several reasons for this. UF-3 has a slight yellowish tint which is exaggerated when the plastic sheet is placed in contact with a photograph (and mount board) because the viewing light must pass through the UF-3 sheet twice — once to reach the print from the illumination source, and a second time when reflected from the print back to the viewer. The added "yellowness" of a print and mount board is readily apparent when compared with walls, glass-framed photographs, and other objects in the room. When a light source is filtered with UF-3, light passes through it only once; in addition, everything in the viewing area is equally affected by the yellowness of the UF-3 filter so the slight color change of the light is not noticed.

The yellowish tint of UF-3 is unavoidable; the UV absorber incorporated into the sheet during manufacture was selected to eliminate essentially *all* of the UV portion of the spectrum (wavelengths below 400 nanometers), and in the process also absorbs some short-wavelength blue light, resulting in the yellowish tint. The visible portion of the spectrum is between 400 and 700 nanometers; wavelengths below 400 nanometers, down to about 280 nanometers, constitute the principal ultraviolet region, insofar as the fading of color photographs is concerned. UF-3, like other UV absorbers, has a somewhat sloped absorption curve and does not reach 80% transmittance until about 420 nanometers. The design of UF-3 attempts to give the maximum protection against the damaging effects of UV radiation and visible light without being "objectionably" yellow.

An orange or red filter would offer much more protection with many organic materials, but this, of course, would be visually unacceptable for most applications. The U.S. Declaration of Independence, the Constitution, and the Bill of Rights, housed in the National Archives in Washington, D.C., have for many years been protected from the effects of the very-low-intensity tungsten illumination in which they are displayed by deep-yellow filters. This is in part as a consequence of grossly improper display of the Declaration of Independence earlier in its history; the document was written in 1776, and the ink inscriptions have faded so much as to now be nearly illegible.

UF-4 is an almost colorless grade of acrylic ultraviolet filter; however, it transmits significant UV radiation above approximately 385 nanometers and is thus a less effective UV absorber than UF-3. Standard grades of transparent Plexiglas (Plexiglas G) have UV-absorption characteristics which are somewhat better than glass, absorbing nearly all UV radiation below about 330 nanometers.

One should avoid framing valuable black-and-white prints with Plexiglas UF-3 and other types of acrylic sheet because over time the plastic might release trace amounts of peroxides or other substances which could harm sensitive silver images; long-term data on this potential hazard is not currently available. This concern probably does not apply to color prints, both because they appear to be less sensitive to low levels of peroxides than are black-and-white prints, and because color prints will have a necessarily limited life on prolonged display due to light-induced dye fading.

Other reasons to frame prints with glass rather than plastics are that glass is much more scratch resistant, less prone to develop dust-attracting static electrical charges, and less expensive than Plexiglas UF-3.

## Even Low-Level UV Radiation Is Very Harmful to Albumen Prints

Albumen prints appear to be uniquely sensitive to even the low levels of UV radiation emitted by incandescent tungsten lamps. As illustrated in **Figure 17.1**, samples of newly processed albumen prints have a significantly reduced rate of yellow stain formation under incandescent tungsten illumination when protected with Plexiglas UF-3. For reasons not yet understood, the degree of stain formation in the glass-filtered albumen print was somewhat *higher* than in the uncovered test sample directly exposed to tungsten light.

Both the glass-filtered and direct-exposure samples stained less near the edges than in the center portions. Samples illuminated with indirect north daylight (through a glass window) for 2 years showed similar staining behavior, with the UF-3 sample staining much less than the glass-filtered sample. During the course of the tests, all of the prints also faded somewhat (red density was lost), with the prints unprotected by UF-3 fading less than the others. The gold-toned albumen prints in these tests were made in 1981 by James M. Reilly, currently director of the Image Permanence Institute at the Rochester Institute of Technology in Rochester, New York.

Although the staining behavior of these modern albumen prints under illumination may in some respects be different than that of historical albumen prints, it would seem prudent to filter light sources used to illuminate albumen prints with UF-3 or another equally effective UV filter. Because of the apparent high sensitivity of silver-albumen images to oxidizing gases, which could be evolved from acrylic plastics such as Plexiglas UF-3, this author advises against long-term framing of such prints with UF-3; glass should be used instead. Framing albumen prints with UF-3 for short periods (e.g., during shipping) will probably do no harm.

During manufacture, albumen papers were often treated with dilute solutions of pink, rose, mauve, or blue dyes to give a slight tint to the albumen layer of the paper; this was done in part in an attempt to counteract the inevitable yellowing suffered by albumen prints. Investigation by Sergio Burgi in 1981 revealed that many of these dyes have extremely poor light fading stability, some fading significantly after only a few months of exposure to low-level, UV-filtered tungsten illumination.[69] Burgi indicated that tinting dyes in albumen papers made before 1880 should be suspected of having particularly poor stability.

## Albumen Prints Should Not be Displayed; Facsimile Color Copies Should Be Used Instead

Because of the high sensitivity of albumen prints to light, this author recommends that the prints not be displayed. Likewise, salted paper prints should not be displayed. Instead, high-quality Ilfochrome or other facsimile color photographic copies should be made and the copies

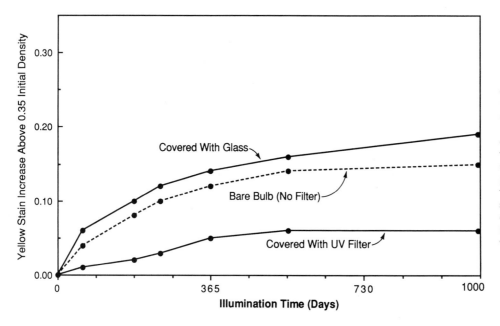

**Figure 17.1** Freshly processed, gold-toned albumen prints exposed to 1.35 klux incandescent tungsten illumination. Yellowing was markedly reduced in the print framed with a Plexiglas UF-3 ultraviolet filter. (For unexplained reasons, the print framed with glass yellowed somewhat more than the uncovered print exposed to bare-bulb illumination.) The prints were made by James M. Reilly.

displayed. Black-and-white copies of albumen prints are not satisfactory because the delicate purple-black image tone and base tint of the prints are not reproduced.

If, however, it is decided to display albumen prints, it is essential that they be periodically densitometrically monitored, especially during and after periods of display and after prints shipped to other institutions on loan have returned. Display illumination levels should be kept low. To minimize staining and fading, Reilly has stressed the importance of storing and displaying albumen prints in conditions of low relative humidity (i.e., 30–40%). If albumen prints cannot be monitored, this author *strongly* advises that they not be displayed, even for short periods of time.

Caution should also be exercised and print monitoring employed when displaying other kinds of 19th-century photographs, such as ambrotypes, cyanotypes, platinum prints, palladium prints, and black-and-white prints that have been tinted or hand-colored with potentially unstable pigments or dyes.[70] It was common practice to add a little pink pigment to the cheeks of people in daguerreotype portraits, for example. Salted paper prints should never be displayed.

Albumen prints and other types of 19th-century photographs should never be loaned to other institutions unless they are sealed in vapor-proof packages and the temperature of the shipping containers can be maintained in the 60–75°F (15.5–24°C) range *at all times* when the prints are in transit; during shipment, the photographs should be accompanied by a representative of the loaning institution to make certain that these temperature conditions are adhered to.

### Placement of Lamps in Display Areas

Within the limitations of the ceiling height, lamps illuminating photographs on a wall should be placed at a distance that provides as even illumination of the prints as possible. Given adequate ceiling height (about 15 feet is ideal), lights should be at about a 45-degree angle to the surface of the prints. Care must be taken to adjust the angle and placement of the lights — and the photographs on the wall — so that specular reflections and glare are minimized. Lighting at too narrow an angle will produce a shadow on the image from the frame or the beveled edge of the overmat; increasing the angle too much may produce a glare image of the lamp in the viewer's eyes or even cast a shadow of the viewer onto the photograph if the person is close to the print. Light fixtures should extend beyond the end of the lamp so that lights on opposite walls will produce a minimum amount of glare on framing glass; bare bulbs should be avoided.

Movable track lights, of the types commonly seen in museums and galleries, are excellent for lighting display areas, as individual lamps can be moved and redirected with ease.[71] Light intensities can be controlled by selecting the proper wattage of lamps, by installing light-absorbing black metal screens, and by using dimmer controls. Incandescent tungsten lamps darken somewhat and decrease in color temperature (about 100K) with age as a result of deposits of evaporated tungsten from the hot filament on the glass envelope. If necessary, this can be compensated for by selecting lamp wattages and re-adjusting the distance of the lamps from the photographs to achieve a somewhat higher light level than desired when the lamps are new; dimmers can be used to lower the light intensity to the desired level and then to maintain that level as the lamps age by gradually decreasing the setting of the rheostats.

Dimmers are also helpful for making minor adjustments in light intensity which may not be easily accomplished by the selection of lamp wattage and location. However, dimmers should be used with restraint, since the color temperature of the light is lowered, and the light becomes progressively redder, as the light intensity is reduced below normal. Low-voltage lamps operated by a transformer require special types of dimmers, and quartz halogen lamps cannot be dimmed beyond a certain point without interfering with the halogen cycle.

February 1983

Recessed incandescent tungsten lamps in a display area at the Art Institute of Chicago.  Although less flexible than track lights, recessed ceiling lamps are unobtrusive and can be particularly advantageous in rooms such as this with low ceilings.

## Design of Photograph Display Areas

In most display areas, flood lamps produce a pleasing, moderate concentration of light on the photograph; if the surrounding areas are somewhat darker than the photograph, the visual appearance of the photograph is enhanced. When walls are painted or covered with a material of gray or other near-neutral color, when flood lamps are used, and when no windows or other sources of bright light are present, photographs will appear to be more brightly illuminated than is actually the case.  By comparison, the same level of light in a room uniformly illuminated by fluorescent lamps will not appear nearly as bright.

White or very light-colored walls should be avoided in display areas, since the bright surfaces will have the effect of reducing the apparent brightness of the print and will increase glare on the glass over photographs on opposite walls.  For many reasons, prints on display should be framed or otherwise covered with glass (see Chapter 15 for a discussion of frames, nonglare glass, and plastic).  Dark or black walls and ceilings should also be avoided since most people do not like the "cave" feeling of darkly painted rooms.

Windows and other sources of bright light should be eliminated in photograph display areas if at all possible.  In buildings that were not designed to be museums, the presence of windows in display areas creates uneven lighting and difficult viewing conditions during daytime hours; in addition, unless special measures are taken, the light in-

February 1983

David Travis, curator of photography at the Art Institute, adjusts a lamp dimmer panel to obtain the desired overall feeling in the illumination of an exhibition.

February 1982

Outdoor windows present serious lighting problems in exhibition areas. In the upstairs galleries at the International Museum of Photography at George Eastman House in Rochester, New York, shown here before the building was closed for renovation in 1988, the glare from daylight through the windows made it difficult to properly view prints, and the intensity of illumination on prints in certain parts of the building during the day was far higher than recommended for proper display, particularly for albumen prints and other sensitive 19th-century materials.

February 1982

The same exhibition area at night. With incandescent tungsten illumination, display conditions were much better than during the day. George Eastman House was the home of George Eastman, the founder of Eastman Kodak Company, and, insofar as possible, the building has been preserved as it was when Eastman lived in the home. This precluded covering the windows. After 1988, the areas pictured here were no longer used to exhibit photographs from the permanent collection.

Jorge Gutierrez – March 1981

An Ansel Adams print on display in the upstairs exhibition area at Eastman House before the area was remodeled and no longer used for print display. The afternoon sun was shining directly on the print through a window. Although the selenium-toned image of this fiber-base print is very stable on exposure to bright light, heating by the intense sunlight could cause emulsion cracking, warping of the print and mount, or other forms of physical damage.

March 1981

At the Friends of Photography Gallery in Carmel, California, rows of incandescent flood lamps hung from the ceiling provided brilliant illumination, with an intensity at the print surface as high as 860 lux. This was in keeping with Ansel Adams's recognition that photographs are shown to their best advantage when brightly illuminated. In 1987 the Friends of Photography moved to new facilities in San Francisco.

tensities on prints in some locations can reach very high levels during certain times of the day or during a particular part of the year, depending on the angle of the sun (see **Table 17.1**) and the length of the day. Ideally, the windows in such a building should be closed off or otherwise made opaque in the exhibition areas; however, the desire to maintain the original architectural integrity of the structure may preclude such alterations. As a compromise, neutral-density glass or acrylic plastic sheeting can be used to reglaze the windows, or opaque curtains can be installed and kept closed during daytime hours. UV radiation from sunlight can most easily be reduced by using a UV filter such as Lucite SAR UF-3 or Plexiglas UF-3 in place of glass — or in addition to glass — in the windows. Various adhesive-coated plastic films are available which can readily be applied to window glass to reduce UV transmission and, if desired, to reduce transmission of visible light as well.[72]

Light levels should be reasonably uniform in display areas, as well as in the rooms or halls leading to the exhibition areas, so that viewers' eyes will have time to adjust to the lighting conditions. The photography galleries in the Art Institute of Chicago, which were opened in 1982, are examples of good gallery design and lighting-fixture placement; while walking to the photography galleries from other parts of the museum, the viewer passes through areas of progressively lower illumination.

### Special Methods of Reducing Light Exposure of Displayed Prints

It is possible to display color photographs at normal room temperatures for extended periods if the prints are made on a dark-stable material such as Ilford Ilfochrome, Kodak Dye Transfer, or Fuji Dyecolor and if the photographs are protected from light except during the actual time that they are being viewed. Opaque cloth covers or curtains can be placed over the print, to be held aside by the viewer when the person is looking at the print, or the

print can be placed in a horizontal box equipped with a door that can be lifted for viewing. If the photograph is located in a darkened area, a push-button (or timed) light switch can be actuated by the viewer to illuminate the print for a short time.

Special techniques of this type have been employed by a number of institutions to display light-sensitive albumen prints and other early forms of photography. Viewer-controlled lighting was used for some of the color photographs in the exhibition *Chasing Rainbows*, curated by Brian Coe of the former Kodak Museum in Harrow, England and exhibited at the Science Museum in London from November 1981 until February 1982. This exhibition contained examples of most of the forms of color photography that existed prior to the introduction of Kodak Kodachrome transparency film in 1935, which marks the beginning of the modern era of color photography. Many of the early color processes are extremely sensitive to light, and partly because of this the exhibition was not sent to other museums after it closed at the Science Museum.[73]

For the same reason, *Color As Form – A History of Color Photography*, curated by John Upton for the International Museum of Photography at George Eastman House, was not loaned to other institutions after it was exhibited at the Corcoran Gallery of Art in Washington, D.C. for 3 months beginning in April 1982 and for an additional 3 months at George Eastman House later that year. Because of the potentially very unstable dyes in many of the early color processes, originals of Autochrome, Finlay Colour, and some other materials were not exhibited; instead, modern Ektachrome transparency copies were substituted. In addition, many of the original photographs in the exhibition were monitored densitometrically by the conservation staff at Eastman House (see Chapter 7).

The Los Angeles County Museum of Art in Los Angeles, California has displayed old, light-sensitive books and works of art on paper in specially constructed cabinets fitted with

February 1982

Salted paper prints and other highly light-sensitive 19th-century photographs displayed at the Art Institute of Chicago are covered with black cloth to protect them from light except during the short periods when they are actually being viewed.

8-inch-deep, Plexiglas-covered drawers. For viewing, the visitor is instructed to gently open one drawer at a time.[74] This space-saving display technique protects objects from exposure to light except for the short periods when they are actually being viewed.

### Facsimile Copies of Unstable 19th-Century Prints in the Historic New Orleans Collection

To avoid light-induced damage to salted paper prints, albumen prints, and other valuable 19th-century photographs owned by the Historic New Orleans Collection in New Orleans, Louisiana, the curatorial staff has made facsimile copies of the prints on Ektacolor paper for display purposes. The use of high-quality color facsimile copies of sensitive 19th-century prints as well as modern color prints inevitably will become more common — and more readily accepted by curators and conservators alike — as print monitoring becomes standard practice in museums and archives. It will then be clearly recognized that many types of photographs are inherently too unstable to survive long-term display, or the often uncontrolled environment of traveling exhibitions, and that facsimile copies provide the only safe means for these images to be viewed by the large audiences that want to see them.

The use of facsimile copies of manuscripts, books, and other valuable artistic and historic objects is gradually gaining acceptance in museums and archives. For example, the Conde Museum near Paris, France has permanently withdrawn a number of rare manuscripts from public view. Speaking about one of the manuscripts, *Les Tres Riches*

*Heures du Duc de Berry*, a 209-page book painstakingly produced by hand by four artists over a 75-year period beginning in 1410, Frederic Vergne, curator of the museum, said, "My overriding duty is to preserve the manuscript. No one will be allowed to see it again. . . . The public and scholars no longer have direct access." In an article entitled "Preservation Takes Rare Manuscripts from the Public," which appeared in *The New York Times* in January 1987, Paul Lewis wrote:

The book is a work of astonishing beauty. Its yellowing vellum pages of handwritten text are exquisitely decorated with illuminated capitals and tiny brightly colored miniatures of religious subjects and scenes from 15th-century life. It is universally recognized as one of the two or three finest illuminated manuscripts in existence.

But for the last couple of years the roughly 250,000 visitors who make their way to the Conde Museum each year have only been allowed to see a high-quality modern color reproduction of the original. . . . The Conde Museum's decision illustrates a trend by museums and libraries everywhere toward cutting down access to rare manuscripts in order to reduce the damage by handling and exposure to light. Increasingly, such institutions are offering scholars and the public high-quality and extremely expensive reproductions of the original that can cost up to $10,000 a copy.[75]

# Notes and References

1. Grant B. Romer, "Can We Afford to Exhibit Our Valued Photographs?" **Topics in Photographic Preservation – 1986** (compiled by Maria S. Holden), Vol. 1, pp. 23–30, 1986. American Institute for Conservation Photographic Materials Group, American Institute for Conservation, 1400 16th Street, N.W., Suite 340, Washington, D.C. 20036; telephone: 202-232-6636. Romer's article was reprinted in **Picture-scope**, Vol. 32, No. 4, Winter 1987, pp. 136–137.

2. At present there are no reliable published data on the long-term effects of visible light and ultraviolet radiation on the images of fiber-base silver-gelatin prints displayed in normal conditions. It has long been believed that properly processed silver images on fiber-base papers are essentially unaffected by exposure to light; lending support to this notion are countless prints of this type which have been displayed more or less continuously for 50 years or more with little apparent deterioration. However, recent information published by Eastman Kodak indicates that light and ultraviolet radiation may indeed cause changes in black-and-white fiber-base prints. In **Conservation of Photographs** (George T. Eaton, editor), Kodak Publication No. F-40, Eastman Kodak Company, Rochester, New York, March 1985, Kodak states (p. 84): "Light has no significant effect upon the silver of an image in ordinary circumstances. However, light can reduce silver ions to metallic silver after oxidizing gases and moisture have acted upon the image. . . . Constant exposure to light can cause gelatin to turn yellow and tends to make it brittle. Paper also yellows with exposure, especially papers used in photographs prior to 1926. Any considerable discoloration is more likely to be caused by oxidation or by the decomposition of residual processing chemicals than by light."

   Kodak has suggested treating modern fiber-base and RC prints with Kodak Rapid Selenium Toner, or certain other toners, to extend the life of the image, particularly when the prints are subjected to prolonged display in a humid environment. For example, see: W. E. Lee, Beverly Wood, and F. J. Drago, "Toner Treatments for Photographic Images to Enhance Image Stability," **Journal of Imaging Technology**, Vol. 10, No. 3, June 1984, pp. 119–126. See also: Eastman Kodak Company, Kodak Polyfiber Paper, Instruction Sheet, KP 79673, May 1983, which says in part: "The life of untoned fiber-base prints that may be exposed to intense or prolonged illumination or oxidizing gases or kept under adverse storage or display conditions, can be extended by the use of Kodak toners." Kodak Rapid Selenium Toner, Kodak Poly-Toner, Kodak Brown Toner, and Kodak Sepia Toner, are recommended for image protection (see comments in the text of this chapter on the image protection offered by various toners and refer to a 1991 report by James M. Reilly and Kaspars M. Cupriks, cited in Note No. 24 below). See also: Eastman Kodak Company, **Quality Enlarging with Kodak Black-and-White Papers**, Kodak Publication No. G-1, February 1985, p. 103, which says: "Apparently light and ultraviolet radiation have no effect on the longevity of black-and-white print images that have been properly toned. . . . The prints can be displayed or kept in the dark with no difference in image stability. Untoned prints exposed to high levels of radiation for long periods of time may show image changes.

   "Such radiation seems to have little effect on the base of prints made on fiber-base papers. Processed and toned . . . prints made on fiber-base papers can be expected to last for generations, whether they are displayed or not."

   The silver images of negatives and transparencies made with the now-discontinued Kodak Professional Duplicating Film 4168 (initially known as Kodak Professional Direct Duplicating Film SO-015) are adversely affected by exposure to light. See: Henry Wilhelm, "Problems with Long-Term Stability of Kodak Professional Direct Duplicating Film," **Picturescope**, Vol. 30, No. 1, Spring 1982, pp. 24–33; and a related article: F. J. Drago and W. E. Lee, "Stability and Restoration of Images on Kodak Professional B/W Duplicating Film/4168," **Journal of Imaging Technology**, Vol. 10, No. 3, June 1984, pp. 113–118.

   The now-obsolete ANSI designation "archival," which was applicable only to silver-gelatin films (not prints), had a number of significant shortcomings that limited its usefulness. As an alternative concept, this author in 1987 proposed an additional, "ultra-stable" category of stability, which included black-and-white or color photographs that met the following requirements: **(a)** support material of polyester film or fiber-base paper (acetate-base films and RC paper are excluded); **(b)** black-and-white images that have been treated with a protective toner (untreated images are excluded); **(c)** color images with dark fading stability equal to or better than Ilford Cibachrome, Kodak Dye Transfer, Fuji Dyecolor, UltraStable Permanent Color, or Polaroid Permanent-Color; **(d)** color images with light fading stability equal to or better than UltraStable Permanent Color

February 1987

At the Historic New Orleans Collection in New Orleans, Louisiana, albumen prints from the late 1800's have been copied with color negative film and printed on Ektacolor paper to retain the warm image tone and yellowed highlights of the original prints (copies made with modern black-and-white papers show little resemblance to albumen prints). The facsimile copies are displayed, allowing the original prints to be stored safely in the dark. With the realization that sensitive materials such as albumen prints cannot be displayed for long periods without harm, this practice is gaining increasing acceptance in museums.

or Polaroid Permanent-Color. This definition of "ultra-stable" was discussed by this author in a presentation entitled, "Polaroid ArchivalColor: A Progress Report on a New, Ultra-Stable Color Print Process," presented at a meeting of the American Institute for Conservation Photographic Materials Group in New Orleans, Louisiana, February 7, 1987. (Subsequent to the New Orleans presentation, Polaroid changed the name to Polaroid Permanent-Color materials.) For further discussion of "archival," Life Expectancy (LE) ratings, and related terms, see Chapter 2. Because of the adoption by ANSI of the promising LE ratings concept, and because of possible confusion with UltraStable Permanent Color prints, this author decided in 1991 to drop his proposed "ultra-stable" designation for extremely stable black-and-white and color materials.

3. For information on UltraStable Permanent Color prints and Polaroid Permanent-Color materials, refer to the discussion in Chapter 1 and the comparative stability data given in Chapter 3 and Chapter 5. Pigment color prints made by the Fresson Quadrichromie process (commonly known in the U.S. as Fresson prints) are also extremely stable and can be displayed under normal illumination conditions for very long periods. In this author's accelerated light fading tests, however, Fresson prints were not as stable as UltraStable Permanent Color prints or Polaroid Permanent-Color prints. Fresson prints are made in a small, Old-World shop run by the Fresson family near Paris (Atelier Michel Fresson, 21 rue de la Montagne Pavee, 91600 Savigny-Orge, France; telephone: 33-1-996-12-60). Fresson prints are produced by hand in very limited quantities and generally have been available only to a select clientele in France (see Chapter 1).

4. Kodak's first RC (polyethylene-resin-coated) paper was called Kind 1594 Paper. First produced in the early 1960's, Kind 1594 Paper was a special-purpose product for U.S. military and aerial-mapping concerns. The paper was not sold in the general market. Kind 1594 Paper was a graded paper with an emulsion similar to that of Kodabromide fiber-base paper. Around the mid-1960's, Kodak converted its Kodak Resisto papers, previously coated with a solvent solution of cellulose acetate, to an RC base; Kodak Resisto papers are used primarily in the graphic arts industry.

In October 1968, Eastman Kodak announced its first black-and-white RC papers for the commercial photofinishing field, Velox Unicontrast RC and Velox Premier RC Papers; placed on the market in 1969, both of the papers were supplied only in rolls. (1968 also saw the introduction of Kodak Ektacolor 20 RC Paper, Type 1822, Kodak's first RC color paper.)

The first general-use black-and-white RC paper available in the U.S. was Luminos RD Rapid Dry Resin Coated Paper; distributed by Luminos Photo Corporation, Yonkers, New York, the paper entered the market about February 1972. Manufactured for Luminos by Turaphot GmbH in Germany, Luminos RD was supplied in several contrast grades and was packaged in 8x10- and 11x14-inch sheets. The paper was advertised to "wash in only 30 to 60 seconds — dries flat and dries quick." The paper had a "perfect" high-gloss surface without the need for ferrotyping, or "glazing," as it is referred to in Europe (at that time, a paper that did not require drying in contact with a chrome-plated metal ferrotype plate or on a polished, chrome-plated drum dryer in order to obtain a high-gloss surface was a totally new concept). Because of the general conversion to RC papers that has taken place since the 1970's, the practice of ferrotyping is now nearly obsolete; most photographers still working with glossy fiber-base papers prefer the tactile, lower-gloss surface which is obtained when these papers are air-dried.

In part because the Luminos brand was not well known (Luminos Photo Corporation is a small company specializing in low-cost products, and Luminos papers have generally been shunned by professional, fine art, and advanced amateur photographers), Luminos RD Rapid Dry Paper initially was viewed as something of a curiosity and appealed primarily to home-darkroom hobbyists; this pioneering RC paper was, nevertheless, a very successful product for Luminos. This author has no information on the stability characteristics of this early version of Luminos RD Paper.

Eastman Kodak's first general-use black-and-white RC product was Polycontrast Rapid RC Paper, introduced in October 1972 and widely available by mid-1973; this paper was supplied in sheets as well as rolls and marked the real beginning of the modern era of black-and-white RC papers. Shortly thereafter, Kodak introduced Kodabrome RC Paper, a graded paper, to supplement the variable-contrast Polycontrast Rapid RC Paper. In 1974 Ilford introduced its first RC paper, Ilfospeed, and followed that in 1978 with Ilfospeed Multigrade, an RC paper with an emulsion based on the original Ilford Multigrade fiber-base paper marketed in 1940. Agfa-Gevaert introduced Agfa Brovira-Speed in 1978, and by 1980 virtually all the world's manufacturers had introduced black-and-white RC papers.

The "RC" name was first used by Kodak in 1968 and registered as a Kodak trademark in 1972. Apparently concluding that over time the RC name would evolve into a generic term to signify any polyethylene-coated photographic paper, Kodak decided in 1976 to abandon the trademark, thus permitting any company to adopt the term RC for its products. Kodak has continued to include RC in the names of its polyethylene-resin-coated black-and-white papers to distinguish them from fiber-base papers. Because staple color papers have virtually disappeared from the market (Kodak Dye Transfer Paper and Fuji Dyecolor Paper are the only remaining examples), having been replaced by RC papers, Kodak no longer felt a need to designate products such as Ektacolor Professional Paper as RC papers, and by 1985 Kodak had dropped RC from the names of its color papers.

Agfa-Gevaert calls its polyethylene-coated products "PE" papers; PE is the internationally accepted plastics-industry abbreviation for polyethylene. Konica calls some of its color products "PC" papers — signifying that they are polyethylene-coated. Oriental uses the term "RP" in the name of its New Seagull RC papers; RP stands for resin-protected. When Ilford introduced Multigrade FB Paper in 1985, the company included "FB" in the name to distinguish the paper from Ilford Multigrade II Paper, a developer-incorporated RC paper that had been introduced several years earlier. FB stands for fiber-base, and to this author's knowledge this was the first time such an abbreviation had been used with a photographic paper. Several years ago, when Kodak replaced the fiber-base Polycontrast Paper with a new paper, it was called Polyfiber Paper. Polyfiber Paper is the fiber-base counterpart to Kodak Polyprint RC Paper;

both papers employ the same emulsion. It appears likely that the terms RC and FB will in time be adopted by all manufacturers.

5. Jack H. Coote, **Monochrome Darkroom Practice**, an Ilford book published by Focal Press, London England, 1982, p. 276.
6. Irvin H. Crawford, Roger E. Democh, and Robert J. Baron, **Highly Stable Resin Coated Paper Products and Method for Making Same**, United States Patent 3,853,592, December 10, 1974.
7. Eastman Kodak Company, "Keeping Characteristics of B/W Prints," **Kodak Studio Light**, Issue No. 1, 1976.
8. T. F. Parsons, G. G. Gray, and I. H. Crawford [Eastman Kodak Company], "To RC or Not to RC," **Journal of Applied Photographic Engineering**, Vol. 5, No. 2, Spring 1979, pp. 110–117.
9. Larry H. Feldman [Eastman Kodak Company], "Discoloration of Black-and-White Photographic Prints," **Journal of Applied Photographic Engineering**, Vol. 7, No. 1, February 1981, pp. 1–9. Originally presented at the **1980 International Conference on Photographic Papers**, William E. Lee, chairman, sponsored by the Society of Photographic Scientists and Engineers (SPSE), Hot Springs, Virginia, August 12, 1980.
10. Eastman Kodak Company, **Kodak B/W Photographic Papers**, Kodak Publication No. G-1, Eastman Kodak Company, Rochester, New York, April 1978, p. 28.
11. Klaus B. Hendriks, "A Discussion of Polyethylene Resin Coated (RC) B&W and Color Papers, Their Properties, and Factors Which May Affect Stability in Dark Storage and Under Display Conditions," presented at **The Permanence of Color – Technology's Challenge, the Photographer's and Collector's Dilemma**, Henry Wilhelm, chairman, a conference sponsored by the International Center of Photography (ICP), New York City, May 6–7, 1978.
12. David Vestal, "RC Report: The TiO2 Blues," **Popular Photography**, Vol. 93, No. 4, October 1978, pp. 80ff. For a general account of the ICP conference proceedings, see: David Kach, "Photographic Dilemma: Stability and Storage of Color Materials," **Industrial Photography**, Vol. 27, No. 8, August 1978, pp. 28ff.
13. This author's prints were made on Kodak Polycontrast Rapid RC Paper purchased in 1974; the 100-sheet box of 8x10-inch F-surface paper had an expiration date of March 1976 and the emulsion number was 94801–73242X.
14. Ctein, "Agfa Multicontrast High Speed Paper," **Darkroom Photography**, Vol. 12, No. 6, June 1990, pp. 50–51, 64. Ctein wrote: "Like other developer-incorporated papers, Multicontrast is pretty insensitive to choice of developer and development; you can't manipulate the print by changing the amount of development without risking muddy blacks. Furthermore, Multicontrast may be prone to base-staining over time, as are other developer-incorporated papers." Also: Ctein, telephone discussion with this author regarding base-staining of developer-incorporated RC papers, September 4, 1990.
15. G. Kolf [Agfa-Gevaert AG], "Modern Photographic Papers – Part 2," (translated into English by A. J. Dalladay), **The British Journal of Photography**, Vol. 127, April 4, 1980, pp. 316–319. This article originally appeared in **Monatliche Fototechnische Mitteilungen**, Vol. 27, No. 11, November 1979, pp. 533–534.
16. Jean Dieuzaide, "Appeal for the Preservation of Genuine Photographic Paper Which Is Faced by the Threat of Cessation of Production," **Camera**, Vol. 57, No. 1, January 1978, p. 44. The document was originally distributed in 1977 at the Rencontres Internationales de la Photographie 1977, in Arles, France. See also: Andy Grundberg, "Arles Festival Ponders Future of B&W Papers, Photo Collecting and Color Imagery," **Modern Photography**, Vol. 41, No. 10, October 1977, pp. 54ff; Marco Misani, "Arles Meeting: Important Though Still Disorganized," **Print Letter** 11, September–October 1977, pp. 1–2; Geoffrey Crawley, "Comment," **British Journal of Photography**, Vol. 125, No. 6140, March 31, 1978, pp. 265–267; Martin Van Leeuwen, "Die Haltbarkeit Von PE- Und RC-Papieren," **Profi Foto**, Nr. 2, 1982, pp. 54–60; and M. Gillet, C. Garnier, F. Flieder, "Influence de l'environnement sur la conservation des documents photographiques modernes," chapter in **Les Documents Graphiques et Photographiques: Analyse et Conservation**, Editions du Centre National de la Recherche Scientifique, Paris, France, 1981 [translated for this author by Marcia Brubeck, June 1983.]
17. Larry H. Feldman, see Note No. 9, p. 9.
18. Eastman Kodak Company, **Conservation of Photographs** (George T. Eaton, editor), Kodak Publication No. F-40, Eastman Kodak Company, Rochester, New York, March 1985, p. 39.
19. Eastman Kodak Company, see Note No. 18, p. 40.
20. Eastman Kodak Company, **Kodak Polycontrast Rapid II RC Paper** (information sheet packaged with paper), Kodak Publication No. KP 73873f, Eastman Kodak Company, Rochester, New York, August 1981.
21. Eastman Kodak Company, **Kodak Polyprint RC Paper** (information sheet packaged with paper), Kodak Publication No. KP 80981a, Eastman Kodak Company, Rochester, New York, October 1984. See

also: Eastman Kodak Company, Kodak Polycontrast III RC Paper (information sheet packaged with paper), Kodak Publication KP 88196, Eastman Kodak Company, Rochester, New York, March 1988.

22. See Note No. 2.

23. James M. Reilly, Douglas W. Nishimura, Kaspars M. Cupriks, and Peter Z. Adelstein, "Stability of Black-and-White Photographic Images, with Special Reference to Microfilm," **Abbey Newsletter**, Vol. 12, No. 5, July 1988, pp. 83–88 (Abbey Publications, 320 E. Center, Provo, Utah 84601; telephone: 801-373-1598). The article is based on a presentation at the **Conservation in Archives Symposium** at the National Archives of Canada, May 1988. Reilly, director of the Image Permanence Institute, and his co-workers based their conclusions about the relative effectiveness of toners on results that they had obtained with microfilm samples treated with a number of toners and subjected to an improved accelerated peroxide fuming test they had developed during 1987–88:

"Gold and selenium treatments provide protection against peroxide attack only in proportion to the degree to which the heavy metal is substituted for the original silver image. In the absence of sulfiding agents, even very high degrees of gold or selenium substitution do *not* provide complete protection. In actual practice, when used as recommended, the metal components of gold and selenium toners for microfilm do very little to protect against oxidation; their effectiveness is almost entirely due to the sulfiding action of other constituents of the toner formulas."

Reilly and his co-workers discussed their findings with Kodak and Kodak "confirmed that in their own recent peroxide testing with microfilm, the selenium toner was depositing selenium, but not preventing oxidant attack, which it had done in tests performed as recently as one year ago. They suspected that small changes in [Kodak Rapid Selenium Toner] formulation made by the manufacturing area were responsible, but were not clear on exactly why."

Sulfiding toners (e.g., Kodak Brown Toner and Poly-Toner), on the other hand, were found to be very effective in the Image Permanence Institute tests, even when used at low concentrations:

"Excellent protection against peroxide attack can be gained by treating microfilm with solutions which lead to the partial **sulfiding** of the silver image. The best compounds to use, as well as methods of application and possible ill effects on physical properties, etc., are unknown at this point, but there are several promising candidates (in particular polysulfides), and the direction to be pursued is now clearly established.

". . .One of the strongest clues to the power of sulfiding agents to protect against peroxide came from experiments with gold toners. Kodak has recommended a formula known as GP-2 since the 1960's for the treatment of microfilm to prevent red spot attack. Because of the high cost it has seldom been used in practice, but it was always regarded as absolute protection. One of the ingredients of GP-2 is thiourea, a known sulfiding agent. In experiments [at the Image Permanence Institute], this formula was indeed completely effective in preventing peroxide attack. However, experiments with the same formula **without** the gold were completely effective. In both the gold toner and the selenium toner, it seemed to be the sulfiding agents, not substitution with gold or conversion to silver selenide, that was providing the bulk of the protection against oxidants."

At the time of this writing, Reilly and his co-workers were continuing this work and could not yet recommend a toner formulation that would provide the aesthetically desirable image intensification afforded to most current fiber-base and RC papers by treatment with Kodak Rapid Selenium Toner, while at the same time providing the increased image protection of a sulfiding toner.

24. James M. Reilly and Kaspars M. Cupriks, **Sulfiding Protection for Silver Images,** Final Report to the Office of Preservation, National Endowment for the Humanities (Grant # PS-20152-87), Image Permanence Institute, March 28, 1991, p. 2. To obtain a copy of the report, contact: Image Permanence Institute, Rochester Institute of Technology, Frank E. Gannett Memorial Building, P.O. Box 9887, Rochester, New York 14623-0887; telephone: 716-475-5199; Fax: 716-475-7230. See also: J. M. Reilly, D. W. Nishimura, K. M. Cupriks, and P. Z. Adelstein, "Polysulfide Treatment for Microfilm," **Journal of Imaging Technology**, Vol. 17, No. 3, June–July, 1991.

25. Eastman Kodak Company, **Kodak Photographic Papers for the Professional**, Kodak Publication No. P4-73, Eastman Kodak Company, Rochester, New York, undated.

26. Eastman Kodak Company, **Faster and Better B/W Print Processing**, Kodak Publication No. G-6, Eastman Kodak Company, Rochester, New York, July 1976.

27. In presentations at the Rochester Institute of Technology, Rochester, New York, September 26, 1978, and at a conference at the Peabody Museum, Harvard University, Cambridge, Massachusetts, October 29, 1978, Glen G. Gray of the Paper Service Division of

Eastman Kodak Company, in the course of discussing the light-induced chemical processes causing embrittlement and eventual cracking of RC papers, also briefly described some of the mechanisms involved in the discoloration of black-and-white images by oxidizing vapors, and mentioned that Kodak was conducting accelerated tests of light-induced image discoloration of framed RC prints illuminated with fluorescent lamps. Improvement in the resistance to discoloration was noted in the "stabilizer in the paper core" version of Kodak RC paper versus the earlier "improved-pigment" type of Kodak RC paper; behavior of the initial formulation of Kodak black-and-white RC paper was not discussed.

Gray's two presentations were based largely on a talk given earlier (entitled, "To RC or Not to RC," by Timothy P. Parsons, Glen G. Gray, and Irvin H. Crawford) at the annual conference of the Society of Photographic Scientists and Engineers, Washington, D.C., May 1, 1978 (their talk was published by SPSE in 1979 – see Note No. 8). Unlike Gray's presentations at RIT and the Peabody Museum in the fall of 1978 (which were not published), neither the original SPSE presentation nor the published article included any discussion of image discoloration of black-and-white RC papers.

28. Rodney R. Parsons, technical services manager, Ilford Photo Corporation, letter to this author, June 13, 1988.

29. As an example, see: Alfred A. Blaker, "The Case for RC," **Darkroom Photography**, Vol. 8, No. 5, September 1986, pp. 22ff. Blaker cited only Kodak sources and quoted an unnamed Kodak scientist as saying: "There is no reason to believe or to suspect that RC black-and-white papers are inferior to conventional or fiber-based papers." In the article, there was no discussion of the possibility that stability differences could exist among RC papers made by different manufacturers. Blaker concluded the article by saying: "I will regard the two types of papers — conventional and resin-coated — as full equals. In fact, if a difference does exist, I've found that almost invariably it favors RC. And though I am withholding final judgment, I believe RC papers will eventually come to be accepted as the superior material." (p. 46).

30. For example, in a presentation by Klaus B. Hendriks, Debbie Hess Norris, and James M. Reilly entitled, "Photograph Conservation: The State of the Art," presented at the annual meeting of the American Institute for Conservation of Historic and Artistic Works, Chicago, Illinois, May 22, 1986, Reilly said: "Apparently, this problem [support cracking of RC papers from the 1970's] is now solved by the incorporation of stabilizers into current RC papers." No reference was given to a particular brand or manufacturer of RC paper. The actual presentation differed in some respects from the version in the conference **Preprints** published by the AIC before the meeting.

31. The principal manufacturers of RC base paper in Western countries are Eastman Kodak Company (USA); Fuji Photo Film Co. Ltd. (Japan); Mitsubishi Paper Mills, Ltd. (Japan); Felix Schoeller, Jr., GmbH & Co. KG (Germany, with a manufacturing division in Pulaski, New York); Oji Paper Company (Japan); and Wiggins Teape Ltd. (England). Kodak does not sell uncoated RC base paper to other photographic manufacturers; however, both Fuji and Mitsubishi do. Oji Paper Company began manufacturing RC base paper in Japan in 1986, with the Konica Corporation (known as Konishiroku Photo Ind. Co., Ltd. until October 1987) among its initial customers. Konica had for years obtained most of its RC base paper from Mitsubishi. Fuji is said to supply RC base paper to Oriental Photo Industrial Co., Ltd., among others. Kodak reportedly buys some RC base paper, made to Kodak's specifications, from Wiggins Teape for use with Kodak products manufactured in Europe. Wiggins Teape also supplies Ilford with RC base paper, and Felix Schoeller supplies RC base paper to Agfa-Gevaert, among others. The Pulaski, New York plant of Felix Schoeller supplied RC base paper to the 3M Company for its 3M High Speed Color Paper until 3M discontinued manufacturing the product in the U.S. in 1983 (3M continued to produce color paper until about 1988 at 3M Italia S.p.A., a 3M subsidiary in Ferrania, Italy).

32. Robert H. MacClaren [National Archives and Records Service], "Accelerated Test Methods and Factors Affecting Photographic Paper Permanence," a presentation at the **1980 International Conference on Photographic Papers**, William E. Lee, chairman, sponsored by the Society of Photographic Scientists and Engineers (SPSE), Hot Springs, Virginia, August 11, 1980. MacClaren reported on accelerated aging tests at the National Archives with processed black-and-white RC papers in which the edge of one RC print was placed against the image area of another. Image discoloration occurred in a line where the edge of the print had been in contact with the emulsion of the adjacent print. MacClaren attributed this to edge-penetration of processing chemicals and termed this type of deterioration the "picture-frame effect." For an account of the conference proceedings, see: Henry Wilhelm, "The 1980 Conference on

Photographic Papers," **Picturescope**, Vol. 29, No. 1, Spring 1981, pp. 25–27.

33. Ilford Photo Corporation, West 70 Century Road, Paramus, New Jersey 07653; telephone: 201-265-6000; toll-free outside New Jersey: 800-631-2522.

34. Peter Krause, telephone discussion with this author, March 10, 1987.

35. Barry Sinclair, national marketing manager for monochrome products and systems, Ilford Photo Corporation, telephone discussions with this author, April 21 and September 15, 1987.

36. Bob Schwalberg, discussion with this author, February 23, 1987.

37. Among fine art photographers and other discriminating users of premium, "silver-rich" fiber-base photographic papers, there is no general agreement as to which are the "best" products. Premium fiber-base papers are characterized by a very high maximum density (deep blacks) and clean, bright whites (all current premium papers contain fluorescent brighteners), and most are supplied only on double-weight, glossy paper stock. Among these papers, an individual's preference inevitably is based on a host of subjective factors, including: image tone; curve shape (tone reproduction characteristics in highlight, midtone, and shadow regions); tonal change and degree of image intensification when the paper is treated with Kodak Rapid Selenium Toner (this author considers toner treatment to be a mandatory part of processing); the tendency for the emulsion to "frill" or otherwise become physically damaged during processing and washing; surface gloss characteristics when the paper is air-dried naturally at room temperature; the degree of curl and cockle which develops during drying; the degree of curl which occurs as a consequence of storage in conditions of cycling relative humidity; edge-lift after dry mounting; consistency of image tone, surface gloss, and response to Kodak Rapid Selenium Toner among available contrast grades (and between emulsion batches); image "dry-down" characteristics; and other visual properties which may be difficult to quantify — or even verbalize — but which nevertheless can be very significant. Price and availability of a wide range of contrast grades and paper sizes may also be important considerations.

Among many discriminating photographers and printers, the most popular papers at the time of this writing in 1992 were Ilford Galerie FB, Ilford Multigrade FB, Oriental New Seagull G Paper, Oriental New Seagull Select VC FB Paper, Kodak Elite Fine-Art Paper, Zone VI Brilliant Paper, Agfa Insignia Paper, and Agfa Portriga-Rapid (a specialized paper with a distinctive warm image tone which some photographers love and others hate). This author's personal favorites are Ilford Galerie FB, Ilford Multigrade FB, and Oriental New Seagull G. Both Ilford Multigrade FB Paper and Oriental New Seagull Select VC FB Paper are, in this author's opinion, distinctly better products than Kodak Polyfiber Paper. Kodak Elite Fine-Art Paper is an excellent product in most respects (the "premium-weight" paper base, which is thicker than normal double-weight paper, is particularly nice), but, in this author's opinion, the surface of Elite when naturally air-dried is not as appealing as the surfaces of Galerie, New Seagull, or Zone VI Brilliant. At the time of this writing, this author had not yet had an opportunity to evaluate Fuji Museum Paper, which was introduced in Japan in 1986 (this product is rumored to actually be Ilford Galerie FB Paper), or Mitsubishi Gekko Paper, which became available in the U.S. around the end of 1986 (Gekko has received excellent reviews in the photographic press — see, for example: Peter Moore and Rosalie Winard, "Modern's Great Paper Chase . . . Second Heat," **Modern Photography**, Vol. 51, No. 3, March 1987, pp. 48–51).

38. David Vestal, "Are Conventional B/W Papers an Endangered Species? – Will Waterproof Printing Papers Replace Other Types Soon? This Open Letter Says 'Proceed with Caution'," **Popular Photography**, Vol. 78, No. 1, January 1976, pp. 85, 132. In voicing his concern about potentially adverse effects of light on RC prints during long-term display, Vestal cited a letter, sent to him by Ilford, stating that up to April 1975, Ilford had made no tests for RC print permanence except those related to washing processing chemicals out of the prints. See also: David Vestal, "The Great Printing-Paper Crunch – A Plea for Old-Fashioned Quality in an Age of Mass-Production Values," **Popular Photography**, Vol. 80, No. 4, April 1977, pp. 91, 198; David Vestal, "The Paper War: Famous Photographers Speak Out on Old and New Black-and-White Enlarging Material," **Popular Photography**, Vol. 81, No. 6, December 1977, pp. 46ff; Arthur Goldsmith, "Editorial – A Voice from the Minority: Let's Save the Old-Time 'Fibre-Base' Papers from Extinction," **Popular Photography**, Vol. 80, No. 4, 1977, p. 10; David Vestal, "B&W Printing for Permanence," Photography How-To Guide, a **Popular Photography** publication, Fall 1977, pp. 6ff; Arthur Goldsmith, "Editorial – How You Can Help Save Quality Printing Papers," **Popular Photography**, Vol. 82, No. 6, June 1978, p. 102; and David Vestal, "Popular Photography Printing-Paper Poll," **Popular Photography**,

Vol. 82, No. 6, June 1978, p. 103 (the results of the "Printing-Paper Poll" were conveyed to Kodak and other manufacturers). The tabulated responses of the more than 4,000 readers who responded to the poll were summarized in: David Vestal, "Paper Poll Answers: Here's What You Told Us About Your Need for Quality Printing Paper," **Popular Photography**, Vol. 84, No. 1, January 1979, pp. 85ff. Among the respondents, Agfa Brovira was the most popular paper, followed by Ilford Ilfobrom, Kodak Polycontrast, Agfa Portriga-Rapid, Kodak Medalist, and DuPont Varigam, in that order. RC papers were the favorite products among only a very small percentage of those responding to the poll.

39. Eastman Kodak Company, see Note No. 7. This article also stated: "Accelerated aging tests indicate that when storage conditions are carefully controlled (approximately constant 21°C [70°F], 50% RH, infrequent exposure to light), prints on resin-coated base should last as long as prints on non-resin-coated base. However, these tests also indicate that when prints are displayed for long periods (several years) or displayed in direct sunlight or stored under uncontrolled environmental conditions, non-resin-coated papers can be expected to have a longer useful life than resin-coated papers. Therefore, non-resin-coated papers are recommended for long-term display and for long-term storage."

40. Eastman Kodak Company, see Note No. 10, p. 28.

41. Eastman Kodak Company, **Preservation of Photographs**, Kodak Publication No. F–30, Eastman Kodak Company, Rochester, New York, August 1979, p. 5.

42. Eastman Kodak Company, see Note No. 18, p. 40.

43. David Vestal, "The Great Printing-Paper Crunch – A Plea for Old-Fashioned Quality in an Age of Mass-Production Values," **Popular Photography**, Vol. 80, No. 4, April 1977, pp. 91, 198.

44. William Messer, "Ilford at Arles," **British Journal of Photography**, August 11 1978, pp. 690–691. In addition see: David Vestal, "Ilford Galerie Enlarging Paper – Is This the Premium Fiber-Base Black-and-White Paper We've Been Waiting For?" **Popular Photography**, Vol. 84, No. 1, January 1979, pp. 88ff.

45. Ansel Adams, **The Print**, The New Ansel Adams Photography Series, Book 3, New York Graphic Society, Little Brown and Company, Boston, Massachusetts, 1983, pp. 49–50.

46. Ansel Adams, see Note No. 45, p. 50.

47. Zone VI Studios Inc., Newfane, Vermont 05345-0219; telephone: 802-257-5161.

48. Eastman Kodak Company, **New Kodak Elite Fine-Art Paper**, Kodak Publication No. P10-85G, Eastman Kodak Company, 1984.

49. Eastman Kodak Company, **Kodak Elite Fine-Art Paper**, Kodak Publication No. G-18, Eastman Kodak Company, Rochester, New York, November 1984, p. 11.

50. Garry Thomson, **The Museum Environment**, second edition, Butterworth & Co., London, England, in association with The International Institute for Conservation of Historic and Artistic Works, 1986, pp. 22–34. See also: Illuminating Engineering Society of London, **IES Technical Report No. 14**, London, England, 1970, pp. 1–7.

51. James M. Reilly, **Care and Identification of 19th-Century Photographic Prints**, Kodak Publication No. G-2S, Eastman Kodak Company, Rochester, New York, 1986, p. 105.

52. Brian Coe, telephone conversation with this author, July 27, 1983.

53. Eastman Kodak Company, **Kodak Color Films and Papers for Professionals**, Kodak Publication No. E-77, Eastman Kodak Company, Rochester, New York, March 1986, p. 49.

54. One recommended luxmeter is the Minolta Illuminance Meter, Model T-1 (the unit reads in both lux and footcandle units), which costs about $500 and is available from Minolta Corporation, 101 Williams Drive, Ramsey, New Jersey 07446; telephone: 201-825-4000; manufactured by Minolta Camera Company, Ltd., 30,2–Chome, Azuchi-Machi, Higashi-ku, Osaka 541, Japan. While not as precise nor as easy to read as the Minolta Illuminance Meter, also recommended is: Panlux Electronic Luxmeter (available with either lux or footcandle scales), about $350 (manufactured by Gossen GmbH, D-8520 Erlangen, Postfach 1780, West Germany), available from Bogen Photo Corporation, Gossen Division, 565 East Crescent Avenue, Ramsey, New Jersey 07446-0506; telephone: 201-818-9500.

For determination of the proportion of total UV radiation present in ambient illumination, or in illumination from a specific light source, the Crawford U.V. Monitor, Type 760 is recommended. The instrument responds to total UV radiation in the 300–400 nanometer band and cannot indicate the percentage at any given wavelength. The Crawford U.V. Monitor is manufactured by the Littlemore Scientific Engineering Company, Railway Lane, Littlemore, Oxford, England OX4 4PZ. In the U.S. the instrument is available from Qualimetrics, Inc., 1165 National Drive, Sacramento, California 95834; telephone: 916-928-1000; toll-free outside California: 800-824-5873. The standard model sells for about $620; a special, high-sensitivity version of

the instrument is available for about $950.

55. R. H. Lafontaine, **Recommended Environmental Monitors for Museums Archives and Art Galleries**, Technical Bulletin 3, Canadian Conservation Institute, National Museums of Canada, Ottawa, Ontario K1A 0M8, July 1978.

56. Ansel Adams, see Note No. 45, p. 164.

57. Eastman Kodak Company, **Kodak Ektacolor Portra Papers**, Kodak Publication No. E-140, Eastman Kodak Company, Rochester, New York, January 1992, p. 4. See also: **Kodak Color Films and Papers for Professionals**, Kodak Publication No. E-77, March 1986, p. DS-64 ("Kodak Ektacolor Professional Paper"). On occasion Kodak has recommended lower levels of display illumination: **Conservation of Photographs** (George T. Eaton, editor), Kodak Publication No. F-40, Eastman Kodak Company, Rochester, New York, March 1985 (p. 109) stated, "For display purposes, tungsten illumination is preferred but whatever light source is used, it should be no more intense than is necessary to provide adequate viewing. An intensity between 54 and 160 lux (5 to 15 footcandles) of incandescent lighting is considered adequate."

58. American National Standards Institute, Inc., **ANSI PH2.30-1985, American National Standard for Photography (Sensitometry) – Viewing Conditions – Photographic Prints, Transparencies, and Photomechanical Reproductions,** American National Standards Institute, Inc., 11 West 42nd Street, New York, New York 10036; telephone: 212-642-4900 (Fax: 212-302-1286). This Standard is a consolidation and revision of **ANSI PH2.31-1969 (R1982), Direct Viewing of Photographic Color Transparencies; ANSI PH2.32-1972 (R1982), Viewing Conditions for the Appraisal of Color Quality and Color Uniformity in the Graphic Arts; ANSI PH2.41-1976 (R1982), Viewing Conditions for Photographic Color Prints; and ANSI PH2.45-1979, Projection Viewing Conditions for Comparing Small Transparencies with Reproductions.** These four earlier Standards are now obsolete.

59. American National Standards Institute, Inc., **ANSI PH2.41-1976, American National Standard Viewing Conditions for Photographic Color Prints,** 1972, p. 10. This Standard has been replaced by **ANSI PH2.30-1985**; see Note No. 58.

60. Eastman Kodak Company, **Quality Enlarging with Kodak Black-and-White Papers**, Kodak Publication G-1, Eastman Kodak Company, Rochester, New York, February 1985, p. 121.

61. Roy S. Berns and Franc Grum, Munsell Color Science Laboratory, Rochester Institute of Technology, **Color Research and Application**, Vol. 12, No. 2, April 1987, pp. 63–72.

62. Richard J. Henry, **Controls in Black-and-White Photography**, second edition, Focal Press (Butterworth & Co., Ltd.), Boston, Massachusetts and London, England, 1986, pp. 105–112.

63. Eastman Kodak Company, see Note No. 60, p. 16.

64. R. E. Birr and C. N. Clark, "Radiation Sources," Section 1 in **SPSE Handbook of Photographic Science and Engineering**, John Wiley & Sons, New York, New York, 1973, pp. 1–141.

65. UV-absorbing tubes and sleeves for fluorescent lamps can be obtained from a number of suppliers, including Conservation Resources International, Inc., 8000-H Forbes Place, Springfield, Virginia 22151; telephone: 703-321-7730. The tubes sold by Conservation Resources are made from Rohm and Haas UVA-7 acrylic resin which is said not to lose UV-filtration effectiveness with age. UF-3 sheets absorb somewhat more UV radiation than does UVA-7. Tubes are also available from Light Impressions Corporation, 439 Monroe Avenue, Rochester, New York 14607-3717; telephone: 716-271-8960; toll-free outside New York: 800-828-6216. Lower-cost sleeves are available from the Solar Screen Company, 53–11 105th Street, Corona, New York 11368; telephone: 212-592-8223.

66. A number of fluorescent lamps are available with low UV emission and improved color rendering characteristics. One such lamp is the Verilux VLX/M, available from Verilux, Inc., 626 York Street, Vallejo, California 94590; telephone: 707-554-6850; Fax: 707-554-8370.

67. Eastman Kodak Company, **Printing Color Negatives**, Kodak Publication No. E-66, Eastman Kodak Company, Rochester, New York, September 1970, p. 41.

68. Rohm and Haas Company, **Ultraviolet Filtering and Transmitting Formulations of Plexiglas Acrylic Plastic**, Plexiglas Design, Fabrication Data, PL-612d, 1979, pp. 2, 3, 5. Rohm and Haas Company, Independence Mall West, Philadelphia, Pennsylvania 19105; telephone: 215-592-3000. Plexiglas UF-3 should not be confused with Plexiglas II UVA which does not contain an ultraviolet absorber. UVA has about the same ultraviolet cutoff point as the standard grades of Plexiglas (which absorb somewhat more UV radiation than ordinary glass). The Plexiglas II series is made to much closer thickness tolerances, and is more expensive, than the standard grades such as Plexiglas G.
Polycast UF-3 and UF-4 are manufactured by Polycast Technol-

ogy Corporation, 70 Carlisle Place, Stamford, Connecticut 06902. DuPont Lucite SAR (Super Abrasion Resistant) and Lucite SAR UF-3 are manufactured by the DuPont Company, Polymer Products Department, Lucite Sheet Products Group, Wilmington, Delaware 19898. (In April 1992, DuPont sold its acrylic sheet business to the British firm Imperial Chemical Industries P.L.C., also known as ICI. It is not known if ICI will continue to use the Lucite trademark in the U.S. in the future.) Licensing and purchasing agreements allow the Rohm and Haas UF-3 and UF-4 trademarks to be used by all three companies. Acrylite OP-2 and OP-3 are distributed by CYRO Industries, Inc., 100 Valley Road, P.O. Box 950, Mt. Arlington, New Jersey 07856; telephone: 201-770-3000. Similar materials in Europe are ICI Perspex VE (similar to UF-3) and Perspex VA (similar to UF-4).
UV-absorbing glass with an optical anti-reflection coating is supplied under the Tru Vue Museum Glass name by Viratec Tru Vue, Inc., 1315 N. North Branch Street, Chicago, Illinois 60622; telephone: 312-943-4200; toll-free: 800-621-8339. A UV-absorbing "safety-glass" version of anti-reflection coated Denglas is available from Denton Vacuum, Inc., 8 Springdale Road, Cherry Hill, New Jersey 08003; telephone: 609-424-1012.
Plexiglas is supplied with protective paper or polyethylene cover sheets on both sides to prevent scratches during cutting and handling. Plexiglas may be cut with a table saw equipped with a fine hollow-ground plywood blade such as those sold by Sears Roebuck, Rockwell, and others. Production shops cutting large quantities of Plexiglas should use one of the fine-toothed, carbide-tipped blades especially designed for cutting acrylic sheet. These blades, which may cost more than $200 each, are available from several companies, including Forrest Manufacturing Company, Inc., P.O. Box 1108, 461 River Road, Clifton, New Jersey 07014; telephone: 201-473-5236. Coarse-toothed saw blades or blades with teeth which have been "set" should not be used because a rough cut and edge chipping will result.
Pre-cut Plexiglas UF-3 sheets (⅛ inch thick) are available from a number of suppliers, including Light Impressions Corporation, 439 Monroe Avenue, Rochester, New York 14607-3717; telephone: 716-271-8960 (toll-free outside New York: 800-828-6216); Conservation Resources International, Inc., 8000-H Forbes Place, Springfield, Virginia 22151; telephone: 703-321-7730 (toll-free: 800-634-6932); Plasticrafts, Inc.,600 West Bayard Avenue, Denver, Colorado 80223; telephone: 303-744-3700; toll-free: 800-800-7567. Light Impressions offers both pre-cut standard sizes for frames and custom-cut sizes.

69. Sergio Burgi, "Fading of Dyes Used for Tinting Unsensitized Albumen Paper," a presentation at the **International Symposium: The Stability and Preservation of Photographic Images**, Klaus B. Hendriks, chairman, sponsored by the Society of Photographic Scientists and Engineers (SPSE) and held at the Public Archives of Canada (renamed the National Archives of Canada in 1987), Ottawa, Ontario, Canada, August 10, 1982.

70. Douglas G. Severson, "The Effects of Exhibition on Photographs," **Topics In Photographic Preservation – 1986** (compiled by Maria S. Holden), Vol. 1, American Institute for Conservation Photographic Materials Group (AIC/PMG), pp. 38–42, 1986. Available from the American Institute for Conservation, 1400 16th Street, N.W., Suite 340, Washington, D.C. 20036; telephone: 202-232-6636. For a somewhat revised version of the article, see: Douglas G. Severson, "The Effects of Exhibition on Photographs," **Picturescope**, Vol. 32, No. 4, Winter 1987, pp. 133–135. Also refer to the discussion in Chapter 7 of the print monitoring program at the Art Institute of Chicago. For a related discussion of the hazards of displaying photographs, see: Grant B. Romer, Note No. 1.

71. Suitable lighting equipment for illuminating photographic display areas is available from many sources, including: Lighting Services, Inc., Industrial Park, Route 9W, Stony Point, New York 10980; telephone: 914-942-2800 (Fax: 914-942-2177); Edison Price, Inc., 409 East 60th Street, New York, New York 10022; telephone: 212-838-5212; and Wiedenbach-Brown Co., Inc., 435 Hudson Street, New York, New York 10014; telephone: 212-243-4500.

72. UV-filter and neutral-density-filter thin polyester plastic films with an adhesive for application to windows and display cases are available from a number of suppliers, including the Solar Screen Company, 53–11 105th Street, Corona, New York 11368; telephone: 212-592-8223; toll-free: 800-34-SOLAR. Also, Scotchtint Solar Control Films are available from the 3M Company, 3M Center, St. Paul, Minnesota 55144; telephone: 617-733-1110; toll-free outside Minnesota: 800-328-1300.

73. Brian Coe, see Note No. 52.

74. Anon., "Drawers Used to Exhibit Light-Sensitive Books," **The Abbey Newsletter**, Vol. 11, No. 2, March 1987, p. 33.

75. Paul Lewis, "Preservation Takes Rare Manuscripts from the Public," **The New York Times**, January 25, 1987, p. H1.

## Additional References

Junetsu Akiyama, Takashi Ichijo, and Reo Mori, "The Relationship Between Dye Fading of Photographic Color Paper and Spectral Energy Distribution," abstract from **Proceedings of the 1st Joint Conference on Color Technology**, November 20 and 21, 1984, Tokyo, Japan.

Stanton I. Anderson and George W. Larson [Eastman Kodak Company], "A Study of Environmental Conditions Associated with Customer Keeping of Photographic Prints," **Second International Symposium: The Stability and Preservation of Photographic Images**, (Printing of Transcript Summaries), Ottawa, Ontario, August 25–28, 1985, pp. 251–282. Available from SPSE, the Society for Imaging Science and Technology, 7003 Kilworth Lane, Springfield, Virginia 22151; telephone: 703-642-9090.

Stanton I. Anderson and Richard J. Anderson [Eastman Kodak Company], "A Study of Lighting Conditions Associated with Print Display in Homes," **Journal of Imaging Technology,** Vol. 17, No. 3, June–July 1991, pp. 127–132.

Thomas B. Brill, **Light, Its Interaction with Art and Antiquities,** Plenum Press, New York, New York, 1980.

Robert Feller, "Control of Deterioration Effects of Light on Museum Objects," **Museum**, Vol. XVIII, No. 2, Paris, France, 1964, pp. 57–98.

Robert Feller, "The Deteriorating Effect of Light on Museum Objects: Principles of Photochemistry, The Effect on Varnishes and Paint Vehicles and on Paper," **Museum News**, Technical Supplement No. 3, Vol. 42, No. 10, American Association of Museums, Washington, D.C., June 1964.

Robert Feller, "Control of Deteriorating Effects of Light on Museum Objects: Heating Effects of Illumination by Incandescent Lamps," **Museum News**, Technical Supplement, American Association of Museums, Washington, D.C., May 1968.

Laurence Harrison, **Report on the Deteriorating Effects of Modern Light Sources**, Metropolitan Museum of Art, New York, New York, 1953.

Laurence Harrison, "Evaluation of Spectral Radiation Hazards in Window-Lighted Galleries," **Recent Advances in Conservation**, Contributions to the **IIC Rome Conference, 1961**, Garry Thomson, Editor, Butterworth & Co., Ltd., London, England, 1963, pp. 1–6.

Klaus B. Hendriks, together with Brian Thurgood, Joe Iraci, Brian Lesser, and Greg Hill of the National Archives of Canada staff, **Fundamentals of Photographic Conservation: A Study Guide**, published by Lugus Publications in cooperation with the National Archives of Canada and the Canada Communication Group, 1991. Available from Lugus Productions Ltd., 48 Falcon Street, Toronto, Ontario, Canada M4S 2P5; telephone: 416-322-5113; Fax: 416-484-9512.

J. Lodewijks, "The Influence of Light on Museum Objects," **Recent Advances in Conservation**, Contributions to the **IIC Rome Conference, 1961**, Garry Thomson, Editor, Butterworth & Co., Ltd., London, England, 1963, pp. 7–8.

Raymond H. Lafontaine and K. J. Macleod, "A Statistical Survey of Lighting Conditions and the Use of Ultraviolet Filters in Canadian Museums, Archives and Galleries," CCI, **The Journal of the Canadian Conservation Institute**, Vol. 1, Canadian Conservation Institute, National Museums of Canada, Ottawa, Ontario K1A 0M8, 1976.

Raymond H. Lafontaine and Patricia A. Wood, **Fluorescent Lamps**, Technical Bulletin No. 7, Canadian Conservation Institute, National Museums of Canada, Ottawa, Ontario K1A 0M8, January 1980.

Warren E. Leary, "New Study Offers More Evidence Linking Cancer to Halogen Lamps, **The New York Times**, April 16, 1992, p. A12.

K. J. Macleod, **Museum Lighting**, Technical Bulletin No. 2, Canadian Conservation Institute, National Museums of Canada, Ottawa, Ontario K1A 0M8, April 1975 (reprinted May 1978).

Lincoln Ross, "Experiments on the Image Stability of Resin-Coated Black & White Photographic Papers," **Topics in Photographic Preservation – 1986**, (compiled by Maria S. Holden), Vol. 1, pp. 31–37, 1986. American Institute for Conservation Photographic Materials Group, American Institute for Conservation, 1400 16th Street, N.W., Suite 340, Washington, D.C. 20036; telephone: 202-232-6636.

Susan E. Schur, "Museum Profile: Yale Center for British Art," **Technology and Conservation**, Vol. 4, No. 1, Spring 1979.

Bob Schwalberg, with Henry Wilhelm and Carol Brower, "Going! Going!! Gone!!! – Which Color Films and Papers Last Longest? How Do the Ones You Use Stack Up?", **Popular Photography**, Vol. 97, No. 6, June 1990, pp. 37–49, 60.

Garry Thomson, "Conservation and Museum Lighting," **Museums Association Information Sheet**, The Museums Association, 87 Charlotte Street, London W1P 2BX, England, May 1970.

Garry Thomson, "Annual Exposure to Light Within Museums," **Studies in Conservation**, Vol. 12, No. 1, February 1967, pp. 26–36.

June 1985

High ceilings permitted this unobtrusive installation of incandescent tungsten track lights in the Pace/MacGill Gallery, one of the leading fine art photography galleries in New York City. To show photographs to their best advantage, the gallery has much brighter illumination — averaging about 650 lux — than that found in most museum exhibition areas. Exhibitions at Pace/MacGill typically last about a month.

# Table 17.1  Survey of Lighting Conditions in Display Areas

These measurements of light intensity were made by the author between 1977 and 1987; a Gossen Panlux electronic illumination meter equipped with a flat diffuser disc was used for the measurements. On photographs and other works of art, the meter probe was placed over the most brightly illuminated portion of the image, next to and on the same plane as the surface of the object. In some instances, the lighting conditions found in a particular room or building are given as a range (e.g., 5000–8000 lux); in other cases, a number of individual readings represent high, low, and intermediate illumination levels.

In the past, the footcandle (fc or fcd) was the most common unit for measuring light intensity in the United States, Canada, and England; however, to conform with current international practice, the measurements reported here are given in lux units (1 lux is equal to 0.0929 footcandle; one footcandle is equal to 10.76 lux). Lux is sometimes abbreviated as lx. As a matter of convenience, illumination levels above 1,000 lux are frequently expressed in kilolux (klux) units; for example, 21,500 lux is usually given as 21.5 klux. For ease in making comparisons, however, kilolux units are not given in this table; all measurements are presented in lux units, regardless of how high a particular reading might be.

Light intensities on photographs were recorded over a very wide range — from a high of 32,000 lux (about 3,000 footcandles) on a Kodak Ektacolor RC print on display at the National Archives of Canada in Ottawa, Ontario, to a low of 8.5 lux (0.8 fc) on an 1872 Julia Margaret Cameron albumen print at the International Museum of Photography at George Eastman House in Rochester, New York; Eastman House also had display illumination levels as high as 5,170 lux (480 fc).

Tungsten illumination levels in museums and galleries ranged from a high of 2,100 lux (195 fc) at the Life Gallery of Photography in New York City, to a low of 8.5 lux (0.8 fc) at the International Museum of Photography at George Eastman House; tungsten illumination levels in photography display areas in museums and galleries typically were in the range of 130–300 lux (12–28 fc). The median intensity of all display locations in museums and archives in which tungsten lamps were the sole source of illumination was 160 lux (15 fc); in commercial galleries the level of tungsten illumination generally was higher, with a median intensity of 430 lux (40 fc).

When reviewing the measurements reported in this table, it should be kept in mind that the author has recommended that, in museums, archives, and galleries, photographs be illuminated with tungsten light at an intensity of about 300 lux (28 fc); some authorities have specified much lower light levels of about 50 lux (4.7 fc) for photographs and other works of art on paper.

The table is divided into four categories, with the median and average illumination intensities in the display areas listed below. The median intensity level is the middle reading of all the measurements when they are arranged in numerical order (if there is no middle value, which occurs when there is an even number of measurements, the median is calculated as the arithmetic mean of the two middle values). The average intensity is simply the numerical average of all the measurements in a group. The median intensity generally gives a better indication of "typical" illumination levels than does an average level; in three of the four groups, a relatively small number of measurements taken in extremely bright display areas caused the average intensity levels to be substantially above the median levels.

Because the fading rate of a color print is directly related to the intensity of the display illumination, the useful "lifetime" (defined as the length of time for a specified amount of fading and/or staining to take place) of a particular type of color print depends to a large extent on where it is displayed; with most modern color prints, the intensity of illumination is a much more significant factor in image fading than is the spectral energy distribution of the light source.

| | | Illumination Intensity | |
|---|---|---|---|
| | Location | Median Level | Average Level |
| A. | Museums and Archives | 215 lux (20 fc) | 1,057 lux (98 fc) |
| B. | Commercial Galleries | 430 lux (40 fc) | 549 lux (51 fc) |
| C. | Public Buildings (e.g., offices, libraries, hospitals, and airports) | 1,325 lux (123 fc) | 3,686 lux (342 fc) |
| D. | Homes | 635 lux (59 fc) | 3,213 lux (299 fc) |
| **A, B, C,** and **D** grouped together: | | 375 lux (35 fc) | 1,808 lux (168 fc) |

*(continued next page)*

## A. Museums and Archives

| | |
|---|---:|
| **The Art Institute of Chicago,** Chicago, Illinois —<br>New photography department galleries (1982);<br>tungsten illumination controlled with dimmers. | 130–160 lux |
| Dimmed tungsten through glass diffusers; "Paper &<br>Light" exhibition in new galleries, 1982; calotype prints. | 55–75 lux |
| Tungsten; 1543 Chinese handscroll, colors on paper. | 375 lux |
| Photographic Print Study Room; indirect fluorescent<br>reflected from domed ceiling, painted white. | 540–860 lux |
| Fluorescent through plastic diffuser; photography room<br>(Room 106). | 240 lux |
| Tungsten; "Color photographs: Marie Cosindas, Eliot Porter." | 170 lux<br>160 lux<br>150 lux<br>125 lux<br>95 lux<br>60 lux |
| Tungsten; selections from the permanent collection. | 130–240 lux |
| Watercolors and drawings (Room 108). | 65–130 lux |
| Prints and drawings (Room 109). | 85 lux |
| The Helen Regenstein Gallery. | 55–65 lux |
| Fabric display durations: 3 months. | 75 lux<br>45–55 lux |
| **Museum of Modern Art,** New York City —<br>(new galleries — 1986) 30-watt incandescent reflector<br>flood lamps; albumen, platinum, and other 19th-century<br>prints. | 65–160 lux |
| 75- and 150-watt PAR incandescent reflector flood<br>lamps; Ektacolor 74 RC, Ektacolor Plus, Ektacolor Pro-<br>fessional, Cibachrome, Dye Transfer, and silver-gelatin<br>prints. | 175–380 lux |
| **Museum of Modern Art,** New York City —<br>(old galleries — 1980) Tungsten lamps, with some diffuse<br>daylight through glass; Ektacolor 37 RC, Kodak Dye<br>Transfer, silver-gelatin, and albumen prints. | 325 lux<br>240 lux<br>130 lux<br>85 lux |
| **International Museum of Photography at George<br>Eastman House,** Rochester, New York —<br>Diffuse daylight on a black-and-white photograph. | 5,170 lux |
| Upstairs, northwest corner; diffuse daylight with some<br>tungsten. | 5,170 lux<br>1,600 lux<br>1,300 lux |
| Upstairs, southwest corner; diffuse daylight through<br>glass with a small percentage of illumination from<br>tungsten lamps; photographs framed with Plexiglas UF–3<br>or glass. | 3,450 lux<br>1,940 lux<br>860 lux<br>650 lux<br>590 lux |
| Upstairs southeast corner. | 1,560 lux<br>1,450 lux<br>1,400 lux |
| Upstairs; diffuse daylight through glass with some<br>tungsten on color print (dye imbibition); print<br>appears to have lost a significant amount of yellow dye. | 1,300 lux |
| 50% daylight, 50% tungsten; 1939 Nickolas Muray<br>photograph. | 1,300 lux |
| "Fashion Show" (photographs), October 8, 1977. | 160–1,720 lux |
| **Brackett-Clark Gallery;** photograph display area;<br>tungsten lamps. | 1,400 lux<br>1,350 lux<br>850 lux<br>650 lux<br>590 lux<br>430 lux<br>370 lux |
| Brackett-Clark Gallery; tungsten, no daylight; 75-watt<br>reflector flood lamps about 6–8 feet from prints; Eikoh<br>Hosoe exhibit, 1982.<br>Upper section of higher print on wall.<br>Lower section of higher print.<br>Lower print on wall.<br>Average illumination. | <br><br><br>380 lux<br>270 lux<br>95 lux<br>160–215 lux |
| Brackett-Clark Gallery; Mark Goodman show; 150-watt<br>reflector flood lamps approximately 8 feet from photo-<br>graphs. | 270–325 lux |
| Tungsten illumination on Dye Transfer, Cibachrome,<br>and Ektacolor prints. | 240 lux |
| Tungsten; temporary exhibition, "The Photographers'<br>Hand" ; Dye Transfer and other color prints. | 160–215 lux |
| Brackett-Clark Gallery; Pierre Petit salted paper and<br>albumen portrait prints; 75-watt reflector flood lamps<br>approximately 6 feet from prints. | 130–160 lux |
| Brackett-Clark Gallery; exhibition,<br>"Steichen – A Centennial Tribute. | 54–75 lux |
| Small room; tungsten. | 32–54 lux |
| Permanent Exhibition Galleries (2nd floor) at night;<br>tungsten. | 32–65 lux |
| Permanent Exhibition Galleries (2nd floor); tungsten,<br>60-watt frosted lamps. | 8.5–32 lux |
| **Metropolitan Museum of Art,** New York City —<br>Stated museum policy is to not exceed 140–215 lux<br>on photographs, displaying color photographs no more<br>than 3–4 months every 5–10 years; UF–3 not used<br>over color photographs. Tungsten; "Counterparts,"<br>photography exhibit, 1982. Overall illumination.<br>Illumination on 1979 Polacolor 2 print.<br>Illumination on calotype print. | <br><br><br><br><br>45–160 lux<br>95 lux<br>55 lux |
| Tungsten; illumination on Egyptian scrolls. | 45 lux |
| **The Historic New Orleans Collection,** New Orleans,<br>Louisiana — Tungsten reflector flood lamps and<br>tungsten halogen lamps with glass filters. "New<br>Orleans Now," a 1987 exhibit of black-and-white<br>photographs of modern New Orleans by Michael<br>Smith; Ektacolor facsimile copies of 19th-century<br>photographs; black-and-white photographs;<br>manuscripts; lithographs. | 130–320 lux |
| **Corcoran Gallery of Art,** Washington, D.C. —<br>Tungsten; "Color as Form — A History of Color<br>Photography," exhibit, 1982. | 32–215 lux |
| **Museum of Fine Arts,** Boston, Massachusetts —<br>Daylight through glass; 1960 Morris Louis painting. | 3,900–4,500 lux |
| Tungsten and daylight through glass in ceramics room. | 3,000 lux |
| Daylight through white shade; John Marin oil painting. | 2,700 lux |
| Daylight through glass mixed with fluorescent. | 700 lux |
| Tungsten with some daylight; 1824 Gilbert Stuart oil<br>painting. | 460 lux |

*(continued next page)*

| | |
|---|---|
| Fluorescent; General Electric Warm White with UV-absorbing cover tubes; metal grid; Gilbert Stuart oil painting. | 240 lux |
| Tungsten; 1757 oil painting. | 130 lux |
| 50% fluorescent mixed with 50% tungsten; Lewis Hine photograph, 1931. | 130 lux |
| Tungsten; Lewis Hine photographs. | 52–130 lux |
| Tungsten; Polaroid SX–70 print. | 110 lux |

| | |
|---|---|
| **National Gallery of Art,** Washington, D.C. — New east building; daylight through tinted window glass; tapestry, paintings. | 17,200 lux<br>1,900 lux<br>860 lux<br>220 lux |
| East building; gallery rooms; diffuse daylight with tungsten. | 270–375 lux |
| East building; tungsten lamps; Picasso painting. | 195–345 lux |
| Old building; mostly tungsten illumination and daylight through ceiling diffuse glass (skylights). Painting room; 13th-century paintings; 5:00 PM. | 1,200 lux<br>775 lux<br>650 lux<br>590 lux<br>375 lux |
| Diffuse daylight; Claude Monet painting. | 645–750 lux |
| Tungsten only; 15th–16th-century paintings. | 110–130 lux |

| | |
|---|---|
| **Hirshhorn Museum and Sculpture Garden,** Washington, D.C. — Daylight through tinted glass on sculptures; no paintings or prints in this area. | 2,700–21,500 lux |
| Second floor; tungsten spot lamps about 8–15 feet away from prints; "Grant Mudford: Photographs." | 195–325 lux |

| | |
|---|---|
| **National Museum of American History, Science, Technology and Culture**, Smithsonian Institution, Washington, D.C. — Photography gallery, third floor; tungsten. | 450 lux<br>345 lux<br>300 lux<br>195 lux<br>160 lux |

| | |
|---|---|
| **Elvehjem Museum of Art,** University of Wisconsin, Madison, Wisconsin — (Fluorescent tubes in skylights for night use.) | |
| Tungsten only. | 240–540 lux |
| Tungsten and daylight (overcast day). | 215–325 lux |
| Tungsten; skylight covered. | 110–150 lux |

| | |
|---|---|
| **Cleveland Museum of Art,** Cleveland, Ohio — Diffuse daylight from full-roof glass skylight on very large fabric tapestry which is severely faded. | est. 5,400–8,600 lux |
| Diffuse daylight from full-roof glass skylight on Murillo oil painting (ca. 1660). | 4,100–4,800 lux |
| Indirect daylight through windows. | 3,450 lux |
| Tungsten lamp; black-and-white photographs. | 200 lux |
| Tungsten. | 130 lux |

| | |
|---|---|
| **Yale University Art Gallery,** New Haven, Connecticut — Mostly tungsten with some diffuse daylight. | 1,240 lux |
| Tungsten exclusively; oil paintings. | 1,130 lux |
| Tungsten exclusively; Fosburgh Collection; oil and watercolor paintings. | 160–750 lux |
| Display case; tungsten illumination when case lid is open; early American miniature paintings. | 340 lux |

| | |
|---|---|
| Tungsten and daylight; 17th-century Chinese drawings and paintings. | 215 lux |
| 1972 Dye Transfer print; tungsten. | 195 lux |

| | |
|---|---|
| **Lyndon B. Johnson Library,** Austin, Texas — Display transparencies mounted on light boxes; yellow dye loss severe, also magenta dye loss, edge-fading effects; illumination measured on d-min film side. (These back-lighted display transparencies are intended to be replaced periodically.) | 1,080–1,600 lux |
| LBJ Oval Office exhibit; fluorescent and diffuse daylight through windows; family photograph on display. | 160 lux |

| | |
|---|---|
| **Humanities Research Center,** University of Texas, Austin — Vault area. | 160–215 lux |
| Michener Gallery; tungsten spot lamps. | 160–215 lux |
| Gutenberg Bible; case monitored. | 325 lux |

| | |
|---|---|
| **Museum of Art,** University of Iowa, Iowa City, Iowa — Print room. | 350 lux<br>170 lux<br>160 lux |
| Tungsten; photography exhibit; Ektacolor 74 RC prints and others. | 300 lux<br>240 lux<br>170 lux |
| Tungsten, about 20% daylight. | 240 lux |
| Oil painting. | 170–260 lux |
| Tungsten, some daylight; photographs exhibited. | 160 lux<br>120 lux<br>85 lux<br>65–75 lux<br>50–65 lux |

| | |
|---|---|
| **Friends of Photography Gallery,** Carmel, California — Tungsten; 150-watt reflector flood lamps, about 6 feet from photographs. | 540–860 lux |

| | |
|---|---|
| **National Archives,** Washington, D.C. — Tungsten; exhibition area; exhibit, "A Matter of Identity." | 100–160 lux |
| Tungsten, UV filter; Bill of Rights. | 32 lux |
| Tungsten, UV filter; Declaration of Independence. | 8 lux |

| | |
|---|---|
| **National Archives of Canada,** Ottawa, Ontario — Direct sunlight each morning on Ektacolor RC print framed behind glass. | 32,000 lux |
| Print display area; fluorescent light through plastic diffuser. | 540 lux |

| | |
|---|---|
| **National Gallery of Art,** Ottawa, Ontario — Gallery policy is to not exceed 50 lux (4.7 fc) on prints, drawings, and photographs. | |
| Photograph area; Ektacolor 37 RC and 74 RC prints, Cibachrome prints, Dye Transfer prints, and black-and-white prints. | 55–85 lux |
| Tungsten lamp; illumination on oil paintings, watercolors. | 300 lux<br>160 lux<br>150 lux<br>130 lux<br>85 lux<br>55 lux<br>32 lux |

*(continued  next page)*

**Galeria de Arte Nacional,** Caracas, Venezuela —          6,200 lux
Diffuse daylight; various rooms.                             3,300 lux
                                                             2,800 lux
                                                             2,600 lux
                                                             1,700 lux

One dark room; mostly daylight with some tungsten.          150–200 lux

Daylight only.                                              110 lux

**Museo de Bellas Artes,** Caracas, Venezuela —             160–430 lux
Tungsten.

50% tungsten, 50% daylight.                                 215–325 lux

## B. Commercial Galleries

**Life Gallery of Photography,** New York City —            800–2,100 lux
Time & Life Building, Room 28-58. Glass-filtered
tungsten halogen lamps 4 to 6 feet from the photo-
graphs; November 1986 exhibit, "Life Photographs
from the First Fifty Years: 1936–1986"; Ektacolor,
Dye Transfer, Cibachrome, and black-and- white
prints. (Illumination intensity in small areas near
the center of some prints reached 4,800 lux.)

**Light Gallery,** New York City —                          860–1,900 lux
Tungsten; May 1982 exhibit of photographs.

**Pace/MacGill Gallery,** New York City —                   460–940 lux
Tungsten; June 1985 exhibit of Ektacolor,
Cibachrome, Kodak Dye Transfer, and
black-and-white photographs.

**Laurence Miller Gallery,** New York City —                325–430 lux
Tungsten reflector flood lamps; November 1986
exhibit, "Real Pictures from 'True Stories',"
by Len Jenshel; Ektacolor Plus prints.

Tungsten reflector flood lamps; November 1986              215–270 lux
photography exhibit, "Cherry Blossom Time in
Japan," by Lee Friedlander; gravure prints.

**Witkin Gallery,** New York City —                         650 lux
Tungsten illumination on color and black-and-white         540 lux
photographs.                                                480 lux

**Castelli Graphics,** New York City —                      325–430 lux
Tungsten reflector-flood lamps; graphics, color
and black-and-white photographs.

**Photofind Gallery,** New York City —                      430–540 lux
Tungsten reflector flood lamps; November 1986
exhibit of Imogen Cunningham black-and-white prints.

**Marcuse Pfeiffer Gallery,** New York City —               110–215 lux
Tungsten reflector flood lamps; November 1986
exhibit, "Illuminations: A Bestiary," by Rosamond
Wolff Purcell; Cibachrome RC prints.

**A Gallery for Fine Photography,** New Orleans,            120–300 lux
Louisiana — Tungsten reflector flood lamps;
February 1987 exhibit of Dye Transfer, Cibachrome,
Ektacolor, contemporary black-and-white photographs,
and 19th-century prints.

**The Weston Gallery,** Carmel, California —                800 lux
Tungsten, brightest area.
Tungsten, overall.                                          130–430 lux

**New West Gallery,** Carmel, California — Tungsten.        160–325 lux

## C. Public Buildings

**Hopkins International Airport,** Central Lobby, Cleveland,
Ohio — (Semi-diffuse sunlight through acrylic skylights.)
Bright areas of lobby.                                      21,500 lux
On fabric mural on wall for many hours each day.           19,400 lux
Diffuse daylight through skylights in darker areas of lobby.   4,100 lux

**National Research Council Library,** Ottawa, Ontario —    10,330 lux
Indirect daylight through very large tinted-glass window;
winter day.

Large wall; sunlight through tinted full-length window.    9,680 lux

Stack area; indirect diffuse daylight through full-length   5,160 lux
window.

Reading room; diffuse daylight through full-length         1,500 lux
window.

Diffuse daylight through glass, mixed with                 1,200 lux
fluorescent lamps with plastic diffusers.

**Lambert International Airport,** St. Louis, Missouri —     6,250 lux
Main terminal; daylight through tinted acrylic.

Main terminal; diffuse daylight through glass;             5,600 lux
commercial Ektacolor prints on display.                    4,950 lux
                                                           3,450 lux
                                                           2,580 lux
                                                           1,180 lux

**Houston Intercontinental Airport,** Houston, Texas —      110–160 lux
Exhibit in main terminal of Ektacolor Professional
prints by Gittings Studio entitled "The People of
Houston." Illuminated by metal-halide lamps and
indirect daylight through tinted glass; prints framed
under glass (1987).

**Law Office,** Des Moines, Iowa —                          3,800–5,160 lux
Diffuse daylight through tinted window glass;
wall area away from window; lithograph on wall
very faded after about 2 years.

**Law Office,** Des Moines, Iowa —                          4,300 lux
Daylight through window glass and fluorescent light.

**Oberlin Art Conservation Laboratory,** Oberlin, Ohio —
Office area: diffuse daylight through glass and direct
fluorescent (General Electric Cool White);
Polacolor 1 print kept on desk for several
years severely faded; estimated 20% daylight.

                                    Across from window.    3,450 lux
                                    Wall near window.       1,130 lux

Direct fluorescent lamps through metal grid.
Some daylight.
                                    On work desk.          2,360 lux
                                    On lower wall.          540 lux

Laboratory; tungsten lamp illumination on Ektacolor        1,180 lux
print.                                                      345 lux
                                                           160 lux

**Motel room,** Oberlin, Ohio —                             56,000 lux
Sunlight through window, at times directly on framed
lithograph on wall.

*(continued next page)*

| | |
|---|---|
| Diffuse daylight through glass. | 3,500 lux |
| | 1,800 lux |
| | 1,560 lux |
| | 970 lux |
| **National Archives of Canada,** Ottawa, Ontario — Office; diffuse daylight through large window onto shelf and wall area. | 3,440 lux |
| Fluorescent lamp through plastic diffuser; work table; some daylight. | 1,400 lux |
| Diffuse daylight and fluorescent through plastic diffuser; approximately 50% daylight and 50% fluorescent light. | 1,180 lux |
| **National Archives,** Washington, D. C. — Office; fluorescent light through plastic diffuser above desk in alcove. | 2,370 lux |
| **Iowa State University Library,** Ames, Iowa — Library reading room; daylight through glass, with some fluorescent directly through metal grid; oil painting on wall. | 2,260 lux |
| Display case; direct fluorescent lamps; photographs not covered with glass. | 860–1,300 lux |
| Reading room; direct fluorescent lamp through wide-spaced metal grid, with some daylight through glass. | 1,180 lux |
| General illumination. | 540–1,200 lux |
| **Television office,** Owings Mill, Maryland — Direct fluorescent lamps; no cover or grid; Westinghouse Cool White. | 1,830 lux<br>1,290 lux<br>1,180 lux |
| **Modern Photography editorial office,** New York City — Fluorescent light through plastic diffuser; some indirect daylight through window glass; Ektacolor prints on display, covered with glass; older Ektacolor prints show significant magenta dye loss. | 1,350 lux |
| Direct Cool White fluorescent light through metal grid (ceiling). | |
| On desk (some daylight). | 590 lux |
| On wall (overcast day). | 325 lux |
| Office wall; color print on display. | 215 lux |
| **University of Iowa Hospitals,** Iowa City, Iowa — Exam room; direct fluorescent lamps through metal grid; Ektacolor print on display without glass; some daylight through window. | 1,500 lux<br>1,300 lux<br>540 lux |
| **Park Plaza Hotel,** Boston, Massachusetts — Daylight through glass. | 195–1,450 lux<br>320–860 lux |
| **Time Inc.,** Time & Life Building, New York City — Office, Room 24-18; fluorescent illumination. | 650 lux |
| **Nassau Bay Resort Motel,** Houston, Texas — Indirect daylight on wall through glass and solar control film. | 430–650 lux |

## D. Homes

| | |
|---|---|
| **House,** Grinnell, Iowa — Direct sun in room (not on a photograph). | 86,000 lux |
| 2nd floor room; snow on ground, indirect daylight. | 2,800 lux |

| | |
|---|---|
| 2nd floor room; nighttime, tungsten light. | 75 lux |
| Kitchen; daylight, snow on ground. | 1,350–1,700 lux |
| Kitchen at night, fluorescent light. | 430 lux |
| Daylight through window glass. | 1,290 lux |
| **House,** Ottawa, Ontario — Kitchen; direct daylight through glass. | 23,670 lux |
| Kitchen; indirect daylight through glass. | 1,720 lux |
| Bright, relatively small area on wall. | 3,900 lux |
| Diffuse daylight through glass. | 1,500–1,720 lux |
| Daylight through window glass. | 1,180 lux<br>860 lux<br>540 lux |
| **Apartment,** Chicago, Illinois — Bedroom; indirect daylight through window glass; large window facing south; white walls; 11:30 AM. | 4,850 lux<br>2,260 lux<br>1,940 lux |
| Living room; indirect daylight through window glass (and through screens in June); 11:30 AM. | 3,660 lux<br>1,940 lux<br>620 lux |
| **Modern house,** Kennett Square, Pennsylvania — Diffuse daylight through glass in summer. | 3,300 lux |
| Indirect daylight through window onto wall. | 480–650 lux |
| **Modern house,** Laytonsville, Maryland — Living room; large windows; indirect daylight. | 700–2,370 lux |
| Room where photographs of seven generations are displayed on a wall; indirect daylight. | 485–1,670 lux |
| **Older house,** Iowa City, Iowa — Indirect daylight through window glass. | 325–1,185 lux |
| **House,** Quebec City, Quebec — Living room walls; indirect daylight through window glass. | 375–970 lux |
| Kitchen; daylight through window glass mixed with tungsten. | 215–485 lux |
| **House,** New Haven, Connecticut — Diffuse daylight through glass. | 860 lux<br>485 lux<br>325 lux<br>215 lux |
| **Old house** (1896), Madison, Wisconsin — Daylight through window glass. | |
| Bedroom — near ceiling. | 590 lux |
| Bedroom — near floor. | 235 lux |
| Living room. | 375 lux |
| Hall. | 45 lux |
| Tungsten light at night; | |
| Dining room. | 48–75 lux |
| Kitchen. | 32–65 lux |
| Living room. | 16–45 lux |
| **House,** Montreal, Quebec — Photograph display area; diffuse daylight mixed with tungsten. | 32 lux<br>11 lux |

# 18. Handling and Preservation of Color Slide Collections

## Selection of Films, Slide Mounts, Slide Pages, and Individual Slide Sleeves

### Introduction

Although color slides can be made from color negative originals, the great majority of 35mm slides are one-of-a-kind transparencies produced by reversal processing of the original chromogenic camera film. The Fujichrome or Kodachrome slide that you put in your projector is in most cases the same piece of film that was exposed in your camera.

When an original color slide becomes faded, physically damaged, or even lost, there is no camera negative from which a new slide can be made. In this respect, original color slides are like the daguerreotypes of a bygone era and the Polaroid instant color prints of today: none have usable negatives.

More than one billion color slides are taken each year in the United States alone. Many important collections have hundreds of thousands of 35mm color slides. Some have millions: the National Geographic Society in Washington, D.C. has between 10 and 11 million color slides in its collection, including a significant number of early Kodachrome slides dating back to the introduction of Kodachrome in the 35mm format in 1936; the Time Inc. Magazines Picture Collection in New York City has over one million slides dating from the late 1930's; Black Star Publishing Company has 3 million; Gamma-Liaison, Inc. has over one million; Magnum has over half a million; and Sygma Photo News, Inc. has over one million slides in its collection.

The Image Bank, a Kodak-owned stock agency specializing in color photography for general coverage, commercial use, and advertising, has more than 20 million images — mostly 35mm color slides — in the collections in its New York City headquarters and the 64 Image Bank sales offices worldwide. The Bettmann Archive has more than 16 million B&W photographs and color slides in its collections. When dealing with such vast numbers, it is easy to lose sight of the fact that original color slides are usually irreplaceable.

The guiding principle for preserving color slides is to treat originals *carefully* — the same way valuable negatives should be handled. Slides must be protected from physical damage, fingerprints, dirt, and scratches. Minor physical damage is often tolerated when slides are projected on a screen; however, such defects can be very objectionable if the slide is used to make a print for display or is reproduced in a book, magazine, or advertising brochure. It is also essential that slides be protected from excessive projector-caused fading (see Chapter 6). The best procedure is to make duplicates from original slides, and to then carefully store the originals in the dark. Working dupli-cates are *essential* to protect an original slide if an image is likely to receive extensive projection or handling.

### Choice of Color Film Is the Most Important Consideration

When stored in a typical air-conditioned office environment (i.e., 75°F [24°C], 50–60% RH), the dark fading stability of slides made on *current* Kodachrome, Fujichrome, Ektachrome, and the "improved" Agfachrome RS and CT films introduced in 1988–89 is sufficiently good that most photographers and commercial users will feel no immediate need to refrigerate such slides. Most photographers are reasonably satisfied if a color transparency lasts their lifetime — or at least their working careers — without obvious deterioration.

This is not to say, however, that humidity-controlled cold storage is not a good idea for stock agencies and other commercial collections. Especially for collections that contain valuable material on earlier films such as Ektachrome Process E-1, E-2, and E-3 films, all of which have *extremely poor* dark fading stability, refrigeration is the only way to slow further deterioration.

Refrigerated storage is also vital for long-term preservation of Process E-4 Ektachrome films, Fujichrome films made prior to 1978 (when improved Fujichrome Process E-6 films were introduced), and all Ansco and GAF color transparency films. Also included in this group, because of their relatively poor dark fading stability, are all pre-1989 Agfachrome RS and CT films (at the time of this writing in 1992, only Agfachrome RS 1000 film was still being manufactured with the earlier type of poor-stability yellow dye), and pre-1991 3M ScotchChrome slide films and Polaroid Presentation Chrome 35mm film (made for Polaroid by 3M in Italy).

For museums and archives, where the goal must be indefinite preservation of color photographs in an essentially unchanged condition, refrigerated storage is mandatory for *all* present and past slide films, even Kodachrome.

To avoid fungus growths on film emulsions, in any collection, with or without refrigerated storage, humidity levels in a storage area should never be allowed to remain above 65–70% for prolonged periods.

For current work, a photographer can make an informed decision about which films are best suited to his or her needs. There are many practical advantages in choosing the most stable slide films available, the most obvious being the extended projection times afforded by the films with the best projector-fading stability as well as the ability to store slides in normal room temperature conditions for the next 50 years or more without objectionable fading taking place.

**See page 629 for Recommendations**

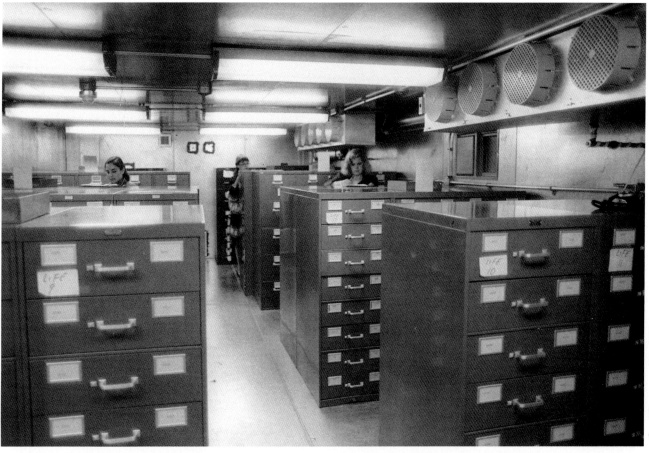

Carol Brower — May 1983

Most of the more than one million color slides and other film transparencies in the Time Inc. Magazines Picture Collection, which includes the files of **Life**, **Time**, **Fortune**, **Sports Illustrated**, **Money**, **People Magazine**, and other publications, are now kept in a cold storage vault located adjacent to the picture collection on the 17th floor of the Time & Life Building in New York City. Constructed in 1983 to preserve the priceless collection, which contains color slides dating back to the 1930's, the vault was designed to operate at 0°F (–18°C) and 30% RH. In recent years, however, because of heavy use of the color collection, the vault has been maintained at 60°F (15.5°C) and 30% RH. Time Inc. Magazines is part of Time Warner Inc.

## Fujichrome and Kodachrome Films Are the Best Choices

When the image stability of a slide film is of even moderate concern, there are really only two logical choices among all the slide films currently on the market: Fujichrome and Kodachrome.

Kodachrome films have the best dark fading stability of *any* conventional color film, either negative or transparency. Kodachrome is also the only chromogenic color film that remains completely free of yellow stain formation during extended dark storage. (Only Ilford Ilfochrome Micrographic film [called Cibachrome Micrographic film, 1984–1991], an ultra-stable color microfilm, has better dark fading stability than Kodachrome. But because of its extremely slow speed — an ISO speed of about 1 — and several other constraints, it is not suitable for normal pictorial photography.)

Kodachrome 35mm slide film was introduced in 1936, and for most of its more than 50-year history the film has had a number of practical limitations for many applications. Until late 1986, when 35mm Kodachrome 200 Professional Film and Kodachrome 64 Professional Film in the

120 roll-film format were introduced, Kodachrome films were supplied only as low-speed 35mm materials: ISO 25, 40 (tungsten), and 64.

In the 1970's and early 1980's, many photographers who otherwise liked the fine grain and extremely sharp images offered by Kodachrome had abandoned the film because the then-available "amateur" Kodachrome 25 and 64 films and the downgraded "amateur" Kodachrome processing at Kodak Processing Labs frequently gave unacceptable performance in terms of color balance and film speed. Most professional photographers felt that the previous Kodachrome II and Kodachrome-X films gave better results.

The introduction of Kodachrome 25 and 64 Professional films in 1983 and "professional" Kodachrome processing by independent labs generally improved the situation and as a result, the use of Kodachrome among professional photographers increased for a while — mostly at the expense of Ektachrome film. At one point it was even rumored that Kodak was thinking about once again marketing Kodachrome sheet film. (Kodak initially introduced Kodachrome sheet film in 1938. The film was discontinued in 1955, with Process E-1 Ektachrome film offered as a

An outer vestibule minimizes temperature and humidity fluctuations within the vault, as, for example, when Beth Zarcone, head of the picture collection, and Linda Kurihara leave the facility.

Temperature and humidity conditions inside the vault are recorded on a circular chart recorder, here being checked by Mary Jane McGonegal and George Zeno.

Carol Brower – May 1983

replacement. The Ektachrome film had the advantage that it could be processed by the user, but it was *far* less stable than Kodachrome — a fact that Kodak was careful to keep secret from professional photographers.) But by around 1990, sales of Kodachrome were declining once again.

For many photographers working with transparency films, the fact that Kodachrome film cannot be processed by the user or most custom labs is a serious obstacle to its regular use. The complex processing procedure requires specially built motion picture-type processing equipment and an in-house analytical lab to monitor the chemistry. Professional-quality processing of the film is increasingly difficult to come by and at the time this book went to press in 1992, was available only in Los Angeles and Miami, or by shipping the film to one of the few Kodalux labs (formerly Kodak Processing Laboratories) still offering "professional" Kodachrome processing. Several amateur-oriented photofinishing labs also process Kodachrome, but by professional standards the quality and consistency of their work are generally unacceptable. Fujichrome, Ektachrome, and Agfachrome, on the other hand, can be quickly processed by the user or by any of the countless labs around the world offering E-6 processing.

A serious drawback of Kodachrome for slide-film users is that, unfortunately, it has the *worst* projector-fading

stability of any slide film currently on the market. How significant this shortcoming is in practice depends on how much a slide might be projected over its entire lifetime. Kodachrome is the best choice when little if any projection of originals is required (for critical commercial applications, this author suggests a maximum of 20 minutes total projection time during the entire life of a Kodachrome slide).

## Fujichrome Films Are Superior to Ektachrome, Agfachrome, and 3M ScotchChrome Films

If significant projection is contemplated, or if Kodachrome is not suitable because of processing requirements or other limitations, Fujichrome professional and amateur films are clearly the best choices among all currently available transparency films. Fujichrome professional films are available in a wide range of speeds and formats, from 35mm to 8x10-inch sheet films, in both tungsten and daylight versions. Speeds of the Fujichrome daylight films range from ISO 50 to 1600 (processed normally, this is currently the world's fastest color transparency film).

Fujichrome films have received excellent reviews in the press, with many top professional photographers praising the color reproduction and image quality of the films.

Thom O'Connor, writing in New York City's *Photo District News*, gave this report on one photographer's reaction to Fujichrome films:

> New York advertising and annual report photographer Jim Salzano was introduced to Fuji three years ago by architect Charles Fazio.
>
> "Charles wanted to make photographs of mosaics on a building," recalls Salzano, "and he suggested we use Fujichrome. I laughed a lot, but he gave me a copy of a photo magazine with a favorable review on the film, so we tried it.
>
> "We shot both Fujichrome and Ektachrome, and had it processed a few different ways. I was amazed at how good Fuji looked. It was incredibly brilliant, with a lot of latitude. It was a lot like Kodachrome, but without the really heavy contrast. The Ektachrome looked flat, it had no life."
>
> Salzano, a heavy Ektachrome roll film user, gradually started moving to Fuji. "I had a lot of Ektachrome in my refrigerator, so I told myself I'd use that on unimportant jobs. But every job seemed important, so I kept using Fujichrome. Finally, I sold off my Ektachrome to a photographer in my building."[1]

Comments like this and the increasing acceptance of Fujichrome films in the mid-1980's greatly alarmed Kodak — this was the first time that Kodak's stranglehold on the professional market in the U.S. had been seriously threatened — and the company embarked on a crash program to try to match the brilliant color saturation offered by the Fujichrome films. The result, introduced with much fanfare at the 1988 Winter Olympics in Calgary, was Ektachrome 100 Plus Professional Film (the "amateur" version is called Ektachrome 100 HC Film).

In this author's tests, both the standard and the new "Plus" and "X" types of Ektachrome films proved to have identical projector-fading stability. Current Ektachrome film and Fujichrome films all have generally similar, yellowish stain-limited, dark storage stability (see Chapter 5). Fujichrome films, however, have approximately *twice* the projector-fading stability of Ektachrome films (see Chapter 6). Though not as stable in dark storage as Kodachrome films, Fujichrome films are more than *5 times* more stable than Kodachrome in projector fading!

In most commercial applications — given the relatively good dark fading stability of current Fujichrome, Kodachrome, and Ektachrome films — the most critical stability factor in slide film performance is projector-fading stability. In this regard, Fujichrome films — both camera and duplicating — clearly stand out as superior to all other transparency films in the world today.

Although current 3M ScotchChrome slide films have relatively good projector-fading stability, the dark fading stability of these films is inferior to that of Fujichrome and most other E-6 films; for this reason, ScotchChrome films are not recommended. Although the dark fading stability of the "improved" Agfachrome RS and CT films introduced in 1988–89 is better than previous Agfachrome films, nei-

October 1982

Participants at the Mid-America Art Slide Libraries meeting in Iowa City, Iowa in 1982 examine Agfachrome slides brought to the meeting. Concern had been expressed that older, humidity-sensitive Agfachrome slides (made before 1984, when Agfa converted its films to Process E-6) were less stable than Ektachrome, Kodachrome, or Fujichrome slides. Agfachrome slides were pulled at random from collections, and this subjective examination indicated that at least under some conditions, the Agfachrome images had faded significantly in a relatively short period.

ther dark fading nor projector-fading stability of the new Agfachrome films is equal to that of Fujichrome.

## Fujichrome Velvia Professional Film Equals or Exceeds the Image Quality of Kodachrome Film

Fujichrome Velvia Professional Film, a 50-speed film introduced in 1990, is the sharpest and finest grain of all Process E-6 compatible transparency films. Velvia is the first E-6 film to equal — or even exceed — the high resolution and very fine grain of Kodachrome 25 film (in terms of image structure, Velvia is substantially superior to Kodachrome 64).

Writing in the June 1990 issue of *Outdoor Photographer* magazine, Galen Rowell, an internationally known wilderness photographer, had this to say about Velvia:

> I ran controlled tests of Velvia against Kodachrome 25, Kodachrome 64, and Fuji Pro 50. On the light table the next morning, I saw the

*(continued on page 630)*

# Recommendations

## Slide Films

- Choose slide films with the best combination of projector-fading and dark fading stability. This is the most critical factor in determining the eventual life of an image. As discussed in Chapter 5, Ektachrome and Fujichrome films have generally similar, stain-limited, dark storage stability. But because Fujichrome and Fujichrome Velvia films are far superior to Ektachrome films in projector-fading stability, Fujichrome films are recommended for most applications. Agfachrome films are an acceptable third choice, after Fujichrome and Ektachrome. Where projection of originals can be avoided, Kodachrome is the best film to use because of its unsurpassed dark fading stability and complete freedom from yellowish stain formation during long-term storage; when kept in the dark, Kodachrome is more stable than any other chromogenic color film — transparency or negative. Unfortunately, Kodachrome has the worst projector-fading stability of any currently available slide film.

- Color negative films should be considered for original photography. To make slides, color negatives can be printed on Kodak Vericolor Slide Film 5072. Color negatives have much greater exposure latitude than transparency films and color corrections can be made when slides are printed from negatives. With negatives stored in a safe place, new slides can be made as needed. This eliminates concern about fading, scratching, or outright loss of irreplaceable originals during projection, handling, or shipping. In addition, color negatives can be used to make high-quality color and B&W prints.

- Films to avoid: 3M ScotchChrome films and Polaroid Presentation Chrome 35mm film (made for Polaroid by 3M) are not recommended because they have inferior dark fading stability compared with Fujichrome, Ektachrome, Kodachrome, and Agfachrome. Polaroid PolaChrome instant color slide films also are not recommended because of poor image stability, very poor image quality, and numerous other practical shortcomings. Advertising by Seattle FilmWorks and other cut-rate processors notwithstanding, use of Eastman, Fuji, and Agfa motion picture color negative films as a method of making slides (and/or color prints) should be avoided.

- Duplicating films: Fujichrome Duplicating Film is recommended. Currently available only in 100-foot rolls, it is hoped that Fuji will supply the film in 36-exposure cassettes. For large-volume duplication (with an internegative), Fujicolor Positive Film LP 8816 and Eastman Color Print Film 5384 are recommended. Agfa CP1 and CP2 print films have very poor dark fading stability and these films should be strictly avoided.

## Slide Mounts

- Kodak cardboard Ready-Mounts and the cardboard mounts used by Kodalux Processing Services (formerly Kodak Processing Labs) are made of long-lasting materials, and accelerated tests indicate they are not harmful to color slide images during prolonged storage; the mounts are satisfactory for most applications (no information is available on other types of cardboard mounts).

- Open-frame (glassless) plastic slide mounts made by Wess Plastic, Gepe, Pakon, and others appear to be satisfactory, although accelerated aging data with slide films in plastic mounts were not available at the time of this writing.

- Glass mounts offer protection from fingerprints and scratches during handling and also maintain the film in a flat plane during projection. Glass mounts do not, however, reduce the rate of fading during projection or in dark storage. Glass mounts are routinely used in slide libraries because the slides are handled frequently by students, faculty, and staff; for libraries and other users that do not require pin-registration, the taped-glass Archival Mount available from Wess Plastic, Inc. is recommended.

- With commercially produced duplicate slides intended for use in slide libraries and other reference collections, 3M Photogard anti-scratch film coating and open-frame plastic mounts are recommended as a low-cost substitute for glass mounts. Photogard should not be used to coat original slides or duplicates intended for reproduction or preservation backup.

## Projection

- Keep the projection time of original slides or nonreplaceable duplicates to a minimum. For general applications, the total accumulated projection time for Fujichrome should not exceed about 5 hours (4 hours for Fujichrome Velvia); with Ektachrome do not exceed 2½ hours; with Agfachrome do not exceed 2 hours; with Kodachrome do not exceed 1 hour (see Chapter 6). For critical applications, much shorter accumulated projection times are recommended. The accumulated projection time, not the length of a particular projection, is what is important. Lecturers who project certain slides repeatedly should be especially cautious. Use expendable duplicates whenever possible; Fujichrome duplicating film is recommended. Avoid high-intensity xenon arc projectors. Likewise, do not use projectors fitted with nonstandard, high-intensity quartz-halogen lamps or that have been modified in other ways to increase lighting intensity.

## Slide Pages

- **Recommended:** Polypropylene notebook pages for slides are best (e.g., 20th Century Plastics, C-Line, Light Impressions, Film-Lok, and DW Viewpacks). This author's top recommendation is the line of EZ2C Super-heavyweight polypropylene pages made by 20th Century Plastics, Inc. The heavier 5.0 gauge of these high-clarity pages gives them much better handling characteristics than the flimsier 3.5-gauge polypropylene pages available from most other suppliers. EZ2C Super-heavyweight pages are available for ring-binder notebooks or with steel top-bars for use in file drawers equipped with frames for hanging files. Also recommended, when used in conjunction with Kimac individual slide sleeves (not necessary for glass-mounted slides), are the rigid, open-frame polypropylene Saf-T-Stor slide pages supplied by Franklin Distributors Corp. The Plastican Slide Frame, a rigid, open-frame, molded polystyrene slide "page," is satisfactory for glass-mounted slides and is particularly recommended for vertical storage of glass-mounted slides in file cabinets.

- Products to avoid: Polyvinyl chloride (PVC) slide pages, especially the widely available plasticized PVC slide pages (e.g., 20th Century Plastics and many other firms). Low-density polyethylene pages (e.g., Vue-All, Print File, Light Impressions, and Clear File) also are not recommended.

## Sleeves for Individual Slides

- Unless kept in inactive storage, slides should be inserted into individual acetate sleeves to avoid fingerprints and other damage. Kimac sleeves are best. Light Impressions individual slide sleeves lack the snug fit of the Kimac sleeves and therefore are not recommended. ImageGuard rigid slide holders, from Image Innovations, Inc., are excellent for protecting valuable slides during shipping and handling; however, at a price of about $1 each, the high cost of the holders will restrict their use in most collections.

## Handling Slides

- Handle slides carefully to avoid fingerprints, scratches, and abrasion. Slides, especially one-of-a-kind, irreplaceable originals, should be treated with the same care given to valuable negatives.

- With valuable slides, retain the originals and supply duplicates to editors, art directors, lecturers, and other users. Important collections should establish two separate divisions. The preservation collection, consisting of originals, is not projected or otherwise subjected to day-to-day use. The working collection, made up of duplicate slides, can be edited on light tables, projected, sent to clients, and so forth. To reduce the risk of losing or damaging originals, provide for in-house duplication whenever possible.

- Store slides in the dark in a reasonable environment. The storage temperature should not exceed 75°F (24°C) and the relative humidity should be kept as low as possible — to avoid fungus growths, slides should never be stored where the relative humidity is above 65–70% for prolonged periods. Humidity-controlled refrigerated storage should be used to preserve valuable historical and commercial collections (see Chapters 19 and 20).

- Slides made with comparatively unstable films (e.g., pre-1978 Ektachrome films, pre-1989 Agfachrome films, 3M ScotchChrome films, and Polaroid Presentation Chrome film, slides printed on pre-1984 Eastman Color motion picture print films, etc.) and slides of any type or age that show any signs of fading or staining should be duplicated on Fujichrome Duplicating Film and the originals placed in humidity-controlled refrigerated storage.

- Do not allow slides to remain on illuminated viewers or light tables any longer than absolutely necessary. Extended exposure to light from an illuminated viewer can cause significant fading. Kodachrome slides are particularly sensitive to this and other types of light fading.

- To avoid potentially serious, irregular image fading caused by room lights, do not leave slides uncovered on desks or tabletops. Be especially careful in rooms that are brightly illuminated with fluorescent lamps or daylight.

end of an era in my results. At the very least, my opinion was that Velvia was the best of all existing worlds. Its resolution appeared to exceed Kodachrome 25 and the other test films. I preferred the color saturation and separation of tones over Fuji Pro 50 and the other films (although some photographers may prefer Kodachrome's relatively muted colors). To my eye, exposure latitude equals the other films, yet with richer blacks. Its granularity rating of 9 equals that of Kodachrome 25, and exceeds Kodachrome 64's 10, and Fuji Pro 50's 11. In my tests, the grain often looks tighter than in Kodachrome 25 because it doesn't build up as much in dark, continuous toned areas such as blue skies or facial shadows.[2]

Since its introduction in 1990, Velvia has made serious inroads in the traditional Kodachrome market — especially in the quality-conscious advertising, fashion, and stock photography business, where the fast turnaround of E-6 processing is a compelling advantage. After a significant part of the professional market that until recently used Kodachrome film moved to Velvia and other E-6 films, a number of major commercial labs in New York, Chicago, and San Francisco that had installed complex and costly Kodachrome processing lines in the late 1980's no longer had enough film coming in to make money on their investment and were forced to leave the Kodachrome processing business.

As high-quality Kodachrome processing became more and more difficult to find, increasing numbers of photographers stopped using Kodachrome. If the market shrinks below a certain critical level, Kodak could decide to abandon Kodachrome altogether.

## PolaChrome Instant Slide Films Should Be Avoided

Polaroid PolaChrome instant color slide film and its high-contrast PolaChrome counterpart are not recommended for general applications because the films have poor dark storage stability in humid conditions; they can also experience potentially serious and uneven image degradation as a result of prolonged projection. The physically delicate silver image layer on the surface of PolaChrome films may also be unusually susceptible to deterioration caused by airborne pollutants and by contaminants in filing materials during long-term storage, although an assessment of this potential hazard is not currently available. PolaChrome films have very poor image quality and suffer from a host of other practical drawbacks (see Chapter 1).

## Slides from Color Negatives and Internegatives

Slides can be printed directly from color negatives, or internegatives made from original transparencies, using, for example, Kodak Vericolor Slide Film 5072. If a slide is made from a color negative, it may be of little consequence if the slide fades or becomes damaged in handling since new copies can be prepared as needed.

If only one copy of a slide is required, shooting with

reversal films such as Fujichrome or Ektachrome is by far the quickest and least expensive method. If the lighting conditions are good and the exposure is precise, one usually can obtain better results from reversal-processed slides than with slides printed from color negatives. For these reasons, when slides are wanted, most are shot with reversal films. Conversely, when color prints are the primary need (by portrait photographers, for example), color negative films are almost always selected.

For reasons of economy, it has long been industry practice to duplicate slides on motion picture color film when large numbers of duplicates from an original are required. Costing much less than Vericolor Slide Film 5072, Eastman Color Print Film 5384 is the film now most commonly used for this purpose. In fact, Eastman 5384 costs far less per foot than any other 35mm film manufactured by Kodak — either black-and-white or color. When you go to a movie, the color image on the screen is projected from Eastman 5384, or a similar motion picture color print film made by Fuji or Agfa. Eastman 5384 is considerably more stable in dark storage than Vericolor Slide Film 5072; the two films have generally similar projector-fading stability.

Because 5384 is a negative-positive material, it must be printed from a color negative. In most cases, however, the originals used for high-volume duplication are transparencies, thus requiring that an internegative be made for printing purposes. In most larger labs, internegatives are made with Eastman Color Negative Film 5247, both because of its comparatively low cost and because it is sensitometrically matched to 5384. Also suitable for printing slides from negatives and internegatives is Fujicolor Positive Film LP 8816, another motion picture print film.

## Millions of Color Slides Printed on Pre-1983 Eastman Color Print Films Are Now Faded Almost Beyond Recognition

The use of color motion picture print films for high-volume, low-cost production of color slides began in the early 1960's with Eastman Color Print Film 5382 (followed by Eastman Print films 5385 [1962], 5381 [1972], and 5383 [1974] — 5381 and 5383 were both used by slide producers until about 1983).

Unfortunately, until the introduction in 1982–83 of Eastman Color Print Film 5384, all Kodak, Fuji, and Agfa negative-positive motion picture print films had extremely poor dark fading stability (current Agfa CP1 and CP2 print films still have very poor dark storage stability). Millions of slides made on these earlier films can be found in slide libraries and nearly all have suffered a severe reddish color shift — the result of catastrophic cyan dye fading. As color images, they are now totally worthless. These slides have faded regardless of whether they experienced frequent and lengthy projection or were stored in the dark and never projected. Motion pictures printed on these films have suffered the same fate: all of them have by now suffered catastrophic dye fading. A ghastly reddish image is all that remains of their once full-color brilliance (see Chapter 9).

One of the major art slide producers, Sandak, Inc. of Stamford, Connecticut, was forced to replace well over one million slides printed on Eastman Color Print Films. Harold

Sandak, the founder of the firm, said the fading problem nearly put the company out of business. (In 1988, after 30 years of operation, Harold and Ruth Sandak, the owners of Sandak, Inc., retired and sold the firm to G. K. Hall & Company, a division of Macmillan, Inc. located in Boston, Massachusetts.)

The Sandak production of *Arts of the United States* — sets of up to 4,000 slides that were sold to colleges, universities, and museums, with a subsidy from the Carnegie Foundation — was one of the first applications of Eastman Color Print Film for art slide production in the United States. A 1961 article described the massive project — which proved to be a disaster when all of the slides faded to a horrendous reddish-magenta color only a few years later:

> The Carnegie Corporation of New York recently sponsored a major project, the photographing of over 4,000 items of Americana to form a permanent collection of color negatives from which color slides, and black and white and color reproductions can be made.
>
> . . . An important feature of the program is the photographic technique used to insure accuracy of reproduction. Usually color slides are duplicated by rephotographing the original slide, with a resulting loss of faithfulness to the original. To combat this problem, and make accurate duplicates readily available, the project decided to use the color negative process, a technique which has been employed in the movie industry, and has more recently become popular in Europe as a means of producing color slides.
>
> . . . All of the slides are permanently mounted in a specially designed plastic frame between thin glass which permits their use in an automatic slide projector.[3]

The introduction of unstable motion picture print films into the slide market was one of the unfortunate legacies of Kodak's policy of secrecy about color stability, a policy which Kodak adhered to from 1935, when Kodachrome film first appeared on the market, until the early 1980's. Sandak and other slide producers were unaware of the exceedingly poor stability of these films when they started to use them. At the time, Kodak had extensive data on the fading characteristics of all its color films and was aware that the films would become severely faded after only a few years, but the company withheld the information and did nothing to discourage slide producers in the U.S. and Europe from using the films.

Instead of color negative films, Kodachrome film would have been a far better choice for the original photography for projects such as *Arts of the United States*. It would also have been better to make duplicates on Kodachrome film that had been pre-flashed to reduce contrast (for many years Kodak processing laboratories made all slide duplicates with pre-flashed Kodachrome). By the time Kodak finally made dark fading stability data for its films public in the early 1980's, many millions of extremely unstable slides had been produced and sold.

## Motion Picture Color Negative Films Should be Strictly Avoided for Conventional Still-Camera Photography

Re-spooled in cassettes for 35mm still cameras, Eastman Color Negative Film 5247 (a tungsten-balanced 100-speed film), Eastman EXR Color Negative Film 5296 (a tungsten-balanced 500-speed film introduced in 1989), Eastman EXR Color Negative Film 5245 (a fine-grain daylight-balanced 50-speed film introduced in 1989), and other Eastman Kodak and Fuji motion picture color negative films are sold to unsuspecting amateur photographers by a number of cut-rate processing labs, including Seattle FilmWorks, MSI/Heritage Color Labs, RGB Color Lab, Images International, Inc., and others. Upon return of the film for processing, the negatives are printed on Eastman 5384 or a similar Fuji or Agfa motion picture print film to produce a set of slides. If the customer desires, color prints on paper are made as well — all at very low cost. Some processors even include a free replacement roll of film with each order in an effort to keep customers coming back. Neither Kodak, Fuji, nor Agfa has ever supplied motion picture color negative films spooled in 35mm cassettes.

Use of motion picture color negative films is ill-advised for still camera applications, especially if optimum-quality color prints are needed; the reader is urged to consult Kodak's publications on the subject.[4] Motion picture color negative films are designed for exposure at $\frac{1}{48}$ second in a motion picture camera, and almost all of these films are tungsten-balanced and therefore should not be used for daylight or electronic flash photography without an exposure-lengthening daylight conversion filter.

These films *cannot* be processed in standard C-41 color negative chemicals — if by accident they are, the rem-jet backing (a black anti-halation, anti-static, scratch-protection layer coated on the backside of motion picture films that is softened and removed in an alkaline bath with mechanical buffing and a water spray rinse, in processing machines that are specially designed for motion picture films) will slough off and contaminate the color developer and other chemicals in the C-41 process. This can be a disaster for any Kodacolor or other normal C-41 films that have the misfortune of going through the processor in the same run. This danger has forced photofinishers to examine every roll of film they receive for processing to determine whether or not it is re-spooled motion picture color negative film; lab workers live in constant fear that a roll of motion picture film will get through undetected and create havoc with a processing machine.

## Projection of Slides

Depending on the film and the pictorial characteristics of an image, slides may show perceptible fading — most obvious as changes in highlight color balance — after as little as 15 minutes of projection time. When repeated projections over a period of weeks or months accumulate to 2 or 3 hours of total projection time, slides on many films exhibit image fading that is readily apparent if the slide is compared with an unfaded original (for a complete discussion of projector-caused fading, refer to Chapter 6).

Fading that occurs during projection is caused almost entirely by light. Although slides are heated to a fairly high temperature during projection, the relatively short time a slide is exposed to heat in a projector means that heat during projection — in itself — makes a negligible contribution to fading. This has been confirmed by accelerated dark fading tests in heated ovens at equivalent temperatures and times of aging (it should be noted, however, that there is some evidence that with certain dyes, very high temperatures during projection can increase the rate of fading caused by the projector illumination). In any event, if a slide were projected long enough for projector heat to cause significant fading, the deterioration caused by the exposure to light would be far more severe.

In the past Kodak often advised that "projection times should not exceed one minute per slide."[5] Many people have misinterpreted this to mean that a slide will get too hot if it is projected longer than 1 minute and that the excess heat will cause both physical damage and disproportionate amount of fading to occur. With conventional slide projectors, such as Kodak Carousel and Ektagraphic projectors (unmodified, with Kodak-recommended lamps, and in good working condition), a slide will never become so hot that physical damage to the film will occur — even after hours of continuous projection. Apparently Kodak's intent in advocating short projection times is to reduce the likelihood that, during normal use, any particular slide will receive an excessive *total* projection time during its life.

High-intensity xenon arc projectors, however, may generate temperatures that are hot enough to cause physical distortion of the film base and, not uncommonly, blistering and other emulsion damage. Plastic slide mounts may be distorted or partially melted by excessive projector heat. Glass-mounted slides are particularly prone to heat damage.

Slides with silver images — including Polaroid PolaChrome instant color slides and all types of black-and-white transparencies — may be more susceptible to heat damage than conventional color slides with dye images. Silver images absorb infrared radiation from the projector lamp (the infrared or heat-absorbing glass filters and dichroic mirrors in Ektagraphic, Carousel, and most other projectors absorb most, but not all, infrared radiation). It is absorbed infrared, in combination with absorbed visible light, that causes the temperature of slides to rapidly rise during projection. Color dye images absorb much less infrared radiation than silver images and therefore tend to stay cooler during projection.

Infrared or heat-absorbing glass filters should never be removed from a projector in an effort to increase screen light intensity; if the filter breaks, the projector should not be operated until it is replaced. Only projector lamps recommended by the manufacturer should be used and high-wattage lamps should be avoided. To help avoid overheating, make sure that the projector fan is functioning properly and that air intakes and exhaust airflow outlets are not obstructed.

Excessive projection of originals is often encountered in educational and training fields where slides are used to accompany lectures. It is not unusual for a particular slide to be projected every time a talk is given over a period of many years; in some cases a slide will remain on the screen

November 1987

James H. Wallace Jr., director and curator of Photographic Services at the Smithsonian Institution in Washington, D.C., examines color slides in the Photographic Services' cold storage vault, which is maintained at 40°F (4.4°C) and 27% RH. More than 175,000 original slides are preserved in the vault, together with hundreds of thousands of black-and-white negatives and duplicate negatives made from nitrate-base originals. Wallace supplies slide duplicates, made in the department's well-equipped lab, to the Smithsonian staff and to outside clients. Most of the slide collection has been put on videodisc for ease of reference.

for 15 minutes or longer to accompany a detailed discussion. Many hours of projection time will soon accumulate and eventually the slide will suffer devastating fading. Unfortunately, it is usually the most important slides that are projected most frequently, and for the longest periods — a kind of self-selection for destruction of the most valuable and visually striking images!

## Duplicates Should Always Be Made When Heavy Use of a Slide Is Likely

When slides are likely to be projected often and/or for extended periods, duplicates are always advised. However, trying to duplicate everything, especially under tight deadlines, can be difficult, expensive, and unwieldy.

For educators and others who give frequent lectures, a practical approach to the projector-fading problem is to review periodically — perhaps once every 6 months — all the slides in current use and have duplicates made of particularly important ones, and of those that experience has shown are frequently projected and that are likely to continue to be used often in the future. In this way, serious damage to crucial material can be avoided. In all situations where frequent or prolonged projection is anticipated, it is beneficial to choose the most stable films available.

In commercial and audiovisual applications, where duplicate slides are more frequently made, it is no less important to care for originals properly. One can go back to a carefully preserved original time and time again to make new duplicates. If an original is damaged or lost, however, and only a duplicate exists, a third-generation copy will have to be made from the second-generation duplicate. Because of losses in shadow and highlight detail, color degradation, and other image-quality losses inherent in the duplication process — all of which are accentuated with each generation — the image quality of a third-generation duplicate is frequently unacceptable.

In some situations — landscapes and studio still-lifes, for example — the photographer may be able to take multiple originals. This is the best and least expensive form of slide "duplicate."

During the past 10 years, this author has given many slide lectures on the stability and preservation of color photographic materials and has gained a firsthand appreciation of the problems inherent in attempting to avoid projection of originals by using only duplicates for this sort of presentation (the lectures are updated with new material every time they are given). Initially, most of this author's slides were Ektachrome and Kodachrome originals. Then, concerned about the fading that occurred with some of the more frequently shown slides, and made duplicates of his most valuable slides this author stopped using Kodachrome altogether because of its poor projector-fading stability. At that point, Fujichrome became this author's film of choice for lecture slides.

In 1988, this author switched to color negative film for everything except in-house studio and copy-stand work. (Initially Kodak Vericolor 400 film was used, but in 1991 this author changed to Fujicolor 400 Professional film because of its finer grain and superior sharpness; Fujicolor Reala 100 film is also used when lighting conditions permit.) A set of proof prints is obtained when the film is processed and, after selections are made from the prints, the negatives are printed on Vericolor Slide Film 5072 to make slides for projection. To have spares on hand, three or four slides are usually made from each selected negative. When required for publication, it is a simple matter to make reasonably good-quality black-and-white prints from the color negatives.

Overall, this approach has proven to be more satisfactory, if somewhat more expensive and time consuming, than working with original slides and duplicates made from originals. Much of this author's photography is done under difficult available lighting conditions with mixed illumination sources, and the wide exposure latitude of color negative films, together with the color balance and density adjustments that are routinely made when slides are printed, has generally resulted in better quality images than had previously been obtained with color reversal films.

After processing and printing, this author's color negatives are stored in a frost-free refrigerator, thus eliminating concern about fading, scratching, or loss of irreplaceable original slides.

## Duplicating Films and Slide Duplicators

Conventional slide films are not well suited for slide duplicating because their contrast is much too high and their curve shape does not allow optimum reproduction of shadow and highlight detail. Also, regular slide films are excessively grainy (ideally, a duplicating film should accurately reproduce the *grain structure* of the original slide, without adding any visible grain of its own to the image). To meet the requirements for duplication, special low-speed, low-contrast, high-resolution, and extremely fine-grain duplicating films are manufactured.

At the time of this writing, Kodak Ektachrome Slide Duplicating Film 5071 (for tungsten-illuminated duplicators); Ektachrome Slide Duplicating Film Type K/8071 (for duplicating Kodachrome originals) and Ektachrome SE Duplicating Film SO-366 (for electronic flash duplicators) were the most commonly used slide-duplicating films in the United States. SO-366 is Kodak's designation for selected emulsion batches of 5071 film that Kodak's tests have indicated will work best with short-duration electronic flash illumination (both films are nominally tungsten-balanced). Ektachrome duplicating films have the same image stability characteristics as standard Ektachrome camera films.

Fuji's slide duplicating film, called Fujichrome Duplicating Film CDU, was not actively marketed in the U.S. until 1985. Because Fujichrome is superior to Ektachrome in projector-fading stability (Fujichrome and Ektachrome duplicating films have similar dark fading stability), Fujichrome Duplicating Film is recommended. Fujichrome Duplicating Film is also preferred by many photographers because of its image-quality characteristics. Larry Lipsky, writing in *Outdoor Photographer* magazine, commented:

> After several years of experimenting with both the Kodak and Fuji films, I must confess a certain preference for the Fuji product. Although all three films come with recommended filter and film speed settings, which can often vary from batch to batch, I personally found

**Table 18.1  Cost of Film to Duplicate a Slide or Make a Slide from a Negative or Internegative (Large Quantities)**

| | |
|---|---|
| Fujichrome Duplicating Film CDU (100-foot roll – from slide)* | $ 0.07 |
| Ektachrome Slide Duplicating Film 5071 (100-foot roll – from slide) | $ 0.07 |
| Kodak Vericolor Slide Film 5072 (100-foot roll – from negative) | $0.10 |
| Eastman Color Print Film 5384 (1,000-foot roll – from negative) | $ 0.02 |

\* Recommended duplicating film.

Film costs based on 1992 list prices for Fuji and Kodak films; processing and slide mounting costs are additional.

**Table 18.2  Cost of Duplicating a 35mm Slide (Small Quantities)**

| | |
|---|---|
| 36-exposure roll of Ektachrome Slide Duplicating Film 5071* | $ 8.95 |
| Kodalux processing and mounting | $ 7.50 |
| Total cost per roll: | $16.45 |
| Cost per duplicate: | $ 0.46 |

*The recommended Fujichrome Duplicating Film CDU is supplied only in 100-foot rolls; 35mm cassettes of the film unfortunately were not available at the time of this writing.
Costs are based on 1992 Kodak and Kodalux lab list prices.

Fuji's CDU film to be more consistent and easier to work with. Duplicates made with this film are incredibly sharp and crisp with exceptional color saturation and pleasing contrast.[6]

When large numbers of duplicates are required from a slide, it is general industry practice to make an internegative (often on Eastman Color Negative Film 5247) and to print the slides on low-cost Eastman Color Print Film 5384; both of these motion picture films require special processing machinery and chemicals. Eastman 5384 is not as stable in dark fading as either Fujichrome or Ektachrome duplicating films; 5384 also is not as stable in projection as Fujichrome.

Kodak Vericolor Slide Film 5072 (processed with standard C-41 color negative chemicals) can also be used to print duplicate slides from an internegative, but due to the relatively high cost of this film, most high-volume commercial laboratories opt for Eastman 5384 instead. The primary application of 5072 is to make slides from original color negatives. The dark fading stability of 5072 is not as good as that of 5384 — or, for that matter, of Fujichrome or Ektachrome films. The approximate cost of duplicating a slide with various Kodak and Fuji films is given in **Table 18.1**.

For routine slide duplicating, there are many practical advantages to having a slide duplicator in-house (if need be, the exposed duplicating film can be sent out for processing). A significant advantage in doing one's own duplicating is that density and color balance corrections can be made to suit the desires of the photographer. Risk of loss or damage to originals is reduced if slides do not have to leave the building, and time will often be saved because orders do not have to be written out and because pick-ups and deliveries are avoided. Even in small quantities, the cost per slide is moderate for in-house duplication (see **Table 18.2**).

A number of good duplicators are available in the price range of $600 to $1,200. Particularly recommended is the Beseler Dual-Mode Slide Duplicator, which features both tungsten and electronic flash illumination, built-in dichroic filtration (which this author considers essential in a slide duplicator), and a contrast-reduction feature that allows "flashing" of the duplicating film during exposure.

Detailed discussion of duplicating procedures is beyond the scope of this book; the reader is referred to the well-written Kodak book, *Copying and Duplicating in Black-and-White and Color,*[7] as well as other references in the field.

Correctly made duplicates are usually quite satisfactory for projection purposes, but because of the somewhat degraded image quality inherent in any duplicate made from a good original, there is often resistance to accepting duplicates for publication purposes; given a choice, publishers prefer to work with originals. But with careful work and the increased image quality that can be obtained with modern duplicating films, there is an increasing, if begrudging, acceptance of duplicates in the publishing field. New York City agencies such as The Image Bank and Gamma-Liaison now routinely supply duplicates to clients. Others, such as Black Star Publishing Company, generally supply originals to domestic clients but send duplicates to foreign clients to avoid possible loss or damage to slides going out of the country.

The highest-quality duplicates have traditionally been done on 4x5-inch sheet film, but the high cost of such duplicates has limited their use. One agency that has made effective use of 4x5 duplicates is Tony Stone Worldwide (TSW), headquartered in London, England. In 1988 TSW purchased Click/Chicago, a leading midwest stock agency.

November 1987

Douglas Wechsler, director of the VIREO collection of bird photographs at the Academy of Natural Sciences of Philadelphia, makes duplicates of originals with a ChromaPro slide duplicator. Producing duplicates in-house not only lowers costs but also, and much more importantly, eliminates the possibility of damage or loss that can occur when irreplaceable originals are sent to an outside lab.

A *Photo District News* article on Click/Chicago's new owner reported:

> Stone says the key to his agency's overseas success, a policy which will be carried over to the Chicago office, is the fact that the agency concentrates on a relatively small number of pictures, but duplicates them many times over. Taking only the best images on file, 50 or so 4x5 dupes are created in "perfect reproduction quality" — Stone says that they are better than the original, although he wouldn't say how they are created. He did, however, say that the company's on-site lab has the capability of creating composite images, enhancing colors and cropping.
>
> The dupes are offered at the same time in many different markets, greatly increasing the prospect of multiple sales. "Our best-selling pictures are duped 80 times or more and sell more than 20 times each year."
>
> Stone says, "Our sales volume outside the U.S. is on par with the top two or three American stock agencies, which would make us one of the largest stock agencies in the world."[8]

Recently, 70mm "enlarged" slide duplicates, with an image area measuring about 2⅛x3¼ inches, have become available at moderate cost. Produced by a number of labs around the country,[9] these duplicates offer better sharpness and finer-grain images than conventional 35mm duplicates, and they are much less expensive than 4x5 sheet film duplicates. Carl Purcell, a world-traveling freelance photographer, is one professional who advocates 70mm duplicates:

> There is always the danger of loss or damage to the original image, which could substantially cut profits or even put a stock photographer out of business. The stock photography business involves careful safeguarding of one's images as well as careful marketing. Duplicating your images — or "duping" — is, therefore, an integral part of both aspects of the trade.
>
> I believe the 70mm dupe will drastically change the way photographers market their pictures, both directly and through agencies. Basically, it allows a photographer to "clone" an outstanding image as many times as desired, making possible multiple, simultaneous submissions on an international basis.[10]

Wilderness photographer and mountaineer Galen Rowell is another advocate of enlarged 70mm duplicates. Rowell's Mountain Light agency, which he and his wife Barbara operate with a small staff in Albany, California, has more than 300,000 slides on file and of these, "the top 500 are stored in a fireproof vault. If someone wants to use one of these, we send out a 70mm reproduction-grade dupe; everything else goes out as originals."[11] The color photographs in Rowell's recent book, *Mountain Light*, were reproduced from 70mm duplicates. A prolific photographer, Rowell typically has about 3,000 transparencies in circulation with prospective clients.

## Digital Transmission and Storage of Color Slide and Color Negative Images

The recent introduction of computer equipment and associated software to transmit high-quality digitized color images over telephone lines marks the beginning of a revolution in the way publishers and commercial picture collections will operate. At the time of this writing, National Digital Corporation,[12] a leader in this emerging technology, had supplied high-resolution digital image-transmission systems to *U.S. News & World Report* (with systems in both its New York City and Washington, D.C. offices), to *Newsweek* magazine, and to several book publishers, including Houghton Mifflin Company in Boston, and Silver Burdett & Ginn (a subsidiary of Simon & Schuster, Inc.) in Norristown, Pennsylvania.

Among the picture agencies using National Digital systems were Sipa Press in its New York City and Paris offices; Sygma Photo News, also in New York City and Paris; Picture Group; After Image, Woodfin Camp; Photo Researchers; Shostal Associates; and the Click/Chicago agency in Chicago, Illinois. The White House also has a National Digital system to transmit images to publications around the world.

Electronic transmission systems eliminate the need to physically send originals (or duplicates) to prospective clients who have access to an image receiver. This not only saves time but also avoids the hazards involved in shipping transparencies, as well as fingerprints, scratches, projector-caused fading, and other damage (or even loss) that occur all too frequently when materials are in the hands of clients.

With a low-resolution image scanner ($7,000), the National Digital system allows quick "previews" to be transmitted to receiving locations for picture selection, with one, four, nine, or sixteen images appearing on the color monitor screen; transmission time is from 12 to 50 seconds per image, depending on its size on the screen.

With the National Digital Production Resolution scanner ($30,000) and Photo Management Workstation ($18,000), digitized images can be transmitted and stored in a "reproduction-resolution" mode. Interfaced with a Scitex, Hell, Crosfield, or other graphic arts laser scanner, color separations can be reproduced directly from transmitted images for printing in magazines, books, or other publications.

Peter Tatiner, writing in *Photo District News*, reported on the reaction of John Echave of *U.S. News & World Report* after using the National Digital system for a year:

> "It's fantastic," says Echave. "It's been doing better than anyone expected." Echave uses it to decide immediately on whether to grant guarantees to participating agencies and for research especially, he says, for stories that require lots of pictures. The most frequent use, though, is to preview pictures sent down by the New York office. "We can see something in advance on a breaking story. . . ." Previewing via NDC allows the magazine to select pictures and lay out pages before the production department has the actual artwork in hand.[13]

1981

Daniel Jones (left), photography curator at the Peabody Museum of Archaeology and Ethnology at Harvard University in Cambridge, Massachusetts, explains to visiting conservator David Kolody the ingenious "index slide" system developed by Jones for color slides preserved in the museum's cold storage vault.  The inexpensive index slides, viewed with a projector or magnifier, afford an excellent visual record of the material in storage.

Henry Wilhelm (2) – April 1988

Daniel Jones looking at color slides in Saf-T-Stor polypropylene slide pages inside the Peabody Museum cold storage vault. Constructed in 1979 with the aid of a grant from the National Science Foundation, the vault is maintained at 35°F (1.7°C) and 25% RH. It was the first humidity-controlled cold storage vault for photographs in an academic institution (see Chapter 20). Included in the Peabody's holdings is a large collection of color slides and 16mm color motion picture film photographed in the field by noted anthropologist and filmmaker Robert Gardner (the founder of Harvard's Film Study Center).

April 1988

Daniel Jones – 1982

Rigid polypropylene Saf-T-Stor pages supplied by Franklin Distributors Corp. are cataloged and housed in metal boxes for storage in the Peabody Museum vault.

This camera set-up was devised by Daniel Jones for producing index slides. Slides in pages are lighted from below to illuminate the images, and from above so that serial numbers, dates, and caption information are visible. Kodachrome 40, a tungsten-balanced film, was chosen for the project because of its sharp, fine-grain images.

An index slide contains the images of 20 slides in a slide page. These slides were photographed in the same Saf-T-Stor rigid polypropylene slide page in which they are stored.

To produce an even more compact reference tool, 20 index slides can be photographed on a single frame. When projected or examined with a magnifier, the 400 images are large enough for most identification needs.

In the early hours of November 9, 1988, the morning after George Bush was elected president of the United States, *Newsweek* magazine used a National Digital system to transmit color slide images from Houston, Texas, where Bush (a voting resident of Texas) had watched the election returns with his family and staff, to the magazine's offices in New York City. One of the photographs, which showed Bush and his wife Barbara greeting supporters and campaign workers at a victory celebration in Houston, was featured on the cover of the magazine's special election issue. The picture had been taken only hours before *Newsweek's* 4:00 a.m. press deadline:

> On Wednesday, November 9, the film arrived in Newsweek's Houston office at 2:45 a.m. Ten minutes later, picture editors in New York were looking at a group of five preview-quality images (at 500-line resolution) for viewing and selection. Two of these images were then scanned in production resolution, transmitted, written to tape and loaded into the Crosfield [graphic arts laser scanner] system.[14]

Stuart Craig, on the staff of National Digital, expects that initially the primary application of digital transmission will be as an "office-to-office system" for publishers that operate in more than one location and for picture agencies that sell to magazines and other clients who also have National Digital equipment and software. Craig says that valuable and frequently needed images can be stored on digital optical discs, and originals "will no longer have to be handled or shipped — they can be put away for safe-keeping."[15]

## Cataloging and Distribution of Color and B&W Images with CD-ROM's and Photo CD's

For stock photo agencies, two technologies that can simplify distribution of color images while at the same time reduce handling of originals and lower duplication costs are the CD-ROM (compact disc read-only memory), and the Kodak Photo CD introduced in 1992. The Image Bank, a leading New York City stock agency purchased by Eastman Kodak for $25 million in 1991, will be a proving ground for the Photo CD in this type of application. For several years, The Image Bank has used videodiscs to distribute catalogs of images to its 60 sales offices worldwide.

*(continued on page 644)*

Carol Brower – October 1987

In excess of one million color slides are in the collection of Magnum Photos, Inc. Headquartered in New York City, Magnum also maintains an office in Paris, France. A cooperative agency owned by its member photographers, Magnum specializes in news, documentary, and feature photos. Lining the wall at the rear are ring-binder notebooks filled with slides in PVC pages, which were being phased out when this picture was taken in 1987.

Carol Brower (2) – May 1983

The notebook filing system at Magnum has been replaced by more accessible hanging pages, stored in file drawers. Magnum found that some of the PVC pages stuck to slides and left gooey deposits on film surfaces. Although only a small percentage of the PVC pages in the collection have reached such an advanced stage of deterioration, the agency replaced all of the PVC pages with new polypropylene pages. Shown here is Susan Duane, a picture researcher at Magnum.

With the need to access slides on a daily basis, commercial picture agencies have generally viewed cold storage as unwieldly. Slides are stored at room temperature and without special humidity control. Because of this, it is crucial for the survival of historically valuable images that photographers selling work through picture agencies choose the most stable slide films available — currently Fujichrome and, if projection can be avoided, Kodachrome.

Carol Brower (2) – May 1983

Like most large picture agencies, Magnum has computerized its files.  Here, Philip Jones Griffiths (left), photographer and president of Magnum at the time, confers with computer programmer Jeffrey Schlesinger.  Commercial agencies are increasingly adopting CD-ROM's, Photo CD's, and electronic transmission equipment to allow low- and/or high-resolution digital images scanned from photographic originals to be distributed to sales offices and directly to clients worldwide.

Philip Jones Griffiths – May 1983

Magnum has an in-house slide duplicator for making copies of slides sent to clients around the world.  Depending on the nature of the request and time constraints, either originals or duplicates are submitted to clients.

Bookkeeper Vijaya Allen operates a Xerox 6500 color copier that can reproduce either individual slides or groups of slides in notebook pages.  The color copies are sent to clients for their consideration.

Art slide libraries, such as this large facility at the School of Art at the University of Texas in Austin, Texas, frequently contain hundreds of thousands of color slides. In a demanding environment such as this, good projector-fading and dark fading stability are essential. Fujichrome films are recommended for originals and duplicates.

## Types of Slide Collections

During the past decade, as snapshot photographers converted en masse to color from black-and-white photography, nearly all of the growth in the amateur market has been in color negative films. It has been estimated that in 1990 color slides accounted for just 5% of the approximately 16 billion color photographs made by amateurs in the U.S. (black-and-white photographs accounted for a mere 2% of the total!).[16] Amateur photographers have shown a very strong preference for color prints. Slide projector sales have fallen steadily over the past few years, and the home slide show is on the verge of becoming a thing of the past.

In many applications, however, the availability of color prints is not the primary need. Color transparency films continue to be the norm in commercial and stock photography, advertising photography, and magazine photojournalism (although most newspaper photographers now use color negative films). Color slides are also very popular in educational and training fields (the filmstrip, a close relative of the color slide, still is popular in elementary

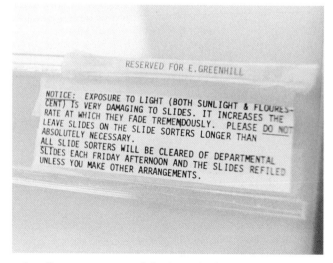

A notice warns users of the hazard of exposing slides to room lights or the more intense illumination of slide viewers.

schools). Slide-accompanied lectures are widely used at conferences and technical meetings; the market for slides with computer-generated color images featuring graphs, charts, and special effects is expanding rapidly. Commercial picture agencies such as Black Star, Magnum, Photo Researchers, Tony Stone Worldwide, The Image Bank, Sipa Press, and Sygma work almost exclusively with color transparencies — the vast majority being 35mm slides.

There are a number of practical advantages to color transparencies when photographs are to be reproduced in magazines, catalogs, books, etc. Since the printing separations are usually made directly from the original transparency, there is no loss of image quality caused by second- or third-generation duplication or the making of positive transparencies or prints from internegatives. Slides and larger transparencies are the lowest-cost form of color photography because they can be viewed directly after processing with no additional labor or materials required to make prints. Editing is simplified and — assuming the exposure and color balance are correct in the original slide — color balance variations that usually appear in making prints are avoided.

The color photographs in large documentary and magazine collections such as the Time Inc. Magazines Picture Collection (part of Time Warner Inc.) and the National Geographic Society consist almost entirely of color transparencies. In the United States, 35mm Ektachrome and Kodachrome films have until recently been the almost universal choice of magazine photographers, although by the mid-1980's Fujichrome films had gained a loyal following among professional photographers, especially commercial photographers and magazine photojournalists.

Because Fujichrome, Ektachrome, and other Process E-6 compatible films are available in high-speed daylight and tungsten versions and can be rapidly processed without complex equipment, they are preferred over Kodachrome for fast-breaking news photography.

Slides have also become increasingly important in commercial and industrial photography over the past decade. Elaborately produced multi-image slide shows, using two or more projectors, often synchronized with a sound track, have been popular in recent years. Tom Hope, a market analyst, commented on the 1986 slide market: "The 2x2-inch (35mm) slide medium continues to dominate all AV systems in total expended dollars. In fact this past year, with the exploding use of computer graphics, total dollars for AV slides and equipment jumped to more than $7 billion."[17]

## Academic Slide Libraries

The academic slide library is a specialized type of slide collection found in most colleges and universities that have art or architecture departments. These collections are usually quite large — many include more than 100,000 slides, most of which are duplicates purchased from commercial suppliers, museums, and other organizations all over the world. Prices for slides in this field are typically $2 or $3 each for copies made on reversal duplicating film or motion picture print film, and $5 or more for "originals" (when photographing a painting or other still object, it is a simple matter to shoot hundreds of identical slides with a camera equipped with a long-roll back).

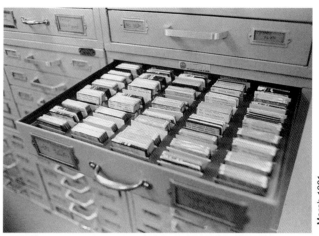

March 1981

Glass mounts can provide physical protection during handling; however, glass mounts offer no added protection against image fading during projection or in storage.

The academic slide library represents one of the more demanding applications for color slides: precise color reproduction and retention of subtle highlight detail are critical, yet the slides are subjected to frequent and prolonged projection — it is not unusual for a professor to have a slide image on the screen for 15 minutes or more while discussing a painting or drawing, and to use the same slide year after year. The most important slides inevitably are the ones that get handled the most and projected the longest.

Because of its superior combination of projector-fading and dark fading stability, Fujichrome Duplicating Film is the recommended film for duplicates sold to slide libraries (Fujichrome and Fujichrome Velvia camera films are recommended for "originals"). While it is more expensive to make duplicates on Fujichrome reversal duplicating film than it is to make them on motion picture print film with an internegative, the total pass-along cost for the better Fujichrome duplicates is only about $0.05 each — a small price to pay considering the extended useful life afforded by the film.

In examining the preservation problems of academic slide libraries, this author has concluded that in the long run the only practical solution is to establish two separate collections: the permanent *preservation collection* and the expendable *working collection*, which consists of a complete set of duplicates made from the preservation collection. The preservation collection holds all of the originals and first-generation duplicates purchased from outside vendors; these slides remain in their original mounts, are never projected, and are never accessed for study purposes. They are stored in the dark in a reasonably cool (refrigerated if possible), low-humidity environment.

Although it is recognized that most commercial slide suppliers will object to this proposal, claiming that it would violate their copyrights and fearing that it could reduce their sales, both users and suppliers should be able to come to an equitable agreement that would ensure that only one duplicate made from each purchased original is circulated at any given time. For the user, there are a number of important advantages to this approach:

- Original slides, whether purchased from outside sources or photographed by staff members, will be preserved.

- Over time, money will be saved. Slides need be purchased only once.

- Replacement duplicates can be made as needed; the color reproduction quality of slides in the working collection can be maintained.

- Unprojected slides in the preservation collection are available for visual comparison with slides in the working collection to determine whether excessive fading has taken place.

- Unfaded originals photographed by staff will be available to make duplicates to distribute to other slide libraries.

- Concern about loss, damage, and projector-caused fading is reduced; the integrity of the collection is maintained.

## Types of Slide Mounts

There are currently four types of common slide mounts:

1. **Cardboard mounts.** The prototype of the modern cardboard slide mount was the Kodaslide Ready-Mount introduced by Kodak in 1939 — 3 years after Kodachrome 35mm film became available in 1936. (Before the introduction of the cardboard Ready-Mount, Kodak returned processed Kodachrome to the customer in strips which then had to be cut into individual frames and placed in glass mounts before the transparencies could be projected.) Kodalux processing laboratories (formerly Kodak Processing Laboratories, now operated by Qualex Inc.) continue to use Kodak cardboard Ready-Mounts for Kodachrome, Ektachrome, Fujichrome, and all other transparency films, including duplicates.

2. **Open-frame plastic mounts.** The Pakon plastic mount was the first widely available plastic mount and is still the most popular,[18] although many other brands are now on the market.

3. **Glass mounts.** Most glass mounts are supplied with the glass sheets already in place in easy-to-assemble plastic or aluminum frames; glass mounts made by Wess Plastic, Inc.[19] and Gepe[20] are among the most popular. Some glass mounts have "pin-registration" to secure precise positioning of the film in the mount — a requirement for multi-image slide presentations. Although glass mounts offer protection against scratches and fingerprints, they are not without their problems (discussed below).

4. **Glass mounts with tape binding.** Long popular with academic slide libraries to protect slides from fingerprints and other physical damage that can result from repeated handling by students and faculty, glass mounts originally were made with 2x2-inch sheets of glass and an interior paper "mask" to locate the film in the proper position and cover non-image areas; they were bound together with gummed paper tape. More recently, metalized polyester pressure-sensitive tape has been used to seal the edges of the two sheets of glass with the piece of film "encapsulated" within, in tight contact with the glass (interior paper or aluminum-foil masks are

not recommended). The taped glass unit is then placed in a plastic or metal frame. Sealing the edges of the glass prevents dust and fungus spores from entering the interior of the mount and minimizes moisture intrusion during periods of high relative humidity; this helps prevent emulsion damage during projection and reduces the likelihood of fungus growth. Recommended is the Wess Archival Mount supplied by Wess Plastic, Inc. (described below).

Although the subject has not yet been comprehensively studied, there appears to be no meaningful difference between Kodalux (Kodak) cardboard mounts (no information is available on other types of cardboard mounts), plastic mounts, and glass mounts in terms of their effect on color film image stability. Many photographers, this author among them, prefer cardboard slide mounts because they handle nicely, weigh much less than plastic or glass mounts, are easy to write and print on, and readily accept rubber stamp impressions.

When projected, color films in glass mounts fade just as fast as do films in open-frame mounts (see Chapter 6). Glass mounts do, however, offer complete protection from fingerprints, dust, and scratches and other physical damage during handling (unless, of course, the glass is accidentally broken, in which case the slide could be seriously damaged). During projection, film mounted between glass becomes hotter than film in open-frame slide mounts, but unless the glass-mounted film should get so hot as to be deformed or suffer other physical damaged, the short periods of exposure to the higher temperatures appear to have little if any significance in terms of image life.

One principal advantage of glass mounts is to insure that the film remains flat during projection so that focus is accurately maintained over the whole image area. This is particularly important in multi-image presentations where images are projected side-by-side or superimposed one on another. Glass mounts also appear to reduce the incidence of fungus attack when slides are stored in humid environments.

## The Problems of "Steam Clouds" and Newton's Rings in Glass Mounts

When slides in traditional glass mounts (with interior paper or aluminum-foil masks) are projected, moisture can evaporate from the heated emulsion and film base and then immediately condense on the comparatively cool cover glass; the result is a disconcerting amoeba-like "steam cloud" that is superimposed over the projected image on the screen. Sometimes a number of smaller "steam clouds" may be observed scattered over different areas of the image. This moisture condensation problem is sometimes called "steaming-up," or the "heat effect." The film heats faster and stays hotter than the cover glass for three reasons: **(a)** more light and infrared radiation is absorbed by the dye image — and is in turn converted to heat — than is absorbed by the transparent glass, **(b)** the outside surfaces of the glass are constantly cooled by the projector fan, and **(c)** the air in the thin cavity between the film and glass acts as an insulator, retarding the transfer of heat from the film to the cooler glass.

If projection continues long enough, the cover glass and air in the thin space between the film and glass will usually become hot enough to cause the condensed moisture "steam cloud" to re-evaporate — the water vapor is re-absorbed by the gelatin film emulsion, with the size and shape of the "steam cloud" changing constantly until eventually it disappears. In extreme cases, the film emulsion will ferrotype (develop areas of irregular gloss) or even adhere to the cover glass. The problem is especially acute when slides are stored in humid environments.

Investigation of the problems of glass-mounted slides by A. G. Tull in England,[21] and more recently by Christine L. Sundt in the U.S.,[22] has made it clear that formation of condensed-moisture "steam clouds" and other difficulties commonly encountered with glass mounts can be largely avoided if certain guidelines are followed.

Glass mounts traditionally have been made with a thin aluminum or paper mask located in the interior of the mount, between the film and glass. Depending on the specific design of the mount, the mask may **(a)** hold the film in the proper position, **(b)** provide sharp borders to the projected image, **(c)** attach the cover glass sheets to the two sides of the mount so that the glass does not have to be handled separately during the mounting operation, and/or **(d)** provide a small air space between the film and glass surfaces in an effort — which is often unsuccessful — to avoid Newton's Rings. (Newton's Rings are rainbow-colored optical interference patterns that may appear on the screen when a glass-mounted slide is projected. They are caused by loose, irregular contact between the smooth surfaces of the film and glass. "Anti-Newton Ring" glass reduces their incidence but does not always eliminate the problem.)

Some glass mounts are made without interior masks, but in most cases their design nonetheless maintains a slight separation between the two sheets of cover glass (this may be intentional, to allow two or more pieces of film to be placed one on top of another in the same mount, or it may result from the method of attaching the glass to the mount frame).

Tull demonstrated that the air gap between the film and cover glass was the principal cause of both condensed-moisture "steam clouds" and Newton's Rings, and he recommended "glass-contact binding" in which interior masks are not included and the film is secured in tight contact with the glass. The elimination of the air space provides a direct heat conduction path from the film to the glass, thus minimizing the temperature differential at the film/glass interface. During projection, the film stays cooler, the glass gets warmer, and moisture condensation on the glass is avoided.

Finding then-available plastic tapes to be unsatisfactory for slide binding (Tull's articles were published in the 1970's), Tull recommended assembling mounts with 2x2-inch pieces of cover glass and gummed paper tape; the non-image areas were masked by attaching strips of a black, pressure sensitive material to the outside of the mount. Tull suggested doing the actual mounting in a fairly humid environment to avoid attraction of dust to the cover glass and film by static electric charges. Since he used moisture-permeable paper binding tape, the slides reached moisture equilibrium with ambient storage conditions soon after mounting was completed.

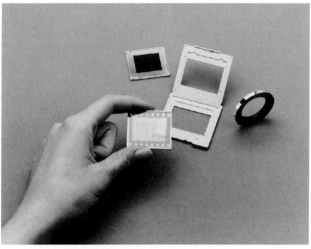

The recommended glass Wess Plastic Archival Mount developed by Wess in consultation with Christine Sundt, a slide and photograph curator at the University of Oregon. Although designed specifically for tape binding, the mount may also be used without tape binding.

## The Wess Archival Slide Mount

Christine L. Sundt, a slide and photograph curator in the Architecture & Allied Arts Library at the University of Oregon who has done considerable research on glass slide mounts and mounting techniques, has suggested a number of improvements to Tull's rather time-consuming "glass-contact binding" method, and has adapted the procedure to commercially available glass mounts. One of Sundt's most important recommendations is that films be conditioned and mounted in a low-humidity environment, and the slide bound with low-permeability metalized polyester tape.[23]

Taping the glass and film together of course requires that the cover glass sheets be easily removed from the mount frame for taping, and this, together with the absence of interior masks, is the basis for the design of the Wess Archival Mount, which was developed by Wess Plastic, Inc. in consultation with Sundt.[24] The mount was introduced in 1988.

For some years Sundt had recommended Swiss-made, aluminum-framed Perrot-Color glass mounts. But when Perrot-Color mounts ceased to be available in the U.S. in 1987, Sundt contacted Wess Plastic, a leading manufacturer of glass slide mounts, to see whether she could interest the company in producing a suitable replacement product. After reading several of Sundt's articles on slide mounting, Wess agreed to work with her on the design of the new mount. Wess Plastic has also developed a manually operated machine to tape the edges of the film/glass sandwich rapidly and precisely; the machine, which costs about $300, will be manufactured if there is sufficient interest in the device.

The mounts are supplied with anti-Newton Ring cover glass sheets that are slightly larger than a standard 35mm frame (so as not to cause buckling should the film expand during projection or storage). The glass is held in position in a pocket molded in a light gray, high-temperature-resistant Noryl plastic frame. The frame itself serves as the mask (two aperture sizes are available). The projected

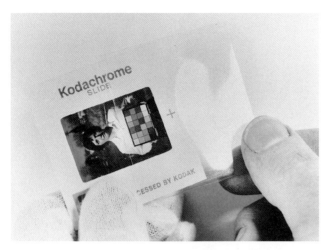

A slide is inserted into a Kimac individual slide sleeve. Made of cellulose triacetate, the sleeves offer excellent protection from fingerprints and scratches during handling. Most types of slide pages can accommodate slides in Kimac sleeves. The National Geographic Society in Washington, D.C. and many other major collections use Kimac sleeves for slides in their active files to protect the slides during handling and editing.

image area can be further reduced (masked) if necessary by applying metalized polyester tape to the outside of the film/glass sandwich prior to placing it in the slide mount — thus avoiding the need to apply tape to the film itself (which in any event should *never* be done!). The mounts are 3mm thick and will fit in standard 80-capacity Kodak Carousel and Ektagraphic slide trays; the mounts are inexpensive, costing about $0.25 each. If desired, the mounts can also be used without taping.

Prior to mounting, the slides should be moisture-conditioned in a low-humidity environment (40% RH or lower) for several hours — or overnight. Slides can also be conditioned by projecting them in an open-frame mount for a minute or two (Sundt says that heating slides to a temperature of 140°F [60°C] appears to kill any fungus spores that may be present, while at the same time reducing the moisture content of the emulsion to a very low level).

Sundt recommends that glass cover sheets be cleaned by swabbing with ethyl alcohol and dried with a clean white cotton cloth. Prior to mounting, both the glass and film should be carefully examined and particles of dust or lint should be blown away using a child's ear syringe or canned, pressurized air.

With the film in place, the film/glass sandwich is taped together around the edges with metalized polyester tape (Horizon Tape Products Company No. 425 Ultra Thin Metalized Polyester Tape, which is metalized on both sides to avoid pinholes and to improve moisture resistance, is recommended by Sundt).[25]

Mounting slides with this procedure prevents periods of high humidity in the slide storage area from affecting the film sealed within the mount. This helps reduce the likelihood of Newton's Rings, fungus growth, and emulsion "ferrotyping" against the cover glass. The interior of the mount is also kept free of dust. The equilibrium moisture content of a piece of film sealed in a mount according to Sundt's method will, over a long period of time, assume an average value of the year-round conditions in the storage area. Short-term humidity changes in the storage area caused by, for example, a week or two of rainy summer weather, will have little effect on the sealed film.

## 3M Photogard for Coating Slides

Producers of slides for slide libraries should consider 3M Photogard film coating (discussed in Chapter 4) as an economical alternative to glass mounts for duplicate slides. Photogard is an abrasion-resistant coating that protects films from scratches, fingerprints, moisture, and fungus. Once applied, Photogard is impossible to remove without destroying the film; for this reason, Photogard is not recommended for valuable original slides.

## Kimac Sleeves for Protection of Individual Slides

Physical protection from fingerprints, scratches, and dirt for individual slides during handling and shipping can be obtained with Kimac cellulose triacetate sleeves, supplied by the Kimac Company, Ltd., of Guilford, Connecticut. The sleeves have a snug fit so that slides will not slip out during handling, but the sleeves are also simple to remove when desired. Slides in Kimac sleeves readily fit into the individual pockets of most slide pages; the slides also fit into most types of slide storage boxes, compartmented drawers, etc. Slides should *always* be in individual sleeves when being sent to a lab for duplication or printing, loaned to clients, or given to printers for making color separations. At a cost of only about $0.05 each, Kimac sleeves are available in quantities of 100, 500, and 1,000 directly from Kimac (see **Suppliers** at the end of this chapter) and from most major photographic supply houses. Kimac sleeves protect circulating slides in the National Geographic Society collection and in many other major publication and commercial operations.

To be serviceable, slide sleeves must be precisely manufactured, with side folds of the proper radius. If the folds are too tight, slides will be difficult to insert and remove. If the folds are too loose, or if the sleeve is even slightly too large, slides may fall out. To date, this author has found Kimac sleeves to be the only suitable product (the polyester individual slide sleeves supplied by Light Impressions Corporation have overly sharp side folds and lack the nice snug fit of the Kimac sleeves).

Some Kimac sleeves manufactured in the mid-1980's were made with a semi-opaque, pressure-sensitive seam adhesive that had a tendency to come unglued with extended usage. Kimac has offered to exchange these defective sleeves for the current type, manufactured with a strong, colorless solvent adhesive.

## ImageGuard Rigid Plastic Slide Holders

For protecting valuable slides during shipping or handling by clients and labs, ImageGuard rigid transparent slide holders offer an excellent, if rather expensive, solution.[26] At a price of about $1 each, the slide holders ac-

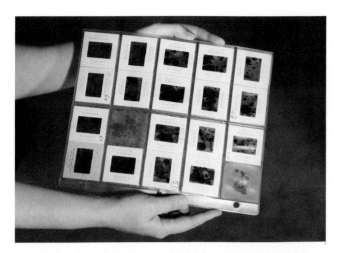

Plasticizer oozed from a flexible PVC slide page onto the surface of Kodachrome slides in the collection of Magnum Photos, Inc. The New York City agency has since replaced all of the PVC pages with new polypropylene pages.

Plasticizer exuding from the PVC caused the Kodachrome film to stick to the slide page.

commodate both cardboard-and-glass mounted slides and are only slightly larger than the slides themselves. By applying a pressure-sensitive label over the top of the holder, the slide cannot be removed without breaking the seal (thus discouraging unauthorized projection or duplication by prospective clients). ImageGuard slide holders are also satisfactory for long-term storage of slides.

## Plastic Slide Pages and the Hazards of Plasticized PVC

During the past two decades, plastic slide pages have become a popular means of storing and viewing slides. Most of these pages are made of heavyweight plasticized polyvinyl chloride (PVC), which gives the pages very good transparency and handling characteristics. Unfortunately, PVC is one of the materials specifically prohibited in the ANSI storage standards — see, for example: *ANSI IT9.2-1991, American National Standard for Imaging Media – Photographic Processed Films, Plates, and Papers – Filing Enclosures and Storage Containers.*[27]

While the actual damage to color slides that PVC pages might cause during long-term storage has been the subject of debate, this author and others have found a disturbing number of flexible PVC slide pages that have seriously deteriorated, with gooey plasticizers exuding from the PVC sheet and sticking to the surfaces of the slides. Because of this, this author strongly recommends that flexible PVC pages be avoided for anything other than short-term applications.

Although the problems of plasticized PVC as a photographic enclosure material are discussed in detail in Chapter 14, it is worth repeating here what R. Scott Williams, a conservation scientist at the Canadian Conservation Institute, said in a 1985 report:

> I have examined two cases where slides were damaged by storage in phthalate plasticized poly(vinyl chloride) enclosures. In the first case,

oily droplets were formed on slides. These were identified as phthalate plasticizers identical to those contained in the poly(vinyl chloride) enclosures. When projected, the droplets on the slide are visible as disfiguring spots on the image.

In the second case, a waxy film formed on slides with protective glass covers. Only slides with glass covers show this phenomenon. Unglassed slides in the same enclosure do not have the waxy film. Analysis of the waxy film showed it to be composed of carboxylate salts of the type used as lubricants or more commonly as heat stabilizers in poly(vinyl chloride), and that these components were also found in the PVC of the enclosure.

In addition, there is the further, often cited, disturbing possibility that the PVC may degrade to produce acidic hydrogen chloride gas. It is to prevent this degradation that PVC must be highly compounded with additives to inhibit these reactions or to scavenge degradation products before they escape from the plastic.[28]

## Polypropylene Slide Pages Are Recommended

Probably the most satisfactory material for flexible slide pages is polypropylene, a clear plastic which, unlike polyvinyl chloride, can be made naturally flexible without the addition of plasticizers. Polypropylene pages are now available from a number of manufacturers.

In this author's opinion, the best flexible polypropylene slide pages are the EZ2C Super-heavyweight polypropylene slide pages manufactured by 20th Century Plastics, Inc., of Los Angeles, California (see **Suppliers** at the end of this chapter). These high-clarity pages are made with heavy 5.0-gauge polypropylene that gives them much greater rigidity and better handling characteristics than the thinner 3.5-gauge polypropylene slide pages supplied by most other manufacturers. The EZ2C Super-heavyweight pages, which cost about $0.45 each, handle much like the popular PVC

July 1991

20th Century Plastics EZ2C Super-heavyweight 5-gauge polypropylene slide pages are recommended by this author as the best available flexible slide pages. The pages are supplied for ring binders (3-ring notebooks) or with top-bars for file cabinets equipped with hanging file frames.

November 1987

Saf-T-Stor rigid polypropylene slide pages are used for reference duplicate files at the VIREO collection (the originals are carefully stored in frost-free refrigerators — see Chapter 19). Located at the Academy of Natural Sciences of Philadelphia, VIREO is said to be the world's largest collection of color photographs of birds.

slide pages. The pages have individual slide pockets and physically cover both sides of the slides. EZ2C [Easy-To-See] Super-heavyweight polypropylene pages are available in several formats, including 3-hole pages for use in ring-binder notebooks: #EZTL2-00, in which slides are inserted from the top; and #EZJV2-00, which are side-loading. Also available is an EZ2C slide page fitted with a plated-steel top-bar for use in file drawers equipped with frames for hanging files: #EZHTL-00, which cost about $0.75 each.

20th Century Plastics, Inc. also supplies less expensive polypropylene pages under the Century-Poly name; these pages, which cost about $0.35 each, are thinner and somewhat less transparent than the recommended EZ2C Super-heavyweight pages. (20th Century Plastics, Inc. is also a leading supplier of plasticized PVC slide pages; the pages are not safe for long-term slide storage and should be avoided.)

Another good if rather expensive line of polypropylene pages are the Super Archival 20 Transparency Files supplied by the British firm, DW Viewpacks Limited. The pages were introduced to the American market in 1985 (see **Suppliers** at the end of this chapter). DW Viewpacks Super Archival pages cost as much as $2.50 each.

Probably also satisfactory are the Poly-C flexible polypropylene slide pages manufactured by C-Line, Inc. of Des Plaines, Illinois. The C-Line pages have also been sold by Light Impressions Corporation, Kleer-Vu Plastics Corporation, and others under private label.

Flexible polypropylene slide pages are also available from the Joshua Meier Corporation under the VPD Hang-20 name, and from Franklin Distributors Corporation under the Perma-Saf name. These pages have provision for hanging bars for suspension in standard letter-size file cabinet drawers.

20th Century Plastics EZ2C Super-heavyweight, DW Viewpacks Super Archival pages, C-Line Poly-C pages, Film-Lok Archival pages, and most other slide pages can accommodate slides in Kimac cellulose triacetate sleeves (described previously). Use of Kimac sleeves in combination with polypropylene slide pages provides a very high degree of physical protection to slides during storage and handling; in addition, the sleeves prevent fingerprints and scratches on slides when they are removed from a page. The sleeves also eliminate the possibility that the surface-coated materials used to make flexible polypropylene (or polyethylene) pages could eventually stick to film surfaces or leave undesirable residues on the film. (See Chapter 14 for discussion of surface coatings and sticking problems associated with polyethylene and polypropylene pages.)

When slides are stored for long periods in non-recommended flexible PVC pages, Kimac sleeves are *essential* to protect film surfaces from plasticizer residues.

## Saf-T-Stor Rigid Polypropylene Slide Pages

The Saf-T-Stor rigid slide page, introduced by Franklin Distributors Corporation in 1975, was the first slide page manufactured with polypropylene. The pages were developed at the request of Peter Waters at the Library of Con-

gress in Washington, D.C. Manufactured in Japan, the rigid translucent white pages have recessed pockets to accommodate 20 slides; the pages can be kept in ring binder notebooks, stored in boxes, or placed in standard file cabinet drawers (hanging bars are available for the pages as an accessory).

Saf-T-Stor pages are very similar in appearance to the rigid PVC pages sold by Joshua Meier Corporation and one should be careful that the proper page is obtained. Saf-T-Stor pages are identified along the edge opposite the ring binder holes with: "No. PV-20 – Franklin Dist. Corp. – Denville N.J. 07834." Surprisingly, the Saf-T-Stor name itself does not appear on the pages.

At a price of about $1.30 each, Saf-T-Stor pages cost much more than 20th Century Plastics EZ2C Heavyweight, C-Line Poly-C, and other flexible polypropylene slide pages.

A significant drawback of the Saf-T-Stor pages when used with slides in glassless slide mounts is that the pages are molded from a single sheet of polypropylene and the open-face slide pockets leave one side of the slides unprotected against scratches, fingerprints, and other physical damage. This problem can be alleviated by placing each slide in a transparent Kimac sleeve. Franklin supplies transparent full-page cover sheets called Saf-T-Covers as an accessory (about $1 each), but when fitted with the cover sheets the pages are rather unwieldy to handle.

Saf-T-Stor pages, with their recessed slide pockets, are thicker than flexible polypropylene pages and require more storage space. However, because of their rigidity, Saf-T-Stor pages handle and stack better, and, unlike the flexible pages, can stand vertically in file drawers or boxes without sagging or curling. Saf-T-Stor pages are used by a number of institutions, including the Library of Congress, the Peabody Museum of Archaeology and Ethnology at Harvard University, and the Visual Resources for Ornithology (VIREO) collection at the Academy of Natural Sciences of Philadelphia (see Chapter 19).

## Other Types of Slide Pages

A very good but rather bulky and expensive "page" for storing slides is the System J slide cassette, which is made of rigid, transparent acrylic plastic. Similar to a thin, two-sided box which opens like a book, each cassette accommodates 24 slides and offers complete physical protection to slides while at the same time allowing unobstructed viewing. System J cassettes cost about $5 each when purchased in quantity. Accessories include storage boxes and cabinets for the cassettes, illuminated viewers, and magnifiers. The cassettes are made in West Germany, where they are sold under the Journal 24 name, and are distributed in the United States by Leedal, Inc.

A rigid slide page that can be recommended for glass-mounted slides is the open-frame, molded polystyrene Plastican Slide Frame. These heavy-duty pages, or "frames," as the Plastican Corporation calls them, resist flexing and sagging and are particularly well-suited for vertical storage of glass-mounted slides in file cabinet drawers (glass-mounted slides are heavier than slides in glassless mounts, and the extra rigidity of the Plastican Slide Frames gives better support to glass-mounted slides than do Franklin Saf-T-Stor and other "rigid" pages). The Plastican pages,

each of which holds 20 slides and costs about $1.25, can also be used in ring-binder notebooks. Because the individual slide compartments in the Plastican Slide Frames are open, both front and back, and leave the surfaces of film in glassless mounts unprotected and vulnerable to scratches, fingerprints, and dust, the pages should not be used with slides in glassless mounts unless the slides are protected with Kimac sleeves. The Plastican Corporation also supplies flexible polypropylene and plasticized polyvinyl chloride (PVC) slide pages.

Low-density polyethylene pages supplied by Vue-All, Inc., Print File, Inc., Light Impressions Corporation, and others are superior to plasticized PVC pages, although not as satisfactory as polypropylene enclosures (see Chapter 14 for discussion of the pros and cons of the various types of plastics used to make slide pages and other photographic enclosures).

## Slide Storage Boxes

To the best of this author's knowledge, the cardboard boxes supplied by Kodalux Processing Services with processed slides are satisfactory for long-term storage of slides (Kodalux labs are a joint venture of Eastman Kodak Company and Fuqua Industries, Inc.; prior to 1988 the labs were operated by Kodak and were known as Kodak Processing Labs). Plastic boxes also appear to be safe for keeping slides — however one should be careful to store slides in plastic boxes in a dark place because, to a greater or lesser degree, the plastic used to make such boxes transmits light which could cause gradual fading of the outermost slides in the box during prolonged storage.

For low-cost storage of larger groups of slides, the economical Lig-free Type II Archival Slide Storage Box (#35ST) supplied by Conservation Resources International, Inc. is recommended.[29] The boxes cost about $5 each in quantities of 5, or $4 in quantities of 10 or more (shipping additional). Each box has a capacity of 360 slides and is $18x2\frac{5}{8}x2\frac{5}{8}$" in size. Also available is a large Master Unit consisting of six #35ST slide boxes inside a drop-front cardboard box $17x19x2\frac{3}{4}$" in size; a Master Unit (#35MU) has a capacity of about 2,190 slides and costs $34.50. Boxes of similar design are also available for mounted 120 roll film transparencies. The interior of these boxes is made of nonbuffered, lignin-free cardboard.

Another good-quality cardboard slide storage box is the Slide-File Box (Code No. 5015) supplied by Light Impressions Corporation.[30] Made of alkaline-buffered, lignin-free cardboard with metal corners, Slide-File Boxes cost $2.00 each in quantities of 10 or more; each box can accommodate about 200 cardboard-mounted slides. The boxes are supplied with movable cardboard interior dividers. Six of the Slide-File boxes will fit inside a Light Impressions Code No. 5012 Drop-Front Box, which is $1\frac{1}{2}Hx11Wx14D$-inches in size ($5.75 singly or $4.60 each in quantities of 10 or more). Unfortunately, the Code No. 5012 box has a shallow interior and is only barely high enough to accommodate the slide boxes. The "standard" Light Impressions 11x14-inch Drop-Front Box (Code No. 2021) is too tall, however, and wastes valuable storage space; in addition, the top of the box tends to sag because it is unsupported by the shorter slide boxes inside. Also recommended is the Light Impres-

sions Slide Stack Box (Code No. 3211), a polypropylene box with a snap-closing lid that accommodates about 50 slides. Slide Stack boxes cost $5.95 for a package of 6.

Light Impressions also sells an attractively finished box called the Photo Archive for Slides (Code No. 4290). Intended for slide storage in the home, the boxes hold only about 600 slides and at a price of $24.95, they are rather expensive.

Very good low-cost polypropylene plastic boxes suitable for slide storage are manufactured by Flambeau Products Corporation.[31]  Box No. M-812, recommended for slides, has 12 interior compartments, each holding about 65 slides (about 800 in total). The box, which has a hinged lid and is made of yellow polypropylene, is 2½x13x9-inches. Flambeau requires a minimum purchase of $200 when ordering directly from the company; No. M-812 boxes cost only $3.24 each (5 boxes to a carton) when purchased direct.

The Conservation Resources, Light Impressions, and Flambeau Products slide boxes also are excellent for packaging slides for storage in a humidity-controlled cold storage vault or frost-free refrigerator.

### Slide Storage Cabinets

A complete discussion of the many slide storage cabinets and other slide storage systems that are available is beyond the scope of this chapter. Christine L. Sundt, a knowledgeable slide and photograph curator at the University of Oregon, has recommended Neumade cabinets (see **Suppliers** at the end of this chapter) as being the best for general slide storage. Sundt cautions against purchase of Luxor slide storage equipment which, in her experience, is not as well-designed as much of the other equipment on the market.

### To Avoid Damage, Never Leave Slides on Desks or Tables Exposed to Light

Many slide users are aware of the damage that can occur if slides remain on light tables for an extended time, but few suspect that exposure to ordinary office illumination while slides sit uncovered on a desktop can cause serious image fading in a surprisingly short period. Such fading may be irregular, assuming, for example, the pattern of rubber bands around a group of slides. Or, if slides in pages are left in the open, casually stacked together, the mount edges of slides in the topmost page may leave clearly defined outlines on the images of slides below.

Robin Siegel, the archivist at the National Geographic Society in Washington, D.C., discovered that after the Illustrations Library was moved into a new office in 1984, some of the slides in the collection began to exhibit unexpectedly rapid image fading — often in strange and irregular patterns. The new office was brightly illuminated with Norelco (Philips) Color 84 full-spectrum lamps in energy-efficient, bare-bulb fixtures. Suspecting that the office lighting might be the source of the problem, Siegel ran a test in which Kodachrome, Ektachrome, and Fujichrome slides housed in polypropylene slide pages were placed on countertops both in the new office and in the less brightly lit area previously occupied by the Illustrations Library. According to Siegel:

> The slides were exposed to approximately 100 foot candles (1,076 lux) of illumination, 18

to 24 hours a day, for 10 weeks. The variation in daily exposure time was because we were never really sure when the cleaning people came in and turned out the lights. The temperature remained between 72° and 75°F (22 and 24°C) and the relative humidity between 45 and 55%. As was expected, the Kodachrome showed a far greater rate of fade than either the Ektachrome or Fujichrome, especially in the magenta dye. The Kodachrome lost as much as 50-percent of the magenta dye by the end of 8 weeks.[32]

Investigating the matter further, Siegel tested various brands of fluorescent lamps, including both standard types and special "UV-free" lamps. She found that the UV output of the lamps made relatively little difference in the measured fading rates of test slides — the total light output of the lamps proved to be the most important factor. These findings led Siegel to recommend that the fluorescent fixtures in the Illustrations Library be operated with only one bulb — instead of the usual two — in each fixture. This, combined with the addition of a plastic diffuser over the light fixtures, would spread the light more evenly in the Library office and lower the overall illumination level.

Siegel also launched a campaign to alert the Geographic staff about the hazards of leaving slides uncovered on tables, desks, and shelves.

## Notes and References

1. Thom O'Connor, "Pros Winners of Film Wars," **Photo District News**, Vol. VII, Issue II, February 1987, pp. 1, 14, 16, 18. See also: David Walker, "Kodachrome's Dramatic Decline," **Photo District News**, Vol. XII, Issue II, February 1992, pp. 14—21.
2. Galen Rowell, "A Major New Film – Fuji Velvia Ups the Ante in the 'Chrome Wars,'" **Outdoor Photographer**, Vol. 6, No. 5, June 1990, pp. 8, 12–13. See also: Jack and Sue Drafahl, "Super Film Shootout! Kodak Kodachrome 25 vs. Fujichrome Velvia . . . Let the Film Wars Continue," **Petersen's Photographic**, July 1990, pp. 86–91; George Craven and Lynn Jones, "Fujichrome Velvia: A New Opportunity for Labs," **Photo Lab Management**, Vol. 12, No. 6, June 1990, pp. 8–12.
3. Anon., "Arts of the U.S.," **American Artist**, Vol. 25, No. 9, November 1961.
4. Eastman Kodak Company, "Using Eastman Color Negative Film 5247 (35mm) and Eastman Color High Speed Negative Film 5293 (35mm) for Still Photography," **TIPS – Technical Information for Photographic Systems**, Vol. 15, No. 2, March–April 1984, p. 6.
5. Eastman Kodak Company, **Conservation of Photographs** (George T. Eaton, editor), Kodak Publication No. F-40, Eastman Kodak Company, Rochester, New York, March 1985, p. 69.
6. Larry Lipsky, "The Artful Dupe," **Outdoor Photographer**, Vol. 5, No. 8, October 1989, pp. 50–55.
7. W. Arthur Young, Thomas A. Benson, and George T. Eaton, **Copying and Duplicating in Black-and-White and Color**, Kodak Publication No. M-1, Eastman Kodak Company, Rochester, New York, September 1984.
8. Jacqueline Tobin, "Tony Stone of London Buys Click/Chicago," **Photo District News**, Vol. VIII, Issue X, September 1988, p. 26.
9. 70mm enlarged slide duplicates are available from a number of labs, including: The New Lab Inc., 22 Cleveland Street, San Francisco, California 94103; telephone: 415-431-8806 (toll-free: 800-526-3165); Comcorps, 243 Church Street, Vienna, Virginia 22180; telephone: 703-938-7750; and Chromatics/Borum Photographics, 625 Fogg Street, Nashville, Tennessee 37203; telephone: 615-254-0063.
10. Carl Purcell, "Do-It-Yourself Stock Photography: Introducing the 70-mm Dupe," **Popular Photography**, Vol. 93, No. 8, August 1986, pp. 16–17.
11. David Weintraub, "What's In Stock? Galen Rowell's Wild Places," **Photo District News**, Vol. VIII, Issue VIII, July 1988, pp. 58–60.
12. National Digital Corporation, Suite 125, 7700 Leesburg Pike, Falls Church, Virginia 22043; telephone: 703-356-5600 (New York City office: National Digital Corporation, Empire State Bldg., Suite 7720,

350 Fifth Ave., New York, N.Y. 10118–0165; telephone: 212-268-0040).

13. Peter Tatiner, "National Digital Delivers," **Photo District News**, Vol. VII, Issue VIII, July 1987, pp. 1, 22.

14. Anon., "Weekly Elects Photo System," **Publishing Technology**, Vol. 2, No. 4, p. 73.

15. Stuart Craig, National Digital Corporation, telephone discussion with this author, September 29, 1987.

16. Photofinishing News, Inc., "Photo Processing – North and South America," **The 1991 International Photo Processing Industry Report,** Chapter 2, p. 1 (1991).  Photofinishing News, Inc., Suite 1091, 10915 Bonita Beach Road,  Bonita Springs, Florida 33923.

17. Thomas W. Hope, "Hope Reports," **SMPTE Journal**, Vol. 96, No. 4, April 1987, pp. 387–388.

18. Pakon plastic slide mounts and mounting machines are manufactured by Pakon, Inc., 106 Baker Technology Plaza, 6121 Baker Road, Minnetonka, Minnesota 55345; telephone: 612-936-9500.

19. Wess Plastic, Inc., 70 Commerce Drive, Hauppauge, New York 11788-3936; telephone: 516-231-6300.

20. Gepe Division, HP Marketing Corp., 16 Chapin Road, P.O. Box 715, Pine Brook, New Jersey 07058; telephone: 201-808-9010.

21. A. G. Tull, "Moisture and the Slide," **The Journal of Photographic Science**, Vol. 22, 1974, pp. 107–110; A. G. Tull, "Film Transparencies Between Glass," Part I, **British Journal of Photography**, Vol. 125, April 1978, pp. 322–323; A. G. Tull, "Film Transparencies Between Glass," Part II and Part III, **British Journal of Photography**, Vol. 125, May 1978, pp. 349–354, 355.

22. Christine L. Sundt, "Moisture Control Through Slide Mounting," **International Bulletin for Photographic Documentation of the Visual Arts**, Vol. 8, No. 1, September 1981, pp. 1–10; Christine L. Sundt, "Moisture Control Through Slide Mounting – Part II," **International Bulletin for Photographic Documentation of the Visual Arts**, Vol. 8, No. 4, December 1981, pp. 8–11; Christine L. Sundt, "Mounting Slide Film Between Glass – For Preservation or Destruction?", **Visual Resources**, Vol. II, No. 1/2/3, Fall/Winter 1981–Spring 1982, pp. 37–62; Christine L. Sundt, "Transparencies in Paper Mounts," **International Bulletin for Photographic Documentation of the Visual Arts**, Vol. 11, No. 4, Winter, 1984, pp. 20-22; Christine L. Sundt, "How to Keep Slide Mounts Clean," **International Bulletin for Photographic Documentation of the Visual Arts**, Vol. 13, No. 2, Summer 1986, pp. 14–15; Christine L. Sundt, **Conservation Practices for Slide and Photographic Collections**, Special Bulletin No. 3, Visual Resources Association, 1989.

23. Christine L. Sundt, "Perrot-Color Mounts – Current Status and Options," **International Bulletin for Photographic Documentation of the Visual Arts**, Vol. 15, No. 4, Winter 1988, p. 22.

24. Wess Plastic Archival Slide Mounts (AGI 001AF for standard 35mm slide image area and AGI 500AF for full-frame images) are available from Wess Plastic, Inc.; the mounts are also available from Light Impressions Corporation.  See **Suppliers** listing below for addresses and telephone numbers.

25. Horizon No. 425 Ultra Thin Metalized Polyester Tape for binding and masking glass slides is available in ¼- and ½-inch widths in 100-foot rolls from Horizon Tape Products Company, 251 West Lafayette Frontage Road, St. Paul, Minnesota 55107; telephone: 612-224-4083. Also available from Light Impressions Corporation; see **Suppliers** listing below for address and telephone numbers.

26. ImageGuard rigid plastic holders for individual slides are available from Image Innovations, Inc.; see **Suppliers** listing below.

27. American National Standards Institute, Inc., **ANSI IT9.2-1991, American National Standard for Imaging Media – Photographic Processed Films, Plates, and Papers – Filing Enclosures and Storage Containers**, American National Standards Institute, Inc., 11 West 42nd Street, New York, New York 10036; telephone: 212-642-4900. See also: **International Standard ISO 10214:1991(E) Photography – Processed Photographic Materials – Filing Enclosures for Storage,** International Organization for Standardization, Geneva, Switzerland.

28. R. Scott Williams, "Commercial Storage and Filing Enclosures for Processed Photographic Materials."  Presentation at the **Second International Symposium: The Stability and Preservation of Photographic Images**, "Printing of Transcript Summaries," sponsored by IS&T, the Society for Imaging Science and Technology, 7003 Kilworth Lane, Springfield, Virginia 22151; telephone: 703-642-9090. The conference was held at the National Archives of Canada, Ottawa, Ontario, August 25–28, 1985.

29. Conservation Resources International, Inc.; see **Suppliers** listing below.

30. Light Impressions Corporation; see **Suppliers** listing below.

31. Flambeau Products Corporation; see **Suppliers** listing below.

32. Robin Siegel, "Light-Fading of Color Slides Left Sitting on Desk Tops," presentation at the 1987 Winter Meeting of the Photographic Materials Group of the American Institute for Conservation, New Orleans, Louisiana, February 7, 1987.  A shortened version of the presentation was published in 1988: "Light-Fading of Color Transparencies on Desk Tops," **Topics in Photographic Preservation – Volume Two**, Photographic Materials Group of the American Institute for Conservation, pp. 62–68, 1988.  American Institute for Conservation, 1400 16th Street, N.W., Suite 340, Washington, D.C. 20036; telephone: 202-232-6636.

## Additional References

Steve Anchell, "Super Slide Dupers — Darkroom Control for Color Practitioners," **Camera & Darkroom**, Vol. 14, No. 8, August 1992, pp. 48–53.

Gene Balsley and Peter Moore, "How to File and Store Slides," **Modern Photography**, Vol. 44, No. 1, January 1980, pp. 104ff.

Norine D. Cashman and Mark M. Braunstein, **Slide Buyers' Guide**, fifth edition, Libraries Unlimited, Inc., Littleton, Colorado, 1985.

Marian Z. DeBardeleben and Carol G. Lunsford, "35mm Slides – Storage and Retrieval for the Novice," **Special Libraries**, Vol. 73, No. 2, April 1982, pp. 135–141.

Nancy DeLaurier, ed., **Slide Buyers' Guide**, fourth edition, Mid-America College Art Association, Visual Resources Group, University of New Mexico, Slide Library, Fine Arts Center, Albuquerque, N.M., 1980.

Etsuo Fujii, Hideko Fujii, and Teruaki Hisanaga, "Evaluation on the Stability of Light Faded Images of Color Reversal Films According to Color Difference in CIELAB, **Journal of Imaging Technology**, Vol. 14, No. 2, April 1988, pp. 29–37; see correction of 2 tables in the article: "Errata," **Journal of Imaging Technology**, Vol. 14, No. 3, June 1988, p. 93.

Betty Jo Irvine, **Slide Libraries**, second edition, Libraries Unlimited, Inc., Littleton, Colorado, 1979.

Eastman Kodak Company, **The Source Book – Kodak Ektagraphic Slide Projectors**, Kodak Publication No. S-74, Eastman Kodak Company, Rochester, New York, October 1984.

Eastman Kodak Company, **Storage and Care of Kodak Color Materials**, Kodak Pamphlet No. E-30, Eastman Kodak Company, Rochester, New York, May 1982.

Peter Moore, "Preservation of the Image," Chapter 10 in **ASMP Stock Photography Handbook**, American Society of Magazine Photographers, Inc., New York, New York, 1984, pp. 148–151.

Gillian Scott, ed., **Guide to Equipment for Slide Maintenance and Viewing**, Mid-America College Art Association, Visual Resources Group, University of New Mexico, Slide Library, Fine Arts Center, Albuquerque, New Mexico, 1978.

Nancy Schuller, ed., **Guide for Management of Visual Resources Collections**, second edition, Mid-America College Art Association, Visual Resources Group, University of New Mexico, Slide Library, Fine Arts Center, Albuquerque, New Mexico, 1979.

Nancy Schuller and Susan Hoover, chairpersons, **Production and Preservation of Color Slides and Transparencies**, a conference in the Advanced Studies in Visual Resources series, University of Texas at Austin, Department of Art and School of Architecture, Austin, Texas, March 27–28, 1981.

Bob Schwalberg, with Henry Wilhelm and Carol Brower, "Going! Going!! Gone!!! – Which Color Films and Papers Last Longest?  How Do the Ones You Use Stack Up?," **Popular Photography**, Vol. 97, No. 6, June 1990, pp. 37–49, 60. The article contained image stability data excerpted from this book and also discussed accelerated test methods.

Susan Garretson Swartzburg, ed., **Conservation in the Library**, Greenwood Press, Westport, Connecticut, 1983.

Henry Wilhelm, chairperson, **Conservation and Preservation Issues Beyond the Book: Slides, Microforms, Videodiscs, and Magnetic Media**, ARLIS-VRA Joint Session (co-sponsored by the Smithsonian Institution), 18th Annual Conference of the Art Libraries Society of North America, Penta Hotel, New York, New York, February 14, 1990.  The presentations included: Klaus B. Hendriks [National Archives of Canada], "Magnetic Media and Optical Disc Storage Technology: The Challenge of Non-Human-Readable Records"; James M. Reilly [Image Permanence Institute, R.I.T.], "Silver Gelatin Microfilm: Update on Toner Treatments for Improved Image Stability"; Henry Wilhelm [Preservation Publishing Company], "The Stability and Preservation of Color Slides: Duplicates for Use, and Cold Storage of Originals Provide the **Only** Answer"; Peter Krause [Consultant], "Cibachrome Micrographic Color Films"; James H. Wallace, Jr. [Smithsonian Institution], "Color Slide Preservation at the Smithsonian: Cold Storage for Originals, Videodiscs for Reference, and Duplicates for Use."

Betsy G. Young, "Picture Retrieval in the Time Inc. Picture Collection," **Picturescope**, Vol. 30, No. 2, Summer 1982, pp. 57–61.

*(See Chapter 18 Suppliers List on following pages . . .)*

# Suppliers

## Recommended Glass Slide Mount

**Wess Plastic, Inc.**
70 Commerce Drive
Hauppauge, New York 11788-3936
   Telephone: 516-231-6300
(Slide mount sold under the Wess Archival Mount name.)

## Flexible Polypropylene Slide Pages

**C-Line Products, Inc.**
1530 East Birchwood Avenue
P.O. Box 1278
Des Plaines, Illinois 60018
   Telephone: 312-827-6661
   Toll-free: 800-323-6084
(Pages sold under the Poly-C name.)

**DW Viewpacks Limited**
Unit 8 Peverel Drive, Granby
Milton Keynes, Buckinghamshire MK11NL
England
   Telephone: 01-0908-642-323
(Pages sold under the DW Viewpacks Super Archival name; available in the U.S. from Sam Flax, Inc.)

**Sam Flax, Inc.**
39 West 19th Street
New York, New York 10011
   Telephone: 212-620-3010
(U.S. supplier of DW Viewpacks Super Archival polypropylene slide pages.)

**Franklin Distributors Corporation**
P.O. Box 320
Denville, New Jersey 07834
   Telephone: 201-267-2710
   Fax: 201-663-1643
(Pages sold under the Perma-Saf name.)

**Joshua Meier Corporation**
7401 Westside Avenue
North Bergen, New Jersey 07047
   Telephone: 201-869-8200
(Pages sold under the VPD Hang-20 name; Joshua Meier is best known for its VPD Slide-Sho and VPD Hang-up Slide-Sho pages which are made of rigid, nonplasticized vinyl; both types of pages are almost identical in physical design to the rigid polypropylene Saf-T-Stor pages listed below.)

**Kleer-Vu Plastics Corporation**
Kleer-Vu Drive
Brownsville, Tennessee 38012
   Telephone: 901-772-5664
   Toll-free: 800-677-3686
(Pages sold under the Pro-Line name [#14914].)

**The Kimac Company, Ltd.**
478 Long Hill Road
Guilford, Connecticut 06437
   Telephone: 203-453-4690
(Pages sold under the Kimac Slide Page name.)

**Light Impressions Corporation**
439 Monroe Avenue
Rochester, New York 14607-3717
   Telephone: 716-271-8960
   Toll-free: 800-828-6216
(Pages sold under the Slide-Guard name.)

**Savage Universal Corporation**
800 West Fairmont Drive
Tempe, Arizona 85282
   Telephone: 602-967-5882
   Toll-free: 800-624-8891
(Pages sold under the Film-Lok Archival Slide Page name.)

**20th Century Plastics, Inc.**
3628 Crenshaw Boulevard
Los Angeles, California 90016
   Telephone: 213-731-0900
   Toll-free: 800-767-0777
(Recommended polypropylene slide pages sold under the EZ2C Super-heavyweight name: top-loading #EZTL2-00 for 3-ring notebooks; side-loading page #EZJV2-00 for 3-ring notebooks; and #EZHTL-00 with top-bar for hanging files. Lighter weight and less expensive slide pages sold under the Century-Poly name: top-loading #PTL20 for 3-ring notebooks and side-loading #PJV20 for 3-ring notebooks.)

## Rigid Polypropylene Slide Pages

**Franklin Distributors Corporation**
P.O. Box 320
Denville, New Jersey 07834
   Telephone: 201-267-2710
   Fax: 201-663-1643
(Pages sold under the Saf-T-Stor name.)

## Low-Density Polyethylene Slide Pages

**Light Impressions Corporation**
439 Monroe Avenue
Rochester, New York 14607-3717
   Telephone: 716-271-8960
   Toll-free: 800-828-6216
(Pages sold under the Slide-Guard Heavyweight Polyethylene slide page name.)

**Print File, Inc.**
1846 South Orange Blossom Trail
Apopka, Florida 32703
   Telephone: 407-886-3100
(Pages sold under the Print File Archival Preserver name.)

**Vue-All, Inc.**
P.O. Box 1690
Ocala, Florida 32678
   Telephone: 904-732-3188
   Toll-free: 800-874-9737 (outside Florida)
(Pages sold under the Vue-All Slide-File and Slide Pak 20 names.)

## Rigid Acrylic Slide Cassettes

**Leedal, Inc.**
1918 South Prairie Avenue
Chicago, Illinois 60616
   Telephone: 312-842-6588
(Cassettes made in Germany under the Journal 24 System name; sold by Leedal under the System J name.)

## Rigid Polystyrene Open-Frame Slide Pages

**Plastican Corporation**
10 Park Place
P.O. Box 58
Butler, New Jersey 07405
   Telephone: 201-838-4363
(Pages sold under the Plastican Slide Frame name.)

## Plastic Sleeves for Individual Slides

**Image Innovations, Inc.**
7521 Washington Avenue South
Minneapolis, Minnesota 55439
   Telephone: 612-942-7909
   Toll-Free: 800-345-4118
(ImageGuard Rigid Slide Holders for protection of slides during shipping and handling; the transparent holders cost about $1.00 each.)

**The Kimac Company, Ltd.**
478 Long Hill Road
Guilford, Connecticut 06437
   Telephone: 203-453-4690
(Sleeves sold under the Kimac Protector name; made of cellulose triacetate.)

**Photofile, Inc.**
2020 Lewis Avenue
Zion, Illinois 60099
   Telephone: 708-872-7557
   Toll-free: 800-356-2755
(Polyester sleeves for individual slides and larger transparencies mounted on cards and sold under the Quik-Mount name.)

**Reeves Photo Sales, Inc.**
9000 Sovereign Row
Dallas, Texas 75247
   Telephone: 214-631-9730
   Toll-free: 800-527-9482
(2¼x2¼-inch high-density polyethylene thumb-cut envelopes for individual mounted slides; sold under the RPS Plastine name.)

**20th Century Plastics, Inc.**
3628 Crenshaw Boulevard
Los Angeles, California 90016
   Telephone: 213-731-0900
   Toll-free: 800-767-0777
(#PGS22-00 sleeves for individual 35mm slides sold under the Polypropylene Film Sleeves name.)

# Suppliers

## Slide-Storage Boxes

### Conservation Resources International, Inc.
8000-H Forbes Place
Springfield, Virginia 22151
    Telephone: 703-321-7730
    Toll-free: 800-634-6932
(Lig-free Type II Archival Slide Storage Box No. 35ST [nonbuffered cardboard on the inside] with 18 interior index/divider tabs; holds about 360 slides [$4.95 each]. No. 35MU, which holds about 2,160 sides, consists of six No. 35ST boxes contained in a larger, drop-front box [$34.50]. Company has sales offices in Ottawa, Ontario; Oxon, England; and Brisbane, Australia.)

### Flambeau Products Corporation
15981 Valplast Road
P.O. Box 97
Middlefield, Ohio 44062
    Telephone: 216-632-1631
(Rigid polypropylene plastic boxes.Box No. M812; size: $13\frac{1}{8}$x9x$2\frac{5}{16}$"; 12 interior compartments; hinged lid; each box holds about 800 slides, with about 65 in each compartment. Boxes are $3.24 each; minimum order direct from Flambeau Products is $200.)

### The Hollinger Corporation
P.O. Box 8360
Fredericksburg, Virginia 22404
    Telephone: 703-898-7300
    Toll-Free: 800-634-0491
(Slide Box No. 1162 made of alkaline-buffered cardboard has 20 separate interior boxes to hold slides; holds a total of about 400 slides. Boxes No. 12210 and No. 12510 hold slides packaged in Kodak 24-exposure and 36-exposure cardboard slide boxes.)

### Light Impressions Corporation
439 Monroe Avenue
Rochester, New York 14607-3717
    Telephone: 716-271-8960
    Toll-free: 800-828-6216
(Slide-File Box No. 5015 made of alkaline-buffered cardboard; 11 inches of file space and supplied with movable cardboard dividers. For storage, 6 of the boxes will fit in an 11x14-inch Light Impressions Drop-Front Box No. 5012. Slide Stack Boxes No. 3211 are polypropylene boxes with tight-fitting lids that accommodate about 50 slides each.)

## Slide-Storage Cabinets and Files

### Multiplex Display Fixture Company
1555 Larkin Williams Road
Fenton, Missouri 63026
    Telephone: 314-343-5700
(Multiplex System 4000 and Director Series)

### Elden Enterprises, Inc.
1 Ramu Road – Toporock
P.O. Box 3201
Charleston, West Virginia 25332-3201
    Telephone: 304-344-2335
(Abodia and Lowdia Slide Storage Systems)

### Neumade Products Corporation
200 Connecticut Avenue
P.O. Box 5001
Norwalk, Connecticut 06856
    Telephone: 203-866-7600
(Neumade Slide Cabinets)

### Luxor Corporation
2245 Delany Road
Waukegan, Illinois 60087
    Telephone: 708-244-1800
    Toll-free: 800-323-4656
(Slide-Bank and Unlimited Slide Storage Systems)

### Bretford & Knox Manufacturing
111 Spruce Street
Wood Dale, Illinois 60191
    Telephone: 708-595-0300
(Acculight Modular Storage Systems)

### Leedal, Inc.
1918 South Prairie Avenue
Chicago, Illinois 60616
    Telephone: 312-842-6588
(Matrix Library Storage Cabinets)

## Moderate-Cost, Manually Operated Slide Duplicators

### Charles Beseler Co.
1600 Lower Road
Linden, New Jersey 07036-6514
    Telephone: 908-862-7999
    Toll-free: 800-237-3537
(Beseler Deluxe Dual-Mode Duplicator)

### Bogen Photo Corporation
565 East Crescent Avenue
P.O. Box 506
Ramsey, New Jersey 07446-0506
    Telephone: 201-818-9500
(Bowens Illumitran 3SC Slide Duplicator)

### Karl Heitz, Inc.
34–11 62nd Street
P.O. Box 427
Woodside, New York 11377
    Telephone: 718-565-0004
(Alpha Master Dia-Duplicator)

### Kenro Corporation
250 Clearbrook Road
Elmsford, New York 10523
    Telephone: 914-347-5520
    Toll-free: 800-592-6666
(Kenro Spectra 1000 Slide Duplicator)

### Byers Photo Equipment Company
6955 S.W. Sandburg Street
Portland, Oregon 97223
    Telephone: 503-639-0620
    Toll-free: 800-547-9670
(ChromaPro Slide 45 Duplicator)

### HP Marketing Corp.
16 Chapin Road
Pine Brook, New Jersey 07058
    Telephone: 201-809-9010
(Kaiser System V Slide Duplicator)

### Photographic & Technical Services
226 Westbourne Grove
London W11 2RU, England
    Telephone: 01-221-0162
(Beseler Dichro Illuminator Slide Duplicator)

## High-Volume Slide Duplicators, Animation Cameras, and Copy Cameras

### Double M Industries
P.O. Box 14465
Austin, Texas 78761
    Telephone: 512-251-4044

### ECB Technologies, Inc.
1140 19th Street, N.W., Suite 300
Washington, DC 20036
    Telephone: 202-223-6906

### Forox Marketing Corporation
250 Clearbrook Road
Elmsford, New York 10523
    Telephone: 914-592-7776

### Hoffman Camera Corporation
19 Grand Avenue
Farmingdale, New York 11735
    Telephone: 516-694-4470

### Hostert Fotomata, Inc.
31 Louis Street
Hicksville, New York 11801
    Telephone: 516-935-5363

### Maron, Inc.
2640 West 10th Place
Tempe, Arizona 85281
    Telephone: 602-966-2189

### Oxberry Division
Cybernetics Products, Inc.
180 Broad Street
Carlstadt, New Jersey 07072
    Telephone: 201-935-3000

### Slidemagic System, Inc.
30401 East Colfax Street
Denver, Colorado 80206
    Telephone: 303-388-2971

# 19. Frost-Free Refrigerators for Storing Color and Black-and-White Films and Prints

An appropriate frost-free refrigerator is currently the only simple way to store color negatives, slides, prints, and motion pictures at low temperature and relative humidity. The photographs will be readily accessible, and there is no need to pre-condition them in a low-humidity environment or to package them in special hermetically sealed containers. The refrigerator section of a suitable combination refrigerator/freezer can maintain a temperature of about 35°F (1.7°C) and keep the relative humidity between 20 and 35% — the optimum level for most types of photographic materials[1] — regardless of ambient temperature and humidity conditions.

At the time of this writing, frost-free refrigerators were being used by a number of photographers, including Adam Bartos, Ellen Brooks, Mitch Epstein, Douglas Faulkner, David Hanson, Joel Meyerowitz, Leo Rubinfien, Stephen Scheer, and Victor Schrager, to store their color films and prints. Some serious collectors, such as Pepe Karmel of New York City, help preserve the quality and value of the color photographs they purchase by storing them in refrigerators.

After *Life* magazine photographer Larry Burrows was killed in Laos in 1971, his Ektachrome transparencies of the Vietnam War were stored in a frost-free refrigerator at the Time Inc. Magazines Picture Collection in New York City. In 1983, when Time completed construction of a large humidity-controlled cold storage vault, Burrows's Vietnam color slides were moved into the new facility along with the more than one million other color transparencies in the Picture Collection. (Time Inc. Magazines is part of Time Warner Inc.)

To preserve Burrows's color work that is not in the custody of Time Inc. Magazines or other publishing companies, Russell Burrows, Larry Burrows's son and caretaker of his father's estate, stores the transparencies in a frost-free refrigerator. Burrows is considered to have been the first photographer to comprehensively record war in color; his color photographs of the Vietnam war were made over a period of more than 8 years. An exhibition of his work, *Larry Burrows: Vietnam – The American Intervention 1962–1968,* was shown at the Laurence Miller Gallery in New York City in 1985. Color photographs from both the Larry Burrows estate and the Time Inc. Magazines Picture Collection were included. The 18 Kodak Dye Transfer prints in the exhibition were printed from the original transparencies; a limited-edition portfolio of some of the photographs in the exhibition was also made available by the Laurence Miller Gallery.

> **See page 658 for Recommendations**

---

> **Notice:** Although storage of photographic materials in appropriate frost-free refrigerators will effectively slow fading rates and greatly extend the life of color photographs, there is a possibility that mechanical malfunction of a refrigerator, improper handling of the photographs, or other factors could result in damage to the photographs. This author believes that if properly maintained refrigerators of a suitable type are used according to the suggestions included in this chapter, if refrigerators are replaced with new units after a maximum of ten years of service, if packages of photographs are *placed in polyethylene bags prior to storing them in the refrigerators,* and if the temperature and relative humidity inside the refrigerators are checked on a regular basis (at least once a week), there is very little likelihood of photographs being damaged. However, neither this author nor Preservation Publishing Company can take any responsibility for damage, regardless of the cause, that may occur as a result of placing photographs in a refrigerator or freezer. Cellulose nitrate film requires storage in special, explosion-proof freezers and should not be kept in an ordinary household refrigerator or freezer — see **Appendix 19.1** on page 675.

## Refrigerated Ektacolor Prints at the Museum of Modern Art

The Museum of Modern Art in New York City obtained a Sears Roebuck Kenmore frost-free refrigerator in 1984 for storing the approximately 100 Ektacolor and other chromogenic color prints in its collection. (By 1992, the number of prints stored in the refrigerator had grown to more than 450.) Some of these photographs were included in the museum's 1984 exhibition *Color Photographs: Recent Acquisitions;* at the close of the exhibition, the prints were removed from their mats and returned to the refrigerator. Perceptible fading and staining of Ektacolor 37 RC and 74 RC prints will occur in less than 10 years in normal room-temperature dark storage, and the museum decided that if it wanted to continue collecting such unstable materials it had to provide refrigerated storage to preserve the prints. Stored at 35°F (1.7°C), Ektacolor 37 RC and 74 RC prints can be kept an estimated 200 years before image deteriora-

February 1989

Russell Burrows, son of the late **Life** magazine photographer Larry Burrows, and Victoria Burrows, Larry Burrows's widow, are shown here with part of the collection of Larry Burrows's 35mm Ektachrome slides taken during the Vietnam war.  Burrows, who arrived in South Vietnam in 1962 and spent more than 8 years covering the war, produced some of the most significant photographs from the Vietnam conflict.  To preserve the images and to protect future income from the sale of reproduction rights, all of the transparencies have been duplicated; the originals are stored in a frost-free refrigerator in Russell Burrows's New York City apartment and in the cold-storage vault at Time Warner Inc. in New York City.  Burrows was killed in 1971 at the age of 44 while covering the South Vietnamese incursion into neighboring Laos.  Burrows was riding in a helicopter over the jungle near the border between the two countries when it was hit by antiaircraft fire; there were no survivors of the crash.

The Museum of Modern Art in New York City began storing Kodak Ektacolor and other chromogenic color prints in a Sears Roebuck Kenmore frost-free refrigerator in 1984. Peter Galassi, now the director of the Department of Photography, is shown here looking into the refrigerator. The Museum maintains that a large, walk-in cold storage unit cannot yet be justified, given the relatively small number of chromogenic prints now in its collection.

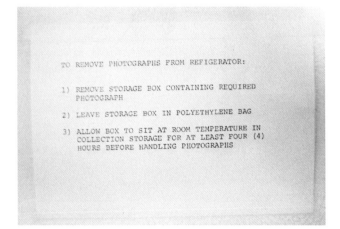

For ease of reference, the approximately 500 color prints in the refrigerator are cataloged in a separate card file (a small black-and-white image of the print is in the upper right corner of the card); the refrigerated prints are also cataloged in the general card index for the collection, using special, color-coded cards.

Included in the collection at the Museum of Modern Art are portfolios of Ektacolor prints by Stephen Shore *(Monet's House and Gardens, Giverny)* and William Eggleston *(Election Eve)*. The portfolios have been wrapped in transparent polyethylene for storage in the refrigerator. Since about 1984, the museum has been acquiring duplicates of most of the color prints it purchases; one set of prints is preserved in the refrigerator while the duplicate set is available for display and study purposes.

A large Ektacolor print by Cindy Sherman is being pulled out of a vertical storage shelf by Peter Galassi. Some prints like this are too big to fit in the refrigerator. At present, the Modern keeps such large chromogenic color prints with the rest of its collection (which, along with black-and-white prints, includes Ilford Cibachrome [Ilfochrome], Kodak Dye Transfer, Fresson Quadrichromie, and other types of color prints that have good dark storage stability) in an environmentally controlled room at 60°F (15.5°C) and 40% RH.

November 1986

# Recommendations

- **Refrigerate photographic materials with poor stability.** It is particularly important to refrigerate color prints made from color negatives on papers that have poor stability (e.g., pre-1984 Ektacolor [Ektacolor 37 RC and 74 RC], as well as pre-1984 Fujicolor, Agfacolor, and Konica Color prints); all pre-1991 Kodak Ektachrome prints; current and past Ektachrome Prestige prints; color negative films with poor stability (e.g., Ektacolor, Vericolor II, Kodacolor-X, Kodacolor II, Fujicolor II, pre-1989 Agfacolor XR and XRS, and pre-1992 3M ScotchColor negative films); and relatively unstable types of color slides and larger transparencies (e.g., Process E-1, E-2, E-3, and E-4 Ektachrome films, Ansco and GAF films, pre-1989 Agfachrome, and some current and all past 3M Scotch color slide films).

- **Do not keep cellulose nitrate film in a refrigerator.** Because of the potential fire hazard associated with cellulose nitrate film, it should be stored only in special, explosion-proof freezers (see **Appendix 19.1** at the end of this chapter).

- **Recommendations for portrait photographers:** To assure customers that top-quality reprints will always be available, color negatives from all prints that have been sold should be refrigerated, especially negatives made with earlier films that have poor stability, such as Ektacolor, Vericolor (the original type), and Vericolor II (including current Vericolor II Type L).

- **Recommendations for fine art photographers:** All color negatives and transparencies, including those made with current films that have improved stability, should be refrigerated. This will assure that top-quality prints matching the original "vintage" prints can continue to be made during the photographer's lifetime and will preserve valuable negatives and transparencies so that upon the photographer's death they may be passed on to a museum in their original condition. Photographers should also preserve at least one copy of all important prints in a refrigerator in order to have a set of guide prints with which to make critical comparisons should new prints be made in the future. Although the dye

stability of Kodak Ektacolor Plus, Ektacolor Professional, Ektacolor Edge, and Ektacolor Portra papers has been improved in relation to earlier Kodak papers such as Ektacolor 74 RC, the new Kodak papers still develop yellowish stain to an unacceptable degree. Storage in a frost-free refrigerator greatly slows the rate of yellowing.

- **Recommended frost-free refrigerators:** For reasons discussed in this chapter, Kenmore refrigerators sold by Sears Roebuck & Co. are recommended. Materials should be stored only in the refrigerator compartment (factory-packed, unprocessed film and paper can be stored in the freezer compartment if desired). For the reasons discussed in this chapter, a refrigerator should be purchased new, and should be replaced after 10 years of service. Large-capacity humidity-controlled refrigerators for museum and archive use are available from Bonner Systems, Inc., 7 Doris Drive, Suite 2, N. Chelmsford, Massachusetts 01863 (telephone: 508-251-1199).

- **Packaging for storage in a refrigerator:** Films and prints should be packaged in envelopes or boxes and placed in polyethylene bags or wrapped with polyethylene and the seams taped with freezer tape. Packaging in polyethylene eliminates the need for pre-conditioning and will prevent moisture condensation on the boxes or envelopes when the refrigerator door is opened or when packages are removed and warmed up to room temperature. Packaging in polyethylene also minimizes the possibility of damage to photographs in the unlikely event of refrigerator malfunction. (For maximum safety with valuable photographs, they should be conditioned in a low relative humidity and then sealed in vapor-proof envelopes before placing them in the refrigerator.)

- **A relative humidity gauge should be placed in the refrigerator:** A dial hygrometer, such as one of the units supplied by Abbeon-Cal, should be placed on an interior shelf and checked about once a week to be certain that the refrigerator is functioning properly. If the hygrometer does not have a self-contained thermometer, a separate thermometer should also be placed in the refrigerator compartment.

tion equals that expected after 10 years of storage at a room temperature of 75°F (24°C).

Speaking in 1987, John Szarkowski, at the time director of the Department of Photography at the Modern, said that he believed that the relatively small number of chromogenic color prints in the Modern's collection did not justify construction of a large-scale cold storage facility such as that at the Art Institute of Chicago. Szarkowski also expressed hope that in the not-too-distant future, the dark fading stability of negative-positive print materials would be improved to the point where refrigerated storage would not be required for acquisitions made on these new materials, just as refrigerated storage is not now required for the Ilford Cibachrome (Ilfochrome), Kodak Dye Transfer, and Fresson Quadrichromie prints in the collection. These

prints, which have extremely good dark fading stability, are kept with the collection's black-and-white prints in a newly constructed print room in which the temperature is maintained at 60°F (15.5°C) and the relative humidity at 40%.

Peter Galassi, now the director of the department of photography at the Modern, says the museum tries to obtain two copies of each color print it purchases, offering to pay the artist's price for one and the "lab price," or actual cost of making the print, for the second copy.[2] In what will probably become a common practice with fine art musuems, one print is kept in permanent storage in the refrigerator while the other copy can be removed from the refrigerator as needed for study and exhibition. The two prints can be compared visually to determine if any fading or staining of the study/exhibition print has occurred.

One of the largest installations of Sears Roebuck frost-free refrigerators for photographic storage is at Project VIREO (Visual Resources for Ornithology) at the Academy of Natural Sciences of Philadelphia. With more than 100,000 color slides preserved in its frost-free refrigerators, VIREO is the world's largest comprehensive collection of bird photographs.

VIREO is equipped with small- and large-volume slide duplicators. In-house duplication allows consistent quality-control, reduces costs, and, most importantly, avoids the possibility that originals will be damaged or lost if sent out for duplication.

Duplicate transparencies are examined on a light table.

November 1987

Project VIREO Director Douglas Wechsler, an active bird photographer specializing in Central and South American birds, supervises the collection. The slides, which have been numbered and entered in a microcomputer-based cataloging system, are stored in transparent plastic boxes in the refrigerators. Note the dial hygrometer on the bottom shelf of the refrigerator; the temperature and humidity levels in each refrigerator are checked frequently.

Duplicate transparencies have been made of all originals, and the duplicates form the work and study collection, stored in Saf-T-Stor rigid polypropylene slide pages housed in file cabinets. Original slides are kept refrigerated and are removed only to make additional duplicates (under certain circumstances, originals have been loaned to publishers for making laser-scanned color separations).

## The Bird Photography Collection at Project VIREO

Another user of Sears Roebuck frost-free refrigerators is Project VIREO (Visual Resources for Ornithology), headquartered at the Academy of Natural Sciences of Philadelphia. In what is said to be the world's largest comprehensive collection of bird photographs, Project VIREO has gathered more than 100,000 color transparencies of birds and cataloged them in a computerized database; more than 140 photographers have contributed to the collection, including Crawford H. Greenewalt, Victor Hasselblad (in addition to the cameras bearing his name, Hasselblad was also well known for his photographs of birds), N. Philip Kahl, Roger Tory Peterson, and Eliot Porter.

In a long-term preservation procedure developed in 1982 by Project VIREO technical director Robert Cardillo,[3] two high-quality duplicates of each original transparency are made on Ektachrome Duplicating Film 5071 (Process E-6). One of the duplicates is sent to the contributing photographer and the other is added to the working collection. The original transparency is placed in one of VIREO's refrigerators for preservation and its physical location added to the computerized database; the original is not projected or otherwise accessed except for making additional duplicates when needed.

With a carefully organized file system in which the color slides are contained in flat plastic boxes — each of which can hold 960 slides — each refrigerator can accommodate about 26,000 35mm color slides. Photographs from the collection are available for commercial publication for a fee, as well as for educational and scholarly use. According to Cardillo, a principal impetus for establishing the VIREO collection was the realization that many early color photographs of birds, especially those made on Ektachrome films, had already seriously faded and "ultimately they lose all value."

To house the Crawford H. Greenewalt collection donated in 1985, VIREO obtained two additional Sears Roebuck frost-free refrigerators to supplement the two units already in operation; to accommodate future acquisitions, a fifth unit was purchased in 1988.

Among other institutions having frost-free refrigerators to preserve photographs are the Museum of Contemporary Photography at Columbia College, Chicago, Illinois; the Colorado Historical Society, Denver, Colorado; the U.S. Geological Survey Photo Library, Denver, Colorado; the Bernice P. Bishop Museum, Honolulu, Hawaii; the New Orleans Museum of Art, New Orleans, Louisiana; the University of Rochester Library, Rochester, New York; the Wisconsin Regional Primate Research Center at the University of Wisconsin, Madison, Wisconsin; and the State Historical Society of Wisconsin, Madison, Wisconsin.

*(continued on page 664)*

## Table 19.1 Estimated Number of Years for "Just Noticeable" Fading to Occur in Various Kodak Color Materials Stored in the Dark at Two Room Temperatures and Two Refrigerator Temperatures (40% RH)

### Time Required for the Least Stable Image Dye to Fade 10% from an Original Density of 1.0

**Boldface Type** indicates products that were being marketed when this book went to press in 1992; the other products listed had either been discontinued or replaced with newer materials. These estimates are for dye fading only and do not take into account the gradual formation of yellowish stain. With print materials in particular (e.g., Ektacolor papers), the level of stain may become objectionable before the least stable image dye has faded 10%.

| Color Papers | Years of Storage at:* 80°F (26.7°C) | 75°F (24°C) | 40°F (4.4°C) | 35°F (1.7°C) |
|---|---|---|---|---|
| Ektacolor 37 RC Paper (Process EP-3) ("Kodacolor Print" when processed by Kodak) | 7 | 10 | 140 | 200 |
| Ektacolor 78 and 74 RC Papers (Process EP-2) ("Kodacolor Print" when processed by Kodak) | 5 | 8 | 110 | 160 |
| **Ektacolor Plus Paper** **Ektacolor Professional Paper** (Process EP-2) ("Kodacolor Print") ("Kodalux Print") | 25 | 37 | 520 | 750 |
| Ektacolor 2001 Paper **Ektacolor Edge Paper** **Ektacolor Royal II Paper** Ektacolor Portra Paper **Ektacolor Portra II Paper** **Ektacolor Supra Paper** **Ektacolor Ultra Paper** **Kodak Duraflex RA Print Material** (Process RA-4, water wash) ("Kodalux Print") | (not disclosed) A | | | |
| Ektacolor 2001 Paper **Ektacolor Edge Paper** **Ektacolor Royal II Paper** Ektacolor Portra Paper **Ektacolor Portra II Paper** **Ektacolor Supra Paper** **Ektacolor Ultra Paper** **Kodak Duraflex RA Print Material** (Process RA-4NP, Stabilizer rinse) ("Kodalux Print") | (not disclosed) A | | | |
| Ektachrome 2203 Paper (Process R-100) | 5 | 7 | 100 | 140 |
| Ektachrome 14 Paper (Process R-100) | 7 | 10 | 140 | 200 |
| **Ektachrome Radiance Paper** (Process R-3) (1991—) | (not disclosed) | | | |
| Ektachrome 22 Paper [improved] (Process R-3) (1991–92) | (not disclosed) | | | |
| **Ektachrome Copy Paper** (Process R-3) Ektachrome HC Copy Paper Ektachrome Overhead Material Ektachrome Prestige Paper Ektachrome 22 Paper (1984–90) | 5 | 8 | 110 | 160 |

| Color Negative Films | Years of Storage at:* 80°F (26.7°C) | 75°F (24°C) | 40°F (4.4°C) | 35°F (1.7°C) |
|---|---|---|---|---|
| Kodacolor II Film | 4 | 6 | 84 | 120 |
| **Kodacolor VR 100, 200, 400 Films** | 12 | 17 | 240 | 340 |
| Kodacolor VR-G 100 Film ("initial type") (Kodacolor Gold 100 Film in Europe) | 8 | 12 | 170 | 240 |
| Kodacolor Gold 200 Film (1989–91) (formerly Kodacolor VR-G 200 Film) Kodak Gold 200 Film (new name: 1991–92) | (not disclosed) B | | | |
| **Kodak Gold Plus 100 Film** **Kodak Gold II 100 Film** (name in Europe) (1992—) | (not disclosed) C | | | |
| **Kodak Gold Plus 200 Film** **Kodak Gold II 200 Film** (name in Europe) (1992—) | (not disclosed) D | | | |
| **Kodak Gold Plus 400 Film** **Kodak Gold II 400 Film** (name in Europe) (1992—) | (not disclosed) E | | | |
| Kodacolor Gold 1600 Film (1989–91) **Kodak Gold 1600 Film** (new name: 1991—) | (not disclosed) F | | | |
| **Ektar 25 Film** (1988—) | (not disclosed) G | | | |
| **Ektar 100 Film** (1991—) | (not disclosed) | | | |
| Ektar 125 Film (1989—) | (not disclosed) H | | | |
| **Ektar 1000 Film** (1988—) | (not disclosed) I | | | |
| **Ektapress Gold 100 Prof. Film** (1988—) | (not disclosed) J | | | |
| **Ektapress Gold 400 Prof. Film** (1988—) | (not disclosed) K | | | |
| **Ektapress Gold 1600 Prof. Film** (1988—) | (not disclosed) L | | | |
| Vericolor II Professional Film Type S | 4 | 6 | 85 | 120 |
| **Vericolor II Professional Film Type L** | 2 | 3 | 40 | 60 |
| Vericolor II Commercial Film Type S | 2 | 3 | 40 | 60 |
| **Vericolor III Professional Film Type S** **Ektacolor Gold 160 Professional Film** | 16 | 23 | 320 | 460 |
| **Vericolor 400 Prof. Film** (1988—) **Ektacolor Gold 400 Professional Film** | (not disclosed) M | | | |
| **Vericolor HC Professional Film** | (not disclosed) N | | | |
| **Vericolor Copy/ID Film** | (not disclosed) | | | |
| **Vericolor Internegative Film 6011** | 3 | 5 | 70 | 100 |

| Color Transparency Films | Years of Storage at:* | | | |
|---|---|---|---|---|
| | 80°F (26.7°C) | 75°F (24°C) | 40°F (4.4°C) | 35°F (1.7°C) |
| Ektachrome Films (Process E-3) O | 3 | 5 | 70 | 100 |
| Ektachrome Films (Process E-4) P | 10 | 15 | 210 | 300 |
| **Kodak Photomicrography Color Film 2483** (Process E-4) | **2** | **3** | **40** | **60** |
| **Ektachrome Films** (Process E-6) ["Group I" types since 1979] | **35** | **52** | **730** | **1,100** |
| **Ektachrome Plus and "HC" Films** Q **Ektachrome 64X, 100X, & 400X Films Ektachrome 64T and 320T Films** ["Group II" types since 1988] (Process E-6) | **75** | **110** | **1,500** | **2,200** |
| **Kodachrome Films** (Process K-14) [all types] | **65** | **95** | **1,300** | **1,900** |

## Motion Picture Color Negative Films

| | 80°F | 75°F | 40°F | 35°F |
|---|---|---|---|---|
| Eastman Color Negative II Film 5247 (1974) | 4 | 6 | 85 | 120 |
| Eastman Color Negative II Film 5247 (1976) | 8 | 12 | 170 | 240 |
| Eastman Color Negative II Film 5247 (1980) | 19 | 28 | 390 | 550 |
| **Eastman Color Negative Film 5247** (1985 name change) | **19** | **28** | **390** | **550** |
| Eastman Color High Speed Negative Film 5293 | (not disclosed) R | | | |
| **Eastman Color High Speed Negative Film 5294** | (not disclosed) R | | | |
| **Eastman Color High Speed SA Negative Film 5295** | (not disclosed) R | | | |
| **Eastman Color High Speed Daylight Negative Film 5297** | (not disclosed) R | | | |
| Eastman Color Negative II Film 7247 (1974–83) | 4 | 6 | 85 | 120 |
| **Eastman Color Negative II Film 7291** | **34** | **50** | **700** | **1,000** |
| Eastman Color High Speed Negative Film 7294 | (not disclosed) R | | | |
| **Eastman Color High Speed Negative Film 7292** | (not disclosed) R | | | |
| **Eastman Color High Speed Daylight Negative Film 7297** | (not disclosed) R | | | |
| **Eastman EXR Color Negative Film 5245 and 7245** | **15** | **22** | **310** | **440** |
| **Eastman EXR Color Negative Film 5248 and 7248** | **20** | **30** | **420** | **600** |
| **Eastman EXR High Speed Color Negative Film 5296 & 7296** | **35** | **50** | **700** | **1,000** |

| Motion Picture Laboratory Intermediate Films | Years of Storage at:* | | | |
|---|---|---|---|---|
| | 80°F (26.7°C) | 75°F (24°C) | 40°F (4.4°C) | 35°F (1.7°C) |
| **Eastman Color Reversal Intermediate Film 5249 and 7249** | **5** | **8** | **110** | **160** |
| Eastman Color Intermediate II Film 5243 and 7243 | 15 | 22 | 310 | 440 |
| **Eastman Color Intermediate Film 5243 and 7243 Improved** | (not disclosed) | | | |

## Motion Picture Print Films

| | 80°F | 75°F | 40°F | 35°F |
|---|---|---|---|---|
| Eastman Color Print Film 5381 & 7381 S | [3 | 5 | 70 | 100] |
| Eastman Color SP Print Film 5383 & 7383 | 3 | 5 | 70 | 100 |
| **Eastman Color Print Film 5384 & 7384** | **30** | **45** | **650** | **900** |
| **Eastman Color LC Print Print Film 5380 & 7380** | **30** | **45** | **650** | **900** |

## * Notes:

The estimates given here have been derived from data in **Evaluating Dye Stability of Kodak Color Products,** Kodak Publication No. CIS-50, January 1981, and subsequent CIS-50 series of dye-stability data sheets through 1985; **Kodak Ektacolor Plus and Professional Papers for the Professional Finisher,** Kodak Publication No. E-18, March 1986; **Dye Stability of Kodak and Eastman Motion Picture Films** (data sheets); Kodak Publications DS-100-1 through DS-100-9, May 29, 1981; **Image-Stability Data: Kodachrome Films,** Kodak Publication E-105 (1988); **Image-Stability Data: Ektachrome Films,** Kodak Publication E-106 (1988); and other published sources.

For many products, including Process E-6 Ektachrome films; Vericolor III, Vericolor 400, Kodacolor VR, Kodacolor Gold (formerly Kodacolor VR-G), Kodak Gold, and Kodak Gold Plus color negative films; and Eastman color motion picture films, storage at 60% RH will result in fading rates of the least stable dye (yellow) approximately twice as great as those given here for 40% RH; that is, the estimated storage time for reaching a 10% dye-density loss will be cut in half.

Furthermore, the dye stability data given here were based on Arrhenius tests conducted with free-hanging film samples exposed to circulating air. Research disclosed by Eastman Kodak in late 1992 showed that storing films in sealed or semi-sealed containers (e.g., vapor-proof bags and standard taped or untaped metal and plastic motion picture film cans) could substantially increase the rates of dye fading and film base deterioration. Therefore, the estimates given here for color motion picture films probably **considerably** overstate the actual stabilities of the films when they are stored in standard film cans under the listed temperature and humidity conditions. (See: A. Tulsi Ram, D. Kopperl, R. Sehlin, S. Masaryk-Morris, J. Vincent, and P. Miller [Eastman Kodak Company], "The Effects and Prevention of 'Vinegar Syndrome'," presented at the **1992 Annual Conference of the Association of Moving Image Archivists**, San Francisco, California, December 10, 1992.) See Chapter 9 for further discussion.

A) Kodak declined to release stability data for Ektacolor 2001 Paper introduced in 1986, or Ektacolor Edge Paper introduced in 1991 (processed with either the "washless" RA-4NP Stabilizer or with a water wash). However, according to a Kodak press release dated

January 21, 1986, and titled "New Kodak Color Paper/Chemicals Offer Exceptionally Fast Processing," the stability of Ektacolor 2001 Paper (Processes RA-4 and RA-4NP) is "comparable to Ektacolor Plus Paper." This author's accelerated dark fading tests with 1988-type Ektacolor 2001 Paper (processed in a Kodak Minilab with Process RA-4NP "washless" chemicals) also indicate that the stability of the paper is generally similar to that of Ektacolor Plus Paper (processed in EP-2 chemicals with a water wash). Ektacolor 2001 Paper was introduced in mid-1986 for use in Kodak minilabs; this was the first Process RA-4 ("rapid access") color negative paper. Ektacolor Portra Paper, a lower-contrast "professional" version of Ektacolor 2001 Paper, was introduced in 1989. Ektacolor Supra, Ektacolor Ultra, and Ektacolor Royal papers were introduced in 1989. Kodak Duraflex RA Print Material (a high-gloss, polyester-base print material) was also introduced in 1989. Ektacolor Royal II Paper was introduced in 1991 and Ektacolor Portra II Paper was introduced in 1992.

B)   Kodak declined to release specific stability data for Kodacolor Gold 200 Film, introduced in 1986 under the Kodacolor VR-G 200 name. This author's tests indicate that the stability of this film is similar to that of Kodacolor VR-G 100 Film (i.e., 12 years storage at 75°F [24°C] and 40% RH for a 10% loss of the yellow dye to occur).

C)   Kodak declined to release stability data for Kodak Gold Plus 100 Film (called Kodak Gold II 100 Film in Europe) that was introduced in 1992 as a replacement for Kodak Gold 100 Film.

D)   Kodak declined to release stability data for Kodak Gold Plus 200 Film (called Kodak Gold II 200 Film in Europe) that was introduced in 1992 as a replacement for Kodak Gold 200 Film.

E)   Kodak declined to release stability data for Kodak Gold Plus 400 Film (called Kodak Gold II 400 Film in Europe) that was introduced in 1992 as a replacement for Kodak Gold 400 Film.

F)   Kodak declined to release specific stability data for Kodak Gold 1600 Film, introduced under the Kodacolor Gold 1600 name in 1989. Kodak has, however, provided data (Kodak Publication E-107, dated June 1990) which indicates that when this film is kept in the dark at 75°F and 40% RH, a storage life of between 19 and 33 years may be expected before a 10% loss of the least stable image dye (yellow in this case) occurs.

G)   Kodak declined to release specific stability data for Kodak Ektar 25 Film, introduced in 1988. Kodak has, however, provided data (Kodak Publication E-107, dated June 1990) which indicates that when this film is kept in the dark at 75°F and 40% RH, a storage life of between 8 and 14 years may be expected before a 10% loss of the least stable image dye (yellow in this case) occurs.

H)   Kodak declined to release specific stability data for Kodak Ektar 125 Film, introduced in 1989. Kodak has, however, provided data (Kodak Publication E-107, dated June 1990) which indicates that when this film is kept in the dark at 75°F and 40% RH, a storage life of between 8 and 14 years may be expected before a 10% loss of the least stable image dye (yellow in this case) occurs.

I)   Kodak declined to release specific stability data for Kodak Ektar 1000 Film, introduced in 1988. Kodak has, however, provided data (Kodak Publication E-107, dated June 1990) which indicates that when this film is kept in the dark at 75°F and 40% RH, a storage life of between 19 and 33 years may be expected before a 10% loss of the least stable image dye (yellow in this case) occurs.

J)   Kodak declined to release specific stability data for Kodak Ektapress Gold 100 Professional Film, which was introduced in 1988. Kodak has, however, provided data (Kodak Publication E-107, dated June 1990) which indicates that when this film is kept in the dark at 75°F

and 40% RH, a storage life of between 8 and 14 years may be expected before a 10% loss of the least stable image dye (yellow in this case) occurs.

K)   Kodak declined to release specific stability data for Kodak Ektapress Gold 400 Professional Film, introduced in 1988. Kodak has, however, provided data (Kodak Publication E-107, dated June 1990) which indicates that when this film is kept in the dark at 75°F and 40% RH, a storage life of between 19 and 33 years may be expected before a 10% loss of the least stable image dye (yellow in this case) occurs.

L)   Kodak declined to release specific stability data for Kodak Ektapress Gold 1600 Professional Film, introduced in 1988. Kodak has, however, provided data (Kodak Publication E-107, dated June 1990) which indicates that when this film is kept in the dark at 75°F and 40% RH, a storage life of between 19 and 33 years may be expected before a 10% loss of the least stable image dye (yellow in this case) occurs.

M)   Kodak declined to release specific stability data for Kodak Vericolor 400 Professional Film, introduced in 1988. Kodak has, however, provided data (Kodak Publication E-107, dated June 1990) which indicates that when this film is kept in the dark at 75°F and 40% RH, a storage life of between 19 and 33 years may be expected before a 10% loss of the least stable image dye (yellow in this case) occurs.

N)   Kodak declined to release specific stability data for Kodak Vericolor HC Professional Film. Kodak has, however, provided data (Kodak Publication E-107, dated June 1990) which indicates that when this film is kept in the dark at 75°F and 40% RH, a storage life of between 8 and 14 years may be expected before a 10% loss of the least stable image dye (yellow in this case) occurs.

O)   The estimate for Process E–3 Ektachrome films is from an article by Charleton Bard et al. (Eastman Kodak) entitled: "Predicting Long-Term Dark Storage Dye Stability Characteristics of Color Photographic Products from Short-Term Tests," **Journal of Applied Photographic Engineering,** Vol. 6, No. 2, April 1980, p. 44. The accelerated-test data given in the article were for Ektachrome Duplicating Film 6120 (Process E-3) and are assumed to apply to Process E-3 Ektachrome camera films; Kodak declined to release dye-stability data for these films.

P)   From Kodak sources; Kodak has not officially released dark fading data for most Process E-4 Ektachrome films (e.g., Ektachrome-X and High Speed Ektachrome).

Q)   Kodak declined to release stain-formation data for its high-saturation "Group II" Ektachrome 100 Plus Professional film and its amateur counterpart, Ektachrome 100 HC Film, both of which were introduced in 1988. Ektachrome 50 HC Film, Ektachrome 64X, 100X, 400X, 64T and 320T films, all of the "Group II" type, were introduced during 1989–1992. This author's accelerated tests with these new films indicate that when yellowish stain formation is considered, their dark storage stability is, overall, similar to that of Ektachrome 100 and other "Group I" Ektachrome films.

R)   Kodak declined to release stability data on which to base estimates for low-temperature storage for these films; however, the company has implied that the films have stability characteristics similar to current Eastman Color Negative Film 5247 — which for 40% RH storage calculates to be about 390 years at 40°F (4.4°C) and 550 years at 35°F (1.7°C).

S)   Kodak declined to release stability data for Eastman Color Print Film 5381 and 7381; however, examination of films in collections indicates that the stability of these film is certainly no better and is quite possibly even worse than Eastman Color Print Film 5383 and 7383.

**End of Notes for Table 19.1**

## Fading Characteristics of Color Materials Kept in a Refrigerator

As discussed in Chapter 5, most color materials will in time suffer objectionable fading, staining, and shifts in color balance if stored in the dark at normal room temperatures — even if the storage areas are air conditioned during warm and humid parts of the year. Estimates of the number of years required for a 10% density loss of the least stable dye for a number of Kodak color film and print materials stored at room temperature and in a refrigerator are given in **Table 19.1**. The Kodak data are based on a relative humidity of 40%. Process E-6 Ektachrome films, Vericolor III, Kodacolor Gold, Kodak Gold, Ektapress Gold, Ektar, Kodacolor VR-G, and Kodacolor VR color negative films, most of which have humidity-sensitive yellow dyes as the least stable dye, can fade approximately twice as fast as these figures indicate when stored at 60% RH. For many photographers, especially those living in tropical or near-tropical areas, it will not be possible to keep the average relative humidity as low as 40%, even in an air-conditioned room.

With most types of color prints stored in the dark, a 10% density loss will, when viewed by the average individual, produce a "just noticeable" color shift and/or loss of image contrast when a print is directly compared with an unfaded but otherwise identical print of the same scene. It is characteristic of most chromogenic color films and prints that one of the three image dyes — usually magenta — is much more stable in dark fading than is the least stable dye, and this differential in fading rates results in increasingly objectionable color shifts as fading progresses. By the time a 10% dye loss in dark fading is reached, Ektacolor and most other chromogenic prints also will have developed significant yellowish stain — this stain may in fact be more objectionable than is the dye fading itself. (At the time of this writing, Kodak had not released data on the dark-storage stain characteristics of any of its color products; however, information supplied to this author by Fuji Photo Film Co., Ltd. indicates that stain formation in chromogenic materials has a temperature dependence which, in a general way, is similar to that of image dye fading — thus low-humidity refrigerated storage should greatly slow the development of stain with these products.)

It is usually possible to make acceptable prints from color negatives that have suffered a 10% dye loss, although the exposure and filtration will be somewhat different from those needed to print an unfaded negative. A 10% density loss is *not* the end of the useful life of a color print or transparency in most applications. However, from a critical point of view, a 10% density loss is visually significant, and it is assumed that anyone going to the effort of storing color materials in a frost-free refrigerator has high standards for color photography and would like to preserve the color images in their original condition — with brilliant colors, sparkling highlights, and crisp image contrast — for as long as possible.

The number of years of storage for a 10% loss to occur is a meaningful measure for comparing the stability of one color material with another, and for evaluating the effects of different storage temperatures.

Seriously faded color negatives produce prints with ob-

May 1981

Joel Meyerowitz, a New York City photographer well known for his fine art and commercial work, stores his color negatives in a frost-free refrigerator. Much of Meyerowitz's fine art photography has been done with Kodak Vericolor II Type L film in the 8x10-inch format. Estimated to lose 10% of its initial cyan dye density in as little as 3 years when stored at normal room temperature, Vericolor II Type L is the least stable of any of Kodak's current color negative films. When the negatives are kept in a refrigerator at 40°F (4.4°C), a 10% cyan density loss will not occur for an estimated 40 years.

jectionable — and uncorrectable — curve crossovers accompanied by reduced overall contrast. This results in prints with a "flat" appearance. In spite of efforts to adjust the filtration for an overall pleasing color balance, such prints will have distinctly different color balances in highlight and shadow regions of the image. Prints made from faded color negatives on Vericolor II, Kodacolor II, pre-1989 Agfacolor XR and XRS, Fujicolor II, Fujicolor HR (prior to the introduction of Fujicolor Super HR in 1986), and Konica Color SR (prior to the introduction of Konica Color SR-V and GX films in 1987), and color-balanced for optimum flesh tones, will have reddish midtones and shadow areas accompanied by greenish highlights. All of these negative films have poor-stability cyan dyes and relatively high-stability magenta dyes.

Fading-rate estimates published by Kodak indicate that, on average, color materials will last approximately 14 times longer at 40°F (4.4°C), and approximately 20 times longer at 35°F (1.7°C), than when stored at a typical room tem-

perature of 75°F (24°C). The Kodak data are based on a 40% RH; the relative humidity in a suitable refrigerator will normally be in the range of 20–35%, which will further extend the life of many of the products listed in **Table 19.1**. The data given in **Table 19.1** are *estimates* only; fading of a particular product may have a somewhat different temperature dependence and may not exactly follow the 14X and 20X factors for the listed refrigerated temperatures. Early versions of some of the products — notably Vericolor II Film Type S and the Process E-6 Ektachrome films — were less stable than the more recent types listed. Improper processing and washing can further reduce the stability of any product, sometimes drastically.

Storage in a *freezer* at 0° to –10°F (–18° to –23°C) will provide an extremely long life for color materials. However, photographs should not be stored in the freezer section of a frost-free unit or in a conventional freezer unless the films and prints are sealed in vapor-proof containers which are then placed in an insulated box (e.g., several thicknesses of cardboard). During the defrost cycle, the temperature of the freezer section rises rapidly from about 0°F (–18°C) to 70°F (21°C) or above. The relative humidity in the freezer section may reach nearly 100% during this period. Unexposed factory-packed film and paper can be stored in the freezer section without supplemental packaging, except for long-term storage when they should be placed in a double-wall cardboard box to prevent the abrupt temperature and humidity changes from affecting them.

Use of a suitable frost-free *refrigerator* for storage will prevent serious deterioration of even the most unstable types of color photographs during the photographer's lifetime, provided they are not mishandled when they are out of the refrigerator. Photographs will, of course, resume fading at the room-temperature rate when they are removed from the refrigerator for printing or duplication; those that are *frequently* withdrawn should be returned to the refrigerator as soon as possible. In most situations, however, photographs need be out of the refrigerator only for a small part of the total storage time. Except in adverse environmental conditions, there is usually no urgency to refrigerate photographic materials immediately after processing and printing. Many photographers will find it practical once a year to gather all *new* negatives and transparencies for which printing has been completed and place the whole group in the refrigerator at the same time.

## What Should Be Preserved in a Refrigerator

A number of factors should be considered in deciding whether or not to refrigerate materials such as Kodachrome films and Process E-6 Fujichrome and Ektachrome transparency films that have relatively good dark fading stability under normal room-temperature conditions. Color negative films with relatively good stability include: Kodak Vericolor III, Vericolor 400, Kodacolor Gold, Kodak Gold, Kodak Gold Plus (Gold II in Europe), Ektapress Gold, and Kodak Ektar films; Fujicolor Super HG, Super G (introduced in 1992), and Fujicolor HG 400 Professional films; and Konica Color SR-V, GX, Super DD, and Super SR color negative films.

Important considerations include the expected keeping time of the photographs, how critical fading might be with the particular images, their perceived value, and the con-

ditions of available room-temperature storage. Keep in mind that the value of a particular photograph often cannot be properly assessed until many years after it is taken.

It is particularly important to refrigerate valuable transparencies made on Process E-1, E-2, and E-3 Ektachrome films, as well as color negatives that were made on Kodacolor II, Vericolor II (including Vericolor II Type L), and older Ektacolor and Kodacolor films — all of which have very poor dark fading stability. Fujicolor II, Fujicolor HR, and pre-1986 Fujicolor Professional color negative films, Konica Color SR negative films, pre-1992 3M ScotchColor Print films, pre-1991 Polaroid OneFilm 35mm color negative films, as well as pre-1989 Agfacolor XR, XRS, XRG and earlier Agfa-Gevaert color negative films all have very poor dark fading stability and should be refrigerated if future printing is a possibility. Unlike Fujichrome and Ektachrome Process E-6 compatible transparency films, the E-6 compatible Agfachrome professional and amateur transparency films introduced in 1984 had very poor dark fading stability (Agfachrome films with improved stability began to appear on the market in late 1988).

Valuable color prints made on Ektacolor, Fujicolor, Konica Color, and Agfacolor papers — all of which had very poor cyan dark fading stability prior to the introduction of improved products in 1984 and 1985 — should also be refrigerated promptly. All types of pre-1991 Kodak Ektachrome papers, in addition to the Kodak Ektachrome Prestige and Ektachrome HC papers that were current at the time this book went to press in 1992, have poor dark fading stability, and valuable prints on these papers should be refrigerated.

Portrait photographers should consider the future sales possibilities of reprints from older Ektacolor and Vericolor II color negatives that have been stored in refrigerators. Fine art photographers working with color negative materials are advised to refrigerate *all* color negatives, since even the improved Kodak, Fuji, and Konica color negative films stored at room temperature will change perceptibly during the photographer's lifetime. For most fine art photographers, color and tone reproduction in prints are critical concerns.

If available room-temperature storage conditions are poor, a frost-free refrigerator is a simple way to properly store both color and black-and-white materials. Refrigerators are especially helpful in the tropics and other humid areas where fungus growths are a problem. Frost-free refrigerators can also be used to preserve chromogenic-dye-image black-and-white films such as Ilford XP-1 and XP-2, and the now-discontinued Agfa Vario-XL; negatives made with these films have poor stability compared with silver-gelatin films.

## The Cost of Storing Photographs in a Refrigerator

The cost of a refrigerator is small in relation to the value of the films and prints stored in it. The cost of only 60 or 70 rolls of processed 35mm color film may equal the purchase price of a new refrigerator. Photographs of personal, artistic, or historical importance must be considered priceless, since once they are faded, damaged, or destroyed, they usually cannot be replaced.

Frost-free refrigerators consume more electrical energy than do the older types of manual-defrost refrigerators —

three or four times as much on the average. Sears Roebuck estimates that the yearly operating cost of a typical Kenmore 18- to 20-cubic-foot frost-free refrigerator/freezer will be about $90 based on electricity costs of $0.09 per kilowatt hour (including tax), which was typical for much of the U.S. in 1988. Some areas have much higher electrical rates; for example, New York City in 1987 had an average residential cost of electricity of $0.14 per kilowatt hour (including tax), which would result in an average yearly operating cost of about $140 for the same Kenmore refrigerator.

## Packaging Photographs for Refrigeration

Slides, negatives, and prints should be packaged in boxes or envelopes which are then placed in polyethylene bags such as Ziploc[4] bags commonly sold in food stores. Negatives and prints can be in sleeves or envelopes — whatever the photographer normally uses to file them (see Chapter 14). A sheet of paper or polyester should be placed on the top and bottom of a stack of prints (or on both sides of an individual print) to prevent direct contact with the polyethylene bag. Separating prints themselves with proper interleaves (such as Atlantis Silversafe Photostore Paper) is generally recommended. If prints are clean and free of rubber-stamp impressions and ink markings on both front and back, however, they can be safely packaged without interleaves, thus conserving limited space available in the refrigerator.

To further conserve space, packaging should be as compact as possible; for example, if prints are matted, it is usually best to remove them from their mats and refrigerate only the prints. Slides can be placed in suitable non-PVC slide pages, left in the original boxes received from the processor, or filed in larger compartmented slide boxes. Low-cost boxes particularly recommended for slides are the Slide-File box available from Light Impressions Corporation, and the Lig-free Type II Archival Slide Storage box supplied by Conservation Resources International, Inc.; these two-piece cardboard boxes come with movable cardboard dividers to form compartments.[5] Rolls of motion picture films should be placed in taped cans, and the cans enclosed in tightly wrapped polyethylene bags.

Although polyethylene bags are not vapor-proof over prolonged periods, they do provide short-term protection from moisture condensation when the cold packages are warming up after removal from the refrigerator. To avoid danger of condensation on the photographs themselves, the packages must not be opened until the photographs inside have reached room temperature — see **Table 19.2** for typical warm-up times. The bags will also protect photographs from possible water damage in the unlikely event that certain parts of the refrigerator's internal defrost system malfunction. Because polyethylene slowly transmits water vapor, photographs need not be conditioned in a low-humidity environment before placing them in the refrigerator; over time, excess water vapor will diffuse through the bag, and the photographs will equilibrate with the low-humidity conditions in the refrigerator.

The refrigerator should not be packed too tightly — space should be left for air to circulate freely between the refrigerator shelves, and in the area between the front of the shelves and the door. It is permissible, however, to tightly pack the refrigerator vegetable and fruit storage drawers with photographs. (Photographs should never be placed directly on the bottom of the refrigerator compartment, and the bottom drawers should not be removed in an effort to increase the available space.)

Even though packaging photographs for storage, monitoring refrigerator temperature and humidity, and performing scheduled refrigerator maintenance may appear complex, use of the refrigerators is actually quite easy once the proper procedures are established. The detailed instructions and precautions given here are simply to make sure that the possibility of damaging irreplaceable photographs is reduced to an absolute minimum.

## Recommended Refrigerators

Research for this book was, to this author's knowledge, the first investigation into the suitability of low-cost, frost-free refrigerators for storing color photographs without the need for vapor-proof packaging.[6] This author has been using a Kenmore frost-free refrigerator/freezer sold by Sears Roebuck and Company for storing color materials since 1975. Sears Roebuck started selling frost-free refrigerators in 1960, although it was several years later before they came into wide use. Frost-free refrigerators eliminate the messy and troublesome manual defrosting that was periodically necessary with earlier refrigerator/freezer designs. Most of the refrigerators sold in the U.S. are now of a frost-free design.

This author's refrigerator/freezer has a 10.6-cubic-foot capacity refrigerator section, which can accommodate about 20,000 35mm color slides in standard cardboard mounts; this figure is based on the slides being packed in standard Kodak 36-exposure cardboard slide boxes, enclosed in tightly wrapped polyethylene bags, with a reasonable amount of care in orderly packing. The 20,000-slide capacity leaves sufficient space between groups of boxes so that air can circulate freely throughout the refrigerator section. At the time of this writing, however, there were only a few thousand slides stored in this author's refrigerator — the remainder of the space was occupied by color negatives, color prints, and unprocessed color film and paper.

Basic design features of suitable refrigerators are given in **Table 19.3**. A type of refrigerator often confused with the true "frost-free" design is known as the "cycle-defrost" refrigerator, generally advertised as having a frost-free refrigerator section but a manual-defrost freezer section. This type of refrigerator functions by having separate cooling coils attached to thin aluminum plates in the refrigerator section. When the unit operates, the coils and plates form a small amount of frost. Between running cycles, the plates rapidly warm up to the temperature of the refrigerator section, which is above freezing, and water from the melted frost is drained off. These units require much less electricity than a true frost-free unit and are often advertised as being "energy saving." *Cycle-defrost refrigerators are not suitable for storing unprotected photographs* because they have very high levels of relative humidity. An older design based on a similar principle had cooling coils located behind the walls of the refrigerator section that were so arranged that they never reached a temperature below freezing. The interior walls of such a refrigerator

Slide pages can be packaged in a polyethylene garbage bag and flip-top museum box. To be able to find a specific slide or negative stored in a refrigerator, it is essential that the materials be cataloged and filed in an orderly manner. All boxes and other packages should be clearly marked as to their contents.

Kodalux (Kodak) 24- and 36-exposure yellow cardboard slide boxes are packaged in an ordinary polyethylene garbage bag, which in turn is placed in a flip-top museum box for storage in the refrigerator.

Carol Brower – 1983

are usually wet with condensed moisture, and the relative humidity level is normally near 100%.

*None of the older manual-defrost refrigerators should be used for storing unprotected photographs,* since they normally have relative humidity levels of between 90 and 100%.

Because this author has not had the opportunity to examine all of the many brands of frost-free refrigerators on the market, this discussion will be limited to general observations about the various types of refrigerators now being sold; in addition, specific information is given for the Kenmore frost-free refrigerator/freezers sold by Sears Roebuck and Company.[7] An important reason for using Sears Roebuck refrigerators is that the company includes a complete parts list with each refrigerator, and replacement parts and service are readily available from any of the Sears outlets in North America.

With the frost-free units recommended here, only the refrigerator section is acceptable for unprotected storage; although the freezer section is also "frost-free," it has much higher levels of relative humidity than the refrigerator section and is not suitable for storing photographs unless they are sealed in vapor-proof containers. The freezer section is safe for storing unprocessed materials that are still sealed in their original vapor-resistant factory packages. By the same token, "frost-free" freezers, which have no refrigerator sections, cannot be used for storing unprotected photographs.

### Large-Capacity "Photoarchive" Refrigerators

In 1992, Bonner Systems, Inc., a supplier of cold storage vaults (see Chapter 20), introduced the Photoarchive line of humidity-controlled refrigerators for museums and archives. Equipped with temperature and humidity recorders, the units are priced from $11,000 and are available in sizes up to 11 feet long x 6 feet high x 3 feet deep. Contact: Bonner Systems, Inc., 7 Doris Drive, Suite 2, N. Chelmsford, Massachusetts 01863; telephone: 508-251-1199.

### Table 19.2   Approximate Warm-Up Times for Various Types of Packages Before They Should Be Opened

| Type of Package | From 35°F to 75°F (1.7°C to 24°C) [40°F (22°C) Temperature Rise] |
|---|---|
| 36-exposure box of slides in Kodalux (Kodak) paper box | 45 minutes |
| Envelope with 6 strips, 6 frames each, 35mm film in polyester or acetate sleeves | 15 minutes |
| 35mm reel of movie film in metal film can | 3 hours |
| 16mm reel of movie film in metal film can | 1½ hours |
| 10 RC or fiber-base paper prints in flat cardboard box | 1 hour |
| 100 RC or fiber-base paper prints in flat cardboard box | 3 hours |

Approximate warm-up times are for single containers of the types listed, with the container wrapped in a single-layer polyethylene bag to prevent moisture condensation and placed on a table so air can freely circulate around the container. Do not stack containers together during the warm-up period unless warm-up times are greatly increased. These warm-up times were determined using packages of refrigerated photographs in which an externally monitored electronic temperature sensor had been placed in the center of the package.

Slide boxes can also be packaged two or three at a time in small, transparent Ziploc polyethylene bags for safe and accessible storage in the refrigerator.

Prints and negatives (shown here in their original processing envelopes) can be packaged in large, gallon-size Ziploc bags.

## How a Frost-Free Refrigerator Maintains Low Relative Humidity

Top-freezer models of suitable frost-free refrigerators have the cooling coils located behind a metal wall in the freezer section; side-by-side models are constructed in a similar manner with the cooling coils in the back of the freezer section. A fan located in the front of the cooling coils circulates cold air from the coils into the refrigerator and freezer sections; the fan operates only when the unit's compressor is running, during which the cooling coils are about –20°F (–29°C). Excess moisture in the air is condensed on the coils in the form of ice crystals (frost) as the air passes over the coils. When the compressor is not running, the temperature of the coils rises to about that of the freezer section (0°F or –18°C), and some of the ice on the cooling coils sublimes directly to water vapor — without passing through a liquid state — gradually raising the relative humidity in the freezer section to as high as 80 or 90%. As the moist but very cold air from the freezer section enters the refrigerator section, it warms to about 35°F (1.7°C). In doing so, the capacity of the air to retain moisture greatly increases, thereby dropping the relative humidity of the air to between 20 and 35% (see **Figure 19.1**). The exact level of relative humidity will vary somewhat with the particular type of refrigerator, as well as with the temperature at which the refrigerator section is operated, but it is not significantly affected by external humidity conditions except when the door is opened and for a short period after it is closed.

Very low relative humidity in a refrigerator dehydrates food left open to the air; this is one of the "problems" of a frost-free refrigerator, according to one manufacturer. However, what is a problem for food storage is an advantage for photographs. As the cooling coils condense moisture from the air, they become covered with frost, which must be removed from time to time or the coils will become clogged with ice and the fan-forced air will not pass through the coils. To remove the ice, most frost-free refrigerators have a timer-controlled "defrost cycle," during which the com-

pressor is shut off and a radiant electric heater located under the coils melts the ice. The heater is switched on at the beginning of the defrost cycle and continues to operate until it is switched off by a "bimetal" thermostatic cut-off located on the cooling coils (the temperature of the coils rises above freezing after the accumulated ice melts), or until the approximately 20-minute defrost cycle is completed. Most current models go through a defrost cycle after each 6 to 8 hours of compressor run time; earlier models had defrost times about twice each day and were not dependent on compressor run time. The water formed

---

**Table 19.3    Design Features of Frost-Free Refrigerators Suitable for Storing Photographic Materials**

---

1. Unit must have separate refrigerator and freezer sections. Sections must have separate doors which may be side-by-side or one above the other.

2. Cooling coils are located *ONLY* in the freezer section.

3. Cooling coils are located in an isolated compartment in the freezer section and cannot be seen without disassembling the unit. No part of the freezer or refrigerator which condenses moisture or forms ice crystals should be visible.

4. Air is forced over the cooling coils and into the freezer section by an internal fan. The fan will make noise when running and a current of cold air can be felt coming out of one or more ducts in the freezer and refrigerator sections.

5. This is the most important design feature: ALL cooling in the refrigerator section comes from cold air blown in from the freezer section by an internal fan.

---

## Table 19.4   Cautions When Using a Frost-Free Refrigerator for Storing Photographs

1. Be absolutely certain that you have the proper type of frost-free combination refrigerator/freezer unit.. Place an accurate hygrometer and thermometer inside, and keep it there at all times. Before putting any photographs or films in the refrigerator, monitor the unit's relative humidity (under operating conditions) daily for at least 2 weeks. Thereafter, check relative humidity and temperature levels at least once a week.

2. Temperature in the refrigerator section should be adjusted to an average of 35–40°F (1.7–4.4°C); the temperature should never drop below freezing (32°F or 0°C). Prolonged temperatures below freezing could result in a blocked condensate drain tube and cause water to leak inside the refrigerator section.

3. Use only the refrigerator section (not the freezer section) for storing processed photographs.

4. Photographs should be put inside envelopes or cardboard boxes which are then placed in polyethylene bags (or wrapped with polyethylene sheets and the seams taped with freezer tape) to protect the photographs from humidity peaks which occur when the refrigerator door is opened, after defrost cycles, or when boxes are removed and allowed to warm up. Heavy Duty Ziploc freezer bags, available from grocery stores, are particularly well suited for this application. Slides may be kept in original cardboard or plastic slide boxes as supplied by the processor, with the boxes placed in polyethylene bags. Packaging the photographs in polyethylene bags will also provide protection from water damage in the unlikely event an interior water leak occurs.

5. The refrigerator should not be too tightly packed with photographs. Space should be provided so that air can freely circulate between the shelves and in the area between the front of the shelves and the door. Particular care should be taken not to block the vent for fan-forced cold air, which is usually located just below the top of the refrigerator section. The air flow in the freezer section should also not be obstructed.

6. Avoid opening the refrigerator door more often than necessary.

7. Food and drinks should never be kept in a refrigerator or freezer used to store photographs.

8. In the event of a power failure of up to 48 hours (2 days) duration, do not open refrigerator door.

9. In the event of a power failure of longer than 48 hours, the unit should be unplugged and the door left open until power is restored.

10. Due to possible fire hazards associated with certain types of refrigerator malfunctions, cellulose nitrate film should not be stored in a frost-free refrigerator or freezer unless special precautions are taken.

---

during this process is collected in a drain pan under the cooling coils and runs through a plastic tube to an "evaporator" pan located near the compressor in the bottom of the refrigerator.

The temperature and relative humidity levels in the refrigerator section remain fairly constant during the defrost period, though there will be a humidity rise for about 15 minutes after the cooling compressor and fan resume operation. When materials are placed in a polyethylene bag (or wrapped with polyethylene sheets or freezer paper, with the seams taped with freezer tape) as suggested, the short rises in relative humidity will have no effect inside the packages. This author's tests indicate that this short humidity peak in the refrigerator section is of such short duration that even a single thickness of paper wrapped around a box of slides will prevent more than a couple of percentage points of humidity rise inside the container. The temperature of the refrigerator rises somewhat immediately after the defrost cycle, but the interior temperature of the pack-

ages of photographs changes very little during this period.

One recently introduced type of Sears Roebuck frost-free side-by-side refrigerator/freezer (Sears Catalog No. 46 R 53781N) has an "adaptive" defrost system which is equipped with sensors that cause the unit to defrost only when an excessive amount of frost has accumulated on the freezer coils; this saves energy if the doors are opened infrequently or if the ambient relative humidity is low, and also results in more stable refrigerator and freezer temperatures. This model, which sold for $1,850 in 1993, is also equipped with electronic temperature indicators for the refrigerator and freezer compartments. The unit has indicator lights and audible alarms that signal if a door has been left open longer than 3 minutes, if the power fails, if the unit is not functioning properly, if the interior temperature rises above a certain limit, and if the temperature has been above a certain level for more than 4 hours. Although expensive, this refrigerator is this author's primary recommendation for photographic storage applications.

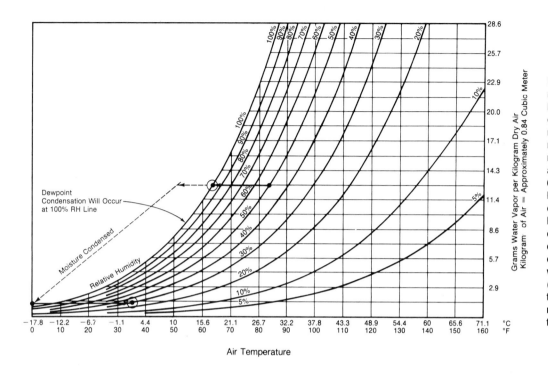

Dewpoint
Condensation Will Occur
at 100% RH Line

Moisture Condensed

Relative Humidity

Air Temperature

**Figure 19.1** A psychrometric chart illustrates how a frost-free refrigerator maintains low relative humidity in the refrigerator compartment. Room-temperature air (e.g., 84°F at 60% RH) is chilled to below 0°F (–18°C) by cooling coils behind the back wall of the freezer compartment. Moisture condenses on the cold coils, and as the air warms up to about 35°F (1.7°C) in the refrigerator compartment, the relative humidity drops to around 30%.

## Recommended Refrigerator Temperature

Sears frost-free refrigerators have a temperature control (usually called the "Cold Control") inside the refrigerator section which should initially be set to the middle position; the precise setting should be determined by placing a thermometer in the refrigerator and adjusting the control until a temperature of 35–40°F (1.7–4.4°C) is obtained. A second control found in most frost-free refrigerators regulates the temperature balance between the freezer section and the refrigerator section; it is usually called the "Usage Control." This control should normally be set in

1978

Cooling coils in the freezer compartment of a Sears Roebuck frost-free refrigerator (the back panel of the freezer section has been removed to show the cooling coils). The electric fan above the coils circulates air past the cold coils, through the freezer section, into the refrigerator compartment, and back to the cooling coils.

the middle, or "B," position. Frost-free refrigerators have only one thermostat, located in the refrigerator section, and the temperature in the refrigerator section determines the on/off periods of the refrigerator compressor. If the freezer temperature is not cold enough after the refrigerator-section temperature has been properly set, the "Usage Control" should be moved toward the "Heavier Freezer Usage," or "A," position. Changes in the setting of the "Usage Control" will not significantly alter the temperature of the refrigerator section, which is determined solely by the position of the "Cold Control."

The refrigerator should be checked periodically over a period of several days to be sure the temperature setting is correct. To minimize the chance of water freezing inside the condensate drain tube and fittings (which would block the tube and eventually result in water dripping down the back *inside* wall of the refrigerator section during a defrost cycle and collecting in a pool at the bottom of the compartment), the temperature of the refrigerator section should be adjusted so that it remains *at or above* 35°F (1.7°C) at all times.

## Cautions

Some basic points to keep in mind when storing photographs in a frost-free refrigerator are given in **Table 19.4**. Under no circumstances should food items be kept in a refrigerator in which photographs are stored. It is especially important that no foods such as ice cream be stored in the freezer section; in the event of a power failure, the ice cream would melt and might drip down through the contents of the refrigerator. Stored foods can give off a variety of chemicals which are potentially harmful to photographs; in addition, there is the very real danger of getting food, oils, etc. directly on storage boxes or photographs as they are removed from the polyethylene bags.

Refrigerators and freezers should be operated in a well-ventilated room — never in a closet or other small enclosed room. Refrigerators, especially frost-free models, give off considerable heat from the compressor motor, the defrosting heater, and the anti-condensation heating wires built into the refrigerator walls near the door openings. Basements are generally not advised because of the possibility of flooding caused by rain, backed-up sewer lines, or broken water pipes. In addition, refrigerators should be in an area that is reasonably free of dust.

Storage of cellulose nitrate films in frost-free refrigerators is *not* recommended because, in the event of certain types of mechanical malfunctions, there is a potential fire hazard with this very flammable type of film. For discussion of long-term storage of cellulose nitrate film in explosion-proof freezers, see **Appendix 19.1** at the end of this chapter.

### Testing the Refrigerator Is Necessary

The operating characteristics of any refrigerator destined for storing photographs must be known before photographs are placed in it. *This prior testing is absolutely necessary.* Designs of refrigerators are constantly changing, and frost-free refrigerators with the characteristics described here may not be available in the future. Also, a person may inadvertently purchase the wrong type of refrigerator. It is especially important that the levels of relative humidity in a refrigerator be checked from time to time during the summer months to be certain that excessive humidity levels do not develop. For instance, a manual-defrost refrigerator with no food in it may, for a time, have an acceptable level of relative humidity during the winter months in temperate climates because of the very low indoor humidity in most buildings when outdoor temperatures are low. But the relative humidity in this type of unit will rapidly rise to near 100% when warmer weather arrives, thus damaging or even destroying any photographs stored within.

At all times, an accurate hygrometer (humidity gauge) and thermometer[8] should be kept inside the refrigerator section and checked whenever the door is opened, keeping in mind that there will be a short period of high relative humidity after each defrost cycle. When purchasing a refrigerator, make certain it is a true frost-free model, with *both* the refrigerator and freezer sections guaranteed frost-free. Then check the hygrometer daily over a period of 2 or 3 weeks to make certain the unit continues to operate within satisfactory limits of relative humidity. The temperature control in the refrigerator section should be adjusted so that the temperature is in the range of 35–40°F (1.7–4.4°C) and does not drop below freezing.

### Refrigerator Mechanical Failure

While this author believes that photographs packed as described above and stored in a refrigerator of the recommended type are subject to very little risk, there is always a possibility that an unnoticed equipment failure or some other circumstance could cause damage to photographs. With reasonable care, there is little chance of trouble. Storing especially unstable materials — such as Kodak Ektacolor

37 RC and 74 RC prints, Process E-3 Ektachrome transparencies, or Kodacolor II, Vericolor II, Fujicolor HR, pre-1986 Fujicolor Professional, Konica Color SR, and pre-1989 Agfacolor XR and XRS color negative films — at room temperature will assure that they will fade to an objectionable degree in a relatively short time; this certainty must be considered when assessing the remote dangers of proper refrigerated storage.

A conventional refrigerator or freezer is less prone to mechanical failure than a frost-free unit. This advantage, however, must be balanced against the possibility of improper sealing or puncture of the vapor-proof packaging which is required when storing photographs in a conventional refrigerator. The inconvenience of pre-conditioning photographs to a low relative humidity and then heat-sealing them in a vapor-proof envelope will discourage most people from even attempting to store photographs in a conventional, non-frost-free refrigerator or freezer.

In addition to compressor or thermostat failure, refrigerant leaks, and other cooling system problems, there are a number of other ways a frost-free refrigerator can malfunction. For example, the plastic drain tube for defrost water on some earlier models came with a rubber grommet on the end, apparently intended to prevent insects from crawling in and clogging the hose; however, it is possible for the grommet itself to clog and cause water to back up and leak inside the refrigerator (the water will slowly drip down the inside back wall of the refrigerator section and accumulate on the bottom under the vegetable drawers). The rubber drain grommet is usually accessible from the front of the refrigerator — it is located just above the removable evaporator pan at the bottom of the refrigerator. The grommet can be removed and cleaned once a year to minimize the chance of its becoming clogged. Sears Roebuck refrigerators apparently no longer have grommets on the drain tubes. As previously discussed, the water drain tube could freeze and become blocked if the temperature in the refrigerator section remains below freezing for a prolonged period. Enclosing packages of photographs in plastic bags will minimize danger in the unlikely event that a water leak does occur.

The defrost system can fail if the defrost cycle timer, interior fan, or defrost heater malfunction. The bimetal defrost thermostatic cut-off can also stick in the open position. Any of these failures can result in the cooling coils accumulating so much frost that the fan can no longer force air through them, and the refrigerator will start to warm up even though the compressor runs constantly.[9] A thermometer which can be read from outside the refrigerator will alert the user should this type of failure occur; a thermostat with an electronic alarm is best as it will immediately sound if the temperature rises above pre-set limits.[10] If the bimetal defrost cut-off sticks in the closed position, the freezer section may become warm during each defrost cycle (this is another reason why processed films and prints should not be stored in the freezer section), and, for a short time after the defrost cycle is completed, the refrigerator section will also become quite warm.

Refrigerators should be checked about once a week to make certain they are operating correctly. A hygrometer and thermometer placed inside will indicate at a glance whether the refrigerator is functioning properly.

## Refrigerators Should be Replaced With New Units After 10 Years

To minimize chances of mechanical difficulty, a new refrigerator should be purchased at the outset; used units should be avoided. While refrigerators can be expected to last many years before mechanical problems with the compressor and cooling system are likely to be encountered,[11] this author strongly recommends that refrigerators in which photographs are stored be replaced after 10 years of use (be sure to write the purchase date on the refrigerator with a felt-tip pen in some easily noticed location, such as on an inside wall near the door opening).

For maximum protection of very valuable photographs, they should be conditioned in a low relative humidity (about 25–40%) and carefully sealed in vapor-proof envelopes before placing them in the refrigerator.

## Humidity-Protected Storage

Old-style refrigerators, which have to be manually defrosted from time to time, do of course maintain a low temperature, but the relative humidity in these units is generally between 90 and 100%. At this high relative humidity, films and prints will stick together, fungus will grow on the photograph emulsions and cardboard slide mounts, and there will be moisture-caused deterioration (hydrolysis) of the color image dyes.

*Photographs stored unprotected in a high-humidity refrigerator will be destroyed in a short time.*

If it is necessary to store photographs in a freezer or high-humidity manual-defrost or cycle-defrost refrigerator, the photographs must be sealed in a true vapor-proof container, such as a properly capped glass bottle or an aluminum-foil/plastic laminated envelope that can be heat sealed. Virtually all types of plastics will absorb and transmit water vapor over time and are thus *not suitable* for moisture protection of photographs in high-humidity cold storage.[12]

Although not strictly necessary, it is best to pre-condition films or prints in a low relative humidity environment (i.e., 25–40% RH) for several days prior to sealing them in a vapor-proof container. Rolls of motion picture film should be pre-conditioned for about 2 weeks.

The Museum of Fine Arts, Museum of New Mexico, located in Santa Fe, New Mexico, has installed a large upright Sears Roebuck Kenmore freezer for storage of Ektacolor prints. The freezer operates at about 0°F (–18°C) and because the relative humidity is uncontrolled, the prints are pre-conditioned to a low relative humidity and then packaged in vapor-proof envelopes before placing them in the freezer. Under the direction of Steve Yates, curator of photography, the Museum obtained the freezer in 1984, initially to house approximately 100 Ektacolor prints from the New Mexico Survey Project commissioned by the Museum. Yates says that providing cold storage is "doing something for the arts and for the artists — instead of hitting them over the head with the stability problems of Ektacolor prints."[13] The museum also has Cibachrome (Ilfochrome), Dye Transfer, and Polacolor prints in its collection; these are stored at room temperature along with black-and-white prints.

Vapor-proof envelopes made of an aluminum-foil/polyethylene laminate that can be sealed with a commercial heat-sealing unit or a household electric iron at a temperature between 250–300°F (120–150°C) are available from Light Impressions Corporation, Conservation Resources International, Inc., and several other suppliers.[14] These envelopes are similar to those in which sheet films are packed at the factory.

For a number of years Kodak supplied vapor-proof Storage Envelopes for Processed Film in 4x5- and 8x10-inch sizes; apparently because of lack of demand, Kodak discontinued the envelopes in 1987.

To minimize the chance of damage caused by an improper seal or puncture of vapor-proof envelopes, the films and prints should be sealed in an envelope and the edges of this envelope folded in so that it can be placed in a second envelope which is then sealed (for further discussion of vapor-proof envelopes and the pros and cons of pre-conditioning photographs to a low relative humidity, see Chapter 20).

In general, this author advises against using any high-humidity cold storage unit for storing valuable photographs, even if they are hermetically sealed in vapor-proof containers. There is the constant risk of improper seals, punctures, or the containers' failing for other reasons. Envelopes may be punctured in handling, causing small tears or pinholes which are not readily visible.

Even if metal cans containing motion pictures are taped shut, adhesive tapes generally give poor long-term protection against vapor transmission. With film cans there is the risk that a particular can may not be properly taped, or that the can will rust during long-term storage.

Any system that requires vapor-proof containers will reduce accessibility to the photographs, increase costs, and probably require trained personnel to pre-condition and properly seal the film containers. There will always be the possibility that a container will fail because of a manufacturing fault, improper sealing, or damage in handling, thus destroying photographs which can never be replaced.

A final objection to refrigerated storage with uncontrolled humidity is that the containers may — depending on the design of the particular refrigerator or freezer — actually become wet with condensed moisture or covered with ice if the temperature is below freezing. This can create a very messy situation and make identification of the containers difficult. At temperatures above freezing, mold and slime may form on the containers in non-frost-free refrigerators.

## Conclusion

Most photographers and conservators will find that storing color photographic materials in a frost-free refrigerator offers the only simple and low-cost method of safely preventing fading and staining of valuable color photographs. The procedures outlined in this chapter will virtually eliminate chances of accidental damage to the photographs.

Without refrigerated storage at low relative humidities, most color photographs will gradually fade and/or stain. Depending on the particular type of color film or print, image deterioration may become objectionable after only a few years of storage under normal conditions.

# Notes and References

1. See, for example: **ANSI IT9.11-1991, American National Standard for Imaging Media – Processed Safety Photographic Film – Storage**, American National Standards Institute, Inc., 11 West 42nd Street, New York, New York 10036; telephone: 212-642-4900.
2. Peter Galassi, Museum of Modern Art, New York City, telephone discussions with this author, March 9 and August 20, 1984. See also: Gene Thornton, "The Modern Still Favors the Documentary," **The New York Times**, August 19, 1984.
3. John P. Myers, Robert F. Cardillo, and Martine A. Culbertson, "VIREO – Visual Resources for Ornithology," **American Birds**, Vol. 38, No. 3, May–June 1984, pp. 267–277. See also: John P. Myers, Robert F. Cardillo, and Martine A. Culbertson, **Visual Resources for Ornithology – VIREO – Annual Report 1983**, (1984), Academy of Natural Sciences of Philadelphia, Benjamin Franklin Parkway, Philadelphia, Pennsylvania 19103; telephone: 215-299-1069; R. W. Norris and E. S. Preisendanz, **Color Transparency Archival Storage**, report prepared by the Engineering Service Division, E. I. du Pont de Nemours & Company, Inc., Engineering Department, Wilmington, Delaware, May 7, 1982; and Norman Schrieber, "Pop Photo Snapshots," section entitled "Bird Tracks," **Popular Photography**, Vol. 19, No. 2, February 1984, pp. 35–36.
4. Ziploc polyethylene bags are made by Dow Brands, Inc., P.O. Box 68511, Indianapolis, Indiana 46268; telephone: 317-873-7000. Ziploc Heavy Duty freezer bags, made of 2.7 mil polyethylene and available in one-quart, one-gallon, and larger sizes, are better suited for storing photographs than the lighter-weight general-use Ziploc bags. Ziploc bags have a waterproof seal along the top edge which is closed by squeezing the bag between the thumb and forefinger as the fingers are run across the top. The bags can be opened and closed repeatedly without losing the integrity of the seal. Larger bags of similar design (Lock-Top Media Bags) can be purchased from: The Highsmith Company, Inc., P.O. Box 800, Highway 106 East, Ft. Atkinson, Wisconsin 53538; telephone: 414-563-9571; toll-free: 800-558-2110. Bags of similar design (Easy-Zip Bags) in a wide variety of sizes up to 14x24 inches, and custom-made bags in any size, are available from Chiswick Trading, Inc., 33 Union Avenue, P.O. Box G, Sudbury, Massachusetts 01776-0907; telephone: 508-443-9592; toll-free in Massachusetts: 800-322-7222; toll-free outside Massachusetts: 800-225-8708. Chiswick requires a minimum order of 1,000 bags in small sizes and 500 bags in larger sizes. Bags of this type (Resealable Polyethylene Bags) are also available from Conservation Materials, Ltd., 1165 Marietta Way, Box 2884, Sparks, Nevada 89431; telephone: 702-331-0582.
5. The Light Impressions Slide-File Box (Code No. 5015)is 2⅜"Hx 2⅛"W x11"D and is made of lignin-free, alkaline-buffered cardboard with metal corners ($3.05 singly or $2.45 each in quantities of 10 or more). Each box can accommodate about 200 cardboard-mounted slides and is excellent for high-density packaging of slides for refrigerator storage or for general, non-refrigerated storage. The boxes are supplied by Light Impressions Corporation, 439 Monroe Avenue, P.O. Box 940, Rochester, New York 14607-0940; telephone: 716-271-8960 (toll-free: 800-828-6216).

   Six of the Slide-File boxes will fit inside a Light Impressions Corporation Drop-Front Box, 1½"Hx11"Wx14"D, Code No. 5012 ($6.85 singly or $5.50 each in quantities of 10 or more). The Light Impressions Code No. 5012 box, a shallow drop-front box, is only barely high enough to accommodate the slide boxes; however, the "standard" Light Impressions 11x14-inch Drop-Front Box (Code No. 2021) is too tall and wastes valuable refrigerator space. Also available from Light Impressions Corporation is the Slide Stack Box (Code No. 3211). Made of yellow polypropylene with a tight-fitting lid, and 2⅝"x2⅛"x2⅛" in size, each box accommodates up to 50 slides; a package of 6 boxes costs $6.95.

   Another cardboard box that is suitable for storing slides in a refrigerator is the Lig-free Type II Archival Slide Storage Box (#35ST) available from Conservation Resources International, Inc., 8000-H Forbes Place, Springfield, Virginia 22151; telephone: 703-321-7730 (toll-free: 800-634-6932). The boxes cost about $5 each in quantities of 5, or $4 each in quantities of 10 or more (shipping additional). Each box has a capacity of 360 slides and is 18x2⅝x2⅝" in size. Also available is a large Master Unit consisting of six #35ST slide boxes inside a drop-front cardboard box 17x19x2¾" in size; a Master Unit (#35MU) has a capacity of about 2,190 slides and costs $34.50. Boxes of similar design are also available for mounted 120 roll film transparencies. The interior of these boxes is made of nonbuffered, lignin-free cardboard. Each box (or Master Unit) should be sealed in a polyethylene bag — or wrapped with a sheet of polyethylene and the seams taped with masking tape or freezer tape

— before placing in a frost-free refrigerator. Upon removal from the refrigerator, the box should be allowed to warm up for about 3 hours before taking it out of the bag. These boxes are, of course, also suitable for storing slides in normal room-temperature conditions.

   Very good low-cost polypropylene plastic boxes suitable for slide storage are manufactured by Flambeau Products Corporation, 15981 Valplast Road, P.O. Box 97, Middlefield, Ohio 44062; telephone: 216-632-1631. Box No. M-812, recommended for slides, has 12 interior compartments, each holding about 65 slides (about 800 in total). The box, which has a hinged lid and is made of yellow polypropylene, is 2½"x13"x9" in size. Flambeau requires a minimum purchase of $200 when ordering directly from the company; No. M-812 boxes cost only $3.24 each (5 boxes to a carton) when purchased direct. These boxes also should be sealed in a polyethylene bag prior to placing them in a frost-free refrigerator.
6. Henry Wilhelm, "Storing Color Materials – Frost-Free Refrigerators Offer a Low-Cost Solution," **Industrial Photography**, Vol. 27, No. 10, October 1978, pp. 32ff. The article was based on a presentation by the author on the use of frost-free refrigerators for storing color photographs given at **The Permanence of Color – Technology's Challenge, The Photographer's and Collector's Dilemma**, a conference held at the International Center of Photography, New York City, May 7, 1978.

   The author first became aware of the low-humidity operating characteristics of frost-free refrigerators when — during a visit to his mother's home in Leesburg, Virginia in 1975 — he observed that an uncovered cake kept in a Kenmore frost-free refrigerator had become partially dehydrated after less than 2 days of storage (this was contrary to all of the author's previous experience with household refrigerators).

   In **Conservation of Photographs**, Kodak Publication No. F-40, Eastman Kodak Company, Rochester, New York, March 1985, use of frost-free refrigerators is recommended. The discussion of frost-free refrigerators for storing photographs (p. 103) is in part taken from this author's 1978 **Industrial Photography** article. Kodak concluded this section by noting that, "The details of unit design and of storage of photographic materials are quite extensive and important. Further information can be obtained from literature on the subject. The custodian should be familiar with these procedures before purchasing or using a frost-free refrigerator or freezer." No literature citations were given, however.
7. Suitable frost-free refrigerators, parts, and service are available from Sears Roebuck and Company, P.O. Box 1530, Downers Grove, Illinois 60515-5721, and the more than 3,000 Sears retail stores throughout North America; telephone: 316-652-7584 (toll-free: 800-366-3000). The following Sears Kenmore low-humidity frost-free refrigerators, suitable for the storage of photographs, were among those listed in the Sears 1993 Annual catalog, which can be ordered from until January 31, 1994 (for advice on suitable models after that date, consult Preservation Publishing Company, P.O. Box 567, Grinnell, Iowa 50112-0567; telephone: 515-236-5575; Fax: 515-236-7052). Prices listed below remain in effect until January 31, 1994:

   – No. 46 R 63041N (7.5-cu.-ft. refrigerator section
      – size: 59"Hx24"Wx28"D)........................$470.

   – No. 46 R 63421N (10.6-cu.-ft. refrigerator section
      – size: 61"Hx28"Wx30"D)........................$530.

   – No. 46 R 63831N (13.3-cu.-ft. refrigerator section
      – size: 67"Hx30"Wx31"D).......................$580.

   – No. 46 R 63651N (11.7-cu.-ft. refrigerator section
      – size: 64"Hx28"Wx30"D).......................$600.

   – No. 46 R 63851N (13.1-cu.-ft. refrigerator section
      – size: 64"Hx30"Wx32"D).......................$630.

   – No. 46 R 63861N (13.3-cu.-ft. refrigerator section
      – size: 67"Hx30"Wx31"D).......................$670.

   – No. 46 R 63031N (14.4-cu.-ft. refrigerator section
      – size: 67"Hx33"Wx31"D).......................$680.

   – No. 46 R 63061N (14.4-cu.-ft. refrigerator section
      – size: 67"Hx33"Wx31"D).......................$730.

   – No. 46 R 63171N (14.3-cu.-ft. refrigerator section
      – size: 67"Hx32"Wx32"D).......................$780.

– No. 46 R 63471N (16.4-cu.-ft. refrigerator section
– size: 67"Hx35"Wx32"D). . . . . . . . . . . . . . . . . . . . . . .$900.
(The above unit is the best buy, in this author's opinion.)

– No. 46 R 63271N (15.0-cu.-ft. refrigerator section
– size: 67"Hx32"Wx33"D). . . . . . . . . . . . . . . . . . . . . . .$930.

– No. 46 R 63571N (17.1-cu.-ft. refrigerator section
– size: 67"Hx35"Wx33"D). . . . . . . . . . . . . . . . . . . . . . .$1,050.

The best (and most expensive) Sears Kenmore side-by-side refrigerator is:
– No. 46 R 53781N (16.6-cu.-ft. refrigerator section
– size: 69"Hx36"Wx34"D). . . . . . . . . . . . . . . . . . . . . . .$1,850.

This unique refrigerator is equipped with external temperature indicators for the refrigerator and freezer compartments. The unit has indicator lights and audible alarms which signal when the door has been left open for longer than 3 minutes; when the interior temperature has risen above acceptable levels; if the unit has been above an acceptable temperature for longer than 4 hours; or if there has been an interruption in electrical power.

Other acceptable Sears Kenmore side-by-side models include:
– No. 46 R 43021N (13.3-cu.-ft. refrigerator section
– size: 66"Hx33"Wx31"D). . . . . . . . . . . . . . . . . . . . . . . $780.

– No. 46 R 43041N (13.3-cu.-ft. refrigerator section
– size: 66"Hx33"Wx32"D). . . . . . . . . . . . . . . . . . . . . . . $830.

– No. 46 R 53071N (12.8-cu.-ft. refrigerator section
– size: 67"Hx32"Wx33"D). . . . . . . . . . . . . . . . . . . . . . . $1,100.

– No. 46 R 53281N (14.5-cu.-ft. refrigerator section
– size: 66"Hx33"Wx34"D). . . . . . . . . . . . . . . . . . . . . . . $1,200.

– No. 46 R 53271N (14.9-cu.-ft. refrigerator section
– size: 67"Hx34"Wx33"D). . . . . . . . . . . . . . . . . . . . . . . $1,300.

– No. 46 R 53471N (14.9-cu.-ft. refrigerator section
– size: 67"Hx36"Wx33"D). . . . . . . . . . . . . . . . . . . . . . . $1,400.

– No. 46 R 53771N (16.6-cu.-ft. refrigerator section
– size: 69"Hx36"Wx34"D). . . . . . . . . . . . . . . . . . . . . . . $1,600.

Most Kenmore refrigerators are equipped with a "Power Miser" switch for shutting off wall heaters located inside the refrigerator walls near the door openings during periods of the year when the ambient relative humidity is low; the heaters prevent moisture from condensing on the somewhat cooled exterior surfaces near the doors of the refrigerator during periods of high relative humidity. The heaters are not necessary in temperate climates during the winter when the indoor relative humidity is generally low. The "Power Miser" switch has no influence on conditions inside the refrigerator.

Most of the refrigerators sold by Sears Roebuck during recent years have been manufactured by the Whirlpool Corporation of Benton Harbor, Michigan. Whirlpool also sells refrigerators under its own name; with the exception of interior and exterior trim, most are essentially identical to the refrigerators sold by Sears Roebuck. Reportedly, Whirlpool sells far more refrigerators to Sears than it markets under its own name (in the 5-year period from 1981 to 1986, Sears Roebuck sold more than 5 million refrigerators).

8. Suitable dial hygrometers (relative humidity gauges) are available from Abbeon Cal, Inc., 123 Gray Avenue, Santa Barbara, California 93101; telephone: 805-966-0810; toll-free: 800-922-0977. Model No. HTAB-176 (with built-in thermometer), $131.64 including shipping; and No. AB-167 (similar to HTAB-169, but without built-in thermometer), $113.87 including shipping. In spite of the manufacturer's claims about the accuracy of these and other hygrometers, they should be carefully calibrated by the user, especially before they are put into service for the first time following purchase — see Chapter 16 for instructions on how to calibrate a hygrometer.

9. Sears Roebuck and Company, Sears Coldspot and Kenmore Refrigerators Service Manual, Sears Roebuck and Company, Chicago, Illinois, 1977.

10. A suitable electronic temperature indicator, with two remote sensors, digital readouts and alarm functions, is the Computemp5, available from Rodco Products Company, Inc., 2565 16th Avenue, P.O. Box 944, Columbus, Nebraska 68601; telephone: 402-563-3596. Price for the unit is approximately $90. The Computemp5 is also available from Abbeon Cal, Inc. (see Note No. 8). Other electronic temperature indicators and alarms available from Abbeon Cal, Inc. include: the Protecto Freeze battery-powered temperature alarm which sounds if the temperature should exceed 25°F (–3.9°C), $36.95; Adjustable Temperature Alarm and Display, Model Q, $158; Adjustable Freezer/Cooler Alarm, Model 200, $87; Model 210, with 100-hour timer to show how long a refrigerator has been off, $100. The sensors of these units can be placed in a small cardboard box (to prevent them from responding during the temporary temperature elevations which occur during each defrost cycle) in the freezer section of a frost-free refrigerator to indicate defrost system or other mechanical malfunction which will lead to overheating inside the refrigerator. Also useful is a product called Flood Alert, available for $20.95 from Abbeon Cal, Inc., which sounds an alarm if water should come into contact with the sensor.

11. Roger B. Yepsen, Jr., **The Durability Factor**, Rodale Press, Emmaus, Pennsylvania, 1982.

12. **Modern Plastics Encyclopedia**, 1984/1985, Vol. 61, No. 10A, McGraw-Hill Company, New York, New York, 1984. See also: **The 1984 Packaging Encyclopedia**, Vol. 29, No. 4, Cahners Publishing Company, Boston, Massachusetts, 1984.

13. Steve Yates, Museum of Fine Arts, Museum of New Mexico, telephone discussion with this author, September 12, 1984.

14. Heat-sealable vapor-proof envelopes called Light Impressions Heat Seal Envelopes are available from Light Impressions Corporation, 439 Monroe Avenue, P.O. Box 940, Rochester, New York 14607-0940; telephone: 716-271-8960 (toll-free: 800-828-6216). Two standard sizes are supplied: Code No. 3920 (4¾x6½-inches; $6.30 for a package of 25) and Code No. 3921 (12x15-inches; $13.25 for a package of 25).

Similar envelopes called Containers for Freezing Photographic Material are available in the 10x12-inch size (minimum order of 500 envelopes) and larger custom-made sizes from Conservation Resources International, Inc., 8000-H Forbes Place, Springfield, Virginia 22151; telephone: 703-321-7730 (toll-free: 800-634-6932). These envelopes are true vapor-proof, heat-sealable, aluminum-foil/polyethylene laminated containers that can provide added security in a frost-free refrigerator, or be used in a double-layer package in a non-humidity-controlled refrigerator or freezer.

Custom-made heavy-duty, heat-sealable vapor-proof envelopes in any size or configuration are available under the XT-08 name (large-quantity orders only) from Quality Packaging Supply Corporation, 24 Seneca Avenue, Rochester, New York 14621; telephone: 716-544-2500 (California office: 3028 East 11th Street, Los Angeles, California; telephone: 213-264-1102).

Custom-made heat-sealable vapor-proof envelopes for films and prints in any size are also available (large-quantity orders only) from Shield Pack, Inc., 2301 Downing Pines Road, West Monroe, Louisiana 71291; telephone: 318-387-4743 (toll-free: 800-551-5185).

Eastman Kodak has given two sources for laminated aluminum-foil/polyethylene material suitable to make vapor-proof storage envelopes: Crown Zellerbach, Flexible Packaging Division, Park 80 Plaza – West I, Saddlebrook, New Jersey 07662; and Northern Packaging Corp., 777 Driving Park Avenue, Rochester, New York 14613. This laminated material can be used to make custom-size envelopes for storage, or for wrapping boxes of films or prints before placing them in a refrigerator. Packages should be wrapped with overlapping seams and taped to completely cover the seams with, for example, 3M Scotch No. 600 Transparent Tape, available at most office supply stores.

## Additional References

Anon., "A Swedish Report on the Preservation of Microfilm in Hermetically Sealed Wrappers," **International Council on Archives Microfilm Committee**, Bulletin L, 1975, pp. 61–66.

J. M. Calhoun, "Cold Storage of Photographic Film," **PSA Journal, Section B: Photographic Science and Technique,** Vol. 18B, No. 3, October 1952, pp. 86–89.

Eastman Kodak Company, **Conservation of Photographs** (George T. Eaton, editor), Kodak Publication No. F-40, Eastman Kodak Company, Rochester, New York, March 1985.

Roland Gooes and Hans-Evert Bloman, "An Inexpensive Method for Preservation and Long-Term Storage of Color Film," **SMPTE Journal**, Vol. 92, No. 12, December 1983, pp. 1314–1316.

D. F. Kopperl and C. C. Bard, "Freeze/Thaw Cycling of Motion-Picture Films," **SMPTE Journal**, Vol. 94, No. 8, August 1985, pp. 826–827.

Charles J. Lewis, "Preserve Priceless Negatives," **The Rangefinder**, Vol. 33, No. 9, September 1984, pp. 54ff.

# Appendix 19.1 – Freezer Storage for Permanent Preservation of Cellulose Nitrate Still-Camera Negatives and Motion Pictures

Because cellulose nitrate film is highly flammable, it should not be stored in a conventional refrigerator or freezer. It is conceivable that an electrical or mechanical malfunction could, under certain circumstances, cause the film to ignite — with potentially catastrophic results not only to the stored film but also to other, nearby photographs and to the building in which the refrigerator or freezer is located. Frost-free refrigerators are, however, suitable for storage of cellulose diacetate black-and-white negatives as well as other types of early and modern "safety" film. For a comprehensive study of the deterioration of early cellulose acetate safety film — some of which in storage has proven to be less stable than cellulose nitrate film — refer to the 1987 publication, *The Acetate Negative Survey: Final Report*, by David G. Horvath.[1]

There is no doubt that storage of cellulose nitrate film at low temperatures will greatly prolong its life, and special "explosion-proof" freezers, in which nitrate film can be kept safely, are being manufactured.

If cold storage facilities are not available, the film should be kept as cool and in as low relative humidity as possible. Nitrate film should be segregated from safety film and kept in separate files — or better yet, in a separate room — as decomposition products from the film can over time seriously harm safety film images, gelatin, and acetate supports.[2]

Even if it appears to be in good condition, nitrate film should not ordinarily be re-washed or otherwise moistened with water because the emulsion may become soft or actually dissolve because of the effects of base decomposition.

Nitrate still-camera negatives should be stored in alkaline-buffered paper envelopes (it is believed that the alkaline buffering will, for a time at least, retard the action of evolved gases from the film on the envelope paper); in room-temperature storage, plastic envelopes and sleeves should be avoided since they restrict the escape of fumes which slowly evolve from the film.

Low-temperature storage in explosion-proof freezers will be discussed later, but first it will be helpful to provide some background on the history and problems of cellulose nitrate films.

## Cellulose Nitrate Film Base

Cellulose nitrate was the support material for the first commercial transparent roll film; it was perfected by George Eastman and his research chemist Henry M. Reichenbach and was first marketed in 1889. Cellulose nitrate roll film was first invented by the Rev. Hannibal Goodwin, who applied for a patent on the film in 1887; however, Goodwin's patent was not granted until 1898. Reichenbach applied for a patent in 1889 and received it shortly thereafter. Goodwin sold his patent to Anthony and Scovill (which later became Ansco, and later still was known as GAF). After a long patent-infringement suit, Goodwin's patent was upheld in 1914, and Eastman paid Ansco 5 million dollars in settlement. Although 5 million dollars was a great deal of money in the early 1900's, the final outcome was nevertheless very much to Kodak's advantage because by the time the matter was settled, Eastman Kodak dominated the worldwide market for flexible roll film and motion picture film.

Flexible film base made possible the development of Thomas Edison's motion picture camera and projector in 1891, and the first commercial cellulose nitrate motion picture film became available in 1895.

In the U.S., most roll films (e.g., 620 and 616 films) and film packs were made of cellulose nitrate until about 1950; professional 35mm motion picture films in the U.S. continued to use this support until 1951 (manufacture of cellulose nitrate still negative and motion picture films continued in some countries until the mid-1950's). Some photographers made 35mm still-camera pictures on spooled motion picture films, and examples of 35mm still-camera negatives made as late as the mid-1950's on cellulose nitrate film base can be found occasionally.

Cellulose nitrate, also known as nitrocellulose, is a pyroxylin plastic. It is made by treating cotton or wood fiber cellulose with a mixture of nitric and sulfuric acid; it is then further processed by adding solvents, camphor as a plasticizer, and other compounds, forming a viscous solution which is then "solvent-casted" on a polished metal drum or other smooth surface. A thin sheet of cellulose nitrate film base remains after the solvents evaporate.

Cellulose nitrate is highly flammable and it was long believed that nitrate films had intrinsically poor long-term storage stability compared with cellulose ester "safety-base" films (e.g., cellulose diacetate, cellulose acetate butyrate, cellulose acetate propionate, and cellulose triacetate). In spite of the poor reputation nitrate film has had insofar as its keeping properties are concerned, there are large quantities of nitrate film that are still in excellent condition after more than 50 years of storage, and many nitrate still-camera negatives remain in better condition than cellulose diacetate and other types of safety-base films from the same period. In fact, under normal storage conditions, nitrate film is considerably more stable than the dye images of many types of color films that have been manufactured during the last 30 years.

When new, nitrate film has good strength and handling characteristics; and this, combined with the difficulty of producing a slow-burning "safety" film equal to nitrate film in physical characteristics, kept nitrate film in use long after the fire hazards of this film base had been clearly recognized.

Stored without air conditioning, humidity control, or an alarm system in an abandoned incinerator building on the grounds of the International Museum of Photography at George Eastman House in Rochester, New York, this large store of cellulose nitrate motion picture films ignited on a hot day in May 1978. Original negatives from 329 motion pictures, some of them classics from the early days of the Hollywood motion picture industry, were destroyed in the fire.

## Identification of Cellulose Nitrate Film

Until recently, Kodak acetate and polyester safety-base black-and-white films had almost always been edge-printed with the word "Safety," although a particular negative cut from a roll may not include the marking. Non-nitrate films made by other manufacturers may or may not include "Safety" in the edge markings. "Safety" means that the film is not highly combustible; that is, under typical conditions it burns no more readily than ordinary paper when ignited. Nitrate film from the 1930's through the 1950's was generally edge-printed with the word "Nitrate"; early nitrate film usually was not identified as to its composition. The dates of last manufacture of Kodak nitrate films in various formats are given in **Table 19.5.**

If an older film has neither "Nitrate" nor "Safety" markings, it should be assumed to be nitrate until proven otherwise. In recent years, however, the word "Safety" has been dropped from many color films; it no longer appears on most Kodak color negative films. The "Kodak Safety Film" imprint on all Kodak color transparency and color negative films was changed to "Kodak" beginning in Sep-

tember 1982. "Safety Film" also is not included in the edge markings of some current black-and-white films.

A simple test to distinguish nitrate film from safety film is to place a small fragment (a piece about ⅛ inch in diameter can be cut from the film with an ordinary paper punch) in a test tube containing trichloroethylene and shake the tube to thoroughly wet the sample. If the sample sinks, it is cellulose nitrate. If it floats, it is an acetate or polyester safety film.[3] Tests also are available to indicate whether the film is nearing the end of its useful life.[4]

Since some photographers keep film and paper in storage even years after purchase, nitrate film continued to have limited use for some time after production of the material ceased. Throughout the 1940's and 1950's, it was a common practice for photographers to load 35mm film cassettes with low-cost nitrate motion picture film; so even though Kodak discontinued sale of packaged 35mm nitrate roll films in 1938, some nitrate film continued to be used for 35mm still-camera negatives until the early 1950's. Also, the manufacture of nitrate film in Europe and Asia continued for some years after Kodak ended nitrate production in the U.S.

**Table 19.5  Dates of Last Cellulose Nitrate Films Manufactured by Eastman Kodak Company in the United States**

| Type of Film | Date |
|---|---|
| X-ray film | 1933 |
| 35mm roll film for still camera | 1938 |
| Portrait and commercial sheet film | 1939 |
| Aerial film | 1942 |
| Film pack | 1949 |
| Roll film in sizes 616, 620, 828, etc. | 1950 |
| 35mm motion picture film | 1951 |

Source: John M. Calhoun, "Storage of Nitrate Amateur Still-Camera Film Negatives," **Journal of the Biological Photographic Association**, Vol. 21, No. 3, August 1953, p. 2.

## Fire Hazards of Nitrate Film

With reasonable precautions, storage of relatively small quantities of cellulose nitrate still-camera negatives packaged in individual paper envelopes does not present a significant fire hazard. The reputation of nitrate film as being extremely dangerous — even explosive — came about because of a series of major fires involving motion picture film and dating back to near the beginning of the motion picture business. The one major fire involving sheet film of which this author is aware occurred in May 1929, when between 6 and 8 thousand pounds of cellulose nitrate X-ray film stored in the basement of the Cleveland Clinic in Cleveland, Ohio caught fire; the heat and toxic fumes produced by the blaze resulted in the deaths of 124 people. Following the disaster, safety requirements for storing nitrate film were made much more strict, and, 4 years after the fire, Kodak converted its manufacture of X-ray film to safety-base materials.

New nitrate film ignites at a temperature of about 266°F (130°C); it contains its own oxidant, so once large quantities of film start to burn, it is difficult to extinguish. As the film begins to decompose with age, the ignition temperature lowers. In the later stages, the decomposition of the film is an exothermic reaction, and if large quantities of the film are present in one location — as might be the case with tightly packed reels of motion picture film — the generated heat will speed decomposition, thus producing even more heat. Under these conditions, it is possible for nitrate film to spontaneously ignite when storage temperatures are greater than about 100°F (38°C) for a prolonged period of time.[5] With proper temperature- and humidity-controlled storage, spontaneous combustion cannot occur.

In the last 15 years, major losses of nitrate motion pictures have occurred from fires in the United States, France, and Mexico. A nitrate motion picture film fire, believed to have started as a result of spontaneous combustion, occurred at the International Museum of Photography at George Eastman House in Rochester, New York on May 29, 1978. Original negatives from 329 motion pictures, including such classics as *Strike Up the Band* starring Mickey Rooney and Judy Garland, were destroyed in the blaze. The film was stored under totally inadequate conditions on the Eastman House grounds in — ironically — an abandoned incinerator which was without air-conditioning or dehumidification equipment and which had no alarms or sprinkler system. The fire started on a hot afternoon after a series of very warm days in Rochester. Losses were estimated to be in excess of one million dollars.[6] In December 1978 there was a large nitrate fire at the U.S. National Archives storage facility outside of Washington, D.C. in Suitland, Maryland in which an estimated 15 million feet of mostly irreplaceable motion picture film was destroyed. This fire started from undetermined causes; it is not believed that spontaneous combustion was a factor.

Persons responsible for keeping large quantities of nitrate film should read the available literature on storage of this material.[7] Particularly useful are *Nitrate Film Testing for the National Archives*, a report prepared by the National Archives and the Naval Ordnance Station of the Department of the Navy following the 1978 Suitland fire,[8] and *Storage and Preservation of Motion Picture Film*, published in 1957 by Eastman Kodak Company.[9]

## Aging Behavior of Nitrate Film

Because of factors not fully understood but likely involving certain aspects of how the film was originally manufactured, some nitrate film appears to have a significantly longer useful life than other nitrate film stored under the same conditions. The temperature and humidity conditions to which any nitrate film has been subjected during its storage history are very important factors in determining its life. Film that has remained in good condition for a great many years in normal storage conditions may in the course of only a year's time suffer significant deterioration. Nitrate collections should be inspected on a regular basis to identify and remove any films that are beginning to visibly deteriorate. John M. Calhoun of Eastman Kodak has described five distinct stages in the decomposition of cellulose nitrate films:[10]

1. Amber discoloration of the film occurs with fading of the picture image.

2. The emulsion becomes adhesive and the films tend to stick together.

3. The film contains gas bubbles and emits a noxious odor.

4. The film becomes soft, welded to adjacent film and frequently covered with a viscous froth.

5. The film mass degenerates partially or entirely into a brownish acrid powder.

Nitrate film that has reached the second or third stage of decomposition is usually very brittle and must be handled with care. According to Calhoun:

>   This type of film brittleness is permanent and severe in contrast to the temporary de-

crease in flexibility which occurs when film is kept at very low relative humidities. The odor mentioned under the third stage is very characteristic of decomposing cellulose nitrate or nitric acid and once known is easily recognized. It is less pronounced but still noticeable in the second stage of decomposition.

Nitrate negatives in the first or second stage — and even many in the third stage — of deterioration can be photographically duplicated.[11] Using a rather time-consuming process, it is possible to remove the emulsion from a deteriorating cellulose nitrate (or acetate) negative and transfer it to a new, stable support; a workable method has been described by Vilia Reed of Eastman Kodak.[12] A negative should be duplicated before any attempt is made to transfer the emulsion. Emulsion transfer is particularly desirable for deteriorating negatives that have significant artifact value (e.g., negatives made by well-known photographers or negatives of historical importance).

As nitrate film decomposes, nitrogen oxides are produced; nitrogen dioxide, together with nitric acid produced by the combination of nitrogen dioxide with moisture from the air, attacks the silver image, gelatin, and film base. Nitrate still-camera negatives should be stored so that there is reasonable air circulation between sheets to slow deterioration; that is, the film should not be stored in sealed containers. As explained by Calhoun:

> The decomposition of cellulose nitrate is autocatalytic, the evolved gases acting as catalysts to accelerate further decomposition. This means that as the decomposition proceeds the reaction goes faster and faster unless these gases are allowed to escape. This is a very important factor in film storage because it means that the life of nitrate negatives depends on the ready escape of these fumes. This is one of the reasons why the thicker sheet film negatives are more likely to decompose than roll film or film pack negatives. It also explains why a quantity of film in close contact with itself, as in a roll of motion picture film or a stack of non-interleaved negatives, is more apt to decompose than individual films stored in envelopes where the nitrogen oxides have a better chance to escape to the air.[13]

## New Research Shows That Nitrate Film Is More Stable, and Modern Cellulose Triacetate Film Is Less Stable, Than Previously Believed

Because in the past most people believed that cellulose nitrate film was inherently unstable and had only a short life — and because of worry about the fire hazards associated with the film — it has often been advised that all nitrate films be duplicated and the originals disposed of. The recommendation was based on two assumptions, the first being that nothing could be done to significantly extend the life of nitrate film, and the second being that modern triacetate safety film was essentially permanent. Research published in 1991 and 1992 by Peter Z. Adelstein, James M. Reilly, Douglas W. Nishimura, and C. J. Erbland at the Image Permanence Institute (IPI) at the Rochester Institute of Technology has shown than neither of these assumptions is necessarily valid:[14]

> The chemical stability of different cellulose ester base films is generally quite similar.
>
> . . . there is no evidence to suggest that diacetate, triacetate or mixed esters have *inherently* different stabilities because of their chemical differences. The often-repeated statement that the obsolete diacetate films are less stable than more recent films is not supported by this study.
>
> . . . it has been established that cellulose nitrate film in storage will not necessarily degrade faster than other cellulose ester base films.
>
> The superior chemical stability of polyester base films supports the conclusions of earlier studies.[15]

In a finding of major importance, Adelstein, Reilly, Nishimura, and Erbland's film base aging studies led them to conclude that under *common* storage conditions, the life of modern cellulose triacetate base film can be significantly shorter than previously thought.

## The Profound Influence of Storage Temperature on the Life of Nitrate Film

Based on data from Arrhenius accelerated aging studies with a large number of cellulose triacetate and cellulose nitrate film samples, Adelstein and his co-workers reported that every 10°F decrease in storage temperature will increase film life by a factor of approximately two. This research marked the first major application of the multi-temperature Arrhenius test method to cellulose nitrate film. In the past, most testing of nitrate film was done at a single, very high temperature (commonly 212°F [100°C]) under either dry conditions or at 50% RH. When subjected to this type of harsh, short-term incubation test, nitrate film does indeed appear to be less stable than cellulose acetate film.

Adelstein and his co-workers also showed that the rate of film base decomposition is influenced by moisture content, and lowering the ambient relative humidity from 60% to 40% RH should more than double the life of the film. The benefits of low-temperature and low-humidity storage were found to be additive. For long-term storage of all types of film, 20–30% RH is recommended.

In 1991, as a result of these studies, the American National Standards Institute, Inc. (ANSI) standards pertaining to photography adopted a maximum life expectancy rating (LE rating) of 100 years for cellulose triacetate film. For polyester-base films, a maximum LE rating of 500 years was adopted. (The long-standing "archival" designation for acetate and polyester-base films is being phased out of ANSI photographic standards in favor of specific LE ratings for different types of film, and for processing and storage conditions.)

The findings of Adelstein and his co-workers are in striking agreement with estimates of temperature dependence of

Alan B. Newman – February 1987

To preserve the original cellulose nitrate negatives made by Clarence John Laughlin (1905–1985), the Historic New Orleans Collection stores the negatives at 0°F (–18°C) and 30% RH. The negatives have been pre-conditioned and sealed in vapor-proof envelopes to avoid any possibility of damage to other materials in the vault by gases that are slowly evolved from the nitrate negatives. Holding a package of negatives in the vault is curator John Lawrence. Recent studies conducted with the Arrhenius test method have produced convincing evidence that nitrate film still in good condition when placed in storage at 0°F (–18°C) will last more than 1,000 years before the film deteriorates to the point where the negatives no longer can be printed.

The 0°F vault for nitrate film storage is located inside the larger 32°F vault. The control panel on the right monitors temperature and humidity levels in both vaults.

Alan B. Newman – February 1987

nitrate-base film decomposition in a 1953 technical article by John M. Calhoun of Eastman Kodak:

> The rate of decomposition of cellulose nitrate is also very dependent on temperature and moisture content. The temperature coefficient of the reaction is about 4 per 10°C or 2 per 10°F which means that the rate of decomposition approximately doubles for every 10°F increase in storage temperature. Moisture absorbed from the air, the amount of which is determined by the relative humidity, also accelerates the decomposition reaction.[16]

## Permanent Preservation of Nitrate Film in Cold Storage

The Arrhenius predictions given by Adelstein and his co-workers for the life of nitrate film stored at various temperatures, which correlate well with the earlier estimates given by Calhoun, indicate that nitrate film should last more than 50 times longer when stored at 25°F (–4°C) — and at least *200 times longer* when stored at 0°F (–18°C) — than when the film is kept at 75°F (24°C). When stored at 85°F (29.5°C), nitrate film is estimated to last only about one-half as long as it will at 75°F (24°C).[17] These figures are only estimates — ongoing research should provide more precise predictions — but they do illustrate the dramatic increase in the life of nitrate films afforded by low-temperature, humidity-controlled storage.

The work by Adelstein and his co-workers is particularly important because it shows clearly that the common belief that nitrate film "cannot be preserved" is simply not correct. A roll of nitrate motion picture film that today is still in good enough condition to last another 6 years at room temperature is predicted to remain in good condition for at least a 1,000 years when stored at 0°F (–18°C) and 30% RH. (The temperature coefficient of cellulose nitrate decomposition appears to be not unlike that of the fading of color photographs: both types of materials benefit greatly from low-temperature storage.)

## Duplication of Nitrate Motion Picture Films Should Stop and a National Cold Storage Program Be Established Immediately

A thorough discussion of the storage and handling of large quantities of cellulose nitrate motion picture film is beyond the scope of this book. It is this author's strong belief, however, that the current practice of piecemeal duplication of nitrate motion pictures by assorted government and private collecting institutions has been a slow and wasteful process.[18] Furthermore, image-quality losses are unavoidable in the duplication process and it is always best to go back to the original (or as close to the original as possible) when making copies. With the availability of improved, electronic defect-suppression and image-enhancement techniques, access to original materials for making film copies, videotapes, and videodiscs will become even more crucial in the future.

Instead of duplication, a far more effective and less expensive method of preserving large quantities of nitrate film is to store it in a well-designed, humidity-controlled cold storage facility with a temperature of 0°F (–18°C) or lower and a relative humidity of about 30%. Working copies or videotapes of the films can be made as needed — and as funding becomes available. Film vaults can be constructed in a manner that minimizes the possibility of a fire starting in a storage area and, in the very unlikely event that a fire should occur, that prevents it from harming more than a small quantity of film.

It is particularly important that the many valuable color motion pictures printed by Technicolor and other firms on cellulose nitrate base be preserved in their original form; color positive films cannot be duplicated without significant losses in image quality. All of the Technicolor prints made from 1932 until about 1951 were made on cellulose nitrate film; these include such classics as *Gone With the Wind*, *Phantom of the Opera*, and *Joan of Arc*, as well as the early Walt Disney animated films such as *Snow White and the Seven Dwarfs*, *Pinocchio*, *Bambi*, *Dumbo*, and *Cinderella*.

A large, centralized, low-temperature film preservation facility with duplication and video transfer capabilities would be a far more efficient use of the millions of dollars that will otherwise be consumed on nitrate duplication during the coming decades. It would require a huge expenditure — money which simply is not available — to immediately duplicate all of the hundreds of millions of feet of nitrate motion pictures still remaining in film archives and private collections around the world. According to Susan Dalton, director of preservation and archival projects for the National Center for Film and Video Preservation at the American Film Institute, as of mid-1989 the film archives held approximately 150 million feet of uncopied nitrate motion picture film awaiting duplication, and the laboratory costs to duplicate the film will amount to at least $300 million.[19]

Furthermore, as research on film base stability by Adelstein and his co-workers has shown, cold storage is also required to preserve the many millions of feet of cellulose-triacetate-base duplicates that have already been made. Even duplicates made with polyester-base film should be kept in cold storage to insure permanent preservation of the gelatin emulsion and delicate silver images.

September 1982

The Time Inc. Magazines Picture Collection stores its extremely valuable collection of between 3 and 4 million cellulose nitrate negatives at 50°F (10°C) and about 50% RH.  Pulling negatives from the files for printing are Joseph Schilling (left) and George Gonzalez (right) of the Picture Collection staff.  Time Inc. Magazines is part of Time Warner Inc.

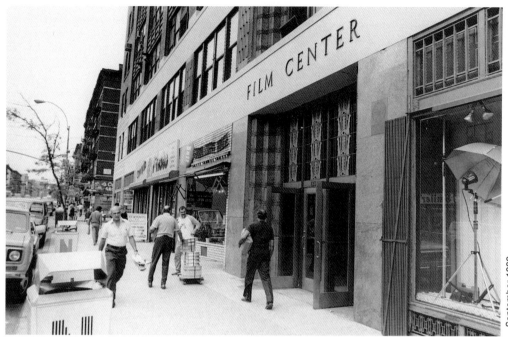

The specially constructed nitrate film storage vault for the Time Inc. Magazines Picture Collection is located in rented space in The Film Center, a commercial motion picture storage facility in New York City. The downtown building is equipped with blow-out panels, fireproof doors and walls, and other fire-safety features.

September 1982

Unless cold storage is provided for existing duplicates and for the vast amount of nitrate film that has not yet been duplicated, ever increasing numbers of motion picture films will deteriorate to the point where they can no longer be used and satisfactory copies can no longer be made. Only a relatively modest amount of money would be required to build a low-temperature storage facility that would prevent this ongoing and tragic loss.

## Institutions Preserving Nitrate Still-Camera Negatives in Cold Storage

When large numbers of negatives are involved, there are many benefits to preserving the originals in cold storage. An important advantage is that constructing and operating a cold storage facility can be far less expensive than duplicating a large quantity of negatives.

Every attempt should be made to preserve original nitrate negatives with important artifact value. An example is the collection of 5,000 nitrate negatives documenting early Peary-MacMillan expeditions in the Arctic and to the North Pole: the negatives, which actually traveled with Peary to the North Pole and on other expeditions, are currently housed at the Peary-MacMillan Arctic Museum at Bowdoin College in Brunswick, Maine.

There are now a number of institutions in the United States that store nitrate still-camera negatives at low temperatures. The most sophisticated nitrate storage facility is at The Historic New Orleans Collection in New Orleans, Louisiana. The two-room, humidity-controlled cold storage facility, which began operation in 1987, has a special area maintained at 0°F (–18°C) and 30% RH for storage of the approximately 12,000 nitrate negatives and color materials in its collections. In spite of the fact that the vault is humidity-controlled, the nitrate negatives were sealed in vapor-proof laminated aluminum-foil bags before being placed in the vault. This was done to protect other materials in

Model No. 3552

1988

Recommended for safe storage of cellulose nitrate film is the Lab-Line Explosion-Proof Freezer Model 3552, available from Lab-Line Instruments, Inc.

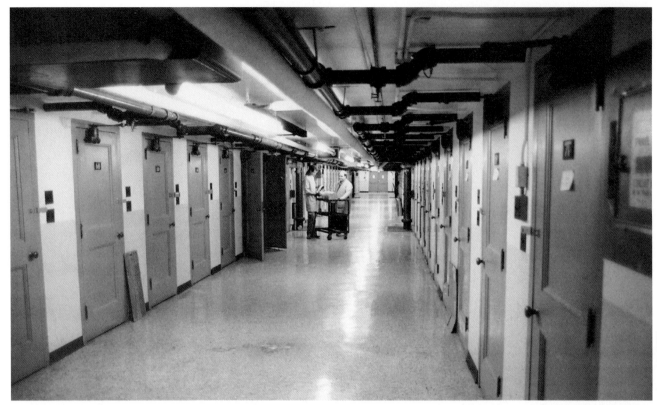

June 16, 1989

The Library of Congress Film Conservation Center at Wright-Patterson Air Force Base near Dayton, Ohio is the repository of over 120,000 reels of valuable original cellulose nitrate black-and-white motion picture camera negatives, duplicate negatives, release prints, Technicolor camera separation negatives, and full-color Technicolor imbibition prints. To reduce fire hazard, the films are segregated in 96 separate fire-proof vaults, all of which are maintained at 50°F (10°C) and 30% RH.

the vault from damage that conceivably could be caused by fumes released from the nitrate films over time, to simplify access and prevent condensation on the negatives during warm-up, and to protect the negatives from damage should a water leak or other accident occur.

John Lawrence, curator of the collection, says that despite the heat and humidity of the New Orleans area, many of the nitrate negatives are still in very good condition, although some are not. Duplicate "working" negatives have been made of the more frequently printed nitrate negatives so that the originals will not have to be repeatedly withdrawn from the storage vault. According to Lawrence, cellulose nitrate negatives in good condition are always retained after duplication. The collection contains many nitrate negatives made by the late Clarence John Laughlin, a well-known photographer who lived and worked in the New Orleans area. Lawrence says, "We are preserving the nitrate originals as artifacts."[20]

A sizable collection of Edward Weston's nitrate sheet-film negatives (together with nitrate negatives taken by W. Eugene Smith and a number of other photographers) is stored in 0°F (–18°C) freezers at the Center for Creative Photography, which is associated with the University of Arizona in Tucson, Arizona. The negatives are sealed in vapor-proof envelopes for protection against moisture in the non-humidity-controlled freezers. Although the Center has duplicated the nitrate negatives in its collection, it intends to preserve the nitrate negatives themselves "for

as long as we possibly can" because they are the actual negatives made by the photographer, according to curator Terence Pitts. The Center houses the archives of Edward Weston, Ansel Adams, W. Eugene Smith, Harry Callahan, Louise Dahl-Wolfe, Aaron Siskind, and a number of other well-known photographers.

About 8,000 nitrate negatives taken by Joseph Dixon of American Indians during the period 1908–1921 are preserved in a 0°F (–18°C) freezer at the W. H. Mathers Museum at Indiana University in Bloomington, Indiana..

Other institutions with 0°F (–18°C) freezer storage for cellulose nitrate films include the University Museum at the University of Pennsylvania[21] and the Humanities Research Center at the University of Texas at Austin.[22]

The Time Inc. Magazines Picture Collection keeps its priceless collection of between 3 and 4 million cellulose nitrate negatives in a New York City commercial film-storage facility at 50°F (10°C) and about 50% RH; the negatives are inspected periodically and any found to be obviously deteriorating are removed and duplicated. The San Diego Historical Society in San Diego, California stores its collection of nitrate still negatives at 55°F (13°C) and 40% RH.

## George Eastman House Drops Plans to Build a Cold Storage Vault in Its New Archives Building

When architects for the International Museum of Photography at George Eastman House in Rochester, New

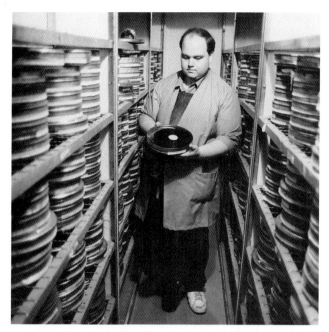

Evan Nesbitt, a vault collection attendant, returns reels of nitrate film that had been withdrawn for duplication on modern safety base film. In addition to its own films, the Library of Congress facility also stores nitrate film for Eastman House and the American Film Institute. The original Technicolor camera separations negatives from **Gone With the Wind** were stored here for some years before they were returned to Eastman House in 1990.

Jim Harwood, a vault collection attendant, holds a roll of the original nitrate Technicolor camera separation negatives from a color sequence in the 1939 MGM movie **The Wizard of Oz**, which starred Judy Garland.

June 16, 1989

Film vault manager Sam Tyler regularly checks the fire alarm control panel. Sensors in each of the 96 vaults will trigger an alarm if there is a mechanical failure in the cooling equipment or if smoke or fire is detected. Smoking is absolutely forbidden in the vault area.

York drew up plans for the museum's new $7.4 million archives building, which was completed in 1988, the design included a humidity-controlled cold storage vault (35°F [1.7°C] and 25% RH) for the museum's priceless collection of contemporary and historical color photographs. The vault was also to be used to preserve the thousands of original cellulose nitrate still-camera negatives in the Eastman House collection. Among these negatives are photographs made by Alvin Langdon Coburn (1882–1936), Nickolas Muray (1892–1965), Lewis Hine (1874–1940), and other historically important photographers. The collection also has a sizable number of original nitrate negatives produced by George Eastman (1854–1932), the founder of Eastman Kodak.

In spite of the fact that the stated purpose of the new archives building was ". . .to better preserve the vast collections of historical photographs, films, technology and library owned by the Museum," the vault was not constructed, apparently in an effort to cut costs.

In 1988, concerned about the inadequate storage conditions provided in the new building, Michael Hager, the negative archivist at the museum, asked the museum to purchase an explosion-proof freezer to preserve the George Eastman negatives. The freezer was not acquired, and Hager is no longer on the Eastman House staff. At the time this book went to press in October 1992, the George Eastman negatives and the other nitrate still negatives in the museum's collections continued to be stored at room temperature, without special protection. It is hoped that Eastman House will soon find a way to provide proper, refrigerated storage for its nitrate negative collection.

## Special Explosion-Proof Freezers for Safe Storage of Cellulose Nitrate Films

There are a number of suppliers of explosion-proof refrigerators and freezers that are safe for storing nitrate films. Freezer units are recommended because their very low operating temperatures will preserve nitrate films far longer than will refrigerators.

A recommended freezer is the Lab-Line Explosion-Proof Freezer Model 3552, available from Lab-Line Instruments, Inc. of Melrose Park, Illinois.[23] The upright unit, which cost $2,775 at the time this book went to press in 1992, is

available in 110-volt (60 Hz) and 220-volt (50 Hz) models and has 21 cubic feet of storage space with 18.8 square feet of shelf space provided on four shelves; it is equipped with a key-locked door.

The freezer has no internal electrical components that could trigger a fire, and for maximum safety, all external components are sealed so that it is safe to operate in an environment where explosive vapors (e.g., natural gas fumes) may be present; it meets National Fire Protection Association Standards as specified in Articles 500–501. The freezer temperature can be set between 23° and –10°F (–5° and –23°C); for storing of nitrate film, it is suggested that the thermostat be set at the lowest possible temperature.

In the event of power outage or equipment failure, the internal temperature of the freezer will gradually rise to that of ambient conditions; in an air-conditioned building, this should present no hazard. However, if the indoor temperature should rise above 95°F (35°C), and the freezer is not functioning, all nitrate film should be removed from the freezer and taken from the building to a safe location.

### Packaging Films for Freezer Storage

Because these freezers operate with a high internal relative humidity, films must be sealed in vapor-proof packages. Vapor-proof storage envelopes made of a paper/aluminum-foil/polyethylene laminate are available in 4¾x 6½-inch and 12x15-inch sizes from Light Impressions Corporation,[24] and in 10x12-inch and custom-made larger sizes from Conservation Resources International, Inc.,[25] Quality Packaging Supply Corporation,[26] and Shield Pack, Inc.[27] To minimize the danger of gradual moisture penetration through pinholes or other punctures in a vapor-proof envelope, films should always be *double-sealed*: that is, they should be placed in an envelope and sealed, and the resulting package inserted into a second envelope and sealed. Films should be interleaved with a high-quality, alkaline-buffered paper such as Howard Paper Company Permalife.

Where possible, films should be pre-conditioned to a low relative humidity prior to sealing them in the envelopes; in cold months in temperate areas, when indoor relative humidities are generally low, conditioning can be easily accomplished by spreading the films out on a table for a day or two (open rolls of motion picture film should be pre-conditioned for about 2 weeks). With still negatives, a relative humidity of 30–40% is recommended. If a low-humidity environment is not available, a closed room with a home dehumidifier and small air conditioner should be able to provide a 45 or 50% RH atmosphere. While preferable, it is by no means essential that nitrate films be pre-conditioned before sealing them in vapor-proof envelopes; if a low humidity environment is simply not available, then the films should be sealed and placed in the freezer in whatever condition they are in.

If paper interleaves are placed between sheets of film and excess air is squeezed from the packages (or drawn out with a hose connected to a vacuum pump) prior to heat-sealing, there is no danger of moisture condensation inside the packages when they are placed in the freezer. (Even if paper interleaves are not used and excess air is not withdrawn from the package prior to sealing, moisture condensation could not occur unless there was only a small piece of film in the package and a large amount of air was sealed inside with the film.)

Upon removal from the freezer, packages must be permitted to warm up to room temperature before they are opened in order to avoid moisture condensation on the cold films.

It has been stated frequently that nitrate films should never be stored in a sealed container because accumulations of gases resulting from decomposition of the film can further accelerate the deterioration. However, storage at 0°F (–18°C) or below virtually halts the decomposition process, and this author believes that sealing films stored at such a low temperature will have little detrimental effect on their life. Certainly, nitrate films will last *far* longer when they are sealed and stored at 0°F (–18°C) than they will when kept unsealed at normal room temperatures.

## Notes and References for Appendix 19.1

1. David G. Horvath, **The Acetate Negative Survey: Final Report**, University of Louisville, Louisville, Kentucky, 1987. The project was funded by the University of Louisville and the National Museum Act. Copies of the 91-page report may be purchased for $8 (which includes first class postage) from: University of Louisville, Photographic Archives, Ekstrom Library, Louisville, Kentucky 40292; telephone: 502-588-6752.
2. J. F. Carroll and John M. Calhoun, "Effect of Nitrogen Oxide Gases on Processed Acetate Film," **Journal of the SMPTE**, Vol. 64, September 1965, pp. 501–507.
3. Eastman Kodak Company, **Conservation of Photographs**, (George T. Eaton, editor), Kodak Publication No. F-40, Eastman Kodak Company, Rochester, New York, March 1985, pp. 89–93.
4. G. L. Hutchison, L. Ellis, and S. A. Ashmore, "The Surveillance of Cinematograph Record Film During Storage," **Journal of Applied Chemistry**, Vol. 8, January 1958, pp. 24–34.
5. Eastman Kodak Company, see Note No. 3, p. 92.
6. "Originals of 329 Movies Burned," **Rochester (New York) Times-Union**, May 30, 1978, pp. 1ff.
7. See, for example: J. M. Calhoun, "Storage of Nitrate Amateur Still-Camera Film Negatives," **Journal of the Biological Photographic Association**, Vol. 21, No. 3, August 1953, pp. 1–13; J. I. Crabtree and C. E. Ives, "The Storage of Valuable Motion Picture Film," **Journal of the Society of Motion Picture Engineers**, Vol. 15, September 1930, pp. 289–305; U.S. General Accounting Office, **Valuable Government-Owned Motion Picture Films Are Rapidly Deteriorating**, Report to the Congress by the Comptroller General of the United States, U.S. General Accounting Office, Washington, D.C., June 19, 1978; National Fire Protection Association, **Standard for the Storage and Handling of Cellulose Nitrate Motion Picture Film**, NFPA 40-1982,See also: John G. Bradley, "Film Vaults: Construction and Use," **Journal of the SMPE**, Vol. 53, August 1949, pp. 193–206; and J. R. Hill and C. G. Weber, "Stability of Motion Picture Film," **Journal of the SMPE**, December 1936, pp. 678–689.
8. M. C. Hudson and Robert MacClaren, **Nitrate Film Testing for the National Archives: December 1978 Fire Investigation**, Indian Head Technical Report 567, Naval Ordnance Station, Indian Head, Maryland, August 31, 1979. See also: J. W. Cummings, A. C. Hutton, and H. Silfin, "Spontaneous Ignition of Decomposing Cellulose Nitrate Film," **SMPTE Journal**, Vol. 54, March 1950, pp. 268–274.
9. Eastman Kodak Company, **Storage and Preservation of Motion Picture Film**, Eastman Kodak Company, Rochester, New York, March 1957. (This is an excellent general reference for both nitrate motion picture films and still-camera negatives; although out of print, it may be available in libraries, or contact Eastman Kodak Company in Rochester, New York.)
10. J. M. Calhoun, "Storage of Nitrate Amateur Still-Camera Film Negatives," **Journal of the Biological Photographic Association**, Vol. 21, No. 3, August 1953, p. 5. See also: J. M. Calhoun, "Cold Storage of Photographic Film," **PSA Journal**, Section B: **Photographic Science and Technique**, Vol. 18B, No. 3, October 1952, pp. 86–89.
11. For a thorough review of various films and procedures for duplicating negatives, see: Klaus B. Hendriks, Douglas R. Madeley, Fred Toll, and Brian Thurgood, "The Duplication of Historical Black-and-White Negatives," **Journal of Imaging Technology**, Vol. 12, No. 4, August 1986, pp. 185–199. See also: Larry Booth and Jane Booth,

"Duplication of Cellulose Nitrate Negatives," **Picturescope**, Vol. 30, No. 1, Spring 1982, pp. 12–18; Vernon Heger and Larry Booth, "Extending the Linear Exposure Scale of Kodak Professional Duplicating Film SO-015," **Journal of Applied Photographic Engineering**, Vol. 9, No. 1, February 1983, pp. 18–23; and Robert Alter, Douglas Munson, Alan Newman, and Peter Krause (William Crawford, ed.), **Guidelines for the Duplication of Historical Negatives** [tentative title], to be published under the auspices of the Northeast Document Conservation Center (NEDCC), Abbot Hall, School Street, Andover, Massachusetts 01810; telephone: 508-470-1010.

See also: Henry Wilhelm, "Problems with Long-Term Stability of Kodak Professional Direct Duplicating Film [Type 4168, Formerly SO-015]," **Picturescope**, Vol. 30, No. 1, Spring 1982, pp. 24–33. This author believes it essential that Kodak 4168 (SO-015) negatives be treated with an image-protective toner (e.g., Kodak Poly-Toner) as a standard part of processing. Untreated negatives have very poor image stability and are not suitable for long-term applications. In 1990 Kodak replaced 4168 film with a new product, Kodak Professional B/W Duplicating Film SO-339. According to Kodak SO-339 film has much better image stability than 4168 film: "Users will find that image stability [of SO-339 film] is suitable for most long-term applications with or without a supplemental toning step. Of course, the image can be toned in the same manner as 4168 film for the highest degree of image stability. Image stability is important for negatives that will be considered for archival applications."

Of particular importance with respect to the stability of black-and-white film and the protection of silver images with a polysulfide toner treatment is: James M. Reilly and Kaspars M. Cupriks, **Sulfiding Protection for Silver Images — Final Report to the Office of Preservation, National Endowment for the Humanities** (Grant # PS-20152-87), March 28, 1991, Image Permanence Institute, Rochester Institute of Technology, Frank E. Gannett Memorial Building, P.O. Box 9887, Rochester, New York 14623-0887; telephone: 716-475-5199; Fax: 716-475-7230. The polysulfide toner treatment for microfilm devised by Reilly and his co-workers is called the "IPI SilverLock Image Protection System." Contact the Image Permanence Institute for additional information.

See also: W. E. Lee, F. J. Drago, and A. T. Ram, "New Procedures for Processing and Storage of Kodak Spectroscopic Plates, Type IIIa-J," **Journal of Imaging Technology**, Vol. 10, No. 1, February 1984, pp. 22–28; F. J. Drago and W. E. Lee, "Stability and Restoration of Images on Kodak Professional B/W Duplicating Film 4168," **Journal of Imaging Technology**, Vol. 10, No. 3, June 1984, pp. 113–118; W. E. Lee, Beverly Wood, and F. J. Drago, "Toner Treatments for Photographic Images to Enhance Image Stability," **Journal of Imaging Technology**, Vol. 10, No. 3, June 1984, pp. 119–126; and F. J. Drago and W. E. Lee, "Review of the Effects of Processing on the Image Stability of Black-and-White Silver Materials," **Journal of Imaging Technology**, Vol. 12, No. 1, February 1986, pp. 57–65.

12. Vilia Reed, "Restoring Old Negative Films," **Photographic Retouching,** Kodak Publication No. E-97, Eastman Kodak Company, Rochester, New York 14650, August 1987, pp. 88–95. See also: Vilia L. Reed, "How to Work Restoration Magic on Wrinkled Negatives," **Professional Photographer**, Vol. 107, No. 2018, July 1980, pp. 87–89. For other approaches to salvaging images from deteriorating nitrate and acetate negatives see: James L. Gear, Robert H. MacClaren, and Mary McKiel, "Film Recovery of Some Deteriorated Black and White Negatives," **The American Archivist**, Vol. 40, No. 3, July 1977, pp. 363–368; Eugene Ostroff, "Rescuing Nitrate Negatives," **Museum News,** Vol. 57, No. 1, September–October 1978, pp. 34–36, 42.

13. J. M. Calhoun, see Note No. 10, p. 4.

14. P. Z. Adelstein, J. M. Reilly, D. W. Nishimura, and C. J. Erbland, "Stability of Cellulose Ester Base Photographic Film: Part I – Laboratory Testing Procedures," **SMPTE Journal**, Vol. 101, No. 5, May 1992, pp. 336–346; and P. Z. Adelstein, J. M. Reilly, D. W. Nishimura, and C. J. Erbland, "Stability of Cellulose Ester Base Photographic Film: Part II – Practical Storage Considerations," **SMPTE Journal**, Vol. 101, No. 5, May 1992, pp. 347–353. See also: James M. Reilly, Peter Z. Adelstein, and Douglas W. Nishimura, **Preservation of Safety Film — Final Report to the Office of Preservation, National Endowment for the Humanities** (Grant # PS-20159-88), March 28, 1991, Image Permanence Institute, Rochester Institute of Technology, Frank E. Gannett Memorial Building, P.O. Box 9887, Rochester, New York 14623-0887; telephone: 716-475-5199; Fax: 716-475-7230. See also: M. Edge, N. S. Allen, M. Hayes, P. N. K. Riley, C. V. Horie, and J. Luc-Gardette, "Mechanisms of Deterioration in Cellulose Nitrate Base Archival Cinematograph Film," **European Polymer Journal**, Vol. 26, pp. 623–630, 1990. See also: Karel A. H. Brems, "The Archival Quality of Film Bases," **SMPTE Journal,** Vol. 97, No. 12, December 1988, pp. 991–993.

15. P. Z. Adelstein, et al., see Note No. 14, p. 353.

16. J. M. Calhoun, see Note No. 10, p. 4.

17. Peter Z. Adelstein, telephone discussion with this author, June 24, 1991.

18. Henry Wilhelm, "Color Photographs and Color Motion Pictures in the Library: For Preservation or Destruction?", chapter in **Conserving and Preserving Materials in Nonbook Formats**, (Kathryn Luther Henderson and William T. Henderson, editors), pp. 105–111, 1991. The book contains the papers presented at the **Allerton Park Institute** (No. 30), sponsored by the University of Illinois Graduate School of Library and Information Science, held November 6–9, 1988 at the Chancellor Hotel and Convention Center, Champaign, Illinois. Published by the University of Illinois Graduate School of Library and Information Science, Urbana-Champaign, Illinois.

19. Frank Thompson, "Fade Out – What's Being Done to Save Our Motion-Picture Heritage?", **American Film**, Vol. XVI, No. 8, August 1991, pp. 34–38, 46; see also in the same issue: Wolf Schneider, "Film Preservation – Whose Responsibility Should it Be?", p. 2.

20. John Lawrence, curator, the Historic New Orleans Collection, telephone discussions with this author, February 12, 1985, September 4, 1986, and January 23, 1987.

21. Ric Haynes, "Emergency Storage for Nitrate Film," **History News**, Vol. 36, No. 1, January 1981, pp. 38–41. See also: Ric Haynes, "A Cold Storage Emergency Procedure for Still Camera Negatives Made With Cellulose Nitrate," **MASCA Journal,** Vol. 1, No. 5, pp. 146–148, December 1980. Published by the Museum Applied Science Center for Archaeology, University Museum, University of Pennsylvania, Philadelphia, Pennsylvania.

22. Siegfried Rempel, "A Conservation Priority for HRC's Photography Collection," **Perspectives on Photography** (Dave Oliphant and Thomas Zigal, editors), Humanities Research Center, University of Texas at Austin, Austin, Texas, 1982, pp. 167–178.

23. Lab-Line Instruments, Inc., 15th and Bloomingdale Avenues, Melrose Park, Illinois 60160-1491; telephone: 708-450-2600; Fax: 708-450-0943. At somewhat lower cost, a Flammable Materials Storage (FMS) version of the freezer (Model 3552-10) is also available from Lab-Line; this unit, which cost $2,360 in 1992, has no interior electrical components but is not certified as safe for operation in explosive environments. For maximum safety, this author recommends the Explosion-Proof units.

24. Heat-sealable, vapor-proof envelopes called Light Impressions Heat Seal Envelopes are available from Light Impressions Corporation, 439 Monroe Avenue, Rochester, New York 14607-3717; telephone: 716-271-8960 (toll-free outside New York: 800-828-6216; toll-free inside New York: 800-828-9629). Two standard sizes are supplied: Code No. 3920 (4¾x6½ inches; $6.30 for a package of 25) and Code No. 3921 (12x15 inches; $13.25 for a package of 25). These envelopes are true vapor-proof, heat-sealable, aluminum-foil/polyethylene laminated containers that can provide added security in a frost-free refrigerator, or be used in a double-layer package in a non-humidity-controlled refrigerator or freezer.

25. Vapor-proof envelopes called Containers for Freezing Photographic Material, supplied in the 10x12-inch size (minimum order of 500 envelopes), and custom-made in almost any size, can be obtained from Conservation Resources International, Inc., 8000-H Forbes Place, Springfield, Virginia 22151; telephone: 703-321-7730 (toll-free telephone: 800-634-6932). Conservation Resources has sales offices in Ottawa, Ontario; Oxon, England; and Brisbane, Australia.

Kodak has given two sources for laminated paper/aluminum-foil/polyethylene material suitable for making vapor-proof photographic storage envelopes: Crown Zellerbach, Flexible Packaging Division, Park 80 Plaza – West I, Saddlebrook, New Jersey 07662; and Northern Packaging Corp., 777 Driving Park Avenue, Rochester, New York 14613. This material can be used to make custom-size storage envelopes.

26. Custom-made heat-sealable, vapor-proof envelopes for films and prints in any size or configuration are available under the XT-08 name (large-quantity orders only) from Quality Packaging Supply Corporation, 24 Seneca Avenue, Rochester, New York 14621; telephone: 716-544-2500 (California office: 3028 East 11th Street, Los Angeles, California 90023; telephone: 213-264-1102). The puncture-resistant XT-08 envelopes are made of a laminate consisting of Tyvek on the outside, a heavy aluminum-foil vapor barrier, and a heat-sealable polyethylene layer on the inside. Quality Packaging has supplied XT-08 envelopes to Lorimar Telepictures Corporation and MGM for packaging of motion picture films and videotapes. The packages are used for protection during routine shipping as well as for room-temperature and refrigerated storage.

27. Custom-made heat-sealable, vapor-proof envelopes for films and prints in any size or configuration are also available (large-quantity orders only) from Shield Pack, Inc., 2301 Downing Pines Road, West Monroe, Louisiana 71291; telephone: 318-387-4743 (800-551-5185).

# 20. Large-Scale, Humidity-Controlled Cold Storage Facilities for the Permanent Preservation of B&W and Color Films, Prints, and Motion Pictures

I kept seeing good color photographs, and I thought, "Well, we need to collect those, too." Attending the conference in Toronto [in 1978 at the Baldwin Street Gallery] was a fundamentally important step in realizing that the solution to keeping color was not difficult — you just freeze it. . . .

Now that we have the cold vault, we certainly do not have to look at a color photograph and say, "That is a great picture, but it will fade in 8 to 10 years and we will either have to show it constantly, or we will have to parade people in and out of the print study room just to get the use out of it [before it fades]." Now we can just say, "That's a great picture and it should be in the collection . . . and it will automatically be preserved. We can buy the most fragile color photographs, and they will be saved."

With the vault, we have a great advantage in collecting — several photographers have said they would make it very easy for us to acquire their work, because at least there would be one place where they know their work would survive. Some have even said they would give us prints at cost. If there were 20 museums with cold vaults, there would be no reason that *we* would have this offered to us. But I don't want to make photographers give us work for less than they want to sell it for. I want them to feel that their photographs are going to a place that actually cares that their work lives for future generations.[1]

David Travis
Curator of Photography
Art Institute of Chicago

Since the middle 1970's, when the poor stability characteristics of most color photographic materials became widely known and discussed in the museum and archive field, there has been a gradual recognition of the fact that the only practical way to preserve color films and prints for long periods is to keep them in the dark in cold storage. Because of newspaper stories, magazine articles, and television programs dealing with color fading, the general public was alerted to the tragic consequences of the eventual loss of the bulk of color motion pictures, television footage, color prints, negatives, and slides of all types. This public concern has encouraged museum administrators to make

funds available for construction of cold storage facilities. The preservation of color collections is increasingly viewed as a basic institutional responsibility by museum directors.

The fact that most color materials *require* cold storage for long-term survival is an unfortunate outcome of the adoption of the chromogenic system of color photography which began with Kodachrome film in 1935 and was followed by Kodacolor, Ektachrome, and Agfacolor in the late 1930's and early 1940's. Chromogenic materials came into almost universal use in the motion picture industry following the introduction of Eastman color negative and color print films in 1950.

Although Kodak, Fuji, Agfa-Gevaert, and Konica have improved the dark fading stability of many of their color materials during the last few years, most materials are still not stable enough to survive long-term storage at room temperature without objectionable fading and/or staining. Improving color stability was a low priority with manufacturers during most of the 1935–1982 period, and museum and archive personnel generally knew little about the stability problem. With their attention focused on black-and-white photography, many curators did not even consider

*(continued on page 691)*

A warning notice posted near the door to the 0°F (–18°C) cold storage vault at the John Fitzgerald Kennedy Library.

See page 697 for Recommendations

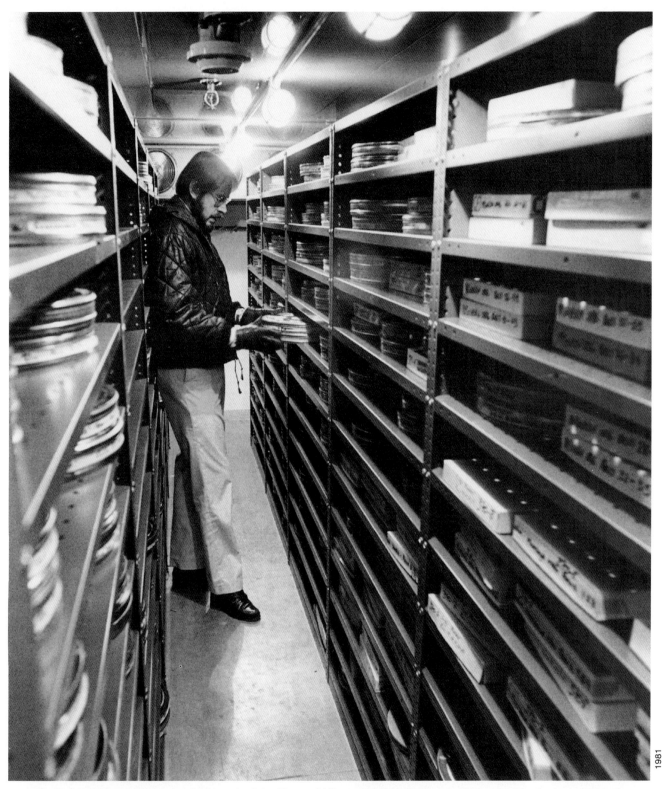

1981

Allan B. Goodrich, audiovisual archivist at the John Fitzgerald Kennedy Library in Boston, Massachusetts, is shown inside the 0°F (–18°C), 30% RH cold storage vault, which preserves the large collection of color negatives, prints, transparencies, and motion pictures at the Library. According to data published by Eastman Kodak, storage at 0°F will, for a given amount of fading to occur, preserve color materials approximately 340 times longer than storage at 70°F (21°C) (e.g., the amount of fading that would occur in 10 years at room temperature is predicted not to take place until about 3,400 years have passed in a 0°F vault). The controlled-humidity environment in the vault eliminates the need for pre-conditioning and sealing films and prints in expensive vapor-proof containers before placing them in the vault.

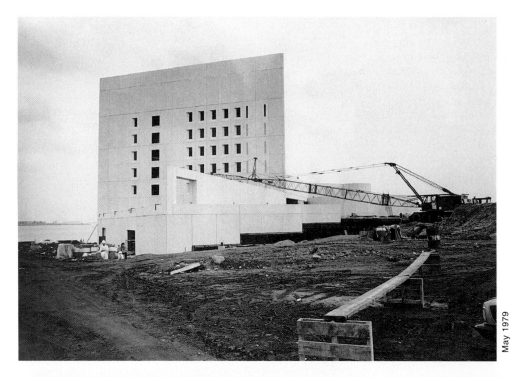

The John Fitzgerald Kennedy Library, one of the presidential libraries, was built with private contributions and is now owned and operated by the National Archives and Records Administration. When this photograph was taken in 1979, exterior construction of the $12 million structure was nearly complete after 2 years of construction. The Library is located at Columbia Point, at the end of a peninsula in Boston Harbor.

May 1979

May 1979

The prefabricated cold storage vault at the Kennedy Library is seen here during assembly. The vault was the world's first 0°F (–18°C) humidity-controlled (30% RH) storage facility for color photographic materials. When this book went to press in 1992, only five other such low-temperature vaults were in operation: three at NASA facilities in Houston, Texas and White Sands, New Mexico; one at The Historic New Orleans Collection; and one at the Jimmy Carter Library in Atlanta, Georgia.

Allan B. Goodrich is seen here with the Kennedy White House negative file, which in this 1979 photograph was being stored in an air-conditioned government warehouse in Waltham, Massachusetts. Significant image fading occurred in the color negatives in the collection during the 20-year period from 1963 (when President Kennedy was assassinated) until the negatives were put in the cold vault after completion of the Kennedy Library.

John Kennedy was the first U.S. President to be photographed primarily in color; the White House negative file, which consists mostly of photographs taken by White House staff photographers, is the most important collection of photographs in the Library. The file contains about 35,000 photographs, of which more than 18,000 are color negatives (mostly Ektacolor Professional and Kodacolor–X films in the 120 format).

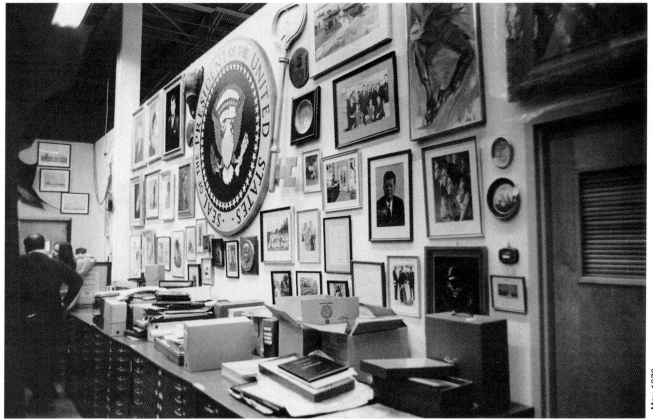

May 1979

In storage at the warehouse, some framed portraits of Kennedy and his family were displayed on this wall together with other artifacts. The Kennedy Library, in common with most other historical collections, emphasizes the preservation of its negatives, motion pictures, and other original materials. Prints made from the negatives are to a certain extent considered to be expendable. This approach differs from fine art collections, which stress preservation of original prints, usually made by the photographer himself or herself. In most cases, fine art museums do not possess or otherwise have access to a photographer's negatives.

Entering the cold storage vault, Goodrich carries a small roll of motion picture film and several boxes of color slides. The very cold, fan-circulated air in the vault requires that a jacket be worn, and visits are usually short.

1982

Linked to temperature and relative humidity controls, an automatic alarm system alerts security personnel if conditions inside the vault exceed preset limits.

color photography to be a serious medium. As was the case during the cellulose nitrate black-and-white era before color, the entertainment motion picture industry, with only a few exceptions, has continued to show little concern about the preservation of its movies. Museums are now trying to come to grips with the preservation of huge amounts of color film from the past five decades, a significant portion of which is already in a seriously faded condition. This is the unfortunate legacy of years of neglecting the importance of good color stability and proper storage conditions on the part of nearly everyone involved.

Museums and archives are faced with a simple choice: either they follow the examples of the John Fitzgerald Kennedy Library, the National Aeronautics and Space Administration (NASA), the Historic New Orleans Collection, the Peabody Museum of Archaeology and Ethnology at Harvard University, the Art Institute of Chicago, and a few other farsighted institutions, which have constructed large-scale, humidity-controlled cold storage facilities to halt further deterioration of their collections, or they can continue to store color materials at normal room temperatures as they have always done.

If cold storage is not provided, one can properly question the effort and expense of acquiring and administering color collections in the first place — since this is being done with the certain knowledge that most of the color films and still photographs in such collections will have severely deteriorated by the time they are seen by future generations. This do-nothing approach is particularly shortsighted because the cost of constructing and operating a cold storage facility is usually very small in relation to the cost of the collections placed in it.

In the past, some institutions — notably the American Film Institute and the Library of Congress — believed that some future technology, such as electronic digital storage or laser holographic separation techniques, would allow copies of color motion pictures to be stored permanently at room temperature with little or no quality loss and at a lower cost than cold storage. Such thinking has now been almost completely abandoned by knowledgeable people in the preservation field. As Lawrence Karr, former director of preservation for the American Film Institute and an early proponent of the "new technology" approach, observed in 1980: "This represents a fundamental shift in the attitude of the American archivists, in particular, since as late as 1971 they felt that future technology would provide the solution to the problem. Since this solution has failed to materialize in the past nine years, the consensus now is

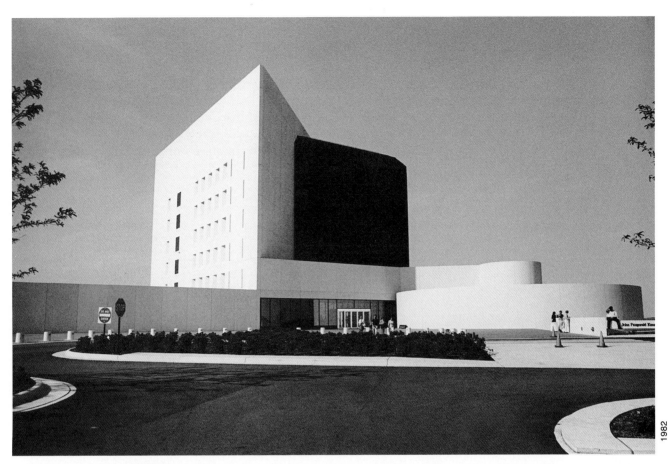

1982

The completed $12 million John Fitzgerald Kennedy Library is a modernistic glass and concrete structure. The Library, which has numerous exhibits highlighting Kennedy's life and a theater where a movie about Kennedy is shown, is visited by tens of thousands of people every year — far more than any of the other presidential libraries. The Library houses the papers and official files of Kennedy from his early years through his presidency. The collection includes nearly 150,000 still photographs and about 6,000 reels of motion picture film; in addition the Library has large numbers of videotapes, audiotapes, books, and a series of more than 1,000 oral history interviews.

that cold storage must be employed as soon as possible."[2]

In April 1980, the American Film Institute and the Library of Congress jointly sponsored the Conference on the Cold Storage of Motion Picture Films. Held in Washington, D.C., the meeting was attended by film archivists from all over the world; they discussed their experiences and problems with cold storage of films and encouraged construction of cold storage facilities by institutions that did not already have them. (Quite surprisingly, only three years later, the American Film Institute seemed to have forgotten the recommendations of the 1980 conference and said: "There is no practical solution for preserving [modern] color film."[3] The Film Institute quickly returned to its long-held notion that while some future technology may solve the problem of color preservation, there was currently little that could be done to save color films.)

Low-temperature, humidity-controlled cold storage is also practical for the permanent preservation of cellulose nitrate film, cellulose diacetate film (an early type of safety film), and cellulose triacetate film, all of which have inadequate stability when kept at normal room temperature and humidity. With large quantities of material, it is much less expensive to preserve the original films than to make

duplicates; in addition, cold storage allows preservation of the original artifacts, and the subtle — or sometimes major — image-quality losses that *always* occur when making duplicates are avoided.

Estimates of the useful life of color photographs kept in cold storage greatly exceed the expected life for most black-and-white photographs stored at typical room temperature and humidity. By placing color photographic materials into a low-temperature vault, they will almost certainly last longer than most other objects in a museum collection. Ideally, all photographs in a museum — both color and black-and-white — should be kept in cold storage, or at least in an area with a controlled, moderate temperature and a relative humidity of 30–40%.

The Art Institute of Chicago has followed this approach and has a humidity-controlled room for black-and-white photographs with a temperature of 60°F (15.5°C) and 40% RH in addition to an adjacent vault for color materials, which currently is kept at 40°F (4.4°C), also at 40% RH. (The color vault was designed to maintain 0°F [–18°C], and although it currently is operated at a warmer temperature to afford more comfortable working conditions for the curatorial staff, the temperature will probably be reduced to

*(continued on page 698)*

## Table 20.1    Estimated Number of Years for "Just Noticeable" Fading to Occur in Various Kodak Color Materials Stored in the Dark at Room Temperature and Three Cold-Storage Temperatures (40% RH)

### Time Required for the Least Stable Image Dye to Fade 10% from an Original Density of 1.0

**Boldface Type** indicates products that were being marketed when this book went to press in 1992; the other products listed had either been discontinued or replaced with newer materials. These estimates are for dye fading only and do not take into account the gradual formation of yellowish stain. With print materials in particular (e.g., Ektacolor papers), the level of stain may become objectionable before the least stable image dye has faded 10%.

| Color Papers | Years of Storage at:* | | | |
|---|---|---|---|---|
| | 75°F (24°C) | 45°F (7.2°C) | 35°F (1.7°C) | 0°F (−18°C) |
| Ektacolor 37 RC Paper (Process EP-3) ("Kodacolor Print" when processed by Kodak) | 10 | 95 | 200 | 3,400 |
| Ektacolor 78 and 74 RC Papers (Process EP-2) ("Kodacolor Print" when processed by Kodak) | 8 | 75 | 160 | 2,700 |
| **Ektacolor Plus Paper** **Ektacolor Professional Paper** (Process EP-2) ("Kodacolor Print") ("Kodalux Print") | **37** | **350** | **750** | **12,500** |
| Ektacolor 2001 Paper **Ektacolor Edge Paper** **Ektacolor Royal II Paper** Ektacolor Portra Paper **Ektacolor Portra II Paper** **Ektacolor Supra Paper** **Ektacolor Ultra Paper** **Kodak Duraflex RA Print Material** (Process RA-4, water wash) ("Kodalux Print") | (not disclosed) [A] | | | |
| Ektacolor 2001 Paper **Ektacolor Edge Paper** **Ektacolor Royal II Paper** Ektacolor Portra Paper **Ektacolor Portra II Paper** **Ektacolor Supra Paper** **Ektacolor Ultra Paper** **Kodak Duraflex RA Print Material** (Process RA-4NP, Stabilizer rinse) ("Kodalux Print") | (not disclosed) [A] | | | |
| Ektachrome 2203 Paper (Process R-100) | 7 | 65 | 140 | 2,400 |
| Ektachrome 14 Paper (Process R-100) | 10 | 95 | 200 | 3,400 |
| **Ektachrome Radiance Paper** (Process R-3) (1991—) | (not disclosed) | | | |
| Ektachrome 22 Paper [improved] (Process R-3) (1991–92) | (not disclosed) | | | |
| **Ektachrome Copy Paper** (R-3) Ektachrome HC Copy Paper Ektachrome Overhead Material Ektachrome Prestige Paper Ektachrome 22 Paper (1984–90) | **8** | **75** | **160** | **2,700** |

| Color Negative Films | Years of Storage at:* | | | |
|---|---|---|---|---|
| | 75°F (24°C) | 45°F (7.2°C) | 35°F (1.7°C) | 0°F (−18°C) |
| Kodacolor II Film | 6 | 55 | 120 | 2,000 |
| **Kodacolor VR 100, 200, 400 Films** | **17** | **160** | **340** | **5,800** |
| Kodacolor VR-G 100 Film ("initial type") (Kodacolor Gold 100 Film in Europe) | 12 | 115 | 240 | 4,100 |
| Kodacolor Gold 200 Film (1989–91) (formerly Kodacolor VR-G 200 Film) Kodak Gold 200 Film (new name: 1991–92) | (not disclosed) [B] | | | |
| **Kodak Gold Plus 100 Film** **Kodak Gold II 100 Film** (name in Europe) (1992—) | (not disclosed) [C] | | | |
| **Kodak Gold Plus 200 Film** **Kodak Gold II 200 Film** (name in Europe) (1992—) | (not disclosed) [D] | | | |
| **Kodak Gold Plus 400 Film** **Kodak Gold II 400 Film** (name in Europe) (1992—) | (not disclosed) [E] | | | |
| Kodacolor Gold 1600 Film (1989–91) **Kodak Gold 1600 Film** (new name: 1991—) | (not disclosed) [F] | | | |
| **Ektar 25 Film** (1988—) | (not disclosed) [G] | | | |
| **Ektar 100 Film** (1991—) | (not disclosed) | | | |
| Ektar 125 Film (1989—) | (not disclosed) [H] | | | |
| **Ektar 1000 Film** (1988—) | (not disclosed) [I] | | | |
| **Ektapress Gold 100 Prof. Film** (1988—) | (not disclosed) [J] | | | |
| **Ektapress Gold 400 Prof. Film** (1988—) | (not disclosed) [K] | | | |
| **Ektapress Gold 1600 Prof. Film** (1988—) | (not disclosed) [L] | | | |
| Vericolor II Prof. Film Type S | 6 | 55 | 120 | 2,000 |
| **Vericolor II Prof. Film Type L** | **3** | **28** | **60** | **1,000** |
| Vericolor II Commercial Film Type S | 3 | 28 | 60 | 1,000 |
| **Vericolor III Prof. Film Type S** **Ektacolor Gold 160 Prof. Film** | **23** | **220** | **460** | **7,800** |
| **Vericolor 400 Prof. Film** (1988—) **Ektacolor Gold 400 Professional Film** | (not disclosed) [M] | | | |
| **Vericolor HC Professional Film** | (not disclosed) [N] | | | |
| **Vericolor Copy/ID Film** | (not disclosed) | | | |
| **Vericolor Internegative Film 6011** | **5** | **48** | **100** | **1,700** |

| Color Transparency Films | Years of Storage at:* | | | |
|---|---|---|---|---|
| | 75°F (24°C) | 45°F (7.2°C) | 35°F (1.7°C) | 0°F (–18°C) |
| Ektachrome Films (Process E-3) [O] | 5 | 48 | 100 | 1,700 |
| Ektachrome Films (Process E-4) [P] | 15 | 140 | 300 | 5,100 |
| **Kodak Photomicrography Color Film 2483** (Process E-4) | **3** | **28** | **60** | **1,000** |
| **Ektachrome Films** (Process E-6) ["Group I" types since 1979] | **52** | **500** | **1,100** | **18,000** |
| **Ektachrome Plus & "HC" Films** [Q] **Ektachrome 64X, 100X, & 400X Films Ektachrome 64T and 320T Films** ["Group II" types since 1988] (Process E-6) | **110** | **1,000** | **2,200** | **37,000** |
| **Kodachrome Films** (Process K-14) [all types] | **95** | **900** | **1,900** | **32,000** |

## Motion Picture Color Negative Films

| | 75°F | 45°F | 35°F | 0°F |
|---|---|---|---|---|
| Eastman Color Negative II Film 5247 (1974) | 6 | 57 | 120 | 2,000 |
| Eastman Color Negative II Film 5247 (1976) | 12 | 115 | 240 | 4,000 |
| Eastman Color Negative II Film 5247 (1980) | 28 | 270 | 550 | 9,500 |
| **Eastman Color Negative Film 5247** (1985 name change) | **28** | **270** | **550** | **9,500** |
| Eastman Color High Speed Negative Film 5293 | (not disclosed) [R] | | | |
| **Eastman Color High Speed Negative Film 5294** | (not disclosed) [R] | | | |
| **Eastman Color High Speed SA Negative Film 5295** | (not disclosed) [R] | | | |
| **Eastman Color High Speed Daylight Negative Film 5297** | (not disclosed) [R] | | | |
| Eastman Color Negative II Film 7247 (1974–83) | 6 | 57 | 120 | 2,000 |
| **Eastman Color Negative II Film 7291** | **50** | **475** | **1,000** | **17,000** |
| Eastman Color High Speed Negative Film 7294 | (not disclosed) [R] | | | |
| **Eastman Color High Speed Negative Film 7292** | (not disclosed) [R] | | | |
| **Eastman Color High Speed Daylight Negative Film 7297** | (not disclosed) [R] | | | |
| **Eastman EXR Color Negative Film 5245 and 7245** | **22** | **210** | **440** | **7,500** |
| **Eastman EXR Color Negative Film 5248 and 7248** | **30** | **285** | **600** | **10,000** |
| **Eastman EXR High Speed Color Negative Film 5296 & 7296** | **50** | **475** | **1,000** | **17,000** |

| Motion Picture Laboratory Intermediate Films | Years of Storage at:* | | | |
|---|---|---|---|---|
| | 75°F (24°C) | 45°F (7.2°C) | 35°F (1.7°C) | 0°F (–18°C) |
| **Eastman Color Reversal Intermediate Film 5249 & 7249** | **8** | **75** | **160** | **2,500** |
| Eastman Color Intermediate II Film 5243 and 7243 | 22 | 210 | 440 | 7,500 |
| **Eastman Color Intermediate Film 5243 and 7243 Improved** | (not disclosed) | | | |

## Motion Picture Print Films

| | 75°F | 45°F | 35°F | 0°F |
|---|---|---|---|---|
| Eastman Color Print Film 5381 & 7381 [S] | [5 | 48 | 100 | 1,700] |
| Eastman Color SP Print Film 5383 & 7383 | 5 | 48 | 100 | 1,700 |
| **Eastman Color Print Film 5384 & 7384** | **45** | **430** | **900** | **15,000** |
| **Eastman Color LC Print Print Film 5380 & 7380** | **45** | **430** | **900** | **15,000** |

## * Notes:

The estimates given here have been derived from data in **Evaluating Dye Stability of Kodak Color Products,** Kodak Publication No. CIS-50, January 1981, and subsequent CIS-50 series of dye-stability data sheets through 1985; **Kodak Ektacolor Plus and Professional Papers for the Professional Finisher,** Kodak Publication No. E-18, March 1986; **Dye Stability of Kodak and Eastman Motion Picture Films** (data sheets); Kodak Publications DS-100-1 through DS-100-9, May 29, 1981; **Image-Stability Data: Kodachrome Films,** Kodak Publication E-105 (1988); **Image-Stability Data: Ektachrome Films,** Kodak Publication E-106 (1988); and other published sources.

For many products, including Process E-6 Ektachrome films; Vericolor III, Vericolor 400, Kodacolor VR, Kodacolor Gold (formerly Kodacolor VR-G), Kodak Gold, and Kodak Gold Plus color negative films; and Eastman color motion picture films, storage at 60% RH will result in fading rates of the least stable dye (yellow) approximately twice as great as those given here for 40% RH; that is, the estimated storage time for reaching a 10% dye-density loss will be cut in half.

Furthermore, the dye stability data given here were based on Arrhenius tests conducted with free-hanging film samples exposed to circulating air. Research disclosed by Eastman Kodak in late 1992 showed that storing films in sealed or semi-sealed containers (e.g., vapor-proof bags and standard taped or untaped metal and plastic motion picture film cans) could substantially increase the rates of dye fading and film base deterioration. Therefore, the estimates given here for color motion picture films probably **considerably** overstate the actual stabilities of the films when they are stored in standard film cans under the listed temperature and humidity conditions. (See: A. Tulsi Ram, D. Kopperl, R. Sehlin, S. Masaryk-Morris, J. Vincent, and P. Miller [Eastman Kodak Company], "The Effects and Prevention of 'Vinegar Syndrome'," presented at the **1992 Annual Conference of the Association of Moving Image Archivists**, San Francisco, California, December 10, 1992.) See Chapter 9 for further discussion.

A) Kodak declined to release stability data for Ektacolor 2001 Paper introduced in 1986, or Ektacolor Edge Paper introduced in 1991 (processed with either the "washless" RA-4NP Stabilizer or with a water wash). However, according to a Kodak press release dated

January 21, 1986, and titled "New Kodak Color Paper/Chemicals Offer Exceptionally Fast Processing," the stability of Ektacolor 2001 Paper (Processes RA-4 and RA-4NP) is "comparable to Ektacolor Plus Paper." This author's accelerated dark fading tests with 1988-type Ektacolor 2001 Paper (processed in a Kodak Minilab with Process RA-4NP "washless" chemicals) also indicate that the stability of the paper is generally similar to that of Ektacolor Plus Paper (processed in EP-2 chemicals with a water wash). Ektacolor 2001 Paper was introduced in mid-1986 for use in Kodak minilabs; this was the first Process RA-4 ("rapid access") color negative paper. Ektacolor Portra Paper, a lower-contrast "professional" version of Ektacolor 2001 Paper, was introduced in 1989. Ektacolor Supra, Ektacolor Ultra, and Ektacolor Royal papers were introduced in 1989. Kodak Duraflex RA Print Material (a high-gloss, polyester-base print material) was also introduced in 1989. Ektacolor Royal II Paper was introduced in 1991 and Ektacolor Portra II Paper was introduced in 1992.

B) Kodak declined to release specific stability data for Kodacolor Gold 200 Film, introduced in 1986 under the Kodacolor VR-G 200 name. This author's tests indicate that the stability of this film is similar to that of Kodacolor VR-G 100 Film (i.e., 12 years storage at 75°F [24°C] and 40% RH for a 10% loss of the yellow dye to occur).

C) Kodak declined to release stability data for Kodak Gold Plus 100 Film (called Kodak Gold II 100 Film in Europe) that was introduced in 1992 as a replacement for Kodak Gold 100 Film.

D) Kodak declined to release stability data for Kodak Gold Plus 200 Film (called Kodak Gold II 200 Film in Europe) that was introduced in 1992 as a replacement for Kodak Gold 200 Film.

E) Kodak declined to release stability data for Kodak Gold Plus 400 Film (called Kodak Gold II 400 Film in Europe) that was introduced in 1992 as a replacement for Kodak Gold 400 Film.

F) Kodak declined to release specific stability data for Kodak Gold 1600 Film, introduced under the Kodacolor Gold 1600 name in 1989. Kodak has, however, provided data (Kodak Publication E-107, dated June 1990) which indicates that when this film is kept in the dark at 75°F and 40% RH, a storage life of between 19 and 33 years may be expected before a 10% loss of the least stable image dye (yellow in this case) occurs.

G) Kodak declined to release specific stability data for Kodak Ektar 25 Film, introduced in 1988. Kodak has, however, provided data (Kodak Publication E-107, dated June 1990) which indicates that when this film is kept in the dark at 75°F and 40% RH, a storage life of between 8 and 14 years may be expected before a 10% loss of the least stable image dye (yellow in this case) occurs.

H) Kodak declined to release specific stability data for Kodak Ektar 125 Film, introduced in 1989. Kodak has, however, provided data (Kodak Publication E-107, dated June 1990) which indicates that when this film is kept in the dark at 75°F and 40% RH, a storage life of between 8 and 14 years may be expected before a 10% loss of the least stable image dye (yellow in this case) occurs.

I) Kodak declined to release specific stability data for Kodak Ektar 1000 Film, introduced in 1988. Kodak has, however, provided data (Kodak Publication E-107, dated June 1990) which indicates that when this film is kept in the dark at 75°F and 40% RH, a storage life of between 19 and 33 years may be expected before a 10% loss of the least stable image dye (yellow in this case) occurs.

J) Kodak declined to release specific stability data for Kodak Ektapress Gold 100 Professional Film, which was introduced in 1988. Kodak has, however, provided data (Kodak Publication E-107, dated June 1990) which indicates that when this film is kept in the dark at 75°F

and 40% RH, a storage life of between 8 and 14 years may be expected before a 10% loss of the least stable image dye (yellow in this case) occurs.

K) Kodak declined to release specific stability data for Kodak Ektapress Gold 400 Professional Film, introduced in 1988. Kodak has, however, provided data (Kodak Publication E-107, dated June 1990) which indicates that when this film is kept in the dark at 75°F and 40% RH, a storage life of between 19 and 33 years may be expected before a 10% loss of the least stable image dye (yellow in this case) occurs.

L) Kodak declined to release specific stability data for Kodak Ektapress Gold 1600 Professional Film, introduced in 1988. Kodak has, however, provided data (Kodak Publication E-107, dated June 1990) which indicates that when this film is kept in the dark at 75°F and 40% RH, a storage life of between 19 and 33 years may be expected before a 10% loss of the least stable image dye (yellow in this case) occurs.

M) Kodak declined to release specific stability data for Kodak Vericolor 400 Professional Film, introduced in 1988. Kodak has, however, provided data (Kodak Publication E-107, dated June 1990) which indicates that when this film is kept in the dark at 75°F and 40% RH, a storage life of between 19 and 33 years may be expected before a 10% loss of the least stable image dye (yellow in this case) occurs.

N) Kodak declined to release specific stability data for Kodak Vericolor HC Professional Film. Kodak has, however, provided data (Kodak Publication E-107, dated June 1990) which indicates that when this film is kept in the dark at 75°F and 40% RH, a storage life of between 8 and 14 years may be expected before a 10% loss of the least stable image dye (yellow in this case) occurs.

O) The estimate for Process E–3 Ektachrome films is from an article by Charleton Bard et al. (Eastman Kodak) entitled: "Predicting Long-Term Dark Storage Dye Stability Characteristics of Color Photographic Products from Short-Term Tests," **Journal of Applied Photographic Engineering,** Vol. 6, No. 2, April 1980, p. 44. The accelerated-test data given in the article were for Ektachrome Duplicating Film 6120 (Process E-3) and are assumed to apply to Process E-3 Ektachrome camera films; Kodak declined to release dye-stability data for these films.

P) From Kodak sources; Kodak has not officially released dark fading data for most Process E-4 Ektachrome films (e.g., Ektachrome-X and High Speed Ektachrome).

Q) Kodak declined to release stain-formation data for its high-saturation "Group II" Ektachrome 100 Plus Professional film and its amateur counterpart, Ektachrome 100 HC Film, both of which were introduced in 1988. Ektachrome 50 HC Film, Ektachrome 64X, 100X, 400X, 64T and 320T films, all of the "Group II" type, were introduced during 1989–1992. This author's accelerated tests with these new films indicate that when yellowish stain formation is considered, their dark storage stability is, overall, similar to that of Ektachrome 100 and other "Group I" Ektachrome films.

R) Kodak declined to release stability data on which to base estimates for low-temperature storage for these films; however, the company has implied that the films have stability characteristics similar to current Eastman Color Negative Film 5247 — which for 40% RH storage calculates to be about 270 years at 45°F (7.2°C), 550 years at 35°F (1.7°C), and 9,500 years at 0°F (–18°C).

S) Kodak declined to release stability data for Eastman Color Print Film 5381 and 7381; however, examination of films in collections indicates that the stability of these film is certainly no better and is quite possibly even worse than Eastman Color Print Film 5383 and 7383.

---

**End of Notes for Table 20.1**

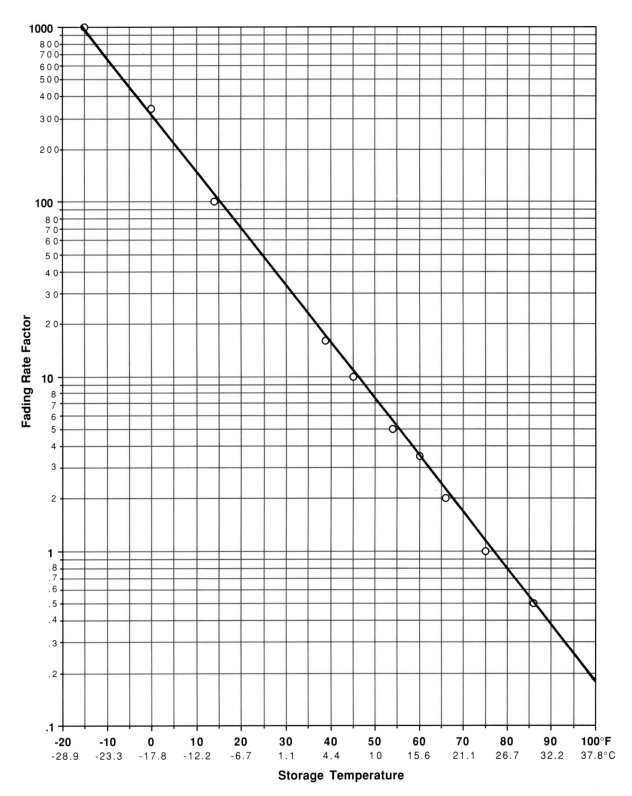

**Figure 20.1** This graph, which illustrates color film and color print fading rates versus temperature at 40% RH, may be used to calculate the approximate fading rate for a color material in cold storage at any selected temperature when an Arrhenius estimate for that product is available (e.g., for storage at 24°C [75°F]). This graph is based on fading-rate temperature-dependence data published by Eastman Kodak Company in **Dye Stability of Kodak and Eastman Motion Picture Films** (Kodak Publication DS-100 [May 1981]) and **Conservation of Photographs** (Kodak Publication F-40 [March 1985]).

# Recommendations

## Who Should Install Cold Storage Facilities?

- **Motion picture studios and film libraries:** Because of the immense commercial value, future earnings potential, and cultural importance of motion pictures and television productions, it is inexcusable not to preserve these films in humidity-controlled cold storage vaults. Cold storage affords simple and accessible long-term preservation of original negatives, intermediates, sound negatives, and magnetic tapes, and, perhaps of equal importance, enables unprojected release prints to be kept the way they looked the day they were made. The cost of suitable facilities is small, and savings in retiming and reprinting will quickly repay the initial investment. With films instantly available in their brilliant, original condition, there will be no delays in future releases, television broadcast, or conversion to high-definition television or other future formats while costly "restoration" efforts are made to salvage faded films. With cold storage available, there is no need to make black-and-white separations, which are not only extremely expensive but are a much inferior method of preserving film images, compared with cold storage of color originals. It is especially urgent that movies made on pre-1985 film stocks (e.g., Eastman Color Print Film 5383 and previous Eastman Color print films), which in general are far less stable than current materials, be refrigerated without further delay.

- **Museums and archives:** Cold storage is the only way to preserve color photographs in their original form for long periods of time. It is absolutely essential that institutions with valuable color photographs or motion pictures in their collections provide humidity-controlled cold storage. Neglecting to do so is shortsighted and irresponsible. Cold storage not only preserves color images but also preserves plastic film base, RC paper, and other support materials. Albumen prints and other unstable 19th-century prints — indeed, all black-and-white photographs as well as books, manuscripts, and works of art on paper — will last far longer if they are kept in cold storage. Restoration and conservation projects involving various works of art can be documented precisely on color film and be preserved unchanged for the benefit of future generations of conservators. Color photographic calibration standards for densitometric print monitoring can also be preserved unchanged to maintain the long-term accuracy of a monitoring program. It is highly unlikely that museums without cold storage facilities will in the future be offered photographers' archives or significant donations of color photographs. No photographer or benefactor wants to donate work to an institution that is unwilling to properly care for it.

- **Commercial picture collections:** Many of the world's most historically and culturally important photographs are found in newspaper and magazine picture collections and in the files of commercial picture agencies — the priceless collections at Time Warner Inc., the National Geographic Society, and the Magnum and Black Star picture agencies are prime examples. For many reasons, commercial picture collections should operate with duplicates and not send precious originals to clients, or otherwise handle them any more than absolutely necessary. Cold storage of inactive originals ensures that they will always be available in excellent condition. It is crucial that particularly unstable films, such as Process E-1, E-2, E-3, and E-4 Ektachrome films and all color negatives prior to around 1985, be refrigerated without delay to prevent further deterioration. Many commercial collections have large quantities of extremely un-

stable Process E-3 Ektachrome sheet and roll films (1959–1977) in their files. The cost of suitable cold storage facilities is very small in relation to the benefits.

- **Microfilm archives:** Because of the inherently poor stability of the fine-grain silver images of black-and-white microfilms, as well as increasing concern about the long-term stability of cellulose triacetate and earlier types of acetate film base in typical storage conditions, it is strongly recommended that microfilms be kept in humidity-controlled cold storage (e.g., at 40°F [4.4°C] and 30% RH). With microfilms, it is particularly important that the relative humidity in storage areas be kept at a low level — never above 40% RH.

- **Nitrate film storage:** Cellulose nitrate film still in good condition can be preserved almost indefinitely when stored at or below 0°F (–18°C), with the relative humidity in the range of 30 to 40%, in explosion-proof freezers (see Appendix 19.1 at the end of Chapter 19). When large quantities of nitrate film are involved, storage vaults should be constructed in isolated areas, away from other storage facilities. It is strongly recommended that original nitrate negatives and motion pictures be permanently preserved, with duplicate copies made as required for printing, projection, or other applications. It is particularly important to save all of the nitrate Technicolor imbibition prints — and the original nitrate camera separation negatives — that still survive (see Chapters 9 and 10).

## Containers for Motion Picture Films in Humidity-Controlled Cold Storage Vaults

- **Packaging:** For long-term storage in humidity-controlled cold storage facilities, color and black-and-white motion picture films should be placed in "vented" plastic cans or vapor-permeable cardboard containers. Standard metal and plastic film cans (taped or untaped), vapor-proof bags, and other sealed containers are not recommended for the long-term storage of acetate-base motion picture films (see page 321 in Chapter 9 for an important discussion concerning the detrimental effects of sealed containers on dye stability and film base stability).

## Storage Temperature and Relative Humidity

- **Temperature:** For museums, archives, and motion picture libraries — most of which have a variety of color materials in their collections — a temperature of 0°F (–18°C) or lower is recommended. This will afford essentially permanent preservation of even the most unstable types of color films and prints. Large collections may find it economical to segregate color materials in groups, according to their dark fading stability characteristics. The most unstable products should be stored at low temperatures and, for economy, the more stable materials can be kept in more moderate conditions. Although many factors can influence the choice of a specific storage temperature, some are difficult to quantify (e.g., how long a particular color print or motion picture should be preserved and how much fading can be tolerated); it is therefore always best to opt for the lowest temperature that funds permit.

- **Relative humidity:** In most situations, 30% RH is recommended. For older motion picture films, which may become excessively brittle at very low humidities, 40% RH is suggested. If materials will be subjected to higher relative humidities in work and study areas when they are withdrawn from a vault, it is preferable to

avoid wide-range humidity cycling by selecting a higher relative humidity in the vault for storage. The reduction in image stability caused by the higher humidity can be compensated for by maintaining a lower storage temperature. Recent studies of emulsion stress and moisture relationships conducted by Mark McCormick-Goodhart of the Smithsonian Conservation Analytical Lab have underscored the dangers to prints and films posed by storage in cycling — or in very low — relative humidities. For reasons discussed in this chapter and in Chapter 9, the practice of pre-conditioning materials to a low moisture content, packaging them in vapor-proof containers, and then storing the packages in vaults with high, uncontrolled relative humidity generally is not recommended.

## Design of Humidity-Controlled Cold Storage Facilities

- **Dehumidifiers:** Cargocaire automatic dry-desiccant dehumidifiers with HEPA filters in the air stream are recommended. Redundant systems should always be specified — in the event that one unit fails (which eventually it most certainly will), the second unit will automatically take over. In most instances, it is recommended that dehumidifier units be installed outside of the storage vault; this will simplify service and also eliminate a potential source of fire danger.

- **Refrigeration and air filtration equipment:** Vaults should be equipped with redundant, independent refrigeration systems. When one system fails, the other should automatically take over. The two systems should be designed so that one can be serviced and even disassembled without impairing the operation of the other. Air filtration systems to remove acetic acid vapors and oxidizing gases should be provided.

- **Alarms and automatic shutdown systems:** It is essential that all cold storage facilities for photographs or motion pictures be provided with fail-safe automatic shutdown systems that will cut off electrical power to all refrigeration and dehumidification equipment, vault door-frame heaters, interior lights, etc. if pre-set limits of temperature or relative humidity deviation are exceeded. At the same time, alarms should sound to alert personnel of the malfunction. Automatic shutdown systems should be tested periodically to be certain they are functioning properly. In the event of an equipment or power failure, the vault door should be kept closed until the interior of the vault reaches ambient temperature; this will prevent excessive humidity levels from developing in the vault and prevent moisture condensation on film cans, print boxes, and other containers within the vault. Storage vaults should be provided with continuous recorders for temperature and RH.

- **Recommended vault contractors:** The design and construction of a properly functioning humidity-controlled cold storage vault for photographic materials involve special expertise, and it is essential that an experienced contractor be selected. Bonner Systems, Inc. is recommended. Bruce Bonner, head of Bonner Systems, Inc., supervised the design and construction of the cold storage vaults at the John Fitzgerald Kennedy Library, the Peabody Museum of Archaeology and Ethnology at Harvard University, and the Art Institute of Chicago, among other institutions. For large installations, Turner Construction Company of New York City is recommended. Turner was the general contractor for the construction of the sophisticated archive buildings for the cold storage of motion picture film at the Warner Bros. and Paramount Pictures movie studios in California.

the zero-degree level in the future.)

Cold storage not only preserves the photographic image but also correspondingly lengthens the life of gelatin emulsions, paper supports, film bases, mount board, photograph albums, mounting adhesives, and so forth.

## Increases in the Life of Color Materials Afforded by Cold Storage

The stability characteristics of color photographic materials have been discussed in detail in Section I of this book. Dark fading data for a representative group of Kodak color film and print materials are given for four different temperatures in **Table 20.1**; the estimated times are computed from the day the material was processed. The estimates given in **Table 20.1** are for a 10% loss, or "just noticeable fading," of the least stable image dye. Most of the dark fading data elsewhere in this book are given in terms of a 20% loss of the least stable image dye; however, this author believes that for critical museum and archive applications, a 20% dye loss is in most cases unacceptable, and that a 10% loss is a more meaningful basis on which to calculate storage times.

Kodak has not yet released estimates of minimum-density stain formation (almost always yellowish in color) during long-term dark storage. In critical museum and commercial applications, yellow stain is a more serious problem than dye fading with most products, especially color prints (e.g., Kodak Ektacolor prints and similar chromogenic materials made by other manufacturers). Rates of stain formation with most color materials are directly related to storage temperature and relative humidity, and cold storage at low humidity will probably reduce stain formation to a degree that approximates the reductions given in **Table 20.1** for dye fading.

## Many Color Films and Prints Will Have Already Faded More Than 10% by the Time They Arrive in a Museum or Archive

In many instances, a color film or print will already have surpassed a 10% image dye loss and/or suffered excessive yellowish stain by the time it arrives at a museum, archive, or film library. If further deterioration is to be prevented, the color materials must immediately be placed in low-temperature storage. To obtain approximately the same life for a variety of products — which may have distinctly different fading rates — larger institutions may want to have two or more storage vaults which can be operated at different temperatures. For example, to reduce the rate of fading to approximately the same level, it is necessary to store motion picture negatives and prints that have inherently very poor image stability (e.g., most Eastman color film stocks in use prior to about 1985) at a lower temperature than is necessary with more recent Eastman and Fuji color negative and print films, nearly all of which have improved stability compared with the earlier products.

The greatly extended keeping times made possible by very-low-temperature storage (in the range of 0°F [–18°C]) are obvious from **Table 20.1**. In most cases the additional expenses of constructing and operating a very-low-temperature facility — instead of one that can maintain a

more moderate temperature of 35°F (1.7°C) — are relatively small. However, for the same amount of dye fading, a given color photograph will last approximately 17 times longer at the lower temperature. An Ektacolor 74 RC print, which will show a noticeable loss of cyan dye in about 8 years when stored at room temperature, will last about 160 years at 35°F before the same amount of fading takes place. Even 160 years is not an adequate life in terms of a permanent museum collection. At 0°F, however, the print is calculated to last about 2,700 years before the same "just noticeable" amount of fading takes place. **Figure 20.1**, which is based on data published by Kodak, shows the approximate fading rate factor for any selected storage temperature.

In some cases — particularly for already-deteriorated materials that have poor inherent stability — temperatures below 0°F (–18°C) may be advised. The often-recommended 0°F temperature is a rather arbitrary figure that had its origin in the frozen food industry. Many food products have only a limited storage life if kept at temperatures just below the freezing point of water, but it was found that colder temperatures could meet most commercial storage requirements. As a result, much of the commercial equipment designed for food storage operates at approximately 0°F. Kodak has recommended storage temperatures as low as –15°F (–26°C) to maximize the life of color materials; at this extremely low temperature, Kodak estimates the life of color films and prints will be approximately 1,000 times greater than when stored at 75°F (24°C).[4]

## The Moisture Content of Films and Prints as Influenced by Temperature and Ambient Relative Humidity

Films and prints normally contain significant amounts of moisture (as a percentage of weight) in the emulsion and support materials. With films, the gelatin emulsion accounts for most of the moisture uptake, but even solid plastic support materials absorb some moisture. Archivists have occasionally expressed fears about possible adverse effects of low-temperature storage on photographic materials, and a frequent concern is that the moisture content of films and prints will rise as the storage temperature drops (in a manner analogous to the way the relative humidity in a closed container of air rises as the temperature decreases — see the discussion of relative humidity in Chapter 16).

It is important to note, however, that the moisture content of paper, film base, gelatin emulsions, and many other solids is not affected by changes in *temperature alone*.[5] Even the actual moisture content, or *absolute* humidity, is not the critical factor. Instead, the moisture content of most photographic materials is determined by the *relative humidity* of the surrounding air. Therefore, film stored with the surrounding air at a temperature of 0°F (–18°C) and a relative humidity of 60% will have almost the same moisture content as film stored at 90°F (32°C) and a relative humidity of 60%. Although the relative humidity of the air is the same 60% at both temperatures, the warmer air would contain about 20 times the moisture content by weight as the colder air. Nonetheless, the moisture content of the films is nearly the same at both temperatures.

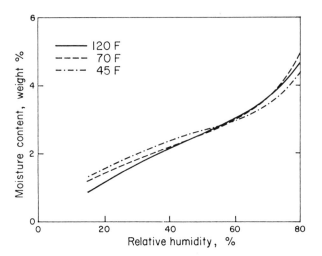

**Figure 20.2** Effect of storage temperature on moisture content of typical motion picture color negative film on cellulose triacetate base. When stored at 60% RH, changes in storage temperature have very little effect; at lower humidities the effect is negligible. (From: Adelstein, Graham, and West, "Preservation of Motion-Picture Color Films Having Permanent Value," **Journal of the SMPTE**, Vol. 79, November 1970. With permission of SMPTE.)

Film sealed with little excess air in a vapor-proof can at room temperature and placed in a freezer at a temperature of 0°F (–18°C) will not experience any increase in moisture content. The moisture content of a typical motion picture film stored at three different temperatures and at various relative humidities is illustrated in **Figure 20.2**. The general relationship shown also applies at temperatures below freezing.

The reader may wonder what happens to the relative humidity of the air which is contained in a film can along with the film itself. The answer is that as long as the can does not leak air, the relative humidity of the air packed in the can with the film will remain essentially unchanged regardless of the storage temperature. This is because the moisture-holding capacity of the air is exceedingly small compared with that of the film, when equal *volumes* of air and film are compared.

For example, film in equilibrium with air at 50% RH might contain 3% moisture by *weight*.[6] Thus a reel of film weighing 1 kg (2.2 lb.) would contain about 30 grams of moisture. Assuming this reel of film occupies a volume of 1048 cc, the amount of air in the can might be about 174 cc, or one-seventh of the total volume of the can. If the can were sealed with the 174 cc of air at 70°F (21°C) and 50% RH, the volume of air in the can would contain only about 0.0015 gram of moisture. This is about 1/20,000 the quantity of moisture in the film.

When a can containing film and a comparatively small quantity of air is put in a refrigerator or cold storage vault, the relative humidity of the air starts to rise as the temperature drops. The film (principally the gelatin emulsion) then begins to absorb moisture from the air to re-establish equilibrium with the relative humidity of the air. Because of the large moisture-holding capacity of the film, virtually all the excess moisture in the air is quickly absorbed by the

film, resulting in essentially no change in relative humidity of the air, or in the moisture content of the film by weight. The important point here is that the equilibrium moisture content of a roll of film in a sealed container is determined by the ambient relative humidity where the film was stored *before* being placed in the cold storage vault.

If, however, a single strip of film containing only a few frames were placed in a large and otherwise empty film can, and then put in a refrigerator and cooled, there would be a significant rise in both the relative humidity of the air and the actual moisture content of the small piece of film. This is because of the proportionately very small volume of film compared with the volume of air. The problem can be easily avoided by keeping free air space in packages to a minimum; if necessary, crumpled paper of good quality can fill excess space.

## Can Moisture in Films Form Ice Crystals at Temperatures Below Freezing?

An often-voiced fear is that moisture contained within an emulsion might form ice crystals at temperatures below freezing (the way water in fruits and vegetables crystallizes when it freezes) and that such crystal formation could distort, blister, or otherwise damage films.

Unlike frozen food, which may contain 90% or more water by weight, a gelatin emulsion contains only about 15% moisture by weight when equilibrated with air at 80% RH. Even if stored in air with a relative humidity as high as 95%, there will not be enough moisture in a film or print to form ice crystals. John Calhoun of Eastman Kodak wrote in 1952 that:

> . . . ice crystals or damage from ice formation has never been found in photographic film stored at below freezing temperatures. The small amount of moisture normally found in photographic emulsions or dry gelatin is not present in the form of liquid droplets but is molecularly adsorbed within the colloid.
>
> In one experiment made by the Eastman Kodak Company in 1939 several types of film were stored for three weeks completely surrounded with dry ice (solid carbon dioxide) in an insulated container. Thermocouples indicated the film to be at a temperature below –100°F [–73°C]. After removal the film was subjected to microscopic examination and no change in the emulsion structure found. Exhaustive photographic tests, and physical tests made on the film before and after processing, showed no detrimental effect of any kind.
>
> . . . there has been considerable practical experience in the storage of film at low temperatures, in some cases for as long as three years at –10°F. Never has any detrimental effect been found, *provided that the film was protected from the penetration of moisture from outside the package.* It makes no difference whether the film is cooled slowly or is quickly frozen in dry ice, or how low a temperature is used.[7]

## Physical Effects of Low-Temperature Storage on Films and Prints

Some film archivists have also expressed vague worries that storage of photographic materials at temperatures below freezing — especially if films and prints are *repeatedly* taken in and out of cold storage, producing temperature fluctuations over a wide range — could eventually cause the following: the emulsion to fall off of films; the base to become so brittle that (even after the film has warmed up to room temperature) the film would break; rolls of motion picture films to become deformed; or other types of physical damage.

There is no published evidence that any of these things have actually occurred as a consequence of cold storage, even though many people have an "intuitive feeling" that rapid fluctuations between 0°F (–18°C) and room temperature *must* put terrific physical stress on rolls of film, and that this stress will eventually cause damage. Such fears probably arise because *people themselves* feel uncomfortable, and can be harmed, as a result of exposure to very low temperatures, and therefore they think that cold storage must be harmful to film, also.

In 1981, in response to this author's questions about possible adverse effects on motion picture film of repeatedly cycling storage temperatures over a wide range, Kodak said:

> Based on our lab data, no physical harm is predicted. We cycle these films repeatedly from deep freeze to room temperatures without detecting any problems. Of course, it's important to protect the film from moisture condensation during the warm-up period.
>
> We have tested 35mm (but not 70mm) thousand-foot rolls of processed film, cycling repeatedly from deep freeze (as low as –61°F [–52°C]) and observing them physically, our main interest being roll integrity (spoking, for instance). . . . On shorter lengths (from several feet to several hundred feet), we have examined the film for all physical properties — image stability, emulsion adhesion, support stability, etc.
>
> There is no demonstrated advantage to lowering or raising the temperature of rolls of film in gradual stages.[8]

Kodak went on to say that in the company's experience over many years, cold storage poses no problems if care is exercised to prevent condensation during warm-up. A great deal of processed and unprocessed film is shipped in the winter, and during transit the temperature of the film may occasionally drop below –30°F (–34.4°C); Kodak reports that it is unaware of any damage caused by this. Roll and motion picture films have also been extensively used in the Space Shuttle, manned trips to the Moon, and other space flight missions where at times films have been subjected to extremely low temperatures; again, Kodak indicates that no problems have been reported.

More recently, Kopperl and Bard of Eastman Kodak published results of a number of freeze/thaw cycling tests conducted by the company.[9] In one experiment, "samples

of film and papers included in the Image Stability Technical Center's long-range sample collection were stored in heat-sealed foil bags in a freezer and removed, thawed, and measured approximately annually for 10 to 15 years. No adverse effects on image stability were seen." In another test:

> Samples of seven films and one color paper were pre-equilibrated at 24°C [75°F] and 45% RH, heat-sealed in foil envelopes, and stored in a freezer at –15 to –12°C [5 to 10°F] for 6 months. During each working day, the samples were removed from the freezer for 4 hours. This was sufficient time for the samples to be at room temperature for several hours during each cycle. They were then replaced in the freezer. Wedge brittleness, mushiness, and wet and dry cycle adhesion tests, similar to those in *ANSI PH1.41* [*ANSI IT9.1-1991*], as well as image stability tests, were performed after the 6 months of cycling. No adverse effects were seen as a result of the freeze/thaw cycling.

In other experiments, rolls of processed black-and-white (Type 5302) and color (Type 5384) motion picture films in taped cans, untaped cans (which afford little protection from moisture), and cans sealed in vapor-proof foil bags were cycled 100 times in and out of a freezer with high, uncontrolled relative humidity. After each 25 cycles, the films were projected and then machine-rewound to simulate actual customer use. "No projection problems or physical defects were observed upon projection of any of the test samples, regardless of the storage method." The films were tested for coefficient of friction, humidity curl, brittleness, and multimetric scratch properties. The slight differences observed between the cycled films and control samples were "not considered to be significant." Image stability tests on the cycled films were also reported, and "no significant changes in density were observed."

### Does the Moisture Content Matter if Film Is Stored at Temperatures Below Freezing?

It has been suggested that at temperatures below freezing, the moisture content of film and the relative humidity of the storage environment may not matter. In fact, there could be serious problems. If a film were stored at 0°F (–18°C) with an ambient relative humidity of 95%, the film would eventually reach equilibrium with the 95% RH air. The moisture content of the film would then be essentially the same as if it were stored at room temperature at 95% RH. Upon removal from the freezer, the film would stick together, swell, and likely support fungus growth. This was dramatically illustrated a few years ago when a large quantity of cellulose nitrate motion picture film was found buried in permafrost in the Canadian Yukon. Much of the film was in good physical condition — even though saturated with frozen moisture — when the find was uncovered. However, once the film was dug up and allowed to thaw, some of it was ruined by the moisture it had absorbed during burial. Films and prints must always be protected from excessive humidity, regardless of the temperature.

### Humidity-Controlled Storage versus Sealing Films and Prints in Vapor-Proof Packages for Storage in Uncontrolled Environments

For many years the standard cold storage facility for motion picture films was a vault with a temperature of about 55°F (13°C) and relative humidity in the range of 45–60%. Refrigeration equipment with cool-and-reheat systems provided marginal control of relative humidity. Films were generally placed in taped cans (which are not totally vapor-proof), and no attempt was made to pre-condition the films at a low relative humidity before placing them in the vault. This was — and still is — typical of "refrigerated" storage facilities in the motion picture industry in Hollywood and elsewhere. Actually, most of the color material produced by the entertainment film industry worldwide is not even stored in refrigerated vaults; instead it is kept in air-conditioned buildings at about 70°F (21°C), or even in totally uncontrolled warehouses. With only rare exceptions, still negatives and prints have not been stored in refrigerated environments.

The development of continuous high-volume dry-desiccant dehumidifiers has made it economically feasible to maintain constant and low relative humidity in a vault, regardless of the temperature — even if the temperature is well below 0°F (–18°C).

Given the total cost of building a cold storage vault, the additional expense of a desiccant humidity control system is not great — typically about 10% of the total vault cost for large-scale installations. Assuming that the walls, ceiling, and floor of the vault have low moisture permeability (as is the case with the low-cost steel- or aluminum-covered prefabricated-panel vaults in virtually all the cold storage facilities constructed in the U.S. in recent years), the added electrical energy required for dehumidification is comparatively small. Once the vault is in operation and the relative humidity is brought down to the desired level, the only additional moisture that must be removed is that which enters the vault when the door is opened, and the very small amount that diffuses through the seals joining the metal vault panels and that seeps in through small leaks. Little or no fan-forced air exchange is needed in most installations. High levels of air exchange with the outside (sometimes called "makeup air") will of course increase dehumidification and refrigeration costs.

Maintaining the relative humidity in a low-temperature storage facility at the recommended level of 30% offers a number of important advantages:

1. The need for vapor-proof storage containers is eliminated, saving time, labor, and, in large collections, considerable expense. Commonly used heat-sealable, laminated paper/aluminum-foil/polyethylene bags and envelopes are cumbersome, waste storage space inside a vault, and must be replaced each time a film or print is accessed. If one follows the recommendations of Kodak and this author, films and prints destined for low-temperature storage with uncontrolled humidity must first be heat-sealed inside one vapor-proof bag or envelope, and then that package must be heat-sealed inside a *second* vapor-proof container to minimize risk of a defective seal or puncture. This double-sealing proce-

dure requires additional expense and labor. Also, sheet films, short strips of films, and prints can be damaged or destroyed should they accidentally slip into the heated area when an envelope is being sealed.

2. There is no danger of damage to films and prints, as could occur if a vapor-proof package failed in an uncontrolled, high-humidity storage vault, especially a vault operated at temperatures above freezing. A defective seal or puncture in a vapor-proof package stored in uncontrolled conditions could go unnoticed for years, allowing the contents to slowly absorb moisture until they have equilibrated at near 100% RH — which likely would result in the destruction of the materials. Storage in two individually sealed vapor-proof bags or envelopes (one inside the other) minimizes, but does not eliminate, this potentially catastrophic hazard.

3. Films and prints need not be pre-conditioned at a low relative humidity before placing them in a low-humidity vault. This not only saves time and labor (pre-conditioning a reel of 35mm motion picture film may require up to 4 weeks) but also greatly simplifies access to materials. The need for expensive pre-conditioning equipment or special conditioning rooms is eliminated. Films that have previously been stored in high relative humidity environments will slowly re-equilibrate to the lower relative humidity inside a low-humidity vault, even if the films are in taped metal film cans. Still photographs in the usual paper or plastic enclosures will generally re-equilibrate to the lower humidity in only a few days.

4. Steel film cans, cabinets, shelving, other equipment, and even the walls of the vault itself will not corrode over time in 30% RH. This eliminates the need for replacement of film cans and other equipment and keeps the storage area free of abrasive rust particles.

The two principal advantages of sealing films in vapor-proof packages are: **(1)** a humidity-control system in the storage vault is not needed, thereby reducing the initial cost and complexity of the vault and somewhat reducing the cost of operation, and **(2)** the films will be better protected from water damage which might result from burst pipes in the area, roof leaks, floods, and other disasters. Sealed films are also protected from airborne pollutants; depending on the storage conditions, this may be of value for black-and-white materials. With color films, however, especially when contained in motion picture cans, normally encountered levels of air pollutants are probably of negligible significance.

Vapor-proof bags, envelopes, or other containers for storing films and prints must be made of materials that have no adverse effects on image stability. Although accelerated test data have not been published, it is generally believed that vapor-proof bags made of a paper/aluminum-foil/polyethylene laminate are adequate for long-term storage of color materials.

Finally, it should be noted that some researchers have expressed concern that cellulose acetate safety-base films

*may* be subject to increased rates of base decomposition if they are sealed in air-tight containers during long-term storage. This is based on the fact that some of the decomposition reactions are autocatalytic and if gaseous decomposition products are not allowed to escape, the rate of deterioration could accelerate (in a manner similar to that which has been documented with cellulose nitrate films). But compared with room-temperature storage — with films packaged in sealed containers or not — low-temperature storage will greatly slow the rate of film-base deterioration (and will also greatly slow the rate of image deterioration).

## Pre-Conditioning Films or Prints Before Sealing in Vapor-Proof Bags or Envelopes

Although it has often been recommended that films and prints be pre-conditioned (or "pre-equilibrated") in a 30–40% RH environment before sealing in vapor-proof packages, it has never been demonstrated that in fact this is actually necessary.

At any given temperature, storage at 30% RH, instead of, for example, 60% RH, will slow color image fading and staining, discoloration and fading of black-and-white images, and film-base deterioration. However, with color materials in cold storage, it is the *low temperature* of storage that is primarily responsible for the slowing of deterioration. The increase in the life of the image afforded by pre-conditioning to a low relative humidity is small by comparison. Moreover, with the majority of older color materials, such as most pre-1983 Eastman Color print and negative films, the cyan dye is the least stable image dye, and the fading rates of the cyan dyes in these products are not greatly influenced by the level of relative humidity; pre-conditioning to a low moisture content will be of little benefit.

There also is concern that pre-conditioning fragile historical films and prints to a very low moisture content — and then periodically taking them out of cold storage and placing them into work areas or darkrooms with significantly higher relative humidity — could cause unwanted physical stress on the emulsions, increase the amount of curl of films and prints without gelatin anti-curl backings, and possibly cause other kinds of physical damage. The ANSI film-storage standards caution against widely cycling relative humidity. From a physical point of view it might indeed be safer to keep films in cold storage under approximately the same moisture conditions that (hopefully) are found in work areas and darkrooms in collecting institutions.

Whatever gain in storage life that might be afforded by pre-conditioning to a low relative humidity can more simply be achieved by lowering the temperature of the storage vault 5° or 10°F. Insofar as the fading rate of a particular color film or print material is concerned, the equilibrium moisture content and the temperature at which it is stored are two essentially unrelated subjects — and they should be thought of separately. The reader is referred to Chapters 2 and 5 for a more detailed discussion of the specific effects of temperature and relative humidity on color image stability.

In large collections in particular, omitting the pre-conditioning step will avoid a great deal of extra handling and

Constructed in 1987, the cold storage vault serving the Moving Image, Data and Audio Conservation Division of the National Archives of Canada in Ottawa is kept at 28°F (–2.2°C) and 28% RH. William O'Farrell, head of the Film Unit, wheels film into the vault. The National Archives is responsible for the preservation of films produced by the National Film Board of Canada, the Canadian Broadcasting Corporation, and other government agencies. Canadian feature films are also acquired for the collection. In late 1996 the unit will move to a large new National Archives installation in nearby Gatineau, Quebec. The motion picture vault in the new facility will operate at 0°F (–18°C) and 25% RH. An advanced air-filtration system will be employed to remove acetic acid vapors, nitrogen oxides, ozone, dust, and other airborne contaminants.

expense. Many films and prints have been stored for years in environments with uncontrolled relative humidity, and there is no compelling need to pre-condition them to a low moisture content simply because the decision has been made to place them in cold storage; in terms of the future life of the materials, the most important consideration is simply to put them in cold storage as soon as possible — and to keep the temperature as low as possible.

Furthermore, as discussed on page 321 in Chapter 9, recent research conducted by Eastman Kodak has shown that storing color films in sealed containers (e.g., ordinary taped or untaped metal and plastic film cans or vapor-proof laminated bags) can *markedly* increase rates of both color image dye fading and acetate film base deterioration!

### A Study at the National Archives of Canada Indicates That Vapor-Proof Bags for a Collection Could Cost More Than an Entire Film Vault

In 1986, in the course of planning a new cold storage vault to house the rapidly growing collection of the Moving Image, Data and Audio Conservation Division at the National Archives of Canada in Ottawa, the staff of the Film Section examined the costs of pre-conditioning motion picture films and packaging them in vapor-proof bags versus the expense of adding humidity-control equipment to the vault — and thereby eliminating the need for the bags.

Capable of housing approximately 17,300 one-thousand-foot cans of 35mm motion picture film and maintaining a temperature of 28°F (–2.2°C) with a relative humidity of 28%, the new vault cost about $100,000. Of that amount, the Cargocaire HC-1125-EBA continuous dry-desiccant dehu-

midifier cost about $11,000. The high-quality, vapor-proof bags available from the Swedish Film Institute, on the other hand, cost $1.30 each (shipping from Sweden additional). For the 17,300 cans of film that eventually will be stored in the vault, the bags would cost $22,490. If one were to follow Eastman Kodak's recommendations for cold storage in non-humidity-controlled facilities, and use two bags for each roll of film (with the film sealed inside one bag and the resulting package sealed inside a second bag to minimize the chance that a tiny pinhole puncture or defective seal could ultimately lead to the destruction of the film), the bag expense would double to a total of $44,980.

Expenditures associated with the equipment and labor to pre-condition and package the films would increase the total cost of the vapor-proof bag method even more. In addition, each time a film is withdrawn from the vault, the bag is destroyed when it is opened and a new $1.30 bag is required when the film goes back to storage. The number of rolls of film than can be kept in a vault is also reduced because a roll of film sealed in a vapor-proof bag requires more space than a roll in a film can.

By controlling the humidity in the vault with an $11,000 dehumidifier, the Archives saved at least $11,500 in additional costs for vapor-proof bags (and that savings assumes only a single bag for each roll of film). If one adds to that figure the $72,600 cost of the Swedish FICA film-conditioning machine discussed later in this chapter, a total of $84,100 was saved. Labor costs associated with the film conditioning and bag sealing process would almost certainly push the actual savings to above $100,000 — enough for the National Archives to build a second humidity-controlled vault capable of storing an additional 17,300 rolls of film!

Four refrigeration compressors operating in a redundant mode cool the vault at the National Archives of Canada. Behind the compressors is a Cargocaire dry-desiccant dehumidifier that maintains 28% RH in the vault.

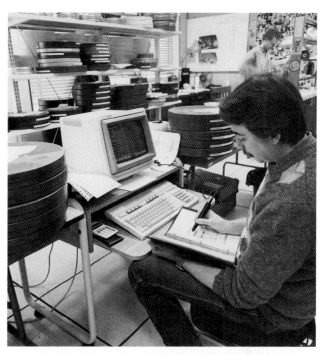

A computer-based catalog system tracks the films in the Archives. Operator Dennis Waugh inputs film titles and other data manually at a Hewlett-Packard computer terminal and uses a lightpen to read data from standardized preprinted bar codes. The bar-code labels are then affixed to the film cans.

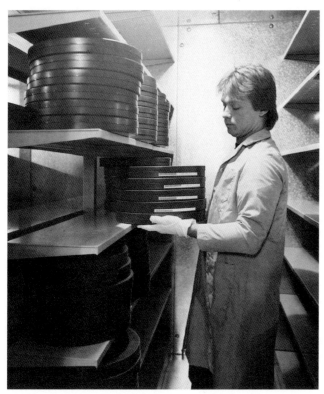

Old metal film cans are replaced with new, color-coded plastic cans, which are stored horizontally on shelves within the vault. The vault can accommodate approximately 17,300 one-thousand-foot cans of 35mm film.

Sign on the vault door. A study conducted by the Film Section of the Moving Image, Data and Audio Conservation Division in Ottawa showed that it was far less expensive and much less labor-intensive to control the humidity in the vault than it would be to pre-condition and package films in vapor-proof bags for storage in a vault with uncontrolled humidity.

National Archives of Canada – 1988 (4)

Other suppliers of vapor-proof bags have quoted prices for bags as low as $0.64 each when purchased in quantities of 50,000 or more at one time (made of less-expensive materials, these bags are less durable than the $1.30 Swedish Film Institute bags, which are heavy-duty bags made with a double layer of aluminum foil to minimize the chance of pinhole punctures). But even at $0.64 each, the cost of 17,300 bags comes to $11,072 — about the same as the price of the Cargocaire dehumidifier in the new Archives vault.

According to William O'Farrell of the Film Section, the comparison of the two storage methods made it clear that it was much simpler and far less expensive to incorporate a desiccation dehumidifier into the design of the vault.[10]

Headed by Roger Easton, the Moving Image, Data and Audio Conservation Division of the National Archives of Canada is the Canadian government's central repository for motion picture films and videotapes, with new material arriving weekly from the National Film Board of Canada, the Canadian Broadcasting Corporation, various government agencies, and even from private citizens. Prints from more than 1,000 Canadian feature films have also been purchased by the Archives and are now preserved in the cold storage vault (unlike the U.S. and some other countries, Canada does not have a mandatory copyright deposit law, and all films must be purchased from their producers). O'Farrell says there are over 200,000 cans of film in the collection, of which perhaps one-third are in color. "We are looking at another few years to identify exactly what additional color films in our collection warrant being placed in the cold storage vault."

The Moving Image, Data and Audio Conservation Division is replacing old metal film cans with new color-coded plastic cans, "as a visual identifier for different types of films and also acts as a deterrent to the deterioration of acetate film base," according to O'Farrell. "Everything is recanned because many of the original cans are rusted, dented, or otherwise in poor condition." To simplify record keeping as films are moved in and out of the vault, computer bar-code labels have been applied to the new cans.

### Methods of Pre-Conditioning Films and Prints

If proper humidity-controlled cold storage is simply not available and it is necessary to pre-condition films or prints before sealing them in vapor-proof containers, there are several methods of accomplishing this. The most obvious way is to store the materials for a period of time in a room in which the desired relative humidity is maintained. Conditioning times may range from a few hours for individual films and prints that are open to the air, to a month or longer for 1,000- or 2,000-foot rolls of 35mm motion picture film. In most geographic locations, maintaining low relative humidity (e.g., 25% RH) on a year-round basis requires the use of a continuous dry-desiccant dehumidifier. If a more moderate level of relative humidity is acceptable, one or more home-type refrigeration dehumidifiers may be placed in a small, air-conditioned room; home dehumidifiers are much less expensive than desiccant units and are capable of reducing the relative humidity to about 45%.

In temperate climates, the simplest solution of all is to restrict the time that materials are sealed in vapor-proof containers to the cold months of the year. In non-humidi-

November 1987

A Swedish FICA film-conditioning and vacuum-sealing machine at the Motion Picture, Broadcasting, and Recorded Sound Division of the Library of Congress in Washington, D.C. Film technician David Lee Reese prepares to vacuum-seal a vapor-proof bag containing a roll of film that has been equilibrated to a low moisture content in the machine. The system is no longer used by the Library.

fied buildings during the winter, the indoor relative humidity is normally at a very low level; for example, as this was being written in Iowa in the winter of 1992, the relative humidity in this author's office was about 25% — the humidity generally remains below 30% for 5 months of the year. Films and prints may be pre-conditioned simply by laying them in the open for a period of a few weeks — they are then ready for sealing in vapor-proof containers. During warm months, when indoor relative humidity is higher, materials destined for cold storage can be accumulated until the next winter; the amount of fading that might occur during an additional few months of storage at room temperature is negligible.

A pre-conditioning method that has been suggested by Eastman Kodak requires placing film in a sealed container along with a measured amount of activated silica gel; the amount of silica gel required is computed from (a) the amount of film being conditioned, (b) the relative humidity in which the film has been stored in the past, and (c) the final humidity desired at equilibrium.[11] Particularly when large amounts of motion picture film are involved, this is a laborious and time-consuming procedure.

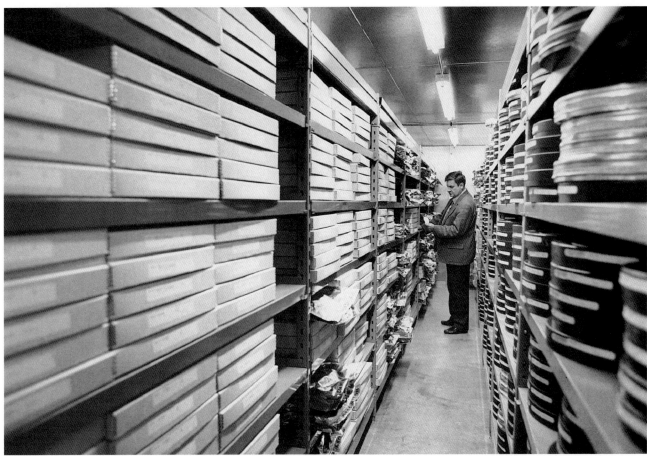

November 1987

Because films sealed in vapor-proof bags are too bulky to fit in standard film cans, the Library had to purchase custom-made boxes and further added to the overall cost of the FICA procedure. After using the FICA system for several years, the Library was forced to give up the procedure because of insufficient staff. David Parker, a film curator at the Library of Congress, is shown here with color films packaged in the FICA vapor-proof bags (left) in the Library's large, 37°F (2.8°C) cold storage facility in Landover, Maryland, outside of Washington, D.C. Although the vault is controlled at 25% RH and sealing films in vapor-proof containers was not necessary to protect them from moisture, the Library staff felt that the FICA system was worthwhile because of the protection afforded to films by the waterproof bags in the event of a mishap during shipping, or of flooding caused by a burst water pipe near the vault. Films are now placed in the vault in standard metal or plastic film cans.

## The Swedish Film Institute Film Conditioning Apparatus (FICA)

A more sophisticated pre-conditioning method, currently in operation at the Swedish Film Institute (Svenska Filminstitutet) in Stockholm, Sweden, involves a specially constructed temperature- and humidity-controlled conditioning cabinet to re-equilibrate rolls of motion picture film in 25% RH air before double-sealing the films in vapor-proof bags in a vacuum chamber.[12] Called the Film Conditioning Apparatus (FICA), the unit incorporates a continuous desiccant dehumidifier; a Purafil air filter to remove airborne contaminants; an air conditioner to remove heat produced by the dehumidifier and other mechanical equipment, and to maintain the temperature inside the cabinet at 68°F (20°C); a device to rewind film under controlled tension; and a vacuum-chamber and heat-sealing unit with which to double-seal rolls of film in vapor-proof bags.

Designed by Roland Gooes and Hans-Evert Bloman of the Swedish Film Institute, the FICA unit is available from the Institute for about $75,000 (with shipping from Sweden

additional).[13] The time required to pre-condition (equilibrate) rolls of film to the desired 25% RH varies from 4 to 7 days, depending on the prior storage conditions of the film. The 80x30–inch cabinet can accommodate more than fifty 1,000–foot rolls of film at one time. For greater capacity, up to four satellite conditioning cabinets, which cost $20,200 each, can be attached to a central FICA unit.

The heavy-duty vapor-proof bags supplied by the Swedish Film Institute for the FICA unit cost $1.30 each (price applies to any quantity, with shipping additional). When a roll of film is first placed in the cabinet, it is rewound under controlled 10.5-ounce tension. After pre-conditioning and sealing in the vapor-proof bags, films may safely be stored in non-humidity-controlled, low-temperature vaults.

The Swedish Film Institute is attempting to preserve *all* Swedish motion picture films; the major funding for the Institute (which is also heavily involved in film production) comes from a 10% tax on all box office receipts and a set fee paid by the video industry for each videocassette sold to the public.[14] The Institute developed the FICA machine to pre-condition and seal camera negatives and printing

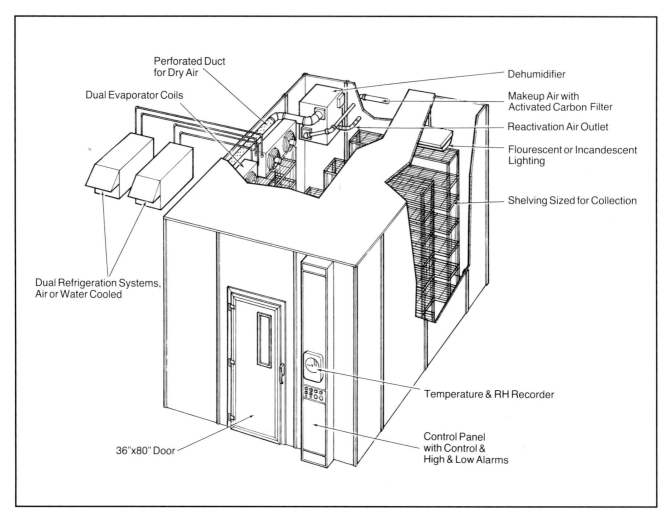

Perforated Duct
for Dry Air

Dual Evaporator Coils

Dehumidifier

Makeup Air with
Activated Carbon Filter

Reactivation Air Outlet

Flourescent or Incandescent
Lighting

Shelving Sized for Collection

Dual Refrigeration Systems,
Air or Water Cooled

Temperature & RH Recorder

36"x80" Door

Control Panel
with Control &
High & Low Alarms

**Figure 20.3** A schematic of a moderate-size humidity-controlled cold storage vault, similar to the installation at the Peabody Museum of Archaeology and Ethnology at Harvard University. Although this drawing shows a dry-desiccant dehumidifier inside the vault, the author recommends that dehumidifiers be located outside of a vault. (Courtesy Harris Environmental Systems, Inc.)

masters for storage in its preservation facility in Stockholm (the color film vaults are kept at 23°F (–5°C) and 40% RH).

In 1986 a FICA unit was purchased by the Library of Congress for pre-conditioning films prior to placing them in the Library's cold storage vaults in Landover, Maryland. Even though the Library of Congress storage vault for color film is maintained at 25% RH and vapor-proof containers are not necessary in such an environment, the Library felt that pre-conditioning color films in the FICA unit and then sealing the film in vapor-proof bags afforded added protection to the films. According to Paul Spehr, assistant chief of the Motion Picture, Broadcasting, and Recorded Sound Division of the Library, sealing films "is sort of a double insurance — it offers the film some protection against water and other types of damage that may happen."[15]

Citing a basement flood a few years ago at the Chicago Historical Society caused by a large water main outside the building that fractured during a construction project, Spehr said that the Library of Congress has had problems with malfunctioning fire sprinklers and burst pipes (although to date there has been no damage to films in the

cold storage vaults). Spehr noted that one difficulty with films sealed in the bags is that they no longer fit in standard film cans or film boxes, so the Library had to purchase costly, specially made, oversize boxes. After using the FICA system for a few years, the Library was forced to abandon the procedure because of budget constraints.

## Construction of Cold Storage Vaults

Most of the photographic cold storage vaults built in recent years have been constructed with prefabricated metal-clad panels with 4- or 5-inch-thick polyurethane foam insulating cores — similar in structure to the walk-in refrigerators found in food stores and restaurants. Indeed, one of the major suppliers of such refrigerated vaults, Bally Engineered Structures, Inc., sells most of its equipment to the food industry; Bally introduced its first urethane foam-core sectional prefabricated vault in 1962. The units are available in virtually any size, up to and including large drive-in buildings.

The aluminum, galvanized steel, or stainless steel cov-

Picture collection staff member George Gonzalez in the interior of the cold storage vault at the Time Inc. Magazines Picture Collection; when this photograph was taken in 1981, the vault was in the final stages of construction.

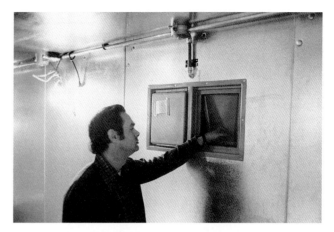

A pressure-relief vent in the wall of the vault is provided to equalize air pressure differences that occur when warm, room-temperature air enters the vault and is cooled when the door to the vault is opened.

The floor plan for the vault shows locations of the file cabinets containing more than one million color transparencies that were moved into the vault after its completion and testing.

An exterior view of the vault. A vestibule and door in front of the vault door provide an air lock to minimize the influx of room-temperature air when the vault is entered. The vault is located in the Time Inc. Magazines Picture Collection in the Time & Life building in New York City.

*Henry Wilhelm – 1981*

ering on both sides of the vault walls not only provides a rigid surface and structural support but also serves as an effective moisture barrier to prevent outside water vapor from entering the vault, thus reducing the dehumidification requirements of the facility. In low-temperature installations, the floor as well as the walls must be insulated.

Vaults of this design can be readily constructed in almost any part of an already-existing building. When located on the ground floor or in the basement of a building, additional floor insulation may be required to prevent the earth beneath the floor from freezing and expanding, possibly causing structural damage to the building; the vault supplier can give advice on this point. The prefabricated vaults can be disassembled and moved to another location with relative ease, and sections can be added in order to expand the size of the vault. The load-bearing capacity of the building floor must be considered in deciding where to locate a vault — particularly when large quantities of motion picture film are to be stored on high-density movable shelving, the weight of the materials in a vault can be considerable.

*Carol Brower – May 1983*

The cold storage vault in operation (although built to maintain 0°F [–18°C] and 30% RH, the vault currently is operated at 60°F [15.6°C] and 35% RH).

The roof of the vault should be waterproof to protect the contents from water dripping on the top as a result of burst pipes, leaking building roofs, fire-extinguishing water sprinkler systems, etc. There are several ways to waterproof the top of a vault: if the vault is not too large, covering it with a large sheet of plastic may suffice. The best approach is to install an "outdoor" roof on the vault; such roofs are available from most vault manufacturers. In general, photographic storage vaults should not be installed in basements because of the danger of flooding from natural causes (e.g., hurricanes), broken water mains, or backed-up sewers. Should a fire break out in the building, a basement may flood with tons of water released by automatic sprinkler systems or with water poured into the building by firefighters.

The design of a typical photographic storage vault is shown in **Figure 20.3**. Ideally, a vault should have a second door with a small air-lock section to reduce the air exchange each time the vault is entered. Doors should be large enough to accommodate shelves, file cabinets, or other equipment that must be moved in and out of the vault. Low-temperature vaults require a pressure-relief port to allow changes in air pressure (caused by sudden temperature changes when the door is opened) to equalize with the air pressure outside the vault.

For the lowest electrical requirements and operating costs, the urethane foam-insulated walls, ceiling, and floor of the vault should be as thick as possible — a minimum of 5 inches is recommended (5 inches is currently the thickest panel construction offered by Bally Case and Cooler, Inc. and most other suppliers).

### Refrigeration and Dehumidification Equipment

The refrigeration equipment for photographic storage facilities is usually of fairly typical design and can be either air or water cooled. It is suggested that two — or even three — completely independent, redundant refrigeration and dehumidification systems be installed so that in the event of mechanical failure, one system will remain operating while the other is being repaired. In many facilities installed recently in the U.S., the equipment has been designed so that the dual refrigeration compressors alternate after each running period. If an upper temperature limit is reached, both compressors will switch on at the same time. Should one compressor fail, the other automatically takes over and will continue to cool the facility until the defective compressor can be returned to service.

Dehumidification equipment should also operate as a redundant system with two or more units. Because the photographs in storage will probably be kept for many hundreds of years — if not forever — many equipment failures will occur as the years pass, and this must be taken into account both in the design of the vault and in the maintenance procedures adopted for the equipment. As James Wallace, Curator/Director of the Smithsonian Institution's Department of Photographic Services in Washington, D.C., said about the design of a cold storage system:

> You have to remember that a cold storage room is a mechanical thing — like an automobile. It runs all the time and you either have to

build in some redundancy or you can expect it to quit every once in a while. You simply cannot put in all of the refrigeration and dehumidification equipment, smoke and temperature alarms, air filters, and everything else and not expect some of this mechanical stuff to break down every now and then. The mistake is to have someone build a vault and present you with the key and then expect it to work absolutely perfectly forever. If we have a temperature where our Ektachrome slides will last 500 years — there isn't a piece of equipment made that will last even a fraction of that time.[16]

Wallace went on to say that the staff should understand the equipment and have both the knowledge and spare parts to do simple repairs. In addition, procedures for handling the collection in the vault during equipment failures should be worked out in advance.

Should all the equipment fail — or in the event of a prolonged power outage — no harm need be done. The temperature inside the vault will gradually rise to ambient conditions and the fading rates of the color materials inside will increase accordingly for as long as the vault is out of operation. A few months at room temperature during a hundred-year period will be of no great significance. If the vault door is kept closed until the inside of the vault has reached room temperature, the relative humidity in the vault will not rise to unacceptable levels during the warm-up period.

Allan Goodrich of the John Fitzgerald Kennedy Library reported that during a power outage, which lasted 2 days, the temperature inside the Library's 0°F (–18°C) cold storage vault rose to about 30°F (–1.1°C) before the electricity was restored; the relative humidity inside the vault remained low throughout the 2-day period.[17]

As discussed below, every vault should be equipped with temperature and relative humidity indicators that can be read from the outside as well as fail-safe automatic high- and low-level temperature electrical shutdown systems and alarms which will sound both at the vault and at a remote location to alert the maintenance staff immediately should conditions in the vault reach unacceptable levels.

### High-Volume Dry-Desiccant Dehumidifiers for Humidity Control in Cold Storage Vaults

Ordinary refrigerated vaults and freezers do not have any system of humidity control, and relative humidities are often close to 100% — far too high for safe storage of unprotected photographs. Conventional refrigeration-type dehumidifiers do not function efficiently at low temperatures, and with most designs it is impossible to obtain relative humidities as low as 30%. In addition, refrigeration dehumidifiers with heated defrost cycles consume large amounts of electricity during operation.

Much more satisfactory are continuous high-volume dry-desiccant dehumidifiers, principally the lithium-chloride-impregnated wheel machines invented by Carl Munters in Sweden and manufactured in the U.S. by Cargocaire Engineering Corporation, Amesbury, Massachusetts (for a description of these machines, see Chapter 16). Cargocaire

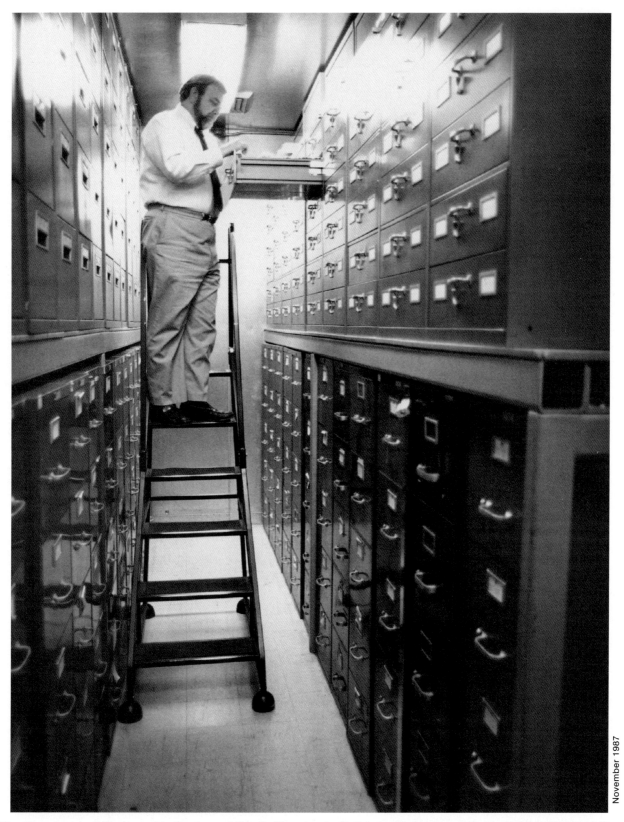

November 1987

The Department of Photographic Services at the Smithsonian Institution in Washington, D.C. constructed this humidity-controlled cold storage vault in 1982 (40°F [4.4°C] and 27% RH). James H. Wallace, Jr., director and curator of Photographic Services, pulls negatives from an upper-level file cabinet in the vault. Color slides, large-format color transparencies, color negatives, black-and-white negatives, and safety-film duplicates of historical cellulose nitrate negatives are stored in the vault.

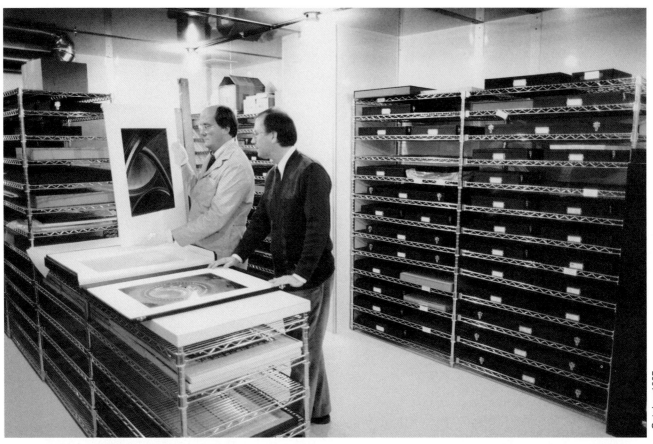

October 1987

Constructed in 1982, the humidity-controlled cold storage vault at the Art Institute of Chicago was the first facility of this type in any fine art museum in the world. Shown here are Douglas Severson, conservator (left), and David Travis, curator of photography, looking at Kodak Ektacolor prints in the collection. Although now being operated at 40°F (4.4°C) and 40% RH for the convenience of the curatorial staff, the vault is capable of operating at 0°F (–18°C), and it is likely that in the future the temperature will be lowered to this level. A second, larger vault operating at the more moderate temperature of 60°F (15.6°C) and 40% RH contains all of the black-and-white photographs in the collection.

dehumidifiers have been installed in most of the photographic cold storage facilities built in the United States during the past 10 years.

A number of institutions, including the Art Institute of Chicago and the Peabody Museum of Archaeology and Ethnology at Harvard University (see below), have reported failures with the reactivation heaters in Cargocaire dehumidifiers. Reactivation heaters drive moisture off the rotating lithium-chloride-impregnated wheel in the Cargocaire units — when the heaters fail, the dehumidifiers cease to function. Humidity control in the vault will be lost and, unless backup dehumidifiers have been installed, the vault will have to be shut down until repairs are made.

Cargocaire acknowledged the problems with the reactivation heaters and introduced several redesigned models in 1989 which, according to the company, should prove to be far more reliable in cold storage applications (for further discussion, see Chapter 16).

### Cold Storage Vaults Must Have a Fail-Safe Automatic Shutdown System

It is *essential* that cold storage facilities be equipped with a fail-safe shutdown system to cut off all electrical

power to refrigeration equipment, dehumidifiers, air make-up fans, door-frame heaters, lights, and all other electrical equipment in a vault, should either the temperature or relative humidity exceed pre-set upper or lower limits. The shutdown limits should be set somewhat outside of the maximum temperature and humidity fluctuations observed in normal operation. The limits should be sufficiently wide so that the system does not unnecessarily shut down when, for example, the vault is frequently entered and exited during a short period.

The shutdown system should sound an alarm when activated and *must* operate independently and be separate from the controls that normally regulate vault temperature and relative humidity, or that are incorporated in dehumidifiers and other equipment. To make certain the shutdown system is functioning properly, it should be tested periodically by separately forcing temperature and relative humidity levels in the vault to exceed the pre-set upper and lower limits. With total system shutdown, failure of a dehumidifier, for example, will not result in the relative humidity inside the vault reaching dangerously high levels.

If a vault shuts down, the door should remain closed until the interior temperature rises to that of the ambient room temperature (during this period the materials stored

in the vault are in no danger — as long as the doors are left shut during the warm-up period, the interior relative humidity will probably even drop somewhat as the air temperature rises to ambient conditions).

## When a Dehumidifier Failed and the Relative Humidity Went Out of Control at Harvard's Peabody Museum

The importance of a total-shutdown system was dramatically illustrated to Daniel W. Jones, Jr., photographic archivist at Harvard University's Peabody Museum of Archaeology and Ethnology, when, during a hot and humid July weekend, the Cargocaire dehumidifier in the vault ceased to function (the vault normally operates at 35°F [1.7°C] and 25% RH). Improper wiring in the vault control circuitry caused a failure in the vault's supposed "fail-safe" shutdown system, and the refrigeration compressors continued to cool the vault. According to Jones, "The warm and humid makeup air kept coming in and the walls inside the vault became dripping wet. When I came in and saw the mess, I was mortified."[18]

Fortunately, the malfunction was detected before damage was done to the collection. Some of the motion picture film cans in the vault became rusted, but the films inside were not harmed. Color slides mounted in slide pages inside of cardboard boxes were also spared from damage.

The defects in the control system have since been corrected and Jones says that now, "If anything goes awry, the whole system shuts down."

Jones stressed the need to periodically test vault control systems in various failure modes, saying that with the Peabody vault, "Nobody had ever put it through its paces to see what would happen." He also advised that a *single* contractor be hired to perform all aspects of the vault installation, doing both the mechanical and electrical work. "When you get a lot of subcontractors involved, you greatly increase the chances of things going wrong."

## Cost of Complete Cold Storage Installations

Most of the museum and archive cold storage vaults constructed in the past few years have cost between $35,000 and $125,000. Harris Environmental Systems, Inc., which built the storage vaults at the John Fitzgerald Kennedy Library, the Art Institute of Chicago, the Peabody Museum, and a number of other institutions, gives the following price estimates for complete installed systems:[19]

- About $42,000 for a 12x12–foot vault with dual refrigeration equipment, and a single 150 CFM (cubic feet per minute) dehumidifier — capable of maintaining 38°F (3.3°C) and 30% RH. Operating costs are estimated at about $285 per month.

- About $55,000 for a 12x12–foot vault with dual refrigeration equipment, a higher-capacity dehumidifier, and a vault air lock — capable of maintaining 0°F (–18°C) and 30% RH. Operating costs are estimated at about $410 per month.

- About $125,000 for a 25x25–foot vault with dual refrigeration equipment, a 500 CFM dehumidifier, and a tem-

February 1983

Cargocaire dry-desiccant dehumidifiers and refrigeration compressors for the Art Institute facility are located in a room adjacent to the vaults. Two compressors are used for each vault; the compressors operate in a redundant mode and if one of the units should fail, the other automatically takes over.

perature- and humidity-controlled vestibule — capable of maintaining 0°F (–18°C) and 30% RH. Operating costs are estimated at about $1,250 per month.

As can be seen by comparing the first two examples, the cost of building and operating a 0°F (–18°C) vault is not much greater than the cost of a 38°F (3.3°C) vault. The colder storage temperature, however, can add *thousands of years* to the useful life of color films and prints. From a cost-effectiveness point of view — given the cultural and monetary worth of most photographic collections — it would seem foolish to build the higher-temperature facility simply to save a little money.

## Access to Materials in Cold Storage

Materials to be stored in a humidity-controlled low-temperature vault should be placed in boxes, portfolio cases, motion picture film cans, and other types of containers that are suitable for the long-term storage of photographs (see Chapter 15). Vapor-proof packing is not necessary,

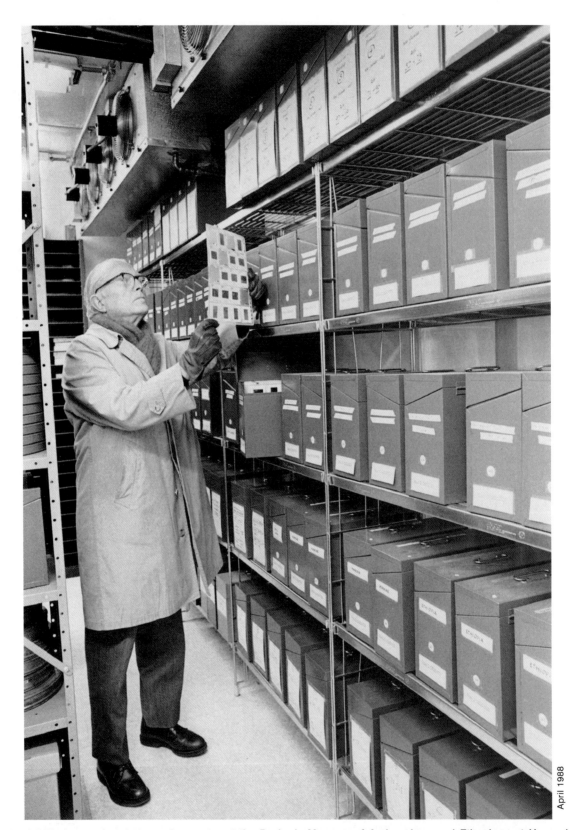

Daniel W. Jones, Jr., photography curator at the Peabody Museum of Archaeology and Ethnology at Harvard University in Cambridge, Massachusetts, looking at a page of color slides in the Museum's cold storage vault (35°F [1.7°C] and 25% RH). Completed in 1979, this was the first example of a humidity-controlled cold storage vault for photographs to be built at an educational institution. For a description of the Peabody's innovative method for making compact color reference copies of the slides kept in the vault, see Chapter 18 (page 638).

Jones changes the charts in the recorder for temperature and humidity in the control panel outside the vault door.

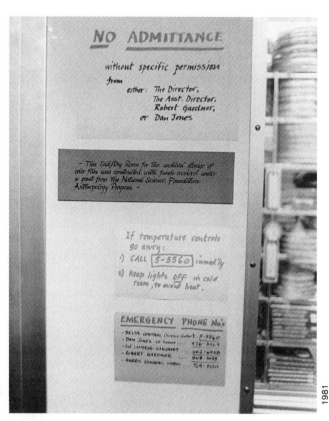

Signs on the vault door. The vault was constructed with a grant from the National Science Foundation.

and under normal circumstances should not be used. Packages can be put in ordinary polyethylene bags if desired. Cans of motion picture films should be placed horizontally on shelves, with not more than ten cans in a stack.

When a package is removed from a vault, it must be protected from moisture condensation until it has warmed to room temperature — or at least until it has warmed above the dew point of the ambient air. Internal warm-up times from 0°F (–18°C) to room temperature for a number of different types of packages are given in **Table 20.2** on page 715. With a walk-in cold storage vault, a supply of polyethylene bags can be kept inside the vault for wrapping packages. Ziploc bags, which can be quickly sealed with the top-locking seam, are handy for this purpose.

A package or can of motion picture film should be placed in a polyethylene bag during warm-up even if the package itself is adequate for protecting its contents from moisture. Moisture condensation on a steel film can will produce rust in areas where the can has been scratched or abraded. Moisture can also harm package labels, cause ink to run or smear, and lead to other damage.

With proper planning, most institutions will find it practical to accumulate requests for material from the vault during each working day and then to remove all the material to the warm-up area at the end of the day. By the next morning, all except very large packages will have warmed to ambient conditions and can be opened. Smaller packages (e.g., a single print or 35mm slide in a plastic bag), which have very short warm-up times, can be available for use almost immediately upon removal from cold storage.

## Zero-Degree F (–18°C), Humidity-Controlled Cold Storage Facilities for the Permanent Preservation of Color and B&W Motion Pictures and Still-Camera Photographs

At the time this book went to press in 1992, institutions in the United States and Canada with cold storage facilities that were operating (or planned) with the temperature and relative humidity conditions recommended by this author for the permanent preservation of color and black-and-white photographic materials included:

• **The John Fitzgerald Kennedy Library** in Boston, Massachusetts. This was the first collecting institution in the world to have a humidity-controlled, low-temperature storage facility. Opened in 1979, the Kennedy Library vault operates at 0°F (–18°C) and 30% RH (an outer vestibule is maintained at about 55°F [12.8°C] and 30% RH). The thirty-fifth President of the United States, John F. Kennedy was in office from 1961 until November 22, 1963, when he was assassinated in Dallas, Texas.

• **The National Aeronautics and Space Administration (NASA)** at the Lyndon B. Johnson Space Center in Houston, Texas. A color film storage vault maintained at 0°F (–18°C) and 20% RH was constructed in 1982, replacing a facility built in 1963 which was operated at 55°F (12.8°C) and 50% RH. In 1987, two new 0°F (–18°C) and 20% RH vaults were constructed — one located in a remote corner of the Johnson Space Center in Houston and the other at

the NASA test facility in White Sands, New Mexico. These two vaults house duplicate sets of the more than 150,000 feet of spaceflight originals preserved in the primary NASA vault. These off-site duplicates serve as backups to insure that the color images of the first humans to set foot on the moon during the Apollo 11 mission in 1969, and other priceless still photographs and motion pictures from space, will not be lost in the event of fire, tornado, earthquake, war, sabotage, theft, or other disaster.

NASA has also made sets of polyester-base black-and-white separations from color films made during space missions that took place from 1961 until 1975 (see page 323); these separations are stored at 70°F (21°C) and 50% RH in a separate building located in NASA's Houston complex.

• **The Historic New Orleans Collection,** in New Orleans, Louisiana. Completed in 1987, one vault is used to store color photographs, early safety-base film, and cellulose nitrate negatives and is maintained at 0°F (–18°C) and 30% RH. A second, larger vault, kept at 30°F (–1.1°C) and 30% RH, is for storage of modern black-and-white prints and safety-base film.

• **The Jimmy Carter Library** at the Jimmy Carter Presidential Center, in Atlanta, Georgia. A vault maintained at 0°F (–18°C) and 30% RH is provided for color negatives, transparencies, and motion pictures; the vault was placed in operation in 1990. Another vault, which began operation in 1987, is kept at 55°F (13°C) and 30% RH and is used to store black-and-white materials and replaceable color films and prints. The thirty-ninth President of the United States, Jimmy Carter was in office from 1977 to 1981. The Jimmy Carter Library opened in 1986. (Carter and his wife Rosalynn are residents of Plains, Georgia.)

• **The National Archives of Canada – Moving Image, Data and Audio Conservation Division,** in Gatineau, Quebec. In late 1996 the National Archives of Canada will open a new Archives building in Gatineau, near Ottawa, that is to include what will probably be the world's best large-scale motion picture and color photography preservation facility. A large vault maintained at 0°F (–18°C) and 25% RH will be provided for the Archives' vast collection of color and black-and-white motion pictures; the vault will also be used for still photographic materials and to preserve selected paper documents.

Other temperature- and humidity-controlled vaults will be provided for storage of audio materials, videotapes, and computer tapes, disks, and other EDP records. A separate storage area maintained at 65.5°F (18°C) and 50% RH will be used to store oil paintings. In all, the new building will have eight separate controlled-environment zones, each of which will meet specific requirements for temperature and relative humidity. A sophisticated air-filtration system will keep airborne contaminants at low levels in all storage and laboratory areas.

The new National Archives of Canada facility, which will establish new standards for motion picture preservation in film libraries, archives, and museums worldwide, will replace the present 28°F (–2.2°C) and 28% RH color film storage vault located in Ottawa. The current National Archives of Canada motion picture film storage facility is discussed elsewhere in this chapter and in Chapter 9.

## Table 20. 2  Approximate Warm-Up Times to Room Temperature for Various Types of Packages

| Type of Package | From 0°F to 75°F (–18°C to 24°C) | From 35°F to 75°F (1.7°C to 24°C) |
|---|---|---|
| 36-exp. box of slides in Kodak paper box | 1 hour | 45 min. |
| Single slide or negative strip in polyester or acetate sleeve | 8 min. | 5 min. |
| Envelope with 6 strips of 35mm film in polyester or acetate sleeves inside envelope | 20 min. | 15 min. |
| 1,000-ft. reel of 35mm motion picture film in metal film can | 5 hours | 3 hours |
| 1,000-ft. reel of 16mm motion picture film in metal film can | 2 hours | 1½ hours |
| 10 paper prints in flat cardboard box | 1½ hours | 1 hour |
| 100 paper prints in flat cardboard box | 5 hours | 3 hours |

Approximate warm-up times are for single containers of the types listed, with the container wrapped in a single-layer polyethylene bag to prevent moisture condensation on the package during warm-up and placed on a table so air can freely circulate around the container. Do not stack containers during the warm-up period unless much longer warm-up times are provided. The listed times will allow the package to warm up to a temperature above the dew point of air at 75°F (24°C) and a relative humidity not above 60%; somewhat longer warm-up times may be needed if more humid conditions are present in the work or study area.

## Medium-Temperature, 25° to 45°F (–3.9° to 7.2°C) Humidity-Controlled Cold Storage Facilities for the Long-Term Preservation of Color and B&W Motion Pictures and Still-Camera Photographs

Institutions in the U.S. and Canada with medium-temperature, humidity-controlled cold storage facilities include:

• **The Lyndon Baines Johnson Library** in Austin, Texas. The photographic storage vault for color films and prints in the Library's collections is maintained at 45°F (7.2°C) and 50% RH. Lyndon B. Johnson served as Vice-President under President John F. Kennedy. Johnson became the thirty-sixth President of the United States after Kennedy was assassinated on November 22, 1963; Johnson continued to serve as president until 1969. The Lyndon Baines Johnson Library, located on the campus of the University of Texas in Austin, opened in 1971. Johnson died in 1973.

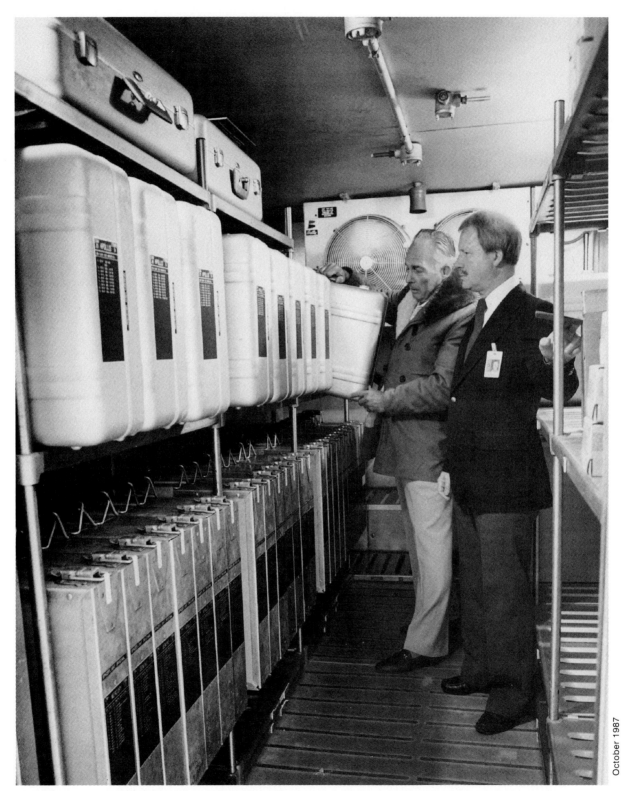

October 1987

NASA staff members Frank Zehentner (left) and Terry Slezak prepare to remove an aluminum case containing rolls of original color film from the primary NASA humidity-controlled cold storage vault built for the permanent preservation of spaceflight films. This is one of the two vaults maintained at 0°F (–18°C) and 20% RH located at the NASA facility in Houston, Texas; the other vault, situated in a remote corner of the NASA property, is used to store a complete duplicate set of the films, together with written documentation. A third NASA vault at the White Sands Missile Range in New Mexico, which also operates at 0°F (–18°C) and 20% RH, houses a second duplicate set of backup copies and documentation of the spaceflight films. See Chapter 9 for additional information on NASA's outstanding preservation program for color materials.

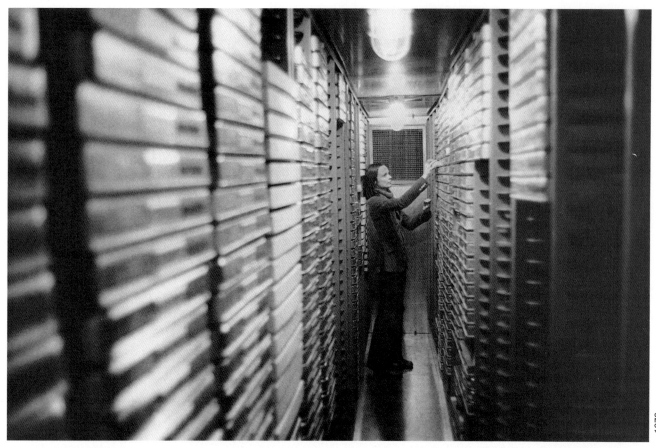

1978

The cold storage vault at the National Anthropological Film Center at the Smithsonian Institution in Washington, D.C. Constructed in 1975 under the guidance of E. Richard Sorenson, at the time the director of the center, the vault operated at 39°F (3.4°C), and a dry-desiccant dehumidifier was used to keep the relative humidity at 50%. In 1985 the archive was moved to a different location in the Smithsonian and is now called the Human Studies Film Archive (35°F [1.7°C] and 25% RH). The original 1975 vault is pictured here. Most of the film in the vault is 16mm Eastman Color Negative Film 7247 which, when stored at room temperature, has very poor image stability. This vault, and the cold storage facility at the Cinematheque Quebecoise in Montreal, Quebec, also completed in 1975, are believed to have been the first humidity-controlled cold storage vaults for color film constructed anywhere in the world.

• **The Human Studies Film Archive**, Smithsonian Institution, in Washington, D.C. A storage vault built in 1975 and operated at 39°F (3.4°C) and 50% RH was replaced in 1985 by a new vault in a different building which is maintained at 35°F (1.7°C) and 25% RH. The Human Studies Film Archive was formerly known as the National Anthropological Film Center. The original 1975 vault, and the Cinematheque Quebecoise facility described below, also completed in 1975, are believed to have been the first humidity-controlled cold storage vaults for color film constructed anywhere in the world.

• **The Cinematheque Quebecoise** in Montreal, Quebec. In 1975 the Cinematheque began operation of a cold storage facility for motion picture film. A vault maintained at 35°F (1.7°C) and 35% RH is provided for color films, and other vaults operating at 50°F (10°C) and 50% RH are used for cellulose nitrate films and black-and-white safety films.

• **The Library of Congress** in Landover, Maryland. Located in Maryland just outside of Washington, D.C., this large facility was opened in 1978. The vault for color materials (mostly motion picture film) is operated at 37°F (2.8°C)

and 25% RH. Three additional vaults capable of housing between 150,000 and 175,000 cans of 35mm motion picture film were constructed in 1986. These vaults are used to store black-and-white motion picture film and operate at 55°F (12.8°C) and 25% RH. The Library of Congress also operates a storage facility for cellulose nitrate motion picture film at Wright-Patterson Air Force Base near Dayton, Ohio (see **Appendix 19.1** at the end of Chapter 19).

• **The Peabody Museum of Archaeology and Ethnology at Harvard University** in Cambridge, Massachusetts. Constructed in 1979 with the aid of a grant from the National Science Foundation, the vault is used for storing color slides and color motion pictures and is maintained at 35°F (1.7°C) and 25% RH.

• **The Gerald R. Ford Library**, on the campus of the University of Michigan in Ann Arbor, Michigan. Opened in 1981, the cold storage vault is maintained at 40°F (4.4°C) and 40% RH; all films in the collection, including black-and-white negatives, color negatives, and color transparencies, are stored in the vault. Gerald Ford, the thirty-eighth President of the United States, had served as Vice-President

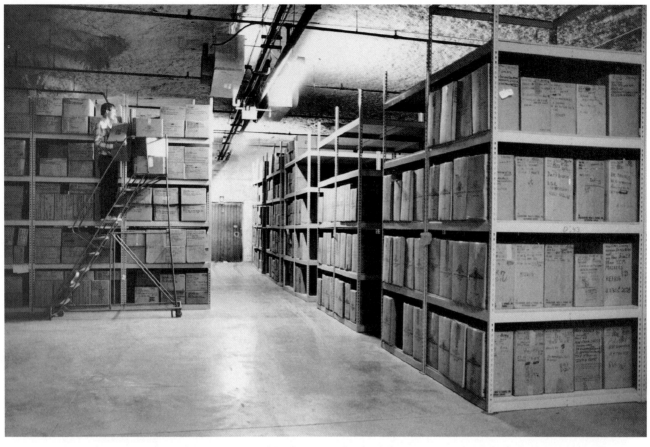

October 1987

The Records Center of Kansas City (a division of Underground Vaults & Storage, Inc. of Hutchinson, Kansas) operates a cold storage facility maintained at 38°F (3.3°C) and 40% RH in an inactive portion of a huge underground limestone mine on the outskirts of Kansas City, Missouri, and rents space at moderate cost. Among the collections stored in the high-security facility is the backup color film archive for the Los Angeles based Turner Entertainment Co. Film Library, which includes original color negatives, interpositives, and other pre-print elements for such films as **Gone With the Wind, 2001: A Space Odyssey, The Wizard of Oz, The Maltese Falcon, Ben Hur**, and other classics (see Chapter 9).  Black-and-white separations (YCM's), sound negatives, and other black-and-white film elements from the Turner Entertainment Co. Film Library are stored in the Underground Vaults & Storage, Inc. high-security underground facility in Hutchinson, Kansas.

under Richard M. Nixon.  Ford became president upon the resignation of Nixon on August 9, 1974 because of the "Watergate" scandal; Ford served as president until 1977.

• **The Art Institute of Chicago** in Chicago, Illinois.  The cold storage vault, constructed in 1982, was the first facility of its kind in an art museum.  The vault was designed to maintain a temperature of 0°F (–18°C) and a relative humidity of 20 to 40%.  However, at the time this book went to press in 1992, the unit was being operated at 40°F (4.4°C) and 40% RH to make access to the color prints stored in the vault more convenient for the curatorial staff.  At some point in the future, however, the temperature of the vault probably will be lowered to 0°F (–18°C).  Adjacent to the low-temperature vault is a larger vault housing all of the black-and-white collection; this vault is maintained at 60°F (15.6°C) and 40% RH.

• **The Smithsonian Institution, Photographic Services Department,** in Washington, D.C.  Constructed in 1982 and operated at 40°F (4.4°C) and 27% RH, the cold storage vault houses the large collection of color transparencies and negatives produced by the staff of the Photographic Ser-

vices Department.  The vault is also used for storing modern black-and-white negatives as well as duplicate negatives made from cellulose-nitrate-base negatives (the nitrate originals were disposed of after duplication).  The vault was expanded in 1992.  (Note: The Photographic Services Department is not part of the Smithsonian's Division of Photographic History, which, at the time this book went to press in 1992, did not have a cold storage facility for its important collection of color photographs.)

• **Time Inc. Magazines Picture Collection**, Rockefeller Center, in New York City.  Constructed in 1983 and designed to operate at 0°F (–18°C) and 30% RH, the vault provisionally is being operated at 60°F [15.6°C] and 35% RH to simplify access.  The facility is used by the Picture Collection to store the more than one million 35mm slides and roll and sheet film color transparencies from *Time, Sports Illustrated, Life, People, Fortune,* and other Time Inc. magazines; some of the transparencies date back to the 1930's.  (Time Inc. Magazines is a part of Time Warner Inc.)

• **The San Diego Historical Society** in San Diego, California.  A cold storage vault for color materials, early safety

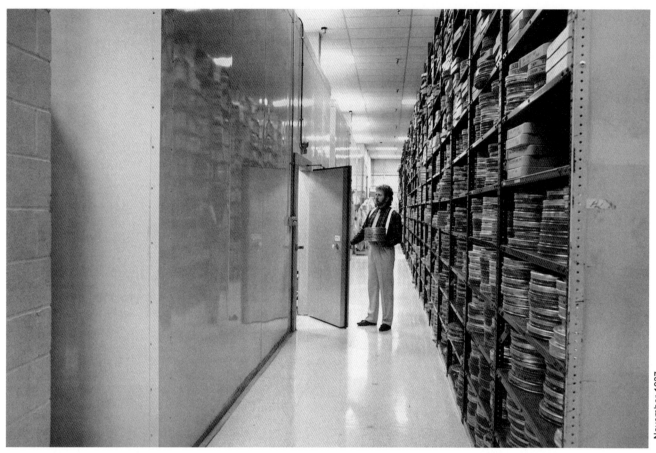

November 1987

National Archives and Records Administration staff member Frank Stephens entering one of the three large humidity-controlled cold-storage vaults for motion pictures at the National Archives' temporary facility in Alexandria, Virginia, just across the Potomac River from Washington, D.C. Two of the vaults, for color motion pictures, are maintained at 35°F (1.7°C) and 30% RH; the third vault, for black-and-white films, is kept at 50°F (10°C) and 30% RH.

films, and cellulose nitrate negatives is maintained at 55°F (12.8°C) and 40% RH; the vault was constructed in 1983 under the direction of Larry and Jane Booth of the Historical Society.

• **Stokes Imaging Services** in Austin, Texas. With a cold storage facility operating at 45°F (7.2°C) and 35% RH, Stokes is believed to be the only commercial color processing lab in the world with a humidity-controlled cold storage vault for storage of processed color negatives, internegatives, and transparencies. The vault was constructed in 1983.

• **The National Archives and Records Administration** in Alexandria, Virginia (across the Potomac River from Washington, D.C.). This large storage facility constructed in 1985 consists of two vaults maintained at 35°F (1.7°C) and 30% RH, and one vault kept at 50°F (10°C) and 30% RH. In December 1993 the National Archives will open a large new facility (to be called Archives II) in nearby College Park, Maryland. Color motion pictures will be stored at 25°F (–3.9°C) and 30% RH in the new building. Color still photographs will be stored at 38°F (3.3°C) and 35% RH; general storage for black-and-white prints, negatives, and glass plate negatives will be maintained at 65°F (18.3°C) and 35% RH. After the move to College Park is completed, the Alexandria cold storage facility will be closed.

• **Records Center of Kansas City** (a division of Underground Vaults & Storage, Inc.)[20] in Kansas City, Missouri. Located in a high-security complex constructed 175 feet below ground in a worked-out section of a huge limestone mine on the outskirts of Kansas City, RCKC operates a large refrigerated vault, constructed in 1986, that maintains a temperature of 38°F (3.3°C) and 40% RH. For small amounts of film or other material, space in the Kansas City vault is rented for $5 per cubic foot per year; the cost is reduced to $3 per cubic foot per year when 2,500 cubic feet or more of space is rented. RCKC handles retrievals, shipping, and refiling of stored materials.

Among the materials stored in the Kansas City cold storage vault are original color negatives, interpositives, and other color pre-print elements for films in the Turner Entertainment Co. Film Library that was acquired when Turner Broadcasting System Inc. purchased MGM/UA in 1986 (retaining the film library, Turner subsequently sold most of the other assets acquired in the purchase; MGM Communications Inc. now operates as an independent company). The Turner Entertainment Co. Film Library, which is valued at more than *$1 billion*, now contains more than 3,300 feature films, including such motion picture classics as *Gone With the Wind, Casablanca, The Maltese Falcon, 2001: A Space Odyssey, Ben Hur*, and *The Wizard of Oz*.

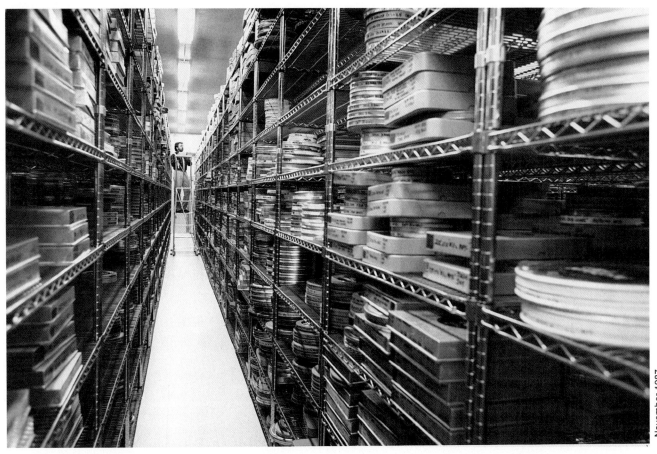

November 1987

The three National Archives cold storage vaults were constructed in 1984 in a rented building. Film storage will be relocated to the new National Archives and Records Administration facility located 8 miles northeast of Washington D.C. in College Park, Maryland; it is scheduled to open in December 1993. The National Archives has been designated as the eventual repository for much of the motion picture film, still photographs, and videotapes produced by U.S. government agencies.

• **The National Archives of Canada – Moving Image, Data and Audio Conservation Division**, in Ottawa, Ontario. In 1986 the Conservation Division of the National Archives (at the time known as the Public Archives of Canada) constructed a color motion picture storage vault which maintains a temperature of 28°F (–2.2°C) and 28% RH. As discussed on page 715, in 1996 the National Archives will open a large new facility in nearby Gatineau, Quebec, that will provide 0°F (–18°C) and 25% RH storage for its vast collection of motion pictures and still-camera photographs.

• **The Arthur M. Sackler Gallery and the Freer Gallery of Art**, Smithsonian Institution, in Washington, D.C. Constructed in 1987, the cold storage vault was designed to maintain 40°F (4.4°C) and 30% RH. The vault serves both the Sackler Gallery and the Freer Gallery.

• **The National Museum of African Art**, Smithsonian Institution, in Washington, D.C. Constructed in 1987, the cold storage vault is maintained at 42°F (5.6°C) and 28% RH. Color and black-and-white motion pictures, 35mm color slides, black-and-white negatives, glass lantern slides, and videotapes are stored in the facility.

• **The National Gallery of Canada** in Ottawa, Ontario. For preservation of the National Gallery Photograph Collection, two temperature- and humidity-controlled vaults were provided in the new National Gallery building, completed in 1988. For storage of 19th-century prints and contemporary black-and-white photographs, one vault is maintained at 59°F (15°C) and 40% RH; for storing color materials, a smaller vault operates at 39°F (4°C) and 40% RH.

• **The Canadian Centre for Architecture** in Montreal, Quebec. With construction of its new building completed in 1988, the Centre has two temperature- and humidity-controlled vaults for its photographic collection. The larger vault, for black-and-white materials, is maintained at 55°F (12.8°C) and 40% RH. A smaller vault for storing chromogenic color prints is kept at 40°F (4.4°C) and 40% RH.

• **National Underground Storage, Inc.** in Boyers, Pennsylvania.[21] Located in an abandoned limestone mine 220 feet below the hills of western Pennsylvania 57 miles north of Pittsburgh, National Underground Storage provides commercial and governmental clients with high-security storage for vital records. Rental space for color and black-and-white motion picture films and other photographic materials is available in vaults maintained at 40°F (4.4°C) and 25% RH and 50°F (10°C) and 35% RH. Some private clients have their own film storage vaults in the underground facility, and at least one well-known movie director stores film here

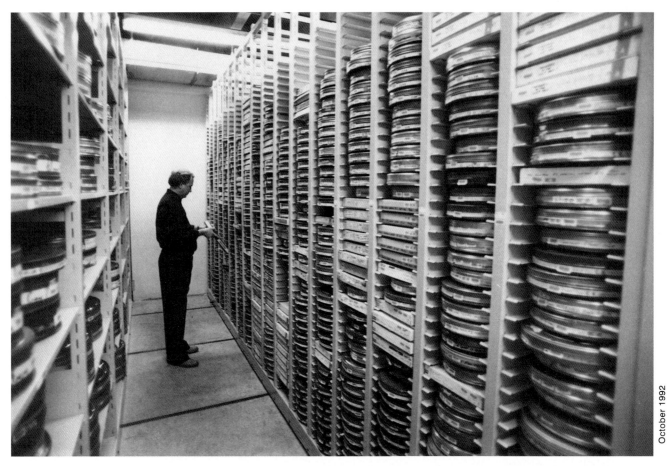

October 1992

The color film storage vault in the Paramount Pictures Film and Tape Archive, located on the Paramount Pictures studio lot on Melrose Avenue in Hollywood. The color film vault, one of nine vaults in the high-security building, is maintained at 40°F (4.4°C) and 25% RH. The Paramount archive building, which was Hollywood's first adequate preservation facility for color motion pictures, went into operation in June 1990. Shown here in a section of the color film vault, which is equipped with movable shelving to conserve space, is Robert McCracken, a supervisor in Archive Operations. McCracken and Bill Weber, Director of Operations Resources at Paramount, manage the operation of the multi-million dollar, 40,000-square-foot facility. See Chapter 9 for further discussion of the motion picture preservation program at Paramount Pictures.

in a vault kept at 0°F (–18°C). The Social Security Administration, the U.S. Patent Office, the National Archives, and other government agencies store vast quantities of microfilm and other types of records at National Underground Storage. It is also a high-security repository for black-and-white separations (YCM's) and other backup film elements for many of the major Hollywood movie studios.

• **Paramount Pictures** in Hollywood, California. In June 1990, Paramount Pictures began operating a new cold storage facility on its Melrose Avenue studio lot in Hollywood for the preservation of its vast film and videotape collection. Consisting of nine vaults, which operate at different temperature and humidity conditions depending upon the film or videotape elements stored in them and how long it is expected that the items will be retained, the facility currently houses over 270,000 reels of motion picture film, as well as a huge amount of videotape from television productions. The facility, which was built at the behest of former Paramount studio head Frank Mancuso, was designed with enough space to accommodate Paramount's expected film and videotape production for the next 20 years.

Color film intended for long-term keeping is stored at 40°F (4.4°C) and 25% RH. Black-and-white films are stored at either 50°F (10°C) and 40% RH for long-term keeping, or 60°F (15.5°C) and 50% RH for medium-term keeping. Paramount is continuing its policy of making a set of fully timed separations (YCM's) for all of its feature films.

Like most other Hollywood studios, Paramount has a strict policy of dividing the various preprint elements for a given film between two or more geographic locations. For example, an original camera negative is kept in Paramount's Hollywood cold storage vault, and the separations are stored in a high-security underground storage facility on the east coast. In recent years the Hollywood studios have become acutely aware of the potential for catastrophic loss of their irreplaceable collections because of fires, earthquakes, or other disasters. The Paramount Pictures cold storage facility is discussed in more detail in Chapter 9.

• **Ronald Reagan Library**, Simi Valley/Thousand Oaks, California. A vault maintained at 35°F (1.7°C) and 45% RH is used for storage of color negatives, black-and-white negatives, color transparencies, and color and black-and-white

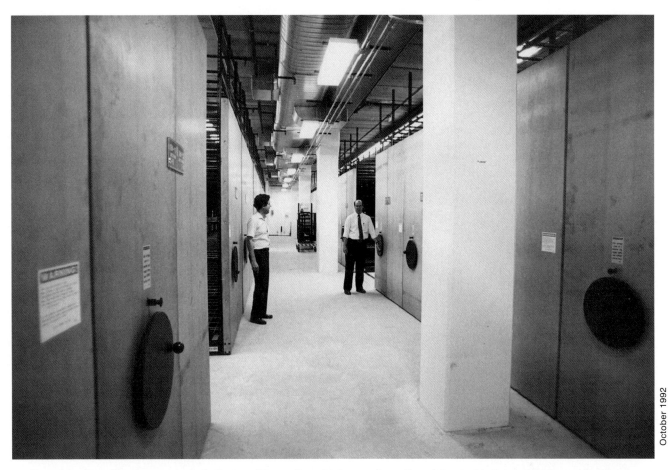

October 1992

One of the three film storage vaults in the new Warner Bros. high-security motion picture cold storage building on the Warner Bros. studio lot in Burbank, California. The color film vault, which is maintained at 35°F (1.7°C) and 25% RH, and the other vaults were operating and in the final phase of testing when this photograph was taken on October 8, 1992. Warner Bros. began moving its film collection into the vaults a few weeks later. Shown here in the larger black-and-white film vault, which, like the two other vaults in the building, is equipped with movable shelving that permits high-density film loading, are John Belknap, manager of Film Vaults/Assets, and Bill Hartman, manager of Asset Inventory Management and Research in Corporate Film Video Services at Warner Bros. The $9-million cold storage facility was designed under the direction of Peter R. Gardiner, vice president of Operations in Corporate Film Video Services at Warner Bros. (a division of Time Warner Inc.). See Chapter 9 for additional discussion of the film preservation program at Warner Bros.

motion picture films (some of which date back to the 1950's). Videotapes, audiotapes, replaceable motion picture prints, and black-and-white prints are kept in a second vault maintained at 60°F (15.6°C) and 45% RH. Manuscripts, books, magazines, newspapers, and other paper documents are stored at 70°F (21.1°C) and 45% RH. The Reagan Library collection includes 1,560,000 still photographs; 88,000 feet of motion picture film; 20,000 videotapes; 22,000 audiotapes; 47 million pages (23,500 linear feet) of manuscripts; 15,000 books; and 25,000 serial publications and other items. Ronald Reagan, who was the fortieth President of the United States, was in office from 1981 until 1989. The Reagan Library was opened in 1991.

• **Warner Bros.**, Burbank, California. The Warner Bros. motion picture studio opened a new high-security cold storage facility on its Burbank studio lot in October 1992 (Burbank is adjacent to Hollywood, just north of Los Angeles). The sophisticated Warner Bros. facility consists of three vaults, one of which is for color film and is maintained at 35°F

(1.7°C) and 25% RH. A second vault is used for separations (YCM's) and other black-and-white materials and is maintained at 45°F (7.2°C) and 25% RH. The third vault is used to store less-critical duplicate film elements and circulating materials and is kept at 50°F (10°C) and 45% RH. An advanced air-filtration system is provided to remove any acetic acid or other gases resulting from film degradation, from Los Angeles air pollution, or from other sources.

Like Paramount Pictures, Warner Bros. has for a long time stored sets of black-and-white separations (YCM's) for each of its feature films in a high-security underground storage facility in Pennsylvania. Warner Bros. is a part of Time Warner Inc. which, with its Home Box Office (HBO) movie service for cable TV subscribers, a far-flung cable TV system, and extensive magazine publishing operations, is the world's largest entertainment company. The architect for the Warner Bros. film storage building was Archisystems International, of Santa Monica, California.[22] As was the case with the Paramount Film and Tape Archives building, the general contractor for the Warner Bros.

facility was Turner Construction Company, which is based in New York City (see **Suppliers** list on page 726 at the end of this chapter). The Warner Bros. motion picture preservation facility is discussed in more detail in Chapter 9.

• **Eastman Kodak Company**, Hollywood, California. In May 1993, Eastman Kodak will open a new building adjacent to the company's Hollywood Marketing and Technology Center that will include three motion picture film storage vaults, totaling 12,000 square feet, in which space will be available on a rental basis.[23] Two of the vaults will be maintained at 45°F (7.2°C) and 25% RH; the third vault will operate at 32°F (0°C) and 25% RH. Operation of a film storage rental facility is a new type of business for Kodak. In announcing the new cold storage facility, Kodak said, "We expect to identify and develop products, practices, and services for asset protection of images and sound originated on motion picture film and magnetic media."

• **The Richard M. Nixon Presidential Materials Project**, under the auspices of the Office of Presidential Libraries of the National Archives and Records Administration in Washington, D.C. Richard M. Nixon, the thirty-seventh President of the United States, held office from 1969 until he resigned on August 9, 1974 because of the "Watergate" scandal. The controversy surrounding his administration and the legal proceedings that began while he was still president and continued after his resignation effectively prevented the establishment of a presidential library for Nixon along the lines of those built for Kennedy, Johnson, Ford, Carter, and Reagan.

Traditionally, the construction of a presidential library is financed with privately raised funds, and the project generally is completed within a few years after a president leaves office. The Ronald Reagan Library, for example, cost $40 million and was completed in less than 3 years after Reagan left office in 1989. Although construction is privately financed, after completion the presidential libraries are maintained and operated by the National Archives and Records Administration through its Office of Presidential Libraries.

At the time this book went to press in 1992, there were nine presidential libraries, the oldest being the Franklin D. Roosevelt Library, which is located in Hyde Park, New York, and was dedicated in 1941. Franklin Roosevelt was the thirty-second President of the United States and was in office from 1933 until 1945. Hyde Park was Roosevelt's birthplace. There is also a presidential library for Herbert Hoover, who was the thirty-first President of the United States. Hoover, who was in office from 1929 until 1933, died in 1964. Located at Hoover's birthplace in West Branch, Iowa, the Herbert Hoover Library was not dedicated until 1962, many years after the Roosevelt Library was established. Presidential libraries are usually located in the president's home state.

In the case of President Nixon, the photographs, motion pictures, audiotapes, videotapes, and manuscripts from the White House years were retained by the government and are handled by the Nixon Presidential Materials Staff in the Office of Presidential Libraries of the National Archives. The materials have been stored at 70°F (21°C) and 50% RH in a building in Alexandria, Virginia, across the Potomac

River from Washington, D.C. All of the original color negatives, color transparencies, black-and-white negatives, audiotapes, and many of the videotapes have been duplicated for reference and study purposes. In 1993 the Nixon materials will be transferred to the new National Archives and Records Administration building in nearby College Park, Maryland. There, the color still photographs will be placed in a cold storage vault maintained at 38°F (3.3°C) and 35% RH. Color and black-and-white motion pictures will be stored at 25°F (–3.9°C) and 30% RH.

Many duplicate White House photographs have been supplied by private collections to the Richard Nixon Library & Birthplace, a privately constructed and administered museum and archive in Yorba Linda, California that opened in 1990. This library, which is not part of the federally administered presidential libraries program, also contains an extensive collection of photographs, manuscripts, and other materials that predate Nixon's presidency. Additional materials from the years following his resignation in 1974 continue to be added to the collection.

• **Future libraries for President George Bush and President Bill Clinton.** George Bush, the forty-first President of the United States and in office from 1989 until 1993, will have a library dedicated in his honor in Texas. Bill Clinton, who will be inaugurated as the forty-second President of the United States on January 20, 1993, is expected to have a library established in Arkansas after he leaves office. Both of these future presidential libraries are almost certain to include low-temperature, humidity-controlled cold storage facilities to preserve their collections of color and black-and-white still photographs, videotapes, audio tapes, and motion pictures.

• **The J. Paul Getty Museum**, Malibu, California. The Getty Museum is constructing a new museum complex in Brentwood (near Los Angeles), and tentative plans call for a 40°F (4.4°C) and 40% RH cold storage vault to be provided for the color photographs in its collection. The new building is scheduled for completion in 1996. At the time this book went to press in 1992, the museum's collection of mostly black-and-white photographs was being temporarily housed in an office building in Santa Monica, California; the temperature in the photograph storage area is maintained at 68°F (20°C) and 40% RH.

In keeping with the collecting philosophy of the Getty Museum, which is generally to refrain from acquiring contemporary art, the museum's Department of Photographs has purchased mostly 19th-century photographs and 20th-century photographs up until around 1950. Because color photography did not gain serious attention in the fine art world until the 1970's, the Getty collection, focused as it is on earlier black-and-white periods, presently contains comparatively few color photographs.

The Getty's modest collection of contemporary color photographs came into the museum as a result of the purchase of several major private collections in 1984, such as those of Chicago collector Arnold Crane and the late New York City collector Samuel Wagstaff. Weston J. Naef, Curator of the museum's Department of Photographs, acknowledges that contemporary photographs presently are not a high priority for his department in terms of new

acquisitions, but he says that this emphasis could change in the future.[24] The Getty Museum, as a beneficiary of the J. Paul Getty Trust, is said to have the largest acquisitions and conservation budget of any art museum in the world. Also supported by the Getty Trust is the Getty Conservation Institute, a major center for conservation research located in Marina del Rey, California.

## Cold Storage Facilities in Other Countries

Cold storage facilities for preserving color motion pictures and still photographs are also found in a number of other countries, including England, Germany, Japan, Norway, Russia, and Sweden. It is not possible to describe most of them here.

In 1970, the Swedish Film Institute in Stockholm, Sweden opened a large motion picture preservation facility which is maintained at 23°F (–5°C) and 40% RH.

In 1987, the National Museum of Modern Art in Tokyo, Japan, began operating a large cold storage facility for motion picture films. Part of the museum's Film Center-Archive in Fuchinobe, Japan, the two-story underground vault can accommodate 120,000 two-thousand-foot cans of 35mm film (approximately 22,000 feature films). One floor of the archive is used to store color film and is kept at 41°F (5°C) and 40% RH. The second floor is for black-and-white film and operates at 54°F (12°C) and 40% RH.

## George Eastman House Sets Aside Plans for a Critically Needed Cold Storage Vault in Its New $7.4 Million Archives Building

In late 1988 the International Museum of Photography at George Eastman House in Rochester, New York, completed construction of a new $7.4 million archives building. The original plans for the building called for a cold storage vault for the museum's priceless collection of historical and fine art color photographs; the vault was also to be used to store cellulose nitrate still-camera negatives (including a large number of nitrate negatives made by George Eastman, the founder of Eastman Kodak Company). Tentative specifications for the vault were set at 35°F (1.7°C) and 25% RH.

When the new building opened, however, the cold storage vault was nowhere to be seen. Despite protests from the conservation staff, plans for the vault had been set aside; apparently, dropping the vault was seen as a convenient way to reduce construction costs.

As a consequence of years of neglect, many of the early color prints and transparencies in the Eastman House collection have already suffered substantial image deterioration. The image stability of many of these early materials is very poor and, with no cold storage provided, deterioration continues at a steady rate. At the time this book went to press in 1992, the Eastman House color motion picture and still photograph collections continued to be stored — and to deteriorate — without adequate cold storage. It is earnestly hoped that Eastman House will find a way to correct this very unfortunate situation.

## Conclusion

The commitment to build and maintain a cold storage vault for preserving photographs has far-reaching implications. It tells the general public in no uncertain terms that the collections have lasting value — and that the institution will take whatever steps necessary to maintain them for generations far into the future.

Once a color photograph — or motion picture — has been placed in a low-temperature storage vault, it is very likely that it will be preserved forever. The longer the photograph is in a cold storage vault, the more significant it will become. Materials that have not been refrigerated will progressively fade until they become useless. Four or five hundred years from now, after most color photographs and motion pictures from this era have faded into oblivion, those relatively few refrigerated movies and photographs that remain in pristine condition will be so prized that their caretakers will see to it that they are refrigerated — at very low temperatures — forever.

Even if "perfect" electronic systems become available for recording and storing high-resolution photographs with no discernible loss of image quality, the original color photographs and motion picture films of the 20th century will continue to have great value as artifacts.

One can cite a number of important collections of color photographs that are now being preserved in humidity-controlled cold storage: Ektachrome transparencies photographed on the surface of the moon by astronauts Neil Armstrong and Edwin Aldrin on July 20, 1969, now securely stored in darkness at 0°F (–18°C) and 25% RH at the Lyndon B. Johnson Space Center in Houston, Texas (with backup sets of color duplicates stored under identical conditions at another site at the NASA facility in Houston, and at White Sands, New Mexico); and *Life* magazine's color photographs of Martin Luther King's nonviolent demonstrations in Selma, Alabama in 1965 (which led to the passage of the Voting Rights Act by Congress), now being preserved in the cold storage vault at the Time Inc. Magazines Picture Collection in New York City.

One can also cite the Ektachrome 35mm color slides photographed by the late Larry Burrows during the Vietnam War, preserved under refrigeration by the Larry Burrows Estate in New York City and by the Time Inc. Magazines Picture Collection; the Joel Meyerowitz and Stephen Shore Ektacolor 37 RC and 74 RC prints in cold storage at the Art Institute of Chicago; the Kennedy White House color negatives, preserved at 0°F (–18°C) and 30% RH at the John Fitzgerald Kennedy Library; the thousands of color movies in the Paramount Pictures, Warner Bros., and Turner Entertainment Co. film libraries; and the color motion pictures of the Stone Age Dani people of western New Guinea, filmed by Robert Gardner in 1961 and now preserved in cold storage at the Peabody Museum of Archaeology and Ethnology at Harvard University.

It is not wishful thinking to believe that these important color images from our time will be preserved, quite literally, forever.

## Notes and References

1. David Travis, curator of photography, Art Institute of Chicago, interviewed by this author in Chicago, Illinois, May 19, 1982. The conference referred to by Travis was a workshop conducted by this author and Klaus B. Hendriks, Director of the Conservation Research Division of the National Archives of Canada (at that time called the Public Archives of Canada), August 7–8, 1978; the workshop was

sponsored by the Baldwin Street Gallery of Photography, Toronto, Ontario. The Baldwin Street Gallery, one of Canada's first photography galleries, was founded in 1969 by American immigrants John Phillips and Laura Jones and continued in operation until 1979. An article by Gail Fisher-Taylor entitled "Colour – A Fading Memory?" and based on the presentations at the workshop was published in **Canadian Photography**, January 1979, pp. 10–11.

2. Lawrence F. Karr, ed., **Proceedings: Conference on the Cold Storage of Motion Picture Films,** American Film Institute and Library of Congress, Washington, D.C., April 21–23, 1980, p. 3.

3. The American Film Institute, **Moving Image Preservation – A Backgrounder** (press release for the inauguration of "The Decade of Preservation" program), the American Film Institute, Los Angeles, California, 1983.

4. Eastman Kodak Company, **Preservation of Photographs**, Kodak Publication No. F-30, Eastman Kodak Company, Rochester, New York, 1979, p. 39.

5. **ASHRAE Guide and Data Book: Fundamentals and Equipment for 1965 and 1966**, American Society of Heating, Refrigerating, and Air-Conditioning Engineers, New York, New York, pp. 411–412, 487, 489.

6. Peter Z. Adelstein, C. Loren Graham, and Lloyd E. West, "Preservation of Motion-Picture Color Films Having Permanent Value," **Journal of the SMPTE**, Vol. 79, No. 11, November 1970, pp. 1011–1018.

7. J. M. Calhoun, "Cold Storage of Photographic Film," **PSA Journal**, Section B: **Photographic Science and Technique**, Vol. 18B, No. 3, October 1952, pp. 86–89.

8. Henry J. Kaska, director, Public Information, Corporate Communications, Eastman Kodak Company, letter to this author, September 23, 1981.

9. David F. Kopperl and Charleton C. Bard, "Freeze/Thaw Cycling of Motion-Picture Films," **SMPTE Journal**, Vol. 94, No. 8, August 1985, pp. 826–827.

10. William O'Farrell, Conservation Branch, Technical Operations Division, National Archives of Canada (serving the Moving Image and Sound Archives Division), telephone discussions with this author, January 23, 1987 and March 11, 1987.

11. Paul Gordon, ed., **The Book of Film Care**, Kodak Publication No. H-23, Eastman Kodak Company, Rochester, New York, June 1983, p. 116.

12. Roland Gooes and Hans-Evert Bloman, "An Inexpensive Method for Preservation and Long-Term Storage of Color Film, " **SMPTE Journal**, Vol. 92, No. 12, December 1983, pp. 1314–1316. (Roland Gooes and Bengt O. Orhall gave an updated presentation on the FICA unit, "An Inexpensive Method for Preservation and Long-Term Storage of Colour Films," at the 128th SMPTE Technical Conference, New York City, October 24–29, 1986; an audio cassette of the presentation is available from the SMPTE.)

13. The Film Conditioning Apparatus (FICA) machine is available from the Swedish Film Institute: Svenska Filminstitutet, Box 27126, 10252 Stockholm 27, Sweden. The FICA machine is manufactured for the Swedish Film Institute by AB Film-Teknik, P.O. Box 1328, S-17126, Solna, Sweden; telephone: 01-146-827-2820 (Stephen Lund, worldwide marketing director).

14. Anthony Slide, "Sweden's Unique Film Institute," **American Cinematographer**, Vol. 68, No. 3, March 1987, pp. 80–84.

15. Paul Spehr, assistant chief of the Motion Picture, Broadcasting, and Recorded Sound Division, Library of Congress, telephone discussion with this author, November 5, 1986.

16. James H. Wallace, Jr., Smithsonian Institution, telephone discussion with this author, September 20, 1983.

17. Allan B. Goodrich, audiovisual archivist, John Fitzgerald Kennedy Library, telephone discussion with this author, February 14, 1985.

18. Daniel W. Jones, Jr., photographic archivist, Peabody Museum of Archaeology and Ethnology, telephone discussions with this author, April 13, 1987, October 5, 1987, and October 29, 1988.

19. Bruce Bonner, Jr., Harris Environmental Systems, Inc., telephone discussion with this author, February 21, 1985. The cost estimates are updated figures based on the typical vault designs and costs given by Bonner in "The Application of Environmental Control Technology to Archival Storage Requirements," presented at the **International Symposium: The Stability and Preservation of Photographic Images**, sponsored by the Society of Photographic Scientists and Engineers (SPSE), Ottawa, Ontario, August 30, 1982. SPSE is now known as the Society for Imaging Science and Technology (IS&T).

20. Records Center of Kansas City (RCKC), a division of Underground Vaults & Storage, Inc., P.O. Box 1723, Hutchinson, Kansas 67504-1723; telephone: 316-662-6769 (toll-free: 800-873-0906). The refrigerated vault in the Kansas City facility replaced a refrigerated vault leased to the MGM Film Library for many years at the Underground Vaults & Storage, Inc. facility located 600 feet underground in an abandoned section of a working salt mine in Hutchinson, Kansas. The Records Center of Kansas City also has available a microfilm and magnetic media storage vault with a temperature of 66°F (19°C) and 40% RH.

21. National Underground Storage, Inc., P.O. Box 6, Boyers, Pennsylvania 16020; telephone: 412-794-8474 (Fax: 412-794-2838).

22. Archisystems International, 1106 Broadway, Santa Monica, California 90401; telephone: 310-395-7088.

23. Eastman Kodak Company, 6700 Santa Monica Blvd., Hollywood, California 90038; telephone: 213-464-6131 (Fax: 213-464-5886).

24. Weston J. Naef, Curator of Photographs in the Department of Photographs at the J. Paul Getty Museum, Santa Monica, California, telephone discussion with this author, October 15, 1992.

## Additional References

John Alderson, "Preserving Photos at the Museum," **Chicago Sun-Times**, April 23, 1982, Photography Section, p. 12.

Anon., "Chicago Art Institute," **Photographs – A Collector's Newsletter**, Vol. 1, No. 4, June 1982, pp. 1–3.

Anon., "Cold Vault Keeps Film Color from Fading," **Harvard University Gazette**, Vol. LXXVI, No. 29, April 10, 1981, pp. 1, 7.

Anon., "Calm, Very Cool, and Collected . . . to Save Film Legacies," **Technology and Conservation**, Spring 1981, pp. 5–6, 8.

Alan G. Artner, "Art Institute Builds Top Home for Photos," **Chicago Tribune**, April 18, 1982, Arts and Books Section.

David Elliott, "A New Beginning for Photography at the Art Institute," **Chicago Sun-Times**, April 18, 1982, Show Section, p. 2.

David Elliott, "A Collectors' Collection at Art Institute," **Chicago Sun-Times,** April 23, 1982.

Douglas Davis and Maggie Malone, "Chicago's Picture Palace," **Newsweek,** May 17, 1982, pp. 108–109.

FIAF (Federation Internationale des Archives du Film), **A Handbook for Film Archives** edited by Eileen Bowser and John Kuiper, FIAF, Coudenberg 70, B–1000, Brussels, Belgium, 1980.

FIAF (Federation Internationale des Archives du Film), **The Preservation and Restoration of Colour and Sound in Films,** FIAF, Coudenberg 70, B-1000, Brussels, Belgium, 1981.

Allan B. Goodrich, "Audiovisual Records at the John F. Kennedy Library: A Profile," **Picturescope**, Vol. 28, No. 3, Fall 1980, pp. 6–7.

Allan B. Goodrich, "Is Color Fugitive?" **History News**, December 1977, pp. 341–342.

Andy Grundberg, "A Museum Puts Its Color Prints on Ice," **The New York Times**, July 18, 1982, pp. H25–26.

Christopher Lyon, "Not Fade Away: Making Sure That Art Endures," **The Reader**, April 22, 1982.

Munters Cargocaire, **The Dehumidification Handbook – Second Edition,** 1990. Cargocaire Engineering Corporation, 79 Monroe Street, P.O. Box 640, Amesbury, Massachusetts 01913-0640; telephone: 508-388-0600 (toll-free: 800-843-5360); Fax: 508-388-4556.

William Poe, "Preservation of Research Sources: Film and Videotape," **Humanities Report**, Vol. 3, No. 10, October 1981, pp. 13–17.

A. Tulsi Ram, D. Kopperl, R. Sehlin, S. Masaryk-Morris, J. Vincent, and P. Miller [Eastman Kodak Company], "The Effects and Prevention of 'Vinegar Syndrome'," presented at the **1992 Annual Conference of the Association of Moving Image Archivists**, San Francisco, California, December 10, 1992.

Douglas Severson, "Temperature and Humidity Conditions in the Photography Collection at the Art Institute of Chicago" (Information Sheet), Art Institute of Chicago, Chicago, Illinois, January 10, 1983.

David E. Sanger, "Kennedy Library: A New Hit in Boston," **The New York Times**, December 16, 1979, Sec. 10, pp. 1, 15.

William Widmayer, "Cold Storage Protects Color Negatives," **American Cinematographer**, March 1961.

Henry Wilhelm, "A Cost-Effective Approach to the Long-Term Preservation of Color Motion Pictures," a presentation at the **123rd Conference and Equipment Exhibit of the Society of Motion Picture and Television Engineers** (SMPTE), Los Angeles, California, October 25–30, 1981.

# Suppliers

## Equipment and General Contractors for Humidity-Controlled Cold Storage Facilities

**Bonner Systems, Inc.**
7 Doris Drive – Suite 2
N. Chelmsford, Massachusetts 01863
 Telephone: 508-251-1199
  (Bonner is recommended by this author
  as a designer and general contractor for
  humidity-controlled cold storage vaults.)

**Turner Construction Company**
375 Hudson Street
New York, New York 10014
 Telephone: 212-229-6000
  (Turner is recommended by this author as a general
  contractor for large, humidity-controlled cold storage
  installations and archive buildings.)

**Archisystems International**
1106 Broadway
Santa Monica, California 90401
 Telephone: 310-395-7088
  (Archisystems is recommended by this author as an architect
  for large, humidity-controlled cold storage buildings.)

**Harris Environmental Systems, Inc.**
11 Connector Road
Andover, Massachusetts 01810
 Telephone: 508-475-0104

**Cargocaire Engineering Corporation**
79 Monroe Street
P.O. Box 640
Amesbury, Massachusetts 01913
 Telephone: 508-388-0600
  (Cargocaire is recommended by this author as a
  manufacturer of dry-desiccant dehumidifiers for
  humidity-controlled cold storage vaults and buildings.)

**Bally Engineered Structures, Inc.**
P.O. Box 98
Bally, Pennsylvania 19503
 Telephone: 215-845-2311

**Kester/Dominion Refrigeration Corporation**
2929 Eskridge Road, Suite P-3
Fairfax, Virginia 22031
 Telephone: 703-560-6644

**Southeast Cooler Corporation**
1520 Westfork Drive
Lithia Springs, Georgia 30057
 Telephone: 404-941-6703
 Toll-free: 800-241-9778 (outside Georgia)

**North Brothers Company**
P.O. Box 105557
Atlanta, Georgia 30348
 Telephone: 404-622-4611

## Vapor-Proof, Heat-Sealable Bags for Cold Storage

**Conservation Resources International, Inc.**
8000-H Forbes Place
Springfield, Virginia 22151
 Telephone: 703-321-7730
 Toll-free: 800-634-6923 (outside Virginia)
  (large quantities only)

**Light Impressions Corporation**
439 Monroe Avenue
Rochester, New York 14607-3717
 Telephone: 716-271-8960
 Toll-free: 800-828-6216
  (several sizes; available in small or large quantities)

**Quality Packaging Supply Corporation**
24 Seneca Avenue
Rochester, New York 14621
 Telephone: 716-544-2500
  (custom-made; flexible packaging)

**Shield Pack, Inc.**
411 Downing Pines Road
West Monroe, Louisiana 71292
 Telephone: 318-387-4743
 Toll-free: 800-551-5185 (outside Louisiana)
  (custom-made; large quantities only)

# INDEX

This index was compiled by Rus Caughron for Carlisle Publishers Services, and was edited by John Wolf, Henry Wilhelm, and Carol Brower. Many of the color films, color papers, and other products appear in this book far too many times to be able to include all page references. The reader is referred to the Table of Contents (pages viii and ix) for additional guidance on where to find image stability data and other information for specific products.

Note especially the recommendations for the longest-lasting color films, color papers, and digital printing systems listed in Chapter 1 (pages 3–6). In addition, special recommendations sections can be found in most chapters (see Table of Contents for "Recommendations" page numbers). Also refer to the "Suppliers" lists located at the end of Chapters 4, 8, 12, 14, 15, 16, 18, and 20 for the names, addresses, and telephone numbers of manufacturers, distributors, and other sources of products.